NATIONAL GALLERY CATALOGUES

THE SIXTEENTH CENTURY
ITALIAN PAINTINGS

VOLUME II
Venice 1540–1600

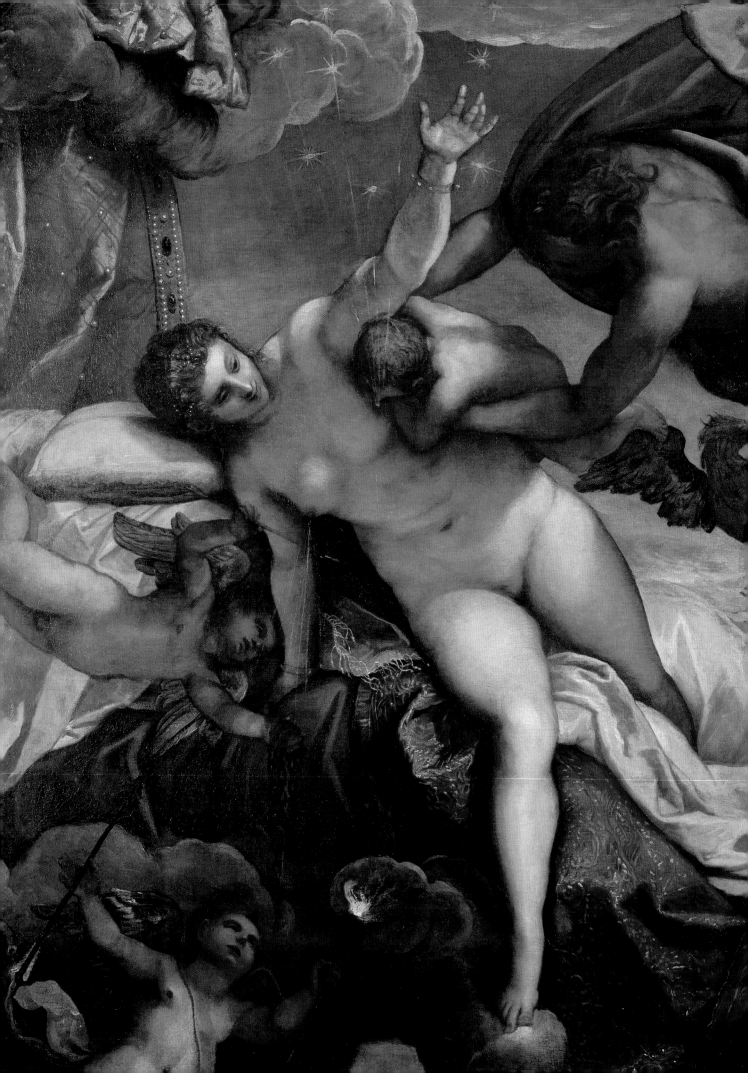

NATIONAL GALLERY CATALOGUES

THE SIXTEENTH CENTURY ITALIAN PAINTINGS

VOLUME II
Venice 1540–1600

Nicholas Penny

National Gallery Company, London

Di 3 1901 04437 8778 ity Press

This catalogue has been funded with a grant from the American Friends of the National Gallery, made possible by a generous donation from Arturo and Holly Melosi through the Arthur and Holly Magill Foundation

For Mary

First published in Great Britain in 2008 by
National Gallery Company Limited
St Vincent House, 30 Orange Street, London WC2H 7HH
www.nationalgallery.co.uk

ISBN 978 1 85709 913 3 hardback
525005

British Library Cataloguing-in-Publication Data
A catalogue record is available from the British Library
Library of Congress Catalog Card Number: 2007943641

Project manager: Jan Green
Edited by Diana Davies
Designed by Gillian Greenwood
Typeset by Helen Robertson
Picture researcher: Karolina Majewska
Production: Jane Hyne and Penny Le Tissier

FRONTISPIECE: Tintoretto, *The Origin of the Milky Way* (NG 1313), detail
PAGE VI: Tintoretto, *Saint George and the Dragon* (NG 16), detail
PAGE XII: Veronese, *The Consecration of Saint Nicholas* (NG 26), detail
PAGE XXVI: Veronese, *The Family of Darius before Alexander* (NG 294), detail

Printed and bound in Italy by Conti TipoColor

Contents

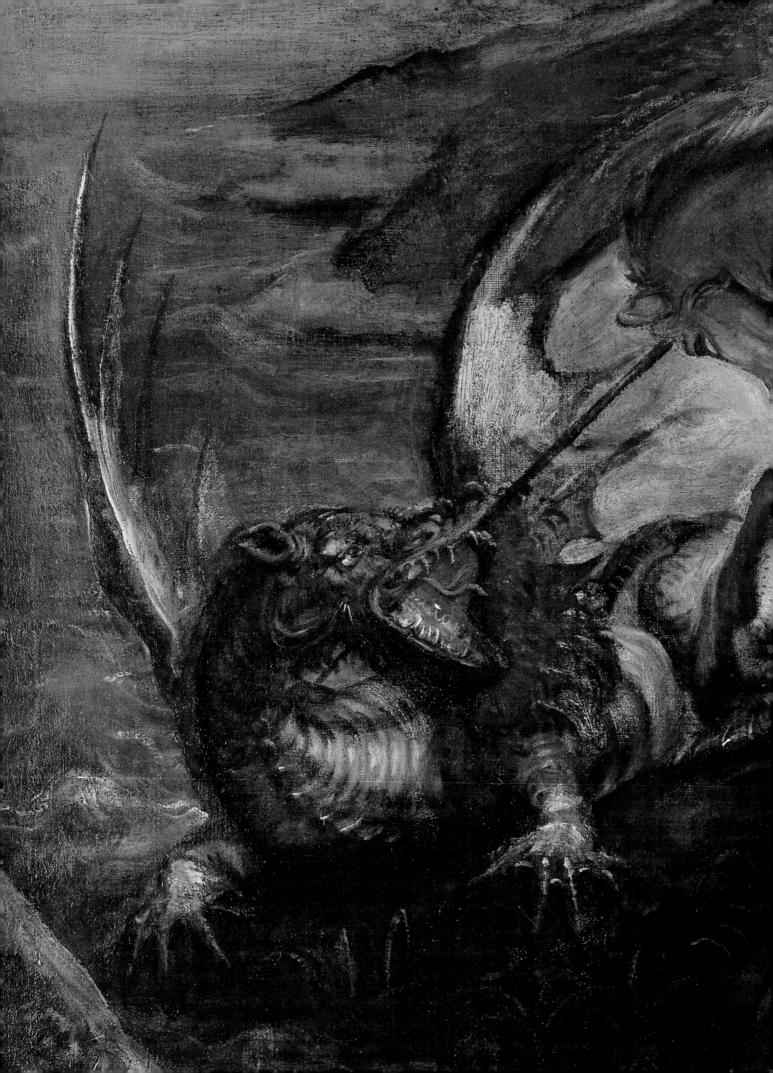

Director's Foreword

The series of catalogues published in the decades after 1945 are one of the proudest traditions of the National Gallery. Internationally acclaimed, they are exemplary in their succinct presentation of fact and cautious advancement of hypothesis. Yet all Gallery catalogues need to be constantly updated, rewritten and republished. We must keep pace with new acquisitions and with what has been learnt and revealed during conservation work. We need to incorporate new information about the pictures and their painters resulting from continuing scholarly research. Advances in techniques of scientific examination have, over the past forty years, transformed our understanding of how many pictures were made. Finally, new methods of photography and reproduction have ensured that the publications in this latest series are distinguished by the clarity and accuracy of their colour plates, technical photography, enlargement of details and comparative illustrations.

As Nicholas Penny observes in the Introduction to this volume, Veronese's altarpiece of the *Consecration of Saint Nicholas* can be claimed as the first old master painting to be acquired for the National Gallery, even though the Gallery had not then been founded. The group of collectors and connoisseurs within the British Institution who purchased this painting were much influenced by Napoleon's Louvre, the magnificence of which made a great impression on visitors to Paris during the early years of the nineteenth century.

Hardly less influential, however, was the memory of the dispersal in London of the other great public collection in Paris, that of the Ducs d'Orléans, of which a full account is provided in an appendix here. The paintings by the great Venetians Titian, Veronese and Tintoretto formed perhaps the most impressive group in the Orléans Collection and many of them eventually found their way to the National Gallery. The special admiration accorded to these artists, and the prestige of the Venetian school generally, has always been clearly reflected in the National Gallery and was confirmed by the single greatest triumph of the Gallery's first director, Sir Charles Eastlake: the acquisition of Veronese's *Family of Darius*, described here in fuller detail than ever before.

This catalogue is rich in information concerning the triumphs as well as the failures of the Gallery's directors and trustees. If a director (Eastlake) was chiefly responsible for the acquisition of Veronese's *Family of Darius*, then the trustees must take credit for the other great triumph, the acquisition of Titian's *Vendramin Family* from the Duke of Northumberland. The history of Titian's great painting is also of interest because it was imported into Britain shortly before the Civil War, when King Charles I and his courtiers were forming the earliest notable collections of old masters ever seen in this country. There is in fact no part of the National Gallery in which King Charles would have felt more at home than the galleries in which the paintings catalogued here are hung, not only because of the Titians, Veroneses and Tintorettos but because of the works by Bordone, Palma Giovane, Schiavone and the Bassano family, who were perhaps more highly esteemed in his day than in ours.

The material presented here about individual works of art is greatly enlivened by Nicholas Penny's scholarly insights into the making of the paintings, the patrons for whom they were made, the tastes which dictated their acquisition by the Gallery, and the pen portraits of the collectors themselves, and the National Gallery is greatly indebted to him for completing this catalogue while employed by our sister institution in Washington.

Publications of this kind are, needless to say, extremely expensive to produce and must be subsidised if they are to be made available at prices affordable not just by libraries and specialists but by a wider interested public and by students. The Gallery is delighted to report that a succession of benefactors have made it possible to publish and print these catalogues to ever rising standards, for sale at moderate prices. For this, our thanks, and the thanks of all those who use and enjoy these catalogues, are due to a distinguished company of donors, ranging from corporations such as Unilever and the British Land Company plc, through charitable organisations such as the Getty Grant Program and the American Friends of the National Gallery, to individual friends and supporters such as Anthony Speelman. Our latest, and perhaps our greatest, debt of gratitude is to Arturo and Holly Melosi, whose magnificent generosity, through The Arthur and Holly Magill Foundation, has secured the future for the rest of this series of National Gallery catalogues.

Charles Saumarez Smith
DIRECTOR, JULY 2007

Acknowledgements

Although I began work on this catalogue fifteen years ago, I only made significant progress drafting entries when I was able to take two months' study leave from the Gallery in 1998. This was possible because Burton Fredericksen, Director of the Provenance Index, invited me to be a guest of the Getty Research Center. Both he and Carol Togneri have been of great assistance to my investigation of the history of collections, and Julia Armstrong-Totten, who remained working for the Index (now called The Project for the Study of Collecting and Provenance) until recently, has also often helped me, especially in my work on the Orléans Collection.

Burton Fredericksen was also one of the two outside readers of this catalogue. The other was Charles Hope. Both have saved me from errors and pointed out important omissions. I am honoured to have had such eminent scholars examine my work with such diligence. I have conceived of the catalogue as something which can be consulted, not only for basic information concerning a painting – exactly when it was made and by whom, who or what is represented in it, who has owned it – but also for an account of how the painting was understood and valued, how presented, reproduced and imitated, and in what setting and company and for what purpose. I have been much influenced in this by the late Francis Haskell who was, appropriately, a close friend of both my readers.

More progress was made on this catalogue during my two years as Andrew W. Mellon Professor at the Center for Advanced Study in the Visual Arts at the National Gallery of Art, Washington, between September 2000 and September 2002. I am most grateful to Henry A. Millon, Dean of the Center, and Earl. A. Powell III, Director of the National Gallery of Art, for appointing me to this professorship, and to Elizabeth Cropper, Dean during much of the time I was at the Center, for her warm support.

Much was done for me during those years by my research assistant Mary Pixley, and by my staff assistant Martha McLaughlin, and although my priority was to complete the first volume of the catalogue of sixteenth-century Italian paintings, devoted to the painters of Brescia, Bergamo and Cremona, I continued working on Venetian artists of the second half of the century. I found that I was not able to cease doing so after I had decided to accept the post of Senior Curator of Sculpture and Decorative Arts, even though I could only devote myself to such work during the evenings and at weekends. Since everything I write is carefully revised by Mary Wall, I have to thank her for much more than tolerating the absorption which this work has entailed.

I have discussed aspects of this catalogue with curatorial colleagues in London – Xavier Bray, Lorne Campbell, Susan Foister, David Jaffé, Luke Syson and Humphrey Wine – as well as with assistants in the curatorial department who have since left, notably Ann Thackray, Susan Jones and Giorgia Mancini. My greatest debt by far is to Carol Plazzotta, in whose care these paintings were placed when I left the Gallery. She read all the entries and made numerous improvements to them. Long before that I discussed many of them with her. She also undertook, over a decade ago, some of the research on the Vendramin family, on the Church of S. Silvestro and on two of the confraternities that commissioned paintings catalogued here. Some of the ideas advanced here were first adumbrated in *Dürer to Veronese* (published in 1999), which I wrote with Jill Dunkerton and Susan Foister, and much of the technical information on the paintings given in this catalogue is best understood in the context of the discussion of how paintings were made in the sixteenth century that Jill Dunkerton contributed to that volume.

Special photography for many details of the paintings reproduced here was supplied by Astrid Athen, Rachael Fenton, Colin Harvey and Colin White of the Photographic Department.

A number of the paintings were examined by me with Martin Wyld, Director of Conservation. More were examined with Jill Dunkerton. It is impossible for me now to recall exactly which of the observations on condition and technique should really be credited to them. What I cannot forget is how much I learned from the experience of looking at the paintings with them. Jill has, in addition, read the entire text, together with Marika Spring of the Scientific Department. They have greatly clarified the technical sections. I am indebted to other members of both departments. Ashok Roy, Director of Scientific Research, helped to take numerous samples, to examine them and to re-examine old ones. Rachel Billinge made available her special experience in the field of infrared reflectography.

Working at a distance I have been especially dependent upon the Department of Libraries and Archive in the National Gallery. Elspeth Hector, the department head, and her staff past and present, especially David Carter, Philip Clarke, Jessica Collins, Alan Crookham, Flavia Dietrich-England, Nicola Kennedy and Jacqui McComish, have both patiently and promptly answered dozens of questions. The notes on arms and armour commissioned by me from Claude Blair for the Gallery's records should be mentioned. So too should the frame survey conducted by Paul Levi (with my assistance) during the 1990s. I am also grateful to John England, formerly Head of Framing in the Gallery, who looked at many frames

with me or for me, and to Hazel Aitken for help locating the frames in retirement or disgrace, which get lost so easily, and the records concerning them, which can also be elusive. I have also of course made much use of the superb library in the National Gallery of Art and in this I received much help from Timothy Chapin.

I notice that Cecil Gould, half a century ago, received much help from Dr Zago of the Archivio di Stato in Venice. I must thank Paola Benussi, one of his successors, for rapid assistance at a late stage in the preparation of the catalogue, and also Linda Borean, for contacting her on my behalf and also for sharing, for over a decade, her discoveries about Venetian collections. Work on these collections is now being undertaken systematically by Dr Borean and her colleagues at the University of Udine, directed by Stefania Mason, and all future catalogues of Venetian art will greatly benefit from this.

Numerous villas which it is not normally possible to visit, and churches and other religious buildings not easy to reach, were inspected by me together with Giuliana Ericani, now director of the museum in Bassano. Many Venetian collections and historic interiors were opened to me by the influence of Roberto De Feo, or at the instigation of the late Sandro Bettagno and of Giuseppe Pavanello. Thomas Worthen and Victoria Avery helped me with the pursuit of archival enquiries. In Milan Marco Brunelli kindly let me study a painting in the Rasini collection. In Rome Kristina Hermann Fiore showed me paintings in the reserve of the Galleria Borghese and Antonello Cesareo arranged for me to see paintings not on exhibition in Palazzo Barberini. In Paris Jean Hubert showed me work undergoing restoration. In Berlin Roberto Contini was especially hospitable and helpful in responding to enquiries, as was Irina Artemieva in St Petersburg, and many other curators in public collections which I have visited all over Europe and North America.

In Britain I have visited many collections and exhibitions of Venetian paintings in the stimulating company of Larissa Salmina Haskell. I am grateful to Terence Suthers of the Harewood House Trust for letting me consult papers and study paintings more closely with the assistance of May Redfern. Jeremy Warren let me consult material in the Wallace Collection archives. Paul Tucker copied for me the letters by Fairfax Murray which he had transcribed. Thomas Tuohy showed me draft entries for his projected book on British collecting. Xavier Salomon shared with me a discovery of his concerning a drawing by Veronese. Roger Bowdler showed me his notes of the bank account of the third Earl of Darnley and also took me on an instructive visit to Cobham Hall. The Duke of Hamilton kindly arranged for some of his family papers to be studied by me in the National Archive of Scotland. The Earl of Crawford and Lord and Lady Balneil let me consult some of the papers at Balcarres. Simon Howard and his librarian Christopher Ridgeway let me consult those at Castle Howard. I have also received much assistance from the staff in public archives; Thea Randall in the Staffordshire Record Office was especially helpful. But in this area of research my greatest debt has been to Alastair Laing, who drew to my attention some important documents relating to the collection of the Earl of Bradford and went with me to Weston Park, where William Mostyn Owen and Jane Martineau ensured that we were able to look closely at all the pictures. He also sent me a transcript of Alexander Hume's will. Michael Burrell not only helped me to interpret this document but also supplied much other important information about Hume's collection.

Alison Benedetti, Elizabeth Concha and Rachel Schulze typed my handwritten text. For other assistance, the specific nature of which I have in some cases forgotten, I must thank the following: Christopher Apostle, Andrea Bayer, Joe Bettey, Jonathan Bober, Giovanna Brambilla, Michael Bury, Charles Cator, Faya Causey, Hugo Chapman, Keith Christiansen, Frances Clarke, Philip Conisbee, John Davidson, Eric Denker, Sylvia Ferino, Sarah Herring, Michael Hirst, Hugh Honour, Cecily Langdale, Alison Luchs, Giorgio Marini, Paola Marini, Suzanne Folds McCullagh, Mitchell Merlin, Louise Rice, John Rich, Francis Russell, Eike Schmidt, Karen Serres, Richard Shone, Letizia Treves, Johanna Vakkari, Wendy Watson, Aidan Weston-Lewis.

Lastly, I must mention those living scholars whose published work on Venetian painters I have frequently consulted: Alessandro Ballarin, Richard Cocke, Paul Hills, Charles Hope, Peter Humfrey, Frederick Ilchman, Paul Joannides, Mauro Lucco, Stefania Mason, David Rosand. With several of the aforementioned I have had helpful discussions about the paintings catalogued here, but none has been more helpful than those I had with the late Roger Rearick, whose insights I always found to be remarkable, even if I sometimes disagreed with his conclusions. Lastly, I should note how impressed I have been by the lectures given by Jennifer Fletcher, some of them first heard thirty years ago, which so vividly recreated the historical circumstances of Renaissance Venice and were so sympathetic to the personalities of the leading artists and to their art.

I wish I could consider that I have deserved the zeal and patience with which Jan Green has coordinated every aspect of this catalogue's production, the care which Diana Davies has given to editing the text, the energy and good humour that Karolina Majewska has expended on obtaining the illustrations, and the imagination and taste that Gillian Greenwood has applied to every aspect of design. Special thanks are also owed to Helen Robertson, typesetter, whose dedication to accuracy has saved me so much trouble. I can only hope that all these colleagues feel, as I do, that it is their book as well as mine.

Nicholas Penny

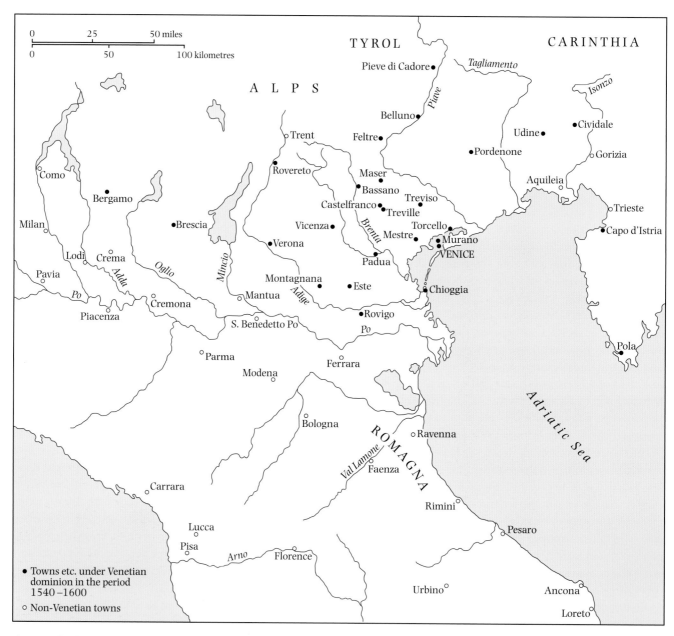

The area of Italy ruled by Venice had been subject to dramatic change earlier in the sixteenth century but was relatively stable during the period covered by this catalogue. The neighbouring states to the south were the Duchies of Ferrara and Mantua; to the west lay the extensive Duchy of Milan governed by a Spanish viceroy; to the north was the still more extensive but less cohesive Holy Roman Empire. Some small places of great artistic importance (such as S. Benedetto Po and Maser) are included, as well as major towns.

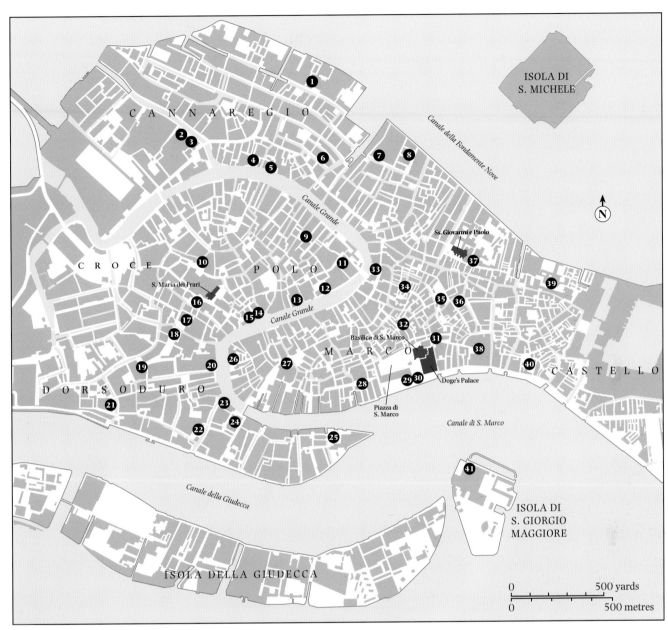

Central portion of the city of Venice showing the city's canals and main pedestrian routes today. Among other changes it should be noted that many canals have been filled in since the sixteenth century and there was then only one bridge across the Grand Canal (that at Rialto near no. 33). The bridges for the railway and for motor vehicles, top left, are obviously also modern.

CHURCHES
I Carmini (19)
Madonna dell'Orto (1)
S. Cassiano (9)
S. Catarina (7)
S. Francesco della Vigna (39)
S. Giorgio Maggiore (41)
S. Giovanni in Bragora (40)
S. Giovanni Elemosinario (11)
S. Giuliano (S. Zulian) (32)
S. Lio (S. Leone) (34)
S. Marcuola (4)
S. Margherita (site of) (18)
S. Maria dei Derelitti (Chiesa dell'Ospedaletto) (37)
S. Maria Formosa (35)

S. Maria della Salute (25)
S. Moisè (28)
S. Pantaleone (17)
S. Sebastiano (21)
S. Silvestro (12)
S. Stefano (27)
S. Trovaso (SS. Gervasio e Protasio) (22)
S. Zaccaria (38)

CONFRATERNITY BUILDINGS
Ospedale dei Crociferi (8)
Scuola della Carità (24)
Scuola Grande di S. Giovanni Evangelista (10)
Scuola Grande di S. Rocco (16)

PALACES AND PUBLIC OFFICES
Biblioteca Marciana (30)
Ca' Rezzonico (20)
Fondaco dei Tedeschi (33)
Palazzo Barbarigo alla Terrazza (14)
Palazzo Contarini / Besarel (23)
Palazzo Cuccina (Coccina) / Papadopoli (13)
Palazzo Grassi (26)
Palazzo Grimani at S. Maria Formosa (36)
Palazzo Manfrin / Venier (3)
Palazzo Pisani Moretta (15)
Palazzo Savorgnan / Galvagna (2)
Palazzo Trevisan in Canonica (31)
Palazzo Vendramin / Calergi (5)
Palazzo Vendramin at S. Fosca (6)
Zecca (Mint) (29)

Introduction

The Venetian School and Foreign Influence

The paintings catalogued in this volume were all made by artists who were active in Venice between 1540 and 1600. Among them only Jacopo Tintoretto, his son Domenico and Palma Giovane were Venetian by birth. Titian, Bordone, Veronese and Mazza came to work in Venice from the *terra ferma*. Schiavone came from one of the Venetian colonies, Giuseppe Salviati from Rome, Sustris and Paolo Fiammingo from the Low Countries. Only Jacopo Bassano, of the artists whose work is catalogued here, never lived in Venice, but he was represented in the city by his sons, three of whom settled there.

By 1600 a Venetian 'school' of painting was recognised by collectors in distant parts of Europe. Artists who saw themselves as heirs to the traditions of Venetian painting represented by Giorgione, Titian, Veronese and Tintoretto thrived in Venice during the seventeenth and eighteenth centuries. The first of these was, arguably, Palma Giovane. Although Venetian writers on art, always close to the marketplace, emphasised what was distinctively Venetian about the city's art, and were not wrong to do so, it is worth recalling that the greatest critical writing on art in sixteenth-century Venice, Lodovico Dolce's *L'Aretino*, strove to portray Titian as the successor of Raphael. And Veronese's great painting *The Family of Darius* – which for Goethe epitomised Venetian life and culture as well as painting[1] – must originally have seemed as novel to his patrons as the architecture of Sansovino, and, in some respects, like that architecture, also Roman.

Indeed, throughout the period 1540–1600 artistic developments which had originated in Rome shortly before or after Raphael's death had a strong influence on Venetian art. Sustris had studied the fictive architecture of the frescoes in the Villa Farnesina and the erudite urban stage set which Raphael had employed for his *Fire in the Borgo*. The prints of Raphael's compositions were the single greatest influence on the early work of Jacopo Bassano. Schiavone, himself a print-maker, imitated the etchings by Parmigianino and introduced into Venice the ethereal elegance of that artist's figure style, as well as the bravura fluency of his painting. Raphael's pupil Giulio Romano designed and directed schemes of decoration in Mantua that were taken up by Veronese,[2] which in turn influenced the highly successful *quadratura* paintings by Cristoforo and Stefano Rosa of Brescia (few of which now survive[3]), and provided the models for the radical foreshortening adopted by both Titian and Tintoretto in the 1540s. Artists came to Venice from Rome at regular intervals in those years, and their work was carefully studied.

Types of Painting

All the greatest artists who were active in Venice during the period 1540–1600 are represented in this catalogue, as are all the major types of painting that flourished there. Several altarpieces – Veronese's *Consecration of Saint Nicholas*, Bassano's *Way to Calvary* and Tintoretto's *Saint George and the Dragon* – illustrate the increasing tendency for this type of devotional painting to employ narrative. Veronese's large *Adoration of the Kings*, closely related to an altarpiece that was painted for a church in Vicenza, and sometimes itself mistaken for an altarpiece, represents a distinctively Venetian type of painting: a large sacred narrative made for the nave wall, often (as in this case) commissioned by a confraternity.[4] Narrative paintings of a landscape format were also favoured for the side walls of confraternity chapels in Venice – Tintoretto's *Christ washing the Feet of the Disciples* is an example.

Fresco painting was more commonly practised in Venice than is commonly realised today, and the reputations of both Titian and Tintoretto were originally established by their work in this medium. Veronese and Salviati also worked extensively in fresco, and their palette may owe something to this. But frescoes were less significant for the decoration of the interiors of major public buildings in the city of Venice than was the case in Florence or Rome. The *Allegories of Love* by Veronese, the *Rape of Ganymede* by Mazza, the *Justice* by Giuseppe Salviati and the anonymous heroic spandrel figure in this catalogue are all examples of pictures which elsewhere in Italy would probably have been painted in fresco.

An easily neglected but important type of painting which is remarkably well represented in this catalogue is that of furniture decoration. In the minds of most art historians small pictures, usually narratives, made for chests, benches and beds, or to fit into wainscots, are associated with Tuscany in the fifteenth and early sixteenth centuries; the paintings made for the Borgherini bedchamber are among the last major examples.[5] Venetian furniture paintings were almost always converted into gallery paintings at a later date and it is very often hard to imagine how they originally looked. However, it is not uncommon to find sixteenth-century walnut chests, which are similar in style to the woodcarvings that have remained *in situ* in sacristies and the like, and such chests often include blank compartments that must once have contained paintings (fig. 1).

The stories of the Rape of Europa, Venus and Adonis, Diana and Callisto, and Diana and Actaeon were all painted as furniture decorations before they became the subjects of larger canvases by Titian and Veronese. Naturally, much furniture painting was routine and there are examples of this in the

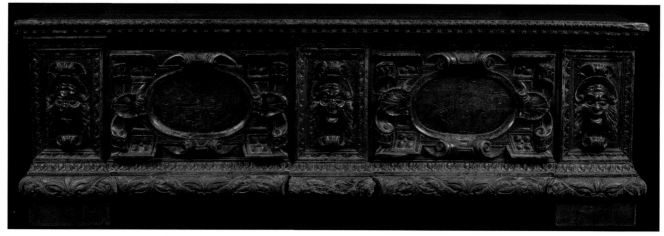

Fig. 1 Venetian late sixteenth-century walnut chest, 55 × 167 × 53 cm. London, The National Gallery.

National Gallery. But it seems possible that patrons of such small works were more prepared to indulge experimental styles of painting. The wooden scrolls that surrounded Schiavone's paintings must have been the same size as or larger than his figures and this must have emphasised the ornamental style in which they are painted. At the same time his soft and indefinite brushwork would have contrasted with the sharp chiselling of the wood.

The period covered by this volume saw the establishment of two related types of painting that became steadily more dominant in subsequent centuries: the gallery picture and the cabinet picture. Titian's *Venus and Adonis* and *Death of Actaeon* are examples of the first category, and Veronese's small *Rape of Europa* is an example of the second. Many of the pictures by the Bassano family that were made in pairs or as part of a larger series must also be considered in these categories. Some of them were commissioned but others (probably the majority) were made for the market. They may often have served as overdoors and thus responded to new ideas in interior decoration as well as to the needs of collectors.

In this period large paintings began to be employed as diplomatic gifts for great rulers. Bronzino's *Allegory* (NG 651) was made for presentation to the King of France and it must have been seen by Paris Bordone when, later in the century, he was working at the French court and produced similarly contrived and erotic compositions.[6] It is likely that Tintoretto's mythological allegory *The Origin of the Milky Way* was sent to the Holy Roman Emperor as some sort of present. The full allegorical significance of such paintings was likely to be ephemeral, or at least topical, but they were surely intended to be incorporated into the decoration of state rooms.

Veronese's *Family of Darius* was not a gallery picture. It was first recorded hanging in a villa where it must have been the chief feature of a large room, and since the subject had been favoured for fresco decorations in villas it seems likely that this painting was considered as a substitute for a fresco. Perhaps the pressure of business in Venice made it hard for

Veronese to leave the city; perhaps he felt that he could achieve much more in oil paint. In the following century, when the *Family of Darius* was taken to the Pisani palace in Venice, it exerted a huge influence on the history paintings made for palaces there, in particular for the great central hall, or *portego*, of such palaces.

Considerable space is devoted in the long entry for Titian's *Vendramin Family* to the ways in which the *portego* seems to have been decorated during the sixteenth century.[7] Large paintings which included the patron's family as witnesses to a religious scene or narrative seem to have been favoured for this setting. So too, probably, were paintings of the shepherds adoring the newborn Christ. In a large canvas by Bonifazio de' Pitati all five adult shepherds adoring the infant Christ must be portraits – exceptionally animated and characterful portraits – of the male members of a Venetian family (fig. 2). *The Vendramin Family* is a related type of group portrait, although it belongs to an older tradition of votive painting made for public buildings. These were sometimes domestic as well as official – at least, that is the case with Jacopo Bassano's early painting of Matteo Soranzo, podestà of Bassano, made for the Sala del Consiglio of the Palazzo Pretorio in that city in 1536, which includes his daughter playing with a dog upon the steps of the Virgin's throne (fig. 3).

The Vendramin Family includes some great portraits, but not long after it was completed Titian began to take markedly less interest in this genre. Portraiture remained very important in Venice but it cannot be denied that most of the independent portraits of this period are rather dull, especially compared with those made in the first half of the sixteenth century, when so many new ideas in portraiture were being developed. Social decorum, following the direction of religious orthodoxy, seems to have become more firmly codified. Paintings of beauties in lascivious undress continued to be made after 1540, however, and were something of a speciality of Paris Bordone.

The entries that follow include much information about the churches and palaces for which the paintings were made,

and more about some of the subjects of the paintings than will usually be found in a catalogue of this kind. Thanks to the success of paintings by Titian and Veronese, the Rape of Europa became one of the great subjects of European art. The subject of Venus trying to detain Adonis from the hunt – a subject which actually seems to have been invented by Titian – enjoyed extraordinary popularity for two hundred years after Titian. More gradually, the Family of Darius came to be a subject akin to that of Orpheus in operas by composers from Monteverdi to Gluck, that is to say, one chosen (often by artists) to encourage comparison, as an act of homage or, paradoxically, as a demonstration of originality.

Royal Collections and Connoisseurship

When we first hear of Titian's *Vendramin Family* being for sale in Venice it was suggested that the King of England, Charles I, was interested in acquiring it. This may have been a ruse to circumvent some legal obstacles to its sale, but it is certainly true that the king was a great admirer of Titian's paintings. One of the works attributed to Titian that came to the Palace of Whitehall with the collection of the Duke of Mantua is the *Concert* catalogued here as the work of an imitator. This might be taken to illustrate the limitations of connoisseurship in this area of art at the Stuart court, but the knowledge of Venetian painting possessed by Van Dyck, the Earl and Countess of

Fig. 2 Bonifazio de' Pitati, *The Adoration of the Shepherds*, c.1530. Oil on canvas, 173 × 248 cm. Private collection, on loan to Mount Holyoke College Art Museum, Massachusetts.

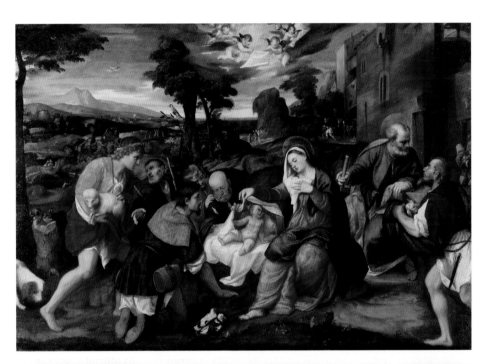

Fig. 3 Jacopo Bassano, *Matteo Soranzo with his Family presented to the Virgin and Child*, 1536. Oil on canvas, 153 × 249 cm. Bassano del Grappa, Museo Civico.

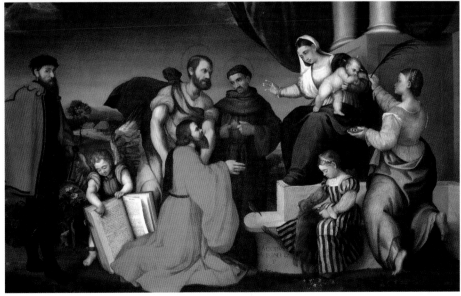

Arundel and Inigo Jones is likely to have surpassed that which was available in London for more than a century after the execution of King Charles I.

The circumstances in which Bassano's *Way to Calvary*, which had been presented to King Charles II, was allowed to leave the royal collection reveal how completely the situation had changed by the late seventeenth century. But at least one courtier – the Earl of Bradford, to whom an appendix is dedicated here – had a clear understanding of the merit of this work. The fact that this painting came to be considered as the work of Veronese during the eighteenth century is suggestive of a decline in the reliable connoisseurship in Venetian art. Genuine works by Veronese did enter the country around 1700 (*The Dream of Saint Helena* and *Christ healing a Woman with an Issue of Blood* in this catalogue are examples), but uncertainty about Veronese's work may have discouraged George III's zeal as a collector.

When, in 1764, a large canvas supposed to be by Veronese was spread upon the floor in Buckingham House, the king, having used a wet sponge 'to examine it with more advantage', turned to his librarian, Richard Dalton, who had had the painting sent to London, and asked him if he knew any artist conversant with the works of Veronese. The engraver Francesco Bartolozzi (1727–1815) was named. He had worked in Venice for nearly thirty years before coming to London at Dalton's behest. The king insisted on his being summoned immediately. 'Upon his appearance the King asked him if he knew the work of P. Veronese, and if he thought that this picture on the floor was an original? Without returning a verbal answer, with a gesture and significant shrug of the shoulders, he in fact told the whole of his mind, and left no doubt of his scepticism. The King immediately ordered the picture to be rolled up; and he left the room – in silence.' This episode (described in a footnote to an obscure publication many years later by someone who claimed to have witnessed it) was said to have been critical in the king's abandonment of his ambition to form 'a gallery of pictures such as had been collected by Charles the first'.[8]

The situation certainly began to change in the last decades of the eighteenth century, and the correspondence of Sir Abraham Hume with the Venetian dealer and connoisseur Giovanni Maria Sasso described here in an appendix provides impressive evidence of this. Nevertheless, the attribution of Venetian pictures, and more particularly the assessment of the part the workshop played in their production, continued to be difficult, and the division of hands in such works was never something of central concern to great connoisseurs such as Morelli, Berenson and Longhi.

John Constable and Titian's *Death of Actaeon*

The first recorded owner of Titian's *Vendramin Family* after it left Venice was Anthony van Dyck. He venerated the great Venetian painter, but it cannot be claimed that this painting had any great influence on his own work, and indeed it only came into his possession at the end of his life. It also seems likely that Tintoretto's *Christ washing the Feet of the Disciples* was acquired by Sir Joshua Reynolds, but, again, it would be difficult to claim that it had any special influence on him.

By far the majority of the paintings catalogued here crossed the Channel from France in the early years of the Revolution or from Italy and Spain after Napoleon's conquests. The mythologies by Titian in the Orléans Collection were greatly admired and ably imitated, although by painters who are not now much studied, most notably William Hilton the Younger (1786–1839).[9] The passages of very free and rough handling in Titian's great Ovidian mythologies are, however, something that very few artists tried to emulate. The great landscape painter John Constable is the most remarkable exception. In the style he developed in the 1820s and 1830s 'areas of shadow, especially, are enlivened with smears and streaks of light-coloured paint, applied with the palette-knife as well as the brush, and dabbed on, or dragged and trailed across the surface.' Such brushwork, which 'viewed in isolation … is mysterious, strangely moving and incredibly free',[10] is generally described as 'forward-looking' but it is hard not to believe that Constable was looking back to Titian, and more specifically to the *Death of Actaeon* (figs 4 and 5). Moreover, Constable began to make his oil sketches – full-size, freely executed works that served as rehearsals for his monumental exhibition paintings – in 1819, the very year in which the *Death of Actaeon* was exhibited at the British Institution. It seems never previously to have been pointed out that Titian's painting must have seemed an exact equivalent to what Constable was striving to achieve in these sketches.

Constable was uneasy about the probable influence of a great national collection of old master paintings, yet his debt to Claude and Rubens is well documented. It is also clear from lectures that he gave in the 1830s that he regarded Titian's example as fundamental for the tradition of monumental landscape painting. But he never mentions the *Death of Actaeon* or any other painting by Titian that he might have seen in a loan exhibition in London or viewed in an accessible private collection there. Instead, he refers to Titian's *Death of Saint Peter Martyr* in the church of SS. Giovanni e Paolo in Venice, which he knew only from descriptions, prints, copies and what he believed were original preparatory drawings.[11] If Constable were less well documented as an artist, and had been less honest in his commentary on his own art, we might suppose that he was anxious to conceal the fact that his work as an artist had been decisively affected by the study of the *Death of Actaeon*. In any case it is difficult to believe that the similarity is entirely coincidental.

The First Paintings Acquired for the National Gallery: West and Veronese

The British Institution, founded in 1805, was a patriotic venture that was felt to be of 'peculiar importance to the United

Fig. 4 John Constable, detail from *The Leaping Horse*, exhibited 1825. Oil on canvas, 142 × 187 cm. London, The Royal Academy.

Fig. 5 Titian, detail from *The Death of Actaeon* (NG 6420).

Kingdom at the present moment' when 'other powers' (the plural is misleading) were striving 'to extend, by the arts of peace, the influence which they have acquired in war'.[12] The pre-eminence of French design and standards of craftsmanship in the luxury arts, well established in the eighteenth century, had now been strengthened and British visitors to Paris in 1802 had also been able to see what Napoleon amassed

in the Louvre. The two related but by no means concordant ambitions of the British Institution were to prepare the way for the establishment of a public collection of old master paintings and to provide some equivalent to state support for living artists by assisting in their training and commissioning major works.

During its first five years of existence the British Institution mounted selling exhibitions by living artists, and displays were

mounted of old master paintings specifically for artists to study. Then, in 1811, we notice a new confidence. A seal was commissioned. A thirty-one-year lease on a neighbouring property was taken out. A committee was formed to organise the first modern loan exhibition (also the first true monographic exhibition) devoted to Joshua Reynolds.[13] No less remarkable as an initiative was the Institution's decision on 13 February 1811 to act on the proposal made in a letter of Alderman Sir Thomas Bernard, Bt, to the Institution's president, the Marquess of Stafford, urging the Institution's governors to organise a subscription to acquire Benjamin West's *Christ healing the Sick* (fig. 6), then approaching completion. The painting would be put on special exhibition and would be placed 'hereafter in our expected National Gallery, as the standard for any works of art to be admitted there'.[14]

This is the earliest reference in the Institution's official papers to the future foundation of the National Gallery, and it is clear that there was real determination that this event would not be long postponed. There was also a patriotic dimension to the appeal because this huge painting (274 × 427 cm) had been commissioned from the president of the Royal Academy by the Pennsylvania Hospital in Philadelphia and could perhaps be described as the first painting to be 'saved

for the nation' from export to America. The payment of 3,000 guineas (£3,150) was said at the time to be the highest ever made to a modern artist and certainly matched the amounts that were being dispensed to artists by the French government.[15] The list of subscribers was headed by the Prince Regent. Entry fees to the British Institution's exhibition subsequently raised more than the cost price and nearly as much again was subscribed for an engraving. In addition to the huge popular success of the painting, the 'published critical response seems to have been uniformly laudatory'.[16]

Privately, however, there were certainly some expressions of dissent. 'Hard, red and mean', Haydon wrote in his diary.[17] At a dinner with fellow artists Fuseli declared that he would not have been the painter of it for twice the price West had received.[18] Most devastating of all was the verdict of the finest critic of the day, William Hazlitt, who discerned that much of the popular fervour excited by West's pictures derived from the 'respect inspired by the subject'. He conceded that West's pictures 'have all that can be required in what relates to the composition of the subject; to the regular arrangement of the groups; the anatomical proportions of the human figure and the technical knowledge of expression'. But the effect was such as might, 'in a good measure, be given to wooden puppets

Fig. 6 Charles Heath, after Benjamin West's *Christ healing the Sick* (completed 1811). Engraving (published 1822), 46 × 73 cm. London, Tate Britain.

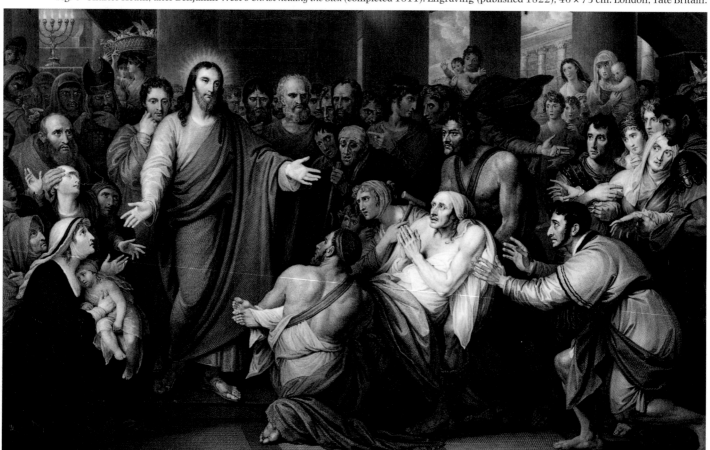

or pasteboard figures, pulled by wires, all taught to open the mouth, or knit the forehead, or raise the eyes in a very scientific manner'.[19] Everything that we know about the Reverend Holwell Carr, Sir Charles Long, Sir Abraham Hume, Sir George Beaumont and Richard Payne Knight – the outstanding collectors of old masters among the directors of the British Institution – would suggest that they were unlikely to have regarded West's picture as (in Sir Thomas Bernard's words) 'the noblest specimen of painting which has ever been produced in this country',[20] did not wish the 'expected National Gallery' to be chiefly considered as a depository for modern art, and certainly did not consider that West's painting should serve as a 'standard'. Their response, however, was not to protest, which would have been politically disastrous, but to make a counter-move.

The adjacent premises that the Institution wished to acquire had been occupied since 1809 by Alexis Delahante (1767–1837), a miniaturist and copyist who had fled from France in early 1795 and had established himself as a highly successful art dealer by 1800, and one, moreover, who enjoyed the highest confidence of Sir Thomas Lawrence.[21] Among the paintings that Delahante had probably not yet moved out of his gallery was Veronese's *Consecration of Saint Nicholas* (NG 26) – a grand public painting, religious in theme (if not as congenial to Protestants as West's), representing many of the qualities of colour and expression that were absent from West's picture.

At a meeting on 22 July, Charles Long and Holwell Carr were 'authorised' to purchase 'Mr Delahante's picture by Paul Veronese ... if it can be obtained for any price not exceeding 1500 guineas', that is, for not more than half the price of West's painting. The Veronese had first been mentioned in April when the West had just been put on display, and at that stage the Institution's governors did not consider that they had adequate funds. Thanks to the receipts from the exhibition of West's painting this was no longer the case in July, and after a certain amount of discussion the purchase was agreed upon at the end of the year.[22] The Veronese was displayed in the following winter in the Institution's exhibition, in a place of honour at the end of the North Room. This too was a painting acquired for 'the expected National Gallery', indeed it is the first old master painting to be thus acquired.

In 1826 Veronese's painting was donated, together with West's, by the British Institution to the National Gallery. The latter was eventually transferred to the Tate Gallery and was so severely damaged by the flood of 1928 that the two works cannot any longer be compared, nor can the implicit criticism of a modern academic performance by some of the most determined founders of the National Gallery now easily be inferred. The care shown by the leading figures in the British Institution not to provoke the hostility of the Royal Academy has deprived us of criticism dwelling on Veronese's superiority, but the weakest point in West's work was the formulaic ('scientific') character of the expressions that were so ably ridiculed by Hazlitt. This very quality, of course, places the work firmly in the tradition of Charles Le Brun's painting of the *Family of Darius*, a work that was taken to be a corrective to Veronese's great painting of the same subject.[23]

The Education of Artists

The British Institution was only able to establish annual loan exhibitions of old master paintings after it had dedicated an exhibition to the chief founder of the British school, Sir Joshua Reynolds, the first president of the Royal Academy, and it was only able to acquire a Veronese after it had acquired a work by West. Similarly, many leading British collectors were careful to acquire modern British works as well as old masters. The immensely rich insurance magnate John Julius Angerstein, who was advised by artists (including West) as well as connoisseurs, is a notable example. His collection, which was bought after his death in 1824 as the foundation of the National Gallery, included a famous painting by David Wilkie, who was still living, as well as works by Reynolds and Hogarth, founders of the 'modern British school'.

Among the anthologies of prints that were published in the 1830s, perhaps the most popular was the *Gallery of Pictures by the First Masters of the English and Foreign Schools*. The majority of the pictures illustrated were from the 'British Gallery' (as the National Gallery was there referred to), and British and foreign, ancient and modern, were deliberately mingled: Veronese, the Revd Peters, Correggio, Copley, Jan Both.[24] Only when the Vernon collection of British paintings was accepted by the Gallery in December 1847 did considerations of space entail the segregation of the modern works in Marlborough House, and only with the appointment of Sir Charles Eastlake as the first director (even though his own paintings were included in the National Gallery, and even though he was also president of the Royal Academy) did the Gallery adopt an acquisition policy that was firmly dictated by art-historical priorities. Even so, it was never forgotten during the nineteenth century that the National Gallery had been established for the benefit of two distinct publics: general visitors and practising artists, especially art students.

It might be supposed that, after the opening of the Tate Gallery in 1897 and the removal from Trafalgar Square of the modern paintings and most of the British school, the obligation to encourage or facilitate the studies of young British painters would weigh far less. This was not the case. Charles Holmes, like all previous directors of the Gallery, was an artist, but during his time as director he was also probably more active and more admired as such than any of his predecessors had been.[25] His art-historical writing is of limited value but his critical writing is of a very high quality. His books about the Gallery's paintings are intended as much for young artists as for the students of art history, and one of the greatest of his many disappointments as director was his failure in 1927

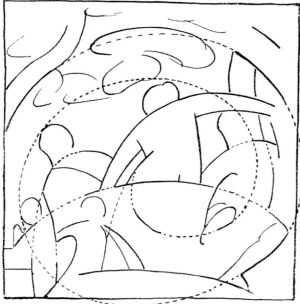

Figs 7 and 8 Tone plan and skeletal sketch of Veronese's *Unfaithfulness* (NG 1318) by Harold Speed. Published in his book *The Science and Practice of Oil Painting*, 1924.

to persuade his trustees to purchase a Chinese fresco. 'The Director strongly recommended that, in the interests of living artists, who draw increasing inspiration from the great schools of the Far East, fine examples of Oriental painting should be available in the National Gallery for ready comparison with other great schools of painting, irrespective of geographical boundaries.'[26]

Holmes is now notorious for his failure to acknowledge the greatness of Cézanne, but he was sufficiently impressed by the advocates of Post-Impressionism to purchase in 1920 what he believed to be an El Greco, the *Agony in the Garden* (NG 3476), a purchase that was acclaimed by Roger Fry in

the *Athenaeum*: 'Here is an old master who is not merely modern, but actually appears a good many steps ahead of us.' Fry believed that El Greco had influenced Cézanne. He certainly influenced the Cubists.[27] But often it was the work of his studio or his followers that proved inspiring, and Holmes's acquisition was a mistake, as J.P. Heseltine, the most discerning connoisseur among his trustees, realised.[28] It is clear too that his purchase of the sketch for Titian's *Trinity* – another mistake, as will be shown – was animated by a feeling that there was something modern, even 'divisionist', about its handling.

Harold Speed (1872–1957), a relatively conservative painter and critic, lamented the increasing influence of art critics (meaning other art critics) not only on the practice of art but on the 'purchasing department of our public galleries'.[29] But the book in which he made this point in 1924 reveals how influenced even he had been by what he called 'extremism' in art, for he provided his readers not only with a 'tone plan' of Veronese's *Unfaithfulness* (NG 1318) but also with a linear skeleton of the composition of the same painting (figs 7 and 8) – acknowledging the resemblance of the latter to 'canvases that in these days are framed and exhibited as finished pictures'. Another author in this period reduced Tintoretto's *Origin of the Milky Way* to an arrangement of cylinders and cubes.[30] It is not fanciful, therefore, to suppose that many young artists, some with their sketchbooks, were finding inspiration in Rooms VI and VII (as they were then numbered), into which Holmes had concentrated the Venetian school from Bellini to Tiepolo, including many of the paintings catalogued here, hanging almost all of them on a level with the eye (see fig. 16, p. 376), as was then the case in 'no other great gallery'.[31]

Mistakes

This catalogue includes many very great paintings. It is indeed very unlikely that any catalogue of the National Gallery will ever include a higher ratio of pictures which are generally acknowledged to be masterpieces. Nevertheless, there are among them works of minor importance, even of poor quality and poor condition. Some of these arrived in the National Gallery as gifts or bequests, or were included in groups of paintings purchased *en bloc* and never disposed of as intended. The most interesting examples for the historian of taste, and for the historian of the National Gallery as an institution, are the mistakes.

It is impossible to prove, but it seems highly likely that Tintoretto's *Christ washing the Feet of the Disciples* was bought at the Hamilton Palace sale by Sir Frederic Burton because he believed that a great painting would be revealed beneath the darkened varnish. But little of the original painting had in fact survived. To compensate for this, in June 1905 the Earl of Carlisle, the trustee then acting as director, persuaded his colleagues on the Board to try to buy Tintoretto's *Presentation* in the Sacristy of the Church of the Gesuati in Venice. The

Treasury agreed, the Italian ministry consented, but the Venetian authorities diverted the picture to the Accademia.[32]

The version of Titian's *Trinity* that Charles Holmes bought – against the judgement of several of his trustees – is another kind of mistake, one with a very long history, which concerns the practice of painting in sixteenth-century Venice. It was generally believed throughout the seventeenth, eighteenth and nineteenth centuries that Titian, Veronese and Tintoretto were in the habit of making small preparatory oil sketches for their larger paintings. There is no evidence that Titian ever did so. Tintoretto did, but only rarely, and technical investigation reveals that he began work on most of his larger canvases by sketching freely on them or by transferring his drawings directly to them. Veronese, on the other hand, is one of the first Italian painters to have adopted the practice of the preliminary oil sketch. He did so at a very early stage of his career,[33] but it is not clear how consistent he was. It is interesting, though, that in his maturity, indeed in his old age, he delighted in paintings of a small size. Holmes's mistake over Titian's *Trinity* has an interesting prehistory which is touched on at several points in this catalogue, notably in discussions of the collecting of Sir Abraham Hume and Samuel Rogers.[34] He was not alone. Roger Fry, when buying paintings for the Metropolitan Museum of Art, also supposed that a spirited copy after Tintoretto's *Last Supper* in S. Trovaso was a sketch by the artist himself.[35]

Another error of judgement is only hinted at in the entries which follow. The late work of Titian has become subject to a veneration which precludes a dispassionate estimate of artistic merit. *The Death of Actaeon* is a remarkable painting, worthy of a place in the National Gallery, but it is unfinished and was never satisfactorily resolved as a composition. The high reputation of *The Virgin suckling the Infant Christ* (NG 3948) coincides more or less with the 'discovery' of the *Shepherd and Nymph* in Vienna. For most critics the limited palette and the incoherence of form are of course essential to the poetic effect, as are the ruthless cancellations, painful revisions and hardly legible features of Michelangelo's last marble carvings. It is refreshing to read Charles Ricketts on the painting in Vienna. He was undecided whether it was unfinished or 'merely decayed down to the underpaint'. Ricketts, who had paid unusual attention to the Titians in the Prado, knew that the artist never abandoned the use of coloured glazes, even in his last works, and doubted that the artist would have wished us to admire the 'hues of cinders and ashes'.[36] In the decade or so before Ricketts was writing, the dim and mysterious paintings of domestic subjects by Eugène Carrière (fig. 9) were in vogue. So too were both paintings and painterly photographs of crepuscular obscurity, and in 1901 Thomas Armstrong wrote to his friend and fellow artist the Earl of Carlisle that he had not only come to appreciate the 'effect of dirty glass in front of a picture' but had also been 'remarking lately that landscape seen through a dirty window has charms which are worth noting'.[37]

Fig. 9 Eugène Carrière, *Motherhood*, c.1890. Oil on canvas, 55.8 × 46.3 cm. New York, The Frick Collection.

Rapacity and Retention

For obvious reasons successful seductions attract more attention than stubborn resistance, so it is worth recording the fact that many Venetian institutions did successfully refuse the offers made by foreign collectors. Thus, in 1670, soon after the mother superior of the Convent of Saint Catharine had turned down Grand Duke Cosimo II de' Medici's offer to buy Veronese's great altarpiece of *The Marriage of Saint Catharine*, the Grand Duke's agents, Paolo del Sera and Marco Boschini, set about the laborious business of bribing every member of the Confraternity of Saint Joseph so that they would agree to sell Veronese's *Adoration* (NG 268). But after two years this project had come to nothing.[38] It was probably a full century later that the Confraternity of the Sacrament in S. Trovaso agreed to part with Tintoretto's *Christ washing the Feet of the Disciples* (NG 1130), but the circumstances remain obscure.

After the return of the paintings which the French had removed from Venice for the Musée Napoléon, the Austrians made it difficult to acquire any major public works in Venice or the Veneto. In the 1830s the Duke and Duchess of Sutherland, among the richest of the British nobility, were purchasing works for the embellishment of their huge new London palace, Stafford House (formerly York House, now Lancaster House). They bought ceiling canvases by Guercino and Zelotti (that by Zelotti was believed to be by Veronese), but the Duchess

realised that they would never obtain the great paintings by Veronese which she most admired and so she commissioned copies of five of these – including the *Marriage of Saint Catharine* that had eluded the Grand Duke, and the *Martyrdom of Saint George* (fig. 1, p. 330) – from Professor Giuseppe Gallo de Lorenzi between 1841 and 1846 for the colossal price of £18,000.[39] By 1848, when these copies were installed in the great staircase hall of Stafford House, the situation in Venice had changed completely.

In September 1848, after its rebellion against Austria, Venice's new republican government planned to secure a huge loan using a large group of the city's masterpieces as security. Niccolò Tommaseo started negotiations in Paris, seeking to engage Richard Cobden, the radical politician and economist, as an intermediary in London. It was estimated that a loan of six and a half million francs could thus be raised. Venice would be allowed twenty years in which to repay the loan at a very high rate of interest. The paintings would be shipped to London and placed on exhibition there; two-thirds of the money raised by entrance fees would go to Venice.[40] A committee of nine experts, including Professor Gallo de Lorenzi, the copyist, Antonio Zen, the dealer, and Natale Schiavoni, the painter (also a dealer), reported on 13 October with a list of 58 paintings together with 40 pieces of wood-carving by the newly fashionable Brustolon. Although it was agreed that certain very great works (Titian's *Assunta*, Veronese's *Cena* and Tintoretto's *Crucifixion* in the Scuola di S. Rocco) were too large to be removed, great masterpieces were included: Titian's *Saint Peter Martyr* and his *Pesaro Altarpiece*, Bellini's S. Zaccaria altarpiece and Veronese's *Saint Catharine* altarpiece among them.[41] But by then public outcry over the proposal had persuaded Daniele Manin to abandon it.

John Ruskin, convinced that 'no man who ever touched canvas possessed powers so magnificent as those of Tintoret', wanted to transfer some of this artist's works from the 'dark and neglected churches of Venice' to the National Gallery. He approached the Marquess of Lansdowne about this on 25 March 1852 and one month later sent Lansdowne a list of four paintings, all of them very large because he wished to emphasise the 'power of the Venetian on a large scale' which 'our little Titian' (as he described *Bacchus and Ariadne*) was 'wholly inadequate to represent'. They were the *Marriage at Cana* in the Sacristy of the Salute, the *Crucifixion* in S. Cassiano, the *Crucifixion* in SS. Giovanni e Paolo, and the *Presentation* in the Madonna dell'Orto. At the suggestion of the trustees, Ruskin next solicited the opinion of Edward Cheney, a keen collector of Venetian art then resident in the city, concerning the value of the works listed. Cheney was in favour of the S. Cassiano and Salute pictures, although not of the third work on Ruskin's list (the *Presentation* seems not to have been considered by him). Ruskin sent Cheney's letter on to Sir Charles Eastlake on 19 May 1852 (Eastlake was not then either keeper or director but he was, by virtue of his position as president of the Royal Academy, a trustee), urging that £7,000 be offered for the S. Cassiano picture and £5,000 for the *Marriage at Cana*, rather than the £3,000 recommended by Cheney, and declining to act unless £12,000 was put aside by the Treasury.[42] This attitude was not well designed to secure official support, and even if a huge offer had tempted the ecclesiastical authorities it is in fact unlikely that the Austrian government would have consented to the sale of such works.

Seventy-odd years later, Austria was impoverished by its defeat in the Great War and an American syndicate was rumoured to have agreed to purchase for 'some two and a half millions' the 'pick of the treasures of the Vienna Gallery'. Britain arranged for a loan of greater value with the idea that 'ten or twelve' of the masterpieces would be exhibited in the National Gallery for a 'period, say, of ten years' as security or pledge. 'The idea was taken up by Lord Curzon, but when the proposal received open official encouragement, it was swelled and complicated by claims from other institutions, and from one of our Allies; was passed on, thus inflated, to the Reparations Commission, and there collapsed in the wind of international talk.'[43] The first rumours of this plan date from October 1919 and by December Holmes had drawn up a list which included Giorgione's *Three Philosophers*, Titian's portrait of Strada and, on a second list, Tintoretto's *Susanna*. He noted for the benefit of the trustees that he had refrained from listing Titian's *Ecce Homo* because of the 'probable needs of Italy and France'. Early in 1921 there was still a real possibility that the loan of art treasures might be exacted from a country whose citizens were in desperate need of food 'in return for releasing … foreign securities which would otherwise have been sold in part liquidation of the advances we have already made'. It is good to discover that one trustee, Lord Crawford, expressed distaste for the whole exercise.[44]

By that date the more realistic preoccupation of the National Gallery was to ensure that it could prevent the exportation to America of the greatest masterpieces in private hands in England. The story of how Titian's *Vendramin Family* was secured for the Gallery is a triumphant one. It required an uncommon political agility as well as commitment on the part of the trustees such as had been conspicuously absent earlier in the century.

Many of the characters in Henry James's light social comedy *The Outcry*, written nearly a century ago, will be recognised in accounts provided here of the acquisitions made in the late nineteenth and early twentieth centuries. They are still recognisable today. Lady Sandgate records the 'general strong feeling that we don't want any more of our national treasures (for I regard my great-grandmother as national) to be scattered about the world' yet she is obliged to toy with selling a portrait by Lawrence of this esteemed ancestor. Lord Theign, opening Dedborough Park to school parties, and ever-courteous to visiting 'picture-men', is nevertheless determined to sell a valuable old master that is discovered in his possession. But

then, infuriated by the publicity and the manoeuvring of dealers, he threatens to give it 'to the Public, to the Authorities, to the thingumbob, to the Nation'.[45]

In considering the history of the National Gallery we must be struck by how much it owes to the determination of a small group of patriotic connoisseurs and collectors within the British Institution to establish a proper home for what had come into the country, and by the symmetrical determination of another small group within the National Art Collections Fund and *The Burlington Magazine* to stop precious things 'going out of our distracted country at a quicker rate than the very quickest – a century and more ago – of their ever coming in'.[46] However, not everything of the highest quality has been saved. If it had been, this catalogue would include Titian's *Rape of Europa*, and another, yet to be written, would include Bellini's *Feast of the Gods*.

NOTES

1. See pp. 381–3.

2. Schulz 1968.

3. Schulz 1961. The fictive architecture of 1559–60 which serves to frame (and distance) Titian's *Divine Wisdom* in Sansovino's library is the most remarkable surviving work by them (ibid., pp. 95–6).

4. See pp. 170 and 401.

5. Dunkerton, Foister and Penny 1999, pp. 129–35. The paintings are by Bacchiacca (NG 1218 and 1219) and Pontormo (NG 1131 and NG 6541–3).

6. See pp. 56–60 and fig. 1, p. 58.

7. See pp. 227–9 and 379.

8. [Dallaway?] 1824, note on pp. xxxi–ii. The passage has not been noticed in discussions of George III as a collector. I do not know upon what grounds James Dallaway has been assumed to be the author in library catalogues. The introductory essay is signed 'D' and the author describes himself as an 'elderly gentleman'. For the royal librarian Richard Dalton (1713?–1791) see the entry by Francis Russell in Ingamells 1997, pp. 1267–70. He was not officially surveyor of the king's pictures until 1778.

9. See especially his *Venus in search of Cupid surprising Diana* exhibited at the Royal Academy in 1820 (London, Wallace Collection, P633). A sketch for this painting was bequeathed to the National Gallery in 1900 (NG 1791, now Tate Gallery NO1499). Hilton's *Sir Calepine rescuing Serena* of *c*.1830 was presented to the National Gallery in 1841 by subscribers. Five paintings by Hilton were also included in the Vernon Collection given to the Gallery in 1847. Another of his paintings was presented in 1897. These seven works are now all in Tate Britain.

10. Kitson 1977, p. 751.

11. See Parris, Shields and Fleming-Williams 1975, pp. 13–16, 157, 218–19; but also Beckett 1965, p. 126, and Beckett 1970, pp. 47–9, 60, 76.

12. National Art Library (Victoria & Albert Musem), RC.V.11, fols 3, 11, 27.

13. Ibid., RC.V.12, fols 176 and 182 (seal); fol. 204 (new premises) and fol. 218 (Reynolds exhibition).

14. Ibid., fols 179–82. The letter was read on 13 February 1811. 1,200 guineas was subscribed by 12 March (ibid., fol. 186) and the exhibition plan was approved on 4 April (ibid., fol. 196).

15. Von Effra and Staley 1986, no. 336, pp. 346–8. However, as these authors note, Jacques-Louis David was paid 100,000 francs (approximately £4,000) for the *Coronation of Napoleon*.

16. The exhibition opened on 8 April 1811 (National Art Library (Victoria & Albert Museum), RC.V.12, fol. 190). Receipts of £2,730 for the engraving are recorded in July 1811 (ibid., fol. 230) and £3,727 10s. on 31 December 1811 (ibid., RC.V.13, fol. 5). Admission money was £3,919 5s. (ibid., fol. 33).

17. Quoted more fully in Von Effra and Staley 1986, p. 348.

18. The dinner took place on 23 May 1811. Farington 1978–98, XI, 1983, p. 3636.

19. Hazlitt 1856, pp. 218–19, 232n, 237. See also Hazlitt 1838, pp. 56–7.

20. National Art Library (Victoria & Albert Museum), RC.V.12, fol. 180.

21. Penrice (undated), pp. 28–32 and note on p. 28; Portalis 1910, pp. 220, 225, 226, 308; Whitley 1928, pp. 131, 198, 213, 215.

22. Smith 1860, pp. 63, 64, 135. National Art Library (Victoria & Albert Museum), RC.V.12, fol. 202 (proposal made on 8 April 1811) and fol. 235 (proposal agreed in July). Delahante was said to have paid £1,716 9s. for the painting (ibid., unnumbered folio corresponding to fol. 240).

23. See p. 380 and fig. 21 on p. 381.

24. Cunningham 1836. The examples cited fall between pp. 56 and 67 in Vol. I.

25. For example Lucas 1924, p. 40: 'The Director…is himself a landscape painter of genius.' For a modest account of his success in the 1920s see Holmes 1936, pp. 357–8.

26. NG 1/9, p. 211, report of the Board meeting of 8 February 1927. See also Holmes 1923, p. x, and 1936, p. 390.

27. The essay was reprinted later in 1920 in *Vision and Design* (Fry 1937, pp. 169–76).

28. NG 1/9: 11 November 1919; see also Holmes 1936, pp. 377–8, where, however, Heseltine is not named. R.H. Benson also dissented. See also, for another El Greco, ibid., p. 340.

29. Speed 1924, p. 19. Speed also published *The Practice and Science of Drawing* in 1913, and *What is the Good of Art?* in 1936.

30. Ibid., pp. 192–4. For the Tintoretto diagram see Bayes 1927, caption to plate facing p. 67 and diagram on p. 153. In this connection see also MacColl 1931, pp. 252–3.

31. Holmes 1923, p. IX.

32. NG1/7 (Minutes, VII), pp. 240, 243, 248, 253, 255, 261, 267, 273 and 281. For the painting see Pallucchini and Rossi 1982, I, p. 167, no. 168.

33. See pp. 337 and 435.

34. See pp. 311 and 459.

35. 07.150. Zeri and Gardner 1973, p. 75, pl. 107. The painting was sold by Sulley from the Methuen Collection. Phillips (1911, p. 136) thought highly of the picture.

36. Ricketts 1910, p. 151.

37. Castle Howard Muniments J22/26, letter to Lord Carlisle of 19 April 1901.

38. Stella Alfonsi 2002, pp. 269–71, especially note 19.

39. Yorke 2001, pp. 134, 136–7 and plates 59, 69, 98. See also Gower 1883, I, p. 4, where the artist is named 'Firenze'.

40. Marchesi 1916, pp. 295–8; Ciampini 1945, pp. 493–4 and p. 712.

41. Fulin 1875, pp. CXVI–CXXVII.

42. NG 5/89/7 (Ruskin's letter to Lansdowne of 25 March 1852), NG 5/90/3 (extract from another letter from Ruskin to Lansdowne listing pictures of 30 April 1852), NG 5/91/2 and 3 (letter from Edward Cheney regarding pictures by Tintoretto of 18 May 1852 and one from Ruskin of the day following).

43. Holmes 1936, pp. 372–3.

44. Papers dating from 1919 to 1925 are in the Gallery's archive, NG 16/12. These include Crawford's letters and Holmes's list, also Andrew McFadyean's letter to Holmes of 20 February 1920 which is quoted here.

45. *The Outcry* was published in 1910. For Lady Sandgate see Book I, chapter 1. For Lord Theign on the national institutions see Book III, chapter 2.

46. The quotation is from Hugh Crimble, the young connoisseur in *The Outcry*, Book I, chapter 4.

The Organisation of the Catalogue

Artists are listed alphabetically and separate works by the same artists are ordered chronologically (rather than by date of accession). The division of an artist's work between catalogues has been avoided in the past, but Titian presents a special problem. His work from before 1540 has been left for another volume and his later productions are presented here together with works by rivals, followers, pupils and imitators.

I have included one painting which seems to be a pastiche made soon after Titian's death (*A Concert*, NG 3) and another which is a copy of one of his compositions, probably made later than 1600 (*The Trinity*, NG 4222), but not *A Boy with a Bird* (NG 933), which has often been taken for a seventeenth-century imitation of Titian. The light cloud of drapery around the upper arm and the outlining of the fingers recall Titian's *Noli me tangere* (NG 270) of *c.*1515. It may be an excerpt from a painting of Venus and Adonis, a composition discussed in this catalogue (pp. 274–91), but if so must, as Paul Joannides has proposed, be an early version. Arguments in favour of the autograph status of this curious morsel are presented by Joannides and Jill Dunkerton in volume 28 of the *National Gallery Technical Bulletin*.

A good case could easily be made for including works by Rottenhammer, Elsheimer and El Greco, all of whom painted in Venice and were formed, or at least reformed, as artists by that experience. But readers will expect to find their work in other catalogues and it is unlikely that my colleagues would have consented to their appropriation. It may therefore seem inconsistent to have included *The Conversion of Mary Magdalene* (NG 1241) which is probably by Pedro Campaña, who was Netherlandish by birth and worked for many years in Spain. He was probably only briefly resident in Venice, but this painting was commissioned by a Venetian patrician both as a record of his family and as a record of a fresco in a Venetian church, so it seemed wrong to omit it.

As in the first volume of the sixteenth-century Italian paintings, the entries, which are more discursive than was formerly the case in the Gallery's catalogues, have been divided into sections with titles intended to help readers select the topic that interests them. Much material concerning previous owners is supplied and much on the circumstances of the work's acquisition, but a succinct, factual summary of provenance is also supplied separately for ease of consultation.

The information on picture frames provided in the first volume attracted more comment in print than any other feature of that book. Here I have also drawn attention both to old frames of distinction and to frames made for the National Gallery. The reader should note that Jacob Simon at the National Portrait Gallery has created an online directory of framemakers which includes all the craftsmen mentioned here as employed by, or as suppliers to, the National Gallery.

An account of the conservators employed by the Gallery to varnish, line, clean, repair and retouch before the establishment of the Gallery's own Conservation Department is incorporated in the introduction to the first volume (Penny 2004, pp. xiv–xv). A great deal of information about the conservation of the National Gallery's paintings is provided and I have tried to relate the conservation history to the provenance, identifying not only nineteenth-century restorers but also, sometimes, those from earlier centuries.

A question-mark is used to indicate a doubt as to the authorship of a painting in preference to the formula of 'Attributed to' or 'Ascribed to'. Comprehensive listing of references made in recent art-historical literature has not been attempted. References in the notes are abbreviations of entries in the bibliography. I have tried to identify the actual authors of exhibition catalogues and of anonymous guides.

List of Artists and Paintings

Jacopo Bassano (*c*.1510–1592)
and his sons Francesco and Leandro

Jacopo Bassano signed many of his paintings 'Jacobus Bassa-nesi' or 'Jacobus a Ponte Bassanensis' (some of the words were often abbreviated or omitted). In documents he is generally referred to as Jacopo Dal Ponte. Bassano del Grappa was his native city, and Dal Ponte was the name by which his father, Francesco il Vecchio (*c*.1475–1539), had been known, on account of the family workshop's location beside the city's bridge. Francesco il Vecchio was in practice as a painter in Bassano del Grappa by 1500 and an idea of the nature of his business may be obtained from an account book for the years 1512–56 entitled 'Libro Secondo', which recorded all the painted goods supplied by the firm: candles, shop signs, confraternity banners, beds, clogs, board games and even confectionery, as well as altarpieces. Under Jacopo and his brother Giambattista the workshop was chiefly known for its paintings in oil and fresco.[1]

By 1548, the year in which Giambattista died, Jacopo's work was familiar to some connoisseurs in Venice, although it was not until the late 1550s that he was commissioned to paint an altarpiece there.[2] Jacopo's eldest son, Francesco (1549–1592), not only collaborated with his father in the early 1570s but co-signed a number of paintings ('Jacobus et Franciscus Filius') shortly before setting up his own workshop in Venice in 1578. The opportunities presented by the fire in the Doge's Palace in the previous year had probably prompted this move.

Jacopo's third son, Leandro (1557– 1622), became his chief collaborator until 1588, when Leandro too moved to Venice to join Francesco. Leandro had sometimes co-signed works with his father during the years of their collaboration. Jacopo was left with the assistance of his second son, Giambattista (1553–1613), whose talents were very limited, and of the Marinali brothers (about whom little is known), until 1589, when his fourth son, Gerolamo (1566–1621), who had been studying medicine in Padua, returned to Bassano to help his father.

After Jacopo's death in 1592, Gerolamo and Giambattista inherited the workshop in Bassano. The nature and extent of the business are apparent from an inventory of the workshop made at this date.[3] Francesco died in the same year, not long after throwing himself from his workshop window, and in the following year Leandro took over the workshop in Venice, separating it from the rest of the family business. He remained in Venice, active as a painter, until shortly before he died. Gerolamo left Bassano for Venice in 1595 and died there. Giambattista kept the family business going in Bassano. After his death, his daughter Chiara married a painter called Antonio Scaiaro, who took the name Dal Ponte and after his death in 1630 was succeeded in the business by his two sons Giacomo and Carlo.[4]

In the following paragraphs something will be said of the career and the style of Jacopo and of his most talented sons, Francesco and Leandro.

Jacopo was sent by his father to Venice in the early 1530s (he was certainly there in 1535[5]) where he joined the large and busy workshop of Bonifazio de' Pitati, who was at that date a painter of real distinction. On Jacopo's return to Bassano he received, in 1536, an important commission from Matteo Soranzo, Bassano's Venetian *podestà* (governor), for a large votive painting to be placed in the Consiglio Comunale. Soranzo is here represented kneeling before the Virgin, with his daughter Lucia playing with a dog at the Virgin's feet and his brother Francesco standing behind him; they are accompanied by their name saints, Matthew, Francis and Lucy (fig. 3, p. xv).[6] This is a more accomplished work than anything known to be by Francesco il Vecchio. It exhibits a flair for painting from life (the angel's wings are those of a bird), the portrait of Francesco Soranzo has force and character, and the group of Lucia with her dog is striking for both its realism and its charm. But the painting is derivative in its dependence on Titian's compositions (the Pesaro altarpiece and the lost votive painting of Doge Andrea Gritti), and clumsy in its architectural setting and somewhat inflated monumentality.

Although the influence of many artists (Savoldo, Moretto, Lotto, Romanino, Pordenone, as well as Titian) has been detected in Jacopo's early work,[7] this is certainly not more important than his study of prints, especially those made after Raphael, in the rapid development of his art, as can be seen in the *Way to Calvary* in the Fitzwilliam Museum (fig. 6, p. 12) of about 1543. However, the *Adoration of the Kings* (fig. 1) painted at about the same date[8] is highly original in its controlled compositional confusion, vividly expressive heads, and brilliant palette, for which no obvious precedent is known. These qualities are found in several of Jacopo's major works of the mid-1540s, of which the National Gallery's *Way to Calvary* (NG 6490) is a superb example.

In Soranzo's votive picture Jacopo's sense of surface pattern is apparent in the way that the sweep of the curtain is continued in Saint Lucy's dress. In the compositions of the mid-1540s the patterns are far more complicated and are checked by formal collisions and surprise repetitions. Jacopo must have studied the prints of Parmigianino and those of his Venetian disciple Schiavone, and by the early 1550s the fluent interweaving of figures in his paintings is supported by the brushstrokes themselves, which contribute as much to the pattern as they do to the description of solid forms or the imitation of texture. Moreover, the figures themselves are subject to elegant distortions, the small heads on long

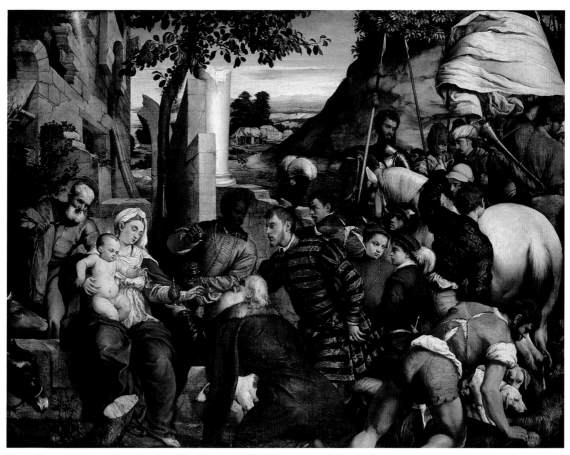

Fig. 1 Jacopo Bassano, *The Adoration of the Kings*, *c.*1543. Oil on canvas, 183 × 235 cm.
Edinburgh, The National Gallery of Scotland.

Fig. 2 Jacopo Bassano, *The Journey of Jacob*, *c.*1560. Oil on canvas, 127.8 × 183.5 cm. The Royal Collection.

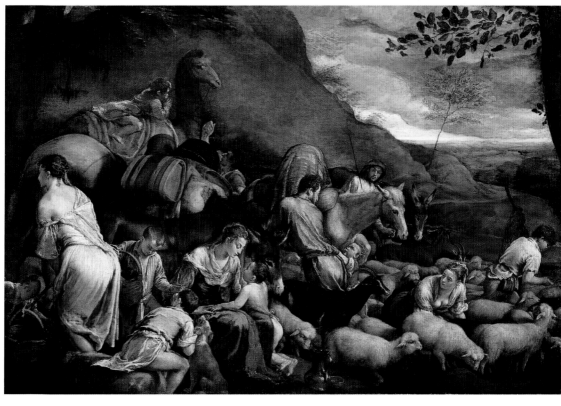

necks often depicted in *profil perdu*. This cultivation of a refined and abstract – one might be tempted to say courtly – style coexisted with rustic elements and scenery: hounds, farm animals, barefooted ragged shepherds. And it may have been the realism with which he recorded rural life that most attracted the attention of connoisseurs.

His first Venetian patrons seem to have been the governors of the city, but by 1546 he had received a notable commission from a Venetian patrician for a painting of the Last Supper, probably intended for the *portego* of his palace.[9] Two years later Conte Antonio Zentani, who is not known to have had contacts with Bassano, commissioned him to paint a portrait of two of his hounds, one of the earliest paintings of its kind,[10] and then, in 1552, Zentani's brother-in-law gave him an even more remarkable commission – a narrative subject of the artist's own choosing ('istoria che a me parerà').[11]

By the later 1550s, around the date of the *Good Samaritan* (NG 277), Jacopo began to forsake 'what may be termed the Grand Style, for one more in unison with untutored apprehensions, and characterised by the introduction of all sorts of familiar objects, whatever may be the subject of the picture. He was perhaps the earliest Italian genre painter.'[12] Jacopo clearly favoured those biblical subjects which enabled him to paint animals. Even if some of these subjects – *The Adoration of the Shepherds*, for example (fig. 2, p. 34) – were common enough or, in the case of the Good Samaritan, not without precedent, others – such as the *Journey of Jacob* (fig. 2) – were new. These were paintings for the home, perhaps occasionally paintings for the collector's gallery. In the 1568 edition of his *Lives* Vasari recorded that paintings 'of animals of all kinds'[13] were to be found in numerous Venetian collections, and no doubt they were often most admired for their lively and novel depiction of animals and the people who tended them (which is not to deny that they were also taken seriously as edifying and exemplary works).

By the later 1560s there is less distortion in figure style, less arbitrary cropping, less compositional confusion and a more orthodox treatment of pictorial space in Jacopo's paintings. His talented eldest son, Francesco, became an active collaborator, a development which coincides with a larger part being played in Jacopo's paintings – altarpieces as well as the biblical pastorals – by an architectural stage and fairly elementary linear perspective, often a diagonal sequence of buildings or a simple, emphatic diagonal wall, with an off-centre vanishing point. It is tempting to suppose that this formula was suggested to Jacopo by the artistic education that he had been careful to give Francesco, for he himself had displayed little interest in such spatial devices in the first thirty years of his professional practice.

It is true that there are some sharply foreshortened walls on the left side of his early *Adoration* (fig. 1), and on the right-hand side of the painting a succession of three figures and a horse all turned away from us, but these devices fail to create a truly three-dimensional effect. In this respect Jacopo Bassano was the opposite of Jacopo Tintoretto, all of whose buildings and figures in active poses contribute to a compelling sense of space. A still more dense massing of figures is found in the National Gallery's *Way to Calvary*, where the forms farthest from the beholder are rhymed in colour as well as shape with those which are closest. The effect – at least originally – of the ass in the *Good Samaritan* and the aerial perspective of its landscape is quite different. Nevertheless, Jacopo remains an artist whose figures never quite break away from the front plane.

During the 1560s Jacopo's paintings became darker and, in addition to sombre landscapes and dark azurite skies, he began to paint nocturnes, influenced by Titian's *Martyrdom of Saint Lawrence* (completed in the late 1550s) and by Tintoretto. He began to paint on a dark ground, a tendency which culminated in the mid-1570s in the use of smooth black stone as a support.[14] But even when his colours are not contrasted with black they are inseparable from a changing and fragmenting light which picks up the bright moss-green or rose-red creases of a sleeve, and gives independent life to white headscarves and ragged shirts. Here the pink shines on an old man's pate, there it does so in a copper basin.

The most original of Jacopo's later paintings, executed together with his sons and other members of the workshop, were the series illustrating the elements, the seasons and the months. In these, narrative is reduced to a minute episode in the distance, or dispensed with altogether, and the subject consists of objects, animals and appropriate incidents scattered busily in the foreground and middle distance. These paintings may owe something to the similar ones made in Venice by Fiammingo (see pp. 78–87) and also to paintings and prints sent to Italy from the Netherlands. Such paintings provided diverting subjects for meditation, although it is hard to believe that they were made with a solemn moralising purpose, as has recently been proposed.[15]

Jacopo had always repeated his figures, reusing expressive faces and poses in different contexts and with minor but significant changes, but by the 1570s he began to work more for the art market and employed his sons and other assistants to reproduce his compositions, so that commercial replication was as much of a motive as creative variation. It is not easy to distinguish the different hands in these works. Francesco and Leandro both signed paintings with Jacopo but they must have collaborated on many that were not identified in this way, and Francesco's name, or Leandro's, on a painting does not necessarily represent a claim to having invented the composition. Jacopo's own late manner is distinctive: at once rough and nervous, at times even tremulous. The handling of much of Leandro's work is also easy to recognise: the impasto has a stringy quality and the lights are often repetitively mechanical in application. The best idea of Francesco's style of painting can be obtained from the battle pictures he made for the ceiling of the Sala del Maggior Consiglio in Venice. His brushwork is flatter than his father's, and his feeling for colour and light far superior to that of his brother.

Leandro was a successful artist in Venice after the death of his father and his brother.[16] He received some major altarpiece commissions (for example, the *Miracle of Saint Lucy* in S. Giorgio Maggiore in 1596) and he worked on versions of the family's stock compositions. In addition, he was a

prolific portrait painter, succeeding Domenico Tintoretto (see pp. 134–5) as the most successful artist in this field in the city. Sometimes his portraits have the grandeur of a Veronese (for example, the portrait of Bastiano Gardalino in Lille[17]); more commonly, they display a prosaic directness which matches the earnest and sober character of the sitter (as in the portrait of a woman with a rosary in a private collection in Scotland[18]).

A few careful early drawings in black chalk by Jacopo Bassano have been identified.[19] His later drawings are among the earliest notable examples of the use of coloured chalks. They are summary and jagged in character: the most beautiful are the head studies, and the most original are the compositional sketches.[20]

In the years following Jacopo's death his fame was broadcast, and his influence extended, by the superb engravings of his paintings made by Jan, Raphael and Aegidius Sadeler.[21] The paintings of Pedro Orrente (1580–1643), Jacopo's accomplished Spanish follower, seem to owe more to a study of these engravings than to a knowledge of the originals.[22] The same may be true of the exquisite miniature pictures made in Jacopo's style on lapis lazuli and jasper and other precious stones, perhaps in Rome.[23]

Jacopo's pastorals, and the replicas and imitations by his sons, were already in princely collections by the time of his death. Throughout the seventeenth century almost all of the great European collectors owned such works, usually in large groups.[24] Theorists of art in Rome and later in Paris could disparage the 'low' character of Jacopo's patriarchs and apostles and his preference for rustic settings, but this did not deter collectors. Such was the demand that by the 1670s the churches of Bassano found it prudent to take special security measures to prevent the illegal removal of his paintings.[25]

Interest declined during the eighteenth century and it is clear that the huge numbers of copies and imitations of his work had damaged his reputation.[26] The recovery of his reputation in the twentieth century was closely associated with the recognition of the evolution of his style and of the special quality of his first mature works. Wart (Eduardo) Arslan's monograph was published in 1931, and again, greatly revised, in 1960. More recently Jacopo's work has been the subject of many outstanding articles and essays by the late Roger Rearick[27] and by Alessandro Ballarin. Ballarin's essays have been republished in what was announced as a complete catalogue of the artist's work;[28] the text of the catalogue has not appeared but the superb plates do much for the study of the artist, and the choice of details and of comparative illustrations constitutes in itself an outstanding critical study.

NOTES TO THE BIOGRAPHY

1. Muraro 1992 publishes the 'Libro Secondo'. A good account of Francesco il Vecchio is supplied by Alberton Vinco da Sesso 1992, pp. 15–23. Francesco's earliest surviving signed work is dated 1519.

2. The central part of his altarpiece for S. Cristoforo, a small island on the Lagoon, survives in the Museum of Fine Arts in Havana (see Rearick 1992, p. cxiv, fig. 26, and p. cxvi, note 175). The altarpiece for S. Maria dell'Umiltà of c.1561 is in the Galleria Estense, Modena (Brown and Marini 1992, pp. 96–8, no. 34, entry by Vittoria Romani).

3. Verci 1775.

4. Habert 1998, p. 46.

5. Brown and Marini 1992, p. 305 (Regesto, compiled by Livia Alberton Vinco da Sesso).

6. Ibid., pp. 10–11, no. 2 (entry by Giuliana Ericani), and p. lxiii (Rearick).

7. Most notably by Ballarin (Ballarin 1967).

8. Brown and Marini 1992, pp. 26–8, no. 10 (entry by Giuliana Ericani).

9. Ibid., pp. 48–50, no. 18 (entry by Maria Elisa Avagnina).

10. The brace of hounds is now in the Louvre (Habert 1989, pp. 18, 68–9, no. 3). There is another portrait by Jacopo of two dogs in the Uffizi but it is later in style (c.1555). Aikema supposes that Zentani had contacts in Bassano but all we know is that the contract was made in Cittadella by a priest from Pesaro. He argues that the painting was intended as a religious allegory (Aikema 1996, pp. 42–9, 69). I see no reason why the patron's motives should have differed from those of the Revd Thomas Vyner, who in 1792 commissioned from Stubbs the foxhounds now in Tate Britain.

11. Muraro 1992, pp. 74–5.

12. Wornum 1854, pp. 23–4. The passage reads like an addition by Eastlake, who was editor of this volume. A footnote explains the meaning and derivation of the word 'genre', evidently a new term, or at least one previously confined to specialists.

13. Vasari 1906, VII, p. 455 ('cose piccole, et animali di tutte le sorte', perhaps meaning by 'cose piccole' low life rather than small pictures).

14. The Crucifixion in the Museu Nacional d'Art de Catalunya, Barcelona (inv. 108373), is, as Ballarin first recognised, an autograph painting on this unusual support. Brown and Marini 1992, p. 152, no. 55 (entry by Livia Alberton Vinco da Sesso).

15. Aikema 1996, p. 144, considers that 'iconographic, semantic and typological analysis' of the months leaves 'no doubt that their original purpose was moralizing'.

16. A good general account of his career is provided by Livia Alberton Vinco da Sesso 1992, pp. 81–101.

17. Habert 1998, pp. 42 and 83, no. 18.

18. Brigstocke 2000, pp. 112–13, no. 36 (entry by Brigstocke).

19. Most notably, the portrait drawing of 1538 in the Louvre (inv. 5679) – for which see Habert 1998, pp. 93–4, no. 50 (entry by Loisel Legrand).

20. For examples of these see Brown and Marini 1992, pp. 238–42, nos 94–6 (entries by Vittoria Romani). For Jacopo's drawings generally see Rearick 1978 and 1986, and Ballarin 1969, 1971 and 1973 (most conveniently consulted in Ballarin 1995–6, I, 1995).

21. Pan 1992, pp. 22–40.

22. Falomir Faus 2001, pp. 35–44.

23. Examples include an Adoration of the Kings in the Kimbell Art Museum, Fort Worth (bequest of Hedy Maria Allen), on plasma (green jasper), the same composition adapted to an oval and on lapis lazuli in a private collection in Brescia (Pilo 1975), and, paired with an Adoration of the Shepherds, and adapted to an octagon, on jasper (wrongly identified as Verona marble), exhibited by Piero Corsini, New York 1986/7.

24. For France see Habert 1998, pp. 47–56. For Spain see Falomir Faus 2001, pp. 19–32.

25. Brown and Marini 1992, p. 319 (Regesto compiled by Livia Alberton Vinco da Sesso).

26. Lanzi 1795–6, II, pp. 114–19.

27. Rearick's fullest account of Jacopo's art is his long essay in Brown and Marini 1992 (Rearick 1992).

28. Ballarin 1995–6.

Jacopo Bassano

NG 6490

The Way to Calvary

*c.*1544–5
Oil on canvas, 145.3 × 132.5 cm

Support

The dimensions given above are those of the stretcher. The ragged edges of the original canvas are largely concealed by putty. This canvas is a heavy herringbone twill, with the weave running horizontally. It is composed of two pieces joined by a horizontal seam that passes below the rope around Christ's waist and through the elbow of the kneeling Saint Veronica. The upper piece is 98 cm wide. Cusping is evident along the upper and lower edges of the canvas but not at the sides, where the painting has probably been slightly trimmed.

The original canvas has been lined on to a fine tabby-weave canvas, presumably by 'W. Morrill liner', whose stamp is visible on the upper bar of the stretcher (which is made of pine, with corner braces). Also on the stretcher are a fringed paper label inscribed 'H.A.B./E204' in ink, and a lozenge-shaped paper label with an orange border inscribed in biro with the number 2890.

Materials and Technique

The canvas has been prepared with a gesso ground (calcium sulphate).[1] Over this ground there is a layer of pale brownish-grey priming of lead white with some black and fine brown pigment. Preliminary sketching in black, and grey paint for both the outline and the modelling, can be detected in the deeper folds of Christ's robe, at the edges of the Virgin's veil and around the clenched fist against the shield.

Christ's pale pink garment is painted with lead white and a little red lake. The large dark green leaves in the lower left corner are painted with verdigris, mixed with a coarse black pigment, and a small amount of lead white.[2] Orpiment and realgar are likely to have been employed for the tunic of the man pulling the rope, top left. The blue of the garment worn by Saint John (upper right, in front of the white horse) is probably azurite but has not been analysed.

X-radiographs suggest that the figure of Christ was blocked in first. The last major compositional elements to be painted were probably Saint John, whose frightened face and raised hands are placed above the grieving Virgin, and the soldier in the centre of the canvas, seen from behind. It is clear that the bar of the cross was painted over Christ's right forearm (which must, however, always have been intended to support it). There are numerous minor pentimenti, especially in the interstices of the figures, which suggests that the composition was somewhat improvised in these areas. Most of the folds of yellow drapery falling in front of the Veronica's right knee were added later and are a notable example of this.

The paint has been worked in some places with the pointed end of a brush handle, for example in the horse's mane, at the back of the Virgin's veil, and in the profile head of a woman above Veronica. What appears to be an incised line can be discerned passing through John's face and perhaps indicates some preliminary design for the horse's head behind him.

Conservation

The history of the painting suggests that it is likely to have been cleaned at least once in the seventeenth century and at least once in the eighteenth, but no treatment is documented before 1834, when the painting was in the collection of the Earl of Bradford at Weston Park. All the paintings there were cleaned by George Barker of Leamington Spa and his daughter in that year. Six pounds was charged for work on this painting on 20 April, a sum higher than that paid for almost any other picture treated. 'Many Figs. Much rep.' is noted. The frame was 'cleaned mended and regilt at the front edge' for £1 4s. 6d. at the same time.[3] It was probably not treated again until it was placed in the care of Horace Buttery in Bond Street in 1959 in preparation for the Royal Academy's winter exhibition in 1960.[4] Morrill's lining (see above) is likely to be of the same date.[5]

In considering the remarkable condition of this picture we may note that it has probably only changed ownership five times in the five centuries it has survived, and has never passed through the hands of the art trade, unless the brothers Reynst are considered to have been dealers. It is also fair to add that several other paintings by Bassano from this period are in an even better state of preservation, perhaps especially the *Flight into Egypt* in the Norton Simon Museum.[6]

Condition

There is some abrasion, notably in the helmet of the figure about to cuff Christ and in the spear, top right; there is some flaking along the lower left edge; some of the paint in yellow areas has deteriorated (it may consist of orpiment and realgar); some of the lake glazes for the shadows on the soldier's back have faded; the blues of John's sleeve and the Virgin's cloak have probably darkened, although the modelling is still apparent. Moreover, there is in the paint an overall crackle of a distinctly horizontal pattern which is especially visible in the paler areas, and minute losses may be detected on the edges of some of the cracks. However, the painting is remarkably well preserved and the impasto is largely intact. The surface has a dry appearance, partly from the roughness of the paint, partly as a result of the deterioration of the unusually thin modern varnish.

Subject and Original Purpose

The title used here is one that was long employed by the family which owned the painting and one that has been used in the National Gallery since the painting was acquired. It is not inaccurate.

The two men in the top right-hand corner of the picture mounted on a grey horse and a mule may be intended to represent the priests and Pharisees presiding over the procession in which Christ carries his cross to Calvary. The artist has tried to suggest that they are part of a larger group by painting, more faintly, the other two faces beside them. The

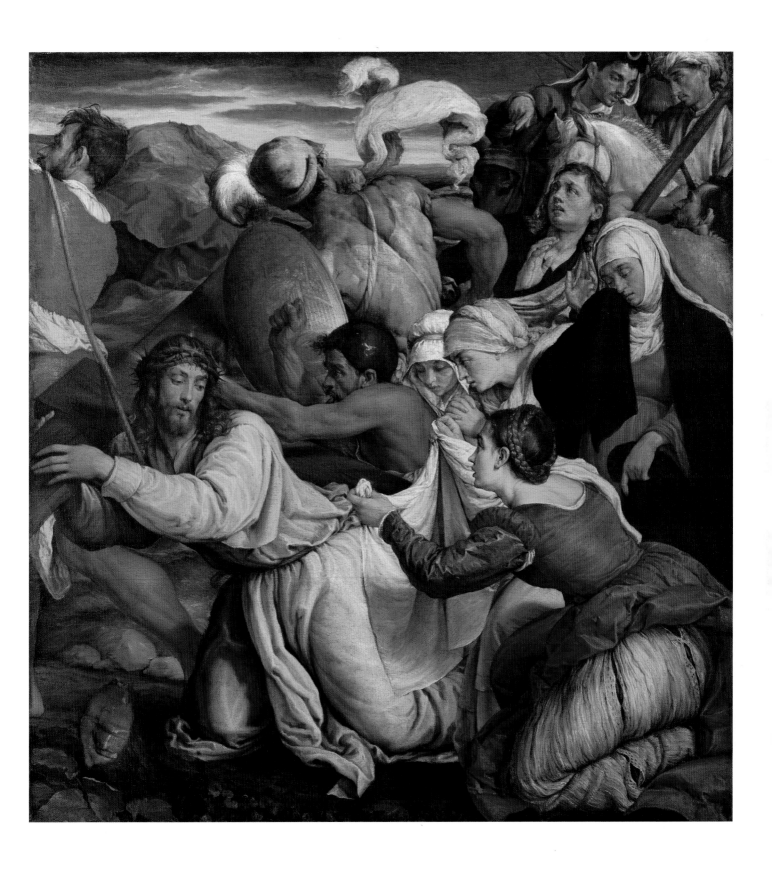

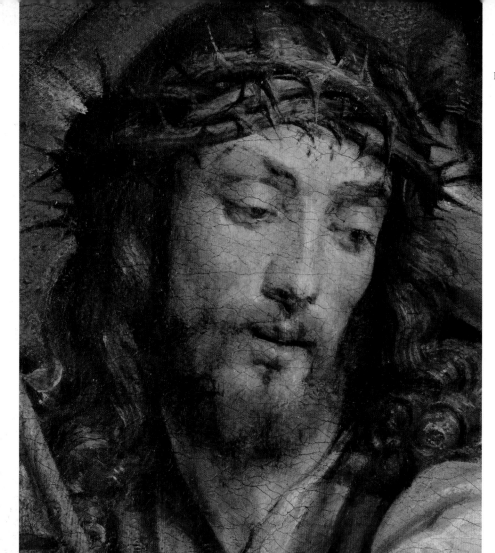

destination of the procession is alluded to by the two crosses on the barren heights which are visible in the distance, on the left-hand side of the painting.

Four executioners are depicted. The most prominent of them is shown from the back in the centre of the composition. Presumably he is intended for a Roman foot-soldier, for he wears something like a cuirass and carries a shield. The shield (of yellow metal, so presumably of brass) is decorated in relief, apparently with a landscape – foliage and perhaps paling can just be discerned. On the right and left edges of the composition there are two bearded men, both wearing orange. They have identical features and are both seen in profile. One pulls the rope attached to Christ's waist, the other carries a ladder. The fourth executioner emerges in the centre below the one holding a shield. He wears a helmet. His left hand is largely concealed but a lock of Christ's hair appears to be between his finger and thumb. He raises his right fist to hit Christ. His mouth is open, so he may also be shouting at Christ or spitting upon him.

It was a well-established convention for the executioners conducting Christ to Calvary to recall the cruel conduct of their colleagues at the Flagellation and Mocking. What is unusual is the way that the Marys are pressed together with the executioners. The Virgin Mary stands to the right, with her right hand raising her blue mantle to her tear-soaked cheek. Two of the other Marys (neither is clearly meant for Mary Magdalene) press forward from behind her. Saint John is also part of this group, and the soldier with the shield pulls John's cloak off his shoulder, an incident which is not mentioned in the Gospels and not commonly represented in paintings of the Passion.

Christ has stumbled under the weight of the cross and turns to look at the cloth that Veronica extends towards him and upon which his likeness (we know) is miraculously imprinted. Veronica seems to have knelt hastily, for her skirt is pulled up to reveal voluminous undergarments. These two figures, linked compositionally by the veil itself, are the two largest ones, and are the nearest to us. The chief subject of the painting is certainly their encounter. The size of this painting, and still more the format, make it almost certain that it was made as an altarpiece and perhaps for a chapel dedicated to Saint Veronica.

Altarpieces in which the principal theme was the Way to Calvary had been introduced relatively recently. Three were commissioned by the Antinori family in Florence between about 1500 and 1505 from Biagio d'Antonio and Antonio del Ceraiolo for S. Spirito (where the latter remains; the former is now in the Louvre)[7] and from Ridolfo Ghirlandaio for S. Gallo

(now in the National Gallery, London, NG 1143).[8] All of these altarpieces include Saint Veronica, and veneration for her may have prompted their creation, but she plays an even more prominent role in Bassano's painting. Another form of devotion which could encourage an altarpiece of this subject was that of the Virgin's swoon. The swoon, the 'Spasimo', of the Virgin is the subject of Raphael's altarpiece made in about 1514 for Palermo, for example, and certainly of Boccaccino's of about 1501 for S. Domenico, Cremona (now in the National Gallery, London; NG 806).[9] Devotion to the Spasimo was a controversial novelty,[10] and the cult of Veronica was also relatively novel and probably controversial.

Apocryphal legends concerning the miraculous healing of the Emperor Tiberius by means of a portrait – a true likeness of Christ, in the possession of a holy woman named Veronica – were in circulation between the eighth and fourteenth centuries. The name Veronica is a variant of the Greek name Berenice but it was perhaps also suggested by the 'vera icon', the true likeness itself. The likeness was said to have appeared miraculously when Christ looked at the linen that Veronica was taking to a painter whom she hoped would make a portrait of him. By the end of the tenth century, the portrait had become a major relic, known as the 'vernicle', preserved in the basilica of St Peter's in Rome. It apparently resembled the miraculous portrait of Christ known as the Holy Mandylion, which had been taken to Constantinople in 944 and is likely to have been modelled upon it. The belief that the image had appeared on the cloth when Veronica wiped the face of Christ, or held the cloth up before him as he

carried the cross, became popular in the fourteenth century and, like the Spasimo, owed much to pilgrimages to the Holy Land, where devotion was focused on the 'via dolorosa', the way to Calvary, and on many incidents associated with this which had no canonical authority. It also must have owed something to the popularity of the Turin shroud, for that too was not merely a miraculous likeness of Christ but also a relic of the Passion.[11]

In the second half of the sixteenth century apocryphal legends were subjected to careful scrutiny by reformers of the Church. Although Veronica continued to be venerated, there were many doubts about her cult, and Carlo Borromeo suppressed the liturgical honours accorded to her.[12] It may be that Bassano's painting was removed from its original ecclesiastical setting during this period and on account of these doubts.

Attribution

As is clear from the painting's early history (for which see the section on Provenance below), it was known to be by 'Bassano', meaning Jacopo Bassano, during the seventeenth and early eighteenth centuries. Thereafter it was recorded as a Veronese. A photograph of a copy of the painting was seen by Arslan, who published it as by Bassano in an article of 1929 and included it in his monograph of 1931.[13] NG 6490 was also given a certain publicity by a *Country Life* photograph of 1945 showing it hanging in Weston Park,[14] but no one seems to have paid it much attention until the opening in June 1957 of an exhibition devoted to Jacopo Bassano, to which the copy (since 1955 the property of York City Art Gallery) was lent and where, when seen in the company of the artist's genuine early works, it declared itself to be a copy.[15] It was then recalled that Denis Mahon had observed in a footnote that the Weston Park painting was likely to be the version which was once in the collection of King Charles II.[16] Three years later, in 1960, NG 6490 was exhibited at the Royal Academy, having been cleaned in the previous year and published by Muraro in *The Burlington Magazine* in February.[17] It has never since been disputed as an original work by Jacopo Bassano.

Date

During the period when NG 6490 was considered to be by Veronese there was no lack of knowledge in England of Bassano's style of painting, but there was hardly any awareness of his earliest mature work, of which the present painting is representative. It is noteworthy that Jacopo Bassano's *Adoration of the Shepherds* in the Royal Collection of the same period was similarly reattributed in the early eighteenth century. However, the latter painting was acknowledged as by Jacopo and correctly dated by Crowe and Cavalcaselle, who, had they visited Weston Park, would surely have recognised NG 6490 as a related work.[18]

NG 6490 must date from close to 1545, as has been recognised at least since 1973.[19] The palette is very close to Bassano's altarpiece of the *Martyrdom of Saint Catharine*, now in the Museo Civico, Bassano (fig. 3), in which there is a very

OPPOSITE:
Fig. 4 Detail of NG 6490 showing the head and hands of Saint John.

Fig. 3 Jacopo Bassano, *Martyrdom of Saint Catharine*, 1544.
Oil on canvas, 151.2 × 134 cm. Bassano del Grappa, Museo Civico.

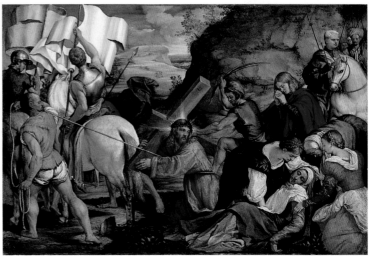

Fig. 5 Agostino Veneziano after Raphael, *Christ carrying the Cross* ('*Lo Spasimo di Sicilia*'), 1517. Engraving, 41 × 28.5 cm. London, The British Museum.

BELOW:
Fig. 6 Jacopo Bassano, *The Way to Calvary*, 1543–4. Oil on canvas, 81.9 × 118.7 cm. Cambridge, The Fitzwilliam Museum.

OPPOSITE:
Fig. 7 Albrecht Dürer, Scene from *The Small Passion*, 1509. Woodcut, 12.7 × 9.7 cm. London, The British Museum.

similar – almost comic – congestion of figures in active and often violent poses. Saint Veronica has the same flushed profile and plaited hairstyle as Saint Catharine; both saints reveal their petticoats as they kneel, and wear the same colours (Veronica in a red dress with green sleeves, Catharine in a green dress with red sleeves).[20] The Saint Catharine altarpiece can be dated from the artist's account book, the *Libro Secondo*, to the summer months of 1544,[21] and NG 6490 must have been completed soon afterwards. However, it is puzzling, especially since it was almost certainly painted as an altarpiece, that it is not included in that same *Libro Secondo*, in which all important commissions of this kind seem to have been recorded. Perhaps it was made for Bassano's own family chapel or as a special favour. It is certainly a painting to which he gave great attention, whether we consider the taut complexity of the composition, the richness and variety of colour, or simply the density of form and intensity of expression.

Sources

Bassano's composition owes much to Raphael's *Spasimo*, which he would have known in Agostino Veneziano's engraving of 1517 (fig. 5). As has often been observed, Bassano drew again and again upon this famous engraving for inspiration.[22] About a decade earlier, in a painting perhaps executed with his father, he had copied four or five figures from it,[23] and he did so again in the *Way to Calvary* in the Fitzwilliam Museum of about 1543 (fig. 6)[24] and in another painting of the same subject in the Christie Collection at Glyndebourne,

Sussex, which is documented as completed in 1549.[25] In NG 6490 the derivation is less obvious. The executioner seen from the rear, for example, seems to be derived from the soldier in the left foreground of Raphael's composition, but with his right arm in a different position.

For the weeping Virgin, Bassano may have turned to the prints of Dürer, and especially to the Virgin as she is depicted in the scene of Christ and Veronica in the *Small Passion* woodcuts of 1509 (fig. 7).[26] It is striking that Bassano's Christ is calmer in expression than Dürer's or Raphael's, but an expression of great distress is instead given to Saint John. The soldier's scarf flying up and twisting and curling against the sky like egg white leaking into hot water resembles the drapery of the angel in Bassano's *Flight into Egypt* in the Norton Simon Museum. It must also have been inspired by the restless flourishes of fabric which are typical of Dürer and of German Renaissance art in general (sculpture as well as painting and printmaking). This conflation of Raphael and Dürer is remarkably similar to that found in designs made by Bernaert van Orley (1488–1541) during the 1520s for tapestries of the Passion woven in Brussels, and indeed it is especially evident in the tapestries now in Madrid (Patrimonio Nacional) and Paris (Musée Jacquemart André) which show Christ carrying the cross.[27]

In addition, it seems likely that the flow of one figure into another and the spatial compression must owe something to the example of the ornamental style introduced into Venetian art by the Salviati and by Schiavone.[28] The prominent tree stump in the lower left-hand corner comes directly from the

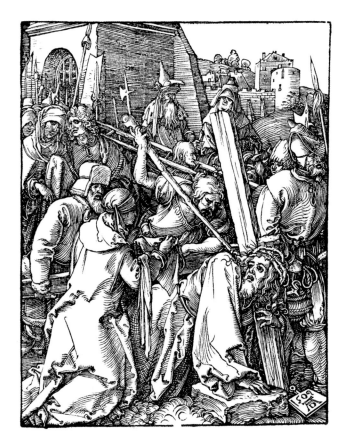

paintings of Bonifazio de' Pitati (see fig. 2, p. xv).[29] Bassano had used this device earlier, in his *Adoration of the Kings* of about 1543 in the National Gallery of Scotland (fig. 1, p. 3).[30] The mounted figures in NG 6490 come from the top right-hand corner of that painting (where there are also echoes of Raphael's *Spasimo*). So by the mid-1540s it is already the case that Bassano reuses more figures from his own earlier paintings than he takes from other artists. The relationship between Veronica and his earlier *Saint Catharine* (mentioned in the previous section) is also significant in this respect.

The *Way to Calvary* in the Royal Collection

Bassano's painting was first recorded in the great collection formed in Venice by Jan Reynst in the 1620s and 1630s, which was inherited by his brother Gerard (Gerrit) in 1648 and taken to Amsterdam. This collection, described here in an appendix (p. 470), formed the basis of a diplomatic gift made by the Dutch Republic to King Charles II of England in 1660, and NG 6490 was recorded, presumably very soon afterwards, in an undated 'Inventory of all his Majestie's pictures in Whitehall in Hampton Court and in Stoare', as in the Palace of Whitehall, one of ten pictures in the 'Square Table Room' – no. 161: 'Bastano. Our Saviour on his knees bearing his Cross &c. Tenn figures more. Dutch pr sent. 4/9 × 4/4.'[31] There were other large Venetian pictures in the room: one by 'Old Palma' (now attributed to Bonifazio),[32] a Veronese workshop painting of the *Mystic Marriage of Saint Catharine*[33] and Titian's *Virgin and Child with the Infant Saint John the Baptist* – all three of them also from the 'Dutch gift' – and Van Dyck's

portrait of the 'king when young laying a hand on a greate dogge with three princesses'.

At the time of this inventory there were few paintings recorded in the queen's apartments at Hampton Court – those in her drawing room and in her bedchamber were probably fixed above the chimneypieces.[34] The queen was Catherine of Braganza (1638–1705). The marriage, which at her insistence had been a private Catholic ceremony, had taken place on 21 May 1662. The king defended her when she became the victim of popular anti-Catholic feeling and calculated libels, especially in the late 1670s. From the moment of her arrival in London her private rooms were of intense interest to Protestants. Samuel Pepys contrived to examine her closet and bedchamber in Whitehall on 24 June 1664: 'She had nothing but some pretty pious pictures, and books of devotion; and her holy water at her head as she sleeps, with her clock by her bedside, wherein a lamp burns that tells her the time of the night at any time.'[35] But it was in the chapel beside St James's Palace, built by Inigo Jones, that her taste, or at least her faith, was most apparent, especially after the autumn of 1682 when Jacob Huysmans's *Holy Family* was installed in an elaborate altar surround designed by Grinling Gibbons beneath a vault and behind an altar tabernacle also painted by Huysmans.[36] In 1669 she acquired Somerset House (then also known as Denmark House) as her dower house and modifications were made for her there in 1671–2 and 1674–5, but chiefly in 1685, after her husband's death, when it became her principal residence.[37]

In the manuscript inventory of His Majesty's goods, the first folio of which is dated 15 February 1688/9, there is a list of fifty-four 'Pictures of the Kings in the Queene Dowager's Custody', of which no. 46 is 'Christ carrying his Crosse with Eleaven figures in it one of the Dutch presents', annotated as by Bassano. These pictures were predominantly religious in character; the only exceptions are two portraits, two flower pieces, a landscape, a 'perspective', and one drawing of an unspecified subject.[38]

Not many of the works cited are attributed but there was a picture of 'Our Lady and Christ and a Priest' by Raphael, an Ecce Homo by Titian, a 'Mantua piece' of Our Lady, Christ and Saint Catharine by 'Parmegan', a Saint Jerome by Metsys ('Quinton'), another 'Mantua piece' by 'Georgoone' of 'our lady, Christ and Joseph', a Good Samaritan by 'Phette' (Fetti), a Magdalen by 'Guedo', and a Nativity by 'Poolingberg'. There were also two other items from the 'Dutch gift': no. 33, 'Our Lady and Christ with a lamb and Joseph', probably a copy of the Holy Family with a Lamb, 'Said to be Raphael', and no. 48, 'Our Saviour with his feet on a cushion, the B. Virgin St John and St Elizabeth' attributed to Titian, both of them included among the works in the Reynst collection which were engraved (the latter had also been in the Square Table room, as noted above).

The queen intended to return to Portugal. The same inventory lists 'goods that went to Portugal for the Queene' in 1687, including a great 'crimson velvet close stoole with gold and silver fringe', a 'looking glasse Table and stands of walnutt tree',[39] but she in fact remained in Somerset House

throughout the reign of James II, and William III permitted her to continue living there – although it did not please him to do so – until the end of 1692. She arrived in Lisbon early in 1693 and died there in 1705. None of the pictures listed as being in her custody has been traced in subsequent records of the royal collection. She had become possessive and difficult, as is clear from a protracted dispute with the Earl of Clarendon which delayed her departure from London. Furthermore, with the change of dynasty there was some general confusion concerning crown property.

Vertue alleged that when the queen dowager left Somerset House the lord chamberlain 'put a stop' to the pictures 'but having one of them he much admired given to him he let them go'.[40] Then, in a fuller account, he recorded that the queen sent some 'few pictures' to Portugal when she 'intended first to go there to live the rest of her dayes – after ye. death of the king' but that she continued to live in Somerset House 'till she saw K Will^m settled – and she unlikely to be much at Ease here ... its reported the Ld Chamberlain then in Office objected then against carrying away any of those pictures but after Viewing them – he was prevailed to accept of one he liked best, & then let them pass.'[41] This last entry is dated 1736, long after the events described (the earlier entry is likely to have been made in 1725), and Vertue is careful to add 'its reported', but the story is likely to have some foundation. If a painting was extracted from the group as a bribe then it must surely have been the Bassano, which is indeed the only painting among those in the queen's 'custody' which is recorded in England after this date.

There is a copy of the engravings of the Reynst collection in the Victoria and Albert Museum, annotated by Thomas Coke, who was lord chamberlain of Her Majesty's household from 1706 until 1727. Under the print of Bassano's painting, there erroneously entitled as by Veronese, he writes: 'Ja: Bassano now att my Ld Torringtons of Twittenham.' This is certainly a reference to Thomas Newport, created Baron Torrington in 1716, who died without issue in 1718.[42] Lord Torrington's father, the Earl of Bradford, was a keen collector, and although he was never lord chamberlain he was comptroller and treasurer of the household under both Charles II and William III. He was a man of unscrupulous character, at least as an art collector, and it is very likely that he was the recipient of the queen's bribe. His collecting and the subsequent history of the paintings he owned are traced in an appendix here (pp. 443–8).

Provenance and Acquisition
See above. Jan Reynst, Venice, before 1648, when inherited by Gerard Reynst. Sold by the latter's widow to the Dutch Republic and presented to Charles II of England in 1660. By February 1689 (modern calendar) in the apartments of Queen Catherine of Braganza in Somerset House, and apparently given by her as a bribe in the winter of 1692, presumably to the Earl of Bradford, in whose family it descended to the 7th Earl, who succeeded in 1981. The earl agreed in 1983 to settle the capital transfer tax to which his estate was subject by arranging a private treaty sale of the Bassano

through Christie's. The painting was studied in the National Gallery in October, then shown in the Royal Academy's exhibition, *The Genius of Venice*, in November. Acquisition was agreed upon in February and announced on 20 March 1984, together with the £300,000 contribution towards its cost made by the National Heritage Memorial Fund.

Print
The painting was engraved and etched in reverse in about 1655–7 by Jeremias Falck (b. Gdansk 1609/10, d. 1677), when it was still in the Reynst collection. The print was made for the volume *Variarum imaginum a celeberrimis artificibus pictarum caelaturae*, published in Amsterdam.[43] Falck seems to have come to Amsterdam specifically to work on this project.[44] There are no significant compositional differences, except that the tops of the heads at the top right, together with a strip of sky, are included in the print. The cusping of the canvas suggests that only a small amount of the picture at most has been lost on the upper edge, so Falck was either imitating an addition which had been made to the painting or changing the composition to make it appear more conventional.

Copy
An old copy of the painting was presented by F.D. Lycett-Green, through the National Art Collections Fund, to York City Art Gallery in 1955. Lycett-Green, then of Constantia, South Africa, bought it in 1936 from W.E. Duits, who had acquired it at Sotheby's in London on 6 November 1935 (lot 126A). The painting had been unsold at a Christie's sale on 15 June 1923 (lot 108) but had in the meantime been published as an original by Arslan.

It seems likely to have been made in Holland shortly before the painting was sent to England. In it, the Virgin wears black, which suggests that the blue had already greatly darkened. The pink of Christ's garment is warmer, no doubt because the lake pigment used by Bassano was not available. The painting is also cropped, very severely on the right side, less drastically on the left.

Exhibitions
London 1960, Royal Academy, *Italian Art and Britain*; London 1983–4, Royal Academy, *The Genius of Venice*; Bassano del Grappa 1992, Museo Civico; Fort Worth 1993, Kimbell Art Museum, *Jacopo Bassano, 1510–1592*.

Framing
The painting arrived in the National Gallery in an English frame of a Carlo Maratta pattern such as we know to have been given to many of the paintings at Weston Park in the early nineteenth century.[45] The decision to reframe it was made immediately upon acquisition, and on 20 March 1984 the press release announcing the acquisition observed that it would be 'newly framed' for exhibition in the galleries two days later. The frame was a Victorian imitation of a Renaissance tabernacle frame, altered in size and regilded. It must have originally been made for another painting. Although this choice of frame was intended as a reminder that the

painting had been made as an altarpiece, it made it hard to display with other pictures. A walnut frame based on Italian patterns of the late sixteenth century was carved for the painting by John England: it was completed at the end of 2002.[46] The beads separating the gadroons on the outside of the inward-curling outer moulding are gilded. So too are the tongues between the acanthus leaves curled over the ogee inside the outer moulding, and also the narrow hollow at the sight edge.

NOTES

1. Verified by EDX. Report made by Marika Spring of the National Gallery's Scientific Department, 21 October 1997.

2. Ibid.

3. Staffordshire County Record Office, Bradford Papers, D1287/4/4 (R/271).

4. Muraro 1960, p. 53. For Buttery see Penny 2004, pp. xiv–xv.

5. For Morrill see ibid., p. xiv.

6. For which see Ballarin 1995–6, II, 3, pl. 147.

7. Bartoli 1999, pp. 231–2, no. 125, and pp. 125–9 (which includes a discussion of the iconography).

8. Gould 1975, p. 100.

9. Penny 2004, pp. 18–29.

10. Ibid., pp. 25–8.

11. For legends of the healing of Tiberius see James 1926, pp. 157–9, and Voragine 1969, pp. 214–15. For the portrait relics generally see Réau 1955–9, II, 1957, chapter 2, p. 19. For a succinct account of Veronica see P.K. Meagher in *The New Catholic Encyclopedia*, XIV, p. 625.

12. Ibid., p. 625.

13. Arslan 1929, p. 17, and Arslan 1931, p. 90.

14. *Country Life*, XCVIII, July–December 1945, p. 866.

15. Zampetti 1957, p. 46, no. 18. Muraro 1957 recognised that it was a copy – an opinion expressed by *The Burlington Magazine* two years earlier ([Nicholson] 1955).

16. Mahon 1950, p. 15, note 4, part 5.

17. Muraro 1960, pp. 53–4.

18. Crowe and Cavalcaselle 1871, II, pp. 291, 486; Shearman 1983, pp. 21–3, no. 16. Even Waagen did not recognise that the *Adoration of the Kings* now in the National Gallery of Scotland was by Bassano (1857, p. 429), although he realised that it had been incorrectly attributed to Titian.

19. Ballarin 1973, p. 108; Brown and Marini 1992, p. 40, no. 14 (entry by Maria Elisa Avagnina).

20. Inv. 436. Brown and Marini 1992, p. 34, no. 13 (entry by Giuliana Ericani).

21. Muraro 1992, p. 36, no. 148.

22. On this topic see, above all, Ballarin 1967, pp. 94–6.

23. Rearick in Brown and Marini 1992, p. LXV and fig. 4.

24. Brown and Marini 1992, pp. 32–3, no. 12 (entry by Giuliana Ericani).

25. Ballarin 1967; Rearick in Brown and Marini 1992, pp. xcvi–xcvii, fig. 18.

26. Dunkerton, Foister and Penny 1999, p. 59.

27. Campbell 2002, pp. 287–313, especially pp. 291–2 and 312–13; for illustrations see fig. 134 on p. 292 and no. 32, reproduced on p. 311.

28. This is persuasively argued by Ballarin 1967 but I do not accept the source in a print by Schiavone that he proposes (p. 98).

29. It is tempting to see the axed stump as having a symbolic meaning in NG 6490, but if so it is a meaning which must be appropriate to a wide range of religious subjects.

30. National Gallery of Scotland, Inv. 100; Brigstocke 1993, pp. 26–7; Brown and Marini 1992, pp. 26–8, no. 10 (entry by Giuliana Ericani).

31. A copy of this inventory is in the National Gallery Library (O.S.) NC 320 (60) Royalty: 2, fol. 10.

32. Shearman 1983, p. 51, no. 46.

33. Ibid., p. 289, no. 317.

34. MS cited in note 31, fols 105–17.

35. Pepys 1894, IV, p. 168. Her lodgings had been prepared in July 1662 and were extended in 1664 and 1668 (Colvin *et al.* 1976, pp. 267, 269).

36. Colvin *et al.* 1976, pp. 244–54.

37. Ibid., pp. 254–9. Many of the chapel's fittings were then moved to the chapel in Somerset House.

38. British Library, Harleian MSS, 1890, fols 69–71.

39. Ibid., fol. 15.

40. Vertue, I, p. 161.

41. Ibid., IV, p. 100.

42. Alastair Laing was the first person to realise this. Denis Mahon (1950, p. 15, no. 15) assumed that it was a reference to Admiral George Byng (1663–1733), who was raised to the peerage as Viscount Torrington in 1721. This was a compelling idea because Byng had many dealings with Portugal and his great-granddaughter married the 2nd Earl of Bradford of the second creation, in whose collection the Bassano was later to be found.

43. Block 1890, pp. 34–5, no. 18 ('Christus das Kreuz tragend', connected with Schiavone rather than Bassano); Pan 1992, p. 69, no. 54.

44. Logan 1979, p. 38, note 2; Block 1890, pp. 10–11.

45. The frame survives in the National Gallery's store. It was number E165 in the inventory compiled by Paul Levi.

46. John England retired as head of framing at the Gallery in February 2001. The work had been agreed upon before his retirement.

Jacopo Bassano

NG 277
The Good Samaritan

*c.*1562–3
Oil on canvas, 102.1 × 79.7 cm

Support
The measurements given above are those of the stretcher. The original canvas, of a rough, open, medium-weight weave, is paste-lined on to two tabby-weave canvases. The borders of the original canvas are concealed by putty and repaint extending between 1 and 2 cm from the upper edge, 2.5 cm from the lower, 2 cm from the left, and 2.5 cm from the right. Cusping is evident on all sides. The painting may have been reduced, as is claimed by Gould, but not by much.[1] The pine stretcher with crossbars dates from 1892.

Materials and Technique
There is a pinkish-grey ground composed of lead white, with some red lead and black pigments, on which there is superimposed a secondary layer, ruddier and darker in colour, of lead white, black, vermilion and lead-tin yellow. No evidence of gesso preparation was discovered in any of the samples that have been taken.[2]

The blue of the sky and the Samaritan's breeches is azurite. This pigment is also used extensively in the landscape and, together with a copper-green glaze, for the foliage. The stripes of the Samaritan's scarf are also of copper green, probably verdigris. For the grass, copper green mixed with lead-tin yellow is thickly glazed with copper green. The silver or pewter flask is painted with charcoal black, lead white and azurite. The brown of the rock formation to the right is composed of vermilion, azurite, lead-tin yellow, black, and earth pigments. No significant pentimenti are revealed by X-radiography.

Conservation
The painting was probably lined, cleaned and restored in the early nineteenth century. After acquisition by the Gallery in May 1856, some of the varnish in the sky was removed and the painting was recoated with mastic varnish. It was varnished again in 1865, and then relined and partially cleaned by 'Morrill' between 1891 and 1893.[3] It was thoroughly cleaned and restored by Ruhemann in 1968. Ruhemann's retouchings of flake losses, cracks and abrasion have slightly discoloured. In a few minor areas (notably the sheath of the Samaritan's dagger and the fringe of his tunic) the original forms could not be detected, and these were rendered by Ruhemann with judicious imprecision.

Condition
The colours of the figures are well preserved. Shrinkage during lining has caused wrinkles, creases and cracks in the paint surface overall. The web-like cracks are especially apparent in the sky, and there are minor losses associated with these. The darker areas are largely illegible due to abrasion and increased transparency. The mule, together with the trees and rocks behind it, can now only be clearly discerned in a strong light. The copper greens in the foliage, and perhaps also in the grass, have darkened. The stripes of the Samaritan's scarf have also changed from green to brown. Not only has the setting been somewhat obscured by darkening but the composition has been altered by it, chiefly because the impact of the foreshortening of the mule is diminished. In addition, it is now not easy to see that the dogs in the foreground are licking up the wounded man's blood.

Subject
The parable of the Good Samaritan is told in the Gospel of Saint Luke (10:30–7). In answer to the question 'Who is my neighbour?' – in other words, 'To whom am I obliged to be charitable?' – Christ related that a 'certain man went down from Jerusalem to Jericho, and fell among thieves which stripped him of his raiment, and wounded him, and departed, leaving him half dead'. A priest travelling along the same road saw him but 'passed by on the other side'. A Levite did the same. But then a 'certain Samaritan' took pity on the man, 'bound up his wounds, pouring in oil and wine, and set him on his own beast, and brought him to an inn, and took care of him', leaving money for the landlord to continue caring for him. 'Which now of these three, thinkest thou, was neighbour unto him that fell among thieves? And he said, He that showed mercy on him. Then said Jesus unto him, Go and do thou likewise.'

Bassano was perhaps the first Italian artist to treat this subject. He did so several times and seems to have made it popular with other Venetian artists, including Veronese.[4] Arslan, and more recently Aikema, proposed that Bassano was following the example of Netherlandish painters whose work was known in Venice, which is plausible but not certain.[5] A notable precedent may have been a painting by Romanino. This, however, may not be earlier than Jacopo's first treatment of the subject.[6]

Attribution, Reputation and Date
The painting was attributed to Jacopo Bassano when it was in the Pisani collection in the mid-eighteenth century and later when it belonged to Sir Joshua Reynolds; but Waagen, when he saw it in Samuel Rogers's collection, described it as by Francesco Bassano.[7] He was perhaps following Buchanan's recollections of the art trade, where it is attributed to Francesco, probably in error.[8] In any case, Anna Jameson in her review of London's collections referred to it as by Jacopo; it was also sold as such in Rogers's sale and catalogued as such by the National Gallery. Waagen also attributed it to Jacopo in the supplement to his survey of English collections in 1857.[9] Something of the painting's reputation is conveyed by Jameson's praise: 'Most admirable for character as well as colour, and far more dignified in feeling than is usual with Bassano.'[10] Eastlake placed it on the list of paintings in Samuel Rogers's collection that he most desired for the Gallery, and it was the second most expensive of these –

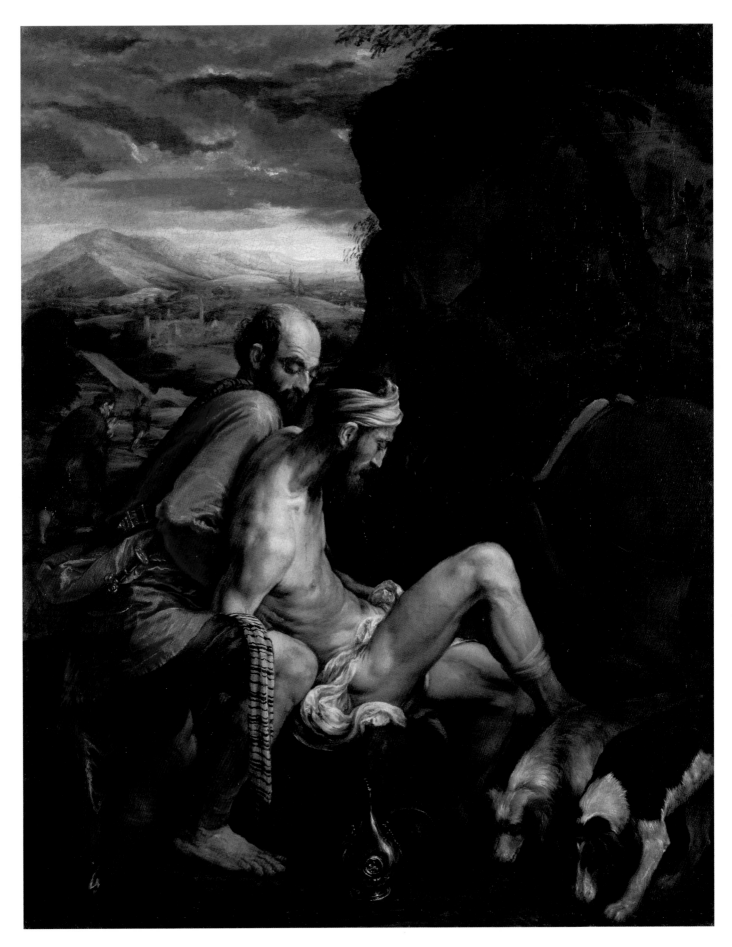

Rubens's *A Roman Triumph* after Mantegna (NG 278) cost more. The attribution to Jacopo was not, it seems, challenged in the twentieth century.

The type of the Samaritan is exceptionally close to the Saint Jerome in the altarpiece of the *Crucifixion with Saints* now in the Museo Civico, Treviso, which is documented as commissioned in the winter of 1561 and set up in the winter of 1562. Rearick justly observes that the scintillating brushwork on the Samaritan's clothes can be exactly paralleled in those of the Magdalen embracing the cross in that work.[11] Ballarin, on the other hand, proposed a date of about 1557.[12]

Versions and Variations

The earliest treatment of this subject by Jacopo Bassano seems to be a painting in the Royal Collection at Hampton Court (fig. 1), which is likely to date from about 1546–8.[13] It is of a horizontal format, the mule faces the viewer, and the rocky bank and trees occupy the left side of the painting rather than the right. The action is also different. The Samaritan binds the traveller's leg, whereas in NG 277 he has already bound his wounds (those on his head as well as his leg) and now lifts him up in order to place him on the mule. The same metal flask features in both paintings, and the bald, bearded model employed for the wounded traveller seems to have been used instead for the Samaritan in NG 277 – or at least studies of the same model were used for both. About a decade later the workshop painted replicas, with minor variations, of this first version, and there is one in the Capitoline collection that is smaller in size but vertical in format and on panel, which must be by Jacopo's own hand.[14]

NG 277 appears to be the first version of the new composition, although, if this is indeed the case, the absence of significant pentimenti is surprising. An unfinished sketch of the composition in Prague should perhaps be considered as preliminary. Neumann proposed that it was an 'abbozzo' kept in the studio as a 'guide for the preparation of similar pictures'.[15] Rearick has instead argued that it was a copy commenced by Jacopo's most talented son, Francesco, which he abandoned, dissatisfied.[16] Several replicas of varying quality were made by the workshop.[17]

Fig. 1 Jacopo Bassano, *The Good Samaritan*, c.1546–8. Oil on canvas, 64.3 × 84.2 cm. The Royal Collection.

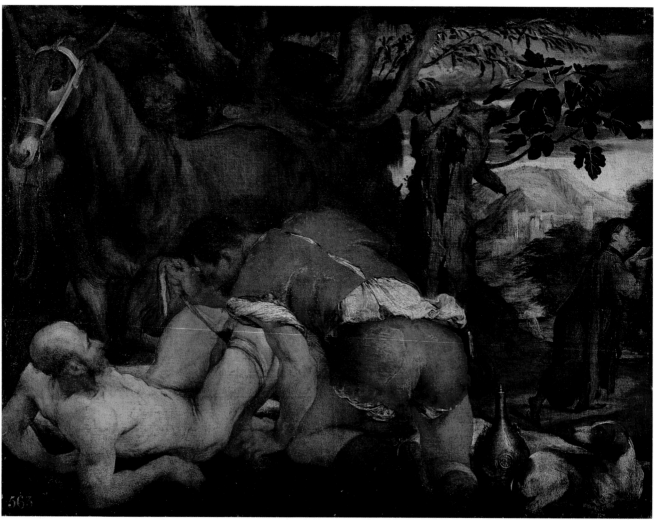

Fig. 2 Jacopo Bassano, study for
NG 277. Black and red chalk on
faded blue paper, 21.6 × 27.4 cm.
London, Courtauld Institute of Art
Gallery.

Fig. 3 Jacopo Bassano, study for
NG 277. Black and coloured chalks
on faded blue paper, 27.1 × 35.4 cm.
Private collection.

Drawing

There is a preparatory drawing in black chalk on discoloured
blue paper in the Witt collection in the Courtauld Institute
(fig. 2),[18] and another, for the traveller, in ruddy brown and
pink chalks, as well as black and white chalks, on a some-
what green-blue paper in a private collection in Chicago
(fig. 3).[19]

Print

The painting, or, as Gould carefully notes, perhaps a 'hypo-
thetical identical replica', was reproduced as an engraving
with some etching by Pietro Monaco (1707–1772) in the
Raccolta di Centododici Stampe di Pitture della Storia Sacra
published by Guglielmo Zerletti in 1763.[20] The print, which is
of high quality, was signed by the artist, with the assertion

that it was drawn, engraved and printed by him ('del. scol. e forma') in Venice. The legend describes the print as the 'Parabola del Samaritano', made after a painting by Jacopo Bassano in the possession of the noble Pisani family.[21] The print differs from NG 277 only in minor respects: there is a little more space at the left, and the Levite's book is less evident. In the painting the vessel on its side behind the flask appears to be a bowl, or perhaps another flask on its side, but in the print it is interpreted as another, larger, flask. The most important difference is that in the print the traveller's cloak extends beneath the two dogs.

Provenance

The print (see previous section) after what is likely to be this painting published in 1763 describes it as belonging to the Pisani family, of which there are several branches (see p. 365). It was probably still in the same collection in 1772 when the print was reissued. From the Pisani the painting seems to have passed briefly to Count Vitturi. Thomas Moore Slade claimed that it was among the pictures he acquired in about 1775 from that Venetian collection (see p. 448).[22] Slade sold the painting to Sir Joshua Reynolds not long before the spring of 1791, when Reynolds included it in the exhibition intended to benefit his servant ('Ralph's exhibition') as no. 52 'Bassan – The Good Samaritan'. It was included in Reynolds's sale at Christie's on 17 March 1795 as lot 48 but was bought in at 44 guineas (£46 4s.).[23] Reynolds was said to have valued it at 100 guineas, but Lady Inchiquin (the artist's niece and heir, later Marchioness of Thomond) valued it at 40 guineas.[24] A year later it was among the group of pictures offered to Joseph Berwick, a woollen draper and banker forming a collection with Farington's advice, at 50 guineas,[25] but when offered at Phillips on 9 May 1798 (as lot 36) it was bought in at 23½ guineas (£24 13s. 6d.).[26] The painting was finally sold as lot 54 on the first day of the Thomond sale (18 May 1821), where it was bought by Henry Rogers for 40 guineas.[27] It is presumed to have been bequeathed by him to his brother Samuel Rogers, at whose sale on 3 May 1856 (the sixth day of the sale) it was lot 709, and was acquired for the National Gallery at 230 guineas (£241 10s.).

Exhibitions

London 1823, British Institution (142; lent by Henry Rogers); Trent 2006, *Romanino* (47).

Framing

In the mid-1970s the painting was given a 'rose corner' frame. This pattern, popular in mid-seventeenth-century France, has flowers carved in relief at the corners: in this case they were also at the centres and were superimposed on

Fig. 4 Corner of the current frame on NG 277.

panels engraved in the gesso. If this was an old frame it had been stripped and regilded, but it is more likely to have been a modern imitation.

In the summer of 1998 it was replaced by a seventeenth-century Italian frame, probably Emilian (fig. 4), which had been acquired from Messrs Wiggins in the autumn of the previous year with money generously donated for this purpose by Dr and Mrs Alan Horan. The carved elements are of walnut, the carcass of poplar. The reverse ogee profile is carved with acanthus leaves and tongues which, unusually, point towards the painting. Smaller vegetal forms at the outer edge have rounded (petal) and pointed (leaf) projections, some of them broken, which make the frame vulnerable to handling. The frame was very slightly reduced at the mitred corners to fit the painting and numerous leaf tips were restored. The pale water-gilding is original. This is one of the finest frames in the National Gallery, distinguished in both execution and design, and in excellent condition.

NOTES

1. Gould 1975, pp. 20–1.

2. Report made by Marika Spring of the National Gallery's Scientific Department on 21 October 1997. The presence of haematite had previously been suspected in these grounds.

3. When the canvas was restretched in December 1997, Dave Thomas found the date of 1892, together with Morrill's name, on the stretcher.

4. Dresden, Gemäldegalerie. Pignatti and Pedrocco 1995, II, pp. 484–5, no. 385.

5. Arslan 1931, pp. 93–4; Aikema 1996, pp. 47–9.

6. Frangi et al. 2006, no. 47 (entry by Ezio Chini). Romanino's painting is in the Toesca Collection, Rome. Shearman (1983, p. 25) was the first to consider it as a precedent and possible source for Bassano.

7. Waagen 1854, II, p. 77.

8. Buchanan 1824, p. 330.

9. Waagen 1857, p. 60.

10. Jameson 1844, p. 392.

11. Rearick 1987, II, p. 4; Rearick in Brown and Marini 1992, p. cxxii. For the Treviso *Crucifixion* see ibid., pp. 103–4, no. 37, entry by Vittoria Romani.

12. Ballarin 1973, pp. 94, 100; the date is retained in Ballarin 1995–8, II, 1996, part 3, caption to fig. 301.

13. Hampton Court, no. 563; Shearman 1983, pp. 23–5, no. 17, pl. 17.

14. A very good replica was with Piero Corsini, New York, in the spring of 1988. Another was in the Baron Hugo Hamilton Collection in Boo, Sweden. For the Capitoline version see Bruno 1978, pp. 32–3, no. 71.

15. Neumann 1967, pp. 84–7, no. 6 (107.5 × 84.5 cm).

16. Rearick does not, however, say why he would have been dissatisfied (Brown and Marini 1992, p. cxxii).

17. Replicas were offered at Christie's, London, 26 July 1968, lot 124; Sotheby's, London, 9 February 1979, lot 57; Christie's, London, 20 October 1972, lot 145; Sotheby's, London, 3 April 1991, lot 127. An elaborate version of the composition is at Chatsworth, Derbyshire, in the collection of the Dukes of Devonshire: the painting is somewhat larger (131 × 117 cm), the Samaritan has a page and wears boots, and the landscape is different.

18. No. 2235.

19. Brown and Marini 1992, pp. 218–19, no. 84 (entry by Vittoria Romani).

20. It was reissued with the plate number 34 in 1772.

21. Pan 1992, p. 126, no. 120.

22. Buchanan 1824, I, pp. 320–34; specifically, p. 330, no. 54.

23. Broun 1987, II, pp. 260–1.

24. Farington 1978–98, I, 1978, p. 317 (20 March 1995).

25. Ibid., pp. 485–6 (30 January 1996).

26. Broun 1987, II, pp. 260–1.

27. Gould 1959, p. 13, assumed that Henry Rogers was an error for Samuel but the painting was exhibited under Henry's name at the British Institution, and Gould noted this in 1975.

Jacopo Bassano and Workshop

NG 228
The Purification of the Temple

*c.*1580
Oil on canvas, 160.5 × 267.5 cm

Support
The measurements given above are those of the stretcher. The original canvas, of a heavy twill weave with numerous slubs, consists of two pieces joined horizontally 47 cm from the upper edge. This canvas is lined onto a finer twill canvas which has been pasted onto a synthetic wooden board 1 cm thick. The board is nailed to an old stretcher of stained pine. The ragged edges of the original canvas are visible on all sides and do not quite extend to the edges of the lining canvas. Cusping can be discerned, especially on the left and right.

Materials and Technique
No trace of gesso was found in the paint samples. There is a priming of very dark, nearly black paint composed of coal black of large particle size and some yellow earth.[1]

Traces of brush drawing in black are visible in many places, for example in the angle of the pillar on the left, in the entablature of the door on the right, in the hands of the boy in the centre, and in Christ's raised right forearm. What may be orthogonal lines, perhaps used to plan the linear perspective, can be seen, in a good light, passing through the stool on the lower right. This black drawing was presumably not made directly on the nearly black priming. There is also evidence of some brush drawing in white or near-white, notably in the collar and hat of the man in the middle distance and in the figures in the distance. A thin line of orange paint, 18 cm in length, passes through the arm of the boy in the lower left corner, 2 cm from the edge of the canvas. Vestiges of a similar line can be discerned on the right edge.

The pale yellow skirt of the woman kneeling with a basket of eggs in the centre foreground is painted with lead-tin yellow. The large lemon-yellow particles, vitreous in appearance, were shown by EDX analysis to contain silicon in addition to lead and tin, suggesting the type II form of the pigment.

Conservation
There is no record of any treatment being given to the painting before it was placed in the National Gallery in February 1853. In 1855 a mastic varnish was applied. In 1888 the painting was cleaned – but probably only superficially – and 'restored' by Buttery. By 1923 the varnish was said to have become so dark that the painting was 'almost invisible'. It was removed by Holder, who applied a new coat of mastic varnish. The picture was 'polished' in April 1938, in March 1939, and in 1953. Blisters were laid in October 1960. The painting was cleaned and retouched in July 1963.

Condition
The original colour and some of the texture of the paint have been preserved wherever lead white was employed, as in the loose white blouse over the kneeling woman's dress, or in the pale orange lights on the curtain looped across the top of the painting (presumably a mixture including vermilion and lead white), or in the brilliant greens and pinks scattered throughout the picture. However, the impasto of these same areas of colour has been somewhat flattened. Some colours have probably faded, notably the red lake glazes on the jacket of the man behind the head of the cow; others have darkened, notably some of the copper greens (for instance the collar of the boy climbing up the pillar on the right). The painting has also darkened on account of the increased translucency of paint layers on top of a black ground, notably in the architecture (especially the rafters of the distant loggia) but also in some of the figures, including the face of the boy looking out behind the two women who seem to be hurrying out of the building on the right. There has also been some abrasion, which, together with the darkening of the paint, has given a ghostly appearance to the figures in the middle distance on the left and has reduced the solidity of the cow and the goats in the foreground.

Subject
The episode is described in all the Gospels: 'And Jesus went into the temple of God, and cast out all them that sold and bought in the temple, and overthrew the tables of the money-changers, and the seats of them that sold the doves; And said unto them, It is written, My house shall be called a house of prayer; but ye have made it a den of thieves. And the blind and the lame came to him in the temple; and he healed them. And when the chief priests and the scribes saw the wonderful things that he did ... they were sore displeased' (Matthew 21: 12–15). The Gospel of Saint John expands significantly on the livestock present and also specifies the manner in which Christ took action: 'And [he] found in the temple those that sold oxen and sheep and doves and the changers of money sitting: And when he had made a scourge of cords, he drove them all out of the temple, and the sheep and the oxen; and poured out the changers' money, and overthrew the tables' (John 2:14–15). Although the subject was rare in painting, there was a notable precedent in an imposing picture made by Stefano Cernotto for one of the Venetian magistracies in about 1535, and Miguel Falomir Faus has pointed out that this certainly influenced Jacopo Bassano.[2] The earliest treatment of the subject by Jacopo was a fresco made with his father for the parish church of Cartigliano in 1535 which has not survived.[3]

Unsurprisingly, in view of their special interest in animals, Jacopo and his associates follow Saint John's account. Other artists who treated the subject, such as Cernotto or Michelangelo earlier and El Greco later, did not give such prominence to cattle, sheep or goats.[4] The indignant witnesses on a raised platform in the middle distance on the left must represent the chief priests and scribes. The group of figures in the distant loggia must be intended for Christ healing the blind

Fig. 1 Detail of NG 228

Fig. 2 Agostino Carracci after Titian, *Portrait of Titian*, 1587. Copperplate engraving, 32.7 × 23.6 cm. Berlin, Staatliche Museen zu Berlin – Preußischer Kulturbesitz, Kupferstichkabinett.

and the lame. The moneychanger grasping his carpet-covered table on the right (fig. 1) bears a strong resemblance to Titian as he appears in the late self portrait engraved in 1587 by Agostino Carracci (fig. 2)[5] and has often been thought to be a satirical portrait of the supposedly mercenary senior artist. Gould pointed out that the type is quite common in Bassano's paintings,[6] and it is true that the moneychanger is not very different in appearance in other versions, except that here he is given a skull-cap. All the same, the idea cannot be conclusively dismissed.

Attribution

The painting was attributed to Jacopo Bassano when it was acquired by the Gallery, and previous references describe it as by Jacopo (Giacomo) Bassano or as simply by 'Bassano'. Waagen regarded it as 'genuine' although 'not first rate'.[7] Arslan in 1929, aware of the many versions of the composition, suggested that this was a copy either by Jacopo's son Gerolamo or by both Jacopo and Gerolamo, but he favoured the latter option in his monograph of two years later.[8] It is possible that Arslan had not seen the picture since it was cleaned in 1923. The National Gallery continued to consider it as by Jacopo, and it was also listed as such by Berenson.[9] In his catalogue of 1959 Gould observed that NG 228 is related to several large dark altarpieces by Jacopo and Francesco in which the figures are 'summary' in handling and the background architecture shown in 'sharply receding (and usually faulty) perspective'. 'Some collaboration' was likely in NG 228, but 'its extent, if any, cannot be established', although he considered that it was minimal.[10] In 1975, however, Gould declared it to be 'probably an autograph work … dating from the last decade of his life, in the 1580s', this period of Jacopo's work having become 'clearer, since the re-reading of a date – 1585 – on the *Susannah* at Nîmes'.[11]

Clearly Gould was influenced here by Ballarin's brilliant reconsideration of Jacopo's late style of painting published in 1966.[12] However, there is every reason to believe that the workshop was responsible for the basic elements of the composition, notably the architectural setting (the mechanical outlining of mouldings especially). Rearick attributed this preliminary work to Gerolamo and suggested that when Gerolamo saw how much poetic mystery had been added to his prosaic painting he left home to study medicine in Padua;[13] but it seems to me impossible to detect the identity of the first artist and also needless to suppose that this artist thought he was painting anything more than a background.

Versions

A large painting (149 × 233 cm) of this subject in the Prado, Madrid (fig. 4), is generally agreed to be the earliest treatment of the subject by Jacopo, perhaps undertaken in collaboration. It is conceived of as a market scene with Christ in the background. Rearick dates this work to about 1569; Ballarin prefers a later date, which seems more likely, although since the painting was damaged by fire in the eighteenth century it is hard to judge.[14] Jacopo returned to the subject soon afterwards with a composition in which Christ is given greater prominence. Rearick argued that the earliest version of this new composition is first found in a painting now in a private collection in Bassano which is a collaboration between Leandro and Jacopo.[15] There are other versions – probably largely by Leandro but in many cases with evidence of Jacopo's intervention – in the Prado, Madrid; the Kunsthistorisches Museum, Vienna; and the Doria Pamphilj Collection, Rome. One example signed by Leandro is in the Musée des Beaux-Arts, Lille, and one, now untraced, formerly in the Samson Collection was signed by Francesco.[16] Three paintings of this subject and size were in the Bassano *bottega* at the

Fig. 3 Detail of NG 228

time of Jacopo's death in 1592.[17] The version in Bassano is unusual in that the moneychanger is placed on the left and the bearded man leans back on the right. NG 228, however, is altogether exceptional. It is the largest version and the only one to include two openings on the right and a loggia in the distance (so that light enters the building from two sides). The foreground composition is also opened out, and a frightened boy with his hands raised (fig. 3) has been added behind the cow. This expressive figure, one of the great inventions of Jacopo's old age, derives ultimately from the Saint John in *The Way to Calvary* (see p. 11). The dog leaping off to the right differs from the dogs in earlier versions, which move in the

opposite direction. A compositional sketch for NG 228 executed in bistre and green earth on paper may be preparatory but is not impossible as a later study.[18]

Previous Owners

Wornum included in his catalogue of 1859 the fact that this painting was one which the Scottish painter Andrew Wilson (1780–1848) had imported into England from Genoa in the early years of the nineteenth century.[19] This information was added at the behest of William Buchanan who, in his old age, had managed to convince himself that his mercenary transactions and those of his associates such as Wilson had

Fig. 4 Jacopo Bassano and Workshop, *The Purification of the Temple*, *c*.1570. Oil on canvas, 149 × 233 cm. Madrid, Museo Nacional del Prado.

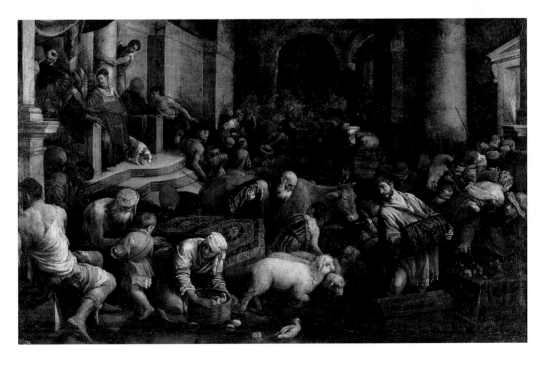

been acts of patriotism which the National Gallery's catalogue should commemorate. There is no reason to doubt the accuracy of Buchanan's claim, and the painting must therefore have been no. 22 in Wilson's sale conducted by Peter Coxe in London on 6 May 1807: 'Jacomo Bassano. The Money-Changers driven out of the Temple. In small life ... purchased at Leghorn.'[20] It was bought in at 32 guineas (£33 12s.). The sale was not a success, despite the high quality of many of the fifty or so pictures that Wilson had imported, perhaps partly because they were considered to be in poor condition, but also because the reserves were too high and the political situation was not conducive to the purchase of luxuries.[21] The Bassano had probably been offered earlier at 39 Sackville Street, the London premises of Wilson's backer, James Campbell. Presumably it was sold privately in the following years.

It has been assumed that Wilson bought the painting from Palazzo Raggi, where Ratti's guide of 1780 describes a 'Cristo, che scaccia i profanatori del tempio, del Bassano',[22] but we cannot be certain since there are so many versions of the picture, and the reference to Leghorn in the sale catalogue seems to indicate another origin.

The painting was presented to the National Gallery by Philip L. Hinds in 1853. There is reason to suppose that Hinds had acquired it in the previous year, at the sale of the 6th Earl of Shaftesbury (1768–1851) at Christie's on 15 May 1852 (lot 48: 'Giacomo Bassano, *Christ driving the money-changers from the Temple*, a grand gallery picture'). If so, the 6th Earl would perhaps have acquired it in 1811, when he inherited from his brother, and modified the interior of, the family seat in Dorset. The price of 35 guineas (£36 15s.) was certainly not as high as might be expected, but the word 'grand' in the description suggests that the painting was larger than most pictures of this class by the Bassano family, as is indeed the case with NG 228. More significantly, it is clear that Hinds bought other paintings at Shaftesbury's sale.[23]

Little is known of Hinds. His collection was sold when he left his London house in 1870. It consisted of nearly a hundred paintings, mostly Dutch, Flemish and Italian and of the seventeenth century. The Bassano would perhaps have been too large for the space available in his house in Portland Place. Other notable acts of public generosity have had their origins in domestic miscalculations.

Provenance
See the previous section. Bought by Andrew Wilson in Leghorn around 1805. Bought in at Wilson's sale on 6 May 1807 (lot 22) in London. Probably acquired by the 6th Earl of Shaftesbury for Wimborne, St Giles, Dorset, and lot 48 at the sale by Christie's of many of the earl's pictures on 15 May 1852,[24] where bought by Hickman, apparently for Philip L. Hinds. Presented to the National Gallery by Hinds in 1853.

Framing
The painting was reframed between June 1962 and December 1964.[25] I have not found any record of the previous frame except Wornum's diary entry for 21 December 1857 noting that it was altered and regilt.[26] In the late 1970s the frame that it had been given was transferred to a Murillo portrait (NG 6448) and replaced by a plain oak moulding salvaged from some of the Gallery's old central-heating cases (fig. 5). This may have been suggested by an idea that Bassano was a rustic artist, but at least the oak was polished and provided a pleasant foil for the darks in the painting. Since so many of the radical framing solutions of the 1970s and 1980s have been abandoned it seems worth recording this one.

In November 1991, in preparation for the new hang of the refurbished Venetian Room in the National Gallery, a reverse frame with very broad and simplified acanthus leaves and tongues on an ogee moulding was reduced in size to fit the painting (fig. 6). The joins at the corners are very awkward and the solution was intended as a temporary measure. It is probably an Italian frame of the seventeenth century, and seems to have retained some of its original gilding. It is not clear how it arrived in the National Gallery's frame store.

Fig. 5 Corner of the former frame of NG 228.

Fig. 6 Corner of the current frame of NG 228.

NOTES

1. Report by Marika Spring of the National Gallery Scientific Department, 21 October 1997.

2. Falomir 2001, p. 79, 220.

3. Muraro 1992, p. 268.

4. NG 1194 (After Michelangelo) and NG 1457 (El Greco).

5. Catelli Isola 1976, p. 34, no. 14 (Bartsch 1802–21, XVIII, p. 121, no. 254).

6. Gould 1959, pp. 11–12.

7. Annotated copy of the catalogue of 1854 in the National Gallery library, p. 43.

8. Arslan 1930, p. 564; Arslan 1931, p. 304.

9. Berenson 1932, p. 57.

10. Gould 1959, pp. 11–12.

11. Gould 1975, pp. 19–20.

12. Ballarin 1966, p. 122.

13. Rearick in Brown and Marini 1993, pp. clxxviii–clxxix.

14. Ibid., p. cxxxix and fig. 41 on p. cxl; Falomir 2001, pp. 80–1, no. 7, and p. 221.

15. Rearick in Brown and Marini 1993, p. clxv and fig. 60 on p. clxvi. The painting was previously in the Reitlinger Collection (sold Sotheby's, London, 9 December 1953, lot 2).

16. For the Prado painting (inv. no. 27) see Falomir 2001, pp. 82–3, no. 8, and p. 222; the Kunsthistorisches Museum painting is inv. 3520; the Doria-Pamphilj painting is Sestieri 1942, p. 60, no. 91; the Lille painting is Brejon de Lavergnée and Scottez-De Wambrechies 1999, p. 150, P18.

17. Verci 1775, pp. 92, 100, and nos 34, 96 and 187.

18. Uffizi P149 attributed to Francesco. 45.4 × 65.5 cm.

19. Wornum 1859, p. 29. The fact was not mentioned in previous catalogues. For Wilson see Brigstocke 1982, pp. 443–53. Brigstocke 1993, p. 29, claims that the version of this painting in the National Gallery of Scotland was 'probably' Wilson's but there seems no reason to question Buchanan's claim for NG 228.

20. Fredericksen 1990, II, p. 133.

21. Ibid., I, p. 26.

22. Ratti 1780, p. 236.

23. Nos 81 (a *Magdalen* attributed to Giorgione) and 96 (a *Boar Hunt* by Paul Potter) in Hinds's sale at Christie's, London, on 11 June 1870 correspond to lots 37 and 56 in the Shaftesbury sale of 15 May 1852, where both were bought by Hickman, who also purchased the Bassano.

24. Almost all of the 57 paintings in the Shaftesbury sale were bought for less than £50. The exceptions were towards the end of the sale, and the most notable was the last lot, the grand Italian landscape by Both, bought in for £500 by Lord Shaftesbury. This is now NG 1917. The sale was perhaps prompted by alterations to Wimborne St Giles. P.C. Hardwick's Italianate towers were added in 1854 so some building was then being carried out (Newman and Pevsner 1972, p. 472).

25. Annual Report of the National Gallery, 1962–4, p. 139.

26. NG 32/67.

Fig. 7 Detail of NG 228

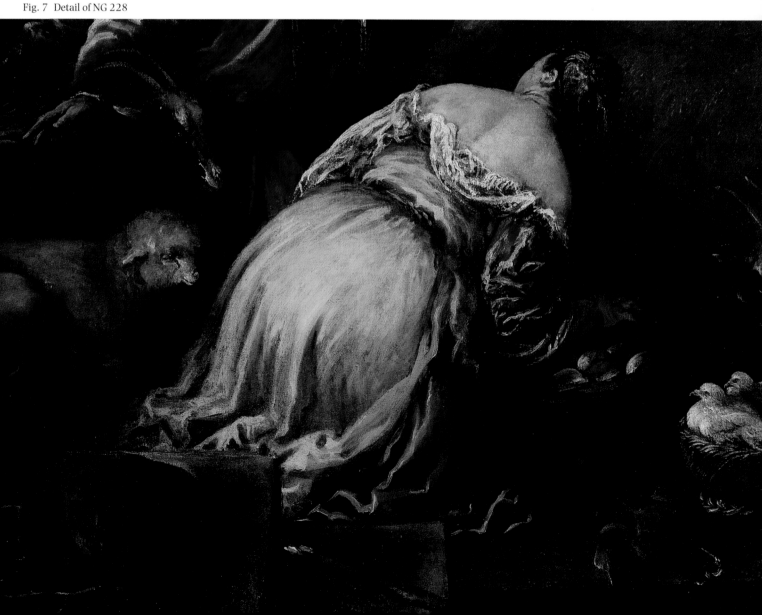

Workshop or imitator of Jacopo Bassano

NG 2148
The Departure of Abraham

*c.*1570–90
Oil on canvas, 82.6 × 116.4 cm

Support
The measurements above are those of the stretcher. The original canvas, of a twill weave, is of medium weight. Its ragged edges (originally turned over the stretcher) mostly extend to the edges of the lining canvas but in some places are about one centimetre short, so the original painted area must have been smaller. The lining canvas is a tabby weave of a medium weight. The stretcher is modern and is made of varnished pine. It has no crossbars.

Materials and Technique
The canvas is prepared with a thin white ground composed of calcium carbonate with earth pigment probably added to it.[1] On top of this ground there is a brown priming of coarsely ground and poorly mixed pigments – red earth, yellow earth, black and lead white.

The dark priming is not entirely concealed; it is visible in the shadows of the white drapery and especially beside the hand and cuff of the mounted women in the centre of the painting. The yellow highlight of the orange-brown cloak of the bald man to the left was found to contain orpiment. The blue sleeve of the man in the foreground to the right is composed of azurite mixed with lead white.[2]

The paint was handled with a very distinctive touch: dry lights dragged across the folds of cloaks, broken brushstrokes creating a flickering effect on the horse's neck and the dog's flank. These effects can seem repetitive, as can the distribution of identical colours – azurite blue, pink, orange brown, vermilion – across the canvas.

Conservation
There is no evidence that the painting received any treatment in the Gallery between its acquisition in 1855, when it was said to be in a state of 'perfect preservation',[3] and May 1957, when it was relined with wax-resin adhesive on to a nylon canvas. This lining was an experiment. Adhesion was poor and the canvas did not stretch as expected. In March 1971 the painting was relined using conventional linen canvas and paste, and it was also cleaned and restored in the following months (fig. 1). The large areas of loss around the edges of the painting on the left were made up with putty toned with dark brown umber and left undefined. The records do not indicate that there was any discussion of whether or not to leave, or even to copy, the extensive painted area covering these losses.

Condition
With the exception of extensive losses around the edges, especially at the left edge of the canvas, the painting is in reasonable condition, although there are flake losses, most notably to the left of God the Father, and also along creases caused by the slackening of the canvas. A few parts of the painting, such as the camel's head in the opening to the right, are abraded and have sunk into the canvas.

Subject
The text followed is from the Old Testament Book of Genesis: 'Now the Lord had said unto Abraham, Get thee out of thy country' (12:1); 'And Abraham took Sarah his wife, and Lot his brother's son, and all their substance that they had gathered, and the souls that they had gotten in Haran; and they went forth to go into the Land of Canaan' (12:5). Abraham must be the older man on the left who turns to hear the word of God. He was 'seventy and five years old when he departed out of Haran' (12:4). The younger man beside him must be his brother's son Lot, unless Lot is supposed to be the baby lifted up to the woman on horseback. The latter is presumably Sarah, who was very much younger than Abraham and 'a fair woman to look upon' (12:11). The baby cannot be Sarah's for she was barren (11:30). The dawn light suggests the urgency of their departure from Haran, the gate of which appears on the right.

This episode was first depicted by Jacopo Bassano around 1570 in a large painting now in a private collection in Montreal.[4] The figures there are smaller in relation to the setting but Abraham is more prominent, placed in the centre, in profile, looking up at God. The only element of that composition which is repeated in NG 2148 is the figure of God the Father emerging from the clouds. In the earlier composition the figures move from left to right (the more usual direction in paintings), but in NG 2148 the direction is reversed and this may have been because it was originally devised as a pendant. However, the *Return of the Prodigal Son*, which served as a pendant to NG 2148 in the eighteenth century, includes figures moving to the left, although in other respects it is a complementary composition, showing evening rather than morning, and taken from the New Testament rather than the Old.[5]

Attribution
When acquired by the National Gallery the painting was said to be in 'perfect preservation' and to be 'by Jacopo Bassano'. The *Return of the Prodigal Son*, its companion, was also attributed to Jacopo and was described as 'untouched, but darker'.[6] These opinions are likely to be Otto Mündler's: he had examined the paintings carefully and, although he had a thorough understanding of conservation, he may have been wrong about the condition; Eastlake, who had a keen sympathy for and extensive knowledge of Jacopo's work, may not have agreed about either the condition or the attribution, for the *Return of the Prodigal Son* was consigned for sale, and NG 2148 was dispatched to Dublin. No one since has suggested that NG 2148 is by Jacopo Bassano. Gould catalogued it as 'After Francesco Bassano?' in 1959 but, noting that the painting in Berlin (see the section on Versions) was signed by Jacopo as well as Francesco, he catalogued it as 'After Jacopo' in

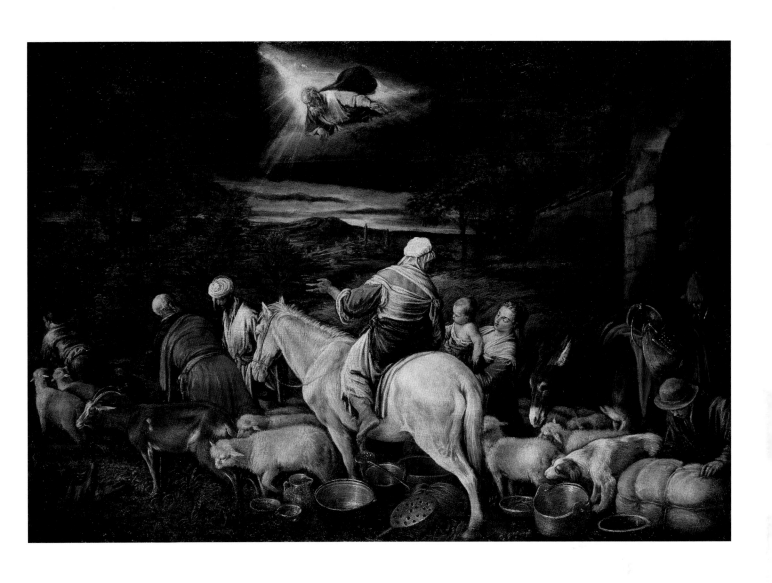

Fig. 1 NG 2148 after cleaning and before restoration.

BELOW:
Fig. 2 Jacopo and Francesco Bassano, *The Departure of Abraham*, *c*.1576–7. Oil on canvas, 93 × 115.5 cm. Berlin, Staatliche Museen zu Berlin – Preußischer Kulturbesitz, Gemäldegalerie.

1975.[7] It may be a product of the workshop but is perhaps just as likely to be by an imitator.

Versions

The 'original' version of this painting has been widely supposed to be the version acquired in 1960 by the Gemäldegalerie, Berlin (fig. 2), which is inscribed as the work of both Jacopo and Francesco ('Jacs. et./ Frans./ fil.p.'). It was first published by Rearick, who believed that it had been painted by Francesco, following a design by Jacopo and with final revisions also by Jacopo.[8] A variant composition with a servant woman in the right foreground, in a private collection in Bassano, is also signed by both Jacopo and Francesco.[9] Francesco is thought to have made many replicas: that in the Rijksmuseum, Amsterdam, may be closest to the Berlin painting, and the enlarged replica by him in the Kunsthistorisches Museum, Vienna (136 × 183 cm), was a model for numerous others.[10] In fact no other composition was more frequently reproduced by the workshop.

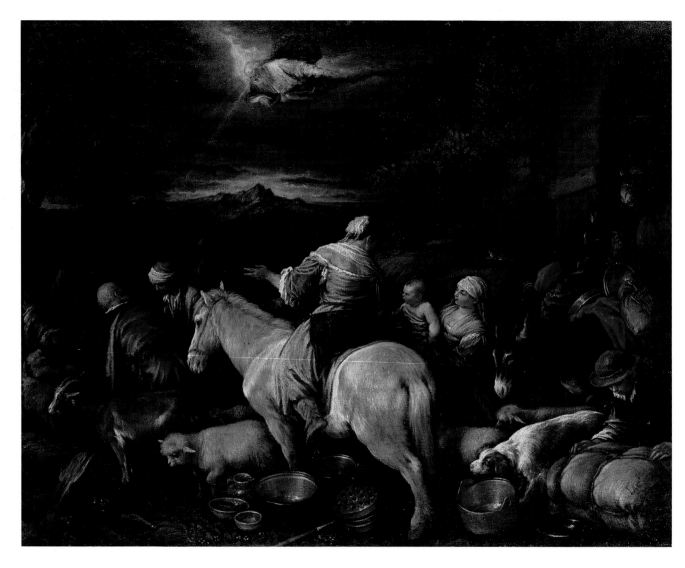

NG 2148 is close to the painting in Berlin but there are differences – notably the treatment of the turban worn by Abraham's companion and the features of the woman holding the baby, which are close to those of the female type preferred by Jacopo. There is a strong possibility that NG 2148 is a replica of a lost painting by Jacopo which pre-dates the Berlin painting. In proposing this, Ballarin has argued that the lost painting is the one that was engraved when it was in the Savorgnan collection in Venice (see below)[11] but there seems no reason to doubt that NG 2148 is identical to the Savorgnan version, from which it follows that not only Otto Mündler but also Barone Galvagna, and probably a number of connoisseurs in Venice in the mid-eighteenth century, were mistaken in believing it to be an original work by Jacopo Bassano.

Print

The painting was engraved (with some etching) by Pietro Monaco using his own drawing for a volume of prints of paintings in Venetian collections, published in 1763 by Guglielmo Zerletti (fig. 3). The next print in the same volume was of the *Return of the Prodigal Son* (fig. 4).[12]

Provenance

The painting, together with its pendant, the *Return of the Prodigal Son*, was acquired from the Galvagna collection in circumstances described elsewhere (pp. 328–9). Both pictures had previously been in Palazzo Savorgnan and had been purchased with the palace by Barone Galvagna. In 1763 prints of them by Pietro Monaco were published as after paintings by Jacopo Bassano and in the possession of Count Francesco Savorgnan in the parish of S. Geremia ('posseduta dal N.H. Conte Francesco Savorniano S. Geremia'). NG 2148 was lent to the National Gallery of Ireland in Dublin in February 1857 and returned in May 1926. The *Return of the Prodigal Son* was sold (see p. 329).

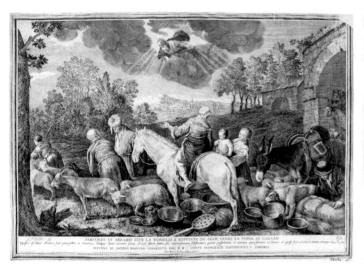

Fig. 3 Pietro Monaco after Jacopo Bassano, *The Departure of Abraham*, 1763. Engraving, 35.7 × 49.8 cm. Bassano del Grappa, Museo Biblioteca Archivio.

Fig. 4 Alessandri and Scattaglia after Jacopo Bassano, *The Return of the Prodigal Son*, 1763. Engraving, 41 × 55.8 cm. Bassano del Grappa, Museo Biblioteca Archivio.

NOTES

1. Report of Marika Spring of the National Gallery's Scientific Department, 2 October 1997. The calcium carbonate was identified by FTIR. EDX analysis 'seems to indicate that it does also have a small component containing Si, Al and Fe, probably from an earth pigment'.

2. Ibid.

3. Report of the Director, 1856.

4. 191 × 257 cm. Formerly in the Hamilton Palace collection. Brown and Marini 1992, p. cxlii, no. 43.

5. Pan 1992, p. 129, no. 122.

6. Report of the Director, 1856.

7. Gould 1959, p. 9; 1975, p. 21.

8. Inv. 4160. Rearick 1968, p. 245; Rearick in Brown and Marini 1992, p. cliv; Brown and Marini 1992, p. 162, no. 60 (entry by Livia Alberton Vinco da Sesso).

9. Rearick in Brown and Marini 1992, p. clv, fig. 51, and see p. cliv, note 283. Another version of this variant composition, apparently sent to Philip II of Spain in 1574,

is in the Escorial. It is plausibly attributed to Jacopo and Francesco by Falomir (2001, pp. 62–3, no. 2).

10. Inv. 1550.

11. Ballarin's opinion is cited by Attardi in Ballarin and Banzato 1991, p. 214.

12. Pan 1992, pp. 128–9, nos 121–2. In this account the Savorgnan paintings are presumed to have been lost.

Follower of Jacopo Bassano

NG 1858
The Adoration of the Shepherds

*c.*1600–25
Oil on canvas, 65.4 × 91.8 cm

Support
The measurements above are those of the stretcher. The edges of the canvas are covered by paper tape between 0.5 cm and 0.8 cm in width. This tape conceals the trimmed edges of the original canvas, which is of a fine tabby weave and has been lined with glue paste on to a coarser canvas also of a tabby weave. There are two distinct horizontal lines in the surface, one about 11 cm from the lower edge and the other 19 cm from the upper edge. These suggest that the painting was at one time folded. There are two tears in the canvas, a jagged diagonal one near the centre and a vertical one lower down to the right. The stretcher, of varnished deal, has one vertical bar.

Materials and Technique
The canvas has a dark priming consisting of coarse black pigment not unlike that found on Bassano's *Purification of the Temple* (NG 228). The Virgin's pink dress contains red lake and lead white. The shirt of the boy with the candle consists of lead white with a little red lake and black.[1] A ruddy brown layer shows through the darkened blue (probably azurite) sky.

Conservation and Condition
The paint surface has been badly flattened by lining. The surface is also abraded, with the salient points of the canvas weave visible in some areas, such as the lilac-grey jerkin of the kneeling shepherd. Although the blue of the sky seems to have darkened, the other colours, pinks and greens especially, have probably survived. However, they are now seen through an old and very brown varnish with a minute crackle. This varnish, of mastic with dammar and some fir balsam,[2] probably dates from before 1847, when the painting was presented to the National Gallery. There is no evidence that the painting has received any treatment in the Gallery.

Attribution
The painting is derived from a composition by Jacopo Bassano, the first and finest version of which is in the Galleria Nazionale, Palazzo Corsini, Rome (fig. 2).[3] As Cecil Gould observed, NG 1858 probably follows a variant of Jacopo's composition made by Leandro Bassano.[4] It may have been made in the family shop but is not easy to attribute to any known hand.

Versions
Jacopo Bassano first painted the *Adoration of the Shepherds* in the mid-1540s at about the same date as the *Way to Calvary* (NG 6490). In his canvases now in the Royal Collection, Hampton Court, and the Accademia, Venice, the shepherds advance from the left – accompanied by the ox and ass in the latter case but by a goat and dogs in the former – towards the kneeling Virgin, who raises a sheet to reveal to them the infant Christ.[5] He then returned to the subject in about 1562 in a canvas now in Palazzo Corsini in Rome, executed in a style very close to that of the *Good Samaritan* (NG 277).[6] There is an autograph repetition of this composition, slightly freer in handling but less brilliant in colour and perhaps a year or more later in date, in the Oskar Reinhardt Collection, Winterthur.[7] Soon afterwards Jacopo returned to the subject, retaining the basic elements in the design – the Virgin unveiling the child, the kneeling shepherd with trussed lambs, another shepherd leaning forward with his hand on his hip – but reversing them. This composition was also taken up by Francesco Bassano.[8]

Elements from these paintings were then developed in the altarpiece of the Nativity known as the *Natività di S. Giuseppe*, of 1568, made for the church of S. Giuseppe in Bassano del Grappa, now in the Museo Civico of that city, where Joseph is moved into the foreground,[9] and in the mid-1570s in another altarpiece, this time with a nocturnal setting, which is today in the Musée National of Fontainebleau,[10] and finally in the great nocturnal *Adoration* painted by the workshop under Jacopo's direction for S. Giorgio Maggiore in Venice in the early 1590s.[11]

Compared with Jacopo's paintings of the early 1560s in Palazzo Corsini (fig. 2) and at Winterthur, from which NG 1858 derives, the figures are smaller in relation to the setting and more space is given to classical ruins and the timber and thatch of the stable. Other differences probably reflect changes made to Jacopo's composition by Leandro. The composition is less crowded, so the ox's nose is not directly behind the sleeping child's head and the kneeling shepherd keeps a more respectful distance. Indecorous or weird elements are censored, such as the kneeling shepherd's bare feet, the grotesque features and nearly maniacal expressions of the two standing shepherds, and the Virgin's sinuous, unstable pose, her huge eyelids and her plump but pointed fingers. The kneeling shepherd's face is now visible in profile and the shepherd behind him holds a staff rather than the ox's horn.

Jacopo's boy with bare buttocks squatting in the lower right corner, who blows on a stick of charcoal that illuminates his cheeks, is repeated in NG 1858, together with the dawn light, but the shaft of heavenly light falling on Christ is omitted and replaced by a glowing light that emanates from Christ himself, as in Jacopo's nocturnal versions of the subject. The motif of the boy blowing on the charcoal, later taken up by El Greco as an independent subject,[12] may have originated as a variation on the peripheral figure holding a candle which appears in many earlier paintings of the Nativity and is taken from the mystical writings of Saint Bridget, who explains that the candlelight was outshone by Christ himself.[13] A surprising addition to NG 1858 is the peacock behind the ass on the left. This exotic bird is often included in fifteenth-century Italian paintings of the Adoration of the Kings[14] but rarely in those of the sixteenth and seventeenth centuries.

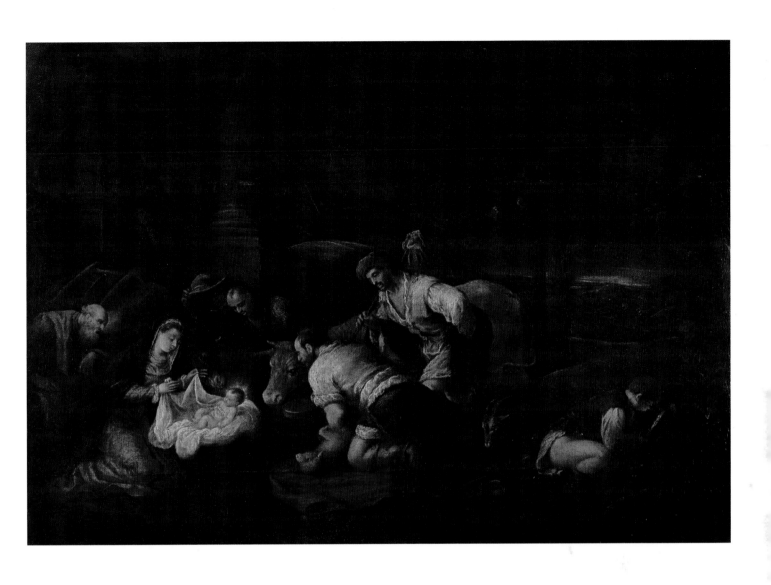

Provenance

Bequeathed by Sir John May in 1847, during a period when the Gallery, after the resignation of Eastlake as keeper, was badly managed. The painting should not have been accepted; once it had been, it was neglected. It was not assigned a National Gallery number until the early twentieth century. Although it was recorded in the catalogue of 1929 as 'withdrawn from exhibition', it may in fact never have been exhibited.[15]

Frame

The carved and gilded frame, which seems to have been made for the painting, is of a late seventeenth-century French pattern (fig. 1). At the sight edge there is an ogee moulding with foliate ornament. This flanks a narrow sanded flat and a broad ogee outer moulding covered with scrolling foliate relief ornament against a background of cross-hatched gesso. The density of the ornament and the lack of variation both in the intervals between the forms and in the height of the relief are typical of English imitations of this type of frame made around 1720–40, but it is also possible that it dates from a century later, when, however, most frames of this kind had press-moulded composition ornament. There is also no evidence, beneath the layers of oil gilding, of water gilding such as one would expect in a French frame of this style.

Fig. 1 Corner of the current frame of NG 1858.

Fig. 2 Jacopo Bassano, *The Adoration of the Shepherds*, *c.*1562. Oil on canvas, 105 × 157 cm. Rome, Galleria Nazionale d'Arte Antica di Palazzo Corsini, Galleria Corsini.

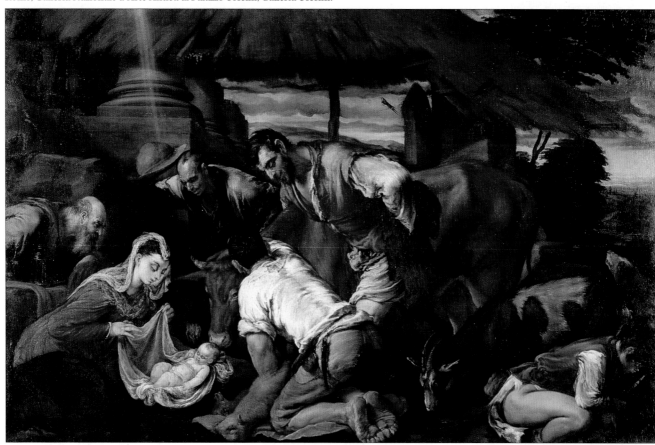

NOTES

1. Report by Marika Spring of the National Gallery Scientific Department, dated 21 October 1997.

2. White and Kirby 2001, p. 82; see NG 2161, Follower of Titian (formerly Follower of Tintoretto), p. 292 in this catalogue.

3. Ballarin 1995–6, II, 1996, Part 2, fig. 802, Part 3, figs 379 and 385.

4. Gould 1959, p. 15; Gould 1975, p. 23.

5. Brown and Marini 1992, pp. 44–8, nos 16 and 17 (entries by M. Elisa Avagnina).

6. Ballarin, as cited in note 3.

7. Ballarin 1995–6, II, 1996, Part 2, fig. 807, Part 3, fig. 384.

8. Ibid., fig. 846 (private collection, Switzerland), and fig. 860 (formerly Dresden) and fig. 861 (Berlin, Staatliche Museen, by Francesco).

9. Ibid., fig. 982.

10. Habert and Loisel Legrand 1998, pp. 72–3, no. 7.

11. Zampetti 1957, pp. 202–3, no. 84.

12. For El Greco's paintings in the Museo Nazionale di Capodimonte, Naples, Harewood House and the National Gallery of Scotland see Davies and Elliott 2003, pp. 226–31, nos 63–5 (entries by Gabriele Finaldi). Jacopo and Francesco also signed an independent painting of a boy blowing on charcoal, which is not now traced.

13. The candle is generally held by Joseph, e.g. in the *Nativity at Night* by Geertgen tot Sint Jans (NG 4081), for which see Dunkerton, Foister *et al.* 1991, pp. 340–1, no. 49.

14. For example, Botticelli NG 1033 (ibid., pp. 312–13, no. 38).

15. [Collins Baker] 1929, p. 414.

Fig. 3 Detail of NG 1858

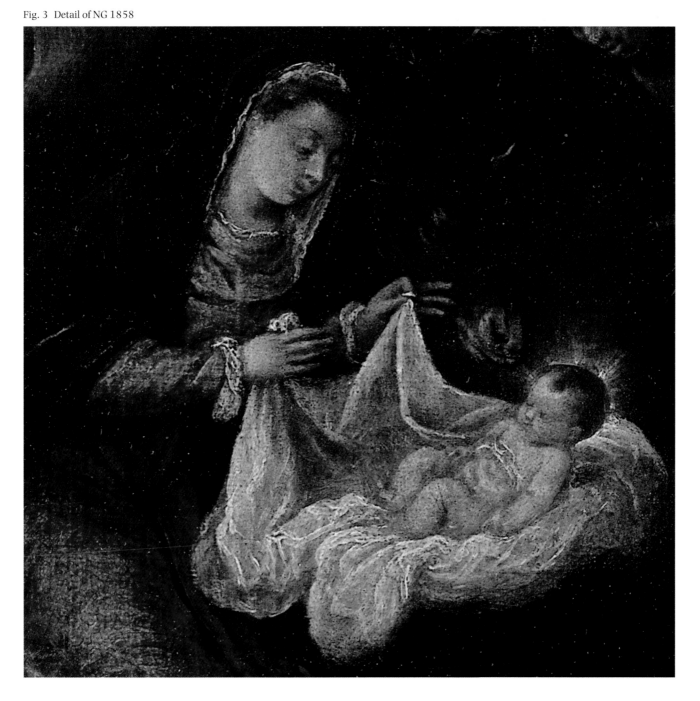

Leandro Bassano

NG 60

The Tower of Babel

*c.*1600
Oil on canvas, 137.1 × 189.2 cm
Inscribed lower left on the shadowed side of a block of stone:
LEANDER A PONTE B...

Support

The measurements given above are those of the stretcher. The original painted surface was slightly smaller, and fragments of unpainted and tattered canvas turnover are now visible, especially on the left. Cusping is apparent on all four sides and is especially pronounced at the top of the canvas, where the distortions to the weave are apparent as much as 7 cm from the edge. This original canvas, of a medium weight and an uneven tabby weave, is composed of three pieces: a single vertical piece with a maximum height of 100.5 cm, and two smaller, vertical strips above, one 110 cm in length, the other (to the right) 79 cm. The canvas is lined with glue on to a tabby-weave canvas which is thicker in the weft than the warp, with numerous slubs. In June 1986 the detached areas of the original canvas were reattached to this old lining canvas with paste and reinforced by strip-lining. A pine stretcher with one horizontal and two vertical crossbars was supplied at the same date. Just to the right of the hoe in the lower right-hand corner, a small patch has been glued to the canvas to repair a puncture.

Materials and Technique

The painting has a dark brown ground consisting of red and yellow earth, black and a small amount of lead white. EDX has revealed that the sky is composed of lead white with ultramarine.[1] The orange sleeve of the woman on the far right is painted with red lead and a small quantity of vermilion and red lake.[2] Much of the composition was outlined with a brush in black and dark brown paint which is visible through or beside subsequent layers of paint, for example in the masonry and around the figures on top of the building. It is noteworthy that no incised lines can be discerned, perhaps because there seems to have been no gesso preparation.

Fig. 1 Infrared photograph of detail showing the signature.

There are no visible pentimenti and it seems likely that the preliminary brush drawing was carefully copied from an earlier painting or cartoon.

Conservation

At some date between its acquisition in 1837 and 1853 the painting was varnished with mastic mixed with drying-oil.[3] In 1855 it was noted that the original canvas was perhaps detaching from the lining canvas.[4] The canvas was tightened in November 1946, and the stretcher treated for woodworm. The painting was 'polished' in August 1948, surface-cleaned in May 1975, and strip-lined in June 1986.

Condition

The painting has been abraded and the high points of the canvas weave are exposed in many areas. The surface has also been flattened, no doubt in lining, although a little of the impasto survives. There are numerous small flake losses, which can be easily seen on the grey horse, the masonry at the lower left, the dog at the lower right, and across the shoulder of the man with a hoe. The green foliage in the upper right-hand corner has probably darkened, as has the water in the middle distance on the right, although whether from transparency (the dark ground showing through) or from the darkening of the pigment is not clear. The painting is in any case coated with a very yellow varnish of mastic and drying-oil that was already recorded on the painting in 1853.[5]

Inscription

The inscription (fig. 1) may have concluded 'BASS', as Gould noted, but the last letters may have been 'B EQs', or something similar, as an abbreviation of 'Eques' in reference to the knighthood conferred in April 1596 by Doge Marino Grimani.[6]

Subject

The version of this composition that was in the collection of the Archduke Leopold William is described in an inventory of 1659 as representing the Tower of Babel ('der Thurn von Babilonia').[7] This is probably the painting which is now in Prague Castle (fig. 2). This same painting has sometimes been supposed to show the building of Solomon's temple,[8] and Neumann in his catalogue of the paintings in Prague Castle of 1967 follows this, observing that, had the Tower of Babel been intended, we would expect more emphasis on the height of the structure.[9] It is, however, also the case that, were the subject to be the Temple of Solomon, we would expect more opulent features. On balance, the richly attired man of giant stature who appears in the middle distance, holding a spear in his left hand and with his right hand raised in admonition (fig. 3), is more plausibly interpreted as Babel than as Solomon. Babel was the son of Nimrod (a son of Noah's son, Ham) who dwelt in the land of Shinar.[10] It was there that the 'children of men' resolved to build a city and a tower which would reach to Heaven. 'And they said to one another, Go to, let us make brick, and burn them thoroughly. And they had brick for stone, and slime had they for mortar.'[11] Although Bassano shows a stonemason at work, he also

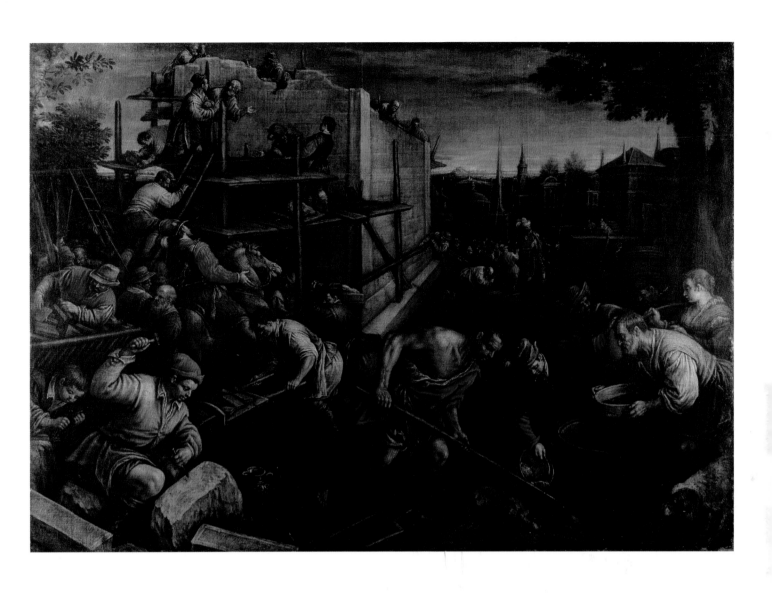

shows bricks and the mixing of mortar. In addition, the subject of the building of the Tower of Babel was more common in sixteenth-century paintings than was the Building of the Temple, and the Bassano family illustrated other episodes from the Book of Genesis.

Giorgia Mancini has made the valuable observation that the figure mixing mortar appears to be derived from the antique marble Meleager then in the Vatican.[12]

Versions

The painting in Prague, which is clearly a fragment (it now measures 136 × 138 cm but was once 174 cm long), is identical in composition to that of NG 60 but was executed with far more energy and spontaneity. It is almost certainly the picture in the Archduke Leopold William's collection that was listed in 1659 as an 'original von Bassan' and engraved in 1660, in the *Theatrum Pictorium*, as by 'Bassano Junior',[13] which presumably was intended to refer to Jacopo's son Francesco. The Prague painting was attributed to Francesco Bassano throughout the nineteenth century but to Leandro in the mid-twentieth century. Neumann convincingly re-

attributed it to Francesco, comparing the crowded figures on the left to a similar group in the *Siege of Padua* which he painted for the Doge's Palace, and the largest foreground figures to those in similar poses in the *Disrobing of Christ* in the Museo Civico, Cremona.[14] Other replicas of the composition are in the Berkshire Museum in Pittsfield, Massachusetts, and the Brass Collection in Venice.[15]

Attribution and Date

NG 60 was described as 'School of Leandro Bassano' in the Gallery's catalogues, but Gould, followed by Arslan, observed that the signature seems genuine.[16] The painting is close in style and handling to other works which are both signed by Leandro and documented as by him, although some of these may be at least partly by the workshop. Citing arguments of Stella Mary Pearce (Newton) concerning the dress of the horseman, Gould suggested 'a dating soon after 1600',[17] but the dress in question appears in other paintings by the Bassano family before that date. If Leandro's knighthood were certainly referred to in the inscription then that would support Gould's dating.

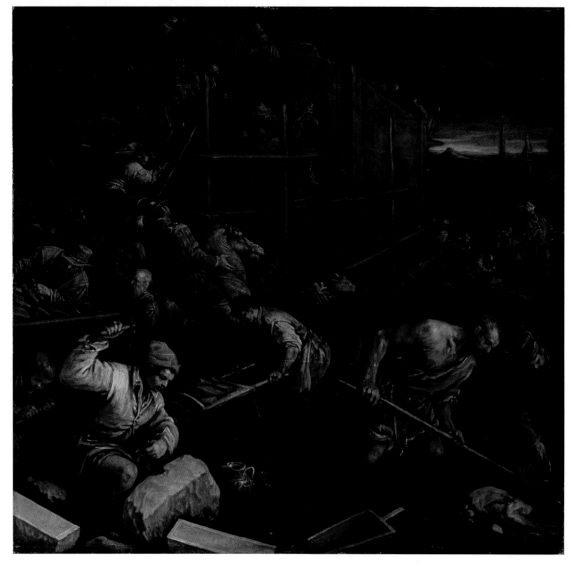

Fig. 2
Francesco Bassano,
The Tower of Babel,
c.1590. Oil on
canvas (fragment),
136 × 138 cm.
Prague, Art
Collections of
Prague Castle.

OPPOSITE:
Fig. 3 Detail of
NG 60 showing
the man of giant
stature.

Provenance

Bequest of Lt Colonel Olney in 1837. On loan to the National Gallery of Ireland, Dublin, 1862–1926.

Exhibition

Vicenza 2005, Museo Palladio, *Andrea Palladio e la Villa Veneta da Petrarca a Carlo Scarpa* (95).

Frame

The painting is in a plain frame with a broad frieze inside a slightly broader hollow. It has a press-moulded rococo clasp at each corner and has been coated with bronze paint. This finish may have been designed to conceal the traces of composition ornament that was stripped from the hollow to save the expense and trouble of repair.

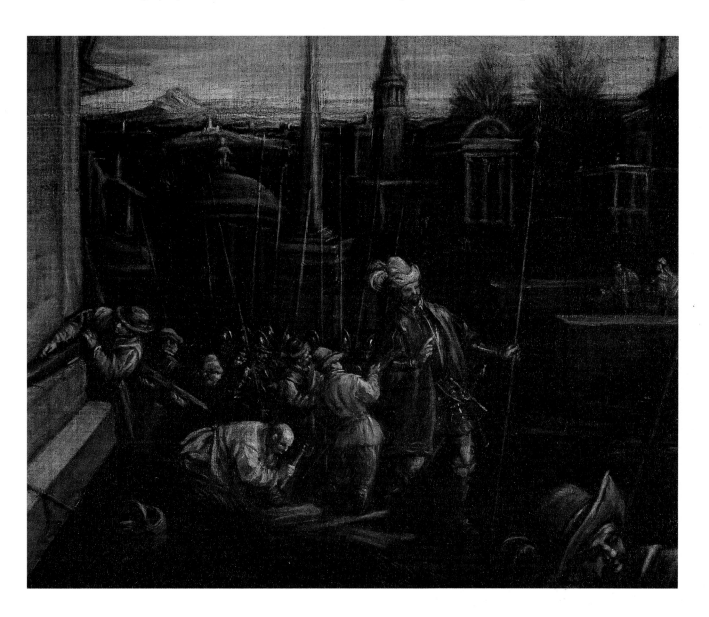

NOTES

1. Report by Marika Spring of the National Gallery's Scientific Department, dated 21 October 1997.

2. Ibid. Nearer the surface, there appears to be some white pigment. This is likely to be basic lead carbonate (lead white) formed from the deterioration of red lead.

3. Parliamentary Commission on the National Gallery, 1853.

4. Manuscript Catalogue.

5. See note 3.

6. Gould 1959, p. 14; 1975, p. 22.

7. Berger 1883, p. xcv.

8. For example in 1797 and on other occasions since, recorded by Neumann 1967, p. 80, no. 5.

9. Ibid.

10. Genesis 10:10.

11. Genesis 11:3–5.

12. Beltrami and Burns 2005, pp. 348–50, no. 95 (entry by Giorgia Mancini).

13. Unnumbered but corresponding with tab. 154. The engraving is by L. Boel.

14. Neumann 1967, pp. 81–3.

15. Recorded by Gould 1975, p. 22.

16. Gould 1959, p. 14; 1975, p. 22.

17. Ibid.

Leandro Bassano

NG 2149
Portrait of a Bearded Man

*c.*1600
Oil on canvas, 66.3 × 55 cm
Inscribed: HIC SATVS EST / CVLTOR PHÆB - /
ORPH - / GRATVS PRINC - / PROMPTVS IN

Support
The measurements given above are those of the stretcher.
The original canvas, of a coarse tabby weave, measures
64.8 × 53.4 cm and is lined with wax on to a tightly woven
tabby-weave canvas. There is a simple pine stretcher. Cusping
is obvious on the upper and left edges, and discernible on
the lower edge, but not visible on the right edge. Since the
inscription has been cut on the right it may be assumed that
the painting has been reduced on that side.

Materials and Technique
No technical examination of this painting has been under-
taken.

Conservation
There is no record of any treatment between 1855, when the
painting was acquired, and 1926, when the darkened varnish
was said to have been removed. This operation can only have
been partial (if indeed it was ever undertaken), since a report
of 1949 describes the varnish as 'discoloured, crazed and
grimed'. When the painting was relined, cleaned and restored
in November 1951, the inscription was revealed. It had been
covered over in a restoration which is likely to have pre-dated
its acquisition by the previous owner, Barone Galvagna,
perhaps around 1830.

The restoration may have taken place when the painting
was lined, probably in the eighteenth century since the
stretcher employed seems to have had no keys. The restoration
in 1951 entailed some filling in of the cracks in the paint
surface and partial retouching of losses, including much of
the hair and beard (the grey hair rather than the white) and
nearly a quarter of the ear.

Condition
The painting is severely abraded, especially in the face and
collar. Parts of the very dark brown tunic are well preserved.
There are extensive flake losses, especially in the clothing at
the lower left and in the man's right shoulder and sleeve. The
brown background is well preserved only in the upper part
of the canvas, particularly on the right.

Inscription
The inscription was first published by Cecil Gould in his cata-
logue of 1959.[1] It is fully legible only in infrared photography
(and reflectography). Caroline Elam points out that it is
couched in the conventional language of Renaissance eulogy
and must mean: 'This man was born to be ... a follower of
Apollo [Phœbus, sometimes given as Phæbus] ... Orpheus ...
pleasing to princes ... ready to ...'.

Attribution and Date
Although the painting is very damaged, enough of it remains
to support its attribution to Leandro Bassano, who was par-
tial not only to this simple, bust-length format but also to the
frowning expression and descriptive technique seen here,
with the short strokes of slightly dry impasto in the higher
areas of hair, beard and collar.[2] Gould classed the painting
as 'Style of Leandro', and before that the formula 'School of
Leandro' had been employed in the National Gallery's cata-
logue. Mündler and Eastlake, as well as Barone Galvagna, the
previous owner, seem to have accepted it as an autograph
work by Leandro Bassano. However, Mündler had not given
the painting much attention. It was one of the works that
Galvagna added to the group that Mündler was purchasing
for the National Gallery.[3]

The style of dress, in particular the large, loose collar (for
which see also p. 192), points to a date in the last years of the
sixteenth century – that is, to the period when Leandro was
most in demand as a portrait painter. Doge Marino Grimani
made Leandro a knight in April 1596 after he had painted
his portrait, which is now in Dresden.[4]

Provenance
In the collection of Barone Galvagna in his palace near
S. Giobbe, Venice, by 1855 and acquired for the National
Gallery by Otto Mündler at the end of that year as part of a
group of ten pictures (as described on pp. 328–9). The paint-
ing arrived at the National Gallery on 2 June 1857 and was
soon afterwards dispatched to the National Gallery of Ireland
in Dublin.[5] It was not included in the National Gallery's
collection until 1915, when it received its current number.[6]
It was returned to the National Gallery in May 1926.

Frame
The gilt 'fluted-hollow' frame with press-moulded compos-
ition ornament is of a basic pattern that was first introduced
in France in the 1770s and remained popular there, as well
as in Britain and elsewhere in Europe, for more than a cen-
tury. This example, which seems to have been made for the
painting, has two somewhat unusual features: a relatively
broad band of continuous foliate scroll on the flat frieze, and
tight tulip-like flowers in the outer moulding, which are
highly unlikely in a frame made in Venice in the first half of
the nineteenth century and untypical of frames made for the
National Gallery in London in the 1850s. It was probably
made for the painting by a Dublin framemaker in 1857. The
painting is unlikely to have been among the Galvagna pic-
tures for which Mündler found frames in Venice[7] and so it
was probably frameless when it arrived in London and would
have been sent on to Ireland in that condition.

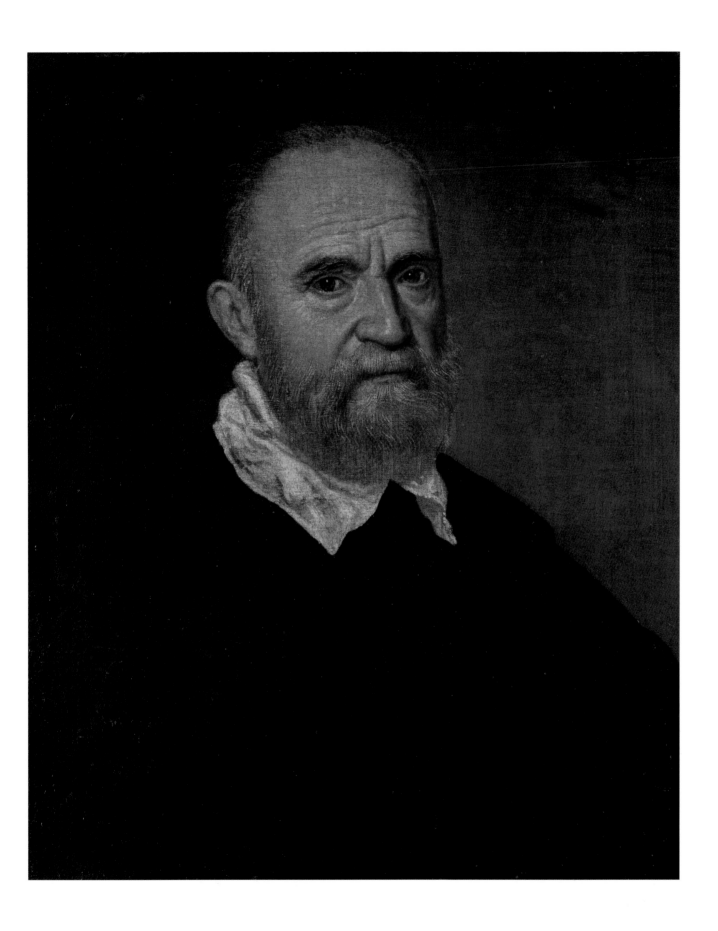

Fig. 1 Detail of NG 2149.

NOTES

1. Gould 1959, pp. 14–15; Gould 1975, pp. 22–3.

2. See in particular portraits by Leandro of Jacopo Bassano wearing a skull cap and a fur collar in the Prado, Madrid, and the Kunsthistorisches Museum, Vienna (Falomir 2001, pp. 159–60), and in the Uffizi, Florence (no. A64), or the portrait of a procurator in the Ashmolean Museum, Oxford (where the lights on the nose are very similar in handling). For the latter see Lloyd 1977, pp. 28–9, no. A445 and plate 22.

3. Mündler 1985, p. 77 (list of desirable works in Galvagna's collection, which does not include NG 2149).

4. Walther 1992, pp. 108–9, no. 281; Gibbons 1963.

5. Wornum MS Diary, NG 32/67.

6. [Burton] 1915, p. 10.

7. Mündler 1985, p. 92.

Paris Bordone

1500–1571

Paris Bordone, as he is now usually known in English (Bordon, the preferred form in Italy, was previously used in National Gallery catalogues),[1] was born in Treviso in 1500, the son of a saddler and a Venetian woman who may have been the illegitimate child of a patrician. By 1508 Bordone's mother, who had been widowed in the previous year, had moved to Venice, where, in 1518, Bordone was recorded as a painter ('ser Paris pictor').[2] Around then he seems to have been given a commission for an altarpiece in S. Nicolò ai Frari which Titian, allegedly out of envy, snatched from him.[3] In old age, Bordone told Vasari that he had briefly been a pupil of Titian but found that Titian had no interest in teaching.

Bordone's first documented work (now destroyed) is a fresco of the story of Noah, painted next to Titian's *Judgement of Solomon* in the loggia of the Palazzo del Capitano in Vicenza, which was paid for by the *comune* of that town on 15 October 1521.[4] An altarpiece painted in the mid-1520s for S. Agostino, Crema (now in the Pinacoteca Tadini, Lovere), is his earliest surviving documented work. Its wit and its agitated forms suggest that he had studied the works of Lotto and Pordenone as well as those of Palma Vecchio and Titian.[5] An undated but undoubtedly early painting by him of a woman with two men, *Gli Amanti* (in the Brera, Milan), reflects his desire (as he expressed it to Vasari) to 'follow the style of Giorgione' ('seguitare la maniera di Giorgione').[6] He was perhaps an itinerant artist during these years, but there is no reason to suppose that Venice ceased to be his principal residence. In 1530 he was recorded in the guild of painters there.[7] Portraits dated in the early 1530s are certainly influenced by German paintings and at least one – of Nikolaus Körbler in 1532 – is of a German sitter, but these paintings need not have been made in Germany.[8]

In 1534 Bordone was commissioned to paint the *Consegna dell'Anello al Doge* ('The Handing Over of the Ring to the Doge'; fig. 1) for the Scuola Grande di S. Marco, and the success of this work (now in the Accademia, Venice) represented a decisive moment in his career.[9] Soon afterwards he married. He travelled to Augsburg, probably in 1540, to work for the great banking family of the Fuggers and in the following years he worked in Milan, again for prominent patrons.[10] Bordone was probably living in Venice again by 1545 and seems to have remained there until his death on 11 January 1571 (1570 by the Venetian calendar), with the exception of a stay in Treviso when working on frescoes in the monastery of S. Paolo in 1557,[11] and a visit to the French court in 1559, which some date to 1538.[12] In addition to at least four daughters he had a son, Giovanni, who was active as a painter between 1582 and 1612, although no works by him have been identified.[13]

About two dozen drawings can be attributed to Bordone with some confidence.[14] The majority of these were executed in black and white chalk on blue paper, and depict single figures, some made from nude models, others made chiefly as drapery studies. In both technique and purpose they are close to Titian's drawings and thus support the idea that Bordone was a pupil of Titian.

Early in his career Bordone was commissioned to paint frescoes in Venice and Treviso, which, being façade decorations, have not survived.[15] Some of those painted in churches in the late 1530s do survive, although they have lost the paint layers that were applied 'secco'.[16] His oil paintings are chiefly on canvas but about half of his altarpieces are on wood.

In addition to portraits (mostly half-length or three-quarter-length in format[17]), Bordone made fanciful paintings of women, many of which were probably not true portraits. These pictures sometimes resemble his erotic mythological and allegorical groups, which tend to be similar in size and format. The other category of picture that he especially favoured was that of the Holy Family with saints in a landscape. In both his profane and his sacred work he seems to have been inspired by the example of Palma Vecchio as well as that of Titian. His most original works are those in which spectacular architectural scenery was as important as the narrative.[18] The style of architecture was in a modern taste and inspired by the designs of Serlio[19] but these paintings in some respects represent a return to a type of narrative picture that had been highly popular in Venice during the period before Titian's maturity. The first of them, the *Consegna dell'Anello*, already mentioned, was designed to hang in the company of such paintings. Bordone may have had a collaborator in these works, since the pictorial space in his other paintings is undisciplined, with little evidence of proper training in linear perspective.

Bordone's work, especially his erotic painting, enjoyed international esteem in his lifetime, and as many of his paintings were of the type described by Vasari as 'quadri da camera' they were easily transported abroad. The paintings he made for German and French patrons seem to have been painted in Augsburg and Paris, but the Ovidian paintings which the Marchese d'Astorga took to Spain and the *Venus and Cupid* that he painted for the Duchess of Savoy were probably sent from Venice.[20] His altarpieces were also painted in, or sent to, cities outside Venice, including Bari, Belluno, Crema and Milan. Several were painted for his native Treviso, but it is striking that none of them seems to have been made for Venice itself, where he was perhaps considered not good enough by the wealthiest patrons, yet too expensive for the poorer ones.

The reverence Bordone expressed for Giorgione when he reviewed his own career for Vasari may have been an indirect way of denying the influence of Titian, yet there is something

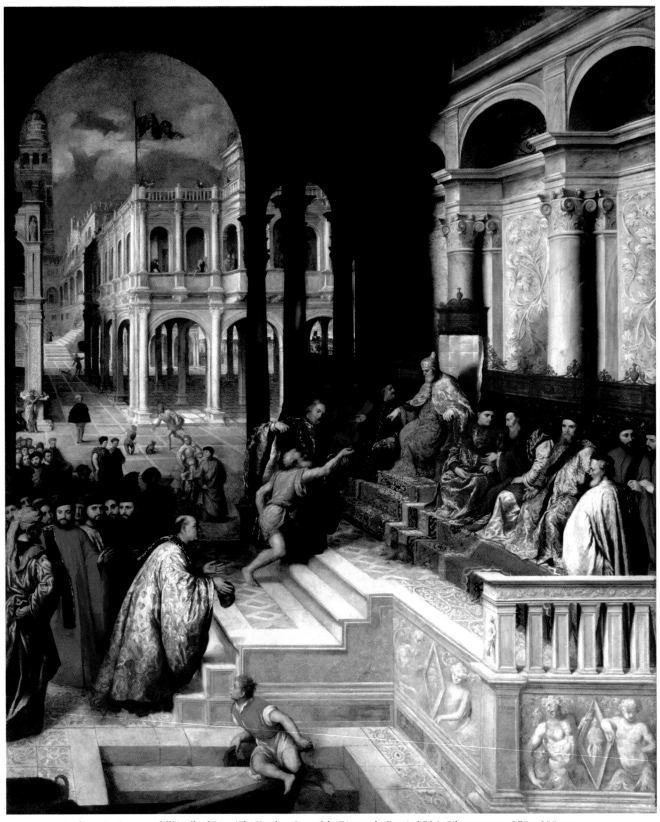

Fig. 1 Paris Bordone, *La Consegna dell'Anello al Doge* (*The Handing Over of the Ring to the Doge*), 1534. Oil on canvas, 370 × 300 cm. Venice, Gallerie dell'Accademia.

Giorgionesque not only about *Gli Amanti* but also about his finest portraits: notably the *Jeweller and his Wife* in Munich and the portrait of *Kraffter* in the Louvre.[21] This poetic quality is lost in his later works. 'He became,' in the words of Frederic Burton, 'one of the most splendid and luminous colourists of the Venetian school; but in respect of form and truth of action his works often leave something to be desired.'[22]

The dating of his work is problematic but it seems clear that after about 1540 he tended to conceal his limited success at depicting action with a formulaic animation in zig-zag drapery folds, in wriggling contours and in stippled and hatched brushstrokes to render sparkling light on foliage. His erotic pictures abound in softly modelled female flesh blushing in response to our admiration, sometimes contrasted with the hard 'overdelineated muscularity' of male torsos; but the softness seems superficial, a fatty covering of 'an impervious and inflexible core'.[23] The contorted and open poses especially of his mythological figures seem highly contrived and have been described as mannerist, but Bordone was largely untouched by the ornamental style that Salviati and Federico Zuccaro brought to Venice and that also arrived there with the prints of Parmigianino.

After about 1560 Bordone's painting became routine, often repetitious and sometimes feeble.

Bordone's work continued to be esteemed by collectors, including British ones, throughout the three centuries after his death. Eastlake was interested in it. He purchased two paintings by him for the Gallery and might perhaps have bought the painting of *Mars and Venus caught in Flagrante by Vulcan* now in Berlin, had he not found the subject 'objectionable'.[24] Bordone's work was then exceptionally well represented in private collections in Britain and today it is well represented in public collections in the UK.

The four-hundredth anniversary of his birth was celebrated in Treviso by the publication in 1900 of a scholarly monograph by Bailo and Biscaro, upon which the valuable modern scholarship of Giordana Mariani Canova and Giorgio Fossaluzza especially has been established.

NOTES TO THE BIOGRAPHY

1. Bordone signed his paintings 'Paris Bordonus Tarvisinus p[inxit]' or 'f[ecit]', or 'O[pus] Paridis Bordono', or 'O. Paris Bordonus in Venetiis', or 'O.D. Paris Bordon'.

2. Bailo and Biscaro 1900, pp. 85–6; Fossaluzza 1984, pp. 123–4.

3. Vasari 1881, VII, p. 462.

4. Ibid.; Ridolfi 1914, p. 230.

5. [Mariani] Canova 1964, p. 82, figs 15–17; Mariani Canova 1984, pp. 56–8, no. 3.

6. Vasari 1881, VII, p. 461 (for Giorgione's influence); [Mariani] Canova 1964, p. 107, fig. 22; Mariani Canova 1984, p. 54, no. 2.

7. He is listed as a 'figurer'. Bailo and Biscaro 1900, p. 87; Fossaluzza 1984, p. 124.

8. Mariani Canova 1984, p. 90, fig. 35, for the portrait of Körbler, then in Vaduz but now in the Liechtenstein Palace, Vienna. This collection also includes the very Germanic portrait of a bearded man dated 1533.

9. Bailo and Biscaro 1900, pp. 86–7; [Mariani] Canova 1964, pp. 93–4, figs 37–42.

10. Vasari 1881, VII, p. 464–5; Mariani Canova 1984, pp. 40–1.

11. Bailo and Biscaro 1900, p. 93.

12. Mariani Canova 1984, p. 41. For a full argument in favour of 1558/9 see Béguin 1987.

13. Bailo and Biscaro 1900, p. 96; Fossaluzza 1984, pp. 137–8.

14. Rearick 1987.

15. Vasari 1881, VII, p. 464; Ridolfi 1914, p. 230.

16. Notably S. Simone Vallada, near Taibon (province of Belluno), and S. Croce, Piladier. For the latter see Coda 1987.

17. One full-length portrait by him is in the Royal Collection, Shearman 1983, pp. 55–6, no. 50.

18. The most notable examples are *Augustus and the Sibyl* in the Pushkin Museum, Moscow (Ekserdjian 1999), *David and Bathsheba* in the Kunsthalle, Hamburg (Mariani Canova 1984, pp. 96–7) and in the Wallraf-Richartz Museum, Cologne ([Mariani] Canova 1964, pp. 76–7, figs 70–3), the *Annunciation* in Siena ([Mariani] Canova 1964, pp. 86–7; Mariani Canova 1984, p. 74, no. 13) and another in Caen (Mariani Canova 1984, pp. 90–1, no. 24), and the *Gladiatorial Combat* in the Kunsthistorisches Museum, Vienna ([Mariani] Canova 1964, pp. 116–17).

19. Gould 1962; Olivato 1987.

20. Vasari 1881, VII, p. 465.

21. For the Munich portrait (Alte Pinakothek, no. 925) see [Mariani] Canova 1964, p. 168, and Mariani Canova 1984, pp. 60–1, no. 5. For the Louvre portrait see [Mariani] Canova 1964, p. 85, and Mariani Canova 1984, pp. 68–9, no. 10.

22. [Burton] 1890, p. 49.

23. Richardson 1980, pp. 23–4.

24. Eastlake MS Notebook 1862.1. fol. 16. See also the printed report of his travels in 1856 where he recorded his interest in the *David and Bathsheba* now in Cologne (for which see note 18).

Portrait of a Young Woman

*c.*1545

Oil on canvas, 100.9 × 82.5 cm

Inscribed ÆTATIS SUÆ / ANN. XVIIII on the architecture above the woman's right shoulder

Support

The measurements given above are those of the stretcher. The painted surface measures 96.5 × 78 cm but the remains of the original canvas measure approximately 94.5 × 76.5 cm (see the section on Conservation below). Tacking holes and cusping can be discerned at the lower edge. These do not survive at the other edges, where, however, clear evidence remains of the stitching whereby the canvas was formerly enlarged. The original canvas is of a medium-fine tabby weave and is lined with wax resin on to a modern tabby-weave canvas of a similar weave. The pine stretcher with crossbars dates from the nineteenth century but was cut down when the picture was altered in format. It is stamped 'G. Morrill'.

Materials and Technique

It is not certain whether the canvas was prepared with gesso, but none was found in the only paint sample which has been taken from the picture.[1] The priming is pinkish beige in colour and consists of lead white with red earth and a little black pigment. Under infrared light, patches of black appear in the deepest shadows of the crimson dress, and hatched black lines in the shadow to the left of the bodice. Three separate layers of red lake and lead white were found in the mid-tone of the dress.[2] The delicate grey hatching of the flesh – most obvious in the eyebrows and below the chin – is characteristic of Bordone, as is the way that the irises with their very large pupils are crossed by a short, slightly curved line of white impasto.

Fig. 1 Detail of the sitter's left eye.

There is only one pentimento of any significance: a series of white marks passing diagonally over the woman's right breast. These perhaps indicate the original position of the pearl necklace.

Conservation

When the painting was acquired in September 1861 Eastlake was aware that it had been enlarged, a practice which he had observed to be common with old masters in Genoese collections.[3] He was at first undecided as to whether or not the extensions should be removed, but we know from Wornum's diary that the painting was consigned to 'Mr Morrill to be lined' and 'the added portions to be partly cut away again'. This operation was complete on 11 December 1861 and between 16 and 19 December the painting was cleaned by Pinti.[4] It was relined, cleaned and restored between June and September 1980, and the remaining additions were removed at that time. A border was left around the original canvas.

Condition

The painting is in very good condition. There are a few small paint losses in the higher of the two distant arches on the left and also in the skin to either side of the nose. It seems likely that the fine veining of the columns in the foreground was originally more evident. The yellow paint of the ornamental chain around the woman's waist has darkened, since it almost certainly represents gold. It has probably become more translucent and hence more affected by the crimson of the dress underneath. The cross, probably painted with the same pigments, is lighter, except for the finial on the left, which was painted over the dress. Very slight abrasion to the shawl where it falls over the dress is likely. The shadows of the pearls and the little blue ribbons on the bodice of the dress appear to be perfectly preserved.

Dating and Attribution

The painting seems always to have been recognised as by Bordone. The facial type and expression, the colour of the flesh, the hatched brushstrokes in the shadows, also the curious anatomy of the left hand, are all typical of him. The style of the dress, especially the puffs at the top of the sleeves, suggests a date in the mid- to late 1540s. A close parallel is found in Lotto's *Portrait of Giovanni della Volta with his Wife and Children* (NG 1047) which was completed in 1547.[5]

Setting, Dress, Accessories and Format

The woman stands in an architectural setting of indeterminate, and surely fantastic, character. There is a *basamento* at approximately shoulder height on the right, and above it there are engaged columns on pedestals and a wood-framed glass window (with panes of bottle glass) aligned with the plinths of the columns. These plinths are unusually low, and also unusual is the fact that they are narrower than the base mouldings of the columns. It is not clear whether there are one or two columns to the left of the window.

In the left-hand corner of the painting there is an opening with two improbably precarious flights of steps rising

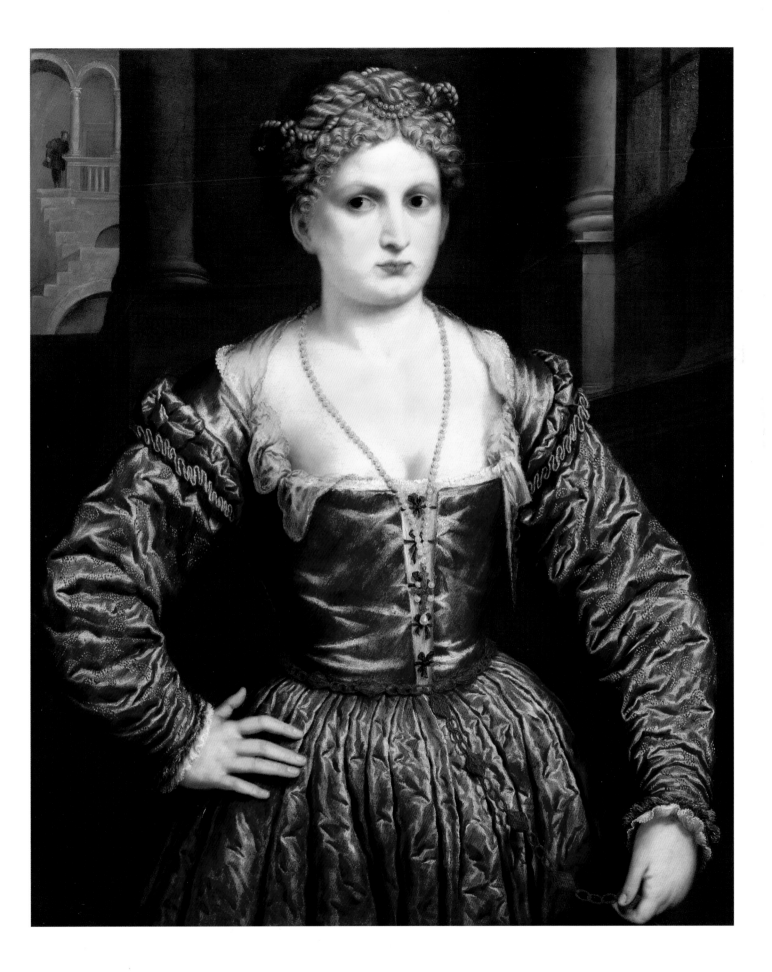

Fig. 2 NG 674 before the 1980 restoration.

Fig. 3 Paris Bordone, *Portrait of a Woman with a Squirrel, c.*1545. Oil on canvas, 102 × 81 cm. Augsburg, Städtische Kunstsammlungen.

at right angles to each other. The stairs lead to what might be taken for an arcaded loggia, two Ionic columns of which are visible, but is more probably meant for a central triple-arched opening, of which we see one half. In any case the higher and wider arch defines the entrance to which these steps lead. A man stands in the entrance. The substructure of the building and the stairs are supported by two arches. As Gould noted, this depends on a staircase which is among the designs published by Serlio in his book of Architecture.[6] It is, however, not as precisely drawn as the Serlian architecture in those of Bordone's paintings in which architecture plays a larger part. In nineteenth-century catalogues the structure was considered to be a 'portion of the hospital at Genoa' and the sitter was said to be a member of the Genoese Brignole family.[7]

The woman wears a necklace of pearls from which a gold cross is suspended. Four pearls identical in size to those strung on the necklace are attached to the cross, and a pear-shaped pearl is pendant from it. There is a blue stone or enamel ornament in the centre of the cross. Around the woman's waist there is an ornamental chain with hollow, perforated, multifaceted ornaments, each separated by three links of the chain. This chain extends to the woman's left hand, which may conceal an object such as a miniature book, a scent bottle, a pomander or a locket.

The sleeves are detachable from the dress, as was usual in this period, and, although they are made from the same crimson silk with crumpled folds, they are embroidered with meandering textured bands. The fine translucent shawl worn around the woman's shoulders appears to have originally covered her breast and to have been opened hastily and tucked negligently into the dress. Such 'sweet disorder' is not usually found in sixteenth-century female portraiture in which the dress is accurately rendered, but there is another example among Bordone's portraits, and Lotto's *Portrait of a Woman inspired by Lucretia* (NG 4256) provides an earlier example. It is somewhat enticing, and one wonders whether it was regarded as provocative and 'loose', like a stray lock or dangling strap in other periods. This, together with the darting glance (active eye movements were deemed inappropriate for a demure maiden) and the boldness of the hand on hip, counteracts the chaste associations of the cross. All of these features except for the hand on the hip are also found in Bordone's portrait known as the 'Donna con lo sciattolo' in the Städtische Kunstsammlungen, Augsburg (fig. 3).[8]

The woman's coiffure is as tidy as it is elaborate, with regularly rippling locks on either side of the central parting, and a long tail of hair wound around the top of the head is bound by knotted plaits that rhyme with two strings of pearls which are also involved.

The format of a three-quarter-length figure framed by architecture and including a column base at head height is found in what is probably Bordone's earliest surviving portrait, the painting of a young man once in the Baring

collection, which seems to be dated 1521 (the last digit is not clear).[9] The pose of one hand on hip, together with the highly elaborate coiffure, is found in a painting by Bordone that probably dates from the 1530s and is in any case of earlier date than NG 674, the so-called *Violante* in the Alte Pinakothek, Munich,[10] which is now generally regarded as the portrait of a courtesan or of an ideal beauty for which a courtesan perhaps modelled. However, the same pose and a very similar architectural setting to that seen in NG 674 are also given by Bordone to a woman of the Fugger family.[11] By contrast, the features of the young woman in NG 674 clearly conform to the artist's female ideal as also found in his mythological paintings. But this need not mean that NG 674 is not a portrait, since portrait painters have often ignored the idiosyncratic particularities of young beauties, and besides it would be very odd for a painting of an anonymous beauty to be inscribed with the information that she is aged nineteen.

Whether the sitter in NG 674 takes liberties which were permissible in a portrait of a young lady painted for her betrothed or is, rather, a mistress painted for her lover is a question which cannot easily be settled, but Bordone depicted many other female sitters with much more provocative states of undress (the original of NG 2097 was probably a case in point).[12] On the spectrum of Bordone's female portraiture, which extends from decorous matron to lascivious courtesan, NG 674 seems to occupy a mid-point.

Possible Companion Painting

Bailo and Biscaro in their monograph of 1900 proposed that this painting, traditionally identified as a 'Portrait of a Lady of the Brignole family', may be the portrait of a 'most lascivious woman' ('donna lascivissima') sent by Bordone to the Genoese Ottaviano Grimaldi from Venice, together with his portrait of Grimaldi himself.[13] The idea was presumably suggested by the fact that NG 674 was once in a Genoese collection. Canova in her monograph of 1964 took up the idea and suggested that the portrait of Grimaldi might be a painting now in the Genoese public gallery in Palazzo Rosso, which is of the 'same size and format' and also includes an architectural view.[14] The sizes are similar,[15] but not the canvas type. Grimaldi was said to have visited Venice in 1524, whereas the male portrait in question is now dated to more than thirty years later.[16] NG 674 was certainly not painted at the same date.

Cecil Gould suggested that a male portrait in the Uffizi might have been painted as the companion of NG 674.[17] This painting is likely to be of a later date, moreover the figure is different in scale and he looks up to the left. Whether placed beside or opposite the woman in NG 674, he would not meet her eyes. The use of the same background motif does not suggest that it was a companion painting.

One aspect of NG 674 which does, however, suggest that it was made for a specific location and hence perhaps as part of a scheme which may have involved another painting is the fact that the light – very unusually in Bordone's œuvre – falls from the right.

Circumstances of Acquisition

The acquisition of NG 674 is described by the Gallery's director, Sir Charles Eastlake, in a letter of 20 September 1861 sent from Naples to the Gallery's keeper, Ralph Nicholson Wornum:

> I have purchased here a portrait of a lady by Paris Bordone – about half length, but enlarged. It came originally from Genoa, where it was the fashion to increase the size of pictures. It will be a question when it reaches England how far to cut it down. I think the original boundary, at least above, would be too close to the head.
>
> I have had great trouble in getting the picture from the proprietor, the Duca di Cardinale (his late title was Duca di Terranuova). He was the owner of the 'Terranuova Raphael' sold a few years since for a large sum to Berlin. At first the Duke would only consent to sell six pictures together, including the P. Bordone for about £1040. I could not agree to this, not caring for the other 5 pictures. I offered £400, including agency & presents to the secretary & household – without fixing the price of the picture. The stimulus of gain to the subordinates was so powerful that the duke was induced to give the picture for 1500 ducats – £257-13-1 – the 'agency' being £146. I have of course the proper receipts.
>
> The picture is safe at Messrs Igguldens, the correspondents of Messrs McCracken. There will be some exportation forms but I hope no difficulty. Please to direct Messrs McCracken to insure, for due time, per £500 to cover expenses.[18]

Eastlake himself was not likely to have been directly involved in this affair. It must have been managed by his Neapolitan agent, whose services he praised in the same letter: 'The agent I have secured here will obtain access for me to the best collections – & he is most fearless in asking Dukes & Princes to sell.' The Gallery's accounts reveal payments made on 18 December 1861 to Messrs McCracken for the cases containing the Bordone and its frame (£13 11s. 9d.) as well as their commission (£2 5s.), and earlier, on 17 October, payments corresponding to those mentioned in Eastlake's letter (£257 13s. 1d. and £146) which were made to a 'Sigr. Carelli',[19] who must therefore have been Eastlake's audacious and ingenious agent. He is presumably to be identified with either Gonsalvo (Consalvo) Carelli (1818–1900), a Neapolitan painter of landscapes and genre scenes, or his brother, the watercolourist Gabriele Carelli (1820–1900). Both artists had English connections and moreover may have known Eastlake when he had resided in Rome.

Wornum's diary reveals that the painting arrived in the Gallery on 16 November 1861. It was hung on 27 December after relining and cleaning and glazed on 4 January 1862 (when its varnish was judged to be completely dry).[20]

Provenance

Duca di Cardinale (formerly Duca di Terranova, Naples) by 1861 and previously, according to him, in Genoa, perhaps in

the possession of a branch of the Brignole family, since the sitter was said by him to have been a member of that family. Purchased from the duke by the National Gallery in 1861. The Duca di Cardinale would have been one of the two sons of Prince Giuseppe Pignatelli Aragona Cortes, Duca di Terranova and Marques de la Valle de Oaxaca (1795–1859). The titles of this family, which had property in Sicily, Spain and Mexico, are notoriously complex – the present head of the family has eighteen titles. Diego, the eldest son of Prince Giuseppe, owned the splendid neo-classical Villa Acton in Naples (now Villa Pignatelli).

Copies

A portrait of oval format, or at least framed as an oval, which was evidently based on NG 674, was sold at Christie's, London, on 27 February 1976, lot 92. The most notable difference was that the woman was not wearing a pearl necklace but had flowers pinned to her breast; it may have been made in the eighteenth century.

Framing

The painting was transported to London together with its Italian frame, which it is likely to have retained until it was reframed at some time between June 1962 and December 1964.[21] Neither of these two frames can now be traced. The painting is currently displayed in a frame made in July and August 1981. It has radial stopped flutes on the principal moulding, which is separated by hollows from the sight edge and from the bead and fillet of the back moulding. To us the execution looks mechanical, the design rather mean and the colour somewhat repellent. The gilding has been rubbed to reveal the red bole beneath and then muffled with a layer of smoky grey.

OPPOSITE:

Fig. 4 Detail of NG 674.

NOTES

1. Report of examination conducted by Marika Spring of the National Gallery's Scientific Department in April 1998.

2. Ibid.

3. See Eastlake's letter quoted in the section on Circumstances of Acquisition.

4. NG 32/67.

5. Typescript notes by Stella Mary Pearce (Newton) dated 19 October 1954 in the National Gallery's dossier suggest a later date than Davanzo Poli 1987, p. 250. For the Lotto see Penny 2004, pp. 92–102.

6. Gould 1962, p. 61.

7. Wornum 1862, p. 40; [Burton] 1890, pp. 49–50.

8. [Mariani] Canova 1964, fig. 144. The flashing eye is also a feature of the portrait formerly in the Radnor collection, for which see Fossaluzza 1987.

9. Exhibited at the Royal Academy (1871, no. 84) as by Titian, to whom it had been previously attributed both in England and in Spain (where it had belonged to Manuel Godoy). It was catalogued by Richter (1889, p. 163, no. 218) as by Titian or Bordone, and later it was supposed to be by Calcar. See Sotheby's, New York, 28 January 2000, lot 15, where it is correctly attributed to Bordone. The portrait of a man in the Louvre (inv. 758), generally attributed to Tintoretto but also sometimes to Calcar, must be by the same hand. Palma Vecchio introduced the motif of high column-bases into Venetian portraiture with his late unfinished pictures in the Querini Stampalia collection.

10. [Mariani] Canova 1964, p. 84, fig. 86.

11. Ibid., p. 64, and Mariani Canova 1984, p. 82, no. 19.

12. [Mariani] Canova 1964, p. 85, fig. 89 (Louvre), and p. 116, figs 90 and 91 (Vienna). See also the portrait of a young lady in the Thyssen Bornemisza Museum, Madrid (no. 55), where both breasts are exposed by the loosening of her bodice.

13. Bailo and Biscaro 1900, pp. 128–9.

14. [Mariani] Canova 1964, pp. 48–9 and 81; the male portrait in Palazzo Rosso is ibid., fig. 88. My notes indicate that it is painted on canvas of a very fine tabby weave.

15. The male portrait measures 110 × 83 cm. This is not identical in size to NG 674 today but it is hard to estimate the original size of NG 674 given that three of the four edges have been cut.

16. Davanzo Poli 1987, p. 252.

17. Gould 1959, pp. 22–3; 1975, pp. 36–8. [Mariani] Canova 1964, p. 99 and pl. 99. It measures 115 × 90.5 cm.

18. Letter in the dossier for NG 674.

19. NG 13/1/3 (by date).

20. NG 32/67.

21. Annual Report for June 1962 – December 1964, p. 139.

NG 1845
Christ as 'The Light of the World'

*c.*1550
Oil on canvas, 90.7 × 74.7 cm

Inscribed on the scroll in dark blue paint:
EGO . SVM . LVX . MV̄D... for 'Ego sum lux mundi'
('I am the light of the World'), words of Christ
in the Gospel of Saint John, 8:12.

Signed on the plinth of the pillar, top left,
in minute black letters, only partly legible:
O. [for Opus] *Paridis Bor...on.*

Support
The measurements given above are those of the stretcher. The painted area is slightly smaller. Cusping is visible along the upper and lower edges of the original canvas (much more clearly so in X-radiographs), and what must be ragged turnover edges are apparent on all sides, so we can be sure that the painting has not been reduced in size. The original canvas is of a medium-weight tabby weave, lined with glue paste on to a canvas of a medium tabby weave that was impregnated with wax. The modern pine stretcher has a horizontal crossbar.

Materials and Technique
The canvas has been prepared with a thin layer of gesso (calcium sulphate, identified by EDX) and a priming of lead white mixed with yellow earth – the ivory tint of the latter is now visible in parts of the sky.[1] The black diagonal hatching now apparent in the shadows of Christ's red garment, especially above his right wrist, is perhaps evidence of dark underdrawing, at least in the figure, whereas the outlining of low-relief foliate ornament in the *basamento* on the right and of rough masonry courses in the wall beside the window is better understood as partly abraded painting.

Minor pentimenti are apparent in many parts of the painting: along the vertical edge of the *basamento* on the left, in the hair, in the outline of the blue cloak on the right, around the fingers and upper part of the wrist of Christ's right hand, and in his left thumb. The line resembling a pentimento under the portion of the scroll that is inscribed LVX is more likely to be a shadow cast by the scroll, which has faded.

At least two types of red lake were used in Christ's red garment. His cloak appears to have been painted with azurite, and the lining was certainly painted with azurite, lead white and a very intense red lake. The underpaint for the cloak contains poorer quality azurite of smaller particle size and a greener hue.[2]

Christ's nimbus is painted with small dots and dashes of lead-tin yellow and ochre, and a similar technique is employed for the gold decorations at the sleeves and neck of his garment. The hatching of the shadows in Christ's eyes and the thin horizontal lines of white crossing the irises are characteristic of Bordone's handling.

Conservation
The painting was said to have been 'repaired and probably cleaned and lined by Eckford about 1884'. Eckford was a London framemaker who was already in practice as a dealer and restorer during the 1840s.[3] On the painting's arrival in the Gallery in 1901 it was described as 'cracked and dry', and as varnished with mastic. The varnish must have been very yellow because the view of the sky was described by the donor's brother as a 'Map of East Europe with seas green and land light grey'.[4]

Condition
The edges of the painting are scuffed, especially the left and upper edges. There is wear on the left side of the plinth, which has impaired the legibility of the signature, also to the right side of the *basamento*, where the relief ornament is fainter and more linear than it is on the left, and in the sky, where the colour of the ground shows through the clouds. There are three long, curved scratches above Christ's head.

The colours of Christ's flesh, his hair and his cloak appear to be well preserved, although it is possible that the lining of the cloak was originally slightly purple. The red of Christ's garment has certainly faded and the colour has also become less unified than it was originally. A deep pink lake is well preserved in a few areas of shadow, notably the elbow of Christ's left arm, but another lake has not only faded but browned. This fading has the effect of making the lights and shadows appear somewhat abrupt, especially the darkest shadows, which are the only ones to have retained their strength. Increased translucency has also had a distorting effect, revealing rapidly hatched lines in some of these shadows (as described above).

Attribution
The painting, which is signed by Bordone, seems never to have been disputed as his work.

Subject, Treatment and Date
A full discussion of related images of Christ as 'Salvator Mundi', as Pantocrator, and as a blessing figure, especially with reference to Venice, may be found in Volume I of my catalogue of the National Gallery's Italian paintings.[5] In NG 1845 Christ clearly presents himself as the Light of the World. His hand is raised in instruction or admonition, with the index finger perhaps directing our attention to Heaven. The painting is sometimes described as 'Christ Blessing',[6] but that is incorrect, since the act of benediction requires the raising of two fingers. The painting was first catalogued in the National Gallery as 'The Light of the World', and later as 'Salvator Mundi',[7] which is not inaccurate. Paintings of this type were kept in a domestic setting and especially in bedchambers but they were also, from an early date, displayed in churches.

The framing of the head with architecture, and in particular the way that the base of the pillar and the pilaster behind it are nearly aligned with Christ's eyes, is a feature of one of Bordone's earliest works – a portrait of a man,

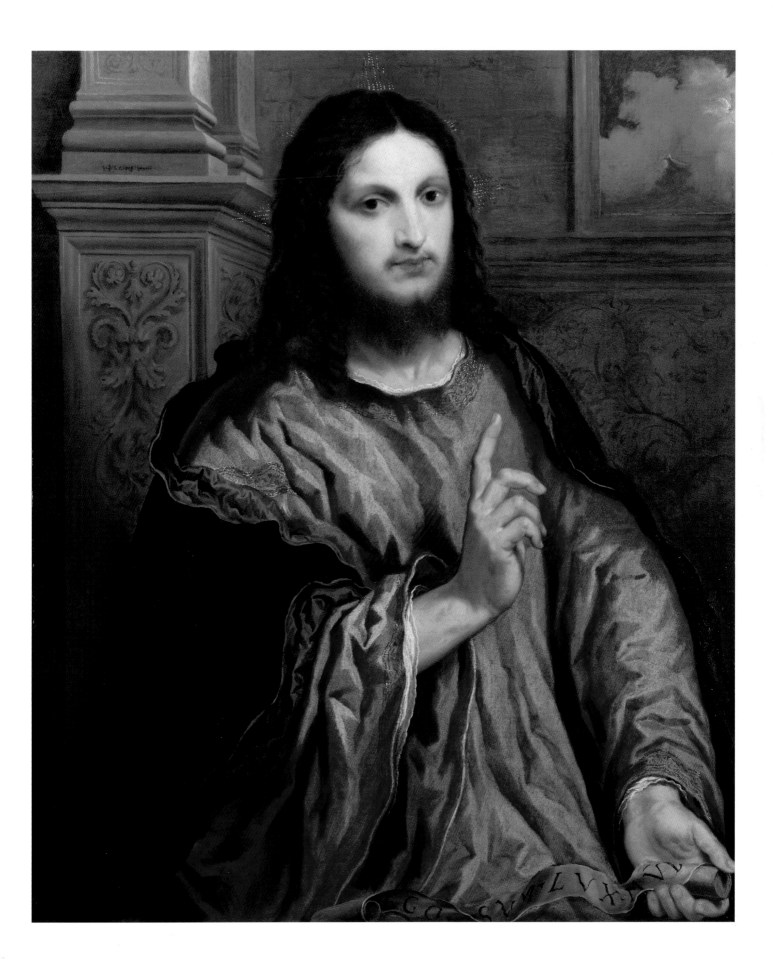

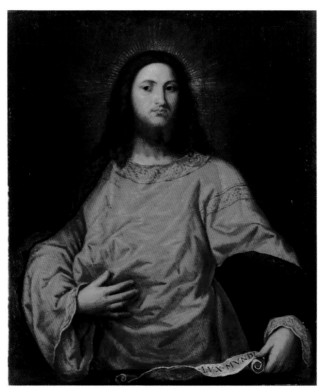

Fig. 1 Paris Bordone, *Christ as 'Light of the World'*, c.1545.
Oil on canvas, 85 × 57 cm. Ravenna, Museo d'Arte della Città.

apparently dated 1521.[8] The architectural features used here are identical to those in Bordone's *Portrait of a Woman with a Squirrel* in the Städtische Kunstsammlungen, Augsburg (fig. 3, p. 48),[9] except for a slightly different relief pattern below the pillar and the absence of relief ornament elsewhere in that painting. The relationship between figure and setting is more monumental and effective in the portrait, which is also perhaps the earlier of the two works.

There are several related paintings of Christ by Bordone. One in which his hand is also raised but with two fingers upright in benediction is in the Mauritshuis in The Hague[10] and perhaps dates from around 1540, because the taut lines of the niche behind the figure are a feature of Bordone's portrait of Krafter in the Louvre which is dated in that year.[11] A painting of Christ in Ravenna (fig. 1) also includes a scroll inscribed with the same text along the bottom and is of similar format, although smaller in size, but the frontal pose gives Christ a more monumental appearance.[12] His left hand is pressed against his side, as if gathering up and holding in place the very loose garment. Although the National Gallery and the Ravenna paintings look likely to be later in date than the painting in The Hague, which we have proposed as of about 1540, it is interesting that the sketchy start of a painting of Christ, similarly posed to the one in Ravenna (but with architecture like NG 1845), was discovered by X-radiography under the Louvre portrait of 1540.[13] The responsive tilt of the head and the rather loose twist to the body which are found in NG 1845 are also evident in Bordone's signed *Flora* in the Louvre,[14] and it is notable that his intimate devotional pictures adopt formulae used for his erotic works.

Versions or Copies

A painting that may be a repetition of NG 1845, or an early copy, is incorporated as a crowning feature (arched in shape and of *giallo di Verona* marble) of the baroque altarpiece frame in the first chapel of the right aisle of the abbey church of S. Benedetto Po. This frame is likely to date from the 1730s (see p. 352 for a discussion of the baroque frames in this church). The principal painting within the frame was the Saint Anthony Abbot by Veronese, and it is unlikely to have had any other painting above it during the sixteenth century. A painting of 'Un Salvatore in atto di benedire' by the hand of Paris Bordone was recorded in the collection of Gaspar de Haro y Guzmán, Marquesa del Carpio, in 1682,[15] but this may be identical, or more closely related, to the Bordones mentioned in the previous section. A copy of NG 1845 is in the Musée Rolin, Autun.[16]

Acquisition by the Gallery

The painting was offered to the National Gallery by the Revd George Greenwood on behalf of his sister, Mary A. Wood, widow of Charles George Wood of 4 Talbot Place, Blackheath, on 29 April 1901 in a letter to the keeper, Hawes Turner. The director, Sir Edward Poynter, annotated the letter with a request to Hawes Turner to acknowledge it and to explain that he would inspect the painting on his return from a visit to Italy which he was about to make. Greenwood wrote again on 14 May explaining that his sister was dying from a chronic disease and there was a risk that there might be a 'serious difficulty carrying out her wish' after her death, since she had not mentioned the painting in her will. The painting was evidently removed to the Gallery on 18 May, and Mrs Wood died two days later. It was accepted by the Trustees at their meeting on 4 July. Greenwood mentioned that Mrs Wood had wanted his name as well as hers to be recorded on the label, and this was done, using the formula 'Presented by Mrs Wood through her brother the Rev. G. Greenwood 1901'. She was partly motivated by a concern to associate her father's name with the picture, but her brother was clearly attached to the painting. In the year following its presentation, Greenwood's wife arranged to have a photograph taken of it as a surprise birthday present for him.[17]

Provenance

Brought to London by a member of the embassy of the Kingdom of the Two Sicilies and presented to Henry Greenwood in about 1815 in appreciation of his charitable endeavours on behalf of a Sicilian woman (see Appendix below). Inherited by his daughter, Mrs Mary A. Wood. Presented by her to the National Gallery in 1901 in circumstances described in the previous section.

Exhibition and Loan

Lincoln, February and May 1929, Usher Art Gallery.

Frame

The painting has a gilt frame of reverse pattern press-moulded in composition with an oak leaf upper moulding and broad

stylised acanthus on an ogee moulding behind it. There is a
pearl and waterleaf ornament at the sight edge. This is a
standard pattern of frame which was used for a wide range of
paintings in the National Gallery in the 1860s and made by
Henry Critchfield, who was then the Gallery's framemaker.[18]
The Gallery did not have a monopoly on the use of this pattern
and it may have been chosen, by coincidence, by the previous
owners of the painting. A more likely explanation is that it
was transferred to NG 1845 when another painting was re-
framed. See also the entry for Veronese NG 1041 (p. 394) for
another frame of this type.

Appendix
HENRY GREENWOOD'S REWARD

About 1819 Mr Henry Greenwood of Guy's and
St Thomas's Hospitals was surgeon to the Surrey
Dispensary, Southwark. There he met an Italian Lady,
Mrs Soden, diseased and starving. She had three
children. Mrs Soden told Mr Greenwood that her
Father was one of the principal nobles of Sicily but that
she had been taken out of her convent as a girl of 15,
by Captain Soden, one of Sir John Stuart's officers.
He forced a Roman Catholic priest to marry them and
took her with him when the English army left Sicily.
Mr Henry Greenwood went to the Sicilian Embassy.

They wrote to Mrs Soden's Father, but he refused all
communication, saying that she was dead to her
family. Her case was brought before the War Office,
Captain Soden being dead, and the pension was given
her as an officer's widow. One of the Sicilian Embassy,
in token of gratitude to Mr Henry Greenwood for his
great kindness to Mrs Soden, gave him the picture of
Our Lord by Paris Bordone, saying that it was painted
for the altarpiece of his family chapel, and had never
been out of their possession.[19]

There is no reason to doubt these facts, recorded in 1901
by Greenwood's son. He had evidently undertaken a little
research since he had the names of two members of the
embassy, the 'Cavaliere di Nigra, and Cavaliere di Pesaro',
but, he added, 'the name of the Ambassador or Minister
is forgotten'. As a postscript he recalled that Mrs Soden's
family name was Ravelli. This family was in fact Neapolitan
but doubtless with interests in Sicily. The embassy would
of course have been that of the Bourbon king of Naples and
the Two Sicilies, and it is more likely that the member of the
embassy's staff who made this remarkable gift to a foreign
– and Protestant – physician came from a Neapolitan family.
Sir John Stuart (1759–1815) was in Sicily for much of 1806
and then again from the autumn of 1807 to the autumn
of 1810.

NOTES

1. Report of April 1988 by Marika Spring of
the National Gallery's Scientific Department.

2. Ibid.

3. For Eckford see Bradley and Penny 2002,
pp. 607–8, especially note 11. Eckford's
work on the painting is mentioned in the
manuscript account of the painting by
George Greenwood, brother of the donor.
Greenwood's notes, dated 24 April 1901,
are kept with the minutes of the Gallery's
board meetings.

4. Ibid.

5. Penny 2004, pp. 300–3, 310–13.

6. [Mariani] Canova 1964, p. 80 and fig. 86.

7. [Burton] 1906, p. 78; [Collins Baker]
1929, p. 30.

8. Sotheby's, New York, 28 January 2000,
lot 15.

9. [Mariani] Canova 1964, p. 97 and
fig. 144.

10. Ibid., p. 79 and fig. 65.

11. Ibid., p. 85 and fig. 62.

12. Ibid., p. 110 and fig. 64. It measures
86 × 57 cm.

13. Béguin 1964 (the X-radiograph in fig. 4).

14. [Mariani] Canova 1964, p. 85 and fig. 89.

15. Getty Provenance Index Inventory
no. I–2626, fol. 113, no. 765 'di palmi 1½
et 1 in circa'.

16. Béguin 1987, p. 20, fig. 2.

17. Letters from George Greenwood to Hawes
Turner of 29 April, 14 May and 10 July
1901, together with his careful description
of the picture, are in the Gallery's archive.
So too are two letters from Mrs H. Greenwood
of 12 and 13 March 1902.

18. Penny 2004, p. 245 and fig. 3.

19. The MS description dated 24 April 1901,
cited in note 3.

A Pair of Lovers

1555–60
Oil on canvas, 139.1 × 122 cm

Support

The measurements given above are those of the stretcher. The original canvas, of fine tabby weave, consists of three pieces. There is a large piece with a vertical seam 28.3 cm from the right edge. The narrow strip on the right consists of two pieces with a horizontal join 124 cm from the upper edge. The original canvas has been trimmed irregularly, and in some places between 1 cm and 0.5 cm of lining canvas is visible at the edges. Cusping is evident along the upper edge, but hardly at all on the others. This fact, and the image itself, suggest that the painting may have been slightly reduced on both sides. The lining canvas, probably of the mid-nineteenth century but dating from before 1860, is also of a fine tabby weave. The stretcher, of varnished deal, with crossbars, dates from the same period.

Materials and Technique

The ground consists of lead white, with no admixture. There seems to be no gesso ground (none, in any case, has been detected in any of the samples taken from the painting), which is a departure from Venetian practice of the first half of the sixteenth century; further research may reveal that it is characteristic of Bordone's later work.

The yellow-green foliage behind the woman is painted with yellow earth, green earth and lead white, with a small amount of azurite sometimes added. The blue of the sky is painted with azurite and lead white.[1]

Pale layers of the blue seem to have covered much of the upper portion of the painting, and the trees were painted over it. But the intense bright blue was painted last and a thin fringe of the earlier colour can be detected around the edges of the foliage, especially in the top right corner.

The instrument in the woman's right hand was painted on top of her index finger and crimson cloak, both of which now show through the pipes. The three visible fingers of the man's left hand were originally positioned lower down and to the left. The outline of the man's body was slightly extended on the right during painting.

When examined closely, the painting is very minutely finished, for instance in the flecks of black and red lake in Cupid's wing, and of red in the man's cheeks, and in the painting of separate, pale hairs in his beard and threads of fabric at the borders of his garment.

Conservation

The painting is likely to have been cleaned around 1840 or 1850, when it was probably sold to Beaucousin (see the section on Provenance below). It may well have been repaired and lined at the same date. A toned varnish concealing the abraded foliage and tree trunks (removed in 1985) was probably applied at that date. The painting was surface-cleaned and revarnished by 'Dyer' in 1888. Blisters were laid with wax in December 1962. The picture was cleaned and restored between February 1985 and March 1986.

Condition

There are tears in the canvas across the man's chest and vertically from his lower lip to his arm. The tears have been sewn up, so the damage is likely to have occurred before the canvas was lined. There is also a large loss, probably a hole, in the man's left thigh, and a smaller, vertical tear in his right thigh.

The upper and lower edges of the painting have been scuffed and there are also flake losses in these areas. Some of the damage in the top left-hand portion of the painting occurred when it was in transit to Bangor in August 1939, at the outset of the Second World War.

The thinner layers of paint have been abraded, especially in the landscape, the shadows of the flesh, and a small area of ground on the extreme right. The brown paint of the pipes held by the woman has become translucent.

The dark brown areas in the leaves at top right, and perhaps the black areas in those on the left, are likely to be darkened copper pigments and would have been greener originally. For the most part the painting is in fine condition, especially in the flesh, the hair and the drapery.

Attribution

The painting seems always to have been acknowledged as the work of Paris Bordone and is entirely typical in format, composition, palette (especially the flesh tones), facial types, anatomy and many significant aspects of the handling, such as the glazed shadows of the crimson cloak and the delicate linear lights on the leaves (fig. 4).

Dating

Cecil Gould proposed a date of about 1540.[2] He was influenced in this by the notes Stella Mary Pearce (Newton) made on Venetian hairstyle, which led her to conclude that the mid-1540s 'would be too late a date for the painting' because there are relatively few small curls along the forehead.[3] There is, however, good reason to suppose that Bordone would have wished to dissociate his mythological and allegorical figures from contemporary fashions of dress and hairstyle.

Although none of Bordone's allegorical and mythological paintings can be dated with complete certainty, it seems very likely that the *Jupiter and Io* in the Konstmuseum, Göteborg (fig. 1),[4] is the painting of this rather rare subject that Bordone told Vasari he had made for the cardinal of Lorraine at the court of the king of France, and it is likely that the *Venus and Cupid* now in the Narodni Museum, Warsaw,[5] is the painting of the subject made on the same occasion for 'Monsignore di Guisa', that is, the Duc de Guise. In character and style, and also in their high finish, these two paintings are very similar to NG 637. Furthermore, there are compositional similarities between NG 637 and *Jupiter and Io* which even made Gould wonder whether they were pendants,[6] although the fact that the left hands of the women in the two paintings are identical,

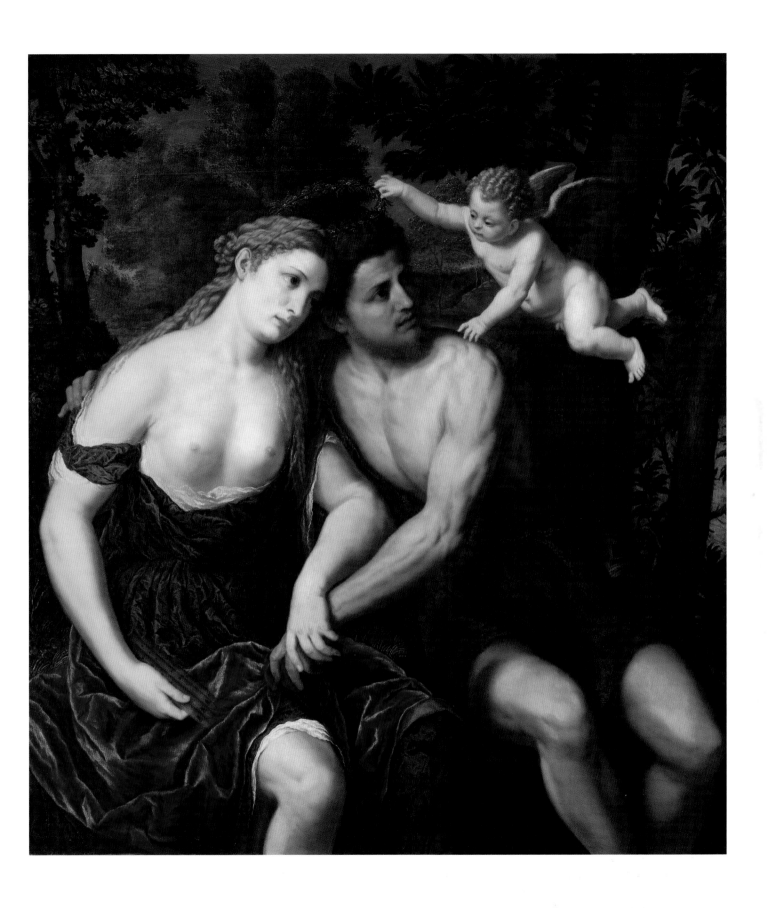

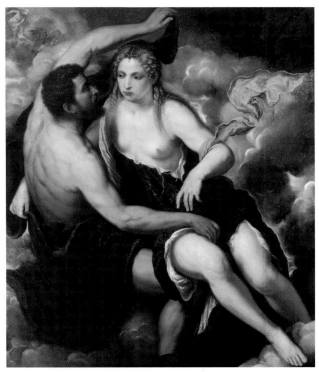

Fig. 1 Paris Bordone, *Jupiter and Io*, c.1559. Oil on canvas, 135.5 × 117.5 cm. Göteborg, Konstmuseum.

and that Io's right leg is nearly the same as that of the male in NG 637. makes it unlikely that this is the case. But it is surely likely that they were painted in the same period.[7]

If Vasari is to be trusted, Bordone's journey to France was made in 1538. It would thus be reasonable to date NG 637 together with the mythological paintings just mentioned, which would have to have been painted then or slightly later.[8] However, there are many reasons to suppose that Vasari was mistaken. A stay in France in 1559 is recorded by other sources and it makes sense that the King Francis who invited Bordone was Francis II, who reigned from July 1559 to December 1560, rather than Francis I, who, although a great art lover, was never very interested in Venetian painting.[9] Furthermore, 1559 is the most appropriate date for Bordone to have received commissions from the distinguished soldier François, 2nd Duc de Guise (1519–1563), and his brother, Charles de Guise, cardinal of Lorraine (1525–1574), both then in high favour at court, the uncles of the queen, Mary Stuart, and indeed the virtual rulers of France during the brief reign of Francis II. Although very ingenious arguments have been adduced to explain why Bordone might have adopted such subjects and compositions in France in the 1530s, it is far easier to understand them as a response to the truly international success of Titian's *Venus and Adonis* (for which see pp. 274–91) during the 1550s.

Subject and Versions

The woman holds in her right hand four attached reed pipes, an imaginary primitive musical instrument. Next to the man's left thigh there is a wooden cask, presumably a water container, with what may be a simple wooden instrument

(perhaps a recorder) above it. These suggest a pastoral, but the woman's clothes, although not elaborate, are neither rural nor simple; the chemise is of the finest cambric, the dress of elaborately patterned silk, the cloak of fabric dyed with the most expensive colour, crimson. And her hair, although loosened, could only have been dressed with the aid of a maid and a mirror.

There are two other versions of the composition, one in the Kunsthistorisches Museum, Vienna (long on loan to the Landesregierung, Salzburg; fig. 2), and the other in the Rector's Palace, Dubrovnik (fig. 3). All three seem to be by Bordone[10] (there is at least one other case of his repeating a painting).[11] The figures in the three paintings appear to be identical in size and may have been made from the same cartoon,[12] but the clothes are different in colour and character, notably in the fact that the woman in both the Vienna and the Dubrovnik paintings wears two rather than three garments. There are minor differences in detail (for example the fall of the woman's hair) and in setting, and major differences in the accessories. In the painting in Dubrovnik the man's water barrel is far larger, and the woman holds a small bow and arrows, as she also does in the painting in Vienna. There is one major difference in action. The woman in the painting in Dubrovnik places her left hand graciously on her chest and seems more attentive towards Cupid. In all three paintings Cupid crowns the man with a wreath, having apparently secured his attention by tapping his shoulder. Cupid's presence suggests by association that of Venus, who is not uncommonly represented as disarming, or having disarmed, her son, thus implying that she is in control of the situation. The crown might therefore be taken to indicate divine approval of the man's advances.

When NG 637 was in the Beaucousin collection it seems to have been described as *Mars and Venus*,[13] but the absence of armour makes this unlikely. It was catalogued by the National Gallery as *Daphnis and Chloe*, an idea which must have been Eastlake's, or must at least have had his approval.[14] The pastoral romance of that title, written in Greek by Longus (probably in about AD 250), was much admired for its tender comedy in the nineteenth century. When his desire for Chloe becomes urgent, Daphnis has 'no idea how to do what he passionately wants to do' and bursts into tears. If the man's expression is supposed to be one of perplexity, and the woman's gesture a rather hesitant discouragement or encouragement of his right hand, then their amorous confusion may well be what is represented in NG 637. It is also appropriate for Chloe to be holding pipes, for she was given a set with special powers.[15]

The story of Daphnis and Chloe was not widely known in modern Europe before Amyot's popular translation into French in 1559 (the Greek was not printed until 1598)[16] and, since Bordone was in France in 1559, it is tempting to see the painting as an immediate response. The incongruously rich clothes argue against this, however, and there is no mention in the narrative of the lovers being crowned by Cupid.

The variant in Dubrovnik was described in the seventeenth century as a painting of Venus and Adonis and is still

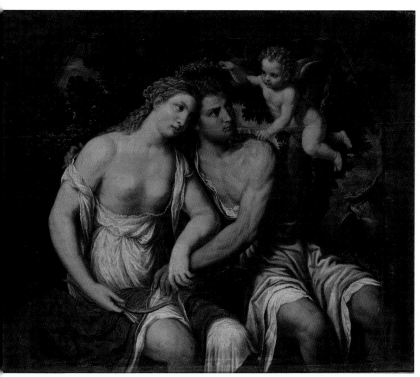

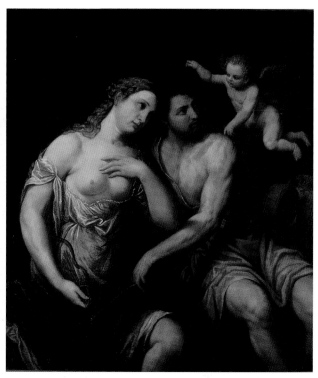

Fig. 2 Paris Bordone, *A Pair of Lovers*, c.1555–60. Oil on canvas, 115 × 131 cm. Vienna, Kunsthistorisches Museum.

Fig. 3 Paris Bordone, *A Pair of Lovers*, c.1555–60. Oil on canvas, 136 × 121 cm. Dubrovnik, Rector's Palace, Cultural Historical Museum.

Fig. 4 Detail of NG 637.

thus described.[17] In this interpretation Venus must be trying to restrain her lover from joining the hunt by removing his bow, yet the man shows no signs of an interest in hunting; the bow is not large enough for him; and it was not Adonis' hunting with a bow that excited Venus' anxiety, but his pursuit of boars and other dangerous prey. If the bow is supposed to be Cupid's, then the painting represents some sort of allegory. If the bow is supposed to be a weapon of the hunt, then the subject of the painting may be Dido and Aeneas who, in Book IV of Virgil's *Aeneid*, seeking refuge from a storm while hunting, consummate their love. This interpretation seems possible, although there is no evidence of a storm. In the inventory of Archduke Leopold William's collection the painting now in the Kunsthistorisches Museum is described as depicting a nymph and her lover,[18] and it seems safer to adopt this more general formula.

Bordone was certainly ingenious at 'repackaging' a basic composition but he also surely lacked the imagination to depict narrative action in a convincing manner. It would be easier to decide which of the three paintings was made first if the way the woman is holding the bow or the pipes carried any conviction. The greater elaboration of NG 637 and the sumptuous idea of featuring two blues in the drapery in addition to the blue of the sky suggest that it may have been the last to be painted.

Provenance

Both of the variants of NG 637 described in the previous section were first recorded in Venetian collections during the seventeenth century.[19] That is the most likely origin also of NG 637. The repetition of the composition suggests that at least two of the three paintings may have been made on speculation.

NG 637 is first recorded in the collection of Edmond Beaucousin in Paris. More about his collection will be found on p. 120. It seems to have been chiefly formed in the 1840s, with many of the paintings bought by C.J. Nieuwenhuys, and often on the London market. Beaucousin clearly had a taste for erotic subjects; he owned, in addition to NG 637, the pair of Schiavones catalogued here: the *Allegory with Venus and Cupid* by Bronzino (NG 651) and Garofalo's *Allegory of Love* (NG 1362). The Beaucousin collection, consisting of 46 pictures, was purchased *en bloc* by Eastlake for the National Gallery on 27 January 1860 for 230,000 francs (£9,205 3s. 1d.),[20] and NG 637 was put on public display on 22 or 23 March 1860.[21]

Framing

There is no record of the frame in which NG 637 was acquired but it seems to have been retained, although 'backed and enlarged', in February 1860 by Critchfield, the National Gallery's framer.[22] Its current frame (fig. 5), which is likely to have been adopted in the 1960s or 1970s, has pierced foliate scrolls of a type made in many parts of Italy during the late seventeenth and eighteenth centuries and especially associated with Bologna.[23] It has clearly been reduced in size by altering the centres of each side.

Earlier examples of such frames are more complex in pattern and more three-dimensional in movement than the relatively flat and linear frame on NG 637. When first introduced, they must have served to unite the paintings with the richly brocaded silks and stamped leather with large florid patterns upon which they were hung. Pierced frames were revived in the nineteenth century and have been a speciality of Italian carvers ever since.

Fig. 5 Corner of the frame of NG 637.

OPPOSITE: Fig. 6 Detail of NG 637.

NOTES

1. Report by Marika Spring of the National Gallery Scientific Department, April 1998.

2. Gould 1959, p. 21.

3. Her typescript is in the dossier for NG 637.

4. [Mariani] Canova 1964, pp. 38–9 and fig. 135.

5. Ibid., p. 114 and fig. 96.

6. Gould 1975, p. 36.

7. There are other instances of this sort of repetition. The right hand of the man in NG 637 with its raised little finger is the same as that of Pluto in Bordone's *Rape of Proserpine* ([Mariani] Canova 1964, p. 120 and fig. 94; sold at Christie's, London, 5 July 1991, lot 2).

8. Mariani Canova 1987, pp. 141–2. However, she had previously dated it as 1545–50 ([Mariani] Canova 1964, p. 10).

9. For arguments in favour of 1559 see Béguin 1987. For the limited interest of Francis I in Venetian art see Cox-Rearick 1996, pp. 89–95.

10. Prijatelj 1987 was the first to propose this. Canova had accepted the Dubrovnik painting only provisionally and had doubted the one in Vienna.

11. Fossaluzza 1987, pp. 194–7, figs 17 and 18.

12. The painting in the Kunsthistorisches Museum now measures 115 × 131 cm but the canvas has been cut down drastically and enlarged again; the painting in Dubrovnik measures 136 × 121 cm.

13. According to Gould 1959, p. 21, note 2 (repeated 1975, p. 36, note 2), who does not give his source.

14. Wornum in his MS Diary (NG 32/67) under 23 March 1860 identified the painting as of Daphnis and Chloe.

15. For the distress of Daphnis at his failure to do what goats and sheep do, see Book III, 14 (Thornley 1935, pp. 150–1). The pipes given to Chloe by the dying Dorco are described at the close of Book I.

16. Thornley 1935, p. xxii. But for an argument that an earlier painting by Titian represents these lovers see Joannides 2001, pp. 199–201.

17. Prijatelj 1987, p. 119, cites documents of 1694 and 1713 in which the Dubrovnik painting is described as 'Adono e Venere'.

18. Berger 1883, p. xciii, no. 126.

19. Prijatelj 1987, p. 119, records the Dubrovnik picture as belonging to Giovanni Alvise Raspi and his brothers. The painting in Vienna came from the Archduke Leopold William, who acquired it from the Duke of Hamilton's collection, whence it came from Bartolomeo della Nave.

20. Robertson 1978, pp. 191–2, 309–11.

21. Wornum MS Diary (NG 32/67).

22. Ibid.

23. There is a notable series of such frames, dated to the early eighteenth century, in the Museo Davia-Bargellini, Bologna. For these see Sabatelli, Zambrano and Colle 1992, pp. 335–40, figs 82–7 (fig. 83 is closest to the one here); also Morazzoni 1953, fig. 47. A pair of paintings by Ubaldo Gandolfi (*Diana and Endymion* and *Perseus and Andromeda*) in Palazzo d'Accursio, Bologna, dating from about 1770, have original pierced and scrolled frames which are somewhat similar to the frame on NG 637.

NG 3122
Christ baptising Saint John Martyr

*c.*1565
Oil on canvas, 63.5 × 70.8 cm

Support
The measurements given above are those of the stretcher. The original canvas is of a fine tabby weave and is lined with paste on to a coarser, open-weave canvas. The tacking holes of the original canvas are visible on all the edges except the upper one, where, however, the presence of cusping indicates that it has not been trimmed to any significant extent. The pine stretcher is old and doubtless Venetian. Adhering to it is an octagonal paper label with a blue border bearing the number 54 in brown ink (characteristic of Layard's collection – see the section on Provenance below).

Materials and Technique
A few pentimenti are visible: the right foot of the angel furthest to the left was originally much lower, and Christ's right heel and his raised hand appear to have been revised. The angel on the right, hovering in the doorway, holds a vermilion-coloured ring from which the keys are suspended. This probably served as an underlayer for another colour (or even for gilding). Behind Christ's right foot there seem to be some letters written in dark brown or black: 'Spiz' seems to be intended.

Conservation
Flaking paint was secured by 'Morrill' in June 1940, and the stretcher was treated for 'woodworm' infestation in 1946. There is no record of any other treatment since the painting came to the National Gallery in 1916.

Condition
The original canvas has been torn in a line to the left of the kneeling saint, and punctured above Christ's head and in his blue cloak. Vestiges of a very dark, deteriorated varnish remain below the present, very yellow, varnish. There are also numerous discoloured retouchings. Christ's blue cloak has probably darkened, and the lake pigment in his robe may have faded.

Attribution and Date
The painting corresponds to one mentioned by Ridolfi in his life of Bordone, as seems first to have been noticed by Hadeln,[1] although the painting had already been recognised as by Bordone. Canova accepts it in her catalogue.[2] The rather feeble drawing, especially of the hands, is characteristic of Bordone's late work such as the *Last Supper* in S. Giovanni in Bragora.[3]

Subject
A young man wearing a rich cloak (its gold threads catching the light) and an ermine cape with three rows of tails kneels on the floor of a prison cell. To his left are wooden stocks and heavy chains with manacles from which he has presumably just been liberated. To his right is the distinctive horned cap of a Venetian doge. Christ stands before him, emptying over his bowed head a cup, apparently of blue and white porcelain. Behind Christ two angels hover, both holding towels, and the further of the two also carrying a ceramic ewer. Another angel, holding keys, appears in the arched entrance on the right. There is a barred arched window behind Christ and what is probably intended as another window to the right of it, which is shuttered. The angle at which the side walls meet the back wall and the recession of the steps is hard to comprehend.

Layard believed the painting to represent 'Christ anointing a doge in prison',[4] and this description was retained by Holmes, among others. Both were aware that anointing is not generally performed in this way but they had presumably concluded that no doge would be in need of baptism. They must also have been surprised by the youthful appearance of the doge. In fact, he is not a doge of Venice but a duke of Alexandria in the third century – Venetians, who took pride in the antiquity of their doge's ceremonial robes, would have had little difficulty imagining them worn in that distant period (Veronese, as noted elsewhere in this catalogue, even gave a triple ermine cape to a Persian queen). Ridolfi recorded two 'piccioli quadretti' in the possession of 'Signora Gradenica Gradenico'– one depicting the marriage of the Virgin and Saint Joseph and the other 'Saint John, Duke of Alexandria, baptised by our Saviour when he was in prison with two angels with towels in their hands' ('San Giovanni Duca di Alessandria nella prigione battezzato dal Salvator e vi sono due Angeli con sciugatoi in mano').[5] This latter must be NG 3122. The relics of Saint John Martyr were translated from Constantinople to S. Daniele in Venice in 1214.[6] Gradenica Gradenico was a nun in the convent of S. Daniele, which doubtless explains her ownership of a painting of Saint John.

The legend of Saint John, a first-century Christian martyr whose original name was Neanias, is adapted from that of Saint Procopius of Caesarea. Neanias, youthful son of Theodosia, ruler of Antioch, was made Duke of Alexandria by the Emperor Diocletian and charged to suppress the Christian community. Converted to Christianity by a vision, he urged his mother to join him in his new faith, but instead she betrayed him to the emperor, at whose command he was tortured and imprisoned. Christ appeared to Neanias in his cell, accompanied by angels, and baptised him, giving him the name of John. He was later martyred.[7]

Provenance
Recorded by Ridolfi in the possession of a patrician nun, Gradenica Gradenico (see previous section). The painting cannot have been made for her; presumably it had been made for another nun in S. Daniele at an earlier date (perhaps one from the same family). Relatively late in his life Sir Henry Layard acquired it from the Venetian dealer Antonio Marcato for 1,000 lire.[8] For Layard's collection see the appendix to Volume I of my catalogue of Italian sixteenth-century paintings.[9] Bequeathed 1894, received 1916.

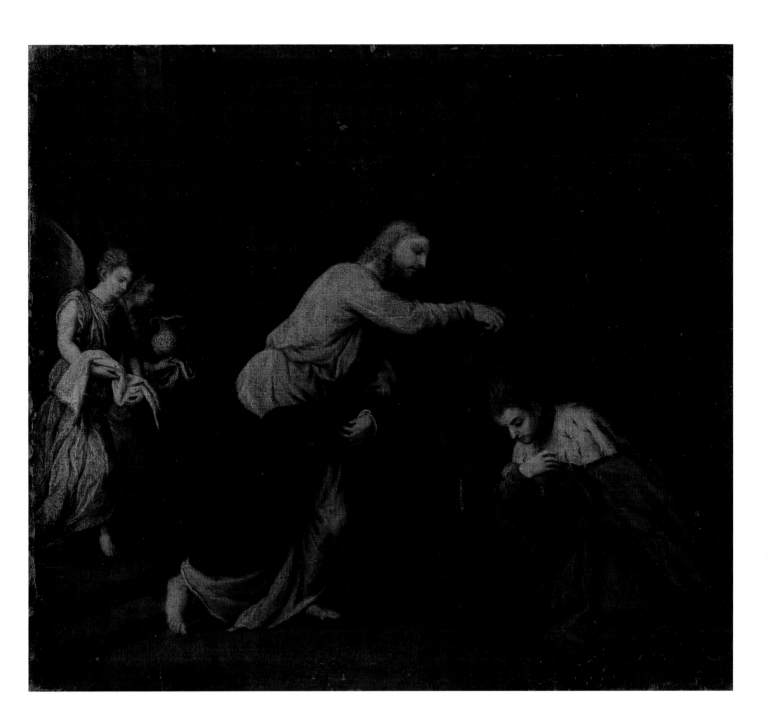

Frame

The painting was reframed between January 1930 and October 1932,[10] presumably with the present frame, which is a modern imitation of a fairly simple type of so-called Sansovino frame popular in Venice in the late sixteenth and early seventeenth centuries.[11] It is of stained oak (which would be unusual in Italy), partially gilded, and the moulding at the sight edge was made as a detachable unit.

NOTES

1. Ridolfi 1914, p. 234, note by editor.

2. [Mariani] Canova 1964, p. 81.

3. Ibid., p. 93 and fig. 151.

4. Layard MS Catalogue, no. 75.

5. Ridolfi 1914, p. 234.

6. Tomaselli 1776, pp. 39–40.

7. Ibid., *passim*.

8. Layard MS Catalogue, no. 75.

9. Penny 2004, pp. 372–80.

10. Annual Report of the National Gallery for 1930–2.

11. For a discussion of this type of frame see Penny 2004, pp. 179–80. For comparable frames see Sabatelli *et al.* 1992, pp. 152–3, no. 32 (Musei Civici, Padua), and p. 332, fig. 37 (Museo Poldi Pezzoli, Milan), also Newbery, Bisacca and Kanter 1990, p. 70, no. 41.

After Paris Bordone

NG 2097
Portrait of a Young Woman

Probably seventeenth century
Oil on canvas, 98 × 75 cm

Support
The measurements given above are those of the stretcher. The original canvas seems to be of a medium-weight tabby weave. It is lined with wax on to a machine-woven canvas of a medium-weight tabby weave. The lining canvas is exposed at the edges, especially at the upper and lower edges, and since some of the original turnover edges survive we can conjecture that the original dimensions were probably about 97 × 74 cm.

Materials and Technique
No technical examination of the painting has been undertaken.

Conservation and Condition
The painting has been severely flattened, and probably damaged by heat, in the process of lining. This operation was almost certainly undertaken before 1870 and perhaps long before. Most of the surface is cracked in a broad pattern but the cracks are smaller in the dark background and in the darker portions of the drapery. The paint surface is worn in the flesh of the woman's left shoulder, in the shadows of the hair, and in the crimson drapery (especially the shadows). There has been some retouching in the darker areas of the background especially, also in the flesh of the woman's left arm, in her forehead, in the drapery, and on her chemise. Her left hand has been partly reconstructed, notably the index finger and thumb. The varnish has also darkened.

Attribution and Date
The painting was attributed to Bordone before its acquisition by the Gallery – apparently by Morelli (as discussed below under Provenance) and certainly in Bailo and Biscaro's monograph of 1900, where the authority of both Berenson and Herbert Cook is cited (although the painting is described as 'alquanto ridipinto').[1] However, it was catalogued as 'School of Bordone' when received in the Gallery in 1906.[2] Gould considered the painting to be by an imitator,[3] and Stella Mary Pearce (Newton) in her analysis of the dress considered it a 'pastiche based on several paintings by Bordone' and that it was probably not executed until after 1730, when the 'absence of a centre parting or emphasis in the hair dressing' would have passed unnoticed.[4] Some of her arguments – for instance that the woman's breasts were 'too far apart, I think, for a Bordone', and that the drapery was hard to explain as a garment and was arranged in a manner suggesting familiarity with hooped skirts – seem dubious, as if devised to support Gould's doubts. Gould, however, and surely correctly, preferred to date the painting in the seventeenth century. He was not aware that there was another version, or versions, probably by Bordone himself (see below), which means that NG 2097 is a copy rather than an imitation. The painting of the gilt ornament on the cushion with its spotty lights reminds us of Bordone's handling and the lady has a very slight flush on her upper chest such as Bordone – and perhaps only Bordone – almost invariably gives his women.

Subject and Meaning
The extent to which the painting, or rather the painting of which it is a copy, is a portrait is debatable but it looks as if it was intended to have an erotic appeal. A carnation together with a sprig (perhaps of thyme) and some white jasmine are tucked into the woman's chemise, and a similar small bouquet which includes a small yellow flower is held in the fingers of her right hand. In some contexts the carnation seems to have been a token of fidelity, hence its popularity in betrothal portraits, and in others it was a religious symbol,[5] but in this case it must be intended to suggest something quite different.

Version
A version of the painting was sold at auction in Lucerne on 29 June 1973 (lot 9, measuring 90 × 67 cm). It looks like a painting by Bordone, especially in the handling of the drapery with its loosely suggestive treatment of a brocaded pattern. The painting sold in Lucerne appears to be identical to one offered for sale by Piero Corsini in New York in 1993, which was published in his catalogue as measuring 90.2 × 68.4 cm but without any provenance and without any mention of the National Gallery's painting. The chief difference is the absence in the Lucerne and Corsini paintings of the necklace in NG 2097.

Provenance
The painting was probably acquired for John Samuel through his friend Hudson on the advice of Giovanni Morelli. It is likely to correspond to the portrait of a woman by Bordone 'per l'amico Hudson' that Morelli mentioned in a letter to Henry Layard written in Bergamo on 20 July 1871.[6] He declared that it was worthy of Layard's collection. Slightly later, however, Morelli qualified his praise. The painting did not really merit 'tous les éloges' ('all the praise') bestowed upon it.[7] John Samuel's collection and Morelli's dubious integrity in his dealings with Hudson are discussed in an appendix in the first volume of my catalogue of Italian sixteenth-century paintings.[8] Samuel's collection was inherited by his nieces, the Misses Cohen, in 1887, and most of it was bequeathed to the National Gallery in 1906, including NG 2097.

Exhibition
London 1894–5, New Gallery (207).[9]

Frame
The painting is currently stored in a gilt slip.

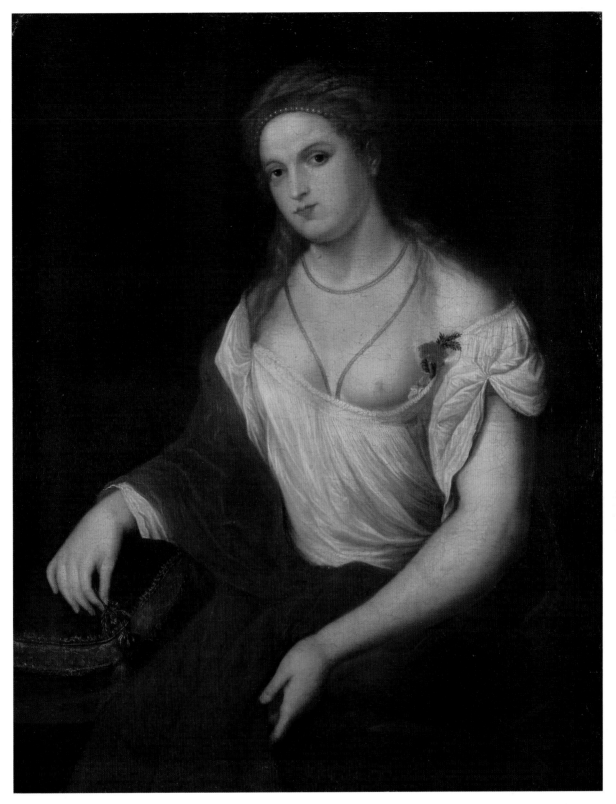

NOTES

1. [Cohen] 1895, p. 23; Bailo and Biscaro 1900, p. 131, no. 43.

2. [Burton] 1913, p. 73 (perhaps reflecting Holroyd's judgement); [Collins Baker] 1929, p. 30.

3. Gould 1959, p. 25, repeated 1975, pp. 39–40.

4. Typescript dated 25 January 1957 in the dossier for NG 2097.

5. See the portrait by Solario (NG 923) and devotional paintings by Raphael (NG 744 and NG 6596) and a follower of the Master of the Saint Ursula Legend (NG 3379).

6. British Library Add.MSS 38963, fol. 113v.

7. Ibid., fol. 118v.

8. Penny 2004, pp. 390–3.

9. *Exhibition of Venetian Art*, p. 39 of catalogue.

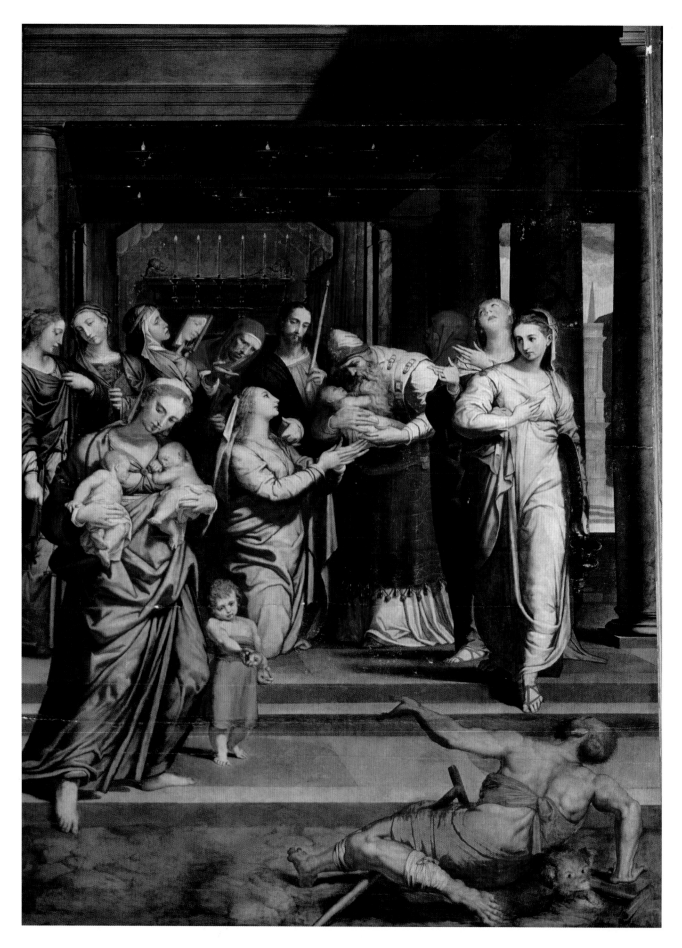

Pedro Campaña (Peeter de Kempeneer)

1503–1580

According to Pacheco, Campaña was born in Brussels in 1503 and worked for a decade in Italy, decorating a triumphal arch in Bologna for the coronation of Charles V as Holy Roman Emperor in 1530.[1] There seems no reason to doubt this, but Palomino's claim that Campaña was a disciple of Raphael and worked in Italy for twenty years, which Pacheco repeats, is highly unlikely.[2] In some reputable art-historical sources it is said that Campaña worked for Cardinal Grimani before leaving Italy.[3] This idea seems to derive from the way NG 1241 was first catalogued by the National Gallery, where it was known that it had a connection with Grimani and assumed that it had been made before the artist went to Spain.

In 1537 'Pedro Campanero flamenco' was paid by the chapter of Seville Cathedral for painting the shutters of the new organ. 'Pedro de Campaña' ('Petrus Campanensis', as he signed some of his paintings) is also recorded in Seville in 1539 and then frequently between 1546 and 1561, when he was much in demand – mostly in Seville (fig. 1) but also in Cordoba and Burgos – as a painter of altarpieces, the majority of which remain there.[4] On 28 May 1563 he succeeded Michel Coxcie as painter and tapestry designer for the city of Brussels and was also given the office of engineer to the Duke of Alba, the governor of the Spanish Netherlands. His death is recorded in 1580 in Brussels.[5] For the purpose of the entry which follows it is important to establish the date when he left Spain. The last reference to his presence there is the contract signed on 7 August 1561 for an altarpiece in the monastery of the Regina Coeli in Seville, so he is unlikely to have departed much before the end of that year. There is also no reason why he should not have travelled back to the Netherlands via Italy. It is possible, but less likely, that he visited Italy later in his life.

There have been several attempts to identify Campaña's early work, but none is entirely convincing and some are certainly mistaken.[6] He was probably a kinsman of Willem de Kempeneer, who directed the weaving of the Brussels tapestries that were sent to the major courts of Europe, and it is reasonable to conjecture that he trained as an artist in the circle of Bernaert van Orley, the leading artist in that city during the 1520s, in whose tapestry designs the inventions of Dürer's prints and of Raphael's cartoons were combined or at least mingled.[7] If this is so, Campaña came from a highly cosmopolitan environment and was trained in an unusually international style.

The signed or documented Spanish altarpieces reveal an artist who was keen to demonstrate his knowledge as a draughtsman: figures tend to be foreshortened, the drapery has deep and complex folds, many faces are tilted, and eloquent long and fine-fingered hands are very conspicuous. Campaña had an interest in extremes of expression. His compositions are often angular and uneasy in the use of pictorial space. Pacheco noted that both his portraits and his depictions of the Passion were admired, and claimed that he was also a sculptor (perhaps meaning that he made designs for sculpture).[8] A few small pictures by him of extraordinary beauty are known (for example fig. 9, p. 74).[9]

The only monograph on the artist is the short one by Angulo Iñiguez in 1951. Its publication perhaps helped to stimulate Longhi's keen interest in Spanish mannerism, reflected in the articles which appeared soon afterwards in *Paragone*.[10]

NOTES TO THE BIOGRAPHY

1. Pacheco 1890, unpaginated; Pacheco 1956, I, p. 248.

2. Palomino 1724, II, p. 369 (1932, IV, p. 27); Pacheco 1956, I, p. 480.

3. For example Thieme-Becker, *Oxford Companion to Western Art*, Macmillan/Grove *Dictionary of Art*.

4. An exception is his *Deposition* in the Museé Fabre, Montpellier, made for the monastery of S. Maria de Gracia in Seville before 1547, one of his earliest surviving documented works. For Burgos see Pérez Sánchez in Banco Bilbao Vizcaya 1995, pp. 86–7, no. 24.

5. Most of the facts as well as some conjectures concerning him are collected in Dacos 1984.

6. Bologna 1953; Sricchia Santoro 1981; Dacos 1984, 1993. The idea that Campaña painted the superb female portrait in the Städel Institute, Frankfurt-am-Main, proposed without argument in Dacos 1993, pp. 146–7, has been widely repeated since, but it bears no resemblance to the portraits in his documented works.

7. Dacos 1987.

8. Pacheco 1890, unpaginated (for sculpture and portraiture); Pacheco 1956, III, p. 190 (for his representation of the Passion).

9. Notably the *Crucifixion* in the Louvre (RF 1986-52) and the *Flagellation* in the National Museum, Warsaw (for which see Dacos 1988 and Griseri 1957, p. 20, fig. 98), a small triptych in a private collection (Griseri 1959, p. 38, fig. 8), the *Deposition* in the Accademia Carrara, Bergamo (Lochis 712; inv. 328), the signed *Adoration of the Shepherds* in Berlin (discussed here in the entry for NG 1241) and the *Crucifixion* signed 'Petrus Kempener' in the National Gallery, Prague (Muller 1966).

10. Bologna 1953; Griseri 1957 and 1959.

Fig. 1 Pedro Campaña, *The Presentation in the Temple*, 1555. Oil on panel. Seville, Cathedral, Capilla del Mariscal.

Pedro Campaña
(after Federico Zuccaro)

NG 1241
The Conversion of Mary Magdalene

*c.*1562
Oil on panel, 29.8 × 58.6 cm

Support
The panel consists of a single piece of pearwood,[1] horizontal in grain and approximately one centimetre thick.[2] It seems not to have been thinned, and it has developed a slight warp and a convex bow. Nails driven into the sides of the panel have caused minor splits. There is a slight ridge on all of the edges with the exception of that on the right. The lower right-hand corner of the panel has been chipped off.

At the right-hand edge of the back of the panel there are vestiges of black stencilled numbers. Also on the back are a fragmentary paper label with the number 25 written in black ink and a brown paper label inscribed in blue ink, 'no II, proprietà di Dr Jean Paul Richter'.

Materials and Technique
The panel was prepared with two preliminary layers, one consisting of lead white, the other of lead white mixed with a little black and yellow earth.[3] The binding medium of the paint is heat-bodied linseed oil.[4]

Ultramarine was used for the sky as well as for some of the draperies, such as the robe of the kneeling man on the left and Martha's cloak. But the artist evidently also favoured the blue obtainable from the cheaper pigment smalt, here used extensively, sometimes mixed with lead white, sometimes under ultramarine (as in Martha's cloak), and sometimes over red lake. In addition, the smalt was sometimes mixed with red lead to form purple.[5] Red lake was also mixed with azurite, and mixed with lead white or glazed over it.[6] Some of this red lake (from the dress of the woman at the extreme right edge) has been shown to derive from the cochineal insect.[7] A green pigment containing copper, probably verdigris, was used, sometimes as a glaze over a mixture of yellow lake, ultramarine, azurite and lead-tin yellow.[8] Changes in these pigments are discussed in the section on Condition.

There appears to be some underdrawing, but it is in a material which is not visible under infrared. However, infrared reflectography does clearly reveal that the majority of the figure composition was carefully reserved. Some of the heads – especially, it seems, the portrait heads – are larger than the areas reserved for them. The head looking out at us at the extreme left is a case in point (see figs 1 and 2); the head of the seated man with a staff is another (see figs 3 and 4), and his head was originally planned to be in profile. All five of the children appear to have been afterthoughts, for they were painted on top of completed areas.[9]

Parallel incised guidelines seem to have been employed; those for the paving are still visible.

Conservation
When acquired by the National Gallery in 1888 the painting was cleaned and varnished by 'Dyer'. Within a year blisters developed and these were repaired by the same restorer. Flaking paint was secured by 'Morrill' in October 1938. 'Lines of flaking' were recorded in 1945, and 'surface cracks' in May 1954. Blisters were laid and losses retouched in December 1961 and the painting was varnished. It was cleaned and restored in 2000. Some residue remains of an old coating which could not be safely removed and this gives a muted effect to some of the colours, especially yellow.

Condition
The surface of the painting is relatively well preserved, although there are thin lines of blistering and flaking along the grain of the wood. There is no evidence of abrasive cleaning.

On the other hand, the colours have changed drastically.[10] Because the red lake has faded, the brilliant rose colour of Christ's robe only survives in the deepest shadows. The lake has also fled from the dress of Martha. The vermilion-red worn by the young man at the extreme left was originally blended with red lake and lead white, but here too the lake has fled, leaving a disturbing contrast.

Because the smalt has both faded and discoloured, Christ's cloak is now a dull grey-brown instead of pale blue. The purple robe worn by the pensive figure in profile standing in front of the third column from the left has turned brown, and the darker purple cloak worn by the man seated in the front left corner has turned dark grey.

Because the copper greens have darkened, the striped fabric of the baldacchino resembles zebra skin, and the green disks in the paving are no longer clearly recognisable as 'serpentine' (as ancient Greek green porphyry was then known). The deep green cloaks of the seated figure with a staff and another figure to the right of the opening, below Martha's pointing arm, are now a dark chestnut brown.

Subject
Christ is shown, seated on a dais, preaching in the temple in Jerusalem. Suspended above him is a large baldacchino. As would usually have been the case at the delivery of a sermon in Italy during the sixteenth century, the congregation is segregated; in this case all the females are gathered in the foreground to the right. Among them is Mary Magdalene on her knees, with head turned towards Christ in adoration and hands outspread in acceptance. There is no mention in the Gospels of Mary being converted by Christ's preaching, but this episode would have been familiar to an Italian public from popular pious literature and from performances staged by confraternities, such as the 'Conversion of Mary', an anonymous *Sacra Rappresentazione* frequently printed in Florence in the second half of the sixteenth century that 'rises to a higher level of dramatic art than any sacred play in English'.[11] In this play Martha, having been cured by Christ, urges her sister to attend his preaching. Mary is not inclined to do so but she agrees when she hears her friend Marcella expand on the beauty of Christ's eyes. Upon hearing Christ's

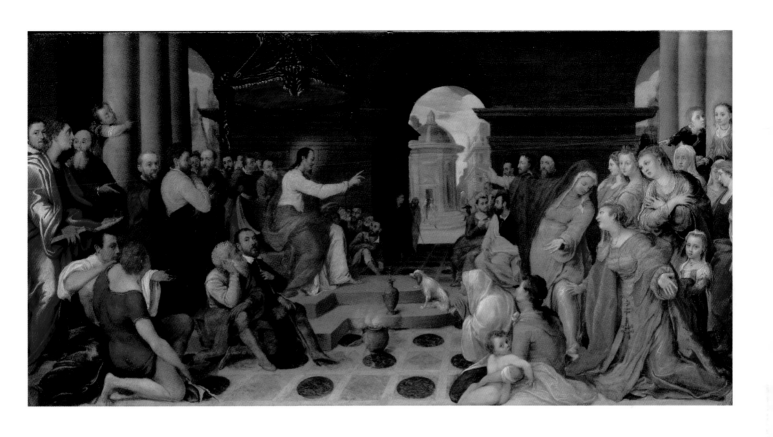

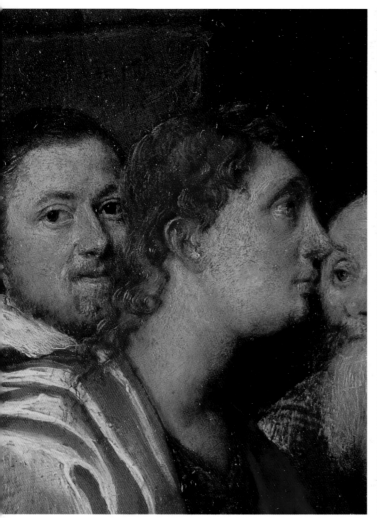

Fig. 1 Enlarged detail of NG 1241 showing heads at left edge.

Fig. 2 Infrared reflectogram detail of the same area.

words she weeps and her heart is melted. Soon after returning home with Martha, she goes to the house of the Pharisee and anoints Christ's feet. The woman in the painting who, turning towards Mary, points at Christ must be Martha (although she has been taken for the Virgin Mary, whom she does resemble in dress). The woman standing behind Mary Magdalene, also obviously smitten with remorse, may be Marcella: she is too luxuriously attired to be Martha.

The subject was unusual in painting but not unprecedented. The predella for an altarpiece dedicated to Mary Magdalene includes this as the first of five key episodes in her life.[12] The Grimani Chapel dedicated to Mary Magdalene in S. Francesco della Vigna in Venice included two large lateral frescoes painted by Federico Zuccaro, one of the Raising of Lazarus (brother of Mary and Martha) and one of this subject, which was indeed (as discussed below) the inspiration for NG 1241.

Setting and Accessories

The wall is perhaps intended to enclose a courtyard of the temple but is as massive as that of a fortified city, and it is

curious that the arched openings in it seem not to be gated. The three tightly grouped columns to either side of the composition have no purpose that can easily be imagined. Presumably they are raised on pedestals on which the children are standing.

Besides the dais and the baldacchino the only furnishings in the temple are a bronze urn wrapped with a light tissue and, behind it, on the first step of the dais, another urn, of silver, with a more elegant shape and a fine neck. These must be for incense, the smoke of which rises from the first and sparks of which fly from the second, but their prominence is puzzling.

Two obelisks crowned with gilded spheres can be seen through the arch on the left. A *tempietto* raised on steps and articulated with pilasters, its ribbed dome clad with green ceramic tiles in a fish-scale pattern, can be seen through the central opening. To its right there is a palace with a balustrade above the cornice.

The vanishing point is high. It coincides with the top of Martha's index finger – that is, to the right of the central opening, which itself is to the right of the centre of the painting.

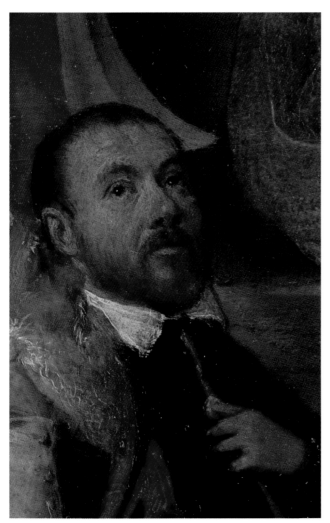

Fig. 3 Enlarged detail of NG 1241 showing head of man seated on steps.

Fig. 4 Infrared reflectogram detail of the same area.

Source

The composition is derived from a fresco painted by Federico Zuccaro in the Grimani Chapel in S. Francesco della Vigna, Venice, or at least from a preparatory drawing made for that work. Zuccaro was in his early twenties and had recently received important commissions from Pope Pius IV in Rome when, in 1562 or 1563, he was summoned to Venice by Giovanni Grimani, presumably to replace his protégé Battista Franco, who had died in 1561.

Zuccaro helped to decorate the staircase of Grimani's new palace at S. Maria Formosa and also made for Grimani's chapel in S. Francesco two narrative paintings on the side walls, and then the altarpiece, the *Adoration of the Kings*, which is dated 1564, thus completing a decorative scheme that Battista Franco had commenced with his frescoes on the ceiling. Despite the admiration elicited by these works and by stage sets painted for Palladio's theatre, and despite ambitious plans for a mural in the Doge's Palace, Zuccaro left Venice in 1565 for Florence, and returned to Rome soon thereafter to complete work begun by his elder brother Taddeo, who died in 1566.[13]

Zuccaro's frescoes of the *Conversion of the Magdalen* and the *Raising of Lazarus* in the Grimani Chapel were severely affected by damp, and the former had been completely lost by the early eighteenth century. Its composition seems to have been recorded in a drawing by Zuccaro, now in the Uffizi (fig. 5).[14] This differs from the Gallery's painting in that Christ is seated in the centre facing out rather than in profile, but there are similarities in the setting, with its clustered column shafts and arched openings, and seven of the female figures have more or less the same pose as figures in NG 1241. There are few similarities between the left side of Zuccaro's composition and that of NG 1241, but the prominent male figure kneeling on his right leg is found in both. There is good evidence that Zuccaro had earlier devised a composition in which Christ was preaching in profile, but he seems to have abandoned it, perhaps because it resembled too closely the composition of the *Raising of Lazarus* intended for the wall opposite.[15] The artist of NG 1241 may have taken such an earlier compositional drawing as his starting point. It is easy to believe that a drawing presented to Giovanni Grimani was then passed by Grimani to Campaña. In any case, Grimani

seems to have commissioned NG 1241 and it was surely his idea to include numerous additional figures, many of them portraits.

It must always have been obvious that many portraits are included in this painting (figs 6–8). John Young described it in 1822 as 'a curious picture, in which are introduced portraits of Sulimein the Magnificent, Francis I, Charles V, Cardinal Bembo, Titian, Giorgione, Bellini, Henry VIII and Anne Boleyn and Queen Elizabeth when a little girl.'[16] We would presume that most of the figures are members of the Grimani family, in accordance with the convention which became popular in Venice in the 1560s for including a large number of family members as witnesses in religious narratives (see pp. 228–9).[17] This fashion was surely influenced by older conventions of including portraits of officials in narratives commissioned for confraternities. After the Council of Trent the new standards of didactic clarity and decorum promoted by the Roman Church made the combination (or confusion) of family commemoration with sacred narrative less popular in paintings made for churches. However, the impulse remained, and it found an outlet in another type of picture.

Giovanni Grimani, Patriarch of Aquileia: His Collection and His Will

In a will dated 29 August 1592, apparently drawn up in his own frail hand, Giovanni Grimani, Patriarch of Aquileia, then 87 years old and anticipating his death (which took place on 3 October in the following year), expressed the wish that he be buried in his own vault in the family chapel which he had built in S. Francesco della Vigna ('nella capella Grimani fabricato da me nello mio proprio Deposito'), there to await, in the company of his forebears, the blessed voice of God ('la benedetto voce di Dio').[18] Giovanni's brother Marco, an admiral of the papal navy, and diplomat, had died in 1544. Another brother, Marino, who had been created cardinal in 1527, had died in 1546, and a third, Vettore, a procurator of S. Marco and a keen patron of architecture and sponsor of S. Francesco della Vigna, had died in 1558. These brothers had all been involved in projects for monuments to Doge Antonio Grimani (their grandfather) and Cardinal Domenico (their uncle) and had begun to make plans as early as the 1540s to create a family tomb on the inside façade wall of S. Francesco. Giovanni took over this idea, commissioning a new façade from Palladio, but the tombs erected on its inside wall were temporary structures and it is striking that they are not mentioned in his will. It seems likely that Giovanni's relations with his brothers had not been entirely harmonious.[19]

Giovanni's will included numerous charitable donations to the poor of his parish and to religious institutions throughout Venice. After listing legacies for his servants, he remembered the sculptor Tiziano Aspetti ('Titian Pittore Scultore') and 'Uberto fiandrese pittore', leaving the sum of a hundred ducats to each of them. They were defined as friends, retainers and members of his household ('domestici amici et servitori'). Aspetti had made the colossal bronze statues for the façade of S. Francesco and was engaged on another, smaller, pair for the Grimani Chapel (a codicil of 28 November 1592

Fig. 5 Federico Zuccaro, *The Conversion of the Magdalen*, 1563. Pen with brown ink on paper, 41.8 × 70.2 cm. Florence, Galleria degli Uffizi.

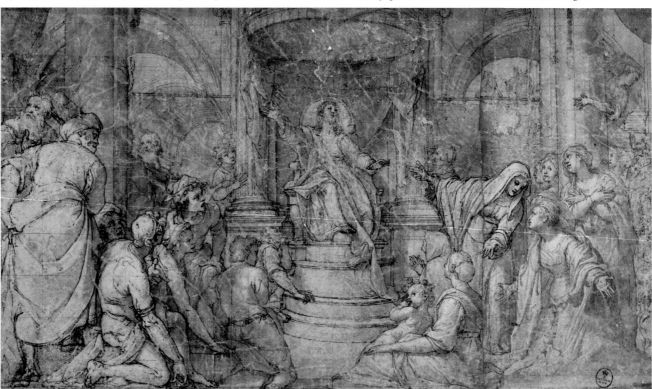

Figs 6, 7, 8 Enlarged details of NG 1241.

obliges Aspetti to complete these). Uberto is discussed below (under 'Attribution').

The great palace that Giovanni Grimani had built near S. Maria Formosa[20] was bequeathed to his nephew Antonio (a son of Vettore) and to the grandsons of Vincenzo, another son of Vettore, ordaining that it should thereafter descend by primogeniture within the family and never be divided up or sold off. The furnishings he realised would be sold; the paintings hanging in the palace he wished to be considered as fixtures; the antique sculpture, although evidently carefully arranged in the palace, he left to the 'Patria' to join the sculpture that his own uncle, Cardinal Domenico Grimani, had bequeathed to the Venetian state in 1523. His intentions were well known and the *antisala* of the great new library was already being modified at Grimani's expense by the architect Scamozzi to serve as a sculpture gallery.[21] He also left to his beloved 'Patria' his pax of gold and mother of pearl encrusted with jewels (which remains to this day in the Treasury of S. Marco),[22] his ebony cabinet 'fitted with cameos and small antique bronzes' with its sixteen columns of the finest alabaster, crowned with silver gilt capitals (which has disappeared),[23] and the famous illuminated breviary which his uncle had intended to bequeath to the Venetian State (since the fall of the Republic, the breviary has been in the Marciana Library).[24]

Giovanni confessed in his will that he must have offended heaven by spending money that could have been put to charitable use on 'medaglie' (of gold, silver and 'metallo') and on cameos and intaglios, ancient and modern. These he wished to be sold, except the pieces placed upon or fitted within his ebony cabinet, many of which had previously belonged to his

brother Cardinal Marino. In the event of any member of his family actually wanting to acquire the cabinet, he made it possible for them to buy it below its market value from the procurators of S. Marco. Grimani must have known of the elaborate arrangements made by Gabriel Vendramin to keep his art collection together in the care of future generations of his family, and his own provisions were more realistic – and more pessimistic. Indeed such pessimism had been the precondition for the munificent donation to his 'Patria'.[25]

Excluded from the paintings to be considered as fixtures in the palace, and distinct from the pax and the ebony cabinet and the antiques destined for the library of S. Marco or the care of the procurators, were three small pictures that Grimani bequeathed to friends. To Alvise Venier as a token of his love ('in segno di Amore') he bequeathed his 'picture of the Adoration of the Kings by Peter the Fleming based on the altarpiece in the chapel in S. Francesco della Vigna' ('il mio quadro dei tre Magi fatto per mano di Pietro fiandra secondo la historia della palla della capella di San Francesco della Vigna'). He noted that the picture was small and was framed ('legato' – literally, 'bound') in ebony. Also 'in segno di amore' he left to Commendator Rimonder his picture of the 'Judgement' ('il Giuditio'), meaning, presumably, the Last Judgement, by the hand of 'Uberto di Fiandra, mio pittore', following the drawing by 'Ferigo Zuccaro', also small and 'legato in hebbano'. Lastly, he left to 'Signor Commendatore Lippomani', again 'in segno di amore', another little picture framed in ebony and painted by Peter the Fleming, this one showing Christ seated, and preaching to the people and to the Magdalen ('il quadreto legato in hebbano dipinto per mano di Pietro di fiandra: la historia e, Iesu Christo che siede, et

predica al populo, et alla Madalena'). It is likely that this last-mentioned picture was NG 1241, which was known in the late eighteenth century to have been a bequest of Giovanni Grimani.

All three of these small paintings had been made after designs by Federico Zuccaro, although in the case of the third this is not specified. The idea that Zuccaro's drawings were used for the *Conversion of the Magdalen* receives support both from the fact that the fresco in the chapel is not mentioned (although in the case of the first painting the altarpiece there is cited) and from the fact that a drawing by Zuccaro is specified by Grimani as the source of the Judgement. However, in the latter case it may be that a drawing had been used because no painting had actually been completed.[26]

It seems reasonable to deduce that these paintings had all been commissioned by Grimani and, if so, then it would be interesting to know how he came to have the idea of having miniature versions made of monumental paintings or projected paintings. He was perhaps aware of one of the most notable precedents, the small versions that Vasari had made of his *Immaculate Conception* altarpiece,[27] and he certainly knew that some of Giulio Clovio's miniatures which had

been commissioned by his brother also belonged to this category.[28] A parallel of a sort is also provided by the way some of Grimani's gems were reproduced – although larger rather than smaller – in the stucco decoration of his palace.[29]

Attribution and Date

As noted above, the small painting of Christ 'preaching to the people and to the Magdalen' mentioned by Grimani in his will is said to be by Peter the Fleming ('Pietro di Fiandra'). At the end of the eighteenth century, in his great history of Italian art, Luigi Lanzi wrote that the Patriarch Grimani had invited Campaña to Venice, where he painted various portraits and the 'famous painting of Magdalene led by Saint Martha to the Temple to hear Christ preach'.[30] Lanzi knew that this painting had been left by Grimani to a friend and had passed in his day into Thomas Moore Slade's collection. Since it is unlikely that Lanzi had read Grimani's will, we must suppose that he had derived this information from another source, such as an inscription on the back of a frame or an old manuscript catalogue. Lanzi seems to have known other small paintings by the same artist and even mentions that these were highly prized by English collectors.

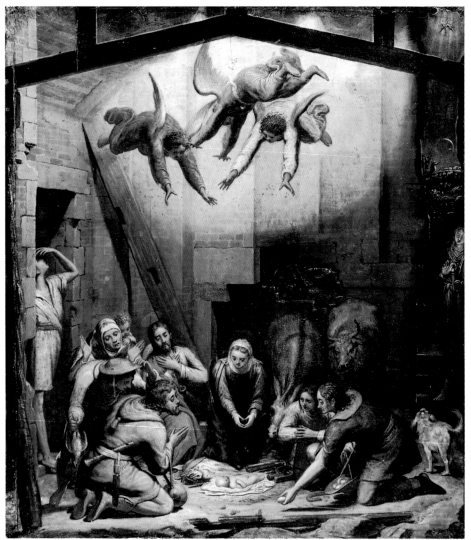

Fig. 9 Pedro Campaña,
Adoration of the Shepherds, 1550s?.
Oil on oak, 27 × 22.5 cm.
Berlin, Staatliche Museen zu Berlin
– Preußischer Kulturbesitz,
Gemäldegalerie.

OPPOSITE:
Fig. 10 After Campaña, labelled
Luca Longhi, *Christ preaching before
the Magdalen*, c.1600, copy of NG 1241.
Oil on poplar, 30 × 58 cm.
Rome, Galleria Borghese.

Shortly after the painting's acquisition by the Gallery, Frederic Burton catalogued NG 1241 as by Pedro Campaña. Campaña's work in Spain was by then well known, and indeed visitors to Seville were instructed to admire the *Descent from the Cross*, originally made for the church of Santa Cruz but by then in the cathedral, a work made famous by the veneration that Murillo was said to have expressed for it; moreover, in the 1880s it was exciting international scholarly attention.[31] Burton supposed that Campaña had travelled to Venice shortly after his work for the emperor's coronation in Bologna in 1530. But that is impossible as the date of NG 1241, on account both of the style of dress in the painting and the connection with Federico Zuccaro (of which Burton had no knowledge). Campaña is said to have returned to Brussels in the year 1563 and, if so, then he may have made the paintings for Grimani earlier in the same year, or just possibly in the previous year, because Zuccaro's fresco painting dated from 1563, and his preparatory drawings are unlikely to date from earlier than 1562. It is also possible that Campaña travelled to Venice at a later date.

The National Gallery dropped the attribution to Campaña in the 1940s. Neil Maclaren, in a draft entry for the catalogue

our expectations of a resemblance to other works by Campaña. There is some resemblance in the handling, in the treatment of light on drapery, and above all in the drawing of the hands, to the exquisite *Adoration of the Shepherds* painted on an oak panel 27 cm high in the Gemäldegalerie, Berlin, which is signed PETRUS CAMPANI (fig. 9).[35] Christ's face in NG 1241 can be compared to that of the youthful Saint Joseph in the *Presentation* of 1555 in the Capilla del Mariscal in Seville Cathedral, and Martha's hands are similar to those of the women in the right-hand side of that picture (fig. 1, p. 66).[36]

Those who do not consider these similarities to be adequate for an attribution to Campaña must suppose that Lanzi or Lanzi's source had no good reason to identify Campaña as Peter the Fleming but had merely looked for a Flemish artist of the right date called Peter and had found Campaña. This is not impossible and Bert Meijer in a recent article on Pieter Cornelisz. van Rijk proposed that this artist was the Pietro mentioned in Grimani's will.[37] What makes this theory highly tempting is the fact that Van Rijk travelled to Italy with Huybrecht Jacobsz., who is almost certainly the 'Uberto di Fiandra mio pittore' who painted one of the three copies

of Spanish paintings in the National Gallery, declared that NG 1241 'bears no resemblance to authentic works by Campaña and was probably painted in Italy by an eclectic Flemish artist of the late XVI century'. This opinion was shared by Cecil Gould.[32]

The connection with Zuccaro's drawing was made by Philip Pouncey in 1955,[33] and the connection with the copies mentioned in Grimani's will was recognised (or re-recognised, given that Lanzi knew of it) by Mantovanelli Stefani in 1990.[34] The avowedly derivative character of NG 1241 must modify

mentioned in Grimani's will. However, I can see no resemblance between NG 1241 and any painting or drawing securely attributed to Van Rijk.

Version
A copy of NG 1241 painted on a poplar panel measuring 30 × 58 cm (fig. 10) is in the Borghese collection (currently on deposit). It came from the Aldobrandini collection and it may have been attributed to Federico Zuccaro when he was still alive. 'No 440 Federico Zucaro' is painted in large black

letters on the back of the panel, which is described as 'un quadro bislongo in tavola con Christo quando predicava nel Tempio alla Maddalena, di Federico Zuccaro, con cornice di ebano' at the division in 1682 of Olimpia Aldobrandini's property between the Borghese and the Pamphilj families.[38] The attribution seems not to have been challenged until Giovanni Morelli, recognising the relationship to the Campaña that his protégé Richter had sold to the National Gallery, suggested that it was a copy by a Venetian artist of the school of Veronese.[39] Adolfo Venturi suggested that this artist was Carletto Caliari.[40] Longhi considered it to be the work of a 'Manierista Venezianeggiante' of about 1570–90.[41] Paola della Pergola proposed Luca Longhi,[42] under whose name it is still catalogued.

The Borghese painting retains the colours which have faded or darkened in NG 1241, and some details of the framework of the baldacchino and of the vases, which may have been abraded in the latter. As described above under Materials and Technique, there are a number of alterations and afterthoughts in NG 1241 – heads which have been moved and children added – all of which are reproduced in the Borghese version, so there can be no doubt that the latter derives from NG 1241. However, the artist of the Borghese version did make minor changes: a third vase is placed on the cornice to the right of the picture; there is a hand in front of the male profile head which is directly behind Martha's wrist; the fabric of the baldacchino is not striped. The picture seems likely to have been painted around 1600, perhaps by one of the artists in Venice known to have been employed to make copies.[43]

Provenance

Almost certainly painted for Giovanni Grimani, Patriarch of Aquileia, and bequeathed by him in 1593 to the Commendatore Lippomani. By about 1775 in the collection of Count Vitturi, Venice, by whom sold to Thomas Moore Slade. Purchased from Slade by Richard Hart Davis, by whom sold to Philip Miles of Leigh Court (for which collection see Appendix below). Catalogued as by Campaña and hung in the Withdrawing Room at Leigh Court, near Bristol.[44] Sold on 28 June 1884 at Christie's (lot 8) for 190 guineas (£199 10s.), where bought by Richter. He was acting, according to *The Times*, for the Berlin museum, but it seems to have been a false rumour (or perhaps there was a misunderstanding with Berlin, or indeed perhaps Bode was disappointed by the work when he saw it). The painting was, judging from a label on the back of the panel, exported to Italy before being sold to the National Gallery in 1888.

Frame

The current frame, a complex moulding of ebonised wood, with some gilded lines and eight turned, gilded wooden studs in the flat, was made for the painting in 2000. It replaced a gilded cassetta frame with a scrolling vine engraved on the flat, which must have been made for it on acquisition, presumably by the Gallery's framemaker at that date, R. Dolman and Son.

Appendix

PHILIP JOHN MILES

William Miles, elected Mayor of Bristol in 1780, made a great fortune in the 'Atlantic trade', owning slave ships, sugar refineries and Jamaican plantations.[45] His son Philip John Miles, who was active in the family's bank (founded with Thomas Goldney in 1752) and the heir to much of his father's wealth, bought the estate of Leigh Court in 1811 and on 13 May 1814 signed a contract with Thomas Hopper to build a new house there within four years at a cost of £1,000.[46] The house (which survives, a Grade 2 listed building, two miles north of the Clifton Suspension Bridge beside the A369) has a plain Greek Revival exterior of Bath stone, a rigidly symmetrical plan and exceptionally lavish plaster ornament.[47] To furnish it Miles purchased a large part of the collection formed by his business partner Richard Hart Davis (sometimes spelled Davies) (1766–1842), MP for Bristol and a noted speculator in pictures and other commodities whose expensive style of living was considered unusual among Bristol's austere merchant class.[48] The transaction took place before October 1816 and very likely in May 1814.[49] Celebrated and notoriously expensive pictures were included, among them the two 'Altieri Claudes', sold by Beckford for £10,000, and Rubens's *Conversion of Saul*, sold by Delahante for £4,000.[50] Important additions were made in the following decade, of luxury furniture[51] as well as pictures. Even after 1822, when a catalogue of etchings of the latter and notes on them by John Young, keeper of the British Institution, was published, some acquisitions were made.

As is clear from Young's catalogue, from watercolours of the interiors, and from Waagen's accounts of his visits in 1835 and 1851, the paintings were hung without regard for date or school, throughout several of the reception rooms, in extravagant frames of the kind that are best preserved in the Dulwich Picture Gallery.[52] Public access seems to have been possible on Thursdays for those who had obtained a ticket from the family bank in Queen Square, Bristol. Miles died in 1845, his son (Sir William, created a baronet in 1859) died in 1878, and his grandson (Sir Philip John, 2nd Baronet) obtained permission to break the entail and consigned the collection to Christie's on 28 June 1884.[53] The house was sold after the death of the 4th Baronet in 1915 and, having long served as an asylum and hospital, was adapted as a conference centre. The National Gallery acquired five paintings at the sale: Gaspard Dughet's *Landscape with Elijah and the Angel* (NG 1159), two Hogarths (*The Shrimp Girl*, NG 1162, and *Miss Fenton as 'Polly Peachum'*, now in Tate Britain), Thomas Stothard's once celebrated *Canterbury Pilgrims*, and Giorgione's *Adoration of the Kings* (NG 1160), then catalogued as by Bellini. Raphael's predella panel of *The Procession to Calvary* (NG 2919), also in this sale, came to the National Gallery in 1913.

NOTES

1. First identified by B.J. Rendle of the Forest Products Research Laboratory (letter of 20 September 1945) and reconfirmed by the Scientific Department of the National Gallery in 2001.

2. 1.1 cm is the maximum thickness.

3. Spring, Penny, White and Wyld 2001, p. 56, captions c and d.

4. Ibid., p. 64, note 24.

5. Ibid., pp. 57–8.

6. Ibid., p. 58.

7. Ibid., pp. 58 and 62, note 19.

8. Ibid., pp. 58–9 and p. 56, caption c.

9. Typescript report made by Rachel Billinge, 6 February 2001.

10. Spring, Penny, White and Wyld 2001 reviews the possible causes of these changes and attempts to reconstruct the intended appearance.

11. D'Ancona 1872, I, pp. 255–302 (pp. 272–7 for the actual preaching); Symonds 1900, I, pp. 289–94, for a paraphrase and translations of extracts (p. 289 for his estimate of its merits). D'Ancona, p. 255, lists the numerous editions.

12. Philadelphia Museum of Art, Johnson Collection, nos 44–7. By Botticelli. Berenson 1913, I, pp. 27–9, fig. 252; Lightbown 1978, II, pp. 77–8, B63.

13. For Zuccaro in Venice see Rearick 1959, pp. 122–3. But it should be noted that his arrival in Venice in 1562 is sometimes stated as a fact (compare the text on Rearick 1959, p. 129, with note 96 in the same article). For a good brief account of Zuccaro's career see the entry by Liana de Girolami Cheney in volume 33 of the Macmillan/Grove *Dictionary of Art*.

14. For a complete history of the restoration of the chapel see Rearick 1959, pp. 137–8. For the drawing see Gere 1966, p. 36, no. 47, fig. 34. The composition was engraved in reverse by Aliprando Caprioli. Additional drawings for the composition (some perhaps copies after Zuccaro's work) are in a private collection in the UK (a drawing for the right side, perhaps retouched by Rubens); in the Royal Institution of Cornwall, Truro; in the Castello Sforzesco, Milan (942/6971); in the Louvre, Paris (inv. 11758); in the Pierpont Morgan Library, New York (1974.24); in the Kupferstichkabinett, Munich (inv. 88); and in Yale University Art Gallery (no. 27B). See also Mundy 1989, pp. 173–7, for the Yale and Pierpont Morgan drawings.

15. Gere 1966, p. 36, where a drawing in the Herbert List Collection is cited. This was sold at Christie's, London, on 5 July 1988, lot 37a (not illustrated). In it Christ is facing right. An even earlier idea may have been to show Christ facing left (see Sotheby's, London, 23 March 1978, lot 36).

16. Young 1822, p. 16, no. 29.

17. One of the men would seem to be based on the portrait by Licinio of Ottavio Grimani dated 1541 (Vienna, Kunsthistorisches Museum, Inv. 1567).

18. ASV, Notarili testamenti, Busta 658, no. 396 (Vettor Maffei). Carol Plazzotta transcribed most of this fascinating document for the National Gallery. Michel Hochmann 1992, pp. 233–41, has provided the fullest and most perceptive account of Giovanni Grimani as patron and collector. His tomb slab is in the centre of the chapel's paving (Rearick 1959, pp. 137–8, note 124).

19. For Marino and Vettore see Hochmann 1992, pp. 233–41. Unlike his brother Marino, and uncle Domenico, Giovanni was not, to his chagrin, created a cardinal, although he is very often described as such – see, for example, Rearick 1959, p. 122 and elsewhere. For S. Francesco della Vigna see Foscari and Tafuri 1983; also Lewis 2000, pp. 242–3, which provides the fullest account of the tomb projects of the Grimani.

20. For this palace see Perry 1981 and Bassi 1978, pp. 228–35.

21. For Domenico's collection see Pio Pachini 1942 and Perry 1978; for Giovanni's antiquities see Pittoni 1903. For the bequest generally see Gallo 1952.

22. Gallo 1952, p. 50.

23. Ibid., pp. 50–1.

24. Ibid., pp. 42–9.

25. This may also have been the case with his uncle, Cardinal Domenico, whose will was disputed by his family – ibid., pp. 37–9.

26. The drawing may have been for a fresco in the Doge's Palace, a commission discussed by Voss (1954), but other possibilities are discussed by Mantovanelli Stefani 1990, pp. 40–2, and Meiger 1999, p. 150, note 17.

27. Corti 1989, pp. 36–7, no. 20. Ballarin 1967, p. 88, makes a good case for the widespread knowledge of this composition.

28. A notable example is the *Conversion of Saint Paul* in Clovio's illuminated commentary on Paul's epistle of c.1537–8, now in the John Soane Museum (vol. 143, MS 11). Cardinal Domenico Grimani had owned the cartoon by Raphael upon which this design was based.

29. For the decoration generally see Perry 1981; for the copies of gems see Perry 1993.

30. Lanzi 1795, I, p. 319.

31. [Burton] 1889, pp. 72–3. For a typical reaction to the *Descent* see Gower (1883, II, p. 315), who considered that 'although hard in colour and angular in drawing' it was a 'powerful work' and one of the two best things in the cathedral sacristy. See especially Dacos 1980, *passim*, and Dacos 1984, pp. 98–9, for the artist's reputation. The *Descent* was copied by Constantin Meunier in 1882, as an official commission, and the interest taken by Justi in the same period is also significant (Justi 1884).

32. McClaren 1970, p. 144; Gould 1975, pp. 333–5.

33. In an addendum to Della Pergola's article on the copy in the Villa Borghese (Della Pergola 1954), published in *Bollettino d'Arte* (XL, 1955, pp. 83–4).

34. Mantovanelli Stefani 1990, pp. 40–2.

35. Inv. no. 1957.

36. Angulo Iñiguez 1951, plates 8–13.

37. Meijer 1999, pp. 138–41.

38. Quoted by Della Pergola 1955, p. 54.

39. [Morelli] 1890–3, I, 1890, p. 317; Morelli 1897, pp. 248–9; Morelli 1991, p. 256.

40. Venturi 1893, p. 103.

41. Longhi 1928, p. 192.

42. Della Pergola 1954, pp. 135–6; 1955, pp. 54–5.

43. Hochmann 1992, pp. 89–90.

44. Young 1822, p. 16, no. 29.

45. Morgan 1993, p. 37 (as shipowner and sugar merchant), p. 149 (as guarantor of slave cargoes), p. 183 (for residence in Caribbean), p. 186 (for great wealth), pp. 189, 191 and figs 7.5 and 7.7 on pp. 194 and 197 (for pre-eminence as importer, chiefly from Jamaica).

46. Bristol Record Office MS 12151 (33). Dr Joe Bettey kindly sent me a photocopy of this document.

47. Cooke 1957, pp. 155–8, illustrates some of the interiors. See also Thornton 1984, fig. 361. One of the rooms was entirely redecorated in a revival of the Adam style, presumably c.1890. Cooke wrongly supposed that this was original.

48. Farington 1978–98, XII, 1983, p. 4279 (7 January 1813); see also X, 1982, p. 3676 (27 June 1810).

49. Ibid., XIV, 1984, p. 4906 (entry for 8 October 1816 mentioning that the sale has taken place). It may be significant that Hart Davis sold 42 Dutch and Flemish pictures at auction on 1 June 1814 – those he sold to Miles were mostly Italian.

50. Redford 1888, I, pp. 361–3. The Rubens is in the Gemäldegalerie, Berlin. For the Claudes see also Farington 1978–98, IX, 1982, p. 3675.

51. For example a magnificent round table of *breccia verde* supported by gilt dolphins, formerly at Fonthill and perhaps Malmaison, which is now in the entrance hall at Wrotham Park. Francis Byng of Wrotham, 1st Earl of Stafford, married Florence, daughter of Sir William Miles, so the families were connected.

52. Thornton 1984, fig. 361, publishes one of the watercolours. For Waagen's 1835 visit see Waagen 1839, III, pp. 134–47, and for his 1851 visit see ibid. 1854, III, p. 185.

53. For an outline of the family see Cooke 1957. For the sale see Redford 1888, I, pp. 361–3. Redford (p. 363) notes that several pictures were sold separately in 1883. A number of works were also bought in, including for example the version of Titian's *Venus and Adonis* illustrated on p. 281 (fig. 5) here.

Paolo Fiammingo

active by 1573, d. 1596

Fig. 1
Paolo Fiammingo,
*Landscape with Diana
Hunting, c.*1590. Oil
on canvas, 98 × 87 cm.
Nancy, Musée des
Beaux-Arts.

Paolo Franceschi (or dei Franceschi) Fiammingo (Fiammingo is the Italian for Fleming), who signed one of his paintings 'Paulus Fransischi', was born in Antwerp and was active as a painter by 1573. During the 1580s and early 1590s he enjoyed considerable success in Venice with gallery pictures in which landscape played an increasingly important part. Between 1584 and 1596 he was enrolled in the Venetian painters' guild.[1] On 16 December 1596 he made a will in Venice; he died there four days later.[2] He was, presumably,

the Pauwels Franck recorded in 1561 as a master in the guild of Saint Luke in Antwerp.[3] If he was aged 50 when he died, as noted in the parish records, he would not have been old enough to qualify for this distinction in 1561, but if he died at the age of 56, as Ridolfi claimed (in 1648),[4] then he would have been.

Gaspare Osello Padavano inscribed an engraving of the penitent Magdalen reclining in a landscape as an invention of 'Paulus Francisci A(n)twerpis'. This print, made in Venice

in 1573, is the first evidence of Paolo's activity as an artist,[5] but no painting or drawing for it has been traced. There is no other evidence that Paolo was working in the Veneto in the 1570s. It has been reasonably conjectured that he spent some time in Florence because some knowledge of the subject matter made popular by Grand Duke Francesco's studiolo is found in his later work, together with echoes of modern Florentine sculpture.[6] Ridolfi discusses Paolo as an associate of Tintoretto, working as a landscape specialist, and there is one painting by Tintoretto, *San Rocco in the Wilderness*, in the chancel of the church of S. Rocco, in which the landscape resembles that in the print of the penitent Magdalen and is very likely by Paolo. Unfortunately, it is undated.[7]

Around 1580 Paolo seems to have obtained some work as a painter of altarpieces and other ecclesiastical commissions in Venice and the Veneto.[8] And in the early 1580s he received his only recorded secular commission in Venice itself: one of the narratives for the Sala del Maggior Consiglio in the Doge's Palace.[9] It occupies a position over a window, which probably reflects Paolo's junior status among the many artists employed, or some official recognition of his limitations as a figure painter. Meanwhile, however, his talent for landscape with poetic or pastoral subjects had been recognised. Christoph Ott, agent of the great German banker Hans Fugger, commissioned four paintings of the elements for the Fugger castle of Kirchheim, near Augsburg, in 1580,[10] and this was followed by commissions for paintings of the Ages of Mankind (1581–2) and of the Continents (1584–6).[11] Seven paintings illustrating the influence of the planets, a set representing the four types of love, another illustrating the four seasons, and some mythologies were also commissioned by, or acquired for, collectors and patrons north of the Alps.[12] Many such paintings were also recorded in Venetian houses – ten landscapes, for instance, in the house of the sculptor Alessandro Vittoria.[13] Companion paintings, generally two or four, also became a speciality of the Bassano family in this period, and the demand for such may be explained by new fashions in interior decoration – not least the painted over-door – and by the increasing prestige of picture collecting and the taste for symmetrical arrangements in the galleries where pictures were displayed.

Paolo may have derived from Tintoretto the practice of bold preliminary brush drawing on the canvas in lead white pigment, but his palette owes more to Veronese, and he also borrowed motifs from the Bassano. He seems only to have painted in oil on canvas. His figures tend to resemble puppets, rubbery in anatomy, and his compositions tend to be loose and always stagey in construction, but his paintings reveal an interest in aerial perspective, in the dissolution of solid forms and of the legibility of motifs in the distance (fig. 1). This interest is especially marked in the few paintings known to have been executed around 1590[14] and is thus thought to be typical of his late work. When Ridolfi, comparing Paolo Fiammingo's paintings with those of Ludovico Pozzoserrato, claimed that the latter rather than the former delighted in the distant prospect ('diletteva nelle lontane') it was certainly an error – perhaps a slip of the pen.[15]

Paolo was almost forgotten for two and a half centuries. The first serious study of his work was made by Peltzer, early in the last century and not long after a study of the patronage of the Fuggers revealed that many of his pictures had survived in German and Austrian collections.[16] Many of his works were only recognised in the mid-twentieth century. Stefania Mason's excellent catalogue of 1978 identified forty-four of his paintings.[17] A few have been added since.[18] His work is little represented in British collections, but there is an exceptionally fine pair of landscapes at Castle Howard[19] and a relatively early painting of the *Annunciation to Joachim and Anna* in Glasgow (Kelvingrove Art Gallery and Museum);[20] in addition, two of the best of the dozen or so drawings attributed to him are in Christ Church, Oxford, and the British Museum.[21]

NOTES TO THE BIOGRAPHY

1. Favaro 1975, p. 142.

2. Ridolfi 1924, p. 83, note 1 (by Hadeln).

3. Rombouts and Lerius 1872, I, p. 223.

4. Ridolfi 1924, p. 83. See also Mason Rinaldi 1978, p. 58.

5. Mason Rinaldi 1978, p. 47 and fig. 1.

6. Mason Rinaldi 1978, pp. 49 and 51 (also notes 8 and 9).

7. Mason Rinaldi 1978, pp. 50 and 66, no. 30, fig. 8. She dates Tintoretto's painting to *c*.1580. See also Pallucchini and Rossi 1982. Meijer 1975 proposed a much earlier date.

8. For altarpieces at Mirano and Schlevisheim (formerly Alte Pinakotek, Munich) see Mason Rinaldi 1978, p. 63, no. 19, fig. 2, and no. 20, fig. 3. For altarpieces and organ shutters for S. Niccolò della Lattuga (dei Frari) see ibid., p. 67, nos 32 and 33, figs 9 and 10.

9. The subject is Pope Alexander III blessing Doge Sebastiano Ziani as he boarded the Venetian fleet. See Bardi 1587. Mason Rinaldi 1978, p. 68, no. 35, fig. 33.

10. Lill 1908, pp. 138–47; Mason Rinaldi 1978, p. 62, no. 16, fig. 5, and p. 70, no. 40, fig. 14.

11. Mason Rinaldi 1978, p. 66, no. 9, figs 29–32 (*Continents*, still at Kirchheim) and p. 70, no. 39, fig. 21 (*The Golden Age*, in a private collection).

12. Mason Rinaldi 1978, p. 68, no. 38, figs 25–8 (*Loves* in Vienna, Kunsthistorisches Museum, nos 2360–2363), and p. 64, no. 21, figs 47–53 (*Planets* in Munich, Alte Pinakothek, nos 4874–4880), and p. 63, no. 18, figs 42–5 (*Seasons* in Madrid, Prado).

13. Savini Branca 1965, p. 287.

14. Mason Rinaldi 1978, pp. 61–2, nos 12–14, figs 58–61 (paintings at Kirchheim which presumably belong to the period 1586–91 as deduced by Lill 1908 from the absence of reference to them in the Fugger archives, which are very full for earlier and later periods).

15. Ridolfi 1924, p. 93.

16. Lill 1908.

17. Mason Rinaldi 1978 (preceded by Mason Rinaldi 1965).

18. For additions see Limentani Virdis 1978. An addition that I would propose is the strange *View of Verona with a Vision of the Holy Family*, dated 1581, in the Allen Memorial Art Museum, Oberlin College, Ohio, currently attributed to Marco del Moro.

19. Mason Rinaldi 1978, pp. 54 and 59, no. 4, figs 64 and 65.

20. Mason Rinaldi 1978, p. 60, no. 7, fig. 41.

21. Mason Rinaldi 1978, p. 73, no. 51, fig. 6 (Christ Church); p. 72, no. 48, fig. 18 (British Museum).

NG 5466

Landscape with a Scene of Enchantment

*c.*1590
Oil on canvas, 185 × 206.5 cm

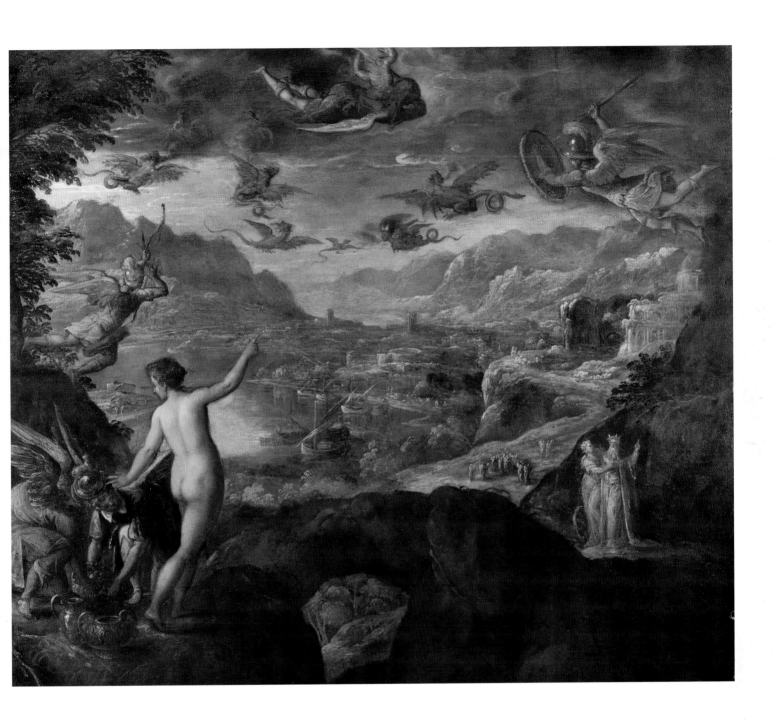

NG 5467

Landscape with the Expulsion of the Harpies

*c.*1590
Oil on canvas, 185 × 206 cm

Support

The measurements given above are those of the stretchers. Both paintings are on heavy canvas of a herringbone weave such as Fiammingo employed in at least one other work.[1] Both canvases are composed of two pieces with a horizontal seam approximately halfway down the painting. Each has been lined with glue paste on to a medium-fine tabby-weave canvas and is on a modern stained pine stretcher with cross-bars. Cusping is very evident at the upper edges, less so at the lower edges, but not on the side. Some trimming of the original painted area may be suspected at the left side of both paintings. Two notches have been made in the sides of both stretchers, cutting about 1.5 cm into the canvas in each instance. Both paintings have been damaged in the corners, and the lower right corner of NG 5467 and the tears and losses at the lower right edge of NG 5466 have been extensively made up with filler.

Materials and Technique

The canvases were prepared with a thin ground of white gesso (calcium sulphate). This ground is covered by an *imprimitura* of lead white toned with carbon black and red earth, to make a pale brown colour which in some areas was never completely covered by paint; this is most evident in parts of the middle distance and in the breaks in the foliage. Smalt was used for the sky but has discoloured. An idea of the original colour may perhaps be obtained from a few patches of bright blue near the flying warrior at the left of NG 5467,

also in the plumes of the headdress in 5466, where the colour has been preserved by mixture with lead white.[2] The cool grey-green of the landscape in the middle distance in NG 5467 is a mixture of azurite and lead-tin yellow with lead white. Some agglomerations of yellow pigment may be discerned in the foliage in the right foreground of NG 5466. These were identified by XRD as poorly dispersed lead-tin yellow 'type 1'. Thus it is clear not only that the paintings were hastily executed but that the paint was probably not prepared with proper care.[3]

There are many pentimenti, the most conspicuous being the right arm of the woman with a snake tail in NG 5466, which was concealed by the artist but has now reappeared.

The preliminary drawings were made in black and white. The black is likely to be pigment applied with a brush but could just possibly be charcoal. It is apparent in NG 5467 beneath the harpies, the distant mountains, and the ships. No underdrawing is visible in NG 5466, except perhaps in the bank in the foreground. The drawing in white is less easy to interpret, for some of it may have been meant to be visible, but it is hard to believe that this is true of the rapid loops to the right of the nearest boats in NG 5467 or of the lines to the left and right of the nude woman's pointing hand.

A certain economy of colour, typical of rapid work, may be observed throughout, for example the way the pink and yellow in the drapery of the flying warrior on the right of NG 5467 is used in the sky at the top left and in touches in the middle distance of the landscape.

Fig. 1 Detail of the distant landscape in NG 5467.

Conservation

Both paintings are likely to have been relined and restored in London soon after they were bought in Venice in 1892: both had been rolled up for some years before this. They were lightly cleaned by Sebastian Isepp in 1943. In October 1944, soon after the paintings were acquired by the Gallery, some loose paint was laid by 'Morrill'. Additional cleaning took place in 1945 and in May 1946. Between October 1954 and May 1955 the lining canvases were repaired and the darkened soft-resin varnish was removed together with some residues of an earlier varnish (which it had concealed) and some darkened retouchings.

Condition

In NG 5466 there are losses along the canvas seam, at the right and lower edges, and in the sky (especially at the centre, towards the upper edge and beside the rock lintel). The retouching in those areas has somewhat discoloured. Some glazing has been employed to cover worn areas, for example over and around the sleeping man to the right.

In NG 5467 there are losses along the canvas seam (on the right and the left), along the lower edge and at the right corner (as noted above), below the hands of the uppermost flying warrior, through the semi-dome of the shadowy ruin in the middle distance to the right, and in the head of the second harpy from the left. This last head has been entirely reconstructed. An extra harpy was removed from the sky – it was a previous restorer's addition but it had perhaps been painted there to conceal underdrawing which had begun to 'grin through' (seven harpies would also have also been more orthodox than eight).

The sky has turned greenish grey owing to the discoloration of smalt. Some of the green foliage, especially in the foreground at the left and in the middle distance to the right of NG 5466, has darkened. With the increased transparency of the paint, the figure to the left of the musician in the same painting has become less substantial, and part of the right arm of the nude woman with a snake tail has begun to reappear (as noted in the section on Technique).

Subject

NG 5467 clearly represents the sons of Boreas pursuing the harpies. The crowned and bearded figure in the middle distance on the right must be King Phineus of Thrace, struck blind and afflicted with the sorrows and pains of old age, whose food was regularly stolen and defiled by flying monsters known as harpies. The woman attending him (fig. 2) may be Fortune because she has a wheel beside her. The winged warriors are Zetes and Calais, the sons of the god of the north wind, Boreas. In the lower left foreground they appear to be instructed by a nude woman to put down food as bait for the harpies. In the sky above they are shown attacking the harpies and expelling them forever. Iris, wife of Zephyrus, the west wind, restrained the sons of Boreas from slaughtering the creatures, in exchange for a promise from them that they would not return. Gould proposed that she

Fig. 2 Detail of NG 5467 showing the crowned and bearded figure attended by Fortune (?).

was the nude woman in the foreground, who seems 'rather to be encouraging the harpy hunt'; but some other person (or personification) may be intended. Gould also noted, as a 'further unexplained peculiarity', 'the monster at the top, centre, who seems to have a combination of wings and human arms and legs (as the sons of Boreas did) but also a head like a bird's and the tail of a harpy'. The figure is in fact a third winged warrior, who is wearing the skin of a lion (with a lion's tail) and wielding what is possibly a club.

The artist's source may not have been the obvious one of the *Argonautica*, the epic romance of the third century BC, by Apollonius Rhodius,[4] although this was readily available in Venice after Aldus published an edition of it in 1521, for the harpies reappeared in subsequent poetry, Roman (Virgil's *Aeneid*, Book III) and Italian (Ariosto's *Orlando Furioso*, Cantos 33 and 34), and it may be that the artist's source was a modern variation on the old story.

The subject of NG 5466 is less easily identified. The setting on the left seems to combine features of the maze and the grotto. Here the lute is played by torchlight and men embrace women, apparently unaware, or at least undismayed, that one of them is a snake from the waist down, another has the

face of a pig and a third has (it seems) the head of a reptile. These figures could be the beastly followers of Circe in the *Argonautica* (Book IV), and what is represented is doubtless some magical garden like the 'Bowre of blis' in Spenser's *Faerie Queene*[5] (with the difference that here it is the women, not the men, who have been turned into beasts).

Also needing to be explained are the naked bearded man sleeping close to the cliff edge on the right; the nude women apparently sliding down a cliff in the cloud at the top left; the two figures, not clearly a male and a female but embracing, who are approaching the lovers in the foreground along the serpentine path. The couple perched on the rock above the table are not certainly lovers (fig. 3); there is a figure with a feather headdress beside them, and the figure with the monster's head points into the distance but at nothing that is visible to us.

Caterina Limentani Virdis has proposed that a pair of paintings at Kirchheim, one illustrating a council of marine gods and another a fantastic seaport, may also illustrate episodes in the history of the Argonauts.[6] But the episodes she proposes are oddly separated, and although the paintings at Kirchheim are certainly similar in character, they are different in size; moreover, the Venetian provenance of the National Gallery's paintings makes it unlikely that they were ever part of the same series.

Attribution and Date

The paintings were sold in Venice as by Tintoretto, but Kenneth Clark accepted them for the Gallery as merely works in his style (see below). In 1959 Cecil Gould attributed them to Pozzoserrato, but in 1975 he recorded his opinion that 'such precision' was 'premature' and assigned them instead to the 'Venetian School', noting connections with work by both Pozzoserrato and Fiammingo, dwelling on the similarities between their work (which he exaggerated), and even speculating on the possibility of a collaboration between them.[7] A few years later, with the publication of Stefania Mason's catalogue, it became clear that the paintings were entirely characteristic of Fiammingo: in compositional character, landscape motifs, figure style, colours and handling. She had in fact correctly attributed the paintings to Fiammingo in 1965, as had Pallucchini five years before that.[8]

An eminence to one side of the foreground, natural rock arches, and sudden drops in ground level found in both NG 5466 and NG 5467 are combined in the same way in the pen drawing by Fiammingo for the *Rape of Proserpine* in the Rijksmuseum.[9] As Gould noted, the *Landscape with Diana Hunting* in the Musée des Beaux-Arts, Nancy (fig. 1, p. 78), is clearly by the same hand as both NG 5466 and 5467 – the use of water in the distance, perfunctory framing foliage and a female figure in the foreground recall NG 5467 especially.[10] The flying hero on the right in NG 5467 recalls the airborne Minerva in the *Birth of Minerva* in Prague.[11] The margins of the lake in both the Prague painting and NG 5467 are indicated by the same single 'dragged' line of dry, pale-pink paint. The use of this pink is in fact typical of the artist,[12] as is the abundance of loosely defined elements in the distance.

Fig. 3 Detail of NG 5466 showing the couple perched on a rock.

Among the works to which these paintings seem closest in handling are the pair at Kirchheim, already mentioned, which must date from late in the artist's career, certainly from after 1585.[13] The daring freedom with which effects of aerial perspective are rendered seems to belong to this period. The hairstyle of the snake-tailed woman in the foreground of NG 5466 is of a type that became popular around 1590.

Setting and Purpose

These two landscapes are unusual among Fiammingo's easel pictures on account of their size and proportions. They may have been painted as mural decoration covering an entire wall above a *basamento*, with pilasters perhaps dividing them, rather than as framed pictures. (In Venice, of course, such murals were generally painted on canvas, rather than in fresco[14] as was the practice elsewhere in Italy.) If this were the case, we would have to suppose that they were part of a larger series, probably of six or more paintings. That indeed seems likely since these two show no evidence (in either subject or composition) of being a pair. This theory is also supported by the claim (see Provenance) that they had originally been 'part of the decoration of one of the rooms in the Palazzo Vendramin'. And murals with similar landscapes

were certainly being painted at that date. The obscure pastoral subjects that were frescoed in the Sala degli Specchi of the garden palace at Sabbioneta by Bernardino Campi in the 1570s or early 1580s, for example, are close in size (about 180 cm high and about 270 cm long).[15] If the paintings did serve an essentially decorative purpose it may explain their exceptionally hasty execution and the air of improvisation in both the narrative and the composition.

Acquisition and Display

The offer of these paintings to the National Gallery – as two landscapes 'in the style of Tintoret' – was drawn to the attention of the Board of Trustees by the director (Kenneth Clark) on 11 November 1943.[16] The offer was perhaps stimulated by knowledge that the Gallery had recently acquired the large sixteenth-century landscape by Niccolò dell'Abate. Clark (author of *Landscape into Art* in 1949) would certainly have been attracted by these paintings, but it is not clear how keen he was to acquire them for the Nation. He was authorised by the Trustees to spend up to £1,500 for them, and in a letter to the vendor of 24 January 1944 he offered £800, his reason being that, 'in spite of their considerable beauty, they present many difficulties from the gallery's point of view. They are

not quite of high enough quality to hang permanently in the Venetian room. On the other hand they are rather large to hang anywhere else.'[17] The Trustees were informed on 1 June that the vendor had consulted Colin Agnew for his opinion of the value and he had replied that a dealer would ask £1,200 from a private owner and £1,000 from a museum.[18] The Trustees approved an offer of £1,000, which Clark made on 5 June and which was accepted the following day.[19]

Provenance

Both bought from A. Marcato, of Casa della Vida, Venice, in October 1892 by Frederick Cavendish Bentinck, who sold them to the Gallery in 1944 (see above). According to Marcato (see Appendix) the paintings had come from Palazzo Vendramin but had been removed 'many years before when certain alterations were carried out'. If, as seems probable, this alludes to the most famous of the Vendramin palaces, Palazzo Loredan-Vendramin-Calergi, one of the greatest early sixteenth-century palaces on the Grand Canal near S. Marcuola, and close to Marcato's own palace, the removal may have taken place when the palace was acquired from the Vendramin by the Duchesse de Berry in 1844. But there is no record of such paintings there before that date, so it has been supposed that she acquired them and then disposed of them before her death in 1865, since they were not included in the sale of her paintings in Paris in April of that year.[20] This explanation does not seem very likely, and the fact is that if one wished to invent a noble provenance for paintings this palace would be a good choice because it was famous and was known to have undergone radical alterations.

Loan

The paintings were placed on long-term loan in Lancaster (formerly Stafford) House between 14 May 1956 and 19 December 1990.

Frames

The paintings have identical frames with sanded flat and outset corners, a pattern associated with Palladian interiors in Britain. They were obviously cut down to fit, presumably as a makeshift arrangement, perhaps when it was decided to lend the paintings to Lancaster House. If so, these frames may have once contained large British paintings of the eighteenth century (perhaps portraits) which had earlier been transferred to the Tate.

Appendix

THE CAVENDISH BENTINCKS AND MARCATO

The Rt Hon. George Augustus Frederick Cavendish Bentinck, MP and Privy Councillor (1821–1891), was an important collector, especially of Venetian art. He was a kinsman of the Duke of Portland – his father, Lord Frederick Cavendish Bentinck, who died in 1828, was the brother of the 4th Duke, who died in 1854.

George Augustus died on 9 April 1891 at Brownsea Island, near Poole, and most of what we know of his collections comes from the posthumous sale at Christie's on 8–11 and 13–14 July 1891 of his possessions, removed both from Brownsea and from his London house, 3 Grafton Street (Bond Street). The reasons for the sale are not clear. His widow, Prudence (née Leslie, b. 1830, a cousin of the Duke of Wellington), lived until 1896.

The collection consisted not only of paintings but of *objets d'art* and furniture, mostly Italian, of the sixteenth, seventeenth and eighteenth centuries, and French of the eighteenth century. The paintings included some good British ones, several important Dutch old masters (among them a celebrated Cuyp) and two Murillos,[21] but mostly Italian works, and by far the larger part of these were from Venice. Many of Cavendish Bentinck's Venetian paintings dated from the fifteenth and sixteenth centuries but he was one of the first serious British collectors of Venetian eighteenth-century art, owning drawings and sketches as well as large oil paintings by Guardi, Longhi, Canaletto and above all Tiepolo, and Venetian mirrors and picture frames also from this period. The National Gallery acquired one of its first Tiepolos (Giovanni Domenico's *Lamentation*, NG 1333) at his sale.[22] The South Kensington Museum made half a dozen purchases there.[23]

The provenance of many items in Cavendish Bentinck's collection was given in the sale catalogue but often in a somewhat garbled form. Dates of acquisition range between 1871 and 1882 and this is likely to be the period in which he was most active. Cavendish Bentinck bought paintings in England (from Alexander Barker's collection, Hamilton Palace and Blenheim, for instance) but chiefly, it seems, from Italy. Among his sources were the Manfrin collection, Count Morosini, Count Albrizzi, Antonio Zen, 'Favenza', Richetti, Barbini, Antonio Carrer, Michelangelo Guggenheim, 'Ruggiere of Venice', 'Usigli of Venice' and 'Marcato of Venice'.[24] This last-mentioned dealer, Antonio Marcato, sold him a cassone, a Veronese, a Tintoretto and some Canalettos. He is mentioned by Levi as combining with other dealers to form the Società Anglo-Veneta Compagnia dell'Arte di Venezia.[25]

George Augustus Frederick Cavendish Bentinck's second son, (William George) Frederick Cavendish Bentinck (1856–1948), was a practising barrister at the time of his father's death in 1891. His interest in art is attested by the fact that he is recorded as a buyer at his father's sale, where he purchased mostly minor works. According to a memorandum in his hand of 3 June 1945, now in the Gallery's archive, he was in Venice in October 1892, the year after his father's death, and visited Marcato, 'the well known antiquary & art expert' at his house Casa della Vida at San Marcuola on the Grand Canal opposite the church of S. Stae:

> My father had had many dealings with Marcato & he was one of his oldest Venetian friends. At the time of my visit Marcato was in a very precarious state of health & he was in bed, but he professed to be very pleased to see me. In the course of our conversation Marcato asked me if I took as much interest in pictures & in works of art as my father had done & I told him that I shared my father's tastes. He then said there was still in his possession a pair of landscapes with

mythological subjects which he had purchased a good many years before & which he had frequently advised my father to buy, but that my father, who admired them very much, had never been able to make up his mind to do so, as he had always said there was no place in either of his houses where these two pictures could be hung. This pair of landscapes, Marcato said, were in his opinion undoubtedly painted by Tintoretto & he would very much like me to see them; they had originally been part of the decoration of one of the rooms in the Palazzo Vendramin & were removed from the Palazzo many years before when certain alterations were carried out. The pictures were brought up to Marcato's bedroom to see & when they were unrolled I saw their merit at once. Marcato then said his health was so bad that he was not likely to live much longer & he was already making arrangements to give up his business. He had added that he had no idea what would be done with these remarkable pictures but that if I cared to possess them he would very much like to sell them to the son of his old friend and if I would give him the price he had originally paid for them I was welcome to have them. I bought these landscapes from him without any hesitation (now forty two years ago) & I was very much obliged to Marcato for his offer. Marcato died a few months later.

Presumably Frederick Cavendish Bentinck had room to display these paintings effectively, but it is easy to believe that he was, in his old age, proposing to move to a more modest home, especially given the inconveniences and expenses faced during the Second World War and afterwards by the owners of large houses. He also presented the superb portrait of his mother at the piano by George Frederic Watts to Northampton Museum, an even finer portrait of his mother with him and his siblings to the Tate Gallery, and a group of sculptures, including six terracotta busts attributed to Vittoria, to the Victoria and Albert Museum.[26]

NOTES

1. *Landscape with Fishermen*, Vicenza, Museo Civico, A454 – Mason Rinaldi 1978, p. 68, no. 37, fig. 69; Barbieri 1962, II, pp. 180–1.

2. Spring, Higgitt and Saunders 2005.

3. Report of the National Gallery Scientific Department 1995–6, p. 11.

4. *Argonautica*, II, lines 178ff.

5. Book 2, Canto XII.

6. Limentani Virdis 1979, p. x.

7. Gould 1959, pp. 66–70; 1975, pp. 310–12.

8. Pallucchini 1959/60, pp. 46–8; Mason Rinaldi 1965, p. 102; Mason Rinaldi 1978, p. 62, no. 15.

9. Mason Rinaldi 1978, p. 71, no. 44, fig. 68 (preparatory for a painting in a private collection in Rome – p. 66, no. 27, fig. 67).

10. Inv. 609; Mason Rinaldi 1978, fig. 16.

11. Mason Rinaldi 1978, p. 65, no. 24, fig. 40.

12. Fučíková (ed.) 1994, pp. 78–9, for a colour reproduction. For another example of pink used in this way, see *Latona and the Rustics*, purchased in 1995 for the Castle Museum, Prague (inv. O.3936).

13. See p. 79, note 14.

14. Camillo Mantovano's work in Palazzo Grimani is a rare case of frescoed wall decoration in a sixteenth-century Venetian palace.

15. For Campi's frescoes see Ventura 1999, pp. 70–2 and fig. 38.

16. NG 1/12 (Minutes of the Trustees, XII), p. 70.

17. Letter of 24 January 1944 (Acquisition file).

18. NG 1/12 (Minutes of the Trustees, XII), p. 80.

19. Letter of 5 June 1944 (Acquisition file).

20. Gemin and Pedrocco 1990, p. 129.

21. Among the British pictures were NG 5842 (Richard Wilson) and NG 5845 (Gainsborough), respectively lots 536 and 558 on 11 July. These two pictures, bequeathed to the National Gallery in 1948, were later transferred to the Tate Gallery. NG 3938 (Attributed to Murillo) was lot 558.

22. 11 July, lot 598.

23. Pope-Hennessy 1964, I, pp. 345–6, no. 370; pp. 515–17, nos 541–3; p. 520, no. 549; also, for an item purchased after the sale from the executors, I, p. 332, no. 362. In addition, Cavendish Bentinck had assisted the museum in one major purchase of its own, that of Bartolommeo Buon's relief of the Madonna della Misericordia (ibid., I, pp. 342–5, no. 369).

24. See Penny 2004, pp. 365–6, for Guggenheim, and p. 366, note 20, for a list of contemporary dealers in Venice. See also Levi 1900, pp. ccliii–cclv, for Zen, Richetti, Barbini and Marcato.

25. Levi 1900, pp. ccliii–cclv.

26. Bryant 2004, pp. 96–7, no. 28 (for the painting in Northampton) and pp. 108–9, no. 33 (for the painting in the Tate) – the donor is here misidentified as the grandson of G.A.F. Cavendish Bentinck. The busts came from the Manfrin collection and only two of them are now accepted as by Vittoria. For these and other gifts to the Victoria and Albert Museum see Pope-Hennessy 1964, I, pp. 238–9, no. 366; pp. 527–8, nos 512–13, and II, pp. 531–4, nos 568–73.

Damiano Mazza

*c.*1550–1576

Fig. 1 Damiano Mazza, *Coronation of the Virgin*, *c.*1575. Oil on canvas, 240 × 245 cm. Venice, Church of the Ospedaletto.

The little we know of Damiano Mazza, a painter from Padua, is largely derived from Carlo Ridolfi's *Maraviglie*, where he is included among the 'Discepoli di Titiano'.[1] Mazza painted the *Coronation of the Virgin* above the high altar of the Venetian church of the Ospedaletto, otherwise known as S. Maria dei

Derelitti (fig. 1). The painting (240 × 245 cm) is still in place, although partly obscured by a baroque tabernacle, but Mazza's ceiling painting for the same church, the Assumption of the Virgin with numerous 'bambinetti & Angeli maggiori in iscorcio' ('infant angels and larger ones foreshortened')

supporting the clouds upon which the Virgin reposed, had been removed from the ceiling during renovation – to Ridolfi's regret – and seems not to survive.[2] The altarpiece is likely to have been under way by 5 October 1575, when Palladio's project for its framing architecture was commissioned by the hospital's governor, Giovan Battista Contarini, although it had not been installed at that date.[3]

Ridolfi also mentions an altarpiece in S. Silvestro, Venice, which from Boschini and others we know was mounted above the last altar on the right.[4] When the church was drastically renovated in circumstances described elsewhere in this catalogue,[5] the altarpiece was removed and sold to a British collector, but it later found its way back to Italy and now hangs near the south entrance of the Tempio Malatestiano in Rimini.[6]

Ridolfi also recorded in the Donà Palace near S. Maria Formosa in Venice 'quadri contenenti Deità, Amori e Satiri con panieri di frutti, colombe e fiori' ('pictures containing gods, loves and satyrs with baskets of fruit, doves and flowers') which have not been traced,[7] and in Padua one other profane work, the most admired of Mazza's paintings, catalogued here. Mazza perhaps enjoyed a reputation for his ceiling paintings: a series of square pictures of Evangelists and Fathers of the Church originally surrounded an octagonal canvas of God the Father in Glory on the ceiling of the Stanza Terrena of the Scuola dei Sartori (the tailors' confraternity).[8]

It is clear from Ridolfi's account that Mazza's œuvre was small but much esteemed by connoisseurs such as the dealer and painter Gamberato, who owned a fragment from a painting of the *Crucifixion* by him. Ridolfi concludes with the statement that Mazza died 'Ne' piu begli anni suoi', that is, in the flower of his youth.[9] He is documented in 1573 as receiving payment for the altarpiece still in the parish church of Noale depicting the Risen Christ with the Roman martyrs Felix and Fortunatus.[10] It would be reasonable to conjecture that he was born about 1550 and was active as an independent artist in the mid-1570s but died in 1576 (the year in which his master, Titian, died) or 1577, otherwise he would surely have been employed in the decoration of the Sala del Maggior Consiglio in the Doge's Palace after the fire of 1577, for it is clear that in the years between 1578 and 1585 all able young artists in the city – including many less talented than Mazza – were recruited for that urgent patriotic task.[11] And Sebastiano Scarpa has in fact discovered that an addition to the register of deaths in the parish of Santi Apostoli made on 25 August 1576 records the death of 'Damiano Pittor de anni 26'. No other painter of this name is known at that date.[12]

NOTES TO THE BIOGRAPHY

1. Ridolfi 1914, pp. 223–4.

2. Ibid.

3. Pilo [1990?], pp. 93–4, 145 and plate 37.

4. Ridolfi 1914, pp. 223–4; Boschini 1733, p. 169.

5. See p. 405.

6. The painting shows Pope Sylvester (S. Silvestro) with Saints Helen and Constantine; Saints Andrew and Nicholas are also included. It was given in 1927 to the Pinacoteca of Bologna (Inv. 1369) and has been placed by that gallery in Rimini. Professor Publio Podio, a dealer who played a part in the story of Kenneth Clark's

'Giorgiones' (see Penny 2004, pp. 295–9), donated the painting to the Pinacoteca (see *Bollettino d'Arte*, 1930, IX, 9, p. 391), having earlier acquired it in London. It is likely to be the 'altarpiece by Mazza' in the Cook Collection which was presented by Herbert Cook to Westminster Cathedral. See pp. 96–7, Appendix 1, for the National Gallery's interest in this painting.

7. Ridolfi 1914, p. 224 (as in the house of the 'Signori Donati'). Tietze-Conrat (1945) suggested that one of these paintings might be the so-called *Wemyss Allegory* in the Art Institute, Chicago (1943·90), but the description is not sufficiently precise to confirm this and the painting seems too

soft – Ballarin's attribution to Sustris seems more convincing (1962, pp. 76–7 and n. 38). For a full discussion of this painting see Lloyd 1993, pp. 248–53.

8. The octagon is untraced. The square paintings are on deposit in the Accademia. Scarpa 1990, pp. 174–7.

9. Ridolfi 1914, p. 224.

10. Hadeln 1913. He makes several additional attributions, none certainly correct.

11. Fiocco 1929, p. 11, believed that Mazza may have died as late as 1628.

12. Scarpa 1990, p. 174.

The Rape of Ganymede

*c.*1575
Oil on canvas, 177.2 × 188.7 cm

Support

The painting was originally shaped as an irregular octagon approximately 170 cm high and 173 cm wide. The three upper sides of the octagon were each 72 cm long, the lowest side was 73 cm, and the remaining four were 71 cm.

The original canvas is of a heavy herringbone weave, coarse and with numerous slubs. There is a vertical seam to the right of the centre. The width of the larger of the two pieces of canvas is 96 cm, which corresponds approximately to that of a standard loom. There is some cusping at the upper and lower edges, and there are traces of tacking holes at about 4 o'clock.

The octagon has been made up to a rectangle with eight pieces of medium-heavy tabby-weave canvas (four large triangular pieces and four narrow rectangles) lined with glue paste on to a canvas of the same type. There is a 'strip-lining' – that is, peripheral reinforcement – of medium-weight twill canvas on all four edges. The stretcher is of stained pine with cross supports at the corners and a central vertical bar. As noted below in the section 'From Salviati to Colonna', an inventory of 1704 describes the painting as an octagon. By 1739, when it was hung in the Stanza de' Quadri of Palazzo Colonna, it had been converted to a rectangle.

Materials and Technique

The painting has a gesso ground, and no evidence of an *imprimitura* has been found. The original layer of paint in the sky is composed of smalt mixed with lead white. Smalt is

Fig. 1 NG 32 with spandrels concealed.

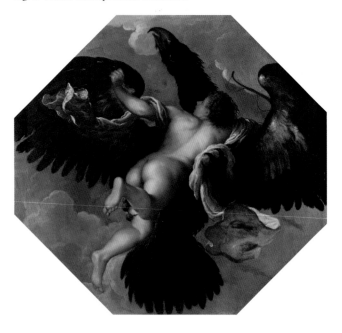

composed of cobalt blue glass that degrades to a warm grey. Subsequent (non-original) layers of paint contain Prussian blue, a pigment that seems to have first come into use in the early eighteenth century.[1]

The painting was rapidly executed, with numerous revisions. X-radiography reveals that the position of the boy's left foot was originally higher, and his right foot was considerably to the left. Numerous minor changes were made to his head. Other pentimenti are obvious to the naked eye, especially those made to the scarf. A higher position to the right was originally proposed for the bow, as is indicated by the preliminary drawing, made with a brush and black pigment, which is now visible. Also visible are a variety of different positions for the eagle's talons.

Conservation

The painting must have been lined in the early eighteenth century, when it was altered to a rectangular format, and was very likely relined when offered for sale in the very early nineteenth.[2] A number of interventions are recorded in the painting's first hundred or so years in the National Gallery: revarnishing in 1862, surface-cleaning in 1876, cleaning and restoration by 'Buttery' in 1890, surface-cleaning in February 1937, strip-lining by 'Morill' in March 1941. The painting was again cleaned and restored between October 1954 and June 1955.

Condition

The surface is abraded overall, most severely along the canvas seam. There is a vertical tear in the canvas on the left of the painting, beside the eagle's wing. The sky has been largely overpainted with Prussian blue, presumably to compensate for the fading of the smalt employed there. Since the same pigment is found in the canvas extensions, this repainting may be coeval with the picture's conversion to a rectangular format in the early eighteenth century, and the use of Prussian blue (as mentioned above) also points to that date. The falseness of the blue was clear to Ramdohr in 1787; he blamed it on Carlo Maratta, in whose studio the painting may well have been converted to a rectangle – although, if so, these operations would have been undertaken before 1713, when Maratta died.[3]

The flesh is for the most part well preserved but Ganymede's trailing left foot is worn. Some drying-cracks on his ear perhaps reflect revisions made by the artist. The eagle's wings are somewhat abraded, and the bare canvas is exposed on the salients of the weave.

The condition of the scarf is more difficult to assess. The brush underdrawing – most noticeable under the higher of the eagle's talons – is black. Originally, it would not have been visible. Where the scarf was painted over the eagle's wing the colour has darkened on account of the wing now showing through. It seems probable that both red earth and a red lake were used but that the latter has faded and survives only as a powdery residue in the shadows on the right.

It may have been the faded appearance of the red as well as the modern sky that Benjamin West had in mind when

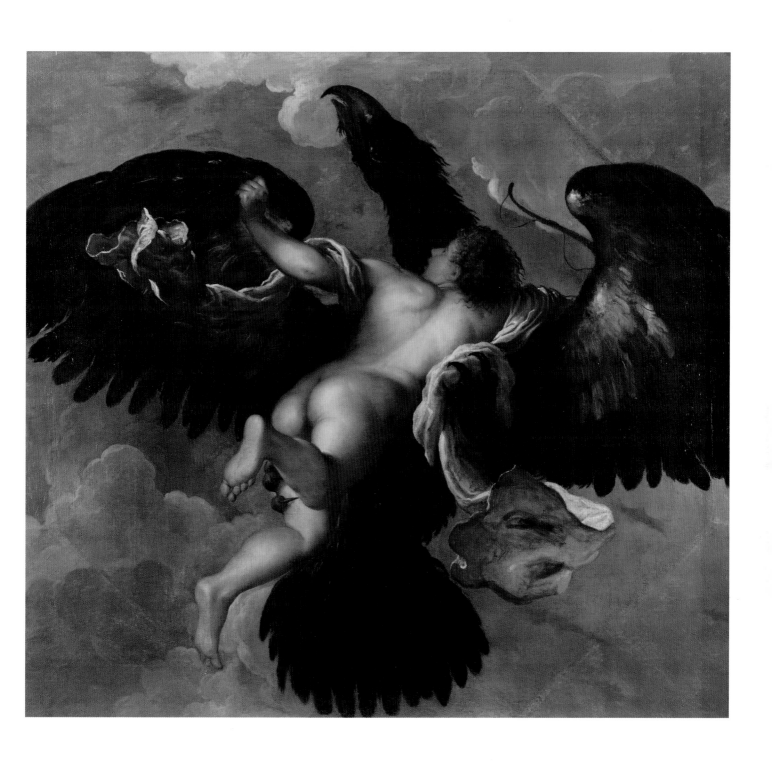

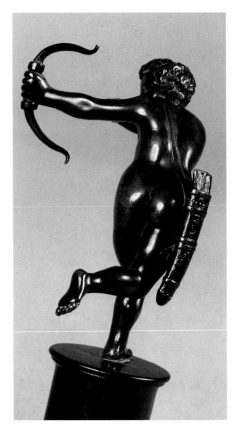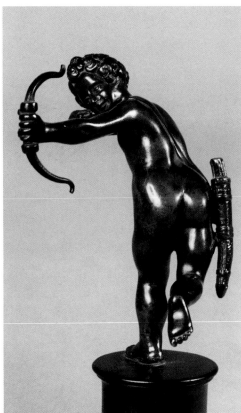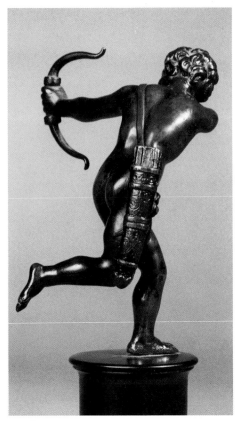

Figs 2, 3, 4 Barthélemy Prieur, *Statue of Cupid*, *c*.1560, bronze – from three different angles. Private collection.

he declared at a dinner on 9 May 1801 – not long after the painting had been acquired (perhaps against his advice) by John Julius Angerstein – that it was in 'imperfect state' and had 'not that colour which Titian left'.[4]

Attribution

The painting was recorded in the Salviati collection in Rome by 1664 as a Titian,[5] and continuously as such throughout the eighteenth century. It was acquired as a Titian by Angerstein, and accepted as such when acquired by the National Gallery. Eastlake was aware of the description of the *Rape of Ganymede* by Mazza in Ridolfi, and a reference to this passage was included in the 1854 edition of the Gallery's *Descriptive and Historical Catalogue*.[6] But the painting was still listed as Titian until 1887, when it was downgraded to 'School of Vecellio' in Frederic Burton's *Abridged Catalogue*.[7] This vague description seems to have stimulated some connoisseurs to claim that it might be by Tintoretto.[8] The Gallery employed the formula 'School of Titian' until Cecil Gould catalogued it as 'Ascribed to Mazza' in 1959.[9]

Cavalcaselle wrote in 1877 that NG 32 was 'probably painted by Domenico [*sic*] Mazza', although it 'may have been executed from one of Titian's designs'.[10] Hadeln in 1913 gave it to Mazza without qualification.[11] He considered that the painting was identical to the one by Mazza which Ridolfi describes, a hypothesis that Gould described as a 'plausible possibility'.[12] More recently, the attribution to Mazza has been dismissed as an 'invenzione' of the late nineteenth century.[13]

It is, however, supported by several close similarities to paintings that are known to be by Mazza. The boy's features and the small curls of his hair are very like those of the angels in the top left corner of the Ospedaletto *Coronation* (fig. 1, p. 88), while the floating scarf is painted in the same way as the billowing raiment of the Risen Christ in the altarpiece in the church at Noale. Furthermore (as is discussed below), a copy of NG 32 – though not known to be such by its owner – was associated with the painting mentioned by Ridolfi.

Recently Rearick argued that NG 32 is a copy of an original painting by Titian in the Kisters Collection,[14] but he did not take account of the numerous revisions which are so apparent in the National Gallery's picture – revisions that would be extraordinary in a copy. The status of the Kisters painting is discussed below. Ridolfi noted that Mazza's *Ganymede* was being claimed as a Titian on account of its 'esquisitezza'.[15] The most surprising aspect of the painting's *fortuna* is that the Salviati were ignorant of Ridolfi's attribution – or were persuaded to ignore it.

Subject, Setting and Source

In Greek mythology the beautiful Phrygian shepherd boy Ganymede was carried off to Olympus by the infatuated Jupiter in the form of an eagle, and was made cupbearer to the gods. The episode was probably most familiar in the Renaissance from the song of Orpheus in the tenth book of Ovid's *Metamorphoses*.[16] It was also familiar from ancient

marble sculptures – a Roman relief panel (presumably part of a sarcophagus), now untraced but recorded in Rome in the mid-sixteenth century,[17] and a Roman replica of an important Hellenistic statue group, perhaps by Leochares, that was acquired in Constantinople by Giovanni Grimani and bequeathed by him to the city of Venice in 1587.[18]

The *Rape of Ganymede* was one of a series of gallery pictures depicting the loves of Jupiter that were painted by Correggio in about 1530,[19] but the subject was most popular for ceilings and was even whimsically proposed for the dome of the Medici Chapel.[20] At the same date Sodoma considered it for a tondo.[21] In the later 1540s Lelio Orsi painted it in fresco, in an octagonal format, at the Rocca di Novellara.[22] About twenty years later Bertani, pupil and successor to Giulio Romano, decorated the vault of a room in the Palazzina della Rustica (now known as the Appartamenti Estivale) of the Ducal Palace in Mantua with this subject.[23] It remained popular for vaults in subsequent centuries.

Although it has been assumed that Mazza's picture reflects the homosexual proclivities of its patron,[24] this is unlikely: Lelio Orsi's painting was made for the *camerino* of the apartments of Donna Costanza da Correggio; Bertani's patron was the newly wed Duke Guglielmo of Mantua. If a painting of this subject stood for anything, it was perhaps divine favour – which explains its conjunction with the *Fall of Phaeton*,[25] an example of the reverse. Alciati even considered the subject as emblematic of the human mind raised up by the godhead.[26] The popularity of eagles in heraldry may also sometimes have been a factor in the choice of subject.[27]

Mazza's composition is one of many experiments made by Venetian artists to emulate Giulio Romano's daring octagonal ceiling painting of the *Fall of Phaeton* of 1527–8 in Palazzo del Tè in Mantua, which was designed not only to be seen from below but to be dramatically effective from more than one viewing position.[28] The impact of Mazza's painting has been reduced by its conversion from ceiling octagon to rectangular gallery picture. When the painting is masked to show its original shape, the eagle's feathers fill one side of the octagon, establishing the chief viewpoint. The outspread wings tie the opposite sides together but the bird's neck and the boy's torso strain against this stable cross, paralleling the other sides of the octagon. The wings would have been cut by the frame, and the boy's left foot and the bird's beak would have only just been contained by it – a constriction that would have greatly enhanced the drama of the composition. Essential to the impression of elevation is the sole of the boy's right foot, which is lit from below, and the scarf that floats freely and lightly below the powerful beating wings of the bird.

Lomazzo mentions that Titian had derived the foreshortened poses for paintings of this kind from studying suspended 'modelli fatti di legno, di terra, & di cera' ('models made of wood, clay and wax').[29] Mazza, said by Ridolfi to have been Titian's pupil, adopted this practice and, unusually, the model he employed has survived in the form of numerous bronze statuettes of Cupid shooting a bow while running (figs 2–4).[30] This figure, remarkable for its pose, which is designed to be seen from numerous viewpoints, as well as for its lightness of movement, was surely invented as a Cupid, but we can easily imagine that, in the form perhaps of a wax, its potential for other purposes was apparent. Some recollection of Cupid may have prompted Mazza to have Ganymede holding a bow in his right hand; but this is not normally an attribute of the shepherd boy. More generally, Mazza's composition surely owes something to Titian's *Venus and Adonis*, which Mazza must have known well (he had perhaps worked on some of the studio replicas), although in this case it is a male figure whose buttocks and profile are presented.

Patron

Ridolfi records that 'in Padova in quelle de i Sonica vedevasi nel soffito d'un bel vedere Ganimede rapito dall'Aquila, quanto in naturale, creduto per la sua esquisitezza di Titiano. Da che si può argomentare, à qual segno di perfettione pervenisse Damiano. Né Ganimede poteva riputarsi men honorato dal pennello di questo eccellente Artefice, che così morbido e vezzoso il dipinse, che dalle penne de' poeti, che lo fecero coppiere di Giove' ('in Padua, in the house of the Assonica, there was to be seen, on the ceiling of a belvedere, Ganymede snatched up by the eagle, large as life, believed on account of its fineness to be by Titian. Such, it may be remarked, was the perfection that Damiano had attained. Nor could Ganymede deem himself less honoured by the brush of this excellent craftsman who painted him with such softness and charm, than he was by the quills of the poets who made him cupbearer of Jove.').[31]

The Assonica were from Bergamo. The member of this family for whom the painting was made was Francesco, who had completed his studies in Padua in 1533 and by 1540 was well established in the legal profession in Venice and Padua.[32] He is known to have acted for Titian in October 1550 and again in 1566.[33] He is said by Vasari, in 1568, evidently on good authority,[34] to have been a 'compare' (a friend) of Titian and to have owned a portrait of himself by Titian and a large *Rest on the Flight* (now in the palace Assonica had built in the parish of Santa Giustina).[35] We also know from Ridolfi that Assonica owned a version of Titian's *Venus with a Musician*.[36] Titian's friend and promoter Lodovico Dolce remarked in a dedicatory epistle dated 10 January 1562 that works 'by the brush of the divine Titian' had been added to 'altri ornamenti' of Assonica's 'magnifica casa'.[37] Dolce does not say that this home was in Padua: we may assume that it was in Venice (where Dolce's book was published), probably at S. Maria Zobenigo,[38] and that Assonica made Padua his principal residence after that date. Mazza's commission is likely to be connected with the embellishment of the Paduan house in Contrà del Maglio near the botanical garden, which was being built in the mid-1550s.[39] Perhaps Titian recommended Mazza. Assonica may also have wished to encourage local talent, for Mazza was from Padua.[40]

Other Versions

Otto Mündler made a note on 22 November 1856 of a painting belonging to the 'Notajo Meneghini' in Padua: 'exactly

the same figure as the one in the Nat[1] Gallery in London, which is called Titian. It is on gold-ground, which, together with the white clouds, produces an excellent effect. The flesh is rather brownish and hard. In very good state. The whole looks like a copy from the London picture. The proprietor assures to be able to prove that his picture is the one mentioned by Ridolfi.'[41] Eastlake made a memorandum of the same picture inside the cover of one of the notebooks he used on his travels in the following year, although it is not clear that he ever saw it.[42] Such a painting may well have been made for the Assonica at the time the original was sold, and we may suspect that the gold ground was considered an improvement on the smalt, which had probably already discoloured. Another copy was sold at Christie's in London on 17 February 1961 as lot 76 with an attribution to Tintoretto. This is the painting in the Kisters Collection, Kreuzlingen, recently published by Rearick as an original by Titian.[43] Its octagonal format suggests that it was made before the original canvas was converted to a rectangle and, as with the version Mündler saw, the most likely occasion for its creation would have been after the removal of the original from the ceiling and before its acquisition by the Salviati. Among full-size copies made of the painting after its arrival in London, one by William Etty, currently untraced, is likely to have been of outstanding quality.[44]

From Salviati to Colonna

Mazza's *Rape of Ganymede* had been removed from its ceiling by 1648, when Ridolfi published his *Maraviglie*, and the painting may already have been for sale as a Titian. If so, it would have probably been in Venice, where Pietro Assonico (a descendant of the original patron) lived. It may indeed have been the painting 'by Titian' that Duke Jacopo Salviati (1607–1672) bought from the Venetian dealer Giuseppe Tornaquinci for 120 scudi in that very year.[45] The Duke belonged to a rich and powerful Florentine family but in 1634 he left Florence and took possession of his family's sixteenth-century palace on the Lungara in Rome, where he moved much of the collection he had inherited – including many major works his ancestors had commissioned from Florentine artists – and combined them with numerous new acquisitions. By 1664 the 'Gannimede di Titiano' was admired there by Bellori, together with many other 'pregiatissime pitture'.[46] It was among the paintings 'sottoposte alla primogenitura' (that is, legally classified as the inheritance of first-born males of the Salviati family) in the inventory notarised in September 1668 of paintings 'parte nella nostra casa di Roma e parte in quella di Firenze' as no. 4: 'un Ganimede in un ottangolo, grande al naturale, con l'aquila che lo rapisce. In tela, mano del Titiano.'[47]

Duke Jacopo was succeeded by his son, Francesco Maria Salviati (1629–1698), and then by his grandson, Francesco Maria's son Anton Maria Salviati (b. 1664), who, however, died in 1704, leaving only one child, the last of this branch of the Salviati, Caterina Maria Zeffirina Salviati, born in the previous year. At this point the paintings were largely concentrated in the Roman palace: nearly 200 of them in the

five rooms of the *piano nobile*, which faced the Tiber – the rooms known as the Appartamento dei Quadri. A hundred smaller pieces were in the adjacent cabinet room known as the Gabinetto dei Cristalli and another 200 or so hung elsewhere in the palace. The most valuable paintings were in the central room of the Appartamento dei Quadri – the Audience Chamber – and among these was 'un quadro rappresentante un Ganimede a ottangolo di Titiano'.[48]

In 1718, when she was 15, Caterina was married to Prince Fabrizio Colonna, hereditary Gran Connestabile del Regno di Napoli (1700–1755). Fabrizio's father, Filippo II Colonna, had in 1703 completed the tripartite gallery in the family palace at SS. Apostoli, which was to be admired as the most magnificent palace in Rome throughout the eighteenth century. There were more than a thousand paintings hanging elsewhere.[49] The art treasures of the Roman Salviati did not flow directly into this great reservoir. Indeed, the legal disputes concerning the division of the property were not settled until 1732,[50] when it was agreed what portion of the works of art from the Roman palace should go to Caterina and above all what could be extracted from the 'fide commisso', or family trust assigned to the male line, as her dowry. Most of the paintings she then inherited personally were bequeathed by her to her eldest son, and the thirty-five previously held in the 'primogenitura Salviati' merged, but as a separate legal entity, with the 'primogenitura Colonna'.[51] Among these thirty-five were the *Ganymede* and several other of the most highly valued Salviati paintings, including a version of Titian's *Venus and Adonis* (NG 34) and Correggio's *Ecce Homo* (NG 96).[52]

The settlement of Caterina's inheritance and dowry and the definitive acquisition of these masterpieces seem to have prompted the creation in the Colonna palace of a new room attached to the Sala degli Scrigni, which forms the north end of the great gallery. This new room was known as the Stanza de' Quadri (now the Sala dell'Apoteosi di Martino V). The ceiling was painted by Benedetto Luti, Pompeo Batoni and Pietro Bianchi, and the old masters were doubtless all in place, probably newly framed, by 4 October 1739, when Pope Benedict XIV visited the palace.[53] From a list compiled soon afterwards we know that *Ganymede* as well as Titian's *Venus and Adonis* were hung here, together with Raphael's Colonna altarpiece (now in the Metropolitan Museum of Art, New York), which had been moved from the Grand Gallery, where it is hard to believe that it would have been happily accommodated. The twenty-five paintings in this room – approximately half of them from the sixteenth century and half from the seventeenth, half of sacred subjects and half of profane ones – were still there, in the same positions, when Caterina and Fabrizio's grandson, Prince Filippo III Colonna (1760–1818), inherited in 1779, as we can ascertain from the official house catalogue of 1783. This was one of the first catalogues to be printed for a Roman palace,[54] a fact that surely reflects the degree to which it was accessible to visitors. Many guidebooks and travel books testify that both *Ganymede* and *Venus and Adonis* merited the adjective 'celebri' that was assigned them in the catalogue.[55]

Prints

The two engravings made of NG 32 mark the two periods when the painting was at the peak of its prestige, as traced in the previous section: its display in the Salviati palace in Rome, when it received Bellori's approbation, and its prominent position in a superb new room of the Colonna Palace, when it was regarded as a canonical masterpiece. Gérard Audran (1640–1703) etched the painting as an octagon, presumably during his stay in Rome in 1666–72, or at least using drawings made in those years. His print, in reverse, inscribed as after 'Titien', is dedicated to 'Monsieur des Cotteault ord.re. de la Chambre de la Musique du Roy'.[56] Domenico Cunego (1727–1803) made an engraving of the painting in 1770, also in reverse, as a rectangle, for Gavin Hamilton's *Schola Italica* of 1771, a publication of forty engravings that was intended as a selection of the finest Italian paintings, exemplary alike for the young artist and the gentleman of taste.[57] The painting was also engraved by J. Outrim for Jones's *National Gallery*.[58]

From Rome to London

In 1797 the French armies extorted massive tribute from the papacy. In 1798 they entered Rome, and the pope was obliged to exact compulsory loans from the richest Roman residents. Prince Filippo sold half a dozen paintings in this year, apparently to a certain 'Giovanni de' Rossi',[59] who may have been acting partly as an agent of the King of Naples. In the winter of 1800–1 *Ganymede* and *Venus and Adonis*, which were among the paintings sold by the Prince, were on display at 20 Lower Brook Street, London, formerly the rooms of the painter and dealer Henry Tresham, which had been taken by Alexander Day to exhibit twenty-nine major works removed from Rome. The paintings did not belong to Day, a miniaturist and copyist who had recently discovered his true talent as an art dealer. Some of the paintings he exhibited had been bought by the young John Rushout (created 2nd Baron Northwick in 1800) with money borrowed from the Roman banker Torlonia through Day's agency and that of Pietro Camuccini, with whom Day often acted in partnership.[60] There can seldom have been so many masterpieces of Italian painting clustered together in a dealer's gallery. Among them were Raphael's *Saint Catherine* (NG 168) and *Garvagh Madonna* (NG 744), Annibale Carracci's *Domine, Quo Vadis?* (NG 9), and Luini's *Christ among the Doctors* (NG 18).[61]

On 6 May John Julius Angerstein, one of the richest collectors in London, bought NG 32 from this sale, together with *Venus and Adonis* (NG 34) and a landscape by Gaspard Dughet, *Landscape with Abraham and Isaac approaching the Place of Sacrifice* (NG 31).[62] On 4 March Joseph Farington recorded in his diary that these three paintings – which he seems to have considered the most notable in the exhibition – were valued at 4,000 guineas (£4,200) each,[63] but it is not to be supposed that Angerstein paid quite so much. Buchanan claimed that the price was 6,000 guineas (£6,300) for the three, and added that, 'considering the high importance of the pictures themselves, being all capital and celebrated performances of these masters, they may be regarded as having been sold much under their real value'.[64] William Seguier, shortly after Angerstein's death, valued the three paintings at £8,000, with NG 32 as the least valuable (at £2,000).[65]

Since NG 32 is now known not to be by Titian, *Venus and Adonis* is considered a workshop replica and the Dughet is little loved, it is worth observing that in the early nineteenth century the paintings were praised in the highest terms by the leading experts both before and, for a while, after they were purchased for the National Gallery in 1824, and Benjamin West, although he questioned the condition of NG 32 (as noted above), had no doubt that it was by Titian. For Abraham Hume it was 'a picture done in Titian's best time, in which he united the richest tints with grandeur of design', and he added that 'the Eagle is fine beyond description'.[66]

Provenance

See above. Almost certainly the painting commissioned for the belvedere of the Casa Assonica, Padua, whence it had apparently been removed by 1648. Acquired in that year, or soon after, by Duke Jacopo Salviati and recorded in his Roman palace by 1664. By descent to Caterina Salviati, who married Prince Fabrizio Colonna in 1717, and legally accepted as part of her dowry in 1732. Sold by her grandson Prince Filippo II Colonna in 1798 to, or through, Giovanni de' Rossi. With Alexander Day and his associates by 1800 and sold by Day in May 1801 to John Julius Angerstein. After Angerstein's death, together with most of his collection, NG 32 was purchased from his executors for the National Gallery in 1824.

Framing and Display

The painting is currently displayed in a relatively simple gilt frame with large egg-and-dart ornament concealed at the corners by an acanthus leaf (fig. 5). It looks like a Roman frame of *c*.1800 and was perhaps Day's. NG 32 seems to have the same frame in a wood engraving of the new gallery (occupying the space now consumed by the main staircase hall) that was featured in the *Illustrated London News* in 1861. Wornum, however, noted, 'Titian's Ganymede frame altered & regilt' on 3 October 1863.[67]

It is reasonable to presume that the painting was framed as a rectangle after it had been given painted additions; that is certainly the format in which it was engraved by Cunego in 1770. However, in the same year Volkmann described the painting as octagonal, as did Ottley in 1832,[68] perhaps because they were familiar with Audran's earlier engraving or because the canvas joins were so apparent, but perhaps also because the frame was fitted with spandrels.

In the inventory of the Salviati palace in Rome made in 1704 (recording an arrangement that may well have been made in previous decades) *Ganymede*'s frame is described as an octagon, 'dorata et intagliata' ('gilded and carved'). Titian's *Venus and Adonis*, listed next,[69] was in a frame with a 'fondo negro et intagli dorati', that is, a black frame with the carved ornament gilded, which suggests that, although they were very likely hung near, or even next to, each other, they were

Fig. 5 Corner of frame of *c.*1800 currently on NG 32.

Fig. 6 Corner of frame of *c.*1739, of a type formerly on NG 32 and NG 34.

not displayed as a pair. In the Stanza de' Quadri of Palazzo Colonna the two paintings were treated as pendants, *Venus and Adonis* 'nell'angolo' and *Ganymede* 'nell'altro angolo' – that is, at either end of the short wall facing the garden. Hanging below the two paintings were Guercino's *Guardian Angel* and Parmigianino's *Raising of Lazarus* (now attributed to Salviati), both still in the collection. The two 'Titians' are given the same measurements (7½ *palmi* high and 8 *palmi* wide), as are the other two pictures ('di circa 4 per alto' and 'di 4 per alto').[70] They would almost certainly have had frames of the same or a very similar pattern, such as can be seen today on many paintings still in Palazzo Colonna (eleven of them still in the same room) and on some paintings known to have come from this collection (fig. 6). Furthermore, because the modern ceiling paintings in this room were in oil on canvas they are likely to have been planned with some reference to the old masters which hung below. Pompeo Batoni's *Peace embracing Justice* and *Tranquillity*, placed above the *Rape of Ganymede* and the *Venus and Adonis*, are not only similar in size but *Peace embracing Justice* (fig. 7), with its diagonal composition, flying drapery and nude back, borrows elements from both the so-called Titians.[71]

Some sort of physical relationship with the *Venus and Adonis* was probably continued in the National Gallery, but the great height at which NG 32 was hung in the 'New Gallery' reflected an awareness by 1861 that it had originally adorned a ceiling (Eastlake indeed knew of its probable provenance) and perhaps also a lower estimate of its quality.

For more than half a century this once-celebrated work has been displayed in the National Gallery's Lower Floor Gallery.

Appendix 1

EASTLAKE AND THE MAZZA FROM S. SILVESTRO

Reporting to the National Gallery Trustees on 10 November 1856 concerning his recent travels in Italy, Eastlake mentioned the possibility of acquiring paintings, not for the National Gallery but to exchange for paintings in Italian public collections. 'A case of this kind is likely soon to occur in Venice. A dealer is in possession of a large work by Damiano Mazza, a scholar of Titian, as yet unrepresented in the Venetian gallery' – we know from Mündler that this is a reference to Mazza's S. Silvestro altarpiece, which was in the hands of Angelo Toffoli, to whom the church of S. Silvestro had consigned for sale Veronese's *Adoration of the Kings* – 'and the superintendents of that gallery are desirous of obtaining it by exchange.' Eastlake went on to inform the Trustees that he had 'already made arrangements, so that if the money equivalent demanded for the Damiano Mazza should be a fair price for a good picture, by a better painter, in the Venetian collection, the picture to be taken in exchange may be transferred to London for the National Gallery. In that case the picture from the Venetian Gallery would be nominally the work purchased for the sum agreed on, and there would be no difficulty about the exportation.'[72] This ingenious scheme came to nothing, probably because, with the purchase of Veronese's *Family of Darius* in the following year, the National

Gallery had begun to acquire a reputation for predatory behaviour, rendering unwelcome any interference by it in the Accademia's affairs. In due course Toffoli found another buyer (very likely Eastlake's rival, John Charles Robinson).[73]

Appendix 2

THE COLLECTING OF DUKE JACOPO SALVIATI (1607–1672)

The collector Duke Jacopo Salviati came from a wealthy Florentine family. He seems to have decided to move from Florence to Rome in May 1634 soon after his wife, Veronica Cibo, taunted him with the decapitated head of his mistress.[74] He moved much of his collection with him. Frescoes were painted for his Roman palace by Giovanni Maria Morandi between 1635 and 1637. He also collected old masters, sometimes on the advice of the artists (notably Francesco Furini[75]) whom he patronised. He probably acquired Mazza's painting around 1648. Silos in his *Pinacoteca*, an anthology of epigrams on celebrated paintings in Rome that was published in 1673, included 36 epigrams devoted to pictures in the Salviati palace and fourteen of these were by Venetians. This was not a reaction against Florentine taste – indeed, no collectors in Europe at this date were keener collectors of the great Venetians than the Florentines. The Duke himself had no aversion to Florentine painting of the sixteenth century since he was careful to have a number of his Florentine masterpieces transferred to Rome; nor was he the first member of his family to own such paintings. Cardinal Antonio-Maria Salviati (1537–1602) had owned a *Mourning Virgin* by Titian, and a Titian *Magdalen* had adorned the 'appartamento nuovo' of Jacopo di Alamanno Salviati (1537–1586) by 1583.[76] But the contrasts between the Venetian and Florentine paintings were especially dramatic in the Salviati palace in Rome, as if to illustrate the steadily increasing literature defining the differences between the great schools of Italian art.

Fig. 7 Pompeo Batoni, *Peace embracing Justice, c.*1737–9. Oil on canvas, 114.3 × 114.3 cm. Rome, Palazzo Colonna, Sala dell'Apoteosi di Martino V.

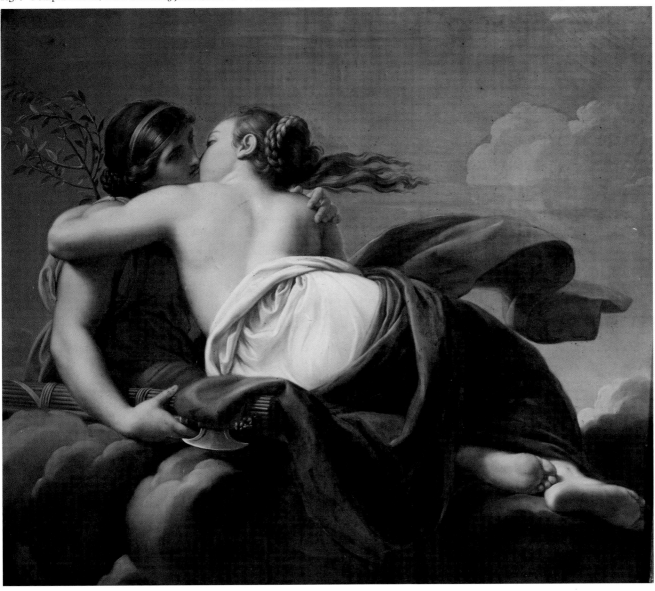

NOTES

1. Smalt was identified by EDX analysis in the scanning electron microscope. The presence of Prussian blue was confirmed by FTIR microscopy. Information from Marika Spring.

2. The manuscript catalogue of 1855 records that lining had taken place at an 'uncertain date'. See also *Report of the Select Committee*, in 1853, appendix no. IV, p. 747.

3. Ramdohr 1787, p. 72. Maratta's restorations of Raphael's frescoes had often involved the overpainting of skies with a vivid blue, which came to seem insensitive. It is unlikely that Ramdohr had any very precise information concerning Maratta's work on this painting. It is not likely that he used Prussian blue, which is not recorded in any oil painting before Watteau's *Gilles* of *c.*1718/19. See Kirby 1993.

4. Farington 1978–98, IV, 1979, p. 1548.

5. [Bellori] 1664, p. 49; Bellori 1976, pp. 108–9. See also Silos 1673, pp. 142–3, Epigram CCLIX, and Silos 1979, pp. 135 and 359.

6. Wornum 1854, p. 189; Ridolfi 1914, p. 224.

7. Burton 1887, p. 187 (nos 3 and 224 were downgraded as well).

8. Addison 1905, p. 119 ('later critics are inclined to claim for Tintoretto the octagon panel [*sic*], No. 32'). Wethey also thought of Tintoretto – 1969, p. 212, cat. X-16.

9. Gould 1959, p. 55; repeated Gould 1975, p. 139.

10. Crowe and Cavalcaselle 1877, II, p. 459.

11. Hadeln 1913, p. 252.

12. Gould 1959, p. 56; 1975, p. 140.

13. Mancini 1995, pp. 148–9, note 20.

14. Rearick 1996, pp. 57–62.

15. Ridolfi 1914, p. 224.

16. Ovid, *Metamorphoses*, X, lines 155–61.

17. Bober and Rubinstein 1986, p. 53, no. 5, plate 5. See also Kempter 1980 for other antique representations of Ganymede.

18. Venice, Museo Archeologico, inv. no. 145.

19. Kunsthistorisches Museum, Vienna, no. 276; Ekserdjian 1997, pp. 282–4, fig. 290.

20. By Sebastiano del Piombo in a letter to Michelangelo of 7 July 1533. Sebastiano clearly knew of Michelangelo's drawing of the subject which he had presented earlier in that year to Tommaso Cavalieri. For a copy of this drawing at Windsor Castle see Gere 1975, pp. 104–5, no. 124, and for a preliminary study see Hirst 1988, p. 112.

21. Bacou and Viatte 1974, no. 76. Earlier, Peruzzi had depicted the subject in the frescoed vault of the Sala di Galatea in the Farnesina (*c.*1511–12) – see Kempter 1980, p. 199, no. 180, fig. 28. However, Peruzzi treated the story as one of many astrological illustrations.

22. Monducci and Pirondini 1987, pp. 80–4, nos 36–50 (entry by Nova Clerici Bagozzi).

23. Berzaghi 1998, pp. 53–61, especially p. 59, fig. 6, for the drawing in the Musée Carpentier, Le Puy, which is preparatory for the lozenge-shaped fresco and is unusual in showing both Jove and the eagle with Ganymede.

24. Rearick 1996, p. 57.

25. For example, in Sodoma's project (for which see note 21). The two subjects are perhaps associated in Michelangelo's presentation drawings.

26. Alciati 1551, p. 6; Morangiu 2002, pp. 33, 64, 65, illustrates a number of plates of Ganymede that were made for Alciati's editions of 1531, 1534 and 1549; see Bocchi 1574, ff. CLXVIII verso and CLXIX recto. Such interpretations derive from Landino's commentaries on Dante.

27. This is argued by Lorandi 1996 with reference to the choice of the Rape of Ganymede for the sculptured bedroom alcove carved for Gerolamo Sottocasa by the Fantoni workshop on the occasion of his marriage in 1785 to Elisabetta Lupi.

28. For Giulio's painting (in oil on plaster) and for the decoration of the Sala delle Aquile generally, see Hartt 1981, pp. 123–6. Other examples of Giulio's influence may be found in Paolo Farinati's octagonal paintings originally made for the loggia of Palazzo Murari Bra in Verona of 1588 but later altered in shape and installed in the Villa Giovanelli at Noventa Padovana, for which see Ericani 1996, pp. 69–86, especially plates IV and V; also, Ericani 2001, *passim*.

29. Lomazzo 1590, p. 53.

30. The bronze in the Bayerisches Nationalmuseum, Munich, is among the best. Weihrauch 1967, pp. 364–5, associated this figure with the bronzes then attributed to the 'Master of the Genre Figures'. These are now acknowledged as mostly by Barthélemy Prieur, and the Cupid has recently been claimed as his invention (for example, by Krahn 1995, p. 432, no. 147), although Candido (Elias de Witte) has also been proposed (see Sotheby's, London, 2 November 2001, entry for lot 55). No attribution is entirely convincing, but then no single surviving example of the bronze is executed with a skill to match the remarkable invention – in other words, nothing very close to the original model seems to survive. That the figure was known in Venice in the 1570s need not exclude the young Prieur as its inventor. Over two dozen casts of the sculpture are known to me, nine of them in the collection of Michael Hall.

31. Ridolfi 1914, p. 224.

32. Mancini 1995, p. 141 (for studies in Padua); Cicogna, III, 1830, p. 152.

33. Ludwig 1903, p. 115 (for 1550), and Pasero 1952, p. 58 and p. 76, n. 46.

34. Charles Hope suggests Bartoli or Verdizotti.

35. Vasari (Milanesi), VII, p. 456. The *Rest on the Flight (Riposo)* is evidently the painting now in the Escorial (Wethey 1969, no. 91).

36. Ridolfi 1914, p. 194.

37. Dolce 1562, II, sig. xxiir–xxiiir.

38. Mancini 1995, p. 141.

39. Mancini 1995, p. 141, notes that the building work was valued for tax purposes in 1557.

40. Assonica's family came from Bergamo, which may explain why he is recorded as the owner of a portrait by Moroni. Ridolfi 1914, p. 148.

41. Mündler 1985, p. 141.

42. Eastlake MS 1857 (iii), inside cover – 'said to be in the house of the notaio Meneghini at Padua – on a ceiling & with a gold ground. He is said to have the documents proving it to be the picture mentioned by Ridolfi.'

43. Rearick 1996, pp. 57–62.

44. Gilchrist 1854, pp. 79 and 82; exhibited at York in 1911; sold Christie's, London, 12 March 1928, lot 139a. Gould 1975, p. 140, also cites a 'sketch copy' at Windsor (6741).

45. Hurtubise 1985, pp. 464–5.

46. [Bellori] 1664, p. 49 (1665 according to end notes).

47. Pisa, Archivio Salviati, Filza 73, Tomo 2, inserto 6 (loan to Scuola Normale, Pisa) – transcript in Provenance Index of Getty Research Institute, P1–34. Information sent to the National Gallery on 31 January 1986 by Burton Fredericksen.

48. Costamagna 2001, no. 79. There was a total of 536 paintings in the Palazzo alla Lungara.

49. Safarik 1996, p. 253.

50. Costamagna 2001.

51. Safarik 1996, p. 606.

52. For the *Ecce Homo* see Safarik.

53. Safarik 1996, p. 599.

54. Anon. 1783. See also Safarik 1996, pp. 628–84.

55. For example, Vasi 1797, p. 277 ('fort beau Rapte de Ganimede').

56. Catelli Isola 1977, p. 61, nos 121 and 122. Hume 1829, p. xxxvi.

57. Hamilton 1771, plate 22. Hume 1829, p. XXXVII, also mentions an aquatint by the Abbé de Saint-Non (1727–1791).

58. Jones and Co., *c.*1835, no. 90.

59. According to annotations to a copy of Anon. 1783, formerly in the possession of Ellis Waterhouse. Very likely he was Giovanni Gherardo de Rossi, the biographer of Angelica Kauffman.

60. Bradbury and Penny 2002, pp. 488–90.

61. Not all masterpieces, however: NG 73 (Ferrarese School) and NG 1173 (Follower of Giorgione) were also included.

62. Wine 2001, pp. 143–6.

63. Farington 1978–98, IV, 1979, p. 1511, and p. 1548, for date of sale. Farington noted that Day was exhibiting 'at the room late Vanderguchts'.

64. Buchanan 1824, II, p. 4.

65. Lloyd 1966, pp. 377–8; Seguier MS valuation.

66. Hume 1829, p. 63. See also Ottley 1832, p. 12, no. v.

67. *Illustrated London News*, 15 June 1861, p. 547; for Wornum, NG 32/67.

68. Volkman 1770, II, p. 282; Ottley 1832, p. 12, no. v.

69. Costamagna 2001.

70. Anon 1783, pp. 20–21 (Safarik 1996, p. 635), nos 116, 120, 121, 125.

71. Clark 1985, pp. 216–17, nos 25–6 and figs 28 and 29.

72. NG 1/4 (Minutes of the Trustees, IV), p. 54. A similar arrangement was discussed as a justification for purchasing more works by Crivelli than seem to have been required. See Gennari Santori 1998, pp. 296–7 and 310. See also Mündler 1985, p. 81,

15 November 1855, which suggests that Selvatico may have first had the idea, and p. 138, 3 November 1856, where the Mazza is specified.

73. Robinson purchased for Cook, in whose collection the altarpiece seems to have been (see p. 89, note 6). For the formation of Cook's collection see Danziger 2004.

74. Hurtubise 1985, pp. 469–70.

75. Corti 1971.

76. Costamagna 2001, note 162, for the *Virgin*, and Fazzini 1993, p. 210, for the *Magdalen*.

Fig. 8 Detail of NG 32.

Palma Giovane

*c.*1548–1628

Palma Giovane, known to Italians as Palma il Giovane, and sometimes in previous centuries in English as 'Young Palma', was born Jacopo Negretto and signed his work 'Jacobus Palma'. He was the son of a minor painter, Antonio Negretto, who was the nephew of the famous Palma now known as Palma Vecchio. Upon Palma Vecchio's death his studio had been taken over by his student Bonifazio de' Pitati (1487–1553), a painter of great talent, who, however, gradually ceased to compete with the major artists in Venice and settled for producing routine works for undiscriminating, often institutional, customers – a business in which he was efficiently assisted and then succeeded by Palma Giovane's father.[1]

Palma was born in Venice in 1544, according to Ridolfi; in about 1550, according to Borghini; later still, if Baglione is to be trusted; and, in the view of modern scholars, in about 1548.[2] The ability he displayed in copying Titian's *Martyrdom of Saint Lawrence* attracted the notice of the Duke of Urbino, Guidobaldo della Rovere, on a visit to Venice in 1564. The Duke sent Palma to Rome, where he was living by May 1567. He received commissions for paintings there (none of which survives) and when he returned to Venice in about 1574 his prominence was soon established by his painting for the ceiling of the Sala del Maggior Consiglio in the Doge's Palace.[3] This proved that Palma had absorbed some of the Roman manner of painting, and in particular the style of Federico Zuccaro, but at the same time he set out to establish his credentials as a Venetian painter and promoted himself

as Titian's heir, acquiring the painter's late *Pietà* and completing it as a monument to him.[4] He was also closely associated with, and owed much to the support of, the city's principal sculptor, Alessandro Vittoria.

By 1590 Palma was the leading painter in Venice, commanding higher prices and securing more prestigious commissions than either Tintoretto's son Domenico or the 'heirs' of Veronese. His tomb, erected in 1621 over the door into the sacristy of SS. Giovanni e Paolo, consists of three shell-lined niches, each containing a bust: that of Titian by Vittoria, flanked by Palma's own bust and that of his great-uncle, with a painted background of angels with trumpets and branches of palm.[5] It is a variant on the triple tombs that were then popular with great patrician families, in which a father, son and uncle are commemorated (as in the Morosini monument discussed on pp. 178–82, and see fig. 2, p. 180). He died in 1628.

A succession of major commissions from state officials, confraternities (fig. 1), churches and wealthy families for walls and ceilings and altarpieces in both Venice and the Veneto fell to Palma. His work is represented in more than forty churches in Venice. But he also painted gallery pictures, perhaps especially in his later years, and some of these were admired by the Holy Roman Emperor in Prague and by the poet Marino in Rome – indeed, together with Cigoli and Barocci, Palma is the painter who is most prominent in Marino's celebrated poetic gallery, the *Galleria*.[6] Little survives

Fig. 1 Palma Giovane, *The Washing of the Feet*, *c.*1591. Oil on canvas, 163 × 378 cm. Venice, S. Giovanni in Bragora.

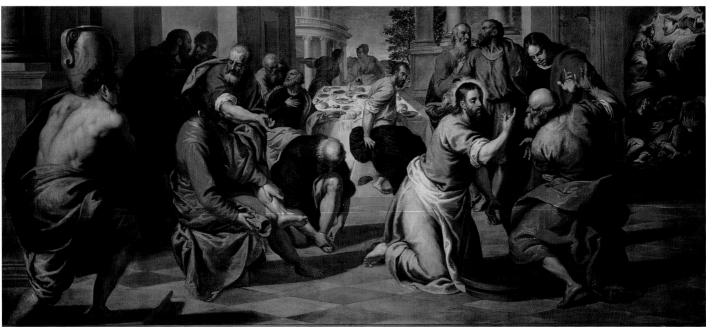

of his work in fresco, apart from the dome of the cathedral of Salò near Brescia,[7] but his experience in this medium, and also his designs for mosaics in the basilica of S. Marco, may have affected the style of his canvas paintings, which are, typically, broadly painted, loose in structure and perfunctory in the definition of setting and accessories, with a palette reminiscent of Titian but with much less textural interest and variety of focus. His style evolved relatively little.

Palma's success depended upon a conscious synthesis of his great predecessors who had become old masters – something also true of the so-called Bolognese eclectics active in Rome in the same period. The influence of Titian is combined with that of Tintoretto. The confidence with which he covered huge areas (such as the ceiling of the church of S. Giuliano[8]) is reminiscent of Tintoretto, and he shared that painter's aversion to placing any figure or form parallel to the picture plane and to using stable verticals and horizontals in his compositions. His figures recline, fall and fly, and are fluently foreshortened, but without Tintoretto's rough and rapid handling and spectacular effects of lighting, and never with his architectural settings and compelling orthogonals.[9]

Despite Palma's considerable talent for portraiture he allowed little that was idiosyncratic in the features or dress of his heroic actors, and only a limited range of facial expression. He was never original or eccentric in his treatment of religious subjects, as Tintoretto had sometimes been, or inclined, as Veronese had been, to embellish sacred narrative with gratuitous ornamental accessories and exotic extras. Occasionally he worked on a small scale on panel and slate, and these works tend to be especially beautiful.

His large œuvre has been admirably catalogued and his achievement judiciously reassessed in Stefania Mason's monograph of 1984.[10] Her catalogue for the exhibition held in Venice in 1990 to celebrate the acquisition of an important group of the artist's drawings included a carefully selected group of paintings that were so varied and vital in handling and character as to counteract the impression of monotony received in the public buildings and churches of Venice.[11] Few of Palma's paintings are in British public collections, but one of his finest portraits is in Birmingham's Museum and Art Gallery,[12] and the two small paintings (made for insertion in a eucharistic tabernacle) which are now in the Fitzwilliam Museum, Cambridge, are of exceptional beauty.[13]

Palma was a versatile and prolific draughtsman and his drawings are well represented in the Ashmolean Museum, which owns a quarto sketchbook of fifty pages by him, as well as other works,[14] and the Victoria and Albert Museum, and above all the British Museum, which owns the only bound album of his drawings to have survived.[15]

NOTES TO THE BIOGRAPHY

1. Cottrell 2002.

2. Fisher 1977, pp. 43–4, reviews Borghini 1730, p. 458, Baglione 1733, p. 173, and Ridolfi 1918, p. 172.

3. Mason Rinaldi 1984, pp. 140–1, nos 528 and 529, figs 12 and 16.

4. Ibid., pp. 135–6, no. 504.

5. Fehl 1992, pp. 320–2.

6. Hochman 1992, pp. 57, 349–50.

7. Mason Rinaldi 1984, p. 108, no. 259, fig. 367.

8. Ibid., p. 135, no. 498, fig. 103.

9. Longhi shrewdly but severely noted that he reduced Tintoretto's wild music to academic formulae ('sistemare in chiaroscuro accademico il contrappunto romantico di Tintoretto'). Longhi 1925, p. 46; 1967, I, p. 15.

10. Mason Rinaldi 1984.

11. Ibid., 1990.

12. Ibid., 1984, p. 76, no. 30.

13. Ibid., pp. 78–9, nos 47–8, figs 50–1.

14. Parker 1972, pp. 215–17, no. 432.

15. Shelfmark 197*d.i. The volume was published by Mason Rinaldi in 1973. It came from the collection of Antonio Maria Zanetti the elder. Zanetti's other volume is the one acquired (unbound) by the Museo Correr in 1986, which was published by Mason Rinaldi in 1990.

Mars and Venus

*c.*1590
Oil on canvas, 132.7 × 168.4 cm

Support
The measurements given above are those of the stretcher. The maximum dimensions of the original canvas, the entire area of which is painted, are 131.5 × 166 cm. This canvas, of a fairly coarse tabby weave, is paste-lined on to a canvas of a medium tabby weave. Tacking holes are visible on the left edge, and there may be a few on the other three edges. Cusping is visible on all four edges, although it is most obvious on the left edge. The painting has not therefore been much reduced. The modern stretcher is of stained pine with one horizontal and two vertical crossbars.

Materials and Technique
There is a ground which is composed of true gesso (calcium sulphate dihydrate) that has darkened on account of its glue binder. There is no *imprimitura*. Red lake was used as a glaze on the red curtain. The drape on the bed is painted with mineral azurite blue, somewhat green in tone and mixed with lead white, which is glazed with ultramarine. This glaze has blanched and discoloured to a flat, dirty grey through which the layer beneath occasionally shines. Ultramarine was used, but perhaps of an inferior quality, and certainly with the addition of much colourless mineral matter.[1]

The burgundy colour of the curtain shows through Mars' dark hair. It may be that the position of his head was altered and in order to achieve a better contrast the artist added highlights to the curtain which were then glazed with a lake pigment that has faded and been abraded. Other revisions to the original design may be detected. If the curtain on the far right is viewed in a raking light the pattern of impasto suggests that originally the folds were arranged differently. The knuckles of Mars' left hand and the highest plume of his helmet seem also to have been painted over something else.

Conservation
There is no record of any treatment of the painting between 1838, when it was acquired, and October 1940, when it was hit by 'bomb splinters'. In December 1940 it was repaired, patched and strip-lined. It was relined with paste in 1967. It was cleaned and repaired between March and June 1979. The varnish removed on that occasion was described as 'darkened and deeply engrained'. Some of it probably pre-dated acquisition.

Condition
There are a few small losses of paint where the canvas was damaged by wartime 'bomb splinters' (see above). The worst loss is on the right shoulder of Venus. Other significant areas of loss include the goddess's left ankle and right thigh and across Mars' cheek and below his left bicep. A few areas are slightly abraded and darkened. It is likely, for instance, that the thinly painted quiver worn by Cupid was originally easier to see. As described above, the blue of the drape on the bed has deteriorated.

Subject and Treatment
The painting represents the adulterous coupling of Venus, the wife of Vulcan, with Mars, the god of war. Venus is the more active of the two lovers and her son Cupid helps to remove the god's footwear. His right hand is easily misunderstood as part of Mars' leg so that he appears to be undoing the thongs with his teeth. The subject was described by Richard Symonds in 1652 as 'A Venus whole body on a bed & Mars a fat red colord knave wch she pulls down & a Cupid pulls off his buskins'.[2] This conveys the bawdy comedy as well as the erotic directness of the picture. It has none of the poetic beauty of Titian's *Venus and Adonis*, from which (as has often been observed) the composition derives,[3] or of Veronese's *Venus and Mars*, which is perhaps recalled by Cupid's role.[4] The treatment also seems hard to reconcile with an allegorical interpretation of the episode (Love conquering War). The way that the bed curtains are drawn back and wrapped around the richly carved posts is perhaps, as Stefania Mason proposes, a 'scherzo', anticipating the lovers' imminent exposure to the merriment of their fellow gods.[5] The billing doves are attributes of Venus. The schematic manner in which they are painted suggests that the painting was never intended to be displayed where it would be closely inspected. The figures are conceived as a sequence of swelling, sometimes spherical, forms which Longhi likened to the components of Sansovinesque balusters so popular in the architecture of Venice.[6] In this case we see a couple of balusters which have tumbled over.

Attribution
The painting was attributed to 'Palma Giovene' when it was in the collection of the 10th Earl of Northumberland in the mid-seventeenth century.[7] The Earl's curator, Symon Stone, would probably have known that it had been acquired as such. He identified it again in an inventory made on 30 July 1671 as by 'young Palma'.[8] Thereafter the attribution was forgotten, and in 1838 the painting was donated to the National Gallery as by 'Tintoretto'.[9] The painting was not catalogued during the nineteenth century but was 'ascribed' to Palma Giovane in 1929[10] and given to him without qualification by Cecil Gould in 1959.[11] This attribution was accepted by Stefania Mason in her catalogue raisonné[12] and does not seem ever to have been disputed in recent art-historical literature.

Date and Related Works
As Gould observed, the painting is close in character, and of course connected in its subject, to the *Venus and Cupid at the Forge of Vulcan* (fig. 1), a signed painting by Palma in Kassel, which is similar in size (114.8 × 167.3 cm) and in palette – but superior in preservation of the blue cover beside the red curtains and the white linen.[13] There is a larger painting of Venus and Mars by Palma (143 × 205 cm) in the J. Paul Getty

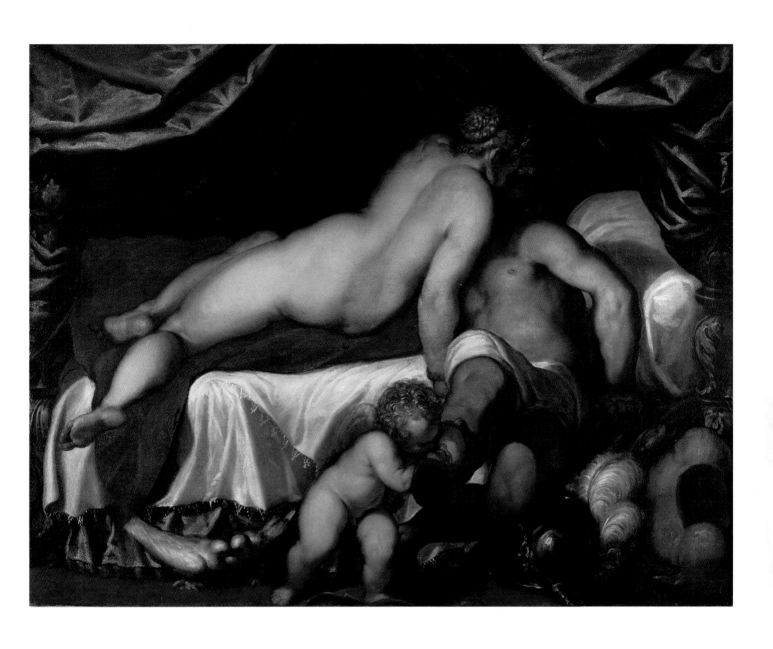

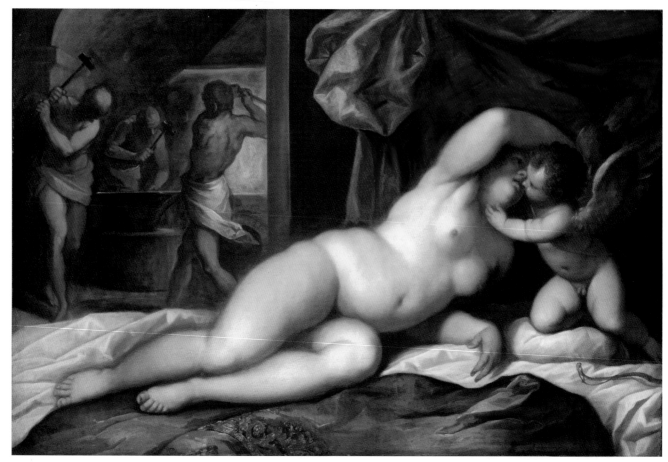

Fig. 1 Palma Giovane, *Venus and Cupid at the Forge of Vulcan, c.*1590. Oil on canvas, 114.8 × 167.3 cm. Kassel, Staatliche Museen.

Museum, apparently dated 'MDC' for 1600.[14] In 1619 the poet Marino requested from Palma a painting of Mars leaving his armour in the care of a nymph as he turns to Venus, who waits for him, naked on her bed. He had given a large canvas of this subject to one of the Doria family and now wanted a smaller version on copper.[15] What may be a preparatory drawing for NG 1866 or for another painting of Mars and Venus is in the British Museum album, mounted on the same page as one for the Kassel painting (fig. 2).[16]

Stella Mary Pearce (Newton) observed that the dressing of Venus' hair, with large raised ringlets at the forehead and a comparatively simple knot at the back of the head, suggests a date in the late 1580s, not before 1585.[17] However, such ringlets are still found in Palma's *Christ and the Adulteress*, signed and dated 1599,[18] so a later date is surely not impossible.

Provenance

Recorded in the collection of Algernon Percy, 10th Earl of Northumberland (1602–1668), in the gallery of his house in London in 1652.[19] The Earl had moved his paintings into Suffolk House from York House (next door) in 1647. The picture may perhaps have been among those from the Duke of Buckingham's collection which had hung in York House and which the Earl acquired in an arrangement made with Parliament (which had confiscated the Duke's property),

but the Earl acquired paintings from other sources too.[20] Inherited by the 11th Earl (Josceline Percy, 1644–1670), it is recorded again, after his death, in an inventory of the pictures at Petworth House in Sussex, the family's principal country seat, on 30 July 1671, valued at £15.[21] It was then the property of the 11th Earl's daughter and her husband, the 6th Duke of Somerset (1662–1748), and, briefly, of the 7th Duke of Somerset, who died in 1750. It is likely to have been returned to Suffolk House, by then known as Northumberland House, before 1750 when, as explained on p. 221, the paintings at Petworth, together with Petworth itself, became the property of the 7th Duke's nephew, the 2nd Earl of Egremont. The paintings in Northumberland House were inherited by the 7th Duke's daughter, who became the first Duchess of Northumberland. Her grandson, the 3rd Duke, presented the painting to the National Gallery.

Acquisition by the National Gallery

Hugh Percy, the 3rd Duke of Northumberland (1785–1847), wrote to the Duke of Sutherland (chairman of the National Gallery's recently formed Board of Trustees) on 2 June 1838: 'My dear Lord Duke / I am anxious to offer the following six paintings as a Present to the National Gallery. 1. The Plague of Ashtaroth [*sic*] by N. Poussin / 2. Mars & Venus by Tintoret / 3. The Holy Family by Jordaens / 4. A Capuchin Friar by Rembrandt / 5. Person devoured by Dragons by Spranger /

6. Jupiter and Leda after Michelangelo / The last mentioned though valuable to Artists is not suited for public exhibition. / On the merits of these paintings I shall not offer any comment as they have lately been inspected by Mr Seguier who can best supply every information to the Trustees.'[22]

The letter is endorsed to the effect that it was received on 6 June and the pictures were accepted, and thanks transmitted to 'His Grace', on the same day. It is not true, as has been repeatedly claimed, that the Duke considered the 'Tintoret' to be in the same category as the *Leda and the Swan* after Michelangelo (NG 1868).[23] However, the Trustees regarded it and the *Leda*, and also the violent Spranger (now given to Cornelis van Haarlem, NG 1893), as unsuitable for public display, therefore these paintings were not numbered until much later in the century. The Poussin (NG 165, now regarded as a copy by Angelo Caroselli[24]), the Jordaens (NG 164[25]) and the very damaged Rembrandt (NG 166[26]) were placed in the galleries.

The donation is surprising, not least because at least one of the paintings, the so-called Poussin, had been bought quite recently by the Duke's father. It is not unduly cynical to suppose that the Duke wanted to get rid of pictures that he considered too explicitly erotic or repellent or gloomy for the comfort of his family home. Of the paintings donated, only the Jordaens does not obviously belong to one or another of these categories. If it seems peculiar that he thought of the National Gallery as a more suitable place for them, we should recall that the Gallery was then considered to be a vital resource for art students and that one part of the new building by Wilkins (only a couple of hundred yards from Northumberland House) was occupied by the Royal Academy. The Duke was not a great collector and art lover like his brother Algernon, the 4th Duke (1792–1865), but he was a friend of learning and the arts who was made a Trustee of the British Museum and High Steward of Cambridge University in 1834, and was also vice-president of the Society of Arts.

Even after being properly registered, NG 1866 seems to have been considered in a distinct and perhaps disreputable

Fig. 2 Palma Giovane, Preparatory drawing for a painting of Mars and Venus. Pen and brown ink on paper, 22.5 × 27.7 cm (including border). London, The British Museum.

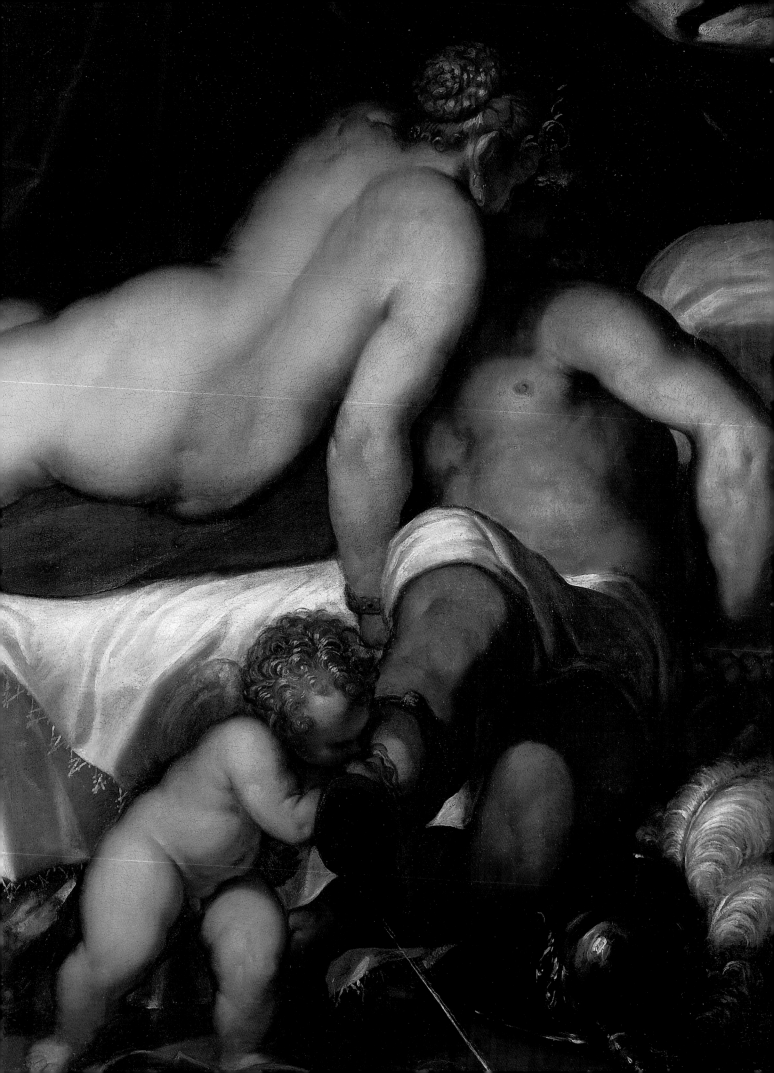

category, because it was one of a very few paintings that were not transported to safety in North Wales shortly before the outbreak of the Second World War.

Exhibitions

London 1979, National Gallery; Venice 1984.

Frame

The painting is currently displayed in a gilt frame with reverse mouldings with foliate corners in press-moulded composition and panels decorated with cross-hatching – a poor imitation, probably of the mid-twentieth century, of a seventeeth-century Italian style.

NOTES

1. Report of the National Gallery Scientific Department dated 28 January 1994.

2. Wood 1994, p. 303, Appendix 2, no. 28, citing British Library, Egerton MSS 1636, fol. 92v.

3. For Titian see pp. 274–88. The comparison was perhaps first made in print by Potterton (1979, p. 49).

4. For the Veronese see Pignatti and Pedrocco 1995, II, p. 378, no. 265. The connection was again made by Potterton (1979, p. 49).

5. Mason Rinaldi 1984, pp. 89–90, no. 132.

6. Longhi 1925, p. 46; 1967, I, p. 15.

7. Wood 1994, p. 303, Appendix I, no. 28 (see note 2 above).

8. Ibid., p. 306, Appendix III, no. 67.

9. National Gallery archive AG5/36/2.

10. [Collins Baker] 1929, p. 266. It had not been included in previous National Gallery catalogues even under lists of works

presented. The same fate had befallen the Spranger and 'Michelangelo' with the same provenance. However, all three paintings had been given Gallery numbers in the course of 1901.

11. Gould 1959, pp. 56–7; 1975, p. 183.

12. Mason Rinaldi 1984, pp. 89–90, no. 132; also 1990, p. 192, no. 82.

13. Gould 1959, p. 57; 1975, p. 183; for the Kassel painting see Mason Rinaldi 1984, p. 88, no. 119, fig. 405.

14. Mason Rinaldi 1984, p. 91, no. 141, fig. 408.

15. Marino 1966, p. 230.

16. British Museum 1862, 0809.111 and 112. See also Mason Rinaldi 1973, p. 132, fig. 163.

17. Typescript in the dossier for the painting (undated but before 1959, when cited by Gould).

18. Mason Rinaldi 1984, p. 85, no. 100, fig. 276; 1990, p. 204, no. 87. Galleria di Palazzo Bianco, Genoa, PB. 2072.

19. Wood 1994, p. 303, Appendix I, no. 28.

20. Ibid., p. 295.

21. Ibid., p. 306, Appendix III, no. 67.

22. National Gallery archive NG5/36/2.

23. See Gould 1959, p. 57, and 1975, p. 184. This error was pointed out to me by Sarah Herring.

24. Wine 2001, pp. 16–23.

25. Martin 1970, pp. 87–9. The painting was lent to the National Gallery of Ireland from 1862 until 1929.

26. Maclaren and Brown 1991, I, pp. 334–5.

OPPOSITE:
Fig. 3 Detail of NG 1866.

Giuseppe Salviati

early 1520s–*c*.1575

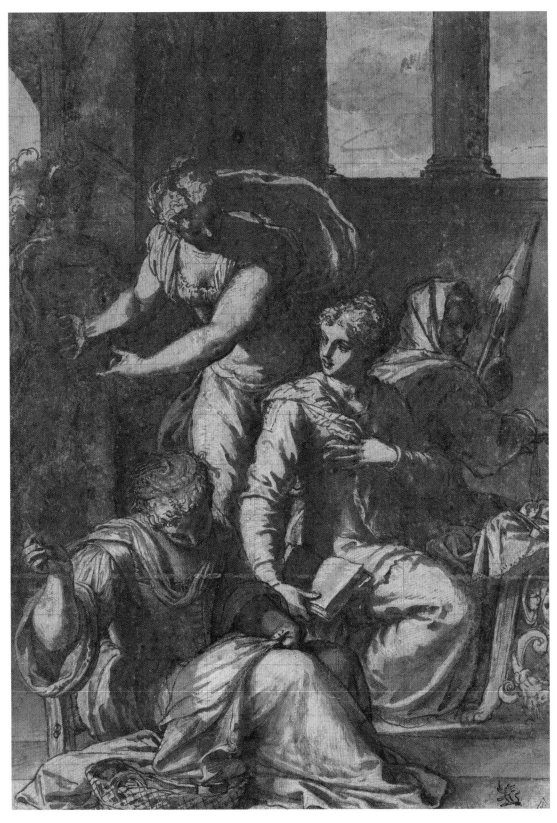

Fig. 1
Giuseppe Salviati,
*Lucretia among her
Handmaidens*, 1557.
Pen, brown ink and
white heightening,
squared with red chalk
on blue-grey paper,
27.8 × 19.1 cm.
Oxford, Ashmolean
Museum.

Giuseppe Porta, who in his earliest surviving signed work names himself 'Ioseph Porta Garfagninus', was born probably in the early 1520s at Castelnuovo, Garfagnana, a territory north of Lucca, ruled by the Este.[1] He was taken to Rome in 1535 by an uncle who was secretary to the archbishop of Pisa and placed in the workshop of Francesco (Cecchino) Salviati, who was the leading Tuscan painter in Rome and one of the most admired artists in Italy.[2] Giuseppe accompanied his master to Venice in 1539 and remained there when Francesco departed in 1541. Certainly by the early 1550s, and perhaps before then, he had assumed his absent master's name and begun to sign his work 'Joseph Salviati' or 'Josephus Salviatus'. Giuseppe returned to Rome in 1562 and stayed until 1565. Francesco, who had been in poor health when his former pupil arrived, died in November 1563, which may have enabled Giuseppe to secure the commission to decorate the Sala Regia of the Vatican.[3] In 1565 Giuseppe returned to Venice, where he died in 1575 or soon afterwards, a victim of the plague.[4]

Giuseppe's earliest signed work is the woodcut title-page of *Le Sorti*, an illustrated fortune-telling book published in Venice in October 1540, and he probably also designed some of the illustrations of female personifications and classical philosophers for that volume.[5] Francesco and Giuseppe seem also to have worked together on frescoes in the Grimani palace,[6] and the latter's proficiency as a mural painter seems to have been especially important in rapidly establishing his reputation in Venice. So too was the fact that Titian was by then reserving his chief artistic efforts for foreign rulers, while Veronese and Tintoretto were yet to establish their reputations in the city. Giuseppe may also have been regarded as something of an intellectual. His expert knowledge of perspective and astrology was mentioned by contemporaries[7] and he published, in June 1552, a short treatise on calculating the curvature of the Ionic volute.[8] He seems to have enjoyed the friendship and support of other Tuscans in Venice, Francesco Sansovino and Danese Cattaneo among them.

Giuseppe Salviati's major works in fresco, inside and outside the Priuli villa near Treviso and on many Venetian palace façades, have not survived, but they were noted for their brilliant colour – for reds and greens and yellows as intense as those used in oil painting.[9] According to Ridolfi he made designs for the leading mosaicists of San Marco, and several important mosaic decorations in the basilica can be attributed to him.[10] Today we are best able to judge his work from the eight surviving altarpieces by him in Venetian churches, the most prominent of which are the *Pala Venier* in the Frari, equivalent in size to Titian's Pesaro altarpiece but on the other side of the nave; the *Descent from the Cross*, originally above the high altar of S. Pietro Martire, Murano, but now in the left aisle, and the *Assunta*, originally above the high altar of S. Maria de' Servi and now in the Rosary Chapel of SS. Giovanni e Paolo.[11]

Two dozen drawings by Salviati survive, many of them in British collections. Among these the drawing of *Lucretia among her Handmaidens* in the Ashmolean Museum (fig. 1) has special importance as a record of a compartment painted by him in fresco on the façade of Casa Loredan in Campo S. Stefano.[12]

Salviati seems to have favoured canvas as a support for his oil paintings, although some small works by him on panel have been identified.[13] A few small paintings of profane subjects seem to have been made by him for collectors.[14] In addition to completing three of the tondi for the Reading Room of Sansovino's library[15] he painted some decorations for the Doge's Palace.[16]

Giuseppe Salviati's importance for the development of Venetian painting, the stimulus that he, together with Francesco Salviati and Vasari, gave to a new direction in Titian's work in the 1540s, and the significant influence they exerted on Schiavone, the young Veronese and, even more so, on the young Tintoretto, was first recognised by Rodolfo Pallucchini in the mid-twentieth century and was studied by him and by other scholars, notably Alessandro Ballarin, in the following decades.[17] McTavish's admirable catalogue of Salviati's paintings and drawings completed as a thesis at the Courtauld Institute in 1981 was published in 1982.

NOTES TO THE BIOGRAPHY

1. McTavish 1982, pp. 19–20.

2. For Francesco Salviati see Monbeig-Goguel *et al.* 1998.

3. McTavish 1982, pp. 244–9, and no. 12, pp. 277–8; Vasari 1568, vii, pp. 35–40.

4. McTavish 1982, p. 63.

5. Ibid., pp. 64–122.

6. Ibid., pp. 38–41.

7. Ibid., p. 61 citing Fioravanti.

8. Ibid., pp. 61–2 and note 79; Burns 1975, p. 101, no. 191 (entry by Burns).

9. Boschini 1660, p. 739.

10. Ridolfi 1648, I, p. 244; McTavish 1982, pp. 214–31.

11. McTavish 1982, pp. 142–60, and no. 33, pp. 301–3; no. 10, pp. 274–6; no. 29, pp. 295–6.

12. A woodcut based on this drawing is dated 1557. Ridolfi 1648, I, p. 241; Jaderosa Molino 1963, pp. 167–8; Parker 1972, I, pp. 369–70; McTavish 1982, pp. 339–41, no. 19.

13. McTavish 1982, pp. 270–2, nos 4–6; also Shearman 1983, pp. 218–20, nos 231–3.

14. McTavish 1982, pp. 266–8, no. 1; Bowes Museum, no. 208, a scene of *Rape* from the collection of Rudolf II, formerly in the Orléans Collection (see fig. 9, p. 465).

15. McTavish 1982, pp. 239–42 and pp. 282–3, nos 16–18.

16. Ibid., pp. 232–8.

17. Pallucchini 1950; Ballarin 1967, pp. 86 and 96–7; Pallucchini 1975.

NG 3942

Justice

*c.*1559
Oil on canvas, 90.2 × 125.1 cm

Support

The measurements given above are those of the stretcher. The original canvas, a twill weave of herringbone pattern running horizontally, measures 86.3 × 104.7 cm. A canvas of a different weave has been added to all the sides except the lower one, and more on the right than the left, to form an approximate semicircle. Cusping is apparent at the lower edge. The painting in its original state is likely to have been a lunette, and the extension, which seems to date from before 1808,[1] may have been made with a knowledge of this previous shape.

Materials and Technique

Extensive underdrawing, applied with a brush, is visible in the sky, and perhaps also in the woman's right hand. Her left arm was originally drawn in a raised position, holding the scales aloft.

Conservation

Apart from the securing of some loose paint (mostly on the extensions) in 1947, the painting has not been treated since acquisition.

Condition

There are numerous vertical cracks in the paint surface, perhaps caused by rolling of the canvas. The surface is also abraded, especially in the sky and in the hair of the figure of Justice. Her flesh is fairly well preserved although numerous chips and small spots have been repainted. Some of the impasto of the jewels in the hair survives, but it is somewhat crushed.

The lake pigment in Justice's pink garment has probably faded, but in the deepest shadows at her left breast, in the fold between her thighs and in the opening of the sleeve beside her projecting left arm the deep rose colour seems well preserved. The scarf flying away from her hair was probably originally green, and traces of this colour remain immediately behind her head.

The varnish, perhaps always tinted and certainly now darkened and discoloured, makes it hard to discern many of the original colours, but the sash just above Justice's thighs appears to be green and yellow, and that at her shoulder, attached to the pink garment, blue and yellow. A greyish layer covering much of the sky may be an addition. The paint on the extensions of the canvas intrudes on to the original painted surface, most notably in the head of the lion on the left.

Attribution

When the painting was in the Cavendish Bentinck collection in the nineteenth century (see the section on Provenance below) it was attributed to Battista Zelotti, whose villa decorations include many women wearing ornamental head-dresses with veils attached to them, and jewelled shoulder straps, such as we see in NG 3942.[2] Zelotti, like Veronese, was probably influenced by Giuseppe Salviati. The great archival historian Gustav Ludwig seems to have been the first to propose Salviati as the artist of this work and he recognised that it was included in two manuscript lists compiled by Pietro Edwards, the picture restorer, agent and connoisseur of Irish extraction, who was a leading figure in the Venetian art world before and during the Napoleonic period.[3] It is not clear whether Edwards himself was responsible for attributing the painting, which he listed as by Giuseppe Salviati, or whether he knew of traditions or records associating Salviati with it. All scholars who have given NG 3942 any attention since 1910, when Richter reported Ludwig's findings, have accepted it as a work by Giuseppe Salviati.[4] If cleaned, it would surely emerge as a fine example of his work, its breadth of handling and palette reflecting the artist's experience of painting in fresco, and its foreshortening suggesting his experience in the decoration of ceilings and palace façades.

Subject and Meaning

The seated female figure holds a sword in her right hand and extends a pair of scales with the other. Behind the scales there is a lion. These are the attributes of Justice. The crescent moon, an attribute of Diana and, in this form especially, of the Immaculate Virgin, appears only on the extensions of the canvas and may not have been included in the original painting. The same is probably true of the lion on the right. The shield lightly supported by her right hand has a gilt scrolling frame enclosing an oval coat of arms, which would be described heraldically as 'quarterly, 1 and 4, or, a cross patée gules, 2 and 3, or, 3 bendlets azure' (that is, divided into four parts, the top left and lower right quarters each with a red ligatured cross on a yellow field, and the top right and lower left quarters with three diagonal blue bands on a yellow field). These are the arms of the branch of the Venetian patrician Contarini family known as the Contarini del Zaffo, founded by Giorgio (Zorzi) Contarini, who was created Count of Zaffo by Caterina Cornaro, Queen of Cyprus, in 1474.[5] The painting was perhaps one of a series of paintings of Virtues and is likely to have been displayed high up in a public building in Venice or the Veneto for which a member of the Contarini family had some responsibility. It may have served as an overdoor or have filled some equivalent arched space.

Original Location and Date

As mentioned in the section on Attribution, NG 3942 appears to be identical to a painting described in two early nineteenth-century documents. A list made by Pietro Edwards of pictures from Venetian public buildings that were sent to Milan in 1808 by the orders of Eugène Beauharnais, Viceroy of Italy (and stepson of Napoleon), includes a lunette-shaped canvas painting by Giuseppe Salviati of 'La Giustizia sedente fra due leoni' ('Justice seated between two lions'). In 1817 Edwards

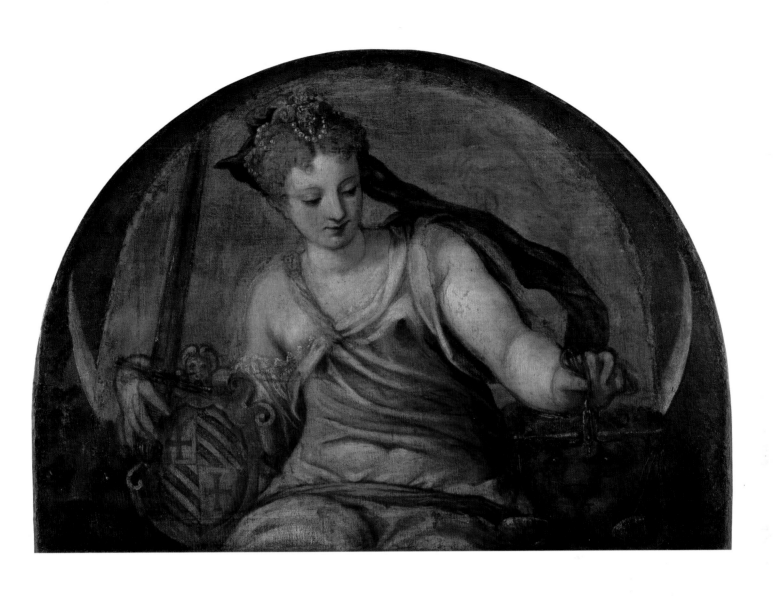

again included it in a list of pictures that the Venetians were evidently hoping to reclaim, describing it as a lunette of a half-figure on canvas, representing Justice by 'Giuseppe Porta' (that is, Giuseppe Salviati).[6] In the earlier of the two documents the picture is described as having been the property of the former senate ('Del fu Veneto Senato'), but in the second one it is connected with the mint ('Pubblica Zecca'). It seems reasonable to infer, as Richter did, that the painting had adorned the offices of the Venetian mint, even though a personification of Justice is not an obviously appropriate image for such a setting.

However, in reply to enquiries sent to him by Cecil Gould in November 1957, Dr Ferruccio Zago of the Archivio di Stato in Venice pointed out that no painting of this description was recorded in the inventory of paintings in public offices compiled in 1725 by the Collegio dei Pittori, nor in another list of pictures in the Zecca extracted from an earlier inventory of 1704.[7] Gould replied that he was not surprised because this was 'not a very important picture – or even a very good one … really a rather uninteresting picture'.[8] However, the lists Zago cites were not compiled for the benefit of visitors to the city but as inventories. The Venetian mint may have served as a depot for paintings in transit or as a store for works removed from other places. It is even possible that the painting had been taken to the mint in Milan.

If the painting was indeed made for the Venetian mint, we can assume that it was commissioned during the year when Tommaso (Tomà) Contarini was Provveditore of the mint (he took office on 5 October 1542) or during the year in which Paolo Contarini occupied the same position (commencing 5 October 1558).[9] It is more likely that the interiors of Jacopo Sansovino's new building (commenced soon after 1535) would have been decorated at the earlier date, and Pallucchini on stylistic grounds alone assigned the picture to the same period.[10] It is not easy to date Salviati's work but there seems no reason why it should not have been painted as early as 1543, although there does seem to be some relationship with the drawing in Oxford of Lucretia and her handmaidens (fig. 1, p. 108), which seems to date from 1557,[11] and McTavish favoured a date around 1558 because the picture 'reveals a painterly, open-grained, handling that is more typical of Salviati's last works'.[12]

Fig. 1 *Justice* hanging in the Mond Room in 1928.

Provenance

As noted above, NG 3942 almost certainly corresponds to a lunette of Justice listed among a group of paintings sent from Venice to Milan in 1808. In 1817, there seem to have been some hopes of reclaiming it. The painting's subsequent history is not clear but it found its way into the collection of George Cavendish Bentinck, which was largely formed in Venice on his numerous visits to that city from the 1850s onward (for more on this collection see pp. 86–7). The painting was lot 759 on the fifth day of his posthumous sale at Christie's, London, 13 July 1891. It was purchased at the sale for 42 guineas (£44 2s.) by Richter for Ludwig Mond. Mond died on 11 December 1909 and the bequest of his pictures to the National Gallery came into effect after the death of his widow in May 1923, although it was delayed for several years on account of disputes with the family.[13]

Display in the National Gallery

When the Mond Room was opened in January 1928, Justice was displayed above the main line of pictures in the centre of the east wall (fig. 1). A decade later Kenneth Clark integrated the Mond paintings with the rest of the collection. After the reopening of the Gallery after the Second World War, the painting seems never to have been shown on the main floor, and indeed public display is most unlikely in its present condition.

Exhibition

London 1975, Hayward Gallery, *Andrea Palladio* (227).

Frame

The painting retains the gilt frame of press-moulded composition ornament that was very likely made for it, presumably at Richter's suggestion, when it entered the Mond collection, but is also possible as Cavendish Bentinck's frame. It consists of a raised garland, rich in fruit, with leaves and ribbons at the centre and leaves at the corners. There are stylised leaves and shields in the outer ogee moulding, and smaller leaves at the sight edge. The spandrels are textured with punched stippling. The toning of the gilding has darkened. A frame of a similar character survives on a Francia from the Mond collection (NG 3927).

NOTES

1. The dimensions of what is almost certainly this painting are recorded by Pietro Edwards in a document of 1817 as 'mezza figura in tela, e mezza tondo, altezza 2-8 pied. venez. larghezza 3-7 pied. venez.' In an earlier document of 1808 the painting's dimensions are not given but it is described as portraying Justice 'between two lions' – since both lions were visible the extensions were presumably in place.

2. For example, Brugnolo Meloncelli 1992, figs 198 and 222. The fragments of Venetian frescoes illustrated by Zanetti (1760, plates 15–18) must also have influenced this attribution.

3. Richter 1910, I, pp. 178–9. The first of these documents is reported to be ASV 'Direzione generale del Demenio Uffizio Economato. Edwards. Quadri. Elenchi ed inventari. Busta 22'. Richter (ibid., p. 180)

also mentions a third manuscript source for which he supplies no reference.

4. Notably Gould 1959, pp. 72–3; Pallucchini 1975, p. 162; McTavish 1982, pp. 272–3, no. 7; Richter 1910, p. 179. For Edwards see Darrow 2001.

5. The Contarini arms had been mentioned in the Cavendish Bentinck sale catalogue, but the relevant branch of the Contarini was identified by Dr Ferruccio Zago of the Archivio di Stato in a letter to Cecil Gould of 29 October 1959 in the dossier for NG 3942.

6. Richter 1910, I, pp. 178–85. See also note 1 above. The second document is ASV, I.R. Governo, 1817, fasc. XXVII, 'Elenco delle pittore consegnate all'ordine del fu Vice Re d'Italia'.

7. Letter from Dr Zago to Gould of 29 October 1959 in dossier for NG 3942. The documents

cited are Museo Correr, MS Cicogna 3750, and a transcription of a lost manuscript in Federico Berchet's *Contributo alla storia dell'edificio della veneta zecca*, Venice 1910, p. 375.

8. Gould's letter to Dr Zago of 6 November 1957 (copy in dossier for NG 3942).

9. Information supplied by Dr Zago in his letter of 29 October 1959 cited in note 7 above.

10. Pallucchini 1975, p. 162.

11. Burns 1975, p. 129 (entry by Bruce Boucher).

12. McTavish 1982, no. 7, pp. 272–3.

13. Saumarez Smith 2006.

Andrea Schiavone

*c.*1510/15–1563

Andrea Meldolla, who signed some of his etchings 'A M',[1] was known as Andrea Schiavone (Andrew the Slav) because he came from the Venetian colony of Zara on the Dalmatian coast, where his father (whose family came from Meldola in the Romagna) held the post of Conestabile. Andrea was probably born between 1510 and 1515; was active, indeed fashionable, by 1541;[2] and died on 1 December 1563, married but with no recorded offspring.[3] A Venetian artist of the fifteenth century (Giorgio Cŭlinović, who signed his paintings Georgius Dalmaticus, 1433–1504) was also known as Schiavone.

Andrea Schiavone was among the artists who were selected by Titian to paint tondi on the ceiling of the Marciana Library in 1556–7, and he later painted two of the philosophers for the niches around the walls of that room.[4] He also received important commissions for churches in Venice[5] and Belluno.[6] Frescoes that he painted on palace façades in Venice were admired but have not survived, nor have any villa decorations, but his proficiency in this medium is apparent from the vaults of the Grimani and Pellegrini chapels in S. Sebastiano, Venice (fig. 1).[7]

However, his reputation as an artist was neither established nor sustained by prominent public commissions. It derived, rather, from his paintings for domestic use and often for collectors. Many of his smaller works were 'historiette' (little narrative pictures) for incorporation in furniture and wainscots. These were probably already being converted into gallery pictures by the early seventeenth century but in Ridolfi's day there were still works by him 'sopra il recinto del letto' – probably meaning a frieze above the step or plinth surrounding the bed – in a palace of the Priuli family, and six 'casse' (chests) adorned with his work belonging to the Ruzzini family.[8] Today a few small pictures made for the choir loft of the church of the Carmine, now serving as organ parapets, are the only surviving works by him to be incorporated in their original woodwork surrounds and these, unusually, were painted on panel.[9] The character of the wooden ornament once around his oil paintings is, however, suggested by the stucco frames of his frescoes (fig. 1) and wooden chests have survived of the kind he must have decorated (fig. 1, p. xiv).

According to Ridolfi, the young Schiavone picked up jobs from the purveyors of ready-made chests, which he decorated with 'historiette, fogliami, grotesche', and from builders who subcontracted the decoration of walls.[10] Although Ridolfi had in fact confused him with a minor artist called Andrea di Nicolò da Carzola, Schiavone may nevertheless have commenced his career in this way. If so, the independence of working for the market may have stimulated his daring innovations, although most artists of this kind strove to meet the predictable popular demand for carefully painted conventional pious images – 'figure divote e diligenti'.[11] What seems certain is that Schiavone's paintings came to be especially valued by other artists. Vasari commissioned a battle painting from him in 1540 or 1541.[12] Alessandro Vittoria is said to have discovered and employed him.[13] Aretino in a letter of 1548 refers to Titian's admiration for his 'bozze de le istorie', his sketchy figure compositions.[14] Domenico Tintoretto showed Boschini a picture by Schiavone that his father, Jacopo Tintoretto, had kept in his studio.[15] There is also evidence that Schiavone's work excited disapproval.[16] His 'modo di dipingere' so dear to fellow artists ('professori') involved the conjuring of forms from 'un misto casuale di tinte' (the apparently fortuitous confusion of paint), with the 'sprezzo' (spirited dexterity) of his brush.[17] This works best on a small scale. In his larger work the figures appear inflated or woolly.

Lomazzo described Schiavone as a disciple of Parmigianino. He adopted the latter's 'ideals of rhythmic grace and irreal beauty'[18] and made numerous variations on poses and compositions found in Parmigianino's prints – and indeed his very activity as a printmaker must have owed something to Parmigianino's example. He also took prints after Raphael as a compositional starting point and painted variations of Titian's pictures.[19] A self-declared lack of originality in invention perhaps dramatised the novelty of his execution.

Richardson's monograph on the artist published in 1980, a work of reliable scholarship and remarkable connoisseurship, reflects the reappraisal of mannerism by art historians in the previous decade and a feeling for the 'vibrating textures, complex accords of colour, and partial mergers of form, chiaroscuro and atmosphere' that reminds us of the hypnotic appeal then exercised by American abstract painting.[20]

Schiavone's work is found in all the major collections of prints and drawings in Britain. His paintings are very well represented in the Royal Collection,[21] but not in public collections.

NOTES TO THE BIOGRAPHY

1. One print, the *Abduction of Helen* of 1547, is inscribed 'Andrea Meldolla inventor': Richardson 1980, pp. 95–6, no. 81.

2. When commissioned by Vasari (for which see note 12).

3. For the biographical facts see Richardson 1980, pp. 6–14.

4. Ibid., pp. 49–53 and 145–8, nos 237–9 (tondi); pp. 174–6, nos 294–5 (philosophers).

5. The altarpiece of the Pellegrini Chapel, S. Sebastiano (*c*.1557–8), and that of the Stonecutters' Chapel in S. Apollinare, which does not survive but is mentioned by Ridolfi (1914, p. 250). For the first of these works see Richardson 1980, pp. 180–1, nos 303–5.

6. Richardson 1980, pp. 153–5, nos 247–9.

7. Ibid., pp. 179–81, nos 299–305. For his façades of Palazzo Zen, Zanni, etc., see Ridolfi

1914, pp. 249, 250, 256; also Boschini 1660, pp. 312–13, and 1964, pp. 344–5.

8. The drawings of pictures in Andrea Vendramin's galleries made in the early seventeeth century include many small works of the square and long horizontal format associated with the decoration of chests (Borenius 1923). For the Priuli and Ruzzini see Ridolfi 1914, pp. 251, 252.

9. Richardson 1980, pp. 149–50, nos 240–2.

10. Ridolfi 1914, pp. 248–9.

11. Ibid.

12. Vasari 1568, III, pp. 595–6 (an appendix to the life of Battista Franco). Richardson 1980, pp. 6–7.

13. Ridolfi 1914, pp. 252–3. Vittoria was also a witness of Schiavone's will, which supports this claim. Richardson 1980, p. 12.

14. Aretino 1957–60, II, 1959, p. 221, letter CDXXIV – see also the poem on p. 378 in which he is coupled with Tintoretto, and the commentary III, ii, 1960, pp. 375–7 and 474. See Richardson 1980, pp. 8–9, for this.

15. Boschini 1674, unpaginated, preliminary biography for Schiavone.

16. Pino 1548, pp. 18–19; Vasari as cited in note 12.

17. Ridolfi 1914, p. 258.

18. Richardson 1980, p. 18.

19. His versions of *Diana and Actaeon* are especially notable: Richardson 1980, p. 163, no. 262; pp. 190–1, nos 327, 328.

20. Richardson 1980, p. 58, for this passage.

21. Ibid., pp. 161–5, nos 259–63; Shearman 1983, pp. 226–33.

Fig. 1 Andrea Schiavone, vault frescoes in the Grimani Chapel: *The Arrest of Christ* with *The Agony in the Garden* (left) and *The Entombment* (right). Venice, Church of S. Sebastiano.

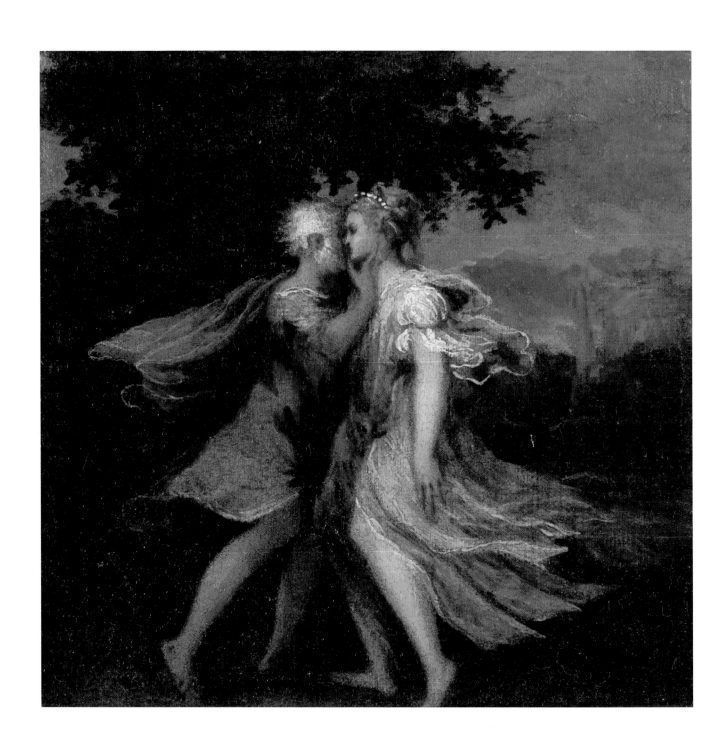

NG 1884
Jupiter seducing Callisto

*c.*1550
Oil on canvas, 18.7 × 18.9 cm

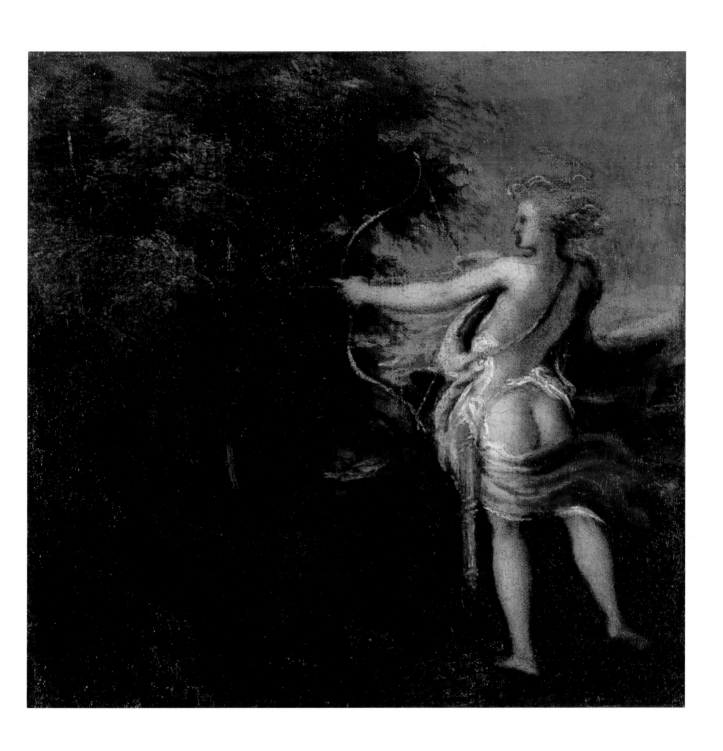

NG 1883

Arcas Hunting

*c.*1550
Oil on canvas, 18.8 × 18.4 cm

Support

The dimensions given above are those of the stretchers. The maximum measurements of the original painted area of both pictures are 17.2 × 17.6 cm. The original canvas is of a fine tabby weave which has been lined on to a heavier canvas of the same type. There is no evident cusping. The edges of the original canvas are partly concealed with putty. The stretchers are of pine and both have a horizontal crossbar. Paper labels marked with the loan numbers (114a and 114b) given to the paintings when they were in the National Gallery of Ireland are affixed to the stretchers. Since the paintings originally decorated the sides of a chest, the canvases were probably glued to thin panels. As discussed below under Previous Owners, they may still have been on panels in the eighteenth century. The vestiges of a wax seal are apparent on the back of NG 1884.

Materials and Technique

Samples taken from both paintings in July 1957 revealed no evidence of a gesso ground, but there is a layer of yellow-brown priming consisting of iron oxide with a little lead white, applied directly to the canvas. The blue of the sky consists of azurite and lead white, and the flesh of lead white with an unusually crimson vermilion.[1]

Very fine threads of shell gold are employed in the archer's hair, bow, arrow and quiver in NG 1883, and in Jupiter's cloak and the clouds in NG 1884. Under magnification it is apparent that 'scraps of gold leaf were laid over still soft underpaint of parts of the foliage and then glazed'.[2] A fingerprint in the red lake in the cloak in NG 1884 reveals that surplus paint was blotted with the fingers.

Conservation

The paintings were cleaned and restored between February 1996 and June 1997. There is no record of any earlier treatment in the Gallery, and the thick varnish removed on that occasion was probably applied before 1860.

Condition

The copper-green glazes in the foliage have darkened. The lake glazes in Jupiter's drapery in NG 1884 have probably faded, so that only the darkest shadows are clearly defined. The colour of the cloak now appears lilac, whereas it was probably originally more purple. There are numerous pin-sized losses on both paintings, and some small chips of paint are missing, notably from the shoulder of the nymph in NG 1883 and from the legs of both the figures in NG 1884.

The Companion Painting and the Subjects

The two paintings were correctly associated by Richardson in 1980 with a larger one of nearly identical height (19 × 49 cm) of Diana and Callisto (or, more accurately, the 'Discovery of the Pregnancy of Callisto by the Nymphs of Diana') in the Musée de Picardie, Amiens (fig. 1).[3] The three paintings were assembled together in the exhibition *Denon: l'Œil de Napoléon* in 2000. It was obvious that they had been made as an ensemble,[4] with the two square canvases presumably decorating the ends of a chest and the horizontal canvas decorating its front.

The subjects of NG 1883 and 1884 had simply been identified as 'mythological scenes' by Gould.[5] Richardson retained these general titles, but they must be presumed to depict other episodes in the story of Callisto, as told in Ovid's *Metamorphoses*.

The nymph Callisto, a favourite of Diana, attracted the attention of Jupiter. When resting in a grove she heard a god greet her and believed that she was in the presence of Diana, whom she addressed as 'divinity' ('salve numen') and as 'greater in my eyes than Jupiter himself'.[6] But it was in fact Jupiter himself, disguised as Diana, and Schiavone has, it seems, depicted in NG 1884 the moment when this becomes

Fig. 1 Andrea Schiavone, *Diana and Callisto*, c.1550. Oil on canvas, 19 × 49 cm. Amiens, Musée de Picardie.

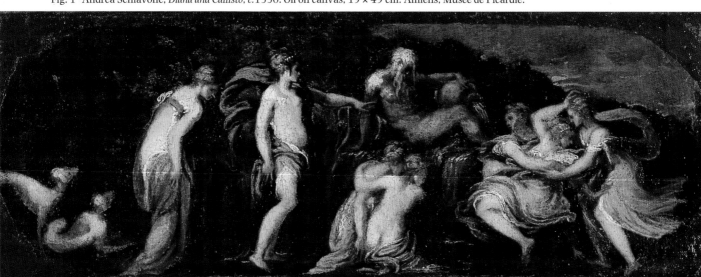

apparent to Callisto. The nymph's knees bend in a curtsey or a faint, her right hand pressed against her thigh (a detail that was not visible before cleaning). Although she struggles, she is unable to resist, and her fellow nymphs reveal her pregnancy to Diana.

The archer in NG 1883 has been supposed to be the god Apollo,[7] but he has no part in this story. In 1999 I proposed that the figure might represent Callisto herself,[8] depicted as she was when she first caught Jupiter's eye, hunting in Arcadia: 'This lass was not one for spending hours spinning soft threads of wool or coiling her hair in varied styles. She was one of Diana's warriors, wearing her tunic pinned by a brooch, her tresses carelessly tied back by a white ribbon, and carrying in her hand a light javelin or her bow.'[9] There are, however, good reasons to doubt this. First, she is not dressed in the same way as Callisto in the other two episodes. Secondly, if the paintings were placed on the right side of the chest (which would be essential for compositional reasons) the sequence would not be chronological. Carol Plazzotta, for these and other reasons, proposed (in April 2006) that the archer was intended as Arcas, Callisto's son by Jupiter. When the pregnancy of Callisto was revealed to Diana (the episode on the front of the chest) the goddess turned her into a bear. Arcas grew up to be a keen hunter and killed a bear without knowing that it was his own mother. Plazzotta's interpretation is confirmed by slight traces of an animal with a snout in the foliage to the left of the painting (previously supposed to be a wild boar) and, indeed, had there not been some special significance in the prey to be seen there, the artist would not have placed the archer so far to one side.

Attribution

The paintings were attributed to Schiavone when they were in the Algarotti, Denon and Beaucousin collections, and when acquired by the National Gallery, and it is unlikely that they had ever been supposed to be by anyone else. In his catalogue of 1959 Cecil Gould wrote that they were 'by or after Andrea Schiavone' but added that their 'present condition precludes a decision between these alternatives' – his hesitation, even his phraseology, reflecting the influence of Martin Davies.[10] Richardson regarded this formula (which Gould preserved in his catalogue of 1975) as 'overcautious'. His claim that the paintings were 'not seriously damaged' and 'surely autograph' was fully vindicated by the cleaning in 1996.[11]

Visual Sources and Dating

Callisto's pose, her profile and her pearl-sown coiffure in NG 1884 recall Psyche in Schiavone's painting of *Cupid and Psyche* in the Metropolitan Museum of Art, New York.[12] The archer in NG 1883 is reminiscent of a figure in one of Schiavone's etchings, especially in the way his drapery billows across his legs and his hair streams backward in the wind.[13] These observations, made by Richardson, do not help us to date the works, nor can we be sure which came first. But if, as seems reasonable, we assume that the *Diana and Callisto* in Amiens is of the same date then we can be fairly certain that the paintings were made after 1548, because that is the date

of an engraving by Vico after Parmigianino which was, as Richardson also remarked, surely Schiavone's inspiration for the imperious pose of Diana (a pose he also borrowed for his own etching of Persephone).[14] The pointing gesture is close to that used by Titian in his painting of the same subject in 1559 but Titian may have taken this idea from Schiavone, as he did other ideas.[15] A date around 1550 seems consistent with Schiavone's development.

Previous Owners

An 'Apollo in un bosco che faetta' and a pendant ('suo simile') showing 'un vecchio che tiene abbracciata una giovine', of the same size, approximately, as NG 1883 and 1884, were published in about 1779 in the catalogue of the collection of Count Francesco Algarotti (1712–1764),[16] the cosmopolitan connoisseur, author and *arbiter elegantiarum* who had acted, in the early 1740s, as art agent for Frederick-Augustus II, Elector of Saxony, and, in the later 1740s and early 1750s, as adviser to Frederick the Great, by whom he was ennobled. Algarotti may have obtained the paintings in his native Venice, when he lived there in 1743–5 or again in 1759–64, but in any case he maintained contact with the city, and some of the two hundred or so pictures that he owned when he died had been acquired by his father and his brother Bonomo (d. 1776). Bonomo's daughter, the Contessa Maria Algarotti Corniani, found the catalogue after his death.[17] It is interesting that Algarotti purchased for Dresden one of Schiavone's most ambitious paintings.[18]

The catalogue of Algarotti's collection describes all three small paintings as 'in tavola'. A possible explanation for this is that the canvases were glued to panels – indeed they were probably made that way, because canvas pictures, when fitted into furniture, were not likely to be on stretchers. NG 1883 and 1884 were regarded as pendants. *Diana and Callisto* was listed next, but as a pendant to another work by Schiavone, *The Queen of Sheba before Solomon*. In all, there were seven paintings by Schiavone in the collection, making him and Carpioni the artists best represented there, after Tiepolo.

The two little paintings are next recorded in 1793, in a letter sent by Dominique-Vivant Denon to a friend, which lists a few pictures that he wished to be sent from Venice to Paris.[19] Vivant Denon (1747–1825) began to collect art while serving as a diplomat in Italy. He was himself an accomplished draughtsman and printmaker with a keen interest in archaeology. He is likely to have acquired the paintings between October 1788 and July 1793, when he was living in Venice. It has been suggested that he obtained them from Anton Maria Zanetti the Elder (1679–1767),[20] because we know (see the section below on Prints) that Zanetti projected a woodcut of the archer in NG 1883 and that Denon acquired Zanetti's great collection of drawings from his nephews in 1791.[21] Zanetti himself had died well before the publication of Algarotti's collection, so it is much more likely that Denon bought the paintings from Algarotti's heirs.

After he had organised the publication of *Voyage dans la Basse et la Haute Égypte* in 1802, Denon's wide knowledge, his diplomatic skill and his ability as an administrator were

Fig. 2 Antonio Belemo, *Callisto Hunting*, 1760s.
Woodcut, 16.4 × 11.2 cm. London, The British Museum.

given official recognition when he was appointed Director
General of Museums. The Musée Napoléon was in large part
his creation, and after the Battle of Waterloo he refused to
cooperate in the restitution of works of art to Italy and Ger-
many. He was also director of the mint and of the factories
of Sèvres and Gobelins, and directed much of the official
patronage of Napoleon, from medals and coins to history
paintings and triumphal arches.[22] After the Restoration he
retired from public life and devoted himself to compiling a
history of world art, based on his own collection. In the
posthumous inventory of his possessions at 5 (modern 7)
Quai Voltaire, Paris, made between 16 and 26 May 1825, the
two Schiavones are recorded as hanging in his bedroom.[23]

In 1793 and again in 1825 the paintings were associated
with *Diana and Callisto*, which, as noted above, had also been
in the Algarotti collection, where, however, the three pictures
seem not to have been recognised as a group. They were
offered together as a single lot (no. 43) at the sale of Denon's
paintings and drawings in May 1826. According to the an-
notated version of the catalogue in the Bibliothèque Centrale
des Musées Nationaux, they were purchased by the artist and
dealer Laurent Durand Duclos for 810 francs.[24] However, a
well-informed publication of 1829 stated that the *Diana and
Callisto* remained in the possession of Denon's nephews.[25]

NG 1883 and 1884 are next recorded, without the *Diana
and Callisto*, in another Parisian collection, that formed by
Edmond Beaucousin (1806–1866) and kept in his second-
storey apartment at 16 Boulevard Montmartre, together
with a choice collection of ivories, bronzes and enamels.[26]
Forty-two of Beaucousin's paintings, almost all of them of
the late fifteenth or sixteenth century, were bought by East-
lake for the National Gallery for £9,205 3s. 1d. (230,000
francs) on 27 January 1860.[27] Beaucousin's chief supplier
seems to have been the London-based dealer Chrétien-Jean
Nieuwenhuys, who was, it seems, disappointed that his client
was selling and therefore no longer collecting. Nieuwenhuys
not only refused to supply Eastlake with information con-
cerning the provenances but disparaged some of the pictures
he himself had sold. Beaucousin was distressed. He had
handled the affair with 'délicatesse de conscience' ('tact and
consideration'). He could understand that Nieuwenhuys was
'contrarié' by the sale, but such behaviour was uncalled for:
'Enfin, le cœur humain a ses faiblesses ...' ('after all at heart
we are all flawed'), he lamented in a letter to Lady Eastlake.[28]

By 21 May, Eastlake had put aside eleven of Beaucousin's
paintings as unsuited for display in the Gallery, and he
explained to the Treasury on that date that he preferred to
transfer these to other public collections rather than sell
them at auction. NG 1883 and 1884 were among the six
dispatched on loan to Dublin on 18 June.[29] Thus Eastlake,
one of the finest connoisseurs in Europe, discarded paintings
which had been treasured by Algarotti and Denon. He cannot
have been insensitive to the colour, movement and pattern
(like a butterfly taking flight) in NG 1884 or the nervous and
witty drawing in NG 1883, but perhaps he felt that the volup-
tuous content was inappropriate for a public collection. This
was a problem with two other, more prominent paintings in
the Beaucousin collection: Bronzino's *Allegory with Venus and
Cupid* (NG 651), which in consequence was partly repainted,
and Garofalo's *Allegory of Love* (NG 1362), which was dis-
patched to the National Gallery of Scotland.[30]

Provenance
See above. Published in the posthumous catalogue of Fran-
cesco Algarotti's collection, 1776. Recorded in the possession
of Vivant Denon in 1793 and in his posthumous sale in May
1826. Bought at the latter sale by Laurent Durand Duclos.
Purchased by the National Gallery from the collection of
Edmond Beaucousin in 1860 and lent to the National Gal-
lery of Ireland in the same year. Returned to the National
Gallery on 29 March 1926.

Prints
In the catalogue of Algarotti's collection it is noted that
Zanetti made a print after NG 1883. This must in fact record
his intention to do so. An impression of the woodcut by
Antonio Belemo (active by 1756, d. 1791; fig. 2) is inscribed
as having been drawn on the woodblock by Zanetti before
his death. Another impression is inscribed with the infor-
mation that the woodblock had passed to Francesco Novelli
(d. 1836), who had commissioned the cutting of the design

from Belemo.[31] Since Novelli was a pupil of Denon in Venice, as we know from the records of the State Inquisitors,[32] it is likely that Denon was involved. If so, it is curious that the woodcut so prominently declares itself as an invention of Parmigianino. This is probably an error on the part of Belemo but perhaps reflects the recognition by Zanetti that Schiavone's source was Parmigianino (see Visual Sources above). The diagonal trunk of a fallen tree is more distinct in the print than it now is in the painting but the bear in the wood was presumably already hard to see, or at least regarded as irrelevant, and the archer now occupies the centre of the composition.

Richard Ford (1796–1858), the collector, connoisseur and traveller who owned one of the impressions of Belemo's print, also etched a copy of it. Denon may have intended to include lithographs of both NG 1883 and NG 1884 in his encyclopaedic anthology illustrating the evolution of the figurative arts, begun in 1816. The *Monuments des Arts du Dessin*, when it was eventually published in 1829, included a lithograph of *Diana and Callisto* by Gounod.[33] There is a proof lithograph of NG 1884, probably intended for this publication, in a private collection.[34]

Frame

Between 1860 and 1996 the two paintings were exhibited in gilt frames with press-moulded composition ornament consisting chiefly of a double line of fluting on the broad outer moulding. The same pattern of frame is recorded on some other small pictures in the Gallery: NG 1887, NG 1888, NG 1304 and NG 652. Despite the misleading numbers, these paintings were all part of the Beaucousin collection acquired *en bloc* in 1860. It is possible that the frame was a standard one given to the paintings by the Gallery's framer at that date but, since examples have been found on no other paintings in the Gallery, and different patterns are known to have then been employed by the Gallery for small paintings, it is more likely that the type of frame was one that Beaucousin had favoured. Since his collection had been formed relatively recently, the condition of Beaucousin's frames was likely to have been acceptable and, even if the style had not been much liked, the Gallery could not easily have justified the expense of reframing, as these paintings were all sent out on loan. The example illustrated in fig. 3 is the frame that remains on NG 652 (*Charity*, formerly attributed to Francesco Salviati, now attributed to Michele di

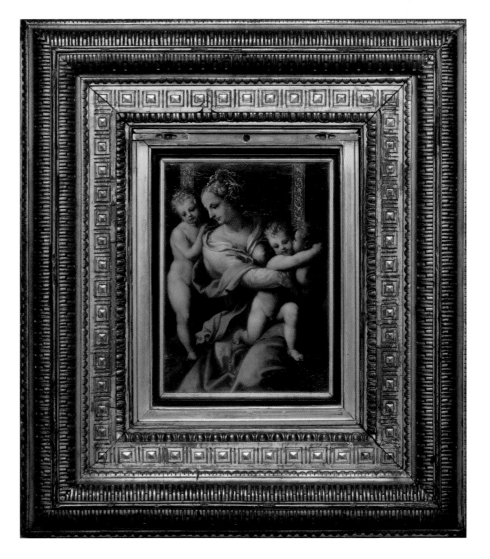

Fig. 3 Michele di Ridolfo Tosini, *Charity*, in its frame of *c*.1850. Oil on wood, 24.5 × 17.8 cm. London, The National Gallery (NG 652).

Ridolfo Tosini) because it is the best preserved, although it is the only one with a frieze decorated with concentric squares. The inspiration for these frames must have been a Tuscan frame of the mid-sixteenth century such as the carved walnut mirror frame in the Lehman collection at the Metropolitan Museum of Art.[35]

After cleaning in 1997 the two paintings were reframed in parcel-gilt walnut mouldings made by the London firm of Paul Mitchell. These were replicas of an architectural profile frame in Mr Mitchell's possession and were designed to recall the furniture into which the paintings would originally have been inserted.

NOTES

1. Report of July 1957 signed by R.J.P. (Joyce Plesters).

2. Treatment Report by Jill Dunkerton.

3. Richardson 1980, p. 152, no. 244, and pp. 165–6, nos 272–3; figs 107–9.

4. Dupuy 2000, p. 440. Exactly the same use of gold and a similar linear application of white impasto was apparent in all three paintings, but it is curious that Callisto's dress is not of quite the same colours in the Amiens picture as in NG 1884 – the white has some blue in it and the yellow is slightly more green.

5. Gould 1959, p. 75; 1975, p. 240.

6. *Metamorphoses*, II, 405–95; this passage 425–31.

7. Selva and Edwards [1776], p. xxii; also in Richardson 1980, p. 165.

8. Massar 2005 has captions for figs 175 and 176 that commence 'here interpreted', which would encourage readers to suppose that the identification of the figures as *Callisto Hunting* and *Callisto embraced by Jupiter* were hers, especially since she claims (on p. 434) that the paintings are still officially titled as 'mythological figures'. But see Dunkerton, Foister and Penny 1999, p. 130, and captions on p. 131, and, in addition, Dupuy 2000, p. 440.

9. *Metamorphoses*, II, 405–15.

10. Gould 1959, p. 75; 1975, p. 241.

11. Richardson 1980, pp. 165–6.

12. Ibid., pp. 168–9, no. 280, fig. 110.

13. Ibid., pp. 104–5, no. 126, fig. 126. Massar (2005) points out that the pose also owes something to Parmigianino's drawing of Ganymede seen from the rear (Popham 1971, no. 512, in the Louvre), which Schiavone copied in an etching (Zerner 1979, p. 101, no. 74).

14. Richardson 1980, p. 104, no. 124, fig. 106 – also pp. 37–8.

15. Ibid., p. 165; for the Titian see Brigstocke 1993, pp. 183–6.

16. Selva and Edwards [1776], p. xxi. The measurements, given to French standards, are six and a half *oncie* square. The catalogue was published in Italian, French and German editions. Of these only the third has either a place or a date of publication (Augsburg 1780). The Italian and French editions are likely to be slightly earlier and, despite the French measurements, the text is likely to have been in Italian originally. I owe all this information to Burton Fredericksen.

17. For Algarotti in general see Haskell 1963, chapter 14. See also Haskell 1980, pp. 409–10, for additional bibliography.

18. The *Infancy of Jupiter* is now in the collection of the Earl of Wemyss and March at Gosford. The painting was published by Humfrey in Humfrey *et al.* 2004, p. 163, no. 56. Anderson 2005, pp. 281–2, recognised it as the painting Algarotti bought in 1743 from the Cornaro family.

19. Dupuy 2000, p. 440 (citing *Lettres à Bettine*).

20. Ibid., as a speculation, repeated in Massar 2005, p. 437, as a fact.

21. Dupuy 2000, p. 452 and p. 498 (third column).

22. Dupuy 2000 covers every aspect of his career. For his collection of paintings see pp. 437–9 (essay by Dupuy).

23. Dupuy 2000, p. 440.

24. Dupuy 2000, pp. 399–400, for the sale in general and the catalogue of his entire collection published in three volumes, and p. 440 for the price and the purchaser.

25. Duval 1829, II, pl. 136.

26. Carol Plazzotta suggests that if the three paintings did all belong to Beaucousin then it may not be a coincidence that *Diana and Callisto* is now in Amiens, which was his native city. Beaucousin had no profession and

was registered as a 'rentier'. This fact together with his address I owe to a letter written to Lorne Campbell by Theodore Reff on 14 August 1996. For the ivories etc. see Hédouin 1847, p. 272.

27. The Trustees agreed on 23 January. 27 January is the date of Beaucousin's receipt. The receipt listed 46 pictures but the Gallery listed 42. Robertson 1978, p. 190 (especially note 27) and pp. 309–11.

28. Letter of 19 February 1860 in the Victoria and Albert Museum, MSS-English, 86.M.39, quoted by Robertson 1978, p. 191. Nieuwenhuys (1799–1883) was a highly successful London dealer who worked in partnership with his father, Lambert-Jean Nieuwenhuys (1777–1862) of Brussels. He sold to the National Gallery in June 1825 Correggio's *Madonna of the Basket*, which his father had bought in Paris in April of that year (Nieuwenhuys 1834, p. 49). They were in a strong position to help form the art collection of Willem II, King of the Netherlands (Hinterding and Horsch 1989, p. 9 and note 17), as they were considered experts in Dutch and Flemish art (pioneers in the 'rediscovery' of Hals, for example – see Nieuwenhuys 1834, p. 131) and in earlier Netherlandish painting, which was well represented in Beaucousin's collection. It is not unlikely that Nieuwenhuys also felt that if his client wanted to sell he should do so through him.

29. Letter of 21 May 1860 (NG 5/313/2), cited by Robertson 1978, p. 191, note 29.

30. Robertson 1978, pp. 191–2.

31. Massar 2005.

32. Dupuy 2000, p. 498.

33. Duval 1829, II, pl. 136.

34. Information from Marie-Anne Dupuy.

35. Newbery, Bisacca and Kanter 1990, pp. 64–5, no. 35.

Fig. 4 Enlarged detail
of NG 1883.

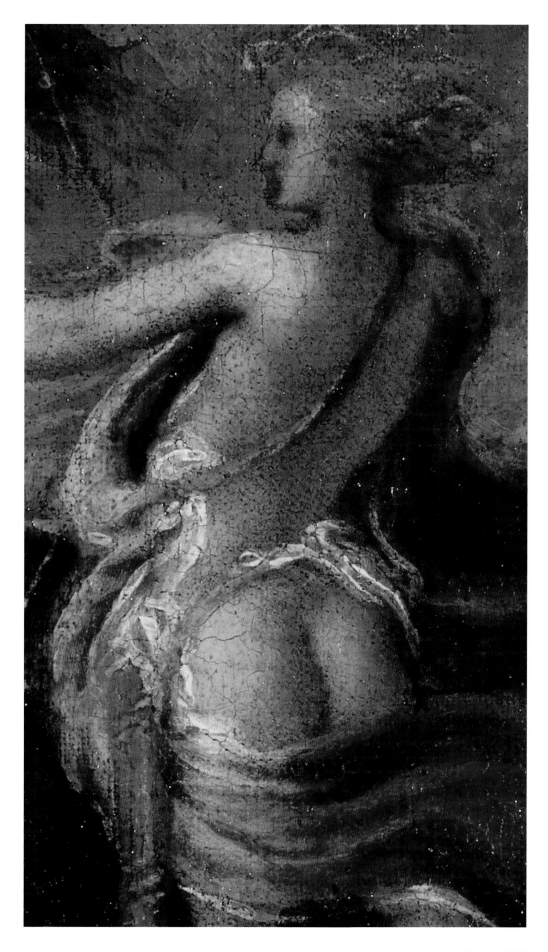

Lambert Sustris

c.1515/20–c.1568

Lambert Sustris, known in Venice as 'Lamberto', signed one of his paintings as 'Lambertus de Amsterdam'. The dates of his birth and of his departure from his native city of Amsterdam are unknown, and the earliest record of his existence seems to be the letters LAM AMSTER... scratched on one of the vaults of the Golden House of Nero in Rome, together with the names of Hermannus Posthumus and Martin van Heemskerck, compatriots who are known to have been in Rome in the mid-1530s.[1] In Venice, according to Ridolfi, Sustris worked for Titian, at first, it is implied, as a student.[2] Ridolfi was writing a century later and he is not entirely reliable (he claimed, for example, that Sustris was born in Germany), but there is no reason to doubt that there was some association between the two artists.

Because of Ridolfi's claim that Sustris painted landscapes for Titian, the mountain scenery in Titian's *Presentation of the Virgin* (fig. 1, p. 128) – different from earlier landscape backgrounds in Titian's work and similar to those in later paintings by Sustris – has been attributed to him[3] and may be at least partly his. The *Presentation* was painted for the Scuola della Carità (now part of the Accademia Galleries) by 1538. During the early 1540s Sustris seems to have worked independently in Padua, for Girolamo Muziano was taught there by 'un si chiamava messer Lamberto fiammingho valente nel disegno, ma tale in colorito che non haveva pari' ('one called Lamberto the Fleming worthy in design but peerless in his colour')[4] and there are strong stylistic reasons for attributing to Sustris a number of works executed in or near Padua, the most important of which are the frescoes in Falconetto's episcopal villa at Luvigliano di Torreglia, which seem to date from about 1542.[5] These reveal him as one of the chief disseminators in the Veneto of the taste of Raphael's Roman followers for trophies, fictive reliefs filled with sinuous figures, and landscapes with ruins.

Ridolfi states that Sustris accompanied Titian on his visit to the Imperial Diet in Augsburg in 1548,[6] and although it has been presumed that he returned with Titian to Venice in 1550 he may have remained in Germany for at least several years. The only painting signed by him is the delightfully lyrical *Baptism of Christ* in the Musée des Beaux-Arts, Caen (fig. 1), which can be identified, from the heraldic device it incorporates, as a commission from Otto Truchsess von Waldburg, Cardinal of Augsburg. A portrait of the cardinal dated 1553, now in Zeil Castle near Zurich, has been

Fig. 1 Lambert Sustris, *The Baptism of Christ*, c.1550. Oil on canvas, 132 × 240 cm. Caen, Musée des Beaux-Arts.

attributed to Sustris, as have several other portraits of the Bavarian nobility dated 1548 and 1552, now in the Bayerisches Staatsgemäldesammlung and the Alte Pinakothek in Munich.

The signed *Baptism* is sufficiently distinctive in style, handling and colour for a large group of paintings of similar size and landscape character to be attributed to Sustris with confidence – among them are other versions of the *Baptism* itself, other sacred narratives such as the *Way to Calvary* (Milan, Brera), pagan narratives such as the *Bath of Venus* (Vienna, Kunsthistorisches Museum) and allegories such as the *Fortuna* (Besançon, Musée des Beaux-Arts). There are enough stylistic similarities to connect these with the Luvigliano frescoes mentioned above, and because the frescoes include enthroned Roman heroes and large fictive sculpture in architectural settings, a good idea of his style as a figure painter can be established. In addition to several portraits, an altarpiece and a fresco in Paduan churches[7] have been attributed to him as well as paintings of the nude Venus[8] in which Titian's models are repeated but with thinner and softer handling that lends them an enervated grace.

The later part of Sustris's career is a mystery. There is no certain evidence that he ever returned to Venice from Germany. Vasari implies that he was dead in his *Lives* of 1568,[9] and this is likely to be reliable because Lambert's son Frederik, who was born in Italy in about 1540 and studied in Rome in 1560, worked for Vasari in Florence between 1563 and 1567.[10]

On a visit to Lille in 1859 Charles Eastlake noted two interesting pictures by Sustris: 'a pale imitation of P. Veronese, Tintoret and indeed of Venetians generally. The colour though wanting force has much sweetness from the balance of warm and cold. The landscape in one is like P. Veronese and perhaps still more like Bassan (on a very light scale – like a Bassan prepared for glazing).' He thought that a 'pale picture' in the 'Madrid Gallery' which was 'ascribed to Tintoret' was probably by 'Zustris' and in 1863 noted that the artist's work could also be studied in Munich.[11]

However, Sustris's œuvre was only properly reconstructed in the twentieth century.[12] It is clear that he was active as a fresco painter, although little now survives by him in this medium.[13] When painting in oil he seems always to have preferred canvas as a support. Apart from the painting catalogued here, there is one other fine example of his oil painting in a British collection, the *Diana and Actaeon* in Christ Church Picture Gallery, Oxford.[14]

NOTES TO THE BIOGRAPHY

1. Dacos 1967, fig. 39; Dacos 1985, p. 434.

2. Ridolfi 1914, p. 225.

3. This idea was first advanced by Roy Fisher in his thesis of 1958, published in 1977. After the cleaning of the painting in the late 1970s this looked even more convincing (as acknowledged by Fantelli 1981, p. 138).

4. Procacci 1954, p. 249 (and note). He may also be the 'Albertus de Olandis Amsterdam' cited in a Paduan document of 1543.

5. Ballarin 1966.

6. Ridolfi 1914, p. 225.

7. Sacristy of S. Maria in Vanzo, Padua, and Oratory of S. Bovo, Padua – for this proposal see Ballarin 1962.

8. In the Rijksmuseum, Amsterdam, the Louvre, Paris, and the Longoni collection. In addition, the *Education of Cupid* in the Kress Collection, El Paso Museum of Art, Texas (Shapley 1961, no. 28, as 'Studio of Titian') seems to me to be certainly by him. The *Judith with the Head of Holofernes* sold Sotheby's, London, 11 December 1985, lot 7, is another characteristic Titianesque work.

9. Vasari 1906, VII, p. 586: 'abitò in Vinezia molti anni... fu padre di Federigo'. This means he was dead by 1567 when Vasari completed work on the book.

10. He then travelled to Augsburg at the invitation of the Fuggers in 1568, after which he was established as court artist to Duke

William V of Bavaria in Munich, where he died in 1599.

11. Eastlake MS Notebook 1859.3, fol. 6r, and 1863.1, fol. 1r.

12. Pelzer 1913; Ballarin 1962; Ballarin 1962–3; Sgarbi 1981; Mancini 1987; Mancini 1993.

13. In addition to the villa at Luvigliano, Vasari mentions the Villa Pellegrini, where Sustris collaborated with Gualtieri Dall'Arzere and Andrea Schiavone.

14. Byam Shaw 1967, p. 74, no. 91, plate 81.

NG 3107
The Queen of Sheba before King Solomon

c.1540–55
Oil on canvas, 80 × 187.3 cm

Support
The dimensions given above are those of the stretcher (excluding fillets of pine tacked to its sides). The original canvas is of a coarse and loose tabby weave. It is lined with glue paste on to a medium-loose tabby-weave canvas with a keyed stretcher that has a single vertical crossbar — an unusual design, perhaps Spanish. The original canvas is slightly smaller than the dimensions given above. Its irregular cut edges are concealed by gummed paper. Cusping in the original canvas is obvious at the upper and lower edges but not at the sides. The figure at the extreme right looks as if it has been cut.

Layard's paper label with a printed blue border and the number 38 written in brown ink is pasted to the stretcher.

Materials and Technique
The painting has a chalk (calcium carbonate) ground. This is unusual in Italian paintings but other examples have been recorded, including Veronese's *Adoration of the Kings* (p. 397).[1] Also unusual are the two priming layers applied on top of the chalk ground. The first is pinkish (of lead white and red lead) and the second pale grey (of lead white and lamp black).

There is evidence of underdrawing in some of the architecture. Red chalk outlines, some perhaps ruled (or following ruled incised lines), are visible in the columns of the central Corinthian temple, in the capitals and entablature of this building and in the entablature of the Doric atrium where Solomon is enthroned. Because the paint has become more translucent it is clear that the figures were painted after the architecture. The lines of the steps and paving show through the figures and so do the greys and the pinkish orange and beige of the paving – which must be intended to represent Verona marble. There seems to have been a revision in the arrangement of the steps, with one originally painted below the vase and lower leg of the kneeling woman near the centre. The lights in the king's robes, on the hangings of his throne, in the scarves and helmets of his attendants, and in the scarf of the queen herself, which are painted with lead-tin yellow, are, characteristically, well preserved; touches of the same pigment enliven the metal reliefs of the metopes of the atrium. The sea and sky are both painted with smalt and lead white over a layer of azurite and lead white. The pink robe of the figure immediately beside the column at the left is painted with red lake and lead white.[2]

Conservation and Condition
There is no record that the painting has received any conservation treatment since its acquisition by the National Gallery. It is obscured by darkened and uneven varnish. Numerous long, vertical but meandering and branched tears (or perhaps cracks from rolling or folding) can be discerned, chiefly to the right of centre, and the retouching, designed to conceal these, has discoloured to grey, as is also the case in numerous smaller areas. The paint, often applied thinly and more or less roughly, has increased in translucence. The sky has faded, on account of the use of smalt as a pigment. Other colours may also have faded. This, together with other problems of condition, makes the painting appear to be more damaged than it is.

Attribution and Date
When Layard acquired the painting in 1872 it was attributed to Bonifazio de' Pitati by Morelli, and Layard published the attribution in his edition of Kügler, together with the interesting idea that it was an unfinished work in tempera to which the oil glazes would have been added. He thought this technique was derived from Giorgione. He also noted that the architecture recalled that in some of Bordone's paintings.[3] In 1896 Frizzoni proposed an attribution to the more 'facile et fluide' Andrea Schiavone in his account of Layard's paintings.[4] By 1912 Paris Bordone and Christoph Swarz had also been suggested.[5] A note in the painting's dossier records that Peltzer, although he did not mention it in his key article on the artist in 1913, considered it to be by Sustris.[6] Berenson expressed the same opinion in a letter to the Gallery in 1932[7] and listed the painting as a Sustris in 1957.[8] This attribution had also been endorsed by several Italian scholars, but Gould in his 1975 catalogue retained the formula he had used in 1959 of 'Venetian School' and regarded Sustris merely as the 'least improbable' of the proposed candidates.[9] Doubts are still occasionally expressed.[10]

The fluently composed groups and the elegant rhythm of the limp drapery can be matched in the signed *Baptism* by Sustris in Caen (fig. 1, p. 124); the parallels with the processional chorus, kneeling woman and demonstrative soldiers in the *Way to Calvary* in the Brera, Milan, are also striking; the *Bath of Venus* in the Kunsthistorisches Museum, Vienna, is especially close because it places numerous pliant female bodies on a classical architectural stage, but also in its palette of soft blue, faded rose, pale grey and straw yellow, such as NG 3107 may be supposed to have originally possessed. These are all paintings with figures of the same size, but NG 3107 may also be associated with the pair of full-length, life-size portraits in the Alte Pinakothek, Munich, of Hans Christof and Veronika Vöhlin, dated 1552, in which a broad rectangular pattern in the paving, marble columns with thread-like grey veins, and a densely composed antique relief are featured. Such architectural and sculptural details can also be matched in the fresco decorations at Luvigliano. Not enough is known of the chronology of Sustris's work to date NG 3107 with precision. It is tempting to give it a date close to the Vöhlin portraits but it may well be earlier and there is reason to think that it may have been painted in Venice, since the subject was favoured there.

Subject
The subject may have been selected as a pretext for depicting a large female cast on an elaborate architectural stage. However, such a low horizontal format is unusual in an

independent composition: the movement of the figures is from right to left (the reverse direction is much more common) and the lighting is also from the right (which is again unusual, except in paintings made for a place in which the actual light came from this direction). This suggests that NG 3107 may have been made for a particular place, perhaps even to hang opposite another painting with a matching processional subject – probably as part of the decoration of furniture in a bedchamber (where this subject had been considered appropriate in the fifteenth century[11]) or possibly as one of a series of paintings decorating the underside of an organ case. In Venice during the sixteenth century the latter paintings were often of this shape and size, and were usually decorated with Old Testament subjects, although they were commonly painted on panel.

Another painting of *The Queen of Sheba before Solomon*, similar in format but far larger (about three metres in length), is in the sacristy of the Frari, Venice. In this painting, once attributed to Bonifazio de' Pitati, the procession moves towards the left and the lighting is from the right, and the painting has a pendant, the *Adoration of the Kings*, with a procession moving in the opposite direction. The paintings are now attributed to Antonio Palma. They were made for the Venetian Mint, for which the subjects were obviously suited. They can be dated to the 1550s because Sansovino's Library is depicted half-completed in the view of the Piazzetta of San Marco behind Solomon.[12] In six ceiling paintings by Tintoretto and his workshop, now in the Prado, Madrid, the panel of *The Queen of Sheba before Solomon* has as its pair *Esther before Ahasuerus*.[13] Other decorative schemes which include *The Queen of Sheba before Solomon* are the six cassone panels by Tintoretto now in the Kunsthistorisches Museum, Vienna,[14] and the canvases in grisaille by Tintoretto's workshop on the ceiling of the Atrio Quadrato of the Doge's Palace.[15] There are several other paintings of *The Queen of Sheba before Solomon*, attributed to Tintoretto, which may have been made as independent works of art.[16]

The Architecture

NG 3107 owes something to an engraving of the same subject attributed to Marcantonio Raimondi or one of his followers (fig. 3): the screen of columns behind the queen and her attendants, the men grouped around a large column, front left, the gesture of the queen and the actions of the men bearing her offerings are all similar. The print may reproduce a design by Baldassare Peruzzi, to whom a similar painting of about 1520 in the Palazzo della Cancelleria in Rome has also been attributed.[17] The arrangement of the buildings in Sustris's painting also resembles that in Peruzzi's *Presentation of the Virgin* in S. Maria della Pace, Rome, of about 1517, and those considered appropriate by Sebastiano Serlio for architectural settings for Tragedy involving 'grandi personaggi' ('characters of high rank').[18] Serlio's treatise on architecture, published in Venice in 1537, has long been acknowledged as an influence on Titian's *Presentation of the Virgin* of about the same date (fig. 1).[19] Serlio was a pupil of Peruzzi and he particularly praised the fictive architecture of the Sala delle Prospettive in Agostino Chigi's villa, the Farnesina, which must have been the inspiration for Sustris's Stanza delle figure all'antica at Luvigliano.[20] One may conclude from this either that Sustris was indebted to Serlio, who urged him to imitate Peruzzi, or, as seems more likely, that Sustris had already studied Peruzzi in Rome before he arrived in Venice. That the landscape in Titian's *Presentation* perhaps owed something to Sustris has already been mentioned. But even more remarkable is the fact that the veined monolithic marble column shafts, the rusticated *basamento* with an arched door cut into it, the combination of Doric and Corinthian buildings, even the obelisk with a spherical finial in Titian's painting, are also found in this very much smaller painting.

OPPOSITE: Fig. 2 Detail of NG 3107.

Fig. 1 Titian, *The Presentation of the Virgin*, 1538. Oil on canvas, 335 × 773 cm. Venice, Gallerie dell'Accademia.

Provenance

Bought by Henry Austen Layard when British ambassador in Madrid, not long before 6 June 1872.[21] A letter from him in 1874, alluding to a Flemish tapestry offered by a dealer called Brachio, mentions that it was the same dealer 'qui m'a vendu le Bonifazio'.[22] For Layard's collection generally see Penny 2004, pp. 372–8. Bequeathed by Layard to the National Gallery, where it arrived in 1916.

Exhibition

London 2000, British Museum.

Frame

The carved and gilded frame (fig. 4) has a cassetta profile. The frieze is filled with a relief of fleshy, overlapping leaves which flow up from the lower corners to the upper ones, from the centre of the upper horizontal and towards the centre of the lower. The leaves are contrasted with a punched ground. The gilding is original. The orange bole underneath is now visible. The style is Spanish and the frame must have been commissioned for the painting by Layard in Madrid. NG 3130, another Layard painting, formerly attributed to Gentile Bellini, also has a frame of this type, as does Antonio Mor's *Portrait of a Woman*, in the Prado (no. 2880).

Fig. 3 Marcantonio Raimondi (or follower?), *Solomon and the Queen of Sheba*, c.1520–5. Engraving, 40.1 × 56.5 cm. London, The British Museum.

Fig. 4 Lower left corner of frame currently on NG 3107.

NOTES

1. Penny and Spring 1996, pp. 47–8.

2. All the pigments cited have been identified by EDX analysis in the SEM.

3. See Morelli's letter in Anderson 1999, p. 169. Layard 1902, II, p. 574 (the text was first published in 1891).

4. Frizzoni 1896, p. 466.

5. Venturi 1912, p. 456.

6. Memorandum in the Gallery's dossier.

7. Undated letter from Nicky Mariano.

8. Berenson 1957, I, p. 168.

9. Gould 1975, pp. 311–12.

10. For example Anderson 1999, p. 169, note 159, who deems it 'optimistic'.

11. See the 'deschi da parto' in the Museum of Fine Arts, Boston, and in the Museum of Fine Arts, Houston.

12. Ivanoff 1979, pp. 392–3, plates 395 and 397. The paintings are on deposit from the Accademia (inv. nos 1294 and 1295), Moschini Marconi 1962, pp. 66–7, nos 110–11. A relationship with Antonio Palma's *Esther before Ahasuerus*, dated 1574, in the Ringling Museum, Sarasota, has been proposed (Tomory 1976, pp. 99–101, no. 99).

13. Pallucchini and Rossi 1982, I, p. 171, no. 185; II, fig. 242.

14. Ibid., I, p. 138, no. 48; II, figs 57 and 58.

15. Ibid., I, p. 186, no. 251; II, fig. 335.

16. For example ibid., I, p. 148, no. 104; II, fig. 131 (then private collection but acquired in 1988 by the Accademia, Venice); I, pp. 148–9, no. 105; II, fig. 132 (Bob Jones University, Greenville); I, pp. 151–2, no. 116; II, fig. 145 (Château of Chenonceaux).

17. Oberhuber 1976 (Bartsch 1802–21, XXVI (originally XIV)), I, p. 22, no. 13; Shoemaker 1981, pp. 168–70, no. 54. I owe this observation to Anne Thackray.

18. Serlio 1584, II, p. 50v.

19. Gould 1962; Olivato 1971.

20. Ballarin 1968, figs 95–8.

21. Anderson 1999, p. 169.

22. British Library, Add MS 38966, fols 204r–204v, Layard to Morelli, 24 April 1874. I owe this reference to Lorne Campbell, who observes that 'Brachio' may be 'Brachis'.

Jacopo Tintoretto (1518/19–1594)
and Domenico Tintoretto (1560–1635)

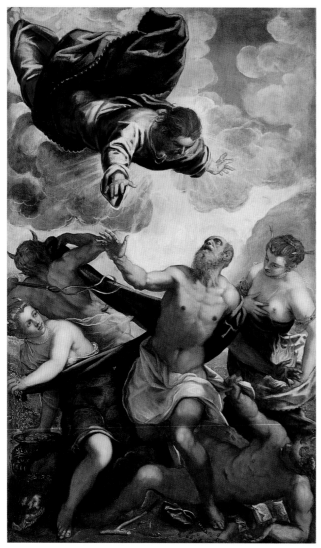

Fig. 1 Jacopo Tintoretto, *The Temptation of Saint Anthony*, c.1577.
Oil on canvas, 282 × 165 cm. Venice, Church of S. Trovaso.

Jacopo Robusti, known as Tintoretto, was born in Venice in 1518 or 1519. The name Tintoretto – literally 'little dyer', in reference to his father's trade – was adopted (or accepted) by the artist from about 1545, and thereafter, on the rare occasions when his name is inscribed on his paintings, it takes the form of 'Tentor', 'Tentoretto' or 'Tintorettus'.[1]

Jacopo's earliest known signed and dated painting is a *Virgin and Child with Saints* of 1540.[2] The Virgin's pose is derived from Michelangelo, whose work – available to Jacopo in prints and in models and casts – was a major source of inspiration in his youth.[3] The infant Christ appears to be trying to fly, an early example of the artist's preference for open and active poses, sometimes bordering on the ridiculous. In the same picture Saint Catherine's wheel, a massive piece of machinery, is typical of the artist's originality and redolent of his artisanal origins. By early 1545 Jacopo had completed two ceiling paintings for Pietro Aretino, which suggests that he was seen as a rising star.[4] Some idea of these can be obtained from the octagonal ceiling pictures with Ovidian subjects in Modena,[5] which are wild in execution, and both comic and grotesque as well as highly dramatic in treatment (see fig. 3, p. 140). Like Schiavone (see pp. 114–23), with whom he may have been associated,[6] Jacopo employed furniture paintings as a means of experimenting with flamboyant handling.

Jacopo also exhibited uncommissioned paintings at the Merceria and the Rialto.[7] However, the chief way that Jacopo found to advertise his talent was by fresco painting. Many earlier sixteenth-century artists had first achieved public notice by painting on the exterior walls of buildings (Titian, Pordenone, Taddeo Zuccaro and Polidoro da Caravaggio are examples); a number of such frescoes are recorded in Ridolfi's life of the artist but only a few scraps of one of them now survive.[8] The subjects often involved dramatic action and sensational effects: equestrian battles, the Conversion of Saul, the Rape of Ganymede. These were all early works, and some at least date from the mid-1540s.

It helps to understand Jacopo's innovative handling of oil paint on canvas if it is considered as equivalent to outdoor fresco painting in speed of execution and concern with viewing from a distance. With the exception of the furniture paintings of the 1540s that have been attributed to Jacopo (for example *Jupiter and Semele*, NG 1476), he made few, if any, oil paintings on wood.[9]

Jacopo's large narrative painting of *Saint Mark rescuing a Slave*, completed in 1548 for the Scuola Grande di San Marco (fig. 1, p. 196), excited great admiration, but also, at least at first, alarm and distaste[10] – a reaction recalling the controversial reception said to have been accorded to Titian's *Assunta* thirty years before, and indeed the *Assunta* must surely have been the painting by Titian that most influenced Jacopo (who was said to have worked briefly in Titian's studio[11]). He imitated the crowding of the figures, their powerful silhouetted gestures, the device of a prominent and active figure seen from behind. However, the figures of the slave and the saint must have made the greatest impression in Jacopo's painting for the *scuola*, and here, as in his lost frescoes, he adopted the sort of foreshortening that was chiefly associated with ceiling painting. He painted figures as large as those in Titian's altarpiece on several occasions and in the early 1560s, by offering to charge only for his expenses, he secured a commission to paint two canvases for the choir of the Madonna

dell'Orto that were more than twice as high as Titian's altarpiece.[12]

By the early 1550s Jacopo had developed all the major characteristics of his mature style. He was the first artist to exploit the dramatic possibilities of linear perspective – the vertiginous rush into depth, the startling contrast of large and small forms – independently of any idea of creating a logically consistent fictional extension of the beholder's space. By placing the vanishing point well above the viewer's eye level he made figures seem to float, depriving us of our own sense of stability. He avoided placing figures parallel to the picture plane and allowed no stable verticals to counteract his restless diagonals. The most daring of his architectural stage sets are those in the paintings of the *Miracles of Saint Mark* made for the Scuola di San Marco between 1562 and 1566 (fig. 2) at the instigation of Tommaso Rangone (for whom see p. 159).[13] However, it was equally common for him to dispense with a perspectival framework in his compositions and to allow the figures themselves to define the space. That is the case, for example, with the *Origin of the Milky Way* (NG 1313) – which, admittedly, is set in the clouds – but also with his altarpiece of the *Temptation of Saint Anthony* (fig. 1).[14]

Nearly 150 drawings by Jacopo survive in charcoal or black chalk on blue paper (more or less faded). They are chiefly studies of nude male youths or of models made of clay or wax. Limbs and torsos tend to be exaggerated in length and loose but elastic in articulation.[15] His drawings include studies of sculptured heads, both antique and by Michelangelo, but rarely from living models, and it is significant that his narrative paintings depend more upon body language than facial expression. His compositions often appear from X-radiography to have been improvised arrangements, on canvas, partly of separate studies that he made on paper. There are few examples of preparatory drawings by him which can be described as compositional studies, and the few *bozzetti* that he made were requested by his patrons.[16]

Fig. 2 Jacopo Tintoretto,
The Removal of the Body of Saint Mark from Constantinople, 1562–6.
Oil on canvas, 398 × 315 cm.
Venice, Gallerie dell'Accademia.

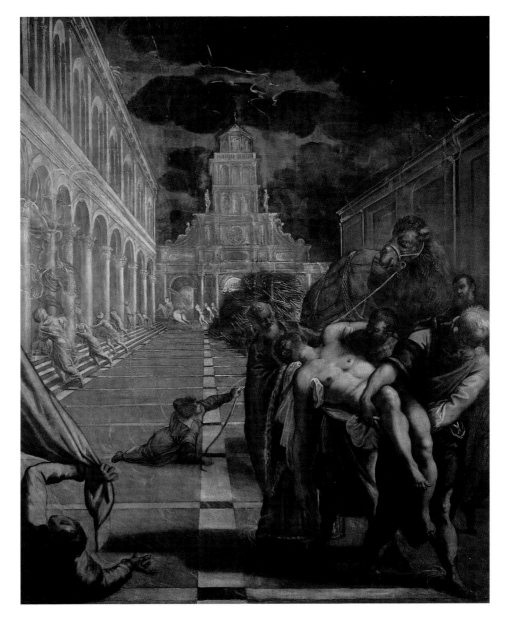

Much of Jacopo's painting itself could also be described as a type of drawing. 'With Tintoretto we are never conscious of the study of plane and surface. From first to last a marked *écriture* in the painting enlivens the merest rough indications of the major masses. Between Tintoretto's high lights and his darks there is hardly a connecting tone; he is like a man playing always in the highest and lowest octaves.'[17] By 1549 he had begun to increase the shadows in his paintings: the large canvas of *Saint Roch ministering to victims of the plague*, completed in that year for the church of S. Rocco, is the first of many dark interiors;[18] NG 1130 is a later example. Most of his later paintings were made on a dark ground.

Jacopo tried with some success to emulate Veronese's brilliant colours[19] (NG 16 is a notable example) but divergence was the most significant result of the competition between these two artists, with Veronese leaving violent movement, unstable spatial effects and unsettling chiaroscuro to Jacopo, and Jacopo generally avoiding opulent accessories, beautiful arrangements of lightly shadowed local colour, and planar composition. A large painting by Veronese can usually be considered as pleasing décor (although it is always more than that) but a large painting by Jacopo Tintoretto is an intolerable presence unless you are absorbed in looking at it.

Only Jacopo's solemn portraits could truly be described as quiet. The heads seem to have been painted from life but the bodies are formulaic and, for reasons of decorum, are given none of the freedom of movement that is typical of his narrative compositions. When he introduces portraits into religious narratives the effect is often extremely awkward.

Jacopo worked much for the Venetian confraternities. The parish-based *scuole* devoted to the Sacrament (described here on p. 170) commissioned large paintings for their *banca* and then for the side walls of their chapels: there was no liturgical need for these paintings and it may be that artists, and above all Jacopo Tintoretto, did something to stimulate the demand.[20] The larger confraternities (the Scuole Grandi), which were immensely rich, spent lavishly on paintings for their great meeting rooms. Jacopo began to paint for the Scuola di S. Rocco in 1564, supplying ceiling paintings for the Sala dell'Albergo. In the following year he painted the *Crucifixion*, one of his greatest works, covering the whole wall of that room. Then, in 1575–8, he supplied paintings for the ceiling and walls of the Sala Grande. And finally, between 1583 and 1587, he painted eight canvases – much the finest of his late works – for the Sala Inferiore.[21] These paintings all remain *in situ*.

The parish confraternities involved people of all social classes, and Jacopo's emphasis on the poverty of the disciples, who sit on rude furniture and wear patched clothing (fig. 2, p. 166), may have been considered appropriate for them.[22] On the other hand, the 'popularising' character of the paintings made for the Scuola di S. Rocco is easily exaggerated – a broken rush seat and a heap of carpenter's tools in the foreground of his *Annunciation* catching the eye more easily than the gilt ceiling and silk tester in the depths of the room.[23]

Throughout his career Jacopo also received commissions from the state, culminating in the gigantic *Paradise* painted on the end wall of the Sala del Maggior Consiglio in the Doge's Palace between 1588 and 1592 (a commission diverted to him after Veronese's death).[24] He also received commissions from patricians, many of whom sat to him for their portraits (NG 4004 is an example), but he was seldom, if ever, engaged in the decoration of villas[25] or of the most opulent burial chapels. His only documented excursion from Venice was to the court at Mantua in 1580 to install the canvases he had painted for the duke,[26] and later in the same decade he was also painting for the Holy Roman emperor and the king of Spain. That he is said to have felt uncomfortable at the Mantuan court and to have declined a knighthood offered by the king of France[27] suggests that he valued independence above status.

If his own best work was sometimes done free of charge or for a low fee,[28] it is also true that the success of his business meant that his workshop played a very large part in his massive production, and many of the paintings that left his studio were of a lower quality than any associated with artists of comparable stature. Fortunately for his reputation, high-quality engravings were made of his finest compositions (some of the best of these were by Agostino Carracci),[29] but his flamboyant technique and his breaches of decorum, already controversial in his lifetime and censured both by Titian's admirers and by Vasari, ensured that in subsequent centuries he received only qualified approval from academic critics.[30]

Jacopo died in 1594 and was buried in the Madonna dell'Orto in the vault of his father-in-law, a wealthy citizen of Venice, whose family was of a notably higher rank than his own. His wife, Faustina, had borne eight children, three of whom – Marietta (who died *c.*1590), Marco and Domenico – were trained as painters. **Domenico** (1560–1635) was a major collaborator with his father from the late 1570s, making a large contribution to the huge *Paradise* canvas that Jacopo was working on in the Doge's Palace.[31] He was also active as an independent artist during the same period.

In accordance with Jacopo's will, his estate passed into the control of his widow, probably because it was clear that Marco could not be trusted to have a proper share in the business, although there was a reluctance to exclude him from the inheritance. At the same time, the will explicitly acknowledged Domenico's status as artistic heir, for he was charged to complete his father's commissions 'using the style and taking the care that he has so often employed on many of my works' ('usando quella maniera e diligentia che ha sempre usata sopra molte mie opere').[32]

Ridolfi records that Domenico had plans to form some sort of academy in which the drawings and models he had inherited from his father would be of public benefit, but that he found the student painters troublesome to manage and abandoned the idea.[33] Instead, he bequeathed to 'Bastian mio giovane' – that is, Sebastiano Casser, the German pupil who had long worked for him – drawings which would be of use to him, including his choice of 150 drawings of men and 50 of women, made from life ('scizzi dal natural'), and also four sculptures ('pezzi de relievo'), including the head of the

emperor Vitellius. The other studio drawings and sculptures were to go to his brother. He also arranged for Casser to marry his widowed sister, Ottavia.[34]

Domenico's artistic eminence in the years following his father's death is clear from the part he played in designing the mosaics of the basilica of S. Marco (documented in 1595 and 1597) and from the fact that he was invited to the court of Mantua (in 1598 or 1599).[35] But it seems that after 1600, although he had plenty of work, major commissions eluded him. If we compare his historical narratives in the Sala del Maggior Consiglio, executed in 1587, with the canvases (Scuola Grande di S. Marco) that he painted twenty-odd years later, illustrating miracles associated with the body of Saint Mark, the evidence of declining powers is very clear. The latter are poorly composed, bland in characterisation, slack in modelling and flat in handling, although the patrons had important connections with his family, and the paintings were part of a series his father had initiated with some of his greatest works (fig. 2, and fig. 1, p. 196).[36] Domenico's decline as an artist is even more apparent after 1620.[37]

As a young man Domenico was known to be well read and he also occasionally wrote poetry himself. His paintings based on the poetry of Lucretius, Ariosto and Marino, made, apparently, on his own initiative, were much admired.[38] The *Tancred baptising Clorinda* in the Museum of Fine Arts, Houston, may be one of these pictures (although taken from Tasso), and if so it illustrates how effectively Domenico adopted the startling foreshortening and cursive brush drawing that were characteristic of his father.[39]

Among the drawings which can be attributed to him, the most remarkable are compositional studies executed in tempera on paper. These were originally thought to be by Jacopo. Sidney Colvin announced in *The Burlington Magazine* that 'Suddenly in the Spring of 1907 there was brought to the Museum [the British Museum] an oblong volume of rich crimson morocco binding of the seventeenth century, containing no less than eighty five original drawings by the master.'[40] Many of these relate to Jacopo's compositions, including the relatively early *Saint Mark rescuing a Slave*, but instead of being preparatory studies for that work they are schematic and analytical studies of it, and of alternatives to it. Although made by Domenico, they may nonetheless be connected with Jacopo's uncompleted project of making 'una quantità di disegni' that would set a seal on some of his inventions ('lasciare impresse alcune sue fantasie'), perhaps by having prints made of them – an episode to which Ridolfi refers in an obscure passage.[41] The fact that the drawings seem to have been influenced by the almost cubist compositional drawings of Luca Cambiaso is also of interest since we know that these were admired by Jacopo.[42]

Domenico also established, at an early date, a reputation for his portraits. Ridolfi lists more than fifty of these by the names of the sitters, who range from Queen Margaret of Austria, consort of Philip III, to doges and cardinals, noblemen from Genoa, the ruling families of Mantua and Ferrara, and English visitors to Venice (including Dudley Carleton, Sir Henry Wotton and the Earl and Countess of Arundel),

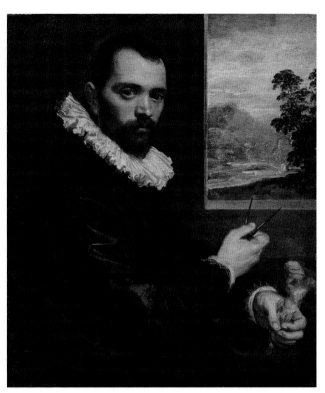

Fig. 3 Domenico Tintoretto, *Portrait of a Sculptor* (*Ascanio de' Christi*), *c.*1590. Oil on canvas, 73.4 × 62.5 cm. Munich, Bayerische Staatsgemäldesammlungen, Alte Pinakothek.

as well as leading Venetian officials, lawyers and artists.[43] No previous Venetian painter had come so close to being a portrait specialist.

Among the few portraits by Domenico that can be identified with near certainty is the one in Munich of a man holding a small carving, who is surely Ascanio de' Christi, a celebrated maker of ivory figures of the crucified Christ (fig. 3).[44] The portrait of a man in the Hermitage, sometimes thought to represent Francesco Bassano, must be by the same hand,[45] and this attribution can be supported by comparison with the two paintings, each packed with portraits of eighteen members of the Scuola dei Mercanti, that Domenico was commissioned to supply for either side of a Nativity in about 1591–2.[46]

There is little stylistic consistency in Domenico's œuvre. The impressive painting of the *Penitent Magdalen* in the Pinacoteca Capitolina, Rome (fig. 4), inscribed as by him, is perhaps the painting of this subject that Jacopo Tintoretto sold for thirty ducats, without his son's permission, to a dealer who had badgered him to do so (Domenico was so angry that Jacopo had to bargain for its return),[47] or perhaps it is the painting of 'una maddalena avvolta in una stora' (Magdalen wrapped in a rough mat) that Domenico is said to have made for Duke Vincenzo Gonzaga of Mantua around 1599.[48] It is not obviously by the same hand as the portraits in Munich and St Petersburg.

Carlo Ridolfi's life of Jacopo was first published in 1642 and was republished six years later with significant additions

in his collection of Lives, the *Maraviglie*, which also included a life of Domenico. Most of what we know about the artists depends on Ridolfi. Hadeln's edition of the 1648 lives, published in 1914 and 1924, remains an essential work of reference (the biographies of the Tintoretto family appear in the second volume).

Jacopo's painting was the subject of great critical reappraisal in the second half of the nineteenth century, chiefly thanks to the enthusiasm of John Ruskin and Hippolyte Taine.[49] More monographs were devoted to him in the early years of the twentieth century than to any other old master. Thode's study in German appeared in 1901, followed by three books in English (Holborn 1903, Phillipps 1911, Osmaston 1915) and others in French and Italian. The first monographic exhibition opened at Ca Pesaro in Venice in 1937 and the monograph of Hans Tietze (completed in 1939 but not published until 1949) was made partly in response to it. The first full catalogue of the portraits and the drawings was supplied by Paola Rossi in 1974 and 1975 and she produced the indispensable catalogue of the paintings attached to Pallucchini's account of the artist in 1982. The most important modern development in the study of Jacopo's art is certainly that of Joyce Plesters,[50] a milestone in the use of scientific analysis to understand an artist's technique, to which this catalogue is much indebted and of which the National Gallery will always be proud.

The conclusions reached by Plesters have been amplified and qualified by Jill Dunkerton in an essay published in the catalogue of the Tintoretto exhibition held at the Prado, Madrid, in 2007. This, together with essays (published in English as well as Spanish[51]) by Robert Echols, Frederick Ilchman, Roland Krischel and the exhibition's curator, Miguel Falomir, make this catalogue the most valuable modern introduction to Tintoretto, and the documentary appendix by Linda Borean will be indispensable for all future study of the artist.

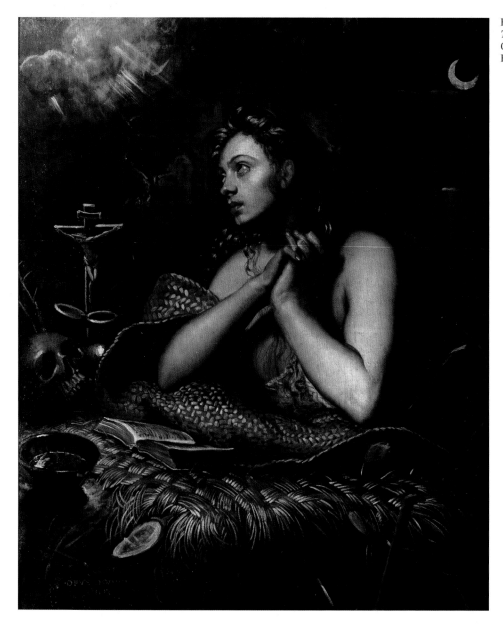

Fig. 4 Domenico Tintoretto, *The Penitent Magdalen*, c.1599. Oil on canvas, 114.5 × 92 cm. Rome, Pinacoteca Capitolina.

NOTES TO THE BIOGRAPHY

1. De Vecchi 1970, nos 67, 144, 145, 148, 222. The first name is given as J. (or Jacomo) and I. (or Iacobus). See also Christiansen 2006, p. 771. For the significance of this choice of name see Nichols 1999, pp. 17–18.

2. Pallucchini and Rossi 1982, I, p. 132, no. 10; II, figs 1, 13–14. The painting was long known as the 'Wildenstein Sacra Conversazione'. It is now in a private collection. See also Falomir 2007, pp. 186–8 (no. 1), entry by Echols.

3. Ridolfi 1642, pp. 6–7; 1924, pp. 13–14. See also Nichols 1999, chapter 1.

4. The *Apollo and Marsyas* in the Wadsworth Athenaeum (Pallucchini and Rossi 1982, I, p. 143, no. 82; II, p. 333, figs 103, 105) has been supposed to be one of the paintings made for Aretino but it does not look like a ceiling painting.

5. Pallucchini and Rossi 1982, I, pp. 134–5, nos 21–34; II, pp. 302–4, figs 31–9.

6. Ridolfi 1642, pp. 9–10; 1924, pp. 15–16, 52.

7. Ridolfi 1642, p. 11; 1924, p. 16.

8. Ridolfi 1642, pp. 10, 12, 14–15, 54; 1924, pp. 15–19, 42. See also Zanetti 1760, pp. viii–ix and plates 8–14. A few fragments of the frescoes on Ca Soranzo survive in a private collection. Pallucchini and Rossi 1982, I, p. 134, nos 17–18; II, p. 299, figs 23–5.

9. A possible exception is the landscape with Saint John on Patmos in the Princeton University Art Museum (1942-1). This panel seems to have been in the collection of the Grand Dukes of Tuscany.

10. Ridolfi 1642, p. 21; 1924, p. 22. Pallucchini and Rossi 1982, I, pp. 157–8, no. 13; II, pp. 368–70; figs 173–6.

11. Ridolfi 1642, p. 5; 1924, p. 13.

12. Pallucchini and Rossi 1982, I, pp. 182–3, nos 236–7; II, pp. 446–53, figs 307–15.

13. Ridolfi 1642, pp. 22–3; 1924, pp. 22–3; Pallucchini and Rossi 1982, I, pp. 183–5, nos 243–5; II, pp. 456–60, figs 323–7.

14. Ibid., I, p. 208, no. 370; II, p. 534, fig. 478.

15. For the models of wax and clay see Ridolfi 1642, p. 8; 1924, p. 15. For deliberate exaggeration see ibid., 1642, p. 8; 1924, p. 18.

16. For the 'bozze dell'inventione' requested from him for the Gonzaga cycle see Pallucchini and Rossi 1982, I, pp. 213–15. The completed pictures are ibid., nos 392–9; II, pp. 551–3, figs 504–9. The *bozzetto* for the *Paradise* in the Doge's palace (stipulated in the competition) is in the Louvre, ibid., I, pp. 215–16, no. 400; II, p. 555, figs 512–13. When Jacopo supplied a completed painting rather than the 'schizzo' requested for the ceiling of the Scuola di S. Rocco (Ridolfi 1642, p. 29; 1924, p. 27) the strategy was perhaps suggested by his actual working methods.

17. Phillips 1899, II, p. 143 (the passage contrasts Tintoretto with Titian).

18. Pallucchini and Rossi 1982, I, p. 158, no. 134; II, pp. 373–5, figs 178–80.

19. According to Ridolfi (1642, p. 47; 1924, p. 38) this was Tintoretto's own claim for his *Assunta* in the Gesuiti (Pallucchini and Rossi 1982, I, p. 168, no. 170; II, p. 398, fig. 223).

20. Hills 1983.

21. Pallucchini and Rossi 1982, I, pp. 200–7, nos 332–56; pp. 225–7, nos 435–40; II, pp. 504–29, figs 429–63, and pp. 578–87, figs 553–64. Nichols 1999, chapters 4 and 5, provides a good general account of the paintings.

22. Nichols 1999, p. 219.

23. Pallucchini and Rossi 1982, I, p. 225, no. 435; II, p. 578, fig. 553.

24. Pallucchini and Rossi 1982, I, pp. 233–4, no. 465; II, figs 90, 589.

25. Ridolfi (1924, p. 67) tells one story which suggests that he did decorate a villa on at least one occasion.

26. Luzio 1913; Phillipps 1911, p. 149; Pallucchini and Rossi 1982, I, pp. 213–15, nos 392–400; II, pp. 551–3, figs 504–9.

27. Ridolfi 1642, pp. 41–2, 47; 1924, pp. 35, 37.

28. Ibid. 1642, pp. 14–16; 1924, pp. 18–21. See on this topic Hills 1993 and Nichols 1999, chapter 3 and Appendix 1.

29. De Grazia 1979. See also Bury 2001, pp. 105–7, no. 66; pp. 192–3, no. 130.

30. Lepschy 1983, pp. 15–36, provides an excellent account of his reputation before Ridolfi, and her third chapter (pp. 57ff.) gives a comprehensive account of his reception in the eighteenth century.

31. Ridolfi 1642, p. 82; 1994, p. 92.

32. The wills were first published in the *Gazette des Beaux-Arts*; Phillipps 1911 supplies a translation as an Appendix. See also Tozzi 1933, pp. 302–4; Ridolfi 1994, pp. 127–8. More evidence of Marco's unreliability ('il suo poco governo') is provided by Faustina's will of 1613, for which see Ridolfi 1994, pp. 129–30.

33. Ridolfi 1924, pp. 262–3; 1994, p. 123.

34. Tozzi 1933, pp. 312–13; Ridolfi 1994, pp. 132–3.

35. Tozzi 1933, p. 304. Tozzi also proposes that Domenico may have been the official painter to the Republic.

36. Ibid., p. 310.

37. Paintings are dated as late as 1626 and 1628. Ibid, p. 311.

38. Ridolfi 1924, p. 262; 1994, pp. 122–3.

39. Formerly Logan collection, Chicago. De Vecchi 1970, p. 278, no. 274; Tozzi 1937, pp. 26–9, and 1960, p. 391; Wilson 1993.

40. Colvin 1910. The drawings were warmly received by other scholars at first (for example Phillipps 1911, p. 136, and Osmaston 1915, II, pp. 119, 125). For a just assessment see Tozzi 1937.

41. The connection with this passage in Ridolfi (1924, p. 64; 1994, p. 95) was proposed by Colvin 1910, p. 261.

42. Ridolfi 1924, p. 68; 1994, p. 102.

43. Ridolfi 1924, pp. 259–61; 1994, pp. 118–21.

44. Kultzen 1971, pp. 123–5, plate 911. Ridolfi (1924, p. 261; 1994, p. 121) calls the sculptor 'Ascanio detto da i Christi, eccellente scultore in avorio'.

45. Artemieva 2001, pp. 108–9, no. 30.

46. Tozzi 1933, p. 302; the paintings are now in the Quadreria of the Accademia Galleries – Nepi Scirè 1995, pp. 85–8, nos 44 and 45.

47. The passage was not included in Ridolfi 1642 but is in the 1648 edition (for which see Ridolfi 1924, p. 67; 1994, p. 100).

48. Ridolfi 1924, pp. 259–60; 1994, p. 118; for the date see Tozzi 1933, p. 306, and 1960, p. 392. 'Stora' is Venetian dialect for 'stuoia'. Domenico certainly made more than one version of this composition. There is a repetition dated 1586 in a church in Pelsen, in the Czech Republic (Pallucchini 1981, I, p. 25, II, fig. 10), and others have been recorded. X-radiography reveals that the *Venus and Mars* in the Art Institute, Chicago, was painted by Domenico on top of a repetition of the *Magdalen* (Lloyd 1993, p. 236, fig. 2).

49. Lepschy 1983, pp. 97–120.

50. Plesters 1979, 1980, 1984.

51. Falomir 2007.

Jacopo Tintoretto?

NG 1476
Jupiter and Semele

*c.*1545?
Oil on spruce, 22.7 × 65.4 cm

Support

The panel is a single plank of spruce,[1] between 2.0 and 2.2 cm thick. The plank was cut tangentially from near the heart of the tree and has a convex warp. The panel seems not to have been reduced. It is covered by a thin gesso ground (composed of pure gypsum).[2] It has been stamped twice on the reverse with a monogram consisting of a double circle enclosing a reversed S linked by a small cross. Also on the back 'S 20/2' is painted in black – the 'S 20' with the use of a stencil and the '/2' loosely – as is 'III 61' (which may be intended for '19 III').

Materials and Technique

The medium is linseed oil. Azurite was used for the sky and Jupiter's cloak, and verdigris is employed below copper green in the tree and landscape. Vermilion has been identified in the flames, together with 'lead tin yellow type one'. Lac and madder lakes have been found in the rose-red hangings.[3]

Infrared light reveals a summary but bold underdrawing made with a brush and a black pigment. It includes a different perspectival scheme for the paving.

Conservation

When the painting was acquired by the Gallery in 1896 it was described as in good condition and with no repairs. After a superficial cleaning it was varnished with mastic. In November 1946 some loose paint was secured in the upper left corner and minor abrasions to the varnish were treated. By then, the painting was described as dirty. Blisters were treated in August 1957 and it was cleaned and restored in April and May 1979.

Condition

There are some old losses in the sky, the landscape, the pillars and the figure of Jupiter. The shadowed areas of Jupiter's cloak are extensively crackled from the shrinking of the oil-rich paint. The eagle flying beside Jupiter might easily be mistaken for part of his cloak, but this may always have been a deliberate effect. The clouds now look somewhat patchy, perhaps because the paint has become more translucent. The dark brown tree to the left may originally have been green.

Subject

The story of Semele was most familiar from the third book of Ovid's *Metamorphoses*. Semele, daughter of Cadmus (founder and ruler of Thebes) and sister of Actaeon, is chosen as a mistress by Jupiter. Eventually, word of her pregnancy reaches Juno, who, disguised as Semele's old nurse, insinuates to Semele that her lover might not really be Jupiter. At the nurse's suggestion, Semele asks him to vow to grant her a special favour, one that she cannot name. He agrees to do so, and she requests that he come to her bed in the form that he has when he visits Juno, 'like himself, the mighty thunderer ... armed with inevitable fire'. Reluctantly, he complies and she is burned to ashes.[4]

The subject is not very common in painting but in the mid-sixteenth century it enjoyed some favour in Venice for the decoration of ceilings and furniture, notably in one of the sixteen octagonal canvases painted by Tintoretto for the compartments in a richly coffered ceiling of Vettore Pisani's palace (fig. 3; one of the artist's earliest works, probably of 1541–2[5]), and in one of eight canvas scenes perhaps painted for the ceiling of another Pisani property by an imitator of Tintoretto at least a decade later.[6]

Original Setting and Companion Paintings

To judge from its size and shape, NG 1476 was originally incorporated into the front compartment of a chest or perhaps into a bed. The orthogonals in the paving have a vanishing point above the picture, so a high viewing point was anticipated. Decorations of this kind seem always to have involved a series of paintings, and two panels of Ovidian subjects – *Latona changing the Lycian Peasants into Frogs* and *Apollo and Diana killing the Children of Niobe* (figs 1 and 2) – in the Courtauld Institute Gallery (bequeathed by Count Seilern) are not only of the same height and painted in the same technique and style as NG 1476, but were shown by Plesters to be painted on wood from the same tree and to be marked with the same stamp on the reverse.[7] *Argos and Mercury*, a painting formerly in the Suida Manning Collection, may also have belonged to this series.[8]

Attribution

The painting was considered to be by Andrea Schiavone when it was included by its owner, Frederic Leighton, in the Royal Academy's exhibition of old masters in 1876;[9] it was catalogued as such in his posthumous sale at Christie's in 1896[10] and subsequently by the National Gallery. However, when it was displayed together with the small canvases by Schiavone (NG 1883 and NG 1884, see pp. 116–23) in the East Vestibule by Charles Holmes, perhaps to test the attribution and perhaps also to suggest the way in which such pictures would have been arranged on a chest, it became clear that they were by another hand. Ellis Waterhouse pointed this out in a letter published by *The Burlington Magazine* in June 1927.[11]

Waterhouse noted that the series of six horizontal furniture paintings in the Kunsthistorisches Museum, Vienna, also on panel and also given to Schiavone, had been published as the work of the young Tintoretto by Hadeln in 1922.[12] He observed that there was a close similarity between the landscape elements in the *Prediction of David* (fig. 4) and those in NG 1476, and also drew attention to the 'convincing parallel' afforded by Tintoretto's *Resurrection* now in the Ashmolean Museum, Oxford.[13] Waterhouse's attribution has generally been followed, notably by Berenson, Pallucchini and Rossi.[14] But notes in the National Gallery's archive by Waterhouse

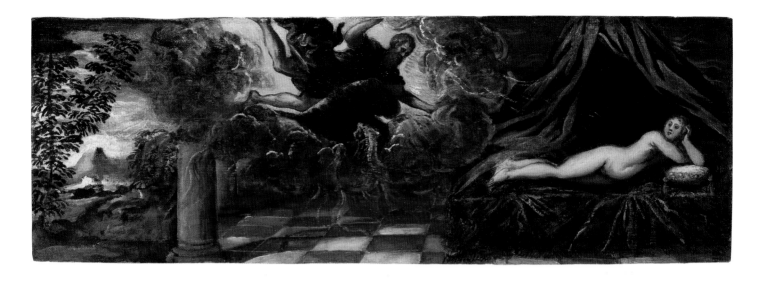

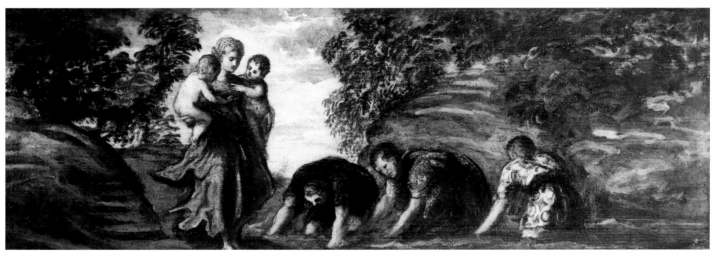

Fig. 1 Attributed to Jacopo Tintoretto, *Latona changing the Lycian Peasants into Frogs*, *c.*1545–8. Oil on panel, 22.9 × 67.1 cm. London, The Samuel Courtauld Trust, Courtauld Institute of Art Gallery.

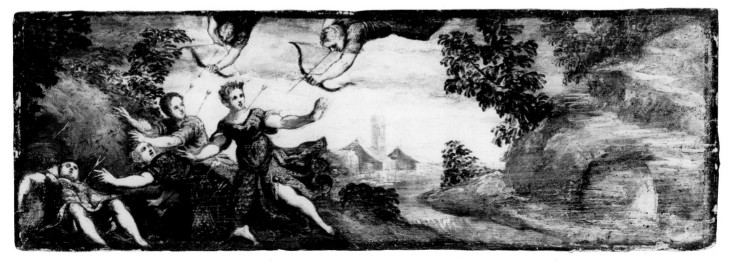

Fig. 2 Attributed to Jacopo Tintoretto, *Apollo and Diana killing the Children of Niobe*, *c.*1545–8. Oil on panel, 22.9 × 67.1 cm. London, The Samuel Courtauld Trust, Courtauld Institute of Art Gallery.

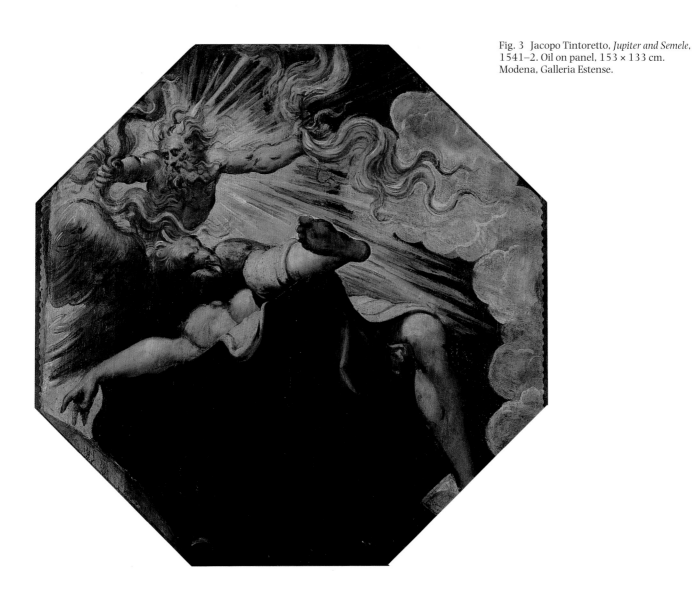

Fig. 3 Jacopo Tintoretto, *Jupiter and Semele*, 1541–2. Oil on panel, 153 × 133 cm. Modena, Galleria Estense.

Fig. 4 Attributed to Jacopo Tintoretto, *The Prediction of David*, 1545–8 . Oil on panel, 29 × 153.5 cm. Vienna, Kunsthistorisches Museum.

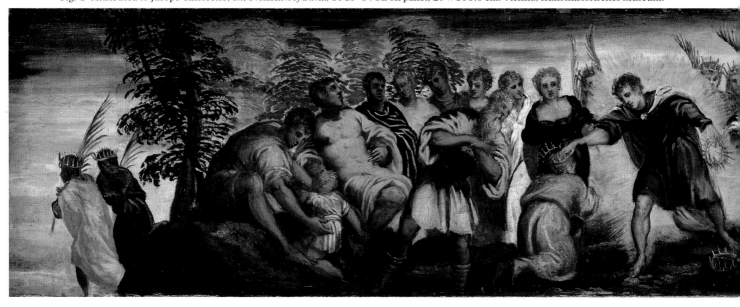

himself describe his own letter as 'rather imprudent'. Gould considered the young Tintoretto as only 'more probable' than Schiavone, and he catalogued the painting as 'ascribed to Jacopo Tintoretto'.[15]

There is good reason to believe that the young Tintoretto was very active as a furniture painter but none of the small paintings attributed to his early phase is a documented work. NG 1476 certainly seems to be by the same artist as the biblical pictures in Vienna, and there are also stylistic affinities with the *Death of the Virgin* in the Cleveland Museum of Art.[16] That this artist also painted the *Crucifixion* in the Museo Civico, Padua, and the *Conversion of Saul* in the National Gallery of Art, Washington,[17] seems very likely.

Provenance
By 1876 in the collection of the painter Frederic Leighton (1830–1896), later Lord Leighton of Stretton, President of the Royal Academy from 1878 when also, ex officio, Trustee of the National Gallery. Bought by the National Gallery at his posthumous sale, Christie's, London, 14 July 1896, lot 362.

Exhibition
London 1876, Royal Academy (189).

NOTES

1. Plesters 1984, p. 25.

2. Ibid., pp. 25, 28.

3. Ibid., p. 25.

4. Ovid, *Metamorphoses*, III: 253–315. The quotations are from William Congreve's libretto for *Semele*, Handel's profane oratorio first performed in London in 1744.

5. Mason 1996, p. 73, fig. 5. The paintings are all in the Galleria Estense, Modena; Pallucchini and Rossi 1982, I, pp. 134–5, nos 21–34 (*Semele* is no. 25); II, p. 360.

6. Museo Civico, Padua, Inv. 2811. Accepted by many Tintoretto scholars (notably by Paola Rossi in Pallucchini and Rossi 1982, I, pp. 141–2, nos 61–75; II, p. 327), the series is rejected conclusively by Vittoria Romani in Ballarin and Banzato 1992, pp. 183–6.

7. Plesters 1984, p. 25. The Courtauld paintings are nos 118 and 119 in 'The Princes Gate Collection'.

8. The painting was no longer in the collection when it was appraised in 1994 (information kindly supplied by Jonathan Bober).

9. No. 189.

10. 14 July 1896, lot 362.

11. Waterhouse 1927. Frölich-Bum 1913 had already questioned the attribution to Schiavone. When he wrote this letter, Waterhouse had recently graduated from New College, Oxford, and was studying El Greco at Princeton, hence his interest in Venetian painting of this date. He was to be appointed to a junior curatorial post in the National Gallery in 1929, under the directorship of Sir Augustus Daniel. Although he stayed there only three years, he made a huge contribution to the library's resources and scholarly records.

12. Hadeln 1922; Pallucchini and Rossi 1982, I, p. 138, nos 48–53.

13. Ashmolean Museum, no. 433; Pallucchini and Rossi 1982, I, p. 173, cat. 199; II, p. 415.

14. Berenson 1932, p. 560; Pallucchini 1951, p. 111; Pallucchini and Rossi 1982, I, p. 139, no. 58 (entry by Rossi).

15. Gould 1959, p. 93; 1975, p. 263.

16. 16.797. Catalogued as by an 'anonymous master' by N.C.W. in the 1982 *Catalogue of European Paintings*. For James Jackson Jarves, who owned the picture by 1883, it was a Tintoretto, and Berenson listed it as 'Tintoretto?'. The painting is also on pine. The unpublished paintings on the underside of the Barco in S. Maria dei Miracoli in Venice also have some stylistic features reminiscent of these paintings: sausage fingers, loose, flame-like drapery, weakly drawn feet, deep eye-sockets.

17. For the *Crucifixion*, inv. 1557 in the Museo Civico, Padua, see Ballarin and Banzato 1992, p. 181, no. 101 (entry by Vittoria Romani), and Pallucchini and Rossi 1982, I, pp. 26, 145, no. 90. For the *Conversion of Saul*, Samuel H. Kress Collection, National Gallery of Art, Washington DC, 1961.9.43, see ibid. 1982, I, pp. 142–3, no. 79, and II, pp. 329–30; also Shapley 1979, I, pp. 468–70, and II, pl. 34.

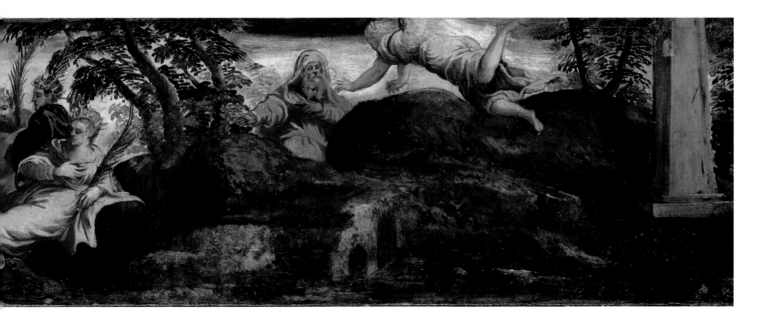

NG 16
Saint George and the Dragon

*c.*1555
Oil on canvas, 158.3 × 100.5 cm

Support

The fine tabby-weave canvas has an average thread count of 18 per centimetre in the warp and 16 in the weft.[1] It has been paste-lined on to a similar but heavier tabby-weave canvas. The stretcher is of varnished pine with crossbars.

Cusping is apparent on all four edges of the original canvas and especially so at the sides. Thus the original dimensions are unlikely to have differed significantly. The edges are ragged but largely concealed by putty of three different types, corresponding to three campaigns of restoration, but an unpainted border remains visible in some areas, notably at the lower left.

Materials and Technique

The canvas was given a thin gesso ground. Extensive underdrawing has recently been revealed by infrared reflectography (fig. 2). Every aspect of the composition was drawn with a brush on the gesso with the exception of God the Father. There were several notable differences from the image that was finally painted. The towers of the city walls were drawn crowned with domes and with the ramparts populated by spectators. The saint's head was placed in a higher position. The princess was positioned higher on the canvas and her head was turned more in profile. The most radical change is in the left foreground where the corpse was more prominent and in an entirely different pose. Tintoretto began to paint this figure but then replaced it with the smaller one. In both cases a grid was employed to transfer the drawing of the figure and can be seen in the underdrawing. This grid is also apparent on the paper in the case of the drawing for the figure in the final composition, which has survived and is discussed below.[2]

The princess's dress is painted with ultramarine mixed with varying proportions of lead white. Azurite was used for some of the other blues (notably in the sea). Malachite mixed with white lead and with lead-tin yellow, or verdigris with lead-tin yellow, are the chief paint mixtures in the landscape: a verdigris was also employed alone as a glaze in the darkest areas. The princess's cloak is painted with red lake.

X-radiography suggests that the tree trunk on the left was an afterthought. A branch, or trunk, was originally painted inclining in the other direction – as is, in fact, easily discerned in a raking light. Other trees or branches may have been tried out and cancelled here. The figures, on the other hand, seem not to have been changed in their essentials, although the drapery folds were improvised on the canvas, and the fingers of the princess's right hand were modified. A small addition breaking the clean sweep of the princess's raised cloak was painted over the dark green behind her and has now darkened. The tail of drapery above her right leg may also have been an afterthought.

Conservation

During its first twenty years in the Gallery the painting was varnished, probably more than once, with mastic varnish mixed with oil.[3] In 1853 a tendency for the original canvas to detach itself from the lining canvas was observed in several parts of the painting. It was revarnished in 1862 and relined in 1866.

No further treatment was recorded until 1940, when slight damage to the surface caused in transport to storage in North Wales at the beginning of the Second World War received attention and cleaning tests were carried out. The painting was 'polished' by 'Holder' in the spring of 1942 and by 'Vallance' in July 1945. A detailed examination of the painting was conducted in June 1945, preparatory to cleaning and restoration, but permission to proceed was not given until December 1961. The work was carried out between February and July 1962.

Condition

The painting has been flattened and abraded in some areas, but the original impasto is reasonably preserved and, in general, where the paint is thickest – in parts of the horse's rump, some of the pink of the princess's cloak, her flesh – the picture can be described as in good condition. Areas which have most obviously suffered from abrasion include the dark green of the foliage on the bank to either side of the tree stump, Saint George's floating cloak, which now reveals an orange underlayer (presumably the glue-darkened gesso ground), and the figure of God the Father in the sky, which was thinly painted in ultramarine and pink and is now more ghostly than was intended. Originally it would have been more obvious that it picked up the pink and blue of the foreground and middle distance. Salient points of the canvas weave are exposed in several places, but in some areas – for instance in the clump of trees on the right and in the spines of the dragon's left wing – the thinly gessoed ground was left untouched by the artist.

The ultramarine of the princess's dress may have blanched a little and the shadows in the skirt are no longer as deep as they must once have been. The back-plate of Saint George's armour is unconvincing in shape and has an oddly scrubbed look which is perhaps only partly intended. Most importantly, the raised part of the princess's cloak looks washed out, the effect of increased transparency. The critic Thomas Griffiths Wainewright in 1821 admired the way that 'the robe of Sabra [the Princess], warmly glazed with Prussian blue, is relieved from the pale greenish background by a vermilion scarf'.[4] Although Wainewright knew little of the history of pigments (Prussian blue had not yet been invented in the sixteenth century), he certainly knew the colour vermilion. However, the tiny quantity of vermilion recorded by Plesters in one sample of the drapery is not considered significant and Wainewright perhaps used the term loosely for red.

Alterations to the Painting: Discoveries in Cleaning

Although the canvas is rectangular, the painting is arched. It must have been originally displayed in a frame with

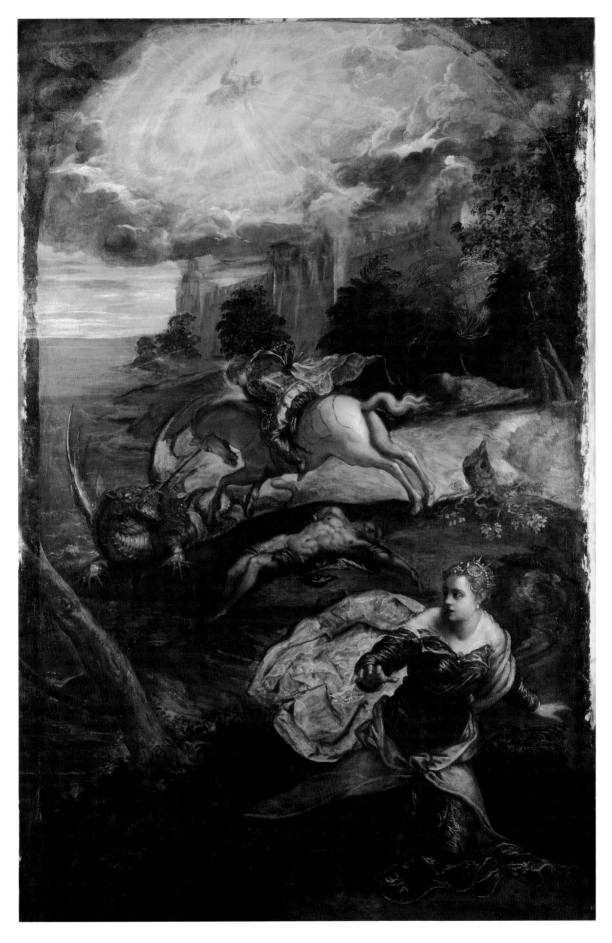

spandrels, as it has been since 1962. The two top corners were left unpainted, save for a thin coat of black pigment. At a later date they were overpainted with clouds, in a creditable imitation of Tintoretto's rapid and loaded brushwork. Much of this remains, concealed from view. The change was presumably made to adapt the painting as a gallery picture.

During cleaning in 1962 the turbulent character of the strip of landscape beyond Saint George became much more evident, and the hypothesis was advanced that it represents a foaming river. However, there seems to be no bank on the far side and there is no continuity between the 'river' and the lake into which it would surely have been intended to flow. More probably it was originally intended as a grassy slope. Forms reminiscent of water are found elsewhere in the painting: the earth behind the princess to the right has the swirling lines of a stream, and the sheer walls of the fortress have the sheen of a waterfall.

Attribution and Date

The painting has always been acknowledged as an entirely autograph work by Tintoretto. Modern scholars have generally regarded it as 'early' or, more precisely, as a painting of the artist's first maturity – that is, of the 1550s. Osmaston in 1915, however, regarded it as a late work and Cecil Gould dated it 'not earlier than the 1560s', arguing that the lighting on the trees was typical of his work in 1565.[5] It is possible to sense that Joyce Plesters, in her account of the relatively orthodox technique used in this painting, would have preferred to assign it to an earlier period than Gould.[6]

The assurance with which space is created and intervals are employed for dramatic effect distinguishes it from the artist's securely dated paintings of the late 1540s – notably the *Last Supper* of 1547 (still in S. Marcuola, Venice), and the *Miracle of Saint Mark* of 1548 now in the Accademia – where the compositions are crowded, but it retains the intense local colour characteristic of those early works. The brilliance is sometimes present in the shadows (as in the red drapery), sometimes in the middle tones (as in the blue),

sometimes in the lights (as in the greens), so that it is 'as if the colours emitted light on their own accord rather than received it from an outside source'.[7] This is an effect never found to the same degree in his paintings dated after 1560. The landscape in NG 16 includes some delicate passages similar to those in the *Susanna* in the Kunsthistorisches Museum, which is generally agreed to have been painted around 1555–60.[8]

The Saint and his Cult

The Canon of Pope Gelasius I (elected 492–d. 496) lists Saint George among the martyrs justly revered by the faithful. He was said to have been a native of Cappadocia, and to have suffered under the Emperor Diocletian, at Nicomedia. By the sixth century the saint's tomb was located at Diospolis (Lydda) in Palestine and 'he had acquired the inheritance of veneration' previously accorded to the pagan hero Perseus.[9] His cult was strong throughout the eastern Mediterranean. It was brought, together with his relics, to Western Europe by the crusaders: Eastern Europeans (Greeks and Slavs) who had long venerated George ensured that he was especially popular in Venice, where many of his relics were collected, as he also was in the rival city of Genoa and in England.

In later medieval art Saint George was generally represented killing the dragon which, according to legend, inhabited the lake outside the city of Lydda (or, in some accounts, Silene). The people of Lydda, having depleted their flocks, had taken to feeding the monster with human beings. George arrived in time to save the only daughter of the king. After subduing the dragon, he bade the princess lead it to the city, where 20,000 people were then baptised in consequence of his prowess. Jacopo da Voragine, relating this episode in the *Golden Legend*, mentions that some sources say that George slew the dragon on the spot.[10] He also concedes that some authorities had expressed some scepticism about this legend. There is indeed no early source for this exploit which may have originated in a misinterpretation by the crusaders of an allegorical relief of the Emperor Constantine.[11] It was much

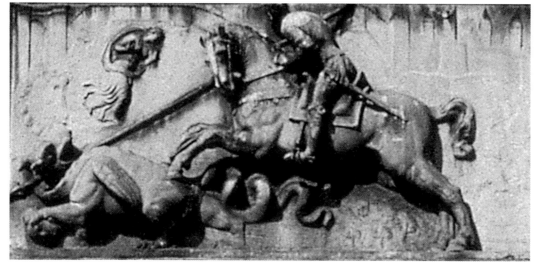

Fig. 1 Pietro da Salò, *Saint George and the Dragon*, 1551–2. Relief from the façade of the Scuola di San Giorgio degli Schiavoni, Venice.

OPPOSITE:
Fig. 2 Digital infrared reflectogram of NG 16.

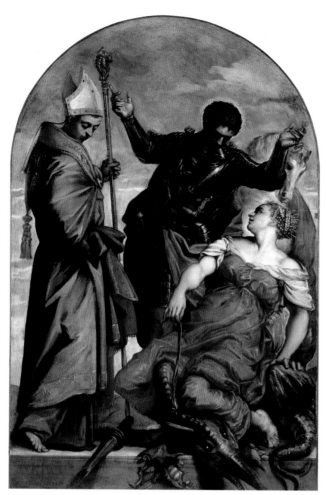

Fig. 3 Jacopo Tintoretto, *Saint George, Saint Louis and the Princess*, 1552. Oil on canvas, 226 × 146 cm. Venice, Gallerie dell'Accademia.

a white field. Tintoretto was commissioned to paint George and Louis of Toulouse together (they were the name saints of his patrons) for the offices of the Magistrati del Sale in Palazzo dei Camerlenghi in Venice in 1552 (fig. 3). He included as a third figure the princess riding on the back of the dragon – she is silhouetted against his white horse and reflected in his breast plate. This departure from convention was evidently controversial: it was deplored by Dolce in his *Dialogo* of 1557 (like many other commentators since, he supposed that Tintoretto had included a third saint in this comic position).[15]

The Subject and its Treatment

Connoisseurs were excited by the daring character of this composition when it was exhibited in London in 1821. 'The *ordonnance* of this highly desirable performance is very characteristic of the school of Rubusti,' wrote Thomas Griffiths Wainewright, noting that the horizon is placed 'two-thirds up the picture' and the figures are grouped in such a manner as to 'shoot obliquely across the canvas from the base to the horizon'.[16] The unorthodox treatment of the subject was also apparent to William Young Ottley in his *Descriptive Catalogue of the Pictures in the National Gallery with Critical Remarks on their Merits* of 1832:

> A very masterful performance, in which, boldly departing from the usual routine, the painter has represented the battle of the Saint with the Dragon, in the middleground of his picture; and has allotted to the Princess, whom he delivered, a prominent situation in the foreground.
>
> The figure of St George is seen in a back view, and is full of spirit: he has just thrust his lance into the extended jaws of the monster; whose former prowess is evinced by the dead body of one of his victims, which is represented, under the horse, a little nearer the spectator. That of the Princess is finely conceived, and very animated. She hears the yells of the dragon, and the din of the combat; and overcome by terror, rushes forward with extended arms. Her dress, a dark blue, relieves her figure, from the light background; and her red mantle, floating behind her, gives increased energy to her action, and augmented effect to the bold fore-shortening of her body.[17]

To this account it is necessary to add Cecil Gould's observation that 'in Renaissance representations of St George and the dragon the princess is most usually shown either on her knees in prayer or else running away. In the present picture Tintoretto has combined the two actions: the princess has suddenly dropped to her knees during flight.'[18] It is perhaps more likely that Tintoretto may, rather, have intended to show her rising from her knees in excitement. Gould also noted that the appearance of God the Father in the clouds was an innovation. It may perhaps have been suggested by the way that the hand of God was frequently introduced by Byzantine artists – a convention with which Tintoretto must have been familiar (see fig. 4).[19]

favoured not only in the visual arts but in vernacular texts, some of which were printed.[12]

Although earlier Venetian paintings of George and the dragon are familiar (especially that by Carpaccio), the subject was most common in relief carvings in stone, many of which, mostly dating from the fifteenth and early sixteenth century, may still be seen in the city.[13] For Tintoretto the most note-worthy of these would have been the relief commissioned from Pietro da Salò for the façade of the Scuola di San Giorgio degli Schiavoni in 1551 (fig. 1) and probably completed by the end of March 1552. It has been plausibly proposed by Roland Krischel that Tintoretto took from this relief the idea of showing the horse with both front legs raised directly above the dragon, which turns its head back, only to be pierced in his open jaws by George's lance. He also notes how Tintoretto, like Pietro da Salò but unlike other artists, shows the lance held on the further side of the horse's neck. The differences are also notable, and Krischel points out that Tintoretto positions the lance in such a way that it can be read as a horn projecting from the forehead of his mount, which, being white, thus seems converted into a unicorn.[14]

Saint George was also depicted as one of a series of standing figures aligned with other saints. In such cases his normal attributes were the dragon and a banner with a red cross on

Most earlier representations of the subject had a horizontal format and it must have been the need to compress the narrative into a vertical one suited to an altarpiece that prompted Tintoretto's novel idea of placing the princess in the foreground. Other painters employing a vertical format had elevated her on a ledge of rock in the middle distance. This is the arrangement in Marco Basaiti's altarpiece of 1520 for S. Pietro in Castello (now in the Accademia, Venice), and Paris Bordone's high altarpiece for S. Giorgio dei Frati Minori in S. Francesco in Noale (Treviso) of *c*.1525 (now in the Pinacoteca, Vatican).[20] The only artist who had previously given the princess such prominence was Cosimo Tura on the organ shutters now in the Museo dell'Opera del Duomo in Ferrara.[21] Since he needed to divide his narrative into two vertical parts he allowed the princess to dominate the left-hand shutter and placed George and the dragon on the right.

More remarkable than the prominence of the princess is Tintoretto's decision to place the saint in the middle distance: 'approchons: ce soldat de Dieu n'est guère visible,' wrote Jean-Paul Sartre in his Marxist essay on the painting, proposing that it was Tintoretto's aversion to the aristocratic world of chivalry that prompted this: 'Georges, c'est l'ennemi personnel du peintre.' Rather in contradiction to this he also asserted that because 'les goûts du Tintoret sont plébéiens' he relished the idea of dispatching the dragon with one decisive blow – the worker smartly bangs in a nail ('bref le travailleur enfonce un clou'), as if it was noble or knightly to falter and dally.[22]

Michael Kitson, in a radio talk given in October 1963, observed how the division of the action makes it possible for us to suppose that what we see is what the princess imagines, or prays for: 'the curious way in which the saint, the dragon, and the corpse are bound together in an enclosed oval, seen over the princess's shoulder, would support this interpretation – though we must not assume that Tintoretto consciously intended the picture to be read in this way.'[23]

The Painting as an Altarpiece
Although a few other paintings did sometimes have an arched shape (the painting of Saint George and Saint Louis of Toulouse mentioned above is a case in point), it is nevertheless reasonable to presume that the painting was intended as an altarpiece. The artist's 'bold departure' from convention becomes more remarkable given this. For an altarpiece it would be small, but not very much smaller than Tintoretto's *Assunta* formerly in San Stin (now in the Accademia, Venice),[24] and it is not hard to find altarpieces of similar size in Venetian churches.[25] However, had the painting been made for a church in Venice it must have been quickly removed from its location, or was perhaps never accepted for such, otherwise Venetian guidebooks of the early seventeenth century would have mentioned it. Ridolfi, in his life of Tintoretto published in 1642, does, however, mention that Tintoretto made 'an altarpiece of St. George killing the dragon' for the chapter house of SS. Giovanni e Paolo that had been removed and replaced by a copy.[26] Such an altarpiece would probably not be as large as those in the main body of the church.

The fact that the painting is first recorded in a Venetian palace in the seventeenth century suggests that it may always have been kept in a private domestic setting, probably originally in a private chapel – the sixteenth-century chapel in Palazzo Grimani, for example, must have had an altarpiece of similar size. Humfrey notes that 'from time to time the maintenance of chapels at home was expressly forbidden by the patriarch, for fear that the nobility would neglect the city's churches; yet these very proscriptions imply that the rule was frequently infringed.'[27] The relegation of Saint George to the middle distance would surely also have disqualified the painting for public worship. For, although it was increasingly common for altarpieces to be narrative paintings, generally representing the martyrdom of a saint, these were so contrived that the saint was clearly visible in the foreground as a focus for prayer.

The *Saint George* Altarpiece in S. Giorgio
NG 16 is unlikely to have been acceptable for an altarpiece in a church, but the composition was adopted, in reverse, by an unknown assistant of Domenico Tintoretto for a major altarpiece about twelve feet (4 m) tall in S. Giorgio Maggiore (fig. 6).[28] Here too the princess is in the foreground and the castle walls are in the distance (in this case the princess's parents are visible beside the walls). The heavens also open, but instead of God the Father there is a circle of six angels from which a shaft of light is emitted, aligned with the saint's lance. The chief difference is that in the larger painting the

Fig. 4 Cretan School, early sixteenth century, *Saint George*. Oil on panel, 82.5 × 65.5 cm. Venice, Hellenic Institute of Byzantine and Post-Byzantine Studies.

saint is relatively prominent and is galloping towards us. Although this painting was greatly admired as a work of art, it was regarded as highly controversial.[29]

The altarpiece was painted for the third altar in the left aisle of S. Giorgio, probably in 1594. At some time between then and his death in 1617 Fortunato Olmo, a monk in the Benedictine congregation of S. Giorgio, described the painting in very defensive terms in his manuscript Cronaca of the monastery and its church.[30] He was aware that the story of the dragon had been dismissed as a 'favola' by 'il Baronio'– Cesare Baronio (1538–1607), known as Baronius, who was not only the greatest authority on the history of the church but enjoyed papal favour: he was appointed confessor of Pope Clement VIII, who made him a cardinal in 1596. Olmo was therefore bold to insist that the story of the dragon was an acceptable subject for an altarpiece. He objected to the weight given to surviving written evidence at the expense of tradition. And, he asked, who knows what sources unknown to us were used by Jacopo da Voragine? (This was a shaky argument, since Voragine conceded that the legends of the saint were doubtful and contradictory.)

Critics of the altarpiece seem eventually to have prevailed. In 1648 Matteo Ponzone was commissioned to paint a replacement for the large altarpiece, which was removed to the sacristy (it now hangs unframed on the entrance wall).[31] Ponzone's saint looks up at heaven but is not engaged in killing the dragon – which orthodox opinion now preferred to regard as a symbol – and the princess is absent. (Baronius speculated that in the earliest representations she had probably been intended as the personification of a province liberated from paganism.[32])

Olmo emphasised the importance of the relics of Saint George (an arm brought to the city from Calabria in 1396 and a portion of his head, acquired in 1462), of which his monastery was guardian, and no one would have denied that George should be venerated as patron saint not only of the monastery but also of the whole city ('come di tutelare e protettore non solo dell'Isola, ma della Città di Venezia ancora'). But some embarrassment over his previous prominence is clear from the fact that the high altar of Palladio's new church – the great sculptural ensemble by Girolamo Campagna, completed in 1591 – was dedicated not to Saint George (as had formerly been the case) but instead to the Trinity, and also from the fact that Saint George's altar was not more richly appointed than that of his co-titular, Saint Stephen.

Tintoretto and the Counter Reformation

Baronius was not the first to cast doubt on the legend of Saint George and the Dragon. Giovanni Andrea Gilio in his Dialogues published in 1564 had listed it first among the stories which were popular but 'falzi, favolosi & apocrifi'.[33] Although there are reasons why Tintoretto's painting would not have been acceptable as an altarpiece, at least in a church, and although the altarpiece which it did later inspire was indeed clearly controversial, it may, paradoxically, have been the case that Tintoretto himself was responding to the

aversion reforming churchmen felt at the promotion of a fable, or at best an allegory, to the same status as a properly authenticated miracle or martyrdom, or an episode of the Gospels. For the emphasis in NG 16 is given to someone whose prayers are answered by God; the saint is reduced to an agent of the divinity, almost to a symbol for divine intervention.

That Tintoretto really was alert to the theological issues involved becomes more plausible if we can find evidence that other artists or patrons in the same period were anxious to avoid the conventional representation of Saint George killing the dragon. Moroni in the central panel of his great polyptych of the mid-1570s above the high altar of S. Giorgio, Fiorano al Serio, showed the kneeling princess as a contemporary lady, with no crown, looking up in gratitude at the saint, who is wearing Roman armour and holding a shattered lance. Moroni was as averse to depicting action as Tintoretto was attracted to it, but his emphasis on supplication and intercession (reinforced by a prominent inscription below) might be said to parallel Tintoretto's.[34]

Evidence of patrons who wished to avoid the traditional image of Saint George may be deduced from the case of S. Giorgio in Braida in Verona, which was rebuilt in the mid-sixteenth century. The previous high altarpiece had probably been a painting by Francesco Caroto of George killing the dragon, which was subsequently transferred to a church dedicated to that saint at Marega di Bevilacqua. Veronese and other artists in the 1550s made designs for a new altarpiece showing violent combat with the dragon but when, in the following decade, Veronese was commissioned to undertake the painting he was given a completely different subject: the saint praying before his martyrdom for the salvation of onlookers who have appealed to him. In the heavens above are the Virgin and Child, other saints and angels, and the three theological virtues.[35]

In Antwerp in 1590 Maarten de Vos did erect an altarpiece with Saint George and the Princess but the allegorical nature of the latter was inescapable, as if to anticipate the argument of Pierre Coton and Molanus in their influential treatises on religious imagery published in 1612 and 1617 that the story is acceptable if we clearly understand that the princess stands for the Church.[36]

Previous Owners

The earliest known record of Tintoretto's painting can be found in Ridolfi's life of Tintoretto included in his Maraviglie of 1648 (it is not included in his separate life of the artist in 1642, unless it is identical with the painting said there to have been in SS. Giorgio e Paolo). He writes that 'Signor Pietro Corraro Senatore' had 'un gratiossisimo pensiero di San Giorgio, che uccide il Drago, con la figliuola del Rè, che impaurita sen fugge, e vi appaiano alcuni corpi de' morti di rarissima forma' ('a most delightful sketch of St. George killing the dragon with the king's daughter who flees in terror and also including some corpses very finely disposed').[37] There is in fact only one corpse but such an error is easily made. It may also be objected that NG 16 is not a sketch, but given the size of painting generally associated with Tintoretto the

assumption is understandable, and it was repeated by more recent authors.[38] Boschini in 1660 describes a painting of the same subject in the possession of the same family in his *Carta del Navegar Pittoresco*:

> L'è un San Zorzi a cavalo bravo, e forte,
> Che de ficon va con la lanza in resta,
> E amazza el Drago, e la Rezina resta
> Libera dal Spavento, e dela morte.
> Questo a Casa Corer fè corer tuti.[39]
>
> (There a Saint George on a mount strong and brave
> Quick as a flash, his lance in its rest,
> Slaughters the dragon, and so puts to rest
> The terror of the Queen whom from death he saves.
> And this all career to see in the Correr palace.)

That this painting is identical to the one in the National Gallery is further suggested by Boschini's marginal note that the picture was almost a miniature – relative, that is, to the rest of Tintoretto's œuvre. How famous the picture really was is hard to tell, given Boschini's love of hyperbole and of puns. Ridolfi records no other paintings in the Correr collection but Boschini mentions a number of modern gallery pictures. These are likely to have been purchased or commissioned around the mid-century by Pietro's son Giacomo Correr (1611–1661), who became a procurator of St Mark's in 1649. The collection has been studied by Linda Borean, to whose researches the following paragraphs are indebted.

Pietro Correr (1582–1651) of the Santa Sofia branch of his family was a distinguished servant of the state, successively Capitano of Cividale, Belluno, Treviso, Bergamo and Verona; inquisitor in the Levant; and then Capitano of Padua and of Brescia. The painting would presumably have been in his 'casa dominicale' at San Polo (which, he declared in his will, he had often had it in mind to embellish and enlarge). In 1649, two years before his death in September 1651, he had the pleasure of seeing his only son, Jacopo, known as Giacomo, elected procurator of St Mark's *de supra* (a post that cost him 25,000 ducats).

Giacomo had a gallery of some one hundred paintings in his apartments in the Procuratorie Nuove in St Mark's square, including the notable modern works mentioned by Boschini, but also many sixteenth-century paintings. An inventory of this collection was compiled after his death, when it was scheduled to be sold (in accordance with his wishes). However, a 'retrato antico' and a 'san Zorzi' which had been in the 'camera sopra il rio' were recorded in a document of 3 February 1662 by his son-in-law as the property of the family and thus inherited from Pietro. The *Saint George* was evidently taken back to the palace in San Polo: a 'san Zorzi senza soaza' in the 'camera prima sopra la canal' appears in an inventory of 10 January 1662, compiled in connection with the return of the dowry of Jacopo's widow, Marina Pisani. The high valuation (100 ducats) confirms the identification, although it is odd that the artists responsible for the inventory (Giuseppe Heintz and Nicolo Renieri) did not record Tintoretto's name. The absence of a frame can be explained by the picture's recent move. The painting presumably remained with the family – that is, with Antonio Correr, a kinsman whom Jacopo's only child, Elisabetta, had been obliged to marry in 1650, and then with Vettore Correr, another kinsman, whom she married in 1676.[40]

A painting which claimed to be the one mentioned by both Ridolfi and Boschini was included in a large and important sale at Prestage's, London, on 2 February 1764 as 'an undoubted picture' by 'Giacomo Tintoretto', with dimensions (5 ft 3 in. × 3 ft 3 in.; 160 × 99 cm) very close to those of the National Gallery painting. It was said to come from the Cornaro family but this was presumably an error, the Corner/Cornaro being a more celebrated patrician family than Correr/Corraro.[41]

The title-page of the sale indicates that it included the entire collection of the 'noble family of Grassi' and 'many bought of the noble families of Cornaro, Corraro, Rezzonico, Mozenigo, and sundry others', so the Corraro family is acknowledged as a source. Unfortunately, the annotated copy of the catalogue does not indicate the buyer of the Tintoretto.[42] The reference to the Grassi does, however, provide a clue as to the identity of the consigner because Pietro Gradenigo recorded in his diary for 31 January 1762 (1763 in the modern calendar) that a certain Monsieur Dublin who was 'seeking all over the world for sumptuous furnishings for a royal court' ('un tale Monsieur Dublin che gira il Mondo per provedere arredi costosi per una corte reale') had purchased a hundred select pictures from the gallery of the 'nobiluomini fratelli Bortolo, Paolo e Giovanni Grassi' and also the splendid tapestries depicting the deeds of Charles V from the Grassi palace.[43] Dublin had perhaps also made a tempting offer to the Correr family.

The painting next emerges in the collection of the Revd Holwell Carr, by whom it was bequeathed to the National Gallery in 1831. He owned it by 1821, when it was exhibited at the British Institution.[44]

Thomas Griffiths Wainewright recalled that it had formerly belonged to 'R. Westall Esq.', that is, to Richard Westall RA (1765–1836).[45] This artist enjoyed considerable success as a painter in oils and watercolour and as an illustrator. His career probably reached a climax in 1811 when Richard Payne Knight commissioned the *Grecian Marriage* from him for a thousand guineas. But in July 1815 his debts necessitated the sale of his entire property.[46] He had already been active as a collector and dealer, and he had sold a group of old master paintings at Phillips on 8 and 9 March 1813, including a *Samson and Delilah* by Tintoretto acquired by Samuel Rogers, and a scene of the doge of Venice in procession, also attributed to Tintoretto, which was bought by Lord Aberdeen (see p. 244). He particularly prized Tintoretto's *Raising of Lazarus*, which he had acquired for 50 guineas by March 1814 and had offered to the Marquess of Stafford for 2,000 guineas. It only fetched 79 guineas in the sale of 1815, which took place on 6 July, despite the care he had taken in cleaning and restoring it and the lavish frame he had had made for it.[47] It was acquired by the Kimbell Art Museum, Fort Worth, having passed through the Holford and Rothermere collections.[48]

Westall turned increasingly to picture dealing after this but not with much success, or at least not with enough, for he was reduced to seeking relief from the Royal Academy and from former patrons.[49] The other big sale in his name was at Phillips on 11 and 12 May 1827 but we know that he consigned 13 lots to Christie's for their sale of 25 June 1825 and Wainewright, who seems to have been a friend, puffed several pictures (a portrait by 'Moroni', a delicate Schiavone and a 'Raphael') to be seen in his house in June 1822.[50] Tintoretto's *Saint George and the Dragon* was lot 34 of Westall's sale on 14 April 1832, so either he in fact owned another version of the painting or, conceivably, he had sold the original to Holwell Carr and was now selling a copy.

Provenance
See above. Almost certainly the property of Pietro Correr by 1648. By descent to Pietro's granddaughter and her husbands. Probably sold by the Correr family around 1762. Sold at Prestage's, London, 2 February 1764, lot 143. Apparently in the possession of Richard Westall before 1821 and perhaps sold by him between 1815 and that date. By 1821 in the possession of the Revd W. Holwell Carr, by whom it was bequeathed to the National Gallery in 1831.

Drawing
There is a drawing in black chalk or charcoal with white heightening in the Louvre (no. 5382) which is preparatory for the corpse (fig. 5). The nude body is undraped and there is

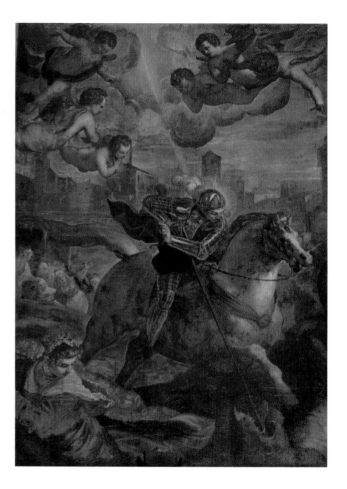

Fig. 5 Jacopo Tintoretto, drawing of a corpse for *Saint George and the Dragon, c.*1555.
Black chalk on faded blue paper, squared for transfer, 25.6 × 41.6 cm. Paris, Musée du Louvre.

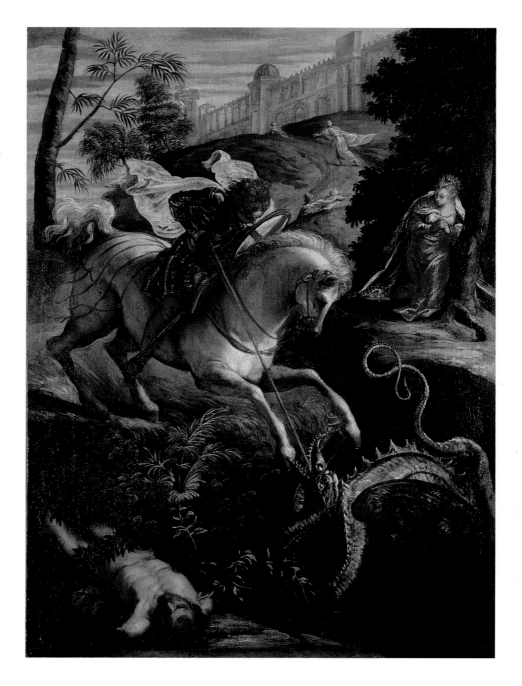

LEFT:
Fig. 6 Unknown artist (after Domenico Tintoretto), *Saint George Altarpiece*, 1594. Oil on canvas, height approx. 400 cm. Venice, Church of S. Giorgio Maggiore.

RIGHT:
Fig. 7 Domenico Tintoretto, *Saint George*, c.1590. Oil on canvas, 122 × 92 cm. St Petersburg, The State Hermitage Museum.

a suggestion of the fingers of the man's right hand emerging from behind his back, by his left hip (an area covered with drapery in the painting). A line by the left foot suggests that the artist already knew that the body would lie on a bank by the shore. The sheet of paper was not large enough for the figure's outstretched left forearm and hand, studies for which were drawn separately below. The drawing is squared. The horizontals are not parallel with the lower edge of the sheet but are calculated in relation to that of the painting.

Version

There is a related painting in the Hermitage, similar in size but rectangular in format and more orthodox in composition with the princess in the middle distance (fig. 7). It is less unified in dramatic conception, with some relatively weak areas such as

the foreground corpse recalling, rather distantly, the slave in *Saint Mark rescuing a Slave* (fig. 1, p. 196). But there are some brilliant passages, such as the calligraphic flourish of the dragon's tail, and the painting is in somewhat better condition than NG 16. When given to Tsar Alexander I in 1806 it was attributed to Veronese. Waagen attributed it to Jacopo Tintoretto in 1864. Gould dismissed it as a pastiche made by the workshop. Fomichova catalogued it as workshop of Tintoretto.[51] Artemieva has made a good case for it as a work by Tintoretto executed at the same date as the National Gallery painting, which she places in the late 1550s.[52] This may be correct, but an alternative explanation is that it is a small and brilliant rehearsal for the S. Giorgio altarpiece by Domenico, executed in an imitation of his father's early style, and not only based on NG 16 but recalling in the fleeing

figures Jacopo's painting of the *Removal of the Body of Saint Mark from Constantinople* (fig. 2, p. 133).

Engraving
NG 16 was engraved by George Corbould for Jones's *National Gallery*, but with God the Father replaced by a celestial light.[53]

Exhibitions
London 1821, British Institution (46); Madrid 2007 (26).

Frame
The painting is shown in a frame with a deep hollow and rich foliate corner embellishments in Frederick Mackenzie's view of the collection when it was still housed in Pall Mall during the early 1830s. This must be the frame that it had when in Holwell Carr's collection and perhaps also when in Westall's possession. It is likely to have been replaced in the early twentieth century, although no record of the replacement seems to have been retained. After the painting was cleaned and restored in the summer of 1962, Cecil Gould commissioned

Arnold Wiggins (then of 25 Chiltern Street, London W1) to adapt for it a curious tabernacle frame (fig. 9) which he had removed from Titian's *Schiavona*. The job was completed by 7 December 1962. The spandrels, the consoles above the capitals, the plinth mouldings and some other mouldings were created by Wiggins. The violent and grotesque figures in the friezes consisting of elastic athletes often with legs turned into vegetal scrolls (fig. 10), the busts in the projections of the entablature, and the simplified and elongated Corinthian capitals are all original features and can be matched in two surviving Spanish frames of the sixteenth century: one was sold at Sotheby's, London, on 8 July 2005 (lot 33) (fig. 8); the other is around the *Deposition* by Pedro Machuca in the Prado (no. 3017).[54] In addition, motifs on all these frames are included in the elaborate carved and gilded ecclesiastical shelving, perhaps intended for the display of relics, to be seen in Vizcaya, the house built near Miami for James Deering between 1913 and 1916, over the design of which the decorator Paul Chalfin presided. This shelving also has a Spanish provenance.[55]

Fig. 8 Spanish sixteenth-century frame, gilt and polychrome walnut. Private collection.

Fig. 9 Current frame around NG 16.

Fig. 10 Detail of current frame showing the frieze.

NOTES

1. Plesters 1980, p. 34.

2. Dunkerton 2007.

3. Select Committee Report, 1853, p. 747.

4. Wainewright 1880, p. 180 (published in the *London Magazine* for September 1821 under the pseudonym C. van Vinckboon).

5. Osmaston 1915, II, p. 179; Gould 1959, pp. 84–6; 1975, pp. 254–6.

6. Plesters 1980, p. 34.

7. Kitson 1963, p. 511.

8. Pallucchini and Rossi 1982, I, p. 173, cat. 200, II, fig. 262–4.

9. *New Catholic Encyclopedia*, VI, p. 354.

10. Jacopo da Voragine 1941, p. 32.

11. Balboni 1965, pp. 514–15.

12. Ibid., p. 522.

13. Rizzi 1917.

14. Krischel 1996.

15. Dolce 1557, f. 27r; 1968, pp. 126–7. The painting is now in the Accademia Galleries. Pallucchini and Rossi 1982, I, p. 165, fig. 213.

16. Wainewright 1880, pp. 179–80.

17. Ottley 1832, p. 57.

18. Gould 1975, pp. 254–5.

19. This was perhaps first pointed out in print by P. Goss in a letter to the *Listener* of 17 October 1963. A prominent example is a relief in the Baptistery of St Mark's. In a few examples the whole figure of Christ appears in the sky (see, for example, Chatzidakis and Djurić 1968, p. 46)

20. These are discussed by Gould 1988, pp. 91–4.

21. Manca 2000, pp. 104–7, no. 10.

22. Sartre 1966.

23. Kitson 1963, p. 511.

24. Pallucchini and Rossi 1982, I, p. 159, cat. 139; II, fig. 186. See also Tintoretto's Saint Catherine altarpiece c.1557–60, private collection, Chicago, 175 × 98 cm (painted for S. Geminiano), in ibid., I, p. 178, cat. 220; II, fig. 286.

25. For example, altarpieces in the west transept wall of S. Trovaso by Palma Giovane, to the right and left of the high altar of S. Giacomo de Rialto, in the chapel to the east of the sacristy of the Carmine, and in the east wall of the atrium of S. Sebastiano (one of which, Titian's *Saint Nicholas* of 1563, is 171 × 91 cm).

26. Ridolfi 1642, p. 50; 1984, p. 44.

27. Humfrey 1993, p. 48 (citing Gallicciolo, *Delle Memorie venete antiche*, II, 1795, pp. 210–14).

28. Ridolfi 1648, II, p. 265; 1984, p. 89, attributes the painting to Domenico, who was probably responsible for the design. As Stefania Mason first pointed out, the execution is not characteristic of Domenico. Domenico's assistant Sebastian Casser was mentioned later in the seventeenth century by a Benedictine chronicler (see Hadeln in Ridolfi 1924, p. 259 n. 2) who was probably consulting the payments.

29. Cooper 1992, pp. 337–49.

30. Olmo, fol. 365 verso, cited by Cooper 1992, p. 339.

31. Boschini (1674, p. 55) records it in the sacristy.

32. Baronius 1586, p. 179. For an explication of Baronius's position see Herklotz 1985, pp. 66–70.

33. Gilio 1564, p. 88.

34. Gregori 1979, pp. 258–9, no. 102.

35. See Marinelli 1988, pp. 266–73, no. 29 (for Caroto, entry by Giuliana Ericani), and pp. 201–3, no. 7 (for Veronese, entry by Sergio Marinelli). On this topic see also Cocke 2001, pp. 105–7, and 194–5, no. 19.

36. Coton is cited by Mâle 1951, p. 374; Molanus 1617, pp. 276–9; Molanus 1996, pp. 372–4.

37. Ridolfi 1648, II, p. 45; Ridolfi 1924, II, p. 54; Ridolfi 1994, p. 81. The relevant paragraph is accidentally omitted in Ridolfi 1984, p. 60.

38. 'Very likely a small study for a large picture' (Phillipps 1911, p. 113).

39. Boschini 1660, p. 329; 1964, pp. 362–3.

40. Borean 1998, chapter 3 and documents 1–3; see also Borean 2003, and especially p. 351, note 11.

41. First day, lot 31 and lot 143 in the general catalogue.

42. Lugt 1346. The copy in RKHD inspected on microfilm has misleading annotations which might be taken to indicate that it was sold for £11 16s. 0d.

43. Gradenigo 1762, fol. 138v. My attention was drawn to this source by Romanelli (in Romanelli and Pavanello 1986, p. 42, note 19).

44. *Painters of the Italian, Spanish, Flemish and Dutch Schools*, no. 46.

45. Wainewright 1880, p. 179. James Greig pointed this out in a letter to Kenneth Clark of 23 January 1937.

46. Farington 1978–98, XI, 1983, p. 3965. The sale was conducted by Phillips on the premises.

47. Ibid., XIII, 1984, pp. 4662–3; also p. 4462. For the painting today see Pallucchini and Rossi 1982, I, p. 199, cat. 327; II, fig. 424.

48. Sold by the Kimbell (inexplicably) at Sotheby's, New York, 19 May 1994, lot 49.

49. See entry in the *Dictionary of National Biography* by Campbell Dodgson.

50. *London Magazine*, June 1822, pp. 245–64.

51. Waagen 1806, p. 70; Gould 1959, p. 85; 1975, p. 255; Fomichova 1992, pp. 323–4, no. 247. See also Falomir 2007, p. 274, no. 26 (entry by Echols and Ilchman).

52. Artemieva 2001, p. 92, no. 22. I was at first disposed to accept this attribution (Penny 2001, p. 721); it is accepted by Dunkerton 2007.

53. Jones and Co., c.1835, no. 26.

54. This frame has been said to date from the nineteenth century but was perhaps only repaired at that date.

55. Information kindly supplied by Dr Laurie Ossman from the house archives.

The Origin of the Milky Way

*c.*1575
Oil on canvas, 149.4 × 168 cm

Support

The measurements given above are those of the stretcher. The original canvas, which has been trimmed irregularly, is between 1.5 and 0.5 cm short of the sides and 0.75 cm short of the upper and lower edges. It is of a medium-weight twill weave (but with one addition of herringbone twill) and has been wax-lined on to a canvas of medium-weight tabby weave. The varnished pine stretcher has crossbars.

There is very little evidence of cusping but some old tack-holes are visible on the left. As explained below, the painting has been cut and the lower part of the composition is now missing. The diagram below (fig. 1) shows the complex structure of the canvas, with the broken lines denoting the missing area. This reconstruction is based on a copy of the painting made before it was cut (fig. 2), and on the assumption that the full loom-width of the canvas found in the upper half of the painting (A) was repeated in the lower half (as was usual practice for Tintoretto).

This account of the structure differs from an earlier one published by the Gallery, which interpreted the lower horizontal seam as a fold. It may indeed have served as a fold but it is certainly also a seam.[1]

Fig. 1 Diagram of the canvas.

A: Twill canvas, full loom-width.

B: Fraction of twill canvas, probably originally the same width as A.

C, D: Strips of twill canvas used to make up the upper edge; D is 117 cm long, both C and D are between 13 and 10 cm wide.

E, F, G: Strips of twill canvas 7 cm wide (herringbone twill in the case of E) used to extend the canvas at the left side. Although original, this extension may represent a change of plan by Tintoretto. There is, however, no reason to suppose that it was made after he had begun the painting. E is 20 cm long.

Materials and Technique

The canvas has no gesso ground, only a dark brown priming layer composed of pigments of numerous colours in drying oil (described by Plesters as a 'palette scraping ground'[2]). The artist's preliminary brush drawing with lead white was made on this dark ground. It can be detected with the naked eye in some areas (for example, around the peacocks) and is clearly revealed in X-radiographs (fig. 3).[3] The most fully modelled figure at this stage was Juno; Jupiter was sketched in at first as a schematic nude with rough loops of drapery thrown round him; the putto at the lower left was hardly more defined than the clouds.

The greatest change to be observed between the preliminary brush drawing and the finished painting is in the figure of Jupiter, who was originally parallel with Juno, not swooping down from above. The eagle and peacocks are not included in the preliminary brush drawing: they may have been afterthoughts to ensure that the subject was properly understood. Perhaps they were also delegated to an assistant. They were possibly sketched in with red lake (a pigment which is visible in neither infrared photography nor X-radiography). Passages of red lake were evident around the peacock before the last restoration.

The layer structure of the paint is fairly complex. A greenish underlayer was employed for Juno's body (a very small quantity of ultramarine is also found in the flesh paint). This underlayer was certainly planned, but the painting of Juno's white bed-linen on top of the red coverlet may represent a revision to the composition (if not an economy in execution).

A number of pigments have been identified. Ultramarine is used in the bed and in Jupiter's cloak and (with lead white) for the sky. Malachite and azurite are used in some of the drapery and in the feathers of the peacocks (where, however, there is a copper-green glaze on top). Vermilion is used in the flames of the torch and in the sash worn by the putto at the lower right and is mixed with red lake (identified as lac) in the mid-tones in the drapery below Juno.

Linseed oil has been identified as the medium in two samples.[4]

Conservation

When the probate inventory for Cobham Hall was compiled in June 1831 a note recorded that the painting was then at Mr Seguier's in Coventry Street. It was doubtless undergoing treatment – probably both cleaning and repair – at that date.[5] On acquisition by the Gallery in 1890 the painting was lined, some 'spots of discoloured restorations removed', and some flaking blisters laid down by 'Morrill'. In the following year the painting was lined again, so that it had two lining canvases. The painting was then cleaned and restored by 'Morrill'. In August 1938 the painting was strip-lined on the upper edge, and some loose paint was secured by 'Morrill'. In October 1945 the painting was 'polished' by 'Vallance'. A report dated 21 January 1952 noted some bulging in the canvas and the very darkened varnish. Cleaning tests were made but cleaning and restoration were not authorised until July 1970. The painting was wax-lined on to a new lining

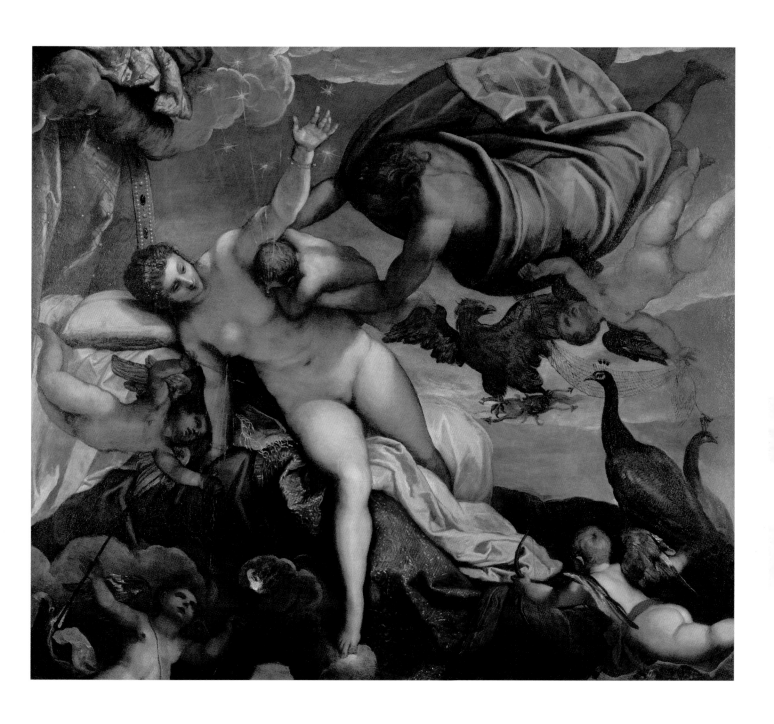

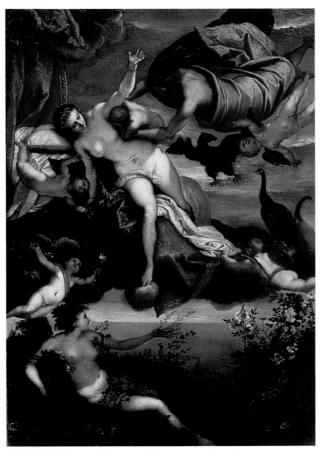

Fig. 2 Late seventeenth-century copy of NG 1313 before it was cut. Oil on canvas, 74.5 × 53 cm. Germany, private collection.

canvas and then cleaned and restored. Work was complete in January 1973.

Condition

The strength and balance of colour in the painting are well preserved but the surface has been damaged, chiefly through pressure in the process of lining. The condition of the flying figure's pink cloak is an especially clear example of this damage, but it is pervasive. The worst losses are in the face of the putto at the lower left. There is a great deal of retouching along the lower horizontal seam and on all the edges of the canvas. The paint is also abraded in the shadowed areas: the flying figure, for example, has been reconstructed as clean-shaven (presumably Mercury), as he was in the painting when it came to the Gallery, but it is clear not only from the attributes in the picture but also from the engraving made from a reliable drawing of the picture as it was shortly before it left the Orléans Collection (fig. 6) that he was meant for the bearded Jupiter. His lower (proper left) foot is a largely conjectural reconstruction, as is the higher (proper left) foot of the putto with the net.

The best-preserved areas of the painting are the putto at the lower right, where the flushed cheek, the highlights beside the thigh, the flashes of yellow in the red belt, and the combination of white, blue, green and yellow in the wings remain much as intended, as do the drapery below Juno and

much of her white bed-linen and pearl-sewn bed-hanging at the top left. The retouchings are often of a somewhat perfunctory character – notably in Juno's face – and some of them have begun to discolour – notably in Juno's flesh. Some of the pentimenti were painted out in restoration (for example, that beside the neck of one of the peacocks).

Changes to the Painting revealed by Cleaning

Some wispy drapery around Juno's thigh turned out to be a later addition and was removed in the early 1970s. It must have been painted before 1727, when a 'linge' on 'la cuisse droite' is mentioned by Saint-Gelais.[6] Some stars in the lower part of the painting and jets of milk expressed from Juno's right breast were also removed. These are not shown in the late eighteenth-century engraving and may well have been added by an English restorer in the early nineteenth century.

Attribution and Dating

The painting has not always been regarded as an entirely autograph work by Jacopo Tintoretto. Loeser, prompted by the inscription on the drawing in the Accademia (see the next section), proposed Domenico Tintoretto.[7] Pallucchini thought it probable that Domenico had painted the putti. The eagle and peacocks are surely even more likely to be the work of a hand other than Jacopo's.[8] Some of the drapery appears to have been studied from real fabric, as is seldom the case with Jacopo's paintings. Also, as will be shown, the original painting included what must have been very carefully painted flowers; it seems likely, given what we know about the artist's talents and disposition, that these were delegated to a specialist. All the same, the painting as it survives was surely designed and in large part executed by Tintoretto and he must have ensured that it was finished with uncharacteristic care.

Gould observed that the painting was 'comparable in design and type' to the four paintings made for the *atrio quadrato* of the Doge's Palace (and now to be seen in the Anticollegio) which date from shortly before the summer of 1578:[9] these are certainly similar in subject matter, and the handling of the light on the flesh of the *Three Graces* as well as the brilliance of the palette suggest that they were painted in the same period. Pallucchini and Rossi also mention the similarities between the figure of Jupiter and that of *God the Father* in the altarpiece of the *Temptation of Saint Anthony* (fig. 1, p. 132), datable to about 1577, and Nichols is struck by the 'similarly rich pigmentation and high degree of finish' which has been revealed by recent cleaning of that painting.[10]

Stella Mary Pearce (Newton) pointed out that the way Juno's hair was brushed up from the forehead to either side of the parting so that, 'as seen from the front, it made, together with the outline of the face, a heart shape', was characteristic of the second half of the 1570s.[11] A date in the 1570s would make Domenico's collaboration impossible.

The Original Composition

A careful, reduced copy of the painting in oil on canvas, probably made in the late seventeenth century but perhaps

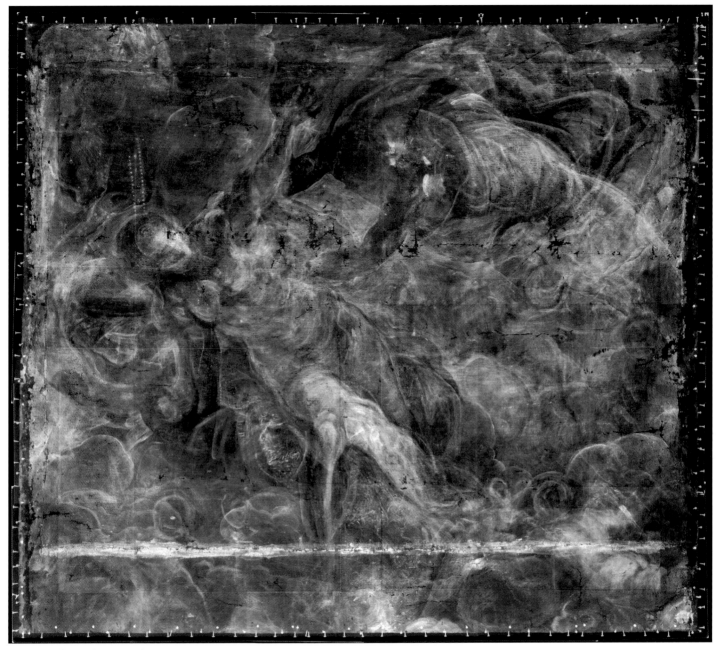

Fig. 3 X-radiograph mosaic of NG 1313.

earlier, is now in a private collection in Germany (fig. 2). The copy reproduces the colours in the surviving portion exactly and differs only in excluding the stars and in adding some drapery to conceal the genital area of Juno, so it must be supposed that it provides reliable evidence as to the appearance of the lower part of the painting, which was cut off (but may survive somewhere, perhaps drastically repainted). The dismemberment must date from before 1727, when the painting was catalogued as '4 pieds 8 pouces by 5 pieds 1 pouce' (its approximate dimensions today).[12]

In this lower part of the copy a nude woman, largely in shadow, reclines on a bank with a large body of water behind her. She is leaning on her right elbow, and her head, in profile, turns upward towards the right. Roots grow from the ends of the fingers of her right hand, which dangles on the bank; shoots grow from the fingers of her left hand, which she extends upward. The horizon line is level with her face and runs just above her left hand. In the lower right-hand corner there are large white flowers which also intersect with the horizon.

Traces of the uppermost flowers have been detected near the lower edge of the National Gallery's painting, later overpainted by a cloud.[13] All the compositional features described above are also present in two drawings made after Tintoretto's original composition, one in the collection of the Accademia in Venice and the other in the prints and drawings department in Berlin.[14]

Figs 4a and 4b: The obverse and reverse of the *Medal of Tommaso Rangone*, *c.*1560. Bronze, 3.5 cm diameter. London, The British Museum.

Subject Matter and Source

The title 'The Origin of the Milky Way', apparently first used when the painting was exhibited at the Art Treasures exhibition in Manchester in 1857, is now too well established to be changed. Nevertheless, 'l'Allaitement d'Hercule', 'the Nursing of Hercules', as the painting was known in the eighteenth century, is more apt, and it should be emphasised that the picture is intended as an allegory rather than, or at least as well as, a mythological narrative.

Jupiter attempted to obtain immortality for Hercules, the offspring of his liaison with the mortal Alcmene. This could be obtained from imbibing the milk of Juno (his lawful wife and the queen of heaven) so he placed the child on the breasts of the sleeping goddess. She was awakened by the vigorous suckling of the infant hero and, according to the *De Astronomia* of Hyginus (a familiar enough source of which many editions were published in Venice in the late fifteenth and early sixteenth centuries), the milk that spurted from her breast formed the Milky Way.[15] This is the episode depicted in the painting we see today.

Hyginus was not, however, Tintoretto's source. The *Geoponica*, a Byzantine textbook on botany, then attributed to the Emperor Constantine, editions of which were printed in the mid-sixteenth century not only in Greek but in Latin and Italian (Italian translations of 1542 and 1549 were printed in Venice),[16] includes a different version of the story, in which the milk from one of Juno's breasts is said to have fallen down to earth and created the milk-white flowers of the lily. As Erna Mandowsky recognised in a remarkable short article in 1938, Tintoretto is likely to have had some knowledge of the *Geoponica* and this is the episode that was depicted in the

painting in its original condition, in which there would have been more emphasis on the flowers than on the stars. The reclining woman awakened to vegetable life by the raining milk must have been meant as Ops, the embodiment of Earth and mother of Jupiter and Juno. This subject is extremely rare in art but Mandowsky pointed out that the reverse of a medal cast in Venice in the mid-sixteenth century commemorating Tommaso Rangone (or Rangoni) shows an eagle (the attribute of Jupiter) placing a child on Juno's breast (figs 4a and 4b). Juno is there surrounded by a chain of stars, below which there are three lilies. Mandowsky further observed that Rangone was closely associated with Tintoretto, and commissioned from him the famous series of paintings of the miracles of Saint Mark for the Scuola Grande devoted to that saint. Tintoretto was obliged, controversially, to include in these paintings prominent portraits of Rangone himself. Mandowsky also noted that the medal must have been fairly well known because Lorenzo Pignoria in his commentary on Vincenzo Cartari's handbook on mythology explicitly refers the reader to it when discussing the myth of the nursing of Hercules. The medal exists in a number of collections, including those of the British Museum, the Museo Correr, the Museo Civico in Padua, and the Museo Nazionale di Ravenna. The example in the Correr bears the date of 1562 and alludes in the inscription on the obverse to honours received by Rangone in that year. The other examples can be assumed to have been cast at an earlier date.[17]

A connection between NG 1313 and Rangone is therefore probable, but an explanation is obviously required. Mandowsky speculated that 'perhaps he [Rangone] was influenced by its connection with his own coat-of-arms which

showed eagles and lilies'. Three lilies are indeed included in Rangone's arms, also three small birds (these also appear on the medal), and two wings. The eagle surmounting the helm on the monument to Rangone on the façade of S. Giuliano in Venice is not, strictly speaking, a part of his arms. This point, made by Gisela Anthofer,[18] does not necessarily mean that there is no connection between the medal and Rangone's arms but it does suggest – as is in any case obvious enough – that the significance for Rangone of this myth about stars and plants and immortality cannot be explained by its affinities with the heraldic devices he selected. His interest in the myth may, rather, have determined the selection of these heraldic devices. Before proposing how Rangone probably intended the medal – and the painting – to be interpreted, his life needs to be examined.

Tommaso Rangone

Tommaso Giannotti, later known as Tommaso Rangone (or Rangoni), and also as Tommaso Filologo, astrologer, astronomer, mathematician, anatomist, physician, philologist and philosopher, was born in Ravenna in 1493. His first publication, the *Prognosticon anni MDXVII*, was a slim volume of astrological predictions made in 1516. He was at that point a protégé of Cardinal Grimani in Rome. He is also recorded as a student in the universities of Ferrara, Bologna and Padua. He took his name from Conte Guido Rangoni, astrologer and *condottiere*, to whose household in Modena and elsewhere he was attached between 1521 and 1527.

In 1528 Rangone settled in Venice, where his medical reputation secured for him employment as physician to the Venetian fleet in 1532–4 and official adviser to the Magistrato alla Sanità in 1535. He was an authority on the plague and on syphilis, topics upon which he published learned works, but his most celebrated treatise was *De vita hominis ultra CXX. annos protrahenda* ('The Life of Man Extended Beyond 70'), which first appeared in Latin in 1550, and was issued in numerous subsequent editions, each dedicated to a doge or a pope. In 1556 it was translated into the vernacular with a dedication to the Dogaressa Zilia Priuli.

By the 1550s Rangone seems to have made a large fortune and was seeking to erect monuments and endow institutions. In 1552 he founded a college in Padua, the 'Palazzo Ravenna', for students from Ravenna and Venice. In the same year he devised a monument for himself opposite the basilica of St Mark, on the façade of the church of S. Geminiano, then newly rebuilt by his friend Jacopo Sansovino. This scheme was deflected by the Senate, which could not countenance a private memorial in so prominent a place (Alessandro Vittoria's bronze portrait bust of Rangone was, however, made for the church in 1571–2 and is now in the Ateneo Veneto), and, instead, Rangone agreed to pay for a large part of the reconstruction by Sansovino of the church of S. Giuliano, which was given a façade designed as a monument for him and incorporating a full-length seated statue cast in bronze by Vittoria in 1556 (fig. 5).[19] For the portal of S. Sepolcro he commissioned in the 1570s the same sculptor to carve in stone a statue (now in the Seminario Patriarcale) of the Apostle Thomas. Rangone's name-saint was given his likeness, thereby circumventing the Senate's prohibition of full-length portrait statues.

In addition to election as prior of the Collegio de' Dottori di Medicina, Rangone was procurator and benefactor of four collegiate churches and convents. He was elected Guardiano Grande of the Scuola Grande di S. Marco in 1562 and in the following year to the same office in the Scuola di S. Teodoro. In 1562 he was knighted by the Doge, Girolamo Priuli, and he was created Count Palatine by the Emperor Maximilian II in 1572. He died in 1577, rumoured to be 110 years old, claiming to be 94, but in fact 84. The funeral he prescribed involved the display of his books, medals, models of buildings, portraits, maps of the heavens and scientific instruments, in a procession of a thousand people. It concluded with his burial in an Egyptian-style sarcophagus of white marble, in the approximate shape of a human being.

The material above is drawn from the long article by Erasmus Weddigen.[20] This provides the fullest and most accurate account of Rangone, and includes a full bibliography. It adds greatly to Mandowsky's suggestion regarding the significance that Tintoretto's painting might have had for Rangone and the section which follows is much indebted to it.[21]

Stars, Plants and Health

Tommaso Rangone, as befitted his other name, Filologo, incorporated on his monument on the façade of S. Giuliano inscriptions in Greek and Hebrew as well as Latin. The Hebrew inscription translates as: 'Tommaso Filologo from Ravenna who wrote many books in various sciences and also found the way of extending the span of human life to 120 years and also erected this structure in the year 5315 [that is, 1555].' It was indeed the secret of longevity for which Rangone was best known: his book on the subject was popular and it seems reasonable to conjecture that this reflected favourably on his medical reputation (and hence, no doubt, his fortune).

Longevity, and the good health that made it possible, could be described as an improvement on the normal mortal terms such as the infant Hercules obtained, even though he was not able to drink enough of Juno's milk to make him fully immortal. On the reverse of Rangone's medal which depicts the nursing of Hercules is the inscription 'A IOVE ET SOROR/E GENITA' ('brought forth by Jupiter and his sister'), which, because of the feminine ending of 'genita', must be, as von Sallet was the first to observe, a reference to their daughter Hebe, goddess of youth.[22] The interpretation, accepted by several scholars, that the relief depicts the birth of Hebe with Jupiter in the form of an eagle assisting cannot be correct as it does not explain why the child is placed on the goddess's breasts, nor does it explain the stars and flowers, and it has no literary source (assisted childbirth would be unusual for a goddess).[23] An alternative proposal, made by Passi, that the motto refers to Persephone, daughter of Zeus and Demeter, is possible but is harder to explain in relation to Rangone's interests, although Passi notes that Persephone was identified with rebirth and was sometimes said to be the daughter of Asclepius.[24]

Fig. 5 Alessandro Vittoria, *Lunette with the Statue of Tommaso Rangone* (sixteenth century), bronze. Venice, façade of the Church of S. Giuliano.

A problem with both explanations is the lack of any clear connection between motto (relating to Hebe or Persephone) and image (depicting Hercules). However, if the nursing of Hercules is understood as an allegory of partial immortality, there is a connection with the idea of youth.

As for the stars and the flowers, the monument on S. Giuliano clearly reveals how central both were to Rangone's learning, for he is represented holding flowers in one hand while the other rests on a tablet inscribed with diagrams of the planets. His practice as a physician would certainly have involved astrology, in which he was an acknowledged expert, and herbs, from which most drugs were extracted. Tintoretto's painting makes sense as an allegory of the physician's art as practised by Rangone and with special reference to the pursuit of longevity, which was central to his whole career and a subject of learned debate as well as popular interest at that period.[25]

The only other allegorical interpretation of the nursing of Hercules to be advanced can be found in one of Mandowsky's footnotes. She tentatively proposed that there may be some connection between the adoption of Hercules and the fact that Rangone adopted the name of a noble family, and this connection was later asserted by the compiler of the catalogue of the medals in the Kress collection,[26] but the obverse of the medal does not include the name Rangone, and Rangone was more disposed to celebrate his own achievements than to commemorate debts to others.

Andrea Alciato in his book of emblems of 1546 illustrates the nursing of Hercules in a manner which, as Gisela Anthofer pointed out,[27] might have suggested the idea of

Tintoretto's composition, but he uses the myth to illustrate the honour due to bastards, one of whom – Hercules – must count as 'il maggior huom, che mai nacque fra nui', and there are no lilies. Several scholars have noted that a reference to the lilies and the milky way could be found in sources other than the *Geoponica*,[28] but the latter remains the most likely source.

The Emperor Rudolf

There are several reasons to suppose that the painting belonged to the Holy Roman Emperor Rudolf II. In the posthumous inventory of his paintings made at Prague in 1621, item no. 295 is described by the intelligent but not erudite compiler as 'wie die Natur in den Wolken getragen wirdt, unter Ir das fruchtbare Erdtreich, ein schön Stück, von Tentoret' ('as Nature is carried on the clouds, below her [we see] the fertile Earth, a beautiful piece by Tintoretto'), a plausible description of NG 1313 in its original condition.[29] To this we can add the testimony of Ridolfi, who said that Tintoretto painted for Rudolf four mythologies, one of which showed Jupiter placing the infant Bacchus on Juno's breast (the confusion between Bacchus and Hercules is easily explained).[30] In addition, it is surely not a coincidence that one of the early drawings of the painting was made by Jacob Hoefnagel, one of Rudolf's court artists. Allegorical mythologies which combined the arcane with the erotic were especially favoured by the emperor,[31] and, if we also bear in mind his interest in astrology and his love of botanical illustration, it must be conceded that no painting could have been better designed to please him.

The suggestion made by Eric Newton that the painting was perhaps made for Rangone himself and then diverted to the emperor was considered unlikely by Gould, who thought the painting better fitted for a 'princely destination' than for a 'doctor's household'.[32] Rangone, however, was no ordinary physician.

We may be sure that the painting was not in Rangone's possession when he died. If it had been, he would have mentioned it in his plans for his funeral, in which all the works of art in his collection, however inconspicuous or cumbersome, were to be paraded. We may deduce that the painting was perhaps made for Rangone but that he decided to present it to the emperor on his election in 1576, or that he commissioned it as a gift for the emperor, or that he presented it to Rudolf's predecessor, Maximilian II, perhaps when (or not long after) he created Rangone Count Palatine in 1572.

Ridolfi wrote that Tintoretto supplied the Emperor Rudolf with 'quattro quadri di favole per le sue stanze con figure a par del vivo'. The subjects are listed by Ridolfi as follows:

le Muse in uno, che ridotte in un giardino formano un concerto di Musica con varij stromenti. Giove nell'altro, che arreca al seno di Giunone Bacco fanciullo, nato di Semele. Il terzo era di Sileno entrato al buio nel letto di Hercole, credendosi goder d'Iole, & Hercole medesimo nel quarto, che si mira in ispecchio adornato di lascivie feminili dall'istessa Iole.

(In one of them the Muses, gathered in a garden, form a musical concert with varied instruments. In another, Jupiter brings to the breast of Juno the infant Bacchus born to Semele. The third one was of Silenus entering the bed of Hercules in the dark, with the intention of enjoying Iole, and the same Hercules in the fourth admires himself in a mirror adorned with feminine voluptuousness by the same Iole.)

Clara Garas argued that the four paintings must have comprised a group or cycle with a flattering message for the emperor, who was sometimes regarded as a modern Hercules.[33] Other scholars have followed her in this.[34] Yet there is nothing in the passage to encourage this idea. Ridolfi does not say that they were hanging together in a single room, and if Hercules was indeed the subject of the group it seems unlikely that he would have mistaken Hercules for Bacchus in the second picture listed. Nevertheless, it is tempting to discern a close relationship (albeit one of which Ridolfi was not aware) between the four works – tempting, that is, until the paintings are envisaged together. *Hercules driving the Satyr from his Bed*, now in the Fine Art Museum, Budapest, is different from the National Gallery's painting in dimensions (112 × 106 cm) and format, style, figure size, compositional character and, most importantly, genre.

Garas proposed, reasonably, that a painting of Hercules and Omphale formerly in the Battistelli Collection in Florence may at least be a record of the fourth composition cited by Ridolfi, but neither this painting nor any of the paintings which may be, or may record, the 'concert of muses' would look any more plausible as companion pieces. All that can seriously be suggested is that Tintoretto, learning that the 'Nursing of Hercules' had been well received, painted other subjects involving the same hero.

Previous Owners
The painting was in the collection of the Duc d'Orléans in the Palais-Royal, Paris, by 1724, and according to the catalogue of 1727 it had come from the collection of the Marquis de Seignelay, who died in 1690.[35] Whereas most of the Emperor Rudolf's paintings passed to Queen Christina of Sweden (and thence to the Duc d'Orléans), there is no trace of NG 1313 in her collection. It must therefore have left Prague after February 1637 (when it is recorded in an inventory in the same words as in 1621 but without the attribution), but before the Swedish army sacked the city in 1648. The painting was probably cut down when, or shortly before, it was in the Seignelay collection. It was certainly in its present format when it was in the Orléans Collection and the preface to the official catalogue of that collection deplored the practice of altering the shape of pictures for decorative purposes. The intention in this instance may have been to adapt the picture to a more convenient format for a ceiling or an overdoor. The manner in which it is described in the Prague inventories precludes the possibility that it had been cut down at that stage.

An account of the Orléans Collection and its dispersal is given in an appendix (see pp. 461–70), as is an account of the Earl of Darnley (see pp. 448–52), into whose collection it passed early in the nineteenth century.

NG 1313 fetched a relatively low sum in the sale of the Orléans paintings at the close of 1798: it was acquired for a mere 50 guineas by Michael Bryan, the organiser of the sale.[36] This may be compared with the 100 guineas paid by Angerstein for each of the *Group of Heads* (NG 7 and 37) then believed to be by Correggio, or the 200 guineas paid by Abraham Hume for Titian's *Death of Actaeon*. But it is more than the sums (between 39 and 46 guineas) paid for Veronese's four *Allegories* when they were resold by Bryan on 14 February 1800. The fact that Bryan himself purchased the Tintoretto and the fact that the Veroneses were unsold when first offered suggest that more interest in them had been expected. They were perhaps exhibited uncleaned and unframed because, as explained in the appendix, they had all served as overdoors – they were thus incorporated in the panelling of the Palais-Royal and were unlikely to have been removed for cleaning in the 1770s. And if they were thought of as overdoors, or indeed as ceiling paintings, that might also have discouraged buyers, for overdoors were less fashionable in British interiors, and few purchasers would have had suitable ceilings.

Acquisition by the National Gallery
The painting was purchased together with the *Allegories* by Veronese (see pp. 410–29) in 1890. Its inclusion in this transaction seems to have been first suggested by Lord Carlisle in June 1889.

Provenance

Probably in the collections of the Holy Roman Emperor Rudolf II and the Marquis de Seignelay. In the collection of the Duc d'Orléans, Regent of France, by 1724. Lot 238 at the sale of the Italian portion of the Orléans Collection at the Lyceum, London, on 26 December 1798, where bought by Bryan. Sold, probably by Bryan, to the Earl of Darnley, in whose family collection it is recorded in June 1831.[37] Purchased from the Earl of Darnley in 1890.

Version

See the section on the original composition for discussion of a reduced copy now in a private collection in Germany (fig. 2) which includes the lower part of the painting. It is just possible that this may be the 'quadretto' in the possession of Andrea Spinola in Genoa which Lorenzo Pignoria in 1615 described as illustrating the mythical formation of the milky way.[38] In that case it was probably made in Italy before the original painting was sent to Prague. It probably corresponds to the

Fig. 6 L.R. De Launay, after a drawing by Duvivier. Engraving of *The Nursing of Hercules* by Tintoretto, published in a *livraison* in the 1780s and then again in the *Galerie du Palais Royal*, 1808.

Point par J. Robusti. Dessiné par Duvivier. Gravé par L.R. De Launay, le J.

L'ALAITEMENT D'HERCULE.

De la Galerie de S. A. S. Monseigneur le Duc d'Orléans.

A.P. D.R.

one with Ludwig F. Fuchs in Munich in 1929 which is cited in Cecil Gould's catalogue – unless, that is, there is more than one painting of this kind.[39] It is likely to have come from England since Wainewright noted in 1821 that 'T. Phillips, Esq. R.A. possesses a repetition of this subject, with an additional group of figures placed under the line of clouds which support the couch of the startled Juno.'[40]

Drawings
See above.

Engraving
Engraved with some etching in reverse by L.R. De Launay le Jeune after a drawing by Duvivier for the *Galerie du Palais Royal*, published in the second volume in 1808, but first issued earlier, and the plate engraved before the Revolution with a dedication to S.A.S. Monseigneur le Duc d'Orléans and bearing his arms (fig. 6).[41]

Exhibition
Manchester 1857, Art Treasures exhibition (definitive catalogue, 298).

Frame
The painting was reframed at the instigation of Philip Hendy between June 1962 and December 1964.[42] No record is known to me of the previous frames. The present carved and gilded frame has beads and rods at the sight edge separated by a hollow from the higher outer moulding ornamented with bunches of leaves and berries. It is a good modern imitation of a pattern of frame favoured in mid-seventeenth-century France of which many examples survive, on both a large and a small scale.[43] The same ornamental motif is found on a border for the title-page of Michel Dorigny's *Livre des diverses grotesques* of 1647 and in some of the panelling of the Musée Carnavalet, Paris, executed in about 1660 under the direction of François Mansart.

NOTES

1. Plesters 1980, p. 39; see also Plesters 1979, p. 22.

2. Plesters 1980, pp. 39–40.

3. First published by Gould in 1978.

4. Plesters 1980, p. 39.

5. Cobham MS Probate Inventory of June 1831, Victoria and Albert Museum (National Art Library), 86.00.9, fol. 141 verso.

6. [Dubois de Saint-Gelais] 1727, pp. 222–3.

7. Loeser 1903, p. 181 (under no. 121).

8. For Domenico's participation in the painting see Fogolari 1913, p. 22, n. 61; Osmaston 1915, II, p. 179; Pedrazzi Tozzi 1960, p. 389. See also Pallucchini and Rossi 1982, I, pp. 212–13, no. 390 (entry by Rossi citing Pallucchini's opinion on p. 213). See Berenson 1957, I, p. 174.

9. Gould 1959, p. 90; 1975, p. 260. The Anticollegio allegories are Pallucchini and Rossi 1982, I, pp. 209–10, nos 373–6; II, figs 482–6.

10. Nichols 1999, pp. 136–7.

11. Typescript note of July 1959 in the dossier.

12. [Dubois de Saint-Gelais] 1727, pp. 222–3.

13. Plesters 1979, pp. 22–3.

14. Inscribed 'Do. Tintoretto' and 'Ja. H.' respectively and ascribed to Domenico Tintoretto and to Jacob Hoefnagel. The former, published by Loeser (1903, p.181), is 35.6 × 25.2 cm; the latter is 20.9 × 15 cm; both are in pen and brown ink with wash.

15. Hyginus, *Fabulae, Liber secundus*, section 43.

16. Mandowsky 1938, pp. 88–93. She cites the Latin edition of the Geoponica

(Venice 1538, cap. XIX, lib. II). For Italian editions see Constantino Cesare 1542, pp. 110r–110v, and 1549, lib. XI, cap. XX. Konečný 2002, p. 258, note 11, cites several editions.

17. Attwood 2003, I, pp. 177–8, nos 236 and 237 (the latter with the date); II, plate 58. The medal seems to be attributed to 'Matteo a Fede' by Rangone himself and Weddigen (1974, p. 46) suggests that this is Matteo Pagano, the wood engraver.

18. Anthofer 1996, pp. 22–3.

19. Martin 1998, pp. 39–42, 70, plate 44.

20. Weddigen 1974.

21. Ibid., p. 50.

22. Fabriczy 1904, p. 83.

23. See for example Salton 1965, no. 64.

24. Passi 1973, pp. 16–21.

25. In addition to Rangone's book, Alvise Cornaro's treatise on diet and longevity, *Della Vita Sobria*, published in 1558, was a best-seller (see Cornaro 1983). For the views of another learned Italian physician on this topic see Siraisi 1997, pp. 78–9, and for theories on longevity in general see Gruman 1966.

26. Mandowsky 1938, n. 6; Pollard in Hill and Pollard 1967, p. 78.

27. Anthofer 1996; Alciati 1546, fol. 15v.

28. Garas 1967 cites Giraldi's treatise on Hercules; Konečný 2002, p. 260, mentions Giraldi (see his note 15 for bibliography) together with Conti 1551 and Cartari 1556.

29. Granberg 1902, Appendix, p. xiv, no. 295.

30. Ridolfi 1918, p. 50.

31. Kaufmann 1988.

32. Newton 1952, p. 169, and 1961. Gould 1959, p. 91. n. 7; 1975, p. 261, n. 7.

33. Garas 1967, pp. 29–48.

34. Notably Nichols 1999, p. 135, and Aikema and Brown 1999, p. 628, no. 195 (entry by Andrew Martin). In the latter case it is proposed that the paintings were made for Rudolf's bedroom.

35. [Dubois de Saint-Gelais] 1727, p. 222.

36. Lyceum, lot 238, see marked copy of catalogue in the National Gallery Library.

37. See note 35 above.

38. Pignoria 1615 as cited by Konečný 2002, p. 262, and note 18.

39. Gould 1959, p. 90; 1975, p. 260.

40. Wainewright 1880, p. 181 (the article appeared first in the *London Magazine*, September 1821).

41. Duvivier may be Benjamin Duvivier (1730–1819), who was a draughtsman as well as a medallist, or Aimée Duvivier, a portraitist active at the right date. L.R. De Launay is likely to be Robert Delaunay (1749–1814), brother and pupil of Nicolas Delaunay.

42. National Gallery Report for the period June 1962 – December 1964, p. 139.

43. Fine examples are on Vignon's *Adoration* in the Birmingham Art Museum, Alabama (1979.5), and on Philippe de Champaigne's *Repentant Magdalen* of 1648 in the Museum of Fine Arts, Houston (1970.26); Mitchell and Roberts (1996, p. 38 and fig. 27) illustrate this type of frame with a drawing of what is claimed as the original frame on Chaperon's *Presentation* of 1639 in the latter institution. The original frames generally have a twisted ribbon at the sight edge.

NG 1130
Christ washing the Feet of the Disciples

*c.*1575–80
Oil on canvas, 204.5 × 410.2 cm

Support

The dimensions given above are those of the stretcher. The original canvas does not quite extend to the upper and lower edges, where approximately 2.2 and 2 cm of lining canvas are visible. The original canvas is a complex structure consisting of one long horizontal piece of heavy twill (A) and four vertical pieces (B, C, D, E), with a long strip of canvas of a medium tabby weave along the top (F) and another strip of the same (G) down the left side.[1]

Fig. 1 Diagram of the canvas.

A is approximately 108 cm high.
B is approximately 56 cm wide.
C and D are approximately 117 cm wide.
E is approximately 111 cm wide.
F is approximately 5 cm high.
G is irregular in width but at no point is it wider than 6 cm.

The long horizontal seam passes through Christ's upper lip and the waist of the disciple drying his foot in the foreground on the right. Vertical seams pass through the face of the disciple holding a torch on the extreme left, just in front of Christ's nose, and through the shoulder of the disciple in green who is standing by the fire.

The painting may have been cut, but probably not by a significant amount. The dimensions of the companion picture of the *Last Supper* in S. Trovaso (figs 2 and 3) are given as 221 × 413 cm.

The lining canvas is of a medium-fine tabby weave. The modern stained pine stretcher has one horizontal bar and three vertical bars.

Materials and Technique

The canvas has a gesso ground on which there is a priming 'of appreciable thickness and consisting almost entirely of charcoal black', but including other pigments, presumably from 'palette scrapings'.[2] On top of this, Tintoretto sketched in the composition with thickly applied lead white, occasionally, it seems, cancelling an idea with more black.

Some of this white brush drawing (in one of the hardest of pigments) has made an unintended appearance on the worn surface of the painting, for example in the legs of the torch-bearing disciple at the front left, in parts of Peter's shoulder, in lines defining the architecture in the background, in the highest of the most distant heads, in the brass basin, just beside the shadowy edge of Christ's left arm, and in the stool at the lower right.

In many areas the paint has darkened because of both wear and increasing translucency, which in their different ways permit the black to be more dominant than the artist can have intended.

Joyce Plesters in her full technical account of Tintoretto's paintings in the National Gallery lists the pigments discovered in the painting, which include malachite in lead white with copper glazes for the shadows in the well-preserved green of the disciple by the fire; smalt blue which has deteriorated to a dark grey in the drapery over the stool; orpiment and realgar, which has also deteriorated, in Saint Peter's orange-yellow robe; and a variety of lakes (including what is probably kermes with lead white for Christ's robe).

Conservation

The painting was relined, cleaned and repaired in 1883, after acquisition. A decade later it was cleaned (perhaps only surface-cleaned) and varnished by 'Buttery' and it was surface-cleaned again in 1907. In 1935 it was cleaned by 'Holder' (with startling results, according to one source[3]). It was 'polished' by 'Vallance' in 1945. Blisters were laid in 1955 and in the following year the painting was cleaned and restored. It was surface-cleaned and revarnished in 1991 and retouched and revarnished in 2004. Changes to the composition resulting from the work in 1956 are discussed below.

Condition

The painting is in poor condition. The damage it has suffered is not always easy to understand and its original appearance is not easy to reconstruct.

Much of the surface is badly abraded but some parts of the painting may never have been finished in the conventional sense. It also retains passages from more than one old campaign of retouching as well as some reconstructions which are misleading.

A few areas are in a reasonable state of conservation: the green dress of the disciple in front of the fire (although his flesh has been rubbed down to the canvas and his stool is almost indecipherable), some of Saint Peter's white hair and beard, the lit portions of the torch-bearer's cloak. Some other areas are relatively well preserved: the yellow jacket of the disciple drying his foot, Christ's face and his rose-coloured robe, although there is a large tear across his chest, the shadows in his flesh are worn, and there is a good deal of repaint on the canvas seam that crosses his face.

There are also forms which are now nearly indecipherable, among them the cat, Saint Peter's left hand, and, most notably, the legs of the torch-bearing disciple. There are also some forms which are legible only because they have been reconstructed: the paving is the area in which this has been accomplished with least authority.

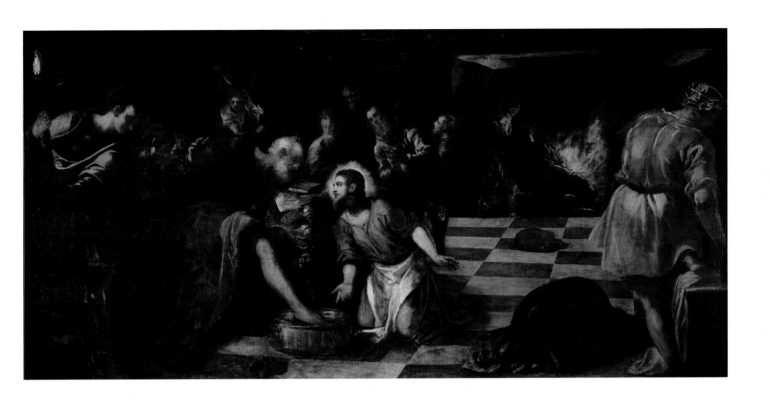

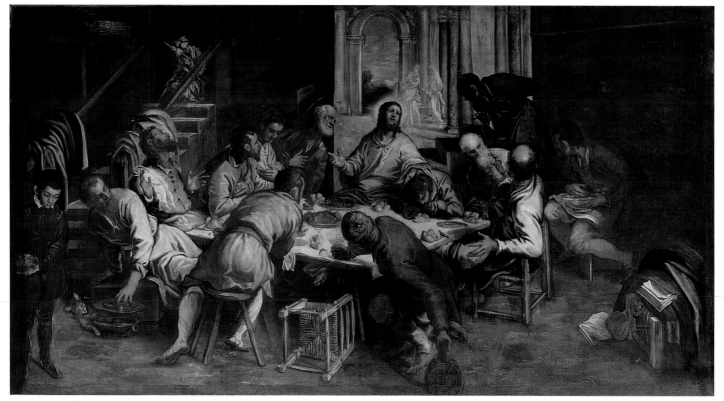

Fig. 2 Jacopo Tintoretto, *The Last Supper*, *c*.1563–4. Oil on canvas, 221 × 413 cm. Venice, Church of S. Trovaso.

Among the more notable specific damages are tears in the top left corner, in the torch-bearer's head, and just above Peter's right hand. The canvas was punctured in the back of the disciple in green. In addition to losses along the main horizontal seam there is a line of other losses slightly lower down, perhaps corresponding to a fold in the canvas.

Notes on the way in which the painting has darkened, some of the white underpainting has been exposed and some of the colours have deteriorated can be found in the section on Materials and Technique.

Later Modifications to the Painting

When the painting was cleaned and restored in 1956 it was discovered that the table in front of the torch-bearing disciple was a later addition, probably designed to mask the 'unfinished' appearance of the disciple's legs (they may indeed have been unfinished but the effect cannot surely have originally been as diagrammatic as it now seems). The table was removed. So too was a layer of 'biscuit' colour that covered the paved floor, certainly not original (it covered damage in earlier paint layers) but old and hard. It was removed by 'gentle scraping', revealing paving-stones of brick red and grey rose, presumably intended for the pinky orange and cream Verona marble that was the norm in sixteenth-century Venice.

This paint layer was very damaged, however, and the reconstruction of the paving was patchy, as if tentative, and yet brash (overemphasising the pattern and the contrast between the colours). The floor of Tintoretto's *Last Supper* (discussed below), which served as a companion picture, also includes paving, but it has been largely scumbled over by the artist (who also painted debris on top of the scumble), and we may wonder whether the floor in NG 1130 – which does, after all, represent the same room (or a contiguous one) – was not originally similar. In any case, there is a disconcerting inconsistency in the paving as reconstructed. In addition to the orthogonal passing below Christ's left knee, there is another only a little to the left which makes no sense in relation to the pattern of the paving elsewhere.

The restorer responsible for the biscuit-coloured overpaint also painted the cat. Something of Tintoretto's original cat had been discovered beneath and it was deemed possible to 'reconstruct' this 'in its original form'.[4] It would be truer to say that the outlines of the original cat were followed. None of the character or colouring typical of Tintoretto's felines survived or was revived.

Further discussion of the question of alterations to the painting's original appearance centres on the print of the painting (fig. 4, an etching with some engraved reinforcement) that was made by Andrea Zucchi (1679–1760) after a drawing by Silvestro Manaigo (1670–1734) with the legend 'Cristo che lava i piedi agli Apostoli del Tintoretto, nella Chiesa di S.S. Gervasio, e Protasio detto S. Trovaso, in Venet[a]'. This print was included in *Il Gran Teatro delle Pitture e Prospettive di Venezia*, a highly ambitious anthology of city views and reproductions of celebrated paintings, published by Domenico Lovisa, which was first announced on 1 April 1715 – and was therefore probably at an advanced stage of preparation at that date – but was first published around 1717.[5] (It is noteworthy

that the companion painting of the *Last Supper* had been engraved more than a century before by Aegidius Sadeler.[6]

The print is not likely to be very reliable: there is little attempt to record the faces and hands of the chief actors accurately and they look like inventions by a contemporary of Piazzetta. The two most obvious differences are that the disciple on the left is not holding a torch and, in place of the

female figure drawing aside a curtain to enter the room at the back left, there is a male figure apparently leaving the room. One possible explanation for these differences is that the draughtsman was obliged to study an already darkened painting inside a dark chapel, but the torch must surely always have been obvious, so perhaps the drawing was damaged or unfinished in this area. The legs of the disciple on the

Fig. 3 Transept chapel of the church of S. Trovaso, Venice, inscribed 1556, showing on the right wall Tintoretto's *Last Supper* (originally on the opposite wall) in the place once occupied by his *Christ washing the Feet of the Disciples* (copy now on the left).

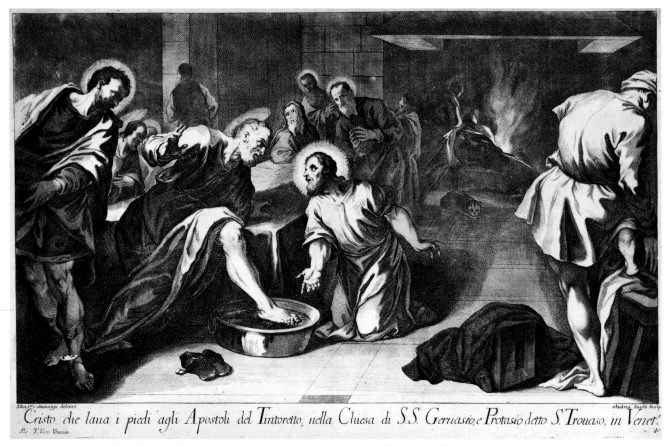

Cristo che laua i piedi agli Apostoli del Tintoretto, nella Chiesa di S.S. Geruasio, e Protasio detto S. Trouaso, in Venet.

Fig. 4 Andrea Zucchi after Silvestro Manaigo, engraving after Tintoretto's *Washing of the Feet*, c.1717. Private collection.

left are not in the least sketchy in the print, in fact they are the most carefully modelled area in the entire composition. It seems clear that the table to the left must have been added after the date at which the preparatory drawing for the print was made and the reason for this addition may have been to conceal the results of a disastrous attempt at cleaning this part of the picture.

Zucchi's print is of special interest for its rendering of the paving. Some sort of pattern can be perceived but it is not the chequerboard that we now see in the painting. There is no contrast between areas of different colour, perhaps because of the difficulty of recording these as well as the chiaroscuro in black and white, but they may also have been less evident in the original at that date. The divisions in the paving feature paired horizontal lines which are more prominent than the orthogonals. That these divisions are not arbitrary inventions is strongly suggested by the two orthogonals in front of Christ which do correspond to those which can still be seen in the painting (as noted above).[7] More important still is the shadow on the paving. The figure of Christ casts a distinct shadow, behind which there is another shadow, and then another which covers the cat, leaving a bar of lit paving just in front of the bench before the fire. These three degrees of shadow, with the light on the table top which is recorded behind Peter as well as on the corner of the table in front of him, are more typical of Tintoretto than the shadows to be seen in the painting in its present state.

The above account is based on the assumption that the engraving is indeed the record of the painting by Tintoretto that it purports to be. Cecil Gould advanced the hypothesis that the print in fact recorded the copy which he believed had already been substituted for the original in S. Trovaso.[8] But there is no compelling evidence for this, nor is it likely, given the claim in the anthology that it had been planned by a consortium of patrician art lovers and art experts (an 'accademia de virtuosi e dilettanti'), that the artists did not know what they were looking at.[9] A decisive argument against Gould's theory is the fact that the painted copy excludes the cat, which is very prominent in the print, as also in NG 1130. More recently Matile has suggested that the substitution may have occurred in 1707, when the paintings were restored, or soon after, but he concedes that there is no real evidence for this.[10]

Attribution and Dating

NG 1130 seems never to have been doubted as a work by Tintoretto. As shown below, it was painted for a chapel, the architecture of which seems to have been completed in 1556. Scholars have agreed that a date fairly soon after 1556 accords with the painting's style. A date in the 1570s is, however, more likely. In its treatment of the subject the painting is markedly different from the four earlier paintings of the same subject wholly or partly by Tintoretto. These works – in the collection of the Earl of Pembroke at Wilton House, in the Art Gallery of Ontario, Toronto, the Laing Art Museum,

Newcastle upon Tyne, and above all the great painting in the Prado, Madrid – are closely related, especially the last three mentioned, which have a very long horizontal format and figures disposed in a very deep open space with remarkable effects of linear perspective to supplement the bold foreshortening of their poses, and architecture designed to show how splendid a stage set the artist could contrive. By contrast there is a greater narrative urgency and a more appropriate setting for the event in NG 1130.[11] The type of interior depicted is in fact reminiscent of the setting of *The First Communion of the Apostles* (usually identified as *The Last Supper*) in the Sala Grande Superiore of the Scuola di S. Rocco, painted by Tintoretto between 1578 and 1581.[12] There is one point of contact with the other earlier versions of the subject painted by Tintoretto: the large figure drying his foot on the right of the painting appears also in the Prado version but seen from the front and on the left – a reminder of the artist's use of sculptural models which could be studied from more than one point of view.

The Subject

The painting illustrates the episode recounted in the Gospel of St John (13:2–17):

> And supper being ended, the devil having now put into the heart of Judas Iscariot, Simon's son, to betray him; Jesus knowing that the Father had given all things into his hands, and that he was come from God, and went to God; He riseth from supper, and laid aside his garments; and took a towel, and girded himself. After that he poureth water into a basin, and began to wash the disciples' feet, and to wipe them with the towel wherewith he was girded. Then cometh he to Simon Peter: and Peter saith unto him, Lord, dost thou wash my feet? Jesus answered and said unto him, What I do thou knowest not now; but thou shalt know hereafter. Peter saith unto him, Thou shalt never wash my feet. Jesus answered him, If I wash thee not, thou hast no part with me. Simon Peter saith unto him, Lord, not my feet only, but also my hands and my head. Jesus saith to him, He that is washed needeth not save to wash his feet, but is clean every whit: and ye are clean, but not all. For he knew who should betray him; therefore said he, Ye are not all clean. So after he had washed their feet, and had taken his garments, and was set down again, he said unto them, know ye what I have done to you? Ye call me Master and Lord: and ye say well; for so I am. If I then, your Lord and Master, have washed your feet; ye also ought to wash one another's feet. For I have given you an example, that ye should do as I have done to you.

Tintoretto places the episode in a large room with a fire beneath a massive hood. Peter (who is also prominent in the companion painting of the *Last Supper* and is there dressed in the same colours) is clearly amazed by Christ. He was generally depicted as saying 'Lord not my feet only', and the usual convention was to show him pointing at his head.

This is found as early as the thirteenth century and most of Tintoretto's contemporaries still favoured it: Bernardino Campi in the duomo of Cremona in the late 1560s and Giuseppe Salviati in S. Polo, for example.[13] But here, presumably, Tintoretto has chosen a slightly earlier or later moment. The disciple drying his foot on the right shows that others have already had their feet washed.

There are twelve people present here, excluding the servant woman, and so Judas has already left. His absence is surprising. In earlier paintings of this subject by other artists he is certainly included,[14] as indeed he is in other works by Tintoretto. He can be clearly discerned in Palma Giovane's painting in S. Giovanni in Bragora (fig. 1, p. 100), even if only hovering in the background. There is in fact good reason to believe that orthodox opinion in the final decades of the sixteenth century would have favoured his presence. Nadal's annotated illustrations to the life of Christ, one of the most influential official publications of the Counter-Reformation Church, first issued in 1593 but under preparation in the previous decade, included Judas in the print representing the Passover Supper, and also in that of the Washing of the Feet, where he appears as the last disciple in line, clutching a purse, and in the next print, showing the disciples re-gathered at the table and Christ instituting the Sacrament. Then, in the next, where the disciples receive Communion, he leaves the room, accompanied by a devil.[15] A possible explanation would be that Tintoretto had depicted him leaving the table in his companion picture of the *Last Supper* and thus excluded him from NG 1130 in order to be consistent with that work, which, as will be argued, he may have completed at an earlier date.[16]

The Popularity and Significance of the Subject

The painting, companion with one depicting the Last Supper, long hung in the chapel dedicated to the Sacrament in S. Trovaso, as is discussed below. The Last Supper was frequently chosen for such chapels in Venice by the Scuola which had charge of them, and it was also the usual subject for a painting made to hang above the *banco* of the Scuola, the bench and desk they maintained in the nave (see below). Christ washing the Feet of the Apostles was also favoured for such locations.

Tintoretto provided a canvas of this subject, together with one of the *Agony in the Garden* (both vertical in format), to hang beside the long canvas of the *Last Supper* above the *banco* of the Scuola del Sacramento in S. Margherita (all three paintings are now in S. Stefano, Venice). A painting of the Washing of the Feet also hung near the equivalent *banco* in S. Lio.[17] Paintings of Christ washing the Feet of the Apostles were paired with the Last Supper in the Sacrament chapels of S. Marcuola and S. Moisè (in the former case both paintings were by Tintoretto, in the latter the *Washing* is by him but the *Supper* is by Palma Giovane).[18] In the Sacrament chapel of S. Polo the *Washing* is on the right-hand wall and *Christ carrying the Cross* is opposite (each is about fourteen feet (420 cm) long), paintings attributed to Giuseppe Salviati. In S. Giovanni in Bragora there is a large painting of this

subject by Palma Giovane (fig. 1, p. 100) with a companion of *Christ before Caiaphas*, probably designed to complement Paris Bordone's *Last Supper*.[19]

This account, which is not exhaustive, is sufficient to suggest that some special explanation of the popularity of this subject is required, for it was not common elsewhere, although found in a few chapels dedicated to the Sacrament, for example that in the duomo of Cremona of 1569; it can also be found in the frescoes of the choir of the church of the Corpo di Cristo in Brescia, of perhaps a little earlier.[20] One notes that when the Last Supper only was depicted for the confraternities, as in the painting of 1548 by Girolamo da Santacroce, now hanging below the organ on the entrance wall of S. Martino at the Arsenal (presumably a painting for the Scuola's *banco*), the episode of the Washing is included very prominently in the background.

The Washing of the Feet may be regarded as a 'parable in action' which illustrates the need for self-abasement and fraternal love, and the need for purification by Baptism – and perhaps for penance to purify post-baptismal sins.[21] Penance was required prior to receiving Communion, and there was a renewed emphasis on the proper preparation for the reception of the Eucharist in the Counter-Reformation Church; this may explain the choice of the subject for chapels of the Sacrament, and Cope pertinently refers to the approval by the Venetian Senate in 1566 of a catechism which cited the Washing of the Feet in this context.[22]

Worthen, however, and chiefly with reference to the subject's popularity above the *banco*, emphasises, rather, the fraternal injunction 'ye ought to wash one another's feet', and the 'new commandment' of Christ given later in the same chapter, 'that ye love one another; as I have loved you, that ye also love one another' (John 13:34) – which was 'the first and most important antiphon in the annual ceremony of the washing of the feet that followed the Mass on the evening of Maundy Thursday', a passage also quoted in the *mariegole* (the official statute books) of the *scuole* to emphasise fraternal and charitable duty.[23]

The Patrons of Tintoretto's *Washing of the Feet*

The painting is first recorded in the chapel of the Most Holy Sacrament in the Venetian parish church of SS. Gervasio e Protasio, generally known as S. Trovaso. This chapel was the responsibility of the Fraternità del Corpo di Cristo, also known as the Scuola, or Confraternity, of the Santissimo Sacramento of San Trovaso, and they must have commissioned the painting from Tintoretto.

Numerous confraternities dedicated to the sacrament of the Eucharist were established in the early years of the sixteenth century in Venice and they soon came to be a regular feature – and their chapels a notable ornament – of the city's churches.[24]

The Scuola of S. Trovaso survives to this day, the only one still active in the city, and its *mariegola* (statute book) is in the parish archive. This seems to have been compiled between late 1536 and 1543, and commences with copies of the foundation documents: the petition of the *parroco* and parishioners

to form the confraternity, the permission to do so granted by the Council of Ten, also the response of the patriarch, Antonio Surian. The petition gave as the confraternity's chief motive to go out 'with torches in honour of the "Sacratissimo Corpo de Christo" when the Sacrament was carried to the sick of the parish'. The permission of the civic authorities granted on 27 April 1506 was terse. They took care to insist that only residents in the 'contrada' of S. Trovaso were eligible and that any dispute would be settled by the Provveditori di Comun. The response of the patriarch, dated 17 April, was much longer, granting indulgences to those who recited on their knees five Paternosters and five Ave Marias at the confraternity's altar, and gave alms and offerings for lights and ornaments for the use of the confraternity, to those who joined the confraternity and attended the funerals for their fellows, and above all to those who escorted the Sacrament to the sick, especially if carrying a torch.[25] There were male and female members (although officers were always male), as was usual with devotional *scuole* (by contrast, only men could belong to the *scuole grandi*, which in origin were penitential confraternities).

An inventory compiled on 10 August 1509 records in the church a lantern (specified as belonging to the confraternity) used for escorting the Sacrament, as well as a bell used on these occasions and a cloth of 'ora da Cologna' for the altar 'del corpo de xpo' and a cloth of 'veludo paonazo' for the Sacrament. They had a *banco*, that is, a bench and desk used for meetings and, on Sundays and festivals, for the display of a crucifix or an image of the sacrificed Christ together with candlesticks. An alms box and the official records would be kept there, including a copy of the 'Bolla del Patriarcha'. As was usual for such confraternities, there was an annual election of the governing body of twelve, the *gastaldo* (chairman), the *avicario* (vice-chairman) and the *scrivan* (secretary), and there were rules concerning regular attendance at mass and funerals. It is noteworthy that the confraternity remained independent of the parish priest, who in September 1616 was expressly forbidden by the Provveditori di Comun from interference in the management of the *scuola*.[26]

The transcript in the *mariegola* of a document of 28 December 1543 makes it clear that the confraternity had obtained permission to demolish a chapel and rebuild it in larger and finer form,[27] but thereafter very little is recorded until the 1590s. Bequests and donations are recorded in the early seventeenth century, including lamps and candlestands of precious metal, but there is nothing else on the decoration of the chapel, and no entry at all after 1758.[28] As Matile has recently shown, the new chapel of the Scuola was not in its present position.[29]

The Chapel of the Most Holy Sacrament in the Church of S. Trovaso

The ancient parish church of S. Trovaso in the *sestiere* of Dorsoduro, which had been erected beside the *rio* named after it (a main waterway connecting the Grand Canal with the Zattere), crumbled to the ground during the night of 12 September 1583.[30] Soon thereafter it was rebuilt 'del tutto',

according to Stringa, writing in 1604, and to the design ('sul modello') of Andrea Palladio.[31] Both statements are dubious. Palladio died in 1580. Unless there were earlier plans for rebuilding the church his designs can hardly have been used, although in a general sense the patterns he had published could have been consulted. Moreover, although much of the church was certainly destroyed, the chapel of the Most Holy Sacrament, bearing the date 1556 on the pillar to the left of the entrance, either survived (as did the painting of the *Temptation of Saint Anthony* by Tintoretto, above an altar inscribed 1577 in the chapel of the Milledonne family nearby) or was rebuilt out of material that could be salvaged. Matile notes that the confraternity were given the choice of two locations for their chapel in the new church.[32] He assumes, understandably, that their new chapel would have been of new design, but since the paintings survived the collapse, so too surely did the architecture of their chapel, which was now rebuilt in a new position. In style it is certainly more like a building of 1556 than one of 1583.

The new position assigned to the chapel of the Most Holy Sacrament gave it greater prominence than it can have enjoyed previously. There are two façades to the church, very similar and more or less equal in grandeur: the high altar is opposite the entrance in the façade in the campo; the chapel that extends from the north arm of the transept faces the entrance in the other façade on the Rio di S. Trovaso.

The chapel (fig. 3) is nearly square in plan (approximately 457 × 533 cm), with Corinthian pilasters of Istrian stone at the corners, supporting the cornice, above which are the thermal (lunette) windows that light the chapel from both sides and a dome with a lantern providing additional lighting. It is paved with orange and cream Verona marble, and the entire altar wall is adorned with an elaborate architectural composition in Istrian stone with gilded details. This incorporates columns of Proconnossos (grey-streaked ancient Greek) marble above the altar table, forming a central aedicule within which, in low relief, a church interior is represented with perspective paving, angels entering the sides, and dome and vault above. The 'altarpiece' of this fictional interior takes the form of a gilt-metal tabernacle door upon which the resurrected Christ is represented, holding a banner. This tabernacle is now partly obscured by a more recent one of silver which rests on the altar table itself.

Low-relief linear perspective of this kind had been a popular feature of the sculpture and architecture of the Lombardi in the late fifteenth century.[33] Its use in S. Trovaso may have been something of a revival. It seems to have stimulated the similar but bolder design adopted for the altar wall of the equivalent chapel in S. Giuliano. In that case the altar wall includes two half-life-size statues of terracotta disguised as bronze. A similar pair – 'finte di Bronzo', according to Stringa,[34] and representing Melchizedek and David – were included in the niches to left and right of the altar in S. Trovaso. These were, however, replaced by Carrara marble statues of the same subjects, sometimes attributed to Giovanni Marchiori (1696–1778) and certainly carved in the eighteenth century. The two angels on the pediment of the

central aedicule must be of the same date, and are surely by the same hand. The *palliotto* (altar frontal) depicting the First Communion of the Apostles in relief is also of white marble, and also an eighteenth-century addition.[35]

The side walls of the chapel are occupied by two large canvas paintings: they are about eight feet (2.4 m) above the paving of the chapel, with a stepped stone ledge beneath them, fitted at regular intervals with hooks, presumably for hangings. As currently arranged, the *Last Supper* by Tintoretto hangs on the right-hand wall and a copy of the *Washing of the Feet* hangs on the left, but it has been proposed that they have been switched (a question which is considered below). The *Last Supper* appears to have been extended by a few inches on all four edges, and there may have been a different style of framing from the simple gilt-wood fillet currently employed. Stringa mentions that the interior of the dome was decorated ('la sua cupola tutto dipinto') but the surface is now bare plaster: however, God the Father is painted in fresco in the lantern.

As mentioned above, the date MDLVI is carved on the pillar at the left of the entrance to the chapel, suggesting that the architecture of the chapel was complete, or at least well under way, in that year. However, as we have seen, permission to create a new chapel was granted at the end of 1543 and it is not impossible that the entrance pillars were the very last features to have been made. It is reasonable to suppose that the altar wall, because of its importance and because it is integral with the scheme of the architecture, belongs to the same date as the chapel. In any case the altar pre-dates the collapse of the church.[36] The side paintings do not relate very happily, in their scale or the proportions, with the sculptural altar wall. But Tintoretto was not always sensitive to such factors. They may of course have looked better in the chapel before the collapse of the church, but there is no reason to believe that they were altered in size to fit into the chapel when it was rebuilt.[37] The complex structure of the canvas of NG 1130 is not unusual for Tintoretto.

Left and Right Walls

As mentioned above, the copy of Tintoretto's *Washing of the Feet* hangs at present on the left wall of the chapel in S. Trovaso, and Tintoretto's *Last Supper* hangs on the right. The lighting in the chapel comes from both directions, therefore the lighting in the paintings provides no evidence of the original arrangement. Nor is the example of other chapels decisive. The *Washing of the Feet* was on the right-hand wall of the Chapel of the Sacrament in S. Polo but on the left in the same chapel in S. Moisè. However, Worthen has correctly observed that Boschini describes the *Last Supper* of S. Trovaso as being on the right in 1664, and since his practice was to give directions from the altar (in this case his words are 'alla destra dell'Altar') this must mean that it hung on the left and this is indeed confirmed by other guidebooks.[38] Its present position is therefore not the original one.

The motive for making this change would have been a desire to put the better (and, of course, original) picture in the best light, and Worthen notes that Tintoretto's *Invention*

of the Cross in S. Maria Mater Domini has been moved for a similar reason. It may be that the change was made when the copy of the *Washing of the Feet* was substituted for the original.[39]

Tintoretto did in fact plan for the *Washing of the Feet* to be seen from the right, from the chapel's entrance. When planning a painting of horizontal format for the side wall of a chapel or chancel he placed the vanishing point emphatically to the side nearer the beholder. Thus, in the *Last Supper* on the right-hand wall of the chancel of S. Giorgio Maggiore the vanishing point is on the right and, in the *Washing of the Feet* in S. Moisè, which was intended for a left-hand wall, it is to the left. Even without the evidence of Boschini, we could deduce from the vanishing point of the *Washing of the Feet* that it was made to be hung on a right-hand wall.

It should be added that when the compositions of the *Last Supper* and the *Washing of the Feet* for S. Trovaso are compared with pairs of paintings made by Tintoretto for the side walls of other chapels or chancels we are struck by the lack of a compositional relationship in the former; it is especially surprising that the vanishing point in the *Last Supper* is not to the left so as to match the one (to the right) in the *Washing of the Feet*. Instead, it is more or less central. One possible explanation for this would be that the *Last Supper* was painted at an earlier date, to hang above the Scuola's *banco*, and was then transferred to the new location – a hypothesis that was first entertained by Professor Worthen.[40]

The earliest certain reference to the painting occurs in *Il Riposo* by Raffaello Borghini, published in Florence in 1584, in a reliable list of Tintoretto's paintings in Venetian churches: 'nella capella del Sacrame[n]to di detta chiesa vi sono duo quadri, nell'uno quando Christo lava i piedi agli Apostoli.'[41] The date at which the painting was removed from S. Trovaso is unknown. Cecil Gould noted that Ridolfi does not mention it together with the *Last Supper*, although in other cases of paired pictures by Tintoretto he refers to both.[42] The best explanation for Ridolfi's omission is that the *Last Supper* was the more admired of the two (and at that date it alone had been engraved – and Ridolfi indeed refers to the print). In any case, Gould distinguishes between the connoisseur (Ridolfi) who does not mention the picture as a Tintoretto and the writers of guidebooks who do, but he fails to take into account Boschini, who was a connoisseur as well as the author of a guidebook, and who does mention the picture.[43]

It is of course true that many guidebooks simply copy prezvious ones, and the fact that a painting by Tintoretto of this subject is recorded in S. Trovaso in *Della pittura Veneziana tratatto* of 1797 is not a sufficient reason for supposing that it must still have been there.[44] Indeed, Paoletti mentions the painting in his guide of 1840[45] and Fontana does so in his of 1847,[46] but the best-informed guidebooks of the early nineteenth century were not so sure about it. Moschini in 1815 expressed some reservations and wondered why Ridolfi had not mentioned it;[47] four years later, he merely observed that it was held to be ('on croit') by Tintoretto.[48] Also, in the *Forestiere Istruito* of 1822 it is merely 'attribuito'.[49] For this reason it seems likely that the copy – which, from its appearance, one would be surprised to learn was painted much more recently than 1790 – was already in place. However, this cannot be proved conclusively.

Paintings of the Washing of the Feet by Tintoretto in London
The English collector Sir Abraham Hume (for whom see pp. 458–61) in a letter of 23 February 1791 to Giovanni Maria Sasso, probably the greatest connoisseur in Venice, reported that a major painting by Veronese was about to arrive in London, and also that 'through other means a very large picture by Tintoretto has arrived to try its fortune in London; it represents the Apostles grouped together before sitting down to the Last Supper. It is a genuine original work but has suffered a good deal and although the heads are spirited in handling the composition is too disjointed.' ('Anche è arrivato per altri mani un grandissimo quadro di Tintoretto, per fare prova della sua fortuna in Londra; rappresenta li apostoli gruppati insieme avanti mettersi a tavola per l'Ultima Cena. E vero originale ma patito assai e benché le teste sono toccate con spirito la composizione è troppa disunita.') It seems likely that this was a painting of the *Washing of the Feet* – indeed, it is hard to think what else it could be – but the oddity of Hume's description perhaps explains why Sasso was unable to identify the picture. In his reply he declared that he knew nothing of such a painting and, having heard no word of it in Venice, he supposed that it had perhaps come from somewhere in the Veneto.[50] It seems possible that the newly imported picture was acquired by Sir Joshua Reynolds and that it was the *Washing of the Feet* by Tintoretto that was exhibited by Reynolds in April 1791 and sold as lot 90 on 17 March 1795, the fourth day of the sale of Reynolds's huge collection.[51] That painting was said to have come from S. Ermacora in Venice – that is, SS. Ermacora and Fortunato, better known as S. Marcuola – which is certainly a confusion since this is the church from which Tintoretto's canvas in the Prado had been removed more than a century earlier; perhaps, however, it was a deliberate confusion, if, as seems possible, this picture had been removed from S. Trovaso quietly or furtively. Reynolds did not hesitate to buy pictures in dubious condition and since he was not buying works to furnish a gallery but rather for reference, for some future public collection and sometimes for sale, he may not have found the size to be a problem.

Another *Washing of the Feet* by Tintoretto was lot 43 at Phillips, London, on 3 June 1814. This picture was bought by Sir Matthew White Ridley, Bt (1778–1836; elder brother of Nicholas, Lord Colborne, who was a Trustee of the National Gallery), and in the following year he presented it to the church of St Nicholas in Newcastle upon Tyne. It is now in the Laing Art Gallery in the same city.[52] It was consigned for sale by Alexis Delahante, who may have bought it with Woodburn at the sale of the Duchess of Brunswick at Phillips on 31 July 1813 (lot 41). This picture had previously belonged to John Symmons[53] and was not likely to have been the one owned by Reynolds.

NG 1130 was certainly in Hamilton Palace, Lanarkshire, by 1835, when it was in a passage near the servants' hall.

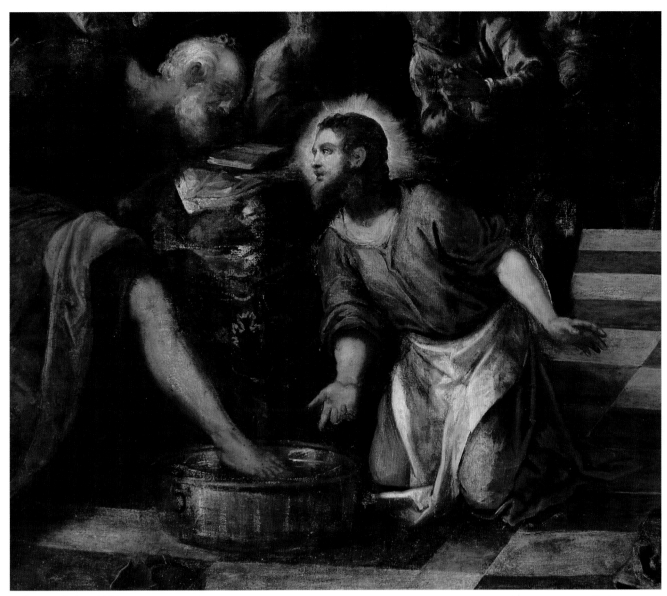

Fig. 5 Detail of NG 1130.

Alexander, 10th Duke of Hamilton, had been eagerly buying paintings from Venice in the early years of the century, before he succeeded to the dukedom, but there are good reasons to doubt that he acquired the painting then. I have found no reference to it in the many surviving letters to his agents in Venice. And he was very insistent that he was only interested in works that were in good condition. It is not unlikely that the painting was acquired on the London market by his father, the 9th Duke, who was certainly active as a collector at the date of Hume's letter and the time of Reynolds's sale.[54]

Linda Borean points out to me that a painting of the *Washing of the Feet* by Tintoretto was among those bought in Italy by the financier John Law before 1722 and sent for sale in London in 1723. Its measurements (12 × 18 *palmi romani*), however, exceed those of either NG 1130 or its companion piece still in S. Trovaso.[55]

Acquisition and Display

NG 1130 was acquired at the sale of the Hamilton Palace Collection at Christie's on 24 June 1882, where it was lot 353. The Gallery seems to have instructed 'Blood' to act and the picture was marked down to him at the low price of 150 guineas (that is, £157 10s.).[56] It was the cheapest of the dozen paintings acquired by the Gallery on that occasion, no doubt partly on account of its inconvenient size.

In common with other acquisitions made on this occasion, the painting was hung on one of several screens in the 'long Italian Room', as was announced to the Trustees on 10 July. It must always have been hard to know where to hang it. Holmes records in his autobiography, *Self and Partners*, a visit to his predecessor, Charles Holroyd, 'now a complete invalid', shortly before his death in November 1917: 'His last request, to hang our big Tintoretto, *Christ Washing Peter's Feet*, over the stairs in the entrance hall, was carried

out when the place was rearranged after the war.'[57] It almost certainly remained in this position until 1936, when it was removed at the instigation of Clark, who, 'by cleaning it and giving it a place in the gallery which it really deserves', almost made of it 'a new acquisition'.[58] When the paintings were re-hung after the Second World War it was given a place with the great Venetian paintings of the sixteenth century and only in recent years has its poor condition been felt to disqualify it from this distinction.

Provenance
Painted for S. Trovaso, Venice (see above); removed from the church after 1715, perhaps around 1790 (see above), and sold to Sir Joshua Reynolds; certainly in the Hamilton Collection by 1835; bought for the Gallery at the Hamilton sale in 1882 (see above).

Print
For Zucchi's etching after Manaigo of *c*.1717 (fig. 4) see the section on Later Modifications.

Frame
The frame the painting had when it was acquired by the National Gallery has not been traced. A new frame with a 'sanded flat' was proposed for it by Francis Draper in October 1934[59] and was perhaps fitted in the months following. The present frame, of a seventeenth-century cassetta pattern (fig. 6), was modified to fit the painting by the firm of Wiggins at some time between July 1956 and June 1958.[60] The running vegetal pattern incised in the gilded frieze is typical of Bolognese frames, and both the acanthus leaves apparently wrapped around the outer moulding and the narrow garland near the sight edge can be paralleled in frames that were made there in the late seventeenth and early eighteenth centuries.[61] The outer moulding is contrasted with the leaves by means of a bird's-foot punch, which is also used for the back moulding.

Fig. 6 Corner of the current frame of NG 1130.

NOTES

1. Plesters 1980, p. 36, describes the weave as herring-bone twill.

2. Plesters 1979, p. 16, and 1980, pp. 37–8.

3. Mayer 1936, p. 281. It is curious that Osmaston (1915, II, p. 179) considered the picture to be in good condition.

4. Plesters 1979, p. 14.

5. For Lovisa see Schulz 2000. Lovisa *c*.1717 does not include any of the reproductions of paintings, but only one copy of this edition has been traced and others may have done so.

6. Chiari Moretto Wiel 1994, p. 36, no. 10. There was also a print derived from Sadeler by 'Iac. Honcruogt'.

7. There are schemes of paving in Tintoretto's paintings in which narrow bands alternate with broad ones (for example, the *Massacre of the Innocents* in S. Rocco or the *Last Supper* in S. Giorgio Maggiore).

8. Gould 1959, p. 257.

9. Schulz 2000, p. 243.

10. Matile 1996, p. 161 and p. 199, n. 53.

11. For the earlier versions see Pallucchini and Rossi 1982, I, pp. 153–4, 156, nos 122–4 and 128; II, pp. 357–60, 364–5.

12. Ibid., I, p. 205, cat. 351.

13. Cope 1979, p. 140.

14. For example, in the fresco by Paolo Caylina, transferred to canvas, in the Museum of Fine Arts, Budapest (inv. 1311), and in Francesco Morone's painting in the Museo del Castelvecchio, Verona (inv. 1439-1B205). In the latter, Judas has a black halo, a convention more commonly found in the fourteenth century.

15. Nadal 1593; ibid. 1594; ibid. 1976, plates 100–4, engraved by Johan and Hieronimus Wiericx. The plates were first projected more than a decade earlier. For the value of Nadal as a measure of orthodoxy see Tomasi Velli 1997.

16. The identity of Judas in the *Last Supper* has been disputed. Rosand (1982, pp. 207–10) supposes he is the disciple with red leggings, but most commentators have assumed him to be the disciple reaching for the wine flask, who does indeed seem not to have a halo.

17. Worthen 1996. In the case of S. Lio, Worthen (p. 716, n. 64) cites the *mariegola* of the confraternity.

18. Cope 1979, pp. 138–43.

19. For S. Giovanni in Bragora see Chiari Moretto Wiel and Novello Terranova 1994, p. 34, and Worthen 1996, p. 725 and note 111; also Mason Rinaldi 1984, p. 124, no. 399, citing the pastoral visit of 1591. The subject was painted in the choir of the oratory of S. Antonio Abate, Udine, by Pellegrino da San Daniele c.1515, perhaps with some reference to the charitable activities of the Fraterna del Pio Ospedale.

20. The convention continued, or was revived, in later centuries. See, for example, the Sacrament chapel of Santa Lucia, Montefiore dell'Aso, by Luigi Fontana (1827–1908).

21. Réau 1955–9, II, 1955, pt 2, pp. 406–8. See also the exegesis of Christ's words on washing in Brown *et al.* 1968, I, p. 451.

22. Cope 1979, pp. 138–43 and 259.

23. Worthen 1996, pp. 705–6.

24. Barbiero 1944. It is estimated that there were sixty-seven such in the city in the eighteenth century – Pullan 1981, p. 14.

25. The orginal *mariegola* was consulted thanks to Don Giammatteo Caputo and the parish priest, Don Begimino. There is a later transcript in the Archivio di Stato: Provveditore di Comun. Reg. Z, fols 309–24 (consulted by Carol Plazzotta). For the date of completion I follow Rigon and Vian in note 4 of the fold-out publication on the confraternity, published by the Associazione Sant'Apollonia in 1996. I did not consult the *Libri de Capitoli* cited by Matile 1996.

26. Archivio Storico del Patriarcato di Venezia, curia II, inventari delle Chiese di Venezia, b. 4, fasc. 5, 1509, for the inventory. For the *banca* see Worthen 1996. The reference to the *bolla* is on fol. 7r of the *mariegola*. For the independence see fol. 319r of the transcript cited in note 24.

27. Fols 12v–15v.

28. There is, however, reference to the building of a burial vault in the chapel in 1653. One other aspect of the *mariegola* is worth mentioning and that is the beautiful preliminary illuminations – a crucifixion on one page (with the signs of the Evangelists in the margin) and opposite this a chalice containing the body of Christ supported by angels (with the Fathers of the Church in the margin). These were the chief images associated with the devotion of the Eucharist in Venice and similar illuminations are to be found in other *mariegole* – that of the Scuola of S. Cassiano (Biblioteca Correr MS IV 203) is especially striking, also that of the Scuola of S. Maria del Giglio displayed in a case in the sacristy.

29. Matile 1996, pp. 159–60.

30. Not destroyed by fire, as stated by Gould (1959, p. 87; 1975, p. 257) and repeated by others. The error seems to originate with Lorenzetti 1926, p. 515.

31. Sansovino 1604, p. 180b.

32. Matile 1996, pp. 160–1.

33. Compare the tabernacle by the Lombardi in S. Maria dei Miracoli and the one attributed to Alessandro Leopardi in S. Maria dei Frari – Cope 1979, figs 24 and 26.

34. Sansovino 1604, pp. 180–1.

35. The oil painting of Christ and the Centurion in the lunette above the altar by Francesco Polazzo (1663–after 1749) was transferred from San Stin.

36. The earliest reference known to me is that to the 'pala marmorea honorifica' on fol. 216v of the Visita Apostolica of 1581 (Archivio della Curia, within the Archivio Patriarcale di Venezia), which Carol Plazzotta examined for me.

37. Matile 1996, p. 160, makes this suggestion.

38. Boschini 1664, p. 363 (Sestier di Dorsoduro, p. 38); for other examples see Lodge 1679. That the *Last Supper* was then on the viewer's left is also implied by Sansovino 1604, p. 181 (Stringa's addition), where it is described first.

39. Worthen 1996, p. 727 and note 124. Matile 1996, p. 164 and p. 199, n. 58, makes the convincing suggestion that this occurred when the chapel was restored in 1843.

40. Letter to me of March 1997.

41. Borghini 1584, p. 554; 1730, p. 453.

42. Gould 1959, pp. 87–8; Gould 1975, pp. 257–8, citing Ridolfi 1924, p. 39.

43. Boschini 1664, p. 363; Boschini 1674, p. 38 (of section on Sestier di Dorso Duro).

44. Anon, II, p. 38 – the assumption is made by Mayer 1936.

45. Paoletti 1837–40, III, 1840, p.156. It is not clear from this account whether *Christ washing the Feet* is on the right or the left but the *Last Supper* is mentioned first, which suggests that it was to the beholder's left.

46. Fontana 1847, p. 90.

47. Moschini 1815, II, p. 295.

48. Moschini 1819, p. 310. However, in his shorter guide of 1834 (p. 170), he expressed no doubts.

49. Anon. 1822, p. 442.

50. Borean 2004, pp. 192–3.

51. For the 1791 exhibition held for the benefit of Reynolds's servant Ralph, in which the Tintoretto was no. 72, see Broun 1987, I, pp. 67ff. For the sale at Christie's see ibid., II, p. 314. Lot 90 was bought by 'Young' for 32 guineas.

52. Pallucchini and Rossi 1982, I, pp. 153–4, no. 124; II, pp. 358–60. The Ridley seat was Blagdon Hall, Stannington, near Newcastle. Sir Matthew had perhaps underestimated the space the painting required.

53. Information from Burton Fredericksen. An annotation of the Brunswick catalogue gives the size as '16 feet long'. He points out that there are other examples of Woodburn and Delahante acting together in 1813 – or at least of both being recorded as the buyer of the same lot.

54. Evans 2003, p. 62, and note 72 for the 1835 inventory. It was than valued at £30. Evans also supplies an admirable account of the 9th Duke's collecting (ibid., pp. 54–5).

55. Borean forthcoming. 12 × 18 *palmi romani* translates as 268 × 402 cm.

56. Presumably the Edmund M. Blood who is recorded in 1880 as having dealings with Bode. The director bid in person for the other paintings which the Gallery acquired: they were obviously major works so his interest would not have surprised anyone, but in the case of NG 1130 he perhaps believed that a great work remained to be discovered beneath repaint and dirt, and did not wish to inspire such a thought in others.

57. Holmes 1936, p. 331.

58. Mayer 1936.

59. Estimate in the Gallery's archive.

60. Annual Report for that period.

61. For the leaves see the frame on the Costa altarpiece formerly in the Zambeccari collection, now in the Pinacoteca Nazionale, Bologna. For a similar combination of leafy mouldings see the frame on the terracotta relief attributed to Giuseppe Mazza, which was lot 143 at Sotheby's, London, on 11 July 2001.

Portrait of Vincenzo Morosini

*c.*1575–80
Oil on canvas, 85.3 × 52.2 cm

Support
The dimensions given above are those of the stretcher. The original canvas of a medium to fine tabby weave is irregularly trimmed. It does not quite extend to the right edge of the lining canvas and in a few areas it has been extended around the stretcher on the left. Cusping is only evident at the upper edge, and the painting was once almost certainly larger (see the section on Original Format below). The back of the lining canvas has been sealed with beeswax. The modern stretcher of varnished pine has crossbars.

Materials and Technique
The canvas has a gesso ground apparently of an irregular thickness. This is covered with a very dark priming composed of miscellaneous pigments (presumed to be palette scrapings). The artist sketched on top of this layer in lead white, apparently cancelling some preliminary ideas to the right of the head, where X-radiographs reveal short diagonal strokes going upward towards the right and long strokes sweeping down alongside the present contour (fig. 1). The X-radiographs also show a pattern of folds dashed in for the curtain but not now visible in it, and reveal that landscape and sky originally extended further to the left but were then partly concealed by the dark wall.

The face is composed of many layers, indicating (unsurprisingly) that it was painted in more stages than other parts. The crimson robe was laid in with red lake; it was then modelled with paler pink and white, and finally glazed with the same red lake (identified as kermes). The stole is painted on top of this. The fur was painted when the crimson beside it was still wet, hence its occasional pink tinge.

The blue of the sky and hills has been identified as azurite, the green of the hills and trees as azurite mixed with lead-tin yellow of the type II form, the green of the curtain as verdigris mixed with large lemon-yellow particles of lead-tin yellow of the same type as in the landscape. The stole has been laid in with a dull yellow layer of yellow earth and red lead. The yellow pattern imitating gold thread is painted with lead-tin yellow type II, again of unusually large particle size, and the orange strokes on the border of the stole are composed of red lead. The medium in every sample taken is linseed oil.[1]

Conservation
The painting was surface-cleaned in 1940. Between October 1978 and January 1979 it was relined with glue and paste, cleaned and restored.

Condition
There is a large tear, more or less horizontal, in the canvas across the man's chest, and there are scattered losses in the sky and elsewhere in the background. The painting of the flesh is fairly well preserved. The curtain dimly perceived on the left of the composition was surely meant to be more apparent; so too, perhaps, was the shadowed back of the man's head. The pale blue-green of the hills has become more transparent, revealing the dark ground beneath.

Original Format
The present format of the painting is unusually narrow, the strip of landscape seems pointless, and the right arm is awkwardly cut. Other portraits by Tintoretto or in his style include narrow strips of landscape in the background but there are none of a similar shape.[2] It is likely that the sitter's right hand was originally visible, perhaps pointing vaguely to the right, the other hanging by his side, as in Tintoretto's portrait of the bearded senator in the Vitetti collection in Rome, where we find the same perfunctory curtain and strip of wall.[3] An alternative explanation would be that the painting was made by Tintoretto as a studio model, knowing that it would be needed for other paintings (three by his workshop are known and are discussed below together with half a dozen by other artists). In this case Tintoretto might not have worried about the format, but the landscape would seem unnecessary in a painting of this type.

Attribution and Dating
The attribution to Tintoretto seems never to have been doubted. By the 1560s Tintoretto had already begun to depict with sympathy the wrinkled flesh, veined foreheads, thin beards and watery eyes of the old men who ruled Venice.[4] The shrewd, slightly suspicious expression with which the present sitter regards the beholder is very close to that of the old man convincingly identified as Giovanni Mocenigo, in a portrait now in the Staatliche Museen, Berlin, which is likely to date from shortly before Mocenigo's death in 1580.[5] The contrast between the careful (but not meticulous) handling of the face and the rapidly dashed-in clothes which is a marked feature of the National Gallery's portrait is found in other paintings of this period by Tintoretto – the portrait of Marco Grimani, datable to 1576–81, in the Kunsthistorisches Museum, Vienna, is a good example – and a very close parallel to the hatched brushstrokes with which the raised threads of the cloth of gold are painted can be found in the cape and cap worn by Alvise Mocenigo in the portrait now in the Accademia, Venice, presumably painted during his reign as doge (1570–7).[6] A date after 1572 for NG 4004 can be deduced from the presence of the stole (see the next section), a date after 1575 seems more likely from both the age of the sitter and comparable works by the artist, and a date before 1580 seems clear from a derivative painting bearing that date (discussed below).

The Sitter, Vincenzo Morosini
Credit for identifying the sitter as Vincenzo Morosini is sometimes given to Dugald Sutherland MacColl (1859–1948), who published the painting in *The Burlington Magazine* when it was proposed to acquire it for the National Gallery in 1924,[7]

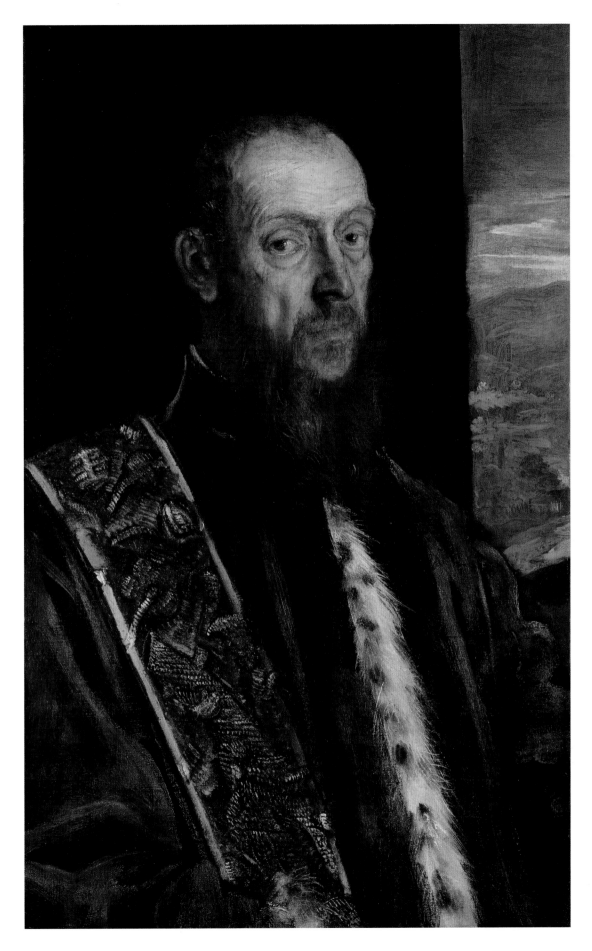

but he did not claim to have made any discoveries, and work is likely to have been done before, given the fact that the painting, when bought by Agnew's in 1923 from Alessandro Contini, was already described as 'Senatore Morosini'. As is discussed below, this identification is based on similarity with two other paintings, one of them inscribed with the sitter's name.

Vincenzo Morosini belonged to one of the oldest, proudest and richest patrician families of Venice. The Morosini and the Contarini were by the sixteenth century the most eminent of the dozen *case vecchie* that claimed descent from the tribunes who elected the first doge in the late seventh century and distinguished themselves both from the *case nuove*, which achieved patrician status after 800, and from the *casate nuovissime* (such as the Vendramin and the Pisani, discussed elsewhere in this catalogue), who were accepted during the War of Chioggia in 1380.[8] The Morosini produced four doges: Domenico, elected 1148; Marino, elected 1249; Michele, elected 1381; and Francesco, elected 1688. In the late thirteenth century they were connected by marriage with the kings of Hungary and Serbia.

In common with most great Venetian families, the Morosini had more than one branch: Vincenzo was a member of the Morosini dalla Sbarra in Canonica (also known as di Sant'Angelo), as distinct from the Morosini dalla Tressa. He was born on 9 April 1511, the son of Barbone Morosini and Elisabetta Giustinian.[9] His older brother Domenico (1508–1557/8) had a distinguished career as ambassador to emperors and popes as well as being Podestà in Verona and Riformatore (vice-chancellor) of the University of Padua. Vincenzo obtained public office, as Prefect of Bergamo, in 1555, but it was only his brother's death two years later that made him the head of his branch of the family, and this must have opened the way to further public offices. In 1565 he was elected by the Senate as one of the five *savi* (chief counsellors, literally 'wise men') of the Terra Firma (the mainland territories of Venice), a very senior post with both military and fiscal responsibilities. Three years later he was entrusted with negotiating the terms of the loan of 100,000 ducats made by the state to the king of France, Charles IX.

In 1571, during the War of Cyprus when a Turkish invasion of the Lagoon was a real threat, Vincenzo Morosini was made Generale sopra i Lidi with command of the defences of the Lagoon, a post that he is said to have filled with expert knowledge and an occasion on which his oratory was memorably exercised. In the following year he was sent as Orator Extraordinary to represent the Republic at the coronation of Pope Gregory XIII. The pope granted him the privilege of adding the dragon in the Boncompagni arms to the Morosini *stemma*. It was probably on this occasion that he was made Cavaliere of the Stola d'Oro, an honour previously accorded by the Senate to his older brother Domenico for his ambassadorial successes.

In 1578 Vincenzo was elected one of the nine procurators of S. Marco. The office of procurator was the most coveted after that of the doge. It was held for life and could be obtained by a high payment (20,000 ducats), although there were always some procurators who were selected for their merit, Vincenzo among them. There were two classes of procurator: Vincenzo was one of the five procurators *de citra*, trustees of the enormous legacies accumulated by the state.[10] In 1584 Vincenzo was made Riformatore of the University of Padua (again following his brother). In 1585, on the death of Nicolò da Ponte, he was balloted for doge, but on failing to obtain adequate support his faction – the Vecchi – helped to secure the election of Pasquale Cicogna.[11]

Vincenzo died on 10 March 1588 and was buried in the chapel granted to him by the Benedictines in the great new church designed by Palladio on their monastery island of S. Giorgio Maggiore. The foundation of a new chapel (and burial vault) is discussed more fully in a separate section below. Morosini's choice of this church is not surprising, for the monastery had been founded on 20 December 982 by his ancestor the Blessed Giovanni Morosini (d. 1012).

The Morosini continued to play a major part in the public life of the city, and Vincenzo's great-grandson, Francesco Morosini (1616–1694), 'il Peloponnesiaco', was accorded in 1687 the unprecedented honour of a bronze commemorative bust commissioned in his own lifetime by the Senate on account of his victories against the Turks as Capitano Generale del Mar.[12] He was subsequently elected doge. On Francesco's brother Lorenzo the Senate bestowed the knighthood of the Stola d'Oro as a hereditary right to pass to his descendants by primogeniture.

The Stola d'Oro

The Stola d'Oro was a Venetian order of knighthood. Although later hereditary in the Morosini family (see above), as also in the Querini and Contarini families, the Stola d'Oro was, in the sixteenth century, bestowed by the Senate as a special distinction, often, it seems, at the behest of a monarch (and hence often associated with diplomatic service).[13] According to later authorities the stole itself was worn on the left shoulder, but in the sixteenth century this was certainly not consistent practice.[14]

Since gowns of gold brocade were a prerogative of the doge, a stole in this material carried a clear message, and it was among the duties of the Cavalieri to escort the doge in processions.[15] The stole is a prominent feature of this portrait and if, as seems likely, the honour was bestowed on the sitter in 1572, the painting, or at least this part of it, must be later in date. The portrait of Vincenzo Morosini in the Doge's Palace inscribed '1580/ VINC.S MAUROC. EQUI' is clearly derived from the National Gallery's painting and so, as mentioned above, provides a *terminus ante quem*. It is larger in format, includes the hands, and is less roughly painted. Presumably in order to match the lighting with that in the room for which it was made, the picture was copied in reverse.

The Altarpiece and Tomb in S. Giorgio Maggiore

The sitter in NG 4004 is the same as that in an inscribed portrait of Vincenzo Morosini in the Doge's Palace, and the same as the donor in the altarpiece commissioned by Vincenzo for his chapel in S. Giorgio Maggiore (fig 3); indeed,

Fig. 1
X-ray mosaic
composition
of NG 4004.

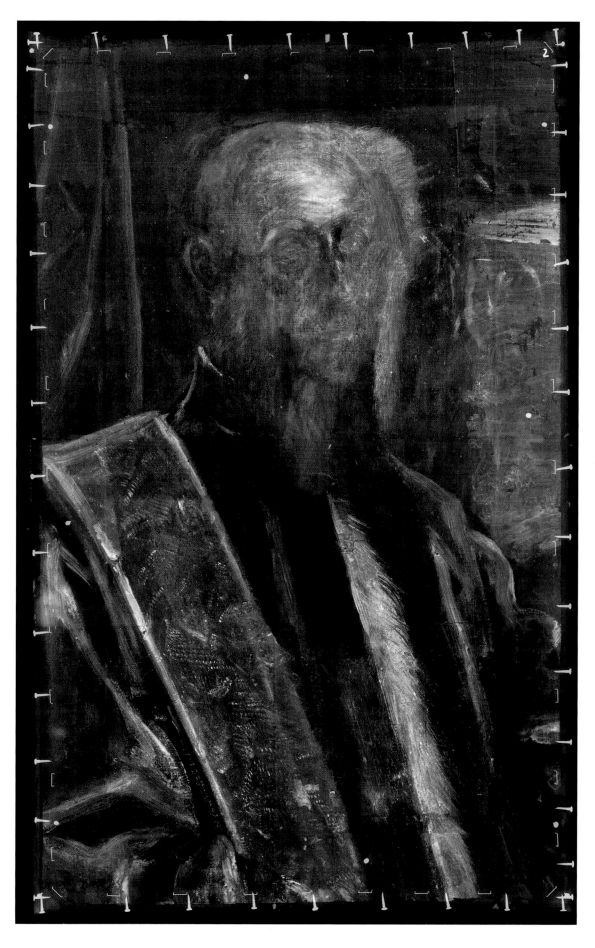

Fig. 2 Wall tomb of Vincenzo Morosini. Venice, Church of S. Giorgio Maggiore, Morosini Chapel.

OPPOSITE:
Fig. 3 Domenico Tintoretto and Workshop, *Saint Andrew with the Morosini Family and the Risen Christ*, *c.*1558. Oil on canvas.
Venice, Church of S. Giorgio Maggiore, Morosini Chapel.

the National Gallery's painting must have been the model for both these portraits.

The chapel in S. Giorgio, which is on the east wall of the north transept, has been studied by Tracy Elizabeth Cooper.[16] Rights to it were granted to Vincenzo on 7 September 1583, a year after the death of his younger son Andrea (born 1557). He was granted the contiguous burial vault on 7 November

with the condition (typical of this period of reform) that no family *stemma* or other claim to ownership be placed upon the vault cover.[17] The chapel had been dedicated to San Pantaleone but was now changed to Saint Andrew, name saint of the deceased son. An endowment for masses for Andrea's soul was also paid for by Vincenzo, and he agreed to furnish the chapel within a space of three years.[18] The altarpiece

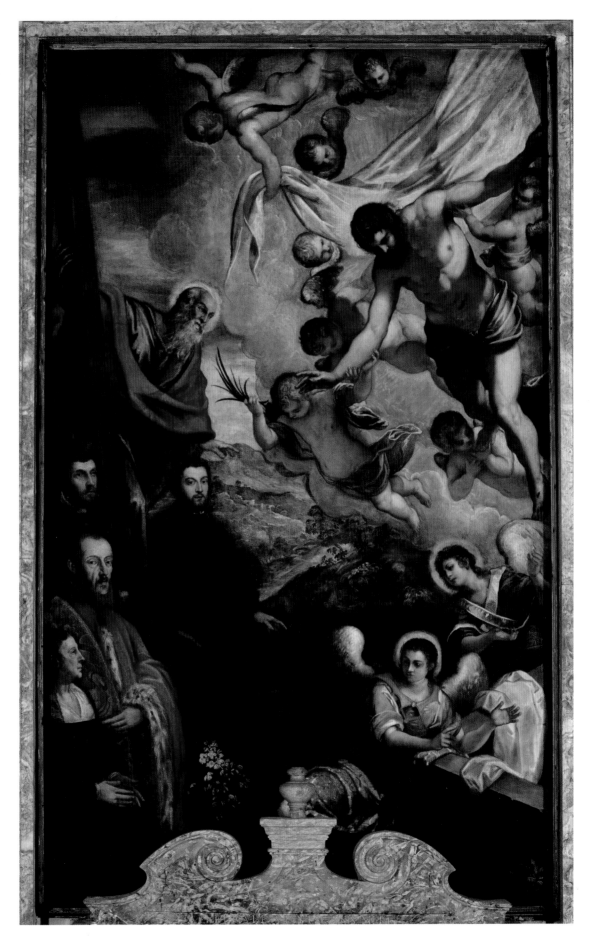

– according to Stringa the work of Jacopo Tintoretto, completed by his son Domenico – was said not to have been finished when Vincenzo composed his will on 22 April 1587. However, it would seem to have been completed by March 1588 because it is not mentioned in a codicil of that date itemising the work that remained to be done in the chapel.[19]

On the right-hand side of the altarpiece, Christ rises to heaven with angels supporting his arms while other angels, below, point towards the empty tomb. To the left is Vincenzo in a scarlet gown lined with lynx and with a stole over his right shoulder, and his wife, apparently kneeling, wearing black and with a black veil in profile against the gold of the stole. She must be his second wife, Cecilia Pisani (widow of Almoro Barbaro), whom he married in 1542 and who may have died in the late 1550s (she made a will in 1558[20]). Behind Vincenzo are his two sons by Cecilia and above them is Saint Andrew, holding his cross.

The composition on the left is clumsy and additive, and on close scrutiny the whole figure of Cecilia turns out to be an addition – painted on a separate piece of canvas which has been sewn in.[21] This may have been done at a later date because her hands and the fingers of her husband on the same portion of canvas are more poorly drawn than any other parts of the painting. The join corresponds with the edge of Vincenzo's stole, which was therefore possibly added to the composition at the same time (but more probably it had been there before, arranged in a less convenient form). If Andrea is the son immediately behind Vincenzo, then it is noteworthy that both he and his mother gaze at the Risen Christ, while the living brother and their father look out at us.

A marble bust of Vincenzo signed A.V.F. (for Alessandro Vittoria Fecit) is displayed on the wall to the left of his altarpiece (fig. 2). It must be the bust recorded in Vittoria's account book as paid for on 26 February 1587 (modern 1588). The money was received by Vittoria's nephew Vigilio Rubini, who may also have been responsible for the carving.[22] The bust crowns a tabernacle of pink and yellow breccia (Verona) marble which frames a black marble epitaph with gilded inscription. There are white stucco child angels on scrolls to the left and right of the bust, and a stucco cherub in the centre below. In design this tabernacle seems to match the altarpiece frame, as Tracy Elizabeth Cooper has observed.[23] The black marble matches that of the square vault cover in the paving below. The inscription lists Vincenzo's offices and honours and then makes mention of Andrea, 'Filium Legum Doctorem' (abbreviated 'F.L.D.') – his son, a doctor of the law, who had died abroad – and the transport of his remains from Constantinople.[24]

The prominent reference to Andrea confirms that it was his loss that was the pretext for the creation of the chapel. The mediocrity of the altarpiece and the bust may make us doubt whether Vincenzo was much of an art lover. But he may in fact have had a special admiration for Tintoretto. In any case, Carlo Ridolfi, in his *Maraviglie* of 1648, noted among the pictures belonging to 'Signor Procurator Morosini' three paintings by Tintoretto: a Virgin and Child with 'molti fanti in cerchio à meza coscia', a Vulcan, 'tolta da un fabro

di naturale, dottissima', and 'una picciola historia di San Lorenzo sopra la graticola, di fierissima maniera' which had been rejected by the Bonomi family for their altar in S. Francesco della Vigna – an early case of an altarpiece adapted as a gallery painting.[25]

Vincenzo Morosini's Will and His Son Barbon
An extract, dated 25 March 1589, from Vincenzo's will (composed on 22 April 1587) is contained in the papers of the procurators of S. Marco.[26] It opens with an expression of dissatisfaction with the conduct of his son Barbon in dealing with the posthumous affairs of Andrea, his deceased son (Barbon's brother), and explains that it was to circumvent a similar neglect after his own death that he elected to make his fellow procurators his executors, bequeathing 200 ducats to be divided among them (doubtless a prudent incentive to vigilance), and charging them with responsibility for his numerous legacies and with the management of his mills, his houses and his farmland (186 fields) for a dozen years, and with ensuring that his son neither sold nor in any way disposed of property during the following twenty years – he was especially anxious that his villa at Polesine, La Barbona, built by Scamozzi, should remain in the family. Legacies to a value of 22,636 ducats are separately listed, including 133 for 'spese de finir la sepoltura' and 153 'alla capella di san Zorzi'. Money was also left for an altar in S. Zuane Novo.[27]

Despite his father's anxieties Barbon (1545–1620) seems to have been regarded as reputable enough to be elected a procurator 'de Supra' in 1615,[28] and it was presumably between that date and his death in 1620 that his own marble bust was added to one side of his father's epitaph, on a separate console of similar breccia. The plinth of the bust is inscribed: BARBONVS MAVROCENVS/ DIVI MAR. PROCVRATOR/ VINCENTII FILIVS. Matching it on the other side is a bust of his long-deceased uncle Domenico, Vincenzo's distinguished older brother: DOMI[NI]CVS MAVROCENVS/ EQVES: VINCENTII/ FRATER.

Monuments with three male effigies often of two but sometimes of three generations of the same family had recently become established in Venice. In this case Vincenzo, who was both procurator and knight, is flanked by a son who was also a procurator and a brother who was also a knight.

Vincenzo Morosini and the Doge's Palace
Following the great fire in the Doge's Palace in May 1574 Vincenzo Morosini and Pietro Foscari were elected 'provveditori' to superintend the reconstruction and redecoration, and their powers seem to have continued after the second fire at the end of 1577.[29] This explains why Morosini's portrait is prominently included (as Giovanna Sarti was the first to observe) in Jacopo Tintoretto's large ceiling canvas of *Doge Nicolò da Ponte kneeling before the Virgin*, made for the palace between 1579 and 1582. Sarti also noted that he occupies

Fig. 4 Palma Giovane, Detail from *Pasquale Cicogna visiting the Oratorio dei Crociferi*, 1586–7. Oil on canvas, 363 × 262 cm. Venice, Ospedaletto dei Crociferi.

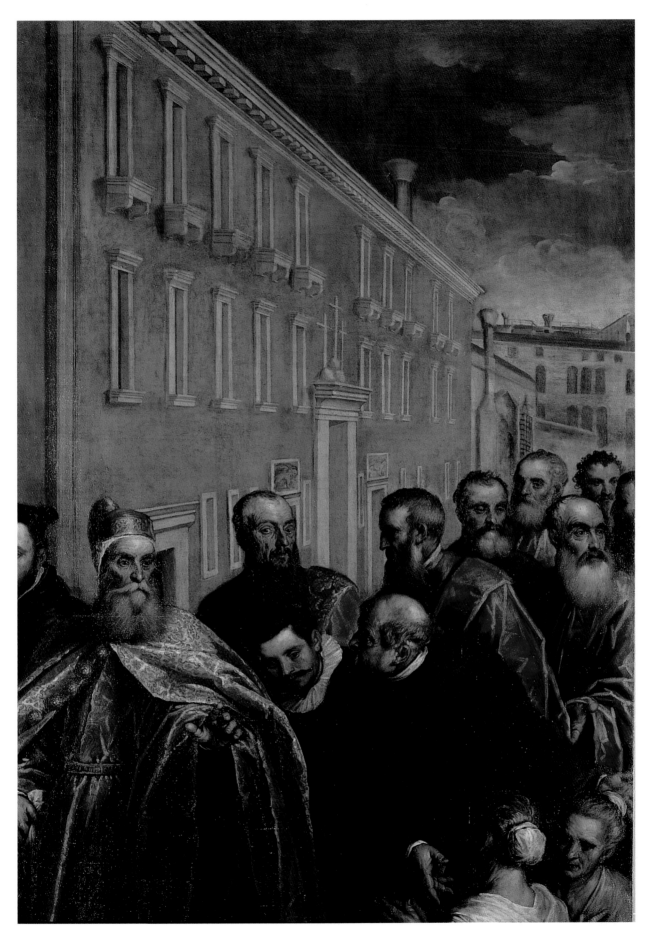

a prominent position behind Doge Ziani in Palma Giovane's painting of *Pope Alexander III and the Doge accepting the Peace Offering from Otto the Son of Federico Barbarossa* executed for the Sala del Maggior Consiglio in about 1584–5.[30] In addition, he is certainly present in the narrative painted only slightly later for the same room by Giulio del Moro of *Doge Ziani receiving Tribute*, again standing beside the doge. Sarti points out yet another painting in which Morosini's portrait is included: the canvas by Palma Giovane (now in the Gemäldegalerie, Dresden) depicting the arrival of King Henri III of France in Palazzo Foscari, this time an event which Vincenzo may well have witnessed, a narrative perhaps commissioned by Vincenzo's fellow 'provveditore' in the Doge's Palace, Pietro Foscari.[31]

Vincenzo Morosini and the Ospedaletto dei Crociferi

Among the responsibilities of the division of the procurators of S. Marco known as *de citra* was the administration of the Ospedaletto dei Crociferi, near the church of the Crociferi, founded by Doge Renier Zen in the mid-thirteenth century and converted in the fifteenth for the support of elderly women of moral probity and proven indigence. Priamo Balbi, a member of the Order of the Crociferi, who fought hard to extract from the procurators the support due to the Ospedaletto, was able to reconstruct the oratory and supervise its decoration with a cycle of canvases by Palma Giovane executed between 1585 and 1592. These remain *in situ* and have always been admired as among Palma's finest works.[32]

In the scene showing Doge Pasquale Cicogna and other dignitaries visiting the oratory on the Feast of the Assumption (fig. 4), a painting datable to 1586 and 1587, Vincenzo Morosini, here wearing his stole over his left shoulder, appears immediately behind the doge – one of the many fine portraits uncomfortably incorporated into the composition.[33] The prominence of the ruling doge in this cycle is due to his veneration for the church of the Crociferi (later converted to that of the Gesuiti and reconstructed in the eighteenth century), where he was worshipping when news of his election reached him, and the prominence of Morosini, as Jennifer Fletcher has pointed out, must be due to his vital support for Cicogna in the election – although it was also appropriate given his position as a procurator responsible for the foundation. It is obvious that Palma has copied Tintoretto's portrait of Morosini, and Jennifer Fletcher informs me that the Libro di Spese of the Ospedaletto includes payments for the carriage of portraits to the oratory so that Palma could refer to them.

Morosini appears again in the painting of an episode which is distant in time – the Doge and Dogaressa Zen with the foundation brief inscribed 'Initium dimidium facti'. In this painting, dated 1585, it was impossible for Palma to follow his model as closely because it would not have been appropriate for the figure being represented to look out at the beholder.[34] It is noteworthy that Morosini kneels beside the doge, whose gold brocade is matched by his stole, and that his hand is also placed on the paper. In fact in this slightly earlier painting Morosini is the most important figure. He

had probably played a key part in the deliberations which had made the new oratory possible and it was no doubt felt important to associate such a powerful figure firmly with the institution. He was in fact expected to be elected as doge in that very year and Cicogna's victory, which had not been expected, doubtless altered the plans for the paintings in this series.[35] Ridolfi identified this figure as 'Signor Borbone Moresino Procuratore di S. Marco', evidently confusing Vincenzo with his son.[36]

Previous Owners

The painting was said by Agnew's, the vendors, to have been acquired in 1922 from 'Count Contini of Via Nomentana in Rome'. The firm's stock books reveal that it arrived in London on 8 October 1923 and was sold on 14 October 1924.[37] 'Count Contini' was Alessandro Contini (1878–1955), one of the leading art dealers of the twentieth century (the title of *conte*, from his maternal ancestry, was formally permitted in 1928 and he added his mother's name, Bonacossi, in 1930).[38]

Contini sold little to British collectors or institutions but was the exclusive supplier between 1927 and 1936 of the great American collector Samuel Kress. He supplied other American millionaires and helped form a number of modern Italian collections. The only other painting in the National Gallery known to have passed through his hands is Cavallino's *Christ driving the Traders from the Temple* (NG 4778), acquired in 1935. The fact that the Tintoretto was imported from Rome does not necessarily mean that its previous history was exclusively in Italy.

Acquisition

D.S. MacColl in a footnote to his article in *The Burlington Magazine* 'put it on record that the suggestion of this acquisition by the National Art Collections Fund originated with Mr Roger Fry'.[39] Although the Trustees of the National Gallery were expecting to make a contribution to the cost of the picture, the chairman of the executive committee of the National Art Collections Fund, Sir Robert Witt, informed Holmes on 3 November 1924 that the committee had decided to pay the whole amount (£5,700), due when public contributors had been taken into account: 'in arriving at this decision they have had before them the fact that the picture is in their view a masterpiece and equal to the highest standards of the Gallery, and that as such it is worthy to represent this Society as a Commemoration Gift in a year which is both the centenary of the National Gallery and the Coming-of-Age year of this Society.'[40]

Provenance

See above. We may deduce that the painting was in north Italy in the 1830s because it seems to have been known to Francesco Hayez, who adopted Morosini's features for the senior inquisitor in his painting *Valenza Gradenigo al cospetto dell'Inquisitore suo padre* of 1832.[41]

Exhibition

London 1945–6, NACF (2).

Frame

The painting is in a carved Italian frame of reverse section dating probably from the first half of the seventeenth century but perhaps from the late sixteenth. It has been reduced to fit the painting. The original gilding is covered by layers of oil gilding and bronze paint which make the carving seem coarser in execution and less clear in design. It is not at first easy to make out the radial gadroons in the front moulding or on the overlapping rosettes in the broader hollow. There is a frame of somewhat similar character on Titian's *Entombment* in the Louvre.[42]

NOTES

1. Plesters 1980, pp. 41–5. This account differs from hers in some particulars, samples having been recently analysed by Marika Spring using EDX.

2. For example Rossi 1974, p. 111, fig. 29 (ex. Holford), and p. 123, fig. 57 (Warsaw), although the latter looks as if it has been cut down.

3. Rossi 1974, fig. 153 and p. 121.

4. As in the *Alvise Cornaro* in Palazzo Pitti, Florence, presumably painted before the sitter's death in 1566, and the great portrait of *Doge Pietro Loredan* in the Fine Arts Museum, Budapest, of 1566–70; Rossi 1973, p. 106, fig. 108, and p. 101, fig. 133.

5. Rossi 1974, p. 98, fig. 176, pl. XV.

6. Ibid., p. 130, fig. 181, pl. XVI, and p. 125, fig. 166.

7. MacColl 1924, XLIV, pp. 266–71.

8. Paoletti 1840, IV, pp. 40–1.

9. Most of what follows depends upon Cicogna 1824–53, IV, 1834, pp. 457–60. See pp. 460–1 for Barbone.

10. For procurators in general see Paoletti 1840, IV, pp. 30–3.

11. For the biography of Domenico and Vincenzo see Cicogna as cited in note 9. For Pasquale Cicogna see Baiocchi 1981, pp. 403–6.

12. See Rossi in Bettagno 1997, no. 24, pp. 338–40.

13. Paoletti 1840, IV, pp. 34–5, 84; Tentori 1785, II, p. 363; IV, p. 35. See also Penny 2004, p. 44. There is a series of full-length portraits of members of the Morosini family wearing the Stola d'Oro in the Museo Correr (nos 1315, 1373, 1374, 1385, 1386).

14. Nicolò and Leonardo Mocenigo in the family portraits in the frieze of Palazzo Mocenigo wear the stole on their right shoulder.

15. Sansovino 1604, p. 344b.

16. Cooper 1992, p. 294.

17. Mozzetti and Sarti 1997, p. 146 (text by Mozzetti).

18. Sansovino 1604, p. 167; Pallucchini and Rossi 1982, cat. 445, fig. 570.

19. Mozzetti and Sarti 1997, p. 146 (text by Mozzetti).

20. Cited by Cooper 1992, p. 301, n. 276. His first wife (married 1536) was the daughter of Agostino Venier.

21. Cooper 1992, p. 301, n. 276, thought that this was probably an addition.

22. Martin 1998, pp. 266–7, cat. 17.

23. Cooper 1992, p. 304, n. 284. The whole of this section is indebted to Cooper's work.

24. The inscription was perhaps first published by Coryat (1905, I, pp. 382–3). Cicogna 1824–53, IV, 1834, p. 350.

25. Ridolfi 1924, p. 52. The small *Saint Lawrence* has sometimes been identified with the painting in Christ Church, Oxford, which, however, does not look like an altarpiece. See the entry on Tintoretto's *Saint George* (pp. 142–53) for a discussion of small altarpieces.

26. ASV, *Procuratori di S. Marco*, Misti, bu. 101. A transcription by Carol Plazzotta is in the National Gallery's dossier.

27. For property in Polesine belonging to the Morosini see Gabbiani 2000, p. 344.

28. For Barbon, also known as Barbone, see Cicogna 1824–53, IV, 1834, pp. 458–9.

29. Mozzetti and Sarti 1997, p. 152 (text by Sarti).

30. Ibid., p. 154, fig.10.

31. Ibid., pp. 156–7.

32. Mason Rinaldi 1984, nos 519–27 a–b.

33. Ibid., no. 522, fig. 93.

34. Ibid., fig. 87 (plates VIII and X).

35. Di Monte 1997 discusses both the probable change of plan and the motives for including Morosini's and other portraits.

36. Ridolfi 1924, p. 180.

37. Microfiche in Getty Provenance Index consulted for me by Burton Fredericksen. The firm's stock number was 6195. Pittalunga (1925, p. 271) claims that the painting came from the 'Raccolta Wallace'.

38. See Anon. 1983.

39. MacColl 1924, p. 271, note 2.

40. The letter is in the dossier. 3 November is more probably the date of receipt than the date of dispatch, since it seems to be in Holmes's hand.

41. Accademia di Brera, inv. 182, on loan to Villa Carlotta, Lake Como. Repetitions of this painting were made in 1835, 1836 and 1845. See Mazzocca 1994, p. 224, no. 176.

42. See also Lodi 1996, nos 13 and 20, for richly carved frames of similar section believed to be from Piedmont and Ferrara.

Follower of Jacopo Tintoretto

NG 3647
The Nativity

*c.*1590
Oil on canvas, 95.3 × 118 cm

Support
The dimensions given above are those of the stretcher. The canvas is a medium-weight twill weave. There are cusped distortions on all four edges, which are especially obvious along the upper edge. Although no original tacking holes are apparent, there is an irregular unpainted border and thus the entire painted surface, which measures approximately 92.5 × 115 cm, survives. The canvas is glue-lined on to a fine tabby-weave canvas. The stained pine stretcher has crossbars.

Materials and Technique
No technical examination of this painting has been undertaken. Changes are visible in the painting of the straw beneath the infant Christ. His white cushion originally rested upon another, darker one with cross-lacing, which may still be seen below the straw. The arrangement of the posts at the entrance to the stable may also have been simplified. In these respects the original composition corresponds to another version of the painting which is presumably earlier (see below).

Fig. 1 Detail of NG 3647.

Conservation
The painting has received no treatment since it was acquired by the National Gallery in 1922, apart from the tightening of the canvas on 25 November 1946. It is likely to have been cleaned when it was last lined, perhaps in the 1880s.

Condition
Much of the original texture of the painting was lost during lining. The flattening of the surface is especially unfortunate in the head of the infant Christ, which is also speckled with brown where darkened varnish was driven into the canvas weave. The blue, probably azurite, used for the Virgin's cloak has darkened, and the green around Joseph's collar and in the landscape may also have done so. The lake used for the rose pink of the Virgin's cuffs has probably faded. This is also surely the case with the pink in her veil, perhaps originally combined with a green representing a luxurious *cangiante* silk. Some red lake in Joseph's purple-grey cloak may also have faded.

Subject
The painting was previously entitled 'The Holy Family', but the sleeping Christ is represented in his birthplace, the stable in Bethlehem, and both Mary and Joseph look down at him reverently, presumably kneeling (the crib would obstruct their knees if they were seated), as in paintings of the Nativity. Unusually, both are dressed with many layers of clothing, although the purple cloak worn by Joseph is conventional, as is the blue of the Virgin's robe. It is unusual for the Virgin's hood to be a separate garment rather than part of the mantle.[1] Her pleated white cap and the white chin cloth, with which it might be connected, recalling a nun's habit, are not easy to parallel in Venetian painting of this period.[2] The poverty of the setting is emphasised: rough thatch and rudimentary timber supports in the stable, and a ragged blanket with patches and holes covering the child, who is sleeping on a bed of straw contained by crude wickerwork. The strip of cloth with a tie cord hanging at the top right must be a swaddling cloth which is being dried. A large and a small dagger are contained in a single sheath at Joseph's waist – a very unusual attribute. The thin rod that he holds is more suggestive of the branch that miraculously blossomed to reveal him as the man chosen to marry the Virgin than of the stout staff that he carries as he walks beside the mounted Virgin on the way to Egypt.

Attribution and Date
When sold in 1858, exhibited in 1878 and again offered for sale in 1884, the painting was attributed to El Greco. Charles Holmes, who was director of the National Gallery when this painting was acquired in 1922, attributed it to Antonio del Castillo y Saavedra,[3] and this attribution was retained in the catalogue of 1929.[4] F. J. Sánchez Canton was perhaps the first scholar to question the idea that the painting was Spanish in origin.[5] Neil Maclaren excluded it from the catalogue of Spanish paintings in the Gallery which was published in 1952 and announced that it would probably be attributed

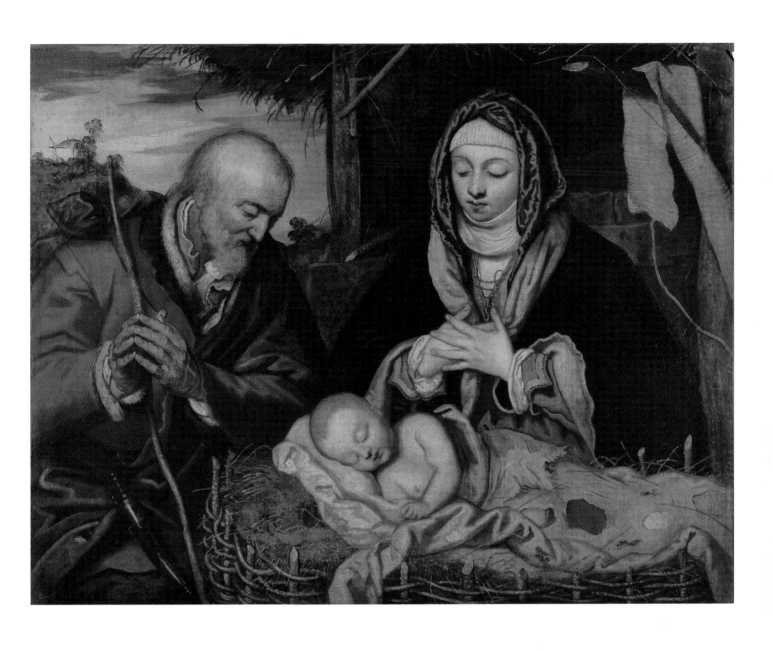

Fig. 2 Detail of NG 3647 showing Joseph's hands.

to Domenico Tintoretto in a future publication.[6] A draft catalogue entry, perhaps by Philip Pouncey, observes that the picture is 'obviously by the same hand as the *Magdalen* in the Capitoline Gallery, Rome, which is signed by Domenico Tintoretto' (fig. 4, p. 136).[7] Gould's correspondence, however, reveals that by 1957 he believed it was the work of a 'Dutch or Flemish artist working in Italy',[8] and a northern European origin was also strongly supported by Stella Mary Pearce (Newton) in her notes on the dress compiled in May 1958.[9] Pearce also favoured a mid-seventeenth-century date and, according to Michael Levey, it was on account of this dating that Gould excluded the painting from his catalogue of sixteenth-century Venetian paintings published in 1959. Levey in his catalogue of later Venetian paintings in 1971 described it as north Italian but not necessarily Venetian, although he felt that some passages were clearly indebted to Tintoretto.[10] Pallucchini and Rossi in their monograph of 1982 attributed NG 3647 to Domenico Tintoretto and dated it to the later 1580s.[11]

The treatment of the subject – the emphasis on straw, rush and wicker, for example – reflects the influence of Jacopo Tintoretto, as does the handling of the paint, not only the decisive brushstrokes which can be seen in the painting of the crib and the thatched roof but the superimposed loops of creamy paint which emphasise the looseness of the skin of Joseph's hands (fig. 2) and the vitality of the contours. On the other hand, despite the steep orthogonals of the stable (converging at the top right), there is nothing dynamic in the treatment of space such as is characteristic of Jacopo

Tintoretto and imitated by his son Domenico. The artist of the present painting was clearly impressed by the work of Jacopo Bassano, whence he has derived the facial type of the Virgin: the unbroken segmental line of the high eyebrows, the large lowered eyelids with the lashes hinted at by flicks of the brush in the shadow below (fig. 1), the exaggerated Cupid's bow of the upper lip and the repeated lines of light on the lower one. This combination of influences suggests that the painting was made in the last decade of the sixteenth century, although a later date is not impossible.

Versions
A variant of this painting (fig. 3), the property of Lt Colonel Cotterell, was sold at Sotheby's, London, on 27 November 1957 (lot 52, attributed to El Greco), and on 12 August 1958 it was described, in a letter to the National Gallery, by Henry T. Duckett, then residing in Venice at Palazzo Sagredo, Campo S. Sofia, as recently purchased by his wife.[12] It was published by Pallucchini in *Arte Veneta* for that year as by the young Jacopo Tintoretto,[13] but in his later monograph on Tintoretto, written with Rossi, it was attributed to Domenico Tintoretto.[14] From photographs this painting seems to be by the same hand as the National Gallery's version, and since some details in it can be seen below the surface of NG 3647, the former version was probably completed first.

Another related painting was published by Hadeln in 1921 as a Jacopo Tintoretto when it was in the Goudstikker collection (fig. 4).[15] A photograph of this painting in the dossier for NG 3647 is annotated with a note that it was stolen

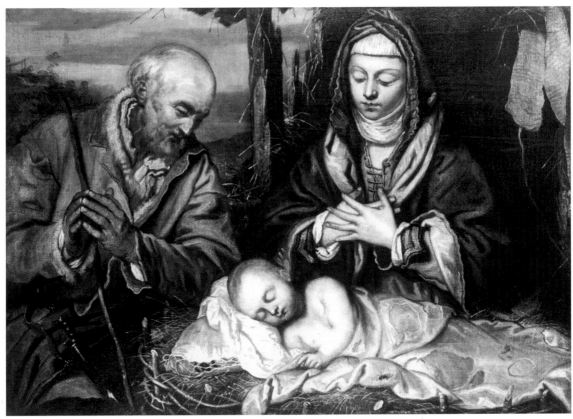

Fig. 3 Follower of Jacopo Tintoretto, *The Nativity*, *c.*1590. Oil on canvas, 85 × 116 cm. Private collection.

Fig. 4 Attributed to Jacopo Tintoretto, *The Nativity*, *c.*1585–95. Oil on canvas, 93.6 × 114.3 cm. Private collection.

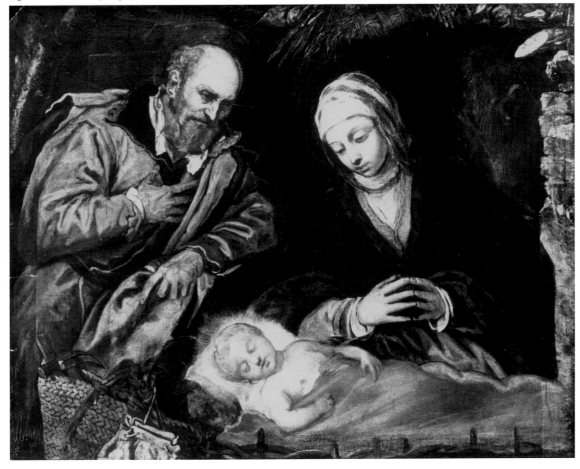

by the Nazis in Paris in 1941. It was last recorded in about 1970 in California.[16] Pallucchini accepted this as by the same artist as the Duckett painting mentioned above, that is, as painted by Jacopo Tintoretto, but later he preferred to attribute it to Domenico.[17] However, it does not appear to be a painting by the same hand. The Joseph is very different in physical type, the Virgin's hands are joined in prayer, Joseph points downward to his tools (absent from the other paintings), the clothes are more generalised, there is no suspended swaddling nor are there holes in the blanket. It is not clear whether this version was painted before or after the Duckett picture and NG 3647.

Drawing

Fröhlich-Bum proposed in 1923 that a drawing in the Albertina, Vienna, is preparatory for this composition, but the similarity is superficial and the connection has long been dismissed.[18]

Provenance

The painting was part of the stock of the prominent dealer Thomas Emmerson that was sold posthumously at Christie's, London, on 22 May 1856 (lot 198, attributed to El Greco), where bought for five guineas (£5 5s.) by 'Baldock'. It was no. 397 in an exhibition at William Cox's London gallery in 1878 and lot 278 in his sale at Christie's, London, on 9 February 1884 (attributed to El Greco), where it was bought in. It was presented in 1922 to the National Gallery by Sir Henry Howorth in memory of his wife, Lady Howorth, together with three other paintings, through the National Art Collections Fund, and was accepted by the Trustees on 13 June of that year.

Fig. 5 NG 3647 in its frame.

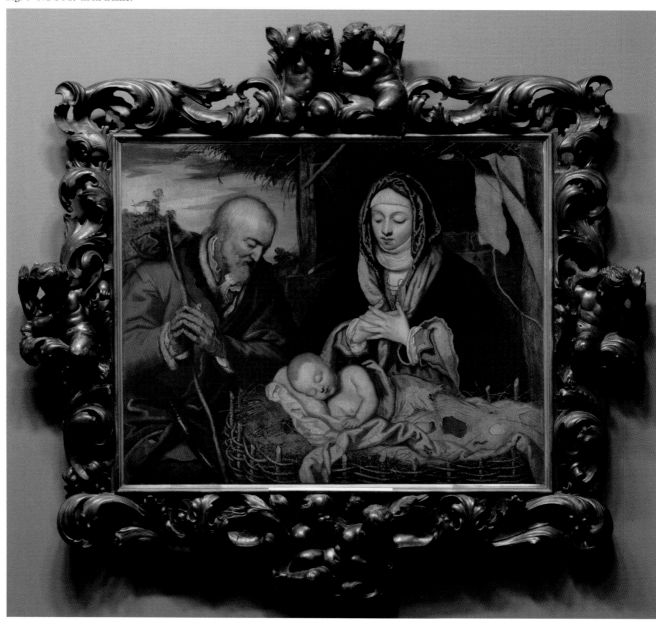

Frame

The painting was acquired in a frame (fig. 5) unlike any other in the National Gallery, and one which it would have been unlikely to retain had it been displayed in one of the main-floor galleries. It is of a baroque design, with large undercut and pierced foliate scrolls, a putto at the centre of both sides, and pairs of putti at the centre of the upper and lower sides. The wood, stained and polished, with a thin gilt border at the sight edge, is pine, probably arollo pine (*pinus cembra*), known as *cembro* in Italian and *cirmolo* in northern Italian dialect. This was the wood preferred by the Besarel firm, to which the frame may be attributed with some confidence. Holmes, who believed the painting to be Spanish, assumed that the frame was 'contemporary' and made of 'Spanish chestnut'.[19]

The Besarel firm traced its origins to 1767, by which time Valentino Panciera Besarel (1747–1811) was active in Susegana, near Belluno. He was carving chairs and bedheads and confessionals in the baroque taste as late as 1800.[20] His son Giovanni Panciera Besarel (1778–1842) was also a woodcarver, but of less repute. Giobatta (Giovanni Battista) Panciera Besarel (1801–1873), Giovanni's son, carved religious statuary in a neo-classical style modified by the ideals of *purismo* and generally painted white, but he also revived the style of his own grandfather and of the great Bellunese baroque sculptor Brustolon, whose work he restored and amplified, imitated and commemorated.[21] The baroque revival was to be a leading theme in the work of Giobatta's son Valentino Panciera Besarel the Younger (1829–1902), who worked in Belluno and, by 1873, in Venice with other members of his family including, eventually, his daughter Caterina (1867–1947). The prominent 'manufactory and depot of artistic furniture' opened in Palazzo Contarini-Duodo-Besarel on the Grand Canal at Traghetto S. Barnaba in 1883,[22] although Valentino's own activity must have been somewhat curtailed two years later after four fingers of his right hand were cut off by a new steam-powered saw.[23]

Valentino the Younger was by far the most famous member of the family. After establishing an international clientele, including a 'Signor Jennings' of London and Philadelphia, the Marquess of Bath and Count Guriev, he eventually enjoyed royal patronage (carving Queen Margherita's gondola and armchairs for the Quirinal Palace in the 1880s).[24] Rich foliate frames with putti were a speciality of his, as exemplified by his patriotic allegory 'unione fa la forza', consisting of a ring of fourteen happy infants, which won a prize in Florence in 1861, and his monument to Brustolon exhibited in Paris in 1878.[25] Details in the figure-carving in the frame of NG 3647 – notably the soft hair flowing across the heads in an S-curve and the narrow 'bracelets' of the flesh at the ankles – can be matched in signed and documented sculptures by him.[26] It must, however, be admitted that he had many imitators across northeast Italy.[27] The frame seems likely to have been acquired for the painting in the mid-1880s: as noted above, the painting was at auction in 1884 and probably changed hands soon after, in the very years when Besarel's business was obtaining new publicity in Venice.

NOTES

1. Transcript in the NG dossier signed by Stella Mary Pearce (Newton) May 1958.

2. Ibid., but Pearce cited Dutch paintings.

3. Holmes 1922, p. 82.

4. [Collins Baker] 1929, p. 59. Also in the *Illustrations of the Continental Schools*, published in 1937.

5. The dossier contains an undated note to this effect. It is mentioned by Levey 1971, p. 242, note 3.

6. Maclaren 1952, p. 91 (Pallucchini and Rossi 1982, I, p. 255, wrongly claim that Maclaren considered it Spanish).

7. Corrected typescript in the dossier.

8. Reply dated 23 October 1957 from H. Gerson to Gould, disagreeing with this theory. See also carbon of letter dated 18 August 1958, replying to Duckett: 'Domenico Tintoretto was, indeed, suggested; but wrongly. I do not think the pictures are Italian at all.'

9. Cited in note 1 above.

10. Levey 1971, p. 242.

11. Pallucchini and Rossi 1982, I, p. 255.

12. Duckett to 'The Secretary' of the National Gallery, 12 August 1958, in the dossier.

13. Pallucchini 1958.

14. Pallucchini and Rossi 1982, I, p. 255, A116.

15. Hadeln 1921. Jacques Goudstikker (1897–1940) was a Dutch art dealer whose paintings were confiscated by Hermann Goering.

16. Burton Fredericksen tells me it was lent to the J. Paul Getty Museum, then in Malibu, by Borwin 'Fred' Anthon, a restorer and dealer, acting on behalf of the owner.

17. Pallucchini 1958; Pallucchini and Rossi 1982, I, p. 239, A5.

18. Fröhlich-Bum 1923 (presumably with Hadeln 1921 in mind), followed by Stix 1925, but not by later scholars, for whom see Birke and Kertész 1997, IV, p. 2206, inv. 23162.

19. Boerio's dictionary of Venetian dialect translates *cirmolo* as *tiglio* (limewood) but other dictionaries make clear that it is *cembro* (pine). For Spanish chestnut see Holmes 1922, p. 82.

20. Angelini 2002, pp. 26–35.

21. Ibid., p. 41, fig. 33 (frame of 1863 for a portrait of Brustolon), p. 48, fig. 49 (baldacchino by Brustolon with additions by Giobatta).

22. His brother Francesco was his partner. For Venice see Angelini 2002, p. 100. For the Palazzo Contarini with its prominent notice on the façade in French and English see pp. 128–9, figs 182, 183.

23. For the accident see ibid., p. 267.

24. Ibid., pp. 155–6, figs 224–5, for royal commissions. For Guriev see pp. 258–9. For the Marquess of Bath he supplied a marble copy of a Cinquecento chimneypiece (p. 111, fig. 111). Unlike other members of his family, it seems, Valentino the Younger modelled in clay, and he presumably had his models carved in marble (busts are also recorded).

25. Angelini 2000, p. 74, fig. 101 (for Florentine prize), and see also p. 130, fig. 184; p. 121, fig. 173; also p. 191, fig. 279 (for Brustolon monument).

26. For example ibid., p. 141, fig. 203, and p. 144, fig. 207.

27. Some of these artists can be conveniently studied in the Museo Bottacin in Padua. Carving of this kind was especially popular in Trieste, where Bottacin lived.

Domenico Tintoretto?

NG 173
Portrait of a Gentleman

*c.*1590–1600
Oil on canvas, 119.5 × 98 cm

Support
The dimensions given above are those of the stretcher. The original tabby-weave canvas has been lined on to a slightly coarser tabby-weave canvas which is considerably wider and longer (extending beyond the rough edges of the original canvas by 6 cm at the lower edge and by 4 cm at the other three edges). There is another canvas of similar weave beneath the lining canvas. The pine stretcher has crossbars. Vestiges of Italian and French printed texts adhere to the lower edge at the lower left[1] – no doubt the paper used to protect the front surface when ironing the canvas during lining, probably in Italy, where much was printed in French as well as Italian. The number 136 is inscribed in black paint with a brush on the back of the second lining canvas.

Materials and Technique
No technical examination of this painting has been undertaken by the Gallery.

Conservation and Condition
The canvas has been torn in a stepped line that crosses the sitter's proper right wrist and lower left arm. There are repainted areas along the tear, in the shadows of the tablecloth and on the right edge of the picture. Some residue of old and darkened varnish has become embedded in the impasto, perhaps by pressure exerted during lining, so that both the flesh of the sitter and his white collar are speckled with brown. The darker paint has been greatly abraded and the ground is visible in the black coat and the nearer part of the landscape.

Although the picture is said to have been cleaned in 1879 and 1885, this was certainly superficial and much of the very yellow and opaque crackled varnish that now obscures the painting is likely to be the mastic varnish mixed with drying oil mentioned as having been applied to the painting in the Select Parliamentary Committee Report of 1853.[2]

Accessories
A few small vestiges of paint suggest that a coat of arms was once painted below the sitter's right wrist (not as something in the painting but as something attached to it). Infrared photography has revealed a pattern in the table carpet, painted in green on a ruddy-brown ground. The left hand probably held a glove folded flat, although only a few traces of this can now be detected. Two rings are worn on the little finger of the man's left hand, one with a table-cut red stone, the other with small red stones surrounding a pearl.

On the table there is a glass vase of ovoid form with a narrow neck and small foot (fig. 1). Between gold vertical bands a white reticulated pattern is apparent in the glass. There is a gilded collar (perhaps of gold or gilded metal rather than glass) to which two slender gilt ornaments are attached, curling in (rather than out, as would be expected for handles) and meeting the rim of the vase, from which projects a small sprig of green leaves (darkened, but perhaps always a dark green). The shape of the leaves suggests that this is juniper. The plant may have emblematic, heraldic or onomastic significance. The glass itself is an unusual accessory, perhaps indicating that the sitter had some connection with the Venetian glass industry.

The landscape seen through the window is indistinct but features a series of intersecting segmental lines at the edge of a field painted with the same brisk brushstrokes that define the lit edges of the buildings and trees.

Dress and Dating
The shape of the coat with its short bunched sleeve is hard to discern on account of the darkened varnish and abraded paint, and the coat and its fur lining are no longer distinguishable in texture from the sleeves of the lower arm. The cuffs are unusual, with fine translucent fabric appearing below the lace turned over the sleeve. The broad, loose, soft and unshapely white collar points to a date around 1590. A very similar one is worn by the young Baldassare Aloisi Galanino in the red chalk portrait drawing by his kinsman Annibale Carracci.[3] The boy was born on 12 October 1577 and was twelve years of age when this drawing was made, according to the inscription on the sheet itself – that is, in 1589 or 1590. Annibale himself wears a similar collar in the profile self portrait in Palazzo Pitti[4] and one is worn by the sculptor or collector (perhaps Bartolomeo della Nave) in the portrait by Palma Giovane in Birmingham Museum and Art Gallery,[5] which, however, is likely to be later in date than 1590, and in fact a somewhat similar collar is worn by Palma in a self-portrait drawing dated 1606.[6]

Attribution
The painting was acquired as a work by Jacopo Bassano, to whom it was consistently attributed in the Gallery's nineteenth-century catalogues. By 1929 the possibility of Francesco Bassano's authorship had been considered,[7] but this may have meant little more than a doubt as to whether the painting was worthy of Jacopo or the date possible for him. Richter recorded that Morelli thought the painting was by Domenico Tintoretto.[8] Fiocco is quoted by Arslan as thinking it might be by Beccarruzzi.[9] Gould excluded Beccarruzzi and Jacopo Bassano on account of the date indicated in the notes on the dress made by Stella Mary Pearce (Newton) and then, with the scrupulous and slightly ostentatious pessimism he had learned from Martin Davies, proposed that several of the Bassano (Francesco, Gerolamo and Leandro) were all 'possibilities' – or would be, were it possible to define their style as portraitists. He opted for the formula 'Venetian school'.[10]

Morelli was probably right. The alert eyes, set lips, and the high light source which casts a dark shadow below the nose, also the somewhat boneless hands and tapering fingers,

Fig. 1 Detail of the glass vase.

the high viewpoint adopted for the table top, the perfunctory painting of the window-opening and the rough, rapid delineation of landscape forms, are all typical of Domenico's portraiture (see fig. 3, p. 135).[11]

Provenance

Alleyne Fitzherbert, 1st (and last) Baron St Helens (1753–1839), from whom acquired by his nephew Henry Gally Knight, who presented it to the Gallery, together with NG 174, in 1839, the year of his uncle's death. The Trustees thanked him on 12 July 1839.[12] Knight (1786–1846) was an author and antiquarian whose 'Syrian', 'Grecian' and 'Arabian' tales and 'Oriental' verses enjoyed a modest success and whose later books (*The Buildings of Normandy* of 1831, *The Normans in Sicily* of 1838 and *The Ecclesiastical Architecture of Italy from Constantine to the 15th Century* of 1842–4) did much to broaden the architectural interests of his educated compatriots.[13] The painting was probably a bequest to Knight. If it was a gift made before his uncle died then he perhaps waited until he could dispose of it without offence.

Framing

According to Ridolfi it was Domenico's policy to embellish his portraits with 'attractive and magnificent borders',[14] very likely referring to the type of frame that is now known as a 'Sansovino frame'.[15] I know of no earlier published reference to an artist's preference for the framing of easel pictures. None of his portraits seems to retain its original frame. The frame on NG 173 was regilded on 30 November 1857 according to Wornum's diary.[16]

NOTES

1. One morsel reads ' ... No far ...', the other '... on Eveque; s'il ...'.

2. Select Parliamentary Committee on the National Gallery 1853, p. 747.

3. Berlin printroom. See Benati *et al.* 1999, pp. 76–7, no. 13 (entry by Catherine Loisel Legrand).

4. Posner 1971, II, p. 27, no. 62.

5. Mason Rinaldi 1977, pp. 96–9, where della Nave was first proposed; the case for this identification is further strengthened in Mason Rinaldi 1984, p. 76, no. 30, and 1990, p. 200, no. 86, although it is not completely certain.

6. Pierpont Morgan Library, IV.82.1. See Mason Rinaldi 1990, p. 212 (entry for the related painting in the Pinacoteca Querini Stampalia, Venice).

7. [Collins Baker] 1929, p. 11.

8. Note in the dossier.

9. Arslan 1931, p. 345; the attribution is not given in the equivalent place in Arslan 1960 (I, p. 349).

10. Gould 1959, pp. 131–2; 1975, pp. 306–7.

11. For the hands especially compare the portrait of a man, sold Phillips, London, 6 July 1999, lot 21.

12. NG 6/1, letterbook 1826–51.

13. See the entry by Warwick William Wroth ('W.W.') in the *Dictionary of National Biography*, XI, pp. 253–4.

14. Ridolfi 1984, p. 92.

15. For this type of frame see Penny 2004, pp. 179–80.

16. NG 32/67.

After Tintoretto

NG 2900
The Miracle of Saint Mark

Probably nineteenth century
Oil on paper stuck to canvas, 42 × 60.2 cm

Support

The dimensions given above are those of the stretcher. The painted surface of the paper measures approximately 40.7 × 59.2 cm. There are small losses at all four corners of the paper but the hole from the pin used to fix it to a rigid support is still visible in the top right corner. The surface of the paper has been prepared with a thin coating of chalk and glue.[1]

Materials and Technique

Analysis has revealed 'Prussian blue', vermilion of the 'wet-precipitated' type, madder lake and Naples yellow. Prussian blue was first introduced in the early eighteenth century.[2] Vermilion of this type was not known in the sixteenth century.[3] The use of these pigments suggests a date after about 1720. Bitumen may also have been used, and if so that would point to a date in the second half of the eighteenth century or the first half of the nineteenth when it was most in favour, although it was in fact used in earlier centuries.[4]

The painting was examined through the back of the paper before it was pasted on to a new canvas in 1988. Preliminary drawing with a brush and (probably) black ink was very apparent. Some of the large masses of shadow were blocked in as solid black at this stage, and other elements, such as the background architecture and the throned figure on the right, were rendered in simplified outline. The painting seems to have been executed 'directly, in a single layer'.[5]

Conservation

In 1988 the paper was removed from the canvas support to which it was glued. It was then pasted on to a fine linen support which was given a new stretcher. The painting has not been cleaned since it was acquired in 1913, and perhaps has never been cleaned at all.

Condition

The painting is disfigured by drying cracks, patterned like alligator skin, in several areas: in the top right corner and in the shadowy areas lower down, in Saint Mark's yellow cloak, and in the cloak worn by the figure in the lower left corner. This could be due to the use of bitumen in these areas. Smaller cracks elsewhere are probably due to the use of an excessively oil-rich paint. The varnish has darkened.

Subject, Status and Date

The painting is a copy – or just possibly a copy of a copy – of a canvas painting by Jacopo Tintoretto (fig. 1), nearly ten times as large (415 × 541 cm), made in 1547 or 1548 for the Scuola di San Marco in Venice and illustrating how the servant of a knight of Provence, who had disobeyed his master's command that he was not to venerate the relics of Saint Mark, was ordered to be stretched on the rack and have his legs broken, but was saved from his torturers by the miraculous intervention of the saint himself.

Tintoretto's painting was always regarded as one of his greatest achievements and as one of the most celebrated works on public view in Venice.[6] In 1797 it was removed from the premises of the Scuola to Paris by the French and hung prominently in the Museé Central (later the Musée Napoléon) until 1815, when it was returned to Venice and displayed, opposite Titian's *Assunta* and in the company of other masterpieces, in the Sala del Capitolo, the great hall of the Accademia Galleries (now the first room entered there on the first floor, formerly the main meeting room of the Scuola della Carità).

For technical reasons (given above under Materials and Technique), NG 2900 cannot have been painted earlier than the eighteenth century, but a later date is more likely. Several British painters travelling to the Continent after Waterloo were interested in Tintoretto's work. George Henry Harlow, a brilliant pupil of Lawrence, made 'studies' – probably painted sketches – after Tintoretto, some of which were included in the memorial exhibition held at 87 Pall Mall, London, after his death, aged 32, in 1819.[7] Preliminary sketches that purported to be by Tintoretto were not uncommon in British collections and the London salerooms in the early decades of the nineteenth century and many of these may in fact have been reduced copies, some of them sketchily executed. Notable among these reduced copies was 'the Miracle of the Slave, the first sketch for the large picture in Venice' included in Alexander Day's sale on 21 June 1833.[8]

Still more notable was a copy just over three feet (one metre) high, recorded as the property of Miss Burdett Coutts in the Manuscript Register of desirable Italian paintings compiled by the National Gallery soon after Eastlake became director in 1855.[9] Its high reputation is suggested by the fact that it was included in the Art Treasures exhibition in Leeds in 1868 and in the Royal Academy exhibition in 1871.[10] The art critic for *The Academy* in 1871 doubted that it was the 'sketch' but considered that it was a 'small copy by the Master ... of the wonderful and overpowering picture in the Accademia'.[11] The compilers of the Register were perhaps of the same opinion, since it is entered there as 'sketch copy'. But it was clearly considered to be of high quality not only because it was entered in the Register but on account of the high price Miss Burdett Coutts had paid for it at the sale of Samuel Rogers (400 guineas). Its previous provenance, given in the Register as 'Matthew Pilkington, Carlton House [that is, the Prince of Wales], Tresham, Hoppner, William Young Ottley, Rogers', is also impressive.[12]

There is no evidence that NG 2900 was ever considered to be by Tintoretto, and the National Gallery's catalogue first entered it as 'perhaps by William Etty (in Venice 1832)'.[13] Since this was published soon after its bequest to the Gallery in 1913, it may record someone's recollection of the painting's origins, but perhaps it is merely the speculation of someone who knew that Etty had been a keen admirer of

Fig. 1 Jacopo Tintoretto, *Saint Mark rescuing a Slave*, 1548. Oil on canvas, 415 × 541 cm. Venice, Gallerie dell'Accademia.

Tintoretto. Etty was dubbed in Italy the 'English Tintoret', and his most ambitious composition, executed only as a sketch, was a homage to Tintoretto's dynamic narratives and dramatic lighting.[14] When he was in Venice – in the winter of 1822/3 rather than 1832 – Etty was attached to the Accademia and made there and elsewhere 'memorials' and 'studies', as he called his sketch copies, of Tintoretto's work, including certainly the *Miracle of Saint Mark*, which is indeed first on the list of paintings worthy of special attention that he drew up in one of his sketchbooks.[15]

However, in technique NG 2900 does not look much like the work of Etty, and it is perhaps more likely to be that of a talented amateur at a later date. James Duffield Harding (1798–1863), one of the most influential teachers of the period, who published several books on the 'principles and practice' of painting, held up Tintoretto's compositions for special admiration.[16] One of his pupils was John Ruskin, who forgot to acknowledge Harding's enthusiasm when he later wrote about Tintoretto in *Modern Painters* as if he were a completely neglected artist,[17] and Ruskin must also have inspired many amateurs to make studies of this kind, including,

perhaps, the first recorded owner of NG 2900, Blanche Lindsay, who is just possibly the author of this work.

Provenance
Bequeathed by Lady Lindsay 1913 (see above).

Exhibition
London 2003–4, Tate Britain, *Turner and Venice* (10, as 'attributed to William Etty').

Frame
The painting came to the National Gallery in a cassetta frame, now very damaged and in store with the number E 236 (fig. 2). The scrolling foliage and attenuated candelabra ornament in the flat is of composition and applied to a punched gold ground. This style of neo-Renaissance frame was favoured by Alfred Stevens for the interiors of Dorchester House in the 1860s.[18] It was in Dorchester House that Lady Lindsay met her future husband in 1863 and it is just possible that she herself painted NG 2900 on their honeymoon in 1864. It is worth mentioning that special attention was given to the

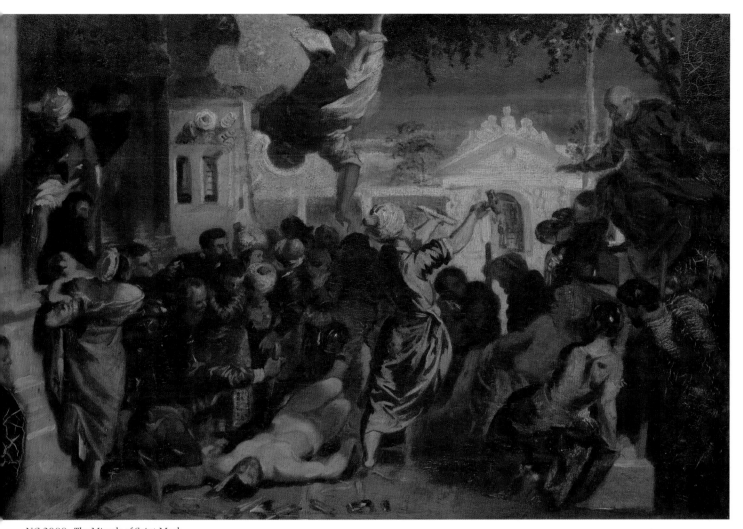

NG 2900 *The Miracle of Saint Mark*

Fig. 2 Corner of former frame of NG 2900.

framing of paintings at the Grosvenor Gallery, which Lady Lindsay helped to direct. She especially mentions the taste of Mr Williams of the firm of Foord and Dickinson and also the aesthetic advantage of glazing the paintings, a practice not allowed at the Royal Academy.[19]

Appendix

BLANCHE LINDSAY (LADY LINDSAY, *NÉE* CAROLINE BLANCHE ELIZABETH FITZROY), 1844–1912

The first recorded owner of NG 2900 was Blanche, the only daughter of the Hon. Henry Fitzroy MP (younger son of the 2nd Baron Southampton) and his wife, Hannah. Hannah was the eldest of the three daughters of the great financier Nathan Mayer Rothschild. She married against her family's wishes, abandoning their faith but retaining a considerable fortune.

Blanche's parents were devastated by the death in 1858 of Arthur, their only other child. Henry Fitzroy died in the following year. His wife then travelled restlessly about Europe but did not neglect to cultivate Blanche's many talents, in languages, literature, music and painting, which were an essential preparation for launching her in London society. This occurred in 1863 and in the following year Blanche fell in love with Sir Coutts Lindsay, a handsome but considerably older man, of notable charm and of an old family, if also with bohemian connections (and illegitimate children). They were speedily married.

Sir Coutts Lindsay (1824–1913) is the subject of a fine biography by Virginia Surtees, from which much of what is here recorded about Blanche is extracted.[20] He was not chosen by Blanche's mother, although she consented to the match. It had been encouraged, indeed probably engineered, by Coutts's sister May, who was married to Sir Robert Holford, in whose spectacular London *palazzo*, Dorchester House,[21] the couple were able to meet, and by Coutts's cousin's wife, Virginia, Countess Somers, a celebrated beauty, of whom

Coutts was certainly an intimate friend. Both women were aware of Coutts's financial needs and Virginia was anxious to see him provided with a domestic establishment from which she could not be easily excluded.

Coutts was a cosmopolitan figure, who had been brought up partly in Italy. In the 1840s he published an ambitious dramatic poem and also developed his talents as an artist. He participated in the enthusiasm for 'early Christian art' promoted by the art-historical studies of his second cousin and brother-in-law, Lord Lindsay (later Earl of Crawford), who believed that Coutts might become a modern Benozzo Gozzoli. He did not. But he studied painting seriously in Paris and exhibited with some success. He was at work on decorative murals in Dorchester House when he met Blanche in 1864. Reluctant acceptance of the limitations of his talent, or at least of the public recognition he was likely to receive, probably coincided with his marriage. Mortified when one of his works was rejected by the Royal Academy in 1872, he conceived the idea of establishing his own art gallery. The Grosvenor Gallery, the one great success of his life, which opened its doors in May 1877 at 135–7 New Bond Street, was thus partly born of his failure as an artist.[22] It also coincided with the failure of his marriage, although the couple may have hoped that it would bring them closer together.

Blanche was very active in planning the gallery. She and Coutts had been happy transforming and decorating Balcarres, his ancestral home in Fife, and their London house in Cromwell Place. Blanche's own ambitions as an artist and as a hostess were also significant. The success of the gallery depended upon the patronage of high society – Princess Louise exhibited her sculpture there and Blanche exhibited a portrait of the princess – but also upon the approval of leading painters who appreciated the ambience of a palatial town house (with cut flowers and Persian rugs) and the opportunity of avoiding the congestion that was typical of the Royal Academy's exhibitions.

In November 1882 Blanche separated from her husband, whose infidelity was by then notorious and who had given the name Lindsay to his illegitimate son. The Grosvenor Gallery remained successful for a while, but after the withdrawal of Blanche's support Coutts's financial affairs became increasingly precarious. Charles Hallé, the gallery's talented manager, and his assistant Joseph Comyns Carr left to found the New Gallery in 1888, and the Grosvenor Gallery closed two years later. Blanche was by then installed in 41 and 42 Hans Place, holding court among her tapestries, old embroideries and turquoise Sèvres, together with her yellow and green parrot and her dutiful daughter Helen. She remained friends with artists but had more to do now with her Rothschild relatives, including 'Mr Alfred' (for whom see pp. 472–5), and relied upon them to claw back her fortune from her husband. But the Church of England retained her allegiance and she found consolation reading the New Testament in Greek. Effie, the elder of her two daughters, was trained as a deaconess and married a vicar. The other, Helen, later went to China as a missionary.

Blanche turned increasingly to literature, publishing novels, children's stories (with her own illustrations) and books of verse, of which the most successful was *From a Venetian Balcony*, published in 1903. During her married life she had often visited Venice, staying in Palazzo Balbi.

NG 2900 could well have been painted by her there. Indeed, we know that it was on her first visit to Italy in 1864 that she started copying old master paintings, as well as buying old textiles. 'It was only when, almost immediately after my marriage, I went to Italy that I began to copy the Old Masters. I had seen but few such pictures. I am ashamed to say that, like many other Londoners, I had never visited the National Gallery.'[23] She was probably happiest working in watercolour (the eight works – portraits, interiors and flower pieces – by her that were included in the first Grosvenor Gallery exhibition were all in this medium) but she certainly also worked in oil.

Blanche died on 4 August 1912. Sir Coutts died less than a year later, not long after marrying his mistress. In accordance with her will, the paintings in Blanche's drawing room were offered to the National Gallery. We may suspect that Alfred de Rothschild, who was a Trustee, had encouraged this bequest, and, if so, it may explain why the director accepted so many mediocre works (the Bellini workshop picture, the fragment by a follower of Fra Angelico, the imitation Guardis, the replica Carmontelle) as well as the important Ghirlandaio predella panel and the fine Hendrik Frans van Lint.[24] On 18 December 1912 Blanche's tortoiseshell rococo fans, porcelain, old lace, tapestries and French furniture were sold at Christie's.[25] Of her own work as a painter nothing seems to remain – except, just possibly, NG 2900.

NOTES

1. Plesters 1984, p. 31.

2. Groen 1996, p. 791.

3. Plesters 1984, pp. 31–2.

4. White 1986, pp. 62–3.

5. Plesters 1984, p. 31.

6. Ridolfi 1642, p. 21; 1924, p. 22; Pallucchini and Rossi 1982, I, pp. 157–8, no. 13; II, pp. 368–70, figs 173–6.

7. Fredericksen and Armstrong 1996, I, pp. 72 and 821. See especially nos 20, 26, 37, 75 and 77. The exhibition (partly of works for sale) opened on 27 May; the closing date is not known.

8. Christie's, 21 June 1833, lot 12 (Lugt 13347).

9. Angela Burdett (1814–1906), youngest daughter of the political reformer Sir Francis Burdett, was adopted as heiress by the widow of her maternal grandfather, Thomas Coutts the banker. She was created Baroness Burdett Coutts in 1871 in recognition of her pre-eminence as a philanthropist.

10. The dimensions (37 × 52 in.) are given in the catalogue for the Royal Academy exhibition in 1871.

11. *The Academy*, 1 February 1871, p. 111 (signed 'W.B.S.'). The *Art Journal* (p. 49) had accepted it as an original sketch.

12. Pilkington was the compiler of a noted dictionary of artists, Henry Tresham was a painter and dealer, Hoppner a leading portrait painter, Ottley a great collector and connoisseur. Burton Fredericksen notes that the painting was lot 93 in the sale of pictures belonging to the Prince of Wales held at Christie's on 7 June 1806, where, however, it fetched a mere two guineas (bought by Tresham).

13. [Collins Baker] 1915, p. 304 (addition authorised by Holroyd).

14. *The Destroying Angel and Daemons of Evil*, Manchester Art Gallery, commenced 1822 and completed 1832, Farr 1958, p. 132, no. 10, pl. 44.

15. Gilchrist 1855, I, pp. 160–3; Farr 1958, pp. 38–9, 118–19 and 127. A study of the *Miracle of Saint Mark* measuring 21 by 30½ inches (53 × 72.5 cm) was lot 145 at Christie's, London, 12 March 1928, 'the property of the late E.W. Smithson', Etty's great-nephew.

16. It is clear that Harding was with Ruskin when Ruskin claimed that he discovered Tintoretto (see especially Ruskin 1977, pp. 210–12).

17. Ruskin 1903–12. See especially *Modern Painters*, II, published April 1846, section II, chapter III, and the Epilogue of 1883, para 13.

18. Penny 2004, p. 368.

19. Lindsay MS, unpaginated notes at the end of the book.

20. Surtees 1993.

21. For Holford and Dorchester House see Penny 2004, pp. 367–9.

22. For the Grosvenor Gallery see, in addition to Surtees 1993, Casteras and Denney 1996 and Newall 1995. It is noteworthy that Blanche herself (Lindsay MS, pp. 137–42) attributed the original idea for the Gallery to 'Old Pratt', who had an 'antiquarian shop' on the corner of Maddox Street.

23. Lindsay MS, p. 151.

24. For the Ghirlandaio (NG 2902) see Davies 1961, pp. 217–20. For the Van Lint (NG 2909) see Busiri Vici 1987, p. 128. It had previously been attributed to Gaspard Dughet, Salimbeni and Poelenburgh. The Carmontelle Mozart (NG 2911) was transferred to the British Museum in 1955. The other paintings listed are NG 2908 (follower of Fra Angelico), NG 2904 and 2905 (imitator of Guardi), NG 2901 (Bellini workshop).

25. Christie's, London, 18 December 1912. For the fans see lots 14–18; for the lace, lots 23–5; for the tapestry, lots 123–31; for the Sèvres, lots 67–77.

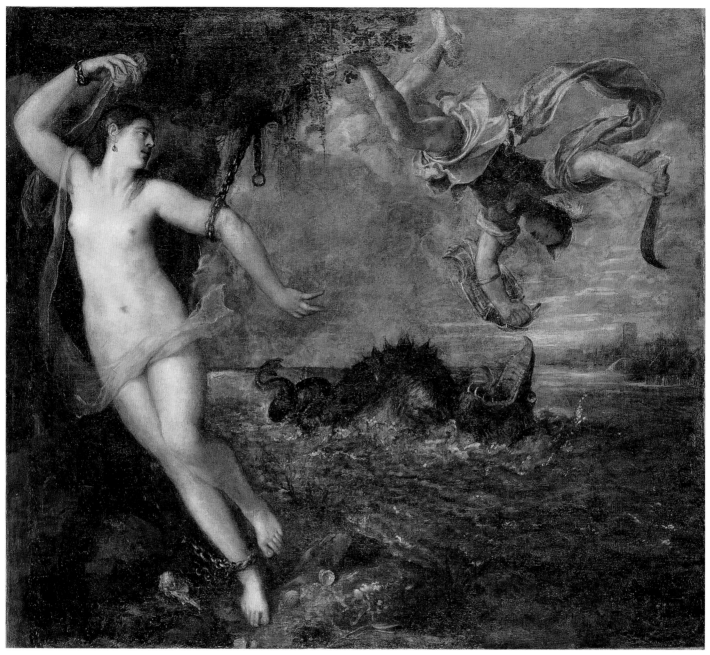

Fig. 1 Titian, *Perseus and Andromeda*, *c.*1553–62. Oil on canvas, relined, 175 × 189.5 cm. London, The Wallace Collection.

Titian

*c.*1490–1576

Tiziano Vecellio, who signed his paintings as 'Ticianus' and then, after the early 1530s, as 'Titianus', has been known in English since the early seventeenth century as Titian. He was born, probably in 1490 or a little earlier, in Pieve di Cadore, in the northern mountainous area of Venice's mainland provinces, to one of the principal local families, members of which held administrative positions. He was sent to Venice, where he studied with Gentile Bellini and then with his brother Giovanni, the leading painter in the city. By 1508 he was associated with the innovative young painter Giorgione and attracted notice with his painting in fresco on the façade of the newly rebuilt Fondaco dei Tedeschi (the German trading warehouse at Rialto). When Giorgione died in 1510 Titian completed at least one of his paintings and seems to have been regarded as his artistic successor.[1]

The National Gallery has several paintings that must be among Titian's earliest works. The *Holy Family with a Shepherd* (NG 4) is a devotional pastoral, more monumental than anything by Giorgione but similar to several of his paintings in its blending of figures with landscape.[2] The heads, as well as the infant, seem painted directly from models. The *Portrait of a Lady* (known as '*La Schiavona*', NG 5385) and the *Portrait of a Man with a Quilted Sleeve* (NG 1944) were also surely painted from life.[3] In addition to the harmony of colour and composition, and the air of self-possession this induces, Titian gave his portrait sitters an alert sensibility. Narrative is implicit in their expressions and attitudes, and Titian's celebrated *Tribute Money* (now in Dresden; fig. 2) represents a natural development of these portraits, in a similar format but another genre.

Soon after the death of Giovanni Bellini in 1516, Titian was granted a sinecure by the Republic. His artistic pre-eminence was, however, chiefly on exhibition in the city's churches. In the *Assunta* (*The Assumption and Coronation of the Virgin*), which he painted on panel probably between 1516 and 1518 for the high altar of the Frari, monumental figures are massed in collective movement, united with shadow, heroic gestures are given a silhouette of unprecedented boldness, and throngs of angels are melted into clouds irradiated by heavenly light. In the *Pala Pesaro* for the same church, executed on canvas between 1519 and 1526, he invented an entirely new type of asymmetrical composition for sacred figures and placed them on a stage defined by imposing, if irrational, classical architecture. Then, in the panel painting depicting the death of Saint Peter Martyr, made for SS. Giovanni e Paolo probably between 1526 and 1530 (destroyed by fire in 1867), he depicted wild scenery and figures engaged in ferocious action such as had never previously been seen in an altarpiece.[4] His *Noli me tangere* (NG 270) of a decade (or more) earlier was a quiet rehearsal for the way in which the landscape forms participate in the composition here, something found in many of his later paintings of both mythological and sacred subjects.[5]

While engaged with these great altarpieces, Titian was receiving increasingly prestigious commissions from the courts of northwest Italy – first from Ferrara, to which *Bacchus and Ariadne* (NG 35) was sent in 1523,[6] and then from Mantua and Urbino. During the 1540s both the Pope (Paul III Farnese) and the Holy Roman Emperor (Charles V Habsburg), and their families, sought Titian's services, especially as a portraitist. For this reason he travelled more in this decade than in any other – to Bologna in 1543, to Rome in 1545–6, to Augsburg in 1548 and again in 1550–1. Despite these travels, Titian completed a large religious narrative for the Venetian palace of a wealthy Flemish merchant (the *Ecce Homo*, fig. 4),[7] and commenced the largest of all his portrait groups, that of the *Vendramin Family* (pp. 206–35).

Titian also took a new interest in paintings with foreshortened figures during the 1540s (he must have been impressed by Giulio Romano's work in Mantua and he was

Fig. 2 Titian, *The Tribute Money*, 1516. Oil on panel, 75 × 56 cm. Dresden, Staatliche Kunstsammlungen, Gemäldegalerie Alte Meister.

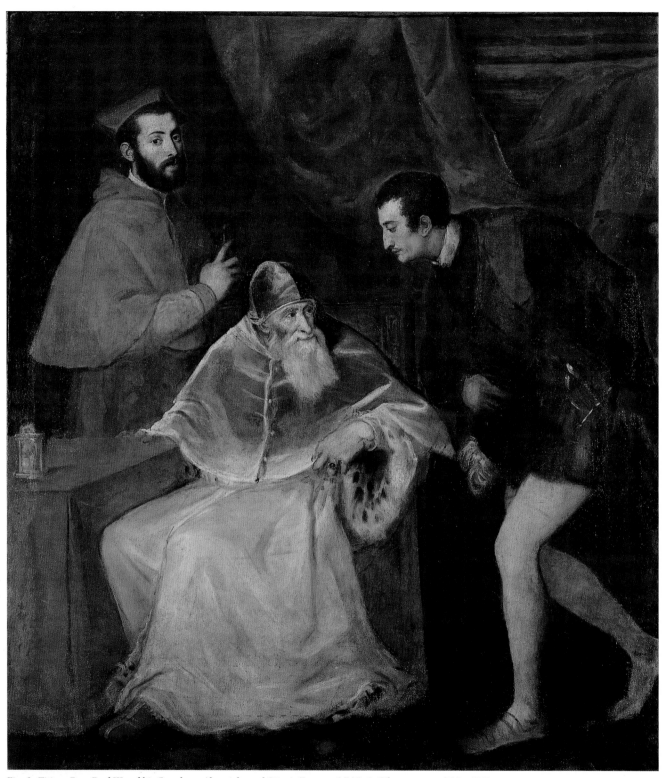

Fig. 3 Titian, *Pope Paul III and his Grandsons Alessandro and Ottavio Farnese*, 1545–6. Oil on canvas, 200 × 173 cm.
Naples, Museo Nazionale di Capodimonte.

certainly aware of the success of Pordenone's sensational fresco of a leaping horseman in Venice itself). He supplied ceiling paintings to S. Spirito in Isola (now in the church of the Salute), the Scuola di S. Giovanni Evangelista (now in the National Gallery of Art, Washington) and the *antisala* of the library of San Marco,[8] but only the last of these looks as if it is a wholly autograph work. His only notable later work of this kind, made for the Palazzo Municipale of Brescia, was in fact probably painted by his workshop.[9] Titian seems to have had little interest in decorative schemes, although he did make designs for mosaics and frescoes, and in any case few artists over sixty years old have much liking for scaffolds. After the 1520s Titian himself seems never to have painted in fresco.

Before 1550 the largest of Titian's paintings (including the *Assunta*) and many of those sent to other cities (notably major altarpieces made for Ancona, Brescia and Milan) were on panel. Wood was also employed as a support for some early furniture pictures and a few small devotional ones (including the Dresden *Tribute Money*). His later works, with the exception of a few that were painted on stone,[10] are almost all on canvas.

The urge to experiment with paint had certainly not diminished. A new interest in bravura handling emerges in some works of the 1540s. Occasionally his painting is as ostentatiously rapid and spontaneous as that of the young artists in Venice of whom he was keenly aware (notably Tintoretto and Schiavone) but after 1550 his paint surfaces, although rough, look like the product of much revision. They have an unprecedented variety of texture, and in them faces, hands, clothes, foliage, jewels and eyes are represented with a wide range of focus as if Titian were anticipating viewers both near and far.[11]

The style Titian adopted when he was about sixty was one to which he adhered for the remainder of his life. It is best exemplified by comparing the *Danaë* that he presented to Cardinal Alessandro Farnese in 1546 with the picture of the same subject presented to Philip II of Spain probably in 1550.[12] In the latter, light becomes an agent, dissolving as well as defining form and colours, and brushstrokes have assumed an independent life, distinguishable from their descriptive function. He began to paint on darker grounds, and his subjects were often dark too, including several nocturnes. He became the greatest painter of faces transfixed by terror, distorted by grief, lost in penitence, blazing with indignation. He also painted fewer portraits after the mid-1550s.[13]

When he was in Augsburg in 1551 Titian had made an agreement with Philip to supply him with paintings on a regular basis. In effect he became a court artist of an unprecedented type, serving the court of Madrid while remaining in Venice.

Fig. 4 Titian, *Christ presented to the People (Ecce Homo)*, 1543. Oil on canvas, 242 × 361 cm. Vienna, Kunsthistorisches Museum.

His great series of *poesie*, taken from Ovid, were sent, together with religious pictures, to Philip until, with the dispatch of the *Rape of Europa* (Boston, Isabella Stewart Gardner Museum) and *The Agony in the Garden* (Escorial) in 1562, his obligations were complete. He was now more than seventy years old. But he continued to work for the Spanish king.[14] The last painting he made for him was the *Saint Jerome in the Wilderness*, sent to Madrid in 1575,[15] a year before he died during the plague on 27 August 1576.

At an early stage in his career Titian made drawings for woodcuts, some of them of great ambition.[16] During the 1560s he collaborated with Cornelis Cort, and perhaps with other engravers, who reproduced his paintings, including works that he sent to Spain (such as the *Venus and Adonis*, the *Trinity* ('*Gloria*') and the *Tribute Money*, all discussed in this catalogue). The prints seldom reproduce the paintings in the form that we know them, suggesting that Titian continued to work on the paintings after they had served as models for the prints, or that the prints were made from later versions of the original painting, or that Titian, when making drawings for the engraver (or supervising those that were made), could not resist making changes.[17]

The nature of Titian's repetitions and variations is much debated but it is certain that he sometimes repeated finished compositions, not merely to satisfy demand but to create new inventions, as in the version of the *Danaë* presented to Philip, already mentioned, and the version of the *Martyrdom of Saint Lawrence* (completed in the late 1550s for a Venetian church), which he sent to Spain in 1567.[18] It is also obvious that his workshop made many repetitions in which he took little, if any, interest. The methods used for replicating his designs were perhaps not consistent, but tracings seem to have been used. There is no evidence that he made small painted studies or kept small painted records, although it has for centuries been assumed that he did so. It seems more likely that he kept full-size painted replicas as 'studio models', and probable that he made some of these himself, or at least prepared them as sketches.[19]

Titian's work after 1540 – and only paintings made after that date are included in this catalogue – is not as well represented in the National Gallery as are the paintings he made in the first two decades of his practice, although the collection includes, in the *Vendramin Family*, several of the greatest portraits he ever made. But the paintings catalogued here do illustrate some of the major problems in interpreting his work: the status of the paintings left in his studio at his death; the possibility that studio assistants took over work he had abandoned; the possibility of his involvement in works made largely by his studio; his return to the subject of an earlier painting. Elsewhere in the United Kingdom, however, are four of the masterpieces that he sent to Madrid: the two great *poesie* on loan to the National Gallery of Scotland (*Diana and Actaeon* and *Diana and Callisto*),[20] also the *Rape of Lucretia* in the Fitzwilliam Museum, Cambridge,[21] and the *Perseus and Andromeda* in the Wallace Collection (fig. 1).[22] Very few surviving drawings by Titian can be dated to the last decades of his life, but his drawings generally are very well represented in British collections.[23]

Titian has never ceased to be one of the three or four most admired and influential European artists; Rubens and Velázquez regarded themselves as in some sense his pupils. And so too (on an entirely different level) did Sir Charles Eastlake, first director of the National Gallery, and Charles Ricketts, author of the finest critical account of his paintings in English, published in 1910. By the latter date reverence for Titian had already begun to be distorted by attempts to detect in his paintings affinities with modern art and in particular to see him as a forerunner of Cézanne, several curious instances of which may be noted in the entries that follow.

Titian was the subject of two of the earliest English-language monographs devoted to old masters – those by Alexander Hume in 1829 and James Northcote in 1830 – but neither provides much additional information to that found in Vasari and Ridolfi. The two volumes of Crowe and Cavalcaselle's biography of 1877, on the other hand, supplied abundant new documentation and began to distinguish a core of autograph paintings. It remains an essential reference work, not entirely superseded by Harold Wethey's three-volume catalogue published in 1969, 1971 and 1975. Among the many twentieth-century Italian writers on Titian, Rodolfo Pallucchini, notably in his great monograph of 1969, has perhaps best understood his complex evolution as an artist. Charles Hope's *Titian* of 1980 is recommended not only for its new documents concerning the artist but for its fresh look at familiar ones, and for its questioning of received ideas and fashionable academic notions concerning Titian's artistic intentions and development.[24]

NOTES TO THE BIOGRAPHY

1. For a recent and full account of Titian's earliest work and its relationship to that of Giorgione, see Joannides 2001.

2. For this painting see Gould 1975, pp. 267–8, and Jaffé 2003, pp. 76–7, no. 2 (entry by Penny).

3. That other portraitists did not paint from the life is hard to prove except in the cases (Holbein's portrait drawings are the best-known ones) where drawings survive which are not only highly detailed but even include notes on colour.

4. For these three great altarpieces see Wethey 1969, pp. 74–6, no. 14; pp. 101–2, no. 55; pp. 153–5, no. 133.

5. For the *Noli me tangere* see Gould 1975, pp. 275–8, and Jaffé 2003, pp. 86–7, no. 7 (entry by Penny).

6. Gould 1975, pp. 268–71, and Jaffé 2003, p. 104, no. 13 (entry by Penny).

7. Wethey 1969, pp. 79–80, no. 21.

8. For the S. Spirito in Isola ceiling see Valcanover 1990, pp. 255–63, no. 38 (entry by Giovanna Nepi Scirè); for that for the Scuola of S. Giovanni Evangelista see ibid., pp. 272–9, no. 42 (entry by Robert Echols); and for that for the library see ibid., pp. 314–15, no. 54 (entry by Valcanover).

9. Wethey 1975, p. 225 and appendix pp. 251–5.

10. Wethey 1969, pp. 115–16, no. 77; the *Grieving Virgin* was sent to Spain in 1554 as a companion piece for the *Ecce Homo* sent there seven years before: both are on stone, the *Virgin* is said to be on marble and the *Ecce Homo* on slate or 'paragone'.

11. For Titian's technique see especially Dunkerton 2003; also Mancini 1999.

12. Falomir 2003, pp. 202–3, no. 27, and pp. 236–7, no. 39 (entries by Falomir).

13. The profile self portrait in the Prado seems to me to be Titian's only really great achievement in this genre during the last twenty years of his life; many would consider the portrait of Jacopo Strada of 1568 (Vienna, Kunsthistorisches Museum) as another.

14. For Titian's relations with the Spanish court see Hope 1988 and Mancini 1998.

15. Falomir 2003, pp. 286–7, no. 60 (entry by Falomir).

16. Rosand and Muraro 1976.

17. For Cort's eight engravings after Titian see Bury 2001, pp. 90–2 and 189–90. Mauroner (1943, pp. 27–8) proposed that Martino Rota also enjoyed a close professional connection with Titian, but if so it was of a different nature (Bury 2001, pp. 190–1).

18. Wethey 1969, pp. 139–40, no. 114 (Venice, Gesuiti) and pp. 140–1, no. 115 (Escorial).

19. The thinly painted version of his portrait of Francis I at Harewood House (fig. 6, p. 456) seems to me to be a small example of such a studio sketch replica. See Wethey 1971, p. 101, no. 36, plate 78.

20. Wethey 1975, pp. 138–41, nos 9 and 10; Brigstocke 1993, pp. 178–86.

21. Wethey 1975, pp. 180–1, no. 34, and Jaffé 2003, pp. 164–5, no. 36 (entry by Jaffé).

22. Wethey 1975, pp. 167–72, no. 36, and Ingamells 1985, pp. 349–60.

23. Wethey 1987; Chiari Moretto Weil 1989.

24. In addition to Hope 1980, see Hope 1980 ('Problems').

Titian and Workshop

NG 4452
The Vendramin Family
venerating a Relic of the True Cross

Begun *c*.1540–3, completed *c*.1550–60
Oil on canvas, 206.1 × 288.5 cm

Support

The measurements given above are those of the stretcher. The canvas is heavy, with a distinctive weave that is the subject of a separate section below. There are 17 threads to the centimetre in the weft and 22 in the warp. This canvas is wax-lined on to a tabby-weave canvas of medium weight. The pine stretcher (probably dating from 1928) has two vertical bars and one horizontal. It retains a paper label from the exhibition of Italian art at the Royal Academy that took place in 1930 (see below).

There is some evidence of possible cusping in the canvas at the side edges but not at the upper and the lower. All of the edges are ragged but they are effectively concealed by both putty and overpainting. Nevertheless, it is clear that on the left side a few areas of the original canvas and paint extend beyond the edges of the present stretcher, and it is likely that, for reasons discussed below (in the section on Attribution etc.), Titian may have originally planned a composition more than 30 cm longer on this side. The painting is also likely to have been trimmed along the lower edge, where the boy's feet were presumably not intended to be cut off. There is a band of brown paint between 1.9 and 3.8 cm wide along the upper edge of the canvas concealed with several layers of paint to match the adjacent sky. It is possible that this is the original border such as has been found on many other Italian paintings of the sixteenth century.

Materials and Technique

There are several notable pentimenti in the painting. The head of the youngest adult on the left was originally painted a couple of inches lower and considerably to the left, so that it was cut by the present edge. This original head may have begun to grin through the sky at an early stage because both early copies of the painting and the engraving of 1732 show cumulus clouds in this area which, presumably, were designed to conceal it. In addition, the legs of the middle-aged bearded man in profile were rapidly sketched with black painted lines to define his pose and action. The lines are now visible beneath his robe. Infrared photography (fig. 3) reveals similar drawing in the arms of this figure and those of the older man. (The diagonal lines, most apparent here at the top left and right corners, indicate retouchings made to conceal stretcher bars.)

During the course of execution changes were evidently made to the angle at which the top of the altar was painted. It seems probable that Titian knew he would be using the area in the lower right-hand corner for figures, since he left the step in reserve. Nevertheless, the drapery is modified at the point where it tumbles down behind the boy on the extreme right. This boy must have been painted after the boy beside him, not least because his hand was painted over the black of his brother's shoulder. The youngest boy with the spaniel must have been painted before the other two, but Titian may not originally have planned to put any figures in this position. Boldly painted shapes in the X-radiograph have not, however, been deciphered.

Samples taken from the painting have revealed a good deal about the preparation of the canvas and the pigments employed.[1] No overall *imprimitura* was detected and the ground appears to have been a simple one of gesso in animal glue.

The flesh colour is lead white and vermilion, with ochres and (possibly) brownish glazes in the shadows. The plum-coloured robe of the grey-bearded man consists of a glaze of natural ultramarine and red lake over an underlayer containing a substantial amount of vermilion. A sample taken from the shadowed area of the sleeve has revealed that there is also a thin scumble of black overpaint in places.

The crimson robe of the central of the three bearded men is a pure red lake mixed with white in the mid-tones and lights. The very dark tunic of the boy in profile, third from the left, has an upper layer of finely ground black pigment over a deep pink layer composed of red lake mixed with white, probably because it was painted over an adjacent cloak. The grey brocade worn by the boy on the extreme left contains some red lake to give the grey a slightly lilac cast. The sky is of natural ultramarine mixed with white.

The altar cloth, where lightest, consists of lead-tin yellow combined with white lead and a translucent copper green (probably verdigris); where darkest, it is similar but is covered by a rich green translucent glaze, probably verdigris that has dissolved in the old binding medium. A cross-section taken of the paint of the altar above the head of the boy holding the dog reveals a cream-coloured layer covered with a darker grey, below the top layer, confirming that changes were made here but not clarifying what they were.

A NOTE ON THE CANVAS TYPE

The canvas has a distinctive damask weave, also known as 'point twill' – 'a type of warp chevron twill based on a point threading with one or more warp points. It usually has a turnover in the weft as well as the warp direction.'[2] The diagonal pattern with crosses within the squares is one that can be found in linen tablecloths represented in European paintings between the fourteenth and seventeenth centuries, including Titian's own.[3]

There is no join in the canvas and it is clear that this type of linen, unlike others that were employed by artists in the sixteenth century, was available in widths considerably greater than a metre, something that was presumably advantageous (along with the ornamental texture) in the dressing of a table. The same canvas, or at least a very similar type, was employed by Titian for his portrait of Paul III Farnese with his grandsons (fig. 3, p. 202), now in the museum at Capodimonte in Naples,[4] which (as argued below) may be of approximately the same date. A related type of canvas was

used for the National Gallery's version of *Venus and Adonis* (NG 34).

The earliest uses of a canvas of this type that I have encountered (although I have not undertaken a systematic survey) are the portrait of Charles V by Parmigianino's workshop currently on the art market in New York and Correggio's *Leda* in the Staatliche Museen, Berlin, both of the early 1530s.[5] Most other examples known to me date from the last decades of that century – in paintings by Giovan Battista Tinti in Parma, Giuseppe Vermiglio and Ambrogio Figino in Milan, Giovan Battista Trotti in Pavia, Vincenzo and Bernardino Campi in Cremona, Giovanni Girolamo Muziano and Domenico Cresti ('il Passignano') in Rome.[6] Despite its use by Titian, however, this canvas type does not seem to have enjoyed special favour in Venice, although in Spain, where it was much used by El Greco (most notably for his *Burial of Count Orgaz*), it came to be known as a 'mantelillo Veneziano'.[7]

Conservation

The painting was, it seems, restored a little more than a century after it had been made. Payment of £2 is recorded for 'mending' the picture in 1651 (see below). In March 1682 (modern 1683) a larger payment was made to Parry Walton for 'lineing, primeing and mending' it. This may have been the first lining. Sir Joshua Reynolds, in a letter of 5 September 1786 to the Earl of Upper Ussory concerning the dispatch of one of the earl's paintings to the restorer Benjamin Vandergucht, noted that Titian's picture had been greatly damaged by cleaning and retouching (presumably undertaken relatively recently): since it had 'been cleaned and painted upon' Reynolds described it as 'hardly worth the name of a good copy'.[8] More than thirty years later, on 18 May 1818, this verdict was repeated (with hyperbole added to compensate for lack of genuine knowledge) by Benjamin West in a conversation with Joseph Farington during the time when the painting was on loan to the British Institution: 'He sd. that picture was totally ruined by a Frenchman who was employed to clean it. He painted over it & substituted His heavy colours for the charming tints of Titian. Nothing remains of the original but a candle stick & part of the upper corner of the right hand of the picture.'[9] In conversation with Samuel Rogers, West went further, to claim that only the flame of the candle remained of Titian's paint.[10] If it had indeed been 'painted over' it would, presumably, have been impossible for West to be so sure about how much had been lost. But Farington seems to have supposed that he spoke with authority.

Farington's diary for 1818 was published in James Greig's edition in November 1928, not long before the National Gallery began to negotiate for the purchase of the picture, and it was at the Gallery's instigation that Lionello Venturi wrote to *The Times* to refute rumours concerning the picture's disastrous condition[11] It was, in fact, at the Gallery's suggestion that the painting had been relined (with glue) by 'Morrill', and cleaned and restored by 'Dyer', in the Gallery's 'repairing studio' in the spring and summer of 1928. Although the Gallery would probably not have known of West's opinion then, they would have been familiar with Waagen's observations

in 1854[12] and those of Crowe and Cavalcaselle in 1879, to the effect that some areas were damaged.[13] Morrill's relining had involved the scraping off of a layer of dark paint on the back of the original canvas, thought perhaps to have been applied as a precaution against damp.

The painting was treated for blistering in 1939, 1945, 1947 and three times in 1960, chiefly in the robes of the older men, in the clothes of the boys on the right, and in the sky to the left. A report of May 1948, signed by Philip Hendy, recommended relining and cleaning, but another of 21 January 1952 did not consider action to be so urgent. In February 1961 the painting was relined with wax resin. It was cleaned and restored between October 1973 and February 1975.

Condition

The more thinly painted parts of the picture are worn, probably as a result of past lining and from cleaning presumably in the treatment of about 1770 or that of 1683 (or in both). The losses, generally small but numerous, can be seen in fig. 3. The salient points of the canvas weave are visible in parts of the sky and in other thinly painted areas such as the fur-lined sleeves. The orange tunic of the boy on the extreme right has suffered badly from flaking. There is a miniature crackle over all the dark areas of the plum robe of the eldest of the three men, and there are many losses in this area and much repainting beside his left sleeve. A patch of dark brown bubbles in the marble of the altar behind the boy with a spaniel may be a result of poor drying but also suggests singeing from an iron during lining. In the robe of the second eldest man (in profile) spots of darkened retouching are evident (easily confused with the artist's underdrawing, now visible because the red paint covering it has both increased in translucency and faded in colour). The drapery that hangs from the altar at the extreme right of the painting does not retain all of its rich, deep green glaze. The mauve stripe in this fabric may once have been richer in colour.

The best-preserved areas are for the most part those most solidly painted, notably the heads of the three adults and that of the boy with a spaniel. In some thickly painted areas of flesh, however, there are distracting wrinkles – notably in the face of the boy on the extreme left and in an area above the oldest man's left hand.

Attribution, Style, Setting, Dating

As is explained in the next section, the painting was described in 1569 – that is, within Titian's lifetime – as by his hand. In the early twentieth century there seems to have been an idea that the painting was by Tintoretto.[14] Since then, the attribution to Titian has never seriously been challenged and, although it was sometimes correctly observed in more recent times that the picture is not entirely Titian's work, Pallucchini and Wethey regarded it as wholly by him in their monographs and Gould did so too in his catalogue.[15]

PREVIOUS PAGES:
Figs 1 and 2 Details of NG 4452

Fig. 3 Infrared photograph mosaic of NG 4452 taken before cleaning, with cleaning tests visible as light patches, centre left.

Sir Abraham Hume included the painting in his monograph in 1829 as 'probably the first assemblage of portraits ever painted by Titian', but by 'first' he perhaps meant 'finest' rather than 'earliest'.[16] Scholars have generally favoured a date after 1550 for the painting. Crowe and Cavalcaselle placed it in about 1559, and Phillips, Ricketts and Benson concurred.[17] However, when the painting was identified by Georg Gronau as of the Vendramin family in 1925 an earlier date had to be considered.[18] In fact, all the best passages in the painting are consistent with Titian's work in the early 1540s. The mobile, rapidly painted features of the youngest boy and his spaniel are close in their handling to the child's face and her pet in Titian's portrait of Clarice Strozzi of 1542 (Berlin, Gemäldegalerie), while the bold modelling and penetrating look of the central bearded man are found also in the portrait of Pope Paul III without a cap, a documented work of 1543 (Naples, Capodimonte), and the dramatic device of figures raised on a marble platform but set against the sky is found in the altarpiece of S. Giovanni Elemosinario (Saint John the Almsgiver) made for the church of that dedication in Venice, an undated work but certainly painted before

December 1541 and probably before 1539. In addition, the idea of a dramatised family portrait of three men of different ages is reminiscent of the great unfinished painting of the three Farnese (Naples, Capodimonte) that Titian painted in 1546 (fig. 3, p. 202).[19]

The Vendramin Family must have been painted for a specific location. The lighting is from the right, which Titian generally avoided in portraits (for the obvious reason that it meant that his painting hand would cast a shadow over the very part of the painting that he was working on). The vanishing point is fairly low, and carefully calculated for the extreme left. The anticipated viewing position that this would imply is one that has the lower edge of the painting at approximately head height. This has surely determined the degree of finish. There is less broad and bravura handling than in the portrait of Doge Andrea Gritti (Washington, National Gallery of Art), which was surely intended to hang above a door or at a similar height, but if the head or hands of the oldest bearded man are compared with those in the portrait of Pope Paul III without his cap (as proposed above), it will be noted how many more descriptive details, such as

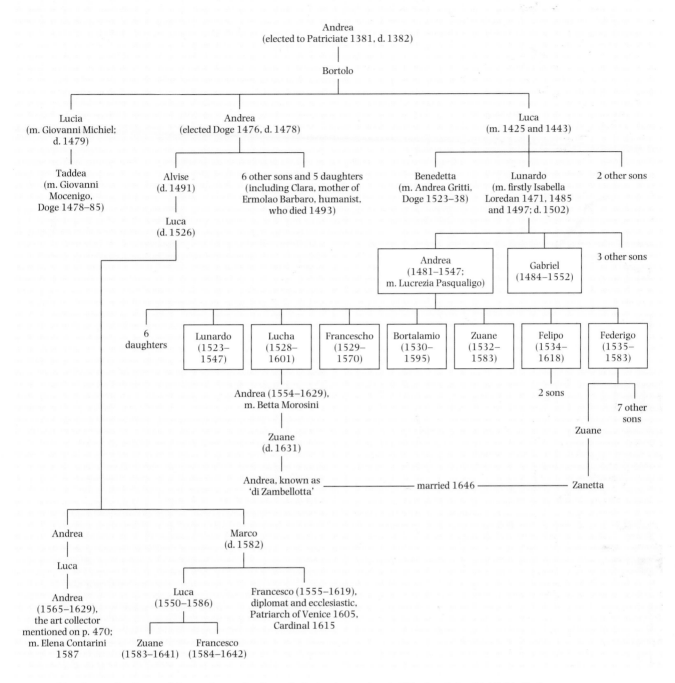

Andrea
(elected to Patriciate 1381, d. 1382)

Bortolo

Lucia
(m. Giovanni Michiel;
d. 1479)

Taddea
(m. Giovanni
Mocenigo,
Doge 1478–85)

Andrea
(elected Doge 1476, d. 1478)

Alvise
(d. 1491)

Luca
(d. 1526)

6 other sons and 5 daughters
(including Clara, mother of
Ermolao Barbaro, humanist,
who died 1493)

Luca
(m. 1425 and 1443)

Benedetta
(m. Andrea Gritti,
Doge 1523–38)

Lunardo
(m. firstly Isabella
Loredan 1471, 1485
and 1497; d. 1502)

2 other sons

Andrea
(1481–1547;
m. Lucrezia Pasqualigo)

Gabriel
(1484–1552)

3 other sons

6
daughters

Lunardo
(1523–
1547)

Lucha
(1528–
1601)

Franceschо
(1529–
1570)

Bortalamio
(1530–
1595)

Zuane
(1532–
1583)

Felipo
(1534–
1618)

Federigo
(1535–
1583)

Andrea (1554–1629),
m. Betta Morosini

Zuane
(d. 1631)

2 sons

7 other
sons

Zuane

Andrea, known as
'di Zambellotta' ————————— married 1646 ————————— Zanetta

Andrea

Luca

Andrea
(1565–1629),
the art collector
mentioned on p. 470;
m. Elena Contarini
1587

Marco
(d. 1582)

Luca
(1550–1586)

Francesco (1555–1619),
diplomat and ecclesiastic,
Patriarch of Venice 1605,
Cardinal 1615

Zuane
(1583–1641)

Francesco
(1584–1642)

Fig. 5 Highly selective family tree of the Vendramin family, with the family members in Titian's painting highlighted in boxes.
OPPOSITE: Fig. 4 Detail of NG 4452.

the finger ring or the hairy ears, there are to be seen in the papal portrait.

However, if the height and lighting were known in advance, it seems very likely that there was a change of mind concerning the width of the picture, for the profile of Lunardo (the adult on the far left) was (as noted above) originally painted slightly lower down and considerably to the left, and was cut by the present edge. If more space was originally planned at the left of the picture, that might explain why the three eldest boys appear to have been crushed into the space.

They also impede the movement of Lunardo and obscure the volume of his figure. The only other explanation would be that Titian did not originally intend to include any of the boys. The composition of the adults and the altar is assured and, having achieved this, Titian would not then have simply tried to squeeze in the lesser figures. The former explanation – that the boys had to be moved when there was a change of plan – is preferable because the boy holding a dog looks as if he was always planned and if one boy were included it would be odd for the others not to be. Against that, however, we can observe

that the boy with the dog may have been a brilliant improvisation which provoked the unfortunate idea of including all the other boys.

The painting of the adult heads and hands, the head of the youngest boy and his dog, and the better preserved passages in the clothing of these figures (especially the fur lining of the sleeves) are typical of Titian at his best. But the boys on the left are a problem not only in terms of composition: their heads are poorly related to their bodies, their features are uncertain in modelling and have none of the vitality we would expect. These parts must have been painted by an assistant, and the same is perhaps true of the last two boys on the right, although there Titian himself may have corrected the assistant's work. Perhaps only two boys were originally planned for the right part of the picture, a conclusion which is supported by the technical evidence (see above, in the section on materials and technique). In any case X-radiography reveals some major revisions in this area, and the present position of the drapery at the back of the altar looks like an improvisation.

It is of course most unlikely that Titian painted the portraits directly on to this canvas. Presumably he made separate studies from the life which he copied or at least consulted. If the children did not sit for him – and we have just observed that most of them were not painted by him – then this would have been known by the family. However, if Titian's other commissions or a change of plan caused a significant delay in completing the painting then the children would have been of the wrong age for the original conception by the time they were inserted, so sittings would not have been expected.

As will be discussed below (in the section on family members), the youngest child must be Federigo Vendramin. He does appear to have been painted by Titian from life and, if so, that would suggest a date of about 1541, since he cannot be much older than five and may even be younger. Lunardo, who must be the youngest adult in profile, was seventeen in that year and he looks like a mature teenager in the painting. He died on 5 October 1547, soon after his father, who died on 31 January 1546 (modern 1547), so their portraits would have been painted before then, unless they are posthumous, as has been suggested by one scholar.[20]

Since the picture seems to have been executed in at least two phases it is worth noting how busy Titian was in the 1540s. The visits he made to Rome in 1545 and to Augsburg in 1548 were at the behest of the pope and the emperor, whose wishes must have prevailed over a commitment to a Venetian patrician, even one who was, apparently, a close friend of the artist.

The workshop assistant who painted at least three of the boys may have been Titian's son, Orazio Vecellio. Orazio was born out of wedlock not long before 1525 and died in 1576. In 1545, when work on this painting had recently begun, Orazio accompanied Titian to Rome, and Vasari noted that he was active there – independently – as a portraitist.[21] In 1550–1 Orazio accompanied his father as an assistant on his visit to Augsburg. He certainly attempted some ambitious compositions – most notably the *Battle of Castel Sant'Angelo*, begun in 1562 and completed in 1564 for the Sala del Maggior Consiglio in the Doge's Palace (destroyed 1577)[22] – but it seems clear that his talent was limited and his role in the workshop came to be more managerial than creative.[23]

Another and perhaps better candidate is Girolamo Dente, called Girolamo di Tiziano, who was aged fifteen in 1525 when he served as a witness at Titian's marriage to Cecilia (Orazio's mother)[24] and who was probably active in Titian's workshop until the mid-1550s.[25] There is no known signed work by him but a painting of the four seasons (recorded in a private collection in Paris in 1934) is said to be inscribed as by him, and a group of other workshop paintings have been plausibly proposed, including the Detroit *Nymph and Satyr* and portraits in Kassel (Gemäldegalerie), Dortmund and Dresden. The faces in these works tend to present 'a certain flattened appearance, and display a kind of indifferent stupor', which is, as Fisher noted, characteristic of the three portraits discussed here.[26] Other examples of these flattened faces intruding into compositions by Titian are the National Gallery's *Allegory of Prudence* (see p. 237) and the *Judith with the Head of Holofernes* in the Detroit Institute of Art.[27]

The Family Members
The painting was described in March 1569 in Palazzo Vendramin (which still stands in the Campiello of Santa Fosca in Venice). It was 'un quadro grando nel qual li sono retrazo la crose miracolosa con messer Cabriel, Andrea Vendramin con sette fioli et messer Cabriel Vendramin, con suo adornamento d'oro fatto di man de messer Titian' ('a large painting in which is depicted the miraculous cross with messer Gabriel, Andrea Vendramin with his seven sons and messer Gabriel Vendramin together with its gold frame made by the hand of Titian').[28] This occurs in an inventory made for the members of the family who appear in the painting as children – a formal document but not one which was very carefully revised, as is clear from the repetition of 'Cabriel' in the description.

Andrea and Gabriel (often called Gabriele by modern scholars but always Cabriel or Gabriel in contemporary texts) were sons of Lunardo Vendramin and Isabella Loredan; their brothers Federico, Filippo and Luca had all died by 1532. They are first recorded as partners in September 1526.[29] The family tree (fig. 5) shows how well connected they were; their aunt was the wife of Doge Andrea Gritti, their great-aunt's daughter was the wife of Doge Giovanni Mocenigo and, above all, their great-uncle was Doge Andrea Vendramin, one of the richest men in Venice and thus in Europe.[30]

As was common among patrician Venetian families, the brothers shared the family palace and only one of them married. Both were respected figures in the Senate, Andrea being one of the electors of Doge Piero Lando in 1538 and Gabriel one of the electors of Doge Francesco Donà in 1545.[31] Andrea made his will on 20 January 1546 (modern 1547) 'in letto amalado ma sanno di mente memoria et intellecto' ('ill in bed but healthy in mind memory and intellect').[32] He died eleven days later.

The will testifies to his close relationship with his 'carissimo et honoradissimo' brother Gabriel, who had long lavished great love and expense on Andrea's children. He had never quarrelled with his brother and clearly looked up to him despite his younger age. Gabriel was named as the executor together with Andrea's wife, Lucrezia Pasqualigo (over whom Gabriel was to have the power of veto), and this was in accordance with an agreement made long before. He was given charge ('governo') of Andrea's youngest sons, but all the children were urged by their father to be 'obedientissimi et obsequentissimi' towards their 'Barba'.

Their sons were Lunardo (Leonardo, born 4 April 1523), Lucha (Luca, born 15 March 1528), Francescho (Francesco, born 29 April 1529), Bortalamio (Bartolommeo, born 10 August 1530), Zuane (Giovanni, born 11 March 1532), Felipo (Filippo, born 30 May 1534), and Federigo (Federico, born 26 December 1535).[33] The last three are not specified in the will, save as the 'other three'. There were also six daughters. Four of these – Isabella, Orsa, Marietta and Chiara – had married, but of these only Orsa and Marietta are mentioned as beneficiaries in the will (the other two had died).[34] Two other daughters, Biancha and Diana, are described in the will with brutal candour as 'donzelle pizocharette mal qualificatte dala natura' ('church mice ill favoured by nature'). The first should be kept at home, the second is urged to take the veil in the convent on Murano where she was already residing.

Doubtless because of his new responsibilities, Gabriel himself made a will soon afterwards, on 3 January 1547 (modern 1548).[35] He died on 15 March 1552. His will, a garrulous and eccentric document, is discussed in the second appendix to this entry. In it he appoints his nephews his heirs. Each is named repeatedly but the last three are distinguished as 'de minor età', and this division between them is reflected in the composition of Titian's painting.

It seems likely, from the appearance of the children, that the painting was commissioned and begun before Gabriel made his will and presumably before Andrea died, although the fact that Andrea is depicted as living is not conclusive evidence of this. Andrea was three years older than his brother, who was born in 1484.[36] It is therefore natural to suppose that he is the older man nearest the altar. Gabriel would then be the larger and most prominent figure leading his brother's children, his adopted children, in prayer. This is the interpretation given in the most thorough scholarly account of the picture by Rosella Lauber.[37] Possible objections to it are given in the first appendix below.

The Clothes

The three adults all wear the style of dress that distinguished Venetian patricians – a gown with wide sleeves (known as *ducale*), to which they were entitled from the age of fifteen. The oldest man in the painting wears a velvet gown of a deep violet purple known as *pavonazzo* (peacock) velvet, the man behind him wears crimson velvet, and the youngest crimson damask. The two velvet gowns are at least trimmed, and presumably fully lined, with fur, as was normal for much of the year. The fur must be that of the lynx.[38]

Stella Mary Pearce (Newton), in notes made for the Gallery, speculated that the oldest bearded man was wearing personal mourning.[39] The colour black was reserved for this purpose, although not exclusively, for it was also worn for Good Friday and sometimes as a vow. However, the colour has darkened considerably (see above) and is meant for *pavonazzo*, not black. This was the colour used for state mourning and during fasts and ember days, although not only on such occasions. There may well be a special explanation for the three different colours of robe, beyond the obvious one that the degree of sobriety corresponds to the age of the men, but the variety depicted would also have been familiar. Thus Sanuto in his diary for 8 September 1515, recording the procession of the procurators on the feast of the Madonna, recorded that Antonio Grimani wore 'veludo paonazo', Nicolò Michiel 'veludo cremeson', Tomà Mozenigo [Mocenigo] 'damaschin cremeson'.[40] A similar variety of gowns is found in other paintings of groups of patricians, for example the *Consegna dell'Anello* (fig. 1, p. 44) by Paris Bordone of the early 1530s,[41] where the *pavonazzo* has remained lighter and brighter, or, later in the century, Palma Giovane's painting of Doge Zen and other dignitaries, dated 1585, in the oratorio of the Ospedaletto dei Crociferi, where the *pavonazzo* worn by one of the senators to the left of the painting is almost as dark as it is in the Titian.[42]

Patricians also wore stoles over their shoulders. In exceptional cases (as in Tintoretto's portrait, p. 177) these were gold, but usually they were red or black, the red apparently sometimes worn as mourning. The oldest man has a red stole over his right arm, and the man behind him a black one over his left. It is curious that the stoles are carried in this way rather than over the shoulder. Perhaps this was intended as a mark of respect before the cross, equivalent to the removal of a cap, but it is noteworthy that in other paintings kneeling patricians are shown with the stoles over their shoulders.

The Relic of the True Cross, the Scuola di S. Giovanni Evangelista and the Rise of the Vendramin Family

As was first pointed out by Philip Pouncey in 1939, the cross in Titian's painting (see detail, fig. 6) is a gothic reliquary of silver gilt and rock crystal which was the greatest treasure of the Scuola di S. Giovanni Evangelista in Venice (fig. 7).[43] It would have been easy for Titian to sketch it because he was employed at much the same date to decorate a ceiling of the Scuola's *albergo*.[44]

Above the foot of the reliquary, which is not visible in the painting, there is a knob of eight small clustered tabernacles with crocketed gables. Rising from these is a four-sided tabernacle from either side of which spring vegetal branches supporting statuettes of the mourning Virgin and Saint John. Above the four-sided tabernacle there is a cross composed of five pieces of rock crystal, the arms lobed in outline and framed with intricately foliated metal from which delicate tendrils curl out to support half-length figures of prophets. Attached to the front of this cross and rising from the apex of the spire of the four-sided tabernacle is a crucifix. The crystal cross is crowned by a separate gabled compartment

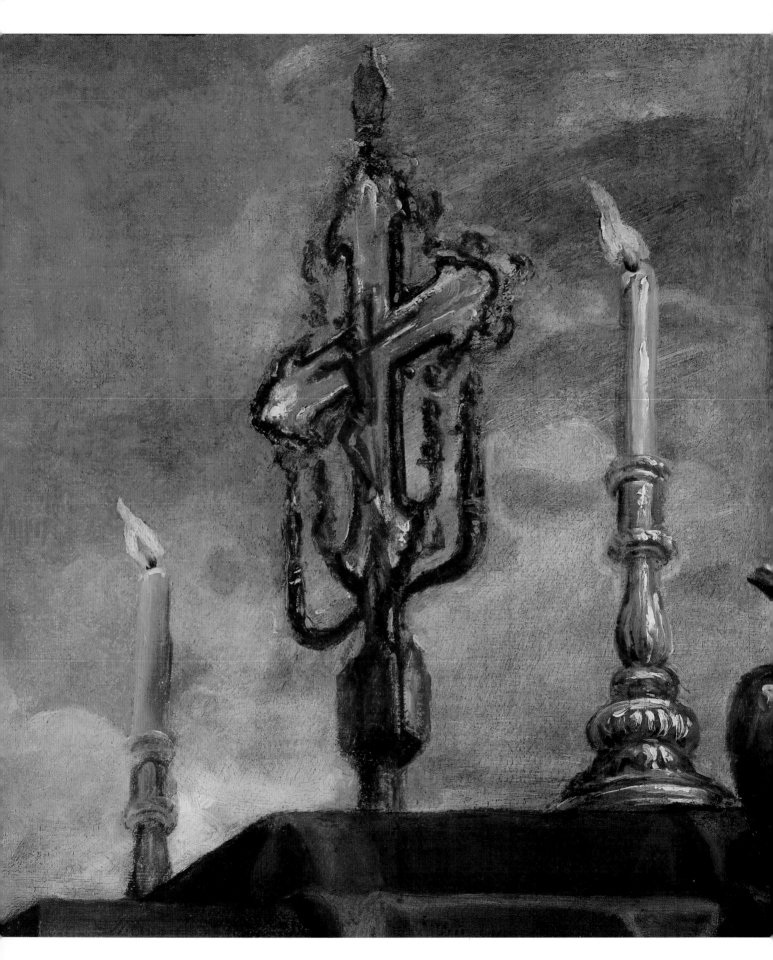

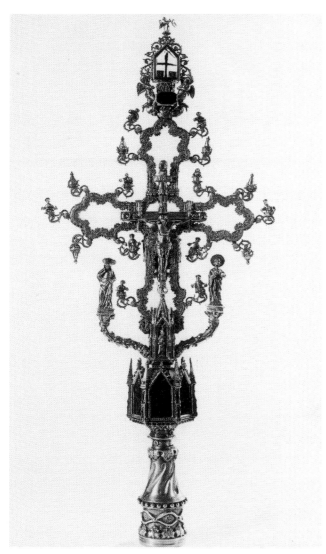

Fig. 7 Reliquary of the True Cross, silver gilt with rock crystal. Venice, Scuola Grande di S. Giovanni Evangelista.

OPPOSITE: Fig. 6 Detail of the cross and altar fittings in NG 4452.

of rock crystal supported by two angels. In this may be seen the two splinters of wood which were said to come from the true cross. They themselves are arranged as a cross. In Titian's broad brushstrokes the details are not evident and, unsurprisingly, the smaller prophets are hardly indicated at all, except in two cases, beside the larger figures of Mary and John, where they seem larger than those in the actual cross. Titian seems also to have omitted the angels which give extra support to the uppermost section, but the angels there today are not gothic and probably date from the restoration of 1789 – they are not apparent in the woodcut by Giacomo Franco that was published in 1590 in Giacomo de Mezi's booklet recording the miracles of this relic. The reliquary seems to combine the work of more than one craftsman but the whole must date from the late fourteenth and early fifteenth centuries.[45]

The Scuola di S. Giovanni Evangelista was founded in March 1261. It was one of four penitential confraternities (Scuole dei Battuti) formed in Venice at that period (the others

were the Scuole of the Carità, of S. Marco and of S. Maria della Misericordia). These developed into rich and influential institutions and were distinguished by the Council of Ten in 1467 as Scuole Grandi. Membership was confined to men (a fact which is perhaps of significance for Titian's painting) and included patricians, who, however, had an honorary role. Such indeed was the prestige of the Scuola di S. Giovanni Evangelista in the sixteenth century that King Philip II and other members of the Spanish royal family became brothers.[46] Membership of the Scuole Grandi was supposed to be limited to 500 or 600 but, in 1576, that of S. Giovanni Evangelista was discovered to be three times larger.[47] The officers, elected annually, were responsible for the administration of hospitals and of extensive rental property, the distribution of alms, and the provision of dowries 'to provide comfortable matches for poor maids'.[48]

The Scuola of S. Giovanni Evangelista moved to the church of S. Giovanni Evangelista in 1307. Work on its new premises was complete in 1354. Fifteen years later Philippe de Mézières, Grand Chancellor of Cyprus, presented to the Scuola a relic of the cross, which had been consigned to his care by his intimate friend Pietro Tommaso, to whom it had been entrusted by friars fleeing from Syria in 1360.[49] Tommaso had been Patriarch of Constantinople from 1364 until his death in 1366. Mézières (1327–1405), a soldier, diplomat and writer from Picardy, was one of the most eloquent champions of the Crusades, of peace among the European powers, and of the notion of a spiritual knighthood. He was made chancellor by Peter of Lusignan when the latter succeeded to the throne of Cyprus in 1358. Mézières visited Venice to obtain funds for Pietro's campaign, and the relic may have been presented as a mark of gratitude for the Scuola's support.[50]

The possession of this relic gave the Scuola new prestige, which in due course led to an increase in its wealth. By 1420 the Scuola's premises had been enlarged and a gothic façade was added in the 1450s. In 1478, Pietro Lombardo commenced work on the magnificent marble entrance screen enclosing a courtyard between the Scuola and the church.[51] It is this entrance which testifies most eloquently to the part played by the cross in the identity of the Scuola, for the lunette, filled with the eagle of Saint John, is crowned with a large copper cross adored by kneeling marble angels and the inscription above the doorway reads:

DIVO IOANNI APOSTOLO ET EVANGELISTAE
PROTECTORI * ET SANCTISSIMAE CRUCI

– that is, 'Dedicated to John, Apostle and Evangelist * and to the Most Holy Cross'.

There were two upper rooms in the *albergo*: a meeting room and a room dedicated to the relic of the cross, with a cycle of paintings recording the miracles it had performed. These paintings had been commissioned in 1414 but the miracles had continued, and more money and better artists became available, so they were replaced in the last decade of the fifteenth century. Most of them survive today in the Accademia and are the work of leading Venetian painters – Gentile Bellini, Vittore Carpaccio, Lazzaro Bastiani, Giovanni

Mansueti, Benedetto Diana – but one painting in the series, destroyed by fire, was signed in 1497 by Perugino, then probably the most admired (and expensive) artist in Italy. Some of the miracles had taken place at the end of the previous century but others showed very recent events – in 1474 when the cross had become impossible to carry at the funeral of a sceptic, in 1490 when it had healed a boy who had fallen from a window, and in 1494 when it had cured a case of lunacy.[52]

The Guardiano of the Scuola who accepted the relic on the confraternity's behalf on 23 December 1369 was Andrea Vendramin, and he is depicted doing so in Lazzaro Bastiani's painting for the Scuola. Andrea was a wealthy merchant, whose family had prospered retailing oil, cured meat and cheese but who was now also involved in the manufacture of hard white soap (made of olive oil from Apulia and ash from Syria, among other ingredients), an industry in which Venice had come to rival Castille.[53] In 1374, as the members of the Scuola advanced in procession to the church of S. Lorenzo, the pressure of the crowd when they were crossing a bridge caused the reliquary to slip. It hovered miraculously above the water of the canal but eluded the grasp of all who tried to rescue it, until Andrea Vendramin himself entered the water and saved it, an event that was recorded for the Scuola by Gentile Bellini in a painting dated 1500.

In addition, Andrea's own business fortunes were saved by the relic. One night, awakening from a dream that his house was in flames, he leapt from his bed and prayed ardently to the cross for protection. On the next day sailors came to the Scuola and described a terrible tempest in which two of his ships had nearly been destroyed. The ships had been saved by a vision of the cross, which had not only calmed the storm but had even restored the cargo that had been cast overboard. When escorted by Andrea into the *albergo* the sailors beheld the reliquary and sank to their knees, exclaiming, 'Questa è quella croce'. This miracle was the subject of the lost painting by Perugino. The cargo was of 'olei da fare savoni bianchi, perchè lui lo faceva fare, come ancor fanno quelli di casa sua' ('oils for making white soap, such as he made and his family – or family firm – still makes'), observed the little book explaining the paintings that was published in 1590, no doubt referring to the factory mentioned in Gabriel's will.

In September 1381, a year before he died, Andrea Vendramin was admitted to the Maggior Consiglio, in return for the massive loans he had made to the state during the War of Chioggia.[54] Andrea's grandson, another Andrea, was elected doge in 1476, though not without some objections that a member of a family of grocers was hardly suited for such an honour.[55] He died in 1478.

Pietro Lombardo and his sons created Doge Andrea's tomb in the Chiesa dei Servi between about 1489 and 1493. It was transferred to the Tribune of SS. Giovanni e Paolo in 1812.[56] In its day it was the largest ever erected in Venice, and one of the most splendid and original to be erected anywhere in Europe. Several of Doge Andrea's sons held high office, and the family business flourished. The brothers Gabriel and Andrea Vendramin discussed above were the grand-nephews of Doge Andrea, and the great-great-grandsons of the Andrea

who, as Guardiano of the Scuola, received the relic of the cross from distant Syria and later rescued it from the canal. Other members of the family (unrecorded in the genealogies of the chief branches) served as Guardiano Grande of the Scuola in the sixteenth century: a Zuane Vendramin was elected in 1529, a Giacomo in 1542 and again in 1551.[57]

The Painting within the Painting
The painting on the altar appears to be a panel composed of separate compartments containing dark figures on a gilt ground, very likely in the Byzantine style, that is, 'alla Greca' (in the Greek style), as it was then known. It may correspond to the one large example of this type which is described in the inventory of the Vendramin family's paintings made in 1569 (see the third appendix below). Devotional paintings 'alla Greca', usually of Christ or the Virgin, and 'dorado' – that is, with gold backgrounds – are common in Venetian household inventories in the sixteenth century, and could be seen in the home of a patrician (for example Paolo Loredan in 1534) or wealthy physician (for example Girolamo da Salis in 1537), as well as in more humble settings and of course in the homes of the large Greek community. They were certainly not confined to persons of old-fashioned or unsophisticated taste but were found in homes which included collections of hardstone cups and large Flemish canvases.[58] Although such paintings were made in Venice, the majority were probably made in Crete where they were commissioned in huge quantities by Venetian merchants.[59] Numerous paintings of Byzantine style, often called 'Madonne Nere', are still venerated in Venetian churches. Some among them are reputed to possess special powers and were presented by great patrician families, such as the 'Madonna della Pace', brought to Venice by Paolo Morosini from Constantinople in 1349 (now in SS. Giovanni e Paolo); the panel which had accompanied the Venetian fleet at Lepanto, bequeathed by the last of the Venier family to the church of S. Maria Formosa; or the Virgin known as the 'Mesopantitissa', brought from Candia in 1672 by Francesco Morosini and enshrined within the high altar of the Madonna della Salute.[60] It is not unlikely that one such picture had a special status for the Vendramin family.

Gentile Bellini's painting of Cardinal Bessarion with two members of the Scuola della Carità in prayer before the Bessarion reliquary (NG 6590, fig. 8), a panel that originally served as the door to a tabernacle containing the reliquary it reproduces, reminds us that some panel paintings could themselves serve as reliquaries – in this case the reliquary panel contained fragments both of the true cross and of Christ's shirt. The seven episodes of the Passion in the panel were commissioned by Cardinal Bessarion (1403–1472), who presented the reliquary to the Scuola.[61] This demonstrates that the Greek style was not regarded by Venetians as archaic (as it was by Vasari) but as an alternative, contemporary style, exotic perhaps and certainly especially suited to some sacred purposes.

In the great religious processions of Venice, the Bessarion and the Vendramin relics were accorded similar honour and prominence. Thus on the Feast of the Virgin in 1515 the

Scuola of the Carità, the second Scuola in the procession, carried their relic – 'l'ancona fo dil Cardinal Niceno' (the tabernacle belonging to the Cardinal of Nicea, that is, Bessarion) – beneath one of their two 'umbrele' (the other one protected an icon painted by Saint Luke). They were followed by the Scuola of S. Giovanni, also with two 'umbrele', one for the leg of Saint Martin encased in silver and the other for 'la santissima Croze di ditto scuola'.[62]

The 'Three Senators of Venice' in the Collections of Van Dyck and the Earls of Northumberland

The Revd William Petty, chaplain to the Earl of Arundel, had left England for Italy by July 1633 to seek out works of art for the earl's collection of paintings and sculpture. In 1636, when Arundel was in Germany, Petty kept in touch with the earl's eldest son, Lord Maltravers. The latter, in a letter addressed to 'Gulielmo Petty a Foiensa', added in a postscript dated 9 September from 'Lalan' that 'I have heard that there is a picture at Vennice to bee sould for 5 or 6 hundre duccatts. I desire that you would enquire diligently after it, if you like it, to give earneste for it, for it is for the king although his name must not be used. As I heare it hath some 4 or 5 figures in it, drawn after the life of some of the Nobility of Vennice. What ye doe must be without Sigr: Neeces knowledge untill it bee past, & I pray lette not him knowe that I did write to ye of it.'[63] This is almost certainly a reference to the *Vendramin Family*, which by December 1641 was in the possession of Sir Anthony van Dyck. Whether it had been acquired by him, or for him (perhaps by Daniel Nys, the 'Neece' of Arundel's letter), or acquired for King Charles I or another collector and passed on to him, as is perhaps more likely, is not known.

The painting was probably the largest and certainly one of the most important paintings in Van Dyck's collection, a collection of interest not only because it was formed by one of the greatest painters of the seventeenth century but because it consisted in large part of the work of one artist, Titian, whose artistic heir Van Dyck aspired to be. The brief account of this collection attempted here depends on the recent studies of Jeremy Wood.

In his Italian sketchbook Van Dyck had made a list of 'le cose de titian', which suggests a special interest, and he certainly acquired some – probably most – of his paintings by Titian in Italy, although he continued to collect after his return to Flanders in 1627. His special sympathy for Titian was acknowledged a year later by King Charles I of England, who entrusted to him the task of restoring *Galba* and copying *Vitellius* from the series of canvases by Titian which had been acquired from Mantua.[64]

In 1635 Van Dyck moved with his collection to London. At some time between his death in December 1641 and 1644 a list was made of thirty-seven paintings that he had owned, probably because they were available for sale. Nineteen of them were described as by Titian and four were copies after

Fig. 8 Gentile Bellini, *Cardinal Bessarion and Two Members of the Scuola della Carità in Prayer with the Bessarion Reliquary*, c.1472–3. Tempera with gold and silver on panel, 102.3 × 37.2 cm. London, The National Gallery (NG 6590).

Titian by Van Dyck himself. The paintings had been inherited by Lady Van Dyck, but she had also inherited the artist's debts. Moreover, her second husband, Sir Richard Price, had debts of his own. By March 1645 a certain Richard Andrewes, having obtained most of the paintings as collateral for some of these debts, smuggled them to Flanders. The group was said to include 'fifteen or sixteen choice portraits by Titian' (the term 'portraits' was probably used loosely). The paintings described do not correspond exactly to the list of paintings mentioned, the chief difference being that both the *Vendramin Family* and Titian's *Perseus and Andromeda* were not included. These, together with other items, had been obtained from Van Dyck's studio and his collection by Sir John Wittewronge, a kinsman of Sir Richard Price, on behalf of his mother, Lady Anne Middleton, as settlement of a debt. It is known that Wittewronge was also endeavouring to claim the paintings in the possession of Andrewes during the winter of 1644/5, but these two, the largest paintings, could not be as easily smuggled, which perhaps explains how he managed to obtain them. On 4 October 1645 Wittewronge sold them for £200 to Algernon, 10th Earl of Northumberland. The latter, however, then sold the *Perseus and Andromeda*, which was soon afterwards recorded on the Continent.[65]

Besides the paintings already mentioned, it seems very likely that Van Dyck had owned the portrait of Cardinal Antoniotto Pallavicini now in the Pushkin Museum,[66] a version of the *Ecce Homo*,[67] and perhaps the portrait of a boy now attributed to Sofonisba Anguissola, now in the Walters Art Gallery, Baltimore.[68] His copies were made after the *Cupid blindfolded by Venus* and *Titian and his Mistress*, both then in the Borghese collection,[69] the *Bacchanal of the Andrians*,[70] a pastoral Holy Family, and the *Annunciation*.

It seems that the earl did not feel quite secure in his possession of the *Vendramin Family* because there was always the possibility that a claim might be made on behalf of Van Dyck's daughter Justiniana. But, after receiving a present of '£80 of lawful money of England', her husband, John Stepney, signed on 10 November 1656 a document renouncing all claims to both *Perseus and Andromeda* and 'the three or four Senators of Venice with their children' by Titian.[71] Since the earl had been a close personal friend of the artist, as well as perhaps the keenest of all collectors of his paintings, he may have felt concern at the treatment of Justiniana by both her mother and her stepfather, as well as apprehension concerning possible legal action.

The 10th Earl of Northumberland (1602–1668) represented one of the oldest and most powerful families in the kingdom and was probably the most important of the noble supporters of the Parliamentary cause in the Civil War. He dissociated himself from the execution of King Charles and thereafter retired from active political life. Between 1640 and 1647 he resided in York House by the Thames amid the great collection of the late Duke of Buckingham, some items of which, including an important Titian,[72] he seems to have acquired from Parliament in lieu of the repayment of loans he had made (Parliament had confiscated the paintings from the duke).

In 1642 the earl purchased Suffolk House, the property next to York House, from his father-in-law, the Earl of Suffolk, and in 1647, when the renovation was complete, he moved there. Given the costs involved in this move, the huge loans he had made to Parliament, and the greatly diminished rents from his properties in the north of England, the earl was not in an easy financial situation when he purchased the two large canvases from Van Dyck's collection, and this probably explains why he sold the *Perseus and Andromeda* almost immediately.[73]

The *Vendramin Family* may have hung, or at least been stored, in York House for a year or so but the paintings there seem to have been moved into Suffolk House in 1647. Payment for a frame for 'ye 3 Senators' was made in 1649.[74] It was perhaps cleaned in 1651, when a payment of £2 is recorded for 'mending the Senators'.[75] Other frames were being made in 1652. The picture was certainly hanging there by 27 December 1652, when Richard Symonds made notes of the collection, recording as 'rarely done'– that is, of exceptional quality – '3 Senators of Venice in their scarlets kneeling afore ye lofty altar. & six boyes. Ritrattoes all. & ye field [meaning background] are clouds'. It is noteworthy that it seems from this account to have hung with smaller paintings by Titian on either side, one of which, the portrait of d'Armagnac, was called 'A Senator of Venice and his secretary'.[76]

As the earl's collection increased during the 1650s its arrangement was modified, and in 1657 payments were made for green and red silk cords (the former for pictures, the latter for mirrors), suggesting that the larger paintings were canted forward from the walls, in the Continental fashion.[77] John Evelyn, who visited Suffolk House on 9 June 1658, mentions the *Vendramin Family* before any other painting as 'one of the best of Titians'.[78] In 1671, after the death of the 11th Earl, Josceline Percy (1644–1670), 'the 3 Senators done by Titian' was the first item in the inventory made of the collection and was valued at £1,000. Very few were valued at more than £100 and no other at more than £200. The total value of the 140 paintings (including those at Petworth and Syon House) was £4,260 10s.[79] The painting gallery seems to have been on the top floor, running the full length of the west range of the house, with windows overlooking the Strand at one end and the Thames at the other.[80]

The 'Cornaro Family' in the Collection of the Dukes of Somerset and the Dukes of Northumberland

The only child and heir of the 11th Earl of Northumberland married Charles, 6th Duke of Somerset (1662–1748), who rebuilt Petworth House in Sussex in the late 1680s. On 20 March 1682 (1683 in the modern calendar) Parry Walton was paid £20 for 'lineing, primeing and mending the peece of the Senatores of Titian'.[81] Although it has been assumed that the painting was taken to Petworth,[82] there is no reason to suppose that it was. Vertue does not mention it in his lists of the pictures there, and it was in London in 1732 when Bernard Baron engraved it (fig. 9). In the small letters below the florid dedication the engraving is identified as after the painting by the incomparable Titian of the Cornaro family

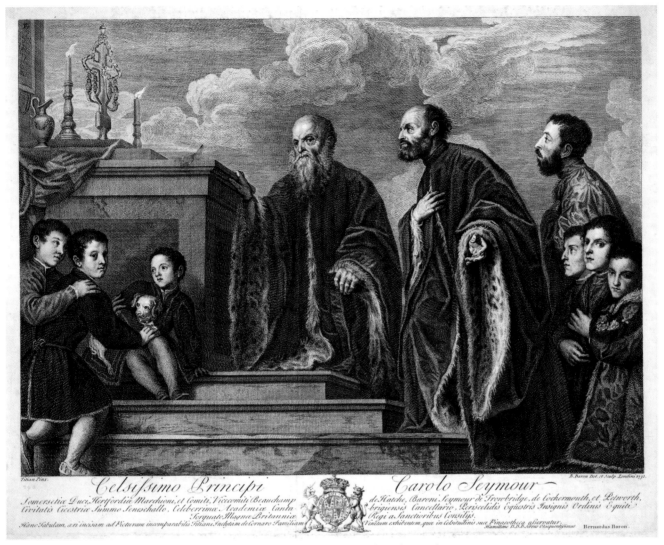

Fig. 9 Bernard Baron, *The Vendramin Family*, 1732. Engraving, 48 × 60.3 cm. London, The British Museum.

('ad picturam incomparabilis Titiani de Cornaro familiam'). This is the earliest reference to the Cornaro family as the subject; thereafter it was seldom identified by any other title until 1925, when it was recognised as the Vendramin Family (and even after that it was frequently called the Cornaro Family). It is not clear why it was supposed that the Cornaro were represented. The Cornaro family was perhaps the most famous of all the old patrician families of Venice (it had supplied a queen of Cyprus as well as four doges, including one who had died in 1722).

Jonathan Richardson the Elder, in the second edition of his *Essay on the Theory of Painting* published in 1725, still referred to the 'Admirable Family Picture of the Senators of *Titian* which the Duke of *Somerset* has.'[83] But he believed that the children were sexually segregated (as they would have been on an English alabaster tomb of the sixteenth or seventeenth century), with the girls 'more Orderly' on the left, contrasting with the boys 'got upon the steps with a dog amongst 'em; a rare Amusement for them while the old Gentlemen are at their Devotions'.

The 7th Duke of Somerset, who inherited the painting in 1748 and was created Earl of Northumberland in 1749, had no male children. On his death in 1750 the collection was divided between his nephew, the 2nd Earl of Egremont, and his daughter Elizabeth, whose immensely wealthy husband, Sir Hugh Smithson, took the name Percy and inherited the earldom by special remainder. He was made Duke of Northumberland in 1766. Syon House and Northumberland House (as Suffolk House became) were part of the share of his duchess, Elizabeth, together with the paintings kept in them.

Admission to Northumberland House was not always easy and although the painting is recorded there by 'The English Connoisseur' in 1766[84] it was not included in C.M. Westmacott's *British Galleries of Painting and Sculpture* of 1824, nor in Passavant's *Tour of a German Artist* in 1836 (recording a visit of 1831). Gustav Waagen did obtain an invitation in 1835 and found the Titian in the dining room, at the head of the imposing marble staircase.[85] It was exhibited by the 3rd Duke at the British Institution in 1818 (no. 86) and 1846 (no. 109),

but in 1856 the 4th Duke of Northumberland singled it out as the only one of his paintings which he would not agree to lend to the Manchester Art Treasures exhibition.[86] His successor, the 6th Duke, did agree to lend the painting to the Royal Academy in 1873 (146), perhaps because it only had to travel less than a mile across London. Its transfer to the family's new (smaller but still palatial) town house, 2 Grosvenor Place, was presumably already envisaged, for in 1874 Northumberland House was demolished.[87]

In about 1900 the painting was taken to Alnwick Castle in Northumberland, where it hung in the great hall known as the Guard Chamber. It is recorded there in the background of Sir Edward John Poynter's portrait of the 7th Duke (1846–1918), dated 1908, which was exhibited at the Royal Academy (of which Poynter was president) in 1909 (fig. 13).[88] It is in some ways surprising that it had not been incorporated long before into the great collection of Italian paintings displayed in the new interiors created at Alnwick in the 1850s, especially since that collection included works by Titian and his contemporaries, notable among them the *Feast of the Gods* by Bellini (the landscape of which Titian modified to match his own paintings) and Titian's double portrait of Georges d'Armagnac and his secretary, which, like the *Vendramin Family*, had belonged to Van Dyck. The sale of the painting to the National Gallery is discussed in detail in the fifth appendix below.

Copies and Engravings

The earliest known copy of NG 4452, by Symon Stone ('Old Stone'), can be seen at Hampton Court.[89] Stone was employed by the Earl of Northumberland as a copyist and curator and is known to have made many copies of paintings in Northumberland's collection, some of which were intended as gifts. It is probable that this copy was among the works of art presented by the earl to Charles II at the Restoration.[90] It may be the first full-size, or nearly full-size, copy to have been made. A large copy attributed to Benjamin West (but without good reason) was sold at Christie's, London, in 1962.[91] It showed more of the boys' feet and therefore possibly reflected the appearance of the painting before it was slightly trimmed at the lower edge. Other large copies are at Auckland Castle, Bishop Auckland,[92] and Dunham Massey Hall (National Trust), Cheshire.[93] This last-mentioned painting is identified in an inventory of 1769 as the work of Francis Harding, who also made accomplished copies of Canaletto and Panini. It seems likely to date from before 1758, when the 2nd and last Earl of Warrington, the probable patron, died, but probably after the death of the 6th Duke of Somerset in 1748, for it is unlikely that the duke, who owned the Titian, would have permitted any copying.[94]

It is noteworthy that in some old copies the composition was altered. One that was sold in 1927 and 1966, which had formerly been in Lady Lucas's collection, omitted the cross and cut off the group at the left.[95] This reminds us of how controversial Titian's picture must have been when it arrived in England. In September 1641 the Long Parliament ordered the immediate destruction of chancel steps and crucifixes in parish churches.[96] During the eighteenth century a crucifix would also have been a rarity on an altar in an Anglican church.

Copies of parts of the painting were also occasionally made. A study of the boys on the left was for sale in 1992.[97] Reduced copies are not common but there is one at Muncaster Castle which is freely and rapidly executed and is attributed to Gainsborough. It may be the copy by Gainsborough that is mentioned among the painter's works and was later acquired by Samuel Rogers, who lent it to the British Institution in 1814 (where it must have exemplified the sort of copy that the Institution itself encouraged).[98]

The painting was engraved by Baron in 1732 (fig. 9).

Provenance

Recorded in March 1569 in one of the Vendramin properties at S. Fosca. Probably available for sale by 1636, and by 1641 certainly in the collection of Anthony van Dyck in London. Acquired about 1644 by Sir John Wittewronge as part repayment of a debt owed by Sir Richard Price, who had married Van Dyck's widow. Sold by Wittewronge on 4 October 1645 to Algernon, 10th Earl of Northumberland. By succession to the 11th Earl's son-in-law, the 6th Duke of Somerset, and then to his daughter Elizabeth, wife of Sir Hugh Smithson, later created Duke of Northumberland. By succession to the 7th Duke, by whom sold in July 1929 to the National Gallery.

Exhibitions

London 1818, British Institution (86); London 1846, British Institution (109); London 1873, Royal Academy (146); London 1930, Royal Academy (168); London 1945, National Gallery, *NACF Exhibition* (15); London 2003, National Gallery (29); Madrid 2003, Museo Nacional del Prado.

Frame

NG 4452 was probably sent from Venice to England without its frame. Payment for a frame was made in 1649 when it was in the collection of the Earl of Northumberland, as mentioned above. The frame which it seems to have had throughout the nineteenth century and which is shown in a photograph of about 1870[99] is probably the same as the one of which a detail is represented in Poynter's portrait of 1908 (fig. 13). It is likely to have been given to the painting in the early eighteenth century, when gadrooned outer mouldings were popular. The painting had been reframed by 13 January 1939 with lengths of baroque carving that remain on it today (fig. 10). These are said to have been found in Palermo[100] – by Roger Fry according to one source, and 'soon after purchase'.[101] This is likely to have been early in Kenneth Clark's directorship of the Gallery for he was at that period very close to Fry. The sight mouldings of acanthus and pears may well have been added in London. The massive scrolling leaves and straps in the hollow frieze are hard to parallel exactly in other picture frames but it is noteworthy that pierced, pulvinated foliate frames were much favoured for Titian's paintings at this date, especially by Duveen.[102] The carving may well be Sicilian and is somewhat

reminiscent of Giacomo Amato's flamboyant designs of about 1690 for the altar of the Pietà in the church of the Pietà, Palermo. The frame was regilded soon after Sir Michael Levey became director in 1973.[103]

Appendix 1

ALTERNATIVE IDENTIFICATIONS OF THE SITTERS

There are five good reasons to question the natural assumption that the older grey-bearded man in the painting represents Andrea, the older of the two brothers, and that Gabriel is the dark-bearded man in profile. Firstly, the young man in profile on the left must be Lunardo, Andrea's son, and he bears a closer resemblance to the bearded man in profile than to the older man holding the altar, so it is easier to believe that the former rather than the latter is his father. Secondly, in memorials and epitaphs it is to be expected that lineage is clearly expressed in composition (as also in word order) and thus if a man kneels in front of children, leading the older boy in prayer and indicating the next in age, that man should be their father, not their uncle. Thirdly, in the earliest document concerning the painting it is described as representing the miraculous cross with Gabriel and Andrea with his seven sons: the person here represented 'with his sons' is more likely to be the central figure than the slightly detached figure by the altar, and the description clearly suggests that Gabriel is the figure nearest the cross. Fourthly, Gabriel Vendramin is likely to have commissioned the painting, for he was a noted art lover and a friend of the artist, and it makes more sense for the patron to be the person looking out of the painting at the presumed posterity for whom it was made. Fifthly,

the character of Gabriel Vendramin, as it emerges vividly in his will, is one of an anxious man with a profound attachment to the family relic, whereas Andrea in his will does not mention the relic and impresses one as a more direct, if no less fervent, personality.

However, if Gabriel is the grey-bearded man, then he must either have looked much older than his older brother (which hardly seems likely) or he must have been painted at a different date. If it is acknowledged that the painting may have been worked on in at least two phases (as the radical alteration in format and the fact that most of the children seem not to have been painted by Titian or from life suggests, and as Titian's numerous other commitments and the deaths in the Vendramin family would also help to explain) then it is possible to imagine that Andrea was painted in the early 1540s and Gabriel a decade later.

It is of course more likely that both men were painted at the same date, but if so then we are left with another problem. There seems to be more than three years' difference in age between the two men. It was for this reason that I was attracted by Stefanie Lew's idea that the oldest man may represent the first Andrea Vendramin, the ancestor who had established the family's fortune and nobility and who was so closely identified with the relic.[104] Gabriel would thus not be present in the painting. This interpretation becomes less extraordinary when we consider that the painting cannot have been intended to be taken literally: there never was an outdoor altar of this type upon which this reliquary was displayed and the painting is more like Titian's *Gloria* (fig. 3, p. 309) than it is like the family portraits of later centuries.

Fig. 10 Corner of the current frame of NG 4452.

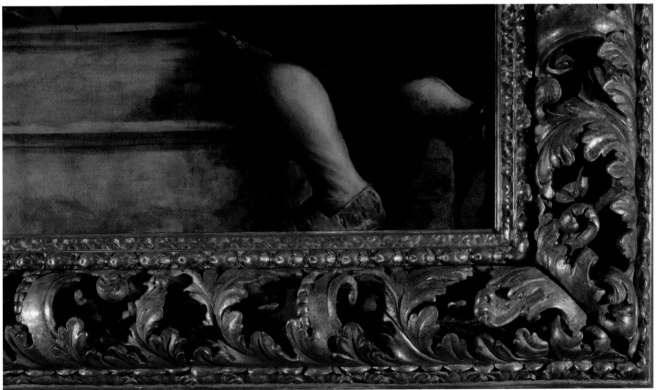

The other figures do not appear to acknowledge the old man's presence. He grips the altar in what seems a somewhat proprietorial way. If painted after the deaths of Lunardo and Andrea then we may be meant to understand that they are joining their ancestor, Andrea, the founder of their family. A somewhat similar conception is apparent in a famous work of art created a century later. Bernini's *Ecstasy of Saint Theresa* in S. Maria della Vittoria in Rome includes sculptures of members of another great Venetian patrician family, that of the Cornaro, who are witnessing the miraculous event and eagerly discussing it. Some of those represented had recently died but they are shown together with others who had died more than a hundred years before.[105] It was certainly not unusual in sixteenth-century Venice for the living to be depicted in the company of figures from the distant past; some examples are discussed elsewhere in this catalogue (pp. 72, 184). A major problem with this interpretation is, of course, that it ignores the evidence of the early inventory. And it must be admitted that Orazio, who helped compile that document, even if he did not take the trouble to ask his father who was represented in two of the independent portraits elsewhere in the palace, probably knew what Gabriel Vendramin had looked like – and had he not, one of the children would probably have put him right.

Appendix 2

GABRIEL VENDRAMIN AND HIS WILL

As mentioned above in the section entitled The Family Members, Gabriel Vendramin's long and rambling will is dated 3 January 1547 (1548 by the modern calendar). However, almost all of it must have been composed before 5 October 1547, when his eldest nephew, Lunardo, died, because the latter is repeatedly referred to as alive – a (relatively) short codicil mentions his death.

Two passages in the will are of direct relevance for Titian's painting. Having expressed his desire to be buried in the family vault of S. Maria dei Servi, Gabriel's first bequest is to his brothers of the Scuola di S. Giovanni Evangelista, a bequest to both those who do and those who do not escort his remains to the grave. The Scuola preserved the relic of the cross that Gabriel venerates in the painting. At the end of the will, in a passage of moving (and perhaps slightly mad) intensity, Gabriel adds another 'venticinque parolete' ('twenty-five little words', but actually there are several hundred) exhorting his nephews never to neglect the interests of their family and those of the Venetian state, never to forget the only means whereby both could flourish: dedication to navigation and wholehearted study of 'la militia maritima'. They should also not neglect the study of letters. They should conduct trade without accruing debts. They must remember how old the family business is. They must remember that their surest intercessor ('il vostro miglior mediante') is the most holy cross of 'messer San Giovanni'. The family fortune is something which they should embrace with all their mind ('cum tuto lo inteleto vostro') and with the utmost care as something they have inherited by the will of God Almighty ('cossa vostra ereditaria dal omnipotente dio').[106]

Most of his will concerns the prospects of the family business, and elaborate precautions to prevent its falling into the hands of 'homeni desoluti et di pocho governo et religion'. He wanted the heirs to buy a ballot box modelled on that of the 'gran conselgio', but with two rather than three divisions, whereby family disputes could be settled, a striking instance of the parallel he felt there to be between the welfare of the state and that of the 'casa Vendramina'. And indeed he attached much weight to the ability of his heirs and successors to appeal to the procurators, citing his will in the event of an irregularity.

The family business was the making, selling and exporting of soap, which involved ingredients imported from Syria and markets as far away as Portugal and England.[107] Factories and warehouses are mentioned in all parts of the city; even parts of the family palace at S. Fosca and the family villa at Stra seem to have been given over to the business. What concerned Gabriel most, indeed obsessively, was the control of the 'Segnio de la luna', evidently the official trademark used to stamp all the green soap made by the Vendramin – a stamp of a star, and another, a 'segnio Morescho' (used for white soap, together with 'il segnio che dice da Venetia'), are also mentioned.

After several pages on this subject Gabriel addresses another topic that is very dear to his heart – 'il mio chamerin', with all the works of art therein and elsewhere in his palace. He wants a proper inventory of these to be made immediately after his death, and he wants the works of art to be placed under seal. He describes his collection in categories. First he mentions 'molte picture a olgio [sic] et a guazo in tavole et telle', all by the hands of most excellent masters. Next he refers to 'carte disegnate a mano' and 'disegni stampidi' from copper and wood. In both categories he notes that some sheets are bound into books, others kept loose or framed. Then there are antiquities 'de pietra et di metallo'. Then 'molti vasi di terra cota antiqui' and medals ancient and modern, and a variety of metalwork 'lavoradi ala damaschina', animal horns, a tiny cameo fashioned as a death's head, entirely in the round, and other things that he could not list.

Gabriel was not the only Venetian to make elaborate provision for the preservation of his collection. Jacopo Contarini in 1595 wanted his studio to be conserved by the descendants of his nephew 'de primo genito in primo genito' and if male heirs were wanting it was to be entrusted to his 'carissima patria'.[108] Another Contarini, Federico, wanted his collection of sculpture, coins, gems and paintings to stay together 'perpetuamente', as he instructed his nephew in 1605.[109] But no one can have gone to greater lengths than Gabriel Vendramin to ensure that his works of art could not easily be dispersed. He proposed that the collection could be opened up when one of his nephews or one of their legitimate male descendants aged over twenty was deemed ready (here the family ballot box would again be used), on account of his learning, to enjoy it, and worthy, on account of his moral character, to care for it. This hypothetical heir would in turn place similar restrictions upon the Camerino, thus transmitting it safely and in perpetuity within the family.

Systems of *fideicommissum* whereby property was inherited under a deed of trust came to be greatly favoured in Italy in the late sixteenth century but in Venice there was a resistance to accept primogeniture, which so often accompanied this, despite the increasing importance of landholdings by the patriciate. Gabriel's peculiar plans for posterity have to be understood in this context.[110]

Gabriel reminded his heirs that the collection was of great financial value but in addition he had invested huge effort of mind and body in its assembly. And it had given him 'uno pocho di reposo et de quiete de hanimo'. Gabriel impresses us from his will as much in need of spiritual calm. He clearly had no real confidence in his brother's children, and perhaps not only because they were so young or because he had little faith in human nature. He hoped that his will would have a good influence on them – and perhaps he hoped that the painting would do so too.

Appendix 3

TITIAN AND GABRIEL VENDRAMIN'S COLLECTION

Marcantonio Michiel made notes of the collection 'in case de m. Chabriel Vendramin' in 1530. It already included notable antiquities, including two of 'pietra rossa', presumably 'rosso antico': a 'nudetto senza brazza et testa' and the head of a laughing satyr, both reputed to have come from Rhodes (so perhaps by-products of the owner's involvement in Mediterranean trade).[111] Delight in fragmentary antiquities was, of course, a sign of real connoisseurship; so too, at that date, was a relish for rare materials. Michiel also noted many of the paintings that, as we will see, were recorded in subsequent inventories – notably Giorgione's *Tempesta* and *La Vecchia*, and a *Virgin and Child* attributed to Rogier van der Weyden.[112]

A decade later, in the postscript to Sebastiano Serlio's third book of architecture, dedicated to the antiquities of Rome, Gabriel Vendramin is mentioned as exceptionally knowledgeable on this subject. Some idea of the fame of his 'studio' may be obtained from the first letter in Anton Francesco Doni's *Disegno* of 1549, where it is listed among the half dozen wonders of the city (that is, the *quattro cavalli divini*, the things of Giorgione, Titian's battlepiece, Pordenone's façade painting on the Grand Canal, Dürer's altarpiece in S. Bartolomeo, and in particular Bembo's studio and that of 'M. Gabriel Vendramino Gentilhuomo Venetiano').[113] Doni also provides a glimpse of the type of learning in which Vendramin delighted when he describes, in *I Marmi*, Vendramin expounding the meaning of the small bronze cupid riding on a lion.[114] That was published in 1552, the year Vendramin died. Three years later Enea Vico in his *Discorsi sopra le medaglie de gli antichi* recalled a very rare coin of Pertinax in the collection,[115] but by then it was probably quite difficult to visit his Camerino – and the coin may no longer have been there.

The palace at S. Fosca was occupied by Gabriel's oldest surviving nephew, Lucha. Word that he was selling medals and drawings reached the ear of his younger brother Federigo – his informant being Alessandro Contarini (probably the same connoisseur to whom Lodovico Dolce had addressed his

letter concerning Titian's *Venus and Adonis*, for which see p. 285). Federigo and his brother Zuane took legal action to ensure that a proper inventory, which their uncle had wished to be made *subito* upon his death, be drawn up; in fact, a series of inventories were compiled between August 1567 and March 1569,[116] but despite the impressive names of the ostensible compilers – Jacopo Sansovino, Tommaso Lombardo da Lugano, Alessandro Vittoria, Tintoretto, and Titian's son Orazio – they are not especially informative. However, they do enable us to envisage something of the Camerino's character. It must have been very crowded, in the manner of the *antisala* of Jacopo Sansovino's library which Vincenzo Scamozzi adapted in the 1590s as a *statuario pubblico* to display the bequests of Cardinal Domenico Grimani (d. 1523) and his nephew Giovanni Grimani, Patriarch of Aquileia (d. 1593),[117] but with far more colour and variety of materials.

The first inventory starts at the top of the room, with heads or busts of marble and terracotta and vases perched on the cornice (the 'soazon de sopra'), interrupted by what seem to have been a series of canvas covers ('tempani atorno') said to have been 'depinti de man de misier Titian'.[118] (The word *timpano* is also used for the covers of Venetian paintings.[119])

At a lower level, on consoles or in niches, fragmentary marble antiquities were arranged symmetrically with smaller items: for example, a satyr's mask with, to either side, small heads in marble and stone, respectively, or a small draped female torso flanked by small heads of a Hercules and a young faun.[120] In cupboards below, blue and white porcelain mingled with hardstone vessels, little boxes of ivory and ebony, miniature paintings, small antique bronzes, a Turkish dagger with a fish-tooth handle, globes, books of drawings and prints, and some precious drawings evidently not only framed but in some sense boxed – for example, 'un quadro dessignado de chiaro e scuro de Man de Raphael de Urbin con un San Pietro et Paolo in aere con La Spada in man con La cassa'[121] ('a picture drawn in light and shade' [that is, not coloured but shaded] by Raphael with Saints Peter and Paul appearing in the sky, the latter with a sword in his hand, with its case or cover', evidently the *modello* for the *Repulse of Attila* now in the Louvre[122]) – and many *cassette con concoli*, doubtless shell-like boxes for the keeping of coins and medals.

Smaller paintings were kept here, for example 'un quadreto de man de Zuan Belin con una figura de dritto et da roverso un cerva' – possibly the miniature portrait by Jacometto in the Robert Lehman collection[123] – and 'una toleta con un re David depinto de man de Andrea Montagna', which has not been identified.[124]

The framed paintings hanging on the walls of the palace are listed separately in the inventory dated 14 March 1569.[125] They seem to have occupied five rooms. Many are described together with their frames, the majority of which are of *noghera* (walnut) with gilded ornaments (flutes, reeds, fillets and beads – *marche, fusarioli, fileti, paternostri*). The first room is unnamed and it might be supposed to be part of the Camerino itself. Thus Anderson claims that the National Gallery's painting, which is the first to be mentioned, 'hung high in Gabriel's camerino, above his collection of antiquities'.

Identifying him as the bearded figure advancing from the left, she suggested that he was gesturing 'out toward his collection beneath him'.[126] One problem with this theory is that the painting does not appear to have been designed to hang at so very great a height (the vanishing point is not below the lower edge of the picture). In addition, since the first inventory mentioned some paintings by Titian at the level of the cornice of the Camerino there seems no good reason why they should not have listed this as well, had it been there.

It seems more reasonable to suppose that in the inventory of 1569 the first paintings to be listed after the contents of the Camerino were those hung in the *portego*, the central chamber in a Venetian palace, which was indeed, as will be shown, the place where we would expect to find a painting such as the *Vendramin Family*. The *portego* was as much a hall or corridor as a room, which would explain why it is not named as a room. Moreover, the four principal rooms of a Venetian palace would generally be linked by a *portego* so we would expect one in this context. The description of the painting in the inventory has already been discussed. It is one of the only two paintings in the collection qualified as 'grando' and is fairly unusual in having a gilded frame – 'adornamento d'oro'. Among the other paintings listed in the same unspecified space were an unfinished Vulcan (without attribution), a Saint Jerome (also without attribution), a male portrait by Palma, and a painting by Giorgione of three heads singing.[127]

Four other rooms are recorded. The last of these seems to have contained a miscellany of paintings, statues, reliefs and drawings, none of them attributed, but in the other three rooms some kind of order seems to have been imposed. One of the rooms must have been a sort of picture gallery, for it included twenty-two modern Italian paintings of medium or small size, including the *Tempesta* and *La Vecchia* and two other paintings by Giorgione, male and female portraits by Palma, and what was described as a self portrait by Raphael.[128]

Another room, perhaps a bedchamber, contained only three paintings, all of them Netherlandish, and a third room, also perhaps a bedchamber, contained four paintings, all said to be by Titian. The latter were a pair of portraits of 'zentildone' and two pictures 'fatto in tondo', one of Christ flanked by two figures, the other a self portrait. The only other picture recorded in this room is a 'quadro grando' of 'nostra dona alla Greca dorado',[129] a Byzantine-style painting to which reference has already been made in the section on the altarpiece within the painting.

The fact that Vendramin owned ornamental paintings by Titian (the *timpani* mentioned above), an unusual small picture and a very ambitious family portrait by him, and a group of paintings attributed to him gathered in a single room, suggests that he had a special relationship with the artist, and the fact that Titian was a witness to a codicil dictated by Vendramin on 13 March 1552, two days before he died,[130] does much to support this idea.

We should not, however, conclude from this that Vendramin owned only works by Titian's own hand. Leaving aside the mixed quality of the family portrait itself, it seems possible that the self-portrait tondo is the painting formerly in the Kaufman collection in Berlin, and the other tondo is perhaps the *Mocking of Christ* in the Louvre.[131] The latter is certainly not autograph, nor is the former, to judge from photographs, but given their shape they were perhaps designed to fit into the architecture of the room, conceivably as overdoors.

Access to the paintings was probably not difficult in the second half of the sixteenth century. The palace was often leased (for some years it was the French ambassador's residence) and, while the Camerino would have been locked up, the *portego* and four contiguous rooms would presumably have been rooms of 'parade'. Francesco Sansovino, in a rapid survey of the city's palaces in his *Descrizione di Venezia* published in 1581, notes that works by Giorgione, Bellini, Titian, Michelangelo and others were to be seen there, conserved by the 'successori' of 'Gabriello'.[132] Although he often mentions notable decorations of façades or interiors, this is the only collection of paintings to which he draws attention.

By 1600 two of the nephews of Gabriel Vendramin were still alive: Lucha, the eldest surviving boy at the time of his uncle's death, and Felipo. Lucha died on 17 December 1601 and immediately afterwards his son Andrea removed most of the paintings from the palace at S. Fosca to his own house at S. Felice. Legal proceedings were initiated by other members of the family and an inventory dated 4 January 1601 (1602 in the modern calendar) was made of fifty-nine items which had been removed – Titian's family portrait, the least portable of the paintings, was, unsurprisingly, not included. The pictures all had to be returned.[133]

According to Scamozzi in his *Idea dell'architettura* of 1615 the collection of antiquities in the Camerino of the S. Fosca palace was still at that date under seal (*sotto sigillo*).[134] Considering the fact that it had been eagerly eyed for half a century by rapacious collectors and their agents, it was surprising that it had survived for so long.[135] The explanation lay in the improbability of any agreement between the brothers who are harmoniously clustered on the steps of the altar in Titian's picture.

Niccolò Stopio explained to his employer Albrecht V, Duke of Bavaria, in September 1567 that all the brothers would be prepared to sell furtively to get cash for gambling and whoring – 'per fare danari da giucare et putanisare'.[136] We should not give too much credence to character sketches made by an art dealer for the benefit of a collector who likes to suppose that he is rescuing treasures from unworthy owners (especially when the proceedings are of doubtful legality). But there is no evidence that any of the children behaved well. In any case, a public sale of the collection or any well-publicised dispersal of a significant part of it was impossible. By 1657 the collection of antiquities was being sold. Some of the legal obstacles had presumably been removed or forgotten twenty years before then, when Titian's *Vendramin Family* was put on the market. Andrea, the great-great-grandson of Gabriel's brother, has been identified by Rosella Lauber as the man most responsible for the sales.[137]

The family had not all fallen on hard times. But the conspicuous wealth in the early seventeenth century belonged

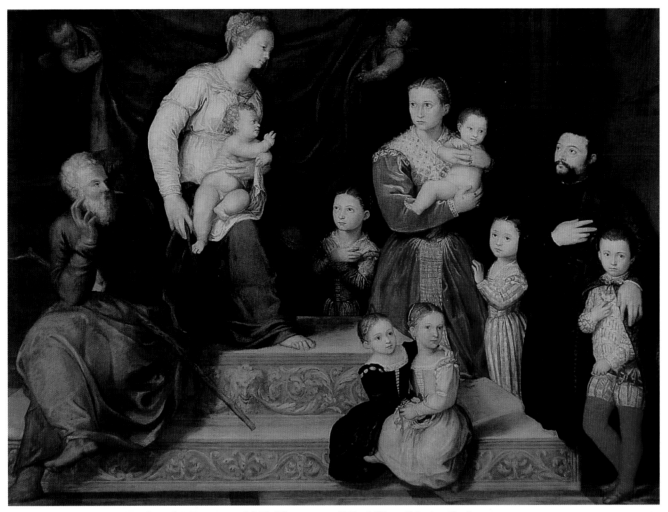

Fig. 11 Anon., *A Venetian Family at their Devotions*, *c.*1565. Oil on canvas, 156 × 207 cm. Private collection.

to another branch, one descended directly from Doge Andrea Vendramin, whose great-great-grandson Cardinal Francesco Vendramin was given by his nephews a burial chapel in S. Pietro di Castello which is among the richest in the city.

Appendix 4

FAMILY PAINTINGS FOR THE *PORTEGO*

The *Vendramin Family* seems to have inspired a fashion for large paintings on canvas of horizontal format depicting Venetian families at worship. These were displayed in their palaces in the city. The most famous example is Veronese's *Cuccina Family* of 1571, measuring 167 × 416 cm, painted for the new palace on the Grand Canal (now Palazzo Papadopoli) erected by this wealthy but not patrician family. Here Alvise Cuccina with his wife Zuana and their seven children (the youngest in the arms of a nurse) and Alvise's two unmarried brothers are supported by the Cardinal Virtues as they kneel or prepare to kneel before the Virgin and Child and Saints John the Baptist and Jerome).[138] Tintoretto's painting, similar in size (216.1 × 416.5 cm) but greatly inferior in quality, of the Doge Alvise Mocenigo with his wife, his brother and his nephews, and angels that appear to be portraits of

deceased children, is another example, probably of the same date and probably made for the same Mocenigo palace in which it was recorded in the seventeenth century.[139] Other examples include the slightly naïve painting of a husband and wife with six children in the company of the Holy Family, probably dating from the 1560s (156 × 207 cm), recently at auction (fig. 11),[140] and the superb picture of the Pagello family consisting of a dozen children shepherded to a crucifix by their parents, convincingly attributed to Giovanni Antonio Fasolo and datable to the early 1570s, now in Vicenza (fig. 12).[141] A mediocre example of the genre by a follower of Tintoretto at Kingston Lacy, probably of the 1590s, is of interest because deceased children (four out of eleven) are distinguished by heavenly crowns.[142]

Most of the five family paintings just described have in common with that of the Vendramin family the presence of one or two uncles as well as a father. This reflects an important feature of Venetian patrician life in which brothers often lived together in the same palace, sometimes also forming a 'fraterna', or family trading partnership. It was also a common feature of Italian noble families generally that some brothers lived under the same roof, thus displaying the cohesion,

economising the expenses and concentrating the wealth of the family.[143] A notable difference in the case of the *Vendramin Family* is the absence of the female sex, which may be explained by the emphasis on male inheritance or by the fact that the relic they venerate was preserved by a male confraternity.

Although we do not know exactly where these paintings hung in the palaces for which they were made in Venice (or, in the case of the Pagello family, Vicenza) it is reasonable to deduce from their size that they were generally intended for the *portego* or *portego de mezo*, a long hall set at right angles to the centre of the façade. This room was lit by the clustered front windows at one end and by windows giving on to a courtyard at the other, and was punctuated in the centre of the long walls by doorways, one of which in the sixteenth century connected with the main staircase.[144] The *portego* could thus often accommodate four large paintings. The three companion paintings of the *Cuccina Family*, the *Road to Calvary*, the *Feast at Cana* and the *Adoration*, all survive but I know of no other series that was certainly painted for a *portego* in the sixteenth century.

A good deal can be learned about the *portego* from palace inventories. The room 'was normally furnished with large tables and dozens of chairs and seems to have served as a dining room'. In a patrician home it could contain banners, arms and armour. 'More than any other room in a Venetian palace, the *portego* exhibited the status of its owner.'[145] There does not seem to have been much consistency in the type of painting displayed there. Large paintings are often mentioned, however – a 'quadro grande con un battaglia turchesca', for example,[146] a 'quadro grande con una cena',[147] a large painting

of 'La Samaritana',[148] and pictures of Saint Christopher, which are likely to have been sizeable.[149]

The family paintings described above do not form a discrete genre. Titian's *Vendramin Family* owes something to the votive painting he made of Andrea Gritti, a composition which is partially preserved in a woodcut (the original, in the Doge's Palace, was destroyed by fire).[150] Tintoretto's Mocenigo group is even closer to the votive paintings of doges, procurators, magistrates and governors that were placed in official buildings in Venice and the *terra ferma*. These were certainly being made in the fifteenth century, sometimes for domestic settings. Thus the painting now in S. Pietro Martire, Murano, of Doge Agostino Barbarigo on his knees before the Virgin and Child, which Giovanni Bellini signed and dated 1488, was 'nel Palazo', meaning presumably in the doge's apartments in the Doge's Palace at the time of his death. It measures 200 × 320 cm, which is close in size to Titian's *Vendramin Family*. So too is the votive painting of Doge Giovanni Mocenigo in the National Gallery (184 × 296 cm), also perhaps painted for a family palace.[151]

The other category of paintings with which the family paintings overlap is that of a religious episode into which the family are introduced as witnesses. One example is Bonifazio's *Adoration* (fig. 2, p. xv). Another is Titian's *Ecce Homo* (fig. 4, p. 203), completed for the Venetian palace of the Flemish merchant Giovanni d'Anna in 1543, together with a painting of the Madonna and other figures which was said by Vasari to include members of the patron's family.[152] As with the *Vendramin Family*, a fairly low viewing point and an approach from one side seems to have been anticipated by

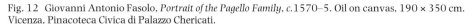

Fig. 12 Giovanni Antonio Fasolo, *Portrait of the Pagello Family*, *c.*1570–5. Oil on canvas, 190 × 350 cm. Vicenza, Pinacoteca Civica di Palazzo Chericati.

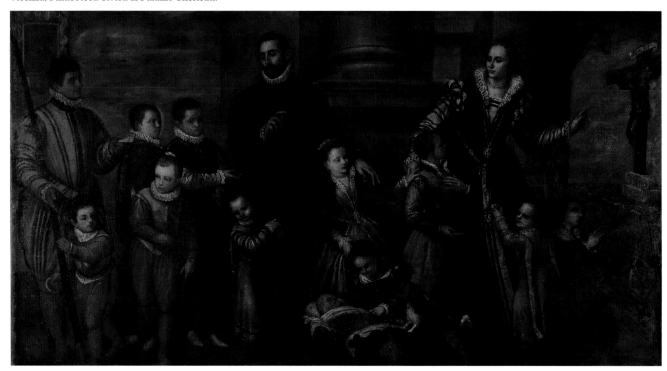

the artist. The vanishing point is here on the extreme lower right of the composition (in the *Vendramin Family* it is on the extreme lower left).

The most remarkable example of this type of painting is Veronese's *Supper at Emmaus* in the Louvre (290 × 448 cm), a work of the late 1550s in which eleven Venetian children, together with two dogs and a cat, their parents and a pair of uncles invade the palatial dining room occupied by Christ, two disciples and the innkeeper.[153] It seems likely that the other, earlier paintings of this subject by Venetian artists were painted for the *portego*, where, as noted above, a large picture of a 'cena' was certainly recorded. They would have been domestic equivalents of the paintings of feasts that were favoured for monastic refectories.[154] What may been an early example of this genre is the painting of Christ with the woman of Canaan by Palma Vecchio which must be the panel described in an inventory of the artist's studio at his death in 1528 as a 'quadro da portego'. The child in this painting certainly looks like a portrait.[155]

The popularity of these paintings may doubtless be related to the paintings of miracles and sacred narrative in the meeting rooms of the Venetian *scuole* which are filled with contemporary witnesses. Thus the precedent for Titian's *Ecce Homo* is clearly his *Presentation of the Virgin* (fig. 1, p. 128), completed for the Scuola of the Carità five years before.[156] This painting is still in its original location (now part of the Accademia Galleries), as is the case with no other painting mentioned in this section.

Appendix 5

THE SALE OF THE *VENDRAMIN FAMILY* TO THE NATIONAL GALLERY

In the middle of the First World War word spread among those who sold paintings and those who owned them that a colossal sum of money had been offered for the great 'Bridge-water Titians' (the *Diana and Actaeon* and *Diana and Callisto* belonging to the Duke of Sutherland, then being stored by the National Gallery in London, now on loan to the National Gallery of Scotland). The Trustees of the National Gallery debated the question of how they could possibly afford to counter bids of this kind and began to make a plan to sell a portion of the Turner Bequest and some of the Dutch pictures that were considered redundant.[157] Such a sale was sure to be controversial and in any case would have required the consent of Parliament, so it was shelved. Then it was learnt that the 7th Duke of Northumberland had agreed to sell Bellini's *Feast of the Gods* to the London dealers Thomas Agnew and Arthur J. Sulley. Charles Holmes, the Gallery's director, was alerted but he was powerless to intervene and the painting was exported. Having been exhibited at the Metropolitan Museum of Art in New York in 1920 as the property of a New York collector, Carl W. Hamilton, it was then sold in 1921 to Joseph Widener of Philadelphia (from whose collection it passed to the National Gallery of Art in Washington).[158]

Titian's *Vendramin Family*, which, like the Bellini, was in the collection of the 8th Duke of Northumberland (1880–1930), who inherited it in 1918, was included in a list of a dozen

Fig. 13 Sir Edward Poynter, *Portrait of Henry, 7th Duke of Northumberland*, 1908. Northumberland, Alnwick Castle.

'paramount pictures' presented to Lloyd George soon after the war. Obviously it was also high on the list of desiderata kept by Joseph Duveen, who was by then the leading dealer in old masters. He would have recalled a letter concerning it, sent to him by Berenson in 1916: 'All the Tintorettos and Paul Veroneses, Rubens and Van Dycks and Franz Hals's, and even Sir Joshuas, Gainsboroughs and Romneys are, when in groups, descended from and inspired by this picture... Here Titian feels, draws and models on a level with Rembrandt at his best but with so much more style and so much more colour. Do you wonder that Van Dyck owned it? There is in the whole world no picture of greater distinction.'[159] This was not the style in which Berenson communicated with Duveen; but Berenson understood that Duveen needed to show his American clients this sort of effusion.

In 1921 Sir Philip Sassoon, Unionist Member of Parliament for Hythe, was made a Trustee of the Gallery. Holmes recalled that he was 'young, rich and clever', and like 'the hero in a novel by Disraeli', meaning that he was cosmopolitan and Jewish and 'in touch with all the great ones of the day'. Sir Philip promptly proposed an amendment to the Finance Act whereby, 'if a national art treasure were sold to a national

institution', it would be 'free from estate, legacy and succession duties'. In August 1922 he obtained the agreement of the Chancellor of the Exchequer, Sir Robert Horne (later the first Viscount Horne), that if any of the paintings on the secret 'paramount list' were to be offered for sale the Government would agree to contribute a special grant of fifty per cent, provided that prices were not greatly out of line with the estimates then given. Only the simplest outline of this plan was ever announced to the House of Commons.[160]

It is very likely that this was the best arrangement that could have been contrived. In the economic climate it was pointless to hope for an increase in the Gallery's 'grant in aid', which had been cut from £10,000 to £5,000 in 1889 and never increased. It was of course essential to ensure that successive chancellors understood exactly what was at stake. It was essential also, in the exceptionally volatile political climate, to ensure that their commitment would not be vulnerable, were the mood of Parliament or the press to be unfavourable on the day that the actual purchases had to be made. At a moment of emergency the National Gallery had secured the counsel of advisers with a shrewd knowledge of politics, and enlightened convictions that were uninhibited by an undue attachment to the procedures of representative democracy.

No less important than influence in the Treasury was knowledge of, and influence on, the art trade, something in which the National Gallery had often, during the previous half-century, been deficient. In October 1925 the Earl of Crawford and Balcarres, recently made chairman of the Trustees for the second time, wrote to the Duke of Northumberland mentioning that he had heard rumours concerning the possible sale of the *Vendramin Family* and reminding him of the advantages of selling it to a national institution.[161] The rumours were probably correct, since Duveen's Paris office had reason to believe that it had been offered to Gulbenkian.[162] The duke replied that he did not need to sell the picture, now that he had cleared the death duties he owed. But he added, ominously, that the 'coal industry etc.' did not encourage 'confidence in the future'.[163] Altogether, this was not reassuring. Crawford may already have decided to approach London's leading dealer. Concealing the detestation he felt for Duveen, Crawford applied what seems to have been the only method of curbing his rapacity, that of flattering him into believing that Britain needed him, and intimating that the government would in some way reward him, or that at least the establishment would embrace him, if he helped to frustrate the painting's sale. Duveen grandly cabled his Paris office to announce that he had 'promised Government' that he would not interfere and that he knew that 'Government will buy it at psychological moment'.[164] He explained to Crawford that the duke had refused an offer of £70,000 four years previously but had also made it clear that he might agree to sell it for £100,000. In both of these instances the duke, without knowing it, had been dealing with agents of Duveen.[165]

In the spring of 1928 the duke agreed to allow the *Vendramin Family* to be restored by Dyer in the Gallery's 'repairing studio'. This enabled the Gallery to judge the painting's condition, about which there had been alarming reports.

The dealer Arthur Ruck visited the studio and boasted that he was buying the painting from the duke. The duke was informed, and dismissed the claim as a 'characteristic piece of impudence'. But his letter was not intended to be reassuring. It ended with a reference to the increased taxation which a Conservative government had felt obliged to impose.[166]

Meanwhile, Duveen's patriotic fervour had begun to wane. 'Doris' (the code name for Berenson within the Duveen firm) reminded him at the end of October 1927 that the Titian was the 'finest, greatest in any private collection'. He was doubtless anxious for the percentage that his endorsement would secure, were it to be sold. Ruck, who was in fact acting for Duveen, reported on 18 May 1928 that Lady Beckwith had informed him that the duke was very excited about the price recently fetched by a Raphael. Duveen cabled from the *Olympic* on 19 May for news about the picture, and no doubt the boast Ruck had made in the repairing studio was related to an approach that he made to the duke in consequence of Duveen's cable. In June, Mary Berenson wrote to her 'dear Joe', reporting to him yet again 'B.B.'s' opinion that the *Cornaro Family* (as it was still commonly known) was 'the finest Italian picture in any private collection, finer, he thinks, than even the Bridgewater ones. Couldn't you get it?'[167] Clearly it was time for the Gallery to approach Duveen again. Sir Robert Witt did so in January 1929 with the grand idea that Duveen should buy the picture and present it to the nation.[168] While Duveen deliberated on this flattering, if somewhat alarming, proposal, the Trustees found themselves with an extraordinary problem.

Early in 1929 it had become clear not only that the *Vendramin Family* was for sale but also that the *Wilton Diptych* would be put on the market. When in February 1927 the Trustees had voted to give an order of priority to paintings on the 'paramount list' the third item had been the Titian and the fourth the *Wilton Diptych*.[169] The Trustees now resolved that both must be acquired and that there must be no question of choosing between them. So the Treasury was informed that two paintings on the 'paramount list' had to be saved – it was the first time that the arrangement had been put to the test. Holmes had warned the Treasury about the Titian in October 1925 and Sir George Barstow had replied curtly that 'you could hardly have called upon us at a more inconvenient moment'. There were now two paintings to be purchased and the timing was especially awkward since the government was facing a general election. On 6 February 1929 Crawford met with Sir Richard Hopkins to learn that the Chancellor of the Exchequer, Winston Churchill, agreed to pay half the price of the Wilton Diptych but was 'not prepared to help the Trustees now' over the Titian, although he would do so 'later on in the year if still responsible for the Treasury'. This decision was said to be 'final', but Crawford insisted on an interview with Churchill on the following day and obtained from him an agreement that negotiations could continue on the basis that there would be Treasury support provided nothing was concluded before the election.[170] At this moment the government could not afford to be seen to hand a fat cheque to a Tory duke, especially one with extensive interests in the coal industry.

The next step was to neutralise the threat presented by Duveen. In March the extraordinary step was taken of making him a Trustee. In response, Duveen revealed to Witt that he had offered £130,000 for the painting through Ruck, stipulating that he would of course offer it to the Nation first.[171] The Trustees therefore knew what they were likely to have to pay. At the end of April the duke informed the Gallery that although 'reluctant to sell' he would consider any offer from the Gallery with sympathy.[172] On 30 May the Labour Party won the election, but without achieving an overall majority. Their leader, Ramsay MacDonald, formed a government on 5 June. He too had been made a Trustee in the previous year and he was now able to provide assurances that there would be no obstacle from the Treasury. The duke agreed to a price of £122,000. The Treasury contributed £61,000, Samuel Courtauld £20,000 and Duveen himself £16,000. The National Art Collections Fund found £5,000 and the Gallery added £10,500 from its purchase fund and £9,500 from the bequest of Claude Phillips.[173] The painting was hung in Room XXVIII on 12 June for a private view, and the room was open to the public on 15 June.

The Duke of Northumberland received the third instalment on 19 July. Five days later the financial secretary to the Treasury asked the Parliamentary Committee for Supply to approve the advance which had been made from the Civil Contingencies Fund. The acquisitions were supported by William Ormsby-Gore (the future Lord Harlech), a Unionist Member of Parliament and a Trustee of the Gallery who declared that he believed it to be the duty of a 'great and wealthy nation' to provide 'the public and visitors to the country with the finest works of art for their spiritual refreshment, education and enjoyment'.[174] But to many Labour Party members it must have seemed as if the whole deal (including the complicity of the prime minister) had been fixed by the 'establishment' (or at least by a cultivated minority within it). And so it had. But the transaction was not as dishonourable as they may have suspected. It was only prudent that the 'paramount' list had been made well in advance and discussed in secret. Furthermore, neither vendor had been paid more than the current market value.

Andrew MacLaren (1883–1975, Member of Parliament for Burslem) and Joseph Batey (1867–1949, Member for Spennymoor, Durham) spoke bitterly of the possible reaction in the distressed mining areas of Durham and Northumberland to this use of public money and to such a favourable deal being struck with an immensely wealthy man who owned so many coal mines. Batey himself had worked in the coal mines at the age of twelve.[175] The claim that on some days the Gallery was free to the public, and the figures quoted for weekend attendance, can have made little impression on them. George Buchanan (1890–1955), the Member for Gorbals, the notoriously poor area of Glasgow, revealed that he had twice visited the National Gallery – 'my wife made me go' – and did concede, by implication, that it was not a resort reserved for the privileged few. But he was clearly unconvinced that the 'spiritual refreshment' it provided could be compared with the school milk the previous government had refused to subsidise.[176]

The acquisition of the *Vendramin Family* and the *Wilton Diptych* was an operation that revealed consummate political skill on the part of the more active Trustees and especially on the part of Sir Philip Sassoon and Lord Crawford. Charles Holmes, the director from 1916 to 1928, played a relatively inconspicuous part in the whole affair, and Augustus Daniel, his successor, almost no part at all. Much of the hard work backstage was due to Holmes, of course, and it was he who in 1921 worked out the details of the amendment of the Finance Act, but by his own admission Sassoon not only proposed and carried the amendment in the House of Commons but was of vital assistance when the scheme was explained to the chancellor: 'There was so much to say that I could say nothing, and had not Sassoon come to the rescue the appeal must have failed completely.'[177] It was an assistant in the Gallery, Collins Baker, who suggested and arranged for the cleaning of the Titian, a very well-timed favour. It is true too that the agitation articulated by *The Burlington Magazine* and the National Art Collections Fund, also the polemics of Claude Phillips, whose bequest was so appropriately employed to help acquire the painting, had supplied the arguments which the Trustees used. Nevertheless, the authority enjoyed by the Trustees in this period was a precondition for this success, just as it had been responsible for several failures in previous decades. No director at that date could hope to have equivalent contacts in Whitehall or to address dukes as equals, or make both the leader of the Labour Party and the most powerful art dealer in the world feel flattered to be allies in a cause that was against their political and business interests, respectively.

The parliamentary debate revealed, however, the vulnerable image that the National Gallery had in this period. During the hard economic climate following the First World War the Gallery had increased (on 4 April 1921) its paying days from two in the week to four, putting the extra receipts towards the purchase grant and endeavouring to enhance those extra funds by means of concerts.[178] The charging had been unpopular enough to prompt art students to march in protest with a banner. They were led by Muirhead Bone (1876–1953, knighted 1937), painter and etcher and a Trustee of the Tate Gallery, who also argued forcefully against this step in *The Burlington Magazine* for May 1923.[179] This was painful for Holmes, who had been so closely associated with the *Burlington*. He had faced great pressure from the Treasury to impose admission charges, and concessions to this pressure probably improved the chancellor's preparedness to enter into the Sassoon agreement. However, Bone was surely correct in saying that the paying days 'create imperceptibly, but very surely, a sense of alienation between the public and the National Gallery. Somehow it is no longer "theirs"'.[180] Yet it was for the public that the Titian was purchased with substantial amounts of public money.

It fell to Daniel's successor, Kenneth Clark, to exploit the circumstances of the Second World War to make the Gallery truly popular as an institution. He also had the tricky job of removing Duveen from the Board of Trustees. Clark himself was comfortable in the highest social circles. Like Sassoon

when he became a Trustee, he was 'young, rich and clever'; unlike Holmes, he did not have to worry about the cost of hotels in Paris.[181] This made it easier for him to accomplish the second of these tasks, and perhaps also the first.

One other episode connected with the acquisition of Titian's *Vendramin Family* deserves to be mentioned because it is of some significance in the history of the National Gallery, and indeed of public art collections generally. Great plans were being made in 1929 to organise one of the largest international loan exhibitions ever mounted, that devoted to Italian art, which would open at the Royal Academy in 1930. The Gallery had never agreed to lend paintings to events of this kind but prior to the sale there had been an understanding that the Titian would be lent. There was considerable political pressure on the Trustees to agree to the loan. The prime minister even let it be known that he was in favour. Lord Crawford was especially opposed to it, sensing that the exhibition represented publicity for fascist Italy: 'I stand for Britain first, and I regret that we should denude ourselves in order to boost a movement which is political in its fundamentals'; 'I am entirely opposed to giving way ... It is not *our* business to make the Italian show a success, and to save Mussolini's face.'[182]

More than half a century would elapse before the Trustees would begin to agree with any frequency to lend masterpieces to loan exhibitions, yet today it seems clear that the very idea of the permanent collection has been altered by an increasing obligation not only to lend but to borrow.

Were anyone to doubt the central role of the loan exhibition, not only in the history of museums but in the history of the art market, they would do well to study the exhibition *The Venetian School: Pictures by Titian and his Contemporaries* that was mounted at the Burlington Fine Art Club between May and July 1914, or rather the illustrated record of the exhibition that was published in 1915, because it included 'four famous pictures at Alnwick Castle three of which have never before been photographed', among them (as no. 64) the 'Cornaro Family', and of course the *Feast of the Gods*.[183] It seems likely that the Club had hoped to borrow these paintings, but that the duke had not agreed. However, by allowing the paintings to appear in the catalogue he did much to quicken the appetite of London's art dealers and North America's collectors and to initiate the moves and countermoves described above.

NOTES

1. What follows is derived from the report compiled by Ashok Roy on 10 March 1994, based on samples taken by Joyce Plesters on 7 October 1973 and by himself on 24 February 1994. See also the summary in the 'Report of the Scientific Department' for 1994–5.

2. Burnham 1981, p. 157. (Jilleen Nadolny supplied this reference.)

3. Notably, in Titian's *Supper at Emmaus* (Wethey 1969, pp. 161–2, cat. no. 142) and his *Last Supper* in the Escorial (ibid., pp. 96–7, cat. no. 41 and plate 118, for a detail showing the pattern). Although this pattern of weave is sometimes said to be typical of Italian table linen it was certainly found outside Italy, as can be seen from Gérard David's *Marriage Feast at Cana* in the Louvre, Inv. 1995.

4. Causa 1964, p. 223, citing Professor Augusti's description of the textile as 'un comune tovagliato'.

5. Jill Dunkerton has pointed out to me that a painting of Saint Onofrius, Saint Nicholas of Tolentino and a Bishop Saint in the store of the Accademia Carrara, Bergamo, painted by Domenico Panetti around 1500 is on a canvas of this kind.

6. For Tinti, see his *Assunta* of 1589 in the Duomo, Parma, and his *Virgin in Glory with Saints Cosmas and Damian* in the Galleria Nazionale, Parma; for Vermiglio and Figino, see their paintings of c.1591 made for S. Maria della Nave of *S. Ambrogio* and the *Sacrifice of Isaac* which are now in Castello Sforzesco, Milan (nos 207 and 1468); for

Trotti, see his *Crucifixion* of 1600 in S. Maria del Carmine, Parma; for Campi, see his *Trasloco* in the Piazza della Prefettura, Cremona; and, for Bernardino Campi, the *Virgin and Child with Saint Joseph and Saint Claudio* of 1569 in S. Agata, Cremona; for Muziano, see his *Saint Francis in Ecstasy* in the Vatican Pinacoteca; for Passignano, see his *Annunciation* in the Chiesa Nuova, Rome. One occasionally notices the pattern on a far smaller scale – for example on Niccolò dell'Abate's *Landscape with a Boar Hunt* in Palazzo Spada, Rome (no. 100).

7. An early example of El Greco's use of this type of canvas is the portrait of a man of c.1575 in Copenhagen (Statens Museum for Kunst, KMSS P146). Examples from the late 1590s are *Saint Martin and the Beggar* and the *Virgin and Child with Saints* in the National Gallery of Art, Washington (Widener Collection, 1942.9.25 & 26). A late example of the use of this canvas type in Italy is Salvator Rosa's *Allegory of Fortune* in the J. Paul Getty Museum (78.PA.231).

8. Reynolds 1929, pp. 158–9.

9. Farington 1978–98, XV, 1984, p. 5203.

10. Quoted from J. Mitford's conversations with Rogers (British Library, Add. MSS 32566, fol. 49) by William T. Whitley in *The Times*, 4 July 1929.

11. *The Times*, 1 August 1929.

12. Waagen 1854, I, p. 393.

13. Crowe and Cavalcaselle 1879, I, p. 304.

14. Ricketts 1910, p. 143, mentions the idea but does not say by whom it had been proposed.

15. Pallucchini 1969, I, pp. 118–19; Wethey 1971, p. 147, cat. no. 110; Gould 1959, pp. 117–20, and 1975, pp. 284–7.

16. Hume 1829, p. 66.

17. Crowe and Cavalcaselle 1877, II, p. 303; Phillips 1898, pp. 88–9; [Benson] 1915, p. 14.

18. Gronau 1925.

19. Wethey 1971, p. 142, no. 101 (Clarice Strozzi); pp. 122–4, no. 72 (Paul III without cap); pp. 125–6, no. 76 (Paul III and his grandsons); Wethey 1969, pp. 138–9, no. 113; and Valcanover *et al.* 1980, pp. 286–8, no. 45 (S. Giovanni Elemosinario altarpiece). The date of the altarpiece can be deduced from Vasari's life of Pordenone, who died in 1539 – Vasari himself first visited Venice in December 1541. I owe this point to Charles Hope.

20. Pallucchini (1969, I, p. 118) was, I think, the first to suggest this possibility.

21. Vasari/Milanesi, VII, p. 448.

22. Ibid., p. 589; Ridolfi 1914, p. 304, note 1.

23. Ridolfi 1914, p. 222; Fisher 1977, pp. 10–23.

24. Ludwig 1903, pp. 114–18.

25. Crowe and Cavalcaselle 1881, II, Appendix, pp. 133–4. Charles Hope points out to me that Girolamo was given an important independent commission by the Scuola della Carità in 1557. The documents concerning the Saint Lawrence copy indicate that he had worked with Titian for thirty years.

26. Hadeln 1934 (for *Four Seasons*); Fisher 1977, pp. 31–42. See also Gronau 1925, pp. 126–7.

27. Wethey 1969, p. 95, no. 44; see also Valcanover *et al.* 1980, no. 69 (entry by Patrice Marandel). The painting is generally considered to be wholly autograph. The same hand painted the heroine's face in two variants of this composition, one on the New York art market (Morassi 1968) and the other in a Milanese private collection (Humfrey 2003, pp. 178–9, no. 65).

28. This transcription, taken from Lauber 2002 (p. 39), differs from that in Ravà 1920, p. 177.

29. Battilotti in Battilotti and Franco 1978, p. 64.

30. The tree follows the careful research of Rosella Lauber and the fuller trees she supplies (2002, pp. 72–8). Lauber has corrected many errors made by other scholars writing of the Vendramin family. Some of these errors derive from the Barbaro genealogy in the Biblioteca Correr, which gives Andrea Vendramin's date of death as 1542 (see, for instance, Anderson 1997, p. 161).

31. All relevant biographical details have been collected by Battilotti in Battilotti and Franco 1978, pp. 64–8.

32. Biblioteca Correr, MSS PD 1356/16. Transcribed for the National Gallery by Carol Plazzotta.

33. Dates taken from the copy of Barbaro's genealogy in the Archivio di Stato, Venice, and from the Avogaria di Comun, Matrimoni con notizie dei figli by Dr Zago of the Archivio di Stato and sent to Cecil Gould. They have been confirmed by Carol Plazzotta from these and other sources. See also Lauber 2002.

34. Reference is also made to 'chiara mia fiola et sua sorella morta' and to 'una nezza fiola' of Isabella.

35. ASV, Notarile testamenti, busta 1208, fasc. 403. Transcribed for the National Gallery by Carol Plazzotta. A portion of this was published in Ludwig 1911, pp. 72–4, but under archival number 1201 rather than 1208, and more by Battilotti in Battilotti and Franco 1978, pp. 64–8.

36. The dates of birth are calculated from ASV, Avogaria di Comun: Balla d'Oro, busta 165/IV, c. 377 r. and v. by Ferriguto (1926, p. 401) and by Battilotti in Battilotti and Franco 1978, pp. 64–8. Dottoressa Paola Benussi of the Archivio di Stato, Venice, very kindly confirmed these dates. Andrea was presented on 19 October 1501 with the note that he would be 20 on 31 October (so he was born on 31 October 1481) and Gabriel was presented on 13 November 1504 aged 20 (so he was born in 1484).

37. Lauber 2002, pp. 29–37. The possibility that the oldest man is Andrea was conceded by Gould (1975, p. 285, last paragraph – compare the equivalent passage in 1959, p. 119). Anderson 1997, pp. 160–1, develops the idea. Previous scholars have on the whole assumed that Gabriel is the figure beside the altar – e.g. Pallucchini 1969, pp. 287–8;

38. For a full discussion of lynx fur see Penny 2004, p. 178.

39. Typescript dated March 1956 in the Gallery's dossiers.

40. Sanuto 1969–70, XXI, 1969, col. 38.

41. Mariani Canova 1964, pp. 93–4.

42. Mason Rinaldi 1984, p. 138, no. 519, and p. 220, fig. 87.

43. Pouncey 1938–9.

44. Wethey 1969, pp. 137–8, nos 111 and 112; see also Valcanover *et al.* 1980, pp. 272–8, nos 42a and b (entries by Echols and Gramigna Dian).

45. De Mezi 1590; Urbani de Ghelof 1895.

46. Sansovino 1581, pp. 100–1.

47. For a general survey see Pullan 1981 and, for a fuller account, Pullan 1971. For patrician membership see Pullan 1971, pp. 72–5. For the numbers in 1576 see ibid., p. 87.

48. Misson 1695, I, p. 310.

49. Cicogna 1855, p. 6.

50. For Mézières see the succinct biography in the eleventh edition of the *Encyclopaedia Britannica*, Cambridge 1911, XVIII, pp. 350–1.

51. McAndrew 1980, pp. 144–9; Lieberman 1980, plates 81–5.

52. Pedrocco in Pignatti 1981, pp. 52–60; De Mezi 1590.

53. For the family's origins as grocers see the note in Barbaro's genealogy in the Biblioteca Correr. For the fortune in soap see Lane 1973, pp. 160–1. That they continued to trade in oil is clear from Finlay 1980, p. 52.

54. Cicogna 1824–53, I, 1824, p. 47.

55. Malipiero 1844, pp. 666–8, especially p. 667; Da Mosto 1966, pp. 245–50 (for Doge Vendramin in general).

56. Luchs 1995, pp. 41–50.

57. Biblioteca Correr, Cicogna MSS, busta 3063, fasc. 10 (transcribed by Carol Plazzotta).

58. ASV, Cancelleria Inferior Miscellanea, Notai Diversi, b. 36, no. 2, fol. 3r (Loredan), and no. 51, fol. 4r (da Solis); for a collector of hardstones etc. who owned a painting of Our Lady 'alla grega' see ibid., no 71, fol. 9r (Massari), and for an owner of large Flemish canvases who also owned a little picture with 'figure greche' see b. 39, no. 26, fol. 6r (Gattina).

59. For the Cretan artists see Chatzidakis 1977 and the articles he cites by Cattapan. See also Bettini 1977.

60. Chatzidakis 1993, section 3; Tramontin *et al.* 1965, pp. 252–6 and 261–3.

61. Bought by the National Gallery at Christie's, London, 12 December 2001, lot 61. For the reliquary see Fiacciadori 1994, pp. 451–3, no. 66.

62. Sanuto 1969–70, XXI, 1969, col. 46 (8 September 1515).

63. British Library, Add. MSS 15970, fol. 38. Springell 1963, p. 250. Jane Roberts pointed out to me that Arundel had permission to use the royal name to obtain works of art for himself, as when he was trying to obtain drawings from Count Galeazzo Arconati.

64. Wood 1990.

65. Ingamells 1982, p. 397, for its appearance in France, but see Wood 1990, pp. 684 and 695, where it is proposed that it went first to Milan.

66. Wethey 1971, pp. 175–6, X-79, pl. 255.

67. Ibid., pp. 79–80, no. 21.

68. Zeri 1976, II, pp. 427–8, no. 298, pl. 205 (where this provenance is, however, not given).

69. For the so-called *Titian and his Mistress* see p. 238. For *Cupid blindfolded by Venus* see Wethey 1975, pp. 131–2, no. 4, and especially Herrmann Fiore 1995.

70. Wethey 1975, pp. 151–5, no. 15.

71. Wood 1990, p. 684, note 28, and Wood 1994, p. 285 and p. 324, note 251. This document, headed 'Release of Money paid for pictures W.II.2', is in the Alnwick Castle MSS at Syon House. A photocopy of it was sent to the National Gallery by the Duke of Northumberland in June 1956.

72. For the transaction see Wood 1994, pp. 281–2. Titian's double portrait of Cardinal Georges d'Armagnac and his secretary Guillaume Philandrier now at Alnwick Castle (Wethey 1971, p. 78, no. 8, pl. 135).

73. Wood 1994, p. 287.

74. Ibid., p. 295, and Appendix I, p. 303, for the move to Suffolk House, and p. 311, note 38, for the payment for the frame.

75. Ibid., p. 311, note 40.

76. British Library, Egerton MSS 1636, fol. 91v, transcribed in Wood 1994, p. 303, as Appendix I.

77. Wood 1994, p. 298.

78. Evelyn in Wood 1994, p. 304, as Appendix II.

79. Wood 1994, Appendix III, pp. 304–8.

80. Wood 1993, especially pp. 64–5.

81. Information sent to me by Jeremy Wood on 8 March 1996.

82. Gould 1959, p. 119 and p. 120, note 17 (repeated 1975, p. 286), citing information sent by the Duke of Northumberland.

83. Richardson 1725, pp. 80–1.

84. Martyn 1766, I, p. 191. It is also praised by Strange (1769, pp. 134–5).

85. Waagen 1838, II, pp. 182–3. The dining room, probably unchanged with regard to the arrangement of the paintings, is shown in a photograph of *c.*1870 (NMR neg. BB 89/1459) drawn to my attention by Jeremy Wood.

86. Pergam 2001, p. 99.

87. Crowe and Cavalcaselle (1877, II, p. 308), having presumably studied the painting at the Royal Academy in 1873, seem to have supposed that it had gone from there to Alnwick. That it in fact stayed in London is clear from notes given to the Gallery by the Duke of Northumberland in 1956.

88. Poynter's portrait is now in the Great Drawing Room at Alnwick (Old Picture List 617, inv. no. 3292).

89. Hampton Court, no. 444. It measures 79 × 112 inches (200 × 284 cm).

90. Wood 1994, pp. 284 and 302 (for Stone), and pp. 297–8 for donations to the King in 1660 and 1661.

91. Christie's, London, 16 November 1962, lot 100, ex Neeld collection, Grittleton.

92. Information from Michael Helston, 7 February 1990.

93. The Dunham Massey copy measures 80 × 120 inches (203 × 304 cm).

94. Information from Alastair Laing in a letter of 20 June 1997. He points out that Harding is documented as working at Stourhead between 1745 and 1758. For Harding generally see Waterhouse 1981, p. 160.

95. Christie's, London, 20 May 1966, lot 38. It measured 83 × 109 inches (210 × 276 cm).

96. Aston 1996.

97. Sold at Bonham's, London, on 19 July 1990, lot 22, and at Peel and Associates, Madrid, 28 January 1992, lot 4.

98. No. 47 in Gainsborough's catalogue of 1789. Sold on 2 June 1792, lot 70, to the Marquess of Lansdowne, at whose sale on 19 March 1806, lot 28, it was sold to Rogers for 110 guineas (£115 10s.) (Fredericksen *et al.* 1990, II, p. 1010). The painting was lot 575 in Rogers's posthumous sale at Christie's, London, on 2 May 1856, where it was bought by 'Morant', possibly for Sir John Ramsden (Waterhouse 1966, p. 125, no. 1031). It is a problem that Gainsborough's painting is said to have been taken from the engraving, which would lead one to suppose that it was in reverse, but that is not true of the painting at Muncaster.

99. National Monuments Record neg. BB 89/1459. Drawn to my attention by Jeremy Wood.

100. Lord Harlech quoted in *The Star* for 13 January 1939 (National Gallery press clippings).

101. Cecil Gould's typescript notes on National Gallery frames.

102. These frames made by Vannoni are discussed in Penny 2004, pp. 87 and 90, note 99. See p. 456, fig. 6, for an example. I hope to publish more on Vannoni in the near future.

103. National Gallery Report, June 1972 – December 1974, p. 94.

104. This idea was first aired by me in the catalogue of the Titian exhibition at the National Gallery in London in 2003 (Jaffé

2003, p. 146), but I have met few scholars who have found it convincing.

105. Lavin 1980, I, pp. 92–3 and 200–1; II, pp. 154–5.

106. See note 35.

107. Lane 1973, pp. 51, 160–1, 261.

108. Perry 1972, p. 96n; Hochmann 1987, p. 457 and note 39.

109. Cortelazzo 1961.

110. For deeds of trust in Italy and Venetian resistance to primogeniture see Davis 1962, pp. 68–72 (especially p. 69); 1975, pp. 84–92; and, for Italy more generally, Barbagli 1984, pp. 176–88.

111. Michiel 1888, pp. 106, 108, 110.

112. The painting is now in Palazzo Doria and is catalogued by Friedländer 1972, pp. 18–19, 90–1 and plates 8–9, as an early work by Gossaert.

113. Serlio 1540, III, p. 155; Doni 1549, pp. 51v–52r.

114. Doni 1552, pp. 40–1.

115. Vico 1555, p. 88.

116. Ravà 1920. For a long complaint by Federigo at the treatment he had received from his brothers see Biblioteca Correr, MSS PD c.1324/9 & 4, and for complicated divisions of the brothers' property see PD c.1347/6, 7, 9 (notes on which have been made for the National Gallery by Carol Plazzotta).

117. Perry 1972.

118. Ravà 1920, p. 161.

119. See p. 242, also Penny 2004, pp. 99–101.

120. Ravà 1920, p. 164, nos 14 and 22.

121. Ibid., p. 174.

122. Cordellier and Py 1992, pp. 239–41, no. 329.

123. Ravà 1920, p. 170; Pope-Hennessy 1987, pp. 240–3, no. 96.

124. Ravà 1920, p. 170.

125. Ibid., pp. 177–9.

126. Anderson 1979.

127. Ibid., p. 643.

128. Ravà 1920, pp. 177–8 ('in camera per notar').

129. Ravà 1920, p. 178.

130. Ludwig 1911, p. 73, citing ASV Notarile Testamenti, Busta 772, no. 220.

131. Inv. 747; Anderson 1979, p. 644, fig. 46.

132. Sansovino 1581, p. 144r.

133. Anderson 1979, p. 642.

134. Scamozzi 1615, I, iii, cap. 19, pp. 305–6.

135. Anderson 1979, p. 641, argues that Titian himself offered to obtain a marble head from this room for the Gonzaga; Charles Hope informs me that the document (of 21 October

1570) strongly suggests that the marble head did not belong to the Vendramin family.

136. Ibid., p. 641, note 22.

137. Ibid., p. 642, for sale of antiquities. See Lauber 2002, pp. 67–71, for other sales and the identification of the family members responsible for them.

138. Gemäldegalerie, Dresden. See, for the patrons, Humfrey 1965, p. 213, note 24. See also Cocke 2001, pp. 197–8, no. 25.

139. National Gallery of Art, Washington DC, 1961.9.44. Shapley 1979, I, pp. 473–4, no. 1406.

140. Sotheby's, London, 8 July 1992, lot 22. There attributed to Badile (1518–60) but the dress would suggest a date after Badile's death.

141. A. 350. Barbieri 1962, pp. 72–3.

142. KL/P/136. The painting is said to show members of the Do Comicro family adoring the Virgin and Child. The uncle and aunts to the right may be by a different hand. Three winged and crowned angels are clearly portraits and the older kneeling girl is also crowned.

143. For restricted marriage in patrician families and 'complex households' see Davis 1962, pp. 62–6; 1975, pp. 93–106, and Barbagli 1984, pp. 189–95. For the 'fraterna' see Lane 1944, pp. 87–92, and Davis 1962, pp. 26–7.

144. Schulz 1982, pp. 76, 84, 87, 89, 102–3, 110–11.

145. Ibid., p. 89 and notes 51–2 on pp. 110–11.

146. ASV, Cancelleria Inferior Miscellanea, Notai diversi, Inventari b. 39 (1554–9), no. 41, fol. 17r, inventory of 1558.

147. Ibid., no. 6, fol. 11, inventory of 1557.

148. Ibid., no. 1, fol. 11r, inventory of Domenico Gritti, 1557. Another painting of the Samaritan Woman is recorded in a *portego* in an inventory for the previous year, ibid., no. 18, fol. 10r.

149. Ibid., b. 36 (1534–9), no. 29, fol. 1, inventory of 1535 and no. 49, inventory of 1536 (1537), fol. 3r.

150. Rosand and Muraro 1976, pp. 240–2, no. 71.

151. NG 750. Davies 1961, pp. 544–7. There are unanswered questions about the provenance of this painting but it does not seem to have come from a public building.

152. Wethey 1969, pp. 79–80, no. 21, pl. 91. Polignano makes a case for the presence of political powers in this picture (1992).

153. Pignatti and Pedrocco 1995, I, p. 135, no. 100.

154. Penny 2004, pp. 103, 140, for examples by Marziale.

155. Quadreria of the Accademia, no. 12 (Gallerie dell'Accademia, no. 310). Rylands 1992, pp. 27, 301, no. A 63. Ludwig (1903, p. 77, note 1) was the first to suggest that this

painting was the one that is mentioned in the inventory.

156. Wethey 1969, pp. 123–4, no. 87, pl. 36.

157. Holmes 1936, p. 314.

158. Shapley 1979, I, p. 43. The exact nature of this sale needs clarification.

159. Berenson's letter of 28 September 1916 to Duveen in New York. Duveen MSS, Getty Research Institute, box 206, folder 21.

160. Holmes 1936, p. 372.

161. NG 14/60/1. The draft of Crawford's letter is dated 14 October.

162. Duveen MSS cited in note 159. Cable from Paris to New York, 12 October 1925.

163. NG 14/60/1. The duke's letter is dated 16 October.

164. Cable from New York to Paris, 12 October 1925. Duveen MSS cited above.

165. NG 14/60/1. Cable dated 16 October 1925 forwarded on 19 October from Duveen's Grafton Street office.

166. NG 1/10 (Minutes of the Board of Trustees, X), pp. 6, 9 (for 'repairing studio'), and pp. 24–5 for Ruck's visit. NG 14/60/1 for the duke's letter dated 3 July 1928.

167. Duveen MSS cited above. Ruck's communication was dated 11 May 1928. The cable from the *Olympic* was sent on 19 May. Mary Berenson wrote on 26 June 1928.

168. Ibid., Witt wrote on 17 January 1929.

169. NG 1/9 (Minutes of the Board of Trustees, IX), p. 216. The highest scores were for Memling's *Donne Triptych* (NG 2675) and Titian's *Three Ages of Man* (Duke of Sutherland Collection, on loan to the National Gallery of Scotland, Edinburgh).

170. NG 14/60/1. Barstow's letter is dated 17 October 1925. Crawford's memos are dated 6 and 8 February 1929. See also NG 1/10 (Minutes, X), pp. 61–2, for report to the Board.

171. NG 1/10 (Minutes of the Board of Trustees, X), pp. 69 and 75–6.

172. Ibid., pp. 82–3.

173. Ibid., pp. 86–8. Duveen had offered up to £20,000 but it was not all needed.

174. *Parliamentary Debates* 1929, columns 1347–81.

175. *Who was Who*, 1941–50, p. 71.

176. *Parliamentary Debates* cited in note 174.

177. Holmes 1936, p. 372.

178. Ibid., p. 370.

179. Bone 1923.

180. Ibid., p. 253.

181. For the cost of hotels in Paris see Holmes 1936, p. 373. For Clark's social position and his relations with the Trustees see Penny 2004, p. 295, and Clark 1974, Chapter 7.

182. NG 26/26 (letter of 16 October 1929) and S 2475 (letter of 2 September 1929; also Daniel's memo of 21 June 1929). For this exhibition in general see Haskell 2000, chapter 7 (pp. 107–27).

183. [Benson] 1915, p. 5. The *Feast of the Gods* was the frontispiece, the other paintings (Palma's *La Musica*, the three figures attributed to Giorgione, and the 'Cornaro Family') were cat. nos 62, 63 and 64. Each is described as 'In the possession of' rather than 'lent by' the owner, but their inclusion in the catalogue has frequently been misunderstood.

Titian and Workshop

NG 6376

An Allegory of Prudence

*c.*1550–65, perhaps completed later
Oil on canvas, 75.5 × 68.4 cm

Support

The measurements given above are those of the stretcher. The original canvas is of a coarse, open tabby weave with thick and uneven threads: 12 threads to the centimetre in the warp (running vertically) and 10 in the weft. This canvas is lined on to a canvas of medium-fine tabby weave.

The ragged edges of the original canvas are partly concealed by putty, but it is clear that they do not extend to the left edge of the lining canvas. Cusping is obvious at the upper and lower edges; it may also be discerned at the sides. There are old tacking-holes (perhaps original) at the lower edge.

The nineteenth-century deal stretcher with crossbars is stamped I PEEL / LINER. The name 'Peel' is not very distinct. A paper label, perhaps removed from an earlier stretcher, is attached to the crossbars. It is inscribed in black ink in what may be an early nineteenth-century hand: 'Pope Paul III / Emp Charles V / alphonso duke of Ferara / by / Titian'. There is also a label for the winter exhibition of 1950–1 at the Royal Academy: 'no. 128' – property of 'Francis Howard Esq. 19 Limeway Terrace, Dorking, Surrey'.

Materials and Technique

The canvas is prepared with a gesso ground. In all the paint samples taken a first layer of a pale warm brown colour has been found. This is likely to be a priming covering the entire surface.

The composition was extensively revised. X-radiographs show that the image was originally bordered on three sides (and perhaps completely surrounded) by a painted frame with a sinuous contour (fig. 1). The frame was not exactly symmetrical and was painted with boldly swept lines: it may have been cancelled before it was finished. A sample taken from the right-hand side of the painting revealed a thick layer of lead white which has been painted over. This might support the hypothesis that a fictive stone frame or cartouche was originally intended.

Changes were made to the face in the centre but there is no evidence that the features were much altered. On the other hand, the profile on the right was originally that of a bearded old man rather than a youth. On the left, another profile was painted over, and in old photographs this is visible to the right of the present profile.

The animal heads were clearly an afterthought. Some of the lower paint layers are apparent in relief: notably, the leafy fringe of a collar just above the wolf's eyes, and a strong diagonal in the shadow to the left of the lion's head. The X-radiographs show broad and vigorous sweeps of paint apparently indicating the folds of a cloak. These pass through the lion's head and overlap those of both the wolf and the dog.

It is not clear whether these preliminary ideas were ever fully executed, and the leafy collar is hard to reconcile with the cloak.

Traces of what is probably vermilion are visible under the brown paint above the cap of the old man. They correspond to a rough patch in the X-radiograph and may represent an earlier idea for a larger cap.

Red paint is also seen lower right, below the dog's muzzle, and a sample confirms that it is present also just above the muzzle. This is composed of lead white and red lake and may be the colour intended for the cloak whose folds have been noted.

The red of the robe worn by the old man is composed of lead white, vermilion and red lake. The ruddy brown spots on the young man's tunic consist of red iron-earth pigment.

There is no good evidence for the claims made in a recent article that the 'head of the old man was painted long after the other two', that the inscription was covered over by the artist and exposed by a later restoration, and that the 'original version' represented the three ages of man.[1] Indeed, it is by no means certain that there was an 'original version' in the sense of a finished picture which was later altered.

Conservation

After being acquired by the Gallery in April 1966 the painting was cleaned and restored in the following June. The abrasion at the edges and in the face of the old man, also the distracting pentimenti in the latter, were made less obtrusive.

Condition

The central face is in good condition. There is considerable abrasion elsewhere, especially in the face of the old man. Increased transparency has made for some distracting pentimenti.

Attribution and Dating

The painting was never, it seems, questioned as a work by Titian during the eighteenth and early nineteenth centuries. Had it been better known in the late nineteenth century, however, its reputation as such might not have survived the competitive scrutiny of the great connoisseurs of that period. It was published as a Titian by Hadeln in *The Burlington Magazine* for October 1924, after it had been included in a loan exhibition that summer at Agnew's.[2] Thereafter, it was accepted by most scholars (including Suida, Tietze, Valcanover, Pallucchini and Wethey).[3] Berenson, however, in his *Lists* of 1957, described it as only in 'great part' by Titian,[4] and he was surely right. Indeed, only the central head is of the quality one would expect, and the head of the young man, puffy and inexpressive, could not be by him. Nor are the animal heads worthy of the artist who painted the puppy in the *Vendramin Family* (see p. 212) or the hound in the full-length portrait in the Gemäldegalerie, Kassel,[5] to mention only two examples.

Nevertheless, the painting was believed to be '100% Titian' by both Hendy, the director of the Gallery, and Gould, the curator, responsible for its acquisition in 1966.[6] The

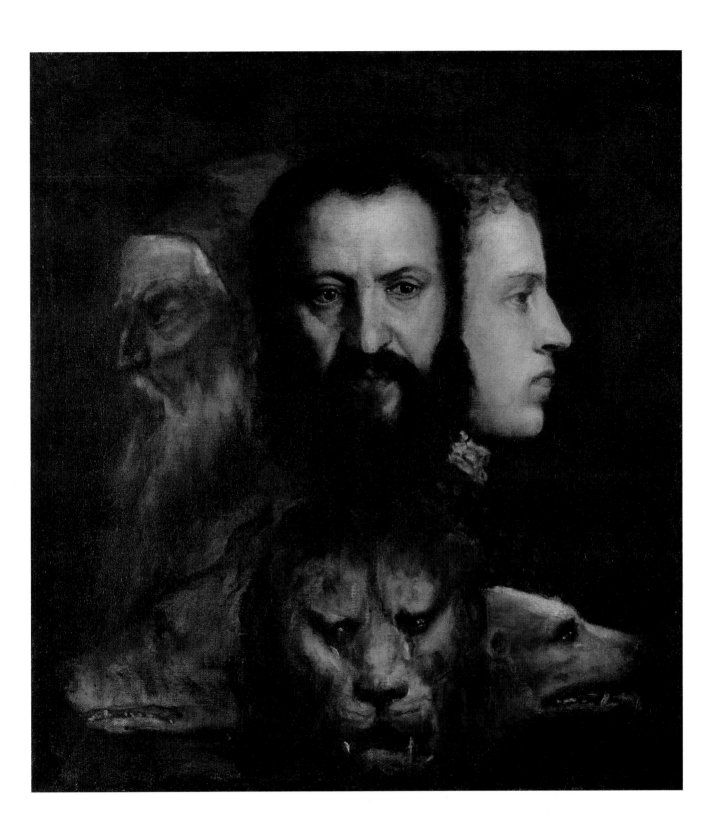

attribution provoked little protest at the time, except from Edgar Wind, who found the 'literal symmetry' to be 'without parallel in Titian's œuvre' and wondered whether it might be the work of Cesare Vecelli.[7] The most recent scholars to have published the painting seem to have no doubts as to its autograph status.[8]

The painting has generally been regarded as a late work, probably of the 1560s, but if the central face is considered in isolation there seems no good reason why it should not have been painted in the 1550s. It compares very well with the bearded head of the full-length portrait in Kassel, which may date from the 1550s or 1560s.[9] The rest of the painting is a different matter and a later date is suggested by the head of the young man, which resembles very closely the heads added by an assistant to Titian's *Vendramin Family* (as discussed below). There are also similarities between the lion's head and the giant carved lion masks on the pedestals of the statues in the late *Pietà*.[10]

Lighting from the right is generally rare in paintings made from life by right-handed artists and is unusual in Titian's portraiture. A notable exception is the portrait of the Doge Andrea Gritti in the National Gallery of Art, Washington, which is designed to be seen from a distance and from below. It was obviously commissioned for a specific setting. The *Allegory*, also lit from the right, may also have played a part in the decoration of a particular room. Of the works for a specific setting recorded as by Titian by contemporary sources, the best candidate would be the paintings he is said to have made for the attic frieze of the Camerino of Gabriel Vendramin (see pp. 225–6), where a heraldic composition and symbolic subject would certainly have been appropriate.

A Posthumous Pastiche?

One explanation of the very mixed quality of the painting would be that it was an unfinished head left in the workshop at Titian's death and then later worked up by another artist. If it is accepted that the painting has (or purports to have) an autobiographical character, this explanation seems more likely. In any case we know that at least one pastiche picture of this kind was manufactured, the so-called *Titian and his Friends* that was in the collection of Charles I and remains in the Royal Collection.[11] The clumsy composition and inconsistent lighting of that picture make it inconceivable that it was Titian's invention. The two flanking figures are copied from independent portraits by him: the self portrait in Berlin, and a portrait from the Kress Collection in San Francisco of a man who holds a letter inscribed 'Di Titiano Vicellio singolare amico'. The central figure seems to represent Andrea de' Franceschi, the chancellor of Venice, and is close to Titian's portrait of him in the Detroit Institute of Art.[12] Another painting possibly in this category is the strange composition known as *Tiziano con l'amorosa* ('Titian and his sweetinge' or 'Titian with a courtesan', as British travellers called it), which enjoyed considerable fame in the seventeenth and eighteenth centuries, when it was in the Borghese collection. It looks like an unfinished portrait of a courtesan, perhaps of the 1530s, to which a caricature of the frail old Titian has been added.[13]

There was an understandable desire to find painted autobiographical evidence of one of the greatest old masters. Posthumous portraits of Titian were made by Pietro della Vecchia (1602/3–1678), which were soon taken for self portraits.[14]

It would be easier to place the National Gallery's painting in the category of false autobiography if the face of the old man bore more of a resemblance to Titian. In addition, the central head does not seem likely to be a study for – or the start of – a portrait such as Titian would have kept in the studio. The almost tearful eyes and the absence of self-possession in the expression make this unlikely. Moreover, the X-radiographs, although clearly revealing that extensive changes were made, do suggest that a triple head was always intended. It may therefore be that Titian accepted the unusual commission for an emblematic painting of this kind, painted the central face and sketched in the other two, but then allowed an assistant or associate to modify and complete it. The youthful face closely resembles those of the children on the left-hand side of the *Vendramin Family*. Since these were certainly completed within Titian's lifetime it is surely likely that this painting also was.

Meaning

The interpretation of the painting, which had been established by the mid-eighteenth century and seems to have survived unchallenged in the nineteenth, is discussed in a separate section below.

When the painting was first published by Detlev von Hadeln in *The Burlington Magazine* for October 1924 the subject was identified as the Three Ages of Man and the animal heads were proposed as a 'symbolical expansion of the idea', alluding to the 'subtlety of old age, the vigour of manhood and probably the frivolity of youth'. Hadeln noted a pair of Venetian woodcuts in which a man of forty was associated with a lion and a man of fifty with a wolf, but conceded that in these the younger man was associated with a calf. And in fact in imagery of this sort the dog is associated with age, not youth. The other problem with this interpretation is that it does not explain the prominence of the Latin text, but this was not as visible in 1924 as it is today.

This takes the form of a superscription divided to correspond with the three heads. It reads: EX PRÆTE / RITO above the old man; PRÆSENS PRVDEN / TER AGIT above the central, middle-aged man; and NI FVTVRV / ACTIONE DE / TVRPET above the youth. Together, this may be translated as 'Learning from Yesterday, Today acts prudently, lest by his action he spoil Tomorrow'. The syntactical oddities are designed to make each part of the sentence accord with the three faces represented below. The faces may thus be taken to symbolise not only the Three Ages of Man but the division of time into past, present and future. The centrality in the inscription of Prudence, *Prudenter*, accords with the idea that this Virtue both attended to past experience and anticipated the future. Some extra significance may be intended by the alliterations, abbreviations and divisions of the words.[15]

Erwin Panofsky and Fritz Saxl, then both *Privatdozenten* at the University of Hamburg, pointed this out in an article

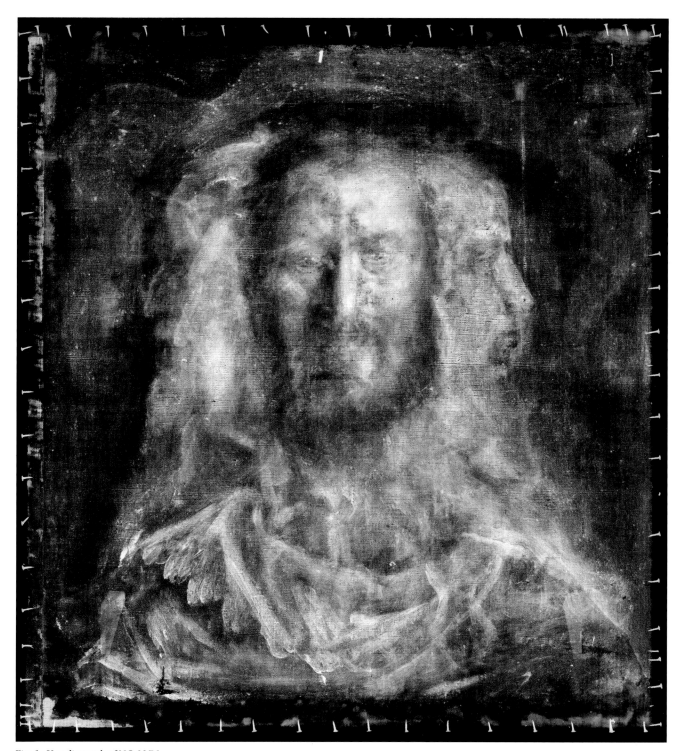

Fig. 1 X-radiograph of NG 6376.

which appeared in *The Burlington Magazine* two years after Hadeln's.[16] They further noted that personifications of Prudence were often given three heads or three faces in addition to the more usual attributes of mirror and serpent. Illustrations of Prudence with a triple face (*vultus trifons*) can be found in fourteenth-century manuscript illumination,[17] and an especially elegant example from the second half of the fifteenth century is the Florentine *pietra serena* relief in the Victoria and Albert Museum inscribed *Prudenza* (fig. 2).[18]

Panofsky and Saxl also suggested a source for the animal heads. Giovanni Pierio Valeriano in his *Hieroglyphica* published in Venice in 1556 proposed as an emblem of Prudence a serpent with three heads – dog, wolf and lion.[19] The source for this monster was given elsewhere by Valeriano as the Hellenistic Egyptian statue of Serapis in the temple near Alexandria described by Macrobius in his *Saturnalia* (probably composed in the early fifth century)[20] and explained as an embodiment of Time: the voracious wolf representing the

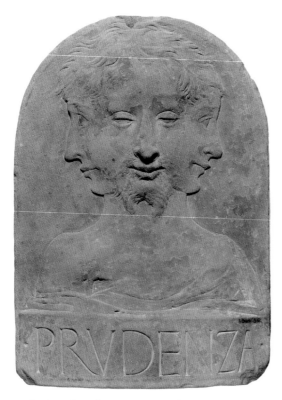

Fig. 2 Style of Desiderio da Settignano, *Prudence*, 1470s.
Stone, 38.4 × 26.7 cm. London, Victoria and Albert Museum.

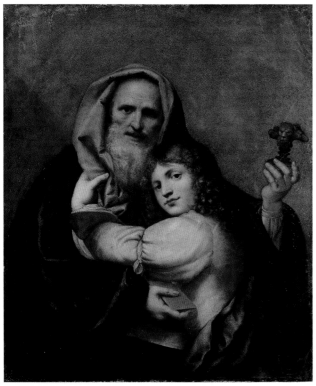

Fig. 3 Pietro Liberi, *Age and Youth*, c.1640. Oil on canvas,
118 × 99 cm. Dresden, Staatliche Kunstsammlungen,
Gemäldegalerie Alte Meister.

past which devours the memory of all things, the vigorous lion representing the present, the dog representing the future, bounding forward, ever full of deceitful hope.

For Macrobius, Serapis was identified with the sun and hence with Apollo. It is clear from Plutarch, who regarded Serapis as a variant of Pluto, that there was no consensus on this point.[21] Such controversies, however, need not have had any relevance for Titian's painting. The connection of the three animal heads with Serapis is mentioned again by Cartari in his *Imagini de i Dei de gli Antichi* published in Venice in 1571. But Macrobius's description also had potential as a psychological drama, and in Giordano Bruno's dialogues *De gli Eroici Furori*, dedicated to Philip Sidney and published in London in 1585, Maricondo, the pessimist, expresses his despair with reference to these animals – the *alan*, *leon* and *can* haunt him at morning, noon and dusk:

> Con l'agro, con l'amaro, con il dolce
> L'esperienza, i frutti, la speranza
> Mi minacciò, m'affligono, mi molce.
> L'età che vissi, che vivo, ch'avanza,
> Mi fa tremante, mi scuote, mi folce
> In absenza, presenza e lontanza.[22]

These six staccato lines may be very freely translated into the following four:

> Experience is bitter, fruits are sour, hopes are sweet.
> The first disturbs, the second disgust, the third assuage.
> Stiff-backed I must the unknown prospect meet
> Though trembling to recall the past and battered by
> the present age.

In this extended sonnet (*sonnetto codato*) even the compensations of hope are false. Whatever the text adopted in the painting, the character of the central face is more suggestive of Maricondo's anxieties than of a bland formula for sagacity. The text may have been in circulation before it was published or it may perhaps have been based on an earlier text.

In the following decade Cesare Ripa published his *Iconologia* which standardised for artists the visual embodiments and attributes of a large range of abstractions. In later editions of this volume Wise Counsel (*Consiglio*) is equipped with a model of the three animal heads as a 'simbolo della prudenza',[23] and although this personification is not frequently found in art it was the subject of a painting by the Venetian Pietro Liberi (1614–1687) now in the Gemäldegalerie, Dresden, in which a benevolent and a venerable old man, embraced by an eager youth, holds a book to indicate his wisdom, and a small model, rather like a chess piece, of the three animal heads to indicate prudence (fig. 3).[24] The picture seems more optimistic, and must also have been much more accessible in its meaning, than Titian's.

The problem that cannot be solved concerns Titian's original intention. This, it seems, was not only to show a triple head without the animal heads, but to paint a triple head with a bearded face as the profile on the right. In this connection it is worth mentioning that there was a type of ancient cameo composed of several conjoined heads commonly

Fig. 4 *Gryllos* cameo. Banded onyx mounted in gold. Uncertain date, 2.95 × 1.95 cm. New York, The Metropolitan Museum of Art, The Milton Weil Collection.

Fig. 5 *Gryllos* cameo. Dappled agate, with granulated gold border made for Catherine the Great. Before 1740, 2.5 × 2.2 cm. St Petersburg, The State Hermitage Museum.

described as a *'gryllos'* cameo. These were probably known by the mid-sixteenth century and they seem to have inspired a remarkable drawing by Parmigianino in which profile bearded heads surround a younger, frontal, female one.[25] A cameo of banded agate in the Hermitage, featuring four bearded male heads and four unbearded, presumably female, heads (fig. 5), is the most remarkable Renaissance exercise in this mode, but its exact date of manufacture is unknown. In other examples an animal head is joined to the human ones (fig. 4), and there are also examples consisting of conjoined animal heads alone.[26] It may be that Titian's painting originated as a design for such a cameo or was at least inspired by one in the possession of a Venetian collector of ancient gems, such as Gabriel Vendramin.

The Painting as an Autobiographical Document

Panofsky, having (together with Saxl) identified the painting as an allegory of prudence in 1926, expanded on this in subsequent publications, citing, for example, the passage in Bruno quoted above, and he eventually developed a theory that the painting was a personal testament by the artist. This theory has obtained widespread support. It is based on the observation that the profile facing left bears some resemblance to Titian himself in old age, as depicted in the Prado self portrait. The central head he proposed as a portrait of Titian's son Orazio (born 1525), and the youth as perhaps his young cousin Marco Vecellio (born 1545, died 1611), who also resided with the artist. He suggested that it commemorated legal and financial measures taken in connection with Titian's estate: notably, the negotiations in the late 1560s for the transfer of the broker's position in the Fondaco de' Tedeschi (the sinecure granted him by the Venetian Republic).[27]

The relative ages of these three members of the artist's family match the three heads fairly well, but the resemblance between the old man and Titian himself is not conclusive; furthermore, Titian's eyes in his self portraits are grey, not brown. There can be no certainty that the central face is a portrait of Orazio, who seems in fact to have had a ruddy brown beard,[28] and the identification of the youth as Marco Vecellio is entirely speculative.

The improbability of Panofsky's identifications has been pointed out by Peter Meller,[29] who proposed instead that the painting might include a portrait of Bernardino Tomitano, a professor of philosophy at Padua whose woodcut portrait published by Jacopo Filippo Tomasini in 1630 does bear a striking (but not a certain) resemblance to the central face here.

Cohen has recently proposed that the painting is an allegory 'not of prudence but of sin'. Noting that sins were commonly personified as animals, she proposes that the animals here recall the leopard, lion and wolf (standing for Luxuria, Superbia and Avarizia) which impede Dante's escape from the dark wood in the opening stanzas of the *Inferno*.[30] This interpretation would only be tenable if the inscription could be ignored (she proposes that it belongs to an earlier version of the painting). Like Panofsky's interpretation, it presupposes that the painting is some sort of personal message – for Cohen, indeed, a confession. The autobiographical emphasis would imply that the painting was entirely autograph, which is hard to believe. It is surely more likely that the painting was commissioned.

The Painting as Political Document

In the inventory of Crozat's collection the painting was simply described as depicting three heads, but in the catalogue of the sale of the Duc de Tallard in Paris in 1756 Pierre Rémy, the expert responsible for the entries on the paintings, proposed that the central head was a portrait of Alfonso d'Este, Duke of Ferrara, presumably on account of a slight similarity to the portrait by Titian (known also in numerous copies) of this notable patron of his.[31] The old man was identified as Pope Julius II, presumably because of the cap and white beard and because the ferocious gaze suited the warrior pope's reputation. The young man was identified more tentatively as the emperor – 'on croit que c'est le portrait de Charles V, étant jeune'. If this theory was not Rémy's, it may perhaps be attributed to Mariette, because we know that the latter supplied the equally ingenious but fanciful interpretation of another painting by Titian in the Tallard sale – that of the full-length portrait in Kassel, which he proposed as a portrait of Dieudonné de Gozon.[32]

The painting was thus seen as a political allegory reflecting the dilemma of the dukes of Ferrara, who, in common with other Italian princes, had to decide whether to support the emperor or the pope. The lion symbolised the duke's courage, the wolf the pope's rapacity, the dog 'la fidélité dans les engagements', all of which rendered the painting 'infiniment curieux & intéressant'. The fury of Julius II had, notoriously, threatened the survival of the duchy of Ferrara, although this was actually because of the duke's allegiance with France. In Lucien Bonaparte's sale the painting was catalogued as *The Triple Mask* – 'the portraits of three of the leading characters of that period; viz. the Emperor Charles V, Pope Julius II, and Alfonso Grand [sic] Duke of Ferrara'.

Someone may have pointed out that Julius II died in 1513, six years before Charles V was elected emperor, because when the painting was exhibited at the British Institution 'Julius II' was changed to 'Paul III'. This merely exchanged one problem for another because Alfonso I d'Este died in 1534, the year of Paul III's election, but a date about then was obviously better suited to the style of the picture than one before 1513. The same title was used – perhaps merely for convenience – in the Carnarvon sale in 1918. The reference to Paul III may also suggest that someone was thinking of Titian's unfinished portrait of Paul III with Alessandro and Ottavio Farnese at Capodimonte (fig. 3, p. 202),[33] for there too we find men of three different ages, and in their relationship political tension and personal rivalry have long been detected.

There are many instances of a political interpretation being given to Italian Renaissance paintings.[34] In the case of the Titian the interpretation must have been influenced by the use of animals in the eighteenth century to symbolise the great European political powers and by the emblematic devices of political caricature. It is not entirely anachronistic to suppose that political allegories could have been made in the Renaissance – there is, for example, a drawing by Amico Aspertini of King Louis XII of France stealing the tiara of Pope Julius II, whose purse is raided by King Ferdinand II of Aragon, and it involves animals as well: the Imperial eagle,

the French cock, the dove of the Holy Ghost. And in 1512 the Bergamasks in Venice celebrated the expulsion of the French from their city by processing with a cock (for France) holding an eel (for Milan) in its mouth, impaled on a pike.[35]

A precondition for the acceptance of the political interpretation was a neglect, even among the learned, of Renaissance emblems. As Panofsky pointed out, Bernard de Montfaucon in his great compendium *L'Antiquité expliquée* seems even to have forgotten the passage in Macrobius on the animals of Serapis.[36] And that Ripa was less frequently consulted is suggested by the fact that by 1765 the meaning of Pietro Liberi's picture in Dresden had been forgotten.[37]

Function

When Hadeln published the *Allegory* in 1924 he suggested that it had been made as the cover for a portrait.[38] The *timpano* – a stretched canvas cover for a painting – seems to have been a Venetian innovation, and was popular in northeast Italy from about 1520. A full discussion of the subject can be found in the first volume of my catalogue of sixteenth-century Italian paintings.[39]

It seems likely that the *Allegory* was intended as some sort of cover, but no portrait has been identified as its pair – with the possible exception of Titian's self portrait in the Prado (this idea, first published by Dülberg, has been repeated by others[40]). However, the *Allegory* is slightly smaller in size than its present stretcher and even if the canvas were originally slightly larger it could have been so only by a very small amount (see the account of the cusping and tacking-edge given in the section on Support), which means that it would always have been too short to cover the Prado painting.

In addition, it may be remarked that although the *Allegory* does have some of the characteristics of a portrait cover – text, formality of design, cryptic and emblematic content – it seems odd to use a painting of heads as a cover, or as a sliding lid, or as a painted reverse for a portrait (and no examples are known). Covers were not only made for portraits, and Panofsky suggested that the painting may have served as the door of a cupboard in Titian's own home.[41]

Previous Owners

No. 157 in the posthumous inventory, compiled on 30 May 1740, of the collection of Pierre Crozat was a painting on canvas measuring 'deux pieds deux pouces et demy de haut sur deux pieds trois lignes de large' and representing 'trois têtes d'homme dont les trois phisionomies ont rapport aux trois animaux qui sont au-dessous d'eux'.[42] This must have been NG 6376. The measurements translate as 71.7 × 65.7 cm, which are somewhat smaller than those of the painting today, but it was on a different stretcher and was perhaps also partly concealed by its frame.

Pierre Crozat (1665–1740), known as 'Crozat le Pauvre' (to distinguish him from his brother Antoine, 'Crozat le Riche'), was an immensely wealthy banker and one of the greatest collectors of the eighteenth century, indeed one of the most avid and discriminating of all collectors of drawings and prints and of engraved gems (he owned the *gryllos* cameo

discussed earlier, see p. 241, fig. 5). His collection of more than four hundred old master paintings seems mostly to have been formed before 1726. He is known to have visited Venice in 1715 and had many contacts with Venetian artists and dealers. But a Venetian picture of this kind could have found its way to northern Europe at an earlier date or indeed have been acquired in Rome, where Crozat went in 1714 to negotiate on behalf of the Duc d'Orléans (as discussed on p. 463) over the acquisition of the collection of Queen Christina of Sweden. The painting was given a high valuation (2,000 livres) in the inventory of Crozat's collection but many paintings were valued more highly (the version of Titian's *Danaë* now in the Hermitage, for instance, at 12,000 livres).[43]

The painting is not mentioned in later catalogues and inventories of the Crozat collection, much of which was bought *en bloc* in 1770 by Catherine the Great. Instead, it found its way, with thirteen other paintings, into the collection of the last Duc de Tallard.[44] Little is known about the formation of this collection, which also included paintings that had belonged to the Prince de Carignan (sold in 1742), the Maréchal d'Estrées (who died in 1737) and the Comte de Morville (who died in 1732), but it seems likely that it was developed greatly after the death in 1728 of the duke's father, Marshal of France under Louis XIV and Ministre d'État under Louis XV.

Our knowledge of Tallard's collection derives chiefly from the elegantly printed, detailed catalogue of his posthumous sale which took place in Paris over a period of ten days between 23 March and 3 April 1756. There were 204 paintings, most of them Italian of the sixteenth and seventeenth centuries. It was a collection in the taste of Rome, and indeed of the Palais Royal, distinguished from those formed by other rich collectors of that period in Paris, almost all of which were, as the author of the introduction to the catalogue observed, filled with 'ces petits Tableaux Flamands et Hollandois'. The notable Dutch and Flemish pictures that were included in Tallard's collection were not small; they included Rembrandt's *Saskia van Uylenburgh in Arcadian Costume* and Rubens's *Watering Place*, both now in the National Gallery (NG 4930 and NG 4815); the collection also included Style of Murillo NG 1286, Poussin NG 39 and (as a Dürer) the Master of Saint Giles NG 4681.

The Duc de Tallard's *cabinet* was noted also for the elegance of its arrangement (there was nothing, the introduction to the catalogue claimed, of the confusion of a shop), with sculpture in bronze and marble, fine furniture and porcelain supporting and punctuating the display of paintings, all of which were in 'riches bordures du dernier gout'.[45]

The *Allegory*, lot 84, was, as explained above, given a long entry expanding on its historical significance. It fetched 660 livres, a fairly high price – slightly more than Rembrandt's portrait of Saskia, considerably more than Veronese's *Finding of Moses*, now in the National Gallery of Art, Washington, and far more than Giorgione's *Virgin and Child*, now in the Ashmolean Museum, Oxford, but less than three rare pieces of Chinese porcelain of olive colour, and much less than a *Cleopatra* by Guido Reni or a pair of famous pastels by Rosalba

Carriera purchased on behalf of 'Madame La Dauphine', who presented them to the king of Poland for the collection in Dresden.[46]

The buyer of the *Allegory* was marked in a copy of the catalogue in the National Gallery as Menabuoni, who was also recorded as the purchaser of a tondo of the *Virgin and Child* by the young Raphael, a *Magdalen* by Feti, a *Temptation of Saint Anthony* by Annibale Carracci, a pair of Bassanos and a portrait by Mor.[47] The Chevalier Menabuoni's *cabinet* in the Hôtel de Limoges in the Rue des Vieux Augustins was described in the year following the sale by Dézallier d'Argenville, who adds the information that Menabuoni was a member of the 'Académie des Arcades de Rome'. This was repeated by Hébert in 1766 in his *Dictionnaire pittoresque et historique*.[48] The collection was 'fort curieux en Tableaux, Bronzes, Estampes, Médailles, Pierres gravées, &c'. The only old master paintings listed were those which Menabuoni had purchased in 1756, but he also owned a 'cerf couché de grandeur naturelle' painted by Oudry, which he is likely to have acquired at an earlier date. In addition, he owned drawings and 'études' by Oudry.[49] Illuminated manuscripts are also mentioned, and a sequence of five hundred portraits of famous men drawn very carefully ('dessinés très-proprement') from portraits in the Uffizi. This hints at a connection with Florence where the Feti and the Annibale Carracci seem to have been exhibited in 1767.[50] Menabuoni is mentioned as resident of Florence by the *Antiquario Fiorentino* in 1771. And it is in Florence that the collection of Giovanni Gasparo Menabuoni (also apparently previously known as Menabuoi) was sold or offered for sale 'Chez M. Vincent Gotti' in 1786 with a catalogue raisonné. Since the Titian is not included we may presume that it had been sold in either France or Florence.[51]

The painting next emerges in the collection of Lucien Bonaparte, the Emperor Napoleon's brother. It is not included in the list of Lucien's pictures compiled shortly after his arrival in Rome in 1804, nor is it included among the etchings after his paintings made in Rome but published by him in London in 1812.[52] This suggests either that it was a relatively late arrival in the collection or that it was not considered an especially valuable item. Since it was sent to London and catalogued by Buchanan at the end of 1814 as a 'chef-d'œuvre, painted at the best time of Titian',[53] it is unlikely to have been acquired in Rome, because works in this category were not allowed to be exported. Many of Lucien's paintings, however, came from Florence and that seems the most likely source. The painting was offered for sale in London on 16 May 1816 as no. 167 and was bought in at 250 guineas. It was illustrated in the *Galerie des tableaux du prince Lucien Bonaparte*, which seems to have been published in 1822, preparatory to the Paris sale held between 25 December 1823 and 15 January 1824, where it was no. 28. It is not clear what sort of sale this was or whether the annotations indicate the offering price, the reserve price or the sale price, but 8,000 francs is written next to no. 28 in the copy now in the Louvre. Its purchaser must have been Samuel Woodburn, who subsequently offered the painting for sale in March 1826.[54]

NG 6376 was bought from Woodburn in 1826, or soon afterwards, for, or by, George Hamilton Gordon, 4th Earl of Aberdeen (1784–1860), scholarly diplomat and statesman, then known as 'Athenian Aberdeen' on account of his travels, much later First Lord of the Treasury and Prime Minister (1852–5), and more than anyone responsible for ensuring that Eastlake became director of the National Gallery.[55] He certainly owned the painting by 1828, when he lent it to the British Institution's exhibition. Aberdeen's taste in pictures was probably fairly conventional[56] but he was certainly attracted by historical portraiture and historical subjects, and not averse to riddles and peculiarities. He bought, for 500 guineas, the portrait of Anton Francesco degli Albizzi by Sebastiano del Piombo, which was sold by Robert Heathcote at Phillips on 5 April 1805 (lot 52, 'the portrait of Lorenzo di Medici, the Outline by Michael Angelo ... a most astonishing performance. Such magnificence could only be produced by the joint efforts of these two celebrated artists, by whom painting is here carried to the zenith of perfection'),[57] and he owned the great Van Dyck portrait of Paola Adorno, Marchesa di Brignole Sale, now in the Frick Collection, New York (in his day believed to be of the Duchess of Savoy).[58] Among other pictures that he is recorded as purchasing are *The Doge and Court of Venice returning from the Ceremony of Wedding the Adriatic* attributed to Jacopo Tintoretto (for 100 guineas at Richard Westall's sale on 9 March 1813)[59] and *Interior of the Inquisition* (for £10 4s. at Jones's auction house, Dublin, 14 May 1812).[60] This last is one of the few old master paintings to remain at his Scottish seat, Haddo House (now National Trust for Scotland). He also owned the very curious picture of a 'wild boy' then attributed to Veronese.[61] Of the paintings that remained with the family until quite recently, the two most distinguished were an *Adoration of the Shepherds* by Veronese now on loan to the Ashmolean Museum, Oxford,[62] and the *Butcher's Shop* by Annibale Carracci now in the Kimbell Art Gallery, Fort Worth.[63]

Presumably Lord Aberdeen kept the Titian in London, at least in 1828, when it was lent to the British Institution. It may have been transferred to Haddo in the middle of the century. It passed in succession to the 5th Earl (d. 1864), the 6th Earl (d. 1870) and the 7th (later created 1st Marquess of Aberdeen and Tamair), who lent it in 1883 to the exhibition in Edinburgh of *Old Masters and Scottish National Portraits*. There it was noted by the *Chronique des Arts* as 'un des plus beaux morceaux de peinture de toute l'exposition',[64] but it seems not to have been known to any of the connoisseurs who might have inspected the picture in London. It was still in the family's possession on 2 October 1901 but its sale seems already to have been discussed.[65]

The 7th Earl was appointed Lord-Lieutenant and Governor-General of Ireland in 1886. He was Governor-General of the Dominion of Canada from 1893 to 1898 and Viceroy of Ireland 1905–15. But high office brought him few rewards, and his philanthropic and other ventures, as well as his wife's charities, seem to have been extravagant. They coincided with the agricultural depression and when he died in 1934 the family estate in Scotland had shrunk to 15,000 acres, from the 75,000 he had inherited.[66] It is not clear when the Titian was sold but the painting was in any case the property of Alfred de Rothschild by 1917.

An account of 'Mr Alfred', a Trustee of the National Gallery, will be found in an appendix (pp. 472–5). The painting was sold shortly after his death by his principal heir, the Countess of Carnarvon (rumoured to have been his illegitimate daughter), at Christie's on 31 May 1918 as lot 157. It was purchased by 'Roberts' for 28 guineas (£29 8s.). Roberts was acting for Francis Howard of Dorking, Surrey (or so we must deduce from the 'F. Howard' written beneath the name Roberts in the National Gallery's copy of the catalogue). Francis Garraway Howard (1874–1954), known as 'Tudie', who had been responsible for organising loan exhibitions at prominent London galleries between 1909 and 1914,[67] was an American-born socialite and philanderer remarkable for his good looks. He became director of the Grosvenor Gallery in 1912 and moved to the Grafton Gallery in 1921. In addition to dealing and collecting for himself, he acted as adviser for Benjamin Guinness and acquired many of the Elizabethan portraits at Ditchley Park. He was the father of Brian Howard (1905–1958), the minor poet and flamboyant homosexual.[68] He was certainly fortunate to acquire NG 6376 for such a low sum. The Aberdeens knew that the painting was of value, for it was insured, according to an inventory of 1899, for £2,000.[69] It was, it would seem, not a painting to Rothschild's taste. Perhaps he acquired it as an investment or as part of a group, and it was taken straight from store to the saleroom after his death. It was, however, careless to let it sell at such a low price.

The painting was borrowed for an exhibition at Agnew's in the summer of 1924, and the firm's books reveal that it was valued, presumably for insurance, at £9,000.[70] Howard died in 1954 and his collection of pictures – old masters and historical portraits – was sold at Christie's on 25 November 1955. There were 55 old masters and 66 historical portraits. The Titian, lot 44, was by far the most valuable item in the first category (or in the second, to which it also had some claim to belong). It was bought by Legatt for 11,000 guineas (£11,550) together with an American partner, probably David Koetser. The National Gallery's Board of Trustees had authorised the director to bid, but the condition of the painting caused him some anxiety and it was also thought unwise to compete in the saleroom against what was rumoured to be determined opposition.[71] In February 1958 an application to export the picture from London to Switzerland was made, with a valuation of £20,000. An objection was made on account of the interest expressed in it by the National Gallery of Scotland and the application was withdrawn. In February 1966 another application was made, this time with a valuation of 2,100,000 Swiss francs (then equivalent to about £173,000). In April 1966 the painting was presented to the Gallery by David and Betty Koetser. David Maurits Koetser was the son of Henry Koetser, an art dealer who had moved to London in 1923. After working in London, at first in partnership with his brothers and then independently, David Koetser moved to New York in 1939. In 1966 he decided to

retire to Switzerland for reasons of health and the presentation of this picture was connected with this reconsideration of his professional position. He soon resumed dealing, based in Zurich. The collection of old master paintings that he owned together with his wife was formed into a foundation in their name, and was loaned, and eventually bequeathed, to the Kunsthaus in that city.[72]

Provenance

See above for a full account. Pierre Crozat before his death in 1740; Duc de Tallard before his death in 1756; lot 84 in the Duc de Tallard's posthumous sale, 23 March–3 April 1756, where bought by Giovanni Gasparo Menabuoni of Paris and Florence; Lucien Bonaparte by 1814; no. 28 in Bonaparte's sale of 25 December 1823–15 January 1824, Paris; with Samuel Woodburn in London by March 1826; the 4th Earl of Aberdeen before 1828; by descent to the 7th Earl; still his property in 1901; Alfred de Rothschild, by 1917; on his death on 31 January 1918 inherited by Almina, Countess of Carnarvon, by whom sold at Christie's on 31 May 1918, lot 157, where bought by 'Roberts' for Francis Howard. Howard's posthumous sale 25 November 1955 (lot 44), where bought by Legatt. Presented in April 1966 by David and Betsy Koetser.

Drawings

A drawing in the Uffizi Galleries of an old man with a book and an owl, wearing a heart on a chain, which has been attributed to Titian by some scholars (including Hadeln in his study of Titian's drawings), evidently represents *Good Counsel* (as recognised by Caldwell in 1973[73]) and has thus been connected with the National Gallery's painting; but the attribution (as acknowledged by Tietze in 1944[74]) is not well founded, nor is there any real connection between the appearance of the old man in the drawing and the old man in NG 6376.

Exhibitions

London 1828, British Institution; Edinburgh 1883, *Old Masters and Scottish National Portraits* (335); London 1924, Agnew's; London 1950–1, Royal Academy Loan Exhibition (209); London 2003, National Gallery (34); Madrid 2003, Museo Nacional del Prado.

Frame

The painting is in a carved and gilt wood frame with a prominent oak-leaf wreath moulding with hollows at either side, pearls at the sight edge, and leaves on a back ogee moulding. The wreath runs from a ribboned centre on each side. The frame, probably Italian and of the late sixteenth or seventeenth century, came from the Gallery's stock. It was reduced (by cutting at the ribbons) to fit the painting, and toned to the instructions of Philip Hendy soon after the painting was acquired by the Gallery in 1966.[75]

Appendix

TRIPLE HEADS IN RENAISSANCE VENICE AND PADUA

A likely source for Titian's painting as it was completed must, as mentioned above, be Valeriano's *Hieroglyphica* of 1556. It has also been suggested that the artist may have been inspired by the woodcut illustrations of the *Hypnerotomachia Poliphili*, the allegorical romance published by the Aldine Press in Venice in 1499. A triple human head occurs in the illustration of a herm facing page y, and a triple animal head occurs in the illustration on the opposite page – both are shown carried in procession in succeeding illustrations (pp. y I verso and y II recto). Artists certainly used the *Hypnerotomachia* (Garofalo's *Pagan Sacrifice*, NG 3928, is a case in point) and that Titian may have referred to it when painting this *Allegory* is suggested by the leafy collar in the X-radiograph, which, as Madlyn Kahr pointed out, resembles the leaves in the woodcut.[76] This connection is uncertain, however, for the heads on the herm are all of the same age, and the animal heads are not distinctly characterised, thus the *Hypnerotomachia* would have been at best a supplementary source.

The *Saturnalia* of Macrobius was familiar to Renaissance scholars and the account of the triple-headed attribute of Serapis which it contained was influential in many different ways, chiefly, perhaps, because it was adopted by Petrarch in his Latin epic *Africa*.[77] But in Petrarch the animal with three heads is an emblem of Time. It probably also had this general significance when it was combined with Fortuna on the reverse of Giovanni Zacchi's medal of Andrea Gritti in 1536.[78] Before Valeriano we cannot assume that the connection with Prudence would have been made, nor in fact can we be certain that the triple face or triple head (*vultus trifons* or *tricipitium*) was invariably the emblem of Prudence.

It is important to emphasise this because Manfredo Tafuri, in a brilliant and influential account of Venice in this period, has proposed that the popularity of triple heads in Venetian art reflects ideals widely shared by the Venetian patriciate.[79] But there seems no good reason why these ideals should not have been given explicit rather than cryptic expression. Moreover, there is little real consistency between the images cited, and in some cases other interpretations of their meaning are more likely.

The three best-known examples of the use of such heads in Venice are the triple boy's head in the centre of the highest of the marble steps of the Virgin's throne in the altarpiece by Fra Antonio di Negroponte of the mid-fifteenth century in S. Francesco della Vigna; the miniature triple head on the ledge of the portrait of a young man attributed to Giorgione and now in the Museum of Fine Arts, Budapest; and the helms crested with three heads supported by the spears held by soldiers dressed *all'antica* which are carved in high relief at either end of the second floor (the higher of the two *piani nobili*) of the Palazzo Trevisan in Canonica (between S. Marco and S. Zaccaria) built in the early decades of the sixteenth century. The first of these examples features three identical faces and may in fact be a Trinitarian symbol (such as is certainly the case with the three heads in the tympanum of the Tabernacolo della Mercanzia in Orsanmichele in Florence, also cited by Tafuri as an emblem of Prudence). Also, it seems odd to consider these three heads in isolation when other, similar, single heads of children occur elsewhere on the throne – heads that would be difficult to associate with Prudence. In

the case of the Palazzo Trevisan carvings, the device must surely have been adopted as a reference to the family name.[80]

For the purpose of the *Allegory of Prudence* the most intriguing of the earlier triple heads in Venice are those that were carved, in the early sixteenth century, in the Istrian stone pilasters which flank the main entrance of Palazzo Vendramin at S. Fosca (fig. 6). Whereas Tafuri asserted that these heads (like those on Palazzo Trevisan) represented the Three Ages of Man – something earlier denied by Arasse – it must be admitted that the bearded head does not look old, and the difference between the other two is not marked.

There was also an 'imagine plastica di una figura tricipite' on the façade of the Dondi palace in Padua. One is also incorporated on the façade of Alvise Cornaro's Odeo – in this case certainly derived from the woodcut in Valeriano's *Hieroglyphica* (Valeriano was close to Cornaro).[81]

For Tafuri the idea of the *tricipitium* is also reflected in other artistic representations of the Three Ages of Man, notably Giorgione's *Three Philosophers*, and other striking representations of the Three Ages were made in Venice during this period, notably the warriors of three generations who support Doge Alvise Mocenigo's sarcophagus, carved by Pietro Lombardo for SS. Giovanni e Paolo in the 1490s, and the frontal head of a young man, perhaps representing Saint John, between a pair of profile busts, apparently of Christ and an older bald and white-bearded apostle, in the panel by Giovanni Agostino da Lodi in the Accademia. This last painting may well be relevant for the form, if not the meaning, of Titian's painting.[82]

Fig. 6 Triple head. Detail of the pilaster from the façade of the Palazzo Vendramin, Venice.

NOTES

1. Cohen 2000, pp. 51–2, 62, 69.

2. Hadeln 1924.

3. Suida 1935, p. 89; Tietze 1936, I, p. 293, plate 249; Valcanover 1960, II, p. 49, plate 120; Pallucchini 1969, p. 317; Wethey 1971, pp. 145–6, no. 107.

4. Berenson 1957, p. 187.

5. Wethey 1971, p. 73, no. 1; Valcanover *et al.* 1990, p. 290, no. 46 (entry by Jürgen M. Lehmann).

6. Report addressed to the Board of Trustees, dated 3 March 1966.

7. Wind 1967, pp. 260–1, note 4.

8. Pedrocco 2001, p. 281 (entry by Maria Agnese Chiari Moretto Wiel); Humfrey 2004, p. 176, no. 64.

9. Wethey 1971, p. 73, no. 1 (as the Duke of Atri); Valcanover *et al.* 1990, p. 290, no. 46 (entry by Jürgen M. Lehmann).

10. Wethey 1969, pp. 122–3, no. 86, plate 136; Valcanover *et al.* 1990, pp. 373–5, no. 77 (entry by Giovanna Nepi Scirè).

11. Shearman 1983, pp. 268–71, no. 294.

12. Wethey 1971, p. 100, no. 34, plate 63 (Detroit); pp. 102–3, no. 39, plate 91 (San Francisco); pp. 143–4, no. 104, plate 209 (Berlin).

13. The Morrison Collection, Sudeley Castle (currently in store). Wethey 1971, pp. 181–2, no. X 102. Hume (1829, p. 69) knew the painting only from a print and believed it to represent Titian and his wife. An intelligent explanation of this picture was supplied by Jameson (1846, pp. 51–2) when it was in the Morrison house in Harley Street, London. She believed it to be a portrait of his daughter, Lavinia, left unfinished by Titian at her death, and that 'the head of Titian, the too significant action, the death's head in the casket, and the Latin inscription' were added later. Waagen (1857, p. 110) agreed that it was partly by a 'scholar'. A related painting in the Hermitage, *La Seduzione*, is attributed to Cariani (Pallucchini and Rossi 1983, p. 122, no. 40).

14. Aikema 1990, pp. 28, 143, nos 173, 174; Wethey 1971, p. 180, nos X 93, X 94.

15. See especially Lebenstejn 1973, also Arasse 1984, p. 296.

16. Panofsky and Saxl 1926, pp. 177–81. The article originated as a letter responding to an enquiry by Campbell Dodgson, who translated it and submitted it to *The Burlington Magazine*.

17. Sherman 1996, p. 127, fig. 34a.

18. Pope-Hennessy 1964, I, pp. 145–6, no. 121; III, fig. 140.

19. Valeriano 1556, XXXII, fol. 229r [*De tricipitio*].

20. Macrobius, I, XX, as quoted by Panofsky 1930, p. 6, note 1.

21. *De Iside et Osiride*, 28 and 78.

22. Bruno 1585, II, chapter 1.

23. Okayama (1992, p. 48) indicates that the emblem is common to illustrations of *Consiglio* in Italian, Dutch and Flemish editions of the *Iconologia* in the seventeenth century, but in fact the first illustrated edition, the Italian edition of 1603, does not include it.

24. Weber 1995, pp. 151–7. Then considered as a studio replica, it is now classed as an autograph work (Marx 2005, II, p. 331, no. 1050, gallery no. 530).

25. The drawing, in the Fondazione Horne, Florence, was in the Arundel Collection. Popham 1971, I, p. 78, no. 130; III, pl. 423.

26. For the eight heads see Kagan and Neverov 2001, p. 178, no. 373/191. Inv. No. K2762. This cameo was purchased by Catherine the Great together with the gem cabinet of the Duc d'Orléans and was previously in the Crozat collection. It was first published in Crozat's collection in 1741 as no. 1312, then by Arnaud and Coquille in 1784, II, p. 64. For the cameo of three heads and a ram see Kris 1932, fig. 16 on plate XXV and p. 29 (now Metropolitan Museum of Art, New York, 39.22.33). There is a replica of this cameo in the British Museum. For a cameo of three animal heads see Arnaud and Coquille 1784, II, pp. 171–4 and pl. 65. This is also in the Hermitage.

27. Panofsky 1930, pp. 1–35 (esp. pp. 1–8; Panofsky 1955, pp. 149–51; Panofsky 1970, pp. 181–205.

28. The point about Titian's eyes was made in a letter to the director of the National Gallery by Hans Buhr, 24 July 1987. For Orazio's beard see the remarkable wax portrait medallion in Humfrey 2004, pp. 368–9, no. 202 (entry by Godfrey Evans). Humfrey writes (p. 176) that 'it may be plausibly argued that the central figure [in the painting] is compatible' with the portrait in the wax. In fact the difference is such as to provide a conclusive case against Panofsky's interpretation. Charles Hope points out to me that the wax appears to be derived from the medal by Ardenti rather than the other way around, but it may still have been made with a knowledge of the colour of Orazio's beard.

29. Meller 1980, p. 324.

30. Cohen 2000, especially pp. 56–7. Her theory was first advanced in an earlier article on animals in Titian's paintings (1998, p. 197).

31. Rémy 1756, lot 84. For the portrait of Alfonso see Wethey 1971, pp. 94–5, no. 26, plate 40 (but this is not the original, as he supposes).

32. Mariette 1720, X, p. 329. Wethey 1971, p. 73, no. 1.

33. Wethey 1971, pp. 125–6, no. 76.

34. For example, Walpole 1747, p. 75, proposing that Bordone's *Augustus and the Sibyl* represented the Emperor Charles V praying to the Virgin for forgiveness for the Sack of Rome.

35. For Aspertini see Faietti and Scaglietti Kelescian 1995, pp. 264–7. For the Bergamasks see Sanuto 1879–1903, XIII, 1886, col. 455 (8 February 1511, modern 1512).

36. Panofsky 1970, p. 196, note 43.

37. Weber 1995, p. 151.

38. Hadeln 1924. The theory is repeated by Suida (1935, p. 89).

39. Penny 2004, pp. 99–101.

40. Dülberg 1990, pp. 52–3, 296.

41. Panofsky 1970, p. 202.

42. Stuffmann 1968, p. 76.

43. Ibid., pp. 11–35. Also Cornaro exhibition 1980, p. 200, no. 7, entry by Gunter Schweikhart.

44. 'Tallart' in *Biographie Universelle* but 'Tallard' in the sale catalogue and most early sources. The thirteen Crozat pictures are identified in his sale catalogue (Tallard 1756).

45. Tallard 1756, introduction p. 3; *Avant-propos*, p. iv.

46. The Rembrandt (lot 156) sold for 602 livres; the Veronese (lot 107) for 400; the Giorgione (lot 88) for 200; the porcelain (lot 1040) for 820; the Reni (lot 61) for 1,520; and the Rosalba (lot 117) for 2,800. Huge prices were also paid by the king of Prussia (notably 7,500 livres for Rubens's *Adoration*).

47. Lots 14, 27, 54, 95, 135; copies of the catalogue recorded in the Getty Research Institute mark these as acquired by M. de Versure or M. de la Versure but in some cases as acquired by Menabuoni (spelled variously), bidding for him.

48. Dézallier d'Argenville 1757, p. 206; Hébert 1766, I, pp. 84–5.

49. Opperman 1977, I, pp. 490–1, no. P355.

50. *Antiquario Fiorentino* 1776.

51. Gotti also offered a collection of 77 paintings formed to 'illustrate the entire history of Tuscan art'. This collection was still on offer in 1793, when the catalogue of 1786 was reissued. It is not clear if the collection was still connected with Menabuoni, whose son's natural history collection and chemistry laboratory are cited in a guide of that year (Anon. 1793, pp. 277–8).

52. Edelein-Badie 1997, p. 279, no. 263.

53. Buchanan 1824, II, pp. 277–8. He mentions the price of 500 guineas.

54. Information kindly communicated by Burton Fredericksen.

55. Robertson 1978, pp. 139–40, for Aberdeen and Eastlake. For a brief survey of Aberdeen and his connection with the arts generally see Smith 2003.

56. Evidence for his taste in paintings is not easy to find but notebooks survive for his continental tour of November 1802 – February 1803 (British Library Add. MS 43335 and 43336). Raphael's portrait of Leo X, which he saw in the Louvre, he considered to be 'the finest in the world' (43335, fol. 39v) and he was especially struck by the works of Veronese, Rubens and Luca Giordano in Genoa (43336, fols 60–62).

57. Now in the Museum of Fine Arts, Houston, nos 61–79. See Howard 1988, pp. 457–9. Also Farington 1978–98, VI, 1979, pp. 2211, 2246, 2278.

58. Frick Collection 14.1.43.

59. Phillips, London, 9 March 1813, lot 84. Sold Christie's, London, 29 May 1849.

60. Said to be from Lord Bristol's collection, lot 10.

61. Sold at Sotheby's in the 1940s. For some years in the collection of Arnold Haskell. Now at the Château de Blois, attributed to Sofonisba Anguissola.

62. Humfrey 2004, pp. 116–17, no. 58. In July 1861 the 5th Earl offered this painting to the National Gallery together with the portrait of Cardinal Pucci then attributed to Raphael (now acknowledged as by Parmigianino and on loan to the National Gallery), for £1,000 each (Board Minutes, IV, pp. 255–6). The portrait, later sold to his kinsman, the Marquess of Abercorn (as was the 'Duchess of Savoy' by Van Dyck), had belonged to the brother of the 4th Earl, Sir Robert Gordon (1791–1847), when it was exhibited at the British Institution in 1837.

63. Malafarina 1976, p. 88, no. 5 (when still in the Aberdeen collection). Sold by the National Trust for Scotland on behalf of the Haddo House endowment, Christie's, London, 7 July 1978, p. 138.

64. 'C' 1883, p. 252.

65. Letter of 2 October 1901 from the 7th Countess cited by Smith 2003, p. 49.

66. Gordon 1985, p. 196.

67. He was Honorary Secretary for the National Loan Exhibition at the Grafton Gallery 1909–10 and organiser and catalogue author of the National Loan Exhibition at the Grosvenor Gallery 1913–14.

68. For Howard generally see Lancaster 1968, pp. 6–12.

69. Haddo House estate archives.

70. Microfilm of 'Property Received' books, vol. for 1923–34, fol. 21, stock no. 781c.

71. Memorandum of 25 November 1955, minute 197. Also NG 1/13, Minutes of the meetings of the Board of Trustees, pp. 258 and 269.

72. Waddingham 1987.

73. Caldwell 1973, pp. 319–22.

74. Tietze 1944, p. 315.

75. Annual Report for January 1965 – December 1966, p. 124.

76. Kahr 1966, p. 125.

77. Book III, lines 162ff.

78. Habich 1922, pl. LXXXV, 5.

79. Tafuri 1995, pp. 10–13, plates 11–13.

80. There is a similar trio, perhaps a *pasticcio*, in a palace corbel in Campiello S. Maria Nova, Venice.

81. Puppi 1980, pp. 199–200, Stucco (7), entry by Gunter Schweikhart.

82. Pointed out to me by Jacqui McComish. Moschini Marconi 1955, p. 170, no. 190.

NG 6420
The Death of Actaeon

*c.*1559–*c.*1575
Oil on canvas, 178.8 × 197.8 cm

Support

The measurements given above are those of the stretcher. The original canvas is a medium-weight twill weave 2/1 (that is, with the threads that are vertical to the painting running over two horizontal threads and under another), with 13 vertical and 18 horizontal threads per centimetre. This canvas has been paste-lined on to a similar type of canvas. The original canvas extends to the edges, except at the centre of the left side, where it is 1 cm short; at the top right corner, where it is 2 cm short; and at the upper edge, where it is slightly turned over (but nowhere by more than 1.5 cm). Cusping is apparent at all four edges, although it is much more pronounced at the left and right. The painting must, therefore, always have been of approximately the size that we see now.

Approximately in the centre of the canvas there is a vertical seam which can easily be discerned. It crosses Diana's left hand and the hind leg of the hound furthest to the left. A triangle of canvas, twill but apparently of a somewhat heavier weave, has been added in the top right corner of the left-hand portion of canvas.

There is an irregular loss in the canvas at the lower right-hand corner, the maximum width of which is 30 cm and the maximum height 24 cm.

The stained deal stretcher with crossbars carries a label for the Royal Academy exhibition of 1893 on its upper member; there is also, at the top left, a circular label with serrated edges inscribed HHB/F200. Beside this 'No. 166' is written in blue pencil, and a numeral (either '16' or '10') is written in black paint. On the lower right-hand corner of the stretcher there is a small rectangular paper label inscribed 'no. 3...' – the second digit has been largely eradicated.

Materials and Technique

The canvas was given a thin gesso ground and then a dark *imprimitura*. Much preliminary drawing was made with a brush and lead white (in some cases perhaps mixed with other pigments), and this reveals numerous changes of plan. At one time Diana had both flying hair and a flying scarf. Her left arm was raised higher, several positions were tried for her bow and, most notably of all, her right arm was originally not raised but hung by her side, only a little bent. The landscape elements appear to have been greatly modified. A major tree planned for the distance on the right was moved into the foreground. The area of most action has also been most repeatedly worked over. It seems likely that Actaeon's body was not at first so far to the right. Parts of the painting are more finished than others, and some parts more credible as deliberately unfinished than others.

In a recent article the late Roger Rearick claimed that Diana 'clearly did not at first shoot an arrow'. However, the

X-radiographs (fig. 2) show that her outstretched arm was holding a bow in each of the several positions proposed for it. The original idea may have been that she should simply hold the bow aloft, but it seems more likely that we were to suppose that she had released the string and the arrow has been discharged. It is not clear. Rearick also supposed that the two sides of the composition were developed independently: when the Diana was laid in, 'the episode of Actaeon devoured by his hounds had not even been sketched in'. There is no technical evidence to support this – nor any to contradict it.[1]

Conservation

The painting was said to be very obscured by darkened varnish in 1914 (see below) and it is likely that it was cleaned shortly after its sale in 1919–20 to Lord Lascelles, probably in Italy.[2] The painting was surface-cleaned and revarnished on acquisition by the Gallery.

Condition

There are numerous flake losses along all of the edges but the worst of these are on the right-hand side of the lower edge and along the seam. The losses form lines which are slightly suggestive of creases caused by folding or rolling. There is a pronounced craquelure, especially in the dark areas. Diana's flesh is generally flattened and abraded. Her face has been retouched, giving her cheek a smooth plumpness and perhaps modifying her lips and nose. The lake has almost entirely faded from her dress. One notable effect which may not have survived is the reflection of Actaeon's legs. The edge of the water is no longer apparent, and other shapes in the water either have re-emerged with the increased translucence of the paint or perhaps were never cancelled. It is generally hard to distinguish between forms which seem vague because they are unfinished and those which are pentimenti or are abraded.

Attribution, Dating and Status

The painting has generally been accepted as by Titian. The first indication of any doubt comes in Roger Fry's review published late in 1911 of the exhibition of Old Masters at the Grafton Galleries. He was 'inclined to think' that the picture was by Titian but with significant additions by assistants. The figure of Diana was 'splendidly constructed and the design here shows all of Titian's power of counterchanging silhouettes of light on dark and dark on light', but the drawing of Actaeon and the dogs was 'heavy and dull' and the colour 'too hot and brown'.[3] He seems never to have considered the possibility that the painting was not finished. I know of no significant opposition to the attribution since then, although Harald Keller in 1969 and Roger Rearick in 1997, among others, have suggested that another hand finished the figure of Diana.[4] Gould, who believed the entire painting to be substantially complete, dismissed this as a 'quaint idea'.[5] If, as seems likely, the painting was in Titian's studio at the time of his death, his heirs may well have wished to give it a more marketable appearance without altering its status as a late work by the master himself. If this were the case they would

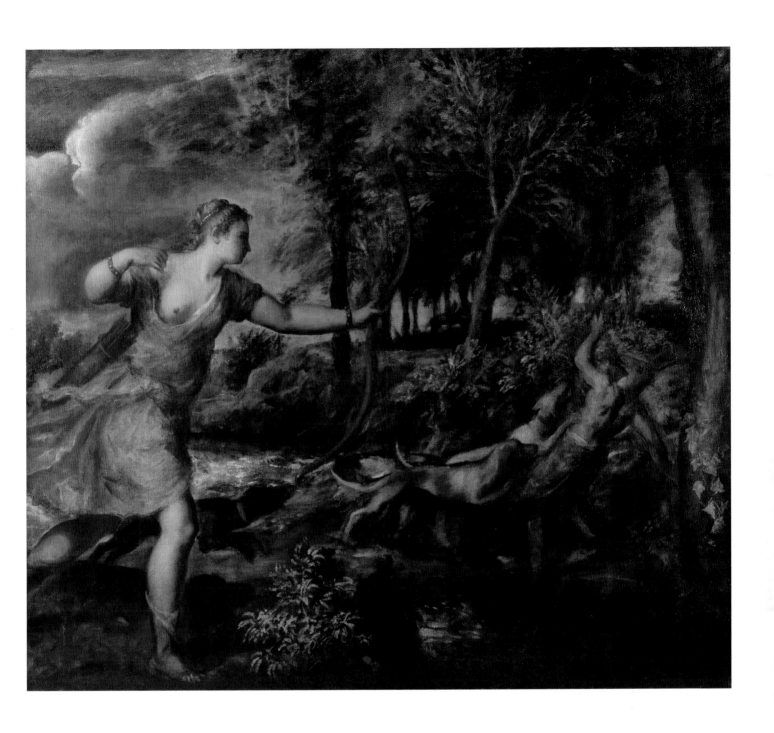

have given the goddess, and especially her face, a more resolved appearance but left the remainder of the painting as it was at Titian's death. The retouching of the goddess's face makes it hard to assess the character of the original painting in this area, but the impassive profile is certainly not typical of Titian. Although there is some resemblance to the head of the angel in the *Annunciation* in S. Salvatore – a painting that had evidently been completed by 1566, when Vasari saw it – the angel's features are more mobile.

Titian died in 1576, but it is likely that many of the paintings on which he was still working, or rather on which he sporadically worked, had been begun long before. In a letter to King Philip II of Spain dated 19 June 1559 Titian wrote of 'due poesie già incominciate, l'una di Europa sopra il Tauro, l'altra di Atheone lacerato da i cani suoi' ('two poetic pieces which are already begun, one of Europa upon the Bull, the other of Actaeon torn apart by his own hounds'). He worked on the painting of Europa together with an Agony in the Garden, reporting on his progress in a series of letters and announcing their completion in a letter of 26 April 1562.[6] It therefore seems reasonable to suppose that he was not working much on the *Death of Actaeon* in these years. It also seems reasonable to suggest that much of the painting that we do see belongs to the late 1560s but that some changes and additions, notably the explosive bush in the foreground, may date from the 1570s.[7]

Fig. 1 Titian, *Religion succoured by Spain*, 1572–5. Oil on canvas, 168 × 168 cm. Madrid, Museo Nacional del Prado.

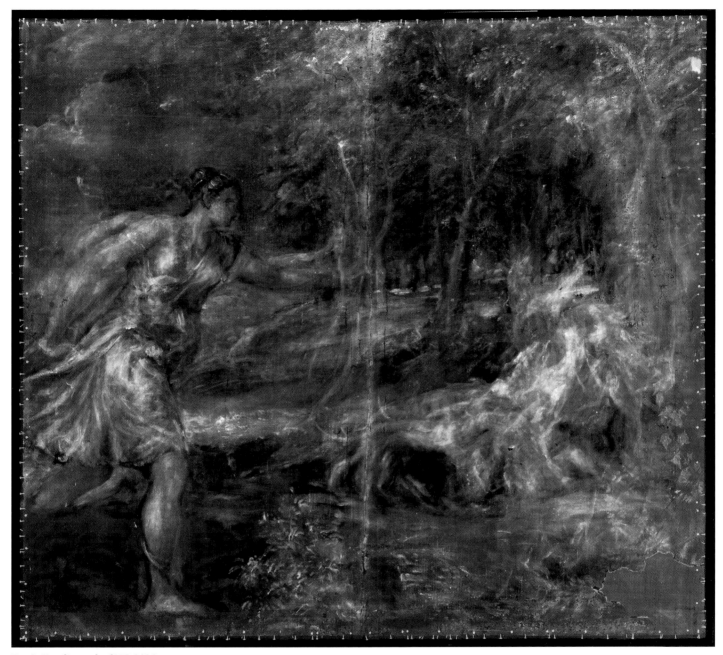

Fig. 2 X-radiograph of NG 6420.

Cecil Gould, writing in *Apollo* in June 1972 when the National Gallery was appealing to the public to help acquire the painting, argued that it represented the artist's late style, in which he had abandoned the 'crimson draperies and ultra-marine skies' of his earlier work. The *Rape of Europa* (Boston, Isabella Stewart Gardner Museum), he claimed, was one of the 'last examples of the polychrome style of painting that Titian had followed ... throughout his long career until that moment'.[8] However, we find intense greens and blues and reds (vermilion as well as crimson) in both the Fitzwilliam Museum's *Rape of Lucretia*, sent to Spain in 1571 and engraved that same year, and the *Flaying of Marsyas* in Kromeriz, which Gould lists among the artist's last works. It is true that after 1560 Titian began to apply these colours in scumbles,

often with his fingers, so that they only half belong to any of the forms and seem to float on the surface of the painting: evidently he painted them last. In the case of the *Flaying of Marsyas*, which, like the *Death of Actaeon*, is likely to have been in the artist's workshop when he died, one can still see passages of smoky preliminary painting (notably the ghostly body of Apollo) but the blood, the dogs' tongues and the ribbons in the trees are brilliant red. But perhaps the most valuable comparison is with *Religion succoured by Spain*, which Titian sent to Philip II in September 1575 (fig. 1). Here there is clearly no reluctance to employ deep rose and blue.[9]

The absence of such colours in NG 6420 is, however, only one of the reasons for supposing that Titian did not consider it complete. In other late paintings with a comparably

asymmetrical composition (*Perseus and Andromeda* in the Wallace Collection is the best example; see p. 200) he contrived to give the entire surface a coherence which NG 6420 does not possess, and the impact of blurred areas of painting (turbulent water, the smoke of torches, indecipherable distances, light piercing foliage) is enhanced by contrast with forms that were more fully modelled, if still often roughly painted, and, indeed, with some that were more detailed (Midas's diadem in the *Flaying of Marsyas* and Lucretia's ear jewel).

To claim that the painting was never finished is not to deny its appeal to Titian, who may well have relished the gradual evolution of his own work, and even come to dread separating himself from his inventions. Nor is it to deny its appeal to younger artists, who seem to have been inspired by the absence of local colour as well as the rough handling in his late paintings. Nor would such works have been unappealing to collectors. As we shall see, this painting was described as incomplete in what seems to be the earliest reference to it after Titian's death, as it also was by Sir Abraham Hume, a later owner, who described it as 'a great painting never finished but quite beautiful' ('un gran quadro non terminato ... ma bello assai').[10]

Subject and Literary Source

As noted above, Titian mentioned a painting of the Death of Actaeon in a letter to King Philip II, describing it as one of two 'poesie' which he had already begun ('già incominciate'). The other paintings of this poetic type that he made for Philip II take their subjects from Ovid's *Metamorphoses*. This is certainly true of *Diana surprised by Actaeon* (now in the collection of the Duke of Sutherland, on loan to the National Gallery of Scotland), which shows the moment of speechless shock – the silence emphasised by barking dogs – when Actaeon disturbs Diana and her nymphs at their bath. Ovid relates how the goddess, not having her arrows to hand (Titian is careful to paint her quiver hanging on a tree), splashes water on his face and dares him to tell the world what he has seen – 'if tell he can'. NG 6420 illustrates the sequel: Actaeon flees; surprised at how fast he is moving, he senses a change in himself; he stops to drink at a stream; he discovers from his reflection that he has become a stag; finds that he cannot speak and is then torn to pieces by his own hounds.[11]

The subject was not entirely new in Renaissance art. A tondo attributed to Matteo Balducci in a private collection shows Diana splashing Actaeon, who is already transformed and is being attacked by his hounds, and there are cassoni panels by Sellaio illustrating the story in Yale University Art Gallery.[12] But it is rare and it may be that Titian had never seen another painting or other representation of the subject.

It has been generally assumed that the woman in Titian's painting is Diana – certainly by Michele Silos in his poem on the painting published in 1673 – 'Hic sylvipotens Diana curvu / Arcu seposito, sinumque nuda'.[13] But, as Gould observed, 'in Ovid's account Diana was not present at the scene of Actaeon's death ... Actaeon had left her naked and without

her weapons only just before.' And, moreover, 'the female in the present picture does not wear Diana's crescent in her hair (as the goddess does in both of Titian's previous depictions of her in the series).'[14] The second of these three points is not entirely just, for the fact that Ovid's narrative speeds forward as Actaeon rushes to his death need not suggest that his end was instantaneous.

As Gould noted, the problem of the absent crescent had earlier exercised the Abbé Fontenay, the author of the text for an engraving of the painting made in the 1790s for the *Galerie du Palais Royal*. Fontenay altered the title from *Diane poursuivant Actéon* to *Mort d'Actéon*: 'Rien cependant ne caractérise cette Déesse. Il faut plutôt croire que le Titien n'a voulu qu'une des Nimphes de Diane, poursuivant ce jeune Prince.' ('Nothing identifies her as the goddess. So we must believe that Titian only intended her as one of Diana's nymphs, in pursuit of the young prince.')[15] This explanation seems inadequate, not so much because the nymphs too were last seen naked, as Gould pointed out, but rather because it is strange to give a mere nymph such prominence in the narrative.

Gould proposed that the figure may not be intended 'as a literal presence but rather as a personification of Diana's vengeance' and in favour of this he observed that 'there was no need for anyone to shoot at Actaeon (as he is shown already half a stag, and already being attacked by his hounds), that (at least now) the female figure's bow has no arrow and no bow string, and that in an earlier state, as shown in the X-rays, the female figure may not have been shooting but merely holding her bow aloft.'[16] This may be true, but it is also possible that here Titian used another literary source, for such a combination of sources is precisely what is found in the *Bacchus and Ariadne*.[17] There were, it seems, late antique accounts of the myth in which Diana played an active part in Actaeon's death.[18]

Richard Cocke has observed that in the early second-century romance *The Golden Ass* by Apuleius there is a description of a spectacular Parian marble statue which represents Diana, her tunic blown back in the breeze, with a brace of bounding hounds on a leash. Behind her there is a cavern with moss and creepers and fruit and, half concealed by these, the alarmed face of Actaeon, already half-transformed into a stag. Actaeon was also reflected in the water which ran by the goddess's feet.[19] The source would not have been obscure – as Cocke observes, Firenzuola's translation of Apuleius was published in Venice in 1550[20] – and Titian is likely to have been attracted to it by the fact that, like the texts he had illustrated for the Duke of Ferrara, it described (or purported to describe) a masterpiece of ancient art – in this case a sculpture, but a sculpture of exceptionally pictorial character (to represent water in marble is difficult enough, but to represent a reflection in the water still more so). Although this passage is not closely followed – for example, only one hound is by the goddess's side in Titian's painting and it is not on a leash – it does license the idea that the vengeful goddess pursued Actaeon. Titian would surely also have wanted the reflection to play a more important part in his painting than is apparent in the form in which he left it:

the pool in the right foreground must have been conceived with this in mind, matching the one upon which the hunter stumbled in the earlier episode.

Visual Sources

Cecil Gould noted that the Diana 'derives visually from an Antique source. An engraving of a cameo, inscribed "Diana Cacciatrice", is included in Lachausse's *Le Gemme Antiche Figurate* (1700) and gives the essentials of the pose, including the leaping hound. Other similarities may be found in the so-called *Diana of Versailles* (Louvre).'[21] However, there is no evidence that the gem in question would have been known to Titian, and although we may detect some similarity in the light Amazonian apparel and the hound, the 'essentials of the pose' are not in fact close. Ancient reliefs of Actaeon attacked by hounds are also known.[22] Any resemblance to the *Diana of Versailles* (known also as the *Diane Chasseresse*) is superficial; Titian is unlikely to have had the opportunity to study this piece or any variant of it.[23]

A Workshop Version of the Painting?

In a letter of 28 November 1568, the imperial ambassador to Venice, Veit von Dornberg, mentioned to the Emperor Maximilian II that Titian could provide paintings of Diana and Endymion, Actaeon at the Fountain, the Death of Actaeon, the Pregnancy of Callisto, Adonis killed by a Boar, Andromeda freed by Perseus, and Europa on the Bull. He was passing on information received from Titian himself and the list of subjects was in the hand of Orazio Vecellio (an identical list was sent to Albrecht V of Bavaria). The emperor replied that in his view Titian was too old to paint well.[24]

In the second, fourth, sixth and seventh of these subjects Titian must have been offering replicas of paintings which had already been dispatched to the Spanish court; that is probably also true of the Adonis subject (although Titian's paintings of Adonis show the young hero parting for the hunt rather than killed by the boar). In the case of *The Death of Actaeon* he may have been offering the original painting, although that had originally been destined for the King of Spain. But this need not mean that the painting was finished, simply that it was in Titian's mind as something that he could easily finish.

There is in any case no good evidence that a second version of the *Death of Actaeon* was made by Titian or by his workshop, or indeed by anyone. The idea that one might have been made was entertained as a serious possibility by Cecil Gould,[25] chiefly because, believing the painting to be a finished work of art, he supposed that it might actually have been sent to Spain. It is not included in the list of paintings by Titian which had been sent to Philip in December 1574.[26] Gould regarded this evidence as inconclusive because, he wrote, 'Titian himself says in that list that there had been many others which he could no longer remember'[27] – but the large narrative paintings are not items that could easily be forgotten, least of all those which had been sent most recently. No mention of the *Death of Actaeon* had been found in any inventory of the Spanish royal collection. All the same,

Gould's hypothesis has been accepted as a fact by at least one eminent scholar.[28]

Previous Owners

THE MARQUESS OF HAMILTON
AND THE ARCHDUKE LEOPOLD WILLIAM

Had the painting been in Titian's workshop when he died, it is likely that it would have turned up for sale in Venice, and it seems that this was indeed the case. Sometime in the years 1636–8 the British ambassador to Venice, Lord Fielding, submitted a list of paintings to his brother-in-law the Marquess of Hamilton.[29] The pictures in it seem to correspond with those which had been in the celebrated collection of Bartolomeo della Nave, the export of which to England is repeatedly referred to by Ridolfi in his *Maraviglie*.[30] The ninth item in this list was 'A Diana shooting Adonis in forme of a Hart not quite finished Pal 12 & 10 Titian'. The Marquess (later Duke) of Hamilton (1606–1649) was one of the half-dozen great collectors at the court of King Charles I. He led the Scottish forces that were defeated by Cromwell's army at Preston in 1648 and was beheaded early in the following year, four weeks after the king. The best record of his collection is the list drawn up after his death, by when the paintings were available for sale, and there we find 'Une Diane tirant avec un arc contre Adonis aussi grand que le naturel elle dans un paisage avec des chiens h.12, la.14 pa'.[31]

The bulk of Hamilton's Venetian paintings were purchased for the Archduke Leopold William, and this painting is clearly represented in the view of the archduke's gallery at Brussels by David Teniers the Younger, now in the Musées Royaux des Beaux-Arts (fig. 3).[32] In addition, a small copy of Titian's painting on panel by Teniers is known.[33] These copies differ no more from Titian's original than is usual with other little copies by Teniers. A print of the painting is included in the *Theatrum Pictorium*, the anthology of prints of the archduke's paintings published in Antwerp in 1660, by which time they had been transferred to Vienna.[34] Cecil Gould made much of the fact that the format was here elongated, showing landscape to the left of Diana, although, as he conceded in a note, such deviations were common in engravings.[35] He made still more of the fact that the painting is reproduced in the *Prodromus* of 1735, which comprises prints of pictures in the imperial collection in Vienna, into which the archduke's paintings had passed by gift and bequest.[36] But the engravings in the *Prodromus* were based on those of the *Theatrum Pictorium*, so this is hardly surprising. Moreover, there is very good reason to suppose that its inclusion in the *Prodromus* was a mistake because there is no mention of a painting by Titian of the Death of Actaeon in the inventory of the archduke's paintings that was made when that collection reached Vienna, or in later imperial inventories.

QUEEN CHRISTINA OF SWEDEN, THE DUC D'ORLÉANS,
SIR ABRAHAM HUME AND THE EARLS OF BROWNLOW

Titian's painting was in the collection of Queen Christina of Sweden in 1662 or 1663, when an inventory was made of the contents of Palazzo Riario in Rome, which she had by

then adopted as her official residence. It was there described as 'Una Diana in piedi in atto di havere saettato Atteone, che lontano si vede presso da cani in un bellissimo paese. Figure al Naturale, con cornice liscia indorata, alto palmi otto, e mezzo, e Larga palmi nove, e mezzo – di Titiano.'[37] The painting does not appear in the inventory of her collection made in Antwerp in 1656[38] but we must assume that it passed from the archduke's collection to hers at around that time – the moment when his collection was moved from Brussels to Vienna. Queen Christina, having just converted to Catholicism, could expect such gifts from Catholic princes at this date.

Queen Christina's collection remained in Rome until 1721, when it was acquired for the Duc d'Orléans in circumstances described on p. 463. That section also describes the display of the painting (pendant with a Cambiaso) in the Palais-Royal and the sale of that collection. NG 6420 was purchased by Sir Abraham Hume Bt (1749–1838) in 1798 for 200 guineas – a relatively low price which reflects its status as an unfinished picture. Lord Berwick paid 700 guineas for the *Rape of Europa* (Bryan paid the same amount for the *Perseus and Andromeda* when it failed to find other purchasers in 1800) and *Diana surprised by Actaeon* and *Diana and Callisto* were retained by the Duke of Bridgewater at a valuation of 2,500 guineas each.[39]

Hume was the author of a book on Titian and also especially appreciative of preliminary sketches by Venetian artists (or what he believed to be such). An account of his collection is included as an appendix, which also explains how this painting was inherited by the Earls Brownlow. Hume's great-grandson, the 3rd Earl Brownlow (1844–1921), was made a Trustee of the National Gallery in 1897. Twenty years before that it would certainly not have been supposed that a nobleman of such wealth would ever need to part with his old master paintings, but the situation was now very different. In a letter of 29 November 1914 addressed to Holroyd, the Gallery's director, Lord Brownlow offered to sell Van Dyck's *Portrait of a Woman and Child* (NG 3011) for £10,000 and the *Death of Actaeon* for £5,000 . 'I only ask from the Gallery what I consider to be a very low price because I am anxious to see them in the gallery.'[40] He went on to explain that they

Fig. 3 David Teniers the Younger, *Gallery of the Archduke Leopold William*, 1651. Oil on canvas, 96 × 129 cm. Brussels, Musées Royaux des Beaux-Arts de Belgique.

would be sold for a much higher price on the open market if the Trustees were not interested.

The Trustees discussed the offer at a meeting held on 8 December. There was some feeling that it was improper to employ public money for such a purpose during wartime, and Alfred de Rothschild, who could not attend the meeting, sent a letter to the chairman to say that he had spoken on the previous day (7 December) with the Prime Minister (Asquith) and he had agreed that it was not the 'right moment' – an opinion Mr de Rothschild had already expressed emphatically in a letter to Holroyd of 3 December.[41] However, the chairman, having spoken with Lord Lansdowne (the 5th Marquess, then leader of the Opposition), concluded that there would be no objection to purchasing pictures if they could be obtained on genuinely advantageous terms. Holroyd reported Lockett Agnew's opinion of the valuations. The Board accepted the offer of the Van Dyck but declined the Titian, the merits of which they felt it was 'impossible' to consider in its 'present condition', although they would be happy to reconsider it if Lord Brownlow were to have it cleaned.[42]

It seems likely that some members of the Board were keen to acquire the Titian but that there was anxiety as to the effect this might have on Alfred de Rothschild, who was not only a friend of the king but the owner of a collection of old master paintings, some of which, it was hoped, he would bequeath to the Gallery. He would be indignant enough at the 'unpatriotic' decision to buy the Van Dyck, which he regarded as an 'indifferent specimen', but he thought that the Titian 'would not fetch £5 at Christies'[43] and its acquisition could well have precipitated his resignation. (A profile of this difficult character is provided in an appendix, pp. 472–5.)

The measure of Rothschild's expertise and of Brownlow's generosity was provided when the war ended. The picture was sold for £60,000 to Viscount Lascelles (later the 6th Earl of Harewood) on 15 July 1919 by Colnaghi's, with payment to be made in two parts, the second a year later. The invoices do not make it clear whether Colnaghi's were selling the painting for Lord Brownlow or as the owner.[44] It seems likely that they had purchased it from him not long before. Tancred Borenius, who advised Lascelles, was rumoured to have received commissions from two parties in the affair but I have seen no evidence for this, and many anecdotes of this kind were circulated later when Borenius's conduct had become flagrantly mercenary. An account of Harewood's collection is given in an appendix, pp. 455–8.

Acquisition by the National Gallery: The Public Appeal
After ten years on loan to the National Gallery, the *Death of Actaeon* was sold by the trustees of the 7th Earl of Harewood at Christie's, London, on 25 June 1971 (lot 27), where it was bought for 1,600,000 guineas (£1,680,000) by Julius Weitzner, who sold it a few days later for £1,763,000 through Martin Zimet to the J. Paul Getty Museum. On 28 July the Reviewing Committee on the Export of Works of Art recommended delaying the export for a year and not granting a licence if a sum of £1,763,000 was made available by that date. The Gallery could not act until it had ascertained how

the government would respond to the announcement which the chairman of the Trustees, Sir John Witt, made on 1 July that the Gallery wished to commit £1,000,000 (of which £600,000 would be an advance against future purchase grants). On 21 October the Department of Education and Science announced that it would permit the Gallery to draw in advance on future grants, provided that no special grants were requested in the period when the purchase grant was docked, and provided that the case was not regarded as a precedent. In addition, they guaranteed £1 for every £1 submitted independently. This doubled the value of the generous contributions promised by the National Art Collections Fund (of £100,000) and the Pilgrim Trust (of £50,000), leaving half of the remaining sum of £463,000 to be found.[45]

The Trustees then took the extraordinary step of launching a public appeal. This was opened on 1 December. All parties to the sale behaved well: Mr Getty and the J. Paul Getty Museum permitted public exhibition in the Board Room (below a 'plastic sheath'), where the painting was seen by 355,869 visitors; Christie's and Weitzner were among the most notable contributors to the appeal.

One motive for the appeal was public dismay at the failure to stop the export of Velázquez's *Juan de Pareja* in the previous year, but many felt that they would rather have contributed to an appeal for that picture than to a picture which the Gallery's director, Martin Davies, evidently found it hard to describe as other than 'difficult' (he considered that, by contrast, the Velázquez was 'replete with undemanding attraction'). Titian's picture, Davies gloomily continued, 'forms a comment on the conditions under which we live' – Titian 'had become pessimistic, perhaps rightly' – and then he added, almost as an afterthought, it was important because of 'the artist's use of his means of expression'.[46]

A further disincentive to public generosity was provided by the government's announcement of its intention to introduce admission charges to the National Gallery – 'why pay to help acquire a picture, and pay again to see it if acquired'.[47] A more optimistic attitude was adopted outside the Gallery, and when Duncan Grant's paraphrase of the painting (fig. 6) was projected on to the safety curtain of the Royal Opera House it was vigorously applauded.[48] The appeal succeeded and a cheque was handed over on 6 July 1972. Lists of the 169 donors who contributed £100 or more were printed in *The Times*[49] and the first of these to be published probably stimulated the final donations that secured the painting.

Provenance
See above. Probably in the artist's possession at his death. Apparently with Bartolomeo della Nave by the mid-1630s, when purchased for the Marquess of Hamilton. Purchased from Hamilton's collection after his execution in 1649 for the Archduke Leopold William; presumably presented to Queen Christina of Sweden when she was resident in Antwerp in about 1656; certainly in her collection by 1662/3 in Palazzo Riario, Rome, where it remained until 1721, when it was acquired from her heirs (or, more precisely, the heirs of her heirs) by the Duc d'Orléans, Regent of France; by descent to

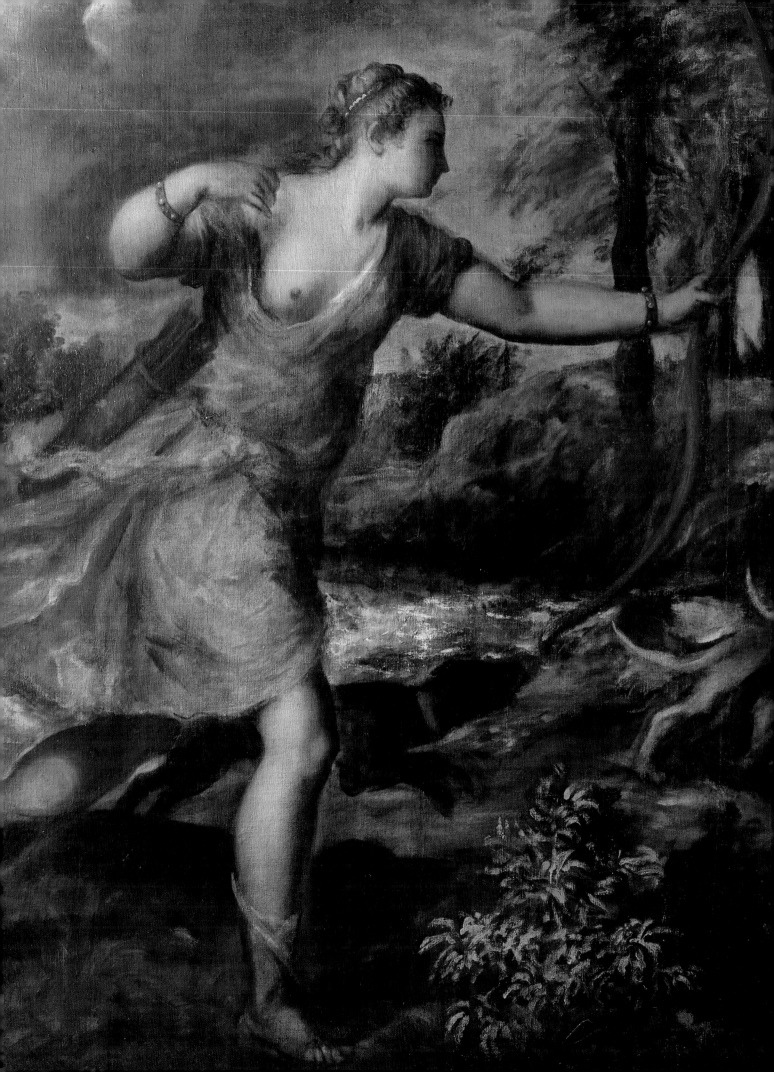

Fig. 5 Jacques Couché after ter Borch, *The Death of Actaeon*, engraving from the *Galerie du Palais Royal*, published in the 1780s and again in 1808. OPPOSITE: Fig. 4 Detail of NG 6420.

the Regent's great-grandson, Philippe Égalité, by whom sold in 1792 to Édouard de Walckiers; acquired from him in the same year by Laborde-Méréville; imported to London by the latter in 1793 and mortgaged to Jeremiah Harman, by whom sold in 1798 to the Duke of Bridgewater, the Earl of Carlisle and Earl Gower; bought early in 1799 by Sir Abraham Hume Bt, from Michael Bryan, agent for the three owners; by descent to the 3rd Earl Brownlow (Hume's great-grandson); sold by Colnaghi to Viscount Lascelles 1919–20; by descent to the latter's son, the 7th Earl of Harewood, by whom sold at Christie's, London, on 25 June 1971 (lot 27); purchased by Julius Weitzner and sold to the J. Paul Getty Museum; export by the latter institution deferred in accordance with the ruling of the Reviewing Committee, and the picture was acquired in July 1972 with a special government grant and contributions from the National Art Collections Fund, the Pilgrim Trust, and a public appeal.

Exhibitions
London 1819, British Institution (118); London 1845, British Institution (53); London 1872, Royal Academy (73); London 1893, Royal Academy (121); London 1894–5, New Gallery (166); London 1910–11, Grafton Galleries (154); London 1930, Royal Academy (169); London 1950–1, Royal Academy (210); London 1960, Royal Academy (84); London 2003, National Gallery (37); Madrid 2003, Museo Nacional del Prado.

Prints
The engraving by P. Lisebetius for the *Theatrum Pictorium* (no. 73) of 1660 was made after the younger Teniers's painted copy, as mentioned above. That by Jacques Couché (fig. 5) after a drawing by Gerard ter Borch made for the *Galerie du Palais Royal* was evidently one of those completed before the Revolution, since the legend includes the title of the duke and

Fig. 6 Duncan Grant, *Diana and Actaeon*, after Titian, 1971.
Watercolour and pastel on paper, 34.8 × 39.3 cm. Private collection.

Copy

A drawing by Duncan Grant in watercolour and pastel, presumably preparatory for a painting in oil, a slide of which was projected on to the curtain at Covent Garden (as described above), was recently in New York (fig. 6). Grant's copy was made at the instigation of Richard Buckle, who invited other British painters to do the same.[50] It is fascinating evidence of how Titian's way of painting could be interpreted as anticipating Cézanne, with whom, of course, Titian was frequently compared. When Titian's painting is converted into an unstable compositional mosaic the awkward relationship between the foreground goddess and the victim in the middle distance seems as deliberate as the interlocking of a pine branch with the distant profile of a Provençal mountain. It is tempting to speculate that Duncan Grant deliberately executed his version in the colours which Cecil Gould had considered to be significantly absent from Titian's painting.

Frame

To judge from the view of the archduke's gallery at Brussels (fig. 3), Titian's *Death of Actaeon* was then framed in a dark-stained wooden moulding with a gilt sight edge. Since Titian's is the only painting shown in a frame of this kind (the other paintings have uniform gilt cassetta frames), that makes it likely that it had come in this frame from a previous collection, perhaps indeed from that of Bartolomeo della Nave (it is in any case a type of frame favoured by Italian collectors around 1630). In Palazzo Riario in the 1660s the painting was in a plain gilt moulding, which it probably kept until it passed into the Orléans Collection in 1721, when it would have been given a frame much like the one it has today. The present frame, however, was not made for the painting, since it has been extended to fit, and it may not be a genuine frame of this period but an accomplished reproduction made in Paris in about 1900 (fig. 7). It is of carved oak. The low-relief strapwork, foliate scrolls and flowers, set off by cross-hatching cut in the gesso, cover the principal ogee moulding and flow on to the sanded flat. There are projections at the centres and corners adorned with foliate palms against a background pattern of diapers cut in the gesso. The original water gilding is obscured by later oil gilding, toning and dirt. According to Cecil Gould's typescript notes,[51] the painting came to the Gallery in this frame, which is therefore probably the frame that the painting had when it was in the Harewood collection.

is centred on his arms. Couché's engraving is quite exceptional among the plates of this great publication in its disregard for the original painting, as if the difficulty of rendering the artist's broken touch in a line engraving licensed the draughtsman and engraver to invent their own version. The pool in the foreground on the right is replaced with a tributary stream corresponding to the lit area of water. On the right a more substantial tree is anchored to the base with a rock, the foliage behind the victim has been darkened so that he appears as a silhouette against it, the trees and sky have been tidied up. On the left the composition has been extended to include Diana's foot, her bow has been given a string, and, while her brow has been left dark, her eye is lit up and her expression strengthened. To some extent the engraving amounts to a criticism of the painting but it also guesses intelligently at how the forms might have eventually been given more clarity by Titian himself. This is especially evident in the painting of the goddess's dress and the interpretation of the fluttering belt and of what was believed (surely correctly) to be a shadow below it.

NOTES

1. Rearick 1997, p. 55.

2. Claude Phillips's observation, made in 1919, on the changes that would occur were the painting to be cleaned was quoted by Borenius in his catalogue of the Harewood collection in 1936 (p. 37). Phillips wrote that 'only to Signor Cavenaghi of Milan could such a precious task be confided' and, had the job been given to someone else, it would have been odd to include this.

3. Fry 1911, pp. 162 and 167.

4. Keller 1969, p. 163; Rearick 1997, p. 55. The only scholar who seems to have doubted it was Herzer in his entry for Titian in Thieme-Becker.

5. Gould 1972; Gould 1975, p. 296, note 4.

6. Mancini 1998, pp. 246–7, for the letter of 19 June, and, for subsequent ones of 22 April 1560, 2 April 1561, 17 August 1561 and

26 April 1562, pp. 263–4, 269–70, 271–2, 289. English translations of these letters are given by Crowe and Cavalcaselle 1877, II, pp. 242–3, 275–6, 305–6, 307–8, 310–11 and 319–20.

7. The passage is very close to one in the upper right corner of the Escorial *Saint Jerome in Penitence* (for which see Wethey 1969, p. 136, cat. 108, plate 195).

Fig. 7 Lower left corner of the current frame of NG 6420.

8. Gould 1972, pp. 464–9.

9. Wethey 1969, p. 124, cat. 88, plate 196 (*Religion succoured by Spain*); Wethey 1975, pp. 153–4, cat. 16, plate 170 (*Marsyas*), and pp. 180–1, cat. 34, plate 164 (*Rape of Lucretia*).

10. Borean 2004, p. 285, letter to same of 5 April 1800 in the National Gallery archive. See also Borean 2004, pp. 33–4. In his monograph on Titian Hume wrote only that 'in parts, it appears not to have received the finishing touches' (Hume 1829, p. 96).

11. Ovid, *Metamorphoses*, II, lines 131–265.

12. Private collection, Scotland, formerly at Haigh Hall. For the cassoni see Fredericksen and Zeri 1972, pp. 187 and 469. The first half of the story is illustrated in a fifteenth-century Sienese cassone panel that was lot 58 at Sotheby's, London, 9 July 1998. Fredericksen also lists a birthplate at Williams College. See also Schubring 1923, pl. 14.

13. Silos 1673, quoted by Canestro Chiovenda 1971. See the description in the Odescalchi inventory of 1713, Archivio di Stato, Rome, Not. A–C. – vol. 5134, fol. 60v., no. 103: 'altro quadro ... rappresenta una cacciaggione di diana.'

14. Gould 1975, p. 293.

15. For a full discussion of the engraving and its date see below, in text.

16. Gould 1975, p. 293.

17. Thompson 1956. I am aware that Holberton 1986 argues that everything in the painting is derived from Catullus.

18. Ciera Via 1995.

19. Cocke 1999; Apuleius 1935, pp. 52–5.

20. Firenzuola 1550, fols 17 recto and verso.

21. Gould 1975, p. 293.

22. Clarke and Penny 1982, p. 126, no. 4 (for cameo and related reliefs).

23. For this statue see Haskell and Penny 1981, pp. 196–8, no. 30. I cannot see any close connection with the Cesi Diana mentioned by Cocke 1999, pp. 308–9.

24. Panofsky 1969, pp. 161–3, quotes this letter and discusses it.

25. Gould 1975, p. 294.

26. Mancini 1998, p. 402. An English translation is provided by Crowe and Cavalcaselle 1877, II, pp. 403–5. Charles Hope informs me that the list is in the hand of Orazio.

27. Gould 1975, p. 294–5.

28. Rearick 1997, p. 48. He asserts that the original version 'has not survived'.

29. Waterhouse 1952.

30. Ridolfi 1914, pp. 83, 140, 168, 169, 201, 222, 253, 336, 395; 1924, p. 203. For Bartolomeo della Nave in general see Lauber and Furtlehner forthcoming.

31. Garas 1967.

32. Brussels, Musées Royaux des Beaux-Arts, no. 458.

33. Ellis Waterhouse informed Cecil Gould on 15 February 1973 that the painting was in a private collection in Oxfordshire (letter in NG dossier) but he had seen it there a 'good many years ago'.

34. *Theatrum Pictorium*, no. 73, by P. Lisebetius after Teniers.

35. Gould 1975, pp. 294–5, and note 11 on pp. 296–7.

36. Stampart and Prenner 1735, plate 18 (centre of second row of pictures).

37. Granberg 1897, p. liii.

38. Granberg 1902, p. xxv.

39. NG 6420 was no. 269 in the Lyceum sale, the *Rape of Europa* was no. 205 in that sale, the *Perseus and Andromeda* was lot 65 in the sale of 14 February 1800, the *Diana surprised by Actaeon* and *Diana and Callisto* were nos 240 and 249 in the Lyceum sale.

40. N7/460/917.

41. Ibid.

42. NG 1/8, pp. 231–2. The chairman on this occasion was J.P. Heseltine. Lord Brownlow himself had chaired the previous meeting on 17 November. Lansdowne was of course also on the Board.

43. N7/460/917, letter of 8 December 1914.

44. Photocopies of the two invoices dated 15 July 1919 and 20 July 1920 were kindly sent to me by May Redfern of the Harewood House Trust.

45. All details of the business are given in the Annual Report for 1971–2.

46. Ibid., p. 26.

47. Ibid., p. 26.

48. Watney 1990, pp. 74–5; Spalding 1997, p. 476. Spalding also notes that the artist contributed £80 to the appeal.

49. Annual Report for 1971–2, pp. 62–4.

50. Watney 1990, pp. 74–5. David Hockney, Keith Vaughan, Robert Medley and Patrick Procktor were also invited. Watney's fig. 63 reproduces another, less free, copy by Grant.

51. National Gallery archive.

NG 224
The Tribute Money

*c.*1560–8 (perhaps begun in the 1540s)
Oil on canvas, 112.2 × 103.2 cm
Signed: TITIANVS / . F.

Support

The measurements given above are those of the stretcher. The original canvas is a tabby weave of medium weight, with 16 threads to the centimetre in the warp and 15 in the weft. This has been paste-lined on to a canvas of a similar weave. Some of the original canvas, including the tacking holes, has been turned over the stretcher, together with the lining canvas, at the upper edge. Strips of canvas were added to the sides and lower edge of the original canvas at an early date. These strips are of a different type, also of tabby weave but with fewer threads to the centimetre (approximately 12 in the warp and 13 in the weft). The status of these additions is not clear, but during the lining that took place in 1937 the strip at the lower edge was treated as a later addition and most of it was turned over the stretcher. The seam is now two centimetres above the lower edge in the lower left corner and slopes down to the right. The strips at the sides remain as they were before the lining of 1937, with seams between 2 cm and 1 cm from the right edge and between 3 cm and 1 cm from the left.

The added strips were prepared with a chalk (calcium carbonate) ground, an unusual preparation which can be found in at least one other sixteenth-century Venetian painting in the National Gallery (see p. 396). The chalk contains some black pigment. No samples have been taken that would reveal the nature of the ground in the chief canvas. However, the way in which Christ's blue cloak is painted with ultramarine and lead white over smalt in the main portion of the canvas, but with smalt only in the lower strip, suggests that this strip was added after significant work had been done on the picture. So too does the use of smalt for the sky in the strip on the left.[1] Since it is likely that Titian worked on the painting for a long time, these additions were probably made by him. Nothing in the provenance of the picture suggests that so radical a modification would have been made at a later date.

The stretcher is of pine, with crossbars, and was probably made in 1937.

Materials and Technique

X-radiography has confirmed changes that could be seen or suspected from the surface, and has revealed many others (figs 2 and 3).

A collar seems originally to have been intended for the Pharisee: it was sketched in rapidly with lead white (or at least with paint containing lead white). The Pharisee's ear was moved. The white linen of his bunched sleeve was much revised and the leather flaps that fall over it were painted afterwards, on top of it. Other forms seem to have been painted out where the scarf meets the belt, and there are revisions near his lower hand.

Christ's head was much revised. It was originally tilted to the left, with the eyes higher – in the case of the left eye, about 2.5 cm higher. A fold of drapery originally passed across Christ's right forearm (this is very clearly visible in the relief of the paint), his neckline was also higher, and the folds of his left sleeve were altered, as was the character of his cuff. The coin was originally less foreshortened and there was lettering on its farther rim, which was covered by the cloak.

Christ's cloak and the sky are painted with ultramarine, mixed with lead white in the sky and painted over a layer of lead white and ochre in the cloak.

The red garment worn by Christ was painted with varying mixtures of lead white, red iron-earth pigments and red lake. The Pharisee's cloak was painted with lead white, ochreous orange and orpiment. The scarf was painted directly on top of this with smalt.[2]

Conservation

The painting was varnished 'with mastic varnish only' after its acquisition by the National Gallery in 1852. The varnish was revived by the 'Pettenkofer process' in 1864. The painting was revarnished after surface cleaning by 'Dyer' in 1888. The 'surface' was 'repaired' by 'Buttery' in 1914. The varnish was again revived by the Pettenkofer process in 1925. After a test patch had been cleaned in April 1934, a decision was made to reline the painting and to restore it early in 1937. The work was undertaken by Helmut Ruhemann between February and September of that year. A wax surface polish, perished and ingrained with dirt, was removed in February 1952.

Condition

The painting is in good condition but abrasion, colour changes, disfiguring pentimenti and the deterioration of the restorations of 1937 all diminish the favourable first impression.

Old photographs reveal that the shadows in the folds of Christ's blue cloak – between the two hands, over Christ's right shoulder, beside his raised arm – have blanched. This has a major effect on the composition because the upper part of Christ's arm no longer appears to project from his body. The blots of yellowed blue on the fold of drapery passing over Christ's left sleeve appear to be areas of discoloured retouching.

The distracting dash of white in the drapery beside Christ's raised hand must originally have been less brilliant – a lake glaze may have faded here.

The face of the Pharisee is very thinly painted and somewhat worn; this is also true of the Scribe (the figure behind him wearing spectacles). The sky, which includes some passages of blue violently dashed in and a cloud swept rapidly around the profile of the Pharisee to the left, is unlikely to have looked so patchy and improvisatory originally. It is the character of the sky that might suggest that Titian had left the painting unfinished. The curious patch of vermilion in the fingers beside Christ's raised index finger might also suggest this explanation.

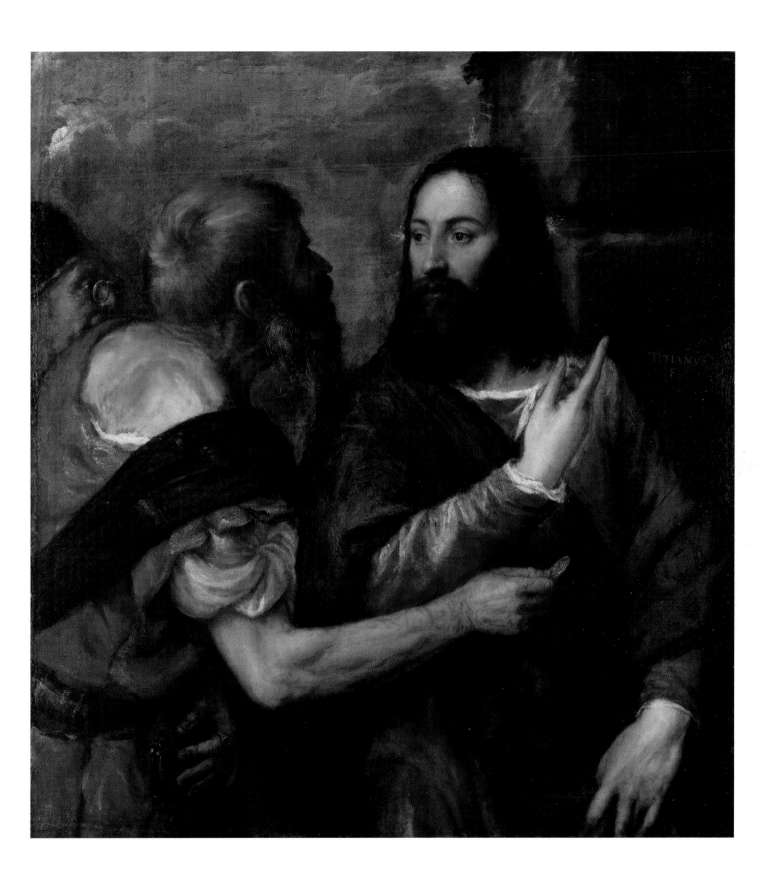

It seems unlikely that the colour of the scarf worn by the Pharisee, a grey-brown with dark brown stripes, is original. The stripes may have been green. The scarf itself was blue but the pigment – smalt – with which it was painted has deteriorated.

The Signature

TITIANVS / .F. is written on the pilaster on the right (fig. 1). The first T is taller than the other letters. The letters are painted with confidence and have (under magnification) the same consistency and particle size – and have also sustained the same damage – as paint of similar character elsewhere. Thus there is no reason to dispute its authenticity.

Attribution and Date

For the two centuries when this painting hung in the sacristy of the Escorial (see below) its status as an autograph work by Titian seems never to have been disputed. It also enjoyed a high reputation when in the collection of Marshal Soult. However, in the year following its arrival in Trafalgar Square some witnesses to the Select Committee of 1853 deprecated its acquisition. The Revd Henry Wellesley, a distinguished collector and connoisseur, especially of drawings, stated that a good director would not have made the purchase. The artist, connoisseur and controversialist Morris Moore said that it was 'falsely ascribed to Titian', although he did not wish to 'condemn it' because it was a work of his school and possessed 'considerable merit of colour'.[3] The Gallery's official catalogues described the painting as by Titian, but Crowe and Cavalcaselle did not accept it as his work.[4] Eventually, in the *Abridged Catalogue* of 1889, Burton changed the attribution from 'Vecellio' (meaning Titian) to 'School of Vecellio'.[5] It retained this designation until, presumably at Holmes's instigation, it was attributed tentatively to Paris Bordone in the catalogue of 1929.[6] In this period the only dissenting voice known to me was that of Charles Ricketts in his monograph of 1910, in which he conceded that there were 'traces of the collaboration of Palma Giovane in the Pharisee, but in substance it remains a fine and genuine picture, and it should be placed on the line'.[7]

When the painting was shown in the *Exhibition of Cleaned Pictures* at the National Gallery in 1947 the painting's status was reconsidered:

> The cleaning makes it plain that the painting of a part of the surface could not be by Titian himself. The more finished parts especially, the beard of Christ's questioner and his right arm and hand for instance, are painted in a niggling manner. On the other hand, the X-rays show equally clearly that the picture is no copy. ... The X-ray transparency of the whole picture ... appears to show a first painting typical of Titian in his last years, and worthy of him in its depth of passion and of form. This is probably one of the many pictures left in his studio at his death and finished by a more ordinary painter.[8]

The text is an example of connoisseurship disregarding the evidence of provenance, from which it is nearly certain that this was the painting Titian described in October 1568 as one he had recently completed and sent to Spain (see below). It seems likely from the technical evidence (see above) that

Fig. 1 Detail of the signature.

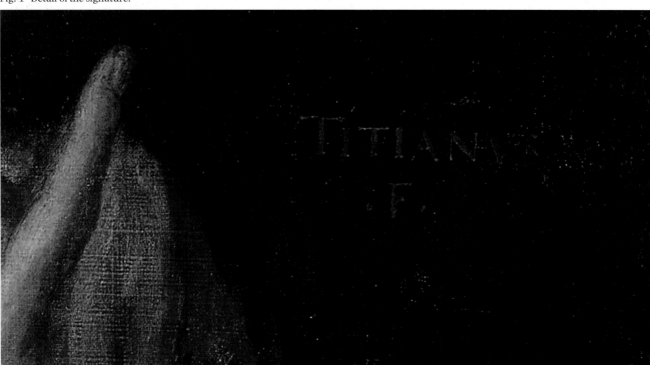

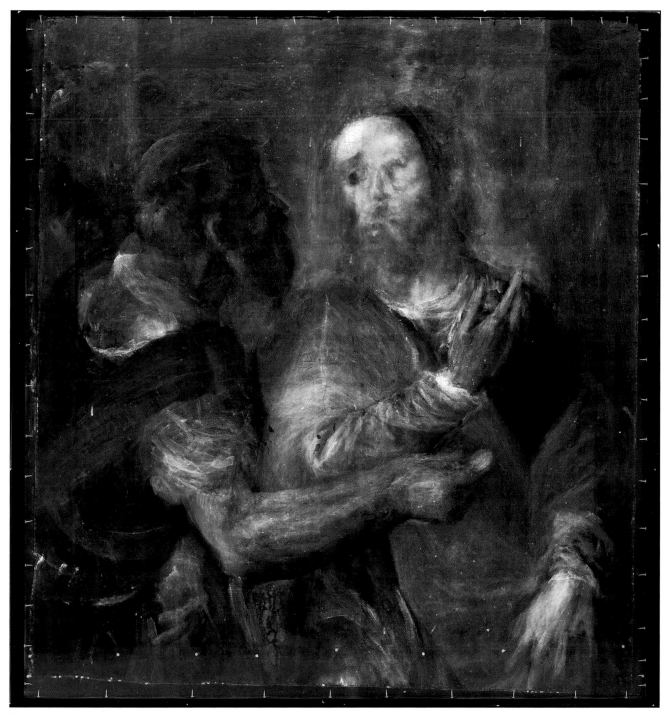

Fig. 2 X-radiograph of NG 224.

the painting was worked on over a long period; and in its original conception, with its powerful contrasts of characterisation and texture, strong gestures and lighting, it recalls the *Ecce Homo* (fig. 4, p. 203), which was completed in 1543.[9] It seems safe to suppose that it was not begun much before that date. It is, however, not impossible that it was executed entirely in the 1560s.

For Gould the 'extent of studio assistance' could not be 'authoritatively defined', but the hypothesis that there had been some such assistance had 'long been recognised'. The areas of execution that he found unacceptable as 'late Titian' were the 'head of the questioner, his white sleeve, and (in its present state) ... Christ's blue mantle'.[10] This was a significant move away from the orthodox view – found in Tietze's monograph of 1936 and Berenson's Lists of 1957 – that the painting was a workshop piece.[11] Wethey went further and declared the picture to be largely autograph.[12] Although it is possible that there was some intervention by assistants in less important passages, the painting is surely characteristic of Titian, especially in the heads and hands.

Fig. 3 X-radiograph of the coin.

Subject

The painting shows Christ being interrogated by the Pharisees who sought to trick him into making a statement offensive to the Roman rulers of Palestine, as recounted by the three Synoptic Gospels.

> Tell us therefore, What thinkest thou? Is it lawful to give tribute unto Caesar, or not? But Jesus perceived their wickedness, and said, Why tempt ye me, ye hypocrites? Show me the tribute money. And they brought unto him a penny. And he saith unto them, Whose is this image and superscription? They say unto him, Caesar's. Then saith he unto them, Render therefore unto Caesar the things which are Caesar's; and unto God the things that are God's. When they had heard these words, they marvelled, and left him, and went their way. (Matthew 22:17–22 – see also Mark 12:15–17; Luke 20:21–26)

Titian has possibly responded to the fact that the Gospels distinguish between two classes of opponent to Christ: 'the chief priests and the scribes' (Luke 20:19), or the 'Pharisees' and the 'Herodians' (Mark 12:13). The spectacles given to the second figure surely suggest that he should be considered as a 'scribe'.

The subject is very rare in art. It is said by Louis Réau and Gertrude Schiller never to have been represented before Titian.[13] It was first painted by him, probably in 1516, for a very special purpose. This version, on panel, now in Dresden (fig. 2, p. 201), seems to have served as a cupboard door in a room in the Via Coperta adjacent to the Castello in Ferrara where Duke Alfonso d'Este kept his considerable collection of ancient coins and medals. Vasari describes it as 'una testa di cristo, maravigliosa e stupenda, a cui un villano ebreo mostra la moneta di Cesare' ('a head of Christ, marvellous and wonderful, to whom a foul jew is shewing the coinage of Caesar') and as something incorporated in a cupboard door ('nella porta d'un armario'). This is confirmed by a letter

written by Alessandro Fiaschi to Duke Ercole II on 29 April 1559 concerning the 'studio delle medaglie', in which there was a chimneypiece with a key on top which opened the door where there was the 'ritratto de Signor Hiésu di mano di Titiano. Sotto detto ritratto sono alcuni cassettini dentro' ('the likeness of Our Lord Jesus by the hand of Titian, behind [or below] the said portrait are some small coffers within').[14]

There was a reason for the Duke of Ferrara's commission of a painting of this subject, beyond the obvious one that it connected Christ and coins, for he owed allegiance to both Pope and Emperor. He had this episode from the Gospels represented on the reverses of the gold coins he had minted, with the motto QVE . SUNT . DEI . DEO. It seems likely that it was the fame of this painting that prompted other artists to paint the subject, and Titian's second version may have originated in a request for a replica or variant on a larger scale. The strength of the ultramarine in the cloak and of the lake in Christ's tunic in the Dresden panel is retained in NG 224 together with more explicit gestures and a less intimate conception of the event. But Titian has given a serene authority to Christ's features. The connection between the two paintings is reinforced by the X-radiographs of NG 224, which reveal that the coin held by Christ was originally almost certainly one issued by Duke Alfonso: the word Ferrara may be discerned on it (fig. 3).

Previous Owners, Reputation and Acquisition

In a letter to King Philip II of 26 October 1568 Titian claimed that the painting had been recently finished and had been sent to Spain. Titian must, therefore, have painted it, or at least completed it, with Philip in mind, although it need not have been commissioned by the king – indeed Titian almost always chose the subjects of the paintings he sent to Philip.

The painting was included in the *Inventario de las ... pinturas ... donados por Felipe II al Monasterio de El Escorial* in the section devoted to the royal gift of 1574.[15] It remained in the sacristy of the monastery when that room was further enriched with paintings – including additional paintings by Titian – by Philip IV in the following century, and was consistently one of the most admired works there: according to the official guide, 'la cabeza y rostro de Christo es la major que creo se ha pintado' ('the head and face of Christ are, I believe, the finest that he ever painted') and indeed in Spain it was regarded as a definitive likeness of Christ.[16]

In late December 1809 Joseph Bonaparte, newly created king of Spain, presented his generals with paintings plundered from the Escorial – NG 224 was one of six given to Marshal Soult.[17] Nicolas-Jean de Dieu Soult (1769–1851), created general in 1794 and Imperial Marshal in 1804, was one of the most talented of Napoleon's commanders, who played a decisive role in the Spanish campaigns of 1808 and 1809. On 14 July 1810, soon after receiving this favour from Joseph, he was appointed, to Joseph's dismay, Général en Chef de l'Armée du Midi, with responsibility for Andalusia, which he governed until 1812. After the surrender of Napoleon in 1814 Soult energetically adopted the royalist cause and was duly rewarded, but he later switched his loyalty back to

Napoleon. After a few years of exile he was reinstated as a marshal in 1820, made a peer in 1827, and then played an important political role under Louis-Philippe (as Président du Conseil and Minister of War in 1840).[18] His collection of pictures was internationally famous, especially for the Spanish works (of which he owned more than 100, as against 22 Italian and 23 Dutch and Flemish), and it had been largely formed in the years 1810–12 by extraction from churches and palaces in Seville, although certainly it was added to subsequently.

The sale of Soult's 'magnifique galerie' in his house in the rue de l'Université took place after the death of his wife in March 1852. The executors arranged for some of the paintings (including the Titian and a Sebastiano del Piombo of Christ carrying the Cross) to be shown by the dealer Nieuwenhuys in London.[19] The auction was held between 19 and 22 May in Paris.[20] The catalogue appealed to the Louvre to avail itself of this opportunity to improve its holdings, and appealed also 'aux conservateurs des musées de province'. The Louvre did indeed buy Murillo's *Immaculate Conception of the Virgin* (lot 57) for 586,000 francs (£24,600), then the highest sum ever paid for an old master painting.[21] Other major Spanish works went to the Berlin museum and the Hermitage.

The Trustees of the National Gallery sent the well-respected dealer William Woodburn (brother and partner of the more difficult Samuel, whose relations with the Gallery were fraught) to bid for them. Woodburn had already viewed the paintings in Paris and in a letter of 23 April he reported to the Trustees on the 'splendid effect' and the 'perfect state' of this signed Titian, the picture which he 'preferred of the whole collection' and which he believed was worth £2,500.[22] On 15 May, when in Boulogne, he asked for precise instructions, and he had received them by 18 May, when he told the keeper that 'the rooms and staircase' of the 'ancienne galerie Lebrun', where the works were on view, 'were filled like a Benefit of Jenny Lind' – a reference to the hugely popular success of the concerts for charity which had recently been given in London by the great Swedish soprano.

On 22 May Woodburn secured the Titian (lot 132) for £2,604. He wrote to recommend the firm of Chenue for its packing and transport. He then stayed on for M. Collot's sale on 25 and 26 May, where he purchased a pastoral scene sometimes attributed to Giorgione (believed by others to be by Palma Vecchio), which, however, was eventually ceded to one of the Trustees, Lord Lansdowne (presumably because it was not deemed to be of good enough quality for the Gallery). The two paintings travelled back together, accompanied by a drawing by Giulio Romano of a female saint brought before the tribunal of a proconsul, in 'pen and sepia heightened with white', which Woodburn bought 'with the intention and hope the Trustees will honor me by accepting it as a small donation to the National Gallery and I shall endeavour to do better in future'.[23]

As mentioned above (under Attribution), the purchase of the Titian was somewhat controversial. But, whatever doubts were entertained by the connoisseurs, the image seems to have captured the imagination of one of the greatest writers of the age. In *Daniel Deronda* (chapter 38) George Eliot describes the scholarly old Jew Mordecai lingering 'in the National Gallery in search of paintings which might feed his hopefulness with grave and noble types of the human form. ... Some observant person may perhaps remember his emaciated figure, and dark eyes deep in their sockets, as he stood in front of a picture that had touched him either to new or habitual meditation: he commonly wore a cloth cap with black fur round it, which no painter would have asked him to take off.' The novelist had certainly also visited the Gallery in this spirit and had perhaps been struck by Titian's picture in particular, for when she describes the meeting between Mordecai and her hero – the 'healthy grave sensitive younger Deronda', who is to be seen as a modern secular redeemer – she comments: 'I wish I could perpetuate those two faces, as Titian's "Tribute Money" has perpetuated two types presenting another sort of contrast.'[24]

Provenance

See above. Sent to Spain by Titian shortly before 26 October 1568. Presented to the Escorial by Philip II, 1574. Presented to Marshal Soult by Joseph Bonaparte in December 1809 and sent to Paris in 1810. Sold, Paris, 22 May 1852 (lot 132), where bought for the National Gallery.

Versions and Variants

Wethey in his monograph of 1969 published what looks like a very good and very accurate old copy of the painting that was in the collection of the Duque del Infantado, Seville. It is of very similar size (100 × 107.3 cm).[25] Whether this is a replica produced in Titian's workshop or a copy made in Spain is uncertain, though the latter is more likely.

An interesting variant on the composition was lot 73 at Christie's, London, on 31 October 1997, where it was catalogued as by a 'Follower' of Titian (fig. 4). It had been in Switzerland for many decades previously but was almost certainly identical to a painting offered as lot 188 in the Sedelmeyer sale in Paris, 3–5 June 1907, with a French provenance.[26] The main figures are the same size as those in NG 224, and it is surely likely that it was made, or at least begun, in Titian's workshop before the National Gallery's picture was sent to Spain in 1568. Another painting of similar size (48 × 40 in.; 121.9 × 101.6 cm), lot 129 at Christie's on 6 June 1938, may also have been a workshop variant (or at least a copy of one), since it combines features from both NG 224 and the Sedelmeyer painting.

In the variant sold in 1938 the Pharisee wears a simpler jacket with long sleeves, and there is a cloak under his arm; he also wears a fur-rimmed bonnet, whereas the man behind him is bareheaded. In the Sedelmeyer painting this last change is retained but the second questioner is represented by a different white-haired and white-bearded head placed on the other side, behind Christ's left shoulder. The Pharisee also has a bare right shoulder, and in place of the bold projecting entablature above Christ's head there is a frieze of bucrania linked by festoons of drapery. One difference in this

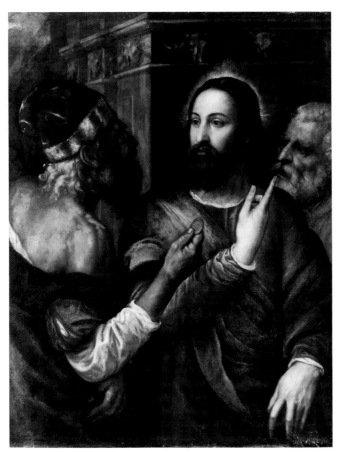

Fig. 4 Copy of Titian's *The Tribute Money*, 1560s. Oil on canvas, 120 × 94.4 cm. Private collection.

Fig. 5 Martino Rota after Titian, *The Tribute Money*, 1560s. Engraving, 27.6 × 22.8 cm. Private collection.

version was not intended: Christ's cloak is a dull grey-brown on account of the deteriorated smalt used for the blue. In other respects the differences can mostly be explained as un-imaginative attempts at invention on the part of assistants, who were perhaps encouraged by Titian not to copy too closely. Just possibly, however, both the dress of the Pharisee in one version and his bare shoulder in the other, and the hat in both, reflect Titian's earlier ideas (and even earlier stages of execution) for the composition. This may also be true of the higher position of the Pharisee's right arm which is found in both.

As noted by Cecil Gould, Titian's design also evidently served as a model for Van Dyck's painting of the same subject of about 1627 in Palazzo Bianco, Genoa.[27] It is sometimes claimed that this composition is reversed, which is not the case, although the Pharisee is and he is placed on the right, which corresponds with the position in the Dresden picture. Van Dyck must have depended on engravings. The painting by Giuseppe Bazzani, now in the Museum of Art, San Diego, is in turn derived from the Van Dyck.[28]

Prints
NG 224 was engraved by Martino Rota (*c.*1530–1583), who, according to Thieme-Becker, was in Vienna by 1568, where

he died. The engraving (fig. 5) is largely accurate but it has a neutral background and there is a greatly exaggerated glory around Christ's head. Some minor differences may perhaps suggest that Titian continued to work on the painting after Rota had made the print. There is no white drapery across the Pharisee's back or at Christ's neck in the print. The Phari-see's purse is attached to his belt with two little brass masks in the print – details characteristic of Titian but perhaps later deleted. The composition extends considerably below Christ's hand as seems to have been Titian's intention, but the way that Christ's extended fingers hold a fold of his tunic must be a misinterpretation. The legend beneath the print is incorp-orated in a sort of plinth divided into sections by acanthus consoles. The central section is inscribed TITIANVS INVEN., together with Rota's name and device. The relevant verses from the Vulgate occupy the larger side sections.[29] Another, later, engraving, by Cornelis Galle (1576–1650) shows the composition in reverse, with another figure behind Christ (that is not, however, similar to the painted variants).[30]

Exhibitions
London 1947, National Gallery, *Cleaned Pictures* (35); Madrid 2001; London 2003, National Gallery (320; Madrid 2003, Museo Nacional del Prado.

Frame

The painting is in a carved and gilded Italian cassetta frame, presumably given to it some time after the completion of conservation treatment in 1937 (fig. 6). The frame may have been altered in size but the regilding makes this unclear. The frieze is decorated with a 'money-pattern' motif, which must have been chosen as a witty reference to the subject of the picture. It consists of overlapping disks, each decorated with a rosette, radiating from the centres. There is pearl ornament on the sight edge and on the outside a fluted rail that curls outwards. A portrait of Neri Corsini as a youth by Giusto Sustermans is recorded in an oval frame of identical section and ornament, which is very likely original to the painting and thus Florentine of about 1640.[31] A coarse relative of this type of frame has rosettes in place of disks.[32] Both types probably derive from a family of fine walnut frames, partially gilded, that were made in Florence in the second half of the sixteenth century, many of which include refined versions of the money-pattern motif.[33]

Fig. 6 Corner of the current frame of NG 224.

NOTES

1. Report of the Scientific Department 1994/5, signed by Jilleen Nadolny.

2. Ibid.

3. Minutes of the Select Committee of Enquiry 1853, evidence given 21 July 1853 by Wellesley, paras 9542–3, and on 22 July 1853 by Moore, para. 9755.

4. Crowe and Cavalcaselle 1877, II, pp. 386–9.

5. [Burton] 1889, p. 187 – but see [Burton] 1888, p. 187.

6. [Collins Baker] 1929, p. 366 ('perhaps by Paris Bordone').

7. Ricketts 1910, p. 177. The expression 'on the line' derives from the most visible range of paintings in the Royal Academy's crowded exhibition hang – those placed above a high dado.

8. [Hendy] 1947, pp. 36–7, no. 35.

9. Wethey 1969, pp. 79–80, no. 21, plate 91.

10. Gould 1969, p. 275.

11. Tietze 1936, II, p. 293; Berenson 1957, p. 187.

12. Wethey 1969, p. 165, no. 148.

13. Réau 1955–9, II, 2, 1957, pp. 321–2; Schiller 1966–80, I, p. 166; Kirschbaum 1972, IV, cols 571–2.

14. Vasari/Milanesi, VII, p. 434; for Fiaschi's letter see Hood and Hope 1977, p. 547 and note 62. For the collection of coins and medals in Ferrara see Campori 1870.

15. Cuevas's inventory p. 139 (cited by Gould 1975, p. 275).

16. Siguenza 1988, p. 529.

17. Cano Rivero 2003, p. 110, note 82, quotes the decree of 27 December 1809 in which the Titian is imperfectly described as 'el dº (sic) del César di Tiziano'. Authority to export the painting from Spain was obtained on 22 August 1810 (ibid., note 83).

18. Ibid., pp. 109–13

19. Minutes cited in note 3 above, evidence of Moore, para. 9756.

20. The sale had originally been proposed for 24–26 May and some catalogues were printed with these dates.

21. The Tsar of Russia and the Queen of Spain were underbidders. The picture was ceded to Spain in 1941 and is today in the Prado.

22. NG/90/1852.

23. Letters in the National Gallery dossier. I can find no further trace of the drawing. The sum spent on the 'Giorgione' was £168. For this episode see Minutes cited in note 3, para. 9761, where Moore alleged that the picture was 'purchased for the Nation' but we have 'never been allowed even to see it' because it was 'considerably taken off our hands by one of the trustees'. The sum of £1,500 had been allocated by the Treasury for this purchase. It cannot be the *Portrait of an Antique Collector*, which was no. 49 in the Lansdowne House catalogue of 1897 (see Pignatti 1971, p. 117, A5, and plate 209), since this is not a pastoral.

24. Book V, chapter 38, paras 5 and 6, and chapter 40, para. 18 (pp. 529 and 552–3 in the Penguin Classics edition of 1986). See Witemeyer 1979, pp. 102–4, for a commentary on the second of these two passages. He assumes that George Eliot had the Dresden *Tribute Money* in mind, and that painting certainly made a great impression on her and on George Lewes during their stay

in Dresden in 1858, but the earlier reference to Mordecai's search in the National Gallery points to NG 224.

25. Wethey 1969, p. 165, copy no. 3, plate 130.

26. Sold as formerly in the collection of Baron de Bully, so presumably Baronne de Bully sale, Château de Cueilly, 21 March 1891 (Lugt 49786), and before that with Chevalier Sebastian Errard, 23 April 1832.

27. Gould 1975, p. 275. For Van Dyck's painting see Barnes *et al.* 2004, p. 155, no. II.8 (entry by Barnes).

28. Inventory no. 1949.084. The painting is 126.7 × 91.8 cm and dated 1742. Not included in the monographs on Bazzani that I have consulted.

29. Bartsch 1802–21, XVI, p. 250, no. 5, Zerner 1979, p. 13, no. 5.1, Mauroner 1843, p. 63, no. 12.

30. The figure behind Christ is presumably meant to be Saint Peter. Catelli Isola 1977, p. 64, no. 168.

31. Brogi neg. no. 13717, a photograph taken in Palazzo Corsini, Florence, *c*.1930. A similar pattern of frame is on Domenico Ghirlandaio's double portrait in the Louvre, Paris (RF 216), but it has an additional slope at the sight edge.

32. Examples are in the Museum of Fine Arts, Boston (Solario, 11.1450), the Metropolitan Museum of Art, New York (Bronzino, 29.100.16), and the Cleveland Museum of Art (Gauguin, 1975.65).

33. Examples are a Kress Collection frame (F0435) in the store of the National Gallery of Art, Washington, and the frame on the Pontormo portrait in the Cini Collection, Venice (v.c.6733).

NG 3948
The Virgin suckling the Infant Christ

*c.*1565–75
Oil on canvas, 76.2 × 63.5 cm

Support
The dimensions given above are those of the stretcher. The canvas is of a coarse and open tabby weave. Cusping is apparent at the lower and upper edges, but not at the sides, where the canvas has been cleanly cut. Two sets of tacking holes are visible at the lower edge, inside the painted area, suggesting that the height of the painting was decreased at an early date, perhaps by Titian himself. The canvas has been lined with a wax resin on to a modern tabby-weave canvas of medium weight on a modern stretcher, with crossbars, of varnished pine.

Materials and Technique
The gesso ground is covered with a dark grey *imprimitura*. Originally, there were pink lake glazes in the shadows of the Virgin's lavender-grey dress, a hint of which survives by the child's feet. The feet themselves are both faded and worn. The lead white drapery between the child's legs is now sufficiently abraded for it to be clear that much of it was painted over the Virgin's dress.

A trail of loosely dragged lead white to the right of the child's hand is perhaps best explained as part of some preliminary compositional brush drawing that was made by the artist on the dark ground. This white would have been concealed by layers of paint which have now been abraded.

Conservation
On acquisition in 1924 the painting included a thin strip of putty at the upper edge, and a broad one (between 1.25 and 1.90 cm) at the lower edge. The latter had been scratched in such a way as to create a texture imitating that of the original canvas. Cavalcaselle maintained that the painting's merits were more apparent when it had been part of the Bisenzo collection, but that it had been subjected to cleaning and repainting soon after it left that collection.[1] Thus a date in the late 1840s seems likely for the putty extensions. However, the evidence of prints and copies (see below) suggests that the picture had been lengthened in some way before it was a hundred years old.

The painting was recorded as having a darkened varnish when it was acquired by the Gallery in 1924, and suspicions that the varnish had been deliberately toned were confirmed in August 1961 when analysis revealed the presence of bitumen.[2] The manuscript catalogue stated that the painting had been cleaned shortly before acquisition, but this was probably a superficial cleaning, and the toned varnish is more likely to have been applied in the late 1840s, the probable date of the treatment alluded to by Cavalcaselle. Polishing was recorded in 1945 and 1956. In August 1961 the toned varnish was removed and in February 1962 cleaning and restoration were completed, treatment which had been proposed to the Trustees by Philip Hendy in May 1948. Relining, which preceded restoration, entailed removing the extensions described above.

Condition
There are numerous small paint losses. The surface has been flattened and worn from ironing during relining and cleaning. In some areas the abraded appearance may have been exacerbated by the grainy effect of small residues of the old, darkened varnish having been driven into the interstices of the canvas weave. The wrinkling of the paint in the Virgin's sleeve may be due to excessive oil. For possible changes in the colour, see below.

Subject
Although the painting was captioned as depicting the Virgin and Child in a seventeenth-century print (see below), and clearly regarded as such by the artists who adapted the composition as a Sacra Conversazione (see below), and described as such in the nineteenth century, it was catalogued in the National Gallery as *Mother and Child*,[3] a designation perhaps chosen by the director, Charles Holmes, and certainly favoured in his own publications.[4]

Paintings of an anonymous mother and child were as rare in the sixteenth century as they were common in Holmes's lifetime, and the claim that Titian's painting belongs to the former category reflects the widespread conviction that it was in some sense a modern work (as is discussed further below). Cecil Gould rightly reverted to the traditional *Madonna and Child*.[5] We have modified this because it was relatively rare in art to show the infant Christ at his mother's breast (there are perhaps half a dozen other examples in the National Gallery[6]) and because, in the centuries when most women in families likely to own good paintings did not nurse their own infants, the subject had a significance which we easily neglect.[7]

Attribution, Dating, Style
The earliest observation on the painting in print seems to have been made by Gustav Waagen in his survey of Lord Ward's collection, published in 1854: 'Titian. – The Virgin and Child: a work not agreeing with the master's characteristics – tenderer and more pleasing in the heads, and much more broken, though very harmonious, in colour.'[8] This reads like a poor translation but it certainly seems to indicate that Waagen had doubts about Titian's authorship on account of both the tender sentiment and the colouring. The former is perhaps less characteristic than the latter, and by 1898, when Claude Phillips wrote his monograph on the artist, the broken brushwork and 'restrained scheme of colour' in the painting were acknowledged as typical of Titian's late work as exemplified by the *Christ Crowned with Thorns* in the Alte Pinakothek, Munich, or the *Nymph and Shepherd* in Vienna.[9] Since then it has been generally agreed that NG 3948 dates from very late in Titian's life.

Gould, however, suggested that the painting was perhaps a revision of an earlier composition[10] (as was the case with

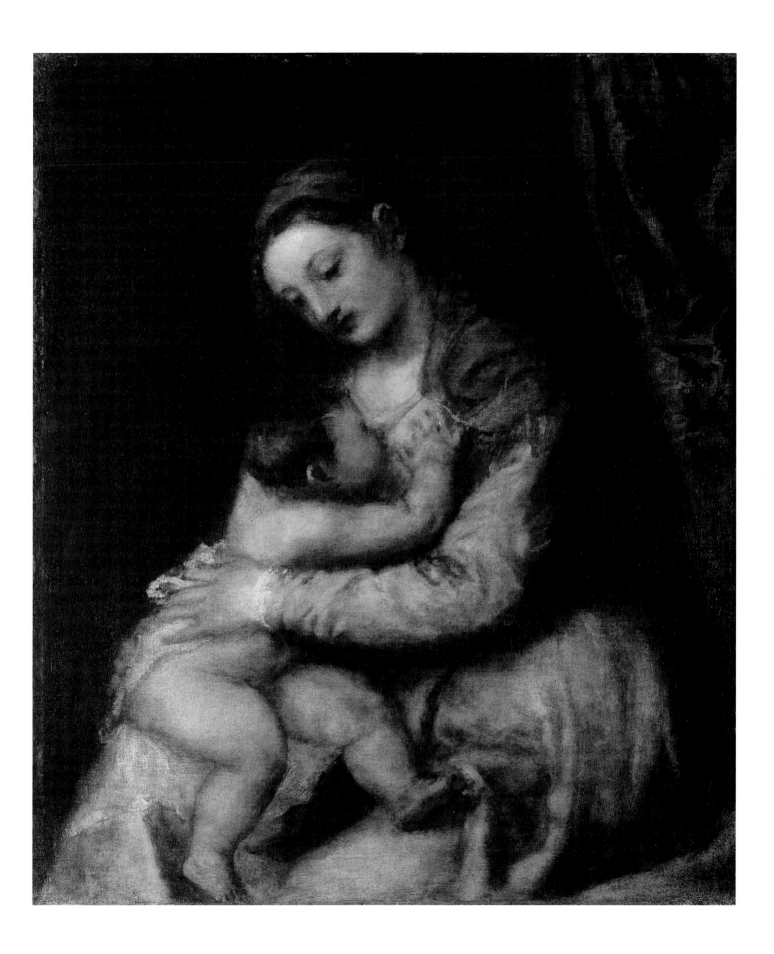

Christ Crowned with Thorns and perhaps the *Nymph and Shepherd*). He cited the fact that an early copy of the composition is in an earlier style (and thus may record an earlier lost painting by Titian). More significant perhaps is the fact that Schiavone's *Holy Family with Saint John* in the Castle Museum, Prague, in which an unusually heavy infant has his legs in the same position, looks as if it was derived from Titian's composition but must date from the mid-1550s.[11]

The torsion of the child and the heroic build of the Virgin represent one of Titian's most notable attempts to appropriate something of the sublime grandeur of Michelangelo, which had been an intermittent ambition throughout his life. This grandeur is here poignantly combined with a fragile tenderness in the Virgin's pensive face and delicate fingers. Cecil Gould compared the painting to the altarpiece in Titian's family chapel in the Chiesa Arcipretale of Pieve di Cadore, a work mentioned by Vasari and thus not executed later than 1567.[12] The Virgin and Child in that altarpiece do indeed have something of the same largeness of form and roughness of surface, but there is a tremulous touch in NG 3948 which suggests a later date, and the inconclusive character of the painting may even indicate that it was a work which the artist kept in his studio and tinkered with in the last years of his life.

Matteo Mancini has published documents concerning how greatly moved Antonio de Gúzman y Zúñiga, Marchese di Ayamonte, was by a painting of the Madonna which he saw when he visited Titian together with the Spanish ambassador, Diego Guzmán de Silva, in the second half of July 1573. Mancini suggests that this picture, which was sent to Ayamonte in November, may have been NG 3948. But if so it is surprising that the payment made to Orazio Vecellio on 19 February 1574 was for only 20 scudi.[13] If the painting was not NG 3948 it may have been a workshop painting derived from it, perhaps one of the copies listed in the relevant section below, but there are many other possibilities.

Reputation

NG 3948 was both copied and engraved at an early date but it was not much commented on in the mid-nineteenth century, perhaps partly because it was not lent to the Manchester Art Treasures exhibition. This may be explained by the fact that it was among the ten pictures that Lord Ward had earlier agreed to lend to Dublin (see the section on Exhibitions and Loans). The picture only became celebrated after 1892, when it was sold to Ludwig Mond for a high price at the Dudley sale. It is not coincidental that 1892 was also the year in which the magnificent new imperial art gallery, the Kunsthistorisches Museum, was opened in Vienna. An unanticipated by-product of the opening was a new conception of Titian's late style, for the artist's *Nymph and Shepherd*, which had not even been included in Crowe and Cavalcaselle's comprehensive survey of the artist's work, was given prominence and excited great interest. It was a 'picture which the world had forgotten until it was added, or rather restored, to the State collection on its transference from the Belvedere to the gorgeous palace which it now occupies'.[14] For Wickhoff, writing in the *Gazette des Beaux-Arts*, the painting in Vienna

was perhaps the last genuine painting by the artist and extraordinary for its pursuit of an 'effet d'unité' reminiscent of Rembrandt but with the underlying tonality not coming from the darkness of an interior but from 'the soft pink glow of dusk' ('la lumière rose du soir').[15] These same qualities were obvious in NG 3948, which excited much more interest when exhibited at the Royal Academy in 1894 than it had done in 1871. It was illustrated in Claude Phillips's monograph in 1898 and praised there as one of Titian's last and most original creations: 'in its almost monochromatic harmony of embrowned silver the canvas embodies more absolutely ... the ideal of tone-harmony towards which the master in his late time has been steadily tending.'[16] It is surely significant that the enthusiasm for Titian's late style coincided with an interest in rough or smudgy handling and deliberately blurred form in contemporary art: Eugène Carrière's near monochrome pictures of solemn maternal subjects were then enjoying especial popularity and critical acclaim (fig. 9, p. xxi).[17]

Mond displayed the painting on an easel in his library, where, in his old age, he found special comfort in contemplating it.[18] Not surprisingly, the critic, historian and dealer Jean-Paul Richter, who must have advised Mond to buy the painting at the Dudley sale, praised it in the highest terms in the luxurious two-volume book he devoted to Mond's pictures in 1910. Having drawn attention to the harmony both of colour and of composition, to the way that the line of the child's back was adjusted 'in order to force the eye to travel up it to the apex of the pyramid', to 'the deep red-brown of the sturdy little round head' in the 'quieter chestnut' of the 'kerchief', and to the fringe of the kerchief, which matches the child's ruddy cheek, he then managed to associate the painting with the art of Byzantium, which was at that moment being rediscovered and imitated by the avant-garde.[19]

Richter declared that the 'rich mosaic of tender colour' applied within a silhouette of 'melodious unity' reflected what Titian had 'learned on his knees from ancient ancones gleaming above the altars of old Venetian churches'[20] – a charming variation on the speculative literature concerning the artist's youth, which had not previously supposed that he had travelled from Cadore to Venice at this early stage in his development. Later in the twentieth century the affinities between Titian's broken colour and fragmentation of form and the earlier mosaics of Venice were often emphasised.[21] It was also possible to associate Titian with the most spiritual art of the seventeenth century: for Charles Holmes, director of the Gallery when the painting was acquired, this was a 'most exquisite and tender example' of a late phase in Titian's art, when he favoured 'darker, almost hueless, pigment lit as it were from within by murky and fitful fires ... attaining thereby to a depth and mystery like Rembrandt'.[22]

Dissenting voices are not easily detected in the early twentieth century, but Harold Isherwood Kay, annotating the catalogue of the *National Loan Exhibition* held at the Grosvenor Gallery in 1913–14, faintly praised the painting as 'pretty' and added that it was 'a little weak'.[23] Cecil Gould, when he came to catalogue the painting in the 1950s, clearly

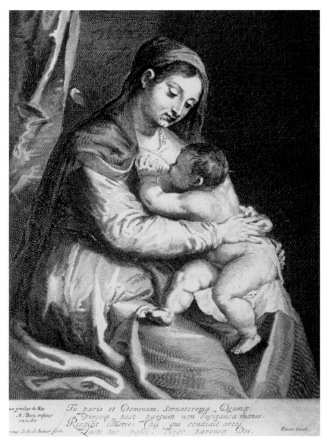

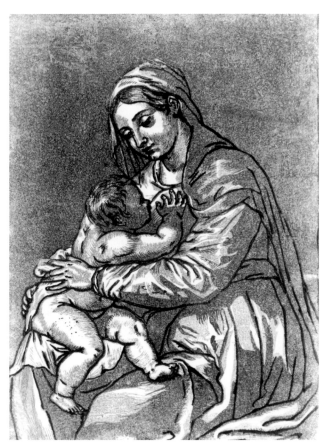

Fig. 1 Pieter de Jode the Younger after Titian, *The Virgin suckling the Infant Christ, c.*1631–2. Engraving, 24.5 × 17.8 cm. Private collection.

Fig. 2 Anon., seventeenth- or eighteenth-century copy after Titian's *Virgin suckling the Infant Christ*. Woodcut, 21.6 × 16.2 cm. Vienna, Albertina.

felt unable to share in the general enthusiasm, and merely considered it as 'accepted and acceptable as a work of his old age'.[24]

Provenance

Bisenzo Collection, Rome, where seen by Cavalcaselle; Lord Ward (later Earl of Dudley) *c.*1843, and certainly by 1850 (see p. 453). Bought by Ludwig Mond at the Dudley sale, Christie's, London, on 25 June 1892, lot 89, for 2,400 guineas (£2,520)[25] and bequeathed by him to the National Gallery, which received the painting on the death of his widow (who retained a life interest in it) in 1924.

Prints

The painting is reproduced in a three-block chiaroscuro woodcut (fig. 2) measuring 21.6 × 16.2 cm. Recorded by Bartsch as after Andrea del Sarto, it was, when published as such in the volume of the *Illustrated Bartsch* devoted to prints of this kind which appeared in 1983,[26] recognised as after the National Gallery's painting by more than one scholar.[27] If, as is easily assumed, this print was made in Venice in the last decades of the sixteenth century, it suggests that the painting must have been well known then.

The painting was certainly reproduced in an engraving inscribed 'Petrus de Iode iunior fecit' which was published in Paris by A. Bonenfant under royal licence (fig. 1).[28] Pieter de

Jode the Younger (1604–?1674) was working for Bonenfant in 1631/2, which is a probable date for the print. It must certainly have been made before the death of Pieter's father in 1634, after which the 'iunior' was no longer used. 'Titian Inv' is inscribed on the right side of the legend, which is chiefly taken up by a Latin quatrain on the Holy Virgin and the significance of her milk. The print seems likely to have been made with direct reference to the original painting, which may therefore have been in Paris or in the Low Countries around 1630. Pieter de Jode was admitted to the Antwerp guild in 1628/9. He is not known to have visited Italy.

Both woodcut and engraving extend the format of the painting, which may reflect the fact that the canvas had already been lengthened. The similarities between the prints are suspect. There is no detail in the woodcut which is certainly derived from the painting, whereas several details are closer to the engraving – especially the Child's fingers. Neither the woodcut nor the engraving includes the fringe of the Virgin's veil. One print derives from the other and, since the woodcut excludes the curtain, it must be the later work (reversing the composition back to its original direction), therefore the woodcut was made not in the sixteenth century but in the seventeenth century, or even the eighteenth. Caroline Karpinski kindly informs me that she will date the woodcut to the seventeenth century on grounds of style in her forthcoming catalogue volume for the *Illustrated Bartsch*.[29]

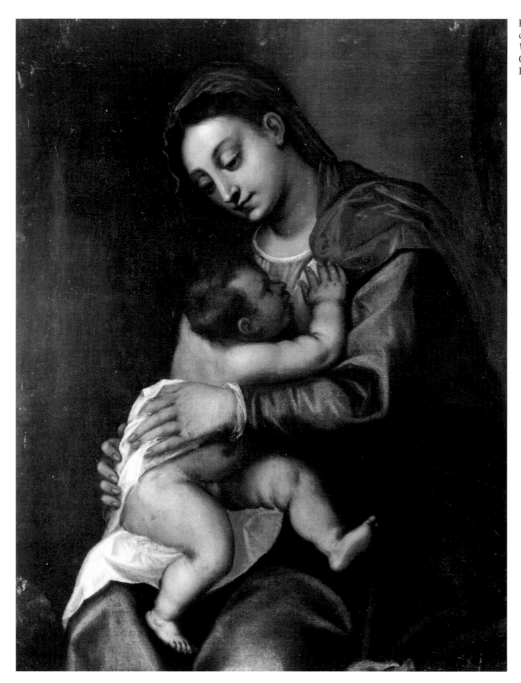

Fig. 3 Anon., seventeenth-
century copy after Titian's
Virgin suckling the Infant Christ.
Oil on canvas, 87 × 68.5 cm.
Private collection.

Copies

Copies of the painting are not uncommon. One such was exported in 1943; others have appeared at auction: lot 117 at Christie's, London, on 6 February 1953; lot 43 at Sotheby's, London, on 15 December 1954; and lot 60 at Sotheby's, London, on 11 April 1968 (fig. 3). Of these, the third mentioned (the one sold in 1954) was horizontal in format and seemed to Gould to be painted in a style more like that of Titian's maturity. But none of the pictures attempts to imitate the artist's late manner.

Several examples of the composition, with a saint added to the right and the left to form a Sacra Conversazione, are recorded: one was in the collection of Gustave Gluck;[30] another, very schematic in character, was in the Worcester Art

Museum;[31] and a third was published in 1928 as an original by Titian by Hadeln, the great scholar of Venetian art. This last work is a fascinating document in the history of taste, which cannot be dismissed as an aberration of Hadeln's since *The Burlington Magazine* agreed to publish it. To Hadeln it seemed reminiscent of *Cézanne* (with whom it was then, of course, even more distinguished to be associated than with Byzantine mosaics or with Rembrandt) and as Gould later mischievously observed it almost looked as if it had been painted by him.[32] It was surely a modern interpretation of Titian made for modernists and as such interesting to compare with the painting exhibited by Vanessa Bell at the Storran Gallery in February 1939 as one of a series of 'paraphrases' by 'about twenty artists'.[33]

Exhibitions and Loans

Dublin 1853, Exhibition Hall, Merrion Square, Irish Industrial Exhibition (93); Dublin 1854, Irish Institution, Royal Hibernian Academy of Arts (101);[36] London 1871, Royal Academy, Winter Exhibition (331); London 1894, Royal Academy, Winter Exhibition (110); London 1913–14, Grosvenor Gallery (47); London 2003, National Gallery (35); Madrid 2003, Museo Nacional del Prado.

Frame

There seems to be no trace or record of the frame or frames in which the painting was displayed when it was in the Dudley and Mond collections. Its present frame was chosen for it by Philip Hendy,[34] presumably in 1962 after a relining had altered the size. It is a gilt cassetta frame with a fluted outer moulding of a pattern typical of Tuscany in the early seventeenth century.[35] The frame has certainly been reduced in size and the collision of the flutes at the corners has been masked with smudged putty. Some at least of the clumsy rosettes and piecrust cherubim with awkward foliate attachments in the flat are surely remade. The toning layer, as well as muffling the gilding, conceals the alterations. Old frames with coarse ornament and matt, often repellent, textures were much favoured for modern paintings in the mid-twentieth century and perhaps seemed appropriate for the rough late style of Titian as well.

NOTES

1. Crowe and Cavalcaselle 1877, II, p. 428. The observation must be Cavalcaselle's.

2. Report by Joyce Plesters of the National Gallery's Scientific Department, dated 10 August 1961.

3. [Collins Baker] 1925, p. 333; [Collins Baker] 1929, p. 364.

4. Holmes 1927, p. 195.

5. Gould 1959, p. 116; 1975, p. 283.

6. Notably NG 29 (Barocci), NG 275 (Botticelli Workshop), NG 728 (Boltraffio), NG 593 (Lorenzo di Credi), NG 293 (Filippino), NG 2595 (Bouts).

7. In Spain and Spanish South America paintings of the Virgin suckling the infant Christ were given a special name, that of the *Virgen de la Leche* and *Virgen de Belén* (*Virgin of the Milk, Virgin of Bethlehem*).

8. Waagen 1854, II, p. 235.

9. Phillips 1898, p. 104 (and see the reproduction on p. 103). For the Munich painting see Wethey 1969, p. 83, cat. 27.

10. Gould 1959, p. 116; 1975, p. 283.

11. Neumann 1967, pp. 237–9, no. 56; Richardson 1980, p. 171, no. 284.

12. Gould 1959, pp. 116–17; 1975, p. 283. For the altarpiece see Wethey 1969, p. 83, cat. 57, plate 47. The picture has often been considered as a workshop piece but there was great enthusiasm for it in the decade following its cleaning in 1951. See especially Valcanover 1951, p. 207 (where the 'stretta affinità' with NG 3948 is mentioned), and Pallucchini 1969, I, pp. 183–4 and p. 198 (where again it is compared with NG 3948).

13. Mancini 1998, pp. 81–3 and (for documents) pp. 378–88.

14. Phillips 1898, II, p. 106.

15. Wickhoff 1893, pp. 16–17.

16. Phillips 1898, II, p.106.

17. For Carrière see Faure 1908 and Geyer *et al.* 1997.

18. Richter 1920, p. 42. I owe this reference to Giorgia Mancini.

19. See, for example, Roger Fry's letter to the editor of *The Burlington Magazine* in 1908, p. 375, explaining that Cézanne and Gauguin were 'proto-Byzantine' artists, rather than 'neo-Impressionists'.

20. Richter 1910, pp. 134–44.

21. For example Wilde 1973, p. 184.

22. Holmes 1923, p. 195.

23. See the copy of the catalogue in the National Gallery library on p. 71 (in the same copy Claude Phillips's opinion that the painting is a 'gem' is recorded). Isherwood Kay (1893–1938) joined the Gallery as a photographic assistant in 1919 and was made assistant curator in 1921 and keeper and secretary in 1934. He died in office.

24. Gould 1959, p. 116–17; 1975, p. 283.

25. In the copy of the sale catalogue in the National Gallery library the lot is annotated as bought by 'Mond' rather than by 'Richter' (who was bidding for Mond); this was also the case with the Rubens landscape (lot 30). This is unlikely to be significant but is perhaps worth recording. The price was one of the highest in the sale, although, surprisingly, identical to that of a Lorenzo di Credi (lot 56). It was, of course, lower than that of Raphael's *Crucifixion*, formerly in Cardinal Fesch's collection and now in the National Gallery, known as the 'Mond Crucifixion', which was bought for 10,600 guineas.

26. Bartsch 1802–21, XII, 1811, p. 54, no. 8; Karpinski 1983, p. 69, no. 8 (54). Examples of the print are in the Albertina, Vienna, the Bibliothèque Nationale, Paris, and the Rijksmuseum, Amsterdam.

27. Both the late Richard Godfrey and David Landau wrote to me at the National Gallery to point this out.

28. The print (Hollstein, IX, p. 211, no. 8) was first drawn to the attention of Cecil Gould by Christopher White on 18 August 1960 – it was not mentioned in Gould's catalogue of 1959.

29. Karpinski (typescript), pp. 311–13.

30. Photographs of all these copies are in the National Gallery's dossier. I have seen none of them in the original.

31. Inv. no. 1931.82. Included in their catalogue of 1974.

32. Hadeln 1928. The painting was the property of a Mr Henneker-Heaton. Gould's comment appears in his second note (1959, p. 117; 1975, p. 284).

33. For the Storran Gallery, which sold modern French and contemporary British painting between 1932 and 1939, see Knollys 1989, and for this exhibition see p. 206: 'One of the most stimulating exhibitions resulted from an invitation to about twenty artists to send us paraphrases or free versions of works by other painters. There was Rogers after Corot, Moynihan and Vanessa Bell after Titian, Gowing after Goya, etc. They made a fascinating but perhaps too varied a show.' Richard Shone kindly informs me that the painting is not in the catalogue of Vanessa Bell's works at Charleston in 1950.

34. Typescript notes by Cecil Gould of frames given to the Gallery's Italian Renaissance paintings.

35. See Baldi, Lisini *et al.* 1992, pp. 141–2, nos 59 and 60. But see also Sabatelli *et al.* 1992, pp. 178–9, no. 54 (an Emilian frame).

36. For both Dublin exhibitions see Stewart 1995, p. 713.

Workshop of Titian

NG 34
Venus and Adonis

*c.*1554
Oil on canvas, 177.9 × 188.9 cm

Support

The measurements given above are those of the stretcher. The original canvas is a medium to heavy twill, woven in a diagonal pattern. (A full discussion of this canvas type is given in the entry for Titian's *Vendramin Family*, pp. 206–10). There are 18 threads per cm in the warp (vertical to the image) and 17 per cm in the weft.[1] This canvas is wax-lined on to a tabby-weave canvas of medium weight. The tattered tacking-edge of the original canvas survives: approximately 2 cm of it adheres to the turnover of the lining canvas on all sides.

Materials and Techniques

The canvas has a gesso ground but there is no overall *imprimitura*.

Much bold and broadly brushed drawing in a black or perhaps umber pigment is visible (and very apparent in infrared photography, fig. 1) in the sky, on the back and shoulders of Venus, and on Adonis' right arm.

The sleeping Cupid and the quiver with its fluttering ribbon are all painted on top of the foliage. Adonis' flesh (and no doubt that of Venus) consists of lead white with a little vermilion, and yellow and brown ochres. The lights in the foliage on the right are painted with lead-tin yellow with a little azurite. These are applied onto the dark green of the foliage, composed of verdigris with a little lead white, azurite, vermilion and black. The dark green glazy verdigris-based paint has discoloured and turned brown, although the presence of red and black pigments suggests that it was never a bright green. The vase at the lower left is painted with a mixture of ruddy iron earths with a copper-green glaze that has discoloured: the lights, painted with lead-tin yellow, seem to have been applied when the lower layer was still wet.

Conservation

The painting had certainly been lined at least once, and probably several times, before it was acquired by the Gallery in 1824. It is likely to have been cleaned in about 1800 before being sold to John Julius Angerstein because it was said that Prince Colonna, 'for motives of devotion', had the buttocks of Venus covered with drapery which was 'afterwards, as far as was possible, obliterated'.[2] After acquisition by the National Gallery it was coated with a mastic varnish mixed with drying oil, removed by John Seguier when he cleaned the picture in 1844. One witness to the Select Parliamentary Committee of Enquiry in 1853 attributed a rapid dulling of the surface to the use of such an oil varnish.[3] In the Manuscript Catalogue of 1855 the visibility of the brush underdrawing in the goddess's back was considered distracting; 'blistering' was also recorded in the dark areas of the foliage,

upper left. The painting was varnished in 1862, and cleaned (probably only surface-cleaned) and varnished again in 1883.

In October 1923 a decision was made to remove the 'much darkened varnish' on account of anxieties concerning the 'crumbling condition' of the right foreground and the foliage at the upper left. The director of the Gallery, Charles Holmes, was impressed by what Holder, the restorer used most frequently by the National Gallery, had revealed and was especially struck by the artist's 'revision of the tree forms to the left'. He announced to the press on 20 November a 'novel departure from custom'[4] – indeed, an unprecedented type of public exhibition: 'To enable this revision and other details of handling to be seen clearly the work will be shown for a month or two in its naked state without the repairs and varnish that are still needed to bring it into proper condition.' In January 1926 it was noticed that Holder's 'repairs' were not effectively covering the foliage that Titian had wished to conceal on the left and they were, accordingly, 'dead coloured more substantially' by him in the following month.

When the painting was transported to Bangor in August 1939 at the outbreak of the Second World War, an accidental gash was made in the paint on Adonis' foot. Between 1939 and March 1940 this damage was patched from behind, filled in and retouched. Some surface dirt was also removed, and the painting was revarnished by Holder. Surface-cleaning was recorded in July 1945 and January 1947. A report in 1948 commented on distortions occasioned by the partial cleaning of 1923. The oil retouchings of that period had darkened and it was claimed that the varnish then applied was already breaking up, perhaps on account of 'the large amount of old perished varnish on which it was superimposed'. This may be more revealing of the aversion to Holder's traditional methods on the part of the 'scientific' Ruhemann than it is informative about the actual condition of the painting. (Holder doubtless had left some varnish but perhaps not a 'large amount'.) It was not until February 1973 that the painting was taken off display for treatment. By then the original canvas was becoming detached from the lining canvas. After relining, cleaning and restoration, the painting was returned to display in September.

Condition

The paint has been worn and, it seems, also overheated in several areas, presumably a consequence of ironing during the lining process. The wear is most evident in the sky above and around the head of Adonis, in his chest, in Venus' back, and in the hounds' legs. There is a fine craquelure in the darker areas of the foliage, with many small losses at the edges of the cracks. There are losses in the sky and in the foliage just above Adonis' right forearm.

The shadows in the crimson drapery upon which Venus sits are likely to have been more distinct. The pink in the cloth protecting Adonis' bare upper arm from the traces of his hounds may have faded. The pale grey-brown beside the pink may originally have been a smalt blue. Much of the foliage may have darkened from discoloration of the copper-green glaze. The paint has also become more translucent in the sky

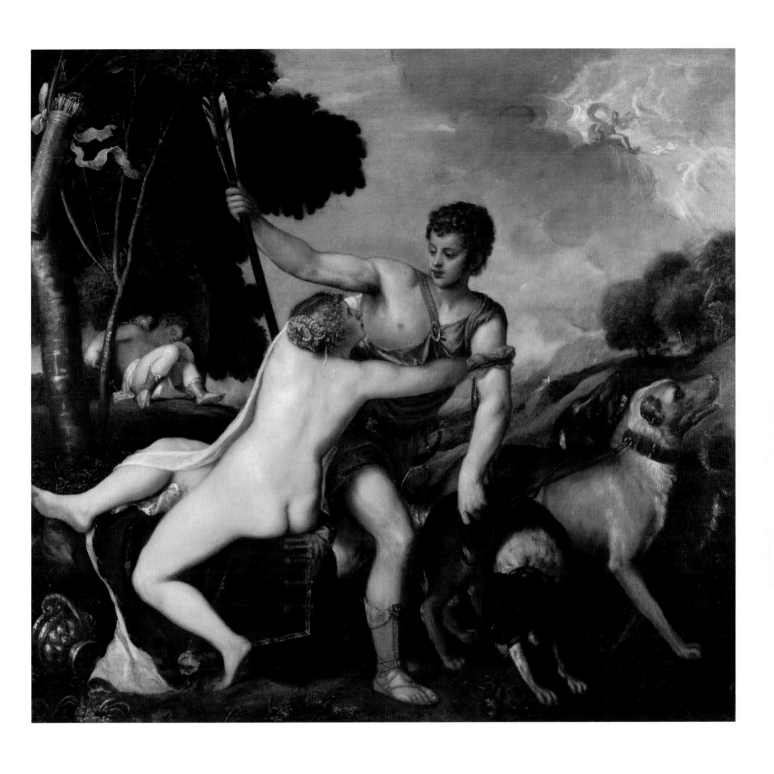

and parts of the flesh, revealing a broadly brushed under-drawing (see below).

Attribution and Dating

The painting is now generally regarded as a product of Titian's workshop. This is surely correct, but Titian himself may have painted the head of Adonis (see detail, fig. 2) and the hair of Venus, and – most significantly – the bold underdrawing with a brush may have been made by him. Much of the landscape is perfunctory and the painting has sometimes been described as unfinished, although this seems unlikely.

There seems to be no record of any scepticism concerning the status of the painting prior to 1800. Indeed, the earliest critical account that is known to us reflects the very great enthusiasm it elicited shortly after its arrival in Palazzo Colonna. Surveying the Titians in the Queen of Sweden's collection which the Duc d'Orléans was seeking to acquire from the Odescalchi family, 'M. Guilbert', in a report written in early July 1720, observed that the larger version there of 'Adonis arrêté par Vénus' required special attention because there was 'un très excellent original' in the imperial collection in Vienna and there was another to be seen in Rome among the paintings added to Palazzo Colonna as part of the dowry of the Duchess Salviati, which is of 'the most sublime perfection of which this great painter was capable' ('dans cette vill-cy apporté à la maison Collonne par la dotte de Madame la Duchesse Salviati, et qui est de la plus sublime perfection dont ce grand Peintre ait été capable'). The Colonna painting, in the opinion of this connoisseur, was much superior to the Queen of Sweden's, which was, however, 'merveilleux'. Despite a previous suspicion that the latter might be an 'excellente copie de Paul Véronèse', the variations in it and that indefinable quality which reveals the master's hand ('un je ne scay quoy qui marque le caractère du maître') led him to conclude that it was an original work by Titian but painted at an advanced age. (This is probably the painting, described below, which is now in the J. Paul Getty Museum.) The smaller and squarer variant in the Queen of Sweden's collection he thought also original but not so late and somewhat 'gâté et négligé'.[5] (This is the version, also described below, recently in Lausanne.) The painting in Vienna is now lost. What is completely clear is that the National Gallery's version, that is, the Colonna version, was considered the finest by a highly respected connoisseur.

This opinion was repeated by other connoisseurs, most notably von Ramdohr in 1787 – 'Dieses hier hat einen grossen Charakter von Originalität' – and the sleeping Cupid (fig. 11) and the beauty of Venus' back were especially commended.[6] However, doubts were expressed as soon as the painting entered Angerstein's collection. At first they concerned its condition. Benjamin West informed Joseph Farington a few days after the sale that 'there is very little in the Venus and Adonis in the state in which Titian left it'.[7] West may have been piqued not to have been employed – or not to have been attended to – as an adviser in this purchase. And it may not be irrelevant that he himself owned another version of the composition (see below).

Hazlitt in the first of his critical essays on great English collections, written just before (and published just after) Angerstein's collection was acquired as the foundation of the National Gallery, simply commented in a note that 'it does not appear to us from the hand of Titian' – although he had no problem accepting *The Rape of Ganymede* and the *Concert* (see pp. 95 and 300).[8] On the whole, Angerstein's *Venus and Adonis* remained in high esteem. William Seguier's valuation of the collection assessed it at £3,500 – less than Sebastiano's *Raising of Lazarus*, less than Claude's *Seaport with the Embarkation of the Queen of Sheba*, but the same as Claude's *Marriage of Isaac and Rebecca* and more than any other picture in the collection.[9] A. J. Valpy in his guidebook (thought to be of 1832) described it as 'one of the finest of the artist's works', and 'one of the very best of the works ever executed by Titian in the class to which it belongs'.[10] Ottley admired every aspect of it, from the pearls entwined in Venus' hair, 'which from their whiteness, give value to the delicate carnation of her figure', to the gold lace edging the crimson velvet cloth on which she sits, which is 'of so subdued a tone, as not to look gaudy'.[11]

Mündler, who annotated the 1847 edition of Wornum's catalogue, in 1855, to the effect that the painting was 'weak in drawing, heavy in tone' and only a 'studio work', was probably expressing a minority opinion.[12] But some lack of enthusiasm for the painting may perhaps be deduced from the apparent uncertainty as to whether or not to hang it high in the new gallery in 1861.[13] It became orthodox to consider the painting as a studio work after the publication of Crowe and Cavalcaselle's *Titian: His Life and Times* in 1877, in which it is described in a note as 'a counterpart of the Madrid example, but painted with less delicacy, and apparently with much help from Schiavone. It might, indeed, have been altogether carried out by that disciple of Titian.'[14] The formula used by Wornum in 1847, by which the painting was listed as by Titian but with a note indicating that he 'painted several repetitions', was, however, retained in all official catalogues of the Gallery until that of 1906.[15] A change was made in the *Descriptive and Historical Catalogue* of 1913, where it is observed that 'the presumable original, with certain differences, is at Madrid'. Five other versions are listed there, and the possibility of Schiavone's authorship is also mentioned.[16] Charles Ricketts, the most perceptive writer on Titian in the early years of the twentieth century, considered the painting in the Prado to be 'sadly disfigured by restorations, but possibly in its time a gorgeous piece of painting'. The picture in the National Gallery was a later 'studio variant ... more empty in execution, but at least undamaged'. He felt that 'Schiavone's touch is not obviously present ... but something in the colour brings his manner to mind.'[17]

When the painting was cleaned in 1923 Holmes was deeply impressed by its quality as well as by the evidence of the revision (as he supposed it to be) in 'the tree forms to the left, over which parts of the sky have been painted'. In the press release announcing the exhibition of the painting 'half-repaired' he claimed that it is a 'first experimental version of the subject by the master himself'.[18] This view was

Fig. 1 Infrared photograph of NG 34.

elaborated by W. G. Constable in the *Illustrated London News* for 1 December 1923.

Four other notable versions of the composition were then in British collections and two of these were much in the public eye during this same period: Lord Spencer's, which was sold that year, after exhibition by Agnew's, to Joseph Widener of Philadelphia (now in the National Gallery of Art, Washington), and Lord Darnley's, sold at Christie's on 1 May 1924 and bought for Julius Bache (now in the Metropolitan Museum of Art, New York).[19] On the eve of the latter sale the *Illustrated London News* published five versions together on the same page. Holmes himself published a succinct article

in *The Burlington Magazine* for January 1924 in which he perceptively identified both the strengths and the weaknesses of the National Gallery's painting and then proposed as the best explanation for its uneven quality and evident revisions that it was the earliest version, earlier than the Prado painting. 'Up to a certain point Titian gave it every care, but then became dissatisfied with certain fundamental defects in the design, and started the work afresh upon a new canvas. This new canvas became the Prado picture. The prior version, in some parts (for example, the white draperies) still unfinished, was disposed of later to a less important patron than the Spanish King.'[20]

This became the official Gallery view, published in the catalogues of 1925, 1929 and 1939. It also won much support elsewhere. A.L. Mayer went further, claiming that the entire painting was unfinished.[21] Tietze-Conrat regarded it as a preliminary sketch of about 1553 that was kept in the artist's workshop and served as the basis for repetitions.[22] The painting was also accepted as by Titian by both Valcanover and Pallucchini.[23] Gould in his catalogue of 1959 considered that the underdrawing must be by Titian and that the artist's touch was 'unmistakeable' in some areas of the drapery and in the vase. Later, however, Gould completely changed his mind and, in his catalogue of 1975, demoted it to the status that it had had before Holmes put forward his claims for it, explicitly designating it as 'Studio of Titian', without any reference to his earlier views.[24] This very uncharacteristic reversal of opinion was never explained.

As will become clear, although I accept that the painting is largely a workshop piece, I consider that Tietze-Conrat may have been correct in her assessment of the picture's status.

Subject

A youth hastens to the hunt holding a feathered spear. His three eager hounds are restrained by traces wound around his upper arm. A woman, nearly naked, seated on a bank seeks to detain him with both arms. A bow and quiver are hung in a tree on the left. Beyond it, in the middle distance, a child slumbers in the half-shade. In the sky at the top right a nude female figure appears on a chariot drawn by a pair of white birds (presumably swans).

Descriptions written in Titian's lifetime make it clear that the youth is Adonis and the woman Venus. It follows that the child is Cupid (and the bow and arrows must be his). The figure in the chariot has been identified as Apollo or Sol, to indicate the dawn, but it must represent Venus at a later stage in the narrative.

Adonis' buskins and his light drapery have little connection with contemporary dress, and, like the cameo clasp on the sash across his chest and perhaps the dressing of Venus' hair, reveal the study of antique sculpture. But Adonis' feathered throwing-spear (sometimes called a javelin) is a 'dart', a contemporary weapon, well documented, although no examples have survived.[25] The quiver hanging on the tree 'appears to be of painted or lacquered wood of a kind of which one or two examples survive in the armoury of the Council of Ten in the Doge's Palace, Venice'.[26] The velvet cloth with braid and buttons upon which Venus sits has often been supposed to be a military jacket but velvet tablecloths were often fastened with such buttons where they fell at the corners.[27]

One of Silos's Latin epigrams on the paintings in the Salviati collection correctly identifies the subject of the version catalogued here as 'Venus and Adonis and his hounds in a single picture'.[28] However, the early descriptions of Titian's painting of Venus and Adonis were not familiar in subsequent centuries and some learned commentators, sceptical of traditional titles and aware that Venus was not described as attempting to detain Adonis in this way in any ancient source, seem to have speculated that the story represented was perhaps that of Cephalus. Ovid at the close of Book VII of the *Metamorphoses* described Cephalus as departing to hunt at dawn with a javelin as his only weapon, and both a javelin and a hound play a fatal part in his story. For Vincente Carducho, citing Titian's paintings in the Alcázar in the 1630s, this composition was of *Diana y Cefiro*.[29] In the late eighteenth century Ramdohr described the version in the Colonna gallery (the one catalogued here) as of Cephalus and Procris.[30] Carducho may have meant Cephalus (rather than the wind god, Zephyrus) by Cefiro and he may have been thinking of Aurora rather than Diana. Aurora, goddess of the dawn, loved Cephalus but could not stop him from thinking of his wife, Procris. Ramdohr must have been thinking of Procris' ill-founded jealousy, which made her suspect Cephalus' motives for hunting. He may also have interpreted the slumbering figure as a reference to Cephalus' slumber in the shade later in the day (Procris then spied on him, disturbed him, was mistaken by him for prey, and was killed with the javelin). That the story of Procris was seen as somehow parallel to that of Adonis is clear from the fact that Veronese painted the *Death of Procris* as a pendant to his *Adonis sleeping in the Lap of Venus*.[31]

Some recent commentators have proposed that the painting is an allegory.[32] But, if such was intended, it seems extraordinary that Dolce in his full contemporary account of the painting (discussed below) does not even hint at this. However, it is hard to resist the idea that Cupid is asleep with his weapons suspended, not only because it is early in the day but as a poetical way of signifying that 'the blandishments and caresses of beauty, unaided by love, may be exerted in vain'.[33]

Literary Sources

The best-known version of the story of Venus and Adonis appears in the tenth book of Ovid's *Metamorphoses*. The previous episode in the book concerns the incestuous passion of Myrrha for her father, King Cinyras. Having been tricked into sexual intercourse with his daughter, Cinyras discovers her identity. She flees, pregnant, and, after supplication to the gods, is turned into the weeping tree that now bears her name. From its bark her son Adonis is born – 'he looked like one of the naked Cupids painted in pictures, differing from them only in dress: for to be truly identical he would have to be given a light quiver.' This passage may have had some influence on Titian in his conception of the sleeping child and the suspended quiver.

Adonis grows up a handsome youth and Venus falls in love with him when Cupid, kissing her, inadvertently wounds her with one of his arrows. She takes to hunting with Adonis but does not pursue the fiercer prey (wolves, bears, lions and boars), about which she warns her lover, telling him the story of Atalanta and Hippomenes. One morning, when Venus has departed in her sky-borne chariot, Adonis goes hunting. His hounds rouse a wild boar. He spears it, but only wounds the beast, which turns on him and sinks its teeth into his groin. The goddess hears his groans from on high.

Fig. 2 Detail of the head of Adonis.

Leaping from her chariot, she finds him dying. She laments his death, and creates from his sprinkled blood a beautiful but fragile flower whose petals are quickly scattered in the wind, after which it is named anemone.

The story had occasionally been illustrated in cassone panels and other paintings.[34] One of the frescoes painted in the mid-1530s by Rosso Fiorentino for the Grande Galerie of the palace at Fontainebleau depicted the chariot hurtling to earth, Venus within it, tearing her hair at the spectacle of her beloved's body, which is supported by nymphs and 'cupids'. Rosso elaborates on Ovid (or the *Lament of Adonis* by Bion of Smyrna, which has also been proposed as a source).[35] A cycle of frescoes by Siciolante painted in the 1550s, in Palazzo Orsini at Monterotondo, illustrates the key episodes in Ovid.[36] But Titian, in his painting, despite his close attention to ancient poetry in other works, invents an episode which is not in Ovid, for Ovid's Venus never attempts to dissuade her lover from the hunt. She simply warns him not to pursue the fiercer prey. And it is she who leaves him, not he who leaves her. Raffaello Borghini in his *Il Riposo* of 1584 expressed regret that Titian had taken such licence with a classic text.[37] Later scholars, as mentioned above, wondered whether another subject was depicted.

It is surely significant that there was intense literary interest in the story of Venus and Adonis during the period in which Titian seems first to have painted it. In 1553 Diego Hurtado de Mendoza's *Fábula de Adonis* was published in Venice. The poet had sat to Titian in 1541 when he was Spanish ambassador to the Venetian Republic.[38] Lodovico Dolce, to whom Titian was certainly well known (see below), paraphrased the *Metamorphoses* in *Ottava rima*: his *Le Trasformationi* was also published in 1553 and he had published his *Stanze ... nella favola d'Adone* in Venice in 1545.[39] Nevertheless, there does not seem to have been a literary precedent for the episode Titian chose to paint. Mendoza does, it is true, describe a final embrace, but with both seated on the ground[40] and Venus' earlier warnings about fierce prey are not so different from Ovid and not associated with their parting.

Visual Sources

Titian's Venus is modelled on a figure which is now supposed to represent Psyche in an ancient Roman marble relief showing her uncovering the sleeping Cupid.[41] In the sixteenth century the relief seems to have been taken for Venus and Vulcan. No other large figure in a major work by Titian comes as close as this to being a 'quotation' and it is tempting to speculate that the artist was prompted to make such a notable act of homage by a learned friend. The marble relief was very famous and was known as 'il letto di Policleto' (the Bed of Polyclitus), with reference to the celebrated ancient Greek sculptor to whom it was attributed. And perhaps it was considered to be a fitting challenge for a 'modern Apelles' to urge him to adopt the invention of a great ancient sculptor.

Lorenzo Ghiberti had owned a version of this relief. Raphael had been asked to acquire it from Ghiberti's family by Alfonso d'Este in 1517 but he did not succeed.[42] It was sold, according to Vasari, by Vittorio Ghiberti to Giovanni Gaddi.[43] A version – perhaps the same version – was, however, acquired by Cardinal Ippolito II d'Este from the collection of Cardinal Ridolfo Pio da Carpi and this was bought by the emperor Rudolf II and subsequently lost in the sack of Prague. Pietro Bembo owned a copy of the relief and so did Cardinal Granvelle.[44] Both men were well known to Titian and had sat to him in the 1540s (Bembo in about 1540 and earlier, Granvelle in about 1548).[45] Moreover, Titian visited Rome in 1545, and there he would probably have seen at least one version of the antique relief. He would also have observed the notable use made of the same pose for the figure of Hebe in the fresco of the *Banquet of the Gods* on the vault of the Loggia di Psyche in the Villa Farnesina (as it is now called) by Raphael's workshop. In addition he would have known of Giulio Romano's adoption of the same pose in his fresco of *Bacchus and Ariadne* in the Sala di Psyche of the Palazzo del Tè in Mantua and may perhaps have noticed its use for one of the stucco reliefs made by Giovanni da Udine for the Sala di Callisto in Palazzo Grimani in Venice (of *c*.1539).[46]

The Different Versions of the Painting

The composition is known in two basic forms which have been distinguished by Wethey as the 'Farnese type' and the 'Prado type'.[47] The National Gallery's painting is an example of the latter type. The hypothesis is here developed that the National Gallery's painting is largely a product of the artist's workshop but may have been painted over a brush drawing made by Titian himself.

In the Prado type the canvas size is about 180 × 200 cm. Adonis is accompanied by three hounds. Cupid lies sleeping in the middle distance. The feathers of the dart are visible. A metal vessel lies toppled on the ground at the lower left. There is usually a chariot in the clouds in the upper right-hand corner. The chief examples of this type are:

(1) The version in the Prado, Madrid (fig. 3), first certainly recorded in Spain in 1626.[48] It is reasonably supposed to be the painting of Venus and Adonis which Titian, in a letter of 10 September 1554, said he was dispatching and which was received in London by Philip (Prince of Spain, recently made King of England by his marriage to Queen Mary) by December 1554. Philip complained (in a letter to Don Francisco de Vargas dated 6 December) that the picture was perfect but for a fold made in packing. It seems likely that he was disturbed by (and did not understand) what must in fact have been the line of the canvas join, which is now indeed very evident: 'El quadro de Adonis que acabó Ticiano ha llegado aquí, y me paresce de la perfición que dezís, aunque vino maltratado de un doblez que traya al traves por medio dél, el qual se desvió hazer al cogelle; verse ha el remedio que tiene.'[49]

(2) The version in London, catalogued here, which has not been traced further back than the Salviati collection in the seventeenth century.

(3) The version in the J. Paul Getty Museum (fig. 4), previously in the Normanton collection at Somerley and traceable to the Orléans Collection, whence it came with the Odescalchi

paintings that had belonged to Queen Christina of Sweden (this painting may be presumed to be one of the two recorded in the queen's collection in 1662).[50]

(4) The version recently in a private collection in Lausanne (fig. 5), formerly the property of Baron von Heyl, acquired from the Miles family of Leigh Court. It belonged to Benjamin West and, like no. 3, had been in the Orléans Collection.[51] It had also almost certainly come from Queen Christina's collection and had previously been in the imperial collection in Prague. It includes the death of Adonis in the distance on the right, and the figure in the chariot must be meant for Venus for it is clearly drawn by swans. This picture was auctioned by Christie's in 1998. Extraordinary claims were made for it by the late Roger Rearick in an article published not long before the sale.[52]

(5) The version in the Museo Nazionale di Palazzo Barberini, Rome, in which Adonis has been given a feathered hat. This comes from the Torlonia collection (but almost certainly not from Queen Christina's collection as has often been claimed).[53]

In addition, a number of copies of this type are known, some of which may be workshop replicas made in the sixteenth century.[54] A reduced copy at Alnwick Castle, Northumberland, which excludes the figure of Cupid and shows Adonis in the hat featured in no. 5 and depicts his death in the distance (as in no. 4), was once thought to be the artist's original *modello*. Crowe and Cavalcaselle considered that none of the finished versions was the equal of this 'original sketch'.[55] The same claim was made by Sir Abraham Hume of the small version (17 × 15½ in.; 43 × 39 cm) in his collection by 1824.[56] We know that a small version was made by Titian's son, Orazio Vecellio, since Titian himself mentions it in a letter of 24 May 1562.[57] It may well be the painting at Alnwick. Titian himself did not like to work on this scale but he was perhaps impressed by the success of Veronese's cabinet pictures and encouraged his son to imitate them.

The five versions are not identical in composition, but nos 2, 3, 4 and 5 correspond as closely in the size and position of the figures as would be expected had a tracing or some such aid been employed. But when the heads in those versions are aligned with the heads in no. 1, Venus' body turns out to be considerably shorter in length than it is in the others,[58] and this is to mention only the most obvious difference. Also, the type of the Adonis in nos 2, 3, 4 and 5 is the same, but in no. 1 it is a distinctly less juvenile model. An explanation for this could be that Titian, prior to sending no. 1 to Philip, knowing that he might want to make other versions and might also wish to have the composition engraved, made a

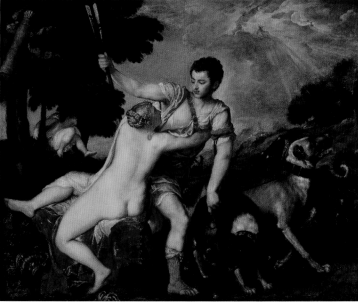

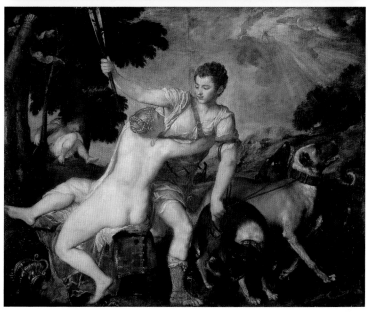

FROM TOP:

Fig. 3 Titian, *Venus and Adonis*, 1553. Oil on canvas, 168 × 207 cm. Madrid, Museo Nacional del Prado.

Fig. 4 Titian and Workshop, *Venus and Adonis*, c.1555–60. Oil on canvas, 160 × 196 cm. Los Angeles, The J. Paul Getty Museum.

Fig. 5 Workshop of Titian, *Venus and Adonis* (Prado type no. 4), 1560–5. Oil on canvas, 177.5 × 200 cm. Private collection.

free copy to serve as a 'studio model'. This he would presumably have sketched in himself, making perhaps some improvements or at least minor changes to the earlier design. In this connection it may be relevant that one of several roughly sketched-in paintings ('*abbozzature*') which Tintoretto acquired from the studio of Titian shortly after his death was, according to Ridolfi, of this subject, although it could well simply have been another unfinished studio replica.[59]

There are several reasons to suppose that version no. 2 – the painting catalogued here – may have been a 'studio model' and must therefore date to around 1554. First, although it cannot be described as a sketch in its present condition, there is clear evidence of bold and freehand preliminary sketching with a brush such as is not apparent in nos 3, 4 or 5. Secondly, it seems to incorporate improvements in the design of Adonis' head, and in devising an effective foil for the profile of Venus. (These are not changes which it is easy to imagine a workshop assistant making if asked to copy the earlier version.) Thirdly, and most significantly, in several important details no. 2 is closer to no. 1 than are nos 3, 4 or 5: in both no. 1 and no. 2 Adonis has a bare shoulder, Venus has no white drapery beneath her buttocks, and the mouth of the metal vessel faces away from the viewer. It may also be noted that the ways in which no. 2 does differ from no. 1 are repeated in nos 3, 4 and 5 – for example, there is the arrangement of the suspended bow and quiver, the addition of pearls to Venus' hair, the more youthful head of Adonis, the increased gap between the face of Adonis and the strap across his chest. On the other hand, many minor variations found in nos 3, 4 and 5 are not repeated in any other version.

A sixth version of the Prado type which had long been at Rokeby Hall in Yorkshire, certainly since 1835 and possibly since 1771, was sold at Christie's, London, on 10 July 2003 (lot 4) and is now in a private collection. It is not in good condition and was probably damaged by fire; it had been much overpainted. X-radiography has revealed that it at one stage resembled the Prado version but was then much revised, incorporating many of the variations observed in the successive versions described above, including the hat of the Barberini version. The painting may thus have been a different type of studio model, one used for trying out and recording successive versions of the composition.[60]

What is proposed here is that nos 3, 4 and 5 are replicas that depend upon no. 2, which in turn was derived from no. 1. But it does not follow that this 'family tree' represents a reliable index of the degree of Titian's involvement in the paintings, for there is no reason why Titian should not have made his own alterations or finishing touches to workshop replicas. A good case could be made for his intervention in no. 3. For example, the painting of the tremulous lights on the jacket Venus sits on, and the way the mountainous background is integrated with the design, with the horizon line continuous with the rippling line of Adonis' belt and the band on his upper arm.[61] Nor can we feel completely certain that no. 1 is an entirely autograph work. At least in its present condition the head of Venus in particular is disappointing. On the other hand, the foreshortened figure of Cupid slumbering in the shade – an invention surely inspired by the *Danaë* – is painted there with a delicacy found in no other version. Moreover, Titian himself was said to have thought very highly of the painting.[62]

The argument concerning the different status of these paintings may seem complicated enough, but it becomes more so when the 'Farnese type' is considered. In this type the composition is condensed, the figures fill the canvas, less of the dart is visible, there are only two hounds, and Cupid, instead of sleeping in the middle distance, is standing by the side of Venus, looking over his shoulder at the lovers and shielding a dove in his hands. It is exemplified by the following three versions:

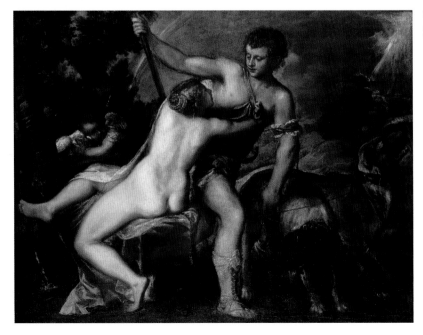

Fig. 6 Titian and Workshop, *Venus and Adonis*, *c*.1560–5. Oil on canvas, 106.8 × 136 cm. Washington DC, National Gallery of Art.

(1) A version in the Farnese collection mentioned by Ridolfi in 1648,[63] documented there in an inventory of 1644, and in Parma in an inventory of 1680. From the last mentioned inventory it is clear that it is a composition of the type under discussion. The next certain documentation of this painting is about 1710.[64] In 1762 it was the subject of a very careful drawing made by the Scottish engraver Robert Strange in the royal collection in Naples, which he included in a catalogue of his work in 1769, which is also the date of his engraving after it.[65]

(2) A version in the National Gallery of Art, Washington (Widener Collection, fig. 6),[66] formerly in the Spencer collection at Althorp, sometimes thought to have been acquired by the Earl of Sunderland from the Barbarigo family in about 1675 and corresponding to the picture recorded by Boschini in 1660 as in the Barbarigo palace.[67] During the second half of the eighteenth century and in the early nineteenth it was attributed to Schiavone.[68]

(3) A version very close in size to no. 2 in the Metropolitan Museum of Art, New York (Bache collection),[69] formerly in the Darnley collection at Cobham and before that in Palazzo Mariscotti.[70] Copies of this type are also known.[71] A drawing at Burghley House by Isaac Oliver records a version of the painting in the collection of the Earl of Arundel.[72]

It is not easy to determine the relationship between the paintings of the 'Farnese type' and those of the 'Prado type'. The Prado type may be earlier, although the reverse is generally assumed to be the case. Ridolfi indeed supposed that the Farnese version was made by Titian in Rome in 1545–6 together with the *Danaë*. The notion that at least one of the versions of the Farnese type was earlier finds some support in the fact that in some respects Farnese nos 2 and 3 are closer to Prado no. 1 than they are to the later versions of the Prado composition. In Farnese no. 2, for example, Adonis still has a bare right shoulder and Venus has no pearls in her plaits. In Farnese nos 2 and 3 the profile of Venus is not set against a contrasting area of lit drapery. On the other hand, the facial type of Adonis is closer to the more youthful type found in nos 2, 3 and 4 of the Prado type. Paul Joannides has recently proposed that the Farnese type originates as early as the 1520s, partly on account of the similarity between the Cupid and the children in the *Worship of Venus* in the Prado.[73] On the other hand, the execution of Farnese no. 2 with its dark (or darkened) sky, ominous atmosphere, smudged lights and the background elements woven into a quivering surface pattern suggests a date relatively late in Titian's life.

Comparison of Farnese type nos 2 and 3 is complicated by their worn condition, but the torsion of Venus' body, the pressure in her toes, the strain in her arm, and the expression on her face in no. 2 are notably more powerful. There are, however, felicities in no. 3 which may have been due to Titian. Some changes to the painting suggest that it was painted after no. 2 and was modelled on it. The drapery over the chest and to the left of Venus' left foot was originally painted as in no. 2, but was then modified.[74] If Strange's engraving[75] is reliable it shows that no. 1 was closer to no. 3 than no. 2 and is thus not plausible as first in the series, as is implied by Ridolfi's statement. In Strange's engraving there is more landscape around the figures than there is in either no. 2 or no. 3 but it looks false and may be an extension made to the print or, more probably, to the painting itself.

The best hypothesis seems to be that Farnese no. 2 was planned, if not painted, at the same time as Prado no. 1 or perhaps a little earlier, but, before it left the workshop, Farnese no. 3 was at least begun and some features of Prado no. 2 were incorporated. Farnese no. 2 seems to me to be largely autograph, and Farnese no. 3 to be partly so. The high reputation of Farnese no. 2 may have been reflected by the fact that Raphael Sadeler II (1584–1632) reproduced it in his engraving dated 1610.[76]

The idea that there was an earlier version of this painting than the one sent to Philip may seem unlikely, given the importance of Philip as a patron; but the *Danaë*, the other mythology supplied to Philip by Titian in this period, was certainly a revised version of an earlier composition; so too, later, was the great altarpiece of the *Martyrdom of Saint Lawrence*, now in the Escorial.[77] Much of the drama is lost when the landscape setting is enlarged, and in all versions of the Prado type, including no. 1, the space on the left, and especially the scale of the chief tree trunk, is confusing. Holmes, who was especially sensitive to composition, was so impressed by the superiority of the Farnese type that he supposed it represented the artist's last thoughts.[78] Many aspects of Farnese no. 2 do, however, make this unlikely, chiefly the head of Venus. One could also argue that Titian tried to extend and elaborate his original, concentrated, figure composition with limited success.

The account of Titian's workshop practice given above may be paralleled in his paintings of reclining nude women made in the same period. Here too we find several paintings deriving so closely from the same prototype that they must be based on the same cartoon or traced from the same example, although in each there are variations in the setting and in the secondary figures. One of these paintings, incidentally – the nude with Cupid and a young organist in the Prado[79] – has the same dark, freely brushed underdrawing that we find in the *Venus and Adonis* catalogued here.

It also seems completely consistent with Titian's personality as a painter that he should himself have intervened in the completion of workshop replicas. More extreme examples than any mentioned above are presented by some of the less familiar versions of the *Danaë*. One of these, with a royal Spanish provenance, now in a private collection in London, includes a remarkable and very exciting version of the attendant crone;[80] another, currently on loan to the Art Institute, Chicago, from the Barker Welfare Foundation, includes an astonishing landscape with vibrant light effects and the face of Jove among the clouds.[81] The variations in quality are nowhere more striking than in the Berlin version of the nude woman with an organ player, where the organ is routine but the dog an inspiration, the painting of the drapery folds dull but that of the organist's head superb.

Perhaps Ridolfi's story – told in his life of Polidoro da Lanciani – that Titian discovered copies of his pictures which had been made by his students without his authority and then modified them for sale should not be dismissed as implausible.[82] At the very least this story surely reflects the slack discipline in his studio, the capricious character of his interventions, and the wildly varying levels of quality in the studio productions.

Engraving

The painting was engraved by W. Holl for Jones's *National Gallery*.[83]

Provenance

NG 34 seems first to be recorded in the collection of Duke Jacopo Salviati (1607–1672) in Palazzo Lungara in Rome by Bellori.[84] It appears in an inventory notarised in September 1668 of 'pitture che esistono parte nella nostra Casa di Roma e parte in quella di Firenze' – no. 30, 'un Adone ritenuto da Venere, con alcuni cani a Lascio, grande al naturale, figure intere. Mano del Titiano; alto 8 e largo oncie 5, in tele'.[85] The *Rape of Ganymede* here catalogued as by Mazza (NG 32) was in the same collection. Both were displayed in the audience chamber of Palazzo Lungara in the first years of the eighteenth century.[86] They both passed into the Colonna collection as part of the dowry of Caterina Maria Zefferina Salviati when she married Prince Fabrizio Colonna in 1718, and in 1732 they were removed from the 'primogenitura Salviati' and incorporated as a distinct legal unit within that of the Colonna.[87] By 1739 they were both hanging in the new Stanza de' Quadri of Palazzo Colonna, where they are also recorded in the printed catalogue of the collection in 1783.[88] The painting was sold in 1798, apparently to a certain Giovanni de' Rossi, and was acquired soon afterwards by Alexander Day, who exhibited it in Brook Street, London, in the winter of 1800–1 and sold it on 6 May 1801 to John Julius Angerstein together with Mazza's *Rape of Ganymede* and Gaspard Dughet's *Landscape with Abraham and Isaac* (NG 31).[89] Angerstein's collection was acquired as the foundation of the National Gallery in 1824.

Framing

The painting is shown in a carved and gilded eighteenth-century frame (fig. 7). The projecting centres and corners are carved with shells against a ground of hatched lines cut in a concentric pattern in the gesso. Scrolling acanthus adorns the ogee slope (also cross-hatched) of the outer moulding. This is separated from the inner moulding of scrolls and leaves by a narrow, sanded flat.

This frame, according to the survey conducted by Paul Levi, is English and probably dates from the 1760s or 1770s but is an imitation of earlier French models. It has been shortened in length and extended in height. It is not known for which painting it was originally made but it was fitted on Titian's *Bacchus and Ariadne* in the 1920s.[90] It was then transferred to NG 34 when the *Bacchus and Ariadne* was given an Italian Renaissance frame 'in the 1960s'.[91]

Before that date the painting is likely to have retained its Angerstein frame. A frame with lavish corner ornaments is featured in the view of the new gallery of Italian Renaissance paintings published in the *Illustrated London News* on 15 June 1861.[92] For the frame types favoured in Palazzo Colonna and Palazzo Salviati see the entry for Mazza's *Rape of Ganymede*, which was then the companion of this painting (p. 96).

Appendix 1

THE COMPOSITION AS A COMPANION PIECE

A letter from Titian to Philip II in 1554 describes the *Venus and Adonis* in relation to the *Danaë*. The style of the letter is clearly not Titian's own, but the content must have originated with him or, at the very least, must have had his approval:

> Et perché la Danaë, ch'io mandai già a Vostra Maestà, si vedeva tutta dalla parte dinanzi, ho voluto in quest'altra poesia variare, e farlo mostrare la contraria parte, acioché riesca il camerino, dove hanno da stare, più gratiosa alla vista. Tosto le manderò la Poesia di Perseo et Andromeda, che havrà un'altra vista diversa da questa; è cosi Medea et Iasone.[93]

> (And because the Danaë, which I have sent to Your Majesty, is shown entirely from the front, I have sought in this other *poesia* to provide some variety and show the figure from another point of view, thus making the *camerino* where they are to hang more pleasing to the eye. In due course I will send the *poesia* of Perseus and Andromeda, which will have yet another point of view; and similarly Medea and Jason.)

There is a reference here to the debates, so enjoyed by theorists of art in the sixteenth century, as to the different merits of sculpture and painting.[94] Scholars who believe that the earliest version of *Venus and Adonis* was painted for the Farnese (a theory considered above) might be tempted to suppose that it was first conceived as a companion piece for the Farnese version of the *Danaë*.

However well Titian hoped the paintings would look opposite each other, they do not look as if they were designed as a pair: the smaller scale of Venus is decisive. Titian surely did not consider that the composition needed to be seen in relation to another – had this been so, Dolce would have mentioned it in his account of the painting (see below). In any case, other versions of the painting were obviously treated as independent works of art. A likely explanation is that Titian recognised that it would be advantageous to send Philip pictures of the same size – hence perhaps the need to enlarge the setting for *Venus and Adonis*, which may (as argued above) not have originally been so extensive.

That Titian was not in fact an artist who planned things precisely would have become obvious to Philip when the companion picture for *Perseus and Andromeda* turned out to be the *Rape of Europa* rather than *Medea and Jason*. The skill with which the compositions of the *Perseus* and the *Europa* complement each other makes it highly improbable that the *Venus and Adonis* was designed as a pair for the *Danaë*. At this

Fig. 7 The current frame on NG 34.

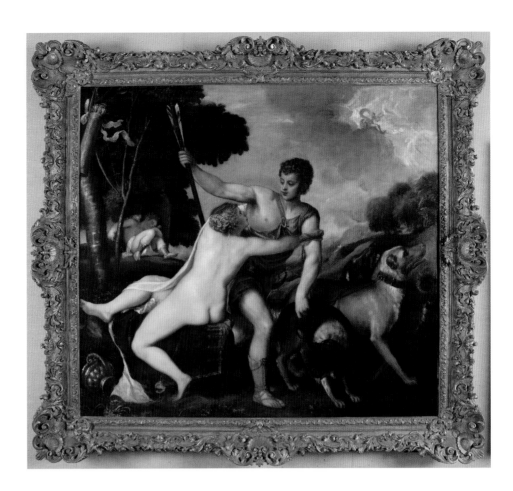

date Titian seems generally to have been interested in the effect of figures seen from the rear – as is revealed by the males in his pictures of nude women enraptured by music.

Even if *Venus and Adonis* was not designed to complement the *Danaë* in composition, it does seem to do so in theme: 'the two subjects very nearly mirror one another: in one case a mortal woman joyfully accepts the love of a god, in the other a mortal man rejects the love of a goddess'; 'here a god meets a mortal in a happy encounter of love, there a mortal leaves a goddess to rush, unwittingly, to his death.'[95]

Appendix 2

LODOVICO DOLCE'S LETTER

Titian's painting of *Venus and Adonis* – or at least the version that was sent to Philip II – was the subject of richly poetic description and critical eulogy. This remarkable episode in the history of publicity took the form of a letter from Lodovico Dolce, a leading literary figure in Venice, to a patrician, Alessandro Contarini, and was published in Dolce's *Lettere di diversi eccellentis. huomini* in 1555.[96] Pietro Aretino had previously devoted colourful prose to Titian's work, but this letter was even more extensive and attracted much more notice. By the time it appeared in print, the painting had left Italy, but the references to pearls on Adonis' sandals, and to the drapery *'di pavonazzo'* (of dark violet-purple) upon which Venus sits, do strongly suggest that it is the Prado version which is described.[97]

Dolce opens his letter by claiming that he is responding to one sent by Contarini to him which described a painting by Raphael. This puts Titian on a par with Raphael, which is important because it was to be the argument of Dolce's *L'Aretino*, the dialogue on painting that he published soon afterwards in 1557, that Titian was the true heir of Raphael.[98] Titian, like Raphael, was presented as a great painter of portraits, of the natural world, of emotion and desire, of moving human narrative (albeit involving gods or heroes).

Dolce discusses the artist's conception of Adonis – his age (a *garzone* of sixteen or eighteen) and his royal blood – and praises in particular something slightly feminine, but not effeminate, in his handsome looks – a mingling of qualities, Dolce reminds us, that were so highly prized in works by Apelles. Next he praises the movement of the figure and the eloquence of the expression. We can read on his lips the comfort he tries to give the goddess – 'e tutto poi serve in vece di parole' ('and so it is that there is no need for words'). Turning to Venus, Dolce especially praises the painting of the flesh and the accurate observation of the spreading buttocks of a seated figure. We cannot fail to imagine that she is alive, he says, and he reminds us of the story of the famous statue by Praxiteles, the Cnidian Venus, which provoked one admirer to an indecent assault, leaving a stain upon her marble thigh. That particular episode would naturally come to mind since it is recounted in connection with a debate on whether the back of the statue or the front was more appealing.[99]

Appendix 3

Shakespeare's long poem *Venus and Adonis*, published in the spring of 1593 and probably composed in the previous year (it was immensely successful and went through numerous editions in the following half-century[100]), has been thought to reflect some knowledge of Titian's painting, at least through engravings (see below).[101] This is because the poem is largely concerned with the goddess's vain attempts to detain the young hunter. But there is little similarity: Shakespeare's hero leaves the goddess by night to join his friends elsewhere at dawn; he is repelled by her ardour, not simply more excited by the prospect of the hunt. What is very likely, however, is that Shakespeare chose the subject partly because of the immense international popularity it enjoyed with artists after the success of Titian's painting. By 1590, indeed, this subject epitomised the new style of mythological picture which was essential furniture for any great prince's palace. In the *Taming of the Shrew* (which Shakespeare is thought to have written in the early 1590s), when Christopher Sly is being treated as a nobleman by the servants they offer to bring him paintings:

> We will fetch thee straight
> Adonis painted by a running brook,

And Cytherea all in sedges hid,
Which seem to move and wanton with her breath.[102]

The five stanzas devoted to the story of Venus and Adonis in Spenser's *Faerie Queene* (published in 1590) also purport to describe a picture of sorts in 'Castle Joyeous':

> The wals were round about appareiled
> With costly clothes of Arras and of Toure;
> In which the cunning hand was pourtrayed
> The love of Venus and her Paramoure,
> The Fayre Adonis, turned to a flowre,
> A worke of rare device and wondrous wit.[103]

It is also likely that there were oil paintings of this subject in British collections by the end of the sixteenth century.[104]

Appendix 4

Titian had indeed made Venus and Adonis one of the most popular of all subjects to be favoured by European artists for gallery paintings. Among artists of the sixteenth century Luca Cambiaso seems to have taken up the story with special enthusiasm. There are several compositions by him of Venus striving to detain Adonis. In one, Cupid restrains the hounds

Fig. 8 Annibale Carracci, *Venus meeting Adonis*, c.1588–90. Oil on canvas, 212 × 268 cm. Madrid, Museo Nacional del Prado.

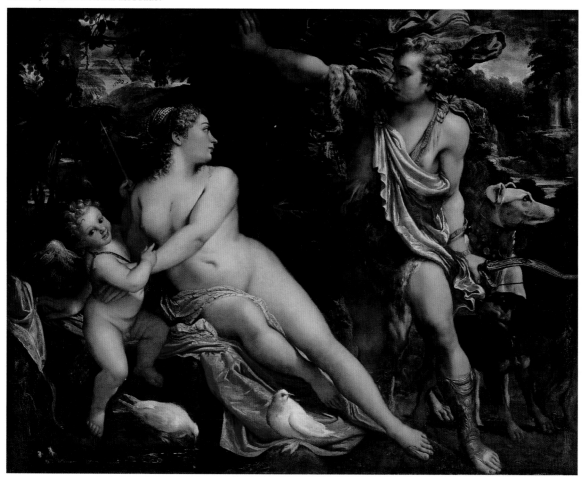

as she clings to him, in another she refuses to yield his hunting horn to him, and in a third she pulls him down to the ground.[105] He also painted the lovers in bed, Venus nude, Adonis nearly so, stroking her chin.[106] And, perhaps as companion pictures, he painted Venus lamenting over the dead Adonis in at least two versions (fig. 8, p. 465).[107] None of these works is dated, but some have been placed (on stylistic grounds) as early as 1560, others towards 1575.

Cambiaso worked in Genoa. The subject of Venus and Adonis was, unsurprisingly, especially popular with artists in Venice. Paolo Veronese's workshop painted Venus attempting to detain Adonis, but Veronese himself painted the exhausted hunter asleep with his head on the goddess's lap, and he painted, or at least made preparatory studies for, other episodes: the couple embracing, the birth of Adonis and his death.[108] One must suppose that leading artists wanted to paint some episode other than the one Titian had made so familiar. Thus Annibale Carracci in about 1590 in one of his finest oil paintings (fig. 8) depicted the first encounter between the goddess and the hunter.[109] But he surely did so as a sort of notional companion piece for Titian's composition.

Interest in the story was international – as witness the series of paintings by Anthonis Blocklandt of Utrecht, engraved by Philips Galle in about 1580, which illustrated the major episodes in the life of Adonis.[110] Another Flemish artist, Hans Bol, in a painting on vellum dated 1589, depicted several key episodes from the story in a landscape setting, with still more episodes painted in ovals on the frame, but the most prominent episode is the scene that Titian invented – the last desperate embrace.[111]

If leading artists sought other episodes in the story, the majority chose to represent this moment and a great many, without following Titian exactly, showed Venus from the rear: this is true of the low relief on the soffit of one of the arches of Sansovino's library (the twelfth arch from the Bacino); of the woodcut in the edition of Ovid's *Metamorphoses* published by Johannes Steinman in Leipzig in 1582;[112] and of paintings by artists as varied as Gilles Backereel[113] and Simon Vouet.[114]

A slightly modified version of Titian's composition was made by Battista Zelotti in an oil painting of about 1562–3 (Dresden, Gemäldegalerie), but in a fresco for the central *salone* of the Villa Roberti at Brugine (Padua) at about the same date he reversed Venus so that she could be seen from the front.[115] In this he was followed by other artists, for example Rottenhammer[116] and, most interesting of all, Rubens.

In Rubens's painting of *Venus and Adonis* of about 1637, now in the Metropolitan Museum of Art, New York (fig. 9),

Fig. 9 Peter Paul Rubens, *Venus and Adonis*, c.1637. Oil on canvas, 197.4 × 242.8 cm. New York, The Metropolitan Museum of Art (37.162).

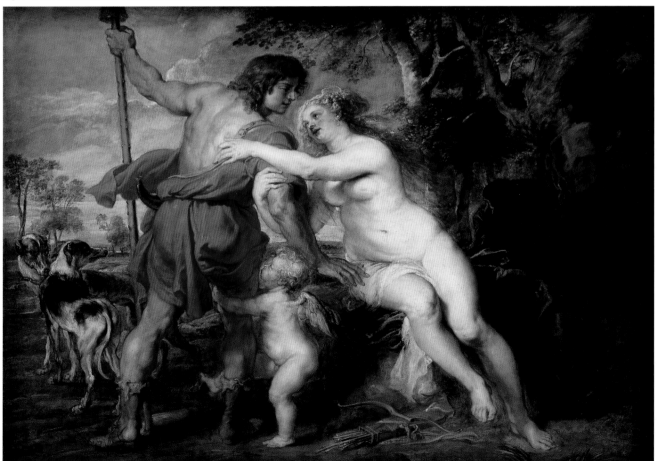

Fig. 10 Giulio Sanuto after Titian, *Venus and Adonis*, 1559.
Engraving, 53.8 × 41.5 cm. London, The Victoria and Albert Museum.

we find the diagonal pose, the yearning torsion, and the contrasted movements of Titian's composition (which Rubens is known to have copied in 1628[117]), but the figures are reversed – Venus is on the right, seen from the front, Adonis on the left, seen from behind – and it is Adonis' head rather than that of Venus which is shown in profile. This painting (like Annibale Carracci's) is a highly sophisticated complement to Titian's.[118] It is also of interest because it reveals Rubens thinking in the same way as Titian did as outlined in his letter to Philip II – and as we know that Velázquez did when he devised his *Rokeby Venus* as a companion for a Venus reclining, and seen from the front, which he believed to be by Titian himself.[119]

Given this interest in different points of view, and the fact that Titian's painting owed so much to a sculptural source, it is of interest that the subject of the last embrace was also popular for small bronze groups made by the finest artists in this medium in Germany, Italy and France in the seventeenth and eighteenth centuries.[120] Ultimately these sculptures, no less than the paintings we have cited, owe much to Titian's example.

The fame of Titian's compositions is obviously also reflected in numerous copies and these were made not only in oil on canvas but in chased metal, and in enamel.[121]

Appendix 5
PRINTS OF THIS COMPOSITION

The official engraving of this composition – that is, the one approved by the artist – is the one signed by Giulio Sanuto and dated 21 September 1559, which claims in the inscription that it is 'da una rariss. pittura dell'unico M. Titiano, fatta dalla sua mano al sereniss. e catholoco FILIPPO' (fig. 10).[122] In view of the fact that Philip had received a painting of this subject from Titian in 1554, this text should not be taken literally. It has, however, been cited by Rearick in support of his theory that the painting sent to Titian in 1554 was returned and replaced by another.[123] It does not support that theory at all because if, as is claimed, the version now in the Prado (Prado type 1, as listed above) was in fact sent later in the 1550s then it should be the model for this print. However, Sanuto's model seems to have been Prado type no. 4, although it retains some features from Prado type no. 2, which perhaps suggests that it was taken from Prado type no. 4 before it was completed. Thus, for example, it includes the dove beside Cupid's feet that is found only in Prado type no. 4 but does not include the white shirt, which is also absent from Prado type no. 2 (and from Prado type no. 1) and is just the sort of detail that might have been added late to Prado type no. 4. In any case, there is every reason to suppose that this print was made with Titian's authority: the fact that the composition is adapted to a vertical format can be explained by the artist's desire to include the text and may also have made the print more suitable for binding into volumes; in other respects it is very faithful to Titian's invention and may perhaps be considered as evidence that Titian did not regard Prado type no. 1 as the best in the series, at least from a compositional point of view. The scholars who would maintain that the Prado painting is the only version in which Titian himself was involved can only explain this by proposing that Titian kept no record (even a drawing) of that work.

The engraving signed by the printmaker and publisher Martino Rota must have been made before Rota's death in 1583.[124] It appears to be derived from Sanuto's. This is also true of the engraving published in 1573 by Nicolò Nelli and the one by Hans Collaert.[125] Abraham Hume also knew of a print by Domenico Zenone dated 1574.[126] Raphael Sadeler's engraving of 1610 has been mentioned.

Sir Robert Strange's engraving of 1769 after the version in the Farnese collection is mentioned above.

Finally, there is the engraving attributed to Giacomo Caraglio by Catelli Isola. This certainly looks as if it is based on Prado type no. 1 in the figures and the dogs especially, although it adopts the same vertical format as Rota's print and gives a similar emphasis to Venus in her chariot. If executed after Rota's print, it proves that a record of Prado type no. 1 survived in Venice. The attribution to Caraglio is a problem, since he is known to have left Italy for Poland in July 1539.[127]

NOTES

1. Report compiled by Jilleen Nadolny, May 1994.

2. Dibdin 1822, pp. 13–14.

3. NG 5/89/1 (ii). Select Committee on the National Gallery, 29 April 1853, p. 61, paragraph 1054.

4. Press release in dossier.

5. Montaiglon 1887–1912, V, 1895, pp. 341–2.

6. Ramdohr 1787, 3 vols, II, p. 72.

7. Farington 1978–98, IV, 1979, p. 1548, entry for 9 May 1801.

8. Hazlitt 1824, p. 13n, but in later editions the observation was incorporated in the text (e.g. Hazlitt 1856, p. 11, conclusion of paragraph 6).

9. Lloyd 1966, pp. 377–8; Seguier MS valuation.

10. Valpy [1832], p. 5.

11. Ottley 1832, p. 11.

12. Wornum 1847, p. 180, no. 35 (annotation by Mündler).

13. In the *Illustrated London News*, 15 June 1861, p. 547, it is shown hanging high on the wall, but in the *London Journal*'s illustration it is much lower.

14. Crowe and Cavalcaselle 1877, II, p. 239n.

15. Wornum 1847, p. 180, no. 35.

16. [Collins Baker] 1913, p. 693.

17. Ricketts 1910, p. 132.

18. The document is dated 20 November 1923.

19. Wethey 1975, p. 193, no. 44 (National Gallery of Art, Washington) and pp. 192–3, no. 43 (Metropolitan Museum of Art, New York). Although the second of these pictures was not sold at auction it had been exhibited by Agnew's and was thus well known in London.

20. Holmes 1924, p. 21.

21. Mayer 1925, pp. 274–5.

22. Tietze-Conrat 1946, p. 85, see Tietze 1936, II, p. 294.

23. Valcanover 1960, II, plate 56; Pallucchini 1969, pp. 142, 300. See also most recently Pedrocco 2001, p. 232, no. 185.

24. Gould 1959, pp. 98–102 (p. 100 for his estimate of Titian's participation); Gould 1975, pp. 98–102.

25. Information from Claude Blair.

26. Ibid.

27. See, for example, the portrait of Philip II *c.*1580, London, National Portrait Gallery, 347.

28. Silos 1979, I, p. 125, and II, pp. 118–19 (epigram ccxxviii).

29. Carducho 1979, p. 434. The notes to this edition speculate that Carducho meant to write Diana and Callisto (note 1146, p. 434) but Carducho had already mentioned the 'dos baños de Diana' (p. 433). The compiler of Queen Christina's collection in 1652 also misunderstood the subject, describing it as 'Josap est ala chasse et une femme qui le tend'.

30. Ramdohr 1787, II, p. 72.

31. Pignatti and Pedrocco 1975, II, p. 241, no. 32 (Strasbourg, Musée des Beaux-Arts) for the *Death of Procris*, and pp. 419–20, no. 311, for its pendant.

32. Rosand 1971–2, pp. 527–46 (especially pp. 535–6).

33. Ottley 1832, p. 11.

34. Lorenzo di Credi or a follower painted a cassone panel with Adonis departing for the hunt (private collection, Scotland) for which the painting depicting his first meeting with Venus (formerly Beit collection) may be a pendant. One of the small narrative frescoes painted by Raphael's associates in Cardinal Bibiena's *stufetta c.*1518 in the Vatican Palace may show Venus and Adonis embracing and it was engraved by Agostino Veneziano (see Mancinelli *et al.* 1984, pp. 205–6, no. 76, entry by Richard Harprath) and Bartsch 1802–21, XIV, p. 360, no. 485.

35. Carroll 1987–8, pp. 244–9; Panofsky 1958, pp. 139–44.

36. Ilari 1992 especially pp. 30–2 (for the episodes selected) and p. 28 (for the date of the paintings – probably either 1554–6 or 1558–60).

37. Borghini 1584, pp. 64–5.

38. For the idea that Mendoza influenced Titian see Beroqui 1946, pp. 140–1. The proposal is revived by Falomir (2003, pp. 238–41).

39. For Dolce see Fehl 1992, p. 110.

40. Mendoza 1553, lines 329–36.

41. Bober and Rubinstein 1986, p. 127.

42. Shearman 2003, I, pp. 285–6. In Beltrame Costabili's letter to Duke Alfonso concerning this on 30 March 1517 it is called 'Lecto de Policrate'.

43. Ibid.

44. Bober and Rubinstein 1986, p. 127.

45. Wethey 1971, pp. 82–3, nos 15–16 (Bembo), and p. 126, no. 77 (Granvelle).

46. Dacos 1977, pp. 210–12.

47. Wethey 1975, pp. 188–94.

48. For this version see above all Beroqui 1946, pp. 77–81 and Falomir 2003, pp. 238–41, no. 40 (entry by Falomir). The latter, however, lacks a discussion of provenance. For this see Wethey 1975, pp. 189–90 citing Cassiano dal Pozzo's journal.

49. Crowe and Cavalcaselle 1877, II, p. 509. The line of a canvas join 'usually becomes prominent after lining' (as Jill Dunkerton observes). However, it seems reasonable to suppose that it was often visible enough before lining: we are in any case not (for obvious reasons) in a position to be sure that it was not.

50. Christie's, London, 13 December 1991, lot 85 (bought for the J. Paul Getty Museum); Wethey 1975, pp. 191–2, no. 42.

51. Hume 1829, pp. 65–6.

52. Christie's, London, 10 July 1998, lot 62. Rearick (1993) proposed that this was the painting sent to Philip in 1554. He supposed that it was returned to Titian to be repaired and that the artist sent another version to Philip in its place. Among the many dubious presuppositions which support this argument the most notable is the idea that Philip could not have misinterpreted a seam as a fold – yet Rearick himself did so, the line in the Lausanne painting being the line of a seam, as was admitted when it was catalogued by Christie's, and not caused by a fold as Rearick claimed. It would, of course, have been extraordinary for anyone to fold a freshly painted oil painting.

53. Inv. 922. Wethey 1975, p. 223, X-40, plate 196. The painting measures 187 × 184 cm. See also Valcanover 1960, II, p. 68, for false provenance and high estimate.

54. Ham House, Richmond; Gosford (the Earl of Wemyss); Harewood House (sold at Christie's, London, 2 July 1965).

55. Crowe and Cavalcaselle 1877, I, p. 150. This painting had been acquired with the Camuccini collection in 1854 (for this transaction see Penny 1993, p. 76).

56. Hume 1824, no. 18. Sold at Christie's, London, on 4 and 7 May 1923, lot 63, for 21 guineas. Another reduced version is recorded by Wethey as having been in the Marignane Collection in Paris.

57. Crowe and Cavalcaselle 1877, II, p. 524.

58. For help in making tracings and placing them over paintings I am grateful to David Jaffé and Richard Charlton Jones of Sotheby's.

59. Ridolfi 1914, I, p. 227.

60. I am grateful to Alec Cobbe for showing me this painting and discussing all the evidence concerning it, which will be published by Jane Turner and Paul Joannides.

61. The autograph status of this picture, or at least a part of it, was discerned by Waagen (1857, p. 366) and by Francis Russell (1988, p. 152).

62. Hope 1997, p. 261 (letter of Niccolò Stoppio in 1567).

63. Ridolfi 1914, p. 179; 1996, p. 93.

64. Wethey 1975, pp. 241–2 (no. L-19). For the inventory of 1644 see Jestaz 1994, p. 177, no. 4394; for that of 1680 see Campori 1870, p. 211, and for that of 1710 see Filangieri di Candida 1902, pp. 220, 282. Hume (1829, p. 34) believed the painting to be still in Naples.

65. For Strange see Ingamells 1997, pp. 905–6. The catalogue is Strange 1769, pp. 168–9.

Fig. 11
Detail of NG 34 showing
the sleeping Cupid.

66. 1942.9.84.

67. Boschini 1966, p. 664.

68. Garlick 1976, pp. 99, 108 and 124 for Althorp catalogues of 1746, 1750 and 1802. In the first of these it is (probably in error) attributed to 'Schidone'.

69. 49.7.16. Zeri and Gardner 1973, pp. 81–2.

70. The painting was acquired in Rome by the Camuccini and sold to Buchanan, who sold it to Darnley (Buchanan 1824, I, p. 123, and II, p. 153).

71. Melbury House, Ilchester; Christie's, London, 28 March 1952 (ex-Payn collection); Kunsthistorisches Museum (now lost).

72. Burghley House, dated 1631. See Wethey 1975, p. 194, plate 193.

73. Joannides 2006; Dunkerton and Joannides 2007.

74. A comparison between these two paintings was organised at the close of the Titian exhibition in 1990 by David Bull in the National Gallery of Art (I happened to attend as a courier). Farnese type no. 3 had been so cleverly restored by John Brealey in 1976 that most scholars were quite sure of its autograph status and superior merits, including indeed David Brown of the National Gallery of Art (see Valcanover et al. 1990, pp. 328–30, no. 60), and although the exhibition was held in Washington, the National Gallery of Art's painting was not included in it.

75. Wethey 1975, plate 95.

76. For Sadeler's print see Hollstein, XXI, no. 277, no. 48. It is attributed to Gilles Sadeler II in Catelli Isola 1977, p. 70, no. 243.

77. Wethey 1969, pp. 140–1, no. 115, plate 181.

78. Holmes 1924.

79. Prado no. 421. See Wethey 1975, pp. 196–7, no. 47, plates 114–20.

80. Wethey 1975, p. 210, no. X-13, plate 200, as in Apsley House. Joannides 2004, pp. 19–24, argues that this was the painting sent to Philip II by the artist. If he is right, it is of surprisingly uneven quality.

81. Wethey 1975, p. 211, X-13, plate 200.

82. Ridolfi 1914, I, p. 227.

83. Jones and Co., c.1835, no. 98.

84. Bellori 1664, p. 49.

85. Salviati MSS in Pisa (see entry for Mazza NG 32, note 46).

86. Costamagna 2001. For a fuller account see p. 94.

87. Safarik 1996, p. 606.

88. Anon. 1783, p. 20, no.116.

89. See entry for Mazza, NG 32, p. 95.

90. Certainly before June 1931, when Francis Draper submitted estimates for making adjustments to it.

91. Typescript record of notes made by Cecil Gould. Although the frame was taken off the Bacchus and Ariadne in the 1960s, it may not have been put straight on to NG 34. The frame needed alteration, and the pretext for the reframing may well have been the restoration in 1973.

92. p. 547. It seems uncertain that this is a reliable record, however.

93. Crowe and Cavalcaselle 1877, II, p. 509 (Prince of Spain to Francisco de Vargas). See also Wethey 1975, p. 189, for a discussion of the misreadings of this text.

94. See especially Rosand 1971–2, p. 535.

95. Hope 1980, p. 114; Fehl 1992, p. 108.

96. Not in the first edition of 1554 but in the second, in which the date 1554 appears on the title page but 1555 appears in the colophon. See also Dolce 1968, pp. 212–17.

97. Wethey (1975, p. 189) supposed that pavonazzo is an error (he perhaps supposed that the colour pavonazzo was a peacock blue; for a discussion of this colour see p. 215). In the Prado version blue is clearly painted over red, with a rich effect not found in the other versions, although smalt blue as well as lake pigments were evidently employed in this area in the Getty painting (see Birkmaier, Wallert and Rothe 1995). In no other version are there pendant pearls on Adonis' buskins.

98. Roskill 1968, pp. 212–17 (appendix), and pp. 348–51 (notes). Dolce's letter to Gasparo Ballini (ibid., pp. 200–11) is a precedent for the Dialogue.

99. Pseudo-Lucian, Affairs of the Heart, paragraphs 11–17, for the Cnidian Venus (and, for the stain specifically, paragraphs 15–16), see Lucian, Essays in Portraiture, 4, and Pliny, Natural History, XXX, iv, 21.

100. Editions are listed in Hyde Rollins's New Variorum Shakespeare: there were six before 1600.

101. Panofsky 1969, pp. 153–4. The idea was refuted by Wethey (1975, pp. 188–9) but is supported by Rearick (1993, p. 34).

102. Induction, ii, lines 51–3.

103. Book III, canto I, stanza xxxiv.

104. The earliest certain record of such a painting that is known to me, however, is the one which is represented, surrounded by family portraits, on the wall behind the Countess of Rothes and her daughters in a painting by George Jameson of 1626 (Scottish National Portrait Gallery, on loan to the National Gallery of Scotland at Duff House).

105. Suida Manning and Suida 1958, fig. 113 (private collection), fig. 339 (Palazzo Bianco), fig. 126 (Italian Embassy, Moscow).

106. Ibid., fig. 114 (Villa Borghese).

107. Ibid., fig. 340 (Palazzo Barberini) and fig. 121 (ex-Orléans Collection).

108. For Adonis Exhausted (Madrid, Prado) see Pignatti and Pedrocco 1975, II, pp. 419–20, no. 311; for Venus detaining Adonis (Augsburg, Staatliche Kunstsammlungen) see ibid., I, pp. 236–9, no. 136; for Venus Mourning (Stockholm, Nationalmuseum) see ibid., I, p. 380, no. 268; for Venus and Adonis Embracing (Vienna, Kunsthistorisches Museum) see ibid., II, pp. 389–90, no. 276; for drawings for a painting of the Birth of Adonis see Cocke 1984, p. 247, no. 105.

109. Madrid, Prado; Posner 1971, II, p. 21, no. 46; Malafarina 1976, p. 97, no. 44. A seventeenth-century source describes this as a famous work made by the artist 'ad emulazione di quella di Tiziano' (Campori 1870, p. 455).

110. Sellink 2001, p. 98, nos 400–3.

111. J. Paul Getty Museum 92.GG.28. For another landscape with numerous episodes of the story see the painting by Hendrick de Clerck and Denis van Asloot (Christie's, New York, 31 January 1997, lot 7).

112. p. 426.

113. Hanover, Niedersächsische Landes-galerie, no. 5 in catalogue of 1954.

114. Thuillier 1990, no. 57, pp. 324–5, no. 57.

115. Brugnolo Meloncelli, Battista Zelotti, Milan 1992, cats 14 and 15, figs 66 and 72. Bozzolato 1979 provides reasons for dating the frescoes in the Villa Roberti to 1552–3 but they are not conclusive.

116. Sotheby's, London, 26 November 1970, lot 30.

117. Wethey 1975, p. 192.

118. Liedtke 1984, I, pp. 151–5, II, plates xi and 61.

119. Bull and Harris 1994.

120. For Gianfrancesco Susini's bronze group of c.1620–30 see Penny and Radcliffe 2004, no. 51 (entry by Marietta Cambareri); for that by Adriaen de Vries dated 1621 see Scholten et al. 1998, p. 80; and for the superb group attributed to Robert Le Lorrain see Wenley 2002, pp. 72–3. In a smaller size there is also Fanelli's small bronze group, probably of the 1630s, of which there is a gilt bronze example in the Walters Art Museum, Baltimore (54.733).

121. For an enamelled gold verge watch (the painting probably by Huaud Père) c.1675 see Christie's, New York, 27 April 1992, lot 84. For a gilt copper locket, South German and of c.1565, in the Cleveland Museum of Art (50–371) see Wixom 1975, pp. 136–7.

122. Bartsch 1802–21, XV, p. 106, no. 11; Mauroner 1943, p. 58, no. 1, plate 49; Bury 1990, pp. 11–12, and p. 43, no. 4.

123. Rearick 1996; see also the entry in Christie's catalogue for 10 July 1998, under lot 62.

124. Bartsch 1802–21, XVI, 1818, p. 282, no. 108; Mauroner 1943, p. 61, no. 1.

125. Agnese Chiari 1982, p. 67, no. 30 (for Nelli), and Catelli Isola 1976, p. 36, no. 23 (for Collaert).

126. Hume 1829, p. xxxix.

127. Catelli Isola 1976, p. 34, no. 12. She also notes a copy in reverse (no. 13).

Follower of Titian

NG 2161
Portrait of a Woman
(perhaps Pellegrina Morosini Capello)

*c.*1558–62
Oil on canvas, 98.8 × 80.7 cm

Support
The measurements given above are those of the stretcher. The original canvas has been trimmed and is of approximately the same dimensions but it ends a little short of the edge in the top left corner.

The original canvas is of a heavy herringbone weave with a direction vertical to the image. There are no seams, but there is a patch lower left, below the fingers of the sitter's right hand. All the edges of the canvas are slightly tattered, suggesting that it has been trimmed not far inside the original edges, but there is no evident cusping.

The stretcher is of plain deal; the label of the carriers James Bourlet is affixed to its upper bar, on which the number A97955 is inscribed. On the left bar there is a customs seal featuring the Habsburg eagle and (only partially legible) the name of the Venetian Academy that authorised exports when Venice was part of the Austrian Empire. Strips of pine about 0.5 cm thick have been nailed to the stretcher on all four sides.

Materials and Technique
The lips and the shading in the flesh are painted with lightly hatched strokes. The eyebrows seem to have been painted with red (probably vermilion, which is certainly present in the flesh generally). The curls were worked with soft strokes, wet in wet.

The canvas has a thin gesso ground with a priming of grey (lead white with carbon black). The blue pigment in the dress is azurite, and Naples yellow (lead antimony oxide) has been identified in the hair and in a highlight on the dress. The presence of the latter pigment was at first thought to cast doubt on the painting's antiquity, since the pigment was believed to have been introduced early in the eighteenth century, but it has since been identified in sixteenth-century paintings (including one by Lotto, NG 1047).[1]

Conservation
In the Director's Report for 1856 the condition of the painting is described as follows: 'the figure untouched; the background in parts restored.'[2] There is no record of any conservation treatment to the painting between its arrival in the Gallery in 1856 and 1953, when it was wax-lined. It was not cleaned, although test patches on the hair, cuff and breast show that cleaning was at one time considered. The painting has been liable to flaking and some wax smears at the right edge suggest measures to prevent this. The painting retains the varnish given to it on acquisition or shortly before, which consists of mastic with dammar and some fir balsam, a composition that is typical of the period.[3]

Condition
There is extensive craquelure – with a distinctly vertical pattern in the green background and a broader reticulate pattern in the flesh and the whites. There are numerous small chips of paint missing at the edges of the cracks. There is some abrasion in the green background which has exposed the salient threads of canvas. Blue pigment in the black of the dress, seen through the very yellow varnish, appears green. The bands and ribbons by which the wig-like bonnet is attached to the hair, perhaps originally a pale pink, have bleached and are now no longer as apparent as must have been intended.

Attribution
Both Mündler and Eastlake considered this painting to be by Pordenone when it was acquired for the National Gallery, and although it has little in common with any paintings accepted as Pordenone's work today it should be taken into account that this artist's identity was then still confused with that of Bernardino Licinio.[4] NG 2161 does have some affinity with the latter's portraits, but it is very different in handling and clearly later in date. Licinio often, for instance, made use of ledges or parapets of a somewhat arbitrary kind – although never two in the same picture, as here. In addition, many of Licinio's female sitters adopt a faintly quizzical expression such as we see here. Many also wear a cap which resembles a wig, and this sitter is wearing a small version of one.[5]

The painting was lent to the National Gallery in Dublin in 1857. When it returned to London in 1926 it was catalogued, for unknown reasons, as 'Veronese School'.[6] Soon afterwards, in 1930, Johannes Wilde, in a remarkable article in the Vienna *Jahrbuch*, attributed several Titianesque portraits to the young Tintoretto.[7] Central to his argument was a fragmentary head in the Museum of Fine Arts, Budapest (fig. 2), and an imposing frontal portrait of a woman in the Kunsthistorisches Museum, Vienna (fig. 1). Wilde did not then know of NG 2161, but Cecil Gould noted in 1959 that Wilde had subsequently pointed out its connection with these paintings[8] – presumably he did so when he came to Britain at the outbreak of the Second World War and was able to study the paintings in North Wales. The handling of NG 2161 is very close to that of the Budapest fragment and both the expression and the drawing of the hands are reminiscent of the painting in Vienna. For Wilde the Budapest and Vienna portraits were by Tintoretto, and they have been widely accepted as such.[9] However, the attribution does not seem certain. Gould evidently had doubts – and may have known that Wilde had come to have them too – for he called these paintings 'Tintorettesque'. For the moment it seems better to catalogue NG 2161 as by a follower of Titian than as the work of a follower of Tintoretto since this early phase of Tintoretto's work (supposing it to have been precisely identified) was not influential.

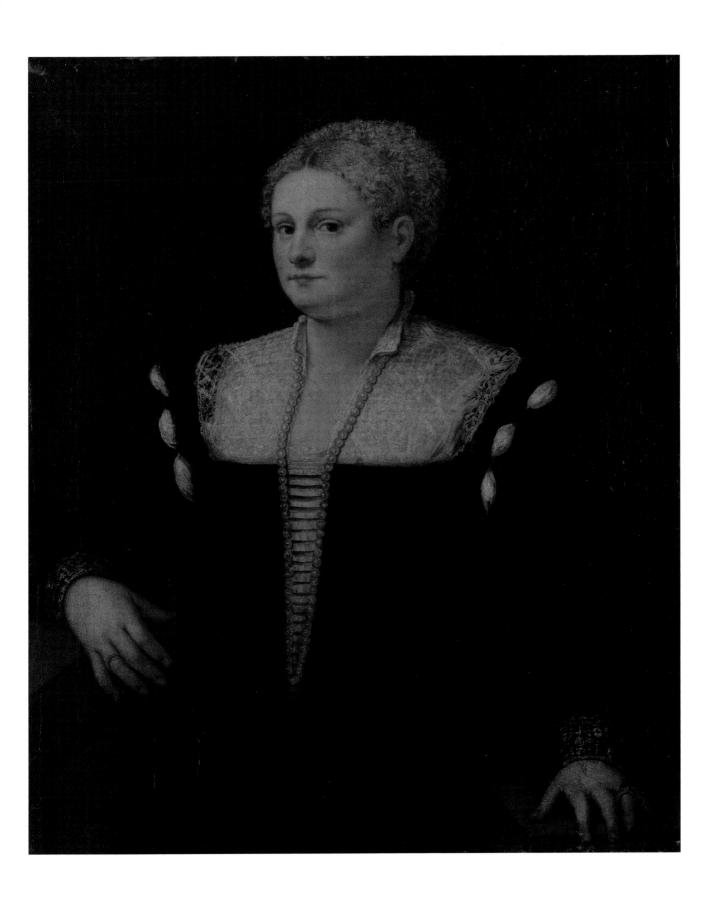

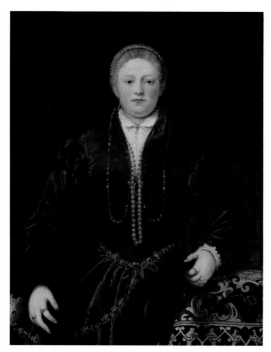

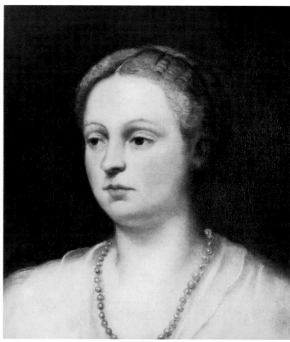

The Identity of the Sitter

When it was first seen by Mündler and Eastlake the painting was said to represent Pellegrina Morosini, wife of Bartolomeo Capello and mother of Bianca Capello. Since the Capello heirs had consigned the picture for sale (see below), this identification was probably based on some family record or tradition.

Little is known of Pellegrina, but her family, the Morosini, are discussed on pp. 176–85 in the entry for Tintoretto's portrait of Vincenzo Morosini (NG 4004). Pellegrina was the daughter of Filippo Morosini. She married in 1544 and had two children, Bianca and Vettor. She must have died before 1559, when her husband, Bortolo (Bartolomeo) Capello, married Lucrezia Grimani, widow of Andrea Contarini. The name Pellegrina came from her father's mother, who was a Contarini.[10] If this portrait represents her, the fashion of her costume suggests that it must have been painted towards the end of her life. She is likely to have been aged about thirty when she died and it certainly seems possible that the sitter in NG 2161 is in her late twenties.

Bartolomeo Capello (1519–1594) belonged to the principal branch of the ancient patrician family that resided at S. Maria Mater Domini. A direct descendant of the great admiral Vettore Capello, he was a prominent figure in Venetian political life from the 1550s but is remembered chiefly on account of his daughter Bianca. She is now thought to have been born in 1548 (her brother Vettor was born in 1547). At the age of 15 she was carried off to Florence by a young Florentine merchant, Pietro Bonaventuri. Marriage in 1563 did little to reduce the scandal since her beauty had already attracted the notice of Prince Francesco de' Medici, who in the following year became Regent of Tuscany. In 1578, immediately after the death of his first wife, Giovanna d'Austria, Francesco married Bianca, who had long been his mistress. Francesco was by now Grand Duke; in the following year there was a state wedding and Bianca became Grand Duchess.

The Capello family and the Morosini, who had hitherto shuddered at the disgrace of an abducted daughter, now basked in the glory and political consequence of a great princess. Bartolomeo moved into a new palace and he and his son were in 1579 made knights of the Stola d'Oro. Bianca died in 1587, shortly after her husband, in circumstances quickly rumoured to be criminal.[11]

The story of Bianca Capello was far better known in the nineteenth century than it is today. It was the subject of operas and romances which may have shed a certain glamour on this painting even in the sober minds of Eastlake and his agent. The National Gallery also acquired a painting long believed to be of Bianca Capello herself (NG 2085) which derives from a fine female portrait by Alessandro Allori.[12]

Dress and Date

The sitter wears a string of pearls – 74 are visible but there may have been as many as 90 in all – which falls over her bosom to form an inverted triangle corresponding to the laced opening of her bodice. She has lace cuffs and a lace 'shoulder cape' tucked into the dress at the shoulders. As can be seen in other paintings (for example Romanino NG 3093), this lace would have descended at the wearer's back, often in a point reaching to the waist. Lace of this kind, together with a dress and sleeves of a similar cut, is worn by the woman traditionally supposed to be Lavinia as a married woman by Titian, in Dresden (generally dated to the 1560s), and also by Giustiniana Giustiniani in Veronese's frescoes of about 1560 in the Sala dell'Olimpo at the Villa Maser.[13] It is of some interest that a major promoter of the Venetian lace industry was the Dogaressa Giovanna Morosina Morosini, wife of Marino Grimani (Doge 1595–1605), who opened a factory employing a hundred hands.[14] However, at this earlier date it is likely that most lace worn by patrician women was made within their own household.

Previous Owners

There is no reason to doubt that the painting was acquired from the heirs of the Capello family. A large group of family portraits is listed in the inventory of Vettor (Vittore) Capello's possessions made in October 1659: the *portego* of the palace included 'un retratto della gran Duchessa di Firenze' and 'un quadro di Gran Duca di Fiorenza', thirteen full-length large-size portraits of the 'Casa Medici' and of the 'Ca Capello', a group of nine 'ritratti di Ca Capello' with 'mascheroni dorati che servono per soaze' and seven other 'quadri di ritratti' together with four landscapes ('paesi'), seven paintings of the planets, two large unframed devotional pictures, two large unframed pictures of women, two large unframed pictures 'con buffoni', and a painting of 'Susana'.[15] These paintings are likely to have been inherited by his son Bortolo (who died in 1700) and his grandson Zuane (who died in 1719), but when Zuane died without a direct heir they may have passed to Piero Capello (1676–1729), who was descended from a Girolamo Capello whose sister Elena had married her cousin, Bianca's brother Vettor, in 1577. The paintings may then have descended directly in this line to Piero's great-grandson, Pietro Benedetto Andrea Capello (1788–1863), from whom this painting was very likely acquired in 1855.

Acquisition

Otto Mündler recorded the painting in his Travel Diary for 14 November 1855: 'went to Prof. Paolo Fabris. A fine portrait of a lady, the mother of Bianca Capello, by Gio. Ant. Licinio Pordenone.' Fabris was a painter and restorer who also acted as a dealer and agent (see pp. 372–3). Mündler showed it to Eastlake, who arrived in Venice the following month: on 5 December, after visiting Fabris, 'we go together to Sr Giraldon, the proprietor of the Pordenone portrait of the mother of Bianca Capello, placed at Fabris's and I obtain it for the sum of 75 Napoleons.' In the Gallery's annual report the work is described as 'Half-length Portrait of a Young Woman of considerable embonpoint, Pellegrina Morosini, wife of Bartolommeo Capello, and mother of the celebrated Bianca Capello' and as purchased from the 'heirs of the Signori Capello' for £60 9s. 1d. Giraldon would therefore have been acting as an agent for the family, although he was in fact a dealer who also had paintings for sale from other sources (Mündler mentions a Cima of the *Pietà* and a Bassano from Ca Pesaro). Some of the Capello family seem also to have been selling pictures directly. Mündler had visited Casa Capelli Cavallo on 1 November and noted, 'pictures for sale but nothing good'. On the same day that the purchase was made, Mündler went to Antonio Zen 'to choose a frame for the portrait by Pordenone, which is brought to his magazine' (that is, his store). The Galvagna pictures (see pp. 328–9) were being framed at the same time.[16]

Provenance

See above.

Loan

The painting was lent in February 1857 to the National Gallery of Ireland, Dublin, and was not returned to the Gallery until March 1926.

Frame

The painting is framed in a variation of a standard neo-classical pattern with a hollow filled with acanthus leaf ornament press-moulded in composition. This cannot be the frame found for the painting in Venice, where the ornament would have been carved. On the other hand, the plain ogee on the inside of the frame and the trios of large pearls alternating with spirally fluted bobbins beside the acanthus are not typical of English frames, so it may perhaps have been made for the painting in Dublin.

NOTES

1. Plesters 1984, pp. 32–3. For Naples yellow see also *Report of the Scientific Advisory Committee*, 1999/2000, p. 5.

2. Director's Report of 1856, p. 28.

3. White and Kirby 2001, p. 82.

4. See Hadeln's notes in Ridolfi 1914, I, pp. 112–13.

5. See Penny 2004, pp. 87–8, for caps.

6. [Collins Baker] 1929, p. 392.

7. Wilde 1930.

8. Gould 1959, p. 94; 1975, p. 264. The phrasing is very misleading.

9. Rossi 1974, p. 101, fig. 51 (Budapest) and p. 128, fig. 85 (Vienna).

10. Her father was Filippo Morosini, the son of Andrea Morosini and Pellegrina Contarini. The last mentioned died in 1497. Information from Barbaro's genealogies in the Biblioteca Correr, Venice.

11. For Bartolomeo see F. Colasanti in *Dizionario Biografico degli Italiani*, 1975, XVIII, pp. 758–60, and for Bianca, XX, pp. 15–16.

12. Langedyk 1981–7, I, pp. 314–27, does not accept NG 2085 as a portrait of Bianca. Gould had also earlier rejected the identification (1975, p. 46). The best preserved example of the type that I have seen is in the Hearst collection at Saint Simeon (Fredericksen 1977, no. 44). If NG 2085 is the painting that was lot 1013 in the Northwick sale in 1859, it is likely to have been the portrait of Bianca acquired by Francis Graves for 50 guineas at the Bernal sale (lot 789) and then offered to Northwick (Worcestershire Record Office, 705:66, Box 9, Bundle 6, letter of 12 March 1855). Graves also bought a picture of 'Pellegrina daughter of Bianca Capello' at the Denistoun sale (Christie's, 14 June 1855, lot 48).

13. See the notes by Stella Mary Pearce (Newton) of 1956 in the Gallery's dossier. For the Veronese see Pignatti 1976, I, cat. 96, p. 118, and II, pl. 207. The diaper pattern in NG 2161 must be very similar to that represented very meticulously by Sofonisba Anguissola in the portrait of a lady with her daughter which was lot 76 at Christie's, London, 8 July 1988.

14. Gheltof 1876, p. 20; Molmenti 1928, I, pp. 154–6.

15. Levi 1900, p. 40.

16. Mündler 1985, pp. 78, 81, 86. The visit is not recorded by Eastlake (1855(2)) in the Venetian section of his notebook largely devoted to notes of the Manfrin collection. Eastlake did, however, record a visit to Palazzo Capello-Sernagiotto, where he saw Lotto's portrait of a Dominican (fol. 50r).

Imitator of Titian

NG 3

A Concert

*c.*1580
Oil on canvas, 100.4 × 126.1 cm

Support

The dimensions given above are those of the stretcher. The original canvas of a fairly fine, probably tabby, weave is lined with glue paste on to a coarsely woven tabby canvas of medium weight. The original canvas has been trimmed irregularly and does not extend to the edges. At the right edge it has been extended with an extra strip of canvas. The original canvas is between 4 and 5 cm short on the right, between 2 and 2.5 cm short on the left, and between 1 and 2 cm short at the upper and lower edges. The 'CR' on the back of the original canvas indicates ownership by Charles I (fig. 1).

The stained-pine stretcher has diagonal corner bars. A label of the Bourlet firm of packers is glued to the left vertical member. Both the character of the lining canvas and the hand-forged nails used to attach it to the stretcher suggest that the current lining dates from before 1800.

Fig. 1 Transmitted light infrared image of the upper right corner of the original canvas, seen from the back.

Materials and Technique

What may be a revision is evident in the grey hair at the back of the music master's neck. X-radiography indicates that the woman's hand may originally have rested on the music master's right shoulder rather than his left, that the face of the viola da gamba player was extended down, the angle of the head of the wind player tilted, the figure of the music master adjusted, and the music book enlarged (fig. 3).

Condition and Conservation

It has long been acknowledged that the painting is in poor condition. William Young Ottley described it as such in 1832.[1] John Landseer in his catalogue of 1834 suggested that a 'glazing' had 'vanished from some of the faces' – notably, from the face of the boy farthest to the right.[2]

The evidence given to the Parliamentary Select Committee on the National Gallery in 1853 reveals that the painting had been varnished with 'mastic varnish mixed with drying oil' on more than one occasion since the establishment of the Gallery.[3] In 1855 the 'general condition' was described in the manuscript catalogue as 'not satisfactory' because of former repairs and an 'unequally discoloured' varnish.[4] An astonishing amount of attention was given to the painting in the next decades. It was varnished in 1862, surface-cleaned and varnished in 1868, surface-cleaned in 1876, surface-cleaned and varnished in 1887.[5] In February 1941 loose paint was laid by 'Morrill'. A report of 1949 commented on the probable disintegration of the lining adhesive, the curling of crackled paint, and the discoloration of varnish, concluding that the painting was 'quite unfit for exhibition or travel'. Some flaking in the centre of the painting and 'loose paint' at top right was treated in February 1953.

The varnish has blanched, as well as darkened and cracked, obscuring areas such as the music master's mouth. As far as can be judged through the varnish, some colours seem to have changed: the music master's dark grey cloak may have had a blue tinge; the moss green of the piping boy's hat has darkened unevenly; the music master's cap, now nearly black, may once have been green (as suggested by a copy of the painting). Relatively well-preserved areas include the plum-coloured jacket (although somewhat abraded) worn by the player of the viola da gamba, the lights on his shoulders, the white of his shirt, just revealed at the neck, and the vermilion hat and its plume. The blond plaits and the pearl eardrop worn by the woman have also survived quite well, but it looks as if glazes must have been removed from her sleeve – most obviously from the hollow beneath her elbow. This sleeve has also been partly repainted. Retouching is also apparent in the music master's cloak, in the background, and near the edges of the painting.

Subject

Five half-length figures are represented in an indeterminate, presumably interior, space. A young man performs on a recorder (of which only the reed is visible); another man, a little older and with a moustache, plays a viola da gamba with six strings; a boy, apparently under ten years of age, sings, accompanied by an older man who with his raised right hand indicates the notes on the music book held open by the boy; a young woman, leaning on the older man's shoulder, listens keenly while looking into the distance. Throughout the nineteenth century the painting was entitled *A Concert, or a Maestro di Cappella giving a Music Lesson.*

The composition seems awkwardly compressed. We may also wonder whether the painting might have been intended to have a pendant in which the figures are facing left. Groups of musicians and music lovers, also groups of lovers, which were neither portraits nor narratives, were popular in Venetian painting in the early sixteenth century, as is most famously exemplified by the *Concert Champêtre* in the Louvre, and the *Concert* and the *Three Ages of Man* in Palazzo Pitti. The authorship of these paintings is much debated but the central figure in the Palazzo Pitti *Concert* is often, and with good reason, considered to be by Titian.

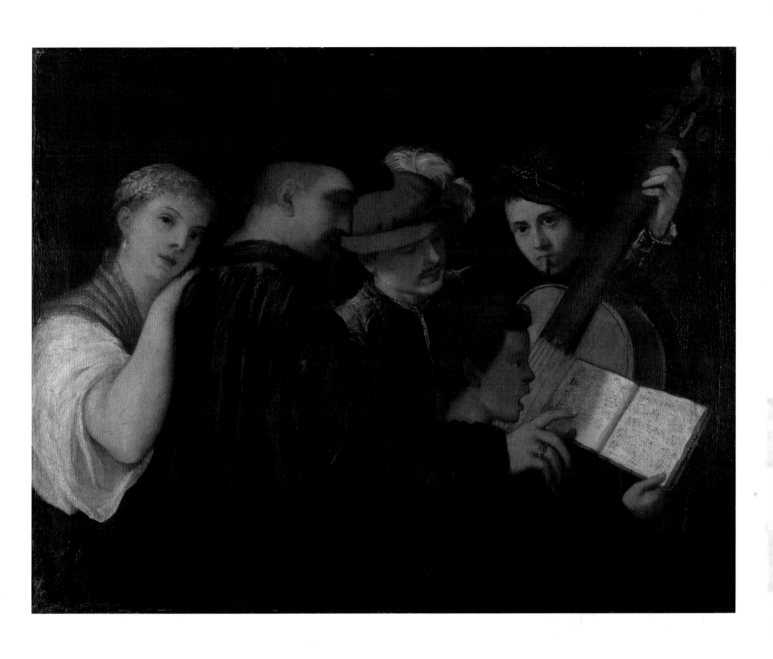

By the late sixteenth century groups of half-length musicians and lovers were associated with both Giorgione and the young Titian, and some at least of these works are likely to be pastiches made at that date. '*L'Appel*' in the Detroit Institute of Art looks like a painting of this type, as does *The Lovers* (familiar also from versions in Casa Buonarrotti and elsewhere).[6] Other artists in Venice specialised in paintings of this type – Parrasio Micheli (active 1547, died 1578) was especially prolific. In inventories 'una musica' is not uncommonly encountered among lists of pictures and must have been a generic term.[7] Several of the paintings made by the young Caravaggio in the 1590s (the *Musical Scene* in the Metropolitan Museum of Art, New York, the *Fortune Teller* in the Louvre, and the *Cardsharpers* in the Kimbell Art Museum, Fort Worth) revived this genre or at least transported it to Rome. Half-length figures, *déshabillé*, with faces half in shadow, wearing plumed caps, grouped into informal compositions, absorbed in music or charged with psychological tension, enjoyed a fresh popularity with his followers both in Rome and north of the Alps.

Dating

A number of artists took up this sort of musical subject in the early sixteenth century, among them Bordone, Licinio, Cariani and Callisto Piazza, but the style of dress here suggests a later date, as does the figure most reminiscent of Titian, the listening female. In physical type, in the dressing of her hair (pulled back from the forehead and wound in tight plaits), also in her expression, she recalls the paintings dating from the mid-sixteenth century which were once believed to depict Titian's daughter Lavinia – especially the young woman holding aloft a basin of fruit, in the Gemäldegalerie, Berlin, the same model as Salome, in the Prado, who has a loose linen sleeve as here, and the woman who catches the light, and our eye, in the centre of the *Ecce Homo* (fig. 4, p. 203), dated 1543, in Vienna.[8] It seems likely that NG 3 is a painting of the second half of the sixteenth century, made in imitation of a subject which had become popular early in the century. It seems unlikely to be a product of Titian's workshop and the X-radiographs (fig. 3) make it most improbable that it is a copy. As a false old master it is perhaps more likely to date from the last decades of the century when the international market for paintings made in an earlier style was beginning to develop.

Attribution and Reputation

The catalogue of the collection of King Charles I compiled by Abraham van der Doort in the 1630s describes a painting three feet three inches high and four feet four inches wide (99.1 × 129.5 cm), in which the light falls from the artist's left ('pijntit opan de lijeht'), featuring 'Some five halfe figures One whereof being a teaching, an other singing, The third playing upon a Bandore, the fourth playing upon a fflute, the ffifth being a woeman listening to the musick painted

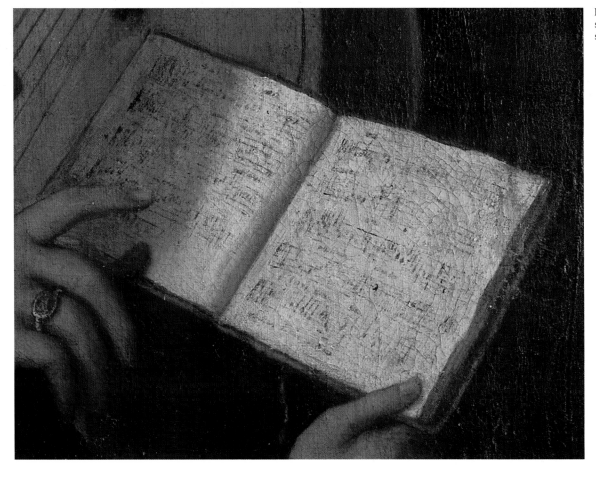

Fig. 2 Detail showing the sheet music.

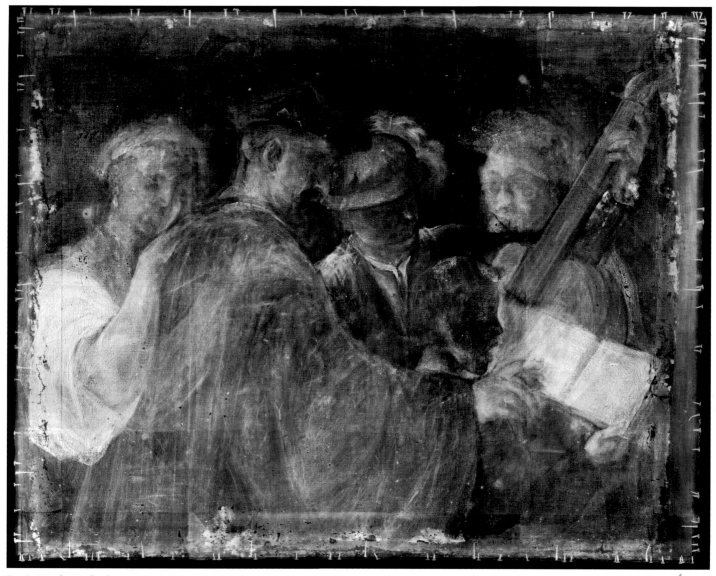

Fig. 3 X-radiograph of NG 3.

uppon cloath halfe figures. Soe bigg as the life in a wodden frame.'[9] This must be a description of NG 3, which was certainly in the Royal Collection. As will be clear, it hung in the finest company in the Palace of Whitehall, was highly valued at the time of the royal sales and fetched a high price there. Van der Doort considered it 'done by Tichian' and noted that it was a 'Mantua peece', that is, from the Gonzaga collection. When in Mantua, as is evident from an inventory of 1626–7, it had hung in a place of honour, highly valued and considered to be 'di mano di Titiano'.[10] The very least that must be concluded from this is that if the composition is an imitation or pastiche of Titian it is likely to have been made before 1600, since the expert advisers of the Duke of Mantua were unlikely to mistake a brand-new painting without provenance or reputation for an old master.

When the painting emerged in the early nineteenth century in Angerstein's collection it was praised in the highest terms and without the slightest doubt as to the attribution. Charles Lamb, raving about the splendours he had seen at

Angerstein's in a letter to William Hazlitt of 15 March 1806, recalled it (slightly inaccurately) and likened it to the music it represents. (The implied analogy between the picture and the music within it became a theme in the appreciation of Venetian painting and was most fully developed more than half a century later by Walter Pater.)

> Then, a music-piece by Titian – a thousand pound picture – five figures standing behind ... sixth playing; none of the heads, [as] M. observed, indicating great men, or affecting it, but so sweetly disposed; all leaning separate ways, but so easy – like a flock of some divine shepherd; the colouring, like the economy of the picture, so sweet & harmonious – as good as Shakespeare's Twelfth Night, *almost*, that is. – It will give you a love of Order & cure you of restless, fidgetty passions for a week after – more musical than the music which it would, but can't, yet in a manner *does*, show.[11]

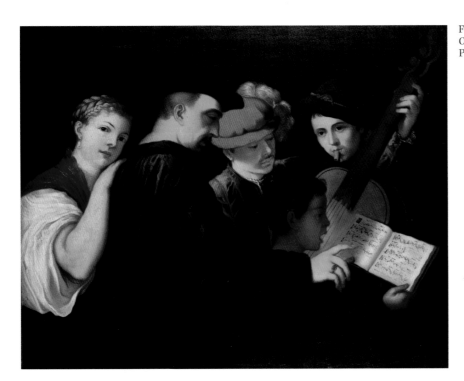

Fig. 4 Copy of NG 3, 1620s?
Oil on canvas, 100 × 125 cm.
Private collection.

This theme is developed with enthusiasm by Hazlitt himself, who found that 'the expression is evanescent as the sounds; the features are seen in a sort of dim chiaroscuro, as if the confused impressions of another sense intervened'.[12] P.G. Patmore in his *British Galleries of Art* (London 1824) wrote that 'nothing can be more characteristic of Titian's style and power than this charming picture'.[13]

On its acquisition by the National Gallery the painting, entitled *A Concert, or a Maestro di Cappella giving a Music Lesson*, remained celebrated as a Titian. 'It has much the appearance of a fortuitous assemblage of concordant spirits; and so little the air of being studied according to preconceived rules of art, that little doubt need be entertained of its being merely a page of the artist's sketch book (assuming that he had one) transferred to Canvass,' wrote John Landseer in his *Descriptive, explanatory, and critical catalogue of fifty of the earliest pictures contained in the National Gallery of Great Britain* of 1834,[14] thereby converting what would normally be regarded as a weakness into a distinguishing feature of a work of genius, careless of the rules. He continued:

> All is spontaneous and done at sight (as the musical phrase is); even the chiaroscuro seems accidental, and not a very fortunate accident, in as much as it attracts too large a portion of the spectator's regard, toward the somewhat heavy arm, and uninteresting white sleeve of a young female singer, who appears waiting to chime in with her counter-tenour, and it allows too little of that regard to flow toward the mass of light, where the music book is introduced, with the singing boy and the upper part of a musical instrument.

He commended the 'pervading musical tone', that 'general interest and intentness', the 'symphonious sentiment', but did wonder whether Hazlitt (whom he quotes) might not have been responding to a dimness in the atmosphere and a pallor in the faces which were due to damage rather than design. Eastlake in his essay 'How to observe', written in 1835, cited the painting, together with *Bacchus and Ariadne* (NG 35), as typifying the 'quietness of mien' and 'solemnity of look' preferred by Titian, even in his paintings of 'festive subjects'.[15]

In 1843 a doubt concerning the painting's credentials was insinuated by Owen Jones, writing under the pseudonym Felix Summerly, in his *Hand Book for the National Gallery*. Having observed that Waagen believed that the painting might be by Giorgione, and that Mr Angerstein paid £1,500 for it, he informed his readers that 'Mr T. Harvey of Norwich told Mr Dawson Turner he has known this picture to have been sold for £30, its real value'.[16] This was very probably art-world gossip, perhaps picked up from John Charles Robinson, Jones's colleague in the South Kensington Museum and a formidable connoisseur of paintings (which Jones was not), deeply involved with the trade and sceptical of the German experts. Otto Mündler, annotating the latest edition of Wornum's *Descriptive Catalogue* soon after his appointment as the Gallery's travelling agent in 1855, declared: 'This I believe to be Titian.'[17] His affirmation has a defiance which suggests the existence of sceptics other than Jones. Soon after, the connection with the Titian in Charles I's collection was emphasised.[18] This may have stifled criticism for a while but Crowe and Cavalcaselle announced in their monograph on Titian of 1877 that the painting was 'far below Titian's powers' and must be by a follower such as Schiavone or Zelotti.[19] The Gallery first officially acknowledged the justice of this in the *Abridged Catalogue* of 1889 when, together with *The Tribute Money* and the *Rape of Ganymede*, the painting was downgraded to 'School of Vecellio'.[20] The name of Padovanino was, it seems, first mentioned by Emil Jacobsen in 1901.[21] No one since Crowe and Cavalcaselle

has revived the attribution to Titian except Suida in 1935, who thought that workshop assistance was probable.[22] The conservation record is also eloquent of a change of attitude: repeated attempts to improve its appearance were replaced by indifference.

Provenance

Purchased with the Angerstein collection, 1824. Recorded in that collection by 1806. The Gallery's catalogues between 1915 and 1929 note that the painting is 'perhaps from R. Strange coll., 1771', but the 'evidence for this' eluded Cecil Gould.

As mentioned above, the painting was in the Gonzaga collection by 1627, was acquired from that collection by King Charles I, and was then in his sale. A detailed account of how it was displayed and how it was valued when in these collections is provided in the appendixes below.

Burton Fredericksen points out that it is possible that NG 3 corresponds with lot 24 in the Pasquier sale of 10 March 1755 which is described as 'Un Concert de Musique vocale' performed by five half-length figures, including a woman with her hand on a man's shoulder. The colour and 'effet' were said to be 'admirable' and the majority of connoisseurs considered it to be by Titian. It was on canvas and measured 36 by 46 *pouces* which is close to NG 3. It was bought by Boucault, 'receveur de la ville', for 853 livres.[23]

Prints

The composition was engraved by Hendrick Danckerts probably during his period in The Hague (1645–53; thereafter, he is recorded in Italy until 1657). Another engraving, by J. Gronsveld (active in Amsterdam from 1679 until his death in 1728), is in reverse and probably derives from that by Danckerts. The latter is inscribed 'Ex collectione regis Magnae Brittanniae'. Danckerts could have visited London or relied on a drawing but it seems likely that he had seen the painting in Holland. NG 3 was also engraved by T. Garner for Jones's *National Gallery*.[24]

Related Paintings and Other Versions

An inventory of the collection of pictures in a Roman palace at S. Andrea della Valle – a collection inherited by Francesco Pio di Savoia – which was compiled on 23 March 1724 includes as item 15: 'Altro quadro rappresentante una musica con quattro huomini et una donna, quale tiena un libro di musica in mano, alto palmi 2 5/6 largo 4 – in tavola con cornice dorata, di Giorgione.'[25] The dimensions, format and support are different from NG 3, and the woman holds the score, but were the entry less detailed, itemising only the number of figures and their sex, the picture might be considered as identical. There are many other descriptions of musical subjects that sound as if they might correspond. What is certainly another version of the painting, identical in composition, said to measure 100 × 125 cm, was offered for sale at Christie's, Monaco, on 15 June 1990 (lot 41, illustrated), with an attribution to a 'Suiveur d'Alessandro Varotari, il Padovanino' but with no reference to NG 3 (fig. 4).

It appears to be identical to the work in a private collection published without qualification in Ugo Ruggeri's monograph.[26] It looks like a copy; the paint is smoother and there are no evident revisions. It could date from the 1620s (as Ruggeri proposes) and such a copy may indeed have been made by Padovanino. The condition is superior to that of NG 3 but the colours are much the same, so it was perhaps made from the original after the greens had darkened. The notes on the musical score are the same as those in NG 3, although more legible. Another version, apparently old but said to be inferior, is at Pommersfelden.[27] Another, reduced in size and with a *trompe l'œil* frame, was lot 142 at Christie's, 9 March 1951.[28] A variant with three or four figures was at Brunswick in 1849, attributed with a question mark to Giorgione.[29] In 1999 a large painting of a concert (137 × 328 cm) with a composition clearly derived from that of NG 3 was for sale, attributed to a 'manierista emiliana', in the gallery of Pietro Scarpa in Venice.

A small painting attributed to Titian, on panel, measuring 15 × 17 in. (38.1 × 43.2 cm) (including the frame) and showing a 'Music master instructing his pupils', belonging to the dealer Noel Desenfans was lot 148 in his sale of 8 April 1786 in London. This very likely corresponds with a painting in the sale of Charles Alexandre de Calonne (1734–1802), the former French finance minister, held at Spring Gardens by Skinner and Dyke in March 1795.[30] Lot 21 on the fourth day of this sale, 26 March, was attributed to Titian and described thus in the catalogue: 'The Master of the Orchestra with his pupils. It is impossible to conceive a group of figures finer placed, or more judiciously placed than in this small picture, presumed to be a repetition of a large one of the same subject; the colouring is rich and harmonious.' According to Buchanan it fetched 46 guineas. It reappeared in Bryan's Gallery, Savile Row, in the sale by private contract on 27 April 1795 of 'that superlatively capital assemblage of valuable pictures formed from the sales of several celebrated collections of M. De Calonne, Baron Nagel, and Sir Joshua Reynolds', as no. 110 with the same title. This is the right period for an acquisition by Angerstein but the description of the picture as small and the reference to a larger version make it certain that it was not identical to the National Gallery's painting but likely that it was a small version of the same composition.[31]

Frame

The painting is in a gilded frame of a neo-classical style with composition ornament (fig. 5). The deep hollow is decorated with acanthus leaves. The outer moulding consists of a garland of bay leaves with berries and the inner moulding is articulated with guilloche ornament. Inside the guilloche, on an ogee moulding, sharp ridged leaves point down to the plain slip bordering the canvas. This slip originally served as a spacer for the glass.

The frame was probably given to the painting when it was in the possession of John Julius Angerstein, and there is good reason to think that the pattern was employed on many paintings in his collection, for we find an identical frame on his *Saint John the Baptist seated in the Wilderness* (NG 25, once

Fig. 5 Corner of the current frame of NG 3.

attributed to Annibale Carracci but now regarded as the work of a follower) and several major works from his collection are shown in frames of this pattern in Frederick Mackenzie's watercolour of the National Gallery when it was still in Pall Mall, including Raphael's *Portrait of Julius II* (NG 27) and Claude's *Seaport with the Embarkation of Saint Ursula* (NG 30). Wilkie's *Village Festival*, which was transferred from the National Gallery (where it had been NG 122) to the Tate Gallery, retains a smaller frame of similar style but with a bay leaf at the sight edge.

Other British collectors in the early 1800s favoured acanthus hollow frames: Holwell Carr, for example, whose *Sogno* (*The Dream*), after Michelangelo (NG 8), retains one with flat burnished inner and outer mouldings, and perhaps the dukes of Northumberland, whose *Plague at Ashdod*, then attributed to Poussin (NG 165, given to the Gallery in 1838), has a reeded outer moulding and egg and dart on the inside, although this pattern, also used for one of Angerstein's pictures (Circle of Annibale Carracci, *Erminia takes Refuge with the Shepherds*, NG 88), may have been selected by the Gallery's keeper. The motif had not gone out of fashion in the 1840s, when we find it employed for the largest picture frame in London, the proscenium arch through which were seen the painted sets of the Royal Opera House, Covent Garden.

Since NG 3 was the painting of this composition attributed to Titian in the Gonzaga collection and later in the collection of King Charles I it must then have had a plain, or at least ungilded, wooden frame (as described below).

Appendix 1

TITIAN'S *MUSICA* IN MANTUA

A painting of musicians attributed to Titian which must be identical to NG 3 is recorded in the inventory of the paintings in his collection ordered by Vincenzo II Gonzaga on 15 November 1626, which is dated (and was thus completed by) 19 January 1627.[32] The painting was one of two overdoors ('doi quadri sopra le porte') in the first *camera* of the

new ducal apartments attached to the ballroom and was numbered 300 – 'uno dipintovi homini che cantano di musica, mezze figure, con cornice fregiata d'oro, di mano di Titiano, stimato scuti 50 et nel altro dipintovi Nostro Signore deposto sopra il sepolcro con cornice stimato scuti 20, in tutto, lire 420'.[33] The identity of the companion piece is uncertain (it is not Titian's celebrated *Entombment*, now in the Louvre, which was recorded elsewhere in the collection[34]). There can be no doubt that the painting was highly esteemed. It had in fact the same valuation as Titian's *Entombment*. Raphael's *La Perla* was valued at 200 scudi, Correggio's *School of Love* at 100, but these were exceptional.[35] Major works by Guercino and Lotto, for example, were valued at less than a third as much.[36]

The position of the painting above a door is of some significance. Concerts were a common subject for overdoors in canvas paintings (as other inventories demonstrate), and above all in fresco decoration, where they often appear to be taking place on a balcony.

Appendix 2

TITIAN'S *MUSICA* HANGING IN WHITEHALL
AND SOLD WITH THE ROYAL COLLECTION

Titian's painting of musicians was acquired for King Charles I through the agency of Daniel Nys (a merchant resident in Venice) and Nicholas Lanier (a musician and connoisseur) from Duke Ferdinando Gonzaga of Mantua and his successor (in 1626) Vincenzo II, and his successor (in 1627) Carlo di Nevers. It was probably one of the paintings packed in cases on board the *Margaret*, which set sail from Venice in April 1628. Van der Doort's description is given above in the section on Attribution and Reputation. Since Van der Doort notes elsewhere frames that were 'guilded' and 'carved' we may assume that the 'wodden frame' he mentions was a plain polished wood moulding – a cassetta frame of a kind much favoured in Mantua and perhaps the same one that the painting had in 1626 (he would not necessarily have recorded the fact that such a frame was 'fregiata d'oro').

There are two reliable indexes of the esteem in which paintings were held in the Royal Collection: the place in which they were hung and the estimate placed on them after the king's death.

When Van der Doort compiled his catalogue[37] eleven paintings by Titian, or believed to be by him, including the *Allocution of the Marqués del Vasto* (now in the Prado, Madrid), the *Entombment* and the *Supper at Emmaus* (now in the Louvre) and the *Nude in a Fur Wrap* (now in the Kunsthistorisches Museum, Vienna), were concentrated in the first 'Privie Lodginge Roome' in Whitehall Palace. The only other artist whose work was included there was Correggio. In the next two rooms (the 'Second and Middle Privie Lodging Roome' and the third 'Lodging Roome' also called the 'Square table Roome') there were paintings by Giulio Romano, Polidoro, Raphael and del Sarto as well as Titian. The Titians were no less important than those in the first room. In the third, there was the portrait of Andrea Gritti, now in the National Gallery of Art, Washington, in the second the 'great Lardge and famous peece' called the *Venus of Pardo* (now in the Louvre). Titian's painting of musicians was also in the second room beside the door. Below it was a narrow horizontal panel painted with children sporting with goats by Polidoro. Beside it was a Holy Family in a landscape, also attributed to Titian, above a narrow painting of Noah's flood, attributed to Giulio.

There can be no doubt that the most valued paintings were assembled in these rooms.

Among the 'severall pictures' from St James's appraised on 16 February 1650 (1649 old style) was 'a picture of ye musicians', marked as 'by Titian' and valued at £150.[38] Although it was reserved as an item of national importance (or at least as fitting furniture for state rooms), the picture was sold on 3 May 1650 to 'Lynchbeck' for £174 10s. Other paintings by Titian were of course more highly valued – the *Marchese d'Avalos* for example, at £250; the *Venus de Pardo* at £500[39] – but the value was higher than most, and the same as that of the nude woman with an organist (now in the Prado).[40]

John Lynchbeck, or Linchbeck – the 'Merchant' who purchased the painting – is also recorded as the buyer of *The Triumph of Titus* attributed to Giulio Romano (for £170 on 19 April 1650), the *Parnassus* attributed to Perino del Vaga (for £117 on the same day), the *Holy Family with Saint Catherine* attributed to Giorgione (for £114 on 7 May), and the *Birth of Hercules* attributed to Giulio Romano. At least two of these paintings (the first two) passed via Jabach's collection to the French royal collection,[41] so Titian's *Musica* may have travelled to France before returning to London. If so, that would make more probable its connection with the painting of a similar character in the Pasquier sale mentioned above.

NOTES

1. Ottley 1832, pp. 10–11.

2. Landseer 1834, p. 127.

3. Select Committee 1853, p. 747.

4. MS Catalogue, under NG 3.

5. Ibid. Dyer's bill of 1887 is in the Gallery's accounts.

6. See the entry (unsigned) for the Detroit painting in Ballarin 1993, p. 349, which provides a convenient summary of scholarly opinions on the picture. For the *Lovers* see Shearman 1983, pp. 69–72, no. 65 (proposing an attribution to Cariani).

7. An early instance of a title of this kind is 'un musico' in an inventory of October 1555 listing the household possessions of Giovanni Battista Companato, ASV Canc. Inf. Misc. Notai Diversi, item 31, fol. 6v: 'Altro quadro ... un musico'. This may have been a painting of a single musician (there are examples by Palma Vecchio and Bartolomeo Veneto) which is clearly a related genre.

8. Wethey 1969, pp. 79–80, no. 21.

9. Van der Doort 1960, p. 17.

10. Luzio 1913, p. 113.

11. Lamb 1976, II, pp. 22–34. This passage was kindly drawn to my attention by Humphrey Wine.

12. Hazlitt 1824, p. 13n.

13. Patmore 1824, p. 15.

14. Landseer 1834, pp. 127–30.

15. Eastlake 1870, pp. 294–5.

16. [Jones] 1843, p. 2. The annotation is followed by an additional question: 'Was this the Titian sold among Mr W. Young Ottley's pictures in 1811?' Ottley's picture was, however, a different composition. His sale catalogue mentions 'a young woman with a guitar' – Christie's, London, 25 May 1811, lot 85 (sale is Lugt 8005; Fredericksen and Armstrong 1993, I, p. 14, no. 889). This picture was bought in at 160 guineas.

17. Annotated copy of Wornum 1854 in NG Library, p. 189.

18. Wornum 1858, p. 211. The provenance was already recorded in Jones and Co., c.1835, no. 51.

19. Crowe and Cavalcaselle 1877, II, p. 459.

20. [Burton] 1889, p. 187, but in the previous year all three paintings were still given to Titian (ibid. 1888, p. 187).

21. Jacobsen 1901, p. 372.

22. Suida 1935, p. 184, plate CCCIVb.

23. Lugt 870. There were 51 paintings in the sale. Pasquier was Député du Commerce at Rouen.

24. Jones and Co., c.1835, no. 51.

25. Bentini 1994, p. 119 (inventory edited by S. Guarino). The entry does not correspond to any painting now in the Capitoline Collections.

26. Ruggeri 1993, pp. 88–9, no. 21.

27. Gould 1979, p. 305.

28. The measurements given were 9½ by 12 inches. Bought by 'Marchant' for 20 guineas from the collection of G.W. Blundell, Elderslie, Ormskirk, Lancashire.

29. Crowe and Cavalcaselle 1912, III, pp. 53–4, Brunswick cat. no. 260.

30. The connection between the Desenfans and Calonne pictures was made by Burton Fredericksen. Other pictures were certainly acquired by Calonne from Desenfans which confirms the connection.

31. For an introduction to Calonne and his collections see [Sutton] 1973.

32. Luzio 1913, pp. 88–136.

33. Ibid., p. 113. See also 'Centro Internazionale', 1998, p. 74, no. 959. There are differences in the style of transcription. I have followed that of 1998.

34. Luzio 1913, p. 92, no. 11. See also 'Centro Internazionale', 1998, p. 51, no. 671.

35. Ibid., p. 90, no. 8; p. 92, no. 9.

36. Ibid., p. 106, no. 236 (Guercino), p. 131, no. 622 (Lotto's *Portrait of a Jeweller*).

37. Van der Doort 1960, pp. 14–22.

38. Millar 1972, p. 269, no. 201.

39. Ibid., p. 313, no. 243; p. 310, no. 184.

40. Ibid., p. 299, no. 17.

41. Louvre, Inv. 423 and Inv. 595, the latter now attributed to Rosso.

After Titian

NG 4222
The Trinity ('La Gloria')

Late seventeenth century?
Oil on canvas, 131.6 × 100 cm

Support

The dimensions given above are those of the stretcher. The dimensions of the painted surface are 130 × 97.5 cm. The tabby-weave canvas of medium weight has been lined with paste on to a finer tabby-weave canvas. Cusping is only evident along the upper edge, but there is no reason to suppose that the painted surface has been reduced significantly on the remaining edges. The pine stretcher has crossbars. Affixed to the back of the lining canvas is a small, round paper label printed with the name 'Battle Abbey' in capital letters and inscribed in ink with the number '1428'. Battle Abbey in Sussex was a Gothic Revival house built out of the ruins of the Norman abbey at Battle by Henry Clutton for Lord Harry Vane (see the section on Provenance) in 1857.

Materials and Technique

The canvas has a ruddy brown ground of a kind that was especially favoured in Italy (but also found in Spain) during the seventeenth century and later. Numerous alterations to the composition as originally painted are visible to the naked eye, and others are apparent in the X-radiographs (which were first made of this painting by Alan Burroughs of the Fogg Art Museum at the remarkably early date of 1927; fig. 2). Among the more notable changes are the following: the crystal orb of Christ (the enthroned figure on our left) was originally larger and was placed on his lap rather than on his left thigh; the Virgin Mary's veil originally billowed out behind her head; John the Baptist's camel-skin cloak originally passed over his left shoulder; a tail of the drapery over Moses' legs originally fell vertically to cover some of the trees below; King David's head at the lower right was originally turned upwards towards his left; the raised right hand of the prominent female figure originally overlapped the shroud worn by the kneeling emperor.

Brilliant blue pigment (presumably ultramarine) is applied as a glaze over lead white in the Virgin's drapery and over pink in King David's drapery, and a green layer is painted over pink in the dress of the prominent female figure.

Conservation

It is reasonable to assume that the painting had been cleaned and restored when it was for sale in London in the second decade of the nineteenth century. When Waagen inspected it in the collection of Samuel Rogers in the early 1830s he admired the 'rich deep tone in the flesh' but noted that the painting was 'unfortunately ... not wanting in re-touches'.[1] It probably received no other treatment save perhaps for additional coats of varnish until after its sale to the Gallery in 1926. The summary history of condition and treatment in the conservation file records, under the date 'Dec. 1926', that the painting was 'formerly obscured by a thick brown varnish. Cleaned by Nico Jungmann, but not finally varnished. A few small spots and rubbings repaired by Holder.' Since there is no other record of Jungmann working for the National Gallery, he was probably employed by Colnaghi's (who had bought the painting in October 1926) in preparation for the meeting on 14 December 1926 at which the Trustees decided to acquire the painting. Holder's work would have been undertaken soon after acquisition, and the decision not to varnish was presumably made in anticipation of his intervention. In February 1941 and February 1948 loose paint was 'laid down', on the first occasion by 'Morrill'. Blisters were treated in January 1978.

Condition

The paint has been flattened in lining. There is a tear across the clouds in the centre of the composition. The surface is badly cracked, perhaps on account of the canvas having been rolled up, as is said to have happened in the early nineteenth century (see the section on Provenance). There are numerous flake losses, especially at the edges of the painting. John the Baptist has probably been more damaged than most of the other identifiable figures, but the losses are chiefly on his back. The surface has been abraded and this has contributed to making some of the revisions described in the previous section distractingly visible (the previous position of Christ's orb is an example) and has rendered the features on some of the faces (that of the empress, for instance) indistinct and expressionless. It may also have made some of the clouds less substantial in form.

Subject and Source

NG 4222 is a copy of Titian's large canvas generally known as '*La Gloria*', but referred to by Titian himself as *The Trinity*, which was commissioned by the Emperor Charles V when he was at Augsburg in 1551, and delivered to him at Brussels in 1554 (fig. 3). The Emperor took the painting with him when he retired to the Estremadura and it was removed to the monastery of the Escorial when his remains were buried there (since 1837 the painting has been in the Prado).[2] Although some aspects of the subject of *The Trinity* are obscure, it was surely conceived as an epitaph, a type of painting or relief sculpture, common in Germany (where Titian's painting was commissioned), in which the patron and his family appear at prayer before the Trinity or some other image central to the Christian faith.

The Emperor and Empress with their son Prince Philip (the future Philip II) and his sisters kneel, wearing only shrouds, before God the Father and Christ – Christ with a shorter beard, sitting at the right hand of his heavenly father and very slightly lower, and nearer to us. Between them the dove of the Holy Spirit appears in a blaze of light. The Virgin Mary glides across the clouds below, wrapped in an ultramarine mantle a shade more intense than those worn by the enthroned figures above. These blues match that of the open sky in the centre of the composition and the white shrouds

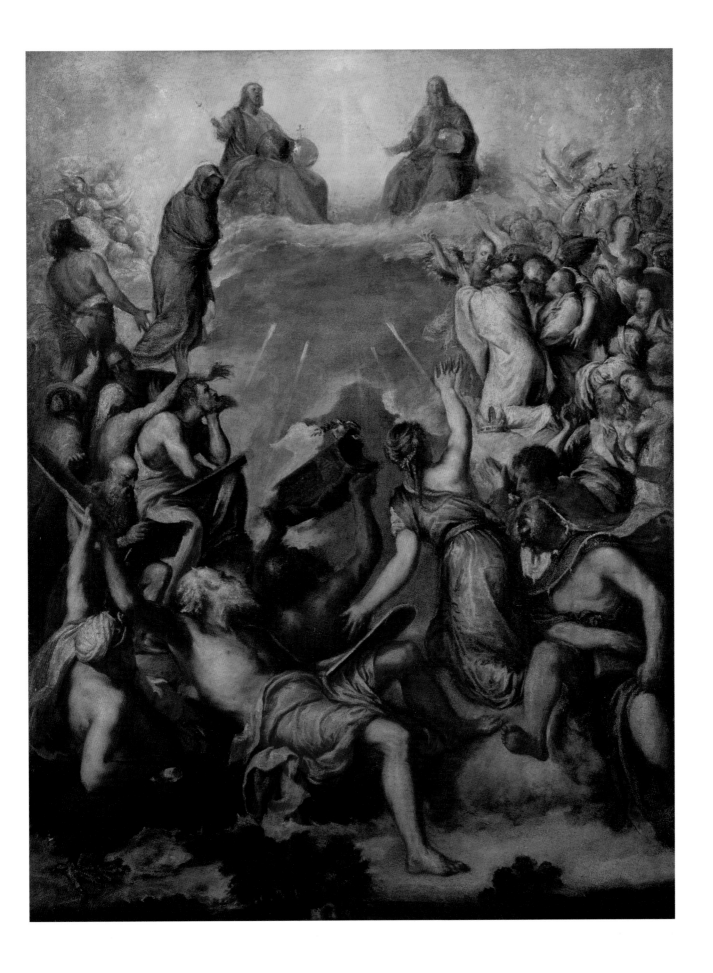

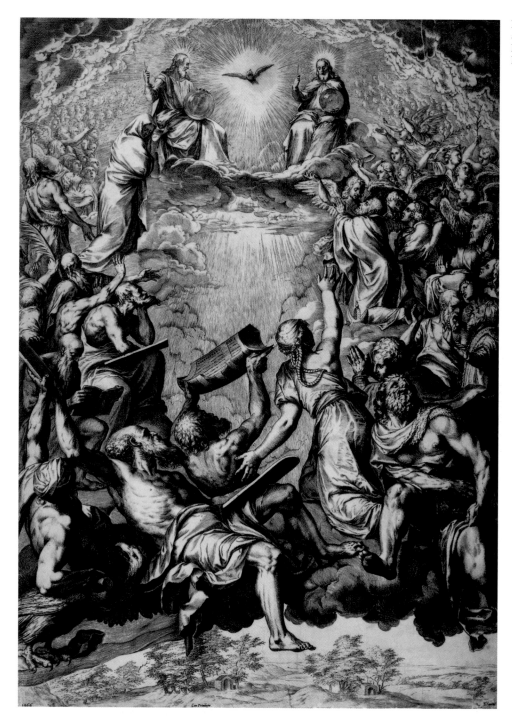

Fig. 1 Cornelis Cort
after Titian, *La Gloria*, 1566.
Engraving, 53 × 38 cm.
London, The British Museum.

of the mortal royalty match the clouds. Behind the Virgin is
John the Baptist and behind the imperial family an angelic
escort and a crowd of other mortals, including Adam and
Eve. The large figures in the foreground include the Prophet
Ezekiel with an eagle, Moses with the Tablets of the Law,
Noah holding aloft the ark, and David wearing a cloak edged
with royal ermine and clutching his harp. Their outstretched
and twisted poses recall those which Titian had recently
invented for scenes of mythological torture and suffering
that had been commissioned by Mary of Hungary,[3] but the
figures here are animated by the celestial vision to which
their attention is directed by a woman seen from the rear. She

is wearing shimmering green silk and has been identified as
Mary Magdalene,[4] although she is more likely to represent a
sibyl, joining with the Old Testament figures in prophecy, or
perhaps to personify the Church, confirming and coordin-
ating their intimations of revelation.

Attribution

Samuel Rogers believed this painting to be an original *bozzetto*
by Titian, a claim which had also been made for it by the two
previous owners (for whom see Provenance below). The attri-
bution was accepted by Passavant and Waagen when they
visited Rogers's collection in the 1830s,[5] but it is probable

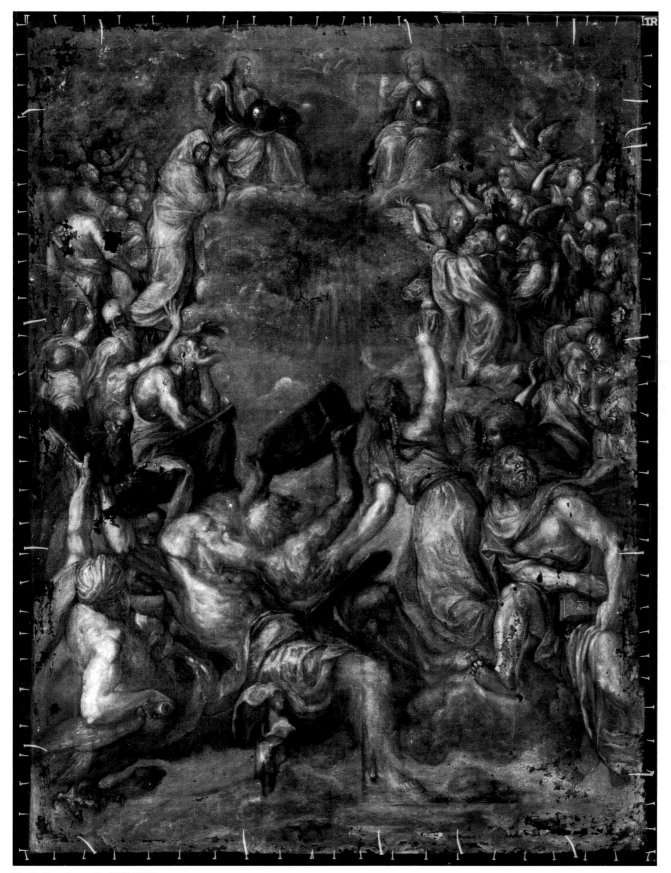

Fig. 2 X-radiograph of NG 4222.

that Eastlake was not convinced. The painting was not among the three paintings which Rogers (perhaps with Eastlake's advice) bequeathed to the National Gallery in December 1855, nor was it among the six paintings that Eastlake persuaded the Trustees to bid on at the sale of Rogers's collection in May 1856.[6]

Lord Harry Vane (later Duke of Cleveland), however, who bought the painting at the Rogers sale, lent it in the following year to the Manchester Art Treasures exhibition, where it was greatly admired by Théophile Thoré, perhaps the most acute of all the many critics who wrote at length on the old master paintings shown there. 'For bravura of handling here is something astonishing' ('Comme bravoure d'exécution, voici une merveille'), he exclaimed.[7] Cavalcaselle, who saw the picture at the Royal Academy's winter exhibition of 1872, described it in a footnote to his great monograph of 1877 written with Crowe as 'a copy and not a sketch; a copy, too, of quite uncertain date'.[8] Nevertheless, it was included in the Cleveland sale in 1902 as a Titian and was presumably bought by Sir William Corry as such.[9] But at Corry's sale the painting sold for 20 guineas, a price which may have reflected its uncleaned condition as well as accumulated doubts. Indeed, it is surely the case that only a Titian that was under some sort of critical cloud would have been allowed to retain so very darkened a varnish.[10]

Otto Gutekunst, one of the partners at Colnaghi's, seems to have been convinced that the painting was by Titian and he solicited from his compatriot Baron von Hadeln, then one of the greatest experts on Venetian art, a highly enthusiastic letter dated 18 November 1926 which, together with a typed translation, eventually came to the Gallery.[11] For Hadeln the painting was neither 'Arbeit' (study) nor 'Skizze' (preliminary sketch) but a 'modello', which for him meant that the composition was more fully worked out. In the nervous energy of the brushstrokes the true personality of the artist ('temperamentvollen') was apparent, and the pentimenti revealed the creative evolution of his ideas, not mere corrections. He also understood that there was some relationship to the engraving of Titian's composition by Cornelis Cort (see below), although he was surely wrong in declaring that this painting served as Cort's model (unless he meant that it had first done so and then been repainted). In February 1927, two months after NG 4222 had been acquired by the National Gallery, Charles Holmes, the director, published the painting as by Titian in *The Burlington Magazine*, making much of the pentimenti as evidence of the painting's authenticity. He was especially struck by the modernity of the technique, by the 'divisionism' of the 'broken green of the Magdalen's dress', by the vibrant 'juxtaposition or superposition of touches of pure colour', worthy of a 'great modern painter'.[12]

At the meeting of the Board of Trustees on the afternoon of 14 December 1926 Holmes had strongly recommended the purchase of the painting, which Colnaghi's were offering at £12,000. The Trustees were divided but agreed by a majority vote. Three of them – Sir Herbert Cook, Sir Robert Witt and Lord Lee – 'desired that their dissent from the [majority] resolution' be recorded. The acquisition was discussed in the context of the 'list of pictures to be protected from sale abroad', which suggests that some Trustees were concerned that the Gallery should not be buying dubious and damaged sketches when it might have to appeal to the Government to secure pre-eminent masterpieces. Holmes was urged to 'do his utmost to induce Messrs Colnaghi to abate their price'.[13] The episode is an interesting one in that it must have done much to confirm doubts concerning Holmes's judgement even among the Trustees who agreed to the acquisition. It is likely that one of the Trustees (Cook and Witt are both possible candidates) appealed to Berenson to help to discredit Holmes's claims for the painting.

In any case, a typed extract from a letter by Berenson dated 24 October 1929 is in the Gallery's dossier. The letter was sent from the Hotel Ritz, Paseo del Prado, written soon after Berenson had re-examined Titian's original. Berenson declared that he had 'approached the problem with every desire to conclude that the National Gallery version was a Titian'– a form of words which is seldom employed sincerely – but had quickly realised that it could not be by him. 'Perhaps the most telling adverse point is that almost all the super-Magnasco tricks in the National Gallery version are exaggerated reproductions of deteriorated states of the Madrid picture.'

Berenson was right to discern a late seventeenth-century character to the handling of NG 4222, although we need not take the reference to Magnasco too seriously (Magnasco was then synonymous with the baroque[14]). Holmes's successors in the Gallery did not believe that the painting was by Titian, and, in correspondence with Kenneth Clark, August Mayer proposed a list of possible artists: Francesco Ricci, Pablo Esquert, Luca Giordano, José Antolínéz and Cerezo.[15] Other authorities merely claimed that the painting was Spanish.[16] The last serious supporter of the attribution to Titian was Tietze in his monograph of 1936. He thought that it might be the sketch Titian had kept in his workshop, but since he thought NG 4222 was large he had perhaps never studied it in person.[17]

The Relationship to Cort's Engraving
Cecil Gould in his catalogue of 1959 carefully tabulated the differences between Titian's painting in the Prado (sent from Venice in 1554) and the engraving of the composition made by Cornelis Cort in Venice, which is dated 1566 (fig. 1).[18] He noted that the preliminary painting of NG 4222 corresponded exactly with Cort's engraving but that it was changed to match the Prado painting, leaving only one significant detail from the print (the angel supporting the empress looks at her rather than at the heavenly vision).[19] Titian must have retained a version of the painting, conceivably a small preliminary sketch, which served as Cort's model, for the painting had been sent to the emperor twelve years before. It might be argued that NG 4222 in its preliminary state was precisely

Fig. 3 Titian, *The Trinity (La Gloria)*, 1551–4.
Oil on canvas, 346 × 240 cm. Madrid, Museo Nacional del Prado.

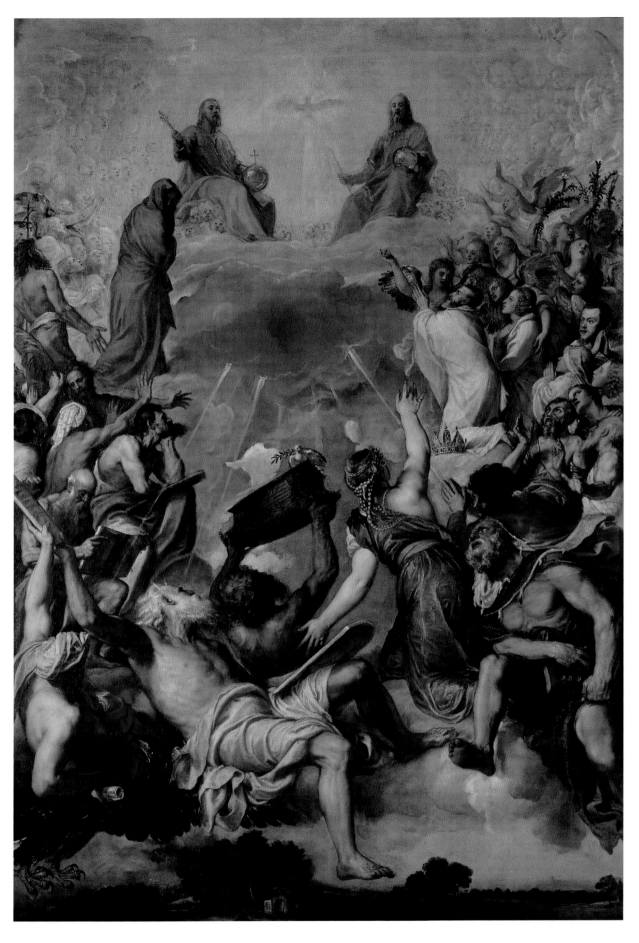

such a painting, or a copy of such a painting. However, Gould was correct in his opinion that this underpainting is too crude to be by Titian. Furthermore, there is every likelihood that the version Titian retained was altered by him after the dispatch of the Prado painting. Indeed, X-radiography of the latter[20] reveals that King David was at no stage envisaged as looking up over his left shoulder, as he does in the engraving, so it is likely that Cort recorded some of Titian's later ideas as well as some of his earlier ones.

It does seem obvious that NG 4222, in its original state, was painted from Cort's engraving and was then revised, very probably by another hand, as Gould implied, to correspond to the finished painting in the Prado. It is possible to imagine that an artist might assume that the engraving after a painting is closer to the painting than it is and would therefore begin work on a copy by reference to it, but it is hard to believe that such was the case here. It seems more likely that a painter of some talent took a mediocre copy based on the engraving and then made a lively record of the painting in the Prado, quite possibly with the idea of selling it as Titian's *bozzetto*. If this ruse succeeded, then it seems not to have convinced more than one or two generations, because by 1800 the painting was entirely neglected. But as an idea it enjoyed a remarkable

second life. It is just possible that the whole painting was concocted (together with its provenance) not long before it is first recorded.

Provenance

An entry dated 23 January 1819 under the heading 'VIRTU' in the commonplace book compiled by the banker, poet and collector Samuel Rogers records a story told him by the 'Danish Minister' in London, 'Mr. D. Bourke', at Cassiobury (the seat of the Earl of Exeter, in Hertfordshire, where, presumably, both were guests) concerning NG 4222, which Rogers had bought, probably quite recently.[21] Comte Edmond de Bourke had served as minister in Madrid between 1801 and 1811 where he had invested in a large scale in paintings driven onto the market by the French occupation. NG 4222 was said to have hung in the billiard room of a 'low tavern' in the city and the players used to strike their cues against it when they lost. The landlord of the tavern was arrested for a murder and condemned to the galleys, and the painting was auctioned, along with all the tavern furnishings, at the jail. It was sold for a dollar to a man who rolled it up and carried it away. Soon afterwards he sold it for five dollars to a friend who expressed curiosity about the roll. Rumours of the

Fig. 4 Detail of NG 4222.

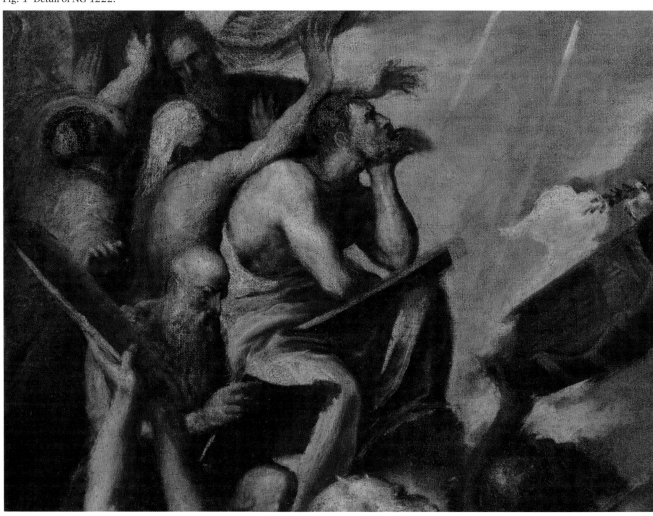

picture's merit began to circulate and eventually the Danish minister bought it, unseen, for 70 guineas. George Augustus Wallis (1770–1847), an English painter turned dealer then active in Spain as an agent for William Buchanan, persuaded the minister to part with it in exchange for a Murillo in 'about 1808', according to Mrs Jameson, who must have heard about this transaction from Rogers.[22] Wallis still had the painting for sale when Bourke arrived in London in 1811, but the price was 600 guineas so he declined to buy it back. It is probably the painting that was offered to Thomas Penrice by George Yates in January 1814[23] and it was indeed from 'Mr Yates, a picture-dealer in Oxendon St Haymarket', that Rogers bought it for 160 guineas, 'giving another picture as part of the purchase money'. It is not impossible that the painting really did come from a Madrid tavern, but low-life provenances of this kind are sometimes used to discourage enquiries about a picture's true origins and, given the huge number of stolen paintings on the market in Spain in the first decade of the nineteenth century, the reasons for discouraging such enquiries were obvious.

It is worth noting that Rogers had a penchant for small versions of large paintings which the relatively confined space of his London house must have encouraged. He believed that he owned Tintoretto's original sketch for *Saint Mark rescuing a Slave* (fig. 1, p. 196). He owned Rubens's reduced and modified copy (NG 278) after one of Mantegna's *Triumphs* and what was then believed to be Rubens's *modello* for his *Horrors of War* (NG 279).

The Trinity was lot 725 in the posthumous sale of Rogers's collection at Christie's, London, on 2–3 May 1856, where it was bought for £283 10s. by Lord Harry Vane, later 4th Duke of Cleveland (succeeding his brothers, the second and third dukes), who probably removed it soon afterwards to his new home at Battle Abbey (see the section on Support above).[24] It was in his posthumous sale on 8 March 1902, as lot 37, where it was bought for 55 guineas (£57 15s.) by Sir William Corry, Bt (1859–1926), director of the Cunard Steamship Company. It was sold with the contents of Corry's home, Claremont, Esher, on 25–28 October 1926 as lot 285 and bought by 'Mears' for Colnaghi's. From them it was acquired by the National Gallery in December. The purchase was made with the aid of the Lewis Fund.

Exhibitions

Manchester 1857, Art Treasures exhibition (229) (provisional catalogue); London 1872, Royal Academy, Winter Exhibition (114).

NOTES

1. Waagen 1837, II, p. 138.

2. Wethey 1969, pp. 165–7; Falomir 2003, pp. 220–3, no. 35.

3. These were painted between 1549 and 1558. The *Tantalus* recorded in Giulio Sanuto's engraving of c.1565 is especially relevant. See Wethey 1975, pp. 159–60, and Falomir 2003, pp. 214–17, nos 32 and 33 (also fig. 118).

4. For interpretations of the female figure see the works cited in note 2. Gould (1959, pp. 125–9; 1975, pp. 300–4) identified the woman as Mary Magdalene but with a question mark.

5. Passavant 1833, p. 86; Passavant 1836, I, p. 193 (recording his visit of 1831); Waagen 1837, II, p. 138. Waagen repeats the curious idea that Noah's ark represents the emperor's coffin.

6. Robertson 1978, pp. 155–6, for the sale. The three paintings bequeathed to the Gallery were Titian's *Noli me tangere* (NG 270), the so-called Giorgione *Man in Armour* (NG 269), and Guido Reni's *Ecce Homo* (NG 271), now believed to be by a follower, and it is likely, given Rogers's close friendship with Eastlake, that this choice was approved by the latter, even if it was not prompted by him.

7. Burger [Thoré] 1857, pp. 80–1.

8. Crowe and Cavalcaselle 1877, II, p. 237n.

9. 8 March 1902, lot 37.

10. It is true, as Jill Dunkerton has pointed out to me, that the *Bacchus and Ariadne* (NG 35) must also have had a darkened varnish at about this time.

11. For Gutekunst see Penny 1992, II, p. xxi. The letter and the translation are in the dossier for NG 4222.

12. Holmes 1927.

13. NG 1/9, p. 206.

14. For the reputation of Magnasco in the 1920s see Haskell 2000, pp. 133–5.

15. For Esquert, Giordano, Antolinez and Cerezo see the letter of 26 August 1934 from Mayer replying to Kenneth Clark (who must have been sceptical of Holmes's attribution). For Ricci (also known as Rizi) see the postcard with a note by Mayer in the dossier. According to Gould (1959, p. 129, note 5) Mayer was supported in the latter idea by F.J. Sánchez Cantón.

16. For example, Porcella's opinion of 1930 as cited by Gould (1959, p. 127).

17. Tietze 1936, p. 211; see Tietze 1937, p. 330, and 1950, p. 381, where he makes no special claim for the painting but does describe it as large.

18. Catelli Isola 1976, pp. 40–1. Titian in a letter to Margherita, Duchess of Parma, describes the copper plate as after 'il disegno della pittura della Trinità'.

19. Gould 1959, pp. 126–7; 1975, pp. 301–2.

20. Falomir 2003, p. 220, fig. 122.

21. A transcription (dated 1958) from this MS commonplace book, which was then the property of Professor Egon Sharpe Pearson, is in the dossier for NG 4222.

22. Jameson 1844, p. 402. This makes sense also for what we know of Wallis's activities, for which see Buchanan 1824, II, p. 229.

23. Penrice (undated), p. 40. The letter from Yates is dated 22 January 1814 and mentions the picture as coming on the market 'this spring'. Yates was an associate of Buchanan, active in the London salerooms between 1813 and 1848 (as we learn from the Getty Provenance Index).

24. Cleveland's collection was not a large one to judge from the 1902 sale at Christie's, which consisted of 47 lots. It was probably formed to furnish his new house. Five pictures came from the Ashburnham sale in 1850 and three others from the Rogers sale. All major schools of painting were represented. Most were certainly minor works but lot 24, by Van der Heyden, a *View of a Dutch Château*, fetched £2,415, and a Gainsborough portrait of James Quin, lot 21, was bought by the National Gallery of Ireland for £430 10s. (the second highest price).

January

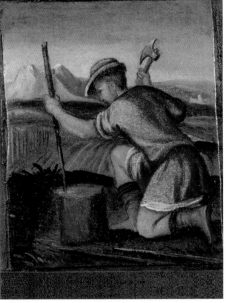

February

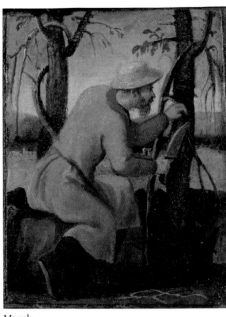

March

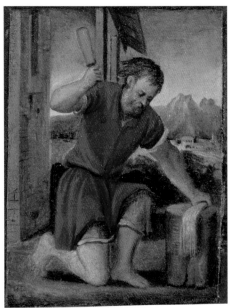

July

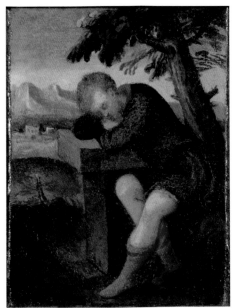

August

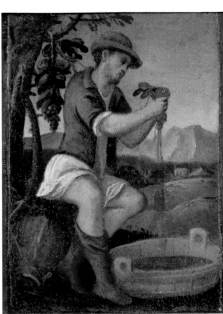

September

Venetian

NG 3109 and NG 3110

The Labours of the Months

*c.*1580

Twelve related paintings on canvas, each glued to a wooden panel measuring between 13.6 and 14 cm in height and between 10.5 and 10.6 cm in width. The twelve paintings are divided between two frames.

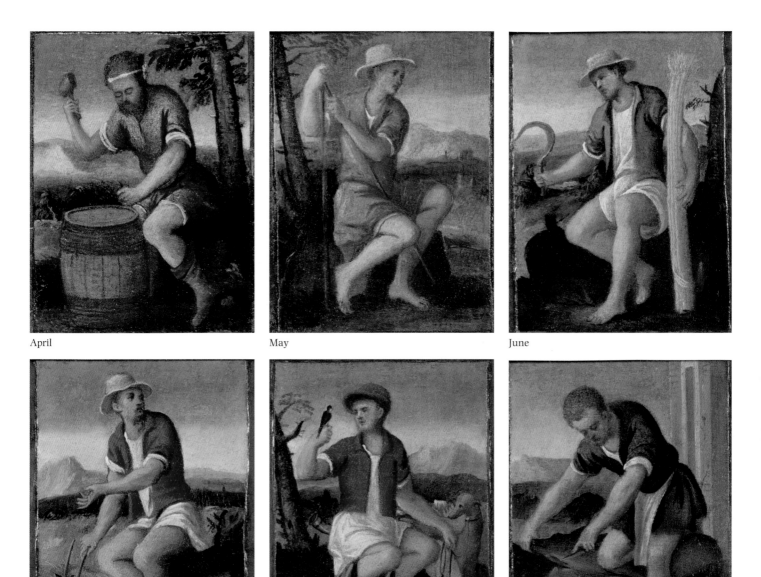

April

May

June

October

November

December

Support

The canvases, all of the same, moderately fine, tabby weave, are cut irregularly. They measure between 12.9 and 13.1 cm in height and between 9.2 and 9.8 cm in width. Each of the canvases is glued to a larger panel, leaving a border of bare wood. The panels are between 0.3 and 0.4 cm thick. A sample from the end-grain of the panel to which the canvas depicting a cooper is fixed (NG 3109, April) was examined by microscope in January 1994 and found to be probably walnut,[1] the wood most commonly used for good Italian furniture. But there is no reason to believe that these panels are the original supports or even old.

Attached to the back of each panel are either two paper labels or one label and traces of adhesive indicating where a second one was once attached. The labels carry numbers in ink and pencil, and also some ink flourishes – perhaps meant for letters – sometimes on the label and sometimes on the bare wood. Although little can be deciphered, it is clear that the panels are numbered 1 to 12 in the order in which they were formerly displayed (see the section on Arrangement of the Paintings below).

Materials and Technique

A full technical examination of these panels has not been undertaken, but ultramarine blue was employed for the sky, and vermilion, sometimes with red lake, for clothing. See under Condition below.

Conservation

The paintings were probably restored not long before they were bought by Layard in early December 1888 (see the section on Provenance below). Extensive, clumsy retouchings concealing old flake losses, together with the very discoloured varnish, were removed when the paintings were cleaned in the winter of 1998. Many of the paintings were treated for blistering in October and December 1939 and again in 1957 and 1975. In 1975 there was also some surface-cleaning and revarnishing.

The canvases seem always to have been securely fixed to their panels since their arrival in the Gallery in 1926, with the exception of a corner of no. 8, which was re-glued in 1940. When the paintings were cleaned and restored in 1998 the panels were left in place.

Condition

The paintings are in good condition. There are creases across a corner or two corners of some of the canvases (most obviously in July and August), and there are some associated losses. In addition, there is a diagonal line of loss, perhaps associated with a split in a previous wooden support, in April and October. In other cases (especially in March) the flake losses may be associated with the orpiment and realgar pigments. The copper greens are likely to have darkened (as in two of the tunics), and a red lake has no doubt faded where glazed over lead white (in February and April).

Attribution and Date

Layard believed that these paintings were by Bonifazio de' Pitati (1487–1553), the Veronese painter who settled in Venice and took over Palma Vecchio's workshop. This attribution was accepted by Berenson[2] and Hadeln,[3] and by the National Gallery, but was qualified or abandoned by some scholars during the 1930s.[4] Gould, although employing the formula 'style of Bonifazio' in his catalogues of 1959 and 1975, did little to support the validity of this formula, conceding that the paintings have 'some generic resemblance' to works which are 'acceptable' as 'products' of Bonifazio's studio, but observing that the 'erratic draughtsmanship ... presupposes an even more distant connection with the master'.[5]

In truth, the proportions of the figures, the wooden poses fluently executed, with soft, almost liquid drapery, the small features and large foreheads, the generalised settings and clothing, are more reminiscent of late sixteenth-century painting in Venice and the Veneto. It seems more likely, as Larissa Salmina Haskell first pointed out to me, that they were painted by an artist in the circle of Lodovico Pozzoserrato (Lodewyk Toeput) of Antwerp, who, after a stay in Venice, settled in Treviso in the 1580s. Although these figures seem very far from the often elegant style of Pozzoserrato's drawings,[6] there is a similarity to the figures that appear in his canvases of the 1580s, such as the *Lazarus and the Banquet of Dives* in the Cappella dei Rettori in the Monte di Pietà of Treviso,[7] or the *Miraculous Draught of Fishes* in the Hermitage, St Petersburg.[8]

Arrangement of the Paintings

When acquired by Layard the paintings were mounted in two frames, each consisting of two rows of three pictures (see fig. 1). The arrangement seems to have been made chiefly with an eye to compositional variety, and the labours were not placed in a sequence corresponding to the months of the year. Thus pig slaughtering was placed on the right of the upper row of the first frame, that is, as March, whereas it is a labour for the end of the year, usually for December and occasionally for November. Vine pruning was placed at the right of the lower row of the second frame, that is, as December, whereas it is a labour for February or March.

A new sequence was devised in 1999 which takes into account the order found in other such cycles, especially in Italy; the clothing or lack of it (figures unshod and wearing hats belong to warmer months); and the fact that the paintings seem to have been planned in pairs, with the figures facing each other (something which is lost when they are seen in their nineteenth-century frames). I also consider it likely that the stronger colours were meant to be distributed throughout the series rather than concentrated in one part or another. In this work I have relied greatly on the research and ideas of Anne Thackray.

1. January (formerly 1): An old man, warmly dressed, seated by a stove.
2. February (formerly 10): Trimming stakes with a hatchet.
3. March (formerly 12): Pruning the vines.
4. April (formerly 9): A cooper at work.
5. May (formerly 11): A young man holding two rods (see the discussion below).
6. June (formerly 5): Reaping a cereal crop.
7. July (formerly 7): Threshing.
8. August (formerly 2): A fruit picker seated in exhaustion.
9. September (formerly 8): Harvesting the vines (pressing grapes).
10. October (formerly 6): Ploughing.
11. November (formerly 4): A hunter with hawk and hounds.
12. December (formerly 3): Slaughtering a pig.

The labours of the months (so-called, for they are never all labours) seem to have first become popular as a subject for art during the twelfth century in carvings around Italian church portals;[9] thereafter they were soon found in Gothic buildings north of the Alps, and came to be common in illuminated calendars all over Europe. By the sixteenth century they were still found in exquisite miniature paintings, and also in fine engravings, as secular fresco decorations, in glazed terracotta roundels and as enamel plaques, but seldom in sculpture and rarely in an ecclesiastical setting. However, artists still made reference to the old portal carvings, and the exhausted fruit gatherer who represents August in this cycle, although somewhat unusual in Italy,[10] is also found in the carvings on the basilica of S. Marco in Venice. Paintings of the months on panel or canvas are much less common than those of the four seasons, but among those that survive are

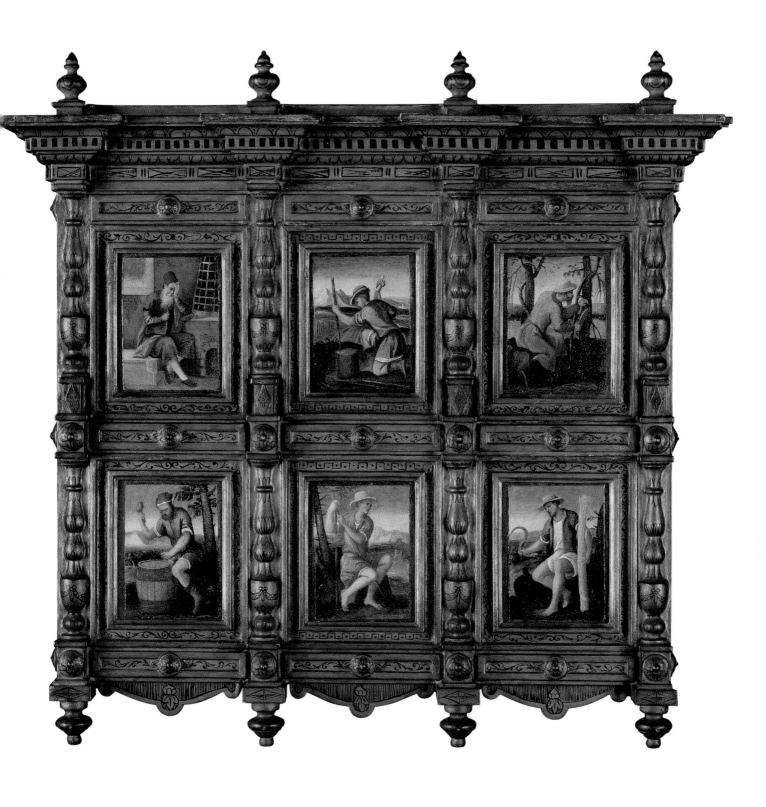

Fig. 1 *The Labours of the Months: January–June.*

twelve panels attributed to the studio of Abel Grimmer which are of similar size (9.8 × 13 cm) to those catalogued here and of similar date, although certainly made in another part of Europe.[11]

We cannot be sure that the order proposed here is correct, but it is certain that the months would have started with January (although the Venetian year began on 1 March). As mentioned above, pruning was sometimes a labour for February.[12] In addition, the huntsman was more usual for May than November. However, bird-catching is found in November in Italian cycles,[13] and other forms of hunting are not impossible for that time of year. Ploughing could also be considered a labour for November, or even August.[14] The labours varied according to context and locality. For a learned patron March might be illustrated not by a labour but by the god Mars, after whom the month takes its name,[15] and in courtly circumstances there might be more of an emphasis on sports and dalliance. North of the Alps, several labours, most obviously those associated with the harvests, occur later in the sequence.[16]

The most puzzling 'labour' represented in these paintings is the one allocated to May, in which a youth holds two rods, with one crossing the other at the top. Although we might suppose that he is making a supporting frame for vegetables or fruit, there seems to have been a tradition in Italy for one of the spring months to be represented by a youth holding crossed branches, often in bud, and this may be what is represented here.[17]

Original Setting and Comparable Decorative Paintings

A possible setting for small paintings of this kind would be a coffered ceiling such as those in Palazzo Mosti, Ferrara, where the 'cassettoni' are decorated with a variety of animals and birds, but it is hard to imagine a ceiling with only twelve small compartments and it would seem odd to repeat the labours of the months in such a decorative scheme. In addition, such ceiling compartments would always be square (or another regular geometric shape), whereas these paintings are rectangular.[18]

A more convincing idea is that the paintings served as the decoration for a pair of doors. The doors of a cabinet of some kind are a possibility, as indeed Layard seems to have realised (see the section on Provenance below), although it would have been an unusually large cabinet. Another possibility is a door for a room. The pine door from the palace of the Bernardo family at S. Polo, Venice, now in the Museo Correr,[19] in which there are three pairs of recessed panels between the broad crossbars, is likely to represent a common medieval pattern in Venice and the Veneto. We can imagine a room with two such old doors, each of which was decorated in the sixteenth century with paintings of six labours, perhaps at the same time that the room was given a painted frieze and ceiling, and was furnished with painted chests and a bed with painted parts by the same artist. I know of no references to panelled doors decorated with paintings, and in fact I know of only one reference to paintings of the months in a Venetian inventory. In September 1647 'dodeci quadretti dei dodeci mesi dell'ano' are listed in the inventory of a villa belonging to Andrea Scarpa.[20] These seem somehow to have been related to paintings of the twelve apostles and to gesso reliefs of twelve emperors, and NG 3109 and 3110 might also have belonged to some such larger scheme of decoration.

A series of eight male figures pointing to signs of the zodiac, each measuring approximately 20.5 × 10 cm, in the Cecil Higgins Art Gallery, Bedford, is painted in a similar style to NG 3109 and 3110.[21] So too are eight canvas paintings glued to wood, each measuring 18 × 7.5 cm, which are in a private collection in Venice, four of them representing the planetary gods and four representing virtues (Charity, Faith, Fortitude and Justice).[22] These groups of paintings could also have once filled the panels of a pair of doors (supposing that the doors had four tall rectangular panels rather than six squarer ones).

Provenance

Sir Austen Henry Layard wrote to his friend and fellow Trustee of the National Gallery, Sir William Gregory, on 8 December 1888: 'I have just picked up 12 little pictures by Bonifazio representing the twelve seasons [sic] of the year which are not bad. They appear to have belonged to a "mobile" or cabinet.' In a later letter he identified the dealer as 'Marini'.[23] The paintings were bequeathed to the National Gallery by Layard in 1896, with a life interest to his widow. They were received by the Gallery in 1916.[24]

Framing

The paintings are incorporated in two curious gilded frames, architectural in character, with double rows of identical engaged baluster columns and a projecting cornice crowned with finials and flat scrolled gables. Both the finials and the gables are very similar to ornaments suspended below the frame. The columns and the seventeen studs applied to each frame are turned rather than carved. The decorative elements – such as the leaves which make the studs into rosettes, the fluting on the balusters, the vine and fret borders to the pictures, or the dentils of the frieze – are not carved but are painted in black on the gold.

The style is perhaps intended to evoke that of the ornamental cabinets of the late sixteenth century, since it was supposed that the paintings came from one of these, but the workmanship is very poor and not at all similar to the frames that were made for Layard's better paintings. They are more likely to be frames made for the dealer who sold the paintings to Layard. Had the pictures been less trifling it would have been more tempting to free them from their cheap carnival costumes.

Fig. 2 Enlarged detail from *November*.

NOTES

1. Letter of 24 January 1994 from Ashok Roy: 'I am fairly certain of the results, allowing for the degraded state of old wood.'

2. Berenson 1894, p. 90.

3. Hadeln 1910, p. 296.

4. Toesca is cited by Gould (1959, p. 18, note 1) as proposing Andrea Schiavone. Westphal 1931, p. 37, believed that they were paintings from Bonifazio's circle.

5. Gould 1959, pp. 18–19; 1975, p. 52.

6. Gerszi 1992.

7. Trentini 2004, p. 197, fig. 11.

8. Artemieva 2001, p. 106, no. 29.

9. Webster 1938.

10. Le Senecal 1924, pp. 150, 165; Webster 1938, p. 62.

11. Phillips, London, 7 December 1993, lot 62.

12. Mane 1983, p. 173.

13. Le Senecal 1924, p. 150. A huntsman with a falcon is also possible for April, as in Marmitta's 'Offiziolo Durazzo' (Bacchi 1995).

14. Ploughing is shown under November by Marmitta (ibid.) and in Reymond Pierre's enamels, but under August in Luca della Robbia's mid-fifteenth-century tin-glazed earthenware ceiling roundel (Victoria and Albert Museum, 7639–1861; Pope-Hennessy 1964, I, pp. 110–11, no. 89; III, p. 79, pl. 106).

15. As in Vasari's decorations for the loggia of Bindo Altoviti of 1553, for which see Grasso 1996.

16. The cooper is shown under both April and August, which cannot be explained in this way.

17. Pointed out to me by Susan Foister in April 2001.

18. Bentini 1985, pp. 222–3.

19. Room 27.

20. Borean 1998, doc. 122. 'Andrea Scarpa detto Venier, Villa di Marcon'.

21. Given by the National Art Collections Fund, 1925.

22. Roberto de Feo kindly arranged for me to visit this old Venetian collection in a palace on the Zattere.

23. British Library, Add. MSS 38950, typescripts of letters sent by Layard to Gregory, pp. 57 and 62 (8 and 29 December 1888).

24. For a full account of Layard's collection and bequest see Penny 2004, pp. 372–80.

Venetian

NG 3108
A Naval Battle

c.1580
Oil on panel, 17.1 × 38.9 cm

Support
The panel appears to be of a coniferous wood, which was much used in Venice for paintings (as well as stretchers for canvas paintings[1]). It was also much used in some parts of the Veneto, especially Verona. The panel is a single plank, 0.9 cm thick, cut tangentially from near the centre of the trunk. It has a marked convex warp.

The panel has been sawn on all four sides but the painting retains its original dimensions and there is a barb to the gesso ground on all four edges (most apparent at the right-hand edge). On the reverse of the panel there are two elaborate printed labels for the Manfrin collection, both with manuscript additions (fig. 5). On one of them the 'A.34' indicates that the painting was no. 34 in Room A.[2] There is also a label with a blue printed border, of the type used for the paintings in Layard's collection. It is inscribed in ink with the number 56. In addition, the number 24 is painted on the wood in black, with another number below, partially deleted but concluding in 3 (as discussed below, under Provenance, this was probably '23'). The painted numerals are preceded by two letters, the first largely concealed by a label and the second the letter 'n' with a bar through it. From other Manfrin paintings we know that the first letter would have corresponded with the room, in this case A – thus Room A, number 23, changed to 24.

Materials and Technique
The palette is economical and all of the distinct colours are repeated in different parts of the painting. The grey-blue – probably azurite – is in markedly higher relief than the other colours.

Conservation
There is no evidence that the painting has received any treatment since it was acquired by the National Gallery, other than the possible retouching of a very small loss in the sea to the left of the boat on the right.

Condition
The painting is in good condition. It is speckled with slightly discoloured retouchings of a number of small losses. Knots in the wood have disturbed the paint surface in two slightly larger areas.

Attribution and Date
When the painting belonged to the Manfrin collection it was believed to be by Bonifazio de' Pitati.[3] This is likely to reflect scholarly opinion in the late eighteenth century, when the collection was formed. Layard also believed that it was by Bonifazio, and this attribution must have been endorsed by his close friend and adviser Giovanni Morelli.[4] After its acquisition by the National Gallery in 1922, the painting was classified as 'Italian School'.[5] Berenson listed it among the works of Schiavone in 1936 and 1957.[6] Gould preferred 'Venetian School', although he thought it 'Schiavonesque'.[7] Richardson in his monograph on Schiavone rejected any connection with this artist and proposed that it was a product of 'Bonifazio's shop'.[8]

The flowing contours of the figures, and of their fluttering skirts, their relatively small heads and large thighs, the city in the middle distance, with the sweeping lines of its roofs echoing the pavilions and the mountains, are distinctive features which are shared with NG 3109 and NG 3110 (for which see pp. 312–17). The figure style is one that is fully developed in Venetian painting only after Bonifazio's death in 1553, by which time Schiavone's introduction of the elegant anatomical flexibility of Parmigianino had begun to be influential. The somewhat flaccid bodies and gestural alliteration, however, recall the paintings of Fiammingo (see pp. 78–87) or Pozzoserrato around 1580, which seems a more likely date.

Subject and Related Paintings
The painting is one of a series of five furniture or wainscot paintings (figs 1–4). Since the subjects are all military and masculine, the paintings were perhaps made for the *portego* of a Venetian palace, where arms and armour were often exhibited (see p. 228), rather than the bedchamber, where Ovidian themes were more common (for example NG 1476, pp. 138–41).

Each panel, more or less identical in size and clearly painted by the same hand, features soldiers in loosely antique attire but wearing, for the most part, the standard burgonets of the second half of the sixteenth century and carrying contemporary lances and swords. There also appear to be cannons in the galley in NG 3108, and in two of the related panels we find sixteenth-century galleons. In two of the series some warriors are also represented wearing long robes and turbans and thus resembling Ottoman Turks, the chief opponents of Venetian power in the sixteenth and seventeenth centuries. Whether this artist was depicting modern campaigns against the Turks in which Venetian (or at least Christian European) forces are given antique dress, or illustrating ancient Roman campaigns against the Carthaginians (say), as if they were modern Turks, is unclear. The series is described below. It may not be complete, and perhaps no specific historical episodes were intended but merely generic scenes of warfare.

1. NG 3108: Soldiers are gathered before the tents on the left. Three of them are mounted. A foot soldier in blue reports to the soldier wearing yellow, who is mounted on a grey horse. Behind, in the middle distance, foot soldiers are massed in battle formation. A group of four soldiers stand in the foreground in the middle of the picture. The one in yellow is distinguished by the fact that he carries a double-handed sword

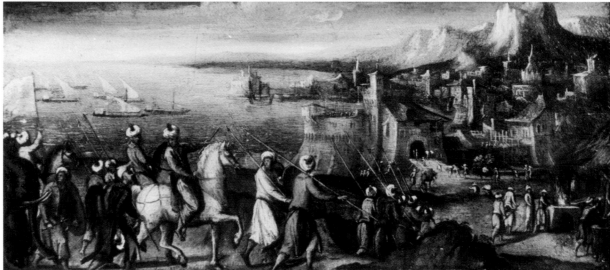

Figs 1–4 *Scenes of Warfare, c.*1580. Oil on panel, fig. 1, 17.8 × 39.4 cm; fig. 2, 16.5 × 38 cm; fig. 3, 17.8 × 39.4 cm; fig. 4, 15.7 × 53.6 cm. All in private collections.

rather than a spear, and he may be meant to represent the figure at the left of the picture who is mounted on a grey horse. His attention is directed towards a naval engagement in which several ships have burst into flame. Galleys are being rowed towards this engagement, and on the right a group of soldiers – perhaps the same as those gathered in the foreground – hasten to board a small rowing boat.

2. Another coastal scene (fig. 1). A group of 'Romans' are gathered to the left in front of a military camp. Two of the group are seated. They receive three emissaries who respectfully remove their turbans. Advancing across the painting from the right are three horse-drawn carts led by turbaned men and loaded with tribute or provisions. More of this procession is visible on a road to the right, in the distance. On the horizon beyond the bay there is a city and, behind it, a mountain range. The scene has been identified as 'Scipio Africanus receiving turbaned envoys'.[9]

3. Also a coastal scene (fig. 2). Turbaned troops advance across the foreground and descend a hill towards a city by the shore.

4. Three 'Romans' sitting in the front left foreground are engaged in urgent conversation (fig. 3). A stream leading into the middle distance is crossed by a wooden bridge. Beyond the stream, troops are gathered before their camp, and in the distance to the right there is a walled city.

5. A broad river is traversed by an arched bridge which has been broken (fig. 4). There are 'Romans' on either side. On the left, a mounted warrior who has leapt across the gap in the bridge attacks four soldiers. In the foreground a mounted warrior fords the stream, and is shot at by an archer. He is perhaps to be identified as the assailant who has leapt across the gap in the bridge. There is a city in the distance. This scene has been identified – absurdly – as 'Horatius on the Bridge'.[10]

Provenance

NG 3108, together with nos 2, 3, and 4 of the sequence listed above, is first recorded in the celebrated collection of more than 450 paintings that was formed by the Marchese Girolamo Manfrin, tobacco magnate and financier, after he purchased Palazzo Venier in Venice (formerly Palazzo Priuli, Fondamenta Venier, Cannaregio, no. 342) in 1787. Manfrin was advised from 1793, if not earlier, by Giovanni Battista Mingardi and Pietro Edwards.[11] A manuscript list of the paintings compiled by the latter in the 1790s includes a group of four pictures by Bonifazio which must correspond with these.[12]

After Girolamo's death in 1802 the collection was inherited by his son Pietro, who died in 1835. It then passed to Pietro's sister Giulia Giovanna, who had married Giovanni Battista Plattis in 1800. On her death in 1849 the collection became the joint property of her children, the Marchese Antonio Maria Plattis (1802–1876) and the Marchese Bortolina (or Lina) Plattis, widow of Baron Sardagna. Negotiations to sell the entire collection commenced in 1851, when a manuscript catalogue was prepared in which these four paintings are numbers 32–35 in Stanza A, attributed to 'Bonifazio' and as 'Storia romana'.

A number of major works were sold from the Manfrin collection in 1856, and later in that year a catalogue of the remaining paintings was printed in which the group is 22, 23, 29, 30, attributed as before. A division had been contrived by 1871, when Antonio Maria's portion was auctioned in Paris on 13 and 16 May – including, presumably, no. 2 of the group. The remaining 215 paintings in Palazzo Manfrin, belonging to the Marchesa Lina, were published in a catalogue dated 1872, in which the three others in the group feature as 22, 23 and 24. The numbers endorsed on NG 3108 (fig. 5) reveal that it was no. 34 in 1851, no. 23 in 1856, and no. 24 in 1872. It was bought by Henry Layard in October 1880 for 100 lire[13] and was part of his bequest which arrived in the National Gallery in 1916.[14]

Fig. 5 Back of NG 3108, showing all the labels and numbers.

Nos 3 and 4 in the sequence (nos 22 and 23 in the Manfrin catalogue of 1872) were later recorded in Dr Szeben's collection in Budapest.[15] No. 2 was in the Oscar Anderson sale at Sotheby's, London, on 16 November 1949, lot 40, and then again at Sotheby's on 30 June 1964, lot 39, and was exported soon afterwards. It is said to have been labelled 'A30', which was very probably a misreading of 'A32'. No. 5 in the group, which seems not to have been in the Manfrin collection, was lot 7, attributed to Schiavone, in the sale of Archibald Russell's collection at Sotheby's, 9 May 1929.[16]

Loans

A label on the frame indicates that NG 3108 was on loan to Cannon Hall, Barnsley, as L 394. The conservation dossier records that inspections of the picture were made in September 1952 and December 1953 at Wolverhampton City Art Gallery.

Frame

The frame is of a modified cassetta pattern (fig. 7) and retains the original burnished water-gilding over a pale orange bole.

Fig. 6 Detail of NG 3108.

The egg-and-dart ornament was carved separately and attached to the outer moulding. The frame is clearly Italian and must date from 1880 or soon afterwards. It was evidently designed to match an earlier frame made for NG 3084 (an *Entombment* by Busati, believed by Layard to be by Sebastiano del Piombo), probably in Milan in the early 1860s.[17]

Evidently NG 3108 must have served as a pendant for 3084. It is not likely to have been intended for glass, which was not used on the paintings in Layard's Venetian palace, but it was adapted for glass and the front moulding cut out and attached with brass pegs after the painting was acquired by the Gallery.

NOTES

1. Eastlake 1870, p. 215 (where *abete* is translated as deal).

2. Misread by Gould 1959, p. 134, note 1, and 1975, p. 308, note 1, as 31, which it does resemble.

3. See note 13 and sources cited in Provenance.

4. For Morelli and Layard see Penny 2004, pp. 372–80.

5. [Collins Baker] 1929, p. 176.

6. Berenson 1936, p. 446; 1957, I, p. 160.

7. Gould 1959, p. 134; 1975, pp. 308–9. Philip Pouncey in a draft entry preferred 'style of Andrea Schiavone'.

8. Richardson 1980, p. 199, D353.

9. Sotheby's, London, 30 June 1964, lot 39.

10. Sotheby's, London, 9 May 1929, lot 7.

11. Haskell 1963, pp. 379–81 and p. 395.

12. Archivio del Seminario Patriarcale, Venice, MSS 788.13 ('Classificazione della Galleria Manfrin'), nos A.107–110.

13. Layard's MS catalogue, no. 56 and no. 77.

14. For a full account of Layard's collection see Penny 2004, pp. 372–80.

15. The photographs of the paintings in the dossier for NG 3108 are endorsed with this information.

16. For A.G.B. Russell see Penny 1992, III, p. 167.

17. The painting was restored for Layard in 1862 – see Anderson 1987, p. 111.

Fig. 7. Corner of the current frame of NG 3108.

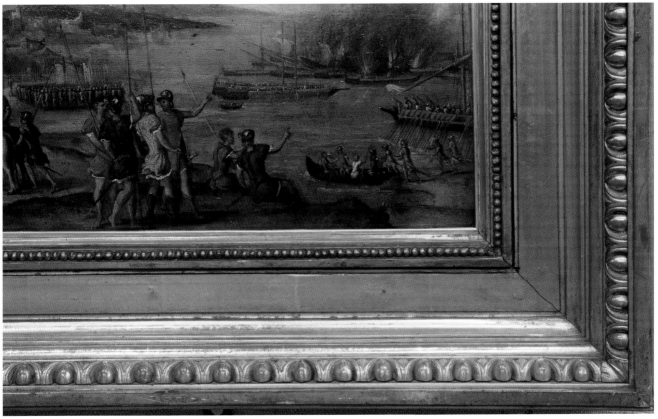

Venetian?

NG 272
An Apostle, Saint, Prophet or Sage

Probably late sixteenth century
Oil on canvas, 152 × 116.2 cm

Support

The heavy twill canvas is paste-lined on to an open-weave tabby canvas. (Prior to pasting, the lining canvas appears to have been tacked to a stretcher with nails hammered straight in and then sideways, to form staples.) The stained-pine stretcher has one crossbar. Originally, the canvas was probably glued to an extensive wooden support; the canvas that we see now is only a fragment of a larger painting of an irregular shape which must have included at least one other figure in a complementary pose. No cusping is apparent. The original canvas and paint continue around the sides of the stretcher, except on the left of the lower edge.

The canvas consists of five separate pieces, as shown in the diagram below (fig. 1). There are no raised seams, nor is there any evidence of stitching, so it must be conjectured that the individual pieces of canvas were applied, side by side, to the original support. In the diagram the dotted line corresponds to the line of the painted arch, and the existence of a join here may be explained by the division of labour, the two canvases with the architectural elements having been painted by a specialist and joined up *in situ*.

The strip of canvas (A) is 1.5 cm wide. The largest piece of canvas (B) is 119 cm high. The irregularly shaped piece, lower left (C), is 31.5 cm high and its maximum width is 62.5 cm. The heights of the irregular pieces on the right are 21.5 cm (D) and 53 cm (E).

Fig. 1 Diagram of the construction of the canvas, showing five separate pieces (A–E). The dotted line indicates the line of the arch.

On the front of the canvas, at the top left, there is a vermilion wax impression of an official seal, 3.5 cm in diameter. It is now much damaged but within the beaded edge it is possible to discern the image of an eagle. It is likely to be an export seal for Venice when under Austrian rule.

Materials and Technique

Some of the outlines in the painting are sharply incised, especially around the head of the figure. There is a ground of ruddy brown which shows through in many areas. The picture is broadly painted, as can be seen from the separate brushstrokes of lead white in the shirt at the top of the figure's right arm.

Conservation

The painting was lined before acquisition in 1856. It was cleaned (probably only surface-cleaned) and revarnished by Dyer in 1884. The surface was described as 'badly bloomed', and the varnish as extremely discoloured, in 1949. The painting was again surface-cleaned and revarnished in 1994. It should be emphasised that the varnishes applied in 1884 and 1994 were laid on top of a layer of varnish which had been applied in the 1850s (or earlier).

Condition

The surface is badly creased in roughly vertical and horizontal lines, especially in the lower left corner. These creases may have been caused by peeling the painting off an earlier support. The blue has faded to dull grey. The features of the face are not easy to discern in the shadowed areas where the paint has both been abraded and become translucent. Some of the outline of the beard is barely visible. The painting is also obscured by a thick and darkened varnish. Retouchings are apparent in the lower part of the man's right hand, in his eyes, and in some of the creases.

Subject and Original Location

The figure evidently occupied the left spandrel of an arch, and there would have been a matching figure on the right. The proportions of the figure, the projecting knee and the simplified rendering of the shoulder, as well as the scale and the breadth of handling, indicate that the canvas was intended to be placed at a considerable height. It may have formed part of the decoration of a church, perhaps in the aisle at the entrance of a chapel, but it is not impossible that it was made for a secular building, perhaps even for a private palace. The right hand clasps a round shaft which could be part of a large key (an attribute of Saint Peter) or of a pilgrim's staff (carried by Saint James or Saint Roch) or even of a banner. Vallati, who gave the painting to the Gallery, believed it to be 'l'estremità di una plenda di un ancra, e sembra sia una figura allegorica' ('the end of the shaft of an anchor, and it seems that this is an allegorical figure'). A key seems the more likely attribute in the architectural setting but the rounded moulding on the shaft above the hand is more typical of a pilgrim's staff. An anchor is an attribute of Hope, but Hope would be represented by a female, as would Navigation and

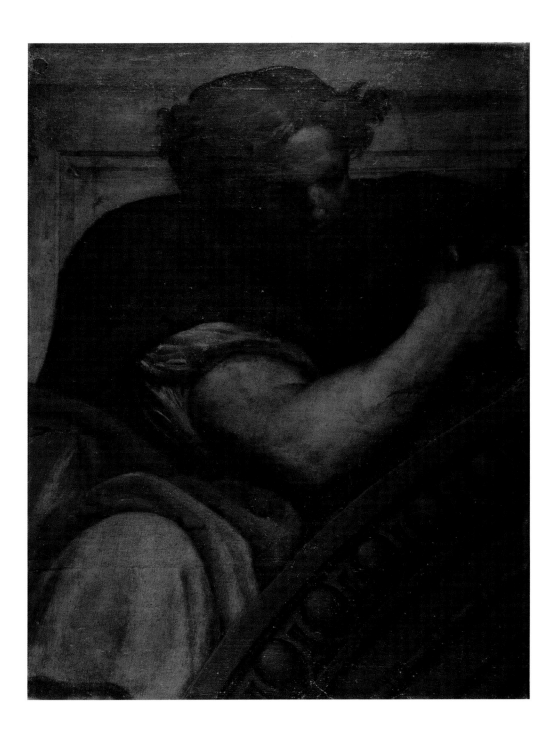

most other secular personifications. Nevertheless, at least one male allegorical figure holding an anchor can be found in sixteenth-century Venetian painting.[1]

Attribution and Date

When first offered to the Gallery the painting had no 'pedigree' but, by the time the Trustees had accepted it, it was said to have come from a 'Church near Venice'.[2] The export seal (see above, in the section on Support) is likely to be Venetian, and certainly it is in Venice that mural decoration was commonly painted on canvas rather than in fresco, although the architectural elements would normally have been carved in stone or modelled and moulded in stucco. Both the handling, which is typical of the contemporaries of Palma Giovane, and the increasing popularity of extensive canvas decorations in the naves of churches make it likely that the painting dates from the last decades of the sixteenth century (if not from the seventeenth). When it was acquired, the Gallery seems to have accepted the donor's attribution to Pordenone,[3] but there seems no good reason for this attribution beyond the fact that the limbs are massive, the forms are foreshortened, and the anatomy is somewhat schematic.

Acquisition and Display

On 4 July 1847 Pietro Vallati, a Roman painter and dealer then visiting London, wrote to Eastlake in his capacity as keeper of the National Gallery, enclosing a 'progetto' for improving the Gallery's inadequate representation of the Italian schools of painting. He would send information on paintings, including a 'dagerrotipo' or some other idea of the composition; if encouraged, he would then send the actual works, at his own expense, and also pay for their return, provided that good reasons were given and the paintings were not kept for more than six months.[4] George Saunders Thwaites, the assistant keeper and secretary, replied explaining that the Gallery could not appoint an agent but would welcome information concerning 'any really fine works by Italian Masters'.[5] However, on 17 March 1855 George Cornwall Legh, MP, wrote to Eastlake enclosing a letter from Vallati, now 'il Cavaliere Pietro Vallati Romano', in which he expressed a wish to give some 'small token' ('piccolo segno') of the debt he owed to British support for his work as an artist ('sua carriera pittorica') by presenting to the National Gallery a picture by Pordenone that was 'un vero esemplare per imparare a dipingere grandi opere' ('a real model for teaching how to paint on a grand scale') and something which had excited much admiration from real experts during the seven years it had been in his possession.[6] The letter was read to the Trustees on 2 April[7] and a reply was sent, presumably encouraging Vallati to send the painting, which was approved by the Trustees at their meeting on 4 February of the following year, with a note that it was 'ordered to be placed in the Gallery'[8] (it was hung in the 'East Room' two days later[9]). The painting had doubtless arrived in the Gallery during the summer, when Eastlake, who was only confirmed in the office of director on 2 July 1855, was travelling in Europe.[10] Eastlake would certainly have realised that it was injudicious to accept presents from dealers, but also that it was too late to deflect the gift without giving offence to Vallati and, more importantly, to Cornwall Legh, who might then join forces with Eastlake's many enemies in the House of Commons.

Every move Eastlake made was watched by these enemies and by their contacts in the art world who fed information to journalists. Vallati returned to haunt Eastlake a few years later in the second part of an anonymous attack on the Gallery in Dickens's *All the Year Round*.

> There was an Apostle of awful size, and very horrible to contemplate, who presided over one of the doorways, and was the handiwork of one PORDENONE. (Another of those illustrious masters whom witness has never had the advantage of hearing about.)
>
> Professor Waghorn [this name is obviously designed to suggest Waagen, who was supposed to have a great influence on Eastlake] begged to remind Professor Fudge that the work in question was a gift, not a purchase. It was the gift of Cavaliere Vallati.
>
> Witness begged the Cavaliere's pardon. It was very liberal of that nobleman. Witness was glad to find that on a subsequent occasion, in 1858, a 'deal' had been effected with Cavaliere by which he became possessed of £303 sterling. How was it, that the liberal donor of the invaluable PORDENONE had been induced to accept that sum?
>
> Professor Waghorn submitted that this question was irregular. There was no connexion between the two transactions – how could there be?
>
> A Juryman remarked that there could be, in this way. 'This same Cavaleerairy might want to come round the country in order to make 'em buy some of his pictures, or what not?'[11]

The sarcastic insinuations were entirely unjustified. The 'deal' referred to was the purchase of the Crivelli *Pietà* which Eastlake and Mündler admired in Rome in 1858.[12] The Gallery paid a low sum for the picture and made more expensive purchases from other Roman dealers. The painting continued to be employed as an overdoor and remained in this position in the new gallery of Italian painting which opened in 1861, in the space now occupied by the main staircase.[13]

Provenance

See above. With Pietro Vallati of Rome 1848. Offered by him to the National Gallery in March 1855. Accepted on 9 February 1856.

NOTES

1. Veronese's painting in the Los Angeles County Museum of Art, generally known as *An Allegory of Navigation*, has an anchor and astrolabe. See Salomon 2006, p. 17, and p. 48, no. 4, for a recent discussion of this, and also p. 15, fig. 4, for a good illustration.

2. NG 1/4 (Minutes of the Trustees, IV), p. 16.

3. NG 32/67, Wornum's Diary for 6 February 1856.

4. NG archive, letter for the year 1847. The 'progetto' is dated 5 July.

5. NG 6/1. His letter is dated July 20 1847.

6. The letter is in the dossier for NG 272.

7. NG 1/3 (Minutes of the Trustees, III), p. 11.

8. NG 1/4 (Minutes of the Trustees, IV), p. 16.

9. NG 32/67, Wornum's Diary for 6 February 1856.

10. Robertson 1978, pp. 139–41.

11. [Collins] 1860, p. 253 (column 1).

12. For the painting see Davies 1961, p. 155. Eastlake MS notebook 1858 (4), p. 16, and Mündler 1985, p. 233.

13. *Illustrated London News*, 15 June 1861, p. 547.

Venetian

NG 2147

Portrait of a Bearded Cardinal

*c.*1580 and later
Oil on canvas, 64.8 × 53.9 cm

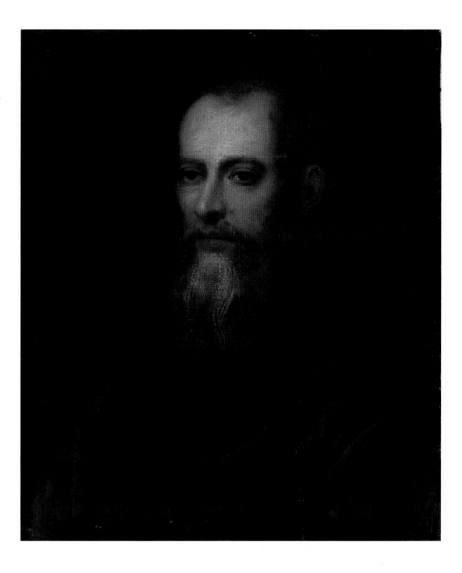

Support

The dimensions given above are those of the stretcher. The canvas has 14½ threads to the centimetre in the warp and 13½ to the centimetre in the weft.[1] It has been wax-lined on to another tabby-weave canvas. The trimmed edges of the original canvas are visible, especially on the right-hand side. The original painted area must have been larger. There is no evidence of cusping at the edges; and the inscription which is now concealed (as described below) was obviously longer originally.

The pine stretcher, probably Venetian, dates from the first half of the nineteenth century. It has corner keys for tightening the canvas, which are secured to the frame with glued linen strips. Nails have also been bent over to tighten the lap joins of the stretcher.

There is a large vermilion seal, only partially legible, affixed by the Accademia delle Belle Arti in Venice, to authorise export, at the back of the stretcher, top left (when viewed from the rear). A loop of twine passes through the seal.

Materials and Technique

The canvas has a double ground of thin gesso which is covered with a dark ground of black charcoal and brown earth. There is red lead in the paint of the braid beneath the cardinal's cape.[2] The folds of the cape are rendered in boldly swept lines of lead white with lake in a manner that may have been intended to recall Tintoretto. Some of these lines, especially the vertical ones which suggest the Venetian *stola*,[3] may belong to the same stage of painting, even though a cardinal would never have worn such an article of dress. It has been proposed that the patch of white in the background to the left indicates a curtain, but this is not certain.[4] Nothing that has been discerned in the materials or technique is incompatible with a date in the sixteenth century.[5]

Conservation

The painting was revarnished in 1926 and some layers of varnish were presumably removed beforehand. Cleaning and relining were recommended in 1949, and the painting was

lined in July 1953 but not cleaned. A new layer of varnish was applied in March 1994 to improve visibility of the image. It is, however, most visible in an infrared photograph dated 9 February 1982.

Condition
The condition of the picture is wretched. There are probably several layers of darkened varnish and some of these may also be toned. The painting has been flattened, presumably when it was lined. It is stippled with discoloured retouching and with the speckled residue of earlier varnish that was driven into the interstices of the canvas weave. On the right-hand side of the canvas, passing just to the right of the sitter's left eye, there is a large vertical line of loss which is connected to one that is smaller and more or less horizontal. The character of this loss is consistent with careless folding of the canvas, causing the brittle gesso and paint layers to break. The survival of small islands of paint within the areas of loss suggests that the canvas itself was not torn.

The Portrait Beneath
Beneath the bearded man wearing a cardinal's crimson stole, X-radiography (dated 1 March 1982) revealed a portrait of a younger, beardless man wearing a braided and buttoned tunic, a small ruff collar, and what appears to be a small wig with rolling curls (fig. 1). The last-mentioned feature suggests a mid-eighteenth-century date, but it is not certain that a wig is what was originally represented, while the tunic suggests a date in the late sixteenth century. On balance it seems likely that this portrait dates from the late sixteenth century. It was perhaps of mediocre quality, or at least judged to be of little interest or value because of its neglected or damaged condition, and the likeness of a grave and dignified senior ecclesiastic was later painted on top of it, following exactly the outline of the head beneath.

Deleted Inscription
The remains of two lines of an inscription rendered in somewhat irregular majuscules with distinctive ligatures can be discerned in the X-radiograph more or less on a level with the sitter's right eye. The inscription is cut at the left edge of the canvas. It seems to read ...RIM above ...NI E. The first letter of the second line is uncertain. The tail of the E is certainly crossed and that of the M is perhaps crossed, and is perhaps also followed by a stop. This inscription, typical of those which were applied to family portraits hung high on palace walls in the seventeenth century, would have identified the original sitter and perhaps an office he held or a distinction he claimed.

Attribution
The painting was attributed to Tintoretto when it was acquired. It was first catalogued by the Gallery in 1925 as 'Style of Tintoretto' and Gould retained this formula in 1959 and 1975.[6]

The Barone Francesco Galvagna and the Sale to the National Gallery
The painting was in the possession of the Barone Francesco Galvagna in the 1850s. He had probably acquired it earlier in the century. Galvagna, having served as a prefect in Verona, Cremona and Venice, was made a baron of the Austrian empire in 1830.[7] His son was born in 1818, which suggests that he himself was born before 1800. He died on 6 January 1860.[8] Between 1839 and 1851 he was president of the Accademia delle Belle Arti in Venice.[9] He owned a choice collection of old masters, mostly Venetian, which he kept in the handsome baroque Palazzo Savorgnan (Fondamenta Savorgnan, no. 349, next to Palazzo Manfrin, in the direction of S. Giobbe), which he purchased in 1826.[10] The collection included some items from the Savorgnan collection, which presumably had been purchased with the palace – notably a group of paintings by Schiavone, one painting by Tacconi, and a pair of paintings attributed to Jacopo Bassano.[11] Some sort of public access must have been possible in the late 1840s, for the collection is described in Fontana's guide for foreign visitors to Venice published in 1847. In addition to listing twenty of Schiavone's best works, Fontana drew attention to a picture of hermits by Palma Giovane, 'nostra Donna di Giambellino', a *Rest on the Flight* and a *Samaritan Woman* by Zuccarelli, pictures by Bonifazio, Licinio, the Bassano family, Pellegrino da S. Daniele, Turchi (l'Orbetto), Tacconi and Tempesta.[12]

Otto Mündler viewed this 'charming' collection on 28 October 1855: 'The most important works are a Madonna and Child by Giov. Bellini, a d° [ditto] by Pellegrino da S. Danielle; a Mad. and Child by "Francisc. Tachoni. 1489" a female bust by G. Palma, il Vecchio. A huntsman, by Giorgione, several excellent portraits by P. Bordone, G. B. Morone & Tintoretto. Several P. Veronese; a dozen A. Schiavone, ornamental pictures painted for Palazzo Savorgnian [sic], several interesting dutch pictures.'[13] A day later in Palazzo Albizzi he found 'one of the daughters of the house to be the daughter-in-law of old Baron Galvagna, and seized the opportunity of making at once my application for the sale of some pictures'.[14] On 2 November he was informed that the Barone was 'reluctant to sell but does not reject altogether'.[15] Mündler proposed a group of eight pictures for 30,000 Austrian francs but his proposal was turned down. On 3 December he made 'new conditions and propositions'.[16] On Christmas Eve his offer of ten pictures for 61,500 Austrian francs was accepted and, after some discussion of the commission due to Quercia della Rovere, who had introduced Mündler to the collection, and enquiries concerning the likelihood of obtaining an export licence, the deal was finally agreed on the last day of that year.[17]

The total cost of the paintings was £2,189 16s. 10d., but the price of each item was not recorded, although the Bellini was valued at 1,000 guineas (£1,050) in the Director's Report for the year 1856. Mündler must surely have been aware that the paintings were unequal in value, and from the circumstances related above it is reasonable to deduce that he accepted more paintings than he would have liked

and that these extra works were chosen by the vendor. However there is nothing in his diary to indicate that he thought that any of them would be unworthy of the National Gallery, although one would like to think that he did, at least in the case of NG 2147.

Eastlake listed all ten paintings in his report but only gave numbers to the Bellini (NG 280), which was put on display in July 1856, and the Morone (NG 285, as Girolamo dai Libri, the picture Mündler had first recorded as by Pellegrino da S. Daniele), which was hung in the Gallery in August.[18] The remaining seven works were described in the Annual Report for 1857 as 'not required' and it was proposed to sell them, together with a larger residue of the Krüger collection, in accordance with the Act of Parliament passed during the previous session.[19] Two paintings, *The Prodigal Son*, attributed to Jacopo Bassano, and *The Triumph of David*, attributed to Tintoretto, were sold for £130 9s. 6d. on 14 February 1857 at Christie's.[20] The remaining five, together with ten paintings from the Krüger residue, were dispatched to the National Gallery of Ireland in Dublin in the same month. Three of these five paintings are included in this catalogue (NG 2147, 2148 and 2149). All were returned to the Gallery in 1926.[21]

Provenance

Purchased in Venice on 31 December 1855 from Barone Galvagna, who had certainly owned it seven years previously and had probably acquired it early in the nineteenth century. Sent from London to Dublin on loan to the National Gallery of Ireland in February 1857.[22] Returned to London in March 1926.

Frame

The painting may have been one of the six that were supplied with antique frames by Antonio Zen shortly after they were acquired for the Gallery by Mündler.[23] If so, no trace survives of such a frame. The frame the painting now has must have been given to it in the 1920s. Old labels indicate that this frame was formerly on (and was presumably made for) a painting of the Vision of Saint Hubert, which the Earl of

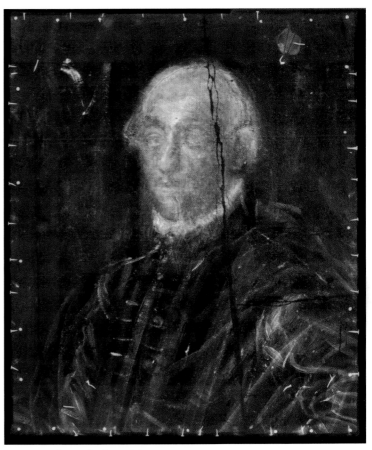

Fig. 1 X-radiograph of NG 2147.

Ashburnham loaned to the exhibition of Early Italian Art at the New Gallery in 1893.[24] Lord Ashburnham's painting was in fact Pisanello's *Vision of Saint Eustace* (NG 1436), which the National Gallery purchased two years later. Before the 1893 exhibition it had been attributed to Dürer. The press-moulded composition ornament of knobbly leaf and berry derives from English gothic architecture of the fifteenth century and would have been considered suitable for a Dürer in the mid-nineteenth century.

NOTES

1. Plesters 1984, caption to fig. 11a.

2. Ibid., pp. 29–31.

3. For the *stola* see p. 178.

4. Plesters 1984, p. 31.

5. Ibid.

6. [Collins Baker] 1925, p. 331; Gould 1959, p. 93; 1975, p. 263.

7. Schröder 1830, I, pp. 355–7.

8. Cicogna, Diary, Biblioteca Correr, MS 2846, fol. 6577.

9. Moschini Marconi 1955, pp. xx and xxi.

10. Lorenzetti 1982, p. 449, where we also learn that Galvagna sold the *palazzo* to the Duke of Modena in 1859.

11. See the Annual Report for 1856, p. 28, for the provenance of the Tacconi and Bassano.

12. Fontana 1847, p. 238. It is easy to imagine that Galvagna's attitude to public access changed after the revolution of 1849.

13. Mündler 1985, p. 77.

14. Ibid., p. 78.

15. Ibid., p. 79.

16. Ibid., p. 83.

17. Ibid., p. 91.

18. Annual Report for 1856, p. 28.

19. Annual Report for 1857, p. 35.

20. Ibid., pp. 36–7.

21. National Gallery archive S002363. NG 2145 (Bonifazio) was returned in February 1926 and NG 2146, 2148 and 2149 in May of the same year. The appearance of some of these paintings in the catalogue of 1925 must have been made in anticipation of prompter action.

22. Minutes of the Trustees, IV, p. 79.

23. Mündler 1985, p. 92. Six frames were found. Galvagna's frames were offered back to him. One imagines that they were standard Empire models which were by then completely out of fashion. If so, that would support the hypothesis that much of his collection was formed before his purchase of Palazzo Savorgnan.

24. No. 163, p. 31, in the catalogue as by 'Vittore Pisano hitherto ascribed to Albert Dürer'.

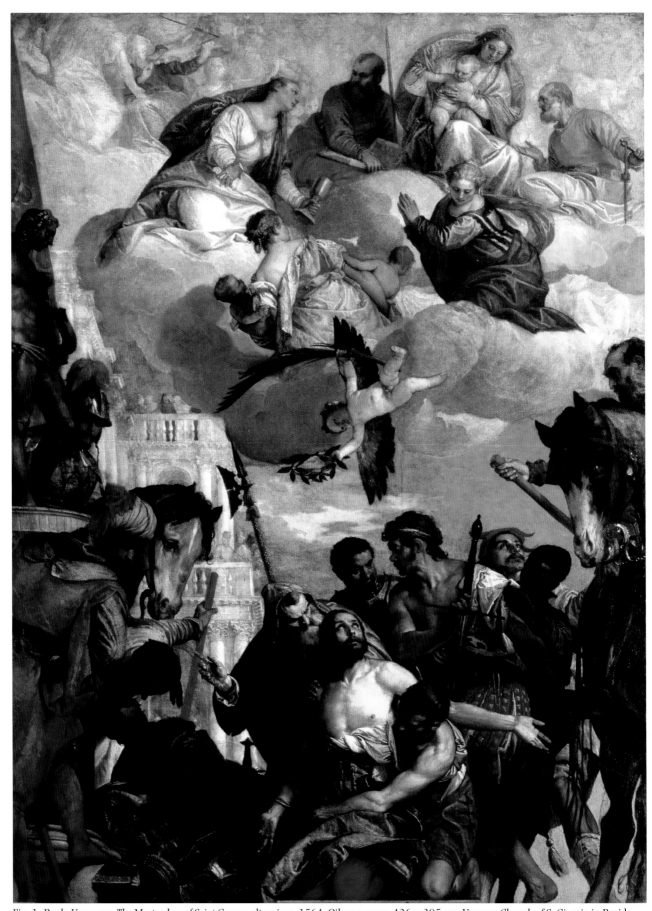

Fig. 1 Paolo Veronese, *The Martyrdom of Saint George*, altarpiece, 1564. Oil on canvas, 426 × 305 cm. Verona, Church of S. Giorgio in Braida.

Paolo Veronese

1528–1588

Paolo, now generally known as Veronese,[1] was born in Verona in 1528, the son of Gabriele, a stonemason. He often signed his name 'Paolo Veronese' in Venice, thus affirming his origin. His humble parentage was emphasised by his earliest biographers but he had connections with higher social ranks, for it has recently been ascertained that his mother, Caterina, was the illegitimate daughter of a nobleman, Antonio Caliari, which explains why, after about 1575, he signed his paintings Paolo Caliari.[2]

Veronese was recorded as an apprentice of Antonio Badile in 1541, but by 1544 he was training with another leading painter in Verona, Giovanni Caroto. Before he was twenty years old he had painted a canvas for the Cappella degli Avanzi in S. Bernardino, Verona, to which all the leading artists of the city (including Badile and Caroto) had contributed works (the painting is lost but a preparatory oil sketch survives; fig. 2, p. 338). During the same years he painted an important altarpiece for S. Fermo Maggiore, Verona.[3] NG 931 belongs to this early period. In technique and palette the young Veronese's paintings are close to those of Badile and Caroto, but some second-hand acquaintance with the heroic inventions of Raphael, or at least of his pupils, and with the supernal elegance of Parmigianino, may be detected.

By 1551 Veronese's reputation was sufficiently well established for him to be commissioned to supply an altarpiece for the new burial chapel of the great patrician family of the Giustiniani in S. Francesco della Vigna in Venice.[4] In the same year he was at work on the extensive fresco decorations for Sanmichele's Villa Soranzo near Treviso, together with his compatriots Battista Zelotti and Anselmo Canneri.[5] In 1552 Cardinal Ercole Gonzaga commissioned him to paint one of the altarpieces in Mantua cathedral, showing the temptation of Saint Anthony Abbot. He must have benefited from this occasion by studying the decorations that Giulio Romano had made, and directed, for the Gonzagas. In 1553 Veronese moved to Venice to work on ceiling paintings for the Doge's Palace, where he was entrusted with the large oval canvas *Jupiter expelling the Vices* for the Sala del Consiglio dei Dieci (now in the Louvre), with its dramatically foreshortened flying and falling figures.[6]

Veronese's precocious mastery of ceiling painting, first demonstrated at the Villa Soranzo and now enriched by study of Giulio Romano, must have been an important ingredient of his success in Venice, which was manifested above all by the ceiling paintings he made for the church of S. Sebastiano in 1556–7 and the ceiling tondos he painted for the library of S. Marco in 1557, for one of which he was awarded a gold chain by Titian and Sansovino.[7] Probably dating from this same period is his *Feast in the House of Simon*, made for the refectory of SS. Nazaro and Celso in Verona (now Galleria Sabauda, Turin),[8] the first of many biblical feasts that he painted for refectories.

Ridolfi claimed that Veronese visited Rome. The most likely date would be 1560, and it is often supposed that this visit had a decisive effect on Veronese's art,[9] but by this date he seems to have been largely formed as an artist, with an established range of compositional devices, figure types and ornamental motifs. His preference for large choruses and luxuriant fabrics was confirmed, as was his aversion to the violent expression and action such as he had depicted in *Jupiter expelling the Vices* and in his Mantuan altarpiece, but which he perhaps felt to be characteristic of his rival, Tintoretto. He continued to work in the same genres with which he had established his reputation: providing fresco decorations for villas (the most important and extensive, and best preserved, are those at the Villa Barbaro at Maser, near Asolo), ceiling canvases (including more for the Doge's Palace), altarpieces (including the high altarpiece of S. Giustina in Padua and that of S. Giorgio in Braida in Verona, fig. 1), and refectory paintings of *cene* – as the suppers or feasts of the New Testament were generally known.

To this repertoire we may add large narrative paintings for *portegos* of Venetian palaces (one of these was a *cena*[10] and thus a domestic equivalent to the refectory pictures) and for the side walls of chapels and elsewhere in churches. He also made some delicate furniture paintings early in his career and a few exquisitely executed cabinet pictures for collectors towards the end of his life.[11] Almost all of his oil paintings were on canvas, and he probably seldom worked in fresco after the mid-1560s. It is noteworthy that two of his finest – and most admired and imitated – works on canvas, the *Rape of Europa* and the *Family of Darius*, were subjects from mythology and ancient history of the kind then favoured for villa frescoes. He also painted mythologies which seem to respond to the *poesie* that Titian was making for the king of Spain. Veronese was a gifted portraitist, and his landscape scenery is always delightful (fig. 2). His association with the leading architects and sculptors (Sanmichele, Sansovino, Palladio and Vittoria)[12] is reflected in his masterly use of sculptural props and architectural settings within his paintings and the successful integration of his painting with the interior spaces for which they were made.

The effect of this 'audaciously brilliant yet never overdazzling colour'[13] depends upon the greys and near-whites of marble, Istrian limestone and stucco – both in his pictures and around them. The illumination in his paintings is that of the open air in a perfect climate, and all the local colours typically preserve some of their brilliance even in shadow. For this reason his paintings lose much in the artificial lighting

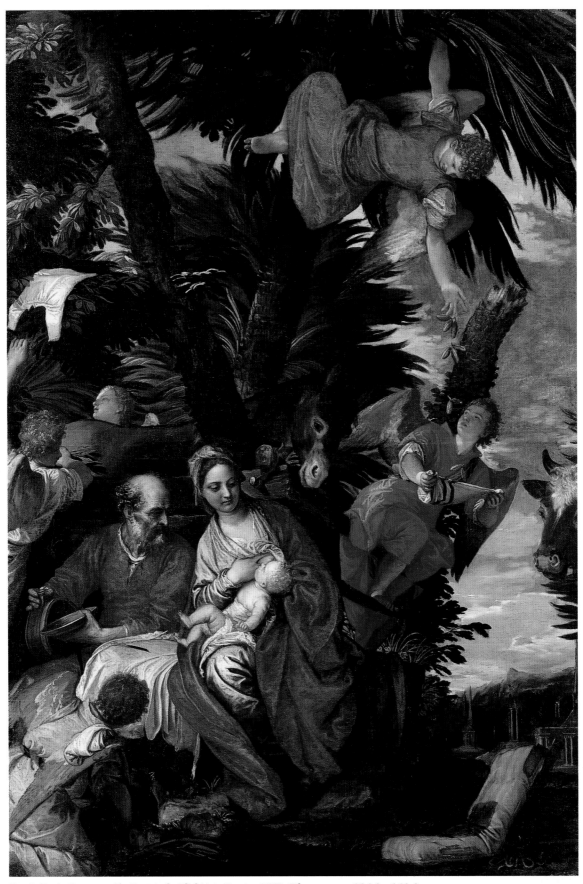

Fig. 2 Paolo Veronese, *The Rest on the Flight into Egypt*, *c.*1580. Oil on canvas, 236.2 × 161.3 cm.
Florida, The John and Mable Ringling Museum of Art, Bequest of John Ringling (SN 82).

favoured in modern museums, which also makes it hard to appreciate the delicacy of his 'carnations', especially the radiant complexions of his women, and the beauty of the translucent pearls and rubies and the golden necklaces, which he makes seem natural accessories of fair flesh and which always come to mind when his work is recalled.[14]

Veronese was summoned before the Inquisition in 1573, evidently in response to objections to the improper prominence and even irreverence of some of the marginal figures in the feast he had painted for the refectory of SS. Giovanni e Paolo,[15] but the small adjustment he made in consequence of this summons suggests the strength of the patrician support (although this was not recorded) upon which he could rely. He was not insensitive to decorum in his altarpieces and other devotional works, and in his late work there is evidence that he attempted to make his palette more sombre and to restrict distracting ornamental extras.[16]

Veronese's much younger brother Benedetto (1538–1598) is recorded as an assistant in the mid-1550s. Francesco Montemezzano (1540–1602) is likely to have joined Veronese's workshop before 1560. A nephew, Alvise del Friso (1559–1611), became a pupil during the 1570s and then a collaborator; he was joined by Veronese's sons – Carlo (known as Carletto, c.1569–c.1592) and Gabriele (1568–1631) – from his marriage in 1566 with Elena Badile, daughter of his first teacher.[17] The role of the workshop seems to have increased steadily, and after 1580 it is rare that we can feel confident that Veronese's was the sole hand involved. For some years after his death the family workshop was active, signing works as his heirs ('Haeredes Pauli') and guarding, and using, the master's drawings.[18]

Many of Veronese's drawings survive and they are well represented in British collections.[19] The most revealing are the preliminary compositional sketches in which chains of figures spring from his fine quill. The most beautiful are the large finished studies on blue paper brushed with wash for the shadows and with white for the lights, which must have been consulted by those making replicas and variants of his compositions. These were complemented by small oil sketches for at least some of his paintings, a practice established early in his career (fig. 2, p. 338), for which there are few precedents.[20]

Although his work was sometimes distrusted by advocates of severe and serious art, Veronese's paintings have always been esteemed by connoisseurs and pursued by collectors, and many of the greatest artists of the three centuries after his death may be counted among his admirers, including Rubens, Watteau, Tiepolo, Delacroix and Renoir.

Carlo Ridolfi's life of Veronese, by far the most important source for our knowledge of his art, was published separately in 1646 and then incorporated two years later into his *Maraviglie*. The first monograph on Veronese was published by a descendant, Paolo Caliari, in 1888 and contains much new documentary material. This was followed by books by Osmond (1927), Fiocco (1929 and 1934), and Pallucchini (1939), who also organised and catalogued the first exhibition of Veronese's work in 1939. Pignatti's catalogue raisonné appeared in 1976 and was republished, much revised with the collaboration of Pedrocco, in editions of 1991 and 1995. It is indispensable, although not always judicious in its assessment of autograph quality. Cocke's publications on the drawings and religious paintings, and Gisolfi Pechukas's on the early work, are major modern contributions to our understanding of the artist.

Every major aspect of Veronese's art, with the exception of his portraiture, is represented in the National Gallery: allegory, history, mythology, biblical narrative, religious image; there are ceiling paintings, an altarpiece and a cabinet picture; and the collection includes one of his earliest paintings as well as works from his maturity.

NOTES TO THE BIOGRAPHY

1. He was in fact often called Paolo Veronese before the twentieth century to distinguish him from Alessandro Veronese, as Alessandro Turchi was then known. This latter artist was once represented in the National Gallery by NG 92, *Cupid and Psyche*, painted on black stone, a work which cannot now be traced.

2. Brugnoli 2000.

3. Gisolfi Pechukas 1982.

4. Pignatti and Pedrocco 1995, I, pp. 54–5, no. 25.

5. Schweikhart 1971; Gisolfi Pechukas 1987.

6. Pignatti and Pedrocco 1995, I, pp. 61–3, no. 33 (Mantuan altarpiece, now Musée des Beaux-Arts, Caen); I, pp. 63–74, no. 34 (Louvre). See also Cocke 2001, pp. 185–6, no. 2, for the Mantuan altarpiece.

7. Pignatti and Pedrocco 1995, I, pp. 104–6, nos 56–8 (nave ceiling, S. Sebastiano); I, pp. 113–14, nos 66–8 (Biblioteca Marciana, Salone Maggiore). For the prize see Ridolfi 1914, pp. 306–7.

8. Ibid., I, p. 136, no. 101.

9. Ridolfi 1914, p. 310, and note 3.

10. Pignatti and Pedrocco 1995, I, p. 135, no. 100.

11. For example, ibid., I, p. 260, nos 158–61 (for furniture pictures now in the Museum of Fine Arts, Boston), and II, pp. 394–6, nos 282 and 283 (for cabinet pictures of the *Finding of Moses* in the Prado, Madrid, and the National Gallery of Art, Washington).

12. See Brizio 1960 for Sanmichele and Palladio.

13. Phillips 1898, pp. 24–5.

14. An early example is Federico Zuccaro's *Il Lamento della Pittura* (Zuccaro 1961, p. 127).

15. Fehl 1992, pp. 223–60.

16. The most remarkable experiment among his late works is the *Crucifixion* painted on black stone in the Pinacoteca in Padua; Ballarin and Banzato 1991, pp. 98–9, no. 118 (entry by Giovanna Baldissin Molli). For developments in his later religious pictures see Humfrey 1995, pp. 253–4. For his religious work generally see Cocke 2001.

17. Crosato Larcher 1967, 1969, 1976, 1990.

18. Gamulin 1986.

19. Cocke 1984.

20. See p. 337.

NG 931
Christ healing a Woman
with an Issue of Blood (?)

*c.*1548
Oil on canvas, 117.5 × 163.5 cm

Support
The dimensions above are those of the stretcher. There is a thin gesso ground covered with a thin layer of pinkish-grey colour which is composed of lead white and small quantities of charcoal-black and orange-red pigments. This layer is varied in colour across the painting, for no apparent purpose.[1]

Materials and Technique
Analysis has determined that walnut oil was the medium employed for the whites and some of the red areas, whereas linseed oil was used for the architecture in the background and for some of the orange drapery. Walnut oil mixed with pine resin was used to create a translucent green glaze.[2]

In Christ's robe, ultramarine mixed with lead white was applied on top of another layer of blue composed of lead white and indigo; for the darker shadows of the robe ultramarine was mixed with red lake. Ultramarine combined with lead white and red lake was also used for the different – slightly violet – blue of the kneeling woman's dress.

The bright orange cloak worn by the woman immediately behind the kneeling woman is painted with red ochre mixed with red lead and some red lake. It was painted on top of a thick green layer consisting of verdigris, yellow ochre and lead white. This may constitute a revision to the colour scheme, but it is noteworthy that a similar use of orange over green is found elsewhere in his work (see p. 344).[3]

X-radiography has revealed many compositional revisions. For example, the line of Christ's right shoulder was lowered and the white drapery of the woman behind him was painted over it. Both this woman's right shoulder and the child running under her cloak were moved to the left.[4]

There are some incised outlines – that of Christ's right arm and those of the legs of the bearded man with a white cloak.

Conservation
Described as in good condition when acquired, the picture was 'surface-cleaned and varnished', and small blisters were repaired, by Dyer in 1888. In July 1935 blisters were laid by Morrill, mainly in the kneeling woman, the female head immediately above her and Christ's head and shoulders. This was preparatory to cleaning by Holder, which was completed in June 1936, 'most of the old varnish' being removed during this operation. The painting was cleaned, restored and relined between 1986 and 1992.

Condition
The picture was described by Gould in 1959 and 1975 as 'much damaged',[5] but the cleaning of 1986 revealed that this was a pessimistic estimate. There are abraded areas – notably in the shoulders of the most prominent of the bearded men, and in the face and shadowed left hand of the kneeling woman, but much of the repaint that was so evident in Gould's day was found to be covering small areas of loss.

Subject
The subject of the painting seems to have been invariably identified as Christ and the Woman taken in Adultery between the mid-eighteenth century and its acquisition by the Gallery in 1876. The passage in the Gospel of Saint John to which this refers (8:3–12) tells how scribes and Pharisees brought before Christ a woman taken 'in the very act' of adultery and demanded what he would have them do with her, knowing that the law of Moses ordained that she be stoned to death. 'Jesus stooped down, and with his finger wrote on the ground.' When pressed further he proposed that 'He that is without sin among you let him first cast a stone.' The accusers then left, 'even unto the last', and Jesus, observing that no one condemned her, said, 'Neither do I condemn thee: go, and sin no more.' If this is the episode represented by Veronese, then the painting must show the accusers reluctantly conceding their own impurity, with some of them beginning to leave. It might be supposed that Christ is pointing down to his writing and the woman is being raised up from the ground, where she had been praying for mercy or has merely collapsed in distress. However, no solicitous women are mentioned in the Gospels and Christ is said to have confronted the woman alone when the accusing men had left. In much later paintings by Veronese's workshop which are certainly of this subject the adulteress is accompanied by a maid when confronted by Christ,[6] but this is a small deviation from the Gospel when compared with the flock of attendants seen here. Nevertheless this may be the subject Veronese intended to represent.

On acquisition by the Gallery the title was changed, presumably by Frederic Burton, to *Saint Mary Magdalene laying aside Her Jewels*.[7] No such episode is described in the Gospels, or in the *Golden Legend*, nor is it represented in sixteenth-century art, although in the famous painting by Charles Le Brun, and in some other paintings of the mid-seventeenth century, the penitent saint appears to be casting off her rich possessions.[8] It is surely not what is depicted here. Although the kneeling woman is wearing what might be an unfastened necklace – or, more likely, a string of jewels that was wound in her hair – she does not seem to be casting it off. Gould clearly had some doubts and conceded that 'the alternative title' – that is, the earlier one – 'might be correct'.[9] A label for the painting that was composed in the 1980s, acknowledging this, suggested that Martha is helping Mary to shed her jewels. But the woman who is supposed to be Martha is in fact holding the kneeling woman's hand.

Pietro Caliari in his monograph of 1888 listed the picture as simply *La Maddalena*.[10] Pignatti in his monograph of 1976 gave its title as *The Conversion of the Magdalen* and he was followed in many publications.[11] However, this subject is very rare in painting (although see pp. 68–70), and never represented as it is in the present work.

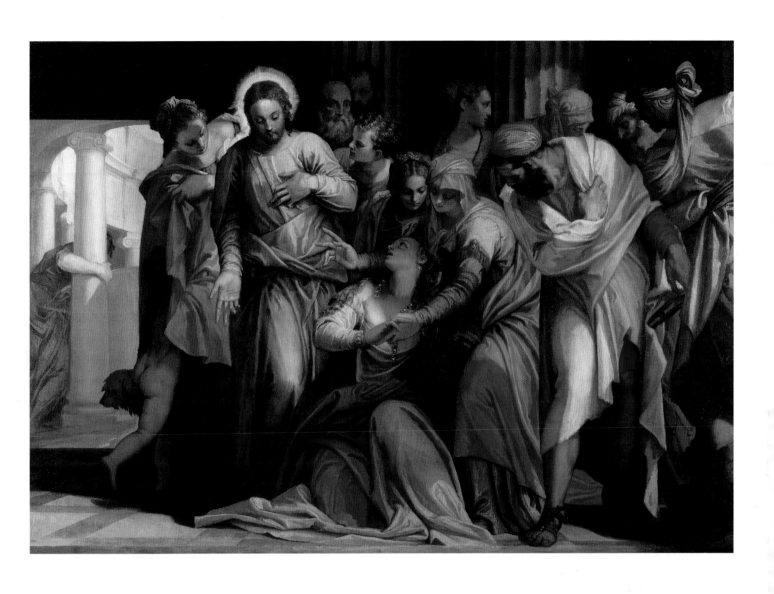

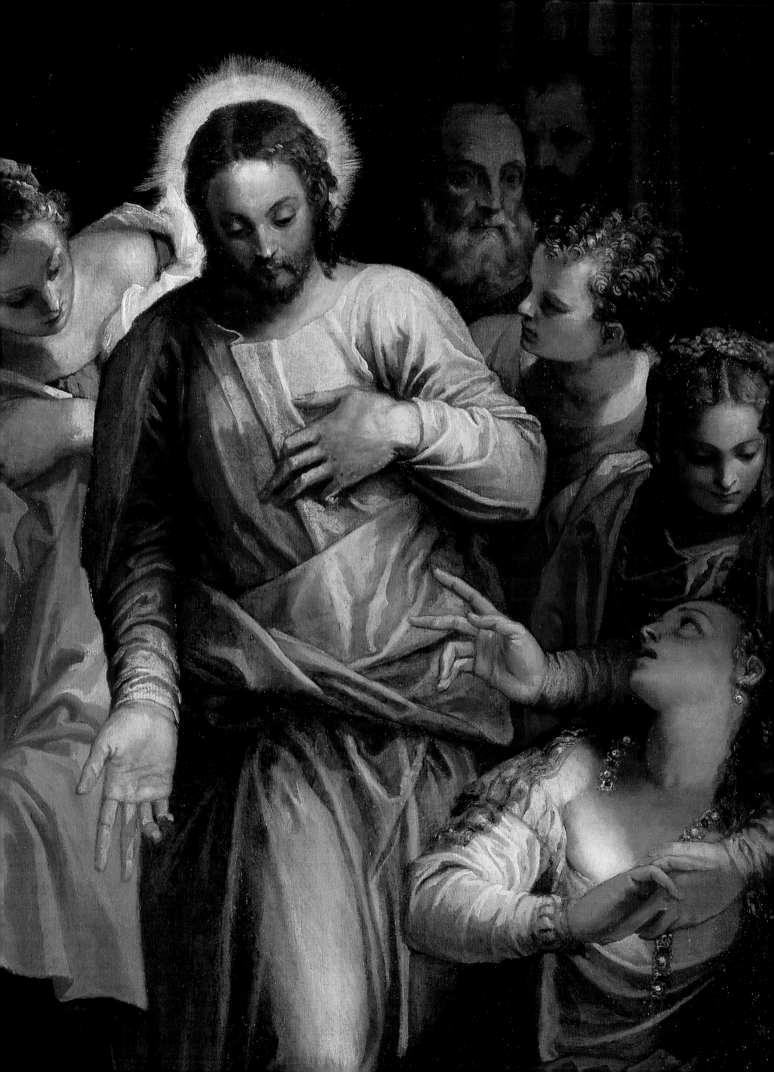

The painting was retitled by me in the early 1990s as *Christ and a Kneeling Woman*. It surely represents a miraculous healing, and soon after the label was changed Louise Woodroffe, secretary of the Curatorial Department, proposed that it might represent Christ healing the Woman with an Issue of Blood.

This miracle is recounted briefly in the Gospel of Saint Matthew (9:20–2) and more fully in the Gospels of Mark (5:25–34) and Luke (8:43–8). In the words of the latter:

> And a woman having an issue of blood twelve years,
> which had spent all her living upon physicians, neither
> could be healed of any, came behind him and touched
> the border of his garment: and immediately her issue
> of blood stanched. And Jesus said, who touched me?
> When all denied, Peter and they that were with him
> said, Master, the multitude throng thee and press thee,
> and sayest thou, Who touched me? And Jesus said,
> Somebody hath touched me: for I perceive that virtue
> is gone out of me. And when the woman saw that she
> was not hid, she came trembling, and falling down
> before him, she declared unto him before all the people
> for what cause she had touched him, and how she was
> healed immediately. And he said unto her, Daughter,
> be of good comfort: thy faith hath made thee whole;
> go in peace.

The painting includes a crowd of people and a woman who looks as if she has just sunk to the ground, who seems both to appeal to Christ and to marvel at him. The men in the painting must be Christ's disciples: the youth with curly hair perhaps Saint John. It is clear from the Gospel that this episode takes place outside the house of Jairus, 'a ruler of the synagogue', which perhaps explains the architecture in the background. It is also perhaps significant that Veronese seems to have painted the *Raising of the Daughter of Jairus* (described in the same chapter of Luke, verses 49–56) at much the same date (as is argued in the section on dating). It may be objected that if the unfortunate woman was impoverished by her medical bills then it is odd that she should be wearing jewels, but Veronese was not always attentive to such details.

This miracle was not commonly represented in paintings but, as it happens, it is almost certainly the subject of a later painting by Veronese[12] and of a painting on copper attributed to Alessandro Maganza of Vicenza.[13] It is not easy to imagine the circumstances for which a painting of this kind would have been made. The most likely explanation is that it was intended for a lateral wall in a chapel, perhaps commissioned by a wealthy physician, or perhaps as one of a series devoted to Christ's miracles like that in S. Bernardino, Verona (see below). The lighting from the right suggests that it was painted for a specific location.

Fig. 1 Detail of NG 931.

Attribution

The painting was considered as by Veronese in all published accounts until Collins Baker's catalogue of 1920, in which it was recorded merely as a work by a 'follower'.[14] This designation was retained in the catalogues of 1925 and 1929[15] and no doubt encouraged Osmond and Fiocco to exclude it altogether from consideration.[16] However, Brizio in 1939[17] and Berenson in 1957[18] accepted the painting as a juvenile production by Veronese, as did Pallucchini in 1943[19] and Gould in 1959.[20] It has not been questioned in recent publications, and uncertainty concerning it in 1920 and for a while thereafter can be explained by a general sense that too much had too easily been accepted as by Veronese. In addition, the distinctive characteristics of the artist's earliest work were not generally acknowledged in the 1920s.

Dating and Relationship to Other Early Works

There are two undisputed early paintings by Veronese, made when he was eighteen years of age, or a little later; both are mentioned by Ridolfi as pictures in which his greatness was first adumbrated.[21] The first is the *Raising of the Daughter of Jairus* painted for the Avanzi Chapel of the Franciscan church of S. Bernardino, Verona. This work was stolen in 1697 and is now known only from a copy commissioned to take its place[22] and from a small oil painting on paper in the Louvre (fig. 2) which is surely a preparatory study (but which, even if it is supposed to be a reduced replica, may also be taken as a reliable record of the colours and the composition).[23] The *Raising of the Daughter of Jairus* was one of four paintings commissioned from the four leading painters in the city, and served as the pendant of the *Resurrection of Lazarus* that Veronese's master (and future father-in-law) Antonio Badile painted for the opposite wall of the chapel, which is endorsed with the date 1546.

The second work is the damaged altarpiece painted by Veronese for the Bevilacqua Lazise Chapel in S. Fermo, Verona, and now in the Museo di Castelvecchio, Verona. An oil *bozzetto* for the composition on paper also survives in the Uffizi, for which there is a preparatory drawing at Chatsworth.[24] Since the chapel was commissioned in 1544 and completed in 1548 the latter date may be right for the altarpiece, although surely it might have been ready shortly before the other decorations were complete.

The crowding of the figures in NG 931 – four or five deep to one side of the picture, and all occupying a shallow foreground stage, contrasted with an opening on the left – is extremely close to what we see in the Louvre sketch, and tilted female heads rather uncertainly attached to necks, as well as the combination of pale rose and apple green, are features of both. In NG 931 Veronese twice employs an oversized hand with the first two fingers outstretched and separate, and the other fingers crooked. Christ gestures in this way with his right hand, as does the woman supporting the kneeling woman with her right hand. As can be seen from the *bozzetto* for the S. Fermo altarpiece, and indeed from pentimenti in the painting itself, Veronese originally intended that the Baptist's left hand should make this gesture. In fact, the drawing at

Chatsworth reveals that he originally had the Baptist gesturing in this way with both his hands. The drapery folds in the S. Fermo altarpiece are also very close to those in NG 931, especially in the sleeves.

Most modern scholars agree that NG 931 is indeed one of Veronese's earliest works.[25] It demonstrates how he grafted on to the style of Badile some of the rhetoric of Raphael, which he knew only at second hand from the work of Giulio Romano – indeed, mostly at third hand in the frescoes executed in Verona's cathedral in the previous decade by Francesco Torbido, employing Giulio's designs.[26] Whereas Christ sways limply, and the pose of the woman behind him is impossible to reconstruct, the figures of the two men on the right are more dramatically articulated. Veronese was always fond of a full chorus but he learned in his later career to allow more space and to use colour in a way that helps to establish it, whereas here the green tunic of the man on the extreme right, because it matches the green worn by the woman furthest to the left, seems to be in the same plane, although he is in fact in front of the disciple in the white cloak and she is behind him. All the same, it is noteworthy how many of the motifs in Veronese's mature work appear here.

OPPOSITE: Fig. 3 Detail of NG 931.

Fig. 2 Paolo Veronese, *The Raising of the Daughter of Jairus*, *c.*1546. Oil on paper, 42 × 37 cm. Paris, Musée du Louvre.

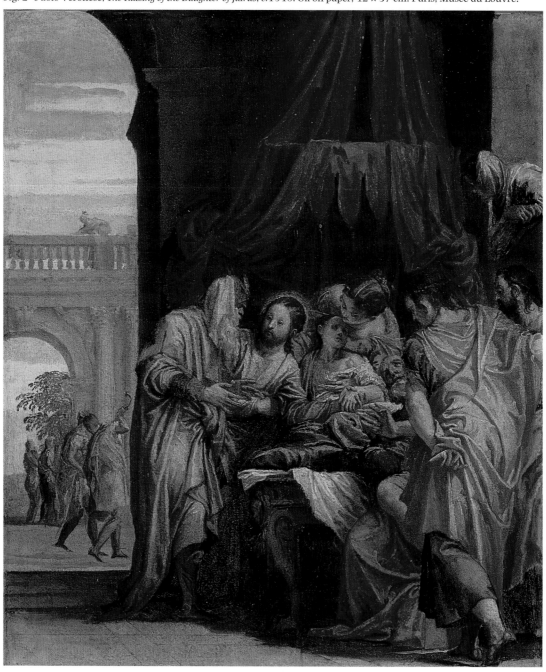

Costume

In the National Gallery's dossier on the paintings there is a long typewritten study of the costumes by Stella Mary Pearce (Newton), dated November 1955. She argues that it is 'impossible that this picture could be by Veronese, and almost equally impossible that it could have been executed in the sixteenth century', concluding that it was painted in the first decade of the nineteenth century, although she is not 'prepared to object' to a date in the seventeenth century. The study dwells on illogicalities such as the looseness of the neckline of Christ's tunic and the strange 'behaviour' of the veil of the woman holding the hand of the kneeling woman, and on features that Newton believed to be inconsistent with sixteenth-century conventions (such as the headscarf worn by the man on the right, who is richly attired, whereas in Veronese's later work such scarves are more often worn by beggars and executioners). The arguments are not strong but it required some courage for Cecil Gould to disregard them, given Newton's prominence in her field.

Architecture

The illogicalities of the costumes are matched by the treatment of the architecture, which is dramatically effective but includes several inconsistencies. The huge fluted column-shaft on the far right is presumably in the same plane as the two others, but its base mouldings appear beside the foot of the bearded man clutching his cloak with his left hand and a book with the other, making it stand considerably forward of most of the figures in front of the other two columns. To the left of Christ's head there is a console supporting the lintel of the door, architrave mouldings for which can barely be discerned extending to the left, but it is impossible to imagine how this feature could relate to the columns. In the distance to the left there is an Ionic colonnade, apparently representing an interior courtyard (fig.4), but the relation of the foremost capital to the entablature above it is fudged and there is a blurred area of painting in front of the plinth, as well as a mysterious wall behind it. Veronese's Bevilacqua Lazise altarpiece in S. Fermo also includes a giant fluted column, but it too is illogical, having no comprehensible relationship to the Virgin's throne.

Veronese was the son of one of the city's leading masons and his elder brother Gabriele also adopted this profession. He would therefore not only have been aware of Michele Sanmichele's architecture in Verona, but would probably have been acquainted with Sanmichele himself from an early age.[27] Certainly in the early 1550s, when working at Sanmichele's Villa Soranzo, he was there as the great architect's protégé.[28] The architecture on the left side of NG 931 must be a recollection of Sanmichele's Ionic *tornacoro*, the great curving choir screen of Verona cathedral, completed in the early 1540s.[29] The distinctively sharp fluting of the large foreground columns is that of the Greek Doric order (there is a fillet between the fluting of other orders). It was not, it

Fig. 4 Detail of NG 931.

seems, used by Sanmichele, or indeed by other architects at that date, but to include fluting of this type is again suggestive of a precocious interest in architecture. As Palladio noted in the first book of his *Quattro Libri* of 1570, Doric columns had no bases in antiquity, but he recommended that they should have mouldings like those of the Ionic order. This is what Veronese has done, although he has placed the columns very much closer together than would ever be the case in a real building (Palladio recommended an intercolumniation of slightly less than three diameters).[30]

Previous Owners

By 1761 the painting, identified as *The Woman taken in Adultery*, by Paolo Veronese, was recorded in the possession of Sir Gregory Page, Bt (1689–1775), the son and grandson of rich City merchants who had been directors of the East India Company. Sir Gregory married in 1721 and made his mark as a collector in the following year by means of two major purchases in Rotterdam. From the aged, hugely admired and extremely expensive Dutch painter Adriaen van der Werff (who died soon afterwards) he purchased a group of ten paintings,[31] and at the Meijers sale on 9 September he secured the twelve paintings on copper of the story of Cupid and Psyche painted (probably for the Queen of Spain) by Luca Giordano.[32] He must have believed that he had obtained the very best that modern Holland and modern Italy could supply. No doubt he owned many more paintings by the time he commissioned John James to build one of the first and most influential neo-Palladian houses in England, Wricklemarsh at Blackheath, to the southeast of the City of London, for the house (completed in 1724) included on its principal floor a gallery measuring 60 by 20 by 20 feet and another room, the dressing room for the State Bedchamber, serving as a second gallery. The smaller paintings were hung in the latter room on crimson silk damask, including most of the Van der Werffs (eventually there were fourteen) and the Veronese catalogued here. A second Veronese (a version of the *Finding of Moses*), four feet four inches in height and six feet long (132 × 183 cm), was the largest picture in the room. Paintings were hung elsewhere in the house as well, and the Luca Giordanos were displayed on walls of green silk in the drawing room adjacent to the gallery.[33]

It is clear that Sir Gregory was still adding to his collection after the house was built, for one of the Paninis that were incorporated over doors and chimneys is dated 1742,[34] and the Batoni *Judgement of Solomon* must also date from this decade or later.[35] These and other Italian pictures seem to have been acquired in Italy by Dr John Clephane, acting as an agent for the London dealer John Blackwood.[36] It may be that old masters were also bought in Italy and Holland, but some were probably acquired on the London market and the Veronese may have been lot 233, 'the Adulterous Woman. P. Veronese', which was in the sale of Josiah Burchett on 6–9 April 1747.[37] It seems likely that Sir Gregory ceased to buy after 1750. The list of paintings given by Dodsley's *London and its Environs* in 1761 is a sure sign that the collection was easily visited by people 'of quality'.[38]

On Sir Gregory's death in 1775 his collection of paintings, together with his estates and his considerable fortune, passed to his great-nephew, Sir Gregory Turner, Bt, who had surely been christened in anticipation of this event and who now changed his family name to Page Turner. Page Turner sold Wricklemarsh in 1783. He pulled down another house that he had inherited, Ambrosden, retaining only his father's seat of Battlesden in Bedfordshire. He sold many of the paintings, some in Paris (these included the Van der Werffs, purchased there for the French crown[39]), and others privately in London (these included the Luca Giordanos, purchased for the British crown[40]) and at Christie's on 8 and 9 May 1783.[41] He did, however, retain a good many pictures, including NG 931.

Upon Page Turner's death in 1805 these paintings were inherited by his eldest son, the 4th baronet, Sir Gregory Osborne Page Turner (1785–1843), a young man who rapidly became intoxicated with the heady speculations of the London art world. He was said to have been imposed upon by dealers, and certainly he was reluctant, or found it difficult, to pay them. It seems that he was compelled to sell a large group of paintings at Phillips on 19 and 20 April 1815, in circumstances which 'are still somewhat mysterious'.[42] They were paintings he had acquired rather than inherited, the most notable being Titian's *Perseus and Andromeda*,[43] now in the Wallace Collection, and Jan Both's Italianate landscape, now in the National Gallery (NG 956).[44] He may have sold, or otherwise disposed of, the Veronese before this date, and he had certainly done so by 1823, when it was exhibited at the British Institution as a work formerly in his collection.[45] In that year Sir Gregory's family were making legal claims that he was insane and their action may have precipitated the sale of his collection at Christie's on 7 and 8 June 1824.[46]

The owner who exhibited the painting at the British Institution in 1823 was William Smith (1756–1835), a Whig politician long noted as an ardent advocate of parliamentary reform, Catholic emancipation and the abolition of slavery.[47] Smith's collection – which he would probably never have described as such – seems to have been of a type designed to fit into the three or four principal rooms of a London terrace house, hence with room for only a few large works. He was a patron of Opie and of Cotman, and he had known Sir Joshua Reynolds (of whose great portrait of *Mrs Siddons as the Tragic Muse* he was the second owner[48]). When Joseph Farington visited him in 1797 he already owned a fine group of paintings.[49] They were mostly landscapes (both old and new – by Wilson, Cuyp, Gaspard Dughet, Vernet, Both and Wynants) but he also owned Jordaens's *Triumph of Religion* and two 'imitations of P. Veronese' which may perhaps have been *bozzetti* by Tiepolo. On 16 May 1829 Christie's held a sale consisting 'chiefly of the property of a gentleman of fine taste lately retired from his residence in London'. Lots 67, 69, 71 and 72 were Smith's paintings and doubtless had come from his house in Park Street, Westminster, which he was giving up in anticipation of his retirement from politics in 1830. The Veronese, lot 69, fetched 100 guineas (£105). Smith evidently kept some paintings in his retirement in South London

(eight were auctioned after his death in 1835).[50] A founder member of the British Institution, he was a supporter of the fine arts and no doubt was in close contact with the art trade, probably selling and certainly buying over the course of several decades, acquiring the Veronese when he was over 50, or perhaps over 60. The man who bought the Veronese in May of 1829 was Wynn Ellis, whose remarkable collection is surveyed by Judy Egerton in her catalogue of the British paintings in the National Gallery.[51]

Provenance

See above. Sir Gregory Page, Bt, by 1761; by descent to Sir Gregory Osborne Page Turner, by whom sold before 1823, when the painting was in the possession of William Smith. Smith's sale, Christie's, London, 16 May 1829, lot 69. Bought by Wynn Ellis, by whom bequeathed in 1876 to the National Gallery.

Exhibition

London 1823, British Institution (130).

Frame

The painting is currently displayed in a fine Spanish cassetta frame of the late sixteenth century, carved (apparently out of pine) and partly gilded (fig. 5). It has an outer moulding of radial gadroons and an inner moulding of bead-and-rod ornament, with half-egg-and-spoon ornament at the sight edge. Both inner and outer mouldings are water gilded on a ruddy brown bole. Pink paint, apparently original, survives in the recesses between the gadroons. The flat is painted brown, probably in imitation of walnut, and decorated at the corners with foliate scrolls in mordant gilding. The inner moulding of the frame was cut to fit the painting and the flat was also reduced in width when the painting was cleaned and conserved in 1992. The painting's previous frame seems not to have been recorded.

The feature of the frame that is characteristically Spanish is the angular, faceted recession between each gadroon, which is emphasised by colour. The workshop replica of El Greco's altarpiece in Orgaz, painted in about 1590, has a frame of this type, which appears to be original.[52] By the end of the sixteenth century such recessions were often larger and the gadroons had developed into a variety of separate rods or ribs, as in the splendid frame of the small panel by the Master of Perea in Yale University Art Gallery, New Haven,[53] and all these motifs, including the angular recessions, are features of the fanciful frames named (with no good reason) after Herrera, architect of the Escorial.[54]

Fig. 5 Lower left corner of the frame of NG 931.

NOTES

1. Penny and Spring 1994, pp. 6–7.

2. Ibid., p. 9.

3. Ibid., p. 9.

4. Ibid., p. 8.

5. Gould 1959, p. 145; Gould 1975, p. 323.

6. Pignatti 1976, I, p. 115, no. A198, and II, fig. 887, and I, pp. 220–1, no. A384, and II, fig. 1049. I owe these references to Carol Plazzotta.

7. Wornum 1877, p. 363.

8. Thuillier *et al.* 1963, pp. 66–7, no. 25 (entry by Thuillier).

9. Gould 1975, p. 323 – but see Gould 1959, p. 145, where he merely notes that the episode represented is not mentioned in the Gospels.

10. Caliari 1888, p. 375.

11. Pignatti 1976, p. 110, no. 47; Pignatti and Pedrocco 1995, I, p. 84, no. 55.

12. Pignatti and Pedrocco 1995, II, pp. 525–6, 1992 (as a workshop picture, which it surely is not).

13. Humfrey 2004, p. 202, no. 78 – formerly Hamilton Collection, now Brodick Castle, National Trust for Scotland.

14. [Collins Baker] 1920, p. 312.

15. Ibid., 1925, p. 355; ibid., 1929, p. 391.

16. Osmond 1927, p. 112; Fiocco 1934, pp. 121–2.

17. Brizio 1939, p. 128.

18. Berenson 1957, I, p. 132.

19. Pallucchini 1943, p. 20.

20. Gould 1959, p. 145.

21. Ridolfi 1914, I, p. 298.

22. Brenzoni 1953.

23. Sueur 1993, pp. 113–15, no. 48. We may calculate the height of the missing picture as *c.*175 cm, to judge from Morandi's work for the same register (Hornig 1976, p. 103, nos A20 and A21).

24. Marinelli 1988, no. 3, pp. 186–91 (entry by Marinelli).

25. A notable exception is Pignatti 1986, pp. 76 and 83, who prefers a date in the early 1550s.

26. Hartt 1981, pp. 203–8, figs 425–30.

27. Rearick 1997, p. 147, makes this point.

28. Vasari/Milanesi, VI (1906), pp. 369–70.

29. For this see Gazzola 1960, no. 17, plates 92–7. The *tornacoro* began to be erected in 1534. No less relevant is the *tempietto* of the Lazzaretto, work on which commenced *c.*1549–52: see ibid., no. 24, and plates 123–9. Some relationship with Bramante's Vatican staircase is also likely (as noted by Timothy Alves in a letter of 23 February 1993).

30. Cap. XV, pp. 22–3.

31. See entry by J.E.P. Leistra in the Macmillan/Grove *Dictionary of Art* 1996, XXXIII, pp. 79–80. Page paid 34,600 guilders.

32. Levey 1991, pp. 94–8, nos 502–13.

33. For the arrangement see Brushe 1985. The presence of NG 931 in this connection was noticed independently by Frank Simpson and Jacob Simon in letters to the National Gallery of 2 April 1976 and 4 September 1978. Simpson also noted the presence of the picture in the posthumous inventory of Sir Gregory's household furniture. The paintings at Wricklemarsh are also listed in a manuscript volume attributed to Martyn, for which see Sotheby's, London, 10 April 1961, lot 116.

34. Arisi 1986, p. 389, no. 317.

35. The painting is untraced but see Clark 1985, p. 210, no. 38, for another version.

36. Ingamells 1997, p. 215 (a reference I owe to Julia Armstrong-Totten). Clephane was active in 1742 and 1744 on Blackwood's behalf – the Imperiali of Vetturia and Volumnia is specified.

37. Information from Julia Armstrong-Totten. No copy of the catalogue is annotated with the size of the picture, the sum it fetched, or the identity of the purchaser.

38. Dodsley 1761, I, p. 315: see also Martyn 1766, I, p. 59.

39. The French sale was handled by Bertels, 8 May 1783. Some of these royal purchases were sold during the Revolution (for example, Sotheby's, Amsterdam, 10 May 2005, lot 118).

40. Details of the sale are not recorded. Confusion has been caused by Frederick, Prince of Wales, having owned copies of these paintings – see Levey 1991, p. 98.

41. Lugt 3573. See also, for jewels, etc., Christie's, 10 November 1775 (Lugt 2451), and, for sculpture, porcelain and furniture, Christie's, 23–29 April 1783 (Lugt 3559). Buchanan (1824, I, p. 32) recorded that a large portion of the pictures were bought by a certain Van Heythusen, whence some of them passed to Thomas Moore Slade.

42. Farington, XII, 1983, p. 4375, for the stories of swindlers. For an analysis of the sale see Fredericksen 1993, I, pp. 83–4, no. 1275 (Lugt 8682).

43. Ingamells 1982, pp. 396–7.

44. MacLaren and Brown 1991, I, p. 49.

45. No. 130 in the catalogue.

46. For the claims of insanity see *Gentleman's Magazine*, 1843, II, p. 92 (his obituary, cited in Ingamells 1982, p. 398, note 37).

47. See the entry by N.M. (Norman Moore) in the *Dictionary of National Biography*, XVIII, pp. 557–9.

48. Mannings 2000, I, pp. 414–15, no. 1619; II, plate 117.

49. Farington, III, 1979, p. 840, entry for 17 May 1797.

50. Lugt 14051, lots 111–18. The most highly priced painting was the last, of a *Dead Christ* by Guido Reni at 100 guineas.

51. Egerton 1998, pp. 414–18.

52. Tiemblo 2002, p. 209, fig. 149.

53. 1975.95.1.

54. For Herrera frames see Grimm 1978, pp. 82–3, plates 135–8; also Mitchell and Roberts 1996, pp. 122–3. An analysis of how this bizarre style of frame evolved is much needed.

The Consecration of Saint Nicholas

1562
Oil on canvas, 286.5 × 175.3 cm

Support

The dimensions given above are those of the stretcher. The canvas is of a coarse herringbone weave identical to that used for the altarpiece of Saint Anthony Abbot which the artist painted for the same church at the same date. Two vertical lengths of canvas are joined to the right of the centre of the painting (the seam passes through the right hand of the officiating bishop and coincides with the left edge of the shadow of the step below him). The narrower of the two strips is between 71 and 72 cm wide. The canvas is wax-lined on a fine tabby-weave canvas. The stretcher is of varnished pine, with one vertical and two horizontal crossbars. At no point does the canvas extend to the edges of the lining canvas. The margin is about 2 cm in most places.

The original canvas was cut diagonally at the upper corners, slightly more at top left (30 cm as against 29 cm from the corner on the upper edge).

A fragment of paper printed with a few words in French is stuck to the lower edge. This is likely to be the remains of a protective facing applied during the lining process.

Materials and Technique

The canvas is covered with a thin layer of gesso, not thick enough to obscure its texture, and over this there is a thin brownish priming layer of charcoal black, red ochre and lead white with a high proportion of medium. Red lake layers found in paint samples beneath the undergarment of the priest in the left foreground can be interpreted as preliminary sketching with a brush.[1]

Two types of blue pigment were employed: ultramarine and smalt (from cobalt glass). The latter has discoloured (see below). Red lake derived from cochineal (probably 'Polish cochineal') was combined with vermilion for the cuffs of the bishop and for the robes covering his feet, and with lead white for the pink stoles worn by the two priests.[2] This lake was also combined with ultramarine to form a purple which has faded (see below). Two types of lead-tin yellow were used: type 1 (the more common one) in the angel, and type 2 in the acolyte's *cangiante* garment.[3] The orange garment of the youth with a turban is of orpiment and realgar, with red ochre in the shadows. There is a green layer beneath which may indicate a pentimento, but a similar layer structure is found in NG 931.[4] This green, like the kneeling saint's drapery, is of verdigris mixed with a little lead-tin yellow and white.

Incisions were made in the paint of the acolyte's *cangiante* surplice with the pointed end of a brush – or some other sharp instrument. This technique is typical of Veronese, as are the diagonal brushstrokes 'cut' against the lines of the folds in the priest's white surplice.

X-radiography reveals no significant revisions to the composition, except for a slight change in the position of the bishop's right hand. It is, however, tempting to speculate that the green foliage which is aligned with the clouds was improvised to provide a more effective foil for the fluttering white alb held by the angel and for the priest's grey hair. Although the two heads behind that of the priest look like afterthoughts, they were not painted on top of the architecture.

Conservation

The painting is likely to have been cleaned at least once when in the abbey church of S. Benedetto: probably when it was reframed in the 1720s,[5] perhaps also when it was moved to the *pinacoteca* of the abbey in the 1790s (see below). It would also have been cleaned and lined in France (see the end of the section on Support; see also the claims made in the mid-nineteenth century, cited below) and it was presumably at that stage that the corners of the canvas were made up. There is no evidence of any dissatisfaction with the painting's condition after its arrival in the National Gallery in 1826. Indeed, in 1834 John Landseer wrote that 'in respect of the collocation of its colours, and the unity of its design ... no praise can transcend its merits'.[6] But less than twenty years later it was felt to be in need of cleaning. John Seguier relined the painting and then cleaned it during the Gallery's six-week closure of 1852. The outcry over its changed appearance and that of other National Gallery pictures treated at the same time led to the appointment of a select committee to investigate the methods employed. In evidence to the committee two artists (William Dyce and Charles Leslie) defended the treatment, but the connoisseurs and collectors Morris Moore and William Coningham, as well as the dealer John Nieuwenhuys, were highly critical and expressed their conviction that glazes had been removed. Coningham, for instance, claimed that the surplice of the more prominent priest had been 'completely flayed'. Seguier in his evidence reported that he had removed a watercolour toning ('I believe it was a solution of Spanish liquorice') applied by a previous owner, Alexis Delahante.[7]

Seguier's claim is highly credible and it does little credit to the critics of the cleaning that they never seem to have suspected that the harmony they had previously admired was at least in part artificial. As usual in debates of this kind, the connoisseurs assumed that the missing glazes had been removed in the most recent treatment, whereas the treatment may in fact have revealed what had long been lost. The allegations made with such authority can only have confirmed Charles Eastlake, the previous keeper and future director of the Gallery, in his unusual belief in the legitimacy (as well as prudence) of deceit. The practice of toning paintings after their cleaning was one which he would institute as director, not – or not only – to avoid a radical departure from a familiar appearance, or from the effect expected, or from the look of neighbouring pictures, but to compensate for earlier damage.[8]

It is impossible now to determine whether Seguier damaged the painting. But some of the abrasion described below was surely the result of earlier treatments.

In 1882 the painting was again lined, this time by 'Morrill'. It was 'surface-cleaned' in March 1938. Flaking

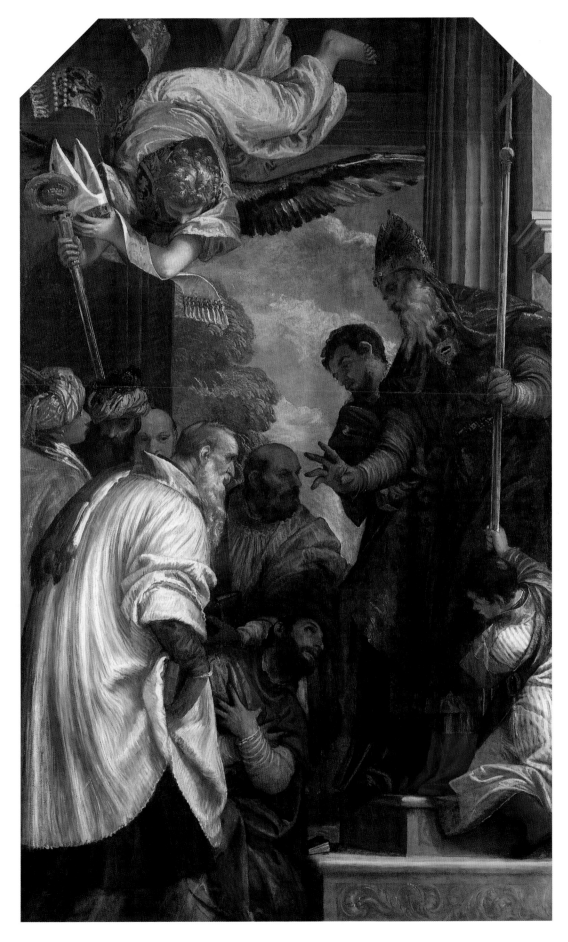

paint was secured in January 1940 and again in October of the same year. It was 'polished' in August 1946. Blisters were laid and the canvas was given its current wax lining in June and July 1953. It was cleaned in 1964, when the made-up corners, as well as non-original strips at the edge of the canvas, were removed.

Condition
The painting has been flattened and abraded, presumably in the process of lining. In a few areas, for example the ends of the bishop's beard, the bare canvas is exposed. The greyer portions of the cloudy sky now have a scrubbed look, largely on account of the degraded smalt. The shadow beside Nicholas's missal, which is cast by the step upon which the bishop stands, has been rubbed and is no longer legible as such. A thin red line on the gloved right hand of the bishop must originally have been part of a ring. Small lines on the neck of the acolyte are perhaps traces of a half-eradicated chain.

Other, larger, changes to the painting were occasioned by unstable pigments. The darker areas of the bishop's robe painted with smalt were originally blue. The only blue that survives is that of the lighter areas painted with ultramarine combined with a little lead white. And this blue was originally somewhat purple, since it contains red lake which has now faded.[9] Similarly, smalt was employed for the undergarment of the more prominent priest and this must originally have been blue rather than the dark grey we now see, since it includes strokes of blue which are of ultramarine and white.[10] By contrast, the greens are well preserved, except for the darkening of the copper green in the pattern on the stole flying up from the angel.

Subject
Saint Nicholas, who lived in the fourth century, was venerated in Constantinople by the sixth century. By the ninth century he had become popular throughout the Eastern Church and, by the eleventh, throughout the West. His relics were removed in 1087 from Myra in Lycia (by then under Turkish rule) to Bari in Apulia, where they remain (hence he is known as Nicholas of Bari).[11] Nicholas is the protector of sailors threatened by storms, of children, prisoners and pawnbrokers, and is a patron saint of Russia, Greece and Sicily as well as of many cities. Legends attached to him, the folkloric character of which was certainly evident to learned churchmen by the mid-seventeenth century. Hence, perhaps, the decision by the Benedictines who commissioned NG 26 to focus on the one certain fact concerning him, that he was a bishop of Myra.

The episode represented by Veronese is that of Nicholas's consecration. Bishops assembled at Myra to elect a new bishop, and a voice in the night revealed to the senior one among them that a pious youth called Nicholas had been divinely chosen and would be the first to appear at the cathedral door on the morrow.[12] Veronese depicts what must be the portico of the cathedral, with the senior bishop consecrating Nicholas, who kneels, flanked by two priests in white surplices. These priests will presumably carry him to the bishop's throne, and may indeed be about to perform this task. Veronese has not attempted to represent dawn light or a congregation of bishops, but the turbans worn by two of the three witnesses must be intended to suggest a location in Asia Minor. Divine intervention is indicated by an angel descending with a crozier, a mitre and two stoles, one of white damask matching the mitre and the other of gold and (darkened) green which, since it is looped round the angel's neck, may be intended as an ornament for the angel himself. An acolyte kneeling beside the officiating bishop helps to support a staff surmounted with a gilt cross such as is carried before an archbishop and is properly speaking a 'crozier' (although that word is commonly applied to the crooked pastoral staff of a bishop like that held by the angel here).

The consecration of Saint Nicholas is included in cycles of his life but in no other independent painting of the subject that is known to us.[13] It seems to have been chosen to illustrate the importance of priestly vocation and of the sacred authority vested in a bishop.

Attribution
NG 26 is described by Vasari as a painting by Veronese,[14] and is indeed (see below) a documented work by him. It is accepted as by Veronese in all official accounts of the Gallery's collection and in all modern monographs on the painter. However, the French sculptor and collector Henri de Triqueti, who was certainly in touch with informed opinion in the art world of his day, declared in 1861, in his book on London's museums, that it was 'considered by many art lovers to be a work by Veronese's son, painted after a sketch by the great master', and hinted that this opinion found support in Boschini.[15] One explanation for this is that in 1832 Ottley (see below) had given the painting the wrong provenance, associating it with the paintings in the church of S. Nicolò at the Frari in Venice, which were indeed only partly by Veronese, as Boschini and other Venetian authorities conceded. But it is also true that Veronese must have had assistants, and it would not be surprising – especially in view of the speed with which the picture seems to have been painted – if some preliminary level of painting or some subordinate parts were delegated to them. The drawing of the crook of the staff held by the angel is not good, and it is illogical for the tip of the angel's wing to pass behind the column, since the scale of the angel suggests that he is the foremost figure in the composition. The angel is little varied from one in the high altarpiece for the church of S. Sebastiano that Veronese had only recently completed. Whether the angel is hasty work by the artist or inferior work by an assistant, it is painted with a boldness which can be explained by the fact that it would have been distant from the viewer.

Original Location and Circumstances of Commission
The painting was made for the abbey church of S. Benedetto Po (S. Benedetto in Polirone, by the Po and its tributary the Lirone), a few miles south of Mantua. This great Benedictine foundation of the eleventh century became, in 1419, a part of the reformed congregation (the Cassinese congregation)

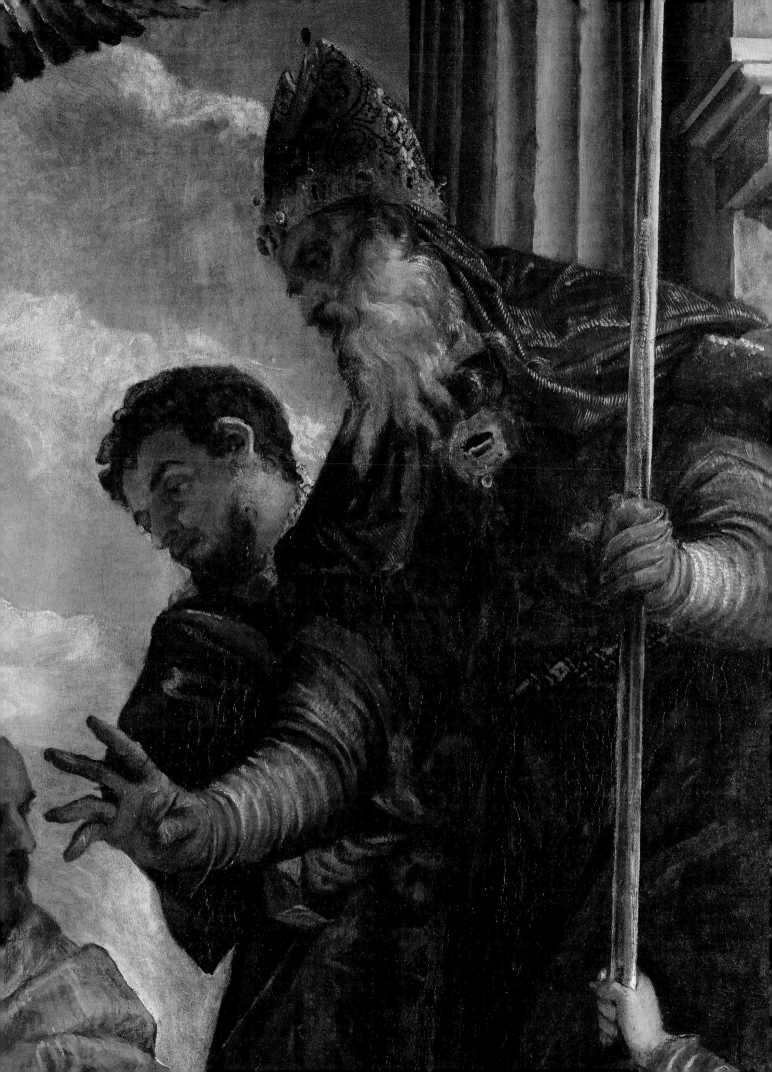

Fig. 2 Paolo Veronese, *The Virgin and Child with Angels appearing to Saints Anthony Abbot and Paul the Hermit*, 1562. Oil on canvas, 285 × 170 cm. Norfolk, Virginia, Chrysler Museum of Art. Gift of Walter P. Chrysler, Jr., in Memory of Della Viola Forker Chrysler, 71.527.

PREVIOUS PAGE:
Fig. 1 Detail of NG 26.

of S. Giustina in Padua. During the following thirty years the abbey church was rebuilt. Pressure to carry out further renovation was stimulated by major bequests in the early sixteenth century. Giulio Romano directed extensive rebuilding and redecoration (including new altarpieces for the ambulatory), which were complete in 1547.[16] Work then began on new choir stalls, and an organ, and the high altarpiece was commissioned from Fermo Ghisoni, a local artist, and Girolamo Bedoli, of local origin.[17] In 1559 Antonio Beggarelli of Modena, himself a Benedictine, was commissioned to make a series of terracotta statues,[18] and on 27 December 1561 three altarpieces for the side chapels were commissioned from Lattanzio Gambara (of Mantua), and three others from Veronese. The agreement (known only in a transcription) was between the Abbey ('Monasterium') and the artist ('Paolo Cagliari of Verona'), distinguished painter ('egregius pictor') resident in Venice, and the subjects to be painted were identified simply as 'de historia Sancti Nicolai, Sancti Antonii, et Sancti Hyeronimi', to be done in the best available colours at the price of 35 scudi each, with 6 scudi extra allowed in each case for pigments ('pro emendis coloribus'), the entire sum coming to 123 gold scudi ('summa in totum est scutorum 123 auri in auro').[19]

Veronese had worked for the Benedictines at SS. Nazaro e Celso in Verona shortly before this date and was also employed by the Benedictine abbot at S. Giustina in Padua during this period.[20] He was, in any case, well known in Mantua for his altarpiece in the Duomo of Saint Anthony Abbot.[21] Veronese's patron was the abbey, or at least its abbot, who was then Andrea Pampuro da Asola (who occupied the office between 1557 and 1562). No lay individual seems to have had a say in commissioning the painting, although one may have chosen the dedication to Nicholas, to whom no chapel had previously been dedicated in the abbey church.

Giulio Romano had given the church a unified architectural character, ingeniously masking irregularities occasioned by the previous structure, and providing stucco and frescoed decorations in all the chapels.[22] The unity anticipates that which we expect in churches built by Palladio in Venice or reordered by Vasari in Florence after the reforms instigated by the Council of Trent. Especially notable is the absence of any concession to the independent initiatives or competitive instincts of families that acquired the rights to burial and private masses in the side chapels. Thus Veronese's three altarpieces made for the first three chapels to be entered from the south side were identical in size and format. Light entered the chapels from large lunette windows above each altar but it was usual for artists painting altarpieces in side chapels to show the light in the picture as if coming from the entrance façade of the church. Veronese follows this convention, in each case painting the light as falling from the right.

The nearest of Veronese's altarpieces to the west entrance depicted Saint Jerome (see fig. 3), the next one Saint Anthony Abbot and Paul the Hermit (fig. 2) and the third (NG 26) Saint Nicholas. The format must have encouraged him to provide a celestial element in each. The Virgin and Child look down from the clouds at Jerome. They appear again in the clouds

above Anthony and Paul, who ecstatically acknowledge their appearance. In the third altarpiece an angel descends to supply Nicholas with his bishop's mitre, crozier and stole. It is notable that the head of Jerome is placed relatively low. More remarkably, that of Nicholas is the lowest of all the heads in the third altarpiece. When NG 26 was placed above an altar, however, the beholder would still have looked up at Nicholas and the compositional device of a great open V would have worked far more effectively than it does when hung as a gallery painting.

Although Veronese would no doubt have welcomed the narrative elements in all of the altarpieces, the choice of episode was surely prescribed, and the treatment approved, by the Benedictines. Indeed, the scene of the consecration of Nicholas had already been selected for one of the frescoed decorations of the chapel.[23] It has also been plausibly argued that the emphasis on the Virgin (not generally associated with Jerome's penitence or with the meeting between the hermits Anthony Abbot and Paul) was consistent with the need for the Benedictines to emphasise their orthodoxy at that date.[24]

As stated above, Veronese was commissioned to paint these three altarpieces on 27 December 1561; on 30 March 1562, when he received final payment of 98 gold scudi, the abbey accounts refer to an advance of 25 gold scudi.[25] As Gould observed, 'the resulting deduction, that the three altarpieces were all executed within three months, takes some believing.'[26] One explanation might be in the local calendar, for in Mantua the new year began on 25 December, so 27 December 1561 would be 27 December 1560 in our calendar. However, the scribe clearly indicated that he was using the date in the style preferred by notaries, and not following popular usage ('stijllum notariorum, non autem secundum comunem usum modo loquendi'), so, unless the scribe wrote exactly the opposite of what he was instructed to write, we must suppose that Veronese either had some informal advance agreement concerning the commission or could work at astonishing speed.

Veronese was not paid much, although a little more than Lattanzio Gambara, who was given 102 gold scudi for his three altarpieces. The high altarpiece, admittedly a panel measuring 484 by 305 cm, cost 350 gold scudi.[27] Perhaps other Benedictine commissions were being dangled. Indeed, in 1562 Veronese also secured two altarpiece commissions for the abbey church at Praglia, near Padua, and, most importantly, he was commissioned to paint the gigantic *Marriage Feast at Cana* for the refectory of the Benedictine abbey of S. Giorgio Maggiore in Venice.[28]

Removal from the Chapel and Removal from the Abbey
Veronese's three altarpieces in S. Benedetto Po were highly praised by Vasari in the second edition of his *Lives*,[29] which should have guaranteed that they attracted special notice thereafter, but Carlo Ridolfi neglected to include them in his comprehensive list of the artist's work. By 1763, when Giovanni Cadioli (a minor painter much employed at the abbey) published his guide to works of art in and around

Mantua, the Saint Nicholas altarpiece seems to have been considered much superior to the others: 'so expressive, and so marvellously painted, that it truly surpasses many others by him which I have seen in Venice and elsewhere.' This estimate was repeated by Pagliari in 1788.[30] Bellodi's modern chronicle of the abbey of S. Benedetto dwells on misfortunes – the flooding of the Po, the rapacity of occupying armies, the reduction of privileges under Habsburg rule[31] – but the wealth of the abbey throughout the eighteenth century is evident from the quantity of new art that was commissioned, which certainly included lavish baroque marble altar frames for Veronese's paintings (discussed below). By Cadioli's day the painting was no longer in the third chapel of the south aisle but had been replaced by Giambattista Cignaroli's *Last Communion of Saint Benedict*, generally dated to about 1748, and moved to the fourth chapel.[32]

In 1786 Mauro Mari was made abbot. This philosopher and mathematician, born in 1746, began radical reforms to the abbey and shortly after 1790 he instigated, in response to a proposal made by Don Benedetto Fiandrini, the abbey's librarian and archivist, the removal of the greatest paintings – including NG 26 – from the abbey church to a *pinacoteca* in the abbey for the convenience of art lovers and because they were being damaged by damp and did not enjoy sufficient light.[33] They were replaced in the chapels in about 1792 by copies.

By September 1796 the monks had largely fled from the monastery, and the fall of Mantua to the French army seemed inevitable. General Bonaparte entered the city on 2 February 1797; the act suppressing the abbey was prepared on 11 February and Bonaparte signed it on 9 March.[34] The painter and collector Jean-Baptiste Wicar was already in the area in his capacity as member of the Commission Temporaire des Arts, charged with extracting major paintings from conquered territory for the Musée Central (later Musée Napoléon) in the Louvre. The prefect of Mantua's library handed over on 23 February a number of paintings including Mantegna's *Madonna della Vittoria* and Veronese's *Temptation of Saint Anthony*.[35] It would be surprising if Wicar did not also have a list of paintings to remove from S. Benedetto Po, with Veronese's *Saint Nicholas* at or near the top of it. However, the need to raise money– ostensibly to compensate the local victims of the war but also to cover war costs and convert the abbey itself into a hospital – may have prompted the authorities to put as many of the abbey's possessions as possible on the market.

Much of the property, including most, if not all, of the paintings not in the church, was acquired later in 1797 by Jean Frédéric Guillaume d'Amarzit, Comte d'Espagnac (1750–1817), and then sold by him to a Swiss merchant living in Milan, Giovanni Giorgio Müller, in June 1798.[36] One of these two may have exported two of the three Veroneses, the *Saint Nicholas* and the *Saint Jerome*, although it is also possible that they were stolen either by soldiers, peasants and monks, who were said to have raided the abbey's stores, or by French officials in Mantua, who are alleged to have acted outside the law.[37]

In any case, both paintings are conspicuous by their absence from the list of 176 pictures, mostly oil paintings, that was made in May 1800 as the property of Müller. Veronese's altarpiece of Anthony Abbot, however, was in this list (valued at 2,250 lire) – it was probably sold afterwards (it is mentioned on a list of exported pictures compiled in 1814) and was then sold in France in April 1820 in the sale of the Comte d'Espagnac, who had presumably continued in some sort of financial partnership with Müller.[38] The painting seems to have remained in France until 1954 when it was acquired by Walter P. Chrysler Jr, who presented it to the Chrysler Museum of Art in Norfolk, Virginia, in 1971. Its provenance between 1814 and 1950 is not recorded.[39]

By about 1810 Veronese's other two altarpieces were in the hands of a French dealer, Alexis Delahante. Despite the war between Great Britain and France in these years Delahante found a way to bring paintings to London, and in 1811 he sold the *Consecration of Saint Nicholas* to the British Institution (as described below). The *Virgin and Child with Saint Jerome in Penitence* was offered by him at Phillips on 3 June 1814 (lot 41), where it fetched 310 guineas (£325 10s.).[40] It was then offered for sale ostensibly as part of William Beckford's collection at Fonthill Abbey, but in fact it was still Delahante's property. It was bought in the Fonthill sale (10–15 October 1823, no. 269),[41] sold by Delahante again in 1831 (29–30 June, no. 81), and destroyed by fire at Yates's galleries in 1836. It is striking that Delahante considered it better to sell altarpieces by Veronese in London, where perhaps there were more wealthy collectors who were prepared to accommodate old masters of this size, rather than Paris.

The *Consecration of Saint Nicholas* in the British Institution and the National Gallery

Veronese's altarpiece was purchased in 1811 by the Governors of the 'British Institution for Promoting the Fine Arts in the United Kingdom'. It was the first old master painting to be acquired by them and was intended as a painting which would adorn a 'future National Gallery'. The full circumstances of this crucial step in the history of the National Gallery are described in the Introduction (pp. xvii–xix). The painting was included in the British Institution's exhibition of Old Masters in 1812, chiefly as a model for art students, and then in more ambitious public exhibitions in 1816 (as no. 87), 1821 (as no. 106) and 1824 (as no. 160). On 13 June 1826 the governors at their annual meeting unanimously resolved that the Earl of Aberdeen be authorised to offer the painting to the Earl of Liverpool (the Prime Minister) for the National Gallery[42] together with Parmigianino's so-called *Vision of Saint Jerome* (NG 33), which Holwell Carr had bought for the British Institution in 1823, and Benjamin West's *Christ healing the Sick in the Temple*, which had been acquired by subscription at the same time as the Veronese (and for twice as much). Given the size of these paintings their display in the Gallery's temporary premises at Angerstein's house near the British Institution in Pall Mall cannot have been easy, but the fact that they were pre-eminently

public works meant that they were admirably adapted to the Institution's primary educational purposes.

We have one full account of the painting's merits from John Landseer, an artist whose taste was formed in the early decades of the century. The scholarly antiquarian and accomplished engraver was especially enthusiastic about the colour. In his *Descriptive, Explanatory, and Critical Catalogue of fifty of the earliest pictures contained in the National Gallery of Great Britain* of 1834 he wrote:

> The emerald green colour which distinguishes the drapery of St Nicholas and which is judiciously spread about (or repeated, as painters technically say) in some parts of the performance, was bold and novel at the time when the Veronese artist first employed it, and is in brilliant opposition to the light ruby reds which play here and there through the picture: both seem to have the effect of electrically kindling the small portions of orange-tinged yellow into sparks of golden splendour; and the crimsons in particular, that of conferring the beauty of harmonious brilliance on that effective white surplice which is so boldly introduced, cast into such picturesque forms, and is so tastefully pencilled.[43]

The merits of NG 26 must have been somewhat obscured by the splendour of the paintings by Veronese that were subsequently acquired and, as noted above, the cleaning of the painting was highly controversial. In addition, although Alexis Delahante described the provenance, more or less

correctly, as from 'the Church of the Monastery of St Benedict, Mantua', William Young Ottley, either ignoring this or doubting it, claimed instead in one of the earliest guides to the National Gallery that it was 'from the Church of S. Niccolo de' Frari' in Venice,[44] doubtless because Ridolfi mentioned this subject among the ceiling paintings of that church, which was suppressed in 1806 (the canvas had in fact been inserted into the ceiling of the first sala of the Accademia Galleries in 1817).[45] Ottley's error was repeated in the Gallery's official catalogues and the correct provenance was not given until Fiocco's monograph of 1928.[46]

Provenance
See above. Abbey church of S. Benedetto Po until about 1790, and then the *pinacoteca* of the abbey, whence removed about 1797. By 1810 with Alexis Delahante. Sold by him in 1811 to the British Institution, by whom presented to the National Gallery in June 1826.

Copies
A full-size copy of the painting was made for S. Benedetto Po soon after 1790, as described above. It is likely to be the work of Giuseppe Turchi from Romagna, who is documented as working in the abbey in 1792.[47] It is still there, now displayed in the nave aisle opposite the entrance of the fourth chapel on the right. The other copies of the painting are less than a third of the size of the original. One measuring 109 × 67.3 cm was lot 4 at Christie's, London, 19 April 1973; another,

Fig. 3 Copy after Veronese, *Saint Jerome in the Wilderness*, *c.*1792. Oil on canvas, 285 × 170 cm. Abbey church of S. Benedetto Po.

Fig. 4 Baroque altar and altarpiece frame in the chapel of St Nicholas in the south aisle of the abbey church of S. Benedetto Po.

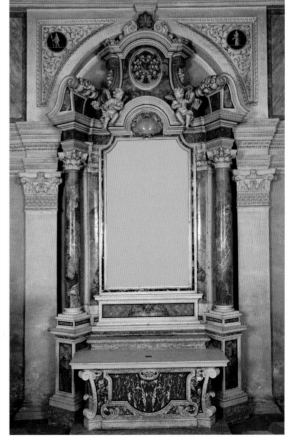

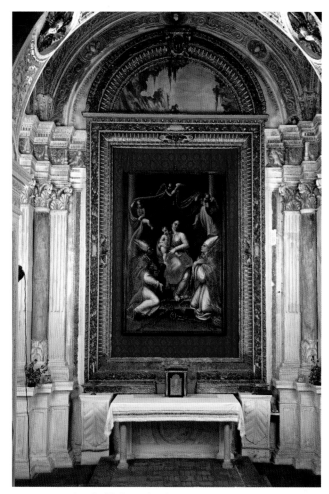

Fig. 5 Painted and gilded wooden frame over the altar in the Oratorio di Santa Maria, *c*.1550, in the abbey church of S. Benedetto Po.

slightly smaller (87.9 × 56.5 cm), was lot 689 in the Christie's sale at Castello de Bendinat, Majorca, 24–25 May 1999. Both of these are likely to be copies made at the British Institution, which encouraged copies of less than half-size, or even at the National Gallery itself.

Exhibitions
London 1812, British Institution; London 1816, British Institution (87); London 1821, British Institution (106); London 1824, British Institution (160); London 1947, National Gallery, *Uncleaned Pictures Exhibition* (41).

Framing
The painting would originally have had a frame designed by Giulio Romano. One altarpiece frame of similar size and almost certainly of similar, if not identical, pattern survives in the abbey church in the Oratory of Mary, also known as the Chapel of the Immacolata, beside the presbytery (figs 5 and 6). The principal ornament consists of a frieze with a dense garland of fruit and vegetables bound by a ribbon which is bordered by egg-and-dart ornament. This encloses a fluted hollow which is interrupted at the centre of each side by cherubim. The wood is gilded in parts and also partly painted

green.[48] Clearly the white, green and gold would have related in an interesting way to Veronese's painting.

The original frame was replaced by the imposing baroque marble frames that still adorn the church (see fig. 4). In this arrangement, coloured marble columns support a canted entablature that breaks in the centre to form a lunette supported by child angels, above which there projects another lunette. Essential to this design is the way that the upper corners of the rectangular altarpiece are cut, for the curving lines relate to the curving lunette.[49] The cut corners of Veronese's two surviving altarpieces for the church have been supposed to be original, but there are no other examples of a sixteenth-century altarpiece with this shape and the canvases were surely reshaped when the altars were given these baroque frames. Their date is not known but the style suggests the 1720s, and extensive work in the nave is documented to 1725–6.[50] An aversion to these very theatrical settings by Abbot Mari and Don Fiandrini, who had strong neo-classical leanings, may have been one motive for removing Veronese's altarpiece to a *pinacoteca* in the monastery.

A gilt neo-classical frame with acanthus ornament in a deep hollow survives in the Gallery's store, its press-moulded 'compo' ornament somewhat damaged. This is the frame in which the painting was first shown in the Gallery and almost certainly the one given to it by the British Institution. Photographs show that this frame was still in use in the 1920s (see fig. 16, p. 376) and it was presumably on the painting when it was taken down for restoration in 1964. After treatment the painting was given the current carved and gilded frame (fig. 7).[51] This is Italian, perhaps Venetian, and of the late sixteenth century, but extended on the sides and with spandrels and a narrow *cavetto* moulding at the sight edge added. The dense ornamentation is not unlike that of the original frame and is of a kind found also in ceiling coffering and on furniture: there is an outer moulding of acanthus, curling inward, with the inner moulding of bay leaf running from the centre to the corners and, between these, a pulvinated frieze consisting of a chain in which broad eight-petalled flowerheads alternate with round six-petalled rosettes.

Fig. 6 Detail of the frame in fig. 5.

Fig. 7 Corner of the current frame of NG 26.

NOTES

1. Penny and Spring 1994, p. 13.

2. Ibid., p. 15.

3. Ibid.

4. See p. 334.

5. Payments for extensive 'restauri pittorici alla chiesa' were made to Giovanni Battista Lorenzetti in April 1723, see Belluzzi 2001, p. 146.

6. Landseer 1834, p. 161.

7. See especially para. 3059. See also Hendy 1947, p. 41, no. 41.

8. For examples of this see Penny 2004, pp. 322–3.

9. Penny and Spring 1994, pp. 13–14, esp. plate 8.

10. Ibid., esp. plate 9.

11. Caraffa, IX (1969), cols 923–45. Myra is now Demre. A bronze statue of Saint Nicholas has recently been replaced in the town square by a coloured plaster effigy of Santa Claus (*Washington Post*, 24 March 2005, pp. A1 and A16).

12. Voragine 1969, p. 18.

13. Jameson 1888, II, p. 461.

14. Vasari 1568, I, pp. 490–1.

15. Triqueti 1861, p. 62 – 'il passe parmi beaucoup d'amateurs pour une œuvre du fils de Paul Véronèse, peinte d'après l'esquisse du grand maître.'

16. Bellodi 1905, pp. 63–4 and 90–1. See also Belluzzi 2001, p. 140, for contracts.

17. Belluzzi 2001, pp. 141–3, and for the high altarpiece see Di Giampaolo 1997, p. 130, no. 28 and fig. 26 (p. 76) – the painting has been in the Louvre for more than 150 years but has never been on display.

18. Belluzzi 2001, p. 144, and Bonsanti 1992, pp. 222–33. One of Saint Nicholas

stands at the entrance to the chapel where the painting originally hung.

19. Belluzzi 2001, p. 144, citing the transcription made by the abbey's late eighteenth-century archivist, which is now in the library of the Getty Research Institute (Papers of Giovanni de Lazara, busta 87030-5).

20. Pignatti and Pedrocco 1995, I, p. 136 and pp. 107–8.

21. Ibid., I, pp. 61–2, no. 33, now Musée des Beaux-Arts, Caen.

22. See Piva and Pavesi 1975; Tafuri 1989; also the analysis in Brown 1997, p. 54.

23. Brown 1997, pp. 56–7. The fresco occupies the western lunette.

24. Ibid., pp. 57–8.

25. Caliari 1888, pp. 52–3.

26. Gould 1959, pp. 140–1 (note 3); 1975, pp. 317–18 (note 3).

27. Di Giampaolo 1997, p. 130, no. 28.

28. Pignatti and Pedrocco 1995, I, pp. 246–8 (for Praglia altarpieces), and pp. 250–2 (for S. Giorgio), and Habert 1992 for the S. Giorgio *Marriage Feast at Cana* (now in the Louvre).

29. Vasari 1568, I, pp. 490–1.

30. Cadioli 1763, p. 128 ('così espressivo, e sì mirabilmente dipinto'); Pagliari 1788, p. 19.

31. Bellodi 1905.

32. Perina Tellini 1981, p. 383. The subject of the painting is currently mislabelled in the church as the 'Eucrestia di S. Nicolo'.

33. Sicoli 2001, p. 122; Negrini 1981, pp. 409–10.

34. Bellodi 1905, pp. 222–4 (for flight of monks), pp. 225–7 (for details of suppression).

35. Sicoli 2001, pp. 111–12.

36. Bellodi 1905, pp. 230–1. Ferrari 2001, p. 73. In these accounts d'Amarzit's name is

given in its Italian form. Burton Fredericksen revealed d'Amarzit's true identity to me.

37. Sicoli 2001, pp. 119 and 120.

38. For the 1814 list see Bellodi 1905, p. 263. The d'Espagnac sale was 4 April 1820, and the Chrysler painting was lot 59 – I owe this reference to Burton Fredericksen.

39. Ferrari 2001, p. 176; Harrison 1995.

40. Fredericksen 1993, II, p. 1086. The purchaser was 'Morant' or 'Seymour'.

41. As Burton Fredericksen pointed out to me, had the painting been Beckford's property it would have been included in the catalogue prepared by Christie's in 1822. It is well known that Farquhar, who purchased Fonthill Abbey in 1822, allowed the sale in 1823 to be packed with other properties.

42. Victoria and Albert Museum (National Art Library), English MSS, RCV, 15, British Institution Minute Books, fol. 44r. Lord Liverpool's letter of acceptance, dated 19 June 1826, is inserted between fols 52v and 54r.

43. Landseer 1834, pp. 160–6.

44. Ottley 1832, p. 45, no. VIII. For Delahante see the entry for Saint Jerome in the sale catalogue, cited by Fredericksen 1993, II, p. 1086.

45. Pignatti and Pedrocco 1995, II, p. 411, no. 211 (and for the series, and the provenance, p. 409).

46. Fiocco 1928, pp. 86, 199.

47. Perina Tellina 1981, p. 389.

48. Golinelli and Piva 1997, plates on pp. 86 and 101.

49. One such is illustrated by Harrison 1995, fig. 3.

50. Belluzzi 2001, pp. 138–9, 148–9.

51. Annual Report for the period June 1962 to December 1964, p. 139.

The Family of Darius before Alexander

*c.*1565–7
Oil on canvas, 236.2 × 474.9 cm

Support
The dimensions given above are those of the stretcher. The canvas, which is of a medium-fine tabby weave, is composed of two pieces joined horizontally with a seam just above the heads of the queen and the queen mother. It was prepared with a layer of gesso containing a significant proportion of calcium sulphate of the anhydrate form, as distinct from the dihydrate which is natural or slaked gypsum.[1] As is also the case with a number of other large paintings by Veronese, there seems to be no *imprimitura*.[2]

Materials and Technique
Both linseed oil and walnut oil have been detected by analysis. The latter is used (as elsewhere in Veronese's work) for the near white of the architecture because it was less yellow in colour than the former, and was believed to have less of a tendency to turn yellow.[3]

Red lake, derived from insect dyestuff, was used for Alexander's crimson garments, for the boots of the boy before the queen mother, and for the rose pink of the kneeling girl's dress; but another type, derived from brazilwood, was used for the stripes in the sash worn by the woman at the far left edge.[4]

Copper green (verdigris) mixed with lead white and lead-tin yellow was used for the cloak of the dark-bearded man beside Alexander. This same copper green was used as a glaze over a similar mixture for the green dress of the kneeling servant on the extreme left of the foreground and the glaze has darkened.[5] The lead-tin yellow already mentioned is 'type II' and is used, mixed with yellow ochre and some yellow lake (plant derived), for the brocade of the kneeling queen.[6]

Orpiment and realgar were employed for the cloak of Hephaestion and for the clothes of the dwarf on the left, where, however, they are mixed with the red iron oxide haematite – a mineral pigment relatively rare in oil painting – and red lead. The yellower lights on the drapery folds consist of pure orpiment.[7]

Three types of blue pigment were employed: ultramarine in all the blue garments of the foreground figures (including the blue and white overdress of the kneeling princesses); azurite as an underlayer for some of the ultramarine and also mixed with red lake (for the purple tassel on the halberd on the extreme left); smalt for the sky (where it has deteriorated to grey) and in a layer below the ultramarine glazes of the cloak worn by the foremost kneeling queen (where it has darkened).[8]

Conservation
See below under Conservation History.

Condition
The Family of Darius has long been especially esteemed for its excellent condition. Indeed, Baron Karl Friedrich von Rumohr, in his notes, made about 1825, declared it to be the 'only surviving touchstone whereby that which was genuine in the colouring of the artist's original works could be estimated ... the treatment of colour especially in the flesh and excellence of execution are such as to render us almost unjust to other great colourists.'[9] From the account of the picture given by O'Kelly Edwards, we may conclude that in Venice connoisseurs attributed its preservation to its having long remained in the same family's care, and 'above all, to the prudent resolution of the owner not to allow either whole or partial copies to be made of it, on account of the destruction of so many first-class pictures by copyists'.[10] This is a reference to the practice of 'oiling out' a painting that was being copied, by which means, Giovanni Battista Volpato believed, the surface of Titian's *Death of Saint Peter Martyr* had been gravely damaged.[11]

Exaggerated repetitions of the conventional estimates of the painting's preservation continued after its removal to London, when Henri de Triqueti, the French sculptor and a well-informed connoisseur, wrote in his *Les Trois Musées de Londres* of 1861 that 'by common consent' ('d'un avis commun') it was 'the artist's best preserved work' ('l'œuvre la mieux conservée du maître'). He explained that its condition was due to its never having been moved from the place where it was painted (not true, as we shall see, but it had travelled relatively little) and its never having been subjected to the attentions of picture cleaners (an absurd supposition and, as noted above, demonstrably incorrect).[12]

The green dress of the servant kneeling at the left edge and the shadows of the deep blue cloak of the foremost kneeling queen have darkened for reasons discussed in the section on Materials. These changes detract very little from the brilliance of the foreground colours, which are also enhanced by the silvery grey setting and the somewhat spectral figures in the distance – a pleasing effect that was, however, not intended. The colour of the sky has changed, for the smalt that was the chief pigment employed has turned grey. Nevertheless, the original sky may have been a relatively pale blue and it was certainly cloudy. The architecture has become translucent in parts (notably to the right), as have the horses and figures painted on top of it on the left and the figures on the balustrade. The latter figures were, however, surely meant to be pale and the supposition that they were left in an unfinished state by the artist is not supported by the fact that they are carefully, if thinly, painted in more than one layer.[13]

The relief carving of scrolling acanthus represented in the frieze of the architectural screen is interrupted above the capitals of the pair of Corinthian columns on the left side of the painting. Above and below these interruptions in the frieze, traces of a projection of the cornice and architrave may be discerned, and other such traces can be found at equivalent points in the entablature (corresponding to blocks in the balustrade above). These were more apparent before the cleaning of 1958, but Veronese's original glazes were not, it seems, damaged on that occasion, since there are extensive vestiges of a natural resin varnish, deliberately tinted (which cannot be original, since it has seeped into cracks in

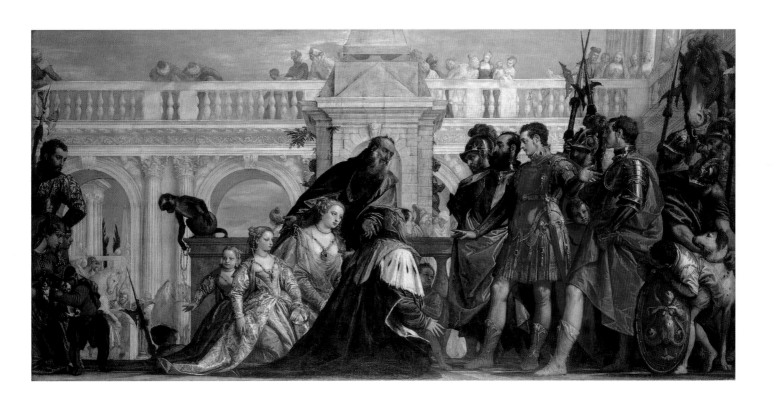

Fig. 1 Detail of NG 294.

the paint).[14] The breaks in this entablature were, presumably, reinforced (perhaps in the varnish layer) after a previous cleaning by someone familiar with the original appearance of the painting or with the preferences of sixteenth-century Venetian architects – or both. Gould thought that 'Veronese had toyed with the idea of a broken entablature. Later restorers in fact fulfilled this.' He added that 'these restorations were removed in the 1958 cleaning.'[15]

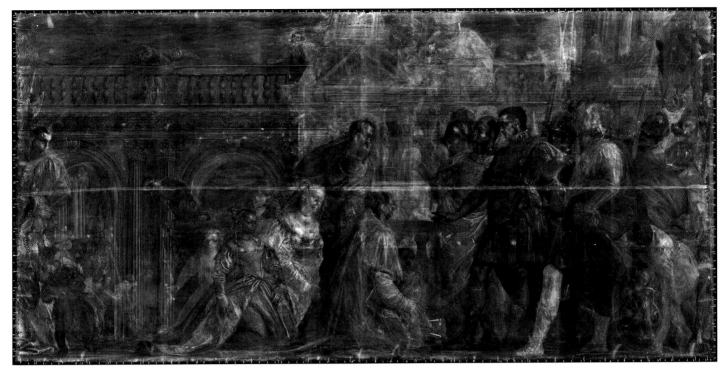

Fig. 2 X-radiograph mosaic of NG 294.

Eastlake's Notes on the Technique and Condition

Eastlake made careful notes on *The Family of Darius* by 'P. V.' in the 'Pisani Pal' during his continental tour of 1852. It should be borne in mind that he was at this date writing as a historian of oil painting and not as the director of the National Gallery. He begins by observing that the Veronese is painted on 'rather fine cloth not ticking' (that is, a tabby weave rather than the twill weave often used for large paintings). Next, he is struck by the thickness of the blue of the queen mother's robes – 'very thick so as almost entirely to conceal cloth – sw. [sweep] of brush seen in its thick substance of col. [colour] perhaps w.o. [walnut oil] its thickness seen on comparing the edge behind in lower part with cols [colours] next it.' He also remarked on the absence of craquelure: 'no cr [cracks] anywhere except slightly from cloth – even grn dress free from cr.' He is interested in the different textures of the paint: 'the d. [dark] green stripes in dress of dwarf ... glossy as comp [compared] with cols near it' and a marked 'thickness of vehicle' seen in the dark green legs of the bearded figure immediately to Alexander's right, as also in parts of the 'purple gr. [grey] drap [drapery]' of the man introducing the royal family. He remarks on the 'system' of 'red macchie opp. [opposed] to cool' – 'macchia' is the Italian word for spot or patch, a term that was gaining renewed currency at this date among Italian painters who valued distinct painterly touches of colour. Presumably Eastlake was struck by the way the lights are painted between eye and nose, and above all between the nose and lips, which from close to seem abrupt. As noted above, this also seems to have concerned Eastlake after the painting arrived in London. He thought the architecture 'ruled and drawn with fine d. [drawn?] lines but not dug in – as far as can be seen'.[16]

Two years later he made more notes and this time he was already perhaps considering the painting's eligibility for the National Gallery: the 'dist [distant] figs. with only preparatory colours against the silvery architecture', the 'green drap. like Bonif [Bonifazio]', the 'head under helmet extremely fine', and the 'pict. altogether in fine state'.[17] Returning in 1856 he was certainly looking for any possible objections to the painting, which by then he intended to purchase. He noted that it is hard to be sure whether Hephaestion's left leg is draped or not: 'if intended for hose it wants folds.' 'The only other defect (except the obvious defects in costume & character) is the sky, which in the parts intended for blue (there are light horizontal clouds besides) is a very light greenish grey, as if the colour had flown.' He also noted the translucent figures on the left but concluded that the picture was in general indeed 'in excellent state'.[18]

The Evolution of the Composition

Few, if any, of Veronese's large paintings are likely to have been painted entirely by his hand, but the superior quality of *The Family of Darius*, apparent in the vital silhouettes of the smallest distant figures as in the slight variations in the ermine tails in the mantle of the foremost kneeling queen, suggests that he worked on every part of it. The fact that the original design was altered to a degree which is unusual in his large paintings also suggests that he himself was wholly responsible for the execution.

Publishing an X-ray mosaic of the painting in 1978, Gould noted parallel horizontal lines extending from the central fountain structure towards the right and concluded that the 'fountain started life as a wall and not as an isolated object' (fig. 2). However, it is also possible to discern massive balusters,

Fig. 3 Detail of NG 294.

OPPOSITE:

Fig. 4 Paolo Veronese, *The Marriage Feast at Cana*, 1562–3. Oil on canvas, 666 × 990 cm. Paris, Musée du Louvre.

Fig. 5 Paolo Veronese, *Saint Sebastian exhorting Marcellus and Marcellianus to go to their Martyrdom*, 1565.
Oil on canvas, 355 × 540 cm. Venice, Church of S. Sebastiano.

the first of which is immediately to the right of the head of the bearded man in the centre, and these support the entablature, the horizontal lines of which Gould observed across the right half of the painting.[19]

Gould also noted what looked like a large figure in the upper part of the painting, to the right of the fountain. He wondered whether Veronese had employed a canvas upon which a different painting had been started or whether he 'had at one time planned a high pyramidal group of figures, with this one standing at a level well above the terrace'. Once the large balusters are discerned it is clear that there were originally large figures leaning over it, almost as large as the chief figures in front of it. Veronese must have found that they competed too much with the main actors. He employed a similar scheme in his *Marriage Feast at Cana* (Paris, Louvre, fig. 4), painted for the refectory of S. Giorgio Maggiore between 1562 and 1563, where large figures hang over the balustrade immediately behind Christ and the disciples, but in that case there is less confusion of form because the figures in front of the balustrade are seated.

When Veronese decided to create the rusticated fountain structure in the centre, he incorporated the entablatures of

the balustrade he had originally planned, and the edge of the pier concluding it, but extended the structure to the left of the pier, thereby encroaching on the distant Corinthian screen, which he had already begun to paint and which he seems to have planned from the start for the left side of the picture – a structure not unlike the one employed to the right of his large painting of *Sebastian exhorting Marcellus and Marcellianus to go to their Martyrdom*, painted for S. Sebastiano in 1565 (fig. 5). Finally, he continued the distant screen across the right side of the painting. The form which the fountain structure was to take was not, it seems, settled immediately. Gould observed that the corners were originally articulated with pilasters. In addition it may at one stage have been envisaged as a pedestal not for an obelisk but for a statue – perhaps a statue of Darius?[20]

Veronese's final revisions are visible to the naked eye. He added the horses and other figures in front of the screen on the left and, last of all, added the head of a halberdier to clarify the sudden change in level and mask the abrupt transition. The halberd is painted over the cloak of the man behind (Veronese could not resist rhyming its blade with the raised leg of the horse).

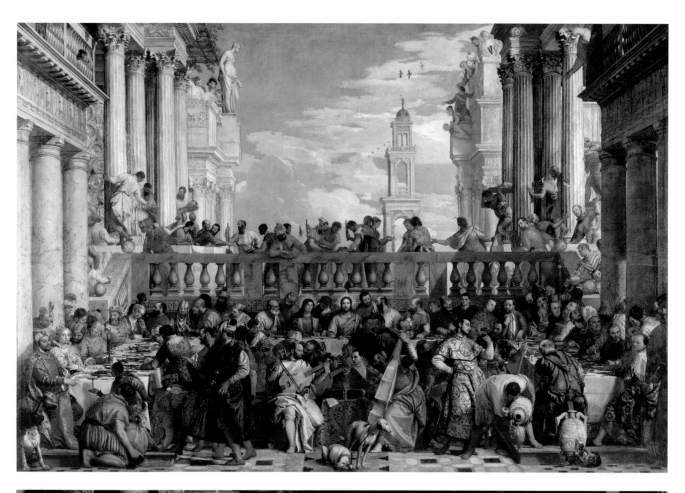

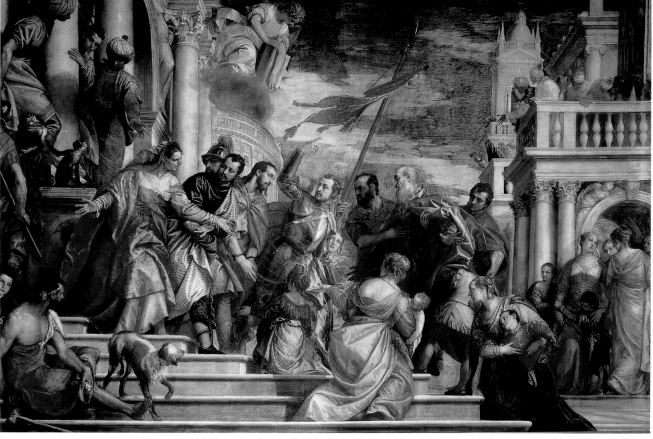

Traces of preliminary drawing probably in charcoal are apparent in the thinly painted background figures and in the architecture. Black and red particles found in the upper layers of the gesso ground in some sections suggest that red chalk was also used for this purpose. Given the revisions described above, it is not surprising that some of the drawing was made on top of paint layers.

Conservation History

Giuseppe Bertani, a minor painter and prominent restorer in Venice, received payment on 9 October 1770 for work done on the painting.[21] The nature of his intervention was described to Mrs Merrifield in the 1840s by O'Kelly Edwards, who claimed that the painting had merely been lined and cleaned and some small losses retouched. In addition, the blue sky had been restored to its original colour. The varnish had not changed but, Edwards noted, the blue sky had turned greenish since it was not 'ultramarine' but 'turchino'.[22] It is unclear whether Edwards, knowing that the sky had changed colour, merely imagined that it had turned greenish (as is the case with many paintings by Veronese in which azurite was employed) or whether he was referring to the way that the overpainting on the sky, concealing the grey of the original, had turned greenish. Edwards's source was his father, Pietro Edwards, the leading restorer in Venice and one of the leading connoisseurs of old master painting there between about 1780 and his death, at the age of 76, in 1821.[23] O'Kelly Edwards (or Merrifield) was mistaken as to the date of the work, which was said by him to be 1778, and also mistaken in claiming that it was done under his father's 'superintendence'. But Pietro Edwards and Bertani had been associates, and Pietro Edwards left numerous notes on his work and may often have spoken of the Veronese (one of the most famous pictures in the city), so the testimony is of real value. The canvas may not have been lined before 1770 but it had almost certainly been cleaned at least once, and the sky had, it would seem, been extensively overpainted.

According to Levi, the painting was also restored by Lattanzio Querena in about 1800.[24] On 31 March 1857 the painting was removed from its stretcher and rolled.[25] On 12 August 1857 Eastlake wrote to Wornum from Cologne:

My thoughts are of course much with the Paolo & the question of the length for the stretching frame recurs to me. In any view of the matter Mr Bentley will have something to do to the right hand edge, & if he can make the whole of that repainted strip look quite like the old work the composition would gain by it, as the arm and hand would be rather unpleasantly cut off if that side were reduced by two or three inches. The question may therefore depend on what Mr Bentley says as to the possibility of a perfect operation. The addition not being by the master himself is certainly rather against it being included, but it is not impossible that it may have been originally by him & that in consequence of chippings and rents at the edge may have been repaired as it is. The present repaint of that strip is worthy of a sign painter, & if done afresh it should be perfect as a restoration, the correct drawing & marking & finally the granulated effect of glazing or of dirt being recovered.

The discolouration in the sky under the arch as well as in and above the balustrade will also require careful revision. The left edge & the upper & lower edges should be left as they are – any little spots where the colour has chipped off being made good.[26]

It is probable that the strip on the right (perhaps Querena's work?) was repainted and other minor work must have been covered in general payments made to Bentley early in 1858.[27]

In a memorandum Eastlake further noted that the painting had been lined 'more than 50 years since', that he would recommend that Bentley 'avoid taking off all the brownish Venetian dirt', that there was a 'spot in the face of the wife of Darius' which required attention. In the manuscript catalogue this 'spot' is further described as a 'rather abrupt' patch of red, 'possibly from the flesh of the women having been, at some former period, partially cleaned'. The effect was, presumably, softened by Bentley, who also 'varnished the picture with mastic varnish'.[28] Since the work is recorded under the date of October it must have been undertaken when the picture was already on the wall – Wornum records that it was hung on 16 September and varnished on 19 September.[29]

The painting was surface-cleaned and varnished by Dyer in 1888, and cleaned and varnished by Buttery in 1913. It was very slightly damaged at the lower left-hand corner in 1917 (it had been in a cellar for safety during the war). Minor spots and damage at the edges were treated by Vallance in 1935. In August 1939, during the painting's transit to Bangor in Wales, three vertical bands of damage were caused to the varnish, which Holder repaired in November 1941. The painting was 'polished' in 1946. It was cleaned and restored in October and November of 1958. One reason for this seems to have been that the damage caused in 1939 was showing again. Complete though the National Gallery's records are, it is not clear at what stage the narrow strip added to the right edge, which we know that Bentley retained, was removed. Since its removal would have supplied a pretext for the reframing, which seems to date from after the 1958 cleaning, we may conclude that it was silently discarded at that date. On the other hand, it is not visible in any of the early photographs of the painting.

Attribution and Date

The painting has always been acknowledged as by Veronese and the quality is such that his workshop is not likely to have been much involved. There has, however, been little agreement on the painting's date. Osmond in 1927 thought it might be as early as 1560[30] and Gould proposed that it was executed as late as 1573.[31] It is likely that Gould arrived at this date by way of his conviction that the painting was made by Veronese not only for a Pisani villa but when he was actually staying in one, in accordance with a tradition discussed in a later section in this entry. This conviction led Gould to

identify a period when Veronese might have wished to retire from the city; an obvious date was after 1573, when he had been obliged to defend himself before the Inquisition.[32]

A date in the early 1570s, or in the early 1560s, does not seem impossible, but Pallucchini's suggestion of 1565–7[33] has more to recommend it, since in this case the painting would be contemporary with, or a little later than, the pair of large lateral paintings that Veronese made for the tribune of S. Sebastiano, *Sebastian exhorting Marcellus and Marcellianus to go to their Martyrdom* (fig. 5) and *The Martyrdom of Saint Sebastian*. These works are closely related to NG 294 in their compositional type and architectural settings, but also have some less conspicuous but telling details in common with it: the device of a monkey crouching on a parapet is employed on the left in *Sebastian exhorting Marcellus and Marcellianus*, as on the left in *The Family of Darius*. In the *Martyrdom of Saint Sebastian* the profile of the statue on the left of the composition is identical to the one to the right of the central fountain in *The Family of Darius*.[34] The horse's head on the extreme right of *The Family of Darius* strongly recalls the one on the right of his *Martyrdom of Saint George* for S. Giorgio in Braida, Verona (fig. 1, p. 330), which there is good reason to date to the mid-1560s.[35] When NG 294 is compared with the S. Sebastiano narratives it must be acknowledged as more lucid in composition, with a more telling use of interval, and with the foreground drama more carefully related to the background architecture. The way that the rhythm of the arches and the fountain niche relates to the movement of the figures from the left is especially effective, as is the way that movement comes to a halt with the verticals framing the shocked profile of the queen mother, whose triangular pose is echoed by the superstructure of the fountain. For this reason *The Family of Darius* must surely be a little later in date. As is mentioned below, a document has now been published which reveals that the painting must have been completed by 1568.

Subject

After his victory over Darius III at Issus in 330 BC, Alexander, then aged 23, visited the distraught family of the defeated Persian emperor, who had fled the field. Sisigambis, the mother of Darius, made obeisance to Alexander's closest friend, Hephaestion, mistaking him for the victor, but Alexander comforted her by graciously observing that Hephaestion was 'another Alexander' (that is, so close a friend that they were as one). Sisigambis was accompanied by Darius's sister, Stateira, who was also his queen, and by the queen's two daughters, both unmarried, the eldest also called Stateira (or, in some accounts, Barsine). These are the figures who kneel, in that order, in the painting. A young son of Darius was also present and is represented by the boy in red beside Sisigambis. Alexander received the family nobly, in the words of Plutarch (as translated by Sir Thomas North) 'ensuring that they never heard word, or so much as any suspicion that should make them afraid to be dishonoured or deflowered',[36] and insisting that they all be treated as royalty and retain their finery. When Darius died he declared that the gods would reward Alexander for the kindness he showed to Sisigambis

and his wife and children. Alexander's biographers stress that no greater deed was ever recorded of him.[37]

There have been different interpretations of the figures on the right in Veronese's painting but Hephaestion must be the figure in dark armour with an orange cloak, who seems, literally, taken aback, and Alexander must be the figure in rose, calming the royal ladies with one hand and indicating his friend, 'the other Alexander', with the other. If this seems too precise a reading of the hand movements, it must be allowed that Veronese often used such gestures to indicate speech and it is Alexander, not Hephaestion, who is recorded as speaking on this occasion.[38] Other interpretations are mentioned in the next section.

Charles Locke Eastlake, nephew of Eastlake the director and himself keeper of the National Gallery, suggested sensibly that the horse 'towering above the figures' was 'probably intended to represent Bucephalus, Alexander's famous charger, of whose huge proportions and sagacity curious stories are told.'[39]

Ancient Sources

Arrian (Lucius Flavius Arrianus),[40] reviewing the numerous earlier accounts of Alexander's life, doubted that his visit with Hephaestion to the family of Darius had ever taken place. He found it recorded in some sources, but according to others Alexander had sent his general Leonnatus to comfort them. It is the latter event which is described in Plutarch's account of Alexander in his *Parallel Lives*, and such was Plutarch's fame that it is natural to suppose that he was Veronese's source. But Plutarch wrote the *Lives* in Greek and, although printed in Florence in 1517 and by the Aldine Press in Venice in 1519, it was not available in a modern language before Jacques Amiot's translation (published in French in 1558 and then translated from French to English by Sir Thomas North in 1579). Knowledge of Plutarch was widespread in the seventeenth century and Ridolfi, in the earliest known mention of the painting,[41] regarded it as illustrating Alexander's continence and magnanimity, 'little imitated by captains of troops for whom murder and rapine are the trophies of victory' – qualities that Plutarch expands upon, mentioning also Alexander's indignant rejection of captured boys and his moderation at table.[42] But it is surely impossible that Plutarch was Veronese's source, for Plutarch never has Alexander address the women, makes no mention of Hephaestion in connection with their meeting, and does not describe the queen mother's error. Moreover, he emphasises the fact that the chief cause of the family's distress was the sight of Darius's chariot and bow, which they mistook for evidence of his death, and neither is present in the painting.

The two fullest accounts of the visit of Alexander and Hephaestion to the family of Darius can be found in the *Historical Library* of Diodorus Siculus[43] and the *History of Alexander the Great* by Quintus Curtius Rufus.[44] The former is a less likely source since it was in Greek, and the relevant chapter was not even available in Latin in Veronese's day. The latter was written in Latin and was printed by the Aldine Press in Venice in 1494 and 1510, and printed at Strasbourg with a

commentary by Erasmus in 1518. These, however, include numerous details that Veronese does not follow: the women are in Darius's tent; Alexander is only accompanied by Hephaestion – who, it is emphasised, is superior in height; Sisigambis's error is pointed out by captive eunuchs; and Alexander raises her as he speaks.

It therefore seems most likely that the artist's source was the simplest and shortest of all those available to him – the *Factorum et Dictorum Memorabilium* of Valerius Maximus – which includes none of the above-mentioned details, although Hephaestion's imposing presence is remarked upon. Here the episode is isolated from a larger narrative of Alexander's life and used as an illustration of noble friendship.[45] Jean-Paul Richter, who was the first to note Veronese's dependence on this source,[46] pointed out that Valerius Maximus had been printed by the Aldine Press in 1534. Even more significant is the fact that it was readily available in Italian – *Valerio Maximo Vulgare* was printed in Venice in 1504, 1509, 1526 and, in octavo, 1537. Indeed, it was as familiar in the Renaissance as it is obscure today.[47]

A recent claim that Plutarch is 'the source' rests on the 'crown on the arm of Darius's eldest daughter which is taken to allude to her imminent marriage to Alexander'.[48] It is possible that Veronese attempted to conflate the princess's prospects as a bride with obeisance to the conqueror – although Plutarch does not in fact mention that any idea of marriage was considered at this moment, the offer was made two years later, before the Battle of Arbela, and the marriage actually took place in 324 at Susa, after the death of the girl's parents.[49] Even so, such a reference would make Plutarch not the only or principal source but, rather, a supplementary one. However, it seems more likely that the crown belongs to the queen and is being carried by her elder daughter, since this would hardly be the right moment to wear it. Apart from the danger that the crown might fall off the queen's head, obeisance necessitates its removal (as is invariably the case with the kings in depictions of the Adoration).

The same scholar argues that Alexander could be 'the more macho figure in the more honorific cloth of gold with laurels on his armour standing close to his standard attributes, the shield and the horse'.[50] Goethe seems to have thought this too (see appendix, below). The possibility of confusion is necessary if we are to understand the queen mother's mistake, but, as explained above, it is Alexander who makes the gracious speech and we would also expect him to be placed nearer the centre of the composition. As Gould correctly observed:

> The figure in red is not only the more conspicuously dressed of the two: he is also the central point in the composition of the picture. And the latter is a factor which does not affect the other characters in the painting, but only ourselves as spectators of it....
> If, therefore, the figure in red is intended as Hephaestion, Veronese would have been intentionally deceiving not only the family of Darius but also everyone who saw his picture. And this seems to me quite uncharacteristic of him.[51]

Dress, Armour and Accessories

Like many other paintings by Veronese, *The Family of Darius* presents a mixture of contemporary dress with the exotic, the fantastic and the imaginatively archaeological. This mixture was sometimes regretted in the seventeenth, eighteenth and nineteenth centuries, but by the 1880s it was widely felt that the 'frank introduction of the costumes of the painter's own time ... gives to his pictures a living interest that more than compensates for any anachronism.'[52]

The plate armour worn by the figure here identified as Hephaestion and by the bearded soldier on Alexander's other side is an accurate representation of Italian armour of about 1560–90. Hephaestion's armour is extremely close, if not identical, to that worn by Saint Sebastian in Veronese's *Saint Sebastian exhorting Marcellus and Marcellianus* of 1565. The guards behind Hephaestion and the soldier with a green cloak wear a type of helmet known as a burgonet, which was used by light cavalry and infantry all over Europe in this period. Their halberds (like the one on the left side of the painting) are of 'a kind that seems to have been used mainly by bodyguards rather than people actually going out to fight battles'.[53] The halberd nearest to the centre of the painting has an unusual trefoil opening in the axe blade and an equally unusual point.[54] In the equipment mentioned so far only the gilded mask on top of the breastplate worn by the soldier with a green cloak and the victorious laurel damascened into the steel of Hephaestion's armour (so as to resemble a reflection) recall the fanciful decorations of parade armour made for courts of the mid-sixteenth century.

Alexander's armour, on the other hand, is based on antique sculpture, which also inspired some of the more elaborate parade armour of the period, such as Bartolomeo Campi's outfit for Guidobaldo II della Rovere dated 1546,[55] and costumes worn in masques. The cuirass (presumably of leather) moulded in the form of the torso (with the navel very evident), the girdle (*cingulum*) at the waist, and the pleated skirt below are all derived from Roman armour, and the buskins (*cothurni*) could have been studied from those in antique statues of Diana. Like his companions to right and left, Alexander wears a long cloak probably inspired by the *paludamentum* of Roman generals. His is deep rose in colour and is carried by a page whose apparently disembodied head appears behind him, whereas his companions hold up their own. However, some modern features intrude even in Alexander's dress. Under his cuirass he wears a mail shirt with a striped pattern in the sleeves made partly of brass and partly of steel rings. His sword is not of an antique pattern but it resembles the ornamental weapons illustrated by Filippo Orsoni of Mantua, whose pattern book of 1554 is in the Victoria and Albert Museum.[56]

The page on the extreme right may be intended as the page who would normally carry the prince's parade shield and helmet. The shield is decorated with a harpy-like creature whose split foliate legs curl over her arms – a close relative of the creatures with lowered heads, pointed breasts, raised hands and projecting bellies found here on the fountain and in many ornamental bronzes in Venice from the

1550s onwards (figs 8 and 9). The high relief and the colour suggest the parade shields in steel, gold and silver that were made by the Negroli in the mid-sixteenth century.[57]

The page leans forward, revealing an imperial eagle emblazoned on the back of his silver jacket. The use of the emblem of the Holy Roman Empire to recall the ancient Roman Empire is found in a shield in Titian's *Ecce Homo* of 1543 in Vienna, and on a banner in his *Martyrdom of Saint Lawrence*, upon which he was working throughout the 1550s.[58] Veronese had taken up this idea for the banner and surcoats of the imperial Romans in his *Martyrdom of Saint Sebastian* of 1565.[59] But to find it used for the Macedonian emperor is perhaps surprising.

The family of Darius wear Venetian dress of the 1560s, but some features seem fanciful, notably the cameo in an elaborate setting which fastens the queen mother's veil at the back of her neck. However, the huge jewel fastened on the breast of the queen and attached by chains to clasps on her shoulders is smaller than the jewelled gold mounts on the dresses worn in Veronese's portrait known as *La Belle Nani* (Paris, Louvre).[60] The blue, white and yellow brocade worn by the two princesses appears to be of the same pattern as that worn by Saint Catherine in Veronese's altarpiece for S. Caterina (Venice, Accademia).[61] The crown carried by the older princess is also very similar to the heavenly crown carried by the angels in that painting: so these may have been studio props. Both princesses wear this brocade for sleeves and overskirt, an arrangement not dissimilar to the dress of Santa Giustina in the high altarpiece Veronese sent to Padua in 1575.[62] The way that their shoulder capes are attached with jewelled chains is reminiscent of *The Rape of Europa* in the Doge's Palace.

The queen mother wears a blue cloak lined with ermine and with a mantle of the same fur. The two rows of separate pelts may be discerned in the mantle, and the black tails of the lower pelts hang free. Ermine was not only the most valued fur but the one that was associated with rulers. The doge kneeling before the Virgin in Veronese's *Madonna del Rosario* of 1573 wears a mantle with three rows of ermine.[63]

The dress worn by the dark-skinned kneeling attendants on the extreme left may be inspired by 'Turkish South Central European' dress, as Stella Mary Pearce (Newton) proposed. The horn-shaped caps also make an occasional appearance in paintings of the Adoration of the Kings.[64] An Eastern setting is more vaguely suggested by the onlookers' turbans.

Probable Patrons and Recorded Owners

The Pisani family, which sold Veronese's *Family of Darius* to the National Gallery in the nineteenth century, owned the painting in the mid-seventeenth century and they must have commissioned it in the mid-sixteenth. The family claimed descent from the ancient Roman patrician family of Piso and certainly did include a great Venetian hero – Vettor Pisani, the great admiral who fought in the wars with Genoa during the fourteenth century.[65] Modern genealogists trace the family back to Nicolò Pisani, son of a wealthy fur merchant, who was admitted to the Maggior Consiglio in 1307.

Fig. 8 Detail of the fountain in NG 294.

Fig. 9 Detail of the well-head in the courtyard of the Doge's Palace, Venice, cast by Niccolò dei Conti in 1556.

From Nicolò's two sons, Bertuccio and Almorò, stem the branches of the Pisani family that came to be known as the Pisani dal Banco and the Pisani Moretta, respectively. Towards the close of the fifteenth century members of the latter branch, whose wealth had been acquired from the salt trade and from banking, acquired estates in the *terra ferma*, including the extensive 'camerlengaria estense', which were divided between four of the sons of Francesco Pisani, who died in 1491.[66]

Of these estates, those at Montagnana were bequeathed by another Francesco to the eldest male descendants of his cousin Zan Mattio (Zuan Matteo) by primogeniture. The first beneficiary was around ten years old in 1567 when Francesco died, and he took the name Francesco (or perhaps had done so already), as did his successors through four generations – a condition of inheritance that was not uncommon in Venice. The reader will find it helpful at this point to consult the simplified family tree (fig. 10) (it only includes Pisani mentioned in this text).

Ridolfi wrote in 1646 that the Veronese was owned by the Pisani.[67] The actual owner must have been the Francesco

who died in May 1648. His eldest son, also Francesco, born in 1619, was elected procurator of S. Marco in 1649 and died in 1673 – he was grandson of the Francesco who inherited Montagnana. Martinioni's 1663 edition of Sansovino's guide explicitly identifies the owner as Francesco Pisani, procurator of S. Marco.[68]

The son of this procurator, also Francesco and also a procurator, witnessed the expiration of the male line when his only son was drowned in 1697, and he spent his last years hoarding wealth for his daughter, Chiara, who was married to Gerolamo Pisani of the Dal Banco branch and thus retained the family name. As will be shown, she seems to have provided Veronese's painting with a spectacular setting.

Returning to the sixteenth century, we must consider the question of which of the Pisani is likely to have commissioned Veronese's painting. The most obvious candidate is Francesco Pisani, who died in 1567. He was the son of Zuanne, a prosperous banker, and both his wealth and perhaps his interest in art are reflected in the splendid villa built for him by Andrea Palladio and adorned with sculpture by Alessandro Vittoria, which still stands just outside the walls of Montagnana, inscribed prominently with his name. The villa was being built in the early 1550s[69] and it has been plausibly supposed that Francesco used his influence in 1555 to obtain for Veronese the commission for the high altarpiece of the *Transfiguration* in the duomo of Montagnana. We know that the 'scritto d'accordo' between Veronese and the local officials and magistrates was signed on 3 June 1555, 'fuori di Montagnana nel palazzo del Mag. Miss. Francesco Pisani'.[70] It has often been thought likely that Veronese's *Family of Darius* was made for Montagnana.[71] A document recently published by Claudia Terribile establishes beyond reasonable doubt that it was in the villa when Francesco died in 1567. A year later Francesco's widow was accused of attempting to sell or appropriate parts of the property at Montagnana bequeathed by her husband to his nephew, and in particular it was alleged that she had

Fig. 10 Family tree of the Pisani Moretta.

Fig. 11 Detail of NG 294.

begun to 'levar per fino le telle et il ferro del quadro pretio-sissimo della historia di Alessandro Magno' ('even to remove the canvases and iron [fixtures] of the most precious picture of the story of Alexander the Great').[72]

The subject was, as will be shown, one that was favoured for the decoration of villas in the Veneto in this period. What is curious is that it is painted in oil on canvas. There is no certain record of any other painting by Veronese on canvas made for a villa, nor indeed any record known to me of a highly esteemed oil painting being commissioned for, or kept in, a Venetian villa in the sixteenth century. The explanation may be that the villa – usually called a palazzo – was not the occasional residence but the principal seat of its owner.[73]

Portraiture in *The Family of Darius*

It has often been assumed that *The Family of Darius* is a glorified family portrait. Hazlitt, for example, called it a 'family picture'; the National Gallery catalogues stated as a fact that 'the principal figures are portraits of the Pisani family'; Cecil Gould declared that such a conclusion was 'inescapable', at least for most of the main figures.[74] However, when Veronese introduced the likeness of a contemporary into heroic company, he usually did so in a more obvious fashion. Examples are the man in red (surely the donor, Simone Lando) on the extreme right of the altarpiece of the *Assunta*, painted about 1584 for the high altar of S. Maria Maggiore;[75] the portrait of the donor Bartolomeo Bonghi supporting the boy healed by Saint Pantaleone in the altarpiece (originally above the high altar) in S. Pantaleone, painted in 1587; the grey-bearded man in the centre of the group under the right-hand arch of the *Feast in the House of Levi* painted in 1573 for the refectory of SS. Giovanni e Paolo (now in the Accademia);[76] and five of the heads (one of them painted on paper and superimposed) at the right-hand table of the *Marriage Feast at Cana* painted in 1562–3 for the refectory of S. Giorgio Maggiore (now in the Louvre; fig. 4).[77]

The family to which the actors in *The Family of Darius* belong is more probably the ideal family of Veronese's imagination. If the warrior with a black beard and receding hair whose head is to the right of Alexander's is one of the Pisani, then we have to ask why the same member of the family would be present in the foreground of *The Coronation of Esther*, painted on the ceiling of the nave of S. Sebastiano by Veronese in 1556.[78] Gould proposed that this figure was not one of the Pisani but a self portrait, although he did not explain why Veronese would portray himself wearing armour. Alexander himself is similar in type to several of Veronese's young male saints, such as Saint John the Evangelist, painted on the ceiling of the sacristy of S. Sebastiano in 1555[79] (he has the same sideboards and wispy beard), and the grey-bearded counsellor who commends the kneeling women is also a type who is familiar as, for example, the brother of the expostulating elders beside Christ in the *Feast in the House of Simon*, painted in 1560 for Verona and now in the Galleria Sabauda, Turin.[80] It is true that the queen herself might be a sister of 'la belle Nani', the sitter of the celebrated female portrait in the Louvre, but she also resembles the artist's Saint Catherine and his Venus. It is not clear whether Ruskin had the queen or the elder princess in mind when he claimed that the whole composition was 'painted only to introduce portraits of the Pisani, and chiefly to set off, to the best advantage, the face of one fair girl'.[81] But, in any case, if there is a single figure that seems most like a portrait it is surely the junior princess, precisely because she is not very attractive.

Even if the Pisani are not represented here, it seems likely that the subject of the painting had special associations for them. It was, however, a familiar one which at least two other prominent Venetian families commissioned in the same period (see below). Nevertheless, it is certainly worth recalling that the Pisani were not merely involved with finance, trade and agriculture but were in the service of the church and state, counting among their kinsmen at this date one great cardinal – Alvise Pisani, Bishop of Padua – and one notable general, Piero, brother of Zan Mattio, who, in the war of Cyprus against the Turks, relieved Capocesta in Dalmatia (1570) and fought at the battle of Lepanto (1571),[82] although he was not noted for the clemency exemplified in this painting.

Family Traditions and the Copy by Minorello at Este
The French engraver Antoine Dézallier d'Argenville (1680–1765) recorded in his *Abrégé de la vie des plus fameux peintres* that when he was shown the great painting of *The Family of Darius*, its owner, 'Procurateur Pisani' (who died in 1737), told him how the painting had come into his family's possession: Veronese had chanced to be travelling in the neighbourhood of Venice when he was caught by bad weather. He asked for refuge in a country house of the Pisani, where he was made most welcome. During his short stay there he painted *The Family of Darius* 'sécrettement', rolled it up and put it under his bed when he departed, and afterwards sent word to the Pisani that he had left something in payment for the cost of his stay.[83]

This story is related without a flicker of scepticism, yet it is unlikely that Veronese could have found a suitable canvas waiting for him, unlikely that he would have been able to work on such a large painting in secret, unlikely that he would have rolled it up while still wet, and very unlikely that any bed would have been large enough to conceal it. It is also very difficult to believe that a composition like this could have been planned and executed in such a short time and in the absence of a specific commission. All the same, there may be a grain of truth in the story: the painting did come to Venice from one of the Pisani villas and perhaps Veronese did paint the picture as some sort of favour.

Twenty-five or so years after the publication of d'Argenville's account, Goethe noted that 'a strange story is told about the painting; the artist had been well received [by the Pisani] and for a long time honourably entertained in the palace; in return he secretly painted the picture and left it behind him as a present rolled up under his bed.'[84] Although the country house was omitted from this version, it doubtless remained in others known to the Venetian antiquarian and chronicler Emmanuele Antonio Cicogna, who recorded in 1834 that the painting was said to have been made for the Pisani villa at Este and left there in return for hospitality.[85] Variations on the same story survive also in later literature.[86]

A full-size copy apparently made by Francesco Minorello (1624–1657), a native of Este, hung in the Pisani villa there. Minorello's copy was taken to Palazzo Pisani to replace the original when it was sold to the National Gallery, and it has been supposed, reasonably enough, by Gould and others that it might have been made to replace the original when that picture was transported to Venice. However, the inscription recorded on it by Mündler included the digits 165-.[87]

If Minorello did paint the copy as a substitute for the original we must ask why he would have painted a pendant for it – for we know that he painted another episode from the life of Alexander on a canvas of the same size, *Alexander bestowing Campaspe upon Apelles*, which also hung in the villa at Este. There is no evidence to suggest that Veronese's original was one of a pair and it would be odd if it had been hung for a century in a room that called out for one. A more likely explanation is that Minorello was simply decorating the villa at Este, mostly with copies of famous paintings but also with one composition of his own. Indeed, Mündler also saw in the villa a copy of Veronese's *Adoration of the Kings* in S. Silvestro, Venice, which he thought to be 'probably by the same hand'.[88] There were three other copies after Veronese in the villa and copies after other artists as well, including Titian's Caesars. Cecil Gould identified a space in the largest room of the villa (then a school) where the painting could fit (rather tightly) but it would have been astonishing if there had not been such a space, since we know that Minorello's full-size copy had hung there.[89] It is now clear not only that the painting was made for another villa, that at Montagnana, but that it was made for a patron, Francesco Pisani, who did not own the villa at Este.

The 'Quadro di Paolo' in Palazzo Pisani Moretta
Giovanni Antonio Massani, reporting to Cardinal Francesco Barberini on 10 July 1632 on paintings by Veronese that

Fig. 12 Family tree of the Pisani.

were perhaps available for sale in Venice, mentioned the four great paintings in the Cuccina Palace (now in the Gemäldegalerie, Dresden), which were available for 12,000 ducats, and an 'historia di Alessandro Magno', surely *The Family of Darius*, which one of the noblemen of the city was prepared to sell for 3,000 ducats.[90] This is the earliest reference to the painting in Venice. The nobleman in question was almost certainly Francesco Pisani (1588–1648). Although his family's chief residence in the first half of the seventeenth century is said to have been in the parish of S. Gregorio,[91] Francesco's will dated 27 October 1647 cites 'la mia casa ... a S. Polo da me comprata' ('my house in the parish of S. Polo bought by me') and since the will further cites that it was flanked by 'Ca Barbarigo' we may be sure that this was the palace still known as Pisani Moretta.[92] The palace had been sold to him by the Bembo family in 1629 and although there were legal obstacles to full occupancy[93] the will makes it clear that he and his family resided there. It is not unreasonable to assume that the Veronese was moved there soon after 1629, presumably from the villa at Montagnana.[94] Francesco wanted this new palace, and presumably its fittings, to descend to his male heirs. When Ridolfi described the painting in his life of Veronese in 1646 as in 'casa Pisani', he doubtless meant this palace. Two years later Francesco Pisani died. In the following year his principal heir, also a Francesco, who was to have occupied the *piano nobile* of the palace together with his mother, Chiara Mocenigo, was elected a procurator of S. Marco. This explains why Boschini in his *Le Ricche Minere della Pittura Veneziana* of 1674 describes the picture as in 'Casa Pisana nelle Procuratie di San Marco', evidently Francesco Pisani's residential quarters within the procuracy.[95]

It is noteworthy that the Veronese is one of only two paintings[96] specifically mentioned by Boschini in an introductory account of the artist's merits. For him the picture exemplified in particular the splendour and variety of colour and ornament in the retinues of 'knights, soldiers, pages,

grooms and dwarves' ('cavalieri, soldati, paggi, staffieri, e nani') that Veronese devised for princes. He admired how the family of Darius kneel in homage – 'the action is so masterly in representation that we are prompted to imitate it' ('azione cosi maestosa, che invita ogn'astante à far il medesimo'). This passage is not only proof of the painting's fame but suggests that access to it cannot have been difficult. It was still in the procuracy in 1691 when it was engraved for Patina's anthology of prints, as described below under Prints.

The next reference to the painting which is known to me comes from the great French connoisseur the Comte de Caylus, who was in Venice in early 1715 and noted: 'dans la maison de Pisani j'ai vu le chef d'œuvre de Paul Véronèse représentant "La Famille de Darius aux pieds d'Alexandre".' There can be little doubt that the 'maison' in question was the Palazzo Pisani Moretta at S. Polo on the Grand Canal (figs 13 and 14) because Caylus proceeds to describe paintings by Titian in the neighbouring Palazzo 'Barbara' – meaning Barbarigo – 'della Terazza'.[97] The Veronese, which is recorded in the procuracy of S. Marco in 1691, moved back to the palace at some time between then and 1715. Caylus noted that the owner was so mad that he made it difficult to view ('le maître de la maison est assez fol pour ne le montrer qu'avec peine') – a reference to Procurator Francesco Pisani, who was by then notoriously miserly and reclusive. 'Few have seen and know the work' ('Peu de gens l'ont vu et le connaissent'), he concludes, though he was presumably directed to it by another connoisseur.

The painting was sought out by subsequent French travellers. Thus Charles de Brosses, who was in Venice in August 1739, noted that it was 'admirable'.[98] In that year work began on the complete reconstruction and redecoration of the palace, although its beautiful gothic façade was preserved (fig. 14). This conversion was the work of Chiara Pisani. Her father had died in 1737 and her husband had died in the following year.

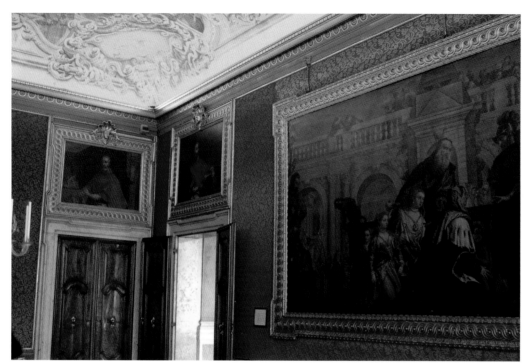

Between 1745 and 1747 payments are recorded in the family's ledger to Giovanni Battista Piazzetta (1683–1754),[99] then probably the most admired painter in Venice, for the dark and tragic canvas showing Alexander moved to tears by the sight of the corpse of the defeated Emperor Darius and removing his cloak to cover it. This painting, now in the Museum of the Eighteenth Century in Ca Rezzonico,[100] is similar in size to Veronese's (240 × 480 cm is the official measurement) and, given the subject matter, it must have been made as some sort of companion for it and in some sort of competition with it.[101]

Charles-Nicolas Cochin in his *Voyage d'Italie* published in 1758, but recording the visit he made in the company of the Marquis de Marigny in June 1751,[102] described the Veronese and the Piazzetta together, as did other later visitors. It is not, however, certain (as has been assumed by most scholars) that the two paintings originally hung as pendants in the same room, for the contrast in colour, mood and figure scale would have been painful. It is noteworthy that there are references in the palace accounts to a 'cameron Piazzetta', and no room containing a Veronese would have been thus described.[103] Furthermore, Cochin does not mention that they are pendants, as he does in other such cases in this and other palace collections.[104]

We would expect paintings of this size and format to hang in the *portego* of the palace and they may have done so (the *portego* was completely redecorated in the 1770s), but it seems more likely that the Piazzetta was originally hung in the room facing the canal on the *piano nobile*, to the left of the *portego*, now known as the Sala Giallo, the ceiling of which was painted by Giuseppe Angeli in the early 1740s.[105] The Veronese was probably hung in the corresponding room on the right – the room it is known to have occupied in the nineteenth century, where Minorello's copy hangs today.

This room is a little over seven metres wide and twice as long. The Veronese would presumably have occupied the centre of the long wall opposite the entrance from the *portego*. It was the vault of this room that Tiepolo was commissioned to fresco in 1743.[106]

Angeli (1709–1798) was a pupil of Piazzetta and it seems likely that their paintings were planned to harmonise. The ceiling by Tiepolo was also surely intended as a homage to the Veronese, matching not only its colours and tonality and its compositional movement but perhaps also its theme. The subject of the painting is usually described as Mars and Venus but this cannot be correct. Michael Levey has proposed instead that it represents the apotheosis of Vettor Pisani[107] – and certainly Venus does seem to be conducting a great warrior, dressed *all'antica*, to Olympus. Tiepolo was acknowledged as the spiritual heir of Veronese but nowhere else could their paintings be seen together like this. (The influence of Veronese's painting on Tiepolo is discussed in another section of this entry.)

After Chiara Pisani's death in 1767 her elder son, Pietro Vettore, continued the work on the palace. In 1752 he had made a splendid marriage with Caterina Grimani, niece of Pietro Grimani (doge between 1741 and 1752), but not long after his mother's death he seems to have despaired of having children; in any case, arrangements were made for his younger brother Vettore to marry Cornelia Grimani, a kinswoman of his wife. This was Vettore's second marriage, his first, in 1753, to the daughter of a mirror engraver, having been annulled. The wedding took place in April 1773 and major works on the *piano nobile* are recorded in the preceding years. The *portego* (now called the Salone) was completely redecorated with stucco decorations, probably by Pietro Castelli, curling around mirrors on the walls and around frescoes on the ceiling by Giacomo Guarana, these latter

completed just before the wedding.[108] In this period there are references in the ledger to the cleaning and restoration of both the Piazzetta and the Tiepolo. In April and May 1772 Domenico Maggiotto was paid a total of 1,100 lire for work on the 'quadro del Piazzetta' and on 9 October 1770 'Iseppo Bertani' was paid 620 lire for 'spese fatte nel quadro di Paolo'. Bertani was paid again on 14 October 1772 'per aver accomodato un quadro', that is, for having put a picture in order, or perhaps for having set a picture in place.[109] Maggiotto (1713–1794) was doubtless selected to work on the Piazzetta because he had been a pupil of that master. Giuseppe Bertani, who died in 1799 at more than eighty years of age, was during the 1760s and 1770s the leading picture restorer in the city and the one who enjoyed most favour with connoisseurs. He was described by Pietro Edwards in 1777 as 'maestro di tutt'i restauratori'.[110] The cleaning is likely to have been carried out in connection with a new display which entailed new framing. At this point or soon afterwards the two paintings were both placed in the Sala with the Tiepolo ceiling, where they were both still described in the 1850s.[111] The frames made for them are now on the Minorello copy

of the Veronese, which was taken here after the Veronese was sold, and on Minorello's companion picture, *Alexander bestowing Campaspe upon Apelles*, which took the place of the Piazzetta (they are described in the section on framing below). This was the magnificent setting in which Goethe saw the Veronese in 1786. It was the only painting that he described in his account of Venice in his *Italian Journey*, and probably the most celebrated painting in private possession in the entire city.

The Sale of *The Family of Darius*

Pietro Vettore Pisani, the son of Vettore by his first marriage, had difficulty establishing his rights as a patrician. Long after his success in achieving this in 1784, claims continued to be made by his half-sister which were a serious drain on his wealth. On the other hand he did nothing to alienate either the French or the Austrians, and the latter officially recognised his title as Conte di Bagnolo in 1819.[112] Palazzo Pisani Moretta remained one of the great attractions of the city, on account of the Veronese, but also because of Canova's *Daedalus and Icarus*, his earliest masterpiece – completed for the palace in

Fig. 14 The fifteenth-century gothic façade of Palazzo Pisani Moretta, Venice. The two windows to the left on the first floor light the room shown in fig. 13, where *The Family of Darius* once hung.

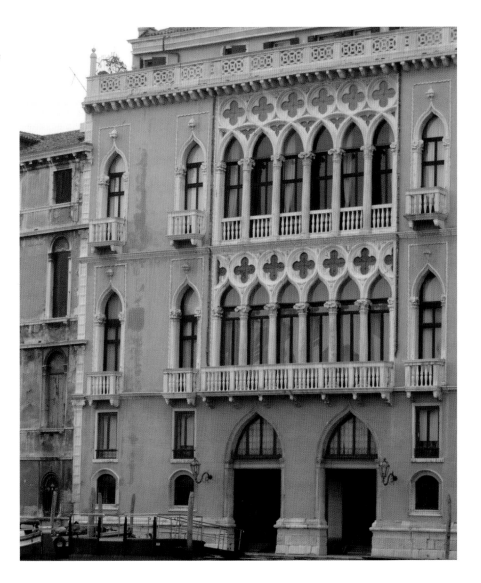

1779 (today in the Museo Correr) – and, gradually, also for its gothic façade.

William Hazlitt, who was in Venice in the spring of 1825, described the palace in his travel notes for the *Morning Chronicle* as second only to Palazzo Grimani in its 'elegance and splendour': 'from its situation on the Grand Canal, it admits a flood of bright day through glittering curtains of pea-green silk, into a noble saloon, enriched with an admirable family-picture, by Paul Veronese, with heads equal to Titian for all but the character of thought.'[113] The palace was mentioned in all the guidebooks and probably gained additional visitors from its proximity to Palazzo Barbarigo, where a group of paintings by Titian, arranged in what was believed to have been his studio, was a more or less compulsory sight for all visitors to the city.[114]

Count Pietro Vettore Pisani died in 1847. The painting and the palace were inherited by his son Vettore (commonly known as Vettor and by the English as Vittore) Daniele, then agd 57. In the following year Venice revolted against Austrian rule, and its provisional government immediately found itself in desperate need of financial support. In May 1848 Count Vettore Pisani contributed larger loans than any other noble-man, with the exception of the Giovanelli brothers.[115] By September the situation was even more desperate and a new bank was established, with its paper money ('moneta patriottica') underwritten by a 'voluntary' loan of three million lire by the Republic's richest citizens. Again Vettore was one of the chief contributors – only the names of Giovanelli, Treves and Papadopoli are higher on the list. In April of the following year he paid out again, and then again in August.[116] On 22 August 1849, not long after he had made his last contribution, Venice submitted to Austria. Count Pisani must have seen very little prospect of ever recovering the more than half a million lire that he had been obliged to contribute to the short-lived Republic and his rents and other income would also certainly have been in decline during these hard years.

In September 1850 Fedor Bruni, director of the Imperial Picture Gallery in the Hermitage, purchased the entire picture collection of the neighbouring Palazzo Barbarigo for 562,000 lire. Probably two years later he wrote to St Petersburg to point out that he knew that Count Pisani would be willing to part with the Veronese if he received a large enough offer for it. Bruni had already offered the 230,000 francs (£9,600) remaining in his budget, and it was not enough, but he believed that another 100,000 would secure the work. It was, he emphasised, the greatest work of this great master. Tsar Nicholas I, having read this appeal, annotated it with a question concerning the cost of the Campana collection (the Marchese Campana's Etruscan antiquities had recently been offered to him), which he evidently regarded as of higher priority, and the comment that there were no additional funds available for Bruni's use.[117]

It is likely that Count Pisani received other offers in the early 1850s and it was said that he authorised his agent, Signor Zen, to accept 15,000 napoleons in the early part of 1853, although he later withdrew this authority.[118] The National Gallery made an offer through Clinton G. Dawkins,

consul general for Lombardy and Venice, but it too was rejected.[119] A greater attraction in Venice for collectors and dealers in these years was the Manfrin collection, which was full of masterpieces that were suitable in size for any gallery, whereas the Veronese was difficult to accommodate and its export required special diplomacy. The most obvious buyers were the British government, the French emperor and the Russian tsar. But during 1854 and much of 1855 these three great powers were at war in the Crimea and support for extra public expenditure on works of art was most unlikely.

In early 1856 it was reported that Signore Dubois, the count's son-in-law, had received an offer of £10,000 from an 'English gentleman'.[120] This was perhaps Alexander Barker, the wealthy London collector who also acted as an agent for the Rothschilds. In June Eastlake obtained the support of the Trustees for an appeal to the Treasury to permit an offer of 10,000 guineas (£10,500) to be made.[121] The ambassador to the Austrian court, Sir Hamilton Seymour, wrote to the Earl of Clarendon on 9 July 1856 to announce that he had consulted Count Thun, minister for foreign affairs, and had ascertained that 'no objections would be raised on the part of the Imperial Government to the exportation of the picture by Paul Veronese'. Seymour had earlier written that he felt 'tolerably certain to receive none but a very unsatisfactory answer. The fact is that any demand for authority to purchase and export a well known picture places the Government in the dilemma either of acquiescing in the loss to the country of a work of art to which a national interest is attached or of making application to the Emperor to purchase the picture for his own gallery.'[122] Conscious of the likely fate of the Veronese, and of the first sales of the Manfrin paintings, the Austrians authorised the purchase of twenty-one major works from the Manfrin collection for the Accademia Galleries at the close of 1856. The emperor also issued in February 1857 a decree making it harder for works of major artistic importance to leave the Veneto, delaying any export licence until the state had decided whether or not to exercise its right to make a pre-emptive purchase.[123]

The British offer of 10,000 guineas (£10,500) was made in the first days of August 1856 by Otto Mündler, the National Gallery's travelling agent, in concert with George Harris, consul general in Venice, through the bankers Carlo and Enrico Dubois (du Bois de Dunilac), the latter being Count Vettore Pisani's son-in-law.[124] On 4 August it was rejected. Eastlake cannot have been surprised, since he had informed the Trustees that he believed £12,000 would be required. In October he was with Mündler in Venice. They visited the painting together and doubtless resolved to continue the effort to secure its purchase. At the close of the month the painter, copyist and restorer Professor Paolo Fabris (1810–1888), whose professional eminence in Venice is indicated by the fact that he was chosen to restore Titian's *Death of Saint Peter Martyr* in 1853, explained to Mündler that Caterin Zen, the count's first agent, had been in his service for twenty-seven years.[125] A clear implication of this was that Zen had the ability to stop any offer made through another channel – notably Dubois – and that access to Zen would have to be

obtained through Fabris. At the very end of the year Harris obtained permission to offer £12,000. There followed a series of difficult meetings between Harris, Mündler, Fabris, Zen and Dubois. On 7 January 1857 Zen introduced to these discussions the hitherto mysterious Avvocato Monterumici, the count's lawyer.[126] Harris seems to have made two mistakes during these weeks. He proposed to pay Zen a higher commission in exchange for a reduction in the price, a proposal that was 'peremptorily' rejected by Zen as 'wounding his feelings and derogatory to his honour'. Harris also gained direct access to the count, who was then residing in Padua, and put the offer to him directly, only to receive a decisive refusal.[127]

In a dispatch of 31 January 1857, Harris explained to Lord Clarendon what he had learnt. 'Count Pisani is easy of access, but invariably consults advisers on questions of money', notably Dubois, Monterumici and Zen, but also 'other dependents all of whom conceive themselves to have a claim on this painting.' Although the count had renounced his intention of selling, all his advisers had an interest in achieving a sale, and there were also domestic incentives for his parting with the picture.

> The count lost his only son five years ago; he is the last male Representative of the principal Branch of the Pisanis – at his decease his vast property will be divided amongst the married daughters or their heirs, and the disposal of this painting which is assumed to be of great value, is most jealously apprehended not only by the sons-in-law, who fear it may be bequeathed to one daughter to the exclusion of the other two, or left to the Academy of Venice, or sold without their common concurrence and profit, but also by the agents and Household who for many years have derived a considerable annual sum from the visitors whom it attracts to the Pisani Palace. Thus many persons who have daily and hourly access to the Count, are united by a common mistrust of each other, and by a common expectation of gain, in preventing his treaty for the sale of this picture without their knowledge.[128]

A frustrating aspect of the negotiations for Mündler and Harris must have been their ignorance of the three daughters' positions. Clearly Dubois represented the interest of one daughter, Zen perhaps protected another and Monterumici a third, but that is probably too simple a picture. Mündler also received anonymous approaches from agents, which he ignored. A comic dimension to the proceedings was added by the fact that all four of the Venetian advisers were eager to do some private business with Mündler, selling him their own paintings or those of their friends.[129] On 8 February the count was still opposed to accepting the offer but by the end of the month the situation had changed. Monterumici spoke with one of the daughters, the Countess Lazzara in Padua, and then with the other two in Venice. On 1 March the count finally accepted an offer of 360,000 Austrian francs (approximately £12,280).[130] The exact terms were laid down by Dubois on 4 March: payment was to be made within the month, in silver coins.[131]

If we wonder what had finally driven the negotiations to a conclusion, the answer may be that the other contenders had begun to fall away. Tsar Nicholas I was not someone who easily changed his mind, and in any case he had died in 1855. The young artist Charles Maréchal wrote to the French Minister of the Interior on 5 May 1856, offering to approach Count Pisani on behalf of Emperor Napoleon III,[132] but although Maréchal was still known to be interested in negotiating in November,[133] there is no reason to believe that he was given encouragement, perhaps because the Louvre already owned great works by Veronese. The British would not wait forever, and the recent support for the Accademia Galleries and, more importantly, the decree of February 1857 reflected the Austrians' concern for retaining major works of art in Venice and might prove fatal to the sale (the British had not, of course, revealed that they had already obtained permission to export the picture).

The count's agreement was by no means the last hurdle. He refused to negotiate on behalf of his advisers and dependants. He was willing to allow them to benefit from the sale but adamant that their share must come from the purchaser – 'for his part he would not give them a glass of water on the occasion'. Indeed, he professed to be amused by the rapacity of his advisers and actually 'repeated without disapprobation Signor Zen's expression that the picture should not leave the Palace unless he [Zen] made a small Estate by it'.[134] These extra payments were the subject of intense discussion and on 18 March Harris was informed by the Treasury that the purchase could proceed, provided that the total cost did not exceed £13,650. Count Pisani was reported soon afterwards to have bitterly regretted his decision: his friends were reproaching him and he was even receiving anonymous letters.[135]

On 27 March Harris obtained authority to draw the money and on the following day Harris and Mündler discussed with the count the preparation of receipts and so on. At 11 am on 31 March the silver was counted out and at midday the Venetian dealer and packer Antonio Zen (no relation to Caterin Zen) began to take down the painting.[136] On the following day the Delegazione (the representatives of the Austrian Empire) ordered the count to stop the transaction, but at noon a case containing the picture was transported across the Grand Canal to Palazzo Mocenigo, Harris's official residence. On the next day commissions were paid to Dubois, Fabris, Monterumici and Zen and, through them, compensation to palace domestics and others. There was so much indignation in the city and on the part of both 'Podestà' (the mayor) and 'Delegato' (Imperial representative) that the count was taking seriously the rumour that he would be fined a sum greater than that which he had received for the painting. Mündler at this point restored calm by revealing Count Thun's prior agreement.[137]

At around this date the count gave a dinner at which it was reported that the coins were placed in three basins in front of his daughters,[138] an almost biblical gesture whereby he perhaps demonstrated successfully to the higher ranks of Venetian society that he himself had gained nothing by the sale. The sale was nevertheless widely regarded as unpatriotic

and seems to have disqualified him from reparations made in the following decade to those who had given loans to the provisional government in 1848–9.

It took six of Antonio Zen's men several hours to remove all the little nails and carefully roll the canvas over a cylinder approximately two feet in diameter. But the exacting and inquisitorial officials at the Accademia insisted on seeing the picture unrolled once again, not only to verify its identity but to ascertain that nothing else had been rolled up with it. 'These were the conditions,' Zen informed Eastlake, 'and you shouldn't be surprised because you can't expect civil behaviour from a savage' ('Non le serva ciò di stupore perchè non avra inteso che sia cortese un selvatico' – Selvatico, the name of the president of the Accademia, literally means wild or uncouth). The export licence had still not been authorised on 7 June, to Mündler's frustration. It was granted on 3 July, and Zen was able to place the painting on the English steamship *Euphrates*, which sailed from Trieste on 14 July 1857.[139]

Even before the painting had left Venice its acquisition was debated in Parliament. On 2 July Lord Elcho, an important collector, informed the House that 'an enormous sum' had been squandered on a 'second-rate specimen … of a second-rate artist'.[140] His motion of censure was not successful, however, and in the correspondence in *The Times* which ensued Ruskin, among others, strongly defended the purchase.[141]

The *Euphrates* docked at Liverpool on 7 August and Wornum recorded the safe arrival of the painting, under seal, in London on 10 August.[142] On 22 August it was removed from the cylinder and placed on a new stretcher by 'Leedham'.[143] On 16 September it was hung in the Gallery. It was varnished, presumably *in situ*, on 19 October.[144] The response of both the press and the public was favourable. Even 'Eyewitness' in Charles Dickens's *All the Year Round*, who was generally much opposed to Eastlake's acquisitions, heartily approved.[145] Queen Victoria, together with the Princess Royal and the Princess of Prussia, made a special visit to inspect the painting on 22 January 1858.[146]

Eastlake fully deserved to be congratulated on this acquisition. His tactic of removing the business from his fellow Trustees to the Treasury was adroit and his taking the precaution of obtaining a diplomatic concession from Austria before serious negotiations began was shrewd. Wornum in his private diary recorded, for the benefit of a distant posterity, that the 'Pisani Paul Veronese' was purchased 'thanks to the public spirit of the secretary to the treasury James Wilson Esq.'[147] This civil servant, not otherwise noticed in accounts of the acquisition, may have had an understanding with Eastlake and must have played a decisive part either in urging his superiors to accept the escalating price or, more likely, in not allowing them to worry about it. Wornum must also be suspected of wishing to divert credit from Mündler. And yet it is hard to believe that the negotiations could have succeeded without such an intelligent and zealous agent on the spot. However, instead of receiving official thanks, Mündler was dismissed from his post by parliamentary vote on 13 July 1858.

The debate in Parliament was occasioned by the annual report of the Committee of Supply. The defence of the

National Gallery's interests had probably been relaxed after the defeat of Lord Elcho's motion in the previous year. On this occasion, however, his motion, seconded by William Conyngham, that the office of travelling agent be discontinued, was actually passed. Elcho was an old enemy of German scholarship and of what he conceived to be the Gallery's cleaning policy; so too was Conyngham.[148] Although they doubtless rejoiced in harming Mündler, their real purpose was to hurt Eastlake. Mündler had in fact occasionally acted with greater independence than was originally envisaged, but most of the allegations made against him, especially in connection with the price of the Veronese and the way it was paid for, were entirely false and were refuted in a closely argued letter sent to the Treasury by Eastlake with the agreement of the other Trustees on 2 August 1858.[149] In consequence of this Mündler was compensated for unfair dismissal and Eastlake felt able to employ him in numerous matters during the coming years.

No doubt it was true, as Mündler claimed, that the painting's beauty suddenly became more apparent when it lay upon the floor of Palazzo Pisani, waiting to be rolled. Antonio Zen indeed claimed for it 'twice the merit, and thus twice the value, that it had when in a position where valances falling over the windows and an obtrusive curtain prevented the appreciation it deserved' ('doppio merito, e quindi valore che non mostrava sul luogo dove i valanghini soppressi alle finestre, ed una indiscreta cortina non permettevano che si gustasse come meritava').[150] But moving a great painting into another light is always an exciting revelation. It was cruel to extract this painting from a historic palace built for munificent hospitality, courteous ceremony and noble retinues such as we see in the painting itself, separating it from the company of a Tiepolo fresco and the sparkle of light on Murano glass chandeliers and the waters of the Grand Canal.

A quarter of a century after the Veronese arrived in London, Henry James described how 'you may walk out of the noon-day dusk of Trafalgar Square in November, and in one of the chambers of the National Gallery see the Family of Darius rustling and pleading and weeping at the feet of Alexander … the picture sends a glow into the cold London twilight. You may sit before it for an hour and dream you are floating to the water-gate of the Ducal palace.' Then, thinking, perhaps unconsciously, of the vicissitudes of empire which the painting itself illustrates, he added the detail that we will be greeted at the water-gate by a beggar – albeit one resembling a doge.[151]

The painting was much copied in the National Gallery and was no doubt carefully studied by artists, but it is curious to note that the place in Europe where the influence of Veronese, and of this painting in particular, was most strong was Vienna in the decades after 1866, when Austria reluctantly yielded Venice to the new kingdom of Italy. This is best exemplified by Hans Makart's *Homage to Queen Caterina Cornaro* of 1873, which is similar in its setting and subject, its compositional rhythms and its ceremonial rhetoric to *The Family of Darius*, but darker in shadows, even richer in palette and nearly twice as large.[152]

Fig. 15 Paolo Veronese, Figure studies made for *The Family of Darius before Alexander*, c.1565.
Black chalk with white highlights on faded blue paper, 17.5 × 29.5 cm. Paris, Musée du Louvre.

Provenance

See above. Probably painted for Francesco Pisani of Monta-
gnana and bequeathed by him to his cousin Zan Mattio. By
descent in the Pisani family from whom purchased in 1857.

Drawing

There is a preparatory study in black chalk heightened with
white on grey-blue paper in the Louvre (fig. 15). It came from
an album assembled in the second half of the eighteenth
century, probably in Venice. The sheet contains a series of
five schematic nude studies, the first three (from the left)
for Alexander and the next for Hephaestion; the fifth figure,
on the right, cannot be identified with any in the painting.
Roseline Bacou observed that the second figure from the left
also resembles in pose a figure in the foreground of Vero-
nese's *Feast in the House of Levi* of 1573 in the Accademia.
This need not suggest that *The Family of Darius* is of a similar
date, since Veronese could easily have reused a pose invented
many years before.[153]

Prints

A fold-out etching of *The Family of Darius* measuring 29.8 ×
48.3 cm, signed by N.R. Cochin '*del et fe*', was included in
Carla Caterina Patina's anthology *Pitture Scelte*, made in
Padua in 1691. The print extends the composition somewhat
at the upper and lower edges and emphasises the projections
in the entablature above the paired columns. It is, however,

not accurate in its representation of Veronese's architecture,
since it shows a pulvinated frieze and one without ornament
other than in these projecting sections. The title given to the
painting is 'Alexander, Victor of Darius, Merciful and Re-
strained' ('clemens et continens'). Patina's anthology included
many notable old masters, most of them Venetian (Titian and
Veronese being most favoured), mingled with some in Patina's
possession, probably for sale.[154] Cicogna in 1834 records an
engraving which had been made by Dal Pian that was then
available for sale in Giuseppe Battagia's shop ('intaglio già
eseguito dal Dal Pian si riproduce oggidi in vendita dal nego-
ziante sig. Giuseppe Battagia'). This is presumably a reference
to the Bellunese engraver Giovanni Maria de Pian (1764–
1800), who left Venice for Vienna in 1797. The print was
said to have been published around 1789.[155]

Copies

As noted above (under Condition) the Pisani had a reputation
in the mid-nineteenth century for not permitting copies of
The Family of Darius. However, some were certainly made
before the picture was sold. The earliest may be that by
Minorello, which was moved, under the supervision of Paolo
Fabris, to Palazzo Pisani Moretta at the end of July 1860 to
take the place of the original (and is still there—see fig. 13).[156]
As noted above, this full-size copy seems to have been painted
for the family's villa at Este and had hung there for two
centuries. It must have been made with direct reference to

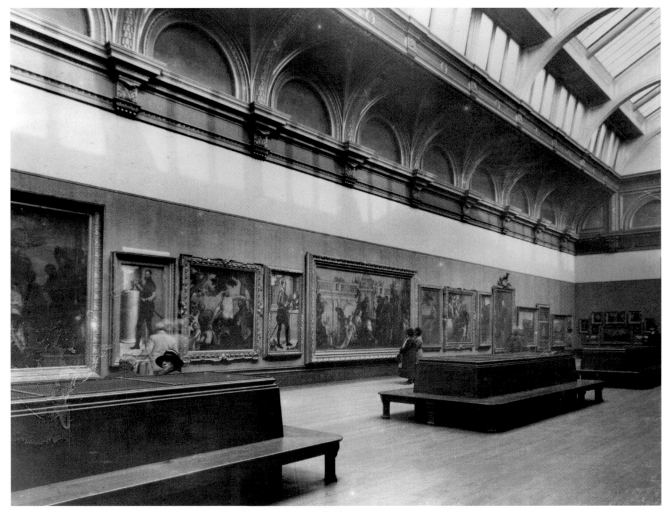

Fig. 16 Room VII (now Room 32) in the National Gallery, as photographed in January 1923.

the original but probably without the use of a tracing because there are small but significant differences.[157]

A full-size copy that looks as if it might date from the seventeenth century is in a private collection in Paris. It was acquired at auction in Paris on 22 April 1872 for 5,000 francs by Ernest Gariel, a building contractor employed by Haussmann, who died in 1884. The picture has remained ever since in the possession of his descendants.[158] There are some differences in the architecture – the obelisk is taller and more tapered, for instance – and in the placement of the figures, probably because the artist was required to alter the format a little, and one major change in colour – the bearded man presenting the royal family wears brown rather than blue. In 1860 a claim was made in Venice, in the *Official Gazette*, that Veronese's original version of *The Family of Darius* was in the museum at Versailles and had been there since 1660. This was certainly a misapprehension but may reflect some knowledge of an old copy that had long been in France.[159] In the previous year the *Gazette* published the claim that an old copy by Luca Giordano had been found which was in the possession of the dealer Toffoli.[160]

There are smaller copies of the painting in the museums in Kassel[161] and Parma.[162] Smaller copies also appeared in the following London sales: Sotheby's, 8 December 1950, lot 169, property of Sir Allan Adair; Christie's, 18 February 1953, lot 104 (as by F. Guardi); 16 July 1954, lot 101; Phillips, 16 April 1996, lot 1. Copies of the painting are known to have been made after it was bought by the National Gallery and some of those listed above probably fell into this category. A copy in a Philadelphia collection in 1926 was said to be old. Another in a private collection in Oak Park, Illinois, about half the size of the original, may be older: the red of Hephaestion's costume suggests that it was made when the original rose had been altered by a yellowed varnish.[163]

Freer copies, some with minor variations and others left unfinished, are liable to be mistaken for an original sketch by the artist. Charles de Brosses, when in Venice in August 1739, observed that he had 'l'esquisse de ce tableau faite par le Véronèse pour l'exécution de son grand ouvrage', with one or two heads finished by the master and much of the rest by his pupils, some only roughed out ('en ébauche').[164] A painting acquired by Giuseppe de Scolari in 1840 attracted some

notice in Venice around the date that the original was sold. Its owner, then president of the Venetian Commercial Court (Tribunale di Commercio), published a booklet about it in 1875, claiming it as the artist's 'modelletto' and tracing it back to the collection of Bishop Coccalin, who died in 1661. He cited many variations in colour and composition, but since the general form of the architecture does not seem to have been different from that in the original we can, even with no knowledge of the painting itself, dismiss its claim, for we know from the pentimenti described above (under the section Evolution of the Composition) that Veronese only settled on the scheme we see during the course of his work on the large painting. The variations were more likely the liberties taken by an eighteenth-century artist.[165] Another 'original sketch' was said to be in the collection of Charles du Bois, brother of Enrico du Bois de Dunilac, one of Count Pisani's sons-in-law, but no trace of this can be found in the family collection or in its records.[166]

Frames

NG 294 is likely to have been reframed four or five times. It was probably given a new frame when it was moved from the Pisani palace to the procuracy of S. Marco around the mid-seventeenth century and perhaps also when it was moved from there to Palazzo Pisani Moretta, and almost certainly when it was re-installed there in about 1772, as mentioned above. The frames currently on the copy of the painting by Minorello and on his painting of *Alexander bestowing Campaspe upon Apelles* must originally have been made for the Veronese and for the Piazzetta. They are precocious examples of neo-classical design, about 27 cm broad and consisting of a wide guilloche frieze bordered by ogee mouldings with finely carved acanthus ornament. The guilloche embraces rosettes of unusual design. The frames have outset corners, reviving a feature of many late sixteenth-century so-called 'Sansovino frames' which were also favoured earlier in the eighteenth century by British Palladian architects. The prominent

Fig. 17 Corner of the former frame of NG 294.

Fig. 18 Corner of the current frame of NG 294.

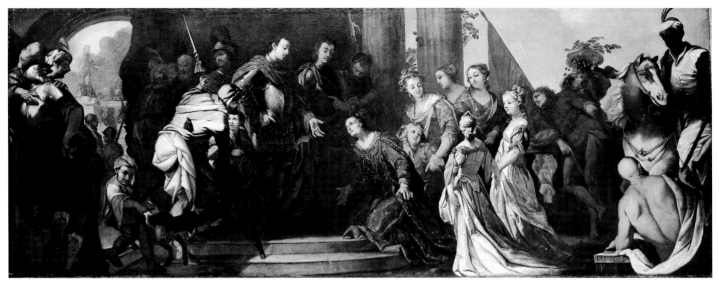

Fig. 19 Antonio Bellucci, *The Family of Darius before Alexander the Great*, c.1710. Oil on canvas, 213 × 564 cm. Oxford, Ashmolean Museum.

guilloche is highly reminiscent of fashionable décor in Paris during the 1770s[167] and this may be explained by a payment of 100 lire on 6 February 1772 (1773 in the modern calendar) to a 'Monsu Anto Rigotie disegnador' for 'Disegno di Fornimento d'appartamento nobile' for 'Rigotie' sounds like a Venetianised French name.[168]

The crisp, curling acanthus on the ogee moulding near the sight edge was obviously carved by craftsmen trained to work in the refined rococo style that was still the norm in Venice in the 1770s. The 'intagliador' may have been Zuane Gai, a member of a prominent clan of carvers, Marco Garbato or Giovan Battista Frattin, all of whom appear in the accounts at this period.[169] The gilder was perhaps Nicolò Zaccalura, who was paid for gilding furniture and frames in the palace during these years.[170]

The frames for the Veronese and the Piazzetta are matched by smaller ones on portraits of Pisani ancestors placed over the yellow Verona marble door-frames, although these have crests composed of masks and shells (fig. 13). They were probably the only other paintings in the room and perhaps encouraged, subliminally, the notion that portraits of the Pisani were present in Veronese's painting as well.

Mündler evidently hoped to find a suitable old frame for the painting in Venice. On 3 April 1857 he noted in his diary, 'the question of the P. Veronese frame is not yet decided. Went to Anto Zen to consult him. He offers to go to Vicenza, where a lady has a frame likely to fit.' On 8 April, Zen reported that he found it excellent but 'too much asked for it'. Count Pisani's intention to replace the painting with Minorello's copy may be the reason why he did not include the frame in the sale to the National Gallery.[171]

On its arrival in the National Gallery the painting was given a frame carved by Messrs Wright, similar to the one they had made for Veronese's S. Silvestro *Adoration*, which still remains on that painting (fig. 6, p. 406). The Gallery's keeper, Ralph Nicholson Wornum, recorded '294 carved

frame by Messrs Wright of Wardour St £45 an improvement on the Toffoli frame' under the date 22 August 1857.[172] This was twelve days after the painting had been unpacked, when it was put on a new stretcher. Therefore it probably indicates the date that work on the frame was commissioned, with the agreement that the pattern for the *Adoration* (supplied by Toffoli) would be followed but the execution improved. The frame was presumably complete by 16 September, when Wornum noted, 'Pisani Paul Veronese hung on the wall of Flemish room.' The painting certainly still had this frame in 1923.[173]

It has not been possible to ascertain exactly when Wright's frame was removed. It may have been adapted to fit another painting. Van Dyck's *Equestrian Portrait of Charles I* (NG 1172), which is now in a frame of this pattern, is not likely to have been given such a frame when it was acquired for the Gallery in 1885 and there must have been other cases of reuse.

The Veronese is now in a carved and gilt frame of uncertain date but late sixteenth or early seventeenth century in style, and perhaps incorporating elements from that period (fig. 18). It consists of a wreath of leaves, vegetables and fruit (pomegranates, figs, pears) with a strap wound within it and acanthus at the corner. Inside the wreath the painting is bordered by stylised fleshy leaves, and larger leaves, also somewhat abstract, are carved on an ogee moulding outside the wreath. This frame is described in the typescript recollections made by Cecil Gould of National Gallery frames as 'Philip Hendy's masterpiece among frames. He found three sides outside in a yard in Venice and had the fourth made specially.' It is likely to have been put on the painting after the restoration in the winter of 1958.

Old frames of a similar character are found around Veronese's *Belle Nani* in the Louvre[174] and Bronzino's *Madonna and Child with Saint John the Baptist* (NG 5280), the last-mentioned retaining its original gilding. The pattern was popular in the last quarter of the nineteenth century, for example in some

works by Leighton,[175] and throughout the twentieth century richly foliate frames involving both a wreath and leaves on an ogee moulding have been considered as especially well suited to Venetian sixteenth-century pictures.

Appendix 1

'THE FAMILY OF DARIUS' BEFORE AND AFTER VERONESE

In common with other subjects drawn from ancient history and poetry that came to be favoured as mural decorations for palaces and villas in the sixteenth century, that of the Family of Darius before Alexander had been painted on at least one wedding chest in fifteenth-century Florence.[176] The first known painting of the subject on a large scale is the fresco made by Sodoma in the 1510s for the principal bedchamber of the villa beside the Tiber, later called the Farnesina, that had been built for the immensely rich banker Agostino Chigi.[177] Then, in the 1520s, Polidoro da Caravaggio chose it as a subject for the fictive reliefs he painted on the façade of Palazzo Milesi, also in Rome.[178] Two decades later Perino del Vaga and Pellegrino Tibaldi chose the subject for one of the fictive bronze reliefs they painted in the Sala Paolina, in Castel Sant'Angelo, Rome, for Pope Paul III (whose baptismal name was Alexander).[179] Taddeo Zuccaro also painted the subject, perhaps as a façade decoration and certainly on the vault of Castello Orsini (now Odescalchi) at Bracciano around 1560.[180]

It seems likely that the Venetian patrician Girolamo Soranzo, or his advisers, knew of the Farnesina frescoes and perhaps those of the Sala Paolina when he commissioned the decoration of the Villa Soranzo, which Michele Sanmichele had rebuilt for him in the 1540s. This was the first major work in fresco by Veronese and must have done much to establish his reputation (see p. 331). Only fragments survive, two of them bearing the date 1551,[181] but Ridolfi describes how the walls of one room were painted with narratives of Alexander cutting the Gordian knot and 'the women of Darius before the same Alexander who ordered that they be treated as befitted queens' ('le donne di Dario dinanzi al medesimo Alessandro che ordina che sieno come regine servite').[182] Battista Zelotti, who worked with Veronese (his compatriot) on the Soranzo frescoes, painted episodes from the history of Alexander a decade or so later, when, together with Battista del Moro, he was commissioned to fresco some of the interior of Villa Godi (now Villa Malinverni) at Lonedo di Lugo near Vicenza. In the great Salone we see two battles between Darius and Alexander ('due fatti d'armi tra Dario ed Alessandro'), one certainly showing Alexander ordering the corpse of Darius to be respectfully covered (the other scene has not been identified)[183] and, opposite the chimney wall in the Sala del Venere, The Family of Darius.[184] Veronese himself returned to the subject in the painting catalogued here, probably a little later in the same decade.

Not only was Veronese's painting unusual because it is on canvas, but also because it has no companion painting that we know of, although of course something of the kind may have been intended. All the other paintings mentioned so far have been part of a series or cycle. And this remains the case with the notable paintings of the Family of Darius made in other parts of Italy later in the sixteenth century – for instance, that by Bernardo Castello in the frescoes of Palazzo Spinola, Genoa, made in the early 1590s[185] – or in the seventeenth century – notably the lunette by Pietro da Cortona in Palazzo Pitti, Florence, in the early 1640s.[186] It is also worth noting that Veronese was unusual in depending only on the minimal text of Valerius Maximus, for all the other surviving representations of the story reveal some knowledge of Quintus Curtius Rufus (at least) by showing the tent of Darius, the eunuch's alarm, Alexander's gesture of personally raising the queen mother, or his gesture of embracing the little prince.

Other large paintings on canvas of the Family of Darius began to be popular soon after the mid-seventeenth century, perhaps not coincidentally when Veronese's painting had begun to be specially commended by connoisseurs and coveted by collectors. The picture by Mattia Preti now in the National Museum of Romania, Bucharest, probably dating from the early 1650s,[187] and the painting in the Ashmolean Museum by Antonio Bellucci (fig. 19)[188] are among the first. Measuring 213 × 564 cm, Bellucci's canvas is even larger than Veronese's, which it resembles in some of the poses and gestures and in the choice of secondary figures (halberdier, dwarf, groom). Although we do not know the settings for which these paintings were originally made, they were surely palace decorations intended for a particular space. And in Venice in the last decades of the seventeenth century this was just the sort of subject that was favoured for the great paintings on the wall of the portego. Antonio Zanchi, indeed, painted The Family of Darius for Ca' Fini in the 1690s.[189] The pair of paintings by Bellucci now in the Museo Civico, Verona, provide another example of this genre: one has always been recognised as depicting the Continence of Scipio, the other has often been published as 'The Family of Darius' but must actually represent Coriolanus yielding to his mother's supplications.[190]

There are smaller gallery pictures of the Family of Darius by Venetian artists but these may well have originated as sketches for larger paintings of this kind. The young Piazzetta, for instance, painted the subject, together with one of Alexander ordering the corpse of Darius to be covered[191] and, as noted above, much later in his career he painted the latter subject on a large scale for Palazzo Pisani Moretta as some sort of companion for Veronese's own canvas.

The subject did begin to be favoured for smaller canvases that might be classified as gallery pictures. Antonio Pellegrini, for example, who had supplied four large episodes from the life of Alexander for the portego of Casino Correr in Murano in 1696, painted a pair of canvases with half-length figures around 1700 – that is, at about the same date as the paintings by Piazzetta mentioned above, and representing the same subjects.[192]

In Venice and the Veneto throughout the first half of the eighteenth century the subject of the Family of Darius enjoyed great popularity not only for palace decorations of all kinds (including shaped canvas overdoors[193]) and gallery

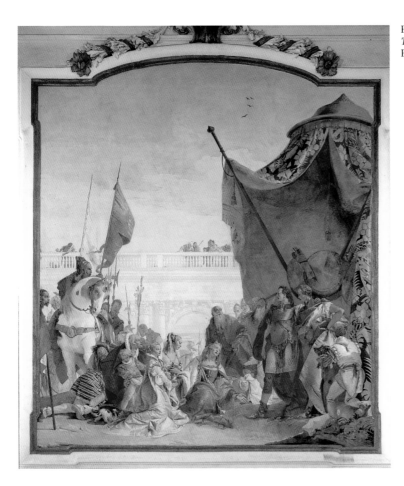

Fig. 20 Giovanni Battista Tiepolo,
The Family of Darius before Alexander, 1743–4.
Fresco. Montecchio Maggiore, Villa Cordellina.

pictures,[194] but also, once again, for frescoes in villas.[195] Patrons may have had a preference for the familiar, but artists may also have wished to claim Veronese as an ancestor, and to make variations on a theme that was especially associated with him was a way of doing so. Above all, this must be true of Tiepolo's fresco of 1743–4 in Villa Cordellina, Montecchio Maggiore near Vicenza (fig. 20).[196] And such homage may also have represented a defence of a tradition in painting that was under some attack from academic art theory. To understand this we need to consider a painting of the Family of Darius made in seventeenth-century France.

Charles Le Brun owed his position as first painter to the French crown to his painting of this subject – generally known as *La tente de Darius* (fig. 21) – which he painted between 1660 and 1661, partly under the admiring eyes of the young King Louis XIV.[197] The fame of this painting was increased by the tapestry made after it at the Gobelins factory,[198] and still more by Edelinck's fine engraving of it[199] and by André Félibien's polemical essay praising its decorum, expressive power, historical accuracy and deliberate reduction of the splendour and excitement – the 'éclat' and 'vivacité'– of colour.[200] Félibien thus defined a type of heroic narrative painting akin to tragic drama, beside which Veronese, with his mixture of fancy dress and high fashion, his large chorus, the captivating splendour of his setting, and the beauty of his colours, suggested the 'excesses' of romance, epic or opera. This exemplary status accorded to Le Brun's painting

prompted pictorial responses of which the most famous in France was *The Family of Darius* by Le Brun's great rival, Pierre Mignard, in 1689, now in the Hermitage.[201]

Le Brun is unlikely to have known Veronese's *Family of Darius* but no artist or art lover of any education in the eighteenth century was unaware of Le Brun's composition and it had some influence on Italian artists.[202] Patina, who was a member of the French academy, when publishing the earliest print of Veronese's painting in 1691 noted that the 'famosissimo' Le Brun, 'Pittore del Re Christianissimo', had painted the same subject in a different way 'and I dare say with as much more beauty as well as with more truth' ('e ardisco dir con tanto più vaghezza, quanto con più verità').[203] However, Venetians pointedly preferred their local classic.

Echoes of the theoretical position articulated by Félibien may still be heard in reactions to Veronese's painting in the mid-nineteenth century, when Eastlake felt obliged to qualify his very great admiration with the observation that Veronese is 'confessedly inferior in the qualities that appeal to the mind'[204] and Triqueti considered the picture to be disfigured by all sorts of 'redundant extras absurdly rigged out in exotic and tawdry finery' ('des figures de comparses ridiculement affublées des plus étranges oripeaux').[205] It also helps us to understand what Baron von Rumohr meant when he marvelled at how the artist's use of colour was such that one overlooked the fact that the action was managed as it might be in a Spanish play.[206]

GOETHE AND *THE FAMILY OF DARIUS*

The first part of the *Italienische Reise* of Johann Wolfgang von Goethe (1749–1832) (first published in German in 1815[207]) includes a famous account of his stay in Venice between 28 September and 14 October 1786, which is remarkable, given the priorities of other cultured visitors to the city, in that it describes – indeed names – only one painting. That this painting is Veronese's *The Family of Darius* is certainly testimony to the fame this painting then enjoyed – it was perhaps the most celebrated picture in a private collection in Venice – but it is clear too that it epitomised much of Goethe's experience of the city. Although Goethe did try his hand at painting, the art that interested him most was the theatre. In addition to staged performances of every kind – opera, tragedy, masked comedy, comedy – he comments on oratorio, dialect storytellers, the singing of *gondolieri*, the performances of star lawyers and popular preachers, and of course the ceremonial procession of the doge in gold and ermine and his escort of nobility in robes and wigs. After theatre, the art that appealed most to Goethe in Venice was architecture, the classical architecture of the sixteenth century, for he had discovered Palladio on his way there and had been converted from his earlier attraction to the gothic.

The Family of Darius, as a highly theatrical performance with a magnificent architectural setting, was certain to command his attention when he saw it on 8 October, and indeed he describes it as a drama. Much has been made of the fact that he evidently supposed that the figure in rose was Hephaestion, but since he observes that 'he turns away and points to the person on the right' ('er lehnt es ab und deutet auf den rechten'), he was clearly writing imprecisely from memory (neither figure turns away). He found 'the gradation in the expression from the mother through the wife to the daughters' ('Die Abstufung von der Mutter durch Gemahlin und Töchter') to be a felicitous touch and remarkable for its truth to nature. 'The youngest princess, kneeling last of all, is a pretty little mouse and has a very attractive, but somewhat independent and haughty, countenance. Her position does not seem to please her in the least' ('die jüngste Prinzess; ganz am Ende knieend, ist ein hübsches Mäuschen, und hat ein gar artiges, eigensinniges, trotziges Gesichtchen, ihre Lage scheint ihr gar nicht zu gefallen').

Goethe must have been affected by the experience of seeing the picture in the palace of one of the most powerful and wealthy old families in the city. Pietro Vettore Pisani, elected procurator of S. Marco in 1776, would almost certainly have been among the nobility whose bearing had so impressed Goethe two days earlier at S. Giustina. Two years previously, after a long and spectacular legal battle – courtroom theatre that had engrossed the whole city – his nephew, also named Pietro Vettore, had been awarded patrician status,

Fig. 21 Charles Le Brun, *The Family of Darius at the Feet of Alexander* ('*La tente de Darius*'), 1660–1. Oil on canvas, 298 × 453 cm. Versailles, Musée National des Châteaux de Versailles et de Trianon.

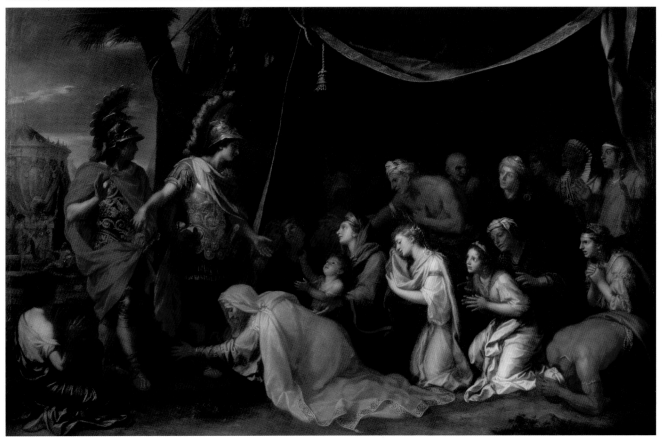

despite the low birth of his mother and the annulment (engineered by his grandmother and uncle) of his father's first marriage. Under an agreement made the year before Goethe's visit, the palace – and the Veronese – were now legally in his possession.[208]

Goethe commented on the painting's excellent state of preservation – it struck him as having just been painted, and in fact it had, we may recall, recently been cleaned. The observations he makes on the skilful distribution of light and shade and the ingenious contrast of local colours are not especially original, but on the following day floating on the sunny lagoon and observing the brilliance of the costumes of the gondoliers, luminous even in their shade, contrasted with green water and blue sky – a scene painted 'chiaro nel chiaro' – he speculated on the formative influence of such scenery on local artists and the advantage they enjoyed over those of us 'whose eye when out of doors, falls on dingy soil, which, when not muddy, is dusty'. He refers here in general to Titian and 'Paul', but it is evidently the latter (that is, Veronese), and in particular *The Family of Darius*, of which he is thinking in this, the first of numerous such meditations on 'Venetian colour'. The passage owes something perhaps to Winckelmann's reflections on the influence of climate and circumstances on ancient Greek art but also looks forward to Ruskin's evocation of the boyhood of Turner and (by comparison) Titian.

It has, as it happens, a special interest for the historian of the National Gallery because it seems to have had a considerable influence on Charles Locke Eastlake, the Gallery's first director, whose familiarity with German thought may be traced back to his cosmopolitan acquaintance in Rome in the second decade of the century, and whose translation of Goethe's *Theory of Colour* was published in 1840. Among Eastlake's most remarkable speculative writings is an account of the influence of the gondola, made in 1830, in which he

OPPOSITE: Fig. 22 Detail of NG 294.

Fig. 23 Detail showing the pendant of the kneeling princess.

dwelt on the advantage ('to be met with *nowhere* else') of viewing the world 'without the trouble of walking about', and expanded on the effect of seeing the sunburnt limbs and faces of gondoliers, fiery against 'cool, neutral architecture', and 'the greenish water' – this vivid effect he considered to be 'undoubtedly the truest idea of a colour, whatever the colour may be, because it is that which the memory most retains'.[209]

Appendix 3
JOHN RUSKIN AND THE 'PISANI VERONESE'

In his early writings on painting Ruskin gave little attention to Veronese. Even after his enthusiasm for Tintoretto had forced him to abandon his general aversion to Venetian sixteenth-century art he had little to say about Tintoretto's great rival. In the 'Venetian Index' that he appended to the third volume of *The Stones of Venice* in 1853 he observes that Veronese's *Europa* is 'one of very few pictures which both possess, and deserve, a high reputation', and has other brisk words of praise for the artist's work in the Doge's Palace.[210] He observes casually that Veronese's works in S. Sebastiano 'seemed destroyed by repainting', although he admits that he 'had no time to examine them justly'. Of *The Family of Darius* he notes simply that he believes it is 'not likely to remain in Venice'.[211] None of this prepares us for his letter to *The Times* on 7 July 1857 defending the price paid for *The Family of Darius* and declaring that it is 'simply the best Veronese in Italy' and that, 'for my own part, I should think no price too large for it'.[212] Three days later he was lecturing in Manchester and again defending the expenditure: 'I wonder what the nation meanwhile has given for its ball-dresses!' Such finery lasted little longer than 'last year's snow' but the 'Paul Veronese will last for centuries'.[213]

Veronese's painting was hung in the National Gallery on 16 September 1857 and Ruskin must have seen a great deal of it, because he was employed there throughout the autumn and winter months of that year in sorting and cataloguing more than 19,000 'pieces of paper, drawn upon by Turner in one way or another'. In his *Notes on the Turner Gallery* he twice illustrates points about Turner by reference to small details of the Veronese – the black of the ermine tails and the shadows in the violets of the princess's robe.[214] Another such observation, surely made at this date, found its way into the fifth volume of *Modern Painters*, which appeared in 1860. It concerned the pearls on the breast of the elder princess:

> The lowest is about the size of a small hazel-nut, and falls on her rose-red dress. Any other but a Venetian would have put a complete piece of white paint over the dress, for the whole pearl, and painted into that the colours of the stone. But Veronese knows beforehand that all the dark side of the pearl will reflect the red of the dress. He will not put white over the red, only to put red over the white again. He leaves the actual dress for the dark side of the pearl, and with two small separate touches, one white, another brown, places its highlight and shadow. This he does with perfect care and calm; but in two decisive seconds. There is no dash, nor

display, nor hurry, nor error. The exactly right thing
is done in the exactly right place, and not one atom
of colour, nor moment of time spent vainly. Look close
at the two touches, – you wonder what they mean.
Retire six feet from the picture – the pearl is there.[215]

Ruskin had not previously been much inclined to praise the
artist who skilfully judged an effect rather than earnestly pur-
sued the truth, and he was more associated with commending
the effortful than the deft. The Pre-Raphaelite painters, whose
painstaking realism he had championed, began to relax their
handling during the same period.

In May 1858, when he had completed his labours on the
Turner drawings, Ruskin set off for the Continent. His inten-
tion had been to explore the Swiss mountains and examine
the character of Protestant shepherds, but he 'unexpectedly
found some good Paul Veroneses at Turin'.[216] Oddly, the
picture that most impressed him there in July was not the
great *Feast in the House of Simon* but *Solomon and the Queen of
Sheba*, which is at least partly a studio work.[217] In his auto-
biography, *Praeterita*, he described how the splendour of the
painting and the sound of military music on a sunny day
opened his eyes to the narrow puritanism exemplified by the
preaching he had felt obliged to listen to in a gloomy Walden-
sian chapel[218] – a narrowness rather well illustrated by his
own recent tirade against ball-dresses. The life-changing im-
pact of the Veronese in Turin was perhaps exaggerated here,
but the painting did make a great impression on him – one,
however, for which he had been prepared less than a year
before in Trafalgar Square. Indeed, it is striking that he was
most captivated by a kneeling maid of honour in a golden
and white robe.[219] This is the portion of the painting which
is very similar to *The Family of Darius*, but in this case Ruskin
could feel that he was making a discovery.

NOTES

1. Penny and Spring 1994, p. 17 and notes
70 and 71.

2. Rioux 1992, p. 134.

3. Penny and Spring 1994, p. 22 and
note 86.

4. Ibid., p. 21, notes 80 and 81 (note that
Alexander is here identified as Hephaestion).

5. Ibid., p. 21, and especially pl. 14.

6. Ibid., p. 20, notes 76–8.

7. Ibid., p. 22, also pl. 15 on p. 21 and (for
haematite) note 84.

8. Ibid., p. 23 and pl. 12 on p. 21 for
ultramarine. For other blues see ibid., p. 20.

9. Rumohr's notes were known to Burton
(see [Burton] 1890, p. 71n.) and also to
Mündler (see Mündler 1985, p. 146), who
was supplied with an extract by a 'Mr Nerly'.
Since Nerly is not identified in the published
edition of Mündler's notebooks, it is worth
pointing out that he was Friedrich Nerly
(1807–1878), born Nehrlich, the protégé
of Baron von Rumohr. He settled in Venice
around 1840 and enjoyed great success as
a painter of Venetian views and café life.

10. Merrifield 1849, II, p. 858n.

11. Quoted in ibid., pp. 730–53.

12. Triqueti 1861, p. 61.

13. Penny and Spring 1994, p. 22.

14. Memo of 12 June 1996 by Ashok Roy to
Martin Wyld in response to allegations made
in a letter to the Gallery's director.

15. Gould 1975, p. 320.

16. Eastlake MS Notebook 1852 (4), fol. 8.

17. Eastlake MS Notebook 1854 (1), fol. 17r.

18. Eastlake MS Notebook 1856 (4), fol. 10,
entry of 14 October.

19. Gould 1978, pp. 10–13.

20. This and the previous two paragraphs are
largely derived from Penny and Spring 1994,
pp. 18–20.

21. See below at note 109.

22. Merrifield 1849, II, p. 856n.

23. For Edwards see p. 110.

24. Levi 1900, p. ccxlvii.

25. Mündler 1985, p. 146 (1 April 1857).

26. NG 5/195/16.

27. NG Archives. A payment of £46 10s.
on 12 January 1858 was for restoring nine
paintings. Bentley had been much employed
by the Gallery throughout 1857. He was paid
for cleaning and restoring 103 Turners on
18 August 1857 and was also paid for
general work 'attending to' the pictures and
'keeping them in order', receiving £48 for this
in the second half of the year.

28. MS Catalogue and MS memorandum –
the latter quoted in the conservation dossier.

29. NG 32/67 (Wornum's Diary).

30. Osmond 1927, pp. 45, 112.

31. Gould 1978, p. 7.

32. Gould was unaware that De Scolari 1875
also connected the picture with the
Inquisition, as did Caliari 1888, pp. 105–6.

33. Pallucchini's unpublished lectures of
1963/4, cited by Pignatti and Pedrocco
1995, I, p. 284.

34. For the tribune paintings in S. Sebastiano
see Pignatti and Pedrocco 1995, I,
pp. 268–70, nos 171 and 173; also Cocke
2001, p. 194, no. 18.

35. See Marinelli 1988, p. 222 (entry by
Filippa M. Aliberti Gaudioso), but also Cocke
2001, pp. 105–7 and 194–5, no. 19.

36. North 1657, p. 567.

37. For example, Diodorus Siculus, xvii, 39.

38. Compare, for example, Veronese's
painting of the *Centurion kneeling before Christ*
(Madrid, Prado) – Pignatti and Pedrocco
1995, I, pp. 282–3, no. 186.

39. Eastlake 1896, II, p. 94.

40. *Anabasis Alexandri*, II.12.3–8.

41. Ridolfi 1914, I, pp. 337–8.

42. Plutarch, *Parallel Lives*, XXI–XXII.

43. *Historical Library*, XVII.37–9.

44. *History of Alexander the Great*, III.16–27.

45. Valerius Maximus, Book IV, *De Amicitia*,
VII, ext. 2.

46. Richter 1933.

47. The book has only recently been included
in the Loeb edition of the Classics (Shackleton
Bailey 2000). There are, on the other hand,
over a hundred separate entries for Valerius
Maximus before 1600 in the British Library
catalogue. See also Briscoe 1993.

48. Jennifer Fletcher made this point in one of
her Slade lectures in 1991. She published it in
a review in the *Burlington Magazine*, February
1996, p. 135.

49. Plutarch XXIX (offer), XXX (death of the
Queen), XLIII (death of Darius) and LXX
(marriage).

50. Philipp Fehl in a letter of 29 July 1958
argued that the figure in rose was
Hephaestion and Cecil Gould made a minor
modification to the 1975 catalogue in
deference to this point of view.

51. Copy of reply to Fehl in NG dossier.

52. Burton 1889, p. 68.

53. Claude Blair's typescript note in the
Gallery's dossier.

54. This is unmatched in any surviving weaponry of the period.

55. Real Armería, Patrimonio Nacional, Madrid, Pyrr *et al.* 1998, no. 54.

56. The point is made by Claude Blair in the Gallery's dossier. For Orsoni see Hayward 1976.

57. For example, the shield dated 1541 made for the Emperor Charles V by Filippo and Francesco Negroli now in the Real Armería, Palacio Real, Madrid.

58. Wethey 1969–75, I, pp. 79–80, cat. 21 and pl. 91 (*Ecce Homo*, Vienna, Kunsthistorisches Museum), pp. 139–40, no. 114, and p. 178 (*Martyrdom*, Venice, Church of the Gesuiti).

59. Pignatti and Pedrocco 1995, I, p. 270, no. 173.

60. Ibid., I, p. 230, no. 127.

61. Ibid., II, p. 329, no. 203.

62. Ibid., II, pp. 328–9, no. 202.

63. Museo Vetrario, Murano. Now generally attributed to Benedetto Caliari but surely designed by Paolo. This important painting was made for a position 'sopra banchi' of the Confraternity of the Rosary in S. Pietro Martire – Ridolfi I, 1914, pp. 330–1. Alvise Mocenigo in Tintoretto's portrait of him with his family, National Gallery of Art, Washington (*c.*1571), has four rows.

64. For example, Prospero Fontana's *Adoration of the Kings* of 1548–50. Michelangelo also incorporated this sort of cap into his fantasy heads.

65. Vettor Pisani died in 1380. His remains were kept in the Villa Chapel at Montagnana from 1814 until 1920, when they were moved to SS. Giovanni e Paolo, Venice.

66. Gullino 1984 and Chiappini di Sorio 1983.

67. Ridolfi 1914, I, p. 334 ('la più vasta tela in casa pisana rappresentò la Costanza di Alessandro').

68. Martinioni 1663, p. 375. On the same page he describes the larger collection of another procurator, Alvise Pisani, 1613–1679, from another branch of the family, who was a Procurator de Supra. The inventory of his apartment is ASV, Giudici di Petizion, B382/47, no. 37.

69. Burns 1975, p. 193, no. 345; Puppi 1973, pp. 288–9; Boucher 1994, pp. 129–33.

70. Caliari 1888, p. 24, note 8.

71. For example, Brunelli and Callegari 1931, p. 337.

72. Terribile 2005, pp. 81–2. Gould was dependent upon a photocopy of Barbaro's *Genealogie Patrizie* in the Archivio di Stato (Barbaro, VI, PP. 113–14). Here Francesco Pisani of Montagnana is abbreviated to Franco and given less prominence than his fertile kinsman, Francesco Pisani son of Vettor (see the family tree). Consequently Gould believed Francesco of Montagnana had two sons and died in 1564. Gould 1978, p. 22, note 10.

73. The 'casa a Montagnana' was described by Francesco as his residence ('mia habitacion') in 1566 – see Gullino 1984, p. 76, note 96.

74. Hazlitt 1826, p. 351; [Burton] 1890, p. 71; [Burton] 1898, p. 88; [Collins Baker] 1925, p. 354; [Collins Baker] 1929, p. 350; Gould 1978, pp. 7–8.

75. Pignatti and Pedrocco 1995, II, p. 461, no. 356. Now in Quadreria of the Accademia – Nepi Scirè 1995, pp. 79–80.

76. Ibid., I, pp. 288–9, no. 194.

77. Habert 1992, pp. 45–50.

78. Pignatti and Pedrocco 1995, I, p. 106, no. 57 (fig. on p. 105). See also Cocke 2001, pp. 84–7, no. 4.

79. Pignatti and Pedrocco 1995, I, p. 79, no. 42.

80. Ibid., p. 136, no. 101.

81. Ruskin 1903–12, XIV, 1904, p. 118 (*Academy Notes*, June 1857).

82. Gullino 1984, *passim*.

83. Dézallier d'Argenville 1762, I, pp. 262–3.

84. Goethe 1962, pp. 78–9.

85. Cicogna 1834, IV, p. 235 – see also VI, p. 905. Cicogna's notes in the Biblioteca Correr (Cicogna MSS 3007, folder 23) reveal no earlier source for this story than d'Argenville.

86. Triqueti 1861, p. 63, has the painting made in gratitude for the tender care Veronese received after a dangerous fall from his horse. See De Scolari 1875, p. 7, for an even later variant on the story, and Caliari 1888, pp. 105–6, who elaborates on the need for a refuge from the Inquisition.

87. Mündler 1985, pp. 148–9. No trace of the inscription remains but a signature and vestigial date of 1656 survive on the pendant of *Alexander bestowing Campaspe upon Apelles*. For this latter painting transferred to Venice from Este in 1921, see Pavanello 1976. Cicogna (VI, 1853, p. 905) gives the subject as the Marriage of Queen Caterina Cornaro.

88. Mündler 1985, p. 148.

89. Gould 1978, p. 5. The measurements he gives do mean that the picture would fit, but it is not true that 'a better fit could hardly be imagined' since the painting would have had very little breathing space.

90. Barcham and Puglisi 2001, pp. 58, 86.

91. Chiappini di Sorio 1983, p. 118.

92. ASV, Cancelleria Inferior, Minuti di testamenti, b.31, no. 3197.

93. Chiappini di Sorio 1983, p. 120 and note 14, implies that the family only moved into the palace in 1672.

94. Terribile 2005, p. 82.

95. Ibid., p. 83, for the idea that Boschini made a mistake and the picture stayed in the family palace.

96. Boschini 1674, pp. 56–7 (in most editions this section is unpaginated). The other painting was a nude Venus.

97. Caylus 1914, pp. 108–9.

98. De Brosses 1991, I, p. 302.

99. Chiappini di Sorio 1983, p. 124 and note 23 on p. 123 – the accounts are complex.

100. Mariuz and Pallucchini 1982, pp. 116–17, no. 121. The *modello*, once also in Pisani ownership, is in the Fitzwilliam Museum (ibid., no. 122). Knox 1992, pp. 202–4.

101. See also, in this connection, Piazzetta's *modelli* in Montauban cited here in Appendix 1.

102. Cochin 1758, III, p. 137. See Christian Michel's edition of 1991 which gives the date of Cochin's visit (Introduction, p. 12).

103. I owe this observation to Maurizio Sammartini.

104. Cochin 1758, III, p. 138.

105. Chiappini di Sorio 1983, pp. 123–4. Payment of 1744.

106. Ibid., pp. 124–5.

107. Levey 1984, p. 509. The *modello* was exhibited at Agnew's in June–July 1985, no. 25 – it was perhaps not known to the restorers of the fresco in Venice in 1996.

108. Chiappini di Sorio 1983, p. 130 and note 37 on p. 126.

109. Biblioteca Correr, MSS Lazara Pisani-Zusto, reg. 308 (Quaderno Pisani del Banco 1767–74), fol. 208, reg. 339, entry 310; fol. 179, entry 326; fol. 226, entry 344 – the last of these references is not given by Chiappini di Sorio.

110. Olivato 1974, pp. 40, 41 and notes 88 and 89 on pp. 67 and 70.

111. Ruskin 1903–12, XI, 1904, p. 398.

112. Chiappini di Sorio 1983, p. 134.

113. Hazlitt 1826, p. 351 (the travel notes published in the *Morning Chronicle* in 1825 were published as a book in 1826).

114. For example Quadri 1821, p. 163; Fontana 1847, p. 240; Selvatico and Lazzari 1852, p. 232 ; Zanotto 1856, p. 592.

115. ASV, Governo Provisorio di Venezia 1848–9, reg.1224. 210,000 lire were loaned.

116. Ibid., reg. 1258. He lent 200,000 lire on 19 September and 239,000 on 20 August 1852. See Ginsborg 1979, pp. 234 and 303–4, for a full analysis of the financial situation.

117. Artemieva 2001, pp. 36–7, for Barbarigo sale, and 1998, p. 43, for the attempt to buy the Pisani picture and the tsar's response, which is an early reference to Campana's efforts to sell his antiquities. Borowitz 1991, p. 31, dates this overture to 1853.

118. Mündler 1985, p. 137, entry for 30 October 1856 reporting what Fabris had told him.

119. Eastlake's report, 'Negotiations respecting the Pisani Paul Veronese', in the

Parliamentary Report for the year ending
31 March 1858, pp. 32–3.

120. Harris's dispatch to the Treasury of
31 January 1857 (copy in NG dossier).

121. Eastlake as cited in note 119.

122. Copies of both letters in NG dossier.

123. An exact account of the Austrian decree
is given by Eastlake in his letter cited in
note 149, p. 3.

124. Mündler 1985, p. 114. Dubois had first
offered his services on 3 January 1856 (ibid.,
p. 91). All – or almost all – the extracts for
Mündler's diary pertaining to the purchase
were published as a continuous text in Gould
1978, pp. 17–20.

125. Ibid., pp. 137 and 138, under
8 November.

126. Ibid., pp. 143, under 22 December and
5 and 7 January 1857. The sum agreed upon
is given in Eastlake's report cited in note 119.

127. Dispatch of Harris to the Treasury of
31 January 1857 (copy in NG dossier); for
the decisive refusal in Padua see also Mündler
1985, p. 144 (22 January 1857).

128. Dispatch of Harris to the Treasury of
31 January 1857 (copy in NG dossier).

129. Mündler 1985, p. 80 (for Dubois), p. 138
(for Caterin Zen), p. 146 (for Monterumici's
friends in Treviso), and p. 147 (for
Monterumici). There are constant references
to Fabris as a dealer or agent. The reference to
Zen's collection is somewhat confusing. He
evidently had one painting with the painter
and dealer Natale Schiavoni but the others
referred to may have been his or Schiavoni's.

130. Ibid., pp. 144–5.

131. Eastlake report cited in note 119.

132. Castellani 1997, p. 135 and note 2,
p. 143.

133. Mündler 1985, p. 138.

134. Harris as cited in note 128.

135. Mündler 1985, pp. 145–6.

136. Ibid., p. 146.

137. Ibid., pp. 146–7.

138. Levi 1900, p. ccxlviii. Levi gives the sum
as 500 gold napoleons but, as noted above,
the coin was silver.

139. Letter from Zen to Eastlake of 22 July
1857 in NG dossier, and Mündler 1985,
p. 156.

140. Hansard, CXLVI, cols 816–46.

141. Ruskin 1903–1912, XIII, 1904, p. 88.

142. NG 32/67 (Wornum's Diary).

143. Ibid.; the Gallery's accounts also record
payment to Leedham of 4 guineas for his
service on 3 September 1857.

144. NG 32/67 (Wornum's Diary).

145. [Collins] 1860, p. 225 – see also p. 223.

146. NG 32/67 (Wornum's Diary), entry for
22 January 1858.

147. Ibid., entry for 1 April 1857.

148. Hansard, CLI, cols 1379–91. The fullest
account of this episode is given by Anderson
in her introduction to Mündler 1985,
pp. 34–8. The bad relations between Elcho
and Conyngham have their roots in the
paranoid aversion that Samuel Woodburn
developed towards Eastlake in the 1840s.

149. The letter was published in the printed
Return to the House of Commons of 2 August
1858.

150. Letter from Zen to Eastlake of 22 July
1857 in NG dossier.

151. 'Venice', an essay of 1882, part V,
second paragraph. The essay was collected
in Italian Hours of 1909.

152. Frodl 1974, p. 335, no. 198 and plates
49–50; Gallwitz 1972, pp. 121–7, no. 77.
The painting, in the Österreichische Galerie,
Vienna, is 400 × 1050 cm. Makart would
have studied The Family of Darius on his visit
to London in the company of Karl von Piloty
and Franz von Lenbach in 1862.

153. R.F. 38.932. The drawing has been
published by Bacou 1984, p. 17, and by
David Scrase in Martineau and Hope 1983,
p. 296, D.76. Both authors identify the figure
in rose as Hephaestion.

154. Patina 1691, pp. 195–6. 'Inter eximia
Pauli Veroniensis opera, illud precipue apud
venetos proceras.' N.R. Cochin is presumed
to have been the son of Noël le jeune
(1622–1695), chief contributor to the
Paduan volume.

155. Cicogna 1834, IV, p. 235. Quadri
in 1821 (I, p. 176) refers to Battagia's
establishment, then in the hands of Signor
Tarma, as a place where prints by Morghen
and other works of art were for sale.

156. Biblioteca Correr, Cicogna MS 3007,
folder 23, and Cicogna 1853, VI, p. 905.
Levi 1900, p. ccxcvii, mentions its restoration
on this occasion. See also note 85.

157. For example, the distance from the front
heel of Hephaestion to the back heel of the
page in white is 77.5 cm but 102 cm in the
original.

158. Commisseur – Priseur Lecocq, lot 70.
Gariel's daughter married the collector Piot.

159. Gazette, 14 December 1860, no. 285,
article by Carlo Malipiero.

160. Cited in Cicogna's notes (Cicogna VI ii
1855, p. 965).

161. Gould 1975, p. 321.

162. Ricci 1896, p. 51 (49 × 92 cm).

163. Photograph and letter in NG dossier.

164. De Brosses 1991, I, p. 302.

165. De Scolari 1875.

166. Mündler 1905, p. 147. Mündler notes
that Charles du Bois died in April 1857.
A letter from Maurizio Sammartini (whose
great-great-grandfather was Enrico du Bois)
to M. Piot explains that no such picture
remains in the family's possession. For the
approximately 800 pictures in this collection
see Mündler 1985, p. 80 (10 November 1855).
Mündler found only one that had any merit.

167. See, for example, Pons 1995,
pp. 324–36, especially the overdoors and
'console en encoignure', p. 329.

168. See Chiappini di Sorio 1983, p. 131.
Also MSS cited above in note 109, Reg. 308
(Quaderno Pisani dal Banco 1767–74,
fol. 226, entry no. 344).

169. For Gai, see Chiappini di Sorio 1983,
p. 121.

170. Ibid., p. 131 and p. 126, note 37
(gilding of a frame carved by Sempronio
Sgualdo).

171. Mündler 1985, p. 146.

172. NG 32/67 (Wornum's Diary). The
NG accounts record payment for this on
12 January 1858.

173. See fig. 16, p. 376.

174. This splendid frame was purchased from
Le Brun by Baron de Schlichting in 1912,
two years before he bequeathed the painting
to the Louvre (Habert 1996, pp. 5–6).

175. For example, The Garden of Hesperides,
Lady Lever Art Gallery, Port Sunlight.

176. Syson and Thornton 2001, p. 73,
fig. 52. The chest is dated c.1440 and
attributed to the workshop of Apollonio
di Giovanni.

177. Huyum 1976, pp. 164–77.

178. For this see the Tibaldi drawing after
Polidoro's façade in Hadjinicolau 1997,
p. 171, xi.i (entry by David Ekserdjian).

179. Gere 1960. See also Gere et al. 1981,
p. 179, plate 12.

180. Gere 1969, pp. 94–6, plates 122b,
124a.

181. Favera 1958; Gisolfi Pechukas 1987.

182. Ridolfi 1914, I, p. 302.

183. Brugnoli Meloncelli 1992, p. 104, for
date of this work, and figs 133–5 and plates
X–XII for the Salone generally. She does not
identify the second battle subject. Pixley
1998, pp. 247–80, provides a full account
of the difficulties of interpreting this scene.
It shows a warrior galloping over a battlefield
holding what seems to be a Roman standard
and startled by a corpse. This need not in fact
be an episode in the life of Alexander but
rather a Roman parallel.

184. Not illustrated by Brugnoli Meloncelli
1992, and not mentioned in her catalogue
entry for this room, p. 105, but see Pixley
1998, pp. 409–14.

185. Bozzo Dufour 1987, I, p. 258, fig. 261.

186. Campbell 1977, pp. 100–3, fig. 35.
As Campbell emphasises, Cortona's
interpretation is in several respects unusual,
because he took the subject as an example
of continence.

187. Inv. 8026/60. Hadjinicolau 1997,
pp. 176–7, xi.4 (entry by Iona Beldiman).

188. Inv. A.140. Magani 1995, p. 211,
R81, attributes the painting to Francesco
Minorello. However, it is acceptable as an
early work perhaps painted by Bellucci in
Vienna between 1709 and 1716, as its

provenance (the so-called Truchsessian Gallery, taken to London from Vienna in 1802) suggests. I am grateful to Burton Fredericksen for pointing this out.

189. Riccoboni 1966, p. 116, fig. 26. He also painted Alexander discovering the corpse of Darius for the *portego* of Palazzo Albrizzi in the early 1660s – a painting which remains *in situ*.

190. Inv. A.307 and 309. Magani 1995, p. 76, nos 5–6. For correct identification of the subject taken to be 'The Family of Darius' see Aikema 1997, pp. 168–9. Aikema notes that other paintings of Coriolanus have been mistaken for The Family of Darius. A case in point is Pittoni's composition sold Sotheby's, London, 16 December 1999, lot 172 – the absence of any regalia is conclusive.

191. Knox 1992, pp. 45–6, figs 38–9. Musée Ingres, Montauban.

192. Knox 1995, pp. 26–7, figs 28–9. Musée de Soissons.

193. For example by Francesco Fontebasso (1707–1769). See Sotheby's, London, 16 December 1999, lot 73. A cycle of Alexander paintings in the Palazzo d'Arco, Mantua, of the late 1730s includes this subject – see Caroli 1988, p. 78 (cats 48 and 49), also fig. 35 and p. 81 for the dating.

194. For example Sebastiano Ricci's *Family of Darius* (companion with a *Continence of Scipio*), North Carolina Museum of Art 1952.9.164/5, for which see Daniels 1976, pp. 103–4, cat. 366, fig. 209 – a painting dated by Daniels *c*.1708–10 – or the Fontebasso in the Museum of Fine Arts, Dallas, Texas, of about 1750, illustrated in the Macmillan/Grove *Dictionary of Art*, 1996, XI, p. 287 (entry by John Wilson), and in Magrini 1988, p. 135, no. 40 and fig. 113.

195. Notably Giambattista Crosato's frescoes in the Villa Marcello, Levada, near Padua, for which see Arcais, Zava Bocazzi and Pavanello 1978, I, p. 178, no. 84.

196. Pallucchini 1968, pp. 107–8, no. 147; Levey 1986, pp. 122–4, and plate III (on p. 117); Gould 1978, p. 16.

197. Thuillier 1963, pp. 72–3, no. 27.

198. See Hadjinicolau 1997, p. 178, xi, no. 5 (entry by Rotraud Bauer for tapestry completed 1688, now in the Kunst-historisches Museum, Vienna, inv. TV7).

199. Edelinck's engraving (on two plates) is undated. The same engraver reproduced Mignard's painting of the same subject in 1707. Robert-Dumesnil 1835–71, VII, 1844, pp. 201–2, no. 42.

200. Félibien 1663, in Félibien 1689, pp. 25–67. See p. 33 for accuracy of costume, pp. 36–9 for variety and complexity of feelings expressed, p. 49 for facial expression and body language, and p. 61 for subdued colour.

201. Baillio 2006, pp. 133–5, no. 34 (the entry is for the related tapestry cartoon by Mignard).

202. Francesco Trevisani's canvas of 1737 in the care of the Patrimonio Nacional, Madrid, exhibited in the Palazzo de la Granja is a notable example (Hadjinicolau 1997, pp. 182–3, xi.9 – entry by José Alvarez Lopera).

203. Patina 1691, p. 196.

204. Eastlake, letter to Secretary of the Treasury, 24 November 1856 (NG dossier).

205. Triqueti 1861, p. 63.

206. See note 9 above.

207. Goethe 1962, pp. 58–90 (for Venice in general), and pp. 78–9 (for Veronese in particular); equivalents in Goethe 1992 are pp. 73–114 and p. 101.

208. Chiappini di Sorio 1983, p. 133, and note 52 on pp. 132–3.

209. Eastlake 1870, pp. 130–1.

210. Ruskin 1903–12, XI, 1904, p. 375 (*Stones of Venice*, III, 'Venetian Index', 1853).

211. Ibid., p. 432 (S. Sebastiano) and p. 398 (Ca' Pisano).

212. Ibid., XIII, 1904, p. 88, the letter was dated 7 July. Already in *Academy Notes* of June 1857 Ruskin had declared that he 'rejoiced' at the purchase (ibid., XIV, 1904, p. 118) and indeed on 6 April in evidence to the National Gallery site commission he made a favourable comment on the acquisition (ibid., XIII, p. 552).

213. Ibid., XVI, 1905, p. 53 (*A Joy Forever*, Part One, delivered 10 July 1857, published in the same year).

214. Ibid., XIII, 1904, pp. 287–8 (*Notes on the Turner Gallery*, 1857).

215. Ibid., VII, 1905, pp. 246–7 (*Modern Painters*, V, 1860, ch. iv, para 18).

216. Ibid., p. 6 (*Modern Painters*, V, 1860, Preface, para. iv – see Introduction, p. xxxviii).

217. Ibid., XXIX, 1907, pp. 88–90 (*Fors Clavigera*, Letter 76, April 1877). The painting's status is controversial; see Pignatti and Pedrocco 1995, II, p. 439, no. 333, and Cocke 1977, p. 786; also Cocke 2001, pp. 66–8.

218. Ruskin 1903–12, XXXV, 1908, pp. 495–6 (*Praeterita*, Part 3, 1888, closing paragraphs of first chapter). For an analysis of this episode see Wheeler 1999, pp. 125–52.

219. For the white brocade see especially Ruskin 1903–12, XVI, 1905, pp. 184–6 (inaugural address to the Cambridge School of Art). For the interest in this figure see Wheeler 1999, p. 136.

NG 1041
The Dream of Saint Helena

*c.*1570
Oil on canvas, 197.5 × 115.6 cm

Support
The dimensions given above are those of the stretcher. The canvas is a fairly heavy plain (tabby) weave[1] consisting of a narrow vertical strip about 15 cm wide along the left edge, joined to a larger piece about a metre wide (corresponding to the width of a standard loom). The canvas has been trimmed on all four edges but there is a slight cusped distortion in the weave at the upper and lower edges, suggesting that little of the painted area can have been lost at top and bottom. The edge of the canvas seems to cut through the saint's raised foot, which suggests that there may be a more significant loss on the left edge. There is a gesso ground on the canvas, *gesso sottile*, rehydrated calcium sulphate (burnt gypsum, slaked) – but no priming layer.[2]

Materials and Technique
Infrared photography reveals very sketchy brush underdrawing in the drapery. It also shows that the bar of the cross was originally placed at an angle that was closer to the vertical: since there is no evidence of a correction to the post of the cross, this change was perhaps made before the latter was painted. Minor revisions to the vertical mouldings and the console window seat can also be detected. The lines of the horizontal mouldings are visible beneath the orange cloth on which the saint's right elbow is resting, so this drapery may have been an afterthought. The white cuff at the right wrist was originally broader. Smalt was used extensively for the sky. The salmon pink of the dress consists of lead white and vermilion. The shadows of both the dress and the skirt were painted with a red lake. Orpiment was used for the drapery beneath the saint's right elbow and over her seat, the shadows painted with red, yellow and brown earth pigments and the lights with lead-tin yellow 'type II'.[3]

Conservation
The painting was lined in 1959, the first time since it was acquired in 1878, and it was cleaned and restored in the following year.

Condition
There are tears in the canvas at the saint's left shoulder and on the lower right side of the painting, in the lower part of her dress. These areas have been retouched and there is also a good deal of retouching concealing abrasion in the sky, the cross, and the body and wing of the infant angel on the right, as well as, more extensively, in the damaged areas under the saint's right foot and further up, on the left side of the canvas. Judging from the copies of this painting (see below), the scrolling acanthus ornament carved in the stone above and below the stone bench was once more legible, as was the sole of the sandal on the saint's right foot. With the

deterioration of the smalt, the sky has turned from a pale blue to a yellow-grey.

Attribution and Date
The painting seems always to have been recorded as by Veronese until 1927, when Osmond challenged the attribution[4] on the grounds of its derivative composition (discussed below). The composition is indeed highly unusual in Veronese's work. Others may well have expressed doubts around this date, for the Gallery's director, Charles Holmes, mentioned in 1929 that a 'certain roughness in the execution has led the hypercritical to suspect that the author was another painter from Verona, Battista Zelotti'; however, he himself did not concur.[5] Fiocco did accept the painting and has been followed by other scholars, with the exception of Arslan, who proposed that it was a work by Benedetto Caliari.[6] A fresco, clearly derived from this painting, in the Stanza al Piano Superiore (the main room of the upper floor) of the Villa Da Mulla Romanziol at Noventa di Piave near Treviso, which was destroyed in the First World War, has been convincingly attributed to Benedetto and probably dates from the 1570s.[7] NG 1041 might surely have been painted in the late 1560s or early 1570s. Rearick proposes a date of 'about 1558', but with no compelling reason.[8] Gould considered it an early work (presumably of the early 1550s) because it reveals 'Central Italian influences' (discussed below) and is, he argued, close in colour and technique to the *Virgin and Child with Saints* in the Pinacoteca, Vicenza.[9] Gould may also have been influenced by a typescript report on the dress by Stella Mary Pearce (Newton), who was 'confident that it was not painted after 1555' on account of the shape of the bodice and the twisted scarf in the hair,[10] but her assumption that Veronese would have depicted a saint wearing a contemporary fashion of dress seems far from certain.

The limited palette and the relative 'roughness' of execution may perhaps reflect the painting's original purpose and location (discussed below) rather than the stylistic choices typical of a particular phase of Veronese's development. All the same, the economy of the execution is masterly. The absence of the sumptuous accessories generally favoured by Veronese and of any pattern or detail in the dress enables light to ripple over softly blended colours in a manner that evokes the idea of a dream flowing through the passive body. Adolfo Venturi likened the effect to that of sunlight gleaming in the concavities of damp sand on the seashore.[11]

Subject and Source
Helen or Helena, mother of the first Christian emperor, Constantine, dreamed that an angel revealed to her the location of the cross on which Christ was crucified and urged her to travel to the Holy Land to seek it out. In due course she excavated three crosses there and, by 'proving' (testing) their healing power, was able to distinguish the True Cross.[12]

The subject was not always recognised as Saint Helena. When the painting was auctioned in 1803 Christie's described it as a 'female Saint in a Vision and Angels descending with the Holy Cross'. Gould considered that the identification of

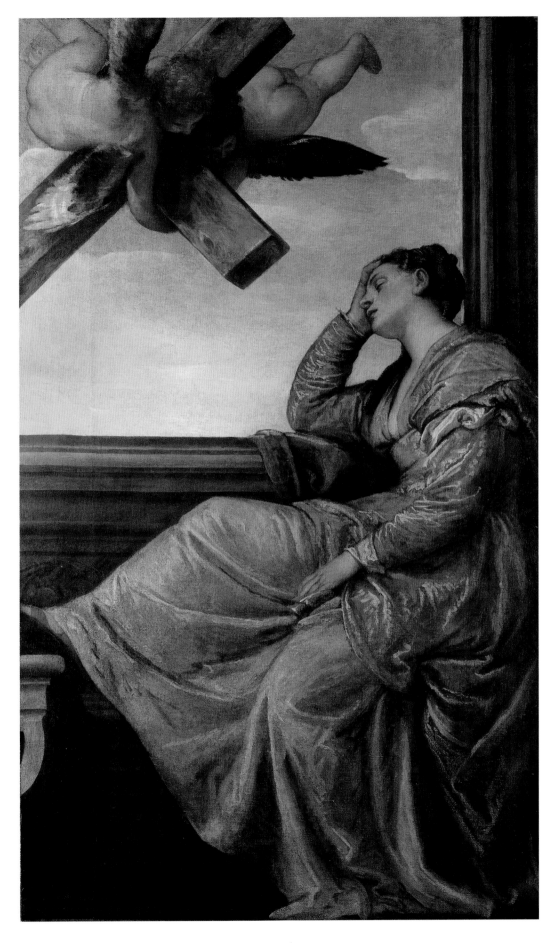

the woman in this painting as Saint Helena 'is universal and probably correct, but the iconography is unusual', noting that in earlier paintings of this saint by Cima da Conegliano and Palma Vecchio she is shown standing by the cross (these, however, are not narrative paintings, and the cross simply represents her attribute).[13] Since the nature of Helena's dream was more specific – it provided her with topographical indicators – he was struck by the 'unsuitability of the presentation to the subject' in the painting but thought that this 'may spring from the fact that the design was not Veronese's own and that it was never intended for Saint Helena'. The design was indeed derived from a print and we cannot be sure that the print was taken to represent Helena, although it seems very likely that it was. But it is surely not 'unsuitable' that the subject of Helena's dream should be so clearly depicted.

The print in question (fig. 1) is an engraving by a follower of Marcantonio[14] that was catalogued in the nineteenth century as perhaps after Parmigianino but thought by some to be after Raphael.[15] Two similar chiaroscuro woodcuts by Zanetti, apparently based on the engraving, have been supposed either to be Veronese's source or to be derived from his painting.[16] That Raphael had already been correctly identified as the inventor of the pose is strongly suggested by Samuel Taylor Coleridge's letter to Robert Southey sent from Portsmouth on 28 March 1804, urging him 'to call on ... Commyn's [sic] the picture cleaner in Pall Mall' to see 'above all' the 'picture of Saint Helena dreaming the vision of the Cross, designed by Raphael and painted by Paul Veronese. That is a poem indeed!'[17] However, during most of the twentieth century the engraving was thought to be after Parmigianino, and the beautiful drawing in the Uffizi upon which the print seems to be based was generally attributed to him.[18] In 1966 the attribution of the drawing was returned to Raphael by Oberhuber[19] and this has been generally accepted ever since.[20] There is no reason to suppose that Raphael intended his figure as a Saint Helena, and she is identified in an early inscription on the drawing as Danaë, perhaps because of her open legs, the abandonment of her pose, and the setting, which it is possible to imagine as an opening in the top of a tower. The pose was adopted for another sleeping heroine by another Venetian painter.[21]

Veronese painted another picture (now in the Vatican Pinacoteca) of the dream of Saint Helena which is generally dated to the late 1570s.[22] It differs from NG 1041 chiefly in the emphasis it places on Helena's imperial status – she wears opulent robes and a jewelled crown, and her pose is less indecorous. The painting is also clearly of a different type, even though its size is similar.

Original Function
The vanishing point of NG 1041 is below the lower edge, thus it was clearly designed to be displayed high above the viewer. Indeed, the low viewing point is the obvious change that Veronese has made from his source: only the sky can be seen through the opening; the mouldings of the opening are seen from below, and the receding, shadowed side of the stone seat is tilted; in addition, the underside of the saint's

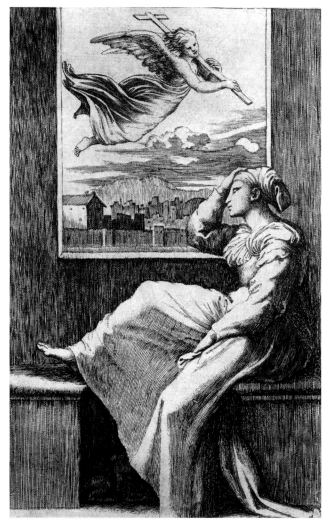

Fig. 1 Anon., after Raphael, *Saint Helena*, c.1520–30. Engraving, 15.2 × 9.3 cm (sheet). London, The British Museum.

chin is visible. Despite its geometrically satisfying composition, with its parallel diagonals,[23] the painting could also be easily imagined as one of a pair, with the companion canvas portraying a saint facing towards the right. If so, it may have been made as one of a pair of canvas shutters for an organ,[24] presumably an outside shutter, since when shutters are open the organ would be playing and a sleeping figure would seem incongruous. Such shutters varied greatly in size but were always placed high in the nave of the church.[25] This canvas is of a size which can be easily matched with existing examples – for example, Veronese's shutters for S. Giacomo, Murano, and those by Zelotti for the church of the Misericordia in Venice.[26] A great variety of subjects were considered appropriate for organ shutters, but a pair of saints, each on a shutter, was a common solution. Usually the figures occupy niches, but a more daring solution was attempted on occasions, as with the Isaiah and David painted by Camillo Boccaccino for S. Maria di Campagna, Piacenza, in 1530 (figs 2 and 3).[27] A later example with two saints (neither of them connected with music and neither of them found on other organ shutters) survives in S. Francesco della Vigna, Venice.[28]

If Helena had a companion saint it would have been her son, Constantine, and indeed she is as often represented with him as she is alone. Their images are commonly found in Franciscan churches that were dedicated to the Holy Cross, the Santa Croce. Furthermore, Helena is always placed on the right, as would have to be the case here.

Early References to Paintings of Saint Helena by Veronese

In 1646 Carlo Ridolfi mentioned in his biography of Veronese, reprinted two years later in his *Maraviglie dell'Arte*, that there were still ('erano ancora') eight paintings with devotional subjects ('quadri di sacre historie') by him in the Casa Contarini in Padua. The Contarini had been major patrons of Veronese and although a Venetian patrician family they had interests and important property in Padua. The eight paintings were all of figures about the size of life ('intorno al naturale'), but they do not seem to have been planned as a series. Ridolfi mentions a *Virgin and Child with Saints*, a *Christ disputing in the Temple* and *Christ with the Centurion*, the last two perhaps corresponding to the large paintings in the Prado, Madrid, and the 'inventione' of Saint Helena 'che dormendo sognavasi veder la Croce tenuta da due Angeletti, nodrendo

Figs 2 and 3 Camillo Boccaccino, *The Prophet Isaiah* and *King David*, 1530. Oil on canvas, each 420 × 195 cm. Piacenza, Musei Civici di Palazzo Farnese.

nella mente quella Santa Regina, benche si dasse in preda al riposo, così santo pensiero' – 'who sleeping dreams that she see the Cross supported by two young angels, that saintly Queen nurturing in her mind even when abandoned to rest, such a holy thought'.[29] Since there is only the child angel in the Vatican *Saint Helena* and there are two in NG 1041 it is tempting to suppose that NG 1041 was the painting once in Casa Contarini. However, if Veronese's painting was in Padua in 1646, it must have been exported to the Low Countries soon afterwards, since Lucas Vorsterman's engraving of it, which seems to date from the 1640s or early 1650s, must have been made there.[30] By the 1660s the painting must have been in the north Netherlands, where it was carefully copied in a brush drawing by Jan de Bisschop.[31] If the Veronese in the Contarini collection was a different painting then perhaps NG 1041 was the *Saint Helena* 'believed to be by Paolo Verona' which was item 22 in the list of pictures in Rubens's house in Antwerp made after the artist's death in 1640.[32] This is likely to correspond to the *Helena* by Veronese which is listed among the possessions of the late Countess of Arundel in Amsterdam in 1655.[33] In any case, NG 1041 is probably the *Helena* painted by Veronese that was praised in a poem by Govaert Bidloo describing the masterpieces belonging to Philips de Flines in Amsterdam, which was published in 1681. This painting was not included in the sale of the De Flines collection held soon after his death in 1700.[34] As we will see, there is reason to believe that NG 1041 came to England from Holland. Nevertheless, it is worth noting that only a few years before it is first recorded in England a *Saint Helena* by Veronese appears on a list of about forty pictures – some of them certainly major works – that purported to come from the collection of the last Duke of Mantua, which Giacomo Querini (1662–1747) took to London to sell when he travelled there on a secret political and trade mission on behalf of the Venetian Republic between the spring of 1715 and the autumn of 1716.[35]

British Owners of Veronese's *Saint Helena*
During the 1740s the antiquarian George Vertue listed Veronese's *Saint Helena* as a 'famous painting' that he had seen at 'Lord Godolphin's'.[36] The entry is undated but the reference is to Francis, 2nd Earl of Godolphin, who married Lady Henrietta Churchill, daughter of the 1st Duke of Marlborough (later, Duchess of Marlborough in her own right). His wife died in 1733 but he lived until 1766. The painting would later be sold with others 'purchased by the late Francis, Earl of Godolphin'. Vertue made, or rather transcribed, another list of Godolphin's pictures from the notebook of Richard Graham, where it is recorded that the *Saint Helena* was 'bot in Holland' for £400[37] – which presumably means that it was bought there by Godolphin, or at least for him. However, it was claimed, when the painting was sold in 1815, that it had once belonged to the 1st Duke of Marlborough, Godolphin's father-in-law, who died in 1722.[38] This could be dismissed as mere speculation were it not for the existence of a careful copy of the painting by Bernard III Lens (1682–1740) which is dated 1721.[39] Alastair Laing has pointed out to me that a copy of Van Dyck's equestrian portrait of Charles I which then hung in Blenheim Palace, the Duke of Marlborough's seat, was dated by Lens in 1720. So it 'seems quite likely that it was in the course of copying pictures at Blenheim that Lens copied your Veronese.'[40] There is, however, no evidence to suggest that any paintings left Blenheim when Marlborough died, and Lens perhaps enjoyed contacts with several members of the family. On the death of the 2nd Earl of Godolphin in 1766 the Veronese may have passed to his son-in-law, Thomas, 4th Duke of Leeds, and on the latter's death in 1789 it would have been inherited by his son, the 5th Duke, who died in 1799. In that case, George William, the 6th Duke of Leeds (1775–1838), is likely to have been the owner who sold the painting at Christie's together with 155 others purporting to be those 'purchased by the late Francis Earl of Godolphin' (his great-grandfather) on 6 and 7 June 1803. The auctioneers did in fact add some paintings belonging to P.J. Tassaert, a dealer, but for the most part the paintings came from the Goldolphin house in Stable Yard, St James's, where they were viewed before the sale. The formula used to describe the paintings offered may suggest that there was some dispute concerning ownership within the family.[41]

The catalogue, which lists the pictures room by room, gives a good idea of their arrangement. As had long been usual in London houses, they were placed throughout the house. It is hard to detect any underlying theme, except in the 'dining parlour', where there were seven pairs of landscapes and *vedute*, including works by Canaletto and Zuccarelli.[42] Dutch and Flemish paintings were mingled with Italian (a ter Borch near a Guido, an Ostade near a Titian). The Veronese hung in the 'study', near – perhaps between – two of Murillo's beggar boys.[43] By far the majority of the 160 lots sold on the two days went for less than £10 and only six pictures fetched more than £100. The Veronese (lot 60 on 6 June) sold for 130 guineas (£136 10s.), less than the Murillos, which went for £267 15s. and £283 10s., and surely less than was hoped, given that this 'very capital and elegant Picture, one of the first works of this great Master', was the first one mentioned in the summary of the contents given on the title page of the catalogue.[44]

The painting was bought at the Godolphin sale by William Comyns, 'who had been active in London art circles since at least 1779' both as a picture restorer and as a dealer, although he was probably better known in the former capacity. He seems to have charged very high fees and to have worked for some of the greatest collectors.[45] By the end of March 1804, it was, as we know from Coleridge's letter (mentioned above), visible in Comyns's Pall Mall premises – very probably newly cleaned. Comyns ceased to be active in the salerooms after 1811, and on 6 May 1815 he consigned 76 lots of pictures for sale at Christie's, very likely his entire stock, perhaps because he was retiring from business. NG 1041 (lot 73) was the star item in the sale, fetching 155 guineas (£162 15s.), and another Veronese (now in the National Gallery of Scotland), of a 'noble Venetian in adoration with a Mitred Abbot', was among the other lots that made a fairly high price – 60 guineas (£63) to the Marquess of Stafford. NG 1041 was

puffed in the catalogue as a 'noble chef d'œuvre ... originally the property of the great Duke of Marlborough ... engraved by several ancient Masters'.[46] Officially, nothing seems to have been bought in at the sale, but the 'Ponsonby' who purchased the Veronese is likely to have been an associate of Comyns, who may well have hoped to make a bigger profit on the picture. If so, he was disappointed, because when offered again at Christie's on 2 March 1816 in the sale of 'a man of Fashion and Taste', where it was consigned by 'Dorrien' (who also seems to have had some connection with Comyns), it fetched 101 guineas (£106 1s.).[47]

The buyer on this occasion was Francis Charles Seymour-Conway (1777–1842), then Earl of Yarmouth, but later 3rd Marquess of Hertford. He had been active as a collector from about 1802. Much of his great collection – one that was noted as much for its furniture and *objets d'art* as for paintings,[48] and greatly extended by the acquisitions made by his son, the 4th Marquess, and then by the latter's illegitimate son and heir, Sir Richard Wallace – is now to be seen in the Wallace Collection. Not, however, all of it. The 3rd Marquess was attended on his deathbed by Charlotte, one of the daughters of his mistress, Lady Strachan – an 'ugly little thing' (as Charles Greville described her[49]) – who married a Hungarian, Count Zichy, and styled herself Countess de Zichy-Ferraris. The disreputable old rake had doted on her and bequeathed to her the luxurious villa of St Dunstan's, which Decimus Burton had built for him in Regent's Park in 1825, together with its contents, which included, hanging in the dining room, the Veronese.[50] Prince Pückler-Muskau, describing a fête in the villa in 1827, emphasised its unified décor with 'flesh coloured stucco', and gold, black bronzes and large looking-glasses, and curtains of crimson and white silk, with furniture and carpets to match.[51] *Saint Helena* had perhaps been chosen for this setting because of its pink and gold, but its pious character must have seemed incongruous. The 4th Marquess disputed the bequest, and it was not definitively settled in the Countess's favour until 1852. She sold the contents on the premises through Phillips, ostensibly 'by order of the executors of the late Most Noble Marquis of Hertford', between 9 and 12 July 1855. Perhaps because there were so few paintings in the sale, there was little competition for them, and the Veronese, which was lot 118 on the first day, fetched a mere 80 guineas (£84).[52]

The painting is then recorded as the property of the Honourable Percy Ashburnham, who had a 'very choice collection of pictures' – mostly sixteenth-century old masters – which he put up for sale at Christie's on 19 May 1860. Only two of the twenty-five paintings he offered fetched high prices, Andrea del Sarto's *Charity* (a version of the famous painting in the Louvre) and the Veronese (lot 74), which sold for £300.[53] Percy was born in 1799, the second son of George, 3rd Earl Ashburnham (1760–1830). He married in 1838 but his wife died ten years later with no surviving issue. Percy's brother Bertram, the 4th Earl, inherited an important collection of old masters, formed at the close of the eighteenth century. Most of this collection was sold at Christie's on 20 July 1850,[54] perhaps partly to fund Earl Ashburnham's

passion for illuminated manuscripts. Waagen was not permitted to study the manuscripts properly despite the intervention of Percy (Waagen describes him as 'an ardent lover of art, and a most admirable man').[55] Perhaps the dispersal of the principal family collection left Percy with no inclination to add his own pictures to those that remained; perhaps that had never been his intention, and he merely sold them because he was giving up his London house at 39 Hill Street.

The recorded buyer at Ashburnham's sale was Hugh Andrew Johnstone Munro (1797–1864), known as 'Munro of Novar' (with reference to his extensive estates in Ross-shire, Scotland), who kept a very large collection of paintings in his London residence, 6 Hamilton Place, near Hyde Park Corner. Unlike his father, Sir Alexander Munro, who had been Consul General in Madrid, and his uncle, Sir Hector Munro, whose military achievements in India were well known, Munro of Novar was engaged in no public service.[56] His father had died when he was twelve and the irregular education consequent upon this may have conditioned the pleasure Munro took in the company of artists. He was an especially keen collector of Turner and Etty, and was a personal friend of both men.[57] Before about 1840 he was more noted as a patron of contemporary painters than as a collector of old masters, but the large sums he spent at the Duke of Lucca's sale in 1841 and at the Stowe sale in 1848 outstripped his purchases from living artists. Munro's collection was expanding dramatically throughout the 1840s and 1850s, with new acquisitions accommodated on easels.[58] He seems never to have stopped acquiring pictures and NG 1041 was bought when he was over sixty. Most of the collection was sold at Christie's in 1878 – the modern works on 6 April and the old masters on 1 June – by Munro of Novar's nephew, H. Munro Butler Johnson, who had inherited the entire estate in 1865. As with the Holford Collection, formed in the same decade, the sixteenth-century Italian pictures were of mixed quality, especially when compared with the Italian baroque paintings and the Dutch pictures,[59] but Veronese's *Saint Helena* (lot 144 on 1 June), fetched the high price of 3,300 guineas (£3,465 – less than the sum fetched by the greatest Turners but slightly more than the Earl of Dudley paid for a Claude seaport).[60] Burton's success in the bid was greeted with 'the loudest applause we ever heard in this room'. Lord Darnley, concerned with his declining rents, may well have begun to consider disposing of his Veronese *Allegories* (p. 424) when he read of the results.

Provenance

See above. Perhaps in the collections of Peter Paul Rubens, Aletheia Talbot, Countess of Arundel, and Philips de Flines. Probably acquired in Holland for the 2nd Earl of Godolphin (d. 1766), by whose heirs or descendants sold Christie's, 6 June 1803 (lot 60). Bought by William Comyns, by whom sold Christie's, May 1815 (lot 73). Bought by 'Ponsonby', sold by 'Dorrien', both perhaps acting for Comyns, Christie's, 2 March 1816 (lot 109), when bought by the Earl of Yarmouth. Bequeathed by him (as Marquess of Hertford) to the Countess Zichy, 1842, and confirmed as hers ten years later.

Fig. 4 Corner of the current frame of NG 1041.

Fig. 5 Corner of the previous frame of NG 1041.

Sold by her on the premises, St Dunstan's Villa, Regent's Park, on 9 July 1855 (lot 118). Bought by 'Emery', who was either acting for Percy Ashburnham or sold it to him soon afterwards. Sold by Ashburnham at Christie's, 19 May 1860 (lot 74). Bought by Munro of Novar. In the posthumous sale of Munro of Novar's old masters, 1 June 1878 (lot 144), where purchased for the National Gallery.

Prints

The engraving by Lucas Vorsterman is discussed above (under Early References). It is dedicated to Helena de Bran, whose name saint it represents. She was the wife of the military agent of the Dukes of Amalfi in the Netherlands.

Copies

The brush drawing by Jan de Bisschop in Philadelphia is discussed above (under Early References). The miniature copy by Bernhard III Lens of 1721 is discussed under British Owners. A full-size copy at Goodwood House, Sussex, looks as if it may date from the eighteenth century.[61] Reduced copies likely to date from the early nineteenth century or later are recorded: one measuring 147 × 55 cm was lot 182 at Sotheby's, London, on 2 June 1972, and another, measuring 122 × 75 cm, was lot 52 on 23 July 1980. It is a striking fact that NG 1041 is included in all the annual lists of most frequently copied paintings in the National Gallery between

1879, the year after it was acquired, and 1893, after which the lists cease.[62] Its popularity might perhaps be explained by its being prescribed as an exercise by London art teachers.

Frame

The painting's carved and gilded frame (fig. 4) is a good modern copy of the seventeenth-century frame that was acquired in 1965 or 1966 for the *Mond Crucifixion*. It was commissioned from 'Pynappel', a talented carver employed by the London firm of frame dealers and framemakers, Arnold Wiggins. Originally intended for the *Rokeby Venus*, it turned out to be 'quite unsuitable' for this purpose, and when a black frame was found for the *Rokeby Venus* – probably in 1968 – Cecil Gould had the gilded frame adapted for the *Saint Helena*.[63] It is a cassetta frame of reverse profile, carved with a foliate running-pattern against a punched ground in the flat. The high inner moulding consists of a wreath of fruit and leaves and a lower outer moulding of only leaves. A frame of similar character but with a different outer moulding has been given to Van Dyck's *Man in Armour* in the Cincinnati Art Museum.

The frame previously on NG 1041, now in store, has a reverse profile with a bay leaf wreath and broad acanthus leaves on an ogee moulding cast in composition (fig. 5). This was a standard gallery pattern, presumably made by Henry Critchfield, which also had been used in the 1860s[64] and must have been given to the painting upon its acquisition.

NOTES

1. There are approximately ten by ten threads in each square centimetre.

2. Penny and Spring 1996, pp. 44–5.

3. Ibid.

4. Osmond 1927, pp. 37–8.

5. Holmes 1923, p. 206 and note. An attribution to 'Zelotto' is found in Richter 1910, I, p. 309; Richter may also have published the idea elsewhere.

6. Fiocco 1934, p. 122; Arslan 1946–7, cited by Pignatti and Pedrocco 1995, II, p. 371; Pallucchini (1943, p. 37) was especially enthusiastic.

7. Crosato 1962, p. 178 and plate 128.

8. Rearick 1988, p. 128.

9. Gould 1959, p. 148; 1975, p. 325. For Veronese in Vicenza (A.77) see Marinelli 1988, pp. 198–200 (entry by Marinelli).

10. Typescript in the National Gallery's dossier dated January 1956.

11. Venturi 1929, pp. 881–2.

12. See *The Catholic Encyclopedia*, VII, 1910, pp. 202–3 (entry by J.P. Kirsch) and *Biblioteca Sanctorum*, IV, 1964, cols 987–92 (life by Agostino Amore) and cols 992–5 (iconography by Elena Croce).

13. Gould 1959, p. 147; 1975, p. 127. For Cima da Conegliano see Humfrey 1983, p. 158, no. 155, pl. 107, and p. 167, no. 165, pl. 46. For Palma Vecchio see Rylands 1992, p. 206, n. 64.

14. Bartsch, XIV, no. 460. The print was copied by another engraver – see Oberhuber 1978, no. 460(A), (342).

15. Passavant, VI, 1964, p. 89, no. 122.

16. Karpinski 1983, nos 3-1 (190) and 3 (190). Karpinski's forthcoming text volume, pp. 1383–4, notes that Mariette recorded that Anton Maria Zanetti as a 'badinage' placed the date 1602 on this print but it did not fool him. In the second state he added R.V. to acknowledge Raphael's invention. Rearick (1988, p. 128) gives Raphael's source as 'Ugo da Carpi's chiaroscuro print'. The National Gallery's catalogues in the early twentieth century cited engravings by 'Bonasoni', which may be a related confusion.

17. Griggs 1932, I, p. 317.

18. Uffizi 1973 F (erroneously 1973 E in Gould).

19. Oberhuber 1966.

20. For example Joannides 1983, no. 342.

21. Recorded in a drawing of a small picture in Andrea Vendramin's collection perhaps by Schiavone. The god Mercury appears in the sky. Borenius 1923, p. 62.

22. Rearick 1988, p. 128, no. 71, 166 × 134 cm.

23. For the geometry of the companion see MacColl 1931, pp. 252–3.

24. This idea was first proposed by Penny and Spring 1996, p. 43.

25. Veronese painted several sets of shutters, notably those in S. Sebastiano, Venice; those for S. Geminiano, Venice (now in Galleria Estense, Modena), and those for S. Giacomo, Murano (now Barber Institute, Birmingham), for which see Pignatti and Pedrocco 1995, I, pp. 126–8, 137–8, and II, p. 520.

26. For the Veronese see above; for the Zelotti in Museo Civico, Padua, see Brugnolo Meloncelli 1992, pp. 101–2, cat. 21, pp. 122–3.

27. Gregori 1990, p. 143, no. 73. Now Museo Civico, Piacenza.

28. Lorenzetti 1982, p. 373, attributed to Parrasio Micheli depicting Saints Augustine and Stephen. The provenance is uncertain.

29. Ridolfi 1646, p. 24; 1648, p. 304; 1914–24, I, p. 318 and note 5.

30. Hymans 1893, cat. 71.

31. Golahny 1981. Pennsylvania Academy of Fine Arts (PAFA #182). The drawing shows more of the angels at the top of the composition and is also extended at the left.

32. Muller 1989, pp. 98–9, no. 22; Jaffé 1996, p. 30.

33. Cust and Cox 1911, p. 284.

34. Golahny 1981, pp. 25–6.

35. Eidelberg and Rowlands 1996, p. 237, citing research of Frances Vivian. No such Veronese is recorded in earlier Gonzaga inventories – 'while it is always possible that Querini manufactured provenances for such works, an equal likelihood is that this document emphasizes how little we can gauge the extent of the Mantuan holdings.'

36. Vertue 1933–4, III, pp. 133–4 (British Museum, Add. MSS 23079, fol. 41v).

37. British Museum, Add. MSS 23085, fol. 33 – this list was not included in the Walpole Society publication (Vertue 1933–4) because it was thought to be a mere duplicate of the list cited in note 36. This was pointed out in a letter of 23 March 1973 sent by Ron Parkinson of the Victoria and Albert Museum to Michael Levey.

38. Comyns sale of 6 May 1815, lot 73.

39. Gouache on vellum, 35 × 24.5 cm. Lot 202, Tajan, Paris, Hôtel Drouot, 26 November 1996; offered again as lot 26, Tajan, Paris, Hôtel Drouot, 26 November 1998.

40. Letter to the compiler dated 7 December 1996.

41. Fredericksen 1993, I, p. 86, gives the 2nd Earl of Godolphin's widow as the probable consigner. Christie's records do not record the consigner's identity.

42. 7 June, lots 73–80.

43. 6 June, lots 58 and 59.

44. For the sale generally see Fredericksen 1993, pp. 32–3, no. 201 (Lugt 6650); for the Van Dycks see ibid., p. 270, and for the Tintorettos see ibid., p. 747.

45. For Comyns see Fredericksen 1988, I, p. 86 (where said to be of Crown Street, Westminster), also Farington, II, p. 373, for the claim made in 1795 that he was paid 15 guineas (£15 15s.) for cleaning Angerstein's Cuyp landscape.

46. Fredericksen 1988, I, p. 86, for analysis of the sale, no. 1284 (Lugt 8699), and II, p. 1087, for the two Veroneses.

47. See Fredericksen 1996, I, p. 5, for an analysis of the sale of 2 March 1816, no. 1368 (Lugt 8822), and the identity of 'Dorrien'. For 'Ponsonby' see Fredericksen 1988, II, p. 1411.

48. Hughes 1981, pp. 11–23; Ingamells 1983.

49. Greville 1938, V, p. 19.

50. It is described in the manuscript inventory of the villa taken 8–10 April 1842, fol. 60 (Wallace Collection Archive). Also recorded in the room was 'an etching after ditto [i.e. the Veronese] by Vosterman' and 'a smaller ditto'.

51. For Pückler-Muskau's letter of 7 April 1827 see Pückler-Muskau 1958, p. 187. The profusion of crimson hangings and upholstery is confirmed by the sale catalogue in the Wallace Collection Library (no. 1020). An exception was the library where the drugget and curtains were green to match the malachite clock case and a display of Sèvres porcelain with a green ground. In the dining room the settees and chairs were upholstered in crimson satin, the fitted drugget was crimson and the curtains of 'crimson India figured satin'.

52. The only recorded copy of this sale catalogue is in the Wallace Collection Library (no. 1020). The buyer of the Veronese is there recorded as 'Emery'. The painting seems to have been sold together with a print ('the original engraved work'). It is interesting to note that lot 542 on 12 July was a blue morocco portfolio of old master drawings including notable works by Veronese. Only eleven paintings were in the sale (lots 118–28). The Veronese fetched the highest price. The second highest was lot 123, Lawrence's portrait of Croker, presumably the painting now in the National Gallery of Ireland (Garlick 1989, p. 175, no. 223).

53. The Sarto, lot 75, sold for 500 guineas (£525). It is now untraced. The sale was Lugt 25596.

54. Lugt 19960. About half of 91 lots were sold for under £100. A number were bought in (including the last three lots – David Teniers's *Village Fête* dated 1648, Cuyp's *Ruined Château*, and Rembrandt's double portrait now in the Gemäldegalerie, Berlin). Lot 50 was Murillo's *Self Portrait* now in the National Gallery (NG 6153) and lot 81 was Guercino's *Presentation* now in the Mahon Collection and on loan to the National Gallery.

55. Waagen 1854, III, pp. 27–30.

56. See the entry for Munro by Kenneth Garlick in the *Dictionary of National Biography. Missing Persons*, Oxford 1993, p. 485.

57. Finberg 1939, especially pp. 266–7, 359, 360–2, 393.

58. Waagen 1854, II, pp. 131–42.

59. Penny 2004, pp. 367–70.

60. Redford 1888, I, pp. 273–7, esp. p. 276.

61. Mason 1839, p. 118, no. 191, as by Passignano. Then in the staircase hall and considered 'by no means a finished specimen of art'.

62. The lists for each year are published in the Annual Reports. Jessica Collins kindly supplied me with this information.

63. Typescript notes made by Cecil Gould. An annotation by Alan Braham in 1980 identifies Pynappel as an employee of Wiggins. For the date of the *Mond Crucifixion* frame see the Annual Report for January 1965 – December 1966, p. 97.

64. See Penny 2004, p. 245, fig. 3.

NG 268
The Adoration of the Kings

Dated 1573
Oil on canvas, 355.6 × 320 cm

Support

The tabby-weave, medium-weight canvas is composed of three horizontally joined pieces, each the standard width of just over a metre. The central piece is 119 cm wide. The other two would be the same, but for the turnover. The upper seam passes across the shaded interior of the arch and above the central climbing shepherd. The lower one passes through the vessel held by the youngest king, through the Christ Child's chest and above the ox's eye. There is a horizontal line of depression in the paint which is more or less equidistant between the two seams (and thus across the centre of the painting).[1] The edges may have been trimmed a little, especially at the sides.

The canvas was prepared with a white ground composed of calcium carbonate bound in glue rather than the calcium sulphate (gesso) that is usual in Italian paintings. There is no priming on this ground.[2]

Materials and Technique

The composition appears to have been very carefully calculated before work on the painting commenced, for few changes were made during execution. However, the farther arch on the right-hand side was originally painted more to the left, and this is now apparent in the sky. Revisions may also be detected in the lower right corner, where an arched supporting structure or a fragment of ruined architecture may originally have been projected. A few other minor revisions may be noted. The uppermost cherub's left wing has been lowered, the sleeve of the attendant holding the dogs in the lower right corner was originally wider, and it is likely that the shadow of Joseph's left arm conceals a revision of its outline.

Underdrawing is now apparent in the architecture. The concentric lines of the arch have been drawn with a charcoal and a device such as a tight string attached to a fixed central point. Other lines appear to have been drawn with a brush, some of them on top of paint layers. Traces of underdrawing suggest that the plume on the helmet of the soldier to the extreme left was once intended to fall the other way. Free and vigorous lines in the beard and hair of the foremost king were probably deliberately left half covered.

It is possible to reconstruct the sequence in which much of the painting was made. The stone architecture and also the camel and the grey horse in front of it were painted before the nearer of the two wooden posts, which was painted over them. The other post was presumably painted at the same time. The shaft of celestial light was painted last. No doubt the impasto of brilliant white highlights in the blue robe and white veil of the Virgin and on the body of Christ were also added at this stage: the piece of white cloth covering the lambs also looks like a late addition, as perhaps are other passages of highlight in the robes of the foremost king and his page.

Many of the pigments have been identified. Azurite is the only blue that was used, for the sky and for the Virgin's cloak. Balthasar's green coat is painted with natural malachite, with some azurite, lead-tin yellow and lead white, with a layer of copper green (verdigris) added for the shadows.[3] The foliage is painted with malachite, verdigris, yellow earth and black. The paint of Joseph's orange coat contains pararealgar (an arsenic sulphide) combined with vermilion in the shadows; the natural mineral form of pararealgar may have been used as a pigment, or it may be present as a deterioration product of realgar.[4] The red brocaded coat worn by Melchior is of red lake mixed with vermilion, red lead and lead white for the lighter pattern. The lake has been identified as Polish cochineal.[5] The red jacket of the page on the left is painted with red earth – probably in the form of haematite – mixed with some red lake as well as with lead white and black, and glazed with red lake in parts.[6]

Conservation

There is no record of any cleaning or conservation treatment when the painting hung in the Venetian church of S. Silvestro between 1593 and 1837, but the decision by the confraternity for whom the painting was made to commission new works by Bellucci, Lorenzetti and Carlo Loth to hang beside this one in the 1670s (as discussed below) is likely to have prompted a cleaning of the painting, perhaps carried out *in situ*.[7] In the mid-eighteenth century a reliable witness noted that the painting was admirable in composition and striking in beauty ('très-bien composée', 'fort belle') but 'gâtée' – that is, worn – perhaps as a consequence of such cleaning, and hard to see, perhaps because of a darkened varnish, as well as the dim light inside the church.[8] When removed from the wall of the church in 1837 the painting was stored 'in a room within the precincts of the building'. It must have been detached from its stretcher and either rolled or folded. Eastlake noted that 'when removed from the church' it was 'folded twice horizontally'.[9] This may refer to the painting's removal to the storeroom, or to its next move, probably in 1855. Eastlake may have mistaken the two horizontal seams for folds or possibly the painting was folded along these seams. In any case, it was restored for Toffoli in 1855, when he hoped to sell it in France. Superfluous repaint applied on this occasion by the Venetian restorer Tagliapietra was removed by 'Bentley' in February 1856.[10] Further cleaning was undertaken in 1891. Some dirt and 'old varnish' was removed when blisters were laid in 1934. These interventions were probably superficial, and even in 1957, a date at which cleaning was not usually light, the treatment was partial.

Condition

There are many losses along both sides of the canvas which are consistent with scuffing that would have occurred when the canvas was rolled or folded for storage. The surface is very abraded in many areas, and in 1957 extensive repainting was carried out along the seams, in Balthasar's knee, around

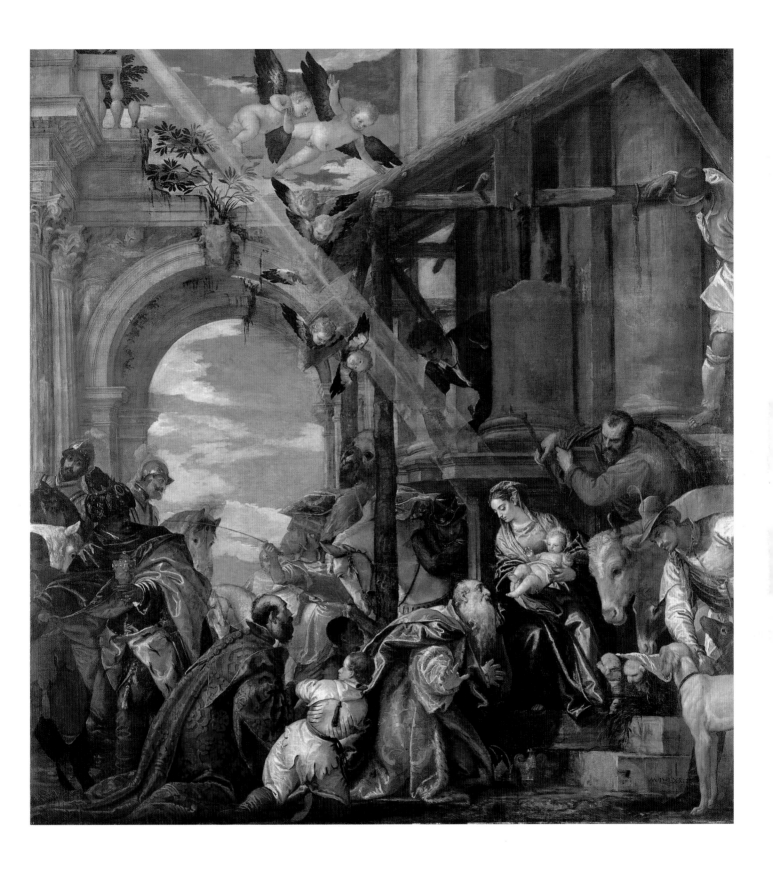

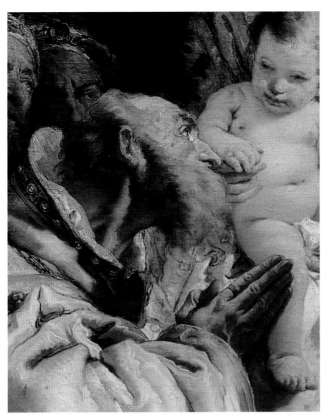

Fig. 2 Giovanni Battista Tiepolo, *The Adoration of the Kings*, 1753, detail. Oil on canvas, 408 × 210.5 cm. Munich, Bayerische Staatsgemäldesammlungen, Alte Pinakothek.

OPPOSITE: Fig. 1 Detail of NG 268.

the head of his page (on the extreme left), and in the Virgin's robes. An area of repainting which is especially evident is the lowest portion of the sky above the neck of the distant grey horse, described in the examination report of 4 January 1957 as representing a 'distant mountain'. Some parts of the repainting have now discoloured, as have some parts of the original painting. Joseph's cloak is a dull grey. The blues (analysed as azurite, see above) have turned slightly green. The foliage has certainly darkened, although the pigments employed (see above) do not suggest that it was originally a bright green. Changes in Veronese's colours and in those used by restorers cannot entirely explain the unbalanced character of the painting. Especially disturbing is the way the shimmering, brilliant green tunic of the groom beating the camel jumps out of the painting, and the relative lack of radiance in the figure of the infant Christ, who was surely intended as the chief source of light.

Date and Attribution

The painting is clearly inscribed at the lower right, on the lowest stone step, with the date 1573 in Roman numerals (this has sometimes been misread as 1571[11]). The inscription is clearly old and is probably original; there is no reason to doubt that it indicates when the picture was made, or at least completed. Gould was the first to point out the other large paintings Veronese is known to have completed in 1573 –

most notably the *Feast in the House of Levi* from SS. Giovanni e Paolo and the *Madonna del Rosario* from S. Pietro Martire, both in the Accademia, Venice – and observed that this fact alone would support the idea that there was a large degree of studio participation.[12]

The painting seems to have caused some disappointment after it was hung in the National Gallery, particularly when it could be compared with the *Family of Darius*. For Charles Allston Collins, writing in the popular journal *All the Year Round* (edited by his father-in-law, Charles Dickens) in 1860, the painting was 'either a bad one, or a spurious one'.[13] A year later a far better informed critic, Henri de Triqueti, detected 'la touche de ses fils ou de ses élèves' in this 'triste et grise' work.[14] Adolfo Venturi in 1929 considered the painting a collaborative work.[15] Pallucchini in 1963 thought it was largely by the workshop, but twenty years later he considered it to be largely by Paolo.[16] In the Gallery's catalogues from 1856 to 1929 the painting was simply recorded as by Veronese. Soon after, curators acknowledged their doubts. Ellis Waterhouse even made a memorandum to the effect that there was no trace of Veronese's hand in the execution.[17] Cecil Gould was more circumspect. He believed that Veronese had designed it 'in the smallest detail', then left 'most of the execution to the workshop', but worked over 'parts of it himself' and especially the Virgin and Child and the foremost king.[18]

Gould also recorded the astute observation of Giovanni Morelli, transmitted by Richter in a letter of 1932, that the painting contained Bassanesque elements.[19] The features of the Virgin, with the nose tapering from a broad top, high arched brows and large eyelids, are indeed typical of Bassano. The rather clumsy incorporation of the ox and the ass (by no means obligatory in a painting of the Adoration of the Kings) is another notably Bassanesque feature, although they do in fact occur in the preliminary drawings (discussed below).

It should be recalled that Veronese was himself fascinated by the achievement of Jacopo Bassano. Ridolfi records that as a child Veronese's son Carlo, born about the date this painting was made, copied many things not only by his father but also by Bassano – 'il cui modo di colpire piaceva a Paolo' ('whose manner of handling Paolo found pleasing') – and made drawings of 'i pastori, le pecore, l'herbette, i fiori & ogni villesco stromento' ('shepherds, sheep, shrubs, flowers and all sorts of rural equipment') at his 'villagio' near Treviso.[20]

Some parts of the painting – the child angels and cherubim, for example – are characteristic of the more competent productions of Veronese's workshop, yet the heads of the two older kings are among the finest Veronese ever painted. The alert features of Melchior (fig. 3) are rendered with quick, deft strokes – certainly not merely an upper layer of paint but the only layer. The head of Caspar (fig. 1) with his great white beard is as animated in its bold preliminary modelling as in its decisive white impasto. In its expressive power it also owes something to Jacopo Bassano. Its prominence in this painting, which was so easy of access in the middle of Venice, made it highly influential on Veronese's eighteenth-century admirers, most notably Sebastiano Ricci and, as Michael Levey has pointed out, Giovanni Battista Tiepolo (fig. 2).[21]

The Patrons

The painting was made for the parish church of S. Silvestro in the *sestiere* of San Paolo, just off the main pedestrian route between the Rialto Bridge and Campo San Polo. The church was founded in 1226. Its interior was described in Stringa's revision of Sansovino's guidebook to Venice published in 1604.[22] The 'quadrone' of the 'tre magi' is here associated with a 'quadrone' of the Betrothal of the Virgin by Camillo Ballini, and with an altarpiece of the Nativity by Lazzaro Bastiani. Since it is clear from other sources – including the Apostolic Visitation of 1581 and the Visitation of Patriarch Priuli ten years later[23] – that the altar of the Nativity and Saint Joseph were the responsibility of the Scuola (Confraternity) di San Giuseppe (Saint Joseph, or Santo Iseppo, as he was known in Venice), it has been reasonably proposed that this *scuola* was also the patron of the paintings by Veronese and Ballini to either side.[24] It is worth noting that most of the side altars in the church were the responsibility of *scuole* – one based on a craft, that of the makers of casks ('botti') whose patron was Thomas à Becket; some on trades, notably the wine merchants; another, that of the Bergamaschi, on place of origin. The Scuola di San Giuseppe was, like the *scuole* of the Sacrament discussed elsewhere in this catalogue, based solely on devotion. It had a large membership which included women and was the oldest *scuola* in Venice to be dedicated to Joseph.[25]

The *Mariegola*, or official statute book, of this *scuola*, which is preserved in the Biblioteca Correr,[26] informs us that it was founded in February 1499 (1500 in modern dating). An agreement of the Chapter of the parish made on 22 May 1510 shows that the *banco*, altar and burial vaults had been assigned to the *scuola* by then.[27] It also lists the members' obligations – to sing vespers on the eve of the Feast of Saint Joseph and Mass on the day itself, and to provide the fees and candles that were to be given to the parish priest. An inventory dated 10 April 1513 reveals the existence of a painted and gilded altarpiece with a gilded cover ('cortina'), together with altar furnishings.[28] Increasing prosperity is suggested by attempts to secure a meeting room near the church in 1545[29] and by the acquisition in 1556 of new ecclesiastical plate.[30] In 1569 the *scuola* had installed walnut stalls on either side of the altar, and the officers had renovated the altarpiece. In 1580 an altar frontal decorated with the *Sposalizio* was also presented by the *scuola*'s officers.[31]

The Nativity, or 'Presepio' (the subject of Bastiani's altarpiece), and the 'Sposalizio' (the subject of the frontal) were the usual subjects favoured by the confraternities that were dedicated to Joseph and feature as illuminated pictures in the *Mariegola*.[32] When the *scuola* had its altarpiece replaced by Carlo Loth (which survives in the church) in the seventeenth century, Loth showed Joseph lifting the newborn child to present him to God the Father, who descends on clouds,[33] but in the sixteenth century it was generally considered adequate to give Joseph compositional prominence.[34]

OPPOSITE:
Fig. 3 Detail of NG 268.

Although a casual reading of Stringa's guidebook might lead one to suppose that the Veronese was an altarpiece, it was placed to the left of the second altar (the altar of Saint Joseph) on the left-hand side of the church.[35] Despite the claim sometimes made that confraternity patronage in Venice declined in the seventeenth century, it seems likely that other paintings high on the left-hand side of the nave were commissioned by this *scuola* or its members – the *Sleep of Saint Joseph* by Antonio Bellucci (1654–1727) and the *Flight into Egypt* by Gregorio Lazzarini (1655–1730). Moreover, Loth's altarpiece was reputedly an exceptionally expensive painting.[36] And we know that attempts to buy the Veronese were resisted (see p. xix).

It should be emphasised that the Veronese and the Ballini were not made for the side walls of a chapel, the side altars in this church being hardly recessed from the nave. They were made as decorations for the nave and were visible when the church was entered: 'As you enter at the great Door, you see on your left hand the famous *Visit of the Wisemen*, by Paolo Veronese.'[37] The practice of completely covering the walls of the nave with painted canvases was indeed not uncommon in Venice during this period. The best surviving example is the convent church of S. Zaccaria. And certainly the *scuole* were often the patrons of these canvases – the gigantic painting by Padovanino of *Saint Liberale saving the Innocents*, dated 1638, on the left wall of the Carmini is indeed inscribed as such. The practice may perhaps have originated with the placing of a large canvas above the *banco* of a *scuola*, as explained elsewhere in this catalogue (p. 169). Boschini specifically mentions that the very large canvas by Paolo Piazza of the *Baptism of Constantine* was placed above the *banco* of the Scuola di San Paolo in the church of S. Polo.[38]

The Kings and their Actions

The Magi, or wise men, who are so briefly mentioned in the Gospel of Saint Matthew as coming to adore the infant Christ, were by late antiquity considered to have been kings. By the late Middle Ages they had become distinct personages, under the names of Caspar (or Jasper), Melchior and Balthasar, the first being always a very aged man, with a long white beard, the second middle-aged, and the third young and frequently dark-skinned.[39] The gifts of gold, frankincense and myrrh that are mentioned in the Gospels were presented, respectively, by Caspar, as king of Tarsus, land of merchants, Melchior from Arabia, and Balthasar from Saba ('land of spices and all manner of precious gems'). In Italian art the contents of the vessels the kings carry are rarely visible, but Veronese (as will be seen) may have adapted the shape of at least one of the containers to the substance it contains.[40] As was usual in the sixteenth century, and indeed in later centuries, Veronese depicts Balthasar with dark skin.[41] As always when the kings are shown paying homage to Christ, Caspar, as the eldest of the three, senior in age, has precedence. He kneels in veneration and kisses – or, more usually, prepares to kiss – Christ's foot.[42] Roman Catholic authorities were aware that Luther had ridiculed the identification of the Magi as kings, but defended it as an idea that had been favoured by many Fathers

of the Church. They saw no harm in the tradition that gave the kings the ages of sixty, forty and twenty and portrayed one of them as black, although they emphasised that this was not canonical.[43]

A leading art historian in a highly influential and much praised book has argued that the subject which is central to paintings of the Epiphany is 'the exposure to the worshipper of the Child's groin ... the demonstration *ad oculos* that he was born "complete in all the parts of a man".'[44] Caspar in NG 268 may be supposed to be engaged in a reverent inspection of Christ's genitalia. But Veronese must have meant us to interpret the position of Caspar's head, the action of the Virgin and the extension of Christ's left leg as facilitating the homage of foot-kissing. In other paintings of this subject, most notably the *Adoration* from Palazzo Cuccina now in Dresden, Veronese depicts the king's lips closer to Christ's foot and there is no possibility of misunderstanding. It is of course true that Christ is often naked, or nearly naked, in paintings of the Adoration, as in most paintings which represent him in his infancy, but it is notable that when Christ's genitalia are covered Caspar still kneels very low before him. In accordance with the reverent nature of the ceremony, Caspar generally looks up at Christ rather than down at the foot he kisses.[45]

Veronese also shows Melchior kneeling, and he clasps his hands in prayer as his page takes hold of the gift. Balthasar is still standing and holding his gift while his page arranges his robes in preparation for kneeling.[46] The figure wearing a feathered hat in the right foreground restrains two hounds in the regal entourage, who might be expected to be excited by the trussed lambs beside the Virgin. These of course are offerings from the shepherds, whose homage has preceded that of the kings. Shepherds are commonly included in paintings of the kings, usually in the background, and here two of them are perched in the ruined classical building, supporting themselves with the beams of the stable.[47]

There are two classical buildings in the background: a double arch with a projecting entablature supported by fluted Corinthian columns on the left (part of a column is also visible on the right), which may be meant to represent a city gate, and a group of massive, smooth column shafts, some of which are shattered, suggesting the pagan temples that Christianity would supersede. Christ occupies the position of a cornerstone in this ensemble. The figure wearing a hat and inspecting Caspar's homage with fierce curiosity may be intended as a spy for King Herod, who was growing anxious about the business of the Magi.

Accessories and Dress
Each of the kings' gifts is contained in a gold (or gilded) vase with a cover. Caspar's is placed on the ground in front of him. It has a small foot, and the body is clasped by four ribs with coin ornament on their outer side. Each rib projects at the shoulder, and scrolls inward towards the cover. Caspar's crown, just visible behind his vase, has a jewelled rim and gable-like points with pearl finials (only one of which can be seen). Ribs appear to rise above the crown, presumably to support a fabric cap.

Melchior's vase is being taken from him by the page in white. (The black page behind it may be presumed to be attending to Caspar's cloak.) Much of the vase is concealed, but it appears to be less elaborate than Caspar's and turned in shape. Melchior's crown is not visible. Balthasar holds his vase in his left hand. Its body is simpler in shape than the other two but richer in surface, being studded with pearls and red stones (presumably rubies). Its foot is visible below his index finger. The cover has a pattern of interlaced arches and is perhaps perforated at the interstices. This, together with the suspension chain that falls through his fingers, suggests that the vessel contains incense; although frankincense is generally Melchior's gift, in some Venetian accounts it was associated with Balthasar.[48] The band of Balthasar's crown is set with a pearl below each simple triangular point. It is worn with a turban adorned in front by what seems to be a large cameo (with a white figure in relief against a dark lower stratum).

Caspar wears a heavy robe of white silk of a large damask pattern in yellow with red outlines. It is open at the waist and in the upper sleeves. The lining or trim of white fur flecked with dark grey (probably meant for lynx) is visible at the cuffs and openings. His cloak of cloth of gold with a blue silk lining is fastened only at the neck.

Melchior wears robes of velvet with two piles ('alto e basso'), cut so that the damask pattern is in relief. This type of velvet and the colour, crimson, made from the expensive dye kermes, was in Venice associated with the robes of the doges and the procurators of St Mark's. The stiff collar raised behind the head is joined to large flaps over the shoulder, turned up to reveal a mauve silk lining. This shoulder robe is fastened at the back with five large, spherical gilded buttons like those used to fasten a doge's tunic. A gold chain is also hung over it, with a flat black stone (perhaps a cameo) suspended from it. A grey fur lining (presumably squirrel) is visible in the large openings of his sleeves and at the cuffs and tail of the robes.

Balthasar wears a green cloak, perhaps of velvet, with vestiges of embroidered devices scattered over it. The cloak has a pale green silk lining, and below it he wears a blue robe turned up at the thigh to reveal an ermine lining. This turn-up, which is found in other paintings of kings,[49] was designed to facilitate riding, and Balthasar also wears leather riding boots that reach to just below the knee.

The page in white wears a tunic with a skirt which has an outline like a leaf, resembling a masque costume that might be worn by a silvan god. The skirt has diagonal vents in the back. Unusually, the sleeves, shoulder pieces and a pointed hood from which a green tassel dangles constitute a single separate garment. The tunic of the man with the hounds is of similar cut and colour, indicating that he may also be one of Melchior's attendants.

The mounted guards on the left seem to be wearing livery with blue and silver bands, and burgonets, which were the standard helmets for light calvary in Veronese's day. The plumes are yellow, whereas those of the soldiers behind Melchior are pink.

Fig. 4 Paolo Veronese, *The Adoration of the Kings*, 1574. Oil on canvas, 320 × 234 cm. Vicenza, Church of S. Corona.

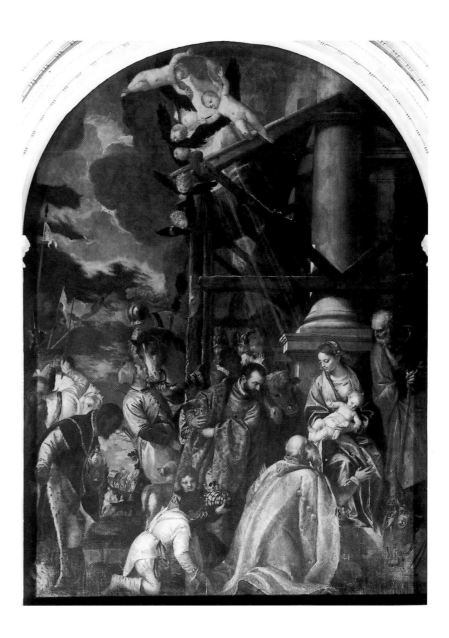

Related Paintings and Drawings

The composition is close to one used by Veronese for an altarpiece in S. Corona, Vicenza, measuring 320 × 234 cm, which was completed by 19 March 1574 for Marcantonio Cogollo, a wealthy textile merchant who had a chapel built in this church in the previous year (fig. 4).[50] The painting remains in S. Corona, although in a different chapel. In this altarpiece the architectural setting consists of a ruined classical building with a timber structure (and lean-to roof) attached. The chief support for the wooden building is in both paintings an unsquared tree trunk. The classical building is simpler in the Vicenza altarpiece, with only one principal column shaft visible, and there is no other architecture on the left. No shepherds have climbed on to the building behind the Holy Family – indeed, none is to be found anywhere in the altarpiece. The child angels and cherubim are differently arranged: the light in the altarpiece comes from them and breaks into the building, lighting parts of it (notably the column base) as well as the Virgin and Child, whereas in the

National Gallery's painting the shaft of heavenly light comes from further to the left and affects the buildings far less.

The Virgin's pose is identical in the two paintings, but differences in the folds of her sleeves and the disorder of her veil make it more likely that they were both worked up from the same small drawing rather than made from the same cartoon (or one taken from a tracing of the other). Caspar is brought closer to the infant Christ in the Vicenza altarpiece and actually kisses one of Christ's feet. His figure is rotated more away from the beholder but it is noteworthy that his hands are similarly placed – raised on either side and with fingers outspread. The other kings are differently arranged, and Melchior, who looks as if he is probably a portrait, stands rather than kneels, in a pose closer to that of Balthasar in NG 268. Joseph is differently conceived and, in the tighter format of the altarpiece, there is no need for the keeper of the royal hounds.

The colouring in the two paintings is similar, with the yellow and crimson damasks of the older kings separated by

the page's silver suit. In the altarpiece the Virgin's cloak is lined with yellow rather than green, and there is altogether less green. Some elements are the same but have been moved to a different position. Thus the mounted guards (with helmets and livery) on the extreme left in NG 268 appear behind Melchior in the altarpiece, and the groom flogging the camel has been moved to the left and turned the other way. The camel is on the extreme edge of the altarpiece and (this is

seldom visible in photographs) other camels are present in the caravan in the landscape distance, which has no equivalent in NG 268.

The altarpiece was celebrated in Vicenza, where it was imitated by Francesco Maffei in a garish paraphrase made for the side wall of the chapel of S. Giuseppe in the Duomo.

The best explanation for the relationship between the two paintings is that they evolved in the artist's workshop at the

Fig. 5 Interior of S. Silvestro, Venice.

same time, and this view is supported, as will be shown, by the evidence of the preparatory drawing (see below).[51] On balance, the altarpiece in Vicenza is likely to be slightly later, as the documents suggest. It seems to concentrate elements which are likely to have been invented for a broader picture, notably the timber roof which, together with the beam of light, parallels the diagonals of the figure composition to great effect in the London painting. The colour seems richer and the contrasts stronger in the altarpiece; it is, however, also in better condition. The apparent difference in palette may help to explain why some scholars have detected a difference in style between the two paintings.[52]

In the Teylers Museum, Haarlem, there is a compositional drawing for NG 268 in pen and ink on blue paper, with white added with a brush.[53] The first ideas appear probably at the top of the sheet, and the last at the bottom. A number of ideas were not used – a king facing to the left, a page (or perhaps shepherd) leaning far over the building, a horse seen from the rear – and some of the ideas are close to the Vicenza altarpiece, notably the studies of Caspar, in which his back is turned towards the beholder. There would certainly have been other drawings, including separate studies for the chief figures. A drawing in black and white chalk on blue paper for Melchior was in the Koenigs Collection in Haarlem,[54] showing the king as he kneels in NG 268 but older and with a white beard. Given his importance to the probable patrons of the painting it is remarkable that Joseph is marginal in the final composition, and even more so at the planning stage. Cocke proposes that Veronese deliberately placed him on the right in anticipation of viewers approaching from the left.[55]

When commissioned to paint the organ shutters for the church of the Ognissanti in Venice in the mid-1580s Veronese reused some of his compositional ideas – the pose of Balthasar in NG 268, the pose of Caspar in Vicenza – for a version of the *Adoration* painted largely, if not entirely, by his workshop, which is today in the Brera, Milan.[56]

The Reconstruction of S. Silvestro and the Removal of the Veronese

Although the campanile probably dates from the fourteenth century and the handsome contiguous *albergo* of the *scuola* of the wine merchants (now a vestry and warm chapel for the shrunken congregation) must date from the sixteenth, the body of the church of S. Silvestro dates from the first half of the nineteenth century and is indeed, together with Gianantonio Selva's churches of S. Maurizio and the Nome di Gesù, the most notable of the neo-classical ecclesiastical interiors in Venice (fig. 5). A large portion of the superstructure of the Carrara marble frame of the altar of Saint Joseph, including a cornice crowned with three angels, fell during the night before Easter Sunday in 1820, prompting the surveys that recommended rebuilding.[57] However, work did not commence until 1836. It was directed by Lorenzo Santi (1783–1839), architect of the splendid staircase and ballroom in the Palazzo Reale (now a part of the Museo Correr), the coffee-house in the Giardinetto Reale, and the majestic Palazzo Patriarcale beside the basilica of S. Marco. Although

Santi died before rebuilding was completed, the work was executed according to his plans.[58]

According to Eastlake in his Annual Report for 1856, 'the internal form of the church had undergone alterations in the course of the architectural repairs so that, when the time came to replace the pictures, as originally proposed, not one of the larger works could be fitted to the new altars and compartments. After much delay, a papal decree, together with an order from the local authorities, was obtained for the sale of those pictures.'[59] This is doubtless the official version of the events and has been repeated ever since.[60] But it is unlikely that the pictures becoming available for sale was the consequence of a miscalculation.

New devotional priorities and aesthetic ideals alike ensured that the order and unity of the new interior, and above all the lucid articulation of the nave walls, were incompatible with the display of a painting of the size of NG 268. Every aspect of the interior was to be simplified, and the number of side altars reduced from the eight recorded in early documents to four. The intention of both the architect and the parish was probably to commission entirely new fittings. Paintings were made for the sides of the chancel, and one huge altarpiece, the *Baptism of Constantine*, was completed. The latter was by Sebastiano Santi (1789–1866) (not related to the architect) and he may also have been responsible for the paintings in grisaille – fictive reliefs for the pulpit, and roundels high on the nave walls. He had also collaborated with the architect on the Palazzo Reale staircase, where he painted the *Triumph of Neptune*. Santi's altarpiece is the only work in the church that fits the architectural frame. Old altarpieces were reused for the other side altars: Carlo Loth's *Nativity*, Jacopo Tintoretto's *Baptism* and Girolamo da Santacroce's *Thomas à Becket*. In the first two cases at least it is surely likely that there was pressure on the parish to retain such great paintings, but it is striking that the new design did nothing to accommodate them.

As for the Veronese, it is clear from the architect's designs that there can never have been plans to place it elsewhere. A decision concerning its disposal was probably deliberately deferred until remodelling was complete. An inscription to the right of the atrium reveals that the church was reconsecrated in 1850.[61] To study the interior is to measure how the funds ran out. On the high altar there are angels carved of Carrara marble by Luigi Ferrari (1810–1894) and splendid gilt-bronze candelabra, but the façade was left bare until 1909. The swags between the Corinthian capitals of the nave are executed in relief, but in the atrium they are merely painted. Yellow Verona marble cladding covers the lower portions of the pilasters and the chancel screen: above, it is replaced by a painted imitation. The poverty of the city in the years following the downfall of Daniele Manin's short-lived republic, when the resources of the Church (which included significant support from the Austrian government) had to be diverted to the starving population and the victims of cholera, would have been weighed against any previous resolutions to retain the Veronese and other old master paintings. But in all probability the sale of the Veronese was foreseen

from the start as a likely source of funding. Between 1837 and 1855 it was stored within the church. In the summer of 1855 it was transferred to the dealer Angelo Toffoli. Other paintings from the church were also sold to him.[62]

Acquisition by the Gallery

Payment of £1,977 to Angelo Toffoli of Venice was authorised on 24 November 1855, three days after he was paid £10 for expenses incurred in forwarding the painting from Paris to London.[63] Payments made to Otto Mündler, the Gallery's travelling agent, around the same date doubtless relate to his part in the transaction.[64] Toffoli had formally purchased the picture from Angelo Cerchieri, parish priest of S. Silvestro, on 1 September 1855. Eastlake heard in October that 'the persons who had the disposal of it' (that is, Toffoli) intended to take it to Paris and offer it first to Baron James Rothschild. 'Under such circumstances I considered that the picture would in all probability become the property of so opulent a collector.'[65] The painting was already on its way to Paris, but Mündler ensured that the picture should go on to London. Rothschild is likely to be the person mentioned by Eastlake as having previously endeavoured to come to 'an arrangement'.[66] The success of this transaction doubtless owed much to Eastlake having himself travelled to Venice – but the fact that Mündler remained there to undertake the negotiations and

was also fully informed about the art market in Paris, where he had been based as a dealer, was still more important. Given the circumstances, it is possible that Eastlake had not viewed the painting, and probable that Mündler had not had the opportunity of seeing it in good viewing conditions. The painting arrived in London on 29 November 1855, was hung on the west wall of the West Room on 1 February 1856, was repaired by Bentley (presumably *in situ*), and was moved on 21 September of the same year to the east wall of the same room.[67]

Frame

No record survives of the frame made for the painting when it was put on display in S. Silvestro but it is likely to have been a modest gilded moulding such as is found on other large paintings hanging on the nave walls of Venetian churches. It was clearly not sent to London with the picture, since we know that the canvas was folded when it was placed in store in Venice. The painting is now displayed in a carved and gilded frame with stylised flat leaves on an ogee moulding enclosing another, smaller, foliate ogee moulding (fig. 6). There is a narrow sanded flat on the outside of the latter and a plain gilded flat on the inside. The frame was made by 'Messrs Wright of Wardour Street': payment of £40 was recorded on 11 February 1856. This seems to have been one of Wright's

OPPOSITE: Fig. 7 Detail of NG 268.

Fig. 6 Lower left corner of the current frame of NG 268.

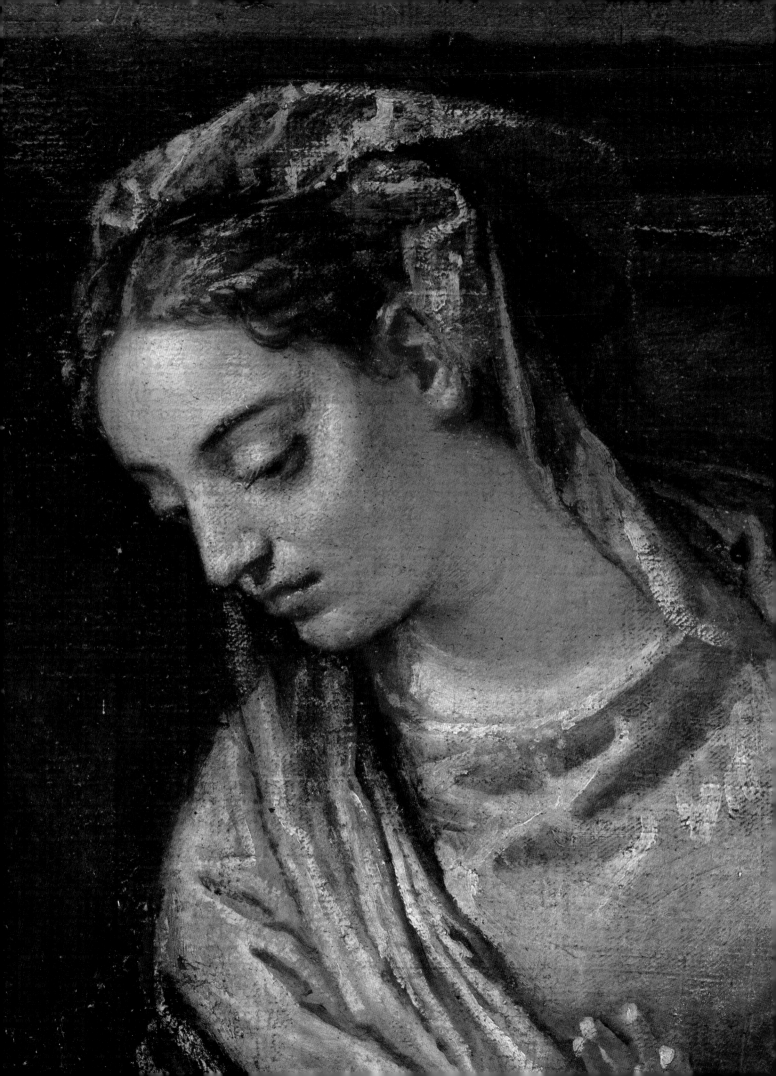

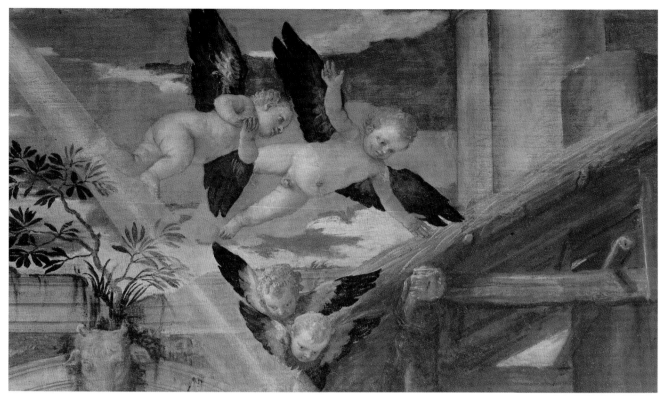

Fig. 8 Detail of NG 268.

earliest jobs for the Gallery. A letter from Wright of 8 February in the Gallery archive indicates that his original estimate was between £25 and £30, but because the work was for the National Gallery he had paid 'every attention to the details of the carving' and had 'fresh prepared the Burnish parts after it had been prepared for oil' (which reveals that originally it was partially water-gilt). He claimed that the cost of the work was about £40 but that it was worth between £65 and £70.[68]

When the painting was glazed later in the century (with glass especially imported from France) the frame had to be modified, which explains the addition of the ugly foliate straps at each corner.

The pattern seems to have been a standard one in the Gallery. A version of the design can be seen on Van Dyck's *Equestrian Portrait of Charles I* (NG 1172), on Joseph Wright's *Experiment on a Bird in an Airpump* (NG 725) and on Reynolds's *Three Ladies adorning a Term of Hymen* (Tate Gallery, N00079). However, the ornament on all of these examples is press-moulded 'composition'. Eastlake in his report to the Trustees noted that the 'new frame … from the freshness of the gilding, does not as yet harmonize with the low tone of the painting.'[69] It is worth noting that the *Family of Darius* (NG 294) was also 'fitted with a carved frame by Messrs Wright' in the following year and this is likely to have been similar, if not identical, to the one made for the *Adoration*.[70]

A note by Cecil Gould dated 30 June 1967 records that 'some years ago' the director (most probably Philip Hendy) wished to reframe the painting in an 'architectural frame' to give it greater importance in the centre of a wall. The idea

was to commission an 'altarpiece frame' and 'Mr Dykes Bower was consulted', on account of his 'success as a pasticheur with the baldacchino of St. Paul's'. The designs were, however, thought to be too elaborate, and nothing was done – a pity, since Stephen Dykes Bower (1903–1994) was a 'civilized, fastidious and scholarly architect' whose baldacchino in St Paul's (erected between 1954 and 1958), in the style of Wren, is superbly designed and executed.[71]

Copies and Derivations

Reduced copies of the entire composition are in the Prado,[72] the Alte Pinakothek, Munich, and the Gemäldegalerie, Dresden.[73] What was claimed to be the *modello* was recorded in 1790 in the Vianelli Collection in Chioggia.[74] A small copy of the lower part of the painting, with variations especially in the background, painted on copper stamped with the date 1607 and the marks of Pieter Stas and the city of Antwerp, was in a private collection in West Sussex in October 1991. There was, evidently, a copy of the lower half of the composition in the 'Royal Gallery' at Windsor Castle, as declared in the legend of the engraving made after it by Simon Gribelin (in reverse, bearing the date 1712).

Print

An engraving by Carlo Sacchi is dated 9 March 1649.[75]

Provenance

S. Silvestro, Venice. Removed to a storeroom within the precincts of the church, 1837. Sold 1 September 1855 to Angelo Toffoli. Purchased from him 24 November 1855.

NOTES

1. Perhaps a fold but more likely a loss of fabric.

2. Penny and Spring 1996, pp. 47–8.

3. Ibid., p. 48, and the caption to plate 15.

4. Ibid., p. 49, and the caption to plate 16.

5. Ibid., p. 49, and the caption to plate 17, also note 77.

6. Ibid., p. 49.

7. Conceivably using scaffolding for Lodovico Dorigny's ceiling painting.

8. Cochin 1758, III, pp. 64–5, recording his visit in June 1751.

9. Annual Report for 1856, p. 27.

10. Eastlake refers to Tagliapietra in the MS catalogue. Lord Elcho alleged in the parliamentary debate in June 1857 (*Hansard*, CXLVI, col. 818) that the Gallery paid for the restoration, but this was untrue.

11. For example, Quadri 1821, p. 273.

12. Gould 1959, pp. 141–2; 1975, pp. 318–19.

13. [Collins] 1860, p. 233 – the article is dated 16 June.

14. Triqueti 1861, p. 62.

15. Venturi 1929, p. 950.

16. Pallucchini 1943, p. 35. Pallucchini's opinion in 1963 is cited by Pignatti and Pedrocco 1995, I, p. 293.

17. Memorandum in National Gallery dossier.

18. Gould 1959, pp. 142–3; 1975, pp. 319–20.

19. Letter in dossier sent by Richter to A.M. Daniel, 8 January 1932.

20. Ridolfi 1646, pp. 59–60; 1914, pp. 353–4.

21. For Tiepolo see Levey 1986, p. 209.

22. Sansovino and Stringa 1604, p. 153B (i.e. 153 verso).

23. Tramontin 1967, pp. 453–533, summarises the full document of 1581 in the Archivio of the Curia Patriarcale (Visita Apostolica MDLXXXI), which was checked for me by Carol Plazzotta. The crucial reference is on fol. 57v. For the 1591 document see Archivio Storico del Patriarcato di Venezia, Segreto IV, Visite Pastorali Priuli, fols 70v–71r, 9 January 1591 (1592 in the modern calendar).

24. First proposed by Humfrey 1988, p. 419, note 82.

25. Tramontin *et al.* 1965, p. 87.

26. Correr, MS IV. 10. (A transcript is in Archivio di Stato di Venezia, Provv. Di Comun., Reg BB, fols 70 ff.) The Correr also holds the *Mariegola* of the Scuola di San Iseppo at San Fosca, MS IV.144.

27. Correr, MS IV.10, fols 1r–4v.

28. Ibid., fols 32r–33r.

29. Ibid., fols 25r–28v.

30. Ibid., fol. 33r (with 'navezella' for 'navicella', and 'calese' for 'chalice', etc.).

31. Ibid., fol. 34.

32. As a frontispiece between fols 20 and 21.

33. Ewald 1965, pp. 27, 94, plate 32.

34. For Joseph in altarpieces and other devotional paintings see Wilson 1996 and Wilson 2001.

35. Sansovino 1604, p. 153 verso. In this text Stringa notes that there are eight altars and then lists five paintings, followed misleadingly by the pictures by Ballini and Veronese which he calls 'quadroni'.

36. The sum of 'cento ungari d'oro' is mentioned by guidebooks.

37. Barri 1679, p. 57.

38. Boschini 1664, p. 247.

39. Jameson 1888, pp. 215–16.

40. The infant Christ is occasionally represented fondling the gold coins in Venetian paintings, for example in the *Adoration* by Girolamo da Santacroce in the Walters Art Museum, Baltimore (37.26). This convention is common in Northern European paintings – see, for example, Gossaert (NG 2790). Carlo Dolci (NG 6523) is unusual among Italian artists in that he depicted both gold and frankincense.

41. This had not been the invariable practice in early sixteenth-century Italy (see, for example, Giorgione NG 1160). Tintoretto, interestingly, felt able to ignore the convention.

42. Very rarely, he kisses Christ's hand, as in NG 2155 (After Joos van Cleve).

43. Molanus 1617, pp. 246–9 (1996, pp. 343–6), cites other, late sixteenth-century, authorities.

44. Steinberg 1996, pp. 64–5.

45. For example, in Jacopo di Cione (NG 574), Attributed to Zanobi Strozzi (NG 582), Filippino Lippi (NG 1124), and Foppa (NG 729).

46. See Girolamo da Carpi, where Balthasar is also assisted by servants (NG 640), and Foppa (NG 729) where his page removes his spurs.

47. See Botticelli (NG 1034) or Gossaert (NG 2790).

48. Fabri 1971, p. 562.

49. For example, Melchior in Girolamo Bedoli's *Adoration* of 1547, Galleria Nazionale, Parma (Di Giampaolo 1997, pp. 126–7, no. 22, and plates on pp. 66–7).

50. Saccardo 1985, pp. 12–29.

51. See the judicious assessment of Marinelli 1988, p. 249, no. 20.

52. Rearick 1988, p. 85, is especially emphatic on this point.

53. B 65. Hadeln 1926, p. 29, pl. 32; Cocke 1984, pp. 160–1, no. 66, and Rearick 1988, pp. 115–16, no. 58. Rearick describes the support as 'blue prepared paper' and he describes the black king as 'Maurice' (Saint Maurice was also black).

54. Missing since the Second World War.

55. Cocke 2001, pp. 115–17 and p. 200, no. 30.

56. Zeri 1990, pp. 264–6, no. 149 (entry by Giovanna Baldissin Molli).

57. Report of inspection May 1820 in the parish archive.

58. For Santi, see Diedo 1843 and Bassi 1978, esp. pp. 185–6, nos 262–3; pp. 188–90, no. 266; pp. 208–9, no. 289; and pp. 230–1, no. 307 (entries by Giandomenico Romanelli). According to the parish archive, Giovanni Antonio Dorigo was the sculptor responsible for executing the four angels.

59. Annual Report for 1856, p. 29.

60. For example, Gould 1959, p. 142; 1975, p. 319.

61. Lorenzetti 1982, p. 607, gives 1843 as the date of completion.

62. For example, Tintoretto's nave painting of the *Agony*, bought by Layard through Hudson, November 1862, and sold on to Sir Ivor Guest in 1867 but destroyed by fire at Canford in 1884 (Fleming 1973, p. 7).

63. NG 13/2, under date, Voucher 48. Ibid., Vouchers 47 and 48, payment to carriers dated 22 November of an additional 2 guineas.

64. Ibid., payment of £189 3s. 1d. on 26 November.

65. Letter of 12 November 1855 reporting on Continental travels preserved in Minutes of Trustees, IV, pp. 6–8 (see p. 17). In the Annual Report for 1856, p. 27, Eastlake says that the pictures from S. Silvestro passed to Toffoli in August.

66. Ibid.

67. Wornum's MS Diary, NG 32/67.

68. NG 13/3, under date, Voucher 80, for the payment. NGS/125/1856, for the letter.

69. Minutes, IV, p. 19.

70. Ibid., p. 117. See also Wornum (MS Diary, NG 32/67), who observed (22 August 1857) that it was 'an improvement on the Toffoli frame', meaning the frame for the Toffoli Veronese, as distinct from the Pisani Veronese, and not, I think, a frame sent with the picture by Toffoli.

71. Burman 2004, pp. 261–3.

72. No. 489, attributed to Farinati.

73. Kultzen 1971, no. 918, for the Munich version. For Dresden, see Marx 2005, II, p. 574, no. 2074.

74. The rare 1790 catalogue of the Vianelli collection is cited by Pignatti and Pedrocco 1995, I, p. 293.

75. Ticozzi 1978, p. 42, no. 28. Mentioned by Boschini 1733, p. 169, and by Eastlake in the Annual Report for 1856, p. 27, so well known, it seems.

traditionally entitled (top to bottom from left):

NG 1318
Unfaithfulness

NG 1324
Scorn

NG 1325
Respect

NG 1326
Happy Union

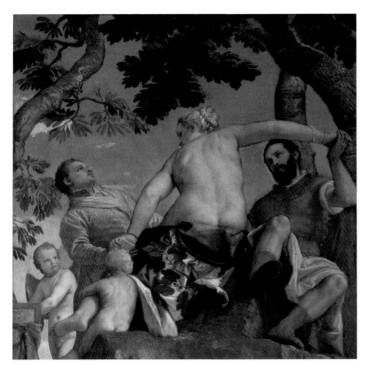

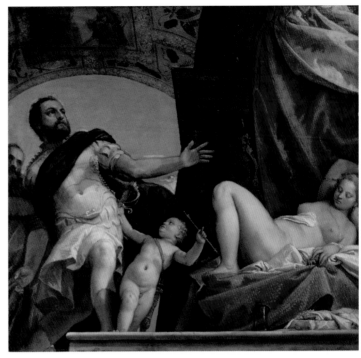

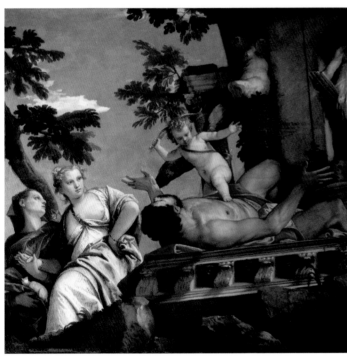

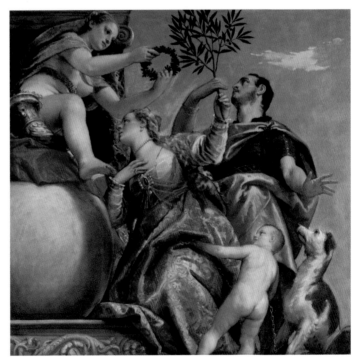

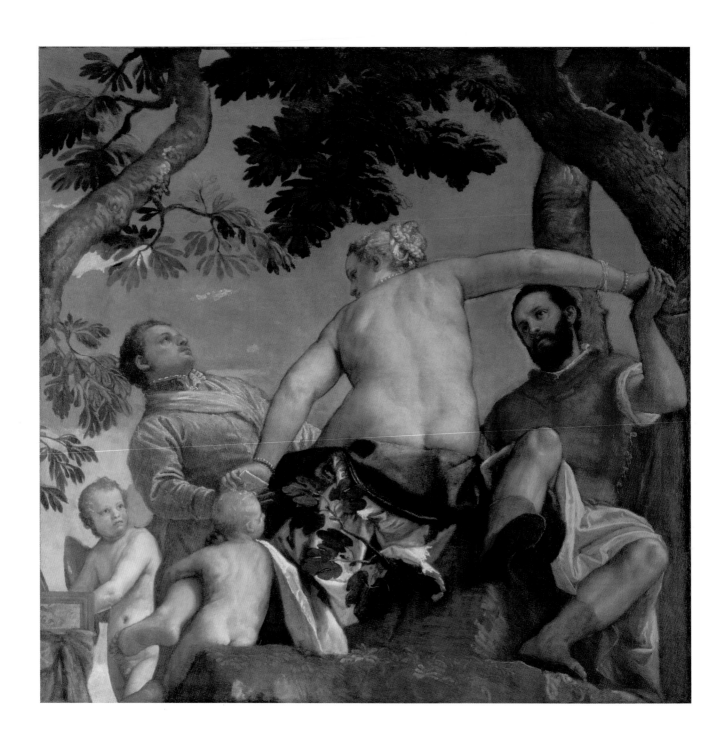

NG 1318

Unfaithfulness

*c.*1575
Oil on canvas
189.9 × 189.9 cm

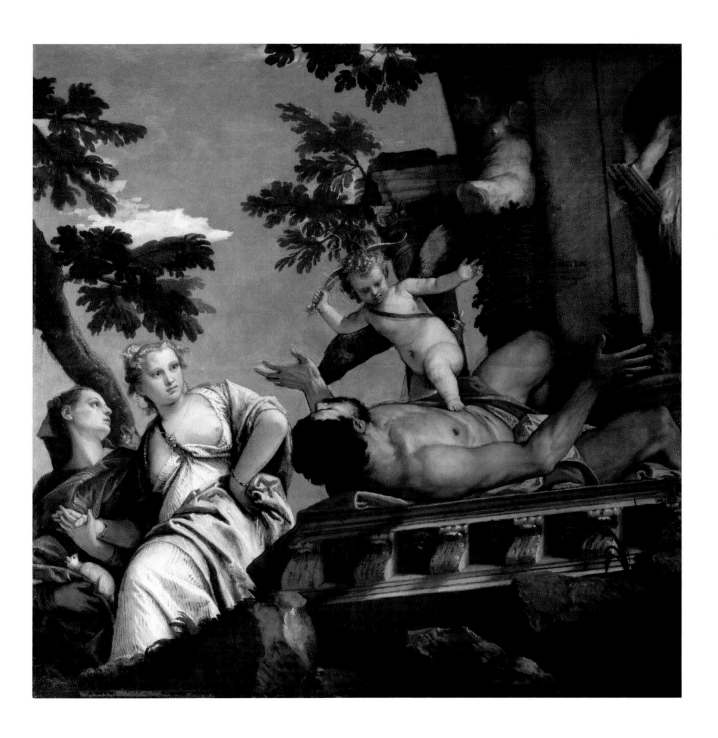

NG 1324

Scorn

*c.*1575
Oil on canvas
186.6 × 188.5 cm

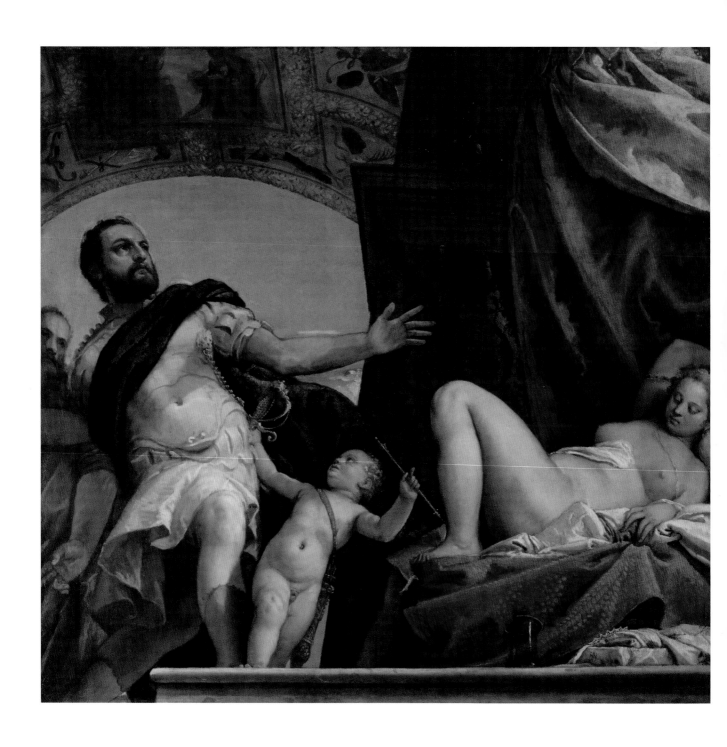

NG 1325

Respect

*c.*1575
Oil on canvas
186.1 × 194.3 cm

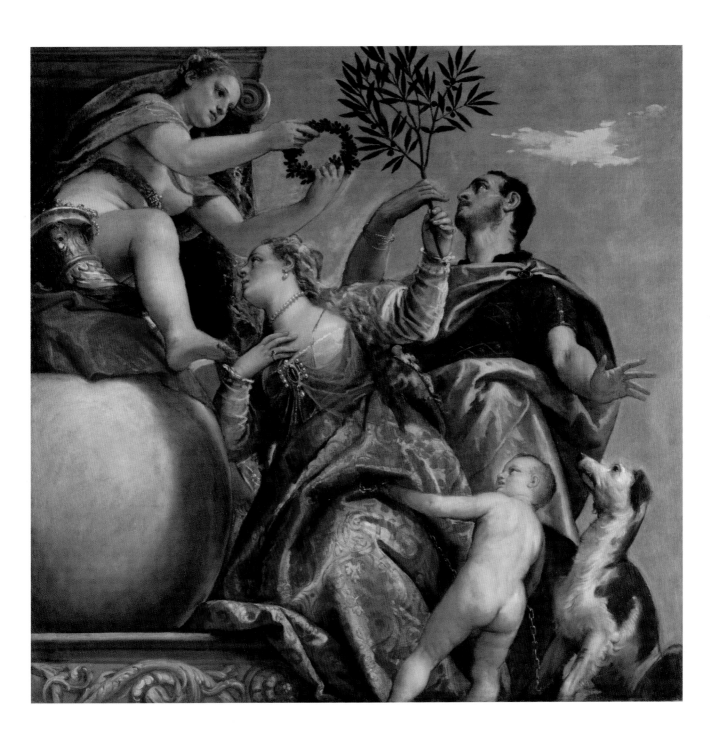

NG 1326

Happy Union

*c.*1575
Oil on canvas
187.4 × 186.7 cm

Support

The dimensions given above are those of the stretchers. The canvas is identical in all four paintings: a plain (tabby) weave of medium weight with 13 by 13 threads to the square centimetre.[1] In each painting the canvas consists of two strips joined with a horizontal seam extending across approximately the centre of the composition (thus, under the chins of both men in *Unfaithfulness*, through the eyes of the more prominent woman in *Scorn*, just below the elbow of the man in *Respect*, through the jewel of the kneeling woman in *Happy Union*). Each of the canvas strips is close in size to the loom width of about one metre that seems to have been standard in Venice.

The edges of the painting have been slightly damaged and in some cases turned over. The sides of *Respect* appear to have been trimmed more severely than those of the other three paintings. It seems likely that the full extent of the man's right hand and more of the woman's head on the pillow were originally apparent.[2] The artist may have been aware that not all of the painted area would be visible within the original frames because thin discontinuous borders, about two centimetres wide, are painted around all the canvases in red-brown and orange-brown paint, perhaps to indicate the area of the canvas that would be visible. The pigment employed for these borders appears to be contemporary with Veronese's painting, although it has been reinforced.[3]

Materials and Technique

The canvas is prepared with a thin gesso ground (calcium sulphate), probably gypsum (calcium sulphate dihydrate),[4] which is coated with a thin *imprimitura* of light greyish-brown colour composed of lead white with some finely ground black and an earth pigment.

The speed and assurance with which the paintings were executed are essential to the effect – to what Holmes described as the 'princely ease and magnificence' of the works.[5] A bold preparatory underdrawing can be discerned, both drawn in black chalk or charcoal and painted in a liquid medium, also in black and, here and there, very finely, in an orange-brown. The black underdrawing can be seen most clearly in the drapery below the right breast of the sleeping woman in *Respect* and outlining the left arm of the man in the same painting. A thin line of brown in the neck of the principal woman in *Scorn* may have served as a guide for the necklace.[6] Some sort of elementary geometrical scaffolding may have been used to help calculate the perspective of the architecture in this painting, as is suggested by the diagonal brushed in black which is just visible in the top right corner.

The sky was completed late in the painting process and it is often thicker around the figures, redefining the position of a head (as in the man's head in *Respect*) or of an arm (as in the man's arm in *Happy Union*). The very last passages were, however, often painted on top of the sky – some of the leaves and also the yellow shoulder-buttons in *Respect*, and some of the foliage above Cupid's bow in *Scorn*). There are many minor revisions – the girdle of the enthroned woman was moved higher in *Happy Union*, as was the head of the hound.

More significant pentimenti are seen in *Respect*, where the red curtain was greatly extended to conceal more of the damask hanging behind it, and in *Scorn*, where Cupid's right arm was originally lower and his left arm higher. It also seems probable that the green drapery over the thigh and buttocks of the woman in *Unfaithfulness* was added, perhaps for the sake of decency, weakening the composition.

Many samples have been taken from these paintings, and the pigments employed have been fully described in the *National Gallery Technical Bulletin* for 1996. No ultramarine was used. Smalt was used for the sky, which has turned grey in all four paintings. The effect is not displeasing, and one scholar has even argued that it was meant to diminish the perspectival depth of the ceiling paintings,[7] but it is not something Veronese can have intended. Smalt was used under azurite for Cupid's wings both in *Respect* and in *Scorn*, where it has completely lost its colour.[8] Very rich, deeply saturated greens composed of copper glazes over verdigris and lead white have survived well (as in the man's cloak in *Respect*), although some of the greens have also darkened. Vermilion and red lake (in some cases analysed as cochineal) were used in combination in some areas, notably the curtain in *Respect*, where there has been some fading of the lake at the top right. Orpiment and realgar were employed for the russet colour of the jacket and boots in *Unfaithfulness* and have degraded. Both linseed oil and walnut oil were used as a medium, the latter less than the former.[9]

Conservation and Condition

As explained elsewhere (p. 462), the paintings served as overdoors when they were in the Orléans Collection and for this reason they are not likely to have been subjected to radical cleaning. They must have been cleaned when they entered the Darnley collection, or shortly before. They were cleaned again in 1947 and then cleaned and restored between 1980 and 1983 (NG 1324 and NG 1325 between 1980 and 1981, NG 1318 between 1981 and 1982, and NG 1326 between 1982 and 1983). NG 1326 was relined on this occasion.

Losses have been retouched at the edges of all four paintings and also along parts of the seam (especially in *Happy Union*). The condition in some places affects our understanding of the volumes depicted (notably in the stone sphere and in the breast and belly of the enthroned woman in *Happy Union*, and in the belly of the sleeping woman in *Respect*). The russet-coloured jacket and boots of the bearded lover in *Unfaithfulness* have lost much of the original modelling on account of the degraded pigments.

As noted above, the colour of the sky has changed from blue to grey, the colour of Cupid's wings has changed, some of the greens have darkened (in the pattern of the damask in *Respect*, and in the leaves in *Happy Union*), and both the subtle rose pink and the pale green in the cloak of the principal woman in *Scorn* have faded. Pentimenti have become apparent (as noted above) and some white patches in the clouds in *Unfaithfulness* and *Scorn* now seem more abrupt than must have been intended.

Inscription

The paper held by the woman in *Unfaithfulness* is inscribed with red letters which appeared to Gould in 1975 to spell 'che / uno possede', meaning 'which one person possesses'. But he put question marks after the first and second word, and wrote that 'there is some doubt about some of these letters'. In 1959, when he first published the inscription, he transcribed it as 'ch... / mi.p(ossede)', again with question marks.[10] Braham proposed, reasonably, in 1970 that 'che uno possede' might mean 'someone who has one man' and might have continued 'should be satisfied', in which case, of course, it is not intended as the contents of the (presumably illicit) note but as a message to the beholder. However, the words could equally be the first part of a cynical adage such as 'she who has had one lover always wants another'. Braham noted that there is a further mark in red after 'che', which is partly concealed. 'This seems unintelligible as part of the inscription and was perhaps added by the artist to ensure that the recession in the area of the picture was not disturbed by letters entirely isolated on the white paper.'[11]

Attribution and Dating

The paintings seem always to have been acknowledged as by Veronese but many scholars have argued that there must have been some studio assistance. Thus Frederick Stephens in a lecture of 1876 expressed the view that the 'broadly drawn outlines' in *Respect* were 'laid on with less refinement and less reserve than elsewhere' and that the forms in this painting 'were originally somewhat carelessly defined, and afterwards rudely corrected with broad, bold touches of dark pigment, the additions being probably due to the master'. He also found the colours in *Respect* to lack the 'silveriness' of the other paintings, and the face of the nymph to be in need of 'the purity of the carnations'.[12] The flesh colours (carnations) of the back of the woman in *Unfaithfulness*, on the other hand, are 'exquisite in the rendering of the white and rose; the greys, so delicious to artistic eyes, have been introduced with amazing skill' – a skill later praised by Holmes as worthy of Velázquez.[13]

Some doubts that the paintings were entirely by Veronese had clearly been entertained in the National Gallery, since Collins Baker's catalogue of 1929 distinguishes 'nos 1318 and 1326' (*Unfaithfulness* and *Happy Union*) as 'wholly by the master's hand'.[14] In the catalogue of the *Exhibition of Cleaned Pictures* in 1947, *Respect* and *Happy Union* were relegated to 'studio of Veronese', only the dog in the latter being considered worthy of Veronese's hand.[15] Gould in his catalogue of 1959 regarded 'the whole series as homogenous to the extent of seeing both autograph and studio execution in all four, only the ratio varying'. Veronese's overall control was such that 'glaring disparities in quality' – such as the 'coarse modelling' of the putto on the extreme left of *Unfaithfulness* – were rare.[16] Marini in his catalogue of Veronese's work in 1968 followed Gould in his conclusion that there was some studio participation in subordinate areas, but this view was dismissed by Pignatti and Pedrocco, who claim that the autograph status has been unanimously acknowledged.[17] To

Fig. 1 Detail of *Unfaithfulness* (NG 1318).

Gould's observations it is perhaps only worth adding that there are some passages of broad and summary handling in the setting – especially the foliage – which could easily have been delegated, but also some rapidly brushed lights on the figures which seem likely to have arisen from a final judgement of how the pictures would look when viewed from a distance and from below, and that final judgement must surely have been Veronese's own.

The dating of the paintings has varied greatly. Many scholars have suggested the 1560s but without giving any reasons. Gould's observations in 1959, based on the notes of Stella Mary Pearce (Newton), that 'the costumes and hairstyles shown would accord best with Veronese's practice in the mid-1570s' is surely just.[18] The way the hair curls back from the brow of the principal woman in *Scorn* is especially significant. Rearick felt that the close resemblance to Veronese's very damaged fresco *Venice distributing Honours* in the Anticollegio of the Doge's Palace, Venice, which was begun shortly after February 1576, was such that the National Gallery's paintings could be dated 'to the end of 1575 and the first three months of 1576'.[19] Although there are similarities between the fresco and the canvases, especially *Respect*, they are not sufficient to justify so precise a date.

Original Setting and Preparatory Drawing

The hypothesis that these four paintings were intended either for a ceiling or for a series of ceilings is confirmed by two features. First, the architectural elements within them are tilted. Secondly, the lower parts of the compositions seem to have been cut, and in several cases the feet of some of the figures are not visible. Both of these features become disconcerting when the paintings are hung on a wall. To writers on art in the eighteenth and nineteenth centuries, when the conventions for ceiling paintings invented in the early sixteenth century still prevailed, it was obvious that these

were ceiling paintings,[20] but in the twentieth century this was sometimes doubted. For Gould it was merely 'plausible enough' and for Pignatti 'probable'.[21]

The composition of each painting forms a strong diagonal, which on a ceiling would help relate the paintings to one another but on a wall could serve no such purpose. This device is obvious enough in all four pictures, but it is most ingenious and most subtly dramatic in *Scorn*, where there is a double diagonal – the line of the bank and the outstretched arm of the statue are paralleled by the thigh and forearm of the principal woman, Cupid's wings and the broken statue of a faun – with which the woman's head, Cupid's head and body, the raised arm of the man and the tree trunk are contrasted. Veronese's love of diagonals is evident in very many of his paintings, but what is distinctive in all these canvases is the studied avoidance of verticals.

A sheet of preliminary figure studies in pen and ink with wash includes designs for figures and figure groups in all four of the paintings (fig. 2), demonstrating that the compositions were developed simultaneously[22] and also that they are essentially figure groups. The trees and the architecture, which might act as scaffolding for a composition, are here merely accessories. The drawing also suggests one other practice of great interest. The wedded couple in *Happy Union* were originally conceived as advancing from the left – the more usual direction of action in a picture – but were then reversed in the painting, presumably to balance the diagonal movement in the other pictures. In addition, Cocke suggests that the five different positions in which the naked man in *Scorn* is drawn shows the attention Veronese gave to problems of foreshortening, perhaps employing a wax model.[23] Xavier Salomon has recently noted that the drawing includes just above the studies for *Respect* five faint capital letters in black chalk. There is a G on the left and on the right A, C and F in a vertical line. Each of these is contained in a square. The letter B, unsquared, is placed in the middle. He has proposed that these letters may provide a clue as to the original arrangement of the canvases.[24]

The first published attempt to reconstruct the original arrangement of the paintings was made by Martin Royalton-Kisch in 1978.[25] He proposed, plausibly, that they were placed on the vault of a square room, with the skies converging in the centre of the ceiling. However, his arrangement of the paintings in the order of *Scorn*, *Unfaithfulness*, *Happy Union* and *Respect* (clockwise, in a circle) reflects ideas which are not entirely convincing. He argues that there are two 'interior' and two 'exterior' scenes, but surely only one of them is truly 'interior'. And he proposes that the men who look out would have been understood as looking at figures in the other paintings: a tempting idea, but not compelling. It seems unlikely that they could easily have been understood to do this, nor are there any other paintings by Veronese in which this sort of interconnection is contrived. On balance

it would seem more likely that they were intended for the ceilings of a suite of four rooms. In each painting the light falls from the same direction, which supports this idea. In addition, it should be noted that in Venice no private residence had a ceiling large enough for all these paintings and no ceiling with four square compartments is recorded.[26] Since many European palaces had parallel suites of rooms for husband and wife, it is possible that two of the paintings were made for a reception room and bedchamber of a man and two for the equivalent rooms of his consort.

Original Patrons

As is discussed below, the paintings are first recorded in a posthumous inventory made in the late 1630s of the collection formed by the Holy Roman Emperor Rudolf II. They were not included in an earlier inventory of Rudolf's collection. If they had been incorporated into a ceiling in Prague Castle, or some other imperial residence (or set aside with the intention of being incorporated), they might not have been listed.

If Rudolf did commission these allegories, he is likely to have done so soon after becoming emperor in 1576. It is tempting to suppose that they were made to decorate a marriage bedchamber. The subjects, although they have never been completely and convincingly explained, are certainly connected with the trials and rewards of love, and are as obscure and elaborate as those usually favoured by Rudolf, though rather more edifying, with lust sternly subdued in one scene, restraint apparently exercised in another, and fidelity certainly celebrated in a third. If the paintings did play a part in such a setting, then the space in the centre of the ceiling would have been intended for the couple's united arms. And it has been ingeniously proposed that the men in each picture are gazing at such a heraldic centrepiece.[27] The only problem with this argument – a very considerable one – is that the emperor never married.

The possibility should therefore be entertained that the paintings were made for another patron north of the Alps and entered the imperial collection indirectly. The chief agent for the importation of high-quality Venetian art into the Empire in the period immediately before Rudolf's accession was Jacopo Strada (1515–1588), whose clients included the Emperors Ferdinand I and Maximilian II, the Elector of Bavaria, Albert V, and the rich banker Hans Jakob Fugger. Strada was not only an art dealer but an architect, and since he had trained under Giulio Romano in Mantua and took a special interest in the interiors of the Palazzo del Tè, which was so celebrated for its ceiling paintings, it is tempting to suppose that Veronese's canvases travelled across the Alps through his agency. If so, it is possible that Strada diverted them to Rudolf on the latter's accession in 1576, although Strada was not much favoured by Rudolf, who employed Strada's son Ottavio in preference, and later took Ottavio's daughter, Anna Maria, as his mistress.[28]

Against the idea that the canvases were made for export is the fact that two of the compositions (*Unfaithfulness* and *Respect*) are recorded in Van Dyck's Italian sketchbook in

Fig. 2 Paolo Veronese, studies for the *Allegories of Love*. Pen and brown ink with bister wash on ivory paper, 32.4 × 22.2 cm. New York, The Metropolitan Museum of Art. Harry G. Sperling Fund, 1975.

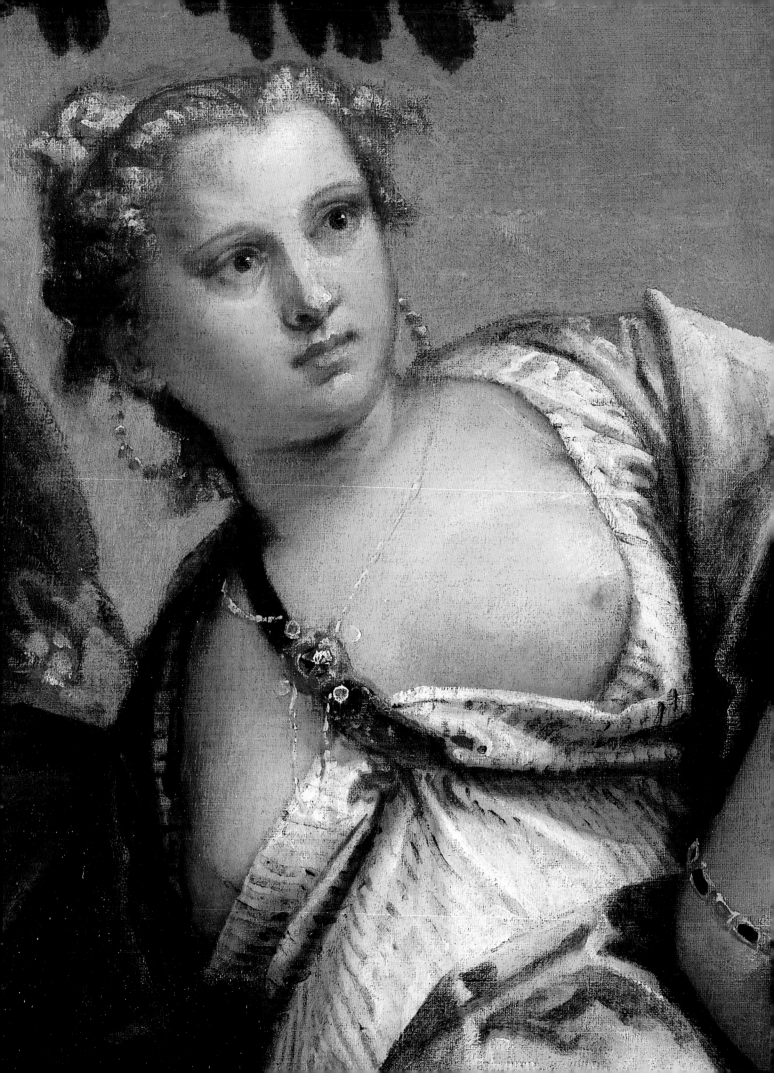

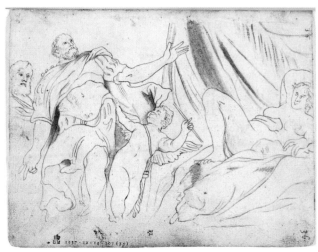

Fig. 4 Anthony van Dyck, drawing after Veronese,
Allegory of Love III (Respect) – from Van Dyck sketchbook.
Pen and brown ink and brown wash over black chalk,
15.5 × 20.2 cm. London, The British Museum.

Fig. 5 Anthony van Dyck, drawing after Veronese,
Allegory of Love I (Unfaithfulness) – from Van Dyck sketchbook.
Pen and brown ink and brown wash over black chalk,
15.5 × 20.2 cm. London, The British Museum.

the 1620s (figs 4 and 5).[29] This is not conclusive, however, since it is known that Van Dyck made drawings from copies and engravings as well as originals.[30] His drawings of the two allegories are neither fluent in line nor confident in composition, and they introduce much awkwardness that is not present in Veronese's paintings. This could be explained by the fact that Van Dyck was working from a copy by a less competent hand, but an equally convincing explanation is that he made the drawings from paintings which were on a ceiling.[31] If this is so, then the paintings can only have been sent to Prague shortly before they are first recorded there in the late 1630s.

Meaning

Descriptions of the paintings in late seventeenth- and early eighteenth-century inventories are vague and inconsistent. The women tend to be identified as Venus and the male warriors as Mars. *Happy Union* was recognised as an allegory, with the enthroned woman as 'perhaps Peace' in 1689 but as Venus in 1721.[32] The earliest recorded titles, and thus the first known interpretation of their meaning, are to be found in the catalogue compiled by Du Bois de Saint-Gelais of the collection of paintings in the Palais-Royal belonging to the Duc d'Orléans, which was published in 1727.[33] *L'Infidélité*, *Le Dégoût*, *Le Respect* and *L'Amour Heureux* illustrate, he believed, the dynamic elements of which marriage consists ('différentes révolutions auxquelles sont sujets bien des mariages'). Although the titles are reminiscent of those given to prints after Watteau and his followers during this very period, they were retained throughout the eighteenth and nineteenth centuries and much of the twentieth, and were translated as *Unfaithfulness*, *Scorn*, *Respect* and *Happy Union* by the authors of the National Gallery publications after 1890. They were

OPPOSITE:
Fig. 3 Detail of *Scorn* (NG 1324).

rejected by Cecil Gould in his catalogue of 1959, and declared 'absurd' by Edgar Wind, yet they continue to be used, especially in the English and Italian versions. *Scorn* was entitled *Disinganno* by Italian scholars, which means 'Disillusionment', and this was the title proposed by Rearick, but this variation, which seems far less appropriate, has not been adopted.[34]

Mariette, in the text he supplied for the second volume of the *Recueil Crozat*, in 1742, declared his uncertainty as to the meaning of the paintings but his certainty that the titles were not adequate, except in the case of *Infidélité*. He thought that *Le Respect* illustrated the power of beauty and *Le Dégoût* Love chastising Lust. Louis-Abel Bonafons, Abbé de Fontenai (1736–1806), in the text he supplied for the complete illustrations of the paintings in the Palais-Royal – a text probably completed in the mid-1780s, although this part of it appeared in the volume published in 1808, two years after his death – also felt that the titles were inadequate. He was not uninterested in the meaning of details and noted that Cupid in *Happy Union* has been divested of his wings to indicate the constancy of married love, but he found it impossible to be sure whether the enthroned woman in that same composition is Venus (as her jewelled girdle might suggest) or Fortune (for whom the globe is a common attribute). He did not mind the uncertainty, which allowed the imagination to wander, and his own speculations were especially stimulated by *Scorn*. The woman with her bare breasts and jewels cannot be a true opponent of pleasure, he wrote, and the punishment administered by Cupid might be intended to show that love is kindled to greater warmth when its advances are rejected. In the case of *Respect*, he argued that it did not matter very much whether the action represented a specific historical deed ('fait particulier') such as the continence of a barbarian warrior or an allegory of the noble struggle ('efforts généreux') of a warrior resisting the appeal of a voluptuous indulgence ('attraits de la volupté'), for only the 'self-esteem of those who believe it possible to know and explain everything' is offended by such obscurity ('le voile peu transparent').[35] Fontenai, having taken

the trouble to consult Ridolfi's life of Veronese, also entertained the misleading idea that the paintings may have come from the ceilings of the Villa Barbaro at Maser.

There seems to have been little interest in the meaning of the paintings in the nineteenth century, though Waagen wrote that he considered *Respect* to be 'very erroneously denominated' since he was sure that it exemplified the 'triumph of passion over reason'.[36]

Writers in the late nineteenth and early twentieth century were so averse to allegory – 'decorative homilies ... a new idiom in decorative art, and one in which failure would seem to be almost inevitable'[37] – that they had little to say about the meaning of the paintings, but Osmond was surely correct to consider them as two pairs, with *Happy Union* opposed to *Unfaithfulness*, and *Scorn* complementing *Respect*.[38]

By the mid-1950s, when Cecil Gould began to write his catalogue of the Venetian school, it was acknowledged that expertise on the sort of meaning that might be present in Renaissance allegorical painting would best be found in the Warburg Institute. Consequently, Gould wrote to Ernst Gombrich, seeking his advice.[39] It is not recorded how Gombrich replied, and the views of a rival scholar, Edgar Wind, were incorporated into Gould's catalogue. Wind, like Osmond, also saw two pairs, but he did not consider that the woman in *Scorn* is expressing anything like scorn, or that the subject of 1318 is unfaithfulness, preferring to see it as 'symbolising the strife of love'.[40] The authority enjoyed by Wind is indicated by the fact that Gould credited him with identifying the relief on the vault in *Respect* as the *Continence of Scipio*, even though Gould knew that Pigler had already done so and also knew that there was some doubt as to whether this was the subject of the relief.[41] The enthroned figure seems to be female, none of the figures can easily be identified as the fiancé, and no tribute can be discerned, either in the vault in the painting today or in the rather clearer depiction of it in an eighteenth-century print (fig. 8).

Wind expanded on the meanings in his *Pagan Mysteries in the Renaissance* in 1967. The man in *Respect* is, he claimed, not turning away from the sleeping woman but approaching her 'with awe', for this represents the 'consummation of love'. He concedes that some 'restraint' is being exercised, but that word seems inadequate to describe the man's refusal to look and the way he twists his body. Wind was most exercised by *Unfaithfulness*, which, he proposed, represented the 'tripartite life' defined by Marsilio Ficino – 'a well-regulated strife between the contemplative, the active and the pleasurable parts of the soul, in which the dominant part is given to pleasure'.[42] Wind was as ingenious in detecting the tripartite life in Renaissance art as theologians had once been in finding emblems of the Trinity in the natural world. The 'dominant' pleasure in this case is 'Voluptas Urania', who turns her back to the world. She 'fills the musical poet with divine meditations' – a reference to the younger man who avoids looking at her, although he receives her note – while 'the man of heroic actions, dressed in a cuirass, returns to her and grasps her hand'. Anticipating the question of how we know this woman to be a celestial being, he refers to her 'exalted station'

(as if she had a throne), her 'noble attendants' (as if the men were her servants) and 'the incontrovertible fact that she turns her back' (as if only celestial beings adopted this attitude) – 'not to mention the winged Cupid playing the spinet' (as if music were exclusively elevating).[43]

Three years later, Allan Braham, then a junior curator at the National Gallery, tentatively pointed out some of the problems with Wind's interpretations in an article in *The Burlington Magazine*. He also drew attention to the difficulties of interpretation, observing of the sphere, cornucopia, girdle, crown of leaves and veil in *Happy Union* that 'the possible readings of these various attributes, taken singly or in various permutations, are almost limitless', and noted in conclusion that the meaning of the series will not be settled, 'failing the discovery of a written text'.[44]

Braham was probably the first scholar to draw special attention to the 'glass beaker' beside the bed in *Respect*, but his suggestion that it shows that the sleeping woman has been drinking wine and so 'would be in no state of mind for resistance' seems unconvincing.[45] No Renaissance wine glass was of this shape. Another scholar has since suggested that the vessel is for urine.[46] (What looks like a thin-necked flask perched on the cornice may be an inverted fan – it certainly resembles one in the print, fig. 8.) In conclusion Braham argued that the 'programme seems designed to pay homage to women on the one hand, and on the other to the state of marriage'. This conclusion is difficult to challenge but it is surprising that he finds the *Happy Union* to be 'clearly Christian in sentiment', as if monogamous felicity were a Christian ideal, or the symbol of the olive branch (for peace), the golden chain (for conjugal attachment) and the hound (for fidelity) dated from the Christian era. More recently Goodman Soellner has observed how closely Veronese's paintings illustrate the progress of love in Petrarchan poetry of a kind that was very familiar to Veronese's patrons. The view of the sleeping beloved is an example of this. She concedes, however, that she knows of 'no close poetic analogue' to the scene in which the woman slips a note into the young man's hand.[47]

A point worth making in conclusion is that the relationship between the scenes is not necessarily sequential. The term cycle is also best avoided if it is taken to suggest narrative development, which seems most unlikely – not least because the same man does not certainly appear in any two scenes (and in particular the man in *Happy Union* certainly does not appear in any of the other scenes[48]), even though the women are always of the same type.

In addition it should be noted that, with the exception of Cupid, the enthroned woman in *Happy Union* and the veiled woman carrying an ermine in *Scorn*, the figures are not likely to be either personifications or divine beings; thus they do not represent love or lust or jealousy or chastity but are men and women who act out scenes illustrating virtues or vices. The nature of the action is perhaps most puzzling in *Unfaithfulness*,

OPPOSITE:
Fig. 6 Detail of *Happy Union* (NG 1326).

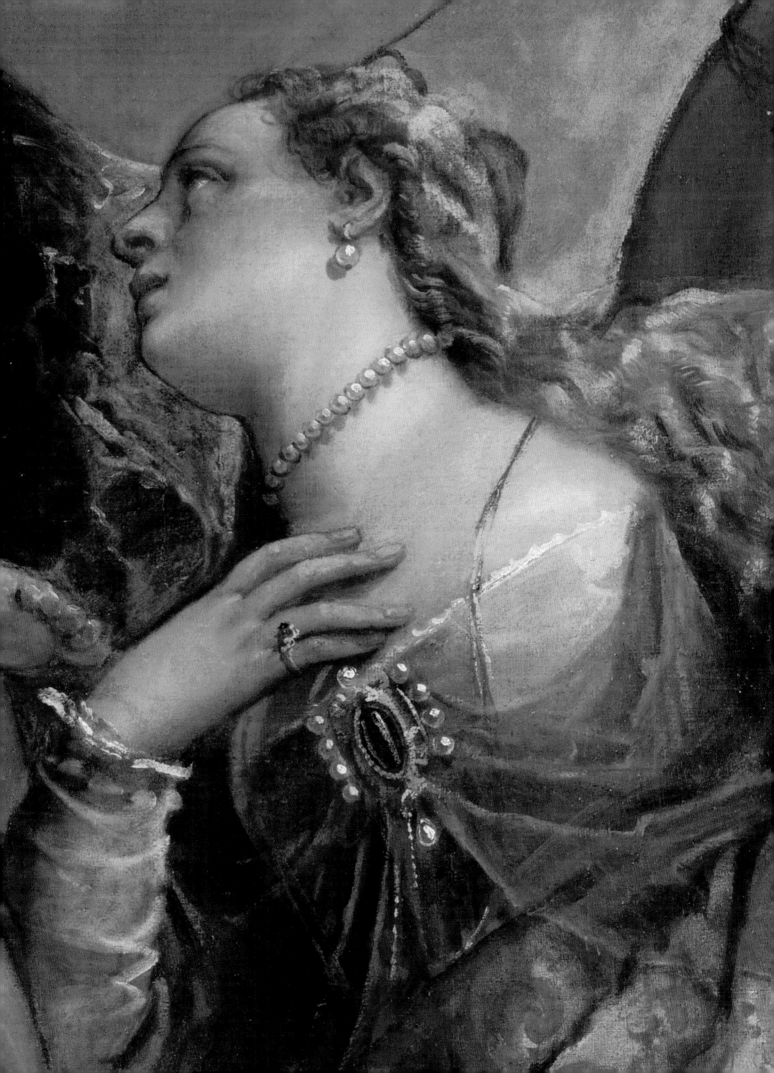

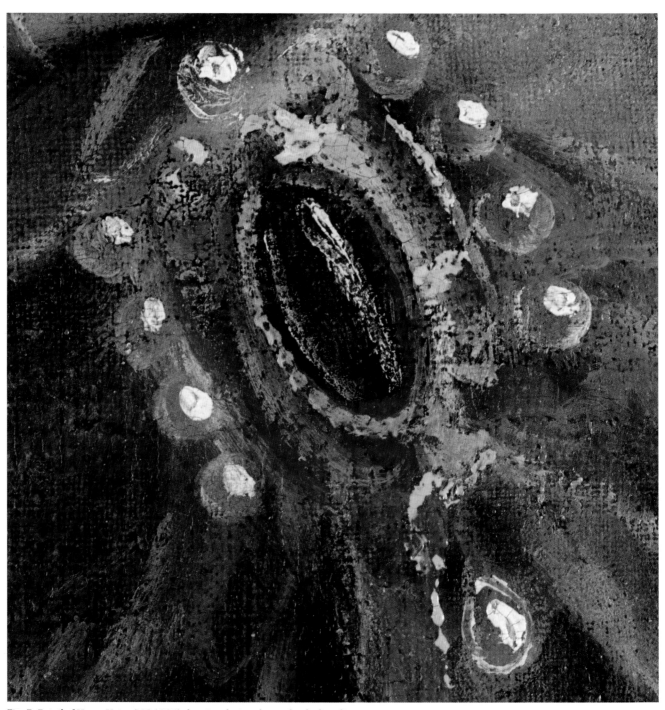

Fig. 7 Detail of *Happy Union* (NG 1326) showing the jewel worn by the kneeling woman.

for even if it represents indecision in courtship rather than marital deceit, there is nothing within the picture to express disapproval of the action represented.

Acquisition by the National Gallery

The 6th Earl of Darnley, who had inherited the great collection formed by the 4th Earl (see pp. 448–52), wrote to the highly respected artist and art dealer Charles Fairfax Murray on 7 January and 25 January 1888, declaring his resolve to send the 'four pictures' by Veronese to Christie's with a reserve of 'not less than £12,000', but also seeking Murray's

advice.[49] Murray, evidently having dissuaded the earl from going to auction, undertook to offer the pictures to private collectors. Learning on 3 March that there was 'no hope in Rothschild quarter' Lord Darnley felt he should 'now speak to Christie's',[50] but again Murray must have dissuaded him.

There is no evidence that Murray persuaded any collector to take an interest in the pictures, except for a reference on 21 May 1889 of a 'certain person' going to see them – 'I do not know whether for foreign or home quarters'.[51] Presumably the paintings were available for inspection in London, and the mystery visitor may have been connected with the

National Gallery. Murray had evidently tried to interest Frederic Burton, in vain, but Murray made sure that others came to hear of their availability. In early June, Thomas Armstrong, director for art at the South Kensington Museum, wrote to his friend George Howard, 9th Earl of Carlisle, a Trustee of the Gallery: 'I am afraid Burton is inclined to poo-hoo them ... they would be a famous acquisition for the Gallery and I hope Berlin or some French jew will not lay hands on them.'[52] Howard then raised the matter with Murray, asking whether Lord Darnley might also be selling the fine Tintoretto.[53] This may be the first germ of the idea that Tintoretto's great painting of the *Origin of the Milky Way* be offered together with the *Allegories*. In a letter dated 21 June Murray asked Bode, director of the museum in Berlin, if he would be interested in negotiating for the Veroneses. This seems to have been in 1890, and was probably a second approach.[54] The reply cannot have been very positive because in the following month William Agnew had taken over negotiations (possibly at Murray's suggestion, since Murray was informally attached to Agnew's, and perhaps because Murray himself was travelling) and was keen to approach the National Gallery again. Lord Carlisle and another artist Trustee, Frederic Leighton, seem to have taken it upon themselves to ensure that Burton respond more positively. Agnew wrote to offer him the Veroneses together with the Tintoretto for £5,000, to be paid over two years. Burton replied on 25 July 1890, rather cautiously: 'I have no doubt that the majority of them [meaning the Trustees], if not all, will sanction the arrangements.' Gregory and Layard apparently had 'qualms'.[55]

One of the Veroneses, however, was held back and kept at Cobham, as Lord Darnley explained, 'by Agnew's advice, – no doubt sound advice, – as it appears more likely to spoil than to help the sale of the others'.[56] From this we can only conclude that Darnley had been informed by William Agnew that the lack of interest in the paintings might be partly explained by the supposedly improper subject matter of NG 1325, in which Cupid appears to encourage a man to take advantage of a sleeping woman.

On 26 July Darnley told Agnew that he wanted to present this painting to the National Gallery. He also wanted the price paid for the others to be kept quiet because it was so low and he had only agreed to it 'after years of vain endeavour to dispose of the pictures both in Europe and America'.[57] What seems to have lain behind this apparent benevolence was Lord Darnley's reluctance to sell five paintings for £5,000 – that is, at £1,000 apiece. Instead, £5,000 would be, or would appear to be, the price for four. This mattered to him because he clearly foresaw the need to sell others of his Italian paintings.

Agnew explained the new situation to Burton and the 'hard tussle' he had had with 'his Lordship'.[58] The cantankerous Lord Darnley was, however, offended that Agnew should have revealed his intentions at this stage. It was, he wrote on 10 September, 'directly contrary to my intentions ... I am innocent of the perverted form which the transaction has taken.' But, he added, 'to tell the truth, I am only too glad to have "le Respect", as it is so curiously designated, off my

hands.'[59] The Board, meanwhile, had met on 5 August and approved a plan to buy some of the pictures for £3,000 and to insure the others for £2,000 until funds were available to purchase them.[60]

Burton now proposed to take *Unfaithfulness* (NG 1318) and the Tintoretto (NG 1313) for £2,500. Lord Darnley agreed on 13 September,[61] as did the Trustees on 15 September.[62] The three Veroneses were already in the Gallery and the fourth must have arrived soon after. Burton seems to have had them hung high, believing that they had been painted for a ceiling, and one Trustee, Lord Hardinge, objected to this.[63] This is a reminder of the difficulty of displaying the paintings, which must have been a major factor in the lack of interest Murray had encountered when trying to sell them. Lord Darnley received a cheque for the remaining £2,500 in June 1891.[64] He had declared the price 'absurd' and grumbled that 'everything Italian appears to be now out of favour',[65] but several years later, when Titian's *Rape of Europa* was offered for sale, it soon emerged that this was not the case. Surprise has been expressed by the far greater sum of £20,000 that the Titian fetched, yet a great difference in value had been clear in 1833, when the Titian was valued at £1,500, twelve times more than each of the *Allegories*, which together were valued at £500.[66]

Provenance

The paintings correspond to nos 449 (*Happy Union*), 451 (*Scorn*), 453 (*Unfaithfulness*) and 455 (*Respect*) in the inventory of the imperial collection in Prague, made after 15 February 1637.[67] They were among the pictures looted from Prague for the Swedish Crown in 1648 and were numbers 96 to 99 in the inventory of Queen Christina of Sweden's collection that was made in 1652.[68] Presumably they correspond to the 'plafon' by Veronese in the inventory of her collection made in Antwerp in 1656, when she was on her way to Rome,[69] and they are listed as 1–4 in the posthumous inventory of her possessions made in Rome in 1689.[70] They passed together with the rest of her picture collection in 1721 to the Duc d'Orléans (for this transaction and the paintings in the Palais-Royal, Paris, see pp. 461–70). They were sold with the Italian portion of the Orléans Collection in 1792 to Walckiers and then to Laborde-Méréville, by whom they were mortgaged to Jeremiah Harman. These paintings were acquired in 1797 by a syndicate consisting of the Duke of Bridgewater, the Earl of Carlisle and Earl Gower, by whom they were consigned to sale through Michael Bryan in December 1798 as lots 169, 181, 243 and 245. These four pictures were not then sold but were re-offered at auction on 14 February 1800, as lots 26, 34, 42 and 57, and then bought by the 4th Earl of Darnley (see pp. 448–52) probably soon afterwards. They are recorded in the picture gallery at Cobham Hall in June 1831, when the probate inventory was compiled,[71] and remained at Cobham until sold by the 6th Earl to the National Gallery in 1890 (NG 1318) and 1891 (NG 1324 and NG 1326). The circumstances of this sale are described in the previous section, where it is also explained why Lord Darnley made a gift of NG 1325 (also in 1891).

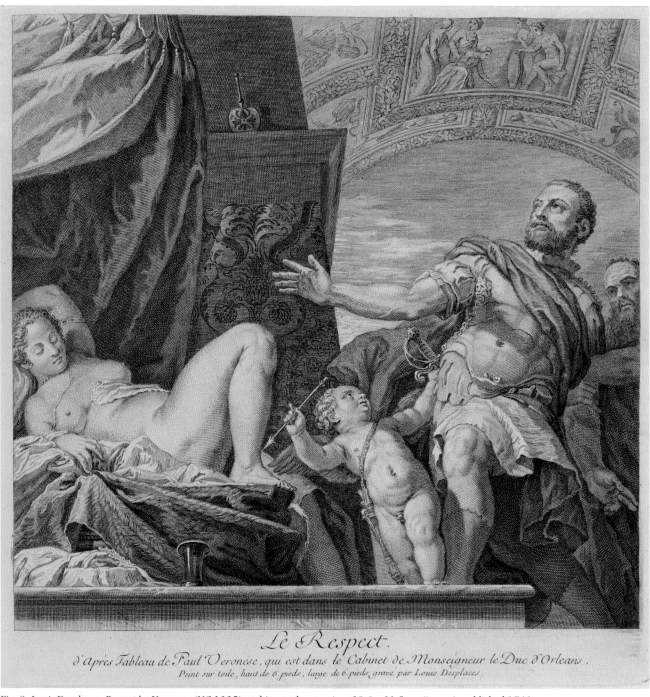

Le Respect.

d'après Tableau de Paul Veronese, qui est dans le Cabinet de Monseigneur le Duc d'Orléans.

Peint sur toile, haut de 6 pieds, large de 6 pieds gravé par Louis Desplaces.

Fig. 8 Louis Desplaces, *Respect* by Veronese (NG 1325), etching and engraving, 30.6 × 31.5 cm (image), published 1742.

Engravings

Prints were included in the second volume of the *Recueil Crozat* published in 1742, a large portion of which was devoted to Veronese. The plates, which are by Simon Vallée (NG 1318), Benoist Audran (NG 1324) and Louis Desplaces (NG 1325 and 1326), were all in reverse and are combinations of etching and engraving (fig. 8). Prints were also included in the second volume of the *Galerie du Palais Royal* in 1808, but as part of a section (consisting entirely of the works of Veronese) which had been published before 1808,

and after drawings made before the sale of the paintings in 1792. Some of these were also engraved in reverse. The engravers were Jacques Couché (engraver to the Duc d'Orléans, who was born in 1759 and was the chief instigator of the publication), who signed NG 1324 (no. XV) and co-signed NG 1325 (no. XIII); Louis-Jacques Cathelin (1739–1804), who co-signed NG 1325 and NG 1326 (no. XIV); Jean Antoine Pierron (active 1780–1812), who signed NG 1318 (no. XVI); and Pierre Alexandre Beljambe (1759–*c*.1820), who co-signed NG 1326 (no. XIV).

The Odescalchi Copies

An inventory of Palazzo Riario in Rome where the collections of the Queen of Sweden were housed was made in December 1713 following the death of the nephew of Pope Innocent XI, Prince Livio Odescalchi, first Duke of Bracciano (b. 1652), who had purchased the palace and the collections in 1699. It reveals that the works of art were arranged in the state rooms exactly as they were described in guidebooks ten years before, but also that something unusual was taking place behind the scenes.[72]

In one room on the ground floor 250 copies, of all sizes, made after famous paintings in the collection were packed, unframed, in cases.[73] Upstairs there were other rooms full of copies, some noted as only 'di primo sbozzo' or 'sbozzata' – 'sketched in' or 'blocked out' – and others as 'quasi finita' – lacking only the final touches. Most of the notable paintings from the Queen of Sweden's collection are listed among these copies, including all of Veronese's *Allegories*: we find mention, for example, of three copies of NG 1318 (a 'Woman', or a 'Venus', 'with two men'), one of them only just begun,[74] and three of NG 1324 (the 'nude man sprawled upon an entablature').[75] The agents of the Duc d'Orléans, who was engaged in protracted negotiations to buy the collection, knew that copies had been made but assumed that this was to ensure that the palace walls would not be denuded after the sale. The duplication makes it clear that something more akin to commercial editions of engravings or plaster casts was being undertaken, although whether at the initiative of Odescalchi or merely with his consent is not clear. A few copies which I have seen seem likely to have been made on this occasion, and they are too accurate to have been made without careful measurements.[76] These copies would have been hard to make without removing the *Allegories* from the 'cielo' of the most important room in the 'appartamento nobile' on the first floor – indeed, given the proximity of the luxurious furnishings in this room, including a baldacchino with flowered brocade of crimson velvet and seats upholstered with the same material,[77] the copies must obviously have been made elsewhere in the palace.

Exhibitions and Loans

London 1818, British Institution (23, 75, 99 and 145); Manchester 1857, Art Treasures exhibition (274, 273, 271 and 272 in the provisional catalogue; 287, 288, 285 and 286 in the definitive catalogue); London 1877, Royal Academy (107, 115, 126 and 95); London 1947, National Gallery, *Cleaned Pictures Exhibition* (42, 43, 45 and 44); Stockholm 1966, Nationalmuseum, *Christina, Queen of Sweden, a Personality of European Civilisation*; Washington 1988, National Gallery of Art (NG 1318 and NG 1324) (63 and 64).

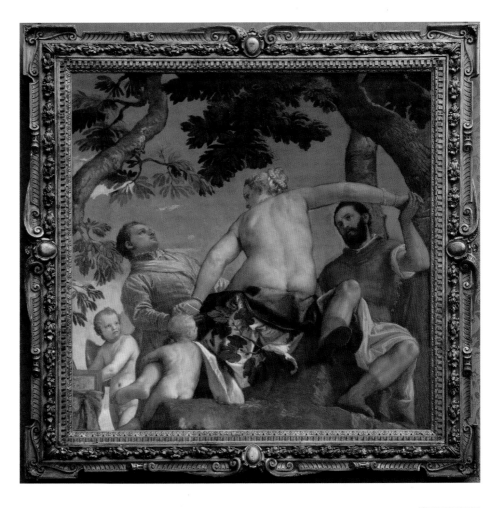

Fig. 9 *Unfaithfulness* (NG 1318) in its current frame.

Frames and Framing

The original frames for the *Allegories* are not recorded, nor are any that were given to them in Sweden, but in Rome they had 'cornici liscie compagne', or 'matching plain [that is, un-carved] mouldings', in 1689. That these mouldings were gilded is clear from an inventory of 1721.[78] As noted elsewhere, in the Palais-Royal they were incorporated into the architecture as overdoors and thus, when removed, would probably have been framed by a narrow moulding at most. Simple frames may also have been supplied before the sale of 1798 by Michael Bryan. There seems to be no record of how the pictures were framed at Cobham, but they were reframed on acquisition by the National Gallery,[79] presumably by Dolman, who was then the Gallery's official framer, with the gilded composition frames that they retain to this day (figs 9 and 10). These are likely to have been designed by Dolman or someone in his employ but were just possibly designed by Burton, or at least developed from his sketches or adjusted to his taste, for he is known to have supplied ideas for the Gallery's frames.[80]

In 1932 the 'fronts' of two of the frames – those on NG 1318 and NG 1326 – were 'cut out' by 'Draper'. In fact, all four frames were treated in this way and the section of each (including the dentils) nearest the painting which had been 'cut out' could then be reattached by means of small brass pegs. The glass and the painting itself can thus be removed without taking the frame off the wall. Minor repairs were also made at different dates.[81]

In the Director's Report of January 1965 to December 1966 the four paintings are listed among those to be reframed.[82] They were not, but by 1990 a large corner of an immensely heavy and deep carved structure reproducing the massive and ornamental framework of a Venetian palace ceiling of the late sixteenth century had long been under curatorial consideration. There may have been some knowledge of the attempts to reconstruct sixteenth-century ceiling settings in North American museums[83] – attempts requiring complex lighting solutions that were alien to the sixteenth century. But by the 1990s it was possible to appreciate that Dolman's frames – inspired by the Sansovino frames of late sixteenth-century Venice, which were well known and much imitated in the later nineteenth century[84] – were among the

best that had ever been made for the National Gallery. The Sansovino design has been modified so that the frames can hang more easily in the company of other types of frame, as may be seen, for instance, in the Venetian room created by Holmes in 1922.[85] The design is also determined by the convenience of manufacture, using multiple components press-moulded in composition. The frames are completely symmetrical so that the moulds used for one side would be good for all the others. Thus the fourteen bunches of fruit and leaves used for each length of frieze (224 bunches for the four frames) were made from two moulds.

Fig. 10 Corner of the current frame of NG 1318.

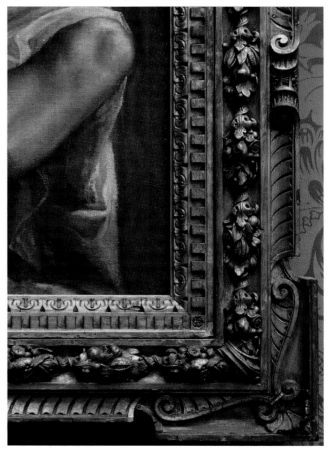

NOTES

1. Penny and Spring 1996, p. 37.

2. This conjecture is supported by the engravings of the painting made when it was in the Palais-Royal (see fig. 8, p. 426).

3. Penny and Spring 1996, p. 52, note 13.

4. Ibid., p 41, note 1.

5. Holmes 1923, pp. 204–5.

6. Penny and Spring 1996, p. 38.

7. Rearick 1988, p. 128.

8. Ibid., p. 37 and note 17 on p. 52.

9. Penny and Spring 1996, p. 41 in the extended captions for plates 4 and 5.

10. Gould 1975, p. 326 (but first published in Braham 1970, p. 209); Gould 1959, p. 151.

11. Braham 1970, p. 209, note 10.

12. Stephens 1877, p. 11.

13. Ibid., p. 13; Holmes 1923, p. 205. Holmes would of course have been thinking of the *Rokeby Venus*.

14. [Collins Baker] 1929, p. 391.

15. Hendy 1947, pp. 43–4, nos 44 and 45.

16. Gould 1959, p. 151 and note 6 on p. 152, repeated in Gould 1975, p. 328.

17. Marini 1968, no. 109; Pignatti and Pedrocco 1995, II, pp. 362–3.

18. Gould 1959, p. 151 and note 5 on p. 152. For earlier date see Osmond 1927, p. 36, and Fiocco 1934, p. 121.

19. Rearick 1988, pp. 128–9. For the Anticollegio fresco see Pignatti and Pedrocco 1995, II, pp. 349–50, no. 234.

20. Notably Mariette 1742, II, p. 67; Stephens 1877, pp. 11, 13.

21. Gould 1959, p. 151; Pignatti and Pedrocco 1995, II, p. 361. Gould later entertained the idea that the paintings had been made for the centres of the ceilings of four separate rooms (typescript letter to Jean-Luc Bordeaux of 10 March 1975).

22. Bordeaux 1975.

23. Cocke 1984, p. 184.

24. I am grateful to Dr Salomon for showing me the paper he wrote on this subject in 2005 and for letting me cite it here.

25. Royalton-Kisch 1978.

26. Schulz 1968 for a survey of Venetian ceilings generally.

27. Rearick 1988, p. 128.

28. For a succinct account of Jacopo Strada's career see the entry in the Macmillan/Grove Dictionary of Art 1996, vol. XXIX, pp. 737–40, entry by Dirk J. Jansen.

29. On both sides of fol. 36 (Cust's pagination), which is fol. 35 in the Vienna facsimile.

30. See Jaffé 2001 for a full discussion of the sketchbook. He notes that some pictures recorded by Van Dyck seem to have been in Spain, not Italy (p. 615), and in some cases it can be proved that Van Dyck used prints (pp. 620–2) and drawings (but see p. 622, note 57). He speculates that Van Dyck may have seen Veronese's cartoons.

31. Royalton-Kisch 1978, p. 161, first made this point.

32. For Venus and Mars see Granberg 1897, Appendix I, p. xv, Appendix III, p. liii, etc. For the interpretation of Happy Union see ibid., Appendix III, p. liii, and Appendix IV, p. xcviii.

33. Du Bois de Saint-Gelais 1727, p. 377.

34. Rearick 1988, p. 126 (no. 64). Rearick also proposed Conjugal Concord in place of Happy Union.

35. Fontenai 1808, II, text on pl. XIII.

36. Waagen 1854, III, p. 20.

37. Osmond 1927, p. 36; see Holmes 1923, p. 204, who found allegory 'disastrous' as an artistic mode.

38. Osmond 1927, p. 36.

39. Copy of letter dated 14 November 1956 in National Gallery dossier.

40. Gould 1959, pp. 150–1.

41. Gould 1959, p. 150, note 1, citing Pigler 1956, pp. 404–9.

42. Wind 1967, p. 274.

43. Ibid., p. 274–5.

44. Braham 1970, pp. 209–10.

45. Ibid., p. 210.

46. Thornton 1991, p. 249, discusses the 'orinale', or 'vaso del corpo', in the Renaissance and notes that such could be made of glass. Unfortunately I have forgotten where I read or heard the idea that the glass flask in Veronese's painting might be such a vessel.

47. Goodman Soellner 1983, p. 23.

48. Royalton-Kisch 1978, p. 161, dwells on the physical similarity between the man in Happy Union and the man in Respect, but they are not identical.

49. John Rylands Library, University of Manchester, English MSS 1281. Paul Tucker kindly drew this to my attention. Murray was evidently abroad when the first letter was sent.

50. Ibid.

51. Ibid.

52. Elliot 2000, pp. 169–70.

53. Castle Howard muniments. From Carlisle to Murray 6 June.

54. This letter is in Berlin. I am grateful to Paul Tucker for the transcription. It may date from 1889.

55. NG 7/132/1890. For Gregory and Layard see the former's letter to Carlisle of 6 August 1890 in Castle Howard Muniments, J22/78. Hardinge was also keen on the acquisition.

56. NG 7/132/1890, Darnley's letter to Burton of 10 September 1890.

57. Ibid.

58. Ibid.

59. Ibid.

60. Minutes of the Board of Trustees, VI, pp. 154–5.

61. NG 7/132/1890.

62. Minutes of the Board of Trustees, VI, p. 165.

63. Ibid., VI, p. 168.

64. Ibid., VI, p. 191.

65. NG 7/132/1890.

66. See Douglas Guest's 1833 valuation, Medway Archive Office U565-F.27, nos 5, 16, 19, 26 (for Allegories) and no. 24 for Titian's Rape of Europa.

67. Granberg 1902, p. 105.

68. Granberg 1897, Appendix I, p. xv (1648), and Appendix II, p. xxx (1652).

69. Granberg 1902, p. xxv (1656).

70. Granberg 1897, Appendix III, p. liii (1689).

71. Victoria and Albert Museum (National Art Library), 86.00.9, fol. 137v.

72. The inventory is Archivio di Stato, Rome (Not. A.C.–Vol. 5134). I studied it on microfilm in the Getty Provenance Index. For the collections c.1703 see Rossini 1704, I, pp. 30–4.

73. MS inventory, fols 33r–46v. The drying seems to have taken place in a palace of the Gritti family.

74. Ibid., fol. 79r (no. 222), fol. 112r (no. 324) and fol. 123r (no. 422).

75. Ibid., fol. 111v (nos 319, 321), fol. 112r (no. 323).

76. Christie's, South Kensington, London, 18 December 1998 (lot 145). A copy at Eastnor Castle in Ledbury, Herefordshire, after one version of Titian's Venus and Adonis looks as if it was made at the same date. At least seven copies of this composition are recorded in the inventory.

77. MS Inventory cited above, fols 74r–74v (nos 200–3); for the baldacchino etc. see fols 74v–76r.

78. Granberg 1897, Appendix III, p. liii and IV, p. xcviii.

79. Report of Director, V, 1895, p. 175.

80. See, for example, Wornum's MS diary (NG 32/67) for 6 June 1874, where new frames for the paintings by Pintoricchio are mentioned 'according to Mr. Burton's pattern'. Such an intervention would be less likely in the 1890s.

81. Draper's estimate for repairs to the cartouche of Scorn is dated 9 March 1933.

82. Report for 1965–6, p. 78.

83. The most notable example was the installation of Tintoretto's Allegory of Sleep from Casa Barbi in the Detroit Institute of Art, and the reconstruction of Titian's Vision of Saint John the Evangelist (1957.14.6) as a ceiling, together with associated panels from the Albergo of the Scuola Grande of S. Giovanni Evangelista in Venice, during the 1990 Titian exhibition in the National Gallery of Art, Washington.

84. See Penny 2004, pp. 179–80.

85. This is recorded in a Gallery photograph dated January 1923. It was completed by 1 April 1922, as we know from Roger Fry's review in the New Statesman of that date.

The Rape of Europa

*c.*1570
Oil on canvas glued to oak panel, 59.5 × 70 cm

Support

The canvas is a medium-weight twill weave. Since it is cusped on all four sides it must originally have been stretched with the nails entering the front face of the stretcher (or possibly a wooden panel). Tears at the edges correspond to the original tack-holes. A series of holes, which encroach slightly on the painted surface, indicate that a second set of tacks must have been employed. The canvas was later glued to an oak panel consisting of two horizontal planks of similar width. The panel is irregular in thickness (between 0.5 and 0.7 cm) and in height (59.5 cm high on the left, 59 cm on the right). Dendrochronological analysis reveals that the planks were from the same tree, a tree originating in the Baltic/Polish region which was felled in either 1618 or, more probably, the 1620s.[1]

An old piece of paper is attached to the lower part of the back of the panel with vermilion sealing-wax. The paper is inscribed in ink, in an eighteenth-century hand: 'V. n°. 87/ l'enlevement / D'Europe' (fig. 2). This corresponds to an inventory of the Palais-Royal, Paris. Another, smaller, paper label was once attached to the back of the panel, in the centre, two-thirds of the way up. In the top left corner there is a large seal with the arms of the Duc d'Orléans (fig. 1) –

Fig. 1 Seal on back of panel.

Fig. 2 Paper inscription on back of panel.

the fleurs-de-lis on the shield have been badly eroded but the collar of the Saint Esprit may be discerned, as may the coronet and a portion of the surrounding motto. There are vestiges of another seal in the lower left corner.

Materials and Technique

The canvas was prepared with a gesso ground which was in turn covered with a thin beige *imprimitura*.

The blues in the painting are azurite – a pigment which in many works by Veronese has tended to turn greenish blue but here is well preserved. Azurite was mixed with red lake for the deep violet-blue cloak of the handmaiden on the right. The deeper shadows of this cloak are also glazed with red lake.

The rose-pink silk lining of Europa's brocaded cloak, which falls over the arm of the handmaiden wearing the blue cloak, is of lead white glazed with red lake. So too is the dress of the woman with outstretched arms on the right. Analysis has revealed that the red lake is cochineal. For the warm pink of Europa's skirt, red lake was mixed with a combination of red lead and lead white.

The pale yellow lights flickering over Europa's skirt are painted with 'type 1' lead-tin yellow. This pigment and yellow ochre are combined with lead white and glazed with yellow lake in the drape lying in the left foreground.

The binding medium is walnut oil.[2]

The palette is highly characteristic of Veronese, especially in the way that pale flesh and flushed cheeks are combined with rose, pink and white drapery, and blond hair is echoed both in local colour and in lights elsewhere in the painting. The most famous illustration of this pink and yellow palette is the Saint Catherine altarpiece now in the Accademia, Venice.[3] As in the Anticollegio version of the *Rape of Europa* discussed below, flesh pink is found not only in the drapery but in 'even the nose and underside of the blond bull' and contributes to the impression 'that the bull could at any moment alter its form to that of a human'.[4]

X-radiography reveals that a large cancellation was probably made with lead white to a painted area to the left of the figures. There are also numerous small revisions elsewhere, the most significant of which is the shifting of Europa's left foot from a position in front of the bull's rear left hoof.

Conservation

Abundant evidence, discussed below, reveals that the painting was relatively clean when it arrived in the Gallery in 1831, although a note in the manuscript catalogue for 1855 indicates that the varnish had greatly darkened. A cleaning recorded in 1881 was probably only superficial, but another layer of varnish was added. Neither was removed when the painting was 'polished' in December 1945. When the painting was cleaned in the first months of 1999 it had one of the darkest varnishes to have survived on any painting in the collection. The yellow lights on Europa's pink dress were impossible to discern, as was the fine brushwork in the dark leaves of the trees and in the lights of the drapery. The surface appeared spotty on account of pooling of the varnish in the depressions of the canvas weave. The lower layer of

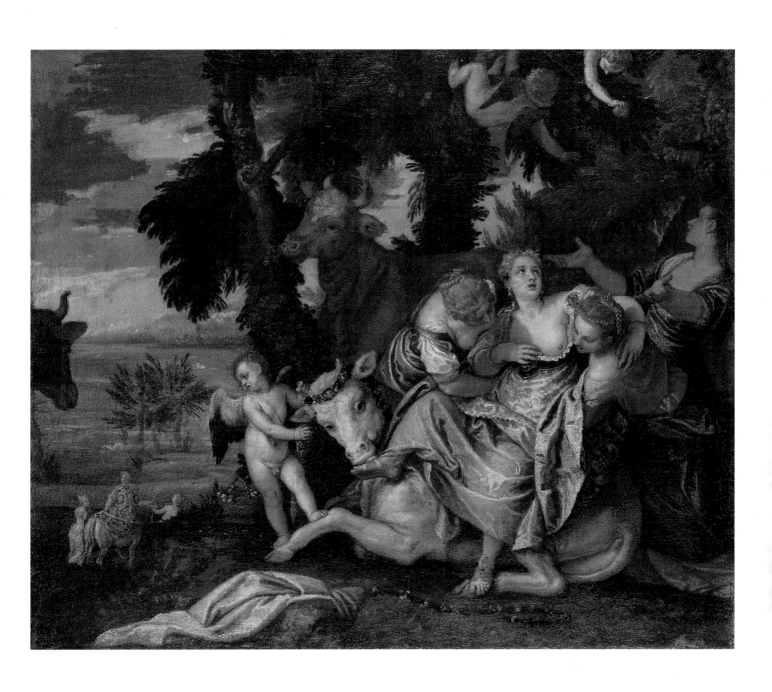

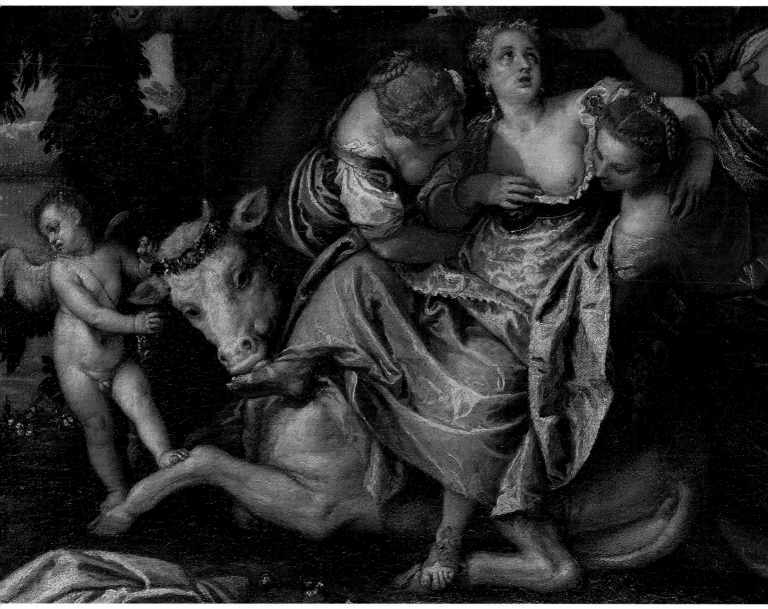

Fig. 3 Detail of NG 97.

varnish, applied before 1831 (perhaps around 1815, after the painting was acquired by Holwell Carr), was a mastic that had been mixed with Copaiba balsam, a plasticising agent which turns brown over time. Another mastic varnish was applied on top of this in 1881.[5]

Loose flakes of paint were laid by 'Morrill' in September 1942. Blisters were also treated in May 1966. The painting was conserved after a cleaning in the first half of 1999.

Condition

The painting is generally in good condition. There are numerous small flake losses at the edges of the canvas, especially the lower edge. There is also some wear to the sky and sea. There are scattered losses to the left of the distant mountainous island, and also small but significant losses in Europa's face.

Some of the lake in the lining of Europa's cloak may have faded, exaggerating the contrast between white lights and wine-red shadows. The green foliage is likely to have darkened somewhat but it must always have been dull, since the paint contains earth pigments mixed with green. The pattern on Europa's brocaded cloak (only visible in shadow to her right) must once have been a brighter green.

Subject and Source

The story of the Rape of Europa is told most famously by Ovid at the conclusion of the second book of the *Metamorphoses*.[6] Mercury is ordered by his father, Jove, to drive a herd of cattle belonging to King Agenor, which graze on the mountainside in Sidon, to the seashore, where the king's daughter, Europa, plays with her companions, the maidens of Tyre. This task swiftly completed, Jove adopts the form of a

young bull, white as snow, with rich folds of skin, shining horns and beguiling eyes. He catches the princess's attention. Too timid at first to touch him, she offers him flowers. He kisses her hands, frolics, lies down. She strokes him, hangs garlands on his horns, then mounts his back. He carries her to the edge of the sea and then swims away with her.

The book closes with the image of Europa in panic, looking back towards the shore, her right hand on the bull's horn, the other on his back, and her clothes fluttering in the breeze. Book Three opens with the god relaxing on Crete and the desperate king dispatching his son Cadmus to search for his daughter.

The artist has depicted the princess as she mounts the bull ('side-saddle') assisted by her handmaidens (fig. 3), who also ensure that she is properly attired for the ride. Divine intervention and amorous intentions are suggested by the *amorini* who are plucking fruit from the trees above and throwing it down to one of Europa's companions, and by another winged infant – surely Cupid, because he wears a quiver of arrows – who seems about to 'take the bull by the horn'.[7] Jove is licking Europa's foot – 'lambendolo con la lingua', as Ridolfi describes it[8] – a delicately salacious detail which is not in Ovid's account but is suggested by his reference to the

god's excitement when he kissed her hands: 'he could hardly wait for the rest.' The herd is suggested by a cow that stands immediately behind the bull nibbling on some foliage, and by another that is looking in on the left. The sequel to the story is depicted in the middle distance to the left, where Jove is carrying the princess out to sea, escorted by Cupid (fig. 4). 'In the extreme distance the bull is wading with her towards an island' – a tiny detail that was noted in the mid-nineteenth-century catalogue[9] but was almost invisible before the recent cleaning.

The exact nature of Europa's actions and her expression are unclear. Landseer proposed that the more 'matronly attendant has presumed to offer some admonition or remonstrance, to which Europa – as we see by the fine turn of her head, and expression of her countenance – is blandly and innocently replying that she entertains no fear'.[10] It is easier to suppose that Europa has been awestruck by the divine charms in the air, and the attendant is surely preparing to catch the fruit that the *amorini* are throwing down rather than admonishing the princess.

Veronese's other paintings of this subject will be reviewed below, but here it should be noted that scholars have generally agreed that the long thin version of the subject in a private

Fig. 4 Detail of NG 97.

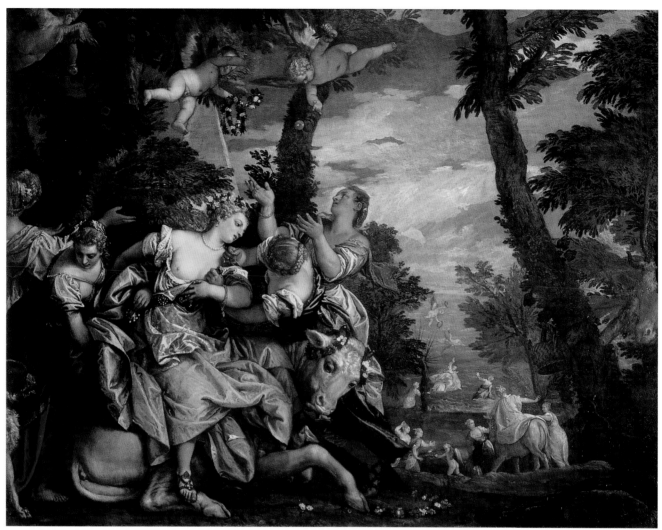

Fig. 5 Paolo Veronese, *The Rape of Europa*, 1573. Oil on canvas, 240 × 307 cm. Venice, Palazzo Ducale, Sala dell'Anticollegio.

collection in Milan (fig. 7) is the earliest. An odd feature of this earlier version is that not only does the action proceed from right to left but the composition is heavily loaded on the right. The explanation for this must be that it was intended to decorate a chest or wainscot – as its proportions in any case suggest – and, as was usual with such decorations, the composition was balanced by a companion picture. The emphasis on garlands might also have been considered appropriate for a chest, given the nuptial references often found in such pictures. However, we need not be surprised that Veronese, unlike Dürer in his drawings of this subject or Rustici in his relief sculpture,[11] and of course unlike Titian in the great painting he made for King Philip II between 1559 and 1562,[12] gives prominence to the princess's preliminary beguilement rather than to her terror and panic, because this is exactly what Ovid does.

Indeed, Veronese's priorities, measured by compositional prominence, match those of Ovid's poem (available to him in translation), measured by lines devoted to each episode. But Titian's treatment depicting the heroine at sea with her frantic handmaidens lamenting on the shore, perhaps stimulated by

a vernacular translation of the romance by Achilles Tatius (published in Venice in mid-century), which opens with a description of a painting of this very episode, was followed by many other artists.[13]

> Ah how the fearful ladies tender hart
> Did lively seeme to tremble, when she saw
> The huge seas under her t'obay her servaunt's law

Such is the alarming moment depicted on the arras in the 'utmost room' of Busyrane's Castle in Spenser's *Faerie Queene*[14] and the scene that Tennyson imagined in one of the paintings in his ideal gallery which showed Europa's mantle 'from off her shoulder backward borne' – a breathtaking line – and a flower falling from one of her hands while the other 'grasped / the mild bull's golden horn'.[15]

Some of Veronese's followers chose to show Europa mounting the bull[16] but most Italian painters in the seventeenth century depicted the goddess carried by the bull out to sea (Cavaliere d'Arpino, Albani, Guido, Strozzi among them).[17] From the late seventeenth century onwards, and surely as a result of the increasing fame of Veronese's painting, his focus

on the beginning of the story was shared by French artists such as Charles de la Fosse and Antoine Coypel,[18] and also of course by Venetian artists,[19] notably Tiepolo,[20] as well as by modellers for small bronze and porcelain groups.[21] However, the painters included, even if only by effects of lighting, more intimations of terror than Veronese.

Size, Format, Status

The format of NG 97 is one that is not typical of furniture paintings, yet it is smaller than we would expect for a painting made for a gallery, let alone a *portego* (for which see p. 228). In his later career Veronese did make exquisite small paintings of the type that later came to be known as cabinet paintings – most famously, several versions of the Finding of Moses,[22] but these are on finer canvas and more minutely detailed than NG 97. However, it was Veronese's practice, with his earliest commissions, to make small preliminary versions in oil (at first, on paper[23]) – indeed, he is one of the first major European artists to have adopted this practice. This painting may have been just such a *modello*, subsequently sold as a cabinet picture. But if it was made as a preliminary study, it was not followed exactly, as is discussed below.

Attribution

Before 1913, when the painting was relegated in the Gallery's sixpenny *Illustrated Catalogue* to 'School of Veronese', there seems never to have been a doubt that it was an autograph work by Veronese. In the larger *Descriptive and Historical Catalogue* of the same year it was described as a finished study 'of', rather than 'for', the larger composition in the Anticollegio of the Doge's Palace in Venice.[24] The reasons for this change are discussed below. The painting is not even mentioned in the surveys of the artist's work that were published in 1927 and 1934.[25] Since then the scholars who have noticed it have dismissed it as a studio production, as a later pastiche concocted with reference to engravings of larger versions of the subject[26] (although the painting is documented as pre-dating any prints of this kind), or as something that was 'painted with fraudulent intent' to pass for a preliminary sketch.[27]

Reconsideration of the painting was prompted by the preparation of this catalogue, and specifically by the conviction that a painting described as a Veronese in the collection of Emperor Rudolf II and in that of Queen Christina of Sweden – both collections that were noted for masterpieces of Venetian art – should not be too easily dismissed as a studio production or as a later derivative work. Furthermore, a painting very prominently displayed and highly valued when in the Duc d'Orléans's collection would surely be one of genuine quality, and a work bought as a Veronese by the Revd Holwell Carr, one of the most discerning connoisseurs of his day, was likely to be precisely that.

After cleaning, the painting's technique and palette were revealed as characteristic of the artist, and the pentimenti and handling were found to be typical of an original work. A slight gaucheness in the composition, as exemplified by the awkward placement of the two cows, can be paralleled in other works by Veronese. In any case, it seems improbable that the cows were added by a studio assistant.

The painting's relationship with other versions of the composition is discussed below.

The Sequence of Veronese's Paintings of the Rape of Europa

The earliest of Veronese's paintings of this subject is most likely the smallest: the previously mentioned version in a private collection in Milan (fig. 7), which was first published in the 1930s[28] and must have been made for a piece of furniture, probably a chest but perhaps a bed or the wainscot beneath a window (a position in which a painting of this subject is recorded in a seventeenth-century inventory[29]). The painting has been justly compared by Pallucchini to some of the smallest frescoed landscapes at the Villa Maser, in which can be found the same deft but free touch and eloquent empty space.[30] These are generally dated about 1560 (although a case has been made for the mid-1550s). In the Milan painting, Europa, accompanied by three handmaidens, balances on the bull's back in the foreground, to the right. The bull licks her right foot. In the centre, a little behind, a handmaiden makes garlands. On the left, in the middle distance, Europa, mounted, approaches the shore.

The National Gallery's painting seems to be next in the sequence. The chief group is also to the right, and the bull also faces left. Europa still has three handmaidens but two of them lean forward to help lift her and her abundant robes. The group to the left which is descending to the shore is virtually identical. Two cows have been added to suggest the herd. The bull is being garlanded by Cupid, and his fellow *amorini* pluck fruit from the trees – a detail perhaps suggested by the *Rest on the Flight into Egypt*, in which angels supply the Holy Family with dates (fig. 2, p. 332). As has already been mentioned, the position of Europa's left foot in NG 97 was originally placed further to the left – that is, it was in the same position as it is in fig. 7.

The National Gallery's painting may have served – and may have been made precisely to serve – as a rehearsal for a larger canvas (240 × 307 cm, approximately four times as large) which is now in the Anticollegio of the Doge's Palace (fig. 5).[31] Here, Veronese reverses the composition (something he also did when painting different versions of the Finding of Moses) and enriches it. Europa has four handmaidens rather than three in immediate attendance, and the two helping her are even more active – one of them is fastening her dress. The flying *amorini*, of whom there are now three, proffer garlands as well as fruit, and the basket of garlands is now in the trees. The two handmaidens who prepare to catch the fruit seem to have been developed from the one who is so engaged in NG 97. The silhouette of the cow's head at the edge of the canvas is softened by foliage, the other cow has been removed, and a pyramid rises behind the trees. Europa's third appearance, waving in panic to her companions on the shore, is more legible. Perhaps because the rich brown of the cow behind the chief figure group is absent, so too is the orange-yellow dress of the handmaiden with the violet cloak which had related to it.

Fig. 6 Studio of Paolo Veronese, *The Rape of Europa*, *c.*1580. Oil on canvas, 245 × 310 cm. Rome, Pinacoteca Capitolina.

Fig. 7 Paolo Veronese, *The Rape of Europa*, *c.*1565–70. Oil on canvas, 25 × 88 cm. Private collection.

A variation on the Anticollegio painting, and of similar size (245 × 310 cm), in the Capitoline collection, Rome (fig. 6),[32] includes features which are closer to the National Gallery's painting, and perhaps its composition was worked out earlier or at the same time (or perhaps NG 97 remained in the studio and could easily be referred to). In this case, Europa looks up at the *amorini* in the trees, and Cupid leads the bull by its horn. Another variation, in the Gemäldegalerie, Dresden,[33] is of a vertical format and shows Europa not only looking up but raising her arm (fig. 8). The Dresden painting is now generally regarded as the work of Carletto[34] and that in the Capitoline as a studio piece – both have merit and in fact, in the Capitoline painting in particular, there are passages which are worthy of Veronese.

More than half a dozen paintings survive which may be workshop copies or adaptations of these compositions. Although it is not appropriate to review all of them here, two are discussed below as perhaps having affected the reputation of the National Gallery's painting. It should also be said that sequences other than the one proposed above are possible. Richard Cocke, for instance, believes that the composition of NG 97 derives from the painting in the Doge's Palace, with Veronese having started it and allowing the workshop to complete it 'as the Palazzo Ducale painting was still in or just about to leave the studio'.[35] This, however, fails to take account of NG 97's connection with fig. 7 and does not explain the workshop's motive for making such a painting.

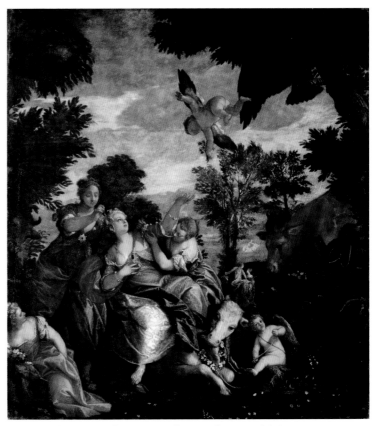

Fig. 8 Workshop of Paolo Veronese, *The Rape of Europa, c.*1580. Oil on canvas, 323 × 295 cm. Dresden, Staatliche Kunstsammlungen, Gemäldegalerie Alte Meister.

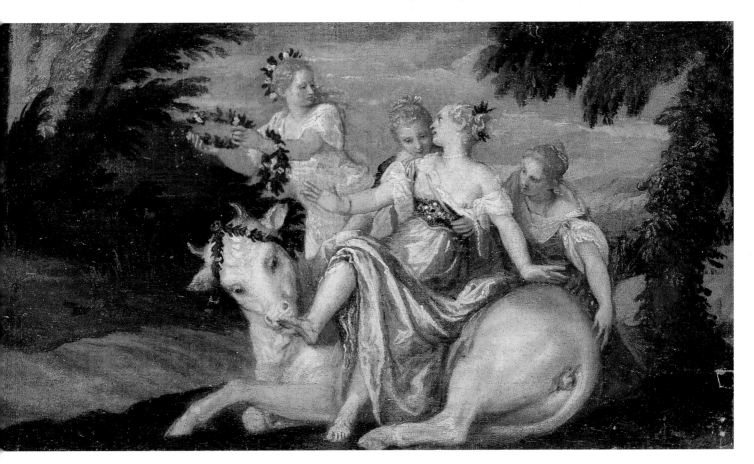

Drawings and Dates for the *Rape of Europa*

A double-sided drawing in the Fachsenfeld collection, Stuttgart, includes studies for the *Rape of Europa*, the *Madonna of the Rosary* and the *Pietà*. The second of these, a workshop piece painted for S. Pietro Martire, Murano, is inscribed with the date 1573, the date which has been deduced for the *Rape of Europa* in the Anticollegio of the Doge's Palace and the *Pietà* (now in Berlin).[36] Since the bull faces right and the *amorini* are in flight in the studies, it seems reasonable to deduce that they were preparatory for the Anticollegio's painting and, in the chronology proposed above, the National Gallery picture must be slightly earlier. Another drawing, in the Louvre (fig. 9), may have been a very early idea, for here too the bull faces left, the composition is relatively simple and the treatment of the trees recalls that in the small version (fig. 7). Cocke, however, observes that the crowning of Europa is a motif of the late version of the composition in Dresden.[37]

Previous Owners

The painting is recorded in an inventory of the collection of the Holy Roman Emperor, Rudolf II, made after 15 February 1637,[38] but is likely to be the 'Europa auf den ochsen' ('Europa on the Bull') 'vom Phryneso' ('by Veronese') in a group of forty-three pictures in the imperial collection listed at the end of the so-called Vienna 'G' inventory compiled around 1610–19.[39] Richard Cocke has noted that most of Rudolf's Veroneses seem to have been acquired from other collections and suggests that a possible source was the wealthy merchant Jakob König, whose collection in Prague included, according to an inventory of 1603, a painting of Europa by Veronese.[40] König's small collection had been formed over the previous quarter-century, and thus the picture may have been acquired directly from the artist or his heirs.

Fig. 9 Paolo Veronese, drawing for *The Rape of Europa*, *c*.1570?
Pen and ink with wash, 11.7 × 14.3 cm. Paris, Musée du Louvre.

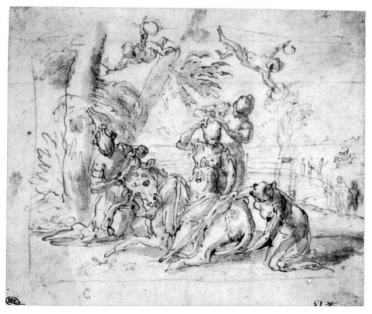

In 1648 much of Rudolf's collection was removed from Prague by Swedish troops and passed into the collection of the Swedish crown. A large part of the collection left Stockholm with Queen Christina when she abdicated in 1656. 'Une petite pièce d'Europa de Paulo Veronees' is listed in an inventory of her possessions made in Antwerp during 18–20 May 1656.[41] The painting was also documented as being among her paintings in Rome both during her lifetime and when they had passed to her heirs,[42] but it is only after the painting was acquired for the Duc d'Orléans and exhibited in the Palais-Royal in Paris that we obtain, both from the prominence of its display and the valuations placed upon it (described in the appendix on the Orléans Collection in this volume), an idea of how highly it was esteemed. Its merits were perhaps less appreciated by the end of the century, and in the Orléans sale of 1798 it was bought for 200 guineas by John Willett Willett of Merly House, Dorset (whose collection is described in the first volume of my catalogue of sixteenth-century Italian paintings[43]). At Willett's sale in 1813 it was bought by Holwell Carr for 140 guineas (£147), a lower price reflecting the depressed economy at that date (other Orléans pictures held up less well – Veronese's *Mars and Venus* now in the National Gallery of Scotland, which had cost Willett 250 guineas in 1798, was bought in at 50). The only disparagement of the picture known to me was expressed by the dealer William Buchanan in April 1809 – and he owned another version of the composition which he hoped to sell to Thomas Hope.[44] Holwell Carr had a distinct preference for paintings that were relatively small in size and in good condition. He doubtless had his Veronese cleaned, probably before he exhibited it in 1818 (see below). The painting's popularity in the National Gallery, to which it was bequeathed in 1831, is described in an appendix below.

Engravings

The painting was engraved in reverse by R. De Launay after a drawing made around 1790. This appeared in the second volume of the *Galerie du Palais Royal* published in 1808. It was also engraved by H. Fernell, in reverse, for Jones's *National Gallery*.[45]

Copies

A copy of the painting, measuring 102 × 104 cm, was offered as lot 210 of the auction sale of old masters in Palais Dorotheum, Vienna, on 24 March 1999. Since it was obvious that this copy had been cut at the upper and lower edges, its original dimensions were probably 120 × 140 cm – exactly twice the size of the National Gallery's picture. To judge from photographs, it looks very like the type of copy that might have been made after famous paintings from Queen Christina's collection in Rome in the early eighteenth century and enlarged to make it a more conventional gallery picture. There was another copy in the Wielemans collection in Brussels in 1972.

Provenance

See above. Perhaps König collection, Prague, about 1580. Rudolf II, Prague. Recorded in the imperial collection in the

second decade of the seventeenth century. Among the paintings belonging to Queen Christina in Antwerp in 1656. In the Orléans Collection by 1721. Orléans sale 1798, lot 47, when bought by Willett. Lot 107 in his sale of 2 June 1813, where bought by Holwell Carr. Bequeathed by Holwell Carr in 1831.

Exhibition
London 1818, British Institution (91).

Framing
Since cleaning in 1999, the painting has been displayed in a carved walnut frame obtained from Sotheby's, London, on 14 April 1999.[46] It is gilded at the sight edge and polished in the hollow (which is somewhat worm-damaged). There is a fluted outer moulding. The insides of each stopped flute and the fine lines dividing each flute are gilded. The frame has been reduced in size, but by very little, since some evidence of leaf ornament remains in each mitred corner. Frames of this type of pattern and finish are often said to be Tuscan, but they are closely related to the furniture made in many different parts of Italy in the second half of the sixteenth century. It is not uncommon for the fluting of the outer moulding to curl inward, towards the painting, rather than out, as here. Notable examples of frames of this kind in public collections include one in the Bayerische Staatsgemäldesammlungen, another around the *Mary Magdalene* by Michele di Ridolfo in the Museum of Fine Arts, Houston (61.67), that around Andrea del Sarto's *Charity* in the National Gallery of Art in Washington (Kress 1957.14.4), and that around Piero di Cosimo's *Virgin and Child with a Dove* in the Louvre. Most importantly, frames of similar pattern were made for paintings by Montini, Salvestrini and Vanni, which are now in the offices of the Museo dell'Opificio delle Pietre Dure, Florence, demonstrating that such frames were made in Tuscany during the seventeenth century.

Appendix
EUROPA IN THE GREAT EUROPEAN GALLERIES
OF VENICE, ROME, DRESDEN, LONDON
Carlo Ridolfi in his *Le Maraviglie dell'Arte* of 1648 recorded that Veronese painted for his powerful patron, the patrician 'Jacopo Contarino' (Jacopo Contarini), a painting about four *braccia* in length of Europa 'seated on the deceitful bull which kisses her foot amorously, licking it with his tongue' ('sedente sopra il mentito Toro, che la bacia amorosamente il piede, lambendolo con la lingua'), which he described at length, quoting Ovid in translation.[47] Boschini in his *Carta del Navegar* of 1660 observes that this was one of three paintings by Veronese belonging to three illustrious Venetian families that were considered 'preciosi in estremo' ('of the utmost value'), the others being the *Family of Darius* (now in the National Gallery) and the *Presentation* (now in Dresden).[48] In 1713 Bertuccio Contarini, the last of his line, bequeathed Veronese's *Europa* to the Venetian state together with the rest of the family collection. By about 1730 it had been hung, together with Contarini's large Bassano, and four Tintoretto

mythologies, previously incorporated in the ceiling of another room, in the Anticollegio of the Doge's Palace.[49] The paintings were given matching white and gold guilloche frames, and the Veronese and Bassano were hinged to enable viewing in different lights (as were the masterpieces in Palazzo Pitti in Florence). The room, intended as a waiting room for ambassadors, was easily accessible to visitors to Venice and had been conceived of primarily as a gallery of Venetian old masters. Other rooms in the palace remained as parts of the Venetian government machine with paintings alluding allegorically to the function of the room or illustrating historical episodes and eminent officers of state. A smaller room, the Sala degli Stucchi, created in 1743 for smaller Contarini pictures, was also primarily a gallery.

The fame and reputation of the Contarini picture obviously increased as a consequence of its eminent and accessible location,[50] but two other paintings of the same subject believed to be by Veronese found their way into major public galleries in the mid-eighteenth century.

Ridolfi also mentioned that Signor Giuseppe Caliari, son of Veronese's son Gabriele and sole heir of the family estate, owned a painting of the *Rape of Europa* together with many other works by his grandfather.[51] In fact, some experts in Venice questioned whether these paintings were autograph works by Veronese, as is clear from the advice given to Cardinal Francesco Barberini in July 1632 when he was enquiring after works by Veronese that were for sale,[52] but Ridolfi's reference may well have helped secure their credentials. By 1663 the Caliari *Rape of Europa* seems to have been installed in Rome, in a new palace belonging to Cardinal Carlo Francesco Pio da Carpi (known also as Pio di Savoia).[53] It attracted considerable notice: Cardinal Leopoldo de' Medici mentioned it to his agent, Paolo del Sera, in 1666 as a reason to be sceptical about another Veronese of this subject which del Sera was trying to buy.[54] Drawings of it remained in Venice, where an engraving after it by Valentin Le Febre (Lefebvre) was published in his *Opera Selectiora* of 1682.[55] In 1724 the French crown considered buying it from Prince Pio di Savoia's heirs, but the price was too high.[56] In 1748 it was among the 126 paintings acquired from Pio di Savoia for the Pinacoteca Capitolina, the new public picture gallery in Rome founded by Benedict XIV and his chamberlain, Cardinal Silvio Valenti Gonzaga.[57] For a century it was one of the chief attractions of that gallery, although today it is not much admired.[58]

In the section that Ridolfi devoted to Veronese's sons and brother, he mentioned that one of the sons, Carletto, had painted 'Europa con molte donzelle intorno' ('Europa surrounded by numerous maidens'). In his great edition of Ridolfi, Hadeln thought this likely to be the version which is in the gallery in Dresden, a composition that does indeed include more 'donzelle' than any of the others.[59] It seems probable that the Dresden painting belonged by August 1664 to the Molin family – in any case, a painting corresponding to the Dresden painting was described by Gerolomo Molin in a letter sent in August 1664 to Carlo II, Duke of Mantua, who had recently been prevented by the Venetian state from acquiring Veronese's *Feast in the House of Simon* from the

Servite monastery. Molin wanted a thousand 'doble' for it and the Duke was said to be interested in buying it a year later.[60]

Yet another *Europa* by Veronese – or just possibly the same painting – was offered for sale in 1666 by the Pisani Moretta. This was the picture that Paolo del Sera drew to Cardinal Leopoldo de' Medici's attention, as mentioned above. The price was considered outrageous. It is interesting that del Sera felt able to reassure the cardinal that Veronese, in common with other Venetians, made 'two or three completely original versions sometimes with little variation and often completely alike' ('due o tre tutte originali e talvolta con poco variatione e molte volte in tutto simili').[61] The Molin painting, like that which had passed into the Pio collection, was engraved by Valentin le Febre (Lefebvre) in his *Opera Selectiora*.[62] Paolo del Sera seems to have acquired it on his own account and offered it in vain to Cosimo III de' Medici in 1671.[63] By 1743 it seems to have passed into the collection of the Marchese Piati and Count Algarotti arranged for its purchase from the daughter of the art dealer Negrenzi by Count Brühl, Chief Minister to Augustus III, King of Poland and Elector of Saxony, for the great imperial gallery in Dresden.[64] Algarotti assured Count Brühl that this picture was greatly esteemed by Giovanni Battista Tiepolo, the leading painter in Venice, from whom indeed Algarotti commissioned a superb copy.[65] The Dresden *Europa* remained a celebrated Veronese through much of the nineteenth century. Now, it is officially classed as a workshop piece.[66]

Meanwhile, the small version of Veronese's *Rape of Europa* catalogued here was also on display in Paris, in what was more or less a public collection. It was admired in the mid-eighteenth century but was still more admired when it went on display in the National Gallery in London. William Young Ottley in 1832 especially praised its colours – the 'creamy whites and yellows'[67] – and Landseer in 1834 admired the way the flesh tones sympathise with the 'pink mantle' and the 'creamy white of the Bull', and dwelt on the amethysts set in Europa's sandals and the 'metallic zone' setting off her bust 'to most inviting advantage'.[68] The earliest reference to the painting as a preparatory study comes in the official summary catalogue of 1838. It is there said to be a study for the 'large picture in the Imperial collection at Vienna' which may have been an error for Dresden.[69] By 1847 the painting in the Doge's Palace is mentioned as the work for which NG 97 was a study and this is repeated throughout the next

half-century.[70] After 1850 the darkening of the varnish had already begun to discourage admiration, but to Waagen, in 1854, it was still clearly 'good, genuine'.[71]

The Contarini *Europa* was engraved in reverse by Francesco del Pedro in the late eighteenth century[72] and again by Antonio Viviani in 1837.[73] Its celebrity in the mid-nineteenth century was reflected and further magnified by the praise Théophile Gautier bestowed upon it as the 'pearl' of all Veronese's paintings.[74] And to Henry James in 1882 it seemed 'the happiest picture in the world': 'the mixture of flowers and gems and brocade, of blooming flesh and shining and waving groves, of youth, wealth, movement, desire – all this is the brightest vision that ever descended upon the soul of a painter.'[75] By the time Osmond wrote his monograph in 1927 none of the other versions seemed worth mentioning.[76]

At this stage it would have been bold to attempt to revive the reputation of any of the other large versions of the *Rape of Europa*. However, the optimism of a dealer and the pride of a collector could promote a smaller painting as a genuine study for the great picture in Venice. Robert (known as Robin) Benson, one of the leading connoisseurs, and most judicious collectors, of Italian painting in Britain in the late nineteenth century, bought at the Blenheim sale in 1880 a *Rape of Europa* measuring 130 × 188 cm and inscribed with the artist's name. In 1926 he sold it together with the bulk of his collection to Duveen.[77] Benson was convinced that this was the *modello* for the Contarini painting – although it looks from photographs like a later variant of the composition – and since he was a Trustee of the National Gallery he may well have been influential in the downgrading of the Gallery's own version.

Charles Fairfax Murray, another connoisseur who had close connections with the National Gallery in the early twentieth century, also owned a painting (77.5 × 134 cm) that was believed to be a *modello* and has the sketchy finish that would be expected in one that was made in the seventeenth or eighteenth century. This painting, which was for a while in the Widener collection, was acquired by the New York dealer Piero Corsini in 1986, and great claims were made for it in his catalogue in 1991.[78] These claims are endorsed in Pignatti and Pedrocco's catalogue raisonné of 1995, where the painting is also illustrated in colour[79] – surprisingly, since its handling does not resemble that of Veronese. Surely it is a loose study made after the Contarini picture.

NOTES

1. Report made by Dr Peter Klein of the University of Hamburg on 3 December 1999.

2. Analysed by GC–MS by the Scientific Department of the National Gallery.

3. Pignatti and Pedrocco 1995, II, pp. 329–30, no. 203. Some of the ceiling paintings of the Sala del Collegio in the Doge's Palace, documented to 1576–8, especially the central oval and the allegory of Recompense, are also good examples: ibid., pp. 339–45, nos 214–30.

4. This is quoted from a typescript paper on the technique of the painting delivered by Jill Dunkerton in 1999 to the Renaissance Research seminar in the National Gallery – a paper to which I am in general greatly indebted.

5. Conservation dossier.

6. *Metamorphoses*, II, 835–77.

7. Landseer 1834, p. 170.

8. Ridolfi 1646, p. 41; 1914, p. 337.

9. Wornum 1847, p. 194.

10. Landseer 1834, p. 171.

11. For Dürer's drawing (Vienna, Albertina) see Panofsky 1955, fig. 57. For Rustici's relief, which is Victoria and Albert Museum A.8 – 1971, see Boucher 2001, no. 25. It might date from the 1490s but is sometimes considered to be of *c.*1520.

12. Isabella Stewart Gardner Museum, Boston, Wethey 1975, pp. 172–5, no. 32.

13. Stone 1972.

14. Book III, Canto XI, Stanza XXX. Edmund Spenser (c.1552–1599).

15. Stanza 30 (the seventh stanza in the fourth part) of *The Palace of Art*, first published in *Poems by Alfred Tennyson* in December 1832.

16. For example, Montemezzano, Christie's, London, 5 July 1991, lot 79; also the frescoes in Villa Emo Capodilista probably by Antonio Vassillachi (L'Aliense) and those in Villa Loredan, attributed to Carletto Caliari, for which see Crosato 1962, pp. 157 and 187, and figs 143 and 130. Above all, and quite early, there is Zelotti's painting in the Villa Godi, for which see Brugnolo Meloncelli 1992, pp. 104–5, no. 25, and fig. 133 (just visible on the left). Another painting of this period attributed to Zelotti hangs in the Italian Embassy in Washington DC.

17. D'Arpino's in the Borghese Gallery (inv. 378), Albani's in the Uffizi (inv. 1890, no. 1366), Guido's in the Mahon Collection on loan to the National Gallery, and Strozzi's in the Gallery in Poznan (MNP FR 430).

18. La Fosse's painting (in Montagu House by 1707) was recently acquired for Basildon Park (National Trust). Coypel's (dated 1726) is in the Virginia Museum of Art, Richmond (97.128). See also Jean-Baptiste Pierre's painting, Sotheby's, Paris, 27 June 2003, lot 28.

19. For example, Francesco Fontebasso in Palazzo Boldù, Venice (a ceiling fresco), and Giovanni-Battista Crosato in the Wadsworth Athenaeum (1962.1) and the Museo Civico, Turin. Also, in Florence, Giandomenico Ferretti (Uffizi, inv. 1890, no. 5447).

20. Tiepolo's *Rape of Europa* of c.1720 in the Accademia, Venice, is both comic and weird. His later copy of the Dresden *Rape of Europa* is discussed below.

21. See, for example, the Meissen group of 1760 modelled by Elias Meyer in Bursche 1980, pp. 317–18, no. 326. For bronze clock ornaments see Mundt 1988, pp. 162 and 265 (nos 92 and 93).

22. Pignatti and Pedrocco 1995, II, pp. 394–8, especially no. 282 (Madrid, Prado) and no. 283 (Washington DC, National Gallery of Art).

23. See discussions of these in the entry for Veronese NG 931. See also the curious painting on vellum of *Christ nailed to the Cross* in the Hermitage (Artemieva and Guderzo 2001, p. 98, no. 25, entry by Artemieva).

24. Anon. 1913, p. 24; [Collins Baker] 1913, p. 737.

25. Osmond 1927, p. 112, and Fiocco 1934, pp. 121–2 (in both cases listing other paintings by the artist in London).

26. Pallucchini 1939 (*Mostra*), p. 163, under no. 68; Pignatti 1976, no. 216; repeated by

27. Gould 1959, p. 153; 1975, p. 330.

28. Fiocco 1934; Morassi 1935–6.

29. Borean 1998, doc. 142 (Giacomo Correr collection 1662).

30. Pallucchini 1939 (*Mostra*), pp. 152–3, no. 64. Pallucchini 1943, p. 37, relates the painting to the *Helena* on account of its fluent touch.

31. Pignatti and Pedrocco 1995, II, pp. 357–9, no. 244.

32. Ibid., but the photograph does not show the entire work.

33. See note 66.

34. This was proposed by Hadeln in Ridolfi 1914, p. 357, note 7 ('möglicherweise').

35. Letter to N.P. of 15 December 1999.

36. Cocke 1984, pp. 154–7, no. 64 and 64v.

37. Ibid., pp. 252–3, no. 107.

38. Gould 1975, p. 330.

39. *Vienna Jahrbuch*, XXVII, 1906–7, ii, p. VII, no. 83 (information supplied by Lorne Campbell).

40. Martin 1995, pp. 46–54. Letter from Richard Cocke to N.P. of 21 December 1999.

41. Duverger 1993, p. 223.

42. Archivio di Stato, Rome, Not. A.C. – Vol.5134, Odescalchi Inventory of December 1713, fol. 72r, no. 123, records it hanging near the *Danaë* and *Leda* by Correggio and Titian's *Bathing Venus* in the chief room of the main floor of Palazzo Riario.

43. Penny 2004, pp. 394–6.

44. Brigstocke 1982, p. 287.

45. Jones and Co., c.1835, no. 73.

46. The purchase was made through Rollo Whately.

47. Ridolfi 1646, p. 41; 1914, p. 337.

48. Boschini 1964, p. 366.

49. Boschini 1733, p. 103 (addition by Antonio Maria Zanetti).

50. Ibid.: 'Il bellissimo quadro'. Lalande 1769, VIII, p. 30: 'passe à Venise pour un des meilleurs ouvrages'.

51. Ridolfi 1646, p. 50; 1914, p. 345.

52. Barcham and Puglisi 2001, *passim* (but especially pp. 58 and 86).

53. Contardi in Bentini 1994, p. 76. The proposal that the Pio *Europa* came from the Caliari heirs was made by Hadeln in Ridolfi 1914, p. 345, note 1 ('möglicherweise').

54. ASF Carteggio d'artisti, V, no. 441, 13 May 1666, quoted Borean 1998, p. 73.

55. Ticozzi 1975, p. 22, no. 44.

56. Montaiglon and Guiffrey 1887–1912, VII, p. 49. For the 1724 inventory see Guarino in Bentini 1994, p. 120.

57. Bentini 1994, p. 6.

58. The painting is currently labelled as a studio production.

59. Ridolfi 1646, p. 63; 1914, p. 357 and note 7.

60. Luzio 1913, pp. 311–14.

61. ASF Carteggio d'artisti, V, no. 441, 13 May 1666, quoted Borean 1999, p. 73, and VI, no. 444, quoted ibid., p. 57, note 135. If anyone is ever inclined to try to trace all notable paintings of this subject attributed to Veronese they will be interested in the painting measuring three and a half by five and a half feet sold at Prestage's auction house, London, 3 February 1764, lot 50 (lot 8 in the first edition) which was said to come from the 'Graci Gallery' (i.e. Palazzo Grassi).

62. Ticozzi 1975, p. 23, no. 45.

63. Stella Alfonsi 2002, p. 269, note 12.

64. For Piati see Woerman 1876, p. 113, and for Negrenzi's daughter, Teresa, see Hübner 1880, p. 143.

65. National Gallery of Scotland, formerly Runciman Collection.

66. Accepted as a Veronese in [Lehninger] 1782, p. 84 (no. 289), but given a question mark in Hübner 1880, p. 143 (no. 342), and classed as by the artist's 'erben' by Woerman 1899, p. 113 (no. 243). In Marx 2005, II, p. 572, no. 2069, it is included as 'Werkstatt'.

67. Ottley 1832, p. 57; Ottley 1835, pp. 13–14.

68. Landseer 1834, pp. 167–75.

69. Anon. 1838, I.32 (repeated Anon. 1840 and 1843).

70. Wornum 1847, p. 194.

71. MS annotations to 1854 catalogue, p. 97.

72. Ticozzi 1975, p. 42, no. 119 (after Fabris, who was also the publisher).

73. Ibid., p. 52, no. 152.

74. The passage occurs in Chapter X. Gautier 1882, pp. 127–8; 1902, pp. 138–9.

75. Part VI of 'Venice', first published 1882, collected in *Italian Hours*, 1909.

76. Osmond 1927, p. 78.

77. Benson 1914, p. 221, no. 110.

78. Dabell 1991.

79. Pignatti and Pedrocco 1995, II, pp. 356–7, no. 243.

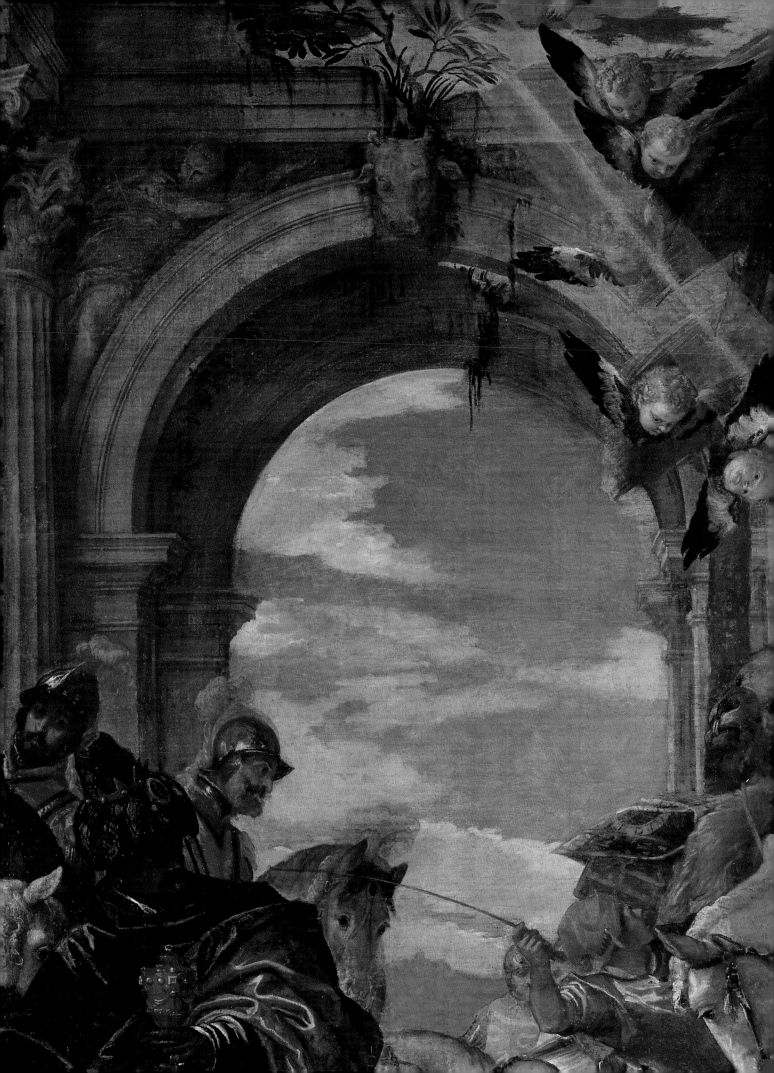

Appendix of Collectors' Biographies

GEORGE HAMILTON GORDON, 4th EARL OF ABERDEEN (1784–1860), see p. 244

COUNT FRANCESCO ALGAROTTI (1712–1764), see p. 119

THE HON. PERCY ASHBURNHAM (1799–1881), see p. 393

EDMOND BEAUCOUSIN (1806–1866), see pp. 60, 120

THE 1st EARL OF BRADFORD (1619/20–1708) and the Paintings at Weston Park

The Newports had been lords of Ercall and sheriffs of Shropshire since the early fifteenth century. Richard Newport, knighted in 1615, was created Baron Newport of High Ercall in 1642 in return for services to the Crown – services which eventually led to imprisonment, fines and exile. He died in 1650, declaring in his will that his family was 'dissolved', his 'chief house ... ruined', and his 'howsholdstuffe and stocke sold'.[1] His son Francis, 2nd Lord Newport, who had also been imprisoned and fined during the Civil War, restored the family fortunes under Charles II, who made him Lord Lieutenant of Shropshire, granted him Shrewsbury Castle in 1666, appointed him Comptroller of the Household and Privy Councillor in 1668, gave him the office of Treasurer of the Household in 1672, and two years later created him Viscount Newport of Bradford (Shropshire). Dismissed from his royal offices by James II, he was restored as Treasurer (Cofferer) in 1689[2] and as Lord Lieutenant under William and Mary, and was created Earl of Bradford in 1694.

The earliest known record of Lord Newport as a collector of paintings comes in 1682, when he was more than sixty years of age. It was then that he purchased fifteen paintings for more than £300 at the sale by 'publick outcry' of Sir Peter Lely's collection and the contents of his studio.[3] His most costly acquisition on this occasion was Van Dyck's portrait of Thomas Killigrew for £83, followed by the same artist's *Sir Walter Pye* for £40. He also bought a self portrait by Van Dyck for £74. Most of his other purchases were apparently minor works by Lely himself – some of them specified as copies and none costing more than £10 – but he also bought a 'landscape of Savary' (Roelandt Savery) for £25 10s., 'flowers of Van Helst' for £35 10s., and 'A Mort Christ' for £36. This last was perhaps a crucifix (ivory crucifixes were commonly framed and hung as pictures).

On Christmas Eve 1685 John Evelyn noted that he 'dined at Lord Newport's, who has some excellent pictures, especially that of Sir Thomas Hanmer, by Vandyck, one of the best he ever painted; another of our English Dobson's painting; but, above all, Christ in the Virgin's lap by Poussin, an admirable piece; with something of most other famous hands.'[4]

There is a good reason to believe that a decade later Newport exploited his royal office to acquire Bassano's *Way to Calvary* (NG 6490), more or less as a bribe from the Queen Dowager, Catherine of Braganza, shortly before she departed for Portugal (the circumstances are described on p. 14). Confirmation of his unscrupulous methods as a collector is found in the note by Jonathan Richardson the Younger, attached to a copy of Holbein's portrait drawing then believed to be of Anne Boleyn:

> when he [the old earl] was Confin'd with the Gout, a little before his Death, He sent to request of my F. [that is, the great collector and writer, and mediocre painter, Jonathan Richardson the Elder] that he would lend him a Book of Drawings to Divert him, wich my F. comply'd with. The E. sent him back the Book in a few days, but without this Drawing. My F. went immediately to wait on him, & found the Drawing hanging by the Bed side in which he lay, in a Frame of Glass. There was other Company in the Room, so my F. could not claim it at that time; but look'd several times at ye Drawing, stedfastly, & look'd at my Ld. My Ld. stood it, discoursing with him, quite unconcern'd; & in two or three days fairly Sneak'd out of the World, & kept the Drawing. My F. could not claim it afterwards of his Heir ... with out accusing Bradford of a most Infamous piece of villany, of which he had no witness.[5]

Something of the personality and the artistic interests of the 1st Earl – and much evidence of his immense wealth and uneasy relations with his family – emerges in the will he signed on 26 December 1699, to which he added more than thirty codicils in the remaining years of his life.[6] He appointed his second son, 'Thomas Newport of Inner Temple London Esq' (born about 1655), sole executor and residuary legatee of all his personal estate, goods, chattels, debts and mortgages, and he clearly had no confidence in his elder son and heir, Richard (born 1644). Especially revealing is the fact that he itemised all his fine silver plate and placed it in the care of trustees as heirlooms, with instructions that his heir was not to 'intermeddle with more than the use and possession thereof'.

Many of the codicils concern bequests to servants and relatives – some were to increase the dowries of his elder grand-daughters[7] or to secure annuities for other members of his family, especially his grandson Richard Newport.[8] And there are complicated instructions to his trustees to complete negotiations to buy land in Shropshire to add to the family property. His chief residence in Shropshire was at Eyton-on-Severn (a house built in the first decades of the seventeenth century, of which a delightful summer house and barn survive). He wished to be buried in the church of St Andrew, Wroxeter, not far from Eyton, and set aside £200 for a tomb in the chancel 'next to that of Sir Richard Newport knight my great grandfather'.[9] His library was to follow his coffin back to Shropshire, and he asked that all his books be carried from London 'to my old closet within the Dineing Room chamber in Eyton House in Shropshire to remain there'. Some paintings were to go there too, as he directed in a codicil dated 1 April 1701:

> My will is that the Picture of Sir Thomas Hanmer holding his Glove in his left hand, a picture of Sir Walter Pye, the picture of Sir

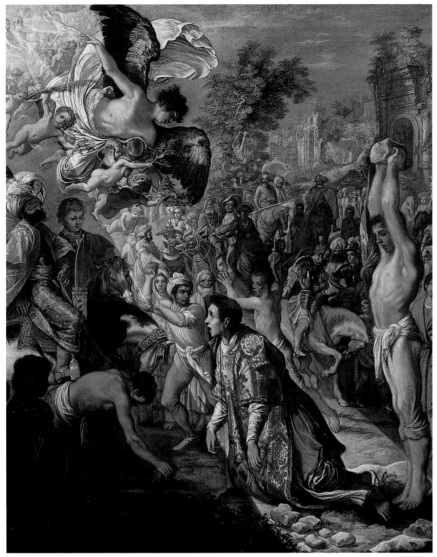

Fig. 2 Adam Elsheimer, *The Martyrdom and Stoning of Saint Stephen*, c.1603. Oil on copper, 34.7 × 28.6 cm. Edinburgh, National Galleries of Scotland.

PAGE 442: Fig. 1 Veronese, *The Adoration of the Kings* (NG 268), detail.

William Killigrew and the picture of Sir Thomas Killigrew (with a Dogs head) that hang in my Dining Roome at Whitehall (all drawne by Sir Anthony Van Dyke) together with my own picture that hangs in my Little Parlour at Twittenham (drawne by Sir Peter Lely) be all sent down carefully to Eyton House in Shropshire to be hung in the parlour there. The first on the south side of the said parlour and the other on the side opposite it above the chimney and there to remain as heirloomes to my ffamily forever.

He revised this plan in another codicil of 6 January 1703 (our 1704): 'Now my will and mind is that that picture of Sir William Killigrew be not sent; but instead thereof the picture of my Lord Chief Justice Lyttleton in his Robes (afterwards Lord Keeper of the Great Seale of England) drawne by Sir Anthony Vandyke.'

In his original will the earl had bequeathed 'to my Lord George Howard his mother's picture being a whole length drawne by Sir Peter Lely', and in addition had given 'to Col. Charles Godfrey his choice of any other picture I shall have at the time of my decease other than the pictures beforementioned'. Recognising that this latter request could conflict with his plans for the parlour at Eyton, he added a codicil on 26 December 1705 'excepting out of' Godfrey's choice those pictures destined for Eyton and also, what was perhaps a recently acquired treasure, 'that whole length picture at

my home in Twittenham of the Queene Mother [the late Queen Henrietta Maria] in a hat with Geofrey the Dwarf in it drawn by Anthony Van Dyke'. This is the great painting now in the National Gallery of Art in Washington.

Obviously the earl held Van Dyck in very high esteem. And the idea of creating a Van Dyck gallery to be kept by his family in perpetuity is truly remarkable. But he may also have wished to commemorate in this room his youthful attachment to the Stuart court, and the group of paintings he hoped to keep together may have been portraits of friends and protectors. Little is known of Sir Walter Pye (1610–1659), father of the Baron Kilpeck who died in exile with James II. Van Dyck's portrait of him has been identified at Arundel Castle, where it was long supposed to represent the 3rd Earl of Arundel.[10] Sir William Killigrew (1606–1695) and his brother Thomas (1612–1683) were both courtiers, poets and playwrights, the latter noted as a wit dear to Charles II and a keen promoter of Restoration theatre. These men were near contemporaries of Sir Thomas Hanmer (b. 1612), who had been, like Thomas Killigrew, a page to Charles I. They were all a few years older than the earl. The Hanmers from Flint were neighbouring landowners to Lord Bradford, and both Sir Thomas Hanmer and his heir, William, feature in property transactions described in the codicils. By contrast Sir Edward Littleton (1589–1645) was a considerably older figure.[11]

It is clear from the Earl of Bradford's will that he kept his paintings in Whitehall and Twickenham. With the exceptions of the group destined for Eyton, Colonel Godfrey's choice, and Lely's portrait of Lord George Howard's mother, all passed to his second son, Thomas Newport, who was then well established in public life. We learn from the handsome ledger stone in the chancel of Wroxeter church that Thomas was Commissioner of Customs under King William and Queen Anne 'upwards of 14 years'. In June 1715 he was made Lord of the Treasury and created Baron Torrington by George I and, soon after, Privy Councillor and Teller of the Exchequer.

The paintings in his father's Whitehall house were moved to Thomas's own residence in Surrey Street, where a 'catalogue of the Pictures of Tho. Newport Esqre' was compiled at some date between his father's death in 1708 and his accession to the peerage in 1715.[12] That the collection catalogued here was almost all inherited may

reasonably be deduced from the fact that the entry for a print (or drawing) of Coypel's *Susanna and the Elders* is annotated 'my own not my fathers'. There were 160 paintings, divided chiefly between the 'new room', the 'gallery', the parlour and the staircase. The remainder of the collection was housed at Twickenham. The earl had evidently felt a strong attachment to his house there, noting that he had spent as much on improving it as he had on purchasing it. He hoped it would provide Thomas with a 'convenient country house for him to dwell in' but made provision that if he failed to inhabit it 'for the space of two months at least in every year' it was to pass to the owner of the manor of High Ercall and be sold to enable improvements to be carried out to that house.[13] It seems that Thomas did live at 'Twittenham' and his third wife, Ann, daughter of Robert Pierrepont, inherited it from him. A manuscript catalogue of the paintings is dated 9 November 1719, six months or so after her husband's death.[14] If we exclude some pictures listed as Lady Torrington's own property, and 28 'India pictures in watercolours'

and 19 'fans made into pictures', there remain some 140 paintings which may be assumed to have been collected by Lord Bradford. These were hung throughout the house, and 90 of them were portraits, including the great portrait of Queen Henrietta Maria already mentioned. Annotations to the Surrey Street catalogue record the transfer of some paintings from town to Twickenham, most of them portraits. There was a 'beauty room' hung with eight female portraits by Lely, Kneller and Van Dyck, no doubt created in imitation of the room at Hampton Court furnished with portraits by Kneller in 1692, and the earlier White Room at Windsor Castle, where Lely's six maids of honour were hung in the 1660s (there were earlier rooms of this type on the Continent[15]).

A 'catalogue' also survives of the paintings in Lady Torrington's town house, no longer in Surrey Street, but with much the same works, albeit differently arranged. In the Surrey Street house small and large pictures had been evenly mixed, which suggests that the former were hung beneath the latter

throughout, but now more than twenty of the finest cabinet pictures were concentrated in the 'closet', although there were also larger pictures in that room and other small paintings elsewhere.[16]

Lord Bradford's collection, as we can reconstruct it from the catalogues made for his son and daughter-in-law, included not only the great Van Dycks but a large portion of the paintings by Elsheimer known to us today, including the *Martyrdom and Stoning of Saint Stephen* (fig. 2), the two panels in the Fitzwilliam Museum, Cambridge, and the series of the story of the True Cross now in the Städel Institut, Frankfurt. It was indeed especially rich in small cabinet pictures – intricate and exquisite works by Rottenhammer, Brill, 'Velvet' Brueghel, Jan Saftleven, Poelenburgh and Van Swanevelt, for example, as well as small scenes of low life by Brouwer and David Teniers, and two pictures by Dou. There were two self portraits by Rembrandt (one of these has been identified as the portrait now in the Norton Simon Museum, Pasadena) and one by 'Francis Holst' (Frans Hals), as well as a seascape

Fig. 3 Family tree of the Earls of Bradford.

Francis Newport, 1st Earl of Bradford (1620–1708)
2nd Lord Newport, created Viscount 1674/5 and Earl 1694,
m. Lady Diana Russell, daughter of the 4th Earl of Bedford

Richard Newport, 2nd Earl of Bradford (1644–1723),
m. Mary Wilbraham, co-heiress of Sir Thomas Wilbraham,
Bt, of Woodley, Chester and Weston (d. 1737)

Thomas Newport (1654/5–1719),
created Baron Torrington 1715,
m. (thirdly) Ann Pierrepoint (d. 1735)

Harry Newport, 3rd Earl
(1683–1734)

Illegitimate son
John Harrison
(heir to unsettled
Newport estates;
d. 1783)

Thomas Newport, 4th Earl
(born 1686/7; died,
of unsound mind, 1762)

Lady Anne Newport
(1690–1732),
m. Sir Orlando Bridgeman
(4th Bt.) (1695–1764)

Sir Henry Bridgeman (1725–1800),
created Baron Bradford 1794

Orlando, 1st Earl of Bradford of 2nd creation
(1762–1825)

George, 2nd Earl of Bradford (1780–1865)

Orlando, 3rd Earl of Bradford (1819–1898)

The 4th, 5th, 6th and 7th Earls, who inherited
in 1878, 1915, 1957 and 1981 respectively,
continue in a direct line of descent

Lady Diana Newport
(d. 1766),
m. Algernon Coote,
6th Earl of Mountrath,
in 1721

7th Earl
of Mountrath
(d. 1802)

by Jan Porcellis and landscapes by 'Barcam' (Berchem) and Claude.

Modern Italian paintings included a *Noli me tangere* attributed to 'Carlo Morat' (Maratta), who died in 1713 and was thus still living when it entered the collection, as well as works by Filippo Lauri (d. 1684), 'Carlooch' (Carlo Loth, d. 1698), Salvator Rosa, Guido Reni, Guercino, Mola and the Carracci. The sixteenth-century paintings were mostly Venetian and believed to be by 'Georgioni', 'Old Palma', Titian, Tintoretto, the Bassani and Veronese.[17]

There was also *Cupid shaving His Bow*, given to Correggio but in fact a copy of the famous Parmigianino,[18] and a '*Monaliza*' by Leonardo. It is easy to smile at these, but the catalogues were clearly compiled by someone who was well informed, and they acknowledge copies, works merely in a master's manner, and anonymous pieces. In general, if portraits are excepted, the better paintings were kept in town. A notable exception is 'Our Saviour bearing the Cross by Bassan', which hung with eight other, miscellaneous paintings in a room 'within' – that is, beyond – the 'beauty room'. One would have expected it to hang with the Venetian paintings (before long, indeed, it would be attributed to Veronese) but it may perhaps have been thought more prudent to keep this picture in a relatively private setting.

Both of Lady Torrington's inventories are annotated to the effect that the pictures had been 'devised' by the will of Lord Torrington to pass after his wife's death to his elder brother, the 2nd Earl, for whom copies of the inventories were made in May 1720.[19] The next inventory known to us records thirty-one cases containing 325 'Pictures belonging to the Rt. Honble. the Countess of Bradford which were sent from London to Weston in Staffordshire' in June 1735, among them '*Our Saviour bearing the Cross*' with the attribution changed from Bassano to Veronese. Lady Torrington had died earlier in the same year, and by then not only had the 2nd Earl died (in 1723) but also – very recently – his son, the dissolute 3rd Earl, who left all unsettled family property to his illegitimate son. The earldom passed to the 3rd Earl's brother, who was, however, 'of unsound mind not sufficient for the government of himself'. The Countess of Bradford who had the pictures in 1735 was the widow of the 2nd Earl and herself quite old. She was the daughter of Sir Thomas Wilbraham, Bt, and heiress of the fine seventeenth-century house Weston Park, with all its lands. She must have known

that she would not have long to enjoy the collection there but she wished to ensure that part of it at least would stay at Weston. She died in December 1737 and was buried there.

In accordance with the countess's will, the collection was divided into equal parts, one of which she wished to be inseparable from the house. The 4th Earl's share had of course to be entrusted to her two other heirs, her only surviving daughters, Anne, who had married Sir Orlando Bridgeman, Bt, of Castle Bromwich, and Diana, who had married the Earl of Mountrath. In the document recording this division some of the paintings are valued. The most highly valued among the 4th Earl's share was the portrait of Queen Henrietta Maria, at £150 – this painting seems to have passed to the Countess of Mountrath – while '*Our Saviour bearing the Cross*' (in the Bridgeman share) was valued at £100, the second highest value given. Many paintings must have been sold either soon after this division or after the death of the 4th Earl (who never recovered his sanity) in 1762. It is at this point that we lose sight of the portrait of Queen Henrietta Maria, the Elsheimers, the Veronese and many other major works. Moreover, it is not clear what happened to those paintings, which were intended to stay forever together at Eyton House. But more than half of the contents of the cases that came to Weston in 1735 remain there today.

Weston passed in 1762 to Sir Orlando's son Sir Henry Bridgeman, the 5th Baronet, who became 1st Baron Bradford in 1794. He spent heavily on improvements to the house, going to Paris to acquire furnishings for it, commissioning the Gobelins tapestries after Boucher, dated 1786, and the marquetry commode stamped by François Gerrard in the same year. At the same date he commissioned 'Capability' Brown to improve the park, which was then graced by the Temple of Diana and the monumental bridge designed by James Paine in 1770. He is not known to have acquired old master paintings – he perhaps felt he had enough of them – but he must have commissioned the insipid group portrait of his family by R.E. Pyne and other individual portraits by this artist. The Stubbs (*Two Horses*) must also have been commissioned, or acquired, in this period.

The 2nd Lord Bradford, who inherited Weston in 1800 and was made 1st Earl (of the second creation) in 1815, had been a crony of the Prince of Wales but he settled down and dedicated himself to

agricultural improvements. The letters written by his wife Lucy (née Byng) to her father, Lord Torrington, on their visit to France during the peace of 1802 reveal that neither she nor her husband had any great knowledge or curiosity concerning works of art (Napoleon's Louvre is hardly mentioned).[20] In that same year, on the death of Charles Coote, 7th Earl of Mountrath, Lord Bradford inherited Weeting Hall in Norfolk and with it came some paintings, including two grand sea pieces by Joseph Vernet, dated 1746, which had been commissioned by Mountrath on the Grand Tour.[21] Weeting was sold to John Julius Angerstein but the paintings came to Weston.

The 'house frame' for the pictures at Weston Park, a slightly coarse Carlo Maratta pattern with broad shields between the acanthus in the ogee hollow, is likely to date from about 1810 and probably reflects a campaign of interior decoration. When he was more than sixty years of age, the earl travelled to Italy, perhaps for reasons of health. In Genoa in March 1822 he was persuaded to buy *en bloc* 27 paintings and 19 bronzes apparently part of a much larger palace collection (the paintings' former numbers are given). This cost him 300 napoleons, and on 2 April, from the same source, he purchased seven more paintings for 60 napoleons.[22] The most expensive item, attributed to Albani, was a mediocre painting of *Hippomenes and Atalanta* adapted from the famous picture by Guido Reni, which cost 50 napoleons.[23]

Under the 2nd Earl, and doubtless prompted by the architectural modifications and consequent redecoration of the house, the paintings at Weston were cleaned, lined, repaired and endorsed with the artists' names. The frames too were repaired, regilded (often only in part), and in some cases replaced. This campaign was conducted, largely on site, in 1834 and 1835 by George Barker, described as a 'painter' (but evidently not very active as such and unrecorded in the dictionaries of art) of Leamington Spa, and later of Coventry, together with his daughter and a gilder, J. Johnson.[24]

Records of the arrangement of the pictures at Weston during the nineteenth century survive in the form of small, neat manuscript catalogues with numbered diagrams of the walls, which must have been kept in each room for reference by the family and their guests. From these it is clear how the paintings were hung in 1837 after the extensive campaign of cleaning in 1834 and 1835, and also how they were

rearranged in 1872 after architectural revisions made upon the 2nd Earl's death in 1865.[25] The arrangement of 1872 was somewhat modified in the 1880s, chiefly to create a gallery of sporting pictures in the Billiard Room (created in 1874 and at first hung with a dozen old masters) and in the adjacent Smoking Room, reflecting the 3rd Earl's passion for hunting and racing and his position as Master of the Horse to Queen Victoria.

There were more than 200 paintings at Weston but the old masters were largely concentrated in two rooms: the Breakfast Room (42 hung there in 1837, 36 in 1872 – the earlier arrangement included a dense concentration of eleven small pictures clustered around the sea piece by Abraham Storck above the chimney) – and the Dining Room (more than 50 pictures hung there in 1837, 44 in 1872). The Dining Room had been converted into what is now the library in 1865 but the amount of space for pictures in the new Dining Room was much the same. Portraits were kept in the old and new library above the bookcases – a common arrangement.

It is easier to follow the arrangements of the paintings than it is to reconstruct the decorative schemes to which they belonged. Weston is a palimpsest of eighteenth-century revivals. By 1865 a probate inventory reveals that Bedroom E was not only hung with the Gobelins tapestries but adorned with 'Old Chelsea china figures', ebony and buhl wardrobes, white and gilt furniture with striped silk upholstery and amber silk window curtains.[26] This cannot have been simply a survival. The firm of Baldock was supplying buhl furniture for the house in the 1840s, and genuine antique French furniture was acquired at the same date. In 1868 the tapestries came downstairs, and later in the century, as the cigar smoke curled around the paintings of hunting and racing in the male rooms, delicate French furnishings arrived in the areas where ladies presided – also more imitation eighteenth-century pieces and the pair of Beauvais tapestries. Much of what we see today, however, reflects the neo-Georgian taste of the 1960s and in particular that of Mary, wife of the 6th Earl, whose redecoration involved new plasterwork, the exchanging and replacing of chimneypieces and the creation of new rooms out of the Billiard Room and the Smoking Room.[27]

The 3rd Earl of Bradford, whose sporting interests have been alluded to above, was not only a wealthy man, with more than 20,000 acres (worth over £40,000 per annum in 1883), but a man at the centre of British political life, perhaps less because he was Lord Chamberlain in Lord Derby's government of 1866–8 than because his wife was an intimate friend of Disraeli. He certainly did not neglect the paintings at Weston.

A manuscript catalogue begun in the 1870s, with pencil notes dating from the 1880s, is written in his hand and shows that he even tried to relate what he owned to the early eighteenth-century records. But the only modern authority to whom he referred was George Barker, the restorer employed by his father.[28] He authorised the publication of Mary Boyle's *Portraits at Weston* in 1888, which contains useful biographical information but is entirely without art-historical knowledge, and then a catalogue, *Pictures at Weston, belonging to the Earl of Bradford*, privately printed in 1895 (very rare), compiled by George Griffiths of Weston-under-Lizard, which is a minimal and amateur affair. It includes photographic illustrations made in Wolverhampton 'from photographs taken by Mr Bowler of Oakengates'. These include one of *'Our Saviour bearing the Cross'*, the Bassano (NG 6490) in the National Gallery here attributed to Paul Veronese.[29]

The importance as well as the size of this painting was acknowledged in the way it was hung. It was the centrepiece of the Dining Room in 1837, with three small pictures below it by Teniers, Brill and Molenaer and a dense symmetrical hang of Dutch, Flemish and Italian paintings to either side of it. In the new Dining Room in 1872 it retained its position at the centre of a somewhat less crowded but similarly miscellaneous arrangement. By 1915 it had been moved to the Breakfast Room, where it was again above the chimney, and it is recorded there by a *Country Life* photograph in 1945. On the death of the 4th Earl in 1915 it was valued at £700,[30] more than any of the other old master paintings, although less than Gainsborough's *Viscountess Torrington* (£900) or Hoppner's *Mrs Gunning* (£2,000). There is nothing surprising in the failure to recognise that the painting was by Jacopo Bassano: indeed it is very different in style from the mature works by that artist represented in other paintings at Weston, but the persistence of the attribution to Veronese is remarkable, and a strong reminder of the isolation of English country house collections.

The first major solvent to be applied to erroneous old attributions given to pictures kept in rural obscurity in the nineteenth century was the curiosity of German scholars. But neither Passavant nor Waagen ever visited Weston. The second solvent was the London loan exhibition. The Bassano was one of six items requested by the Royal Academy for their Winter Exhibition in 1875,[31] but Lord Bradford did not on this occasion agree to lend, and the painting's true identity did not emerge until it was exhibited at the Royal Academy in 1960. The third and most effective solvent was an interest in selling, which at the end of the nineteenth century was sure to attract experts to a great house, however remote. This seems not to have been a temptation for the Bradfords until the second half of the twentieth century.

During the 1950s an absurd but spectacular Snyders was sold to an American collector.[32] Other paintings were sent to auction in 1963. The Holbein drawing was sold to the British Museum in 1975. The Bassano was sold to the National Gallery in 1983. The Heritage Lottery Fund's grant to the Weston Park Foundation in 1986 ensured that many of the remaining paintings would remain in the house, but some still belong to the family, and a group of characteristic small cabinet pictures were auctioned in 1992.[33]

NOTES

1. *Dictionary of National Biography*, XIV, entry by 'G.G.' (Gordon Goodwin).

2. Evelyn 1908, p. 403, notes that he was confirmed in this post on 21 February 1689. Other sources give the date as 1691.

3. British Library, Add. MSS 16174, Executor's Account Book 1679–91, fol. 39r ('Lord Newport'). Not all of these purchases can be deduced from the annotated printed copies, for which see Anon. 1943.

4. Evelyn 1908, p. 362. There is no subsequent record of the Poussin in the collection but it is tempting to speculate that it was the *Pietà* now in Dublin.

5. Brown 1982, pp. 535–6, no. 1539. The purloined original is now in the British Museum, 1975-6-21-22. Rowlands 1993, pp. 148–9, no. 324, follows Brown in assuming that the culprit was the 3rd Earl.

6. MS in Family Record Centre, PROB. 11/504, Sig. 229. The will was proved on 7 October 1708.

7. Mary was born in 1681/2 and died in 1711, unmarried. Elizabeth was born in 1688, married James Cocks in 1718 and died in 1732.

8. He, however, seems to have predeceased the earl.

9. The marble wall monument to him in St Andrews incorporates an urn but no effigy and is unsigned. Alastair Laing pointed out to me that it is very similar to that to Admiral Churchill in Westminster Abbey by Grinling Gibbons.

10. Rogers 1982.

11. Sir Henry Littleton, Bt, of Arley and Hagley married in 1665 Elizabeth Newport, daughter of Lord Bradford, who in a codicil of 4 February 1701 bequeathed £500 to her, provided that she not take Edward Harvey as her second husband. She did, and the bequest was cancelled.

12. This catalogue is bound into a quarto volume kept at Weston, a copy of which was supplied to Alastair Laing by Keith Verrall. It occupies fols 1–21 of one end of the book. Lady Torrington's two catalogues occupy fols 1–28 at the other end.

13. MS cited in note 6. A codicil of 26 April places responsibility not with the owner of the manor but with his trustees.

14. See note 12.

15. For the Galleria delle Belle made by Ferdinando Voet for Palazzo Chigi, Ariccia, see Petrucci 2005, p. 10 and plate on p. 11, also pp. 61–8 for the repetitions elsewhere.

16. See note 12.

17. These attributions were probably optimistic, but Veronese's *Christ and the Centurion* may be the fine workshop picture now in Toledo, Ohio (66.129).

18. Kunsthistorisches Museum, Vienna, no. 62; Freedberg 1971, pp. 184–6, fig. 79.

19. The will was proved 4 June 1719 (PROB 11/569 sig. 116.). Two pictures of Robert Long, Esq., and Frances, his wife, were bequeathed to Mrs Frances Long. All other pictures were 'devised', as stated here. I am grateful to Lorne Campbell for this reference.

20. Staffordshire County Record Office. D 1287/18/9 (P/1056).

21. Commissioned through Dr John Clephane in January 1745, soon after the earl succeeded. For Clephane see also p. 341 and Ingamells 1997, pp. 214–16.

22. Staffordshire County Record Office. D 1287/4/4 (R/741).

23. The attributions to Genoese hands – Badaracco (for Giuseppe Badaracco) and Ratto (for Giovanni Agostino Ratti) – are likely to be reliable, however.

24. Barker also worked on the pictures at Castle Bromwich in 1842. He also auctioned some old master paintings in that year (Lord Bradford bought a couple of lots). In 1843 he was working on the pictures at Burghley. Staffordshire County Record Office, Bradford Papers, D 1287/4/4 (R/271).

25. Ibid., D 1287/4/4 (R/170–183).

26. Ibid., D 1287/4/11 (R/751). Inventory compiled by E. and H. Forster.

27. For the home and furniture see Hussey 1945 and Kwiatkowski n.d.

28. Staffordshire County Record Office, Bradford Papers, D 1287/4/3 (R/175).

29. Griffiths 1895, opposite p. 21; no. 121 in catalogue.

30. Staffordshire County Record Office, Bradford Papers, D 1287/4/9 (R/295).

31. Ibid., D 1287/4/4 (R/295), letter of 12 November 1875. Lord Bradford did lend to the National Portrait Exhibition in 1869 and occasionally to other exhibitions.

32. W.J. Pirig of Colorado Springs sold it at Sotheby's on 28 November 1962, lot 81, where it was bought by the Banque de Paris et Pays Bas, Antwerp (Robels 1989, pp. 225–6, no. 66).

33. Christie's, 21 November 1980 (lots 38 and 39); 18 December 1980 (lots 68 and 69); 23 January 1981 (lots 156–60); 6 March 1981 (lot 110); Sotheby's, 1 April 1982 (lots 1–5).

QUEEN CATHERINE OF BRAGANZA (1638–1705),
see pp. 13–14

GEORGE AUGUSTUS FREDERICK CAVENDISH BENTINCK (1821–1891),
see pp. 86–7, 113

PIERRE CROZAT (1665–1740), see pp. 242–3

THE 4th EARL OF DARNLEY (1767–1831)

John Bligh succeeded his father as 4th Earl of Darnley in 1781. He travelled in northern Europe before coming of age in 1788 and, shortly thereafter, went on to Italy. In Rome in 1789–90 he bought highly restored antique busts and statues, copies of famous antiquities, and some slabs and columns of antique marble.[1] On his return to England he married and was soon engaged in making extravagant modifications to Cobham Hall, his great Elizabethan house in Kent. The 3rd Earl (1719–1781) had already much embellished and modernised Cobham, employing as his architect James Wyatt. Over the course of the next thirty years the Gilt Hall was clad with marble, the Long Gallery was transformed into a picture gallery, and a new library was created.[2] In 1818 the earl returned to Italy, where he bought more ancient marbles and also commissioned from Canova a version of the *Naiad* in the Royal Collection.[3]

The 4th Earl was said to be very proud, with 'the high notions of the old nobility, in manner uniform, cold and reserved'. His annual income was estimated by his contemporaries at £20,000,[4] but one is not surprised to learn that he left the family fortune considerably impaired. A posthumous inventory compiled for fire insurance listed more than 160 pictures at Cobham Hall, with a total value of more than £30,000.[5] This collection included *The Rape of Europa*, one of the half-dozen greatest mythological paintings by Titian (now in the Isabella Stewart Gardner Museum, Boston), as well as the four *Allegories* by Veronese, Tintoretto's *Origin*

of the Milky Way and Titian's *Portrait of a Man with a Quilted Sleeve*, all of which are today in the National Gallery and all but the last mentioned of which are included in this catalogue. With the exception of the Titian portrait, the source of which is obscure, these paintings all came from the sale in 1798–9 of the Italian portion of the Orléans Collection, although it is noteworthy that none of them was purchased there directly – the *Rape of Europa* was bought soon after the sale from Lord Berwick, and the other paintings were also acquired after the sale or from Bryan.[6]

At the earlier Orléans sale (of 1793) Lord Darnley bought Rubens's *Head of Cyrus brought to Queen Tomyris* for 1,200 guineas.[7] No one who had spent a fortune on such a picture (fig. 4) is likely to have had an aversion to gruesome subject matter, and Darnley also acquired for the colossal price of £6,000 from Angelo Bonelli the *Death of Regulus* formerly in Palazzo Colonna – Salvator Rosa's masterpiece as a historical painter (now in the Virginia Museum of Fine Arts, Richmond).[8] Rosa was clearly a favourite painter of Lord Darnley. He also owned Rosa's *Birth of Orion* (also from the Colonna collection), a version of *Jason with the Dragon* and *Pythagoras and the Fishermen* (now in Belgium).[9] This last was an early purchase, probably made in about 1791 from his friend Thomas Moore Slade, who lived in Rochester and was thus a close neighbour.[10]

Darnley's judgement was not always secure and this is especially evident if we consider his purchases from the Vitturi collection (for which see also the entry for Pedro Campaña's *Conversion of Mary Magdalene* (NG 1241)). The collection was acquired *en bloc* by Slade in Venice in the mid-1770s, displayed in the gallery of his home in Rochester, and sold by him in 1791 after the failure of his speculation in a new method for making broadcloth (and before he secured the Dutch, Flemish and French portion of the Orléans Collection, as described on p. 466).[11] It would not be fair to suggest that Slade regarded his noble and prodigal young friend as a convenient means of disposing of the less promising items in his collection, for he sold him Rosa's *Pythagoras* and offered him Claude's great *Embarkation of Saint Ursula*, which he turned down (soon afterwards the Claude found its way into Angerstein's collection and so into the National Gallery). However, of the five 'Titians' that Darnley acquired from the Vitturi collection – 'Christ giving the

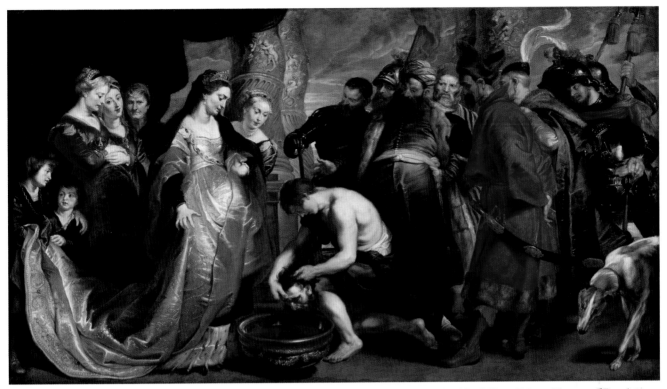

Fig. 4 Rubens and Workshop, *The Head of Cyrus brought to Queen Tomyris*, c.1622–3. Oil on canvas, 205.1 × 361 cm. Boston, Museum of Fine Arts.

blessing', 'His own portrait and Don Francesco del Mosaico', 'Venus and Cupid, in a Landscape', 'the Tribute Money' and 'Charles Fifth (whole-length)' – only the first was accepted as by Titian by Waagen in the mid-nineteenth century and none was accepted by the end of the century.[12] If we are inclined to ridicule we should consider the case of Sir Abraham Hume, an undoubted connoisseur, who was advised by acknowledged experts and acquired even more false Titians at the same date. Other Vitturi paintings acquired by Darnley include works attributed to Regnier, Barocci, Pietro della Vecchia and Guido Reni, which have not been traced.[13] That Darnley himself had doubts about some of his early purchases is suggested by the fact that he consigned twenty-five paintings to auction anonymously at Christie's on 6 and 7 May 1796 (most of them, however, were bought in).[14]

Whatever errors Darnley may have made in his selection of pictures from the Vitturi collection, they clearly reveal that he was early attracted by the work of Titian. To the *Europa* and the National Gallery's portrait and the five Vitturi 'Titians' just listed must be added several works attributed to Titian in Darnley's sale of 1796;[15] also Titian's *Venus and Adonis* from the Mariscotti collection bought from Buchanan after 1804 (now

in the Metropolitan Museum of Art, New York),[16] which is certainly a good replica; versions of the Naples *Danaë*[17] and the *Venus adoring herself in a Mirror*,[18] which are also likely to have been works of equivalent quality; and the *Scourging of Christ*, which was auctioned as a Schiavone in 1819 and attributed to this artist again later in the century by Waagen, but was believed by Darnley to be a Titian.[19] The *Danaë* was valued in the insurance inventory mentioned above at £4,000 (more than the *Queen Tomyris* by Rubens and the *Europa* by Titian, valued at £3,000 and £1,000 respectively). It was described in the inventory as 'very highly esteemed by the late Earl' and this is confirmed by the fact that he commissioned an enamel copy of it from Nathaniel Bone.[20]

Darnley continued to collect paintings throughout his life, although probably less actively in the 1820s. He was evidently a keen follower of the auctions, where he often bought at low prices;[21] but, as his bank account reveals, he also paid high sums to leading dealers, notably William Buchanan and Angelo Bonelli.[22] In the former's coarse, eager, shrewd letters written between 1805 and 1808 harrying his salesman in London, David Stewart, Darnley is characterised as a special admirer of Rubens and Van Dyck as well as of Titian and the Venetians.[23] The insurance inventory

attributed ten paintings to Rubens, of which, after the *Queen Tomyris*, the most important was probably the sketch for *The Triumph of Henri IV* now in the Metropolitan Museum of Art, New York.[24] There were also major works by Snyders and Jordaens and, among half a dozen Van Dycks, what was simply stated to be his 'finest picture', the double portrait of the Stuart brothers now in the National Gallery (NG 6518), which then hung in its 'massive richly carved frame'[25] above the great marble chimneypiece carved by Richard Westmacott the Elder for the Gilt Hall (or Music Saloon, as it was then known). The double portrait, however, had been inherited, the 1st Countess of Darnley having been a Stuart. Portraits seem to have been the only pictures that Darnley inherited – or rather retained, for he sold the old masters acquired by his father at Christie's in 1802. Among these there were no fewer than four Claudes, which all fetched respectable prices[26] – revealing evidence of how little appeal tranquil imagery held for the 4th Earl (it will be recalled that he had turned down the offer of Claude's *Embarkation of Saint Ursula*).

Beauty, however, did appeal to him and, together with Titian, Rosa and Rubens, his greatest enthusiasm was probably for Guido Reni. Among the fifteen works attributed to Guido in his possession was the *Daughter of Herodias*

from the Colonna collection, the magnificent painting now in the Art Institute, Chicago;[27] a still more highly valued version of the *Liberality and Modesty*;[28] and a *Massacre of the Innocents*, which was doubtless a copy although catalogued as an autograph work.[29] Darnley did own copies after Guido which he knew to be such. Indeed, not only was there a painted copy of the *Aurora* at Cobham,[30] but Richard Westmacott the Elder had copied it as a relief on the great chimneypiece in the Gilt Hall.[31] A copy of Raphael's *Transfiguration* also had a place of honour in Darnley's collection and he purchased small copies of Raphael's cartoons in 1801.[32]

Changes in attribution have created obstacles to an assessment of Darnley's collection. It is uncertain under what name we might now find the *Judas betraying Christ* that was attributed to Guido, a highly valued painting which was also copied by Bone.[33] No less mysterious is Guido's *Saint Teresa*, bought by Wiggins in 1957, probably for its frame.[34] The seventeenth-century paintings had sunk in value by the time they were sold in the twentieth century. Annibale Carracci's *Toilet of Venus* which Darnley bought at the Orléans sale, valued in 1833 at £400, fetched 21 guineas (£22 1s.) in 1925 (today in the Pinacoteca Nazionale, Bologna).[35] The *Finding of Moses* now in the National Gallery (NG 3142, as perhaps by Gargiulo) was lotted unframed and without any attribution together with an anonymous family portrait in the 1957 auction, where it was bought by Contini-Bonacossi, who believed it to be by Cavallino.[36]

Lord Darnley was an occasional patron of modern artists. He bought a version of Reynolds's *Infant Samuel* from the artist in 1791[37] and purchased from Gainsborough's widow the copy Gainsborough had made in 1785 of Van Dyck's *Stuart Brothers*.[38] From Benjamin West he bought the small original sketch for that artist's celebrated composition of *Christ Rejected*, dated 1811, presumably after its exhibition at the Royal Academy in 1815, when it was very highly praised.[39] Just over ten years later he commissioned William Etty to paint the *Judgement of Paris*, which was exhibited to much applause at the Royal Academy in 1826, but it did not please him and he was dilatory in paying for it.[40] Finding the money to pay for modern art in these years seems to have been a frequent problem. He quarrelled with Canova's heirs over the cost of his *Naiad*, mentioned above, which was completed for him after Canova's death. He probably commissioned or purchased Harlowe's *Dominican Friar* on his second Italian trip, and perhaps also *Jacob and Rachel at the Well* by a mysterious 'Wallace of Florence'.[41] From Douglas Guest, 'historical painter formerly lecturer on the Fine Arts in the Royal Institution', he commissioned a painting of his second son in the guise of Hercules strangling serpents.[42] In 1807 Guest sold to Darnley Correggio's *Zingarella*, presumably a copy of the painting in Capodimonte, and this was puffed by Guest when he compiled the insurance inventory.[43] Perhaps Guest was retained as an adviser, even as a curator, by Lord Darnley.

In 1806 the *Queen Tomyris* seems to have been on display at Cobham, but the other paintings in Darnley's collection were kept in his London house in Berkeley Square. By 1819 the picture gallery at Cobham with its crimson hangings was full of paintings and open to 'strangers' every afternoon and to all 'travellers' by appointment.[44] From Guest's catalogue of 1833 we can deduce that the old masters were concentrated in the gallery and its two skylit vestibules, although others were to be seen on the great staircase, and full-length ancestral portraits hung in the dining room in uniform frames that were part of its panelling. Only the *Regulus* and a painting of Neapolitan history were recorded in Berkeley Square[45] and these presumably came to Cobham when Darnley's town house was sold in 1836. Guest mentions that the gallery included Etruscan vases and had shelves under the windows filled with folios 'of prints and on every subject connected with art history', including, for example (as we discover from the probate inventory of 1831), volumes of engravings of the Orléans Collection.[46] The gallery must have been quite as cluttered as a drawing room of around 1860. In addition to its eighteen carved and gilt armchairs and the ottoman, all upholstered in crimson damask (matching the walls), there were five 'turkey carpets', library tables, a full-size billiard table, a harpsichord, large china jars, models of the Swiss mountains and cases full of Sèvres and Dresden porcelain.

Edward, 5th Earl of Darnley (1795–1833), died soon after his father, and his son, John Stuart (1827–1896), did not come of age until the late 1840s. Cobham, in the care of his mother, was, like so many other great houses in that period, less liberally shown than had previously been the case, and in 1843 it was reported as open only on Fridays to those with tickets, which could be secured for a shilling at the local school and libraries.[47] An anonymous guide-book in the following year complained that there were 'few really fine and genuine specimens' among the paintings and these were not seen by 'ordinary visitors'.[48] The visitors' books from 1819 to 1891 survive and from these it is clear that local tradesmen, craftsmen and clerks – printers, booksellers, dockyard assistants – and their families had always been among the visitors.[49] With the popularity of day trips down the Thames to Gravesend by steamer, the number of visitors from London greatly increased[50] and on 26 July 1851 C.L. Eastlake wrote his name and that of 'Gustav Waagen from Berlin' in the book.[51] Waagen knew of plans for improving the display and recorded that the 6th Earl had recently bought a large Carlo Dolci (of Saints Catherine of Siena and Mary Magdalene presenting a portrait of Saint Dominic to two friars).[52]

The diary kept by the young earl on his continental tour in 1850 'with my little wife' (Lady Harriet Mary Pelham) reveals him to have been a diligent visitor of galleries, with genuine, if largely predictable, enthusiasms. In Florence in November William Spence acted as *cicerone* and guided the couple to 'picture shops', in one of which they had bought a portrait of Girolamo Benivieni believed to be by Lorenzo di Credi (a version of NG 2491).[53] Darnley made other purchases and it may have been to make space that he allowed Christie's to sell 'thirty gallery works from the collection of a nobleman; and 3 antique marble statues' on 12 July 1862.[54] Most of the paintings were minor and all of them fetched low prices but Orléans paintings were included, among them the so-called Giorgione of *Milo of Croton*[55] and a pair of pictures by 'Spagnoletto', also given to Rosa, of *Democritus* and *Heraclitus*.[56] In addition, the colossal marble *Antinous*[57] from the Great Hall was sold for 21 guineas, certainly a fraction of what it must have cost.

Comparison of plans of the picture gallery made in the first decades of the nineteenth century with the structure that survives today makes it clear that major changes were made by the 6th Earl, probably during the 1850s. The two top-lit vestibules at either end of the gallery were opened up so that they formed parts of the same space, and a niche was opened opposite the central gallery window, in which Canova's *Naiad* was placed. The arrangement

undoubtedly diminished the space for hanging pictures and helps to explain the sale of 1862.

That the collection remained a matter of pride seems clear from the lecture on it delivered by F.G. Stephens in 1876. By then the Titian portrait had established itself as one of the most famous works in the collection – lent to the Royal Academy in the previous winter and before that to the Art Treasures exhibition in Manchester. Stephens records the four Veroneses and the Tintoretto in a room to the south of the picture gallery, known as Queen Elizabeth's Chamber.[58] They had previously been in one of these vestibules together with the majority of the more admired pictures.[59]

The earliest evidence known to me of the 6th Earl's intention to sell comes in letters of early 1888 to Charles Fairfax Murray concerning the sale of the Veroneses. The paintings were eventually sold together with the Tintoretto to the National Gallery through Agnew's in complicated circumstances described in the entry here for the *Allegories*. This did not solve Lord Darnley's financial problems, however, and on 28 April 1894 Lionel Cust (director of the National Portrait Gallery) wrote to Lord Carlisle that 'my uncle, Lord Darnley, has asked me to tell *you* privately, as representing the Trustees of the National Gallery, that he is anxious to sell *them* his famous picture of "Europa" by Titian now at Cobham Hall. He is very unwilling to part with it. ... he cannot ask for less than £5,000 for the picture though he would be quite ready to accept the money in three successive annual instalments.'[60] The Trustees at their meeting on 1 May 'after a brief discussion' declared themselves 'unable to entertain the offer'.[61] Having thus discharged his patriotic duty, the aged earl presumably invited foreign offers, but it was his son Edward, the 7th Earl (1851–1900), who accepted from Bernard Berenson, acting for Mrs Gardner of Boston, the sum of £20,000 for the painting in June 1896.[62] The death duties that this settled fell due again in November 1900 when the 7th Earl was succeeded by his brother Ivo.

When the Veroneses were available the director of the National Gallery, Frederic Burton, had been lukewarm and dilatory, to the distress of many informed art lovers and of the more active of the Gallery's trustees. This and other incidents made it possible to diminish the authority and independence of his successor, but there was no guarantee that the Board of Trustees would act

decisively or wisely, and by the time Titian's portrait became available their chairman, Lord Lansdowne, was resolutely opposed to bothering the Treasury with requests for special grants even 'for first rate works'. Both Lord Carlisle, the most responsible and one of the most senior trustees, and Burton's successor as director, Sir Edward Poynter, were informed, immediately after the Earl's death in 1900, by Cust (the 7th Earl's cousin) that the Titian was likely to be sold. But the Board did nothing. Three years later Cust wrote again to Poynter indicating that the 8th Earl was proposing to sell the Titian, together with a Reynolds and the Van Dyck, and offering to intervene on the Gallery's behalf. Early in 1904 Poynter was able to enquire as to the price of the Titian and the Van Dyck but it took him four months to get the trustees to make an offer – one that was way below what was asked and was immediately rejected. The paintings were sold instead to the dealer Sir George Donaldson. Poynter then persuaded Donaldson to offer the Gallery the Titian for the price he had paid for it. The trustees then took another couple of months to decide to buy it (by a majority of six to three). Poynter had to raise most of the £30,000 by appealing to wealthy art lovers (Lord Iveagh, Waldorf Astor, Pierpont Morgan, Alfred Beit). The whole deplorable episode made it clear to all owners that it would be difficult to sell anything, however pre-eminent, to the National Gallery and it left Poynter keen to retire.[63]

Other important paintings were sold privately from Cobham in the following years. By 1909 the Rubens sketch was with Colnaghi and by 1919 Lord Lascelles (later 6th Earl of Harewood, see pp. 455–8) owned the *Queen Tomyris*.[64] A public sale of paintings took place at Christie's on 1 May 1925, two years before the 8th Earl's death. Large sales were conducted on the premises by Sotheby's on 22 and 23 July 1957 and the house was sold to the Ministry of Work four years later. It is currently occupied by a school for girls (the Westwood Educational Trust). Some family portraits remain there, many of them copies, and a single survivor from the great collection formed by the 4th Earl, the half-size copy of Raphael's *Transfiguration* in its original Carlo Maratta frame. But superb fittings elsewhere remind us of the former splendour of the house.

NOTES

1. Wingfield-Stratford 1959, pp. 281–5.

2. Colvin 1978, pp. 948–9, 952.

3. Sold at Sotheby's, London, on 23 July 1957 as lot 409, 'Pauline Borghese'. Now in the Metropolitan Museum of Art, New York. A cupid attributed to Canova that was sold by the earl's grandson at Christie's on 12 July 1882 (lot 131) for 180 guineas is likely to be the 'small figure in marble' mentioned immediately after Canova's *Nymph on a Couch* in the probate inventory of 1831 (fol. 142v).

4. Farington 1978–98, VI, 1979, p. 2263, 10 March 1804, citing Sir Richard Westmacott.

5. Guest 1833.

6. Buchanan 1824, I, p. 112, reports Lord Berwick's purchase of the *Europa* for 700 guineas.

7. Ibid., I, p. 168.

8. Kitson 1973, p. 28. For the price see Guest 1833.

9. Guest 1833, nos 57, 28 and 38. The *Jason* has not been traced. The *Orion* was in a private collection in 1963.

10. Buchanan 1824, I, pp. 328–30.

11. Ibid., I, pp. 320–4 (but the dates have to be deduced).

12. Ibid., I, pp. 328–30. For the Christ see Wethey 1979, plate 216; for the double portrait see Wethey 1971, II, p. 183. This last picture was bought for £5 at Sotheby's, 23 July 1857 (lot 320).

13. The Regnier is no. 52 in Guest 1833, highly valued at £300, but the Barocci, the Guido and the Pietro della Vecchia are not to be found there.

14. The marked copy in Christie's archive clearly shows Darnley as both consigner and purchaser.

15. Christie's, London, 6 May 1796, lot 54 (portrait of a friar), and 7 May, lots 45 and 94 (*Saint Margaret* and a self portrait). There was also a copy of *Venus and Adonis*.

16. 49.7.16. Sold at Christie's on 1 May 1925 as lot 79.

17. Wethey 1975, p. 133. Sold at Christie's on 1 March 1925 as lot 83 for 160 guineas.

18. Wethey 1975, p. 202. Said by Waagen to be much damaged. Bought by Darnley from the Orléans collections for 300 guineas. Sold Christie's, 1 May 1925, no. 81. Darnley also owned a copy of this picture kept in Lady Darnley's room according to the probate inventory of 1831, lot 140. This was then sold for £4 on 12 July 1862 (lot 112).

19. Consigned by Philippe Panné, Christie's, 29 March 1819, lot 90 (sold for 66 guineas). Considered as a Titian in Guest 1883. The painting is not in Richardson 1980.

20. Guest 1883, no. 72. The copy by Bone is no. 130, valued at £250.

21. An example would be the 12 guineas he paid for a Snyders consigned by the Duke of Bridgewater at Coxe, 13 May 1802, lot 34.

22. Notes made in the records of Coutts Bank kindly communicated by Roger Bowdler. There are records of payments of £400, £415 and £735 between January 1806 and May 1809 to Buchanan, and of £500, £525, £550, £400 and £1,000 between August 1811 and September 1815 to Bonelli.

23. Brigstocke 1982, pp. 123, 173, 231–2, 254, 283, 295, 365, 391, 411.

24. Liedtke 1984, pp. 151–63.

25. Guest 1833, no. 96, there valued at £1,000. The frame survives around the copy now in the Gilt Hall.

26. Christie's, 8 May 1802. There were 61 lots. The Claudes fetched £220 10s., £115 10s., £210 and £273.

27. Guest 1833, no. 29, valued at £1,200.

28. Ibid., no. 59, valued at £1,500. Sotheby's, 23 July 1957, lot 316, listed by Pepper 1984, p. 280, as a copy, but he admitted that he had not seen it.

29. Guest 1833, no. 35, valued at £600. The painting had belonged to Reynolds.

30. Guest 1833, p. 107.

31. Gunnis 1951, p. 423. This was apparently commissioned in 1778 and thus for the previous earl. Related chimneypieces are at Powderham Castle and Goodwood.

32. Guest 1833, nos 39 and 61. Bought at auction 17 February 1801, lot 84.

33. Ibid., no. 62, valued at £400, and, for Bone, ibid., no. 132.

34. Ibid., no. 59, valued at £200. Sotheby's, 23 July 1857, lot 299.

35. Ibid., no. 9. Christie's, 1 May 1925, lot 11.

36. Sotheby's, London, 23 July 1957, lot 377, £32 6s. Presented to the National Gallery by Count Contini-Bonacossi. It is not possible to match with any painting in the 1833 list and it is possible that the Darnley provenance was invented.

37. Guest 1833, no. 49, valued at £350. Reynolds's ledger notes that it cost 75 guineas. It was sold at Christie's on 1 May 1925 as lot 66, where bought by Agnew, who sold it to Major J.S. Courtauld, at whose sale on 27 October 1938 it was lot 249 (bought in).

38. Christie's, 1 May 1925, lot 20. Now St Louis Art Museum, inv. 1928.168. Waterhouse 1958, p. 124, no. 1017.

39. Guest 1833, no. 63, valued at £400. Christie's, 1 May 1925, lot 90. Now in the University of Rochester Art Gallery, New York. Von Effra and Staley 1986, p. 360, no. 354.

40. Farr 1958, pp. 49–50, 122. The bank account cited in note 22 records payment to Etty between 1826 and 1829.

41. Guest 1833, nos 31 and 110. George Harlow enjoyed great fashionable success in Rome in 1818 but died in the following year. Aidan Weston-Lewis notes that Wallace is likely to be George Augustus Wallis (1770–1847), resident in Florence from about 1817.

42. Guest 1833, no. 166.

43. Ibid., no. 23 (Correggio). The Correggio, valued at £2,000 in 1833, sold for 22 guineas (£23 2s.) at Christie's on 1 May 1925 as lot 13.

44. Britton 1801–15, VII, 1806, p. 603; Neale 1818–23, II, 1819, unpaginated.

45. Guest 1833, last pages.

46. Probate inventory, items 111r–117v.

47. Summerly 1843, pp. 65–6.

48. Anon 1845, kindly shown me by Roger Bowdler.

49. Medway Archives Office, U565-F13 (1–3).

50. Mandler 1997, pp. 73 and 427.

51. Medway Archives Office, U565-F13 (2), unpaginated.

52. Waagen 1854, pp. 17–26; Baldassari 1995, pp. 130–2. Sold at Sotheby's on 23 July 1957 as lot 310, and then cut into pieces by the art trade. (See McCorquodale 1993, pp. 344–6.)

53. Medway Archives Office, U565-F31. The painting had been offered to the National Gallery in 1847–50 (see Gould 1975, p. 101). It was sold at Christie's on 1 May 1925 as lot 25 for 180 guineas. For further dealings with Spence see Fleming 1979, p. 500, note 53.

54. Christie's, lots 89–131.

55. Lot 93, sold for 10 guineas. Guest 1833, no. 85, valued at £50. Darnley had paid 40 guineas for it at the Orléans sale. Waagen realised that this had nothing to do with Giorgione. Another painting in the collection, *Caesar presented with the Head of Pompey* (for which see Rylands 1992, p. 214, A54), was believed to be by Giorgione.

56. Sold for £2 and £1 15s.

57. Lot 130, sold for 21 guineas. (See probate inventory, lot 142r.)

58. Stephen 1876, p. 14.

59. Deductions concerning the hang can be made from the probate inventory and from Guest 1833. There is also a plan of the picture gallery in Medway Archives Office, U565-P27.

60. NG7/171/1894.

61. Minutes, VI, pp. 270–1.

62. Sprigge 1960, p. 128. See also Hendy 1974, p. 259.

63. Letters to Poynter from Cust of 14 November 1900 and 11 November 1903 are in the dossier for the Titian together with Lansdowne's letter to Poynter and a sympathetic letter of 20 April 1904 from J.P. Heseltine.

64. Liedtke 1984, pp. 156–63. For the *Queen Tomyris* see McGrath 1997, II, pp. 14–25, no. 2.

DOMINIQUE-VIVANT DENON (1747–1825),

see pp. 119–20

THE EARL OF DUDLEY (LORD WARD) (1817–1885)

William, 11th Baron Ward of Birmingham, who was created Viscount Ednam and Earl of Dudley (of the second creation) in 1860, spent much of his vast income from land – especially his land in Staffordshire, which was rich in iron and coal – on rare minerals (most notably the 'Star of South Africa', a diamond subsequently known as 'The Dudley'[1]) and on ceramics[2] and paintings. He was, together with the Duke of Hamilton and the Marquess of Hertford (both of whom were older), the last member of the British nobility to collect works of art on a princely scale.

Lord Ward was the heir of John William Ward, 1st Earl of Dudley, 4th Viscount Dudley and Ward, and 9th Baron Ward (1781–1833), foreign secretary between 1827 and 1828, a talented, educated, well-read and scholarly man whose increasing eccentricities (notably soliloquies in two voices and absence of mind) led to his confinement in 1832. With his death a year later the earldom and viscountcy became extinct but the barony passed to his second cousin, the Revd William Humble Ward (also of unstable mind), who died in 1835.[3] The first earl had already adopted his second cousin's oldest son, the subject of this entry, as the chief recipient of his immense fortune, but the young man was for a while restrained from full use of it by trustees – fortunately so, since he accumulated large gambling debts and was sent down from Oxford after 'incidents at a race course'.[4]

As a young man Lord Ward's private life was clouded by scandal. His first wife, Selina de Burgh, whom he married in 1851, was expelled from his house, in the year of their marriage, after he discovered her adultery. She died soon afterwards, in sordid circumstances, at Schwalbach in Germany.[5] There is some evidence that he was, at least intermittently, mentally deranged in the late 1860s.[6] The obituarist of his second wife, Georgiana Moncrieffe (whom he married in 1865), recalled his 'benevolent and bountiful, but whimsically despotic' behaviour, and the fact that he insisted that his countess wear her richest clothes 'even at the remotest shooting lodge in the Highlands'.[7] Little that is known of his character would seem to have qualified him for a position of public responsibility, yet he served as a trustee of the National Portrait Gallery from 1863 to 1866 and as a trustee of the National Gallery from March 1877 until shortly before his death in 1885.[8] In the nearly ten years of his trusteeship of the National Gallery he attended only two meetings, and there is no evidence that he gave any attention to the Gallery's business – or that anyone remonstrated with him concerning this.

Lord Ward inherited an art collection of some importance from the first earl. It is unclear when this was formed, but perhaps he purchased pictures in 1814–15 when in Paris and Italy, or on his later continental travels in 1817 and 1821–2. Shortly before Lord Dudley's death, Passavant admired Raphael's *Three Graces* (now Musée Condé, Chantilly) in Dudley House, together with a painting attributed to Van Eyck (now in the National Gallery, as the work of the Master of Saint Giles). Not long afterwards another German traveller, Gustav Waagen, gave a fuller account of this 'mixed collection', mentioning that it included fine works by Giovanni Bellini, Francia and

Pintoricchio, as well by Cuyp, Jacob Ruisdael and Simon de Vlieger.[9]

The young Lord Ward seems to have wished to improve this collection and in Rome, where he was leasing Palazzo Albani in the summer of 1847, he bought a collection of sixty pictures from Count Guido di Bisenzo for 36,000 scudi, and a handful of masterpieces from the reserved portion of the vast collection of Cardinal Fesch, Napoleon's uncle, for 27,000 scudi.[10] No lists of these acquisitions seem to survive and so it may be deduced that Lord Ward's Italian paintings such as Titian's *Virgin suckling the Infant Christ* which did not come from the Fesch collection came from Bisenzo.[11] However, he is likely to have bought paintings from other sources. It must have been in this period, for instance, that he was persuaded to buy a controversial version of the Dresden *Magdalen* by Correggio in the Odescalchi collection.[12]

Pre-eminent among the Fesch paintings were Raphael's *Crucifixion*, now in the National Gallery (NG 3943, *The Mond Crucifixion*), and the still more highly valued monochrome by Rembrandt of the *Preaching of the Baptist* (now in Berlin), both of which the National Gallery had attempted to buy at the Fesch sale in the spring of 1845.[13] From Fesch also came Fra Angelico's *Last Judgement* (now in Berlin), and from the Bisenzo collection the *Pietà* then given to Mantegna but by Crivelli (now in the Metropolitan Museum of Art, New York), which had originally crowned a polyptych from Ascoli Piceno (now NG 788).[14] These examples alone suffice to suggest the impact which must have been made by the exhibition of Lord Ward's collection in the Egyptian Hall in Piccadilly when it opened on 1 May 1851.[15] The 50,000 visitors who came to see it in the following fifty-two weeks (among them many 'foreigners of talent and distinction' who had travelled to London for the Great Exhibition) would have found the early Renaissance far better represented in Piccadilly than in Trafalgar Square. The exhibition was continued in the summer of the following year (during June and July). It was open every day 'without the slightest charge' even to cover costs.[16] Lord Ward agreed to lend ten paintings to the Irish Industrial Exhibition in Dublin in 1853 and then nine of the same to the Irish Institution in the following year. Titian's *Virgin suckling the Infant Christ* was among these, which perhaps explains why it was not shown at the Manchester Art Treasures exhibition. The Egyptian Hall seems still

to have been open in the summer of 1855 'as free as the National Gallery, and closed only one day in the week'.[17] Perhaps the munificence with which Lord Ward granted access to his collections stimulated the hope that he might bequeath some of his paintings to the nation. If so, that might explain why he was later selected as a trustee of the National Gallery.

Lord Ward's taste was by no means confined to Renaissance painting. A *Venus* by Canova and Rembrandt's *Saint John Preaching* and some other Dutch pictures were included in the Piccadilly exhibition. Waagen's account (published in 1854 but based on what he had seen in 1851) mentions a Tiepolo, almost certainly one of a pair now in the National Gallery (NG 1192 and NG 1193, both certainly in Dudley's collection by 1868).[18] The *Art Journal* noted only one British painting, a celebrated landscape by Richard Wilson of the River Dee, bought in 1849 at the Coningham sale.[19] There were no modern British paintings, although Lord Ward did acquire some very expensive modern art. He commissioned a version of the *Greek Slave* from the sculptor Hiram Powers (completed in 1848), which he lent to the Art Treasures exhibition in Manchester in 1857.[20]

The collection was probably moved from the Egyptian Hall into Dudley House at 100 Park Lane in 1858, when Samuel Whitfield Daukes (1811–1880)

had completed the remodelling there (the house still survives although much modified internally).[21] In the mid-1850s Daukes also remodelled Witley Court in Worcestershire (an estate purchased in 1838) as Lord Ward's country house. This was an exercise in classical style but with baroque aspects and detailing of exceptional refinement. It is now a shell.[22] The gardens were designed by William Andrews Nesfield (1794–1881) and it was probably Nesfield's idea to create the great Perseus and Andromeda fountain carved by James Forsyth in 1857–60.[23] This, together with the fountain shown at the Paris Exhibition of 1867 and then set up in the marketplace at Dudley in the West Midlands, is perhaps especially revealing of the patron's taste – he is said to have helped design the settings of the jewellery he commissioned, and may also have influenced these bold inventions. He certainly must have agreed with Daukes's idea of integrating the parish church of Great Witley into the design of the house and on the redesign of that church to accommodate the portions of the early eighteenth-century chapel at Cannons.[24] Lord Ward deserves to be remembered as an important promoter of both the conservation and the revival of the baroque.

The picture collection, which continued to expand, was probably divided between Park Lane and Witley Court. Old photographs record the galleries in both houses. That in Dudley

Fig. 5 Photograph of 1882 showing the picture gallery at Witley Court, Worcester, designed by Samuel Daukes.

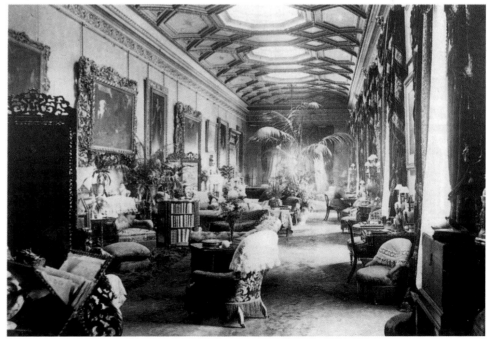

House was 82 feet long, 21 feet wide and 33 feet high, with glazed domes and massive gasoliers and pairs of rich Ionic columns, the paintings covering almost all available wall space.[25] By contrast, the gallery at Witley Court (fig. 5) had something of the character of a drawing room and a conservatory, with clusters of upholstered furniture and palms, lit both from richly draped windows and from apertures in the elegant traceried ceiling.[26] There was no uniform pattern of frame but some of those given to the paintings were very rich. The exceptional frame that had been placed around Garofalo's *Pagan Sacrifice* (NG 3928) by 1868, a rich polished walnut cassetta with applied gilt carved ornament, survives in the National Gallery's frame store.[27]

Public access to these houses was probably very limited but in 1868 Lord Dudley (as he had become) lent forty of his paintings to the National Exhibition of Works of Art, which was shown in George Gilbert Scott's newly built Infirmary in Leeds. Thirty-three of them were displayed in the 'Dudley gallery', likened by the *Art Journal* to the Tribuna in Florence.[28] They included works that were completely different in taste from those which had been the chief attractions in 1851. Of special interest was the larger part of Murillo's series of the *Prodigal Son* (now in the Beit collection in Ireland) which Dudley had purchased in the previous year at the sale of the Marquess of Salamanca in Paris (3–6 June 1867). Also shown was Murillo's early and very large *Death of Saint Clare* (now in Dresden), bought by Dudley at the Soult sale in Paris a few years before.[29] Garofalo's *Pagan Sacrifice* also came from the Salamanca sale.[30]

The London public was given a more complete view of the collection at the second of the Royal Academy's newly instigated winter exhibitions of works of the old masters, held in 1871, where 128 of Lord Dudley's paintings were hung together, mostly in Gallery VI. The *Art Journal* was struck by the 'equally liberal supply of schools spiritual and sentimental', with some French sensuality as well ('an unrivalled display of meretricious and alluring female forms by Greuze').[31] During the 1870s Dudley was openly weeding his collection (something which he had probably been doing privately in previous decades). Forty-six paintings were offered at Christie's on 7 April 1876. But he was also buying lavishly at the same date, paying huge prices for Turner and Landseer, de Hooch and Ostade.[32] Other sales were held at Christie's on

3 May 1884 and 22 May 1886, shortly before and shortly after his death. There were also private sales soon after his death – the Duc d'Aumale acquired Raphael's *Three Graces* for £25,000; Berlin secured the Fra Angelico for £10,000; Cornelius Vanderbilt obtained, for £20,000, Turner's *Venice from the Porch of the Madonna della Salute*, which he then presented to the Metropolitan Museum.[33] The *Three Graces* was surely a painting that the National Gallery needed, since it is companion to the *Vision of a Knight* (NG 213), but the director, Frederic Burton, was by then commonly felt to be insufficiently zealous. He too made overtures to the heirs, but in order to secure the relatively modest prize of Ercole de' Roberti's *The Israelites gathering Manna* (NG 1217) in 1886.[34]

Ninety-one of Lord Dudley's paintings were put up for sale at Christie's on 25 June 1892. They included Raphael's *Crucifixion*, the *Virgin suckling the Infant Christ* by Titian (NG 3948, catalogued here), Garofalo's *Pagan Sacrifice*, and fresco fragments by Correggio, all bought by J.P. Richter for Ludwig Mond.[35] They were eventually bequeathed to the National Gallery. The National Gallery also acquired, with the Salting Bequest, some important Dutch pictures that were included in the sale: Jacob van Ruisdael's *A Ruined Castle Gateway* (NG 2562), Adriaen van Ostade's *Interior of an Inn* (NG 2540),[36] and also a Ghirlandaio *Virgin and Child with Saint John* (NG 2502) which Salting had obtained by 1875. Frederic Burton was outbid at the sale for *The Mass of Saint Giles* (NG 4681); it was, however, presented to the Gallery by the National Art Collections Fund in 1933.[37]

From this account it may be supposed that Lord Dudley owned only masterpieces, but among the Bisenzo pictures was *The Virgin and Child with Saints Dominic and Catherine of Siena* (NG 2484), now agreed to be 'by some feeble follower of Perugino', which came to the Gallery with the Salting Bequest.[38] From the Manfrin Collection via Alexander Barker (with whom Lord Dudley had considerable dealings) came a pastoral *Madonna and Child with Saints* attributed to Palma Vecchio, now catalogued as Style of Bonifazio (NG 3536).[39] From the same source came a copy of Titian's *Three Ages of Man* attributed to Giorgione and now untraced.[40] Another forgotten Giorgione in Dudley's collection was the once-celebrated '*Souper Vénitien*' sold by Celotti to Anatole Demidoff.[41] But no one collecting Venetian paintings of the sixteenth century avoided errors of this kind.

Lesser sales of Dudley's paintings took place in 1900, 1926, 1947 and subsequently. It seems to have taken his heirs a long time to locate everything that he had acquired. Thus the 'Dudley Madonna', the exquisite low-relief marble carving attributed to Desiderio da Settignano (or Donatello), acquired by the Victoria and Albert Museum in 1927, was discovered at Himley Hall in Staffordshire in the 1920s.[42]

NOTES

1. 'The Dudley' was discovered in 1869 and bought by Dudley for £25,000. It was formed into a tiara with 95 smaller diamonds. Publicity is not given to the present whereabouts.

2. Redford 1888, I, p. 400, for the 10,000 guineas he spent on a 'rose pompadour' *garniture de cheminée*.

3. *Dictionary of National Biography*, XX, p. 782 (entry by John Andrew Hamilton).

4. Radmore 1996, p. 27.

5. Cardigan and Lancastre 1909, pp. 45–50. They married on 24 April 1851 and she died on 14 November of the same year.

6. Halévy 1935, p. 83, reported in 1869 that Lord Ward had his 'tête à l'envers' and believed himself to be pregnant with a grand piano. See also Cardigan and Lancastre 1909, pp. 67–8.

7. *The Times*, 4 February 1929. The lodge was presumably on the Invergary estate at Inverness.

8. Minutes of the Trustees, V, pp. 81 and 267.

9. Passavant 1833, pp. 103–4; Passavant 1836, I, pp. 229–31 (his visit was in 1831); Waagen 1838, II, pp. 397–8 (by 1837 the Trustees had understandably removed the little Raphael from the house).

10. *Kunstblatt*, no. 38, 5 August 1847, p. 152.

11. Little is recorded of this collection. However, it received some publicity during the 1830s when paintings in it were engraved for Giuseppe Melchiorri's *L'Ape Italiana delle Belle Arti*, together with fulsome essays (most of them by Melchiorri himself): I, 1835, pp. 37–9 (pl. XXIII–IV; 'Raphael'), pp. 42–3 (pl. XXVII, Ghirlandaio, NG 2502); II, 1836, pp. 1–4 (pl. I, 'Poussin'); III, 1836, pp. 11–12 (pl. VIII, 'Mantegna', in fact Crivelli), pp. 30–2 (pl. XIX, 'Giotto'), and pp. 46–7 (pl. XXVIII, 'Ingegno').

12. *London Review*, 2 May 1863. The *Athenaeum*, 5 July 1851, pp. 722–3, claimed that this purchase was made from the Roman dealer Vallati. Waagen (1854, II, p. 234) did not believe in the attribution.

13. For the National Gallery's bidding see Robertson 1978, p. 88. The Rembrandt is Gemäldegalerie cat. 828K. It was acquired by Bode at the Dudley sale, 25 June 1896, for £2,625 (2,500 guineas). See Brown, Kelch and Van Thiel 1991, p. 178, no. 20 (entry by Van Thiel). Since this is likely to have cost Lord Ward more than 14,000 scudi (the price at which it was bought in at the Fesch auction) it accounts for more than half the sum he paid.

14. Zeri and Gardner 1973, p. 23.

15. Connoisseurs such as the Eastlakes were able to visit the collection two years before (see Robertson 1978, p. 108).

16. *Art Journal* 1851, pp. 149–50; 1852, p. 198. The space in the Egyptian Hall used for the

display was later known as the Dudley Gallery when (between 1865 and 1875) it housed an annual exhibition of watercolours.

17. *Athenaeum*, 14 July 1855.

18. Waagen 1854, II, p. 235. For the Tiepolos see Levey 1956, p. 96, notes 21–2, and p. 98, note 18. These were certainly in Dudley's collection by 1868.

19. For Coningham see Haskell 1991. The Wilson, sold at Christie's on 25 June 1892, lot 22, is *The View of the River Dee (with Anglers)*, no. II, Constable 1953, p. 174 (then in the collection of Mrs J.S. Courtauld).

20. Wunder 1991, II, pp. 161, 166. The version now in the Corcoran Gallery of Art, Washington DC (no. 73.4), was originally commissioned by Lord Ward but was released by him to James Robb of New Orleans. The version carved in its place (which was, at Ward's insistence, a replica with variants) is said (ibid., p. 166) to have been destroyed by enemy action at Witley Court in 1944, but no such action is recorded by Gray 1997. Much that survived the fire of 7 September 1937 was auctioned in 1938 and more still was sold by a salvage dealer in 1954 (Gray 1997, pp. 16–17).

21. Pearce 1986, p. 134. Daukes is frequently misspelled Dawkes.

22. Hussey 1945, pp. 1036–9; also Gray 1997.

23. Gray 1997, pp. 30–6.

24. Hussey 1945, pp. 992–5.

25. Pearce 1986, p. 133, fig. 99.

26. Gray 1997.

27. IT 3 in Paul Levi's frame survey. The frame bears a label for the Leeds exhibition of 1868.

28. *Art Journal* 1868, p. 137.

29. For the *Prodigal Son* series see Gaya Nuño 1978, nos 260, 262, 264, 266, 267, 269. One of the series (the Prodigal's Return) was acquired from the Vatican in exchange for a Fra Angelico and a Bronzino! For the Saint Clare (Dresden, Gemäldegalerie, 703B) see ibid. no. 12.

30. Gould 1975, pp. 95–6.

31. *Art Journal* 1871, p. 49. Halévy (1935, p. 83) also mentions his passion for Greuze.

32. Redford 1888, I, pp. 217, 246, 436.

33. Butlin and Joll 1977, pp. 193–4, no. 362; Metropolitan Museum 99.31.

34. Minutes of the Trustees, VI, pp. 11, 13.

35. Lots 81, 89, 64, 54, 55.

36. For the Salting Bequest see Penny 2004, pp. 387–90. For the Ghirlandaio see Davies 1961, p. 223.

37. Minutes of the Trustees, VI, pp. 223–4 and 226.

38. Bought by Salting at the 1892 sale (lot 40) but sold by him and then reacquired by him after 1904. Davies 1961, p. 413.

39. Gould 1975, p. 33.

40. Lot 66 in the 1892 sale, bought by Farrer.

41. For Celotti see Penny 2004, pp. 363–4. Lot 65 in the 1892 sale.

42. Himley had been the chief seat of the 1st Earl of Dudley (for its history see Radmore 1996). It was seldom occupied by the Lord Dudley who is the subject of this essay, but after the sale of Witley Court and Dudley House the family retreated there. For the relief see Avery 1998.

BARONE FRANCESCO GALVAGNA (*c*.1795–1860),

see pp. 328–9

THE 6th EARL OF HAREWOOD (1882–1947)

Henry George Charles Lascelles, Viscount Lascelles and (from 1929) 6th Earl of Harewood, was the only British nobleman to collect old master paintings on a grand scale in the twentieth century. The virtual abandonment of this activity by others of his class must be related to a decline in wealth, but since the extravagant recreations of horse racing and blood sports retained their popularity, some further explanation is required. It may be observed that Lascelles bought most of his pictures from old British collections and housed them in historic buildings which he did much to preserve. Thus his collecting may be related to that concern for preserving the national 'heritage' which manifested itself in the foundation of the National Art Collections Fund and the National Trust.

He travelled to Italy as a young man and made some minor art purchases in Rome in 1906,[1] but he began collecting seriously only after inheriting a large fortune from his great uncle, the 2nd (and last) Marquess of Clanricarde, in 1916 – a reward for civil behaviour towards an uncouth and miserly old bachelor.[2] This bequest included a substantial collection of Dutch and Flemish paintings and some Italian landscapes and *vedute*.[3] Lascelles concentrated on acquiring Italian paintings of the sixteenth century together with some earlier Italian works and several later Spanish ones. The only major Flemish painting that he bought was quite unlike those he had inherited.

Most of Lascelles's major acquisitions were made within a five-year period: El Greco's *Man, Woman and Monkey* from Arthur Ruck in September 1917 for £10,000; Titian's *Francis I* (fig. 6) in the same year from Agnew's, who had bought it in Munich from the heirs of the painter Franz von Lenbach (1836–1902); Sebastiano del Piombo's group portrait then described as *Amerigo Vespucci relating the Discovery of America* (now in the National Gallery of Art, Washington) from Colnaghi in August 1918 for £12,000; Cima da Conegliano's *Saint Jerome* in March 1918 for £4,000; Rubens's *Queen Tomyris* (now in the Museum of Fine Arts, Boston) from Ruck

in June 1919 for £21,000; and Titian's *Death of Actaeon* (now in the National Gallery, see pp. 248–59) for £10,000, spread over 1920 and 1921.[4] By 1921 he had acquired a house in which to display the collection, and his purchases declined thereafter both in quantity and in importance. In 1922 he married Princess Mary, only daughter of King George V and Queen Mary (from 1932, Princess Royal).[5]

Lascelles employed Tancred Borenius as his adviser. He could not easily have done better. Borenius (1885–1948) was born in Wiborg, Finland. He had a doctorate in art history (from Helsingfors), something which, since Gustav Waagen, had been regarded as a Germanic absurdity by much of the London art trade. He had, moreover, worked with Von Bode in Berlin and at the Prussian Institute in Rome. However, Borenius's flamboyant Finnish patriotism spared him from the prejudice against everyone and everything German which was so strong in Britain during the period of the Great War. 'The Doctor', as Borenius came to be known, obtained a lectureship (later a professorship) at University College in 1913 and his new edition of Crowe and Cavalcaselle's *History of Painting in North Italy* had appeared in the previous year.[6] By 1916 his academic credentials were complemented by a knowledge of London's art trade and, through his active role in the Burlington Fine Arts Club, by an acquaintance with the leading gentlemen connoisseurs, including both Sir Herbert Cook and Robert Benson, with whom he collaborated in 1913 and 1914.[7] He met Lascelles through the club, and his anxiety to be accepted into English society ensured that he was especially zealous in his service to him.

Lascelles was serving at the Front when he decided to form his collection, so it is not surprising that he depended upon someone else to research, negotiate and bid for him. But it is clear from letters exchanged with Borenius on the occasion of the sale by Sotheby's of old master drawings from Wilton House in July 1917, and from Poynter's collection in April 1918, that Borenius was free to negotiate with dealers on Lascelles's behalf, to disregard items that Lascelles had selected as of interest, and even to bid on works which Lascelles had not selected (which at the Poynter sale included a major drawing by Signorelli and 'the finest Carracci drawing known to me'[8]).

In many respects the collection reflected Borenius's tastes and interests. A drawing by Montagna bought at the

Fig. 6 Titian, *Portrait of Francis I, c.*1539. Oil on canvas, 101 × 83 cm, in its frame by Ferruccio Vannoni, *c.*1925. Yorkshire, Harewood House.

Poynter sale for the high price of £960 was one that Borenius had not known when he published his monograph on the painters of Vicenza in 1909, but he published it in a separate article two years before the sale together with a Carpaccio which Lascelles also bought,[9] and there were several fine paintings by artists from the neighbouring cities of the Veneto also dating from the early sixteenth century.[10] The *Saint Jerome* by Cima da Conegliano and the portrait of a Mocenigo procurator by Alessandro Longhi (both now at Harewood) were discoveries by Borenius, published in advance of their purchase by Lascelles.[11] Not all the attributions are now accepted: the Rubens, for instance, is considered to be partly a workshop piece.[12] It now seems obvious that the portrait of an old man described as 'Sebastian Cabot' by Lotto when bought in 1920 for £2,700 is not by Lotto,[13] nor, clearly, is the *Saint Sebastian* bought from Langton Douglas in 1917 for £924, painted by Antonio Pollaiuolo.[14] But in the former case the attribution was approved by both Roger

Fry and Bernard Berenson (it was first challenged by Roberto Longhi). In the latter case Borenius was careful to catalogue the painting as by the 'school' of Pollaiuolo. It is hard to believe that anyone else could have formed a finer collection in the first five years of his employment by Lascelles.[15] The collection assembled for Lascelles was in many ways as remarkable as that formed by J.C. Robinson for Sir Francis Cook in the 1860s and 1870s or that formed by John Paul Richter for Ludwig Mond in the 1880s.

That Lascelles was interested in buying old master drawings as well as paintings obviously reflects his seriousness as a collector. He was indeed prepared to pay very high prices for them. Having failed to secure a magnificent finished study by Veronese for one of the ceilings of the Doge's Palace at the Wilton sale, he then bought it from Agnew's for an additional ten per cent, paying £1,815.[16] An expensive frame of carved pearwood was supplied for this drawing in 1919,[17] which indicates that the drawings as well

as the paintings were intended to be hung (something that had been rare in British collections during the nineteenth century). After the display in his new home was complete, Lascelles bought little in the field of old master drawings.[18] Chesterfield House in Great Stanhope Street, which Lascelles bought, restored and furnished for his royal bride and his collection, was perhaps the masterpiece of Isaac Ware, completed in 1749 for the 4th Earl of Chesterfield. It contained distinguished stucco work, some of which was rococo in style and some more in the manner of James Gibbs.[19] Two of the larger paintings retain superb frames carved in a style to match the stucco.[20] Other paintings were given Renaissance revival frames of the kind made in Florence by Vannoni for Duveen (fig. 6).[21]

On the death of his father in 1929, Lascelles became the 6th Earl and inherited Harewood House near Leeds in Yorkshire, a handsome classical house built for Edwin Lascelles by John Carr of York between 1759 and 1765 and given superb interiors designed by Robert Adam, which were completed in the early 1770s.[22] Lascelles had surely been thinking about the family collections long before he inherited them. In December 1917 he had purchased one of Lawrence's full-length portraits of the prime minister George Canning for 1,000 guineas[23] – Canning being an important family connection, for Lascelles's grandmother had been his granddaughter. In 1919, 1927 and 1931 Lascelles had bought watercolours by Thomas Girtin which had belonged to the important group of Girtin's work formed by his pupil and champion Edward Lascelles (1764–1814, eldest son of the 1st Earl of Harewood, who inherited from his uncle Edwin, the builder of the house) but had been sold by the 4th Earl in 1858.[24] By August 1931 some of the old master paintings were being sent from London to Harewood[25] and in April 1932 the remaining contents of Chesterfield House were auctioned. The house was demolished five years later.[26]

In 1931 Lord Harewood sold the Canning jewel, then still believed by many to have been designed by Benvenuto Cellini, at Sotheby's for £10,000.[27] This may have been to help pay death duties. He must of course have also been affected by the economic depression. In any case he was now over fifty years of age and doubtless wished to concentrate his energy and resources on restoring and improving the family seat. The furniture made by Chippendale for

Adam's interiors was reassembled and re-upholstered. Some of Sir Charles Barry's modifications were removed. Sir Herbert Baker made a new dressing room for the Princess Royal in the Adam style.[28] Holder cleaned the landscape overdoors by Turner and Reynolds's great full-length portrait *Mrs Hale as Euphrosyne* (then in the library).[29] Paintings were also commissioned for Harewood from Seago and Munnings.[30] These were more conservative works than Nevinson's *A Strafe* which he had bought in 1916, or indeed than Sargent's *Marble Quarries* which he acquired in 1926.[31] However, in 1936, when it came to having himself commemorated full-length in robes of the Order of the Garter, Harewood did not turn to one of the established portrait painters but to William Nicholson, who did not normally undertake commissions of this kind, and it is a remarkable tribute to him that Nicholson agreed to embark on this heroic but doomed endeavour.[32]

Also in 1936 Borenius's catalogue of works of art belonging to the Earl of Harewood was privately printed. This might be taken as an indication that the collection of old master paintings and drawings was complete, and also that it was hoped that it would be preserved at Harewood, together with the family portraits and the watercolours and the great collection of porcelain which had been there for over a century. In fact Lord Harewood and the Princess Royal continued to acquire old master paintings, even if on a relatively small scale,[33] and they showed no aversion to the idea of selling works. Indeed, Bassano's *Sower* (now in the Thyssen-Bornemisza Collection) had been sold in 1934,[34] Simone Martini's *Angel of the Annunciation* (now in the Kress Collection, National Gallery of Art, Washington) in 1936,[35] and sales continued after the publication of the catalogue: the Rubens was sold in 1941 to the Museum of Fine Arts, Boston, through Robert Langton Douglas. And at the end of the war, when the survival of the great country houses must have seemed doubtful, Harewood did not categorically reject the possibility that Titian's *Death of Actaeon* might have to be sold. Duveen's London office called New York on 1 May 1944 regarding 'Owner Titian in Leeds', with a note that an interview regarding the picture had been 'politely refused unless can submit direct offer'.[36]

Harewood's views on the conservation of the nation's heritage had been outlined in a draft letter written on 12 May 1922, when he was Lord Lascelles. It is addressed to 'Sir Charles' (presumably Sir Charles Holmes, director of the National Gallery).[37] Although Harewood was, of course, aware that works of art could be exempt from inheritance tax, provided that they were not sold, he pointed out that so long as levels of taxation were very high the owners of large properties would always be tempted to sell them, because the alternative was to pay the tax 'out of that portion of the estate which brings in income'. An ideal solution would be for owners to find a way to generate income from the art. Schemes designed merely to compensate owners who made their houses and works of art available for public viewing, such as Sir Charles was exploring, would be hard to operate fairly and would, he believed, be unlikely to enjoy the support of the Treasury. The public had been allowed to visit Harewood House between the wars, but this was not considered as a commercial venture and indeed it was claimed that Lord Harewood was 'put to enormous expense' by the damage that had been caused to his drives by 'char-a-bancs'.[38]

In the half-century following Harewood's death in 1947, incentives to open houses to the public and ways of making access a genuinely commercial proposition were in fact devised.[39] Harewood House is one of the most successful examples of this, but it entailed a transformation of the nature of the house such as would have been impossible to imagine when it was not only a private residence but a royal one. The Harewood House Trust provides public recreation and education on so large a scale that few taxpayers could object to the grants given to support the maintenance of the building.[40] Old master paintings and modern art are part of the appeal, and enough of the former remain for them to be fairly described as a rich collection. Many paintings have, however, been sold, including, of course, Titian's *Death of Actaeon*. That painting was one which many felt to be more appropriately displayed in the National Gallery, and the 7th Earl of Harewood, when obliged to sell it, did his best to ensure that it stayed in the country. Richard Buckle, who did much to promote the appeal to acquire it 'for the Nation', was not only a friend of Lord Harewood but the author of a guidebook to Harewood House.[41] After the 6th Earl's death the house had been offered to the Government and, after obscure negotiations, declined.[42] Since then it may be said to have become a form of public property although with private accommodation for the family that created it. The great paintings it houses are on the whole more happily displayed than they would be in most public galleries.

NOTES

1. Borenius 1936, nos 93–4, and p. 66, nos 122–3.

2. Hermann 1981, p. 241 (but the claim that the reward was quite unexpected is hard to believe).

3. Borenius 1936, pp. 77–98, nos 142–203 (Dutch), and pp. 59–73, nos 106–41 (Flemish). Landscapes by Rosa (ibid., p. 26, nos 55–7) were sold at Christie's, London, 2 July 1965, lots 55–7. *Vedute* by Guardi and Canaletto (see ibid., pp. 9 and 14, nos 10–12 and 22–4) were sold at Christie's, 2 July 1962, lots 50–1.

4. For these pictures see Borenius 1936, pp. 28–30, no. 62; pp. 47–8, no. 85; pp. 63–4, no. 117. The prices given here come from accounts in the archive at Harewood House shown me by May Redfern. I do not know the amount that was paid for the Titian portrait, for details of the acquisition of which I depend on Wethey 1971, p. 101, no. 36.

5. In some accounts Lascelles is said to have purchased Chesterfield House in 1922, but, if so, he must have occupied it previously because the archive at Harewood House includes a receipt for rehanging pictures there in July 1921.

6. Crowe and Cavalcaselle 1912. For Borenius in general see Hermann 1981, pp. 240–4, also Sitwell 1974, pp. 162–3, and Langton Douglas 1948.

7. Benson 1914, p. xx, acknowledges his help, and Borenius's catalogue of the Cook Collection at Doughty House was published in 1913 (Borenius 1913).

8. Letters from Borenius to Lascelles of 24 and 25 April 1918 are in the archive at Harewood House. For a letter of 2 August 1917 from Lascelles in the trenches see Hermann 1981, p. 161. The Carracci was by Ludovico Carracci and was lot 31 on 24 April 1918; the Signorelli was lot 174 on the day following.

9. Lot 93. See Borenius 1909, pp. 101–12, for an excellent account of Montagna's drawings. See Borenius 1916 for his publication of the drawing (Puppi 1962, p. 147, fig. 166).

10. For example, the *Siege* by Domenico Morone (Borenius 1936, p. 21, no. 43) and Morando's portrait bought from Langton Douglas in 1918 and now in the National Gallery of Victoria (Borenius 1936, pp. 20–1, no. 42; sold at Christie's on 2 July 1985).

11. Borenius 1911 (for Cima) and Borenius 1915 (for Longhi).

12. Boston, Museum of Fine Arts, 41.40. See McGrath 1997, II, pp. 14–25, no. 2 (and pp. 20–1 for the part of the workshop).

13. The picture was bought on 24 June 1920. See Borenius 1936, p. 20, no. 41, citing Fry and Berenson 1932, p. 309. The painting is at Harewood House.

14. Bought on 1 March 1917. See Borenius 1936, p. 24, no. 49. Also at Harewood House.

15. One or two of the paintings now at Harewood House are in poor condition – most notably the two panels by Giovanni Bellini – but it is possible that when Borenius recommended them they looked very different.

16. Sotheby's, London, 5 July 1917, lot 438. Borenius 1936, p. 40, no. 74. See Cocke 1984, pp. 208–9, no. 88.

17. Payment is dated 26 February 1919. Receipts from Colnaghi indicate that the drawings by Claude which Lascelles bought were also framed.

18. Thirteen old master drawings were bought for Lascelles by Agnew's at the Northwick sale on 5 and 6 July 1921. Thereafter, the works on paper that he acquired were usually watercolours. Many of the drawings were sold or offered for sale at Christie's on 2 July 1965 and 25 June 1968.

19. Colvin 1978, p. 866 (pp. 864–7 for Ware in general). See also Country Life for 25 February and 4 March 1922.

20. Rubens's Queen Tomyris (Borenius 1936, pp. 63–4, no. 117), now in Boston, and the full-length Veronese portrait still at Harewood. However, the frame of the latter appears to have been made for a Guido Reni, presumably the Magdalen bought for 17 guineas at Christie's, London, on 25 January 1918, which in 1936 was at Goldsborough Hall (Borenius 1936, p. 25, no. 51). The Rubens hung at the top of the staircase in Chesterfield House.

21. Receipts from Vannoni are dated 1931 and 1932, but the frame on the Titian portrait – a fine example of a pierced hollow frame – was certainly earlier in date since it is shown in a painting of the library by Richard Jack dated 1928. It incorporates the French king's emblem of the salamander.

22. Colvin 1978, p. 193 for Carr and p. 52 for Adam; Hussey 1956, pp. 61–9 for Harewood in general.

23. Part of the 'Peel Heirlooms' sold by Robinson and Fisher on 8 December 1917.

24. The receipt for the second of these is dated 21 March 1927. The other dates are given in Borenius 1936, pp. 132–3, nos 306–8 (the last one is in fact specified as a purchase by the Princess Royal). For Edward Lascelles and Girtin see also Hawcroft 1975, pp. 54–5. For other Girtins bought by Lascelles see Borenius 1936, p. 134, nos 310–13. One Girtin alone seems never to have left the collection (ibid., no. 309).

25. See the letter from Borenius to Harewood of 14 August 1931 in the Harewood House archive.

26. Some elements were salvaged. For instance, the gates now on the Leeds Road at Harewood came from Chesterfield House, and parts of the railings were used for the front door of the house. Other pieces of railing were sold at Christie's, London, on 3 October 1994 as lot 104.

27. Sotheby's, 16 July 1931. Acquired by the Victoria and Albert Museum M.2697-1931. It is not now regarded as a Renaissance work.

28. Baker 1944, p. 140. He recalled that the Princess took a keen interest in heraldry and symbols. He also advised on the lighting of the pictures and of the Adam rooms.

29. Receipt dated 31 March 1930. Reynolds's painting had previously hung in the gallery. By 1936 it had been moved to the Music Room – an inspired position which one scholar supposed had been intended by the artist (Penny 1986, pp. 27–8).

30. For these paintings see Harewood 1995.

31. Langton Douglas was paid 1,000 guineas for the Sargent on 22 September 1926 (receipt in Harewood House archive). The Nevinson (Borenius 1936, pp. 158–9, no. 385) was

purchased as A Straffing from the Leicester Gallery, London.

32. Payments to Nicholson were made between 1936 and 1938 but the picture was presumably complete in 1936, when included in Borenius 1936, p. 159, no. 386. Harewood also owned The Discreet Diner (ibid., no. 387).

33. For instance a capriccio by Canaletto was bought in 1937 (sold at Christie's on 2 July 1965, lot 76), and in 1945 and indeed in 1947, after Lord Harewood's death, the Princess Royal bought a couple of the little replicas of Italian paintings made by David Teniers, twenty-six examples of which had been bought by Lascelles – one of the series had also been inherited from Clanricarde (Borenius 1936, p. 69).

34. See Ekserdjian 1988, pp. 28–9, no. 5.

35. 1939.1.216.

36. Duveen Papers, Box 321. Reel 176 (cables from London).

37. My attention was drawn to this letter by the typescript of a lecture given at Harewood by Jane Sellars on 30 October 2000 which was shown me by May Redfern.

38. Mandler 1997, p. 303.

39. For this episode generally see especially Mandler 1997.

40. Harewood c.1995, p. 3.

41. Buckle 1959.

42. Mandler 1997, p. 340 and p. 460, note 69.

FRANCIS CHARLES SEYMOUR-CONWAY, 3rd MARQUESS OF HERTFORD (1777–1842),

see p. 393

SIR ABRAHAM HUME BT (1748/9–1838)

Abraham Hume married in 1771, succeeded to his father's baronetcy in the following year, served as high sheriff of Hertfordshire, where he owned the estate of Wormleybury, in 1774, and sat as Member of Parliament for Petersfield 1774–80 and Hastings 1807–18. He was elected a fellow of the Royal Society in 1777 and served as vice president of the Geological Society (of which he was a founder) from 1809 to 1813.[1] He formed a collection of minerals and a very fine collection of paintings. He was one of the most discerning connoisseurs of painting in Britain.

The first evidence of Hume's picture collecting appears in 1779, the date he recorded for the acquisition of Bassano's Journey of Abraham from the painter, connoisseur, dealer and noblemen's guide in Italy, William Patoun (d. 1783).[2] Patoun sold him other paintings as well, including the Venus and Cupid by Cambiaso which is now in the Art

Institute in Chicago,[3] and gave him three sketches by Barocci.[4] Hume's friendship with Sir Joshua Reynolds must also have quickened his taste for old master paintings. An interest in technique is suggested by the fact that Reynolds, at Hume's suggestion, painted his wife on wood rather than canvas.[5] Reynolds bequeathed to Hume the choice of his pictures by Claude; he took the Sunrise View of the Roman Campagna (now in the Metropolitan Museum of Art, New York).[6] Hume also bought at Reynolds's sale at least one of the artist's sketches and an old copy of Leonardo's Mona Lisa.[7]

Hume's collecting must have been stimulated by the Grand Tour that he made in 1786–7 with his wife and their eldest daughter.[8] They made purchases in Florence, Rome and Venice. In particular, in Venice he acquired two portraits believed to be by Titian.[9] He also made contact with the scholarly Venetian dealer Giovanni Maria Sasso (1742–1803), who had previously acted as a supplier for other English collectors,[10] and thereafter he employed Sasso as an agent. Their correspondence in Italian survives in the National Gallery's archive and the archive of the Seminario Patriarcale of Venice and has recently been published by Linda Borean together with a full scholarly commentary.[11]

A fascinating aspect of this correspondence is the very keen interest that Hume had in the condition of the paintings he was offered and his knowledge of not only artists' techniques but also those of picture restorers. Hume was a declared enemy of picture cleaning, which he believed had had an especially ruinous effect on Venetian paintings. An attractive feature of the Descriptive catalogue of a collection of pictures, comprehending specimens of all the various schools of painting, which Hume had privately printed in 1824,[12] is the acknowledgement of 'Mr Sasso' in his preface: 'no one deserved more the confidence that was placed in him, possessed more knowledge or acted with greater integrity.'[13]

Of the 154 paintings in this catalogue, 45 are Venetian, and this was the school in which Hume (and Sasso, of course) took most interest. The only examples of what he regarded as the early phases of European art in the collection were Venetian. Notable among these were Giovanni Bellini's Portrait of a Condottiere (now in the National Gallery of Art, Washington[14]) and the Adoration of the Shepherds by Catena (now in the Metropolitan Museum, New York),

which Sasso had obtained for him from the Giustiniani collection in 1791 as a late work by Giovanni Bellini, and which 'might to inexpert eyes seem to be the work of Titian when still under Bellini's tutelage'.[15] In 1819 he purchased from Féréol Bonnemaison in Paris the exquisite *Rest on the Flight into Egypt with Saints* by Cima da Conegliano (now in the Gulbenkian Foundation, Lisbon), which Waagen considered the 'most beautiful little picture of domestic devotion that I have ever seen by this master'.[16]

However, it was Titian and Titian's followers that Hume valued above all. He wrote the first book on Titian to be published in England (*Notices of the Life and Works of Titian*) and believed that he owned twenty-one of his works. Among these, several of the portraits are fine examples of paintings influenced by Titian, but perhaps the only painting that Hume believed to be by Titian which is highly regarded today is the *Death of Actaeon*.[17] Here, then, is the weakness in his connoisseurship.

Hume believed that the 'real genius of a master is more peculiarly displayed in his first thoughts' and that the finished work was often equivalent to a copy, albeit made by the artist's own hand, an idea that he perhaps owed to Reynolds or to Patoun. It was the priority given to sketches that partly explains why Waagen considered the collection to be one that might have been formed by a painter.[18] And indeed Hume was an amateur painter.[19] He was pleased to acquire the *Death of Actaeon* precisely because it had 'not received the finishing touches' and one could admire, in the trees and water especially, the 'spirit and vigour with which Titian exercised his pencil, in laying in his pictures'.[20]

One of the Titians in Hume's collection (today at Belton House in Lincolnshire) was a small version of the *Penitent Magdalen* which Sasso had acquired in 1791 from the Muselli collection. It is doubtless a copy, but is of superb quality and was accepted as a Titian by Ridolfi in the seventeenth century and by Waagen in the nineteenth[21] – as well as by Sasso in the eighteenth. However, this is not a characteristic example because it is a highly finished picture. The problem with many of Hume's Titians is that they were small works which he – and Sasso – believed to have been made as preparatory sketches for larger works, but which now seem more likely to have been free studies by later artists.[22] On the other hand, he certainly owned exquisite preliminary sketches on panel by Rubens

(such as *The Meeting of King Ferdinand of Hungary and Cardinal-Infante Ferdinand of Spain at Nördlingen*, now in the J. Paul Getty Museum[23]) and by Van Dyck (such as *Saint Sebastian tended by an Angel* (fig. 7), now in the same museum and previously in the collection of Kenneth Clark[24]), and it is easy to understand how he would have assumed that the practice of seventeenth-century Flemish artists followed that of the great Venetians of the sixteenth.

The above account has not done justice to the wide range of Hume's taste. He owned very good Bolognese paintings, many of which he also acquired by correspondence, using as his agent Sasso's friend Giovanni Antonio Armano.[25] He also owned a few very choice Dutch ones, including Rembrandt's *Aristotle contemplating the Bust of Homer*, now in the Metropolitan Museum, New York,[26] and Aelbert Cuyp's *The Maas at Dordrecht*, now in the National Gallery of Art in Washington.[27] Most of the pictures in his collection were small – the *Death of Actaeon* must have been the largest – which is unsurprising since he kept them in his London house, 29 Hill Street, Berkeley Square.[28] One larger painting that Hume acquired from Sasso, *The Last Supper*, recently recognised as an important early work by Jacopo Bassano (he believed it to be by Palma Vecchio), was presented by him in 1797 to the parish church of Wormley in Hertfordshire.[29] His will reveals that four Renaissance portraits (one of them

Fig. 7 Anthony van Dyck, Oil sketch for *Saint Sebastian tended by an Angel*, *c.*1630–2. Oil on wood, 40.6 × 30.5 cm. Los Angeles, The J. Paul Getty Museum.

attributed to Tintoretto) were 'fitted into the walls of the drawing room' at Wormleybury surrounded by 'Gibbins carving' (presumably frames in the style of Grinling Gibbons).

Although the printing of his catalogue in 1824 suggests that Hume regarded his collection as complete, some copies include an appendix listing twenty-two additional acquisitions, the latest of which is dated to 1829, when he was nearly eighty.[30] By then he must have been much exercised as to the future of his collection. He gave his Claude *Sunrise* to his eldest daughter, Amelia (a talented painter of landscapes), and her husband, Sir Charles Long (created Baron Farnborough in 1826), but they had no children and Lady Farnborough died in 1837, a year before her husband and her father. On the other hand, Hume's younger daughter Sophia, who had married John Cust, 2nd Baron and 1st Earl Brownlow (1779–1853), in 1810 and died in 1814, had left two sons, John Hume Cust, Viscount Alford, and Charles Hume Cust, and a daughter, Lady Sophia Cust, the eldest child. The majority of the paintings were assigned as heirlooms in 1834 to Viscount Alford,[31] but a number of others were separately bequeathed to him and to Charles and Lady Sophia (who had married Christopher Tower in 1836).[32]

Alford died young, in 1851, before his father, and the paintings passed to his son John (1842–1867), who became 2nd Earl Brownlow in 1853, when still a minor. He also inherited the massive Bridgewater estates and took the surname and arms of Egerton with the earldom. By 1851 the paintings were mostly divided between Ashridge Park, Hertfordshire, and Belton House, Lincolnshire.[33] On the 2nd Earl's premature death his heir was his younger brother Adelbert, the 3rd and last Earl of Brownlow (1844–1921). It was he who sold a Van Dyck portrait of a mother and child to the National Gallery in 1914[34] and also tried to sell the *Death of Actaeon* to the Gallery at the same time. After his death most of the paintings kept in Ashridge and at Carlton House Terrace in London were dispersed in sales in 1923 and those kept at Belton were sold in 1929.[35] There was a further sale in 1984,[36] in which year Belton House, together with a few items in Hume's collection, was acquired by the National Trust.

Hume is important not only as a collector but as a founding director of the British Institution, which did much to foster the atmosphere in which the creation of the National Gallery became possible. He was related by marriage to the Duke of Bridgewater, who acquired a sizeable portion of the Orléans Collection (Hume's wife, Lady Amelia Egerton, the daughter of John Egerton, Bishop of Durham, was the sister of the last two Earls of Bridgewater, and niece of the last two dukes). His eldest daughter's husband, Charles Long, Lord Farnborough – known as the 'king's spectacles' because he was chief adviser to King George IV on his collection, and on much that the king planned for the embellishment of London – was perhaps the single most influential figure in the London art world in the early nineteenth century. Hume seems to have been on very close terms with him and they were depicted together in Pieter Wonder's painting of *Patrons and Lovers of Art*.[37] But Hume seems to have had little interest in British art after the death of Reynolds, indeed little interest in modern art of any kind except, typically, for a few very choice Venetian paintings, notably several Canalettos, including the celebrated view of the Pra della Valle which Tiepolo was said to have kept in his bedroom,[38] and an erotic pastoral which, together with a delightful portrait of his daughter Sophia, Domenico Pellegrini seems to have painted for him in London.[39] However, at the very end of his life he seems to have been taken by the talents of William Collins (1788–1847), whose *Landscape with Children examining Fish on the Sea Shore* was among the last works added to the revised edition of his catalogue.[40]

NOTES

1. Burrell 2003, pp. 86–8. provides a succinct biography. See also Russell 1984 and Lloyd 2004.

2. For Patoun see Ingamells 1997, pp. 746–7. For the Bassano see Hume 1824, no. 41.

3. Lloyd 1993, pp. 58–9, no. 88.

4. For the Baroccis see Hume 1824, nos 49, 50 and 51. One of these (49) is in the Ringling Museum, Sarasota, S 35, now regarded as an unfinished copy (Tomory 1976, p. 168, no. 177).

5. Hume 1824, no. 138; Mannings 2000, I, no. 965 (as on canvas laid down on panel), II, fig. 1455. The painting is at Belton House.

6. Hume 1824, no. 136; Metropolitan Museum 47.12. See also Rothlisberger 1968, I, p. 235, no. 591, for a notable drawing by Claude in Hume's collection.

7. Hume 1824, no. 48; Burrell 2006.

8. Ingamells 1997, pp. 533–4; Borean 2005, pp. 19–24. It is possible that he had previously made this tour as a bachelor.

9. Hume 1824, nos 12 and 13. See Wethey 1971, p. 175, no. X78.

10. For a general survey of Sasso see Orso 1985–6.

11. Borean 2005.

12. Hume 1824.

13. Hume 1824, unpaginated preface.

14. Hume 1824, no. 2; NGA 1939.1.224 (Kress). Now recognised as a portrait of Giovanni Emo but cautiously catalogued as 'attributed to Giovanni Bellini' by Brown (in Boskovits and Brown 2003, pp. 75–81), but surely a superb example of Bellini's early portraiture severely damaged when on the art market in the early twentieth century. It was perhaps one of the paintings acquired by Hume from Dr Pellegrini in Venice in 1786. See Borean 2005, p. 81.

15. Hume 1824, no. 1; Metropolitan Museum 69.123; identified as by Catena by Berenson; Robertson 1954, pp. 60–1, no. 36 (when with Contini Bonacossi); Zeri and Gardner 1973, pp. 18–19; Borean 2005, p. 82.

16. Hume 1824, no. 3; Humfrey 1983, pp. 108–9, no. 61; Waagen 1854, II, p. 314. The attribution to Cima was acknowledged by Hume in a note on page 50 of the revised edition of his 1824 catalogue.

17. Hume 1824, no. 22.

18. Waagen 1838, II, p. 201.

19. A landscape by him was the last item on the list of paintings given by Hume as heirlooms to the Brownlow family.

20. Hume 1824, no. 22.

21. Waagen 1838, II, p. 202; Borean 2004; Borean 2005, pp. 71–2, 188–91, and fig. 32.

22. Examples include Hume 1824, no. 14, the 'original study' for Titian's *Presentation*, bought 1790, sold 1923 for 16 guineas (lot 59), bought for the family and now at Belton House, see Borean 2005, p. 69 and fig. 28; no. 16, the 'original study' for Titian's *Venus and Adonis*, bought 1792, sold 1923 for 21 guineas (lot 18), now untraced; no. 21, the 'original study' for *La Fede* by Titian, sold 1923 for 20 guineas (lot 64), also untraced. The very good copy after Tintoretto's *Removal of the Body of Saint Mark* (Borean 2005, p. 160, note 99 and fig. 49) is another example. For the whole question of sketches before and after see Borean 2005, pp. 65–72.

23. Hume 1824, no. 96. J. Paul Getty Museum, 87.PB.15.

24. J. Paul Getty Museum, 85.PB.31.

25. Armano deserves more study. For what has been published concerning him see Borean 2005, pp. 1–4, note 3. Ludovico Carracci's *Flagellation* (Musée de la Chartreuse, Douai) merits special notice (Hume 1824, no. 65; Broggi 2001, I, pp. 119–22, no. 14; II, figs 46–8; Borean 2005, fig. 5).

26. Hume 1824, no. 116; Bredius 1971, p. 594, no. 478, fig. on p. 386. It is typical of Hume that he declined to purchase the companion painting *Homer Dictating*, which was imported with the *Aristotle* from Naples in 1814 but was in less good condition. In addition, Hume formed a large collection of Rembrandt's etchings, which were sold at Christie's on 1 June 1878.

27. Hume 1824, no. 111; National Gallery of Art 1940.2.1. For Waagen this was the 'capital picture of the whole collection' (1838, II, p. 206). NG 2532, a landscape by Wijnants, also comes from Hume's collection.

28. Waagen 1838, II, pp. 206–7, describes the paintings as hung throughout the house. Hume may also have kept a few of his paintings at Wormleybury, his house in Hertfordshire.

29. Joannides and Sacks 1991; Borean 2005, pp. 85–6.

30. Hume 1824 (revised), no. 162, Rubens's sketch for the *Death of Hippolytus*, bought from Alexander Day, who acquired it in Rome. I am grateful to Michael Burrell for information about the revision of the 1824 catalogue.

31. 118 paintings were given in entail in a deed of settlement dated 27 February 1834 (119 are listed but no. 23 is given two numbers in error). A transcript of this document, together with transcripts of later lists of 1851 and of the early twentieth century, made by Ellis Waterhouse, are in Box A1.6.31 in the library of the National Gallery.

32. For Lady Sophia's pictures see Burrell 2003, p. 68 (and entries for P28-32, M2-3, M8-10 and M13). An annotated copy of the revised 1824 catalogue records her ownership of two small pictures by Schiavone and a Pietro della Vecchia (nos 158–9 and 165 in Hume 1824, revised). These are mentioned by Hume in his will, as is a Hare by Weenix. Her brother Charles was bequeathed a landscape by Castiglione, a Wouwermans and a Veronese of *Rebecca at the Well* among other pictures. I am grateful to Alastair Laing for showing me a transcription of Hume's will made by Peter Hoare in December 2006.

33. Waagen 1854, II, pp. 313–14. According to a list of June 1851 (for which see the former note), the *Death of Actaeon* was kept at Belton.

34. NG 3011.

35. Christie's, London, 4 and 7 May 1923, and 3 May 1929.

36. Christie's, Belton House, 30 April – 2 May 1984 (the Property of Lord Brownlow and the Trustees of the Brownlow Chattels settlement). Lots 582–6 offered on 1 May were paintings from Hume's collection.

37. The painting, in a private collection, was exhibited at the British Institution in 1831. Sketches for the figure groups are in the National Portrait Gallery (Borean 2005, p. 92, fig. 42, and p. 95, fig. 44).

38. Borean 2005, pp. 88, 124, 128, 207, 209, 213, 215, 217, 225. The *Pra della Valle* is in a private collection (Constable and Links 1989, I, pp. 383–4, no. 376). At 40 *zecchini* it was costly, but Sasso explained that this was the price paid by Tiepolo 'che lo teneva nella sua stanza come cosa preziosa', and Canaletto's works were in such demand with foreign visitors that hardly any remained in Venice. Sasso's description of the picture's subtle spatial effects, the grading of the colour of the earth from sandy yellow to green, the repose that this gave to the eye, the harmony between air, buildings and ground, is masterly; and he concludes with an appeal to the artist in Hume: 'insomma è un quadro che pare poca cosa ma è tutto artificio e so che piace molto alli professori' ('all in all it is a picture which seems slight enough but which is a work of the highest artistry and a delight, I know, to experienced painters').

39. Borean 2005, pp. 88–9, fig. 39. She also reproduces a print of a remarkably Titianesque *Bacchante* (fig. 40), justly observing that Hume may well have encouraged this aspect of Pellegrini's work. This latter painting was lot 69, Sotheby's, London, 23 November 2006. For the portrait of Sophia, dated 1797, see Burrell 2003, pp. 84–5, P28.

40. Hume 1824, p. 49, no. 167. It was bequeathed to his grandson Charles Hume Cust together with

'Two Pictures of Dogs by Stubbs Another picture of a Terrier called Flow by Ward' (which corresponds with ibid., nos 146, 147 and 148).

BLANCHE, LADY LINDSAY (1844–1912), and SIR COUTTS LINDSAY (1824–1913), see pp. 198–9

GIOVANNI GASPARO MENABUONI (fl. 1750s and 1760s), see p. 243

PHILIP JOHN MILES (1773–1845), see p. 76

HUGH ANDREW JOHNSTONE MUNRO ('MUNRO OF NOVAR') (1797–1864), see p. 393

ALGERNON PERCY, 10th EARL OF NORTHUMBERLAND (1602–1668), and descendants, see pp. 104–5, 219–22, 229–31

THE ORLÉANS GALLERY

Some of the greatest paintings included in this catalogue – chief among them Tintoretto's *Origin of the Milky Way*, Veronese's four *Allegories* and Titian's *Death of Actaeon* – belonged for much of the eighteenth century to the Orléans Collection, the most magnificent and important collection of paintings in France, surpassing in the judgement of some connoisseurs even that of the Crown.[1] It was formed by Philippe, Duc d'Orléans (b. 1674), regent from September 1715 until his death on 2 December 1723, and was a major attraction for visitors to Paris for nearly seventy years.

A total of twenty-five paintings now in the National Gallery once hung in the palace of the Orléans family, the Palais-Royal, among them Sebastiano del Piombo's *Raising of Lazarus* (NG 1), Annibale Carracci's *The Dead Christ Mourned* (NG 2923), Rubens's *Judgement of Paris* (NG 194), Netscher's *Lady teaching a Child to Read* (NG 884), Le Valentin's *Four Ages of Man* (NG 4919), Ludovico Carracci's *Susanna and the Elders* (NG 28), the *Circumcision* from Giovanni Bellini's workshop (NG 1455), and Raphael's

Mackintosh Madonna (NG 2069). These are still esteemed, although the last mentioned is a mere ghost of its former self, but some of the paintings in the National Gallery which came from this source have lost the reputations which they enjoyed there, and which they retained in the last century perhaps partly because of this provenance. Notable among these casualties of taste are the *'Études du Corrège'*, groups of heads copied from Correggio's fresco in the apse of S. Giovanni Evangelista (NG 7 and 37), the *Birth of Jupiter* from the workshop of Giulio Romano (NG 624), and the four long furniture paintings with subjects from Roman history long attributed to the same artist (NG 643.1 and 2, and NG 644.1 and 2), also paintings now demoted to Style of Reni (NG 177, *Saint Mary Magdalene*) and Circle of Annibale Carracci (NG 25, *Saint John the Baptist seated in the Wilderness*). The *Death of Saint Peter Martyr* (NG 41), now considered as by Bernardino da Asola and little regarded, was then highly esteemed as a Giorgione. A few years ago one might have placed Veronese's *Rape of Europa* in this same category, but now that it has been cleaned it is hard to deny that it is worthy of the artist to whom it was attributed. Another major work from the Orléans Collection, Eustache Le Sueur's *Alexander and his Doctor* (NG 6576), was discovered in 1991 by Alastair Laing hanging as an overdoor in the dining room of a London club in St James's Square; it was acquired for the Gallery in September 1999.[2]

The Duc d'Orléans was notorious for his private pursuits – his dabbling in chemistry and alchemy, his supper parties with an inner circle of disreputable cronies, his blatant indifference to religious orthodoxy and conventional morality. But in forming a great picture collection he was acting in accordance with accepted notions of princely magnificence. Dynastic status and indeed public benefit were motives as important as personal delight. Although he possessed some artistic talent himself,[3] he seems to have taken rather little interest in the work of living French artists, with the exception of Antoine Coypel (1661–1722), who decorated the new gallery of the Palais-Royal. In the guides to his collection we find a Watteau, *Les Singes Peintres*, but this seems to have been made as a pendant for an older painting, 'La Musique des Chats de P. Breugle', and thus had probably been prompted at least partly by the requirements of symmetry.[4] Nor is he especially noted for his interest in modern Italian painting, although he

did commission major works by leading artists in Florence, Rome, Genoa and Bologna.[5]

FURNISHING THE PALAIS-ROYAL

The palace which came to be known as the Palais-Royal was built for Cardinal Richelieu in the 1620s and was bequeathed by him to the Crown. Louis XIV gave it to his brother, 'Monsieur', in 1692, when the latter's son, the future regent (then Duc de Chartres), married his legitimised daughter, Mademoiselle de Blois. When Monsieur died in 1701 the palace was granted to his son, now the Duc d'Orléans. Thereafter, some rebuilding and much redecoration was undertaken, chiefly under the direction of Gilles-Marie Oppenord (1676–1742), who was appointed Premier Architecte du Duc d'Orléans in 1715. A great new gallery had been built by Jules Hardouin-Mansart for Monsieur along the Rue de Richelieu at right angles to the library wing to the west of the palace. It was completed in the year of Monsieur's death and we know it to have been decorated with lacquer cabinets, loaded with oriental porcelain, as were the chimneypieces and side tables. A prelude to its magnificence and a climax to the suite of rooms in the library wing was provided by a Grand Cabinet or Cabinet des Glaces (with paintings hung on the mirrors[6]).

In 1702, soon after his succession, the Duc d'Orléans commissioned Coypel to paint the vault of the gallery with scenes from the *Aeneid*, which he completed in 1705.[7] By then the palace already contained many paintings of the kind which had inspired these splendid compositions. Further canvases, not originally envisaged, were completed by Coypel for the gallery walls in 1715, and the architectural decoration, now in Oppenord's hands, had been revised by 1717. Its climax was a semicircular end wall, where a chimneypiece was crowned with a marble bust, to either side of which bronze putti carried lights. Above the putti, stucco drapery was parted to reveal a great mirror, and winged youths supporting armorials broke into the cornice. The chimney was flanked by a pair of Corinthian pilasters framing obelisks hung with trophies and surmounted with eagles. More mirrors multiplied these splendid ornaments on either side.[8] This was the most notable incorporation of Roman theatrical baroque architecture into France, created by an architect who was well aware that the palace was

intended to house a collection which came from a great Roman palace. Half a century later it was still 'impossible to imagine anything more richly furnished or decorated with more art and taste'.[9]

Under Monsieur the principal state rooms had been decorated with porcelain, tapestries and paintings, but as his son's collection grew these rooms were increasingly dominated by paintings. Architectural sculpture tended to replace porcelain – as in the chimneypiece of the gallery just described. By 1717 the duke (now established as regent) was already anticipating a huge increase in his collection with the purchase of the Queen of Sweden's picture collection. Oppenord redesigned the Grand Cabinet, hereafter generally known as the Salon à l'Italienne. Antoine Crozat wrote to the sculptor Pierre Legros, who had settled in Rome, to obtain the dimensions of the four allegories by Paul Veronese which 'His Royal Highness' wishes to have placed in a room which 'Monsieur Hoppenor [Oppenord] is decorating ['fait orner'], on the ceiling of which these paintings must be put'.[10] The intention was probably to place these paintings not on a ceiling but above the doors of the salon; in any case, that is where they would eventually be displayed.

Unfortunately no visual record of this room as completed has been traced, although some of Oppenord's designs for it survive. He planned carved panelling and sculptural ornament for the walls. This was executed around the high clerestory windows above the gallery with its wrought-iron balustrade. The walls below were treated more simply because they were densely hung with paintings on crimson damask.[11] The plan to incorporate the Veroneses as overdoors probably conflicted with Oppenord's personal preferences because he generally proposed irregular shapes for paintings in this position – in accordance with his tendency to give movement to all the divisions of wall and vault. The birth of the rococo paradoxically coincided with a more respectful attitude to old master paintings, and it was out of the question to cut or otherwise adapt canvases by an artist like Veronese – indeed in the catalogue of the regent's collection the Queen of Sweden was rebuked for having altered some paintings to fit the ceiling compartments of her 'chambre' and 'salle d'audience'.[12]

Italian old masters were displayed in this room in carved and gilded frames above the ebony cabinets encrusted with rare stones and a pair of elaborate bronze

groups supported by marble-topped tables – an effect inevitably reminiscent of the Tribuna in the Uffizi in Florence. One of the cabinets incorporated miniature copies made by Pierre Mignard of the frescoes in the gallery of Palazzo Farnese in Rome, one of the chief models for Coypel's paintings in the adjacent gallery.[13] From the above account it will be clear that if paintings were originally acquired partly as ornaments for the palace, it was probably also the case that the design of interiors was modified to accommodate more paintings, and, most interestingly, that there was a relationship between the style of painted, sculptural and architectural decoration in the palace and the character of the collection which it housed. Before examining how the paintings were distributed through the palace something must be said of the sources of the collection.

THE ACQUISITION OF THE QUEEN OF SWEDEN'S PAINTINGS

The Orléans Collection, formed over a period of some twenty years, amounted at the regent's death to more than five hundred works (495 items in the published catalogue). It consisted chiefly of paintings of the sixteenth and seventeenth centuries. Venetian artists were especially well represented. Bolognese, Roman, Dutch and Flemish artists were also present in force. Florentine paintings were conspicuously absent (if the works attributed to Raphael and Michelangelo are excluded), as were Spanish (the *Discovery of Moses*, thought to be by Velázquez, was in fact by Orazio Gentileschi[14]). There were very few paintings of the early Renaissance (Bellini's workshop *Circumcision* was exceptional).

Only fifteen of the paintings in the official catalogue had belonged to Monsieur, the regent's father, although many more than this had been inherited.[15] Many works had been presented to the regent in the hope of, or as the price for, favours and offices. Some came from other major French collections (Raphael's *Saint John the Baptist* from the Président de Harlay; Annibale Carracci's *The Dead Christ Mourned*, Titian's *Noli me tangere* (NG 270) and Tintoretto's *Origin of the Milky Way* (NG 1313) – also Raphael's *Bridgewater Madonna* and Domenichino's *Christ carrying the Cross* now in the Getty Museum – from the Marquis de Seignelay). Sebastiano del Piombo's *Raising of Lazarus* was extracted from the cathedral of Narbonne in return for a

large repair grant and a copy. The Abbé Dubois obtained Poussin's *Seven Sacraments* (now National Gallery of Scotland) in Holland in 1716.[16]

To some respectable people of the clerical and professional classes the regent's infatuation with paintings may have been considered almost as deplorable as his private life. Mathieu Marais noted in his diary in June 1723 that pressure had been applied on the Chapter of Reims Cathedral to yield its paintings which were attributed to Titian and Correggio to the regent. He was said to have left his new mistress at St-Cloud to view these acquisitions: 'It isn't clear which of his two obsessions is the stronger' ('on ne sait pas quelle est la plus forte de deux passions'). Connoisseurs, Marais claimed, found it surprising that he should have no taste for the arrangement of pictures, 'mettant un tableau de dévotion auprès d'une nudité, un tableau de grande architecture auprès d'un paysage, et ainsi du reste' ('putting a religious picture beside a nude, a picture with monumental building in it next to a landscape and so forth').[17] In fact, of course, the mingling of sacred and profane was usual in princely galleries at this date and the comment is chiefly of interest as evidence that the regent was personally involved in the hanging of his pictures.

By far the greatest single source for the Orléans Collection was the group of 123 paintings from the collection of Queen Christina of Sweden. The exiled queen died on 19 April 1689, leaving her art collections to Cardinal Azzolino, who died shortly afterwards on 8 June. A decade later in 1699 the cardinal's nephew and heir, Marchese Pompeo Azzolino, sold them to Don Livio Odescalchi, Duke of Bracciano, nephew of Pope Innocent XI, a great art collector and patron, and it was his heirs and nephews – Cardinal Odescalchi, Archbishop of Milan, and the young Prince Baldassare Odescalchi, Duke of Bracciano – who in 1713, shortly after Don Livio's death, let it be known that the old master paintings and the antique sculptures might be for sale. They had inherited Don Livio's debts as well as his collection.

The Duc d'Orléans employed the wealthy connoisseur and collector Pierre Crozat (1665–1740) – 'Crozat le Pauvre' – to negotiate on his behalf during the winter of 1714–15. Crozat managed to view the collection with M. Amelot on 25 January 1715 in the Palazzo Odescalchi – Charles-François Poërson, the director of the French Academy in Rome, noted that there were a good many 'nuditez', some of which (presumably Correggio's *Leda* and *Io* among them) were covered with curtains. There were so many pictures (more than four hundred) and the Correggios and Veroneses were of such special importance that Amelot returned to inspect them on 6 February.[18]

In March Crozat began serious negotiations. He perceived that the prince, who was proposing to marry, wanted to retain a magnificently appointed palace, and so made an offer which excluded some of the tapestries and its richly upholstered furniture. He also made it clear that the paintings were his first priority. And the sculptures were in fact eventually sold separately to the King of Spain.[19] For the paintings alone he offered 60,000 Roman scudi, which he considered to be higher than their market value. The Odescalchi wanted 100,000. Crozat increased his offer to 75,000 and then left Rome with the matter unsettled. The emperor had been mentioned as a possible rival purchaser, but Crozat thought that he would be happy with copies (these were being made for the Odescalchi anyway).[20] In September 1715 Louis XIV died and the Duc d'Orléans became regent – virtual ruler of France. His greatly increased purchasing power cannot have made the sellers more inclined to compromise, and the new Duchess of Bracciano may not have wished to see her new residence stripped. Perhaps for this reason Crozat proposed purchasing only a group of the paintings, even proposing at one point a handful of the famous erotic paintings by Correggio and Titian.[21] Some moves were again made in 1717 and by 16 March Poërson understood that his regent had 'conclu le marché du cabinet' – including 'figures de marbres' and 'plusieurs colonnes' as well as paintings. There must have been grounds for optimism given the plans made for the Veroneses already mentioned. By the end of April, there was also talk of a rival buyer, Prince Eugène of Savoy.[22] But the wealth of the Duchess of Bracciano seems to have made selling a less urgent matter.

In May 1720 Filippo-Antonio Gualtiero (1660–1728), an Italian cardinal closely attached to the French Crown, noted for his interest in both art and learning, was approached by the Abbate Calcaprina on behalf of the Duke of Bracciano, now recently widowed and probably pressed by his uncle's debtors. Gualtiero wrote to Crozat seeking clarification as to what had been offered for what, and assurances that Crozat was acting as sole agent for the regent. By then the regent had, it seems, raised his offer for the paintings to 90,000 scudi, and this was increased by an extra 3,000 or so scudi 'pour pot-de-vin'.[23]

In the negotiations which took place in the following months Gualtiero was apprehensive on several counts. First, he was worried about the condition and authenticity of the paintings. He forwarded a remarkable report from a certain M. Guilbert on the perplexing duplicates among the Titians, the holes in the Raphaels, the repaint on the Correggios, and so on. The report was not found too worrying. And as for the substitution of modern copies, alleged to be a common Italian trick, it was agreed that experts at the French Academy in Rome would carefully vet each picture.[24]

Gualtiero's second worry concerned the frames, some carved and gilded, others of ebony, all old and outdated, awkward and heavy to transport, but of some use and value. The Duke of Bracciano, keen to keep these for the copies he was having made for his palace, offered in their place the tiny panels by Raphael of Saints Francis and Anthony (now in the Dulwich Art Gallery), but this was rejected as trifling and eventually the frames (and the Raphaels) were ceded to the French.[25]

The cardinal's third and greatest worry was the obtaining of a licence from the pope (Clement XI, Albani) to export the paintings from Rome, and indeed it required numerous audiences with the Bishop of Sisteron, a personal letter from the regent, the intervention of Cardinal Albani, much discussion of whether or not the exports should be taxed and more than six months to secure this. The contract was finally signed on 14 January 1721. Crozat hurried to Holland with diamonds to help raise the required funds. But the pope died on 19 March without making any agreement and the new pope, Innocent XIII, elected on 13 May, did not agree until June. The paintings were then restored under the eye of Poërson by 'Signor Domenico', packed with extreme care (the canvases rolled on cylinders, and not laid flat with the panels as Guilbert had recommended) and sent on the first stage of their journey to France by sea. They were landed in the south of France and then travelled overland, for Cardinal Gualtiero had lost a great library in a shipwreck and did not trust the Atlantic. They took a long time to reach Paris and were not inspected by the new owner until shortly before 13 December.[26]

It had been suggested that the regent might like to hang the pictures in their old frames while new ones were made and also as a historical exercise, in order to see what they looked like when they had belonged to the Queen of Sweden – 'cette grande Princesse', the fame of whose collection was 'si répandue dans toute l'Europe'.[27] It is not known whether this was done, but new frames were certainly made (one or two probably survive on smaller paintings from the collection).[28] The regent can have enjoyed his new possessions for little more than a year before his death, but arranging pictures was something in which he took special pleasure. The censorious Marais quoted earlier is not the only evidence for this. *Les Curiositez de Paris* in 1719 noted that he changed the paintings in the *cabinet* in which he normally worked 'pour considérer l'harmonie dans différentes situations'.[29]

ACCESS AND ARRANGEMENT
On the death of the regent on 2 December 1723, the Palais-Royal with its collections passed to his only son, Louis d'Orléans, known as 'Louis le Pieux'. When this Duc d'Orléans retired from public life in 1742 the palace became the chief residence of his son Louis-Philippe d'Orléans, who inherited it in 1752. He in turn entrusted the palace to his son, Louis-Philippe-Joseph d'Orléans, Duc de Chartres, at the end of 1780. During this period, although there were many changes to the order in which the pictures were hung, to the route taken by visitors, to the way the rooms were named and to the number of rooms open, the collection was easily visited by amateurs and artists alike.[30] After a sale of Dutch and Flemish paintings in 1727,[31] the collection was clearly regarded as in some sense complete and the *Description des Tableaux du Palais Royal* published in the same year and reissued ten years later was an official account of what was intended to be a permanent collection.[32] This catalogue was clearly designed to be of use not only to connoisseurs but to visitors with modest artistic education: the biographies of the artists and the descriptions of the paintings established a model that was to be followed over a century later by the 'descriptive and historical catalogue' published by the National Gallery.[33]

La Font de Saint Yenne in his polemical *Réflexions sur quelques causes de l'état présent de la peinture en France...*, published in The Hague in 1747, contrasted the liberal arrangements in the Palais-Royal with the relative confinement of the pictures belonging to the Crown.[34] Such criticism probably helped to bring into being the new royal gallery in the Palais du Luxembourg which opened to the public in 1750.[35] New attractions were also to be found in the Palais-Royal: notably in the 1750s the new Salon de Psiche with sculpture by Coustou, paintings by Jean-Baptiste-Marie Pierre, and white *boiseries* designed by Pierre Constant d'Ivry.[36]

Two of Correggio's erotic paintings, of Io embraced by a cloud and Leda coupling with the swan, were damaged by Louis le Pieux in a demented mood and these were sold in 1753 after they had been repaired.[37] The outrage which this episode aroused testified to general familiarity with the collection and a strong sense that it was not merely the property of the family. When, during the 1770s, the paintings were systematically restored (and many of the paintings on panel transferred by a novel method to canvas), the widespread concern at their condition and alarm at their treatment again reflected this.[38]

It is impossible to trace here in any detail the way in which the old master paintings were hung, but some general points can be made as well as some more particular observations about the paintings catalogued here. Most of the smaller Dutch and Flemish paintings were at first segregated in a suite of rooms, sometimes known as the Cabinets des Roués, where the regent had retired for his chemical experiments and his private suppers. Two of these *cabinets flamands* were named after the fabric on the walls: the Cabinet Jaune and the Cabinet Bleu (by contrast, the larger French and Italian paintings were hung on red fabric).

There were two suites of larger rooms which ran side by side down the west or library wing of the palace (parallel with the Rue St-Honoré). These were the Grands Appartements to the north of the wing and the Petits Appartements to the south. Sacred and profane paintings of the sixteenth and seventeenth centuries were consistently intermingled in these rooms, thus in the *cabinet* of the Duc d'Orléans Veronese's *Rape of Europa* was listed in the company of the *Communion of the Magdalen* and the *Martyrdom of Saint Stephen*.[39] It is hard to detect much order in the rooms, although the name of one of them, the Chambre des Poussins, reflects the fact that this artist's work was originally concentrated there with Le Sueur's tondo of *Alexander and his Doctor*, a homage to Poussin, above the chimney.[40]

The arrangement of paintings in Oppenord's great Italian salon seems not to have changed between the regent's posthumous inventory of 1724 and the dismantling of the gallery in the mid-1780s.[41] Veronese's *Allegories of Love*, as has been mentioned, served as overdoors, and below these hung his four great mythological allegories now divided between the Frick Collection, the Metropolitan Museum and the Fitzwilliam Museum. Titian's *Rape of Europa* (now in the Isabella Stewart Gardner Museum, Boston) and its companion, *Perseus and Andromeda* (now in the Wallace Collection), were displayed on either side of the chimneypiece, each in a cluster of five paintings which included, presumably at some height, the head studies then attributed to Correggio. Titian's *Death of Actaeon* hung on one side of the door entering the Galerie d'Énée; its pendant was Cambiaso's *Death of Adonis*, a smaller painting but with figures of comparable size and a similarly tragic theme, and apparently a similar preference for smoky greys over strong local colour (see fig. 8).[42]

Tintoretto's *Origin of the Milky Way* also served as an overdoor, hung in the Seconde Pièce d'Enfilade of the Grands Appartements. To either side of it were two large canvases by Luca Giordano of the *Pool at Bethesda* and the *Cleansing of the Temple* (sent by the king of Spain to Paris in exchange for some Mignards). Opposite was a 'Salviati' (Giuseppe della Porta), supposedly of the *Rape of the Sabines* (now in the Bowes Museum at Barnard Castle), which possesses figures with similarly outflung limbs (fig. 9).[43]

Somewhat surprisingly, Titian's *Noli me tangere* was hung as an overdoor in the Galerie à la Lanterne in the Petits Appartements.[44] There were fifty-two other paintings in this room, which, at least in 1749 and 1765, included many that were related in style: the National Gallery's *Death of Saint Peter Martyr*, the *Amour Piqué* (Wallace Collection) and *Gaston de Foix* (Castle Howard), all then believed to be by Giorgione, and Titian's early *Three Ages of Man* (National Gallery of Scotland). But the room also contained the Bellini workshop *Circumcision*, an early Lotto (now in the National Gallery of Scotland) and works by Raphael, Poussin and others which were certainly less congruous.[45]

THE COLLECTION COMMEMORATED AND THREATENED
When, on 30 December 1780, the Duc d'Orléans entrusted the Palais-Royal to his son, the Duc de Chartres, the art

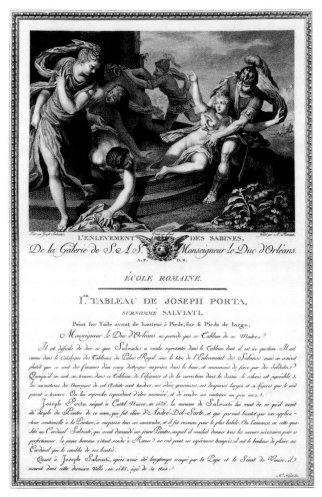

Figs 8 and 9 LEFT: Gérard-René le Vilain, after a drawing by Duvivier of Luca Cambiaso's *Death of Adonis*. RIGHT: Antoine Louis Romanet, after a drawing by Antoine Borel of Giuseppe Salviati's *The Rape of the Sabines*. Both engraved and etched together with the text by Abbé de Fontenai. Published in the 1780s and then again in 1808.

collections were explicitly excluded. This was confirmed in another legal document early in the following year.[46] It seems likely that the duke feared that his son might sell the collection in order to settle debts or to finance extravagant new ventures. Soon after he had gained control of the palace, the Duc de Chartres commissioned his architect, Victor Louis, to reorder and partly rebuild it, developing the perimeter of the gardens as commercial property, and altering the interiors.[47] The new plans, according to a guidebook of 1787, included a public museum on the first floor above the public gardens in which all the 'beautiful artistic productions, scattered throughout the palace, would be reunited' and this seems to be confirmed by surviving drawings.[48] It was an ambition typical of the period, in which the collections of the Crown were also being reorganised and the Palais du Louvre was taking the first steps towards being the museum that we know today. Among the few ventures that were

realised in the Palais-Royal was a museum for children which opened in 1785.[49]

On 13 December 1785 – less than a month after the death of his father (on 18 November) – the new duke had obtained a royal privilege for one of the most ambitious publications of its kind: *La Galerie du Palais Royal gravée d'après les tableaux des différentes écoles*, edited and published by the 'graveur de son cabinet', Jacques Couché (b. 1759). Advertisements for the first *livraison* were published early in 1786.[50] By August of that year the paintings from the walls of the great rooms were displayed on large easels 'in the middle of each room … obliquely to the light, resting partly upon each other'.[51] This was for the convenience of the twenty draughtsmen employed to copy the 396 paintings, which were eventually engraved and etched in 352 plates.[52] A 'description historique' – a critical appreciation with a brief biographical note on the artist – by the Abbé de Fontenai was engraved

together with each plate. The *Galerie* was issued to subscribers quarterly in *livraisons* (each of six plates) and thirty of these appeared regularly from 1 February 1786 until the Terror halted the enterprise. By then the paintings had been sold, but because preparatory drawings of most of them had been made Couché was later able to revive the publication.[53]

There were precedents for this great undertaking: the *Recueil Crozat* published between 1729 and 1742 in three volumes was devoted to notable works of art in the great collections of Paris, including over thirty paintings in the Orléans Collection, and the great series of engravings of the gallery in Dresden appeared in 1753;[54] but the most obvious and recent precedent was an ominous one. The anglophile Duc de Chartres as well as any French engraver would have been aware of the London print-seller John Boydell's scheme to reproduce the whole collection of old

masters formed by the English prime minister Sir Robert Walpole (Lord Orford) at Houghton Hall in Norfolk, employing forty-five printmakers to do so. Work had commenced on this undertaking by 1773, and publication, in parts, to subscribers began in the following year. Then, in 1779, the collection was sold *en bloc* to Catherine the Great and, when completed in 1788, the two huge volumes commemorated rather than celebrated a British collection – one now subsumed in that of 'Her Most Imperial Majesty the Empress of Russia'.[55]

Intimations of the probable fate of the Orléans paintings may indeed have stimulated the creation of an equivalent record of it. An earlier publication of a similar character was that of the finest gems of the Orléans Collection, the *Principales pierres gravées*, the engravings of which appeared between 1780 and 1784.[56] In 1787 the Duc d'Orléans sold his entire collection of gems to Catherine.

In March 1788 negotiations were under way for the sale of 478 of the Orléans pictures to a syndicate organised by the London auctioneer James Christie, who had also helped to sell the Walpole collection.[57] Serious investigations as to the value of the collection were renewed on Christie's behalf by the Flemish-born painter Philip J. Tassaert in June 1790.[58] This was not the first time since the acquisition of the collection that an attempt had been made to assign a value to the paintings. Each of the inventories made shortly after the death of the regent, his son and his grandson in March 1724, February 1752 and August 1785 did so. The estimates fluctuated: Veronese's four *Allegories of Love* were valued at 32,000 livres in 1724 and 1752 but at 24,000 in 1785; the versions of Titian's *Venus and Adonis* never fell below 5,000 or rose above 6,000 livres; Titian's *Noli me tangere* was valued at 8,000, then fell to 2,000 and then jumped to 3,600; Tintoretto's *Milky Way* was put at 2,400 in the first two inventories, as was Veronese's *Rape of Europa*, but in 1785 the former was considered to be worth a mere 800 and the latter a mere 150.[59]

Obviously the paintings were not easy to value, and when the duke was said to be about to accept Christie's estimate of 50,000 guineas the Duchesse de Bourbon (to whom he would, under the terms of his father's will, be obliged to share the proceeds of any such sale) had the collection valued by Le Brun at twice as much. The English newspapers were full of rumours. But 100,000 guineas was too much for Christie. One scheme

was for twenty 'persons of the first fashion' to raise a large part of the sum, opening a subscription for the remainder, reselling the pictures to those who had subscribed and then offering what was left over at a public auction. An objection frequently made against the speculation was that too many of the pictures were too large for 'our London houses'.[60] The Prince of Wales, a former crony of the duke, was said to have promised to advance 70,000 of the 100,000 guineas requested – scepticism regarding his ability to do so may have been combined with doubt as to the desirability of being junior partner to him in such a deal. In any case the plan foundered.[61] And so too did a plan to purchase between twenty and thirty of the finest paintings for the French Crown.[62]

THE COLLECTION DIVIDED
AND EXPORTED

In all early accounts it is said that the duke needed to fund his political campaign to have himself made regent – a campaign that soon resulted in the abandonment of his titles and his adoption of the name Philippe-Égalité. But his motives are likely to have been as confused as his own finances. In any case during the summer of 1792, when his political prospects were especially intoxicating – and precarious – and his debts no less pressing, he agreed to sell his French and Italian paintings to the banker Édouard Walckiers[63] of Brussels for 750,000 livres. Soon afterwards the German, Flemish and Dutch paintings (147 items) were sold for 350,000 livres to Thomas Moore Slade, who had very nearly succeeded in purchasing the entire collection in the previous year.[64]

Slade was acting for a consortium consisting of the 7th Lord Kinnaird together with Mr Morland and Mr Hammersley, partners in Kinnaird's father-in-law's bank. He removed the paintings from Paris with difficulty. The duke's creditors tried to obstruct the transporters and the indignation of protesting artists threatened to create further problems. During April 1793 the pictures – amplified by other works (259 pictures were offered) – were exhibited at 125 Pall Mall, the former premises of the Royal Academy, where the sale was handled by Mr Wilson.[65]

Meanwhile Walckiers had sold on the Italian and French paintings (unpacked) for 900,000 livres to his cousin, another banker, François-Louis-Joseph de Laborde-Méréville (1761–1802), to whose family, perhaps significantly, the Duc d'Orléans was indebted. The new

owner began to build a gallery on to his new *hôtel* in the Rue d'Artois (today Rue Lafitte) to accommodate them. Like Walckiers and the duke, he was active in reformist politics. But as the Revolution advanced he disowned it and prepared to emigrate.[66] Early in 1793 he was in London together with his paintings. In April of that year Philippe-Égalité was arrested and on 6 November he was guillotined.

Laborde mortgaged the collection for £40,000 to Jeremiah Harman (1764–1844), an eminent banker (a director of the Bank of England between 1794 and 1827) who was himself to be an important collector of paintings (several of which were acquired after his death for the National Gallery) and also the first and most important patron of the young Charles Eastlake.[67] Some at least of the paintings were possible to view but the majority were presumably kept in store.[68] It is sometimes claimed that the paintings were sold outright to Harman, but Laborde retained the right to reclaim them within five years. Had these terms been slightly different he might have been able to save the paintings for France, where he returned briefly in September 1797.[69] However, under the terms agreed, ownership was transferred to Harman, who sold the paintings, in the early summer of 1798, for £43,500 to the art dealer Michael Bryan (1757–1821), who was acting for a syndicate of three noblemen.[70] Benjamin West and Charles Long, aware that a sale was imminent, had a plan to which both the prime minister, William Pitt the Younger, and King George III had given their support, to acquire the finest 150 pictures for £44,000 as a national collection. But either they made the offer too late or it was clear to the vendors that the offer was uncertain and would have entailed a considerable wait.[71]

The leading partner in this syndicate was Francis, the 3rd and last Duke of Bridgewater (1736–1803), a man with little taste for art and even less knowledge of it, who was a keen speculator (now chiefly remembered for his massive investment in canal building). His associates were his heir and nephew George Granville Leveson-Gower (1758–1833), then Lord Gower, later 2nd Marquess of Stafford and eventually 1st Duke of Sutherland, and Frederick, 5th Earl of Carlisle (1748–1825), who had married Lord Gower's sister, Lady Margaret Leveson-Gower. Lord Carlisle contributed a quarter of the purchase price and Lord Gower an eighth.[72] Although Lord Gower

had the smallest share he may have been the principal mover. He had been British ambassador in Paris between 1790 and 1792 and would therefore probably have been *au fait* with every move made to save or sell the collection.[73] It is likely to have been Carlisle who approached Michael Bryan, or was approached by him; we know that he had been buying pictures from Bryan (and selling pictures to him) since at least 1796.[74]

Between 26 December 1798 and 31 July 1799, 138 paintings were placed on exhibition at Bryan's gallery (88 Pall Mall) and 158 – the larger ones – at the Lyceum, a large exhibition space in the Strand. We know how they were displayed from drawings made by the diarist Joseph Farington. In Bryan's gallery Titian's *Noli me tangere* hung in the small room in the centre opposite the door, and Veronese's *Rape of Europa* on one of the short walls of the long gallery, the lowest of a tier of four pictures. In the Lyceum Sebastiano del Piombo's *Raising of Lazarus* occupied the centre of a wall, flanked by Titian's *Diana and Actaeon* and his *Diana and Callisto*. This must certainly have been impressive but the height of the room was such that it was possible to hang two large paintings, by Tintoretto and Le Brun, above the Sebastiano. Two of Veronese's *Allegories of Love* were among the highest pictures on the same wall; the two others occupied the same position on the wall opposite.[75]

For English art lovers who could afford the admission fee of half a crown (the usual sum to prevent the attendance of the common public was a shilling) the event was, at least in recollection, a revelation. 'A new sense came upon me, a new heaven and a new earth stood before me,' Hazlitt recalled in his essay 'On the Pleasure of Painting', published in *The London Magazine* for 2 December 1820.[76] But the display was without glamour, many pictures were apparently unframed, and the catalogue was free of description, let alone the usual auctioneers' hyperbole. This had also been true of Slade's sale in 1793. Mary Berry reported that the Lyceum was in any case too far from the fashionable haberdashers to attract society.[77] Lady Amabel Lucas visited Bryan's gallery a dozen times but made fewer visits to the Lyceum, which was colder and where she noted that the paintings 'look more dirty, or more sunk in their colours than those at Bryan's as they are mostly very large, fill an immense room so as to touch one another, and are without frames, the collection does not look so pleasing. The Venus detaining Adonis; the Actaeon

and the Callisto of Titian whose colouring looked so fine at the Palais Royal, did not appear so beautiful here.' She bought paintings from both places, however.[78] About sixty per cent of the works exhibited were sold. Sixty-six of them were re-offered at Bryan's gallery on 14 February 1800, with reduced reserves, and most were disposed of.

The sale as a whole was not managed in a straightforward way and even the exact number of the paintings for sale is not quite clear.[79] All three syndicate members made changes to the selection made for themselves as the sale progressed. Thus, at one stage Lord Gower agreed to take the *Lot and his Daughters* attributed to Velázquez (now recognised as by Orazio Gentileschi) which Henry Hope had previously agreed to buy for 500 guineas. Carlisle hoped for a while to claim Raphael's *Madonna del Passeggio* (the public price for which was 3,000 guineas) but this was later taken by the Duke of Bridgewater. He also considered buying Titian's *Rape of Europa*, which Lord Berwick eventually purchased for 900 guineas.[80]

It is clear that there was no cash profit for the syndicate. On top of the purchase price of £43,500 they had to pay more than £1,800 for framing, carpenters, catalogues, advertising, doorkeepers and insurance and a little over £3,360 to Bryan as his commission. Sales, together with door money, brought in nearly £10,000 less than this outlay. There is, however, no evidence that they expected to do better, and the value of the paintings assigned to them was nearly £35,000.[81] One episode in particular does need further explanation and that is the auction sale by Coxe, Burrell and Foster on 13 May 1802 at which all members of the syndicate consigned some of the pictures they had reserved. The sale was badly timed and little noticed and the results must have been very disappointing: Titian's *Noli me tangere*, for example, consigned by Lord Gower, fetched 250 guineas (£262 10s.) whereas its price to the public had been calculated as 400 guineas.[82]

It is worth listing those paintings which fetched – or were valued at – more than a thousand guineas: of these the most notable was Sebastiano del Piombo's *Raising of Lazarus*, for which Angerstein paid 3,500 guineas on the first day (26 December 1798). At the earlier sale in April 1793 Richard Payne Knight had paid 1,000 guineas for *The Cradle*, then attributed to Rembrandt (now in the Rijksmuseum). The *Judgement of Paris* by

Rubens, also in that sale, was retained by Lord Kinnaird at a valuation of 2,000 guineas.[83] The other most prized paintings were retained by the Duke of Bridgewater's syndicate. Lord Carlisle kept Annibale Carracci's *Dead Christ Mourned* (valued at 4,000 guineas), the Duke of Bridgewater kept Raphael's *Madonna del Passeggio* (valued at 3,000 guineas), Titian's *Diana and Actaeon* and *Diana and Callisto* (at 2,500 guineas each), Poussin's *Sacraments* (this series at 4,900 guineas) and his *Moses striking the Rock* (at 1,000 guineas), Annibale Carracci's *Diana and Callisto* (at 1,000 guineas) and Correggio's *Madonna of the Basket* (at 1,200 guineas – in fact an early copy of the painting now in the National Gallery).[84]

POSTHUMOUS INFLUENCE

In 1806 Couché returned to the business of engraving the Orléans Collection, and two years later the three volumes of the *Galerie du Palais Royal* were finally published. French art lovers were reminded of what they had lost. Of the Bridgewater syndicate Croze-Magnan observed, in the *Notice Historique* which prefaced the first volume, that English art lovers, 'true to their national character, make public interest a matter of commercial speculation' ('les amateurs anglais, conservant le caractère national, spéculèrent sur la curiosité publique').[85] It is hard to deny the justice of this verdict. What had been acquired by a prince partly for the benefit of the public had fallen into the hands of a 'nation of shopkeepers'. Equally, however, it was hard to feel that the French were the victims of foreign rapacity when the Musée Napoléon was bulging with plunder.

The art dealer William Buchanan in his *Memoirs of Painting with a Chronological History of the Importation of Pictures by the Great Masters into England Since the French Revolution*, published in two volumes in 1824, interpreted the commercial acumen and private greed of the British nobility as patriotic zeal, and concluded his account of what was, after all, the dispersal into private hands of a great public collection, with the optimistic assertion that public institutions were about to develop in Britain which would match those on the Continent – 'the present epoch will ever be memorable in the history of this country, by his Majesty having declared his pleasure that England shall possess a Public and National Gallery of the works of the great painters, and thus given a pledge to his people, that the period of

GEORGE THE FOURTH will be to ENGLAND, what that of FRANÇOIS PREMIER was to FRANCE.'[86]

These sonorous words must strike the reader of Buchanan's coarse and mercenary business letters[87] as somewhat comic. But it is not entirely ridiculous to claim that the presence in Britain of so many great paintings, and above all of so many great paintings which had once formed a public collection, did something to inspire more liberal attitudes in private owners.

In 1803 Earl Gower succeeded as Marquess of Stafford and also inherited from his uncle, the Duke of Bridgewater, the latter's collection of paintings. Until his death in 1833 (by when he had been created Duke of Sutherland) both his own and the Duke of Bridgewater's portions of the Orléans Collection hung together in Cleveland House in London, forming the 'Stafford Gallery'. A top-lit picture gallery already existed on the first floor. To this Charles Heathcote Tatham built another gallery, also top-lit but with grand coffered apses. He added a dining room and drawing room, both with bay windows overlooking St James's Park, and an ante-room between them which was hung with the Poussins. Tatham's new rooms were for French and Italian paintings. The old gallery was filled with Dutch and Flemish masters. These were far more austere interiors than any these paintings had adorned in former centuries. The only furniture in Tatham's new gallery seems to have consisted of a pair of massive side-tables with dolphin supports, and chairs lining the walls – both doubtless served to keep people from getting too close to the pictures, which were hung in symmetrical patterns (but without uniform frames).[88]

That public visitors to the Stafford Gallery were anticipated is clear from the catalogue raisonné by John Britton published for their use in 1808 (the same year as that in which the motives of the English were denigrated by Croze-Magnan), and the small numbered ivory tag on each frame facilitated consultation of this catalogue. Lord Stafford's grandson, the dilettante sculptor Lord Ronald Gower, recalled that 'long before the National Gallery had been formed, the gallery ... at Cleveland House ... was to the English art student, in a limited degree indeed, what that of the Louvre is to the French.'[89] Visits were restricted to Wednesday afternoons over four summer months in 1806 and 1807, and thereafter for three summer months, to those who had tickets. These were only issued to acquaintances of the marquess or

of a member of his family or to those recommended by such acquaintances. Season tickets were granted to artists on the recommendation of a member of the Royal Academy. 'It is expected, that if the weather be wet, or dirty, that all visitors will go in carriages.'[90] Britton in his preface defended these arrangements as necessary, given the 'ignorance, vulgarity or something worse' of the 'lower orders' and the 'frivolity, affectation, and impudence' of that class of 'lounging persons' so abundant in modern London, but what is more significant than the reasons provided is his defensive tone, surely adopted in response to the 'reproach of foreigners' that great collections in France and Italy had been open to 'the emulous artist, and to every person of laudable curiosity'.[91]

The foundation of the British Institution in 1805, with Lord Stafford as its first president, was made in the same cultural climate: at its loan exhibitions of old master paintings held in the summer months, masterpieces from the Orléans Collection were for a while reassembled. In 1816 some of these masterpieces – including Titian's *Venus and a Lute Player*, Veronese's *Hermes, Herse and Aglauros*, Palma Vecchio's *Venus and Cupid in a Landscape* and Guido Reni's *Risen Christ appearing to the Virgin* – were among the paintings bequeathed by Richard, 7th Viscount Fitzwilliam of Merrion (b. 1745) to the University of Cambridge, together with funds to erect the museum that now bears his name. This was the first public collection of major old master paintings in Britain. The National Gallery was founded in 1824 with the acquisition of Angerstein's collection, which also included a significant portion of the Orléans Collection.

Meanwhile groups of Orléans paintings were sometimes displayed as such in the houses where they were to be found. In Castle Howard, the seat of the Earls of Carlisle, the Orléans pictures were hung in uniform frames upon dark green silk. Visitors were anticipated and here too the numbered ivory disks attached to the lower edge of each frame helped visitors to consult the catalogue for the 'Orléans Room'.[92]

The share of the Duke of Bridgewater passed on the death of his nephew (the Lord Gower who had belonged to the syndicate, who became Marquess of Stafford and briefly Duke of Sutherland) to his second son, Francis (1800–1857), who took the name Egerton in 1833 and was made 1st Earl of Ellesmere in 1846. Charles Barry rebuilt Cleveland House for him between 1840 and 1854; the

great new picture gallery of what was soon called Bridgewater House was completed in 1851 and most of those who visited it then and in the following decades were aware that the great Titians and Raphaels (now on loan to the National Gallery of Scotland from the current Duke of Sutherland) had once adorned the Palais-Royal, just as when these paintings hung in the Palais-Royal they were known to have once belonged to the Queen of Sweden.

NOTES

1. Piganiol de la Force 1765, I, p. 329; Yorke MS, V, p. 234.

2. Wine 2001, p. 226 (for provenance) and pp. 235–9 for a full account of the picture's fortune.

3. Folliot 1988, p. 69, no. 36, for the paintings by him of Daphnis and Chloe, now only recorded in Audran's engraved illustrations for a limited edition of Amyot's translation of this romance printed in 1718.

4. [Du Bois de Saint-Gelais] 1727, pp. 76–7. Another Watteau, a *Bal Champêtre*, was later recorded in the collection.

5. Bréjon de Lavergnée 1983.

6. Folliot 1988, pp. 54, 55, and 59, no. 33.

7. Already admired by Brice 1706, I, pp. 141–2. For Coypel's painting in the palace see Mardrus 1988, pp. 79–94.

8. Brice 1717, I, p. 204; Folliot 1988, pp. 62–5 and, for the great chimneypiece wall, pp. 70–1, no. 40.

9. Piganiol de la Force 1765, I, p. 328.

10. Montaiglon V, 1895, pp. 66–7.

11. Folliot 1988, pp. 63, 72–3, nos 46–8.

12. [Du Bois de Saint-Gelais] 1727, p. xi of Preface.

13. For Mignard see [Le Rouge] 1733, I, p. 160.

14. Christiansen and Mann 2001, pp. 238–40, no. 48 (entry by Christiansen).

15. Mardrus 1990, p. 294.

16. Stryienski 1913, pp. 9–16; Mardrus 1988, pp. 95–116.

17. Marais 1863–8, II, 1864, p. 465.

18. Montaiglon IV, 1893, pp. 344, 350–1, 356–7, 360, 366–7; Stryienski 1913, pp. 19–20.

19. Crozat was still anxious in August 1720 to have the antiquities included in any sale to the Duc (Montaiglon V, 1895, p. 363). For the sale to Spain see ibid., VII, 1896, p. 59. For the context see Haskell and Penny 1981, p. 62.

20. Montaiglon V, 1895, pp. 371, 373–7, 379, 410–11.

21. Stryienski 1913, pp. 20–1, citing the correspondence between Gualtiero and Crozat in the British Museum.

22. Ibid., p. 25.

23. Montaiglon V, 1985, pp. 326–31, 337–8, 356–60; Stryienski 1913, pp. 23–4.

24. Montaiglon V, 1895, pp. 339–45, 365, 412. For Guilbert see also p. 276.

25. Ibid., pp. 344, 365, 373, 376–7, 381; VI, 1896, pp. 5, 7.

26. Ibid., V, 1895, pp. 344, 375–7, 382–7; VI, 1896, pp. 5–11, 109; Stryienski 1913, pp. 26–31.

27. The expression is used by Poërson in a letter to d'Antin of 14 January 1721 (Montaiglon VI, 1896, p. 5).

28. An example is around Domenichino's *Vision of Saint Jerome* in the collection of Sir Denis Mahon and currently on loan to the Ashmolean Museum.

29. [Le Rouge] 1719, p. 103 – repeated after the regent's death in the editions of 1723 (I, p. 147) and 1733 (I, p. 167).

30. Bauche 1749, p. 293, notes that the numbering of the paintings no longer makes sense; Hébert 1766, p. 341, explains that the recent fire in the palace opera house had involved rearrangements. Later guides frequently warn the reader that changes are in train.

31. Croze-Magnan in Fontenai 1808, p. 3.

32. [Du Bois de Saint-Gelais] 1727; the volume was no longer anonymous in the second, posthumous edition of 1737.

33. Wornum 1847 was edited by Eastlake and initiated by him as Keeper of the National Gallery, although published after his resignation.

34. La Font de Saint Yenne 1747, p. 40.

35. McClellan 1994, pp. 25–48.

36. See [Dézallier d'Argenville] 1765, pp. 78–80 (Salon de Psiche).

37. Stryienski 1913, pp. 70–1. For Louis le Pieux in general see Mardrus 1988, pp. 117–22.

38. The transfers from panel were recorded on the backs of the paintings. See, for instance, the note by Hacquin on the back of NG 643 and 644. Payne Knight's recollection of the transfer of the Sebastiano makes alarming reading ([Knight] 1814, pp. 283–4). This was published long afterwards, but Knight was in Paris as a young man in 1773, which is the date at which he claimed elsewhere that 'the French cleaners' were 'first employed to repair, or rather destroy' the Venetian paintings which he regarded as the worst victims ([Knight] 1810, p. 315). See also, for contemporary comments on the brash new varnish, Yorke MS, V, pp. 232, 234, and more generally on the methods being employed, Walpole 1973, p. 344 (letter of 25 August 1771).

39. Archives Nationales, Posthumous Inventory of March 1724, photocopy in the Getty Provenance Index, fol. 139, item 1697 and adjacent entries.

40. Mardrus 1996; Wine 2001, pp. 235–6.

41. The last published list of the pictures is Thiéry 1887 (I, pp. 257–8) but the paintings may by then already have been removed to easels.

42. Manning and Suida 1958, fig. 121 (tav. LXXV). In the Stafford Gallery the painting was described as 'faint and pale' in the flesh (Britton 1808, p. 26). For this room see [Dézallier d'Argenville] 1749, pp. 75–7; Bauche 1749, pp. 311–13; Hébert 1766, pp. 354–5; Thiéry 1787, I, p. 287.

43. For this room see Bauche 1749, p. 308, and Hébert 1766, pp. 349–50. The Giordano is untraced – see Ferrari and Scavizzi 1992, I, p. 401; II, figs 1084 and 1085, pp. 925–6. For the Salviati see [Du Bois de Saint-Gelais] 1727, p. 267, and Fontenai 1808, Vol. I.

44. Bauche 1749, p. 300.

45. Ibid., pp. 300–2.

46. Forray 1988, p. 149.

47. Ibid., pp. 149–54.

48. Thiéry 1787, I, p. 270; Forray 1988, p. 153.

49. Thiéry 1787, I, p. 272.

50. Mardrus 1990, pp. 79ff.

51. Trumbull 1953, p. 103.

52. These drawings, surviving in six volumes in the Bibliothèque d'Art et d'Archéologie (Fondation Doucet), are described by Joubin 1924.

53. The plates are variously entitled 'De la Galerie de S.A.S. Monseigneur le Duc d'Orléans', 'De la Galerie du Palais Égalité', 'De la Galerie du Palais d'Orléans', 'De la Galerie du Palais Royal'. The title-page for the first volume was issued to subscribers in 1786 and so dated – hence all three volumes are sometimes thought to have been published at that date. See Croze-Magnan in Fontenai 1808, I, p. 4.

54. Mardrus 1990, p. 81.

55. Rubinstein 1996, pp. 65–73.

56. Arnauld and Coquille 1780–4, with engravings by Augustin de Saint-Aubin (1736–1807), draughtsman and engraver to the Duc d'Orléans.

57. The figure of 418 is given in error in Mardrus 1988, p. 98. The contract is in the Bibliothèque Nationale. See also Sutton 1984, p. 358.

58. Four letters from Tassaert to Christie were sold at Sotheby's, London, 7 July 1958; their content is described in Russell 1990.

59. The valuations are given by Stryienski 1913. I have checked them against the photocopies made from the inventories in the Archives Nationales by Colin Bailey for the Provenance Index of the J. Paul Getty Museum.

60. Victoria and Albert Museum Albums of Press Cuttings, PP 17.4, II, pp. 546, 548, 578, 581, 598.

61. Sutton 1984, pp. 357–72 (especially pp. 358–9).

62. See McClellan 1994, p. 67, for Alexandre-Joseph Paillet's plan, submitted to the Comte d'Angiviller, for a group of pictures to be acquired by the king.

63. The name is spelled differently by all the major sources. I have followed Suzanne Tassier's entry in the *Biographie Nationale de Belgique*. Édouard-Dominique-Sébastien-Joseph Walckiers (1758–1837), known as 'Édouard le Magnifique', had many important Parisian contacts – his sister and niece were married to close members of the Orléans circle. He himself had similar political ambitions in Brussels to those of the Duc d'Orléans in Paris, and he was ruined by the revolution which he helped to unleash.

64. Buchanan 1824, I, pp. 59–60, quotes from a memorandum by Slade which gives the date of his first visit as 1792, and this date is often repeated (e.g. by Sutton 1984, p. 359). But since Slade also recalled first arriving in Paris on the day that the king fled, this must have been on 21 June 1791. The year in which he returned to Paris and made the purchase must have been 1792. It seems that the paintings could be viewed in Slade's house at Chatham before the sale (ibid., pp. 161–4).

65. Lady Kinnaird was a daughter of Mr Ransom in whose bank Morland and Hammersley were partners. Mr Assinder of Barclays Bank presented photocopies of manuscript lists of paintings acquired by Morland, Hammersley and Kinnaird to the National Gallery on 18 January 1961

and noted that large advances were made to the duke by Ransom and Company (NG archive, Box AIV.17.1). The paintings were shown 'without the embellishment of a new varnish, without repairing the few accidents of time, and without the decoration of magnificent gilded frames'. Unsold pictures were exhibited at 16 Old Bond Street in May 1795 (88 items). The sale actually opened in April, as Pomeroy (1997, p. 30) notes.

66. For Laborde see Boyer 1967. Slade (see Buchanan 1824, I, p. 161) reported the rumour that the duke had lost a vast sum at billiards to M. Laborde the Elder, and Sutton (1984, p. 362) makes an interesting conjecture on this business.

67. Robertson 1978, p. 249, for Harman generally, and for paintings (Rembrandt, NG 190; Reni, NG 191; Dou, NG 192) bought from his collection by the National Gallery, ibid., pp. 82 and 295.

68. Farington 1978–98, II, 1978, p. 590; III, 1979, pp. 793 and 850, reports on visits made by Sir George and Lady Beaumont and by Benjamin West.

69. The rapid visit to France (not mentioned in Boyer 1967) is mentioned by Farington (1978–98, IV, 1979, p. 1132). Laborde also returned for a while to France in 1800. Buchanan claimed that he was guillotined and although he corrected this error (1824, II, p. 379) it has been repeated (e.g. Sutton 1984, p. 361). He formed another collection which was sold at Christie's on 6 and 7 January 1801 (not mentioned in Boyer 1967). He died in London on 2 October 1802 and was buried at Holme Pierpont near Nottingham, his country residence. A letter from Lucy Elizabeth, Lady Bradford, to her father, Lord Torrington, of 23 November 1802, describing how she had dined with 'Madame de la Borde' (evidently Laborde's mother) in Paris during the peace, sheds light on one source of the family's fortune. She was no longer wealthy ('I am not sure she has a carriage') and Lady Bradford noted that the 'State of St Domingo is a most serious loss to them ... their possessions there were immense' (Staffordshire County Record Office, D1287/18/9 (P/1062)). The French evacuated Haiti in November 1803, but the colony was in several respects 'lost' considerably earlier.

70. Castle Howard Muniments J14/27/1 for the agreement signed by all members of the syndicate in Bryan's presence on 13 June 1798. Buchanan (1824, I, p. 18) and Soullié (1843, p. 14) give £43,000 as the sum and this has been repeated in many, perhaps most, later accounts.

71. Our only source for this episode is a conversation with West recorded by Farington in January 1799. Farington 1978–98, IV, 1979, p. 1132.

72. Castle Howard Muniments J14/27/1.

73. Sutton 1984, p. 363.

74. He bought the Gossaert *Adoration* (NG 2790) from Bryan in March 1796, disposing of a Poussin in part payment. For this and other transactions with Bryan see Castle Howard Muniments J14/27/2 and 3 and J14/28/5, 6, and 13.

75. The drawings are illustrated and discussed by Haskell 2000, pp. 25–6. The Tintoretto was a sketch for the *Paradise*, perhaps the painting in the Thyssen-Bornemisza Museum, Madrid. The Le Brun was the *Hercule terrassant Diomède* ('Hercules vanquishing Diomedes') now in the Nottingham Castle Museum. Because the numbers in Bryan's catalogue follow the hang

of the paintings in tiers going up and down the walls, this might lead one to suppose that the *Allegories* were separated at random, but the symmetry of the arrangement in fact made their relationship obvious.

76. Hazlitt 1902–6, VI, 1903, p. 14.

77. Berry 1866, II, p. 86 (5 March 1799).

78. The passage quoted was written on 4 January 1799. Yorke MS, XVII, p. 280. Her visits were made between 29 December 1798 and 29 April 1799. Ibid. XVII, pp. 275, 277–80, and XVIII, pp. 4, 5, 19, 26, 42, 57. Humphrey Wine pointed these entries out to me.

79. Castle Howard Muniments J14/27/4 includes a memorandum to the effect that two pictures had accidentally been given the same number and J14/27/1 includes a note referring to 'seven or eight pictures more [than the 298 listed] ... now in possession of the Duke of Bridgewater'.

80. Ibid. J14/27/14 for *Lot and his Daughters* reserved for Gower, but annotated as purchased by Hope; J14/27/6 for Raphael reserved for Carlisle; J14/27/7 for *The Rape of Europa* reserved for Carlisle and J14/127/9 for the same picture sold to Lord Berwick. The whereabouts of the *Lot and his Daughters* is not clear (see Christiansen and Mann 2001, pp. 183–4, no. 37, especially notes 3, 7 and 8 (entry by Christiansen)).

81. For the original outlay of £43,500 see Castle Howard Muniments J14/27/1; for the door money of £1,574 0s. 6d., framing charges etc. of £1,826 1s. 8d. and Bryan's commission of £3,361 5s. 0d. see J14/27/11 and 13, where the sales are also recorded. Pomeroy (1997, pp. 29–30) Correctly noted that the syndicate did not make a cash profit as has often been claimed. However, she reckons the sales at £34,617 10s. 6d., which omits the £3,711 16s. owed by the purchasers at the date of the statement in J14/27/13. Her calculation (ibid., p. 31, note 14) of the attendance figures must also be questioned since it fails to take into account the fact that season tickets were obtainable and purchasers (with their parties) could make numerous visits.

82. For an analysis of the sale see Fredericksen 1988, p. 20, no. 110.

83. Or so Buchanan reported. There is also evidence that it was retained by Slade (see Sutton 1984, p. 362).

84. The valuations given here for the syndicate's pictures are the 'public prices' assigned to them. Castle Howard Muniments J14/27/14 reveals that the cost to the members of the syndicate, the so-called 'proprietor's price', was calculated as a midpoint between the 'cost price' (an agreed division of the original total purchase price) and the 'public price' presumably recommended by Bryan: this 'proprietor's price' was £3,000 for the Carracci; £2,250 for the Raphael; £3,750 for the pair of Titians; £3,750 for the *Sacraments*; £750 for the *Moses*; £900 for Carracci's *Diana* and the same for the supposed Correggio.

85. Buchanan 1824, I, p. 4.

86. Ibid., I, p. 216.

87. Brigstocke 1982.

88. Britton 1808.

89. Gower 1883, I, p. 82.

90. Britton 1808, preliminary note.

91. Ibid., p. vi.

92. The arrangement is shown in a watercolour by Mary Ellen Best made in July 1832. Four

Orléans pictures remain today at Castle Howard: two portraits, the delightful little poetic pastiche probably by Pietro della Vecchia (once regarded as a portrait of Gaston de Foix by Giorgione) and the portrait group of figures at prayer by Bedoli which was thought to represent the Dukes of Ferrara by Tintoretto.

SIR GREGORY PAGE BT (1689–1775), see p. 341

THE REYNST BROTHERS AND THE 'DUTCH GIFT'

Gerard (Gerrit) Reynst, one of the most successful merchants in Amsterdam at the close of the sixteenth century, was founder and director of the Brabant Company. He became a leading figure in that company's successor, the India Company, and was elected governor-general of the Dutch East Indies in 1613. He arrived in Indonesia in the following year but died there at the end of 1615, not long after his eldest son, Pieter, who was lost at sea on the way to joining him. Two sons survived: Gerard and Jan, born in 1599 and 1601 respectively. They also prospered as merchants and formed one of the most important art collections in Holland in the mid-seventeenth century.[1] This has been investigated with exceptional scholarship by Anne Marie Logan, and what follows depends largely on her book.

It was a collection of Italian and Italianate paintings and thus, almost certainly, largely the creation of Jan, who by 1625 was living in Venice, where he was known as Giovanni Reinst. There was a notable picture gallery in his palace which was praised by Ridolfi.[2] Jan maintained close contact with his elder brother in Holland, who was a partner in his trading ventures and perhaps also in his collecting. In 1634 they together purchased the grand house on the Keizersgracht known as De Hoop (still standing, but much changed), and by 1638 many works of art had been sent there from Venice. More followed after Jan died, in Venice, unmarried, on 26 July 1646.[3]

It is unlikely that Jan Reynst would have purchased as well as he did without advice. The dedication of the first part of Carlo Ridolfi's *Le Maraviglie dell'Arte* to him (and in smaller type to Jan's brother – 'Gerardo senatore d'Amsterdamo') suggests that Ridolfi may have had some association with him. Ridolfi noted that the artist Nicolò Renieri had been a friend of Jan, and since Renieri was recorded as owning half-a-dozen pictures attributed to Bonifazio, Schiavone, Sustris, Tintoretto, Titian and Veronese which had belonged to Jan, it is reasonable to infer that these were bequests, or possibly pictures of which Renieri, who was active as adviser, valuer, agent and dealer, had owned a share, or, indeed, perhaps pictures for which Jan had not paid at the time of his death.[4]

In the year before he died Jan Reynst emerged as a public figure, first representing the Levant merchants in their negotiations with the States General over the taxation of foreign freight on Dutch vessels, and then representing the States General itself in negotiations with the French, whose navy was harrying Dutch vessels suspected of trading with Spain.[5] Gerard, by contrast, achieved only a certain prominence in Amsterdam, serving as one of the city's thirty-six councillors between 1646 and 1658, the year in which, on 29 June, he fell into the Keizersgracht and drowned.[6]

Our chief source of knowledge of the Reynst collection comes from sets of engravings of the finest paintings and sculptures in it, probably begun in 1655 but left incomplete on Gerard's death three years later.[7] The enterprise was perhaps inspired by the illustrations of sculptures in the possession of the Marchese Vincenzo Giustiniani in Rome, the *Galleria Giustiniani*, commenced by 1631 and published in about 1640.[8] David Teniers's reproductions of 244 of the finest paintings in the great collection of Archduke Leopold William in Brussels belongs to the same period, and Gerard must have been aware of this and also of Hollar's etchings after works of art in the collection of the Earl of Arundel (a collection even closer to hand, since it was partly housed in Amsterdam between 1643 and 1654).[9] But an even more important precedent may have been the seventeen richly illustrated catalogue volumes of Andrea Vendramin's collections, compiled by 1627 under the title *Musaeo Andreae Vendrameno* – perhaps the first-ever illustrated catalogue of a private museum, although as far as we know never intended for publication. Jan Reynst acquired this collection *en bloc* (and doubtless with it the seventeen volumes, of which six survive) probably shortly after Vendramin's death in 1629.[10]

Quite why Gerard Reynst commissioned these engravings is not clear. They certainly broadcast the magnificence of his collection, but was he anxious to record it because he had intimations of its ephemerality? Did he

wish to enhance its value in anticipation of its sale? Was it indeed always primarily regarded as an investment? The mercantile families of Amsterdam had fewer aspirations to dynastic splendour than those of the noble houses of Venice: a confidential and 'exclusive' offer to sell the collection had, in fact, been made in January 1650 to Queen Christina of Sweden, apparently with Gerard's consent, and it was hinted that the magistrates of the city of Amsterdam had made overtures to obtain the antiquities as embellishments for the new town hall[11] (in emulation of the library in Venice and the Palace of the Conservators in Rome).

The Vendramin collection was a cabinet of curiosities. There were fossils, shells, plants, gems, inscriptions and urns (including what was claimed to be the tomb of Aristotle), as well as sculpture and pictures, and, indeed, the 140 or so paintings reproduced in the 150 pen drawings of the volume entitled *De Picturis*[12] seem not to have been especially distinguished. Fewer than ten of them have been identified and none was included among the thirty-three paintings selected for reproduction in the engravings commissioned by Gerard, although one, a nude woman in a landscape by Cariani, was later presented to the king of England and remains in the Royal Collection.[13]

When, at the Restoration, King Charles II left Scheveningen for England on 2 June 1660, the states of Holland and West Friesland, hoping to secure an alliance, prepared a valuable diplomatic gift. It was clear that paintings would be welcome from the fact that the king had in April reserved seventy-two paintings in the possession of the dealer William Frizell.[14] So the officials in charge approached Gerard's widow, who agreed to part with twenty-four paintings and twelve antique sculptures for 80,000 guilders. Four modern Dutch works were added (including Saenredam's *View of the Groote Kerk* of 1648, now in the National Gallery of Scotland, and *The Young Mother* by Gerrit Dou of 1658, now in the Mauritshuis[15]). The 'Dutch Gift' was viewed with pleasure by the English court in November. The paintings selected from the Reynst collection were mostly from the sixteenth century, and the majority of these were Venetian. They were no doubt chosen with an eye to replacing the works of this character which had belonged to Charles I and had been sold by the Commonwealth. The chief attractions remaining in the Reynst collection were modern works, among

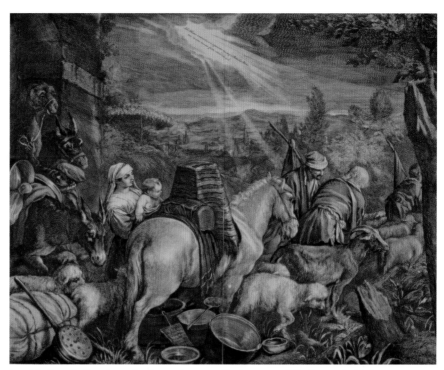

Fig. 10 Cornelis Visscher, after Jacopo Bassano, *The Departure of Abraham*, *c*.1655–7. Etching and engraving, 30.4 × 37.4 cm (image). Bassano del Grappa, Museo Civico.

them two masterpieces by Jan Liss,[16] Bernardo Strozzi's *Old Courtesan*, Feti's untraced *Vision of Saint Peter*, Pieter van Laer's *Ambush*, and a version of Guido Reni's *Susanna and the Elders* (another version of which is NG 196).[17]

Jacopo Bassano's *Way to Calvary* (NG 6490) was the largest painting in the gift. Slightly surprising omissions are the more characteristic paintings by Bassano, all four of which were engraved.[18] The *Departure of Abraham* (see fig. 10) and the *Annunciation to the Shepherds* (similar in composition and perhaps pendants, the former being the Old Testament type of the latter) may have been overdoors and inconvenient to remove from the Reynst house, but the *Entombment* (an untraced variant of the 1574 altarpiece) and the *Virgin and Child with Saint John* (untraced but close to a composition known in a painting once at Chatsworth) would have been appreciated, especially when we recall how highly esteemed Bassano was among English collectors at that date. Perhaps it was known that the Royal Collection already had good examples of Bassano's mature style.

The paintings sent to England also included Titian's *Sannazaro*, Giorgione's *Concert*, Parmigianino's *Athena*, Lotto's *Andrea Odoni* and Giulio Romano's *Isabella d'Este*, as well as lesser works by Schiavone, Bonifazio and (as mentioned) Cariani.[19] Standards of curatorship were

not what they had been under Charles I, and the portraits by Lotto and Giulio, for example, were not properly annotated in the royal inventory as part of the Dutch gift. Moreover, the new king was not especially careful of crown property. Guercino's *Semiramis* seems to have been given by him to his mistress Barbara Villiers (her descendant the Duke of Grafton sold it and it is today in the Museum of Fine Arts, Boston[20]). Jacopo Bassano's *Way to Calvary* and two other paintings from the Reynst collection were later recorded in the apartments of his queen.[21] Worse was to follow. William III exported paintings to his palace of Het Loo in Holland, including Dou's *Young Mother*, and senior officials at his court were either rewarded with pictures or not prevented from rewarding themselves with them. The Saenredam mentioned above turned up in the sale of William van Huls, Clerk of the Robes and Wardrobe,[22] while the Royal Cofferer, Viscount Newport, soon to be created Earl of Bradford, seems to have obtained the Bassano as a bribe (see p. 14).

The residue of the Reynst collection was sold at the end of May 1670,[23] a year before the death of Gerard's widow. Gerard's son Joan (b. 1636), a friend of the artist Karel Dujardin (with whom he travelled to Rome in 1675), was the last of the male line of this branch of the Reynst family.[24]

NOTES

1. Logan 1979. For the family background see pp. 13–15.

2. Logan 1979, pp. 10–11, 33.

3. Ibid., pp. 19–20.

4. Ibid., pp. 35, 67, notes 65 and 89. Logan's hypothesis is that the pictures were a bequest.

5. Ibid., pp. 31, 33.

6. Ibid., p. 26.

7. Ibid., pp. 39–41. The publications are generally abbreviated as the *Caelaturae* and the *Icones*. The title-page of the former reads *Variorum Imaginum a celeberrimis artificibus pictarum caelaturae elegantissimis tabulis rapraesentae.*

8. Ibid., p. 51. See also Gallottini 1998.

9. For Teniers see Claerbergen 2006, and for Hollar see Pennington 1982, pp. XXII–XXIII, and Waterfield 2006.

10. Logan 1979, pp. 67–75. The *Dactylioteca* recording the gems, coins and medals in the collection of Abraham Gorlaeus was an earlier illustrated catalogue and, moreover, published (in 1601), but its scope was narrower.

11. Ibid., p. 89.

12. British Library, Sloane MS 4004, published as Borenius 1923. See also Borenius 1932.

13. Logan 1979, pp. 113–18, no. 9; Shearman 1983, p. 72, no. 66.

14. Reade 1947.

15. Logan 1979, pp. 75–86, for the gift in general (but see also Mahon 1949 and 1950). The Dou and the Saenredam are reproduced by Logan on pp. 73 and 80.

16. *Brothel Scene*, Kunstsammlung, Cassel, Inv. 187, and *Saint Paul in Ecstasy*, Gemäldegalerie, Berlin, Inv. 1858 – see Logan 1979, pp. 126–9, nos 14 and 15.

17. For the Strozzi, which is perhaps the painting in the Pushkin Museum, see Logan 1979, pp. 146–8, no. 30; for the Feti, ibid., pp. 118–19, no. 10; for the Van Laer, ibid., pp. 160–1, no. 40; for the Guido Reni, ibid., pp. 139–41, no. 23.

18. Ibid., pp. 110–14, nos 2, 3, 5 and 6.

19. Shearman 1983, pp. 118–21, no. 116 (Giulio); pp. 144–8, no. 143 (Lotto); pp. 183–4, no. 186 (Parmigianino); pp. 251–2, no. 270 (Titian).

20. Logan 1979, pp. 124–8, no. 13.

21. See p. 13.

22. Last recorded in the Royal Collection in 1714. See White 1982, pp. xxxix–xl.

23. Logan 1979, pp. 90–1.

24. Ibid., pp. 27–8.

SAMUEL ROGERS
(1763–1855), see pp. 306–8, 311

ALFRED DE ROTHSCHILD
(1842–1918)

Nathan Mayer Rothschild (1777–1836), son of a Jewish banker in Frankfurt, arrived in Manchester from Germany in 1799 and soon moved to London, where he transformed the financial operations of Europe and established the most powerful banking dynasty in the modern world, with branches in Germany, France and Britain. His British grandchildren were fully accepted in the uppermost echelons of society and were at ease in the royal enclosure at Ascot and the smoking room at Sandringham.[1] Alfred Charles de Rothschild, known as 'Mr Alfred', was the fourth child and second son of Nathan's son Baron Lionel de Rothschild (1808–1879). His elder brother, Nathan Mayer Rothschild (1840–1915), known as 'Natty' among his friends, was created Baron Rothschild of Tring in 1885 (his father had been a baron, but of the Austrian Empire). Both brothers had been friends of the Prince of Wales when they were up at Cambridge and remained on close terms with him. Their cousin Hannah (1851–1890) married Lord Rosebery, who was prime minister in 1894–5.

Alfred was active in politics and a champion of the Unionist cause in the late 1880s, in which, as also in financial affairs, he followed his brother's lead. Owing to his declining health he refused re-election as director of the Bank of England in 1890 (he had been the first member of the Jewish faith to be entrusted with the management of that institution) but he did agree to serve as a trustee of both the National Gallery and the Wallace Collection, taking up the former appointment on 30 May 1892. His eligibility is likely to have been apparent since the summer of 1884, when he had helped the National Gallery's trustees in their negotiations with the Duke of Marlborough.[2] Charles Holmes, who became director of the Gallery shortly before Alfred's death, recalled that he was respected 'for his wealth, his masterful temper and his collection of pictures, from which they [the other trustees] optimistically imagined that the Gallery would receive some very considerable benefit'.[3]

The expectation of such a benefit had not in fact been obviously misplaced. Alfred was a friendly rival of his cousin and brother-in-law Baron Ferdinand de Rothschild (1839–1898), the builder of Waddesdon, who bequeathed his great collection of *objets d'art* (partly inherited from his father, Baron Anselm (1803–1874)) to the British Museum.[4] Furthermore, Lord Rothschild (Alfred's brother 'Natty') was one of the three wealthy individuals who stepped forward in 1890 to secure from Lord Radnor a Moroni (NG 1316), a 'Velazquez' (NG 1315, now attributed to Mazo) and Holbein's *Ambassadors* for the Gallery, certainly with Alfred's agreement and perhaps at his prompting.[5] Alfred himself made contributions towards the cost of acquiring the great portraits of Jacob Trip and Margaretha de Geer by Rembrandt (NG 1674 and 1675) in 1899,[6] and the Gossaert *Adoration of the Kings* (NG 2790) in 1911.[7] It is likely that he encouraged the bequest by the Misses Cohen of John Samuel's collection[8] and perhaps also that of Lady Lindsay.[9] He himself bequeathed to the Gallery only one painting from his great collection, Reynolds's full-length portrait of Lady Bamfylde (now in Tate Britain), and although this must have been a disappointment the painting was an example of a type of portrait that was far more admired then than is the case today.[10]

Because of his position in high society and in the world of finance Alfred was almost certainly well informed about families which might be obliged to sell, or at least consider selling, their paintings. In any case, he and other members of his family were often offered paintings (Lord Darnley's *Allegories* by Veronese, for example – see p. 424) far in advance of the National Gallery. But I have found no evidence that he ever shared information of this kind with the director or his fellow trustees, and it is unlikely that he would have felt any obligation to do so. Just as the Marquess of Lansdowne (created a trustee in 1894) and the Earl Brownlow (created one in 1897) were not embarrassed by the fact that they were engaged in the selling of major old master paintings while serving as trustees of the Gallery, so Alfred did not feel inhibited about buying such paintings for himself when he was one. Both Alfred and Lord Lansdowne had a very conservative vision of the National Gallery, regarding it as an institution to be protected rather than developed. They were inclined to regard the director as little more than a head clerk whose aspirations needed to be crushed and whose initiatives needed to be curbed. Alfred had a low opinion of Poynter and no confidence in Holroyd and did much to destroy the morale of both men and the health of the latter. His contacts with Agnew's and, through them, with Fairfax Murray enabled him to save the Gallery from acquiring a fake in the winter of 1908.[11] But most of his interventions were less fortunate.

In 1894, two years after Alfred's appointment as a trustee, Burton retired as director. There had been general

dissatisfaction with Burton's performance during the 1890s and it was natural in these circumstances to question the nature of the director's authority, but the 'Rosebery minute', which removed most of the director's powers, was a fatal step, making almost impossible any 'definite policy of purchase or for arresting the unhappy exodus of works of art'.[12] The wiser trustees were opposed to the minute[13] and it was believed that Alfred was responsible for it both because he had been highly critical of Burton and because he had easy access to Lord Rosebery's ear.[14]

In 1897 Alfred declared Holbein's *Christina of Denmark* (NG 2475) to be unworthy of the National Gallery[15] – luckily its acquisition was made possible by an anonymous private donation to the National Art Collections Fund. In 1904 he opposed the purchase of Titian's *Portrait of a Man with a Quilted Sleeve* (NG 1944).[16] The frustrations of attempting to persuade the trustees even to consider this acquisition led to Poynter's resignation. In 1908 Alfred professed himself to be 'astonished beyond words' by the plan to pledge money granted to the Gallery in advance for *A Family Group in a Landscape* by Hals (NG 2285), which he regarded as an 'extremely coarse specimen of the master'.[17] His indignation led him to threaten to reveal his dissent to the newspapers; and, presumably to counter any such action, the senior trustee, George Howard, Lord Carlisle (appointed in 1881), felt obliged to obtain an exact record of his poor attendance at meetings.[18] In 1914 Alfred stopped the acquisition of Titian's *Death of Actaeon* (catalogued here).[19] In 1916 he objected to the acquisition of Masaccio's *Virgin and Child* (NG 3046).[20] In the same year he expressed his view that the Gallery should be closed for the duration of the war. In the following year he reiterated his conviction that it was 'not the right moment' to purchase paintings.[21]

Alfred de Rothschild seems to have been a fastidious aesthete. The privately printed catalogue of his collection published in 1884 includes photographs of the exquisitely arranged rooms in his London house, 1 Seamore Place (fig. 11). A famous Greuze (*Le Baiser envoyé*) was hung above a Riesener secrétaire, with mounts by Gouthière embellished with a large enamel plaque copied from Boucher. The Louis XV table was also inlaid with porcelain, and a set of *gros bleu* Sèvres vases adorned the chimneypiece. A famous Teniers hung

Fig. 11 J. Thomson, photograph of a room in 1 Seamore Place, London, published 1884.

below an Aelbert Cuyp, an Isack van Ostade above a Wouwermans.[22] The arrangements must have changed soon afterwards, when he completed the furnishing of his country house, Halton, in the vale of Aylesbury. In this skilfully modified version of Mansart's Château de Maisons[23] all the French paintings ('with the exception of the two famous Greuzes, a charming little Watteau and four small but delicious Fragonards'[24]) would be 'cunningly framed' in the white and gold panelling.[25] Exquisite blooms adorned the tables inside as well as the view from every window. These were furnished by an army of sixty gardeners, who also maintained the winter garden (where Alfred himself conducted a Hungarian band) in perfect order and at a constant temperature.[26] The experience of creating and managing such a place may have proved useful for his work at the Wallace Collection. Alfred was given credit for the decision to display the collection in Hertford House,[27] and his 'judgment and aptitude for hanging pictures' and arranging everything for public viewing was commended by his colleagues.[28] In Trafalgar Square he was not able to intervene in this manner. The 'despot' of the Board of Trustees[29] attended meetings infrequently and intervened negatively.

The catalogue of Alfred's collection compiled by Charles Davis in 1884 contains a text of no interest but superb photographs by J. Thomson of Grosvenor Street. These are of special value because

the paintings are illustrated in their frames, the latter being mostly imitations of French mid-eighteenth-century style. The first volume includes 212 paintings, many inherited from Alfred's 'dearly beloved father', although those which belong to this category are not indicated.[30] The second volume records the 'Sèvres china, furniture, metal work and *objets de vitrine*', many of them also inherited – ivory tankards, rock crystal vases, French enamels, some noted Pallissy ware,[31] and the once-famous 'Orpheus Cup'.[32]

The paintings fall into three distinct categories, all of which had been for some time favoured by his family: French eighteenth-century pastoral and gallant pictures (Lancret, Boucher, Greuze), English portraits of the late eighteenth century (Reynolds, Gainsborough and Romney) and the sort of Dutch seventeenth-century painting that had been most admired in eighteenth-century France – landscapes, of course, but also David Teniers's marvellous painting on copper of elegant company, then known as *The Marriage of the Artist* (private collection); Metsu's *Duet (Le Corsage Bleu)*, now in the Bearstead Collection at Upton House; and De Hooch's *A Dutch Court-yard*, now in the National Gallery of Art, Washington).[33] The collecting of porcelain and exquisite goldsmiths' work was also by then traditional in Alfred's family but I have found little evidence that he continued to collect much in these areas after the publication of his catalogue,[34]

whereas he certainly increased his collection of paintings, buying some of his grandest portraits by Gainsborough, Reynolds and Romney at the Earl of Lonsdale's sale in 1887, for example, and in 1907 acquiring, in league with Agnew's, the Ashburton collection, from which he extracted masterpieces for himself (including Metsu's *Woman Seated Drawing*, NG 5225).[35]

Among his fellow trustees at the National Gallery were John P. Heseltine, whose interests as a collector embraced both medieval and modern art, and Lord Carlisle, who was himself an amateur painter of distinction. Had Alfred shared their interest in contemporary art he would perhaps have shown more respect for Poynter and Holroyd, both of whom were successful artists of real stature. The keenest collector on the Board apart from himself was Robert (known as Robin) Benson but his passion was for Italian Renaissance paintings, of which Alfred owned very few.[36] Alfred had no interest in exploring novel areas of aesthetic experience such as Duccio and the early Sienese painters (collected by Benson) or El Greco (an interest of Heseltine's), to say nothing of icons, Buddhist sculpture, ancient Asian ceramics or post-Impressionism. In 1906 *The Burlington Magazine* lamented the paralysis afflicting the National Gallery on account of the 'insane' insistence on unanimity among the trustees, which made it impossible to acquire anything that did not conform to a certain trustee's 'preference for art of what may be called the glorified chocolate box type'.[37]

To the readers of *Les Arts* and *The Connoisseur* – less adventurous journals (also recently founded) – Alfred's taste was entirely admirable.[38] And, if it was old-fashioned, it was not about to go out of favour. In 1918, when Alfred died, the army was encamped in the grounds of Halton, and soon afterwards the house was occupied by the Royal Air Force, but its careful imitation of the French eighteenth century, tactfully modified by modern amenities,[39] was already being copied in the houses of Joseph Duveen's American clients, who were also eager to furnish such houses with Riesener commodes and Sèvres vases and paintings by Romney, Lancret and de Hooch.

Alfred bequeathed some of his paintings to his family, and one Reynolds, as has been mentioned, went to the National Gallery; but the large majority of his collection was inherited by Almina, Countess of Carnarvon, the daughter of Mrs Wombwell, formerly Mlle Marie Boyer, an actress rumoured to have been

Alfred's mistress. In his will he had expressed the hope that they would be regarded as heirlooms, but three months after his death she disposed of 27 paintings (including Titian's *Allegory of Prudence* catalogued here, together with much more highly prized works by English, French and Dutch masters), and she sold another 58 at Christie's on 22 May 1925.[40] Other works were sold to dealers, among them Joseph Duveen, who secured from her in 1924 the de Hooch for Andrew Mellon and one of Romney's most famous pictures of Emma Hart and two of Gainsborough's most splendid full-length female portraits for Henry Huntington.[41]

Alfred's most important legacy to the National Gallery was indirect and unintended. The most deplorable aspect of the 'Rosebery minute' was the fact that in bestowing new power on the trustees it imposed no obligations on them. Alfred's notoriously poor attendance and his preference for denunciation over debate must have helped prompt Lord Asquith's minute of 1916 by which trustees were appointed for seven years rather than for life.[42] The next generation of trustees showed a new degree of commitment and enterprise, as is described elsewhere in this catalogue in the complicated story of how Titian's *Vendramin Family* (and with it the *Wilton Diptych*) was secured for the national collection.

NOTES

1. For the family generally see Ferguson 1998.

2. National Gallery Archive 7/63/1884. See also the letters of Sir William Gregory to Howard (later Lord Carlisle) of 17 June and of Harding to Gregory of 27 June 1884, Castle Howard Muniments J22/78.

3. Holmes 1938, p. 331.

4. Thornton 2001.

5. In the official records the donation was made by Lord Rothschild (see Penny 2003, p. 212) but it is interesting that Erskine (1902, p. 71) wrote that Alfred 'helped, with a substantial donation from his firm, Messrs. Rothschild'.

6. National Gallery Archive 7/232/1899.

7. Ibid. 7/397/1911 (£500).

8. Penny 2004, pp. 390–2.

9. See pp. 198–9.

10. Mannings 2000, I, p. 71, no. 104; II, plate 83 and fig. 1179. Alfred specified that it should not go to the Tate Gallery but it did, in 1949.

11. Holmes 1936, p. 232. Letters from Heseltine to Carlisle of 16 December and 31 December 1908 and 4 January 1909 refer to this incident, Castle Howard Muniments J22/78.

12. Holmes and Collins Baker 1924, pp. 65–6, 68, 70; Holmes 1936, p. 232.

13. See especially Carlisle's draft letter to Rosebery of 22 April 1894 concerning the

minute which he considered to be 'seriously disadvantageous to the best interests of the gallery'. Castle Howard Muniments J22/78.

14. Holmes 1936, p. 232.

15. National Gallery Archive 7/209/1897.

16. Ibid. 7/288/1904.

17. Ibid. 7/347/1908.

18. Castle Howard Muniments J22/78, letter to Carlisle from Hawes Turner (the Keeper) of 18 August 1908 providing the information that Alfred had attended 19 of the 58 board meetings held since he was created a trustee.

19. See p. 276.

20. National Gallery Archive 26/101, letter to Holroyd of 8 February 1916.

21. Ibid., letter to Holroyd of 3 July 1917.

22. Davis 1884, I, no. 51 (Greuze); II, no. 98 (secrétaire); no. 101 (table); I, no. 29 (Teniers), no. 12 (Cuyp), no. 42 (Wouwermans) and no. 25 (Isack van Ostade).

23. The architect was William R. Rogers, a partner of William Cubitt and Co. Drawings were published in *The Architect* on 17 November, 1 December, 22 December 1893, pp. 312, 344, 390, and on 12 January and 9 February 1894, pp. 32 and 96.

24. Erskine 1902, p. 71.

25. The character of the interior is described by Warwick 1931, pp. 89–91.

26. For the gardeners see Field 1973 and for the band and other details see Parrott 1968.

27. Erskine 1902, p. 71.

28. The opinion of Bertie Mitford and Murray Scott concerning Alfred's taste is quoted by Edward Hamilton in his diary on 5 April 1900 (Thornton 2001, pp. 211–12, note 116).

29. Holmes (1936, p. 224) uses this expression, one which he is not likely to have invented.

30. A full account of the division of Lionel's estate agreed upon in 1882, together with a list of all the paintings involved, is said to be in the archive of N.M. Rothschild.

31. Davis 1884, II, nos 151–4.

32. Ibid., II, no. 149.

33. For the Teniers, as it was then interpreted, see Erskine 1902, pp. 73–4. See Klinge and Lüdke 2005, pp. 268–71, no. 85 (entry by Lüdke). For the Metsu see Gore 1964, pp. 34–5, no. 120, and Laing 1995, pp. 178–9, no. 65. The de Hooch is NGA 1937.1.56, Andrew Mellon Collection. It was sold to Mellon by Duveen in 1924.

34. In this connection, the donation of a silver Tucher cup to his brother-in-law Ferdinand is perhaps significant (Thornton 2001, pp. 193–4).

35. Prévost-Marcilhacy 1995, p. 164, describes the Ashburton purchase. In Agnew 1967, p. 46, the 61 paintings are simply said to have been bought by Agnew's. See Maclaren and Brown 1991, I, 260, for the provenance of the Metsu, which was presented to the Gallery by Lord Rothermere in 1940. Among the trustees Heseltine at least was aware of Alfred's involvement. He informed Carlisle of it in a letter of 22 October 1907, Castle Howard Muniments J22/78.

36. In Davis's catalogue of 1884 there were only two Italian pictures, nos 79 and 80, attributed to (and perhaps copies of) Domenichino and Reni. In addition to Titian's *Allegory of Prudence*,

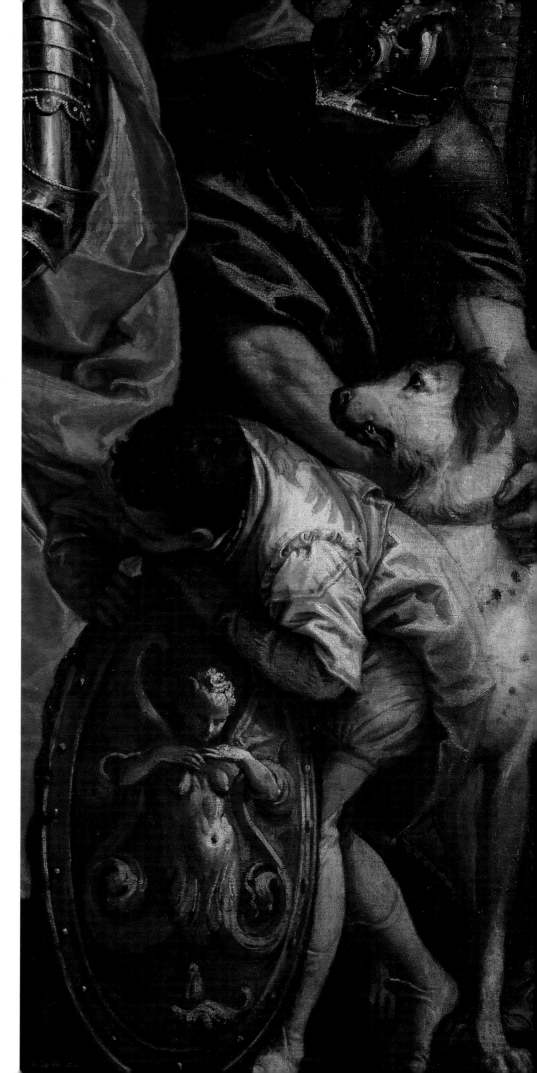

catalogued here, Alfred owned the *Toilet of Venus* (now Courtauld Institute, London), then attributed to Veronese (sold at Christie's on 31 May 1918, lot 158, by Lady Carnarvon), also the Giovanni Bellini *Portrait of a Gentleman* (now in the National Gallery of Art, Washington) and a Botticelli *Virgin and Child* recently on the art market (sold Christie's on 22 May 1922, lot 58, by Lady Carnarvon).

37. The leader appeared in the special issue of June–August 1906 (II, pp. 5–7). This may be the earliest use of 'chocolate-box' to disparage a type of taste, an expression that remained popular for a century. The author was probably C.J. Holmes.

38. For example Erskine 1902, Villars 1902 and De Nolhac 1903.

39. The electric lighting was admired at both Halton (see Warwick 1931, p. 90) and Seamore Place (see, for instance, Erskine 1902, p. 71, for picture lights, and p. 79 for cabinets 'lighted from within by electricity').

40. The suggestion has been made that Lady Carnarvon's sales were precipitated by the unexpected death of the 5th Earl (the Egyptian archaeologist) in 1923 but this is not entirely plausible. That Alfred was her father is sometimes denied.

41. See Asleson 2001, pp. 100–4, no. 16, and pp. 146–50, no. 25, for Gainsborough's portraits of Elizabeth Beaufoy and Henrietta Read; and ibid., pp. 424–7, no. 92, for Romney's *Emma Hart*.

42. Holmes and Collins Baker 1924, p. 74.

Fig. 12 Detail from Veronese, *The Family of Darius before Alexander* (NG 294).

List of publications cited

Acidini Luchinat, Cristina, ed., *Il Mito di Europa – da fanciulla rapita a continente* (exh. cat. Uffizi, Florence, 2002–3), Florence 2002

Adam, A.E., *Beechwoods and Bayonets – the Book of Halton*, Buckingham 1983

Addison, Julia de Wolf, *The Art of the National Gallery: A critical survey of the schools and painters as represented in the British Collection*, London 1905

Agnese Chiari, M., *Incisioni da Tiziano*, Venice 1982

Aikema, Bernard, 'Le Decorazioni di Palazzo Barbaro-Curtis', *Arte Veneta*, XLI, 1987, pp. 147–53

Aikema, Bernard, *Pietro della Vecchia and the heritage of the Renaissance in Venice*, Florence 1990

Aikema, Bernard, *Jacopo Bassano and His Public: moralizing pictures in an age of reform*, Princeton 1996

Aikema, Bernard, 'Exemplum virtutis: "The Family of Darius before Alexander" in Renaissance and Baroque Art' in Hadjinicolau 1997, pp. 164–70

Aikema, Bernard, and Beverly Louise Brown, eds, *Renaissance Venice and the North: Cross currents in the time of Dürer, Bellini and Titian* (exh. cat. Palazzo Grassi, Venice, 1999), London 1999

Aikema, Bernard, Rosella Lauber and Max Seidel, *Il collezionismo a Venezia e nel Veneto ai tempi della Serenissima* (papers given at a convegno at the Kunsthistorisches Institut, Florence, in 2003), Venice 2005

Alciati, Andrea, *Emblematum libellus*, Venice 1546

Alciati, Andrea, *Diverse imprese accommodate a diverse moralità*, Lyon 1551

Alberton Vinco da Sesso, Livia, *Jacopo Bassano. I Dal Ponte: una dinastia di pittori*, Bassano 1992

Anderson, Jaynie, 'A further inventory of Gabriel Vendramin's collection', *The Burlington Magazine*, CXXI, October 1979, pp. 639–48

Anderson, Jaynie, 'Layard and Morelli' in *Austen Henry Layard tra l'Oriente e Venezia* (Symposium held in Venice, October 1983), ed. F.M. Fales and Bernard J. Hickey, Rome 1987, pp. 109–38

Anderson, Jaynie, *Giorgione: the painter of 'poetic brevity'*, Paris and New York 1997

Anderson, Jaynie, *Collecting, Connoisseurship and the Art Market in Risorgimento Italy: Giovanni Morelli's Letters to Giovanni Melli and Pietro Zavaritt (1866–1872)* (Memorie dell'Istituto Veneto di Scienze, Lettere ed Arti, LXXXII), Venice 1999

Anderson, Jaynie, 'Count Francesco Algarotti as an advisor to Dresden', in Aikema, Lauber and Seidel 2005, pp. 275–86

Angelini, Giovanni, and Ester Cason Angelini, *Gli scultori Panciera Besarel di Zoldo* (exh. cat. Palazzo Crepadona, Belluno, and Chiesetta dell'Addolorata, Forno di Zoldo, 2002), Belluno 2002

Angulo Iñiguez, Diego, *Pedro de Campaña*, Seville 1951

Anon., *Catalogo dei Quadri, e pitture esistenti nel palazzo Colonna*, Rome 1783

Anon., *Guida al Forestiero per osservare con metodo le rarità e bellezze della città di Firenze*, Florence 1793

Anon., *Il forestiere istruito nelle cose più pregevoli e curiose antiche e moderne della città di Venezia*, Venice 1819, 1822

Anon., *A Catalogue of Pictures in the National Gallery*, London 1838, 1840, 1843 (this was the official summary guidebook, presumably the responsibility of the Gallery's successive keepers)

Anon., 'Editorial: Sir Peter Lely's Collection', *The Burlington Magazine*, LXXXIII, August 1943, pp. 185–91

Anon., 'Alessandro Contini-Bonacossi', *Dizionario Biografico degli Italiani*, XXVIII, 1983, pp. 523–6

Anthofer, Gisela, *Tintoretto as a Mythological Painter*, MA Report, Courtauld Institute of Art, London, 1996

Antonini, [Abbé] Annibale *see* Bauche [Jean-Baptiste] fils

Antonucci, G., 'La Leggenda di S. Giorgio e del drago', *Emporium*, LXXVI, 1932, pp. 79–89

Apuleius, Lucius, *The Golden Ass*, trans. W. Adlington in 1566 but revised, London 1935

Arasse, Daniel, 'Titien et son allégorie de la Prudence: un peintre et des motifs' in *Interpretazioni Veneziane: Studi in storia dell'arte in onori di Michelangelo Muraro*, ed. David Rosand, Venice 1984, pp. 291–310

Aretino, Pietro, *Lettere sull'Arte di Pietro Aretino*, commentary by F. Pertile, ed. E. Camesasca, 3 vols in 4, Milan 1957–60

Arisi, Ferdinando, *Gian Paolo Panini e i fasti della Roma del '700*, Rome 1986

Arnaud, François, and Henri Coquille, *Description des principales pierres gravées du cabinet de S.A.S. Monseigneur le duc d'Orléans*, 2 vols, Paris 1780–4 (the second volume's colophon has the date 1785; Arnaud seems to have only helped with the text of the first volume)

Arslan, Wart, 'Contributo a Jacopo Bassano', *Pinacotheca*, I, 1929, pp. 178–96

Arslan, Wart, *I Bassano*, 2 vols, Bologna 1931; 2nd edn (under the name Edoardo Arslan), Milan 1960

Arslan 1946–7 *see* Pignatti and Pedrocco 1995, II, p. 371

Artemieva, Irina, '"Della Veneziana scuola siamo ricchi veramente"' in *Capolavori nascosti dell'Ermitage*, ed. Irina Artemieva, Giuseppe Bergamini and Giuseppe Pavanello (exh. cat. Castello di Udine, 1998), Milan 1998, pp. 19–58

Artemieva, Irina, 'Vicende della pittura veneta rinascimentale all'Ermitage' in Artemieva and Guderzo 2001, pp. 1–58

Artemieva, Irina, and Mario Guderzo, *Cinquecento veneto. Dipinti dall'Ermitage* (exh. cat. Museo Civico, Bassano del Grappa, 2001), Milan 2001

Asleson, Robyn, *British Paintings at the Huntington*, New Haven 2001

Aston, Margaret, 'Puritans and Iconoclasm, 1560–1660' in *The Culture of English Puritanism, 1560–1700*, ed. C. Durston and J. Eales, Basingstoke and London 1996, pp. 92–121

Attwood, Philip, *Italian Medals, c.1530–1600, in British Public Collections*, 2 vols, London 2003

Avagnina, Maria Elisa, 'La tecnica pittorica di Jacopo Bassano attraverso le fonti' in Brown and Marini 1992, pp. ccxlv–cclvi

Avery, Charles, 'A fascinating enigma', *Quarterly* (the National Art Collections Fund magazine), Winter 1998, pp. 47–9

Bacchi, Andrea, *et al.*, *Francesco Marmitta*, Turin 1995

Bacou, Roseline, and Françoise Viatte, *Italian Renaissance Drawings from the Musée du Louvre: Roman Tuscan and Emilian* (exh. cat. Metropolitan Museum of Art, New York, 1974–5), New York 1975

Bacou, Roseline, *et al.*, *Acquisitions du Cabinet des Dessins 1973–1983* (exh. cat. Musée du Louvre, Paris, 1984), Paris 1984

Baglione, Giovanni, *Le Vite de' pittori, scultori ed architetti*, Rome 1733

Baiocchi, A., 'Pasquale Cicogna', *Dizionario Biografico degli Italiani*, XXV, 1981, pp. 403–6

Bailo, Luigi, and Gerolamo Biscaro, *Della Vita e delle opere di Paris Bordon*, Treviso 1900

Baker, Herbert, *Architecture and Personalities*, London 1944

Balboni, Dante, 'Giorgio, santo, martire' in *Bibliotheca Sanctorum*, Rome 1965, pp. 511–25

Baldassari, Francesca, *Carlo Dolci*, Turin 1995

Baldi, Renato, Giovan Gualberto Lisini, Carlo Martelli and Stefania Martelli, *La Cornice Fiorentina e Senese. Storia e tecniche di restauro*, Florence 1992

Ballarin, Alessandro, 'Profilo di Lamberto d'Amsterdam (Lamberto Sustris)', *Arte Veneta*, XVI, 1961, pp. 51–81

Ballarin, Alessandro, 'Lamberto d'Amsterdam (Lambert Sustris), le Fonti de la critica', *Arte dell'Istituto Veneto di Scienze, Lettere ed Arti*, CXXI, 1962–3, pp. 335–66

Ballarin, Alessandro, 'Una villa interamente affrescata da Lamberto Sustris', *Arte Veneta*, XX, 1966, pp. 244–9

Ballarin, Alessandro, 'Jacopo Bassano e lo studio di Raffaello e dei Salviati', *Arte Veneta*, XXI, 1967, pp. 77–101

Ballarin, Alessandro, 'La decorazione ad affresco della villa veneta nel quinto decennio del Cinquecento: La villa di Luvigliano', *Bollettino del Centro Internazionale di Studi di Architettura Andrea Palladio*, X, 1968, pp. 115–26, figs 93–104

Ballarin, Alessandro, 'Introduzione ad un catalogo dei disegni di Jacopo Bassano', part one: *Arte Veneta*, XXIII, 1969; part two: *Studi di Storia dell'Arte in onore di Antonio Morassi*, Venice 1971; part three: *Arte Veneta*, XXVII, 1973; collected in Ballarin 1995–6, I, 1995, pp. 145–79, 181–9, 199–241

Ballarin, Alessandro, *Jacopo Bassano*, 2 vols, Cittadella 1995–6 (the first volume, *Scritti, 1964–1995*, was published in 1995 in two parts; the second, comprising plates of Bassano's paintings, was published in three parts in 1996; three other volumes were announced but have not yet been published – these include the catalogue which would accompany the plates and a volume devoted to the 'figli di Jacopo Bassano a Venezia')

Ballarin, Alessandro, and Davide Banzato, eds, *Da Bellini a Tintoretto: Dipinti dei Musei civici di Padova*, Rome 1991

Banco Bilbao Vizcaya, *Tesoros de la Catedral de Burgos* (exh. cat.), Madrid 1995

Barbagli, Marzio, *Sotto lo stesso tetto. Mutamenti della famiglia in Italia dal XV al XX secolo*, Bologna 1984

Barbantini, Nino, ed., *La Mostra del Tintoretto* (exh. cat. Ca' Pesaro, Venice, 1937), Venice 1937

Barbieri, Franco, *Il Museo civico di Vicenza*, 2 vols, Venice 1962

Barbiero, G., *Le confraternite del Santissimo Sacramento prima del 1539*, Treviso 1944

Barcham, William L., and Catherine R. Puglisi, 'Paolo Veronese e la Roma dei Barberini', *Saggi e Memorie di Storia dell'Arte*, XXV, 2001, pp. 55–87

Bardi, Girolamo, *Dichiaratione di tutte le istorie che si contengono nei quadri posti novamente nelle Sale dello Scrutinio, & del Gran Consiglio, del Palagio Ducale*, Venice 1587

Barnes, Susan J., Nora De Poorter, Oliver Millar and Horst Vey, *Van Dyck: a complete catalogue of the paintings*, London and New Haven 2004

Barnes, Susan J., and Arthur K. Wheelock, Jr., *Van Dyck 350* (National Gallery of Art, Washington, Center for Advanced Study in the Visual Arts, Symposium Papers XXVI), Washington DC 1994

Barocchi, Paola, ed., *Trattati d'Arte del Cinquecento*, 2 vols, Bari 1961

Baronius (Cesare Baronio), *Martyrologium Romanorum*, Rome 1586

Barri, Giacomo, *The Painter's Voyage of Italy*, trans. 'W.L.' [William Lodge], London 1679

Bartoli, Roberta, *Biagio d'Antonio*, Milan 1999

Bartsch, Adam von, *Le Peintre Graveur*, 21 vols, Vienna 1802–21

Bassi, Elena, *et al.*, *Venezia nell'Età di Canova* (exh. cat. Museo Correr, Venice, 1978), Venice 1978

Battilotti, Donata, 'Gabriele Vendramin' in Maschio 1994, pp. 226–9

Battilotti, Donata, and Maria Teresa Franco, 'Regesti di Committenti e dei primi collezionisti di Giorgione', *Antichità Viva*, XVII, 1978, pp. 58–86

Bauche [Jean-Baptiste] fils, *Mémorial de Paris et de ses environs*, 2 vols, Paris 1749 (Bauche was the publisher, who signs the dedicatory epistle; the original text is by the Abbé Annibale Antonini)

Bayes, Walter, *The Art of Decorative Painting*, New York 1927

Beckett, Ronald Brymer, *John Constable's Correspondence with C.R. Leslie R.A.*, Ipswich 1965

Beckett, Ronald Brymer, *John Constable's Discourses*, Ipswich 1970 (Suffolk Records Society, XIV)

Béguin, Sylvie, 'A propos de quelques peintures attribuées à Paris Bordon au Musée du Louvre', *Bulletin du Laboratoire du Musée du Louvre*, 1964, IX, pp. 1–16

Béguin, Sylvie, 'Paris Bordon en France' in Fossaluzza and Manzato 1987, pp. 9–27

Bellodi, Rosolino, *Il Monastero di San Benedetto in Polirone nella storia e nell'Arte*, Mantua 1905

[Bellori, Giovanni Pietro], *Nota delli Musei, Librerie, Galerie...* 1664, ed. Emma Zocca, Rome 1976 (this anonymous publication may in fact not be by Bellori but by Fioravante Martinelli; see Daly Davis 2005)

Belluzzi, Amedeo, 'Documenti Polironiani. L'apparato decorativo di San Benedetto in Polirone nei regesti del Fiandrini' in Piva and Simonelli 2001, pp. 133–52

Belotti, Bortolo, *Storia di Bergamo e dei Bergamaschi*, 3 vols, Milan 1940; rev. edn, Bergamo 1959

Beltrami, Guido, and Howard Burns, *Andrea Palladio e la villa Veneta da Petrarca a Carlo Scarpa* (exh. cat. Museo Palladio, Vicenza, 2005), Vicenza 2005

Benati, Daniele, *et al.*, *The Drawings of Annibale Carracci* (exh. cat. National Gallery of Art, Washington DC, 1999–2000), Washington DC 1999

Benson, Robert Henry, *Catalogue of Italian pictures at 16, South Street, Park Lane, London and Buckhurst in Sussex, collected by Robert and Evelyn Benson*, London 1914

[Benson, Robert H.], *The Venetian School; pictures by Titian and his Contemporaries* (exh. cat. Burlington Fine Arts Club, London, May–July 1914), London 1915

Bentini, Jadranka, ed., *Bastianino e la pittura a Ferrara nel secondo cinquecento*, Bologna 1985

Bentini, Jadranka, ed., *Quadri Rinomatissimi: il Collezionismo dei Pio di Savoia*, Modena 1994

Berenson, Bernhard, *The Venetian Painters of the Renaissance with an index to their works*, London 1894; 2nd edn, 1906

Berenson, Bernhard, *Catalogue of a Collection of Paintings and Some Art Objects* [the Johnson Collection, vol. I], Philadelphia 1913

Berenson, Bernard, *Italian Pictures of the Renaissance*, Oxford 1932

Berenson, Bernard, *Italian Pictures of the Renaissance: The Venetian School*, 2 vols, London 1957

Berger, Adolf, 'Inventar der Kunstsammlung des Erzherzogs Leopold Wilhelm von Österreich', *Jahrbuch der Kunsthistorischen Sammlungen des Allerhöchsten Kaiserhauses*, I, 1883, part 2, pp. LXXIX–CLXXXVII

Bernardini, Maria Grazia, ed., *Tiziano Vecellio: Amor Sacro e Amor Profano* (exh. cat. Palazzo delle Esposizioni, Rome, 1995), Rome 1995

Beroqui, Pedro, *Tiziano en el Museo del Prado*, Madrid 1946

Berry, Mary, *Journals and Correspondence*, 3 vols, London 1865

Berzaghi, Renato, 'Giovan Battista Bertani (1516?–1576)' in *Manierismo a Mantova*, ed. Sergio Marinelli, Milan 1998, pp. 53–61

Bettagno, Alessandro, ed., *Venezia da Stato a Mito* (exh. cat. Fondazione Giorgio Cini, Venice, 1997), Venice 1997

Bettini, Sergio, 'Ascendenze e significato della pittura Veneto-Cretese' in *Venezia Centro di Mediazione tra Oriente e Occidente (secoli XV–XVI). Aspetti e problemi*, ed. Hans-Georg Beck *et al.*, II, Florence 1977, pp. 691–703

Białostocki, Jan, 'Le Vocabulaire visuel de Jacopo Bassano et son *Stilus humilis*', *Arte Veneta*, XXXII, 1978, pp. 169–73

Birke, Veronika, and Janine Kertész, *Die Italienischen Zeichnungen der Albertina*, IV, Vienna 1997

Birkmaier, U., A. Wallert and Andrea Rothe, 'Technical Examinations of Titian's Venus and Adonis: a Note on Early Oil Painting Technique' in *Historical Painting Techniques, Materials and Studio Practice*, Preprints of a Symposium, University of Leiden, 26–9 June 1995, ed. A Wallert *et al.*, Getty Conservation Institute, 1995, pp. 111–17

Block, J.C., *Jeremias Falck, sein Leben und seine Werke*, Danzig, Leipzig and Vienna 1890

Bober, Phyllis Pray, and Ruth O. Rubinstein, *Renaissance Artists and Antique Sculpture*, Oxford 1986

Bocchi, Achille, *Symbolicarum Quaestionum*, Bologna 1574

Bode, Wilhelm von, Georg Gronau and Detlev von Hadeln, eds, *Archivalische Beiträge zur Geschichte der venezianischen Kunst aus dem Nachlass Gustav Ludwigs*, Berlin 1911

Bologna, Ferdinando, 'Osservazioni su Pedro de Campaña', *Paragone*, XLIII, July 1953, pp. 27–49

Bone, Muirhead, Letter to *The Burlington Magazine*, XLII, May 1923, pp. 251–4

Bonsanti, Giorgio, *Antonio Begarelli*, Modena 1992

Bordeaux, J., 'A Sheet of Studies for Veronese's Four Allegories of Love', *The Burlington Magazine*, CXVII, September 1975, pp. 600–3

Bordignon Favero, Elia, *Giovanni Battista Volpato: critico e pittore*, Treviso 1994

Bordignon Favero, Giampaolo, *La Villa Soranza di Michele Sanmicheli a Castelfranco Veneto*, Treviso 1958

Borean, Linda, '"Ricchezze virtuose": il collezionismo privato a Venezia nel Seicento (1630–1700)', PhD diss., Università degli Studi di Udine, 1998

Borean, Linda, '"Con il maggior vantaggio possibile". La vendita della collezione del procuratore di San Marco Giacomo Correr' in *The Art Market in Italy*, Modena 2003, pp. 337–54

Borean, Linda, 'Le "Maddalene penitenti" di Tiziano', *Studi Tizianeschi*, Venice 2004, pp. 44–7

Borean, Linda, *Il carteggio Giovanni Maria Sasso–Abraham Hume (Lettere artistiche del Settecento veneziano, 2)*, Venice 2004

Borean, Linda, 'Nuovi elementi e considerazioni sulla collezione di John Law', Proceedings of the Symposium held at Caen in May 2006, to be published in 2007

Borenius, Tancred, *The Painters of Vicenza 1480–1550*, London 1909

Borenius, Tancred, '*St Jerome* by Cima da Conegliano', *The Burlington Magazine*, XIX, September 1911, pp. 318–23

Borenius, Tancred, *A Catalogue of the Paintings at Doughty House, Richmond. Vol. I, The Italian Schools*, London 1913

Borenius, Tancred, 'The Reconstruction of a Polyptych by Signorelli', *The Burlington Magazine*, XXIV, October 1913, pp. 32–6

Borenius, Tancred, 'A Portrait by Alessandro Longhi', *The Burlington Magazine*, XXVI, February 1915, p. 181

Borenius, Tancred, 'Two Unpublished North-Italian Drawings', *The Burlington Magazine*, XXIX, October 1916, pp. 271–2

Borenius, Tancred, ed., *The Picture Gallery of Andrea Vendramin*, London 1923

Borenius, Tancred, *Catalogue of the Pictures and Drawings at Harewood House and elsewhere in the collection of the Earl of Harewood*, Oxford 1936

Borghini, Raffaello, *Il Riposo*, Florence 1584; Florence 1730

Borowitz, Helen and Albert, *Pawnshop and Palaces: the fall and rise of the Campaña art museum*, Washington DC and London 1991

Boschini, Marco, *La Carta del Navegar pitoresco*, Venice 1660, and Anna Pallucchini, ed., Rome 1964

Boschini, Marco, *Le Minere della Pittura*, Venice 1664 (1st edition of Boschini 1674)

Boschini, Marco, *Le ricche minere della pittura veneziana*, 2nd edn, Venice 1674

Boschini, Marco, *Descrizione di tutte le pubbliche pitture della città di Venezia e isole circonvicine*, Venice 1733

Boskovits, Miklos, and David Alan Brown, *Italian Paintings of the Fifteenth Century*, National Gallery of Art, Washington, Oxford 2003

Boucher, Bruce, *Andrea Palladio: the architect in his time*, New York 1994

Boucher, Bruce, ed., *Earth and Fire. Italian terracotta sculpture from Donatello to Canova* (exh. cat. Museum of Fine Arts, Houston, and Victoria and Albert Museum, London, 2001), New Haven and London 2001

Boyer, Ferdinand, 'Les collections de François de Laborde-Méréville (1761–1802)', *Bulletin de la Société de l'histoire de l'art français, année 1967*, 1968, pp. 141–52

Bozzo Dufour, Colette, *et al., La Pittura a Genova e in Liguria*, 2 vols, Genoa 1987

Bozzolato, Giampiero, *Tra Natura e Paesaggio: I Roberti e il Palazzo di Brugine*, Padua 1979

Bradbury, Oliver, and Nicholas Penny, 'The picture collecting of Lord Northwick', *The Burlington Magazine*, CXLIV, Part I, August 2002, pp. 485–96; Part II, October 2002, pp. 606–17

Braham, Allan, 'Veronese's Allegories of Love', *The Burlington Magazine*, CXII, April 1970, pp. 205–10

Bredius, Abraham, *Rembrandt: the complete edition of the Paintings*, revised by Horst Gerson, London 1971

Brejon de Lavergnée, Arnauld, 'Le Régent, amateur de l'art moderne', *Revue de l'art*, LXII, 1983, pp. 45–8

Brejon de Lavergnée, Arnauld, and Annie Scottez-De Wambrechies, *Catalogue sommaire illustré des peintures, Musée des Beaux-Arts de Lille, I. Écoles Étrangères*, Paris 1999

Brenzoni, R., *La Prima Opera di Paolo Veronese*, Verona 1953

Brescianini, B., *Figurazioni dei mesi nell'arte medioevale italiana*, Verona 1968

Brice, Germain, *Description nouvelle de la Ville de Paris*, 2 vols, Paris 1706

Brigstocke, Hugh, *William Buchanan and the nineteenth-century Art Trade*, London 1982

Brigstocke, Hugh, *Italian and Spanish Paintings in the National Gallery of Scotland*, 2nd edn, Edinburgh 1993

Brigstocke, Hugh, *et al.*, 'A Poet in Paradise': *Lord Lindsay and Christian Art* (exh. cat. National Gallery of Scotland, Edinburgh, 2000), Edinburgh 2000

Briscoe, John, 'Notes on Valerius Maximus', *Sileno*, 1993, pp. 395–408

Britton, John, *Catalogue raisonné of the pictures belonging to the Most Honourable the Marquess of Stafford in the gallery of Cleveland House*, London 1808

Britton, John, *et al., Beauties of England and Wales*, 18 vols, London 1801–15

Brizio, A.M., 'Rileggendo Veronese', *Emporium*, XVIII, 1939, pp. 123–30

Brizio, A.M., 'La pittura di Paolo Veronese in rapporto con l'opera del Sanmicheli e del Palladio', *Bollettino del Centro Internazionale di Studi di Architettura Andrea Palladio*, II, 1960, pp. 19–25

Broggi, Alessandro, *Ludovico Carracci (1555–1619)*, 2 vols, Bologna 2001

Broun, Francis, *Sir Joshua Reynolds' collection of paintings*, PhD thesis, Princeton University, 1987

Brown, Beverly Louise, 'Veronese and the Church Triumphant: the Altarpieces for San Benedetto Po', *Artibus et historiae*, 35, 1997, pp. 51–64

Brown, Beverly Louise, and Paolo Marini, eds, *Jacopo Bassano* (exh. cat. Bassano del Grappa and Forth Worth, 1992), Fort Worth 1992

Brown, Christopher, Jan Kelch and Pieter van Thiel, *Rembrandt: the Master and his Workshop* (exh. cat. Gemäldegalerie, Berlin, Rijksmuseum, Amsterdam, and National Gallery, London, 1991–9), London 1991

Brown, David Blayney, *Ashmolean Museum, Oxford: Catalogue of the collection of drawings, IV, the Earlier British Drawings*, Oxford 1982

Brown, Raymond E., *et al.*, eds, *The Jerome Biblical Commentary*, 2 vols, Englewood Cliffs 1968

Brugnoli, Pierpaolo, 'Nuovi documenti su Paolo Veronese e la sua famiglia', *Verona Illustrata*, XIII, 2000, pp. 11–19.

Brugnolo Meloncelli, Katia, *Battista Zelotti*, Milan 1992

Bruno, Giordano, *De gli Eroici Furori*, London 1585

Bruno, Raffaele, ed., *Pinacoteca Capitolina*, Bologna 1978

Brushe, John, 'Wrincklemarsh and the collections of Sir Gregory Page', *Apollo*, November 1985, pp. 364–71

Bryant, Barbara, *George Frederic Watts: Portraits* (exh. cat. National Portrait Gallery, London, 2004), London 2004

Buchanan, William, *Memoirs of Painting, with a Chronological History of the Importation of pictures by the Great Masters into England since the French Revolution*, 2 vols, London 1824

Buckle, Richard, *Harewood. A Guide Book*, Leeds 1959 (revised 1962)

Bull, Duncan, and Enriquetta Harris, 'The Companion of the "Rokeby Venus"', *The Burlington Magazine*, CXXXVI, August 1994, p. 555

Burman, Peter, 'Decoration, Furnishings and Art since 1900' in *St Paul's: The Cathedral Church of London 604–2004*, ed. Derek Keene, Arthur Burns and Andrew Saint, New Haven and London 2004, pp. 258–68

Burnham, Dorothy, *A textile terminology: warp and weft*, London 1981

Burns, Howard, *et al., Andrea Palladio 1508–1580. The Portico and the Farmyard* (exh. cat. Hayward Gallery, London, 1975), London 1975

Burrell, Michael, *et al., The Christopher Tower collection of family portraits, pictures and miniatures*, London 2003

Bursche, Stefan, *Meissen: Steinzeug und Porzellan des 18. Jahrhunderts. Kunstgewerbemuseum Berlin*, Berlin 1980

[Burton, Frederic William, and others], *Descriptive and Historical Catalogue of the Pictures in the National Gallery: Foreign Schools*, London 1887, 1888, 1889, 1890, 1892, 1894, 1898, 1901, 1906, 1913 (Burton's version of the catalogue appeared in 1889 – the 74th edition – with a preface dated December 1888, which he signed. His name appears on no other edition. Some of Wornum's notices were retained but all biographies and most entries were Burton's. After his retirement, additions were made by others. Many entries were significantly modified in the 81st edition of 1913 and thereafter replaced by Collins Baker)

Bury, Michael, *Giulio Sanuto. A Venetian Engraver of the Sixteenth Century*, Edinburgh 1990

Bury, Michael, *The Print in Italy 1150–1620* (exh. cat. British Museum, London, 2001), London 2001

Busiri Vici, Andrea, *Peter, Hendrik e Giacomo Van Lint*, Rome 1987

Butlin, Martin, and Evelyn Joll, *The Paintings of J.M.W. Turner*, 2 vols, New Haven and London 1977

Byam Shaw, James, *Paintings by Old Masters at Christ Church, Oxford*, Oxford 1967

'C', 'Correspondance d'Angleterre: Exposition de tableaux anciens à Édimbourg', *La Chronique des Arts et de la curiosité*, XXXI, 13 October 1883, pp. 251–2.

Cadioli, Giovanni, *Descrizione delle Pitture, Sculture ed Architetture, che si osservano nella città di Mantova e ne' suoi contorni*, Mantua 1763

Caldwell, Joan, 'An allegory of *Good Counsel* by Titian', *Commentari*, XXIV (n.s.), October–December 1973, pp. 319–22

Caliari, Pietro, *Paolo Veronese, sua vita e sue opere*, Rome 1888

Campbell, Malcolm, *Pietro da Cortona at the Pitti Palace*, Princeton 1977

Campbell, Thomas P., *Tapestry in the Renaissance: Art and Magnificence* (exh. cat. Metropolitan Museum of Art, New York, 2002), New Haven and London 2002

Campori, Giuseppe, *Raccolta di cataloghi ed inventari inediti di quadri, statue, disegni, bronzi, dorerie, smalti, medaglie, avori, ecc., dal secolo XV al secolo XIX*, Modena 1870

Campori, Giuseppe, 'Enea Vico e l'antico museo estense delle medaglie', *Atti e memorie della Reale Deputazione di storia patria per le provincie modenesi e parmensi*, VII, 1873, pp. 1–11

Campori, Giuseppe, 'Tiziano e gli Estensi', *Nuova Antologia di scienze, lettere ed arti*, XXVII (series I), 1874, pp. 581–620

Campori, Giuseppe, *Artisti degli estensi. I pittori*, Modena 1875

Campori, Giuseppe, *Documenti inediti per servire alla storia dei musei d'Italia*, Florence and Rome (Ministero della pubblica istruzione), II, 1879, pp. 100–55

Canestro Chiovenda, Beatrice, 'Atheone lacerato dai cani suoi', *Commentari*, XXII (n.s.), April–September 1971, pp. 180–3

Cano Rivero, Ignacio, 'Seville's Artistic Heritage during the French Occupation' in *Manet/Velázquez: The French Taste for Spanish Painting*, ed. Gary Tinterow and Geneviève Lacambre (exh. cat. Metropolitan Museum, New York, 2003), New Haven and London 2003, pp. 93–113

Canova, Antonio, ed., *Di Villa in Villa. Guida alla Visita delle Ville Venete*, Treviso 1990

Caraffa, Filippo, and Giuseppe Morelli, *Bibliotheca Sanctorum*, 13 vols, Rome 1961–70

Cardigan and Lancastre, Adeline Louise Maria, Countess of, *My Recollections*, London 1909

Carducho, Vicente, *Diálogos de la pintura*, Madrid 1633, republished in Sánchez Cantón, ed., *Fuentes Literarias*, II, Madrid 1933, pp. 63–115, and new edn, Madrid 1979

Caroli, Flavio, *Giuseppe Bazzani: l'opera completa*, Milan 1988

Carroll, E.A., *Rosso Fiorentino* (exh. cat. National Gallery of Art, Washington, 1987–8), Washington DC 1987

Cartari, Vincenzo, *Le imagini, con la spositione de i dei de gli antichi*, Venice 1556 (1st edition of Catari 1571)

Cartari, Vincenzo, *Imagini dei Dei degli Antichi*, Venice 1571

Castellani, Francesca, '"L'éclat de la lumière et le luxe de la couleur." Un itinerario nel mito dei maestri veneti attraverso le copie francesi dell'Ottocento' in Bettagno 1997, pp. 135–45

Casteras, Susan P., and Colleen Denney, eds, *The Grosvenor Gallery: a Palace of Art in Victorian England* (exh. cat. British Art Center, New Haven; Denver Museum of Art; Laing Art Gallery, Newcastle, 1996), New Haven 1996

Catelli Isola, Maria, *Immagini da Tiziano dalle collezioni del Gabinetto Nazionale delle Stampe* (exh. cat. Villa della Farnesina, Rome, 1976–7), Rome 1977

Causa, Raffaello, 'Per Tiziano: un pentimento nel Paolo III con i nipoti', *Arte Veneta*, XVIII, 1964, pp. 219–23

Cavalcaselle, Giovanni Battista, and Joseph Archer Crowe, *Tiziano, la sua vita e i suoi tempi*, 2 vols, Florence 1878

Caylus, Comte de, *Voyage d'Italie*, ed. Amilda A. Pons, Paris 1914

'Centro Internazionale d'Arte e di Cultura di Palazzo Te', *Inventario della Raccolta Gonzaga 1626–1627*, Mantua 1998

Chatzidakis, Manolis, 'La peinture des "Madonneri" ou "Vénéto-Crétoise" et sa destination' in *Venezia Centro di Mediazione tra Oriente e Occidente (secoli XV–XVI). Aspetti e problemi*, ed. Hans-Georg Beck *et al.*, II, Florence 1977, pp. 673–90

Chatzidakis, Manolis, and Vojislav Djurić, *Les Icones dans les Collections Suisses* (exh. cat. Musée Rath, Geneva, 1968), Geneva 1968

Chatzidakis, Nanò, *Da Candia a Venezia. Icone Greche in Italia* (exh. cat. Museo Correr, Venice, 1993), Athens 1993

Chiappini di Sorio, Ileana, *Palazzo Pisani Moretta: economia, arte, vita sociale di una famiglia Veneziana nel diciottesimo secolo*, Milan 1983

Chiari Moretto Wiel, Maria Agnese, *Tiziano: corpus dei disegni autografi*, Milan 1989

Chiari Moretto Wiel, Maria Agnese, *Jacopo Tintoretto e i suoi incisori* (exh. cat. Palazzo Ducale, Venice), Milan 1994

Chiari Moretto Wiel, Maria Agnese, with C. Novello Terranova, *Chiesa di S. Giovanni in Bragora*, Venice 1994

Christiansen, Keith, 'An Unknown "Christ Mocked" by Tintoretto', *The Burlington Magazine*, CXLVIII, November 2006, pp. 767–71

Ciampini, Raffaele, *Vita di Niccolò Tommaseo*, Florence 1945

Cicogna, Emmanuele Antonio, *Delle Inscrizioni Veneziane raccolte ed illustrate*, 6 vols, Venice 1824–53

Cicogna, Emmanuele Antonio, *Breve notizia intorno alle origini della Confraternità di San Giovanni Evangelista in Venezia*, Venice 1855

Cieri Via, Claudia, 'Diana e Atteone: continuità e variazione di un mito nell'interpretazione di Tiziano' in *Die Rezeption der Metamorphosen des Ovid in der Neuzeit*, ed. Hermann Walter and Hans-Jürgen Horn (Proceedings of International Symposium, Werner-Reimers-Stiftung, Bad Homburg, 22–5 April 1991), Berlin 1995, pp. 150–60

Claerbergen, Ernst Vegelin van, ed., *David Teniers and the Theatre of Painting* (exh. cat. Courtauld Gallery, 2006–7), London 2006

Clark, Anthony M., with Edgar Peters Bowron, *Pompeo Battoni: a complete catalogue of his works*, New York 1985

Clark, Kenneth, *Another part of the wood: a self-portrait*, London 1974

Clarke, Michael, and Nicholas Penny, *The Arrogant Connoisseur: Richard Payne Knight* (exh. cat. Whitworth Art Gallery, University of Manchester, 1982), Manchester 1982

Cochin, Charles-Nicolas, *Voyage d'Italie*, Paris 1758

Cocke, Richard, Review of *Veronese, L'opera completa* by Terisio Pignatti, *The Burlington Magazine*, CXIX, November 1977, pp. 786–7

Cocke, Richard, *Veronese's Drawings*, London 1984

Cocke, Richard, 'Titian the second Apelles: The Death of Actaeon', *Renaissance Studies*, XIII, 3, 1999, pp. 303–11

Cocke, Richard, *Paolo Veronese: Piety and Display in an Age of Religious Reform*, Aldershot 2001

Coda, Egidia, 'Un'aggiunta al catalogo del Bordon. Precisazioni e note sugli affreschi di Pialdier' in Fossaluzza and Manzato 1987, pp. 173–82

[Cohen, Louise and Lucy], *A Catalogue of Pictures by Italian masters of the fifteenth, sixteenth, seventeenth and eighteenth centuries, collected by John Samuel*, London 1895

Cohen, Simona, 'Animals in the paintings of Titian, a key to hidden meanings', *Gazette des Beaux-Arts*, CXXXII, November 1998, pp. 193–213

Cohen, Simona, 'Titian's London *Allegory* and the three beasts of his *Selva Oscura*', *Renaissance Studies*, XIV, 1, 2000, pp. 46–69

Coletti, Luigi, *Il Tintoretto*, Bergamo 1940

[Collins, Charles Alston], 'Our eye-witness at the National Gallery', *All the year round*, 16 and 23 June 1860, pp. 222–8 and pp. 251–8

[Collins Baker, Henry Charles], et al., *National Gallery: Descriptive and Historical Catalogue of Foreign Pictures in Trafalgar Square*, London 1915, 1920, 1921, 1925, 1929 (Collins Baker's catalogues replaced those by Burton. The last of them, the 86th, was reprinted without revision in 1936.)

Colvin, Howard M., J. Mordaunt Crook, Kerry Downes and John Newman, *The History of the King's Works*, CV, 1976

Colvin, Howard, *A Biographical Dictionary of British Architects*, London 1978

Colvin, Sidney, 'Tintoretto at the British Museum – I and II', *The Burlington Magazine*, XVI, January 1910, pp. 189–200, and February 1910, pp. 254–61.

Constable, William George, *Richard Wilson*, London 1953

Constable, William George, revised by J.G. Links, *Canaletto*, 2 vols, Oxford 1989

Constantino, Cesare, *De notevoli e utilissimi ammaestramenti dell'agricoltura, di Greco in volgare novamente tradotto per Pietro Lauro*, Venice 1542

Conti, Natale, *Mythologiae, sive explicationis fabularum libri decem*, Venice 1551

Cooke, Robert, *West Country Houses*, Bristol 1957

Cooper, Tracy Elizabeth, *The History and Decoration of the Church of San Giorgio Maggiore in Venice* (DPhil thesis, Princeton, 1990), Ann Arbor 1992

Cope, Maurice E., *The Venetian Chapel of the Sacrament in the Sixteenth Century* (University of Chicago thesis, 1965), New York 1979

Cordellier, Dominique, and Bernadette Py, *Raphaël: son atelier, ses copistes* (Inventaire général des dessins italiens), Paris 1992

Cornaro, Alvise, *Scritti sulla Vita Sobria*, ed. Marisa Milani, Venice 1983

Cornforth, John, 'Stafford House Revisited, I', *Country Life*, 7 November 1968, pp. 1188–91

Cortelazzo, Manlio, 'L'eredità di Federico Contarini: gli inventari della collezione e degli oggetti domestici', *Bollettino dell'Istituto di Storia della Società e dello Stato Veneziano*, III, 1961, pp. 221–79 (inventory by Maria Cipollato p. 221; glossary by Cortelazzo p. 254)

Corti, Gino, 'Contributi alla vita e alle opere di Francesco Furini', *Antichità Viva*, 10, no. 2, 1971, pp. 114–23

Corti, Laura, *Vasari*, Florence 1989

Coryat, Thomas, *Coryat's Crudities*, 2 vols, London 1905

Costamagna, Philippe, 'La collection de peintures d'une famille florentine établie à Rome: l'inventaire après décès du Duc Anton Maria Salviati dressé en 1704'. *Nuovi Studi*, VIII, 2000, pp. 177–233

Coton, Pierre, *Institution Catholique où est declarée et confirmée la verité de la foy*, Paris 1612

Cottrell, Philip, 'The artistic parentage of Palma Giovane', *The Burlington Magazine*, CXLIV, May 2002, pp. 289–91

Cox-Rearick, Janet, *The Collection of Francis I: Royal Treasury*, New York 1996

Crosato, Luciana, *Gli affreschi nelle ville vente del Cinquecento*, Treviso 1962

Crosato Larcher, Luciana, 'Per Carletto Caliari', *Arte Veneta*, XXI, 1967, pp. 108–24

Crosato Larcher, Luciana, 'Note su Benedetto Caliari', *Arte Veneta*, XXIII, 1969, pp. 115–30

Crosato Larcher, Luciana, 'Note per Alvise Benfatto del Friso', *Arte Veneta*, XXX, 1976, pp. 106–19

Crosato Larcher, Luciana, 'Nuovi contributi per la decorazione della Soranza', *Arte Veneta*, XXXI, 1977, pp. 72–9

Crosato Larcher, Luciana, 'La bottega di Paolo Veronese' in *Nuovi studi su Paolo Veronese*, ed. Massimo Gemin, Venice 1990, pp. 256–65

Crowe, Joseph Archer, and Giovanni Battista Cavalcaselle, *A History of Painting in North Italy*, 2 vols, London 1871

Crowe, Joseph Archer, and Giovanni Battista Cavalcaselle, *Titian: His Life and Times*, 2 vols, London 1877; revised edn 1881

Crowe, Joseph Archer, and Giovanni Battista Cavalcaselle, *A History of Painting in North Italy*, revised and annotated by Tancred Borenius, 3 vols, London 1912

Cunningham, Allan, *The Gallery of Pictures by the First Masters of the English and Foreign Schools*, 2 vols, London n.d. (1836)

Cust, Lionel, and Mary Cox, 'Notes on the Collections formed by Thomas Howard, Earl of Arundel and Surrey, K.G.', *The Burlington Magazine*, XIX, August and September 1911, pp. 278–86 and 323–5.

Da Mosto, A., *I Dogi di Venezia*, 2nd edn, Milan 1966

D'Ancona, Alessandro, *Sacre Rappresentazioni dei secoli XIV, XV e XVI*, 3 vols, Florence 1872

D'Arcais, Francesca, Franca Zava Boccazzi and Giuseppe Pavanello, *Gli Affreschi nelle ville venete dal seicento all'ottocento*, 2 vols, Venice 1978

Dabell, Frank, *Venetian Paintings* (exh. cat. Piero Corsini Gallery, New York, October–November 1991), New York 1991

Dacos, Nicole, *Le Logge di Raffaello: Maestro e bottega di fronte all'antico*, Rome 1977

Dacos, Nicole, 'Pedro Campaña dopo Siviglia: arazzi e altri inediti', *Bollettino d'Arte*, n.s. VIII, 1980, pp. 1–44

Dacos, Nicole,'Fortune critique de Pedro Campaña – Peeter de Kempeneer', *Revue belge d'archéologie et d'histoire de l'art*, LIII, 1984, pp. 108–16

Dacos, Nicole, 'Hermannus Posthumus, Rome, Mantua, Landshut', *The Burlington Magazine*, CXXVII, July 1985, pp. 433–8

Dacos, Nicole, 'Autour de Bernard van Orley, Peeter de Kempeneer et son compagnon', *Revue de l'Art*, LXXV, 1987, pp. 17–28

Dacos, Nicole, 'La Crucifixion du Louvre et les premières œuvres espagnoles de Peeter de Kempeneer', *Revue du Louvre*, 3, 1988, pp. 231–6

Dacos, Nicole, 'Entre Bruxelles et Séville, Peeter de Kempeneer en Italie', *Nederlands Kunsthistorisch Jaarboek*, 1993, XLIV, pp. 142–64

[Dallaway, James?], *An Account of all the Pictures exhibited in the rooms of the British Institution, from 1813 to 1823*, London 1824

Daly Davis, Margaret, 'Giovan Pietro Bellori and the "Nota delli Musei, librerie, galerie, et ornamenti di statue e pitture ne' palazzi, nelle case, e ne' giardini di Roma (1664)": modern libraries and ancient paintings in Seicento Rome', *Zeitschrift für Kunstgeschichte*, LXVIII, 2005, pp. 191–233

Daniels, Jeffery, *Sebastiano Ricci*, London 1976

Danziger, Elon, 'The Cook collection, its founder and its inheritors', *The Burlington Magazine*, CXLVI, July 2004, pp. 444–58

Darrow, Elizabeth, 'Pietro Edwards and the Restoration of the Public Pictures of Venice 1778–1819: Necessity Introduced these Arts', PhD thesis, University of Washington 2000, Ann Arbor 2001

Davanzo Poli, Doretta, 'Abbigliamento Veneto attraverso un'iconografia datata 1517–1571' in Fossaluzza and Manzato 1987, pp. 243–54

Davidson, Caroline, *The World of Mary Ellen Best*, London 1985

Davies, David, John H. Elliott, *et al.*, *El Greco* (exh. cat. Metropolitan Museum of Art, New York, and National Gallery, London, 2004), London 2003

Davies, Martin, *The earlier Italian schools*, National Gallery Catalogues, London 1961

Davis, Charles, *A description of the works of art forming the collection of Alfred de Rothschild*, London 1884

Davis, James Cushman, *The Decline of the Venetian Nobility as a Ruling Class*, Baltimore 1962

Davis, James Cushman, *A Venetian Family and its Fortune, 1500–1900* (American Philosophical Society), Philadelphia 1975

De Brosses, Charles, *Lettres Familières*, ed. Giuseppina Cafasso, 3 vols, Naples 1991

DeGrazia Bohlin, Diane, *Prints and Related Drawings by the Carracci Family* (exh. cat. National Gallery of Art, Washington, 1979), Washington DC 1979

Della Pergola, Paola, 'Contribuiti per la galleria Borghese', *Bollettino d'Arte*, XXXIX, 1954, pp. 134–40

Della Pergola, Paolo, *Galleria Borghese: I Dipinti*, I, Rome 1955

De Mezi, Giacomo, *Miracoli della Croce Santissima*, Venice 1590

De Nolhac, Pierre, 'Some pictures by Boucher in Mr Alfred de Rothschild's collection, London', *Les Arts*, no. 19, July 1903, pp. 10–11

De Scolari, Giuseppe, *Del Celebre Quadro di Paolo Caliari la Famiglia di Dario della nobil casa Pisani di Venezia ora nel Museo Nazionale di Londra e del suo modelletto originale ad olio esistente in Verona*, Verona 1875

De Vecchi, Pierluigi, *L'Opera Completa del Tintoretto*, with essay by Carlo Bernari, Milan 1970

Dézallier d'Argenville, Antoine-Joseph, *Abrégé de la vie des plus fameux peintres*, 3 vols, Paris 1745–52; 4 vols, 1762

[Dézallier d'Argenville, Antoine-Nicolas], 'M.D.', *Voyage pittoresque de Paris*, Paris 1749; revised edns 1752, 1757, 1765

Díaz Pedrón, Matías, and Mercedes Royo-Villanova, *David Teniers, Jan Brueghel y los gabinetes de pinturas*, Madrid 1992

Dibdin, Thomas Frognall, *Aedes Althorpianae; or an account of the Mansion, Books and Pictures at Althorp*, London 1822

Diedo, A., *Delle Lodi di Lorenzo Santi, architetto (Atti della I.R. Accademia di Belle Arti in Venezia)*, Venice 1843

Di Giampaolo, Mario, *Girolamo Bedoli*, Florence 1997

Di Monte, Michele, 'Vincenzo Morosini, Palma il Giovane e il ritratto di gruppo veneziano', *Venezia Cinquecento*, VII, no. 13, January–June 1997, pp. 159–74

Dodsley, R. and J.D., *London and its environs described*, 6 vols, London 1761

Dolce, Lodovico, *Dialogo della Pittura di M. Lodovico Dolce intitolato l'Aretino*, Venice 1557

Dolce, Lodovico, *Le Orationi di Marco Tullio Cicerone*, Venice 1562

Dolce, Lodovico, *Dolce's "Aretino" and Venetian Art Theory of the Cinquecento* (the text of Dolce's dialogue is edited and translated and accompanied by an essay by Mark W. Roskill), New York 1968

Doni, Anton Francesco, *Disegno*, Venice 1549

Doni, Anton Francesco, *I Marmi*, Venice 1552

[Du Bois de Saint-Gelais, Louis-François], *Description des tableaux du Palais-Royal*, Paris 1727

Dülberg, Angelica, *Privatporträts: Geschichte und Ikonologie* (Ph. diss., 1985, Cologne), Berlin 1990

Dunkerton, Jill, 'Observations on the Conservation history and technique of the *Tribute Money* in the National Gallery, London' in Mancini 1999, pp. 117–25

Dunkerton, Jill, 'Titian's painting technique' in Jaffé 2003, pp. 45–59

Dunkerton, Jill, 'Tintoretto's under-drawing for *Saint George and the Dragon*', *National Gallery Technical Bulletin*, 28, 2007, pp. 26–35

Dunkerton, Jill, Susan Foister, Dillian Gordon and Nicholas Penny, *Giotto to Dürer*, New Haven and London 1991

Dunkerton, Jill, Susan Foister and Nicholas Penny, *Dürer to Veronese*, London 1999

Dunkerton, Jill, and Paul Joannides, 'A Boy with a Bird in the National Gallery: Two Responses to a Titian Question', *National Gallery Technical Bulletin*, 28, 2007, pp. 36–57

Dunkerton, Jill, and Marika Spring, 'The Development of painting in coloured surfaces in sixteenth-century Italy' in *Painting Techniques: History, Materials and Studio Practice*, ed. Ashok Roy and Perry Smith (Papers to a Congress in Dublin, 1998), London 1999, pp. 120–30

Dupuy, Marie-Anne, ed., *Dominique-Vivant Denon: L'œil de Napoléon* (exh. cat. Musée du Louvre, Paris, 1999–2000), Paris 2000

Duval, Amaury, *Monuments des Arts du dessin chez les peuples tant anciens que modernes, recueillis par le Baron Vivant Denon*, 4 vols, Paris 1829

Duverger, Erik, *Antwerpse Kunstinventarissen uit de Zeventiende eeuw*, VII (1654–1658), Brussels 1993

Eastlake, Sir Charles Lock, *Contributions to the Literature of the Fine Arts* (second series with a memoir compiled by Lady Eastlake), London 1870

Eastlake, Charles Locke, *Pictures in the National Gallery* (text for photogravures plates published by Franz Hanfstaengl of Munich in 2 volumes 1896)

Echols, Robert, 'Giovanni Galizzi and the Problem of the *Young Tintoretto*', *Artibus et Historiae*, XVI, 31, 1995, pp. 69–110

Edelein-Badie, Béatrice, *La collection de tableaux de Lucien Bonaparte, Prince de Canino*, Paris 1997

Egerton, Judy, *The British School, National Gallery Catalogues*, London 1998

Eidelberg., M., and C.W. Rowlands, 'The Dispersal of the last Duke of Mantua's paintings', *Gazette des Beaux-Arts*, May–June 1994

Ekserdjian, David, *Old Master Paintings from the Thyssen-Bornemisza Collection* (exh. cat. Royal Academy of Arts, London, 1988), Milan 1988

Ekserdjian, David, *Correggio*, New Haven and London 1997

Elliott, David B., *Charles Fairfax Murray. The Unknown Pre-Raphaelite*, New Castle, Delaware 2000

Ericani, Giuliana, 'Tra Padova e Verona. Dipinti e disegni inediti di Paolo Farinati e Felice Brusasorci', *Verona Illustrata*, IX, 1996, pp. 69–86

Ericani, Giuliana, ed., *Una villa e i suoi tesori: Dipinti, affreschi e stucchi in Villa Giovanelli a Noventa Padovana* (exh. cat. Palazzo del Monte, Padua, 2001), Padua 2001

Erskine, Mrs Steuart, 'The Collection of Mr Alfred De Rothschild', *Connoisseur*, III, May 1902, pp. 71–9

Escott, Beryl E., *The Story of Halton House*, published for the RAF, 1984

Evans, Godfrey, 'The Hamilton Collection and the 10th Duke of Hamilton', *Journal of the Scottish Society for Art History*, VIII, 2003, pp. 53–72

Evelyn, John, *The Diary*, ed. Austin Dobson, London 1908

Ewald, Gerhard, *Johann Carl Loth*, Amsterdam 1965

Fabri, Felix, *The Wanderings of Felix Fabri*, 2 vols, New York 1971 (reprint of vols VII and VIII of *The Library of the Palestine Pilgrims' Text Society* 1887–97)

Fabriczy, Cornelius von, *Italian Medals*, London 1904

Faietti, Marzia, and Daniela Scaglietti Kelescian, *Amico Aspertini*, Modena 1995

Falomir Faus, Miguel, *Los Bassano en la España del Siglo de Oro* (exh. cat. Prado, Madrid, 2001), Madrid 2001

Falomir Faus, Miguel, ed., *Tiziano* (exh. cat. Prado, Madrid, 2003), Madrid 2003

Falomir Faus, Miguel, ed., *Tintoretto* (exh. cat. Prado, Madrid, 2007), Madrid 2007

Fantelli, Pierluigi, 'Lambert Sustris' in Mason Rinaldo and Pallucchini 1981

Farington, Joseph, *The Diary of Joseph Farington*, 16 vols and Index Vol., ed. Kenneth Garlick and Angus Macintyre (vols I–VI) and Kathryn Cave, Index compiled by Evelyn Newly, New Haven and London 1978–98

Farr, Dennis, *William Etty*, London 1958

Faure, Elie, *Eugène Carrière*, Paris 1908

Favaro, E., *L'Arte dei pittori a Venezia e i suoi statuti*, Venice 1975

Favera *see* Bordignon Favera

Fazzini, Antonio, 'Collezionismo privato nella Firenze del Cinquecento', *Annali della Scuola Normale Superiore di Pisa*, XXIII, 1993, pp. 191–224

Fehl, Philipp P., *Decorum and Wit*, Vienna 1992

Félibien, André, *Les Reines des Perses aux pieds d'Alexandre, peinture du Cabinet du Roy*, Paris 1663 (reprinted in Félibien 1671, 1689)

Félibien, André, *Description de divers ouvrages de peinture faits pour le Roy*, Paris 1671, 1689

Ferguson, Niall, *The House of Rothschild: the World's banker, 1849–1999*, London 1998

Ferino-Pagden, Sylvia, with Wolfgang Prohaska and Karl Schütz, *Die Gemäldegalerie des Kunsthistorischen Museums in Wien*, Vienna 1991

Ferrari, Daniela, 'Il patrimonio monastico di Polirone negli inventari relativi alla soppressione' in Piva and Simonelli 2001, pp. 71–82

Ferrari, Oreste, and Giuseppe Scavizzi, *Luca Giordano*, 2 vols, Naples 1992

Ferriguto, A., 'I committenti di Giorgione', *Atti del R. Istituto Veneto di Scienze, Lettere ed Arti*, LXXXV, 1926, pp. 399–410

Fiacciadori, Giovanni Francesco, ed., *Bessarione e l'Umanesimo* (exh. cat. Biblioteca Marciana, Venice), Naples 1994

Field, Ernest, 'Gardening Memories at Halton', *Country Life*, 11 October 1973, pp. 1062–4

Filangieri di Candida, Antonio, 'La Galleria Nazionale di Napoli', *Gallerie Nazionali Italiane, Notizie e Documenti*, V, 1902, pp. 208–354

Finberg, Alexander Joseph, *The Life of J.M.W. Turner*, Oxford 1939

Finlay, Robert, *Politics in Renaissance Venice*, London 1980

Finocchi Ghersi, Lorenzo, 'Gli stucchi Veneziani' in *'La bellissima maniera': Alessandro Vittoria e la scultura Veneta del Cinquecento* (exh. cat. Castello del Buonconsiglio, Trent, 1999), Trent 1999, pp. 85–93

Fiocco, Giuseppe, *Paolo Veronese*, Bologna 1928

Fiocco, Giuseppe, *Venetian Painting of the seicento and settecento*, Florence 1929

Fiocco, Giuseppe, *Paolo Veronese*, Rome 1934

Firenzuola, Agnolo, *L'Asino d'Oro*, Venice 1550

Fisher, M. Roy, *Titian's assistants during the later years* (PhD thesis for Harvard University, 1958), New York 1977

Fleming, John, 'Art Dealing and the Risorgimento, Part 1', *The Burlington Magazine*, CXV, January 1973, pp. 4–17; Part II, CXXI, August 1979, pp. 492–508; Part III, CXXI, September 1979, pp. 568–78

Fletcher, Jennifer, Review of *Painting in Renaissance Venice* by Peter Humfrey, *The Burlington Magazine*, CXXXVIII, February 1996, p. 135

Florence: *Mostra di disegni degli Zuccari*, Galleria degli Uffizi, Florence 1966

Fogolari, Gino, *Venezia: I disegni delle Re. Gallerie dell'Accademia*, Milan 1913

Folliot, Franck, 'Le Palais-Royal à l'époque de Philippe d'Orléans Régent' in *Le Palais-Royal* (exh. cat. Musée Carnavalet, Paris, 1988), Paris 1988, pp. 53–78

Fontana, Gianjacopo, *Manuale ad uso del forestiere in Venezia*, Venice 1847

Fontana, Gianjacopo, *Cento palazzi fra i più celebri di Venezia*, Venice 1865

Fontenai, Abbé de (Louis Abel de Bonafons), *La Galerie du Palais Royal gravée d'après les tableaux des différentes écoles*, 3 vols, Paris 1808 (partly published in fascicles, see pp. 465 and 467)

Fomichova, Tamara D., *Venetian painting: fourteenth to eighteenth centuries* (Catalogue of Western European Painting, the Hermitage), Moscow and Florence 1992

Forray, Anne, 'Le Palais Royal de Philippe Égalité' in *Le Palais-Royal* (exh. cat. Musée Carnavalet, Paris, 1988), Paris 1988, pp. 144–214

Fosca, François [Georges de Traz], *Tintoret*, Paris 1929

Foscari, A., and Manfredi Tafuri, *L'Armonia e i Conflitti: La Chiesa di San Francesco della Vigna nella Venezia del '500*, Turin 1983

Foscari, Lodovico, *Affreschi esterni a Venezia*, Milan 1936

Fossaluzza, Giorgio, 'Codice diplomatico bordoniano' in *Paris Bordon* (exh. cat. Palazzo dei Trecento, Treviso, 1984), Treviso 1984, pp. 115–40

Fossaluzza, Giorgio, 'Qualche recupero al catalogo ritrattistico del Bordon', in Fossaluzza and Manzato 1987, pp. 183–202

Fossaluzza, Giorgio, and Eugenio Manzato, eds, *Paris Bordon e il suo tempo* (Acts of the Convegno Internazionale di Studi, Treviso, 28–30 October 1985), Treviso 1987

Frangi, Francesco, *et al.*, *Romanino, un pittore in rivolta nel Rinascimento italiano* (exh. cat. Castello del Buonconsiglio, Trent, 2006), Milan 2006

Fredericksen, Burton B., *Handbook of the Paintings in the Hearst San Simeon State Historical Monument*, Sacramento, CA, 1977

Fredericksen, Burton, with Julia I. Armstrong and Doris A. Mendenhall, *The Index of Paintings sold in the British Isles during the Nineteenth Century*, I (1801–5), Santa Barbara 1988; II (1806–10), 2 vols, Santa Barbara 1990; III (1811–15), 2 vols, Munich 1993; IV (1816–20), 2 vols, Santa Monica 1996 (revised versions of these volumes can be consulted online)

Fredericksen, Burton B., and Federico Zeri, *Census of pre-nineteenth-century Italian Paintings in North American public collections*, Cambridge, MA, 1972

Freedberg, Sydney, *Parmigianino: His works in Painting*, Cambridge, MA, 1950

Friedländer, Max J., *Jan Gossart and Bernart van Orley*, (The Early Netherlandish Painters, VIII), Leiden 1972

Frizzoni, Gustavo, 'La Galerie Layard', *Gazette des Beaux-Arts*, XVI, 1896, pp. 455–76

Frodl, Gerbert, *Hans Makart*, Salzburg 1974

Fröhlich-Bum, Lili, 'Some unknown Venetian drawings in the Albertina', *The Burlington Magazine*, XLIII, July 1923, pp. 28–33

Fry, Roger, 'Exhibition of Old Masters at the Grafton Galleries – II', *The Burlington Magazine*, XX, December 1911, pp. 160–7

Fry, Roger, *Vision and Design*, Harmondsworth 1937 (1st edn London 1920)

Fučíková, E., ed., *Capolavori della pittura veneta del Castello di Praga* (exh. cat. Palazzo Crepadona, Belluno) Belluno 1994

Fučíková, E., and L. Konečný, 'Einige Bemerkungen zur "Geschichts-Allegorie" von Paolo Fiammingo und zu seinen Aufträgen für die Fugger', *Arte Veneta*, XXXVII, 1983, pp. 67–76

Fulin, Rinaldo, ed., 'Venezia e Daniele Manin', *Archivio Veneto*, IX, i, 1875, pp. CVII–CLXIX

Fullerton, Peter, 'Patronage and pedagogy: the British Institution in the Early Nineteenth Century', *Art History*. V, March 1982, pp. 59–72

Gabbiani, Bruno, ed., *Ville Venete: La provincia di Rovigo*, Venice 2000

Gallo, R., 'Le donazioni alla Serenissima di Domenico e Giovanni Grimani', *Archivio Veneto*, L–LI, 1952, pp. 34–77

Gallottini, Angela, 'La "galleria Giustiniana". Nascita e formazione', *Rendiconti dell'Accademia Nazionale dei Lincei*, IX, 1998, pp. 233–70

Gallwitz, Klaus, *Makart* (exh. cat. Staatliche Kunsthalle, Baden-Baden, 1972), Baden-Baden 1972

Gamulin, Grgo, 'Per gli eredi di Paolo Veronese', *Arte Veneta*, XL, 1986, pp. 160–3

Garas, Clara, 'Le tableau du Tintoret du Musée de Budapest et le cycle peint pour l'empereur Rodophe II', *Bulletin du musée hongrois des Beaux-Arts*, no. 30, 1967, pp. 29–48

Garlick, Kenneth J., 'A Catalogue of Pictures at Althorp', *The Forty-fifth Volume of the Walpole Society*, 1974–6

Garlick, Kenneth J., *Sir Thomas Lawrence*, London 1989

Gautier, Théophile, *Voyage en Italie*, Paris 1882

Gautier, Théophile, *Journeys in Italy*, trans. Daniel B. Vermilye, New York 1902

Gaya Nuño, Juan Antonio, *L'Opera Completa di Murillo*, Milan 1978

Gazzola, Piero, *Michele Sanmicheli* (exh. cat.), Verona 1960

Gemin, Massimo, and Filippo Pedrocco, *Ca' Vendramin Calergi*, Milan 1990

Gennari Santori, Flaminia, '"They will form such an ornament for our gallery": la National Gallery e la pittura di Carlo Crivelli' in *Giovanni Battista Cavalcaselle conoscitore e conservatore* (Acts of the Convegno held in Verona 1997), ed. Anna Chiara Tommasi, Venice 1998, pp. 291–312

Gere, John A., 'Two late fresco cycles by Perino del Vaga: the Massimi Chapel and the Sala Paolina', *The Burlington Magazine*, CII, January 1960, pp. 9–19

Gere, John A., *Mostra di disegni degli Zuccari* (exh. cat. Uffizi, Florence), Florence 1966

Gere, John A., *Taddeo Zuccaro*, London 1969

Gere, John A., *Drawings by Michelangelo* (exh. cat. British Museum, London, 1975), London 1975

Gere, John A., *et al.*, *Gli Affreschi di Paolo III a Castel Sant'Angelo* (exh. cat. Castel Sant'Angelo, Rome, 1981–2), Rome 1981

Gerszi, Réz, 'The draughtsmanship of Lodewijk Toeput', *Master Drawings*, XXX, Winter 1992, pp. 367–95

Geyer, Marie Jeanne, *Eugène Carrière* (exh. cat. Musées de Strasbourg, 1997), Strasbourg 1997

Gibbons, Felton, 'Doge Marino Grimani by Leandro Bassano, knight', *Record of the Art Museum Princeton University*, XXII, 1963, pp. 22–34

Gilchrist, Alexander, *Life of William Etty, R.A.*, 2 vols, London 1855 (reprinted as one volume, Wakefield 1978)

Gilio, Giovanni Andrea, *Due dialoghi da M. Giovanni Andrea Gilio da Fabriano; nel primo de' quali si ragiona de le parti morali ... nel secondo si ragiona degli errori de pittori*, Camerino 1564 (reprinted in Barocchi 1961)

Ginsborg, Paul, *Daniele Manin and the Venetian Revolution of 1848–49*, Cambridge 1979

Gisolfi Pechukas, Diana, 'Two oil sketches and the youth of Veronese', *Art Bulletin*, LXIV, March 1982, pp. 388–413

Gisolfi Pechukas, Diana, 'Veronese and his collaborators at La Soranza', *Artibus et historiae*, XV, 1987, pp. 67–108

Gisolfi Pechukas, Diana, 'Tintoretto e le facciate affrescate di Venezia' in Rossi and Puppi 1996, pp. 111–14 and 314–16

Goethe, Johann Wolfgang von, *Italian Journey*, trans. Wystan Hugh Auden and Elizabeth Mayer, London and New York 1962

Goethe, Johann Wolfgang von, *Italienische Reise*, ed. Christof Thoenes, Munich 1992 (vol. 15 of *Münchner Ausgabe, Sämtliche Werke*)

Goffen, Rona, *Titian's Women*, New Haven and London 1997

Golahny, Amy E., 'Jan de Bisschops' "St Helena" after Veronese', *Master Drawings*, XIX, 1, 1981, pp. 25–7

Golinelli, Paolo, and Paolo Piva, *L'abbazia di San Benedetto Po: storie di acque, di pietre, di uomini*, Verona 1997

Goodman-Soellner, Elise, 'The Poetic Iconography of Veronese's Cycle of Love', *Artibus et historiae*, VII, 1983, pp. 19–28

Gordon, Archie [5th Marquess of Aberdeen], *A wild flight of Gordons*, London 1985

Gore, R. St John, *Upton House: The Bearsted Collection: Pictures*, London (National Trust) 1964

Gould, Cecil, *The Sixteenth-Century Venetian School, National Gallery Catalogues*, London 1959

Gould, Cecil, 'Sebastiano Serlio and Venetian Painting', *Journal of the Warburg and Courtauld Institutes*, XXV, 1962, pp. 56–64

Gould, Cecil, 'The Cinquecento at Venice. II. The *Death of Actaeon* and Titian's mythologies', *Apollo*, June 1972, pp. 464–9

Gould, Cecil, *The Sixteenth-Century Italian School, National Gallery Catalogues*, London 1975

Gould, Cecil, *The Family of Darius before Alexander by Paolo Veronese*, London [1978]

Gould, Cecil, 'An X-Ray of Tintoretto's "Milky Way"', *Arte Veneta*, XXXII, 1978, pp. 211–13

Gould, Veronica Franklin, *G.F. Watts: The last great Victorian*, London and New Haven 2004

Gower, Lord Ronald [Lord Ronald Leveson-Gower], *My Reminiscences*, 2 vols, London 1883

Gradenigo, Pietro, 'Commemoriali, Diario ed Annotazioni curiose occorse in Venezia', Biblioteca Correr, MS Gradenigo Dolfin Collocamento, no. 67, IX (commencing 1 July 1762)

Granberg, Olof, *La galerie de tableaux de la Reine Christine de Suède ayant appartenu à l'empereur Rodolphe II*, Stockholm 1897

Granberg, Olof, *Kejsar Rudolf II's Konsthammare*, Stockholm 1902

Grasso, Monica, 'Fasti romani di un banchiere', *Gazzetta Antiquaria*, XXVII, 1996, pp. 26–31

Gray, Richard, *Witley Court, Hereford and Worcester*, English Heritage guidebook, London 1997

Gregori, Mina, 'Giovan Battista Moroni' in *I Pittori Bergamaschi: Il Cinquecento*, III, ed. Pietro Zampetti, Bergamo 1979, pp. 95–377

Gregori, Mina, ed., *Pittura a Cremona dal romanico al Settecento*, Milan 1990

Gregori, Mina, ed., *Pittura tra il Verbano e il Lago d'Orta dal Medioevo al Settecento*, Milan 1996

Greville, Charles, *The Greville Memoirs, 1814–1860*, ed. Lytton Strachey and Roger Fulford, 8 vols, London 1938.

Griffiths, George, *Pictures at Weston, belonging to the Earl of Bradford*, Weston-under-Lizard 1895

Griggs, E.L., *Unpublished letters of S.T. Coleridge*, 2 vols, London 1932

Grimm, Claus, *Alte Bilderrahmen*, Munich 1978

Griseri, Andreina, 'Perino, Machuca, Campaña', *Paragone*, LXXXVII, March 1957, pp. 13–21

Griseri, Andreina, 'Nuove schede di Manierismo Iberico', *Paragone*, CIII, May 1959, pp. 33–43

Gronau, Georg, 'Archivalische Beiträge zur Geschichte der Venezianischen Kunst', *Italienische Forschungen* (Kunsthistorischen Institut Florenz), IV, 1911

Gronau, Georg, 'Concerning Titian's Picture at Alnwick Castle', *Apollo*, II, September 1925, pp. 126–7

Gruman, Gerald, 'A History of Ideas about the Prolongation of Life', *Transactions of the American Philosophical Society*, n.s. LVI, part 9, Philadelphia 1966

Guest, Douglas, MS catalogue of the pictures at Cobham Hall ... compiled by Douglas Guest, 1833, Medway Archives Office, Strood, U565.F27 unpaginated

Gullino, Giuseppe, *I Pisani dal Banco e Moretta: Storia di due famiglie Veneziane in età moderna*, Rome 1984

Gunnis, Rupert, *A Dictionary of British Sculpture*, London 1951

Habert, Jean, *Véronèse: Une dame vénitienne dite La Belle Nani*, Paris 1996

Habert, Jean, *Bassano et ses fils dans les musées français*, (exh. cat. Musée du Louvre, Paris, 1998), Paris 1998

Habert, Jean, *et al.*, *Les Noces de Cana de Véronèse* (exh. cat. Musée du Louvre, Paris 1992–3), Paris 1992

Habich, Georg, *Die Medaillen der italienischen Renaissance*, Stuttgart and Berlin 1922

Hadeln, Detlev von, 'Bonifazio Veronese' in Thieme-Becker, IV, Leipzig 1910, pp. 294–6.

Hadeln, Detlev von, 'Damiano Mazza', *Zeitschrift für bildende Kunst*, XXIV, 1913, pp. 249–54

Hadeln, Detlev von, 'Einige wenig bekannte Werke des Tintoretto', *Zeitschrift für bildende Kunst*, XXXII, 1921, pp. 189–92

Hadeln, Detlev von, *Venezianische Zeichnungen des Spätrenaissance*, Berlin 1926

Hadeln, Detlev von, 'Two unknown works by Titian', *The Burlington Magazine*, LIII, August 1928, pp. 53–7

Hadeln, Detlev von, 'Girolamo di Tiziano', *The Burlington Magazine*, LXV, August 1934, pp. 84–9

Hadeln, Detlev von, *Paolo Veronese*, ed. G. Schweikhart, Florence 1978

Hadjinicolaou, Nicos, ed., *Alexander the Great in European Art* (exh. cat. Thessaloniki 1997/8), Thessaloniki 1997

Halévy, Ludovic, *Carnets*, ed. Daniel Halévy, 2nd vol., Paris 1935

Hall, Michael, 'Die englischen Rothschilds als Sammler' in *Die Rothschilds* (exh. cat.), Frankfurt-am-Main 1994, pp. 267–91

Hamilton, Gavin, *Schola Italica*, Rome 1771

Harcourt-Smith, Simon, *The Family of Darius before Alexander*, London n.d.

Harewood, George Lascelles, 7th Earl of, *Harewood, Yorkshire: A Guide*, Leeds [?] 1995

Harrison, Jefferson C., *Paolo Veronese in San Benedetto Po: Two Masterpieces Reunited* (exh. leaflet Chrysler Museum of Art), Norfolk, VA, 1995–6

Hartt, Frederick, *Giulio Romano*, New York 1981

Haskell, Francis, *Rediscoveries in Art*, London and New Haven 1976

Haskell, Francis, *Patrons and Painters*, London 1963, revised London and New Haven 1980

Haskell, Francis, and Nicholas Penny, *Taste and the Antique*, London and New Haven 1981

Haskell, Francis, 'William Coningham and his collection of Old Masters', *The Burlington Magazine*, CXXXIII, October 1991, pp. 676–81

Haskell, Francis, *The Ephemeral Museum*, New Haven and London 2000

Hawcroft, Francis W., *Watercolours by Thomas Girtin* (exh. cat. Whitworth Art Gallery, University of Manchester, and Victoria and Albert Museum, London, 1975), London 1975

Haydon, Benjamin Robert, and William Hazlitt, *Painting, and the fine arts: being the articles under those heads contributed to the seventh edition of the Encyclopaedia Britannica*, Edinburgh 1838

Hayward, John. F., *Virtuoso Goldsmiths and the Triumph of Mannerism*, London 1976

Hazlitt, William, *Sketches of the Picture Galleries of England*, London 1824

Hazlitt, William, *Notes of a Journey through France and Italy*, London 1826

Hazlitt, William, *Criticisms on Art and Sketches of the Picture Galleries of England*, 2nd edn, London 1856

Hébert, *Dictionnaire pittoresque et historique*, 2 vols, Paris 1756

Hédouin, P., 'Memling', *Annales archéologiques*, VI, 1847, pp. 256–78

Hendy, Philip, *An exhibition of cleaned pictures (1936–47)*, London 1947 (Hendy signs the introductory text – he may not have been author of all the catalogue entries but presumably endorsed the reattributions incorporated in them)

Hendy, Philip, *European and American Paintings in the Isabella Stewart Gardner Museum*, Boston 1974

Herklotz, Ingo, '*Historia Sacra* und Mittelalterliche Kunst während der zweiten Hälfte des 16. Jahrhunderts in Rom' in *Baronio e l'arte* (Acts of the Convegno Internazionale at Sora, 1984), ed. Romeo de Maio *et al.*, Sora 1985, pp. 23–72

Hermann, Frank, *Sotheby's: Portrait of an auction house*, New York and London 1981

Herrmann Fiore, Kristina, 'Venere che benda Amore' in Bernardini 1995, pp. 389–420

Hill, George F., revised and enlarged by Graham Pollard, *Renaissance medals from the Samuel H. Kress collection at the National Gallery of Art*, Oxford 1967

Hills, Paul, 'Piety and Patronage in Cinquecento Venice: Tintoretto and the Scuole del Sacramento', *Art History*, VI, 1983, pp. 30–43

Hills, Paul, 'Tintoretto's Marketing' in *Venedig und Oberdeutschland in der Renaissance*, ed. B. Roeck, K. Bergdolt and A. Martin, Venice 1993, pp. 107–20

Hinterding, Erik, and Femy Horsch, '"A small but choice collection": the Art Gallery of King Willem II of the Netherlands (1792–1849)', *Simiolus*, XIX, 1989, pp. 5–122

Hirst, Michael, *Michelangelo and his Drawings*, New Haven and London 1988

Hochmann, Michel, 'La Collection de Giacomo Contarini', *Mélanges de l'École française de Rome*, XCIX, 1987, pp. 447–89

Hochmann, Michel, 'Le mécenat de Marino Grimani', *Revue de l'Art*, XCV, 1992, pp. 45–51

Holberton, Paul, 'Battista Guarino's Catullus and Titian's *Bacchus and Ariadne*', *The Burlington Magazine*, CXXVIII, May 1986, pp. 347–50

Holborn, J.B. Stoughton, *Jacopo Robusti, called Tintoretto*, London 1903

Holloway, James, 'H.A.J. Munro of Novar', *Review of Scottish Culture*, VII, 1991, pp. 9–13

Holmes, Charles J., *Notes on the Science of Picture-making*, London 1911

Holmes, Charles J., 'Recent additions to the National Gallery', *The Burlington Magazine*, XLI, August 1922, pp. 76–87

Holmes, Charles J., *Old Masters and Modern Art. The National Gallery Italian Schools*, London 1923

Holmes, Charles J., 'Titian's *Venus and Adonis* in the National Gallery', *The Burlington Magazine*, XLIV, January 1924, pp. 16–22

Holmes, Charles J., 'A preparatory version of Titian's *Trinity*', *The Burlington Magazine*, L, February 1927, pp. 52–9

Holmes, Charles J., *A Grammar of the Arts*, New York 1932

Holmes, Charles J., *Self and Partners (Mostly Self), being the reminiscences of C.J. Holmes*, London 1936

Holmes, Charles J., and Henry Charles Collins Baker, *The Making of the National Gallery, 1824–1924*, London 1924

Hood, William, and Charles Hope, 'Titian's Vatican altarpiece and the picture underneath', *Art Bulletin*, LIX, no. 4, December 1977, pp. 534–52

Hope, Charles, 'Problems of interpretation in Titian's erotic paintings' in *Tiziano e Venezia* (papers of the Convegno Internazionale di Studi, Venice, 27 September–1 October 1976), 2 vols, Vicenza 1980, pp. 111–24

Hope, Charles, *Titian*, London 1980

Hope, Charles, 'La produzione pittorica di Tiziano per gli Asburgo' in *Venezia e la Spagna*, Milan 1988

Hope, Charles, 'Hans Mielich at Titian's Studio', *Journal of the Warburg and Courtauld Institutes*, LX, 1997, pp. 260–1

Hornig, Christian, *Cavazzola*, Munich 1976

Howard, Elizabeth, 'New evidence on the Italian provenance of a portrait by Sebastiano del Piombo', *The Burlington Magazine*, CXXX, June 1988, pp. 457–9

Hübner, Julius, *Catalogue of the Royal Picture Gallery in Dresden*, trans. J. Pond, revised by B.S. Ward, Dresden 1880

Hughes, Peter, *The Founders of the Wallace Collection*, London 1981

Hume, Abraham, *A Descriptive Catalogue of a collection of Pictures comprehending Specimens of all the Various Schools of Painting*, London 1824 (revised 1829 or later with additions but retaining the title page and date of 1824)

Hume, Abraham, *Notices of the life and works of Titian*, London 1829

Humfrey, Peter, *Cima da Conegliano*, Cambridge 1983

Humfrey, Peter, 'Competitive Devotions: The Venetian *Scuole Piccole* as Donors of Altarpieces in the Years around 1500', *Art Bulletin*, LXX, September 1988, pp. 401–23

Humfrey, Peter, *The Altarpiece in Renaissance Venice*, London and New Haven 1993

Humfrey, Peter, *Painting in Renaissance Venice*, New Haven and London 1995

Humfrey, Peter, Timothy Clifford, Aidan Weston-Lewis and Michael Bury, *The Age of Titian: Venetian Renaissance Art from Scottish Collections* (exh. cat. National Galleries of Scotland, 2004), Edinburgh 2004

Humfrey, Peter, and S. Holt, 'More on Veronese and his patrons at San Francesco della Vigna', *Venezia Cinquecento*, V, no. 10, July–December 1995, pp. 187–214

Hurtubise, P., *Une famille témoin. Les Salviati*, Vatican City 1985

Hussey, Christopher, 'Witley Court, Worcestershire', *Country Life*, 8 and 15 June 1945, pp. 992–5, 1036–9

Hussey, Christopher, 'Weston Park, Staffordshire', *Country Life*, 9, 16 and 23 November 1945, pp. 910–13

Hussey, Christopher, 'Restoration of Lancaster House', *Country Life*, 12 November 1953, pp. 1572–6

Hussey, Christopher, *English Country Houses: Mid Georgian*, London 1956

Huyum, A., *Giovanni Antonio Bazzi – 'il Sodoma'*, New York 1976

Hymans, Henri, *Lucas Vorsterman, Catalogue raisonné de son œuvre*, Brussels 1893

Ilari, Cristiana, 'Il mito di Adone nel Palazzo Orsini di Monterotondo', *Storia dell'Arte*, LXXIV, 1992, pp. 25–47

Ingamells, John, 'Perseus and Andromeda: the provenance', *The Burlington Magazine*, CXXIV, July 1982, pp. 396–400

Ingamells, John, *The Wallace Collection. Catalogue of Pictures. I.*, London 1985

Ingamells, John, *A dictionary of British and Irish travellers in Italy, 1701–1800, compiled from the Brinsley Ford archive*, London and New Haven 1997

Ivanoff, Antonio, 'Antonio Negretti detto Antonio Palma' in *I Pittori Bergamaschi: Il Cinquecento*, III, ed. Pietro Zampetti, Bergamo 1979, pp. 379–99

Jacobsen, Emil, 'Italienische Gemälde in der Nationalgalerie zu London', *Repertorium für Kunstwissenschaft*, XXIV, 1901, pp. 339–75

Jacobsen, Emil, 'Das Museo Vendramin und die Sammlung Reynst', *Repertorium für Kunstwissenschaft*, XLVI, 1925, pp. 15–38

Jaderosa Molino, Giuseppina, 'Riconoscibili decorazioni ad affresco di Giuseppe Porta detto Salviati', *Arte Veneta*, XVII, 1963, pp. 164–8

Jaffé, David, 'The Earl and Countess of Arundel: Renaissance collectors', *Apollo*, August 1996, pp. 3–35

Jaffé, David, 'New thoughts on Van Dyck's Italian sketchbook', *The Burlington Magazine*, CXLIII, October 2001, pp. 614–24

Jaffé, David, ed., *Titian* (exh. cat. National Gallery, London, 2003), London 2003

James, Montague Rhodes, *The Apocryphal New Testament being the Apocryphal Gospels, Acts, Epistles, and Apocalypses*, Oxford 1928 (first published 1924)

Jameson, Anna, *Companion to the most celebrated private galleries of art in London*, London 1844

Jameson, Anna, *Memoirs and Essays illustrative of Art, Literature and Social Morals*, London 1846

Jameson, Anna, *Legends of the Madonna as represented in the Fine Arts*, 7th edn, London 1888

Jestaz, Bertrand, with Michel Hochmann and Philippe Sénéchal, *L'Inventaire du palais et des propriétés Farnèse à Rome en 1644*, Rome (École Française de Rome) 1994

Joannides, Paul, *The Drawings of Raphael: with a complete catalogue*, London 1983

Joannides, Paul, *Titian to 1518: the assumption of genius*, New Haven 2001

Joannides, Paul, 'Titian in London and Madrid', *Paragone*, LV, 58(657), November 2004, pp. 3–30

Joannides, Paul, 'Titian and the Extract', *Studi tizianeschi*, IV, 2006, pp. 135–48

Joannides, Paul, 'Titian's Repetitions' in *Titian: Materiality, Likeness, 'Istoria'*, ed. Joanna Woods-Marsden, Turnhout 2007, pp. 37–52

Joannides, Paul, and Marianne Sachs, 'A "Last Supper" by the young Jacopo Bassano and the sequence of his early work', *The Burlington Magazine*, CXXXIII, October 1991, pp. 695–9

Jones, Owen, *see* Summerly, Felix

'Jones and Co.' (Publishers), *The National Gallery of pictures by the great masters*, London *c.*1835–8 (This volume, illustrating 114 paintings, is usually dated 1840, but Elspeth Hector points out that it includes Gainsborough's Schomberg portrait, which was presented in August 1835 but withdrawn in May 1836, which suggests that the book was published before the latter date. The preface mentions the new building by Williams 'now rising', which implies a date before completion in 1839 and certainly before the opening in 1838. It is possible that the book was published in serial form, in which case the dates inscribed by hand in the Gallery's copies – '1835' and '[1838]' – may well be correct and 1840 may perhaps be the year in which the series was completed.)

Joubin, André, 'Les dessins originaux de la Galerie du Palais royal', *Gazette des Beaux-Arts*, March 1924, pp. 169–74

Justi, Carl, 'Peeter de Kempeneer', *Jahrbuch der Preuszischen Kunstsammlungen*, V, 1884, pp. 154–79

Kagan, Julia, and Oleg Neverov, *Splendeurs des collections de Catherine II de Russie: le cabinet de pierres gravées du Duc d'Orléans* (exh. cat. Mairie du Vᵉ arrondissement, Paris), Paris 2000

Kagan, Julia, and Oleg Neverov, *Le Destin d'une collection: 500 pierres gravées du cabinet du duc d'Orléans*, St Petersburg 2001

Kahr, Madlyn, 'Titian, the "Hypnerotomachia poliphili" woodcuts and antiquity', *Gazette des Beaux-Arts*, LXVII, 1966, pp. 119–27

Karpinski, Caroline, ed., *Italian Chiaroscuro woodcuts* (*The Illustrated Bartsch*, XLVIII, formerly 12), New York 1983 – the text volume for this is forthcoming

Kaufmann, Thomas DaCosta, *The School of Prague: Painting at the Court of Rudolf II*, Chicago and London 1988

Keller, Harald, *Tizians Poesie für König Philipp II von Spanien*, Wiesbaden 1969

Kempter, Gerda, *Ganymed. Studien zur Typologie, Ikonographie und Ikonologie*, Vienna 1980

Kimball, Fiske, 'Oppenord au Palais-Royal', *Gazette des Beaux-Arts*, XV, February 1936, pp. 113–17

Kirby, Jo, 'Fading and Colour Change of Prussian blue: occurrences and early reports', *National Gallery Technical Bulletin*, 14, 1993, pp. 62–71

Kirschbaum, Engelbert, *Lexikon der christlichen Ikonographie*, 8 vols (1968–76), Freiburg 1972

Kitson, Michael, 'Painting of the Month', *The Listener*, 3 October 1963, pp. 510–12

Kitson, Michael, *Salvator Rosa* (exh. cat. Hayward Gallery, London, 1973), London 1973

Kitson, Michael, 'The Inspiration of John Constable' (Fred Cook Memorial Lecture 1976), *Journal of the Royal Society for the Encouragement of Arts Manufactures and Commerce*, CXXIV, 1977, pp. 738–53

Klinge, Margret, and Dietmar Lüdke, *David Teniers der Jüngere 1610–1690* (exh. cat. Staatliche Kunsthalle, Karlsruhe, 2005–6), Karlsruhe 2005

[Knight, Richard Payne], 'The Works and Life of J. Barry', *Edinburgh Review*, XVI, August 1810, pp. 293–326

[Knight, Richard Payne], 'Northcote's *Life of Reynolds*', *Edinburgh Review*, XLVI, September 1814, pp. 263–92

Knollys, Eardley, 'The Storran Gallery', *The Burlington Magazine*, CXXXI, March 1989, pp. 203–7

Knox, George, *Giambattista Piazzetta*, Oxford 1992

Knox, George, *Antonio Pellegrini 1675–1741*, Oxford 1995

Konečný, Lubomír, 'Emblematics, Agriculture, and Mythography in *The Origin of the Milky Way* by Jacopo Tintoretto' in *Polyvalenz und Multifunktionalität der Emblematik* (Multivalence and Multifunctionality of the Emblem)', (Proceedings of the 5th International Conference of the Society for Emblem Studies, Munich, 1999), Berlin 2002, pp. 255–68

Krahn, Volker, *Von allen Seiten schön* (exh. cat. Skulpturensammlung, Berlin, 1995–6), Berlin 1995

Kris, Ernst, *Catalogue of postclassical cameos in the Milton Weil collection*, Vienna 1932

Krischel, Roland, 'Tintoretto e la scultura veneziana', *Venezia Cinquecento*, VI, no. 12, July–December 1996, pp. 22–5

Kultzen, Rolf, and Peter Eickemeier, *Venezianische Gemälde des 15. und 16. Jahrhunderts* (Bayerische Staats-gemäldesammlungen), 2 vols, Munich 1971

Kustodieva, Tatyana K., *Italian Painting: Thirteenth to Sixteenth Centuries* (The Hermitage), I, Florence 1994

Kwiatkowski, A. *et al.*, *Weston Park: the Official Guide*, c.1990

Lalande, Joseph-Jérôme Lefrançais de, *Voyage d'un François en Italie*, 8 vols, Venice 1769

Lamb, Charles and Mary Anne, *The Letters of Charles and Mary Anne Lamb*, ed. Edwin W. Marrs, 3 vols, London 1976

Lancaster, Marie-Jaqueline, ed., *Brian Howard: Portrait of a Failure*, London 1968

Landseer, John, *A Descriptive, Explanatory and Critical catalogue of fifty of the earliest pictures contained in the National Gallery*, London 1834

Lane, Frederic C., *Andrea Barbarigo: Merchant of Venice, 1418–1449* (Johns Hopkins University Studies in Historical and Political Science, LXII, i), Baltimore 1944

Lane, Frederic C., *Venice and History*, Baltimore 1966

Lane, Frederic C., *Venice, a Maritime Republic*, Baltimore and London 1973, pp. 160–1

Langedijk, Karla, *The portraits of the Medici: 15th–18th centuries*, 3 vols, Florence 1981–7

Langton Douglas, Capt. R., Obituary of Tancred Borenius, *The Burlington Magazine*, XC, November 1949, p. 327

Lanzi, Luigi, *Storia pittorica della Italia*, 3 vols, Bassano 1795–6

Lauber, Rosella, 'Per un ritratto di Gabriele Vendramin. Nuovi contributi' in Borean and Mason 2002, pp. 25–75

Lauber, Rosella, and Simone Furtlehner, 'Bartolomeo Dalla Nave' in *Il Collezionismo d'arte a Venezia: il Seicento*, ed. L. Borean and S. Mason, Venice 2008

Lavin, Irving, *Bernini and the Unity of the Visual Arts*, 2 vols, New York and London, 1980

Layard, Austen Henry, *Handbook of Painting. The Italian Schools. Based on the Handbook of Kugler*, 2 vols, London 1902

Lebenstejn, J.C., 'Un tableau de Titien, un essai de Panofsky', *Critique*, 1973, nos 315–16, pp. 821–43

[Lehninger, Johann August], *Abrégé de la vie des peintres, dont les tableaux composent la galerie électorale de Dresde*, Dresden 1782

Lepschy, Anna Laura, *Tintoretto Observed. A documentary survey of critical reactions from the 16th to the 20th century*, Ravenna 1983

[Le Rouge, Georges-Louis] 'M.L.R.', *Les Curiositez de Paris*, 2 vols, Paris 1719, 1723, 1733

Le Senecal, Julian, 'Les Occupations des Mois', *Bulletin de la société des antiquaires de Normandie*, XXXV, 1924 (the entire issue is devoted to this article)

Levey, Michael, *The Eighteenth Century Italian Schools, National Gallery Catalogues*, London 1956

Levey, Michael, *The Seventeenth and Eighteenth Century Italian Schools, National Gallery Catalogues*, London 1971

Levey, Michael, Review of *Palazzo Pisani Moretta* by Ileana Chiappini di Sorio, *The Burlington Magazine*, CXXV, August 1984, p. 509

Levey, Michael, *Giambattista Tiepolo: his Life and Art*, New Haven and London 1986

Levey, Michael, *The later Italian pictures in the collection of Her Majesty the Queen*, 2nd edn, Cambridge 1991

Levi, Cesare Augusto, *Le collezioni Veneziane d'arte e d'antichità dal secolo XIV ai nostri giorni*, 2 vols in 1, Venice 1900

Lewis, Douglas, *The Drawings of Andrea Palladio*, New Orleans 2000

Lieberman, Ralph, *Renaissance Architecture in Venice, 1450–1540*, New York 1982

Liedtke, Walter A., *Flemish Paintings in the Metropolitan Museum of Art*, 2 vols, New York 1984

Lightbown, Ronald, *Sandro Botticelli*, 2 vols, London 1978

Lill, G., *Hans Fugger und die Kunst*, Leipzig 1908

Limentani Virdis, C., 'Un catalogo per Paolo Fiammingo', *Antichità Viva*, 1979, ii, pp. 49–50

Lindsay MS: the Recollections of Blanche Lindsay (typescript of a text dictated by Blanche around 1910 to her daughter Helen, probably incorporating material drafted at an earlier date), private collection, Scotland

Lloyd, Christopher, 'John Julius Angerstein, 1732–1823, Founder of Lloyd's and of the National Gallery', *History Today*, June 1966, pp. 373–9

Lloyd, Christopher, *A Catalogue of the Earlier Italian Paintings in the Ashmolean Museum*, Oxford 1977

Lloyd, Christopher, *Italian Paintings before 1600 in the Art Institute of Chicago*, Princeton 1993

Lloyd, Christopher, 'Abraham Hume', *Oxford Dictionary of National Biography*, XXVIII, 2004, pp. 731–2

Lodi, Roberto, *La Collezione di cornici, Catalogo no. 4*, Modena 1996

Loeser, Carlo, 'Note intorno ai disegni conservati nella R. Galleria di Venezia', *Rassegna d'Arte*, III, no. 12, December 1903, pp. 177–84

Logan, Anne-Marie S., *The 'cabinet' of the brothers Gerard and Jan Reynst*, Amsterdam and New York 1979

Lomazzo, Giovan Paolo, *L'idea del Tempio della pittura*, Milan 1590

Longhi, Roberto, 'Giunte a Tiziano', *Arte*, XXVIII, 1925, pp. 40–50

Longhi, Roberto, *Precisioni sulla Galleria Borghese*, Florence 1928

Longhi, Roberto, *Saggi e ricerche 1925–1928*, 2 vols, Florence 1967

Lorandi, Marco, *I profani trionfi dei Fantoni: l'alcova Sottocasa*, Bergamo 1996

Lorenzetti, Giulio, *Venezia e il suo estuario*, Trieste 1974 (first published Venice 1926)

Lovisa, Domenico (publisher), *Il Gran Teatro di Venezia ovvero descrizione esatta di cento delle più insigni Prospettive, e di altretante celebri Pitture della medesima Città*, Venice c.1717

Lovisa, Domenico (publisher), *Il Gran Teatro delle Pitture, e Prospettive di Venezia in due tomi diviso*, 2 vols, Venice 1720

Lucas, E.V., *A Wanderer among Pictures*, New York 1924

Lucas MS diaries, Diaries of Lady Amabel Lucas, née Yorke (1751–1833), Baroness Lucas and Dowager Viscountess Polwarth, later created Countess de Grey in her own right, 37 vols, Leeds District Archives, West York Archive Service

Luchs, Alison, *Tullio Lombardo and Ideal Portrait Sculpture in Renaissance Venice*, Cambridge 1995

Ludwig, Gustav, 'Neue Funde im Staatsarchiv zu Venedig', *Jahrbuch der königlich preussischen Kunstsammlungen*, XXIV, 1903 (supplement)

Ludwig, Gustav, *Archivalische Beiträge zur Geschichte der venezianischen Kunst*, ed. Wilhelm von Bode, Georg Gronau, Detlev von Hadeln (Italienische Forschungen, IV), Berlin 1911

Luzio, Alessandro, *La Galleria dei Gonzaga venduta all'Inghilterra nel 1627–28*, Milan 1913 and Rome 1974

MacColl, David S., 'Tintoretto's Vincenzo Morosini', *The Burlington Magazine*, XLIV, June 1924, pp. 266–71

MacColl, David S., *Confessions of a Keeper and other papers*, London 1931

MacGregor, Arthur, *The Late King's Goods: Collections, Possessions and Patronage of Charles I in the Light of the Commonwealth Sale Inventories*, London and Oxford 1989

MacLaren, Neil, *The Spanish School, National Gallery Catalogues*, London 1952, 1970

MacLaren, Neil, revised and expanded by Christopher Brown, *The Dutch School, National Gallery Catalogues*, 2 vols, London 1991

Magani, Fabrizio, *Antonio Bellucci*, Rimini 1995

Magrini, Marina, *Francesco Fontebasso*, Vicenza 1988

Mahon, Dennis, 'Notes on the "Dutch Gift" to Charles II', parts 1–111, *The Burlington Magazine*, XCI, November and December 1949, pp. 303–5, 349–50, and XCII, January 1950, pp. 12–18

Malafarina, Gianfranco, *L'Opera Completa di Annibale Carracci*, Milan 1976

Mâle, Émile, *L'art religieux de la fin du XVIᵉ siècle, du XVIIᵉ siècle et du XVIIIᵉ siècle: Étude sur l'iconographie après le Concile de Trente*, Paris 1951

Malipiero, Domenico, 'Annali Veneti dall'Anno 1457 ai 1500', *Archivio Storico Italiano*, VII, 2, 1844

Manca, Joseph, *Cosmè Tura*, Oxford 2000

Mancinelli, Fabrizio, *et al.*, *Raffaello in Vaticano* (exh. cat. Città del Vaticano, 1984–5), Milan 1984

Mancini, Matteo, *Tiziano e le corti d'Asburgo*, Venice 1998

Mancini, Matteo, ed., *Tiziano: técnicas y restauraciones* (Proceedings of International Symposium, Museo del Prado, Madrid, 3–5 June 1999), Madrid 1999

Mancini, Vincenzo, 'Note sugli esordi di Lambert Sustris' in *Per ricordo di Sonia Tiso*, ed. C.L. Virdis, Ferrara 1987, pp. 61–72

Mancini, Vincenzo, *Lambert Sustris a Padova: La Villa Bigolin a Selvazzano*, Padua 1993

Mancini, Vincenzo, *Antiquari, 'vertuosi' e artisti: saggi sul collezionismo tra Padova e Venezia alla metà del Cinquecento*, Padua 1995

Mandler, Peter, *The Fall and Rise of the Stately Home*, New Haven and London 1997

Mandowsky, Erna, '"The Origin of the Milky Way" in the National Gallery', *The Burlington Magazine*, LXXII, February 1938, pp. 88–93

Mane, Perrine, *Calendriers et techniques agricoles (France-Italie, XIIᵉ–XIIIᵉ siècles)*, Paris 1983

Mannings, David, *Sir Joshua Reynolds: a complete catalogue of his paintings*, 2 vols, London and New Haven 2000

Marais, Mathieu, *Journal et Mémoires sur la Régence et le règne de Louis XV (1715–1737)*, ed. M. de Lescure, 4 vols, Paris 1863–8

Marchese, Vincenzo, *Storia documentata della rivoluzione*, Venice 1916

Mardrus, Françoise, 'Le Régent, mécène et collectionneur' in *Le Palais-Royal* (exh. cat. Musée Carnavalet, Paris, 1988), Paris 1988

Mardrus, Françoise, 'La Galerie du Palais-Royal: Mémoire de l'art' in *Seicento: la peinture italienne du XVIIᵉ siècle et la France* (Rencontres de l'École du Louvre), Paris, 1990, pp. 79–90

Mardrus, Françoise, 'La Galerie du Régent et la peinture du Seicento' in *Seicento*, cited above, pp. 293–308

Mardrus, Françoise, 'À propos du voyage de Sir James Thornhill en France' in *Nicolas Poussin (1594–1665)* (Actes du Colloque organisé au Musée du Louvre, October 1994), 2 vols, Paris 1996, pp. 811–33

[Mariani] Canova, Giordana, *Paris Bordon*, Venice 1964

Mariani Canova, Giordana, 'Paris Bordon: profilo biografico e critico', and catalogue entries, in *Paris Bordon* (exh. cat. Palazzo dei Trecento, Treviso, 1984), Treviso 1984, pp. 28–50

Mariani Canova, Giordana, 'Paris Bordon: problematiche cronologiche' in Fossaluzza and Manzato 1987, pp. 137–57

Mariette, Pierre-Jean, *Abecedario*, Paris 1720

Mariette, Pierre-Jean, *Recueil d'estampes d'après les plus beaux tableaux et d'après les plus beaux desseins qui sont en France dans le Cabinet du roi, dans celui de monseigneur le duc d'Orléans, & dans d'autres cabinets...* II, la suite de l'école romaine et l'école vénitienne, Paris 1742 (continuation of first volume by Joseph-Antoine Crozat, published 1729, generally known as the *Recueil Crozat*)

Marinelli, Sergio, ed., *Veronese e Verona* (exh. cat. Museo di Castelvecchio, Verona, 1988), Verona 1988

Marinelli, Sergio, 'I modelli emiliani nella cultura figurativa veneta: Parmigianino, Reni, Guercino' in *La pittura emiliana nel Veneto*, ed. Marinelli and Angelo Mazza, Modena 1999, pp. 269–92

Marini, Remigio, *L'Opera Completa del Veronese*, Milan 1968

Marino, Giambattista, *Epistolario*, ed. Angelo Borzelli and Fausto Nicolini, 2 vols, Bari 1911–12

Marino, Giambattista, *La Galeria*, ed. Marzio Pieri, Padua 1979

Marino, Giambattista, *Lettere*, ed. Marziano Guglielminetti, Turin 1966

Mariuz, Adriano, and Rodolfo Pallucchini, *L'Opera completa del Piazzetta*, Milan 1982

Marongiu, Marcella, *Il mito di Ganimede prima e dopo Michelangelo* (exh. cat. Casa Buonarroti, Florence, 2002), Florence 2002

Martin, Andrew John, 'Eine Sammlung unbekannter Potraits der Renaissance aus dem Besitz des Hans Jakob König', *Kunstchronik*, XLVIII, 1995, pp. 46–54

Martin, Gregory, *The Flemish School, National Gallery Catalogues*, London 1970

Martin, Thomas, *Alessandro Vittoria and the Portrait Bust in Renaissance Venice*, Oxford 1998

Martineau, Jane, and Charles Hope, *The Genius of Venice, 1500–1600* (exh. cat. Royal Academy, London, 1983), London 1983

Martinioni, Giustiniano, *Venetia città nobilissima et singolare*, Venice 1663 (Sansovino's guide of 1581 with Martinioni's numerous additions)

Martyn, Thomas, *The English Connoisseur*, 2 vols, London 1766

Marx, Harald, ed., *Gemäldegalerie Alte Meister Dresden: illustrierter Katalog*, 2 vols, Cologne 2005 (the catalogue is by Elisabeth Hipp)

Maschio, Ruggero, ed., *I tempi di Giorgione*, Tivoli 1994

Mason, William Hayley, *Goodwood, its house, park and grounds: with a catalogue raisonné of the pictures in the gallery of His Grace the Duke of Richmond*, London 1839

Mason Rinaldi, Stefania, 'Appunti per Paolo Fiammingo', *Arte Veneta*, XIX, 1965, pp. 95–107

Mason, Stefania, 'Il libro dei disegni di Palma il Giovane del British Museum', *Arte Veneta*, XXVII, 1973, pp. 125–43

Mason Rinaldi, Stefania, 'Tre momenti documentati dell'attività di Palma il Giovane', *Arte Veneta*, XXIX, 1975, pp. 197–204

Mason Rinaldi, Stefania, 'Paolo Fiammingo', *Saggi e Memorie di Storia dell'Arte*, XI, 1978, pp. 45–80

Mason Rinaldi, Stefania, *Palma il Giovane: l'opera completa*, Milan 1984

Mason Rinaldi, Stefania, *Palma il Giovane 1548–1628: Disegni e dipinti* (exh. cat. Museo Correr, Venice, 1990), Venice 1990

Mason, Stefania, 'Intorni al soffitto di San Paternian: gli artisti di Vettore Pisani' in Rossi and Puppi 1996, pp. 71–5

Mason Rinaldi, Stefania, and Rodolfo Pallucchini, eds, *Da Tiziano a El Greco. Per la storia del Manierismo a Venezia* (exh. cat. Palazzo Ducale, Venice, 1981), Venice 1981

Massar, Phyllis D., 'A Woodcut by Antonio Belemo', *Print Quarterly*, XXII, December 2005, pp. 434–7

Matile, Michael, 'Quadri laterali, ovvero consequenze di una collocazione ingrata. Sui dipinti di storie sacre nell'opera di Jacopo Tintoretto', *Venezia Cinquecento*, VI, no. 12, July–December 1996, pp. 151–206

Mauroner, Fabio, *Le Incisioni di Tiziano*, Padua 1943

Mayer, August L., 'Tizianstudien', *Münchner Jahrbuch der Bildenden Kunst*, II (n.s.), 1925, pp. 267–84

Mayer, August L., 'Christ washing his disciples' feet, by Tintoretto', *The Burlington Magazine*, LXIX, December 1936, pp. 281–2

Mazzocca, Fernando, *Francesco Hayez. Catalogo Ragionato*, Milan 1994

Mazzocca, Fernando, et al., *Giuseppe Molteni (1800–1867) e il ritratto nella Milano romantica* (exh. cat. Museo Poldi Pezzoli, Milan, 2000–1), Milan 2000

McAndrew, John, *Venetian Architecture of the Early Renaissance*, Cambridge and London 1980

McClellan, Andrew, *Inventing the Louvre: Art, Politics, and the Origins of the Modern Museum in Eighteenth-Century Paris*, Cambridge 1994

McCorquodale, Charles, 'Reconstructing Carlo Dolci's Montevarchi altarpiece', *The Burlington Magazine*, CXXXV, May 1993, pp. 344–6

McGrath, Elizabeth, *Corpus Rubenianum Ludwig Burchard: XIII(I) Subjects from History*, 2 vols, London 1997

McTavish, David, *Giuseppe Porta called Giuseppe Salviati* (PhD thesis, Courtauld Institute, London, 1981), New York and London 1982

Meijer, Bert W., 'Paolo Fiammingo reconsidered', *Mededelingen van het Nederlands Instituut te Rome*, XXXVII, 1975, pp. 117–30

Meijer, Bert W., 'Pieter Cornelisz. van Rijck and Venice', *Oud Holland*, 113, 1999, no. 3, pp. 137–51

Meller, Peter, 'Il lessico ritrattistico di Tiziano' in *Tiziano e Venezia* (papers of the Convegno Internazionale di Studi, Venice, 27 September–1 October 1976), 2 vols, Vicenza 1980, pp. 325–35

Mendoza, Diego Hurtado de, *Fábula de Adonis*, Venice 1553

Merrifield, 'Mrs' [Mary Philadelphia], *Original Treatises dating from the XIIth to XVIIIth centuries, on the Arts of Painting...*, 2 vols, London 1849

Michiel, Marcantonio, *Der Anonimo Morelliano: Marcanton Michiel's Notizia d'opere del disegno*, ed. Theodor Frimmel, Vienna 1888

Misson, Maximilien, *A New Voyage to Italy*, 2 vols, London 1695 (trans. from the French, published in 1691)

Mitchell, Paul, and Lynn Roberts, *A History of European Picture Frames*, London 1996

Millar, Oliver, ed., 'The Inventories and Valuations of the King's Goods 1649–1651', *The Walpole Society*, XLIII, 1970–2, 1972

Molanus [Jan Vermeulen], *De Historia SS. Imaginum et Picturarum...*, Antwerp 1617

Molanus [Jan Vermeulen], *Traité des saintes images*, trans. F. Boespflug, Paris 1996 (the translation accompanies the Latin texts of 1570 and 1594)

Molmenti, Pompeo, *La Storia di Venezia nella vita privata dalle origini alla caduta della Repubblica*, 3 vols, Bergamo 1926–8

Monbeig-Goguel, Catherine, *et al.*, *Francesco Salviati ou La Belle Manière* (exh. cat. Villa Medici, Rome, and Musée du Louvre, Paris) Paris 1998

Monducci, Elio, and Massimo Pirondini, eds, *Lelio Orsi* (exh. cat.), Reggio Emilia 1987

Montaiglon, Anatole de, and Jules Guiffrey, eds, *Correspondance des directeurs de l'Académie de France à Rome avec les surintendants des Bâtiments*, 18 vols, Paris 1887–1912

Morassi, Antonio, 'Opere ignote o inedite di Paolo Veronese', *Bollettino d'Arte*, XXIX, December 1935, pp. 249–58

Morassi, Antonio, 'Una Salomè di Tiziano riscoperta', *Pantheon*, XXVI, 1968, pp. 456–66

Morazzoni, Giuseppe, *Le Cornici Bolognesi*, Milan 1953

Morelli, Giovanni, *Della pittura italiana: studii storico-critici*, ed. Jaynie Anderson, Milan 1991

[Morelli, Giovanni ('Ivan Lermolieff')], *Kunstkritische Studien über italienische Malerei*, 3 vols, Leipzig 1890–3

Morgan, Kenneth, *Bristol and the Atlantic Trade in the Eighteenth Century*, Cambridge 1993

Morselli, Raffaella, 'Vincenzo Gonzaga, Domenico Tintoretto e altri artisti veneziani' in Borean and Mason 2002, pp. 77–117

Moschini, Giannantonio, *Guida per la città di Venezia*, 2 vols, Venice 1815

Moschini, Giannantonio, *Itinéraire de la ville de Venise*, Venice 1819

Moschini, Giannantonio, *Nuova guida per Venezia*, Venice 1834

Moschini Marconi, Sandra, ed., *Gallerie dell'accademia di Venezia*: I. *Opere d'arte dei secoli XIV e XV*, Rome 1955; II. *Opere d'arte del secolo XVI*, Rome 1962

Mozzetti, Francesco and Giovanna Sarti, 'Biografia, immagine e memoria: storia di Vincenzo Morosini', *Venezia Cinquecento*, VII, no. 13, January–June 1997, pp. 143–58 (paragraphs 1–4 by Mozzetti; paragraphs 5–7 by Sarti)

Muller, J., *Rubens, the Artist as Collector*, Princeton 1989

Muller, Priscilla, 'The Prague Crucifixion signed "Petrus Kempener"', *The Art Bulletin*, XLVIII, 1966, pp. 412–3

Mündler, Otto, *The Travel Diaries of Otto Mündler 1855–1858*, ed. Carol Togneri Dowd, The Fifty-first volume of the Walpole Society, London 1985

Mundt, Barbara, ed., *Die Verführung der Europa* (exh. cat. Kunstgewerbemuseum, Berlin, 1988), Frankfurt-am-Main 1988

Mundy, E. James, *Renaissance into Baroque. Italian Master Drawings by the Zuccari 1550–1600* (exh. cat. Milwaukee Art Museum and the National Academy of Design, New York, 1989–90), Milwaukee 1989

Munro H.A.J., *Complete Catalogue of the Paintings, Drawings etc. belonging to H.A.J. Munro of Novar*, London 1865

Muraro, Michelangelo, 'The Jacopo Bassano exhibition', *The Burlington Magazine*, XCIX, September 1957, p. 292

Muraro, Michelangelo, 'Bassano's *Way to Calvary*', *The Burlington Magazine*, CII, February 1960, pp. 53–4

Muraro, Michelangelo, 'Affreschi di Jacopo Tintoretto a Ca' Soranzo', *Scritti di storia dell'arte in onore di Mario Salmi*, III, Rome 1963, pp. 103–16

Muraro, Michelangelo, *Il libro secondo di Francesco e Jacopo dal Ponte*, Bassano 1992

Nadal, Jeronimus [Gerónimo] (S.J.), *Evangelicae Historiae Imagines*, Antwerp 1593

Nadal, Jeronimus [Gerónimo] (S.J.), trans. Agostino Vivaldi, *Immagini di storia evangelica*, Rome 1599

Nadal, Jeronimus [Gerónimo] (S.J.), *Evangelicae Historiae Imagines*, ed. Nino Benti, Bergamo 1976 (a reprint of Nadal 1599, with the plates from Nadal 1593)

Neale, John Preston, *Views of the Seats of Noblemen and Gentlemen in England, Wales, Scotland and Ireland*, first series, 6 vols, London 1818–23; second series, 5 vols, London 1824–9

Negrini, Franco, 'Una politica del restauro: Mauro Mari, L'età delle riforme e Il neoclassico mantovano' in Piva 1981, II, pp. 406–11

Nepi Scirè, Giovanna, *Guida alla Quadreria (Gallerie dell'Accademia di Venezia)*, Venice 1995

Neumann, Jaromír, *Picture Gallery of Prague Castle*, Prague 1967

Newall, Christopher, *The Grosvenor Gallery Exhibitions: Change and Continuity in the Victorian Art World*, Cambridge 1995

Newbery, Timothy J., George Bisacca and Laurence B. Kanter, *Italian Renaissance Frames* (exh. cat. Metropolitan Museum of Art, New York, 1990), New York 1990

Newman, John, and Nikolaus Pevsner, *Dorset*, Harmondsworth 1972

Newton, Eric, *Tintoretto*, London 1952

Newton, Eric, 'Painting of the Month', *The Listener*, 15 June 1961

Nichols, Tom, *Tintoretto: Tradition and Identity*, London 1999

[Nicolson, Benedict], 'The Lycett Green gift to York', *The Burlington Magazine*, XCVII, April 1955, p. 99

Nieuwenhuys, Christian Jean, *A Review of the Lives and Works of some of the most Eminent Painters*, London 1834

Nordenfalk, Carl, *et al.*, *Christina, Queen of Sweden – a personality of European civilization* (exh. cat. Nationalmuseum, Stockholm, 1966), Stockholm 1966

North, Sir Thomas, *The Lives of the noble Grecians and Romans*, London 1657

Northcote, James, *The Life of Titian, with anecdotes of the distinguished persons of his time*, 2 vols, London 1830

Oberhuber, Konrad, 'Eine unbekannte Zeichnung Raffaels in den Uffizien', *Mitteilungen des Kunsthistorischen Institutes in Florenz*, XII, 1966, pp. 225–44

Oberhuber, Konrad, ed., *The Works of Marcantonio Raimondi and of his School* (*The Illustrated Bartsch*, XXVII, formerly 14, part 2), New York 1976

Okayama, Yassu, *The Ripa Index: Personifications and their attributes in five editions of the Iconologia*, Doornspijk 1992

Olivato, Loredana, 'Per il Serlio e Venezia: Documenti nuovi e documenti rivisitati', *Arte Veneta*, XXV, 1971, pp. 284–91

Olivato, Loredana, 'Provvedimenti della Repubblica Veneta per la salvaguardia del patrimonio pittorico nei secoli XVII e XVIII', *Memorie dell'Istituto Veneto di Scienze, Lettere ed Arti*, XXXVII, 1974, pp. 47–66

Olivato, Loredana, 'Paris Bordon e Sebastiano Serlio. Nuove Riflessioni' in Fossaluzza and Manzato 1987, pp. 33–40

Opperman, Hal N., *Jean-Baptiste Oudry*, 2 vols (PhD thesis, 1972), New York and London 1977

Orso, Michela, 'Giovanni Maria Sasso mercante, collezionista e scrittore d'arte della fine del settecento a Venezia', *Atti dell'Istituto Veneto di Scienze, Lettere ed Arti*, CXLIV, 1985–6, pp. 37–55

Osmaston, Francis Plumptre Beresford, *The Art and Genius of Tintoret*, 2 vols, London 1915

Osmond, Percy Herbert, *Paolo Veronese*, London 1927

Ottley, William Young, *A Descriptive Catalogue of the Pictures in the National Gallery with critical remarks on their merits*, London 1832, 1835

Pacheco, Francisco, *Libro de Descripcion de Verdaderos retratos de illustres y memorables varones*, Seville 1890 (facsimile of the MS volume dated 1599)

Pacheco, Francisco, *Libro de descripción de verdaderos retratos de ilustres y memorables varones* [1599], ed. Francisco Javier Sánchez Cantón, Madrid 1932

Pacheco, Francisco, *Arte de la pintura* [1638], ed. Francisco Javier Sánchez Cantón, 2 vols, Madrid 1956

Pacheco, Francisco, *El Arte de la Pintura*, ed. B. Bassegoda i Hugas, Madrid 1990

Pagliari, F., *Breve Descrizione delle pitture ... che si osservano nella Città di Mantova*, Mantua 1788

Pallucchini, Anna, 'L'opera completa di Giambattista Tiepolo', Milan 1968

Pallucchini, Rodolfo, *Mostra di Paolo Veronese* (exh. cat. Ca' Giustinian, Venice), Venice 1939

Pallucchini, Rodolfo, *Veronese*, Bergamo 1939, revised edn 1943

Pallucchini, Rodolfo, *La giovinezza del Tintoretto*, Venice 1950

Pallucchini, Rodolfo, 'Un'altra opera giovanile del Tintoretto', *Arte Veneta*, XII, 1958, pp. 202–3

Pallucchini, Rodolfo, *Tiziano*, 2 vols, Florence 1969

Pallucchini, Rodolfo, 'Per gli inizi veneziani di Giuseppe Porta', *Arte Veneta*, XXIX, 1975, pp. 159–66

Pallucchini, Rodolfo, ed., *Tiziano e il Manierismo europeo* (exh. cat. Fondazione Giorgio Cini, Venice, 1978), Florence 1978

Pallucchini, Rodolfo, *La pittura veneziana del Seicento*, 2 vols, Milan 1981

Pallucchini, Rodolfo, *Bassano*, Bologna 1982

Pallucchini, Rodolfo, and Paolo Rossi, *Tintoretto: le opere sacre e profane*, 2 vols, Milan 1982

Pallucchini, Rodolfo, and Paolo Rossi, *Giovanni Cariani*, Bergamo 1983

Palomino (de Castro y Velasco), Antonio, *El museo pictorico, y escala optica*, 3 vols, Madrid 1724

Pan, Enrica, *Jacopo Bassano e l'incisione* (exh. cat. Museo Civico, Bassano del Grappa, 1992), Bassano 1992

Panofsky, Erwin, *Hercules am Scheidewege und andere antike Bildstoffe in der neueren Kunst*, Leipzig and Berlin 1930

Panofsky, Erwin, *Albrecht Dürer*, 2 vols, Princeton, 1943

Panofsky, Erwin, *The Life and Art of Albrecht Dürer*, Princeton 1955 (4th edn of above)

Panofsky, Erwin, 'The Iconography of the Galerie François Premier at Fontainebleau', *Gazette des Beaux-Arts*, LII (6th series), September 1958, pp. 113–77

Panofsky, Erwin, *Problems in Titian, mostly Iconographic*, New York 1969

Panofsky, Erwin, *Meaning in the Visual Arts*, New York 1955, Harmondsworth 1970

Panofsky, Erwin, and Fritz Saxl, 'Letter to the Editor', *The Burlington Magazine*, XLIX, October 1926, pp. 177–81

Paoletti, Ermolao, *Fiore di Venezia*, 4 vols, Venice 1837–40

Parker, Karl T., *Catalogue of the Collection of Drawings in the Ashmolean Museum, Vol. II: Italian Schools*, Oxford 1956, revised 1972

Parliamentary Debates (Official Report, House of Commons), 5th series, vol. 230, 15–26 July 1929 (2nd volume of the session 1929–30)

Parris, Leslie, Conal Shields and Ian Fleming-Williams, *John Constable: Further Documents and Correspondence*, London and Ipswich 1975 (Suffolk Record Society, XVIII)

Parrott, Hayward, 'Household in the Grand Manner', *Country Life*, 5 December 1968, pp. 1466–7

Paschini, P., 'Le collezioni archeologiche dei prelati Grimani del Cinquecento', *Rendiconti della Pontificia Accademia Romana di Archeologia*, V, 1927, pp. 149–90

Pasero, Carlo, 'Nuove notizie archivistiche intorno alla loggia di Brescia', *Commentari dell'Ateneo di Brescia*, CLI, 1952, pp. 49–91

Passavant, Johann David, *Kunstreise durch England und Belgien, nebst einem Bericht über den Bau des Domthurms zu Frankfurt am Main*, Frankfurt-am-Main 1833

Passavant, Johann David, *Tour of a German artist in England: with notices of private galleries, and remarks on the state of art*, 2 vols, London 1836

Passavant, Johann David, *Le peintre-graveur*, 6 vols, Leipzig 1860–4

Passi, Romano, *Le medaglie del Ravennate Tommaso Rangoni detto 'il Filologo'*, Milan 1973

Patina, Carla Caterina (Charlotte Catherine Patin), *Pitture scelte e dichiarate*, Cologne 1691 (also published in Latin in Padua in the same year)

Patmore, Peter George, *British Galleries of Art*, London 1824

Pavanello, Giuseppe, 'Dipinto seicenteschi in Ca' Pisani-Moretta: Luca Ferrari e Francesco Minorello, *Arte Veneta*, XXX, 1976, pp. 180–1

Pearce, David, *London's Mansions*, London 1986

Pedrazzi Tozzi, Rosanna, 'La Maturità di Domenico Tintoretto in alcune tele ritenute di Jacopo', *Arte Antica e Moderna*, XII, October–December 1960, pp. 386–96

Pedrocco, Filippo, *Titian: the Complete Paintings*, London 2001

Pelzer, R.A., 'Lamberto van Amsterdam', *Jahrbuch der Kunsthistorischen Sammlungen des allerhöchsten Kaiserhauses*, XXXI, 1913, pp. 221–46

Pelzer, R., 'Niederländisch-Venezianische Landschaftsmalerei', *Münchner Jahrbuch der bildenden Kunst*, I, 1924

Pennington, Richard, *A descriptive catalogue of the etched work of Wenceslaus Hollar 1607–1677*, Cambridge 1982

Penny, Nicholas, 'Raphael's "Madonna dei Garofani" rediscovered', *The Burlington Magazine*, CXXXIV, August 1992, pp. 67–81

Penny, Nicholas, *Catalogue of European Sculpture in the Ashmolean Museum 1840 to the Present Day*, 3 vols, Oxford 1992

Penny, Nicholas, 'Bassano and Barcelona: Venetian paintings from the Hermitage', *The Burlington Magazine*, CXCIII, November 2001, pp. 720–2

Penny, Nicholas, *The Sixteenth-Century Italian Paintings*, I, *National Gallery Catalogues*, London 2004

Penny, Nicholas, and Marika Spring, 'Veronese's paintings in the National Gallery: Technique and Materials', Part I: *National Gallery Technical Bulletin*, 16, 1995, pp. 4–29; Part II: *National Gallery Technical Bulletin*, 17, 1996, pp. 32–55

Pepper, Stephen, *Guido Reni*, Oxford 1984

Pepys, Samuel, *The Diary of Samuel Pepys*, ed. H.B. Wheatley, IV, London 1894

Pérez-Higuera, Teresa, *Medieval Calendars*, London 1998

Pergam, Elizabeth, '"Waking the soul": The Manchester Art Treasures Exhibition of 1857 and the State of the Arts in Mid-Victorian Britain', PhD diss., Institute of Fine Arts, New York University, 2001

Perry, Marilyn, 'The Statuario Publico of the Venetian Republic', *Saggi e Memorie di Storia dell'Arte*, VIII, 1972, pp. 75–150

Perry, Marilyn, 'Cardinal Domenico Grimani's Legacy of Ancient Art to Venice', *Journal of the Warburg and Courtauld Institutes*, XLI, 1978, pp. 215–44

Perry, Marilyn, 'A Renaissance Showplace of Art: The Palazzo Grimani at Santa Maria Formosa, Venice', *Apollo*, CXIII, 1981, pp. 215–21

Perry, Marilyn, 'Wealth, Art and Display: the Grimani Cameos in Renaissance Venice', *Journal of the Warburg and Courtauld Institutes*, LVI, 1993, pp. 268–73

Petrucci, Francesco, *Ferdinand Voet: ritrattista di Corte tra Roma e l'Europa del Seicento* (exh. cat. Castel Sant'Angelo, Rome) Rome 2005

Phillips, Claude, *Titian: a study of his life and works*, 2 vols, London 1898

Phillipps, Evelyn March, *Tintoretto*, London 1911

Phyrr, Stuart W., et al., *Heroic Armor of the Italian Renaissance: Filippo Negroli and his contemporaries* (exh. cat. The Metropolitan Museum of Art, New York, 1998–9), New York 1998

Piganiol de la Force, Jean-Aymar, *Description historique de la Ville de Paris et de ses environs*, 2 vols, Paris 1765

Pigler, Andor, *Barockthemen: eine Auswahl von Verzeichnissen zur Ikonographie des 17. und 18. Jahrhunderts*, 2 vols, Budapest 1956

Pignatti, Terisio, *Giorgione*, London 1971

Pignatti, Terisio, *Veronese*, 2 vols, Venice 1976

Pignatti, Terisio, ed., *Le Scuole di Venezia*, Milan 1981

Pignatti, Terisio, 'Gli esordi pre-veneziani di Paolo Veronese', *Arte Veneta*, XL, 1986, pp. 73–84

Pignatti, Terisio, and Filippo Pedrocco, *Veronese, Catalogo Completo dei dipinti*, Florence 1991; *Veronese*, 2 vols, Milan 1995

Pilo, Giuseppe M., *La Chiesa dello Spedaletto in Venezia*, Venice, undated (c.1990)

Pino, Paolo, *Dialogo di Pittura*, Venice 1548

Pittaluga, Mary, *Il Tintoretto*, Bologna 1925

Piva, Paolo, *Da Cluny a Polirone: un recupero essenziale del romanico Europeo*, San Benedetto Po 1980

Piva, Paolo, ed., *I secoli di Polirone: committenza e produzione artistica di un monastero benedettino*, 2 vols (exh. cat. Museo Civico Polironiano), 1981

Piva, Paolo, and Giancarlo Pavesi, 'Giulio Romano e la chiesa abbaziale di Polirone: documenti e proposte filologiche' in *Studi su Giulio Romano: omaggio all'artista nel 450 della venuta a Mantova*, San Benedetto Po 1975, pp. 53–115

Piva, Paolo, and Maria-Rosa Simonelli, eds, *Storia di San Benedetto Polirone: l'età della soppressione*, Bologna 2001

Pixley, Mary Louise, *Patronage and the construction of nobility: the Villa Godi Fresco Cycle and the Villa's role in the Veneto and the Politics of a sixteenth-century Patrician Family* (PhD diss., University of Pennsylvannia, 1998), Ann Arbor 1998

Pizzo, Marco, 'Livio Odescalchi e i Rezzonico. Documenti su arte e collezionismo alla fine del XVII secolo', *Saggi e Memorie di Storia dell'Arte*, XXVI, 2002, pp. 119–53

Plesters, Joyce, 'Tintoretto's paintings in the National Gallery', Part I: *National Gallery Technical Bulletin*, 3, 1979, pp. 3–24; Part II: 4, 1980, pp. 32–47; Part III: 8, 1984, pp. 24–35

Polignano, Flavia, 'I ritratti dei volti e i registri dei fatti. L'"Ecce Homo" di Tiziano per Giovanni d'Anna', *Venezia Cinquecento*, II, no. 4, July–December 1992, pp. 7–53

Pomeroy, Jordana, 'The Orléans Collection: its impact on the British art world', *Apollo*, CXLV, February 1997, pp. 26–31

Pons, Bruno, *Grands décors français, 1650–1800*, Dijon 1995

Pope-Hennessy, John, *Catalogue of Italian Sculpture in the Victoria and Albert Museum*, 3 vols, London 1964

Pope-Hennessy, John, *Italian Paintings in the Robert Lehman Collection*, New York 1987

Popham, Arthur E., *Catalogue of the Drawings of Parmigianino*, 3 vols, New Haven and London 1971

Portalis, Roger, *Henry-Pierre Danloux peintre de portraits et son journal durant l'émigration (1753–1809)*, Paris 1910

Posner, Donald, *Annibale Carracci: A Study in the Reform of Italian Painting around 1590*, 2 vols, London 1971

Potterton, Homan, *Venetian Seventeenth Century Painting* (exh. cat. National Gallery, London, 1979), London 1979

Pouncey, Philip, 'The Miraculous Cross in Titian's "Vendramin Family"', *Journal of the Warburg and Courtauld Institutes*, II, 1938–9, pp. 191–3

Prevost-Marcilhacy, Pauline, *Les Rothschild, bâtisseurs et mécènes*, Paris 1995

Prijatelj, Kruno, '"Venere e Adone" di Paris Bordon nel Palazzo dei Rettori di Dubrovnik (Ragusa)' in Fossaluzza and Manzato 1987, pp. 119–23

Procacci, Ugo, 'Una "Vita" inedita del Muziano', *Arte Veneta*, VIII, 1954, pp. 242–64

Pückler-Muskau, Prince Hermann von, *A Regency Visitor: The English Tour of Prince Pückler-Muskau described in his letters 1826–1828*, ed. E.M. Butler, New York 1958

Pullan, Brian, *Rich and Poor in Renaissance Venice*, Oxford 1971

Pullan, Brian, 'Natura e carattere delle scuole' in Pignatti 1981, pp. 9–26

Puppi, Lionello, *Bartolomeo Montagna*, Venice 1962

Puppi, Lionello, *Andrea Palladio*, 2 vols, Milan 1973

Puppi, Lionello, 'Tiziano tra Padova e Vicenza' in *Tiziano e Venezia* (papers of the Convegno Internazionale di Studi, Venice, 27 September–1 October 1976), 2 vols, Vicenza 1980, pp. 555–7

Puppi, Lionello, ed., *Alvise Cornaro e il suo tempo* (exh. cat. Loggia and Odeo Cornaro, also Sala del Palazzo della Ragione), Padua 1980

Quadri, Antonio, *Otto Giorni a Venezia*, Venice 1821

Radcliffe, Anthony, and Nicholas Penny, *Art of the Renaissance Bronze*, London 2004

Radmore, David F., *Himley Hall and Park: A History*, Dudley 1996

Ramdohr, Friedrich Wilhelm Basilius von, *Über Mahlerei und Bildhauerarbeit in Rom*, 3 vols, Leipzig 1787

Ramsey, P.A., ed., *Rome in the Renaissance: the city and the myth* (Proceedings of the 13th Annual Conference of the Center for Medieval and Early Renaissance Studies), Binghamton, NY, 1982

Ratti, Carlo Giuseppe, *Instruzione di quanto può verdersi di più bello in Genova in pittura, scultura, ed architettura*, Genoa 1780

Ravà, Aldo, 'Il "camerino delle anticaglie" di Gabriele Vendramin', *Nuovo Archivio Veneto*, n.s., XXXIX, 1920, pp. 155–81

Reade, Brian, 'William Frizell and the Royal Collection', *The Burlington Magazine*, LXXXIX, March 1947, pp. 70–5

Rearick, W. Roger, 'Battista Franco and the Grimani Chapel', *Saggi e Memorie di Storia dell'Arte*, II, 1959 (1958–9), pp. 105–39

Rearick, W. Roger, *Tiziano e il disegno veneziano del suo tempo* (exh. cat. Gabinetto Disegni e Stampe degli Uffizi, 1976), Florence 1976

Rearick, W. Roger, 'Early Drawings of Jacopo Bassano', *Arte Veneta*, XXXII, 1978, pp. 161–8

Rearick, W. Roger, *Iacobus a Ponte Bassanensis. I: Disegni giovanili e della prima maturità, 1538–1548*, Bassano del Grappa 1986

Rearick, W. Roger, 'The Drawings of Paris Bordon' in Fossaluzza and Manzato 1987, pp. 47–61

Rearick, W. Roger, *The Art of Paolo Veronese 1528–1588* (exh. cat. National Gallery of Art, Washington, 1988), Cambridge 1988

Rearick, W. Roger, 'Vita ed opere di Jacopo dal Ponte, detto Bassano, c.1519–1592' in Brown and Marini 1992, pp. LVII–CCLVI

Rearick, W. Roger, 'Titian's Later Mythologies', *Artibus et Historiae*, XXXIII, 1996, pp. 23–67

Rearick, W. Roger, 'Paolo Veronese's Earliest Works', *Artibus et Historiae*, XXXV, 1997, pp. 147–59

Réau, Louis, *Iconographie de l'art Chrétien*, 3 vols (vol. 2 in 2 parts, vol. 3 in 3 parts), Paris 1955–9

Redford, George, *Art Sales: a history of sales of pictures and other works of art*, 2 vols, London 1888

Rémy, Pierre, *Catalogue of the posthumous sale of the Duc de Tallard*, Paris, 23 March–13 May 1756

Reynolds, Joshua, *Letters of Sir Joshua Reynolds*, ed. F.W. Hilles, Cambridge 1929

Ricci, Corrado, *La Reale Galleria di Parma*, Parma 1896

Riccoboni Alberto, 'Antonio Zanchi e la pittura veneziana del Seicento', *Saggi e Memorie di Storia dell'Arte*, V, 1966, pp. 54–135

Richardson, Francis L., *Andrea Schiavone*, Oxford 1980

Richardson, Jonathan, *Essay on the Theory of Painting*, London 1725 (1st edn 1715)

Richter, Jean-Paul, *The Mond Collection; an appreciation*, 2 vols, London (privately printed) 1910

Richter, Jean-Paul, 'The Family of Darius by Paolo Veronese', *The Burlington Magazine*, LXII, April 1933, pp. 181–3

Richter, Louise, *Recollections of Dr. Ludwig Mond*, London (privately printed) 1920

Ricketts, Charles, *Titian*, London 1910

Ridolfi, Carlo, *Vita di Giacopo Robusti detto il Tintoretto, celebre pittore cittadino veneziano*, Venice 1642

Ridolfi, Carlo, *Vita di Paolo Caliari Veronese, celebre pittore*, Venice 1646

Ridolfi, Carlo, *Le Maraviglie dell'Arte; ovvero le vite degli illustri pittori veneti*, Venice 1648; ed. Detlev von Hadeln, 2 vols, Berlin 1914 and 1924

Ridolfi, Carlo, *The Life of Tintoretto and of his children Domenico and Marietta*, trans. Catherine and Robert Enggass, University Park, PA, 1984

Ridolfi, Carlo, *Vite dei Tintoretto*, Venice 1994 (reprint of lives of members of the Tintoretto family from Tintoretto 1648, with an introduction by Antonio Manno and appendices printing wills of family members edited by Alessandra Schiavon)

Ridolfi, Carlo, *The Life of Titian*, ed. Julia Conaway Bondanella *et al.*, University Park, PA, 1996

Rioux, Jean-Paul, 'La matière picturale' in Habert *et al.* 1992, chapter 3

Ripa, Cesare, *Iconologia, overo Descrittione dell'imagini universali cavate dall'antichità*, Rome 1593, 1603

Rizzi, Alberto, *Scultura esterna a Venezia: Corpus delle sculture erratiche all'apperto di Venezia e della sua laguna*, Venice 1917

Robels, H., *Frans Snyders*, Munich 1989

Robert-Dumesnil, A.P.F., *Le peintre-graveur français*, 11 vols, Paris 1835–71 (Supplement to Bartsch, q.v.)

Robertson, David, *Sir Charles Eastlake and the Victorian Art World*, Princeton 1978

Robertson, Giles, *Vincenzo Catena*, Edinburgh 1954

Robertson, Giles, *Giovanni Bellini*, Oxford 1968

Roethlisberger, Marcel, *Claude Lorrain: The Drawings*, 2 vols, Berkeley and Los Angeles 1968

Roethlisberger, Marcel, *Claude Lorrain: The Paintings*, 2 vols, New York 1979 (1st edn New Haven 1961)

Rogers, Malcolm, 'Two portraits by Van Dyck identified', *The Burlington Magazine*, CXXIV, April 1982, pp. 235–8

Romanelli, Giandomenico, and Giuseppe Pavanello, *Palazzo Grassi*, Venice 1986

Rombouts, Ph., and Th. van Lerius, *De Liggeren en andere historische Archieven der Antwerpsche Sint Lucasgilde*, 2 vols, Antwerp 1872

Rosand, David, 'Palma il Giovane as Draughtsman. The early career and related observations', *Master Drawings*, II, 1970, pp. 148–61

Rosand, David, 'Ut Pictor Poeta: Meaning in Titian's Poesie', *New Literary History*, III, 1971–2, pp. 527–46

Rosand, David, *Painting in Sixteenth-Century Venice: Titian, Veronese, Tintoretto*, Cambridge 1997 (revised edn of *Painting in Cinquecento Venice*, New Haven 1982)

Rosand, David, and Michelangelo Muraro, *Titian and the Venetian Woodcut* (exh. cat. National Gallery of Art, Washington, Dallas Museum of Fine Arts and Detroit Institute of Arts, 1976–7), Washington DC 1976

Roskill, Mark, *Dolce's 'Aretino' and Venetian art theory of the Cinquecento*, New York 1968

Rossi, Paola, *Jacopo Tintoretto: I Ritratti*, Venice 1974

Rossi, Paola, *I disegni di Jacopo Tintoretto*, Venice 1975

Rossi, Paola, 'Per la grafica di Domenico Tintoretto', *Arte Veneta*, XXIX, 1975, pp. 205–11

Rossi, Paola, 'Per la grafica di Domenico Tintoretto, II', *Arte Veneta*, XXXVIII, 1984, pp. 57–71

Rossi, Paola, and Lionello Puppi, eds, *Jacopo Tintoretto nel quarto centenario della morte*, Padua 1996

Rossini, Pietro, *Il Mercurio Errante delle Grandezze di Roma*, 2 vols, Rome 1704

Rowlands, John, *Drawings by German Artists ... in the Department of Prints and Drawings*, 2 vols, London 1993

Royalton-Kisch, Martin, 'A New Arrangement for Veronese's Allegories in the National Gallery', *The Burlington Magazine*, CXX, March 1978, pp. 158–62

Rubinstein, Gregory, 'The Genesis of John Boydell's *Houghton Gallery*' in *Houghton Hall: the Prime Minister, the Empress and the Heritage*, ed. Andrew Moore (exh. cat. Norwich Castle Museum and Kenwood House, London), London 1996, pp. 65–75

Ruggeri, Ugo, *Il Padovanino*, Soncino 1993, no. 21

Rumohr, Carl Friedrich von, *Italienische Forschungen*, ed. Julius Schlosser, Frankfurt-am-Main 1920

Ruskin, John, *Academy Notes*, London 1857

Ruskin, John, *The Works of John Ruskin*, ed. E.T. Cook and Alexander Wedderburn, 39 vols, London 1903–12

Ruskin, John, *Ruskin in Italy: Letters to his Parents 1845*, ed. Harold I. Shapiro, Oxford 1972

Russell, Francis, *The Picture Collection at Belton House*, Christie's, on the premises, 30 April–2 May 1984 (unpaginated preface)

Russell, Francis, 'The Hanging and Display of Pictures 1799–1850' in Gervase Jackson-Stops *et al.*, *The Fashioning and Functioning of the British Country House* (Studies in the History of Art, 25), Washington DC 1989, pp. 133–53

Russell, Francis, 'James Christie, P. J. Tassaert and Negotiations for the Orléans Collection', *Christie's International Magazine*, May 1990, pp. 8–10

Rylands, Philip, *Palma Vecchio*, Cambridge 1992

Sabatelli, Franco, Patrizia Zambrano and Enrico Colle, *La Cornice Italiana*, Milan 1992

Safarik, Eduard A., *Collezione dei dipinti Colonna. Inventari 1611–1795* (Provenance Index of the Getty Art History Information Program: Italian Inventories 2), Munich etc. 1996

Saint-Gelais *see* Du Bois de Saint-Gelais

Salmon, Béatrice, *Collection du Musée des Beaux-Arts de Nancy*, Paris 1999

Salomon, Xavier F., *Veronese's Allegories: Virtue, Love, and Exploration in Renaissance Venice*, New York 2006

Salton, Mark, *The Salton Collection*, Bowdoin College Museum of Art, Brunswick, ME, 1965

Sansovino, Francesco, *Venetia città nobilissima et singolare, descritta in XIIII libri*, Venice 1581

Sansovino, Francesco, *Venetia città nobilissima et singolare*, greatly amplified by Giovanni Stringa, Venice 1604

Sansovino, Francesco, *Venetia città nobilissima et singolare*, with emendations and additions by Giovanni Stringa and Giustiniano Martinioni, Venice 1663

Sanuto (often spelt Sanudo), Marino, *I diarii di Marino Sanuto*, ed. Nicolò Barozzi, Guglielmo Berchet, Rinaldo Fulin and Federico Stefani, 58 vols, Venice 1879–1903; reprinted Bologna 1969–70

Sartre, Jean-Paul, 'Saint Georges et le dragon', *L'Arc*, XXX, 1966, pp. 35–53

Saumarez Smith, Charles, with Giorgia Mancini, *Ludwig Mond's Bequest* (exh. cat. National Gallery, London), London 2006

Savini Branca, Simona, *Il collezionismo veneziano nel '600*, Padua 1964

Scamozzi, Vincenzo, *L'Idea della Architettura Universale*, Venice 1615

Scarpa, Sebastiano, 'Alcune note su Damiano Mazza: cronologia, il ciclo dei Sartori, la pala dell'Ospedaletto', *Arte-Documento*, III, 1990, pp. 174–9

Schiller, Gertrud, *Ikonographie der Christlichen Kunst*, 6 vols in 7, Gütersloh 1966–80

Scholten, Frits, *et al.*, *Adriaen de Vries* (exh. cat. Amsterdam, Stockholm and Los Angeles, 1998–9), Amsterdam 1998

Schröder, Francesco, *Repertorio genealogico delle famiglie confermate nobili e dei titolati nobili esistenti nelle provincie venete*, 2 vols, Venice 1830

Schubring, Paul, *Cassoni, Truhen und Truhenbilder der italienischen Frührenaissance*, Leipzig 1923

Schulz, Juergen, 'A forgotten chapter in the history of Quadratura painting: the fratelli Rosa', *The Burlington Magazine*, CIII, March 1961, pp. 90–102

Schulz, Juergen, 'Le fonti di Paolo Veronese come Decoratore', *Bollettino del Centro Internazionale di Studi di Architettura Andrea Palladio*, X, 1968, pp. 241–54

Schulz, Juergen, 'The Houses of Titian, Aretino and Sansovino' in *Titian. His world and his legacy*, ed. David Rosand, New York 1982

Schulz, Juergen, 'Il Gran Teatro di Venezia di Domenico Lovisa' in *Studi in onore di Renato Cevese*, Verona 2000, pp. 443–57

Schweikhart, Gunter, 'Paolo Veronese in der Villa Soranza', *Mitteilungen des Kunsthistorisches Institut in Florenz*, XV, 1971, pp. 187–206

Seguier, William, Manuscript valuation of the collection of John Julius Angerstein, British Library, Liverpool Papers, Add. MSS 38298, fols 88–9 (this itemised list corresponds with the total valuation for the same pictures signed by Seguier on 26 December 1823 in the Corporation of London Archive, F/ANG/32)

Sellink, Manfred, ed., *Philips Galle*, Part III (*The New Hollstein*), Rotterdam 2001

[Selva, Giovanni Antonio, and Pietro Edwards], *Catalogo dei quadri, dei disegni e dei libri che trattano dell'arte del disegno della galleria del fu sig. Conte Algarotti in Venezia*, Venice c.1779 (not before 1777)

Selvatico, Pietro, and V. Lazzari, *Guida di Venezia*, Venice 1852

Serlio, Sebastiano, *Tutte le Opere*, Venice 1584

Sestieri, Ettore, *Catalogo della Galleria ex-fidecommissaria Doria-Pamphilj*, Rome 1942

Sgarbi, Vittorio, 'Giovanni de Mio, Bonifazio de' Pitati, Lamberto Sustris: indicazioni sul primo tempo del Manierismo nel Veneto', *Arte Veneta*, XXXV, 1981, pp. 52–81

Shackleton Bailey, D.R., ed. and trans., *Valerius Maximus: memorable doings and sayings*, Cambridge, MA, and London 2000

Shapley, Fern Rusk, *Catalogue of the Italian Paintings*, 2 vols, Washington DC 1979

Shearman, John, *The Pictures in the Collection of Her Majesty the Queen: The Early Italian Pictures*, Cambridge 1983

Shearman, John, *Raphael in Early Modern Sources (1483–1602)*, 2 vols, New Haven and London 2003

Sherman, Claire Richter, *Imagining Aristotle*, Los Angeles 1996

Shoemaker, Innis H., *The Engravings of Marcantonio Raimondi* (exh. cat. Spencer Museum of Art, University of Kansas, and elsewhere, 1981–2), Lawrence, Kansas, 1981.

Sicoli, Sandra, 'La dispersione del patrimonio artistico nell'età della soppressione con riguarda a Mantova e a San Benedetto Po' in Piva and Simonelli 2001, pp. 109–24

Sigüenza, Fray José de, *La Fundación del monasterio de El Escorial*, Madrid 1605 (reprinted 1963, 1988)

Silos, Ioanne Michaele, *Pinacotheca sive Romana pictura et sculptura*, Rome 1673; reprinted in 2 vols, ed. Mariella Basile Bonsante, Treviso 1979

Siraisi, Nancy G., *The Clock and the Mirror: Gerolamo Cardano and Renaissance Medicine*, Princeton 1997

Sitwell, Osbert, *Queen Mary and Others*, London 1974

Smith, Claire, 'The 4th Earl of Aberdeen as a Collector of Italian Old Masters', *Journal of the Scottish Society for Art History*, VIII, 2003, pp. 47–52

Smith, Thomas, *Recollections of the British Institution*, London 1880

Soullié, Louis, *Ancienne Galerie d'Orléans au Palais-Royal*, Paris 1843

Spalding, Frances, *Magnificent Dreams*, Oxford 1978

Spalding, Frances, *Duncan Grant: A Biography*, London 1997

Speed, Harold, *The Science and Practice of Oil Painting*, London 1924

Sprigge, S., *Berenson: a biography*, London 1960

Springell, Francis C., *Connoisseur and Diplomat*, London 1963

Sricchia Santoro, Fiorella, 'Pedro de Campaña in Italia', *Prospettiva*, XXVII, October 1981, pp. 75–86

Stampart, Franz van, and Anton Joseph von Prenner, *Prodromus*, Vienna 1735

Stefani Mantovanelli, Marina, *Arte e committenza nel Cinquecento in area Veneta. Fonti archivistiche e letterarie*, Padua 1990

Steinberg, Leo, *The Sexuality of Christ in Renaissance Art*, 2nd rev. edn, Chicago and London 1996

Stella Alfonsi, Maria, 'Cosimo III de' Medici e Venezia. I primi anni di regno' in *Figure di collezionisti a Venezia*, ed. Linda Borean and Stefania Mason, Udine 2002, pp. 265–301

Stephens, F.G., *On the pictures at Cobham Hall: an address delivered in the picture gallery, July 27th, 1876*, London 1877 (reprinted from *Archaeologia Cantiana*, XI)

Stewart, Ann M., *Irish Art Loan Exhibitions 1765–1927*, 3 vols, Dublin 1990–5

Stone, Donald, 'The Source of Titian's *Rape of Europa*', *Art Bulletin*, LIV, March 1972, pp. 47–9

Strange, Sir Robert, *A descriptive catalogue of a collection of pictures ... with a catalogue of thirty-two drawings from Capital Paintings*, London 1769

Streeter, Edwin W., *The Great Diamonds of the World*, Ann Arbor 1971

Stryienski, Casimir, *La Galerie du Régent*, Paris 1913

Stuffmann, Margret, 'Les tableaux de la collection de Pierre Crozat', *Gazette des Beaux-Arts*, LXXII, 1968, pp. 11–143

Sueur, Hélène, *Le dessin à Vérone aux XVIᵉ et XVIIᵉ siècles* (exh. cat. Musée du Louvre, Paris), Paris 1993

Suida, Wilhelm, *Le Titien*, Paris 1935

Suida, Wilhelm, and Bertina Suida Manning, *Luca Cambiaso*, Milan 1958

Summerly, Felix [pseudonym for Owen Jones], *Day Excursions out of London*, London 1843

Summerly, Felix [pseudonym for Owen Jones], *Felix Summerly's Handbook for the National Gallery*, London 1843

Surtees, Virginia, *Coutts Lindsay*, Norwich 1993

Sutton, Denys, 'Charles Alexandre de Calonne, Economist and Collector', *Apollo*, January 1973, pp. 86–91

Sutton, Denys, 'The Orléans Collection', *Apollo*, May 1984, pp. 357–72

Symonds, John Addington, *A History of the Renaissance in Italy: Italian Literature in two parts*, 2 vols, London 1900

Syson, Luke, and Dora Thornton, *Objects of Virtue: art in Renaissance Italy*, London 2001

Tafuri, Manfredo, 'The Abbey Church of S. Benedetto al Polirone' in *Giulio Romano* by Christoph L. Frommel *et al.*, Cambridge 1989, pp. 266–75

Tafuri, Manfredo, *Venezia e il Rinascimento*, Turin 1995

Tellini Perina, Chiara, 'Interventi pittorici del settecento' in Piva 1981, II, pp. 381–403

Tellini Perina, Chiara, 'La Quadreria Polironiana dispersa e la pittura del settecento' in Piva and Simonelli 2001, pp. 153–66

Tentori, Cristoforo, *Saggio sulla storia civile, politica, ecclesiastica ... della Repubblica di Venezia*, 12 vols, Venice 1785–90

Terribile, Claudia, 'La "Famiglia di Dario" di Paolo Veronese: la committenza, il contesto, la storia', *Venezia Cinquecento*, XV, no. 29, January–June 2005, pp. 63–107

Thieme, Ulrich, and Felix Becker, eds, *Allgemeines Lexikon der bildenden Künstler von der Antike bis zur Gegenwart*, 37 vols, Leipzig 1910–50

Thiéry, Luc-Vincent, *Guide des Amateurs et Étrangers Voyageurs à Paris*, 2 vols, Paris 1787

Thode, Henry, *Tintoretto*, Leipzig 1901

Thompson, Graves H., 'The Literary Sources of Titian's *Bacchus and Ariadne*', *The Classical Journal*, LI, March 1956, pp. 259–64

Thornley, George, trans., *Daphnis & Chloe by Longus*, revised and augmented by John Maxwell Edmonds, London and Cambridge, MA, 1935

Thornton, Dora, 'From Waddesdon to the British Museum', *Journal of the History of Collections*, XIII, no. 2, 2001, pp. 191–213

Thornton, Peter, *The Italian Renaissance Interior 1400–1600*, New York and London 1991

Thuillier, Jacques, *Vouet* (exh. cat. Grand Palais, Paris, 1990), Paris 1990

Thuillier, Jacques, *et al.*, *Charles le Brun 1619–1690* (exh. cat. Château de Versailles, 1963), Paris 1963

Ticozzi, Paolo, 'Le incisioni da opere del Veronese nel museo Correr', *Bollettino dei Musei Civici Veneziani*, XX, 1975, pp. 6–89

Ticozzi, Paolo, *Immagini dal Veronese. Incisioni dal secolo XVI al XIX* (exh. cat.), Rome 1978

Tiemblo, María Pía Timón, *El Marco en España*, Madrid 2002

Tietze, Hans, *Tizian: Leben und Werk*, 2 vols, Vienna 1936

Tietze, Hans, *Titian: Paintings and Drawings*, Vienna 1937

Tietze, Hans, *The Drawings of the Venetian Painters*, New York 1944

Tietze, Hans, *Tintoretto: The Paintings and Drawings*, London 1948

Tietze, Hans, *Titian: The Paintings and Drawings*, London 1950 (2nd English edn, revised from 1937)

Tietze-Conrat, Elizabeth, 'The Wemyss Allegory in The Art Institute of Chicago', *Art Bulletin*, XXVII, December 1945, pp. 269–71

Tietze-Conrat, Elizabeth, 'Titian's workshop in his late years', *Art Bulletin*, XXVIII, June 1946, pp. 76–88

Tomaselli, Giovanni Battista, *Memorie spettanti alla vita di S. Giovanni Martire Duca d'Alessandria*, Venice 1776

Tomasi Velli, Silvia, 'Federico Barocci, Clemente VIII e la "comunione di Giuda"', *Prospettiva*, LXXXVII–LXXXVIII, July–October 1997, pp. 157–67

Tomory, Peter, *Catalogue of the Italian Paintings before 1800: The John and Mable Ringling Museum of Art*, Sarasota 1976

Tozzi, Rosanna, 'Notizie biografiche su Domenico Tintoretto', *Rivista di Venezia*, XII, June 1933, pp. 299–316

Tozzi, Rosanna, 'Disegni di Domenico Tintoretto', *Bollettino d'Arte*, XXXI, July 1937, pp. 19–31

Tramontin, Silvio, 'La visita apostolica del 1581', *Studi Veneziani*, IX, 1967, pp. 453–533

Tramontin, Silvio, Antonio Niero, Giovanni Musolino and Carlo Candiani, *Culto dei Santi a Venezia*, Venice 1965

Trentini, Francesco, 'Immagini apocalittiche. Toeput, Treviso, il Monte di Pietà', *Venezia Cinquecento*, XIV, no. 27, January–June 2004, pp. 169–225

Triqueti, Henri de, *Les Trois Musées de Londres*, Paris 1861

Trumbull, John, *The autobiography of Colonel John Trumbull: Patriot-Artist, 1756–1843*, ed. Theodore Sizer, New Haven 1953

Urbani de Ghelof, Giuseppe Marino, *Guida storico-artistica della Scuola di S. Giovanni Evangelista*, Venice 1895

Valcanover, Francesco, 'La mostra dei Vecellio a Belluno', *Arte Veneta*, V, 1951, pp. 201–8

Valcanover, Francesco, *Tutta la pittura di Tiziano*, 2 vols, Milan 1960

Valcanover, Francesco, *L'Opera completa di Tiziano*, Milan 1969

Valcanover, Francesco, ed., *Tiziano* (exh. cat. Palazzo Ducale, Venice, 1990), Venice 1990

Valcanover, Francesco, *Tiziano: I suoi Pennelli sempre partorirono espressioni di vita*, Florence 1999

Valeriano, Giovanni Pierio, *Hieroglyphica*, Venice 1556

Valerius Maximus nuper editus, Venice 1534

Valpy's National Gallery of paintings and sculpture: illustrated with forty-six beautiful engravings on steel..., London [1833]

Van der Doort, Abraham, 'Abraham van der Doort's Catalogue of the Collections of Charles I', ed. Oliver Millar, *Walpole Society*, XXXVII (1958–60), 1960

Vasari, Giorgio, *Le vite de' più eccellenti pittori, scultori ed architettori*, ed. Gaetano Milanesi, 9 vols, Florence 1878–85

Vasi, Marien, *Itinéraire instructif de Rome*, Rome 1797

Ventura, Leandro, 'Il Palazzo del Giardino a Sabbioneta e la sua decorazione' in *Vespasiano Gonzaga Colonna 1531–1591: L'uomo e le opere* (Convegno di Studi, Teatro Olimpico di Sabbioneta, 5 June 1999), Viadana 1999, pp. 57–77

Venturi, Adolfo, *Il Museo e la Galleria Borghese*, Rome 1893

Venturi, Adolfo, 'La formazione della Galleria Layard a Venezia', *L'Arte*, XV, no. 57, December 1912, pp. 449–62

Venturi, Adolfo, *La Pittura del Cinquecento* (Part IV of vol. IX of *La Storia dell'Arte Italiana*), Milan 1929

Verci, Giovanni Battista, *Notizie intorno alla Vita e alle Opere de' Pittori, Scultori e Intagliatori della città di Bassano*, Venice 1775

Vertue, George, 'Note books', *Walpole Society*, 6 vols with an Index vol.: XVIII (I, 1930); XX (II, 1932); XXII (III, 1934); XXIV (IV, 1936); XXVI (V, 1938); XXIX (Index to I–V, 1947); XXX (VI, inc. index, 1955)

Vico, Enea, *Discorsi sopra le medaglie de gli antichi*, Venice 1555

Villars, Paul, 'La collection de M. Alfred de Rothschild', *Les Arts*, no. 2, March 1902, pp. 15–23

Volkmann, Johann Jakob, *Historisch-kritische Nachrichten von Italien*, 3 vols, Leipzig 1770–1

Von Effra, H., and Allen Staley, *The Paintings of Benjamin West*, New Haven 1986

Voragine, Jacobus de, *The Golden Legend of Jacobus de Voragine*, translated and adapted from the Latin by Granger Ryan and Helmut Ripperger, 2 vols, New York 1941; 1 vol., 1969

Voss, Hermann, 'A Project of Federico Zuccari for the "Paradise" in the Doges' Palace', *The Burlington Magazine*, XCVI, June 1954, pp. 172–5

Waagen, Gustav Friedrich, *Kunstwerke und Künstler in England und Paris*, 3 vols, Berlin 1837–9

Waagen, Gustav, *Treasures of Art in Great Britain*, 3 vols, London 1854; *Supplemental volume*, London 1857

Waagen, Gustav, *Die Gemäldesammlung in der Kaiserlichen Ermitage zu St. Petersburg*, Munich 1864

Waddell, M.-B., *Evangelicae Historiae Imagines: Entstehungsgeschichte und Vorlagen*, Göteborg 1985

Waddingham, Malcolm R., 'Introduction' in *The Paintings of the Betty and David M. Koetser Foundation*, Zurich 1987

Wainewright, Thomas Griffiths, *Essays and Criticisms*, ed. W. Carew Hazlitt, London 1880

Wake, Jehanne, *Kleinwort Benson: the history of two families in banking*, Oxford 1997

Walpole, Horace, *Aedes Walpolianae*, London 1747

Walpole, Horace, *Correspondence*, ed. W.S. Lewis, vol. 35, New Haven 1973

Walther, Angelo, *et al.*, *Gemäldegalerie Dresden: Alte Meister. Katalog der ausgestellten Werke*, Dresden and Leipzig 1992

Warwick, Frances, Countess of, *Afterthoughts*, London 1931

Waterfield, Giles, 'Teniers' *Theatrum Pictorium*: its genesis and its influence' in Claerbergen 2006, pp. 40–57

Waterhouse, Ellis K., 'Three pictures at Trafalgar Square', *The Burlington Magazine*, L, June 1927, p. 344

Waterhouse, Ellis K., *Titian's Diana and Actaeon* (Charlton lecture), London and New York 1952

Waterhouse, Ellis K., *Gainsborough*, London 1958 (reprinted 1966)

Waterhouse, Ellis K., 'A note on British collecting of Italian pictures in the later seventeenth century', *The Burlington Magazine*, CII, 1960, p. 57

Waterhouse, Ellis K., *Italian Art and Britain* (exh. cat. Royal Academy of Arts, London, 1960), London 1960

Waterhouse, Ellis K., *The Dictionary of British 18th Century Painters in oils and crayons*, Woodbridge 1981

Watney, Simon, *The Art of Duncan Grant*, London 1990

Weber, Gregor, 'Vom Rätsel einer Hieroglyphe zum "Guten Rat" von Pietro Liberi', *Dresdener Kunstblätter*, 5, 1995, pp. 151–7

Webster, James Carson, *The Labors of the months in antique and mediaeval art* (Northwestern Studies in the Humanities, no. 4), Princeton 1938

Weddigen, Erasmus, 'Thomas Philologus Ravennas: Gelehrter, Wohltäter und Mäzen', *Saggi e Memorie di Storia dell'Arte*, IX, 1974, pp. 10–76

Weihrauch, Hans Robert, *Europäische Bronzestatuetten*, Brunswick 1967

Wenley, Robert, *French Bronzes in the Wallace Collection*, London 2002

Westphal, Dorothee, *Bonifazio Veronese*, Munich 1931

Wethey, Harold E., *The Paintings of Titian*, 3 vols: *1. The Religious Paintings*, London 1969; *2. The Portraits*, London 1971; *3. The Mythological and Historical Paintings*, London 1975

Wheeler, Michael, *Ruskin's God*, Cambridge 1999

White, Christopher, *The Dutch Pictures in the Collection of Her Majesty the Queen*, Cambridge 1982

White, Raymond, 'Brown and Black Organic Glazes, Pigments and Paints', *National Gallery Technical Bulletin*, 10, 1986, pp. 58–71

White, Raymond, and Jo Kirby, 'A Survey of Nineteenth- and early Twentieth-Century Varnish Compositions found on a Selection of Paintings in the National Gallery Collection', *National Gallery Technical Bulletin*, 22, 2001, pp. 64–84

Wickhoff, Franz, 'Les Écoles italiennes au Musée Impérial de Vienne (part one), *Gazette des Beaux-Arts*, IX, January 1893, pp. 5–18

Wilde, Johannes, 'Wiedergefundene Gemälde aus der Sammlung den Erzherzogs Leopold Wilhelm', *Jahrbuch der Kunsthistorischen Sammlungen in Wien*, IV, 1930, pp. 245–66

Wilde, Johannes, *Venetian art from Bellini to Titian*, Oxford 1974

Wilson, Carolyn C., 'Domenico Tintoretto's *Tancred Baptizing Clorinda*: A Closer Look', *Venezia Cinquecento*, III, no. 6, July–December 1993, pp. 121–38

Wilson, Carolyn C., 'Francesco Vecellio's "Presepio" for San Giuseppe, Belluno: Aspects and Overview of the Cult and Iconography of St. Joseph in Pre-Tridentine Art', *Venezia Cinquecento*, VI, no. 11, January–June 1996, pp. 39–74

Wilson, Carolyn C., *St. Joseph in Italian Renaissance Society and Art*, Philadelphia 2001

Wind, Edgar, *Pagan Mysteries in the Renaissance*, Harmondsworth 1967

Wine, Humphrey, *The Seventeenth Century French Paintings*, National Gallery Catalogues, London 2001

Wingfield-Stratford, E., *Lords of Cobham Hall*, London 1959

Witemeyer, Hugh, *George Eliot and the Visual Arts*, New Haven and London 1979

Wixom, William D., *Renaissance Bronzes from Ohio Collections* (exh. cat. Cleveland Museum of Art), Cleveland 1975

W. L. [William Lodge], *The Painter's Voyage*, Rome 1679

Woermann, Karl, *Katalog der Königlichen Gemäldegalerie zu Dresden*, Dresden 1876, 1899, 1902

Wood, Jeremy, 'Van Dyck's "Cabinet de Titien": the contents and dispersal of his collection', *The Burlington Magazine*, CXXXII, October 1990, pp. 680–95

Wood, Jeremy, 'The Architectural Patronage of Algernon Percy, 10th Earl of Northumberland' in *English Architecture Public and Private: Essays for Kerry Downes*, ed. J. Bold and E. Chaney, London 1993, pp. 55–80

Wood, Jeremy, 'Van Dyck and the Earl of Northumberland: Taste and Collecting in Stuart England' in Barnes and Wheelock 1994, pp. 281–324

Wornum, Ralph Nicholson, *Descriptive and Historical Catalogue of the pictures in the National Gallery with biographical notices of the painters*, London 1847, 1854, 1857, 1859, 1862 (The 1847 volume was the first of a new style of catalogue made under Eastlake's guidance and including much material by him. Unlike the earlier summary guides it was arranged alphabetically and the inclusion of lives of the artists meant that it also served as a biographical dictionary.)

Worthen, Thomas, 'Tintoretto's Paintings for the Banco del Sacramento in S. Margherita', *Art Bulletin*, LXXVIII, 1996, pp. 707–32

Wunder, Richard P., *Hiram Powers: Vermont sculptor, 1805–73*, 2 vols, Newark and London 1991

Yorke, James, *Lancaster House*, London 2001

Young, John, *A Catalogue of the Pictures at Leigh Court, near Bristol*, London 1822 (Young was responsible for both the plates and the notices)

Zampetti, Pietro, *Jacopo Bassano* (exh. cat. Palazzo Ducale, Venice, 1957), Venice 1957

Zanetti, Anton Maria, *Varie pitture a fresco de' principali maestri veneziani*, Venice 1760

Zanotto, Francesco, *Nuovissima Guida di Venezia*, Venice 1856

Zeri, Federico, assisted by Elizabeth F. Gardner, *Italian Paintings: A Catalogue of the Collection of the Metropolitan Museum of Art: Venetian School*, New York 1973

Zeri, Federico, *Italian Paintings in the Walters Art Gallery*, 2 vols, Baltimore 1976

Zeri, Federico, ed., *Pinacoteca di Brera. Scuola Veneta*, Milan 1990

Zerner, Henri, ed., *Italian Artists of the Sixteenth Century* (*The Illustrated Bartsch*, XXXIII, formerly 16, ii), New York 1979

Zuccaro, Federico, *Scritti d'arte*, ed. D. Heikamp, Florence 1961

Zugni-Tauro, A.P., *Gaspar Diziani*, Venice 1971

A NOTE ON MANUSCRIPT MATERIAL CITED

References are made in the notes to manuscript material (chiefly letters) studied in British family papers – for example, those of the Earls of Carlisle and of the Dukes of Hamilton – and also to material studied in public and church archives in Venice – for example, confraternity manuscripts in the care of the parish of S. Trovaso, the parish records kept in S. Silvestro, and wills, inventories and financial records in the Archivio di Stato di Venezia (here abbreviated to ASV). Most frequent reference, however, is made to the Archive of the National Gallery itself: the minutes of the meetings of the Board of Trustees, with the associated papers, the Gallery accounts, the diary and other papers of Ralph Nicholson Wornum, and above all the notebooks or travel diaries kept by Sir Charles Eastlake on his continental tours between 1852 and 1864 (there is also one for 1830). Since there is more than one notebook for each annual tour, the number of the notebook cited is given in parentheses – thus 'MS notebook 1864 (2)' for the second in 1864. I have published an account of Eastlake's methods and motives for compiling these notebooks in 'Un'introduzione ai taccuini di Sir Charles Eastlake' in Anna Chiara Tommasi, ed., *Giovanni Battista Cavalcaselle: Conoscitore e conservatore* (papers from the Convegno held in 1997 at Legnago, Verona), Venice 1998, pp. 277–89. They are currently being transcribed and edited by Susanna Avery-Quash for publication by the Walpole Society.

Changes of attribution

since the publication of *The Sixteenth Century Italian Schools* **by Cecil Gould in 1975**

OLD ATTRIBUTION	INVENTORY NUMBER	NEW ATTRIBUTION
Ascribed to Damiano Mazza	NG 32	Damiano Mazza
After Paolo Veronese	NG 97	Paolo Veronese
Venetian School, sixteenth century	NG 173	Domenico Tintoretto?
Jacopo Bassano	NG 228	Jacopo Bassano and Workshop
Venetian School, sixteenth century	NG 272	Venetian?
Pasticheur of Federico Zuccari	NG 1241	Pedro Campaña (Peeter de Kempeneer)
Ascribed to Tintoretto	NG 1476	Jacopo Tintoretto?
Ascribed to Andrea Schiavone	NG 1883	Andrea Schiavone
Ascribed to Andrea Schiavone	NG 1884	Andrea Schiavone
Imitator of Paris Bordon	NG 2097	After Paris Bordone
Style of Tintoretto	NG 2147	Venetian
(?) After Francesco Bassano	NG 2148	Workshop or imitator of Jacopo Bassano
Style of Leandro Bassano	NG 2149	Leandro Bassano
Follower of Tintoretto	NG 2161	Follower of Titian
(?) Venetian School, sixteenth century	NG 3107	Lambert Sustris
Style of Bonifazio	NG 3109	Venetian
Style of Bonifazio	NG 3110	Venetian
Titian	NG 4452	Titian and Workshop
Venetian School	NG 5466	Paolo Fiammingo
Venetian School	NG 5467	Paolo Fiammingo
Titian	NG 6376	Titian and Workshop

Index by inventory number

Index

Page numbers in *italics* refer to captions/illustrations. Page numbers in **bold** refer to main section on artist.

Photographic credits

All photographs are © The National Gallery, London, unless otherwise indicated.
Every effort has been made to contact copyright holders of photographs and we apologise for any omissions.

AMIENS © Musée de Picardie, Amiens: p. 118, fig. 1. AUGSBURG © Städtische Kunstsammlungen, Augsburg, Karl und Magdalene Haberstock-Stiftung: p. 48, fig. 3. BASSANO DEL GRAPPA © Courtesy of the Direzione del Museo Biblioteca Archivio di Bassano del Grappa: p. xv, fig. 3; p. 10, fig. 3; p. 31, fig. 3; p. 31, fig. 4; p. 471, fig. 10. BERLIN Gemäldegalerie © Staatliche Museen zu Berlin, Bildarchiv Preussischer Kulturbesitz. Photo: Jörg P. Anders: p. 30, fig. 2; p. 74, fig. 9. Kupferstichkabinett © Staatliche Museen zu Berlin. Photo: Volker-H. Schneider: p. 24, fig. 2. BOSTON, MASSACHUSETTS © 2006 Museum of Fine Arts, Boston: p. 449, fig. 4. BRUSSELS Musées Royaux des Beaux-Arts de Belgique, Brussels © Koninklijke Musea voor Schone Kunsten van België. Photo: Cussac: p. 254, fig. 3. BUDAPEST © Szépművészeti Múzeum, Budapest: p. 294, fig. 2. CAEN © Musée des Beaux-Arts, Caen. Photo: Martine Seyve: p. 124, fig. 1. CAMBRIDGE © The Fitzwilliam Museum, University of Cambridge: p. 12, fig. 6. DRESDEN © Gemäldegalerie Alte Meister, Staatliche Kunstsammlungen Dresden: p. 201, fig. 2; p. 240, fig. 3; p. 437, fig. 8. DUBROVNIK Rector's Palace, Cultural Historical Museum Dubrovnik © Cultural Historical Museum Dubrovnik. Photo: Vlaho Pustic´: p. 59, fig. 3. EDINBURGH © National Galleries of Scotland, Edinburgh: p. 3, fig. 1; Photo Antonia Reeve, Edinburgh: p. 444, fig. 2. FLORENCE Galleria degli Uffizi, Florence © Soprintendenza Speciale per il Polo Museale Fiorentino: p. 72, fig. 5. GÖTEBORG © Göteborgs Konstmuseum. Photo: Ebbe Carlsson: p. 58, fig. 1. KASSEL © Staatliche Museen Kassel: p. 104, fig. 1. LEEDS © By kind permission of the Earl and Countess of Harewood and the Trustees of the Harewood House Trust: p. 456, fig. 6. LONDON The British Museum, London © Copyright The Trustees of The British Museum: p. xviii, fig. 6; p. 12, fig. 5; p. 13, fig. 7; p. 105, fig. 2; p. 120, fig. 2; p. 130, fig. 3; p. 158, figs 4a and b; p. 221, fig. 9; p. 306, fig. 1; p. 390, fig. 1; p. 421, figs 4 and 5. Courtauld Institute of Art Gallery, London © SCT Enterprises Ltd: p. 19, fig. 2; p. 139, fig. 1; p. 139, fig. 2. © Royal Academy of Arts, London: p. xvii, fig. 4. The Royal Collection © 2007, Her Majesty Queen Elizabeth II. Photo: A.C. Cooper: p. 3, fig. 2; p. 18, fig. 1. The Victoria and Albert Museum, London © V&A Images / V&A Museum: p. 240; fig. 2; p. 288, fig. 10. The Wallace Collection, London © By kind permission of the Trustees of the Wallace Collection: p. 200, fig. 1. LOS ANGELES, CALIFORNIA © The J. Paul Getty Museum: p. 281, fig. 4; p. 459, fig. 7. MADRID © Museo Nacional del Prado, Madrid: p. 25, fig. 4; p. 250, fig. 1, p. 281, fig. 3; p. 286, fig. 8; p. 309, fig. 3. MANTUA San Benedetto Po Abbey © Photo: Carlo Perini, S. Benedetto Po: p. 351, figs 3 and 4; p. 352, figs 5 and 6. MODENA Galleria Estense Modena © Archivio Fotografico, Soprintendenza per il Patrimonio Storico Artistico ed Etnoantropologico di Modena e Reggio Emilia. Photo: V. Negro: p. 140, fig. 3. MONTECCHIO MAGGIORE Villa Cordellina Montecchio Maggiore © Photo: Francesco Turio Böhm, Venice: p. 380, fig. 20. MUNICH © Bayerische Staatsgemäldesammlungen, Alte Pinakothek Munich: p. 135, fig. 3; p. 399, fig. 2. NANCY © Musée des Beaux-Arts, Nancy: p. 78, fig. 1; NAPLES Museo Nazionale di Capodimonte, Naples © Soprintendenza Speciale per il Polo Museale Napoletano. Photo: Laura Eboli: p. 202, fig. 3. NEW YORK © Copyright The Frick Collection, New York: p. xxi, fig. 9. The Metropolitan Museum of Art, New York. Photograph © The Metropolitan Museum of Art: p. 241, fig. 4; Photograph © 1983 The Metropolitan Museum of Art: p. 287, fig. 9; The Metropolitan Museum of Art, New York, Harry G. Sperling Fund. 1975 © The Metropolitan Museum of Art, New York: p. 418, fig. 2. NORFOLK, VIRGINIA © Chrysler Museum of Art: p. 348, fig. 2. OXFORD © Copyright in this Photograph Reserved to the Ashmolean Museum, Oxford: p. 108, fig. 1; p. 378, fig. 19. PARIS Musée du Louvre, Paris © RMN, Paris: p. 359, fig. 4; p. 438, fig. 9; © RMN, Paris. Photo: Jean-Gilles Berizzi: p. 150, fig. 5; Photo: Christian Jean: p. 338, fig. 2; Photo: Michèle Bellot: p. 375, fig. 15. PIACENZA Palazzo Farnese, Musei Civici di Palazzo Farnese © Property of the Italian State: p. 391, figs 2 and 3. PRAGUE Art Collections of Prague Castle © Photo Picture Library of Prague Castle: p. 38, fig. 2; PRIVATE COLLECTION © Estate of Duncan Grant/ licensed by DACS 2008: p. 258, fig. 5; Private collection © Photo Courtesy of the owner: p. 19, fig. 3; p. 92, figs 2–4; pp. 436–7, fig. 7; p. 453, fig. 5. Private collection © Courtesy Photo Christie's Images Ltd, London: p. 281, fig. 5; p. 300, fig. 4. © Collection of the Duke of Northumberland. Photo Photographic Survey, Courtauld Institute of Art, London: p. 229, fig. 13. RAVENNA © Ravenna, Museo d'Arte della Città: p. 54, fig. 1. ROME Galleria Borghese, Rome © With kind permission of Archivio Fotografico, Soprintendenza Speciale per il Polo Museale Romano: p. 75, fig. 10; Galleria Nazionale d'Arte Antica di Palazzo Corsini, Galleria Corsini Rome © With kind permission of Archivio Fotografico, Soprintendenza Speciale per il Polo Museale Romano: p. 34, fig. 2. Palazzo Colonna, Rome © ICCD Istituto Centrale per il Catalogo e la Documentazione, Rome: p. 97, fig. 7. © Pinacoteca Capitolina, Rome. Photo: Studio Fotografico Idini: p. 136, fig. 4; p. 436, fig. 6. SARASOTA, FLORIDA © Collection of The John and Mable Ringling Museum of Art, The State Art Museum of Florida: p. 332, fig. 2. SEVILLE Catedral de Santa María de la Sede Seville © Institut Amatller d'Art Hispànic, Arxiu Mas, Barcelona: p. 66, fig. 1. SOUTH HADLEY, MASSACHUSETTS © Mount Holyoke College Art Museum: p. xv, fig. 2. ST PETERSBURG © With permission from The State Hermitage Museum, St Petersburg: p. 151, fig. 7; p. 241, fig. 5. VENICE Church of the Ospedaletto, Venice © Archivio I.R.E. Venezia © Photo: Soprintendenza per i Beni Artistici e Storici di Venezia: p. 88, fig. 1. Church of S. Giorgio Maggiore, Venice © Photo: Francesco Turio Böhm, Venice: p. 180, fig. 2; p. 181, fig. 3. Church of S. Giuliano, Venice © Photo: Francesco Turio Böhm, Venice: p. 160, fig. 5. Church of S. Sebastiano, Venice © Photo: Francesco Turio Böhm, Venice: p. 115, fig. 1; p. 359, fig. 5. Church of S. Silvestro, Venice © Photo: Francesco Turio Böhm, Venice: p. 404, fig. 5. Church of S. Trovaso, Venice; Curia Patriarcale, Venice © Immagine Fotostudio Baldini Treviso, Photo: Luigi Baldini: p. 166, fig. 2; p. 167, fig. 3. © Photo: Francesco Turio Böhm, Venice: p. 132, fig. 1. Gallerie dell'Accademia, Venice © Soprintendenza Speciale per il Polo Museale Veneziano. Courtesy of Ministero per i Beni e le Attività Culturali: p. 44, fig. 1; p. 128, fig. 1; p. 133, fig. 2; p. 146, fig. 3; p. 196, fig. 1. © Hellenic Institute of Byzantine and Postbyzantine Studies, Venice: p. 147, fig. 4. Ospedaletto dei Crociferi, Venice © Photo: Francesco Turio Böhm, Venice: p. 183, fig. 4. Palazzo Ducale, Venice © Photo: Francesco Turio Böhm, Venice: p. 434, fig. 5. Palazzo Vendramin, Venice © Photo: Francesco Turio Böhm, Venice: p. 246, fig. 6. S. Giovanni in Bragora, Venice © Photo: Francesco Turio Böhm, Venice: p. 100, fig. 1. Scuola di S. Giorgio degli Schiavoni © Sarah Quill/ Venice Picture Library / The Bridgeman Art Library: p. 144, fig. 1. VERONA Church of S. Giorgio in Braida, Verona © Soprintendenza per il Patrimonio Storico Artistico ed Etnoantropologico per Verona, Vicenza e Rovigo: p. 330, fig. 1. VERSAILLES Musée National des Châteaux de Versailles et de Trianon © RMN, Paris. Photo: Gérard Blot: p. 381, fig. 21. VICENZA © Pinacoteca Civica di Palazzo Chericati, Vicenza: p. 228, fig. 12. Church of S. Corona, Vicenza © Soprintendenza per il Patrimonio Storico Artistico ed Etnoantropologico per Verona, Vicenza e Rovigo: p. 403, fig. 4. VIENNA © Albertina, Vienna: p. 271, fig. 2. Kunsthistorisches Museum, Vienna © KHM, Vienna p. 59, fig. 2; p. 140, fig. 4; p. 203, fig. 4; p. 294, fig. 1. WASHINGTON, DC © Board of Trustees, National Gallery of Art: p. 282, fig. 6; p. 426, fig. 8; p. 473, fig. 11.